Adobe Photoshop CC for Photographers
2015 Release

A professional image editor's guide to the creative use of Photoshop for the Macintosh and PC

Martin Evening

Focal Press
Taylor & Francis Group

NEW YORK AND LONDON

First published 2016
by Focal Press
70 Blanchard Road, Suite 402, Burlington, MA 01803

and by Focal Press
2 Park Square, Milton Park, Abingdon, Oxon OX14 4RN

Focal Press is an imprint of the Taylor & Francis Group, an informa business

Notices
Knowledge and best practice in this field are constantly changing. As new research and experience broaden our understanding, changes in research methods, professional practices, or medical treatment may become necessary.

Practitioners and researchers must always rely on their own experience and knowledge in evaluating and using any information, methods, compounds, or experiments described herein. In using such information or methods they should be mindful of their own safety and the safety of others, including parties for whom they have a professional responsibility.

Product or corporate names may be trademarks or registered trademarks, and are used only for identification and explanation without intent to infringe.

Library of Congress Cataloging-in-Publication Data
Evening, Martin.
Adobe Photoshop CC for photographers : 2015 release : a professional image editor's guide to the creative use of Photoshop for the Macintosh and PC/Martin Evening.
 pages cm
 1. Adobe Photoshop. 2. Photography--Digital techniques. 3. Computer graphics.
 I. Title.
 TR267.5.A3E94 2015
 006.6'96–dc23 2015012787

ISBN: 978-1-138-91700-2 (pbk)
ISBN: 978-1-315-68929-6 (ebk)

Contents

2 Camera Raw image processing 89

3 Sharpening and noise reduction 265

4 Image editing essentials 317

6 Extending the dynamic range 417

7 Image retouching 453

11 Automating Photoshop 695

Index 713

Please read first

The introduction of the Adobe Creative Cloud has brought with it a number of changes to the way Photoshop and other programs within the Creative Cloud are delivered to Adobe customers. You can choose to subscribe to the Cloud either with a full Cloud subscription, which gives you access to all the programs in the Creative Suite, as a single-product subscriber, or by subscribing to the Photography Plan, which incorporates Lightroom. For some, this 'rental' approach can be more cost effective. The main advantage is that Cloud subscribers are able to access new program features as interim program updates are released. And here is the rub for readers of Photoshop books: as soon as a new version of Photoshop is released there will be these interim updates where new features are added, making all the current books out of date.

This doesn't just affect print books, but associated e-books as well. My response has been to provide bulletin updates of all the latest changes in Photoshop that are relevant to photographers and post these to the book website: photoshopforphotographers.com. You will notice that I have done this since the announcement of Photoshop CS6.1 and will continue to do so as new updates are released. This particular book is an updated edition of the original Adobe Photoshop CC for Photographers, which was first published in 2013. In this version I have updated all the pages where the user interface has changed and included all the latest Photoshop and Camera Raw features that have been added to the program since then.

In revising this book I have had to cut some of the content that was in the previous edition. The Configuring Photoshop and Image Management chapters have been removed and are now provided as PDF chapters on the photoshopforphotographers.com website. The main reason for this was to make way for new content. The content in these two chapters has mostly remained unchanged in the last few versions of the program, especially with Bridge. You will also find lots of other content available from the book website, and you can also be kept fully updated via my Facebook page: facebook.com/MartinEveningPhotoshopAndPhotography.

Introduction

When I first started using Photoshop, it was a much simpler program to get to grips with compared with what we see today. Since then Adobe Photoshop CC has evolved to give photographers all the tools they need. My aim is to provide you with a working photographer's perspective of what Photoshop CC can do and how to make the most effective use of the program.

One of the biggest problems writing a book about Photoshop is that while new features are always being added Adobe rarely removes anything from the program. Hence, Photoshop has got bigger and more complex over the 18 years or so I have been writing this series of books. When it has come to updating each edition this has left the question, "What should I add and what should I take out?" This edition is completely focused on the essential information you need to know when working with Photoshop, Camera Raw and Bridge, plus all that's new in Photoshop CC for photographers.

One of the reasons why this series of Photoshop books has become so successful is because I have come from a professional photography background. Although I have had the benefit of a close involvement with the people who make the Adobe Photoshop program, I make no grandiose claims to have written the best book ever on the subject. Like you, I too have had to learn all this stuff from scratch. I simply write from personal experience and aim to offer a detailed book on the subject of digital photography and Photoshop. It is not a complete guide to everything that's in Photoshop, but it is one of the most thorough and established books out there; one that's especially designed for photographers.

This title was initially aimed at intermediate to advanced users, but it soon became apparent that all sorts of people were enjoying the book. As a result of this, I have over the years adapted the content to satisfy the requirements of a broad readership. I still provide good, solid, professional-level advice, but at the same time I try not to assume too much prior knowledge, and make sure everything is explained as clearly and simply as possible. The techniques shown here are based on the knowledge I have gained from working alongside the Photoshop engineering team at various stages of the program's development as well as some of the greatest Photoshop experts in the industry—people such as Katrin Eismann, the

late Bruce Fraser, Mac Holbert, Ian Lyons, Andrew Rodney, Seth Resnick, Jeff Schewe and Rod Wynne-Powell, who I regard as true Photoshop masters. I have drawn on this information to provide you with the latest thinking on how to use Photoshop to its full advantage. So rather than me just tell you "this is what you should do, because that's the way I do it", you will find frequent references to how the program works and reasons why certain approaches or methods are better than others. These discussions are often accompanied by diagrams and step-by-step tutorials that will help improve your understanding of the Photoshop CC program. The techniques I describe here have therefore evolved over a long period of time and the methods taught in this book reflect the most current expert thinking about Photoshop. What you will read here is a condensed version of that accumulated knowledge. I recognize that readers don't want to become bogged down with too much technical jargon, so I have aimed to keep the explanations simple and relevant to the kind of work most photographers do.

We have recently seen some of the greatest changes ever in the history of photography, and for many photographers it has been a real challenge to keep up with all these latest developments. Photoshop has changed a lot over the years, as has digital camera technology. As a result of this, as each new version of Photoshop comes out I have often found it necessary to revise many of the techniques and workflow steps that are described here. This is in many ways a personal guide and one that highlights the areas of Photoshop that I find most interesting, or at least those which I feel should be of most interest. My philosophy is to find out which tools in Photoshop allow you to work as efficiently and as non-destructively as possible and preserve all of the information that was captured in the original, plus to take into account any recent changes in the program that require you to use Photoshop differently. Although there are lots of ways to approach using Photoshop, you'll generally find with Photoshop that the best tools for the job are often the simplest. I have therefore structured the chapters in the book so that they follow a typical Photoshop workflow. Hopefully, the key points you will learn from this book are that Camera Raw is the ideal, initial editing environment for all raw images (and sometimes non-raw images too). Then, once an image has been optimized in Camera Raw, you can use Photoshop to carry out the fine-tuned corrections, or more complex retouching.

The Ultimate Workshop

Adobe Photoshop CC for Photographers can be considered an 'essentials' guide to working with this latest version of Photoshop. But if you want to take your Photoshop skills to the next level I suggest you might like to take a look at *Adobe Photoshop CS5 for Photographers: The Ultimate Workshop*. This is a book that I co-authored with Jeff Schewe. It mainly concentrates on various advanced Photoshop tricks and techniques and is like attending the ultimate training workshop on Photoshop.

What's different in this book

This version has been re-edited to put most of its emphasis on the Photoshop tools that are most essential to photographers as well as all that's new in Photoshop CC. There are a number of significant changes I would like to point out here. First, the book does not come with a DVD. All additional content is now available online via the photoshopforphotographers.com website. Go to the main page shown below in Figure 1 and click on the 'Access online content' button. Here, you will be able to access movie tutorials to accompany some of the techniques shown in the book and download many of the images to try out on your own.

Since the CS6 edition came out I have removed some sections, such as the chapters on Color Management and Web Output. The content in these had barely changed over the years. In order to make way for new content I decided it was time to remove these and provided them as PDFs on the book website. For example, there is a 32-page printable guide to all the keyboard shortcuts for Photoshop, Camera Raw and Bridge.

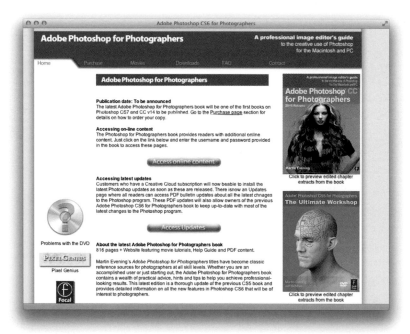

Figure 1 To access the online content, go to photoshopforphotographers.com and click on the 'Access online content' button, which will take you to the Adobe Photoshop for Photographers Help Guide page shown in Figure 2. There is no log-in required, though you will be given the opportunity to sign up for new updates about the book.

Lastly, there is a Tools & Panels section in the Help Guide (Figure 2) with illustrated descriptions of all the tools and panels found in Photoshop.

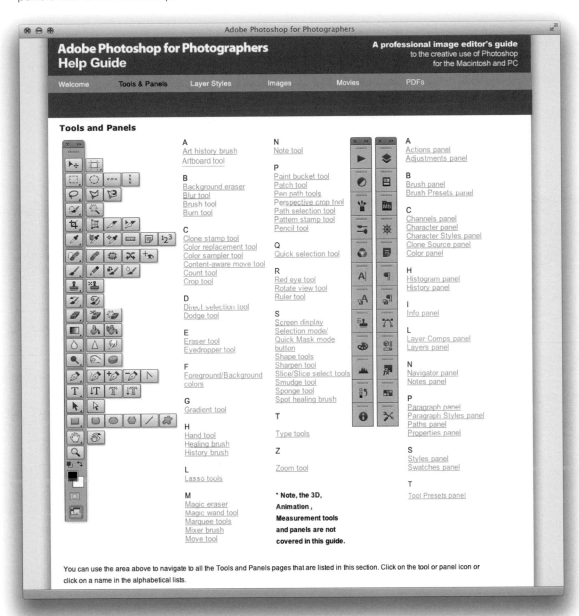

Figure 2 This shows the Tools and Panels section of the *Adobe Photoshop for Photographers Help Guide*, where you can access extra content such as movie tutorials, PDF documents and download some of the images used in this book.

Contacting the publisher/author

For problems to do with the book or to contact the publisher, please email: focalpressmarketing@ taylorandfrancis.com. If you would like to contact the author, please email: martin@martinevening.com. To keep updated via Facebook, go to: facebook.com/ MartinEveningPhotoshopandphotography.

Acknowledgments

I must first thank Andrea Bruno of Adobe Europe for initially suggesting to me that I write a book about Photoshop aimed at photographers. Also, none of this would have got started without the founding work of Adam Woolfitt and Mike Laye who helped establish the Digital Imaging Group (DIG) forum for UK digital photographers. Thank you to everyone at Focal Press: my editor, Kimberly Duncan-Mooney, production editorial manager, Siân Cahill, deputy production editorial manager, Nicola Platt, and editorial assistant, Anna Valutkevich. The production of this book was done with the help of Rod Wynne-Powell, who tech edited the final manuscript and provided me with technical advice, and Soo Hamilton, who did the proofreading. I must give a special mention to fellow Photoshop alpha tester Jeff Schewe for all his guidance and help over the years (and wife Becky), not to mention the other members of the 'pixel mafia': Katrin Eismann, Seth Resnick, Andrew Rodney, and Bruce Fraser, who sadly passed away in December of 2006.

Thank you also to the following clients, companies and individuals: Adobe Systems Inc., Peter Andreas, Amateur Photographer, Neil Barstow, Russell Brown, Steve Caplin, Jeff Chien, Kevin Connor, Harriet Cotterill, Eric Chan, Chris Cox, DPReview, Eylure, Claire Garner, Greg Gorman, Mark Hamburg, Peter Hince, Thomas Holm, Ed Horwich, David Howe, Bryan O'Neil Hughes, Carol Johnson, Julieanne Kost, Peter Krogh, Tai Luxon, Ian Lyons, John Nack, Thomas Knoll, Bob Marchant, Marc Pawliger, Pixl, Herb Paynter, Eric Richmond, Addy Roff, Gwyn Weisberg, Russell Williams, What Digital Camera and X-Rite. Thank you to the models, Jasmin, Kat, Kelly and Sundal who featured in this book, plus my assistants Harry Dutton and Rob Cadman. Thank you to reader Richard Crack who provided some useful design tips for the book redesign. And thank you too to everyone who has bought my book. I am always happy to respond to readers' emails and hear comments good or bad (see sidebar).

Lastly, thanks to all my friends and family, my wife, Camilla, who has been so supportive over the last year, and especially my late mother for all her love and encouragement.

Martin Evening, June 2015

Chapter 1

Photoshop fundamentals

Let's begin by looking at some of the essentials of working with Photoshop, such as how to install the program, the Photoshop interface, what all the different tools and panels do, as well as introducing the Camera Raw and Bridge programs. You can also use this chapter as a reference, as you work through the remainder of the book.

This latest version of Photoshop is formally known as 'Photoshop CC'. Unlike Photoshop CS6 and earlier programs, this version is only available if you take out a subscription to the Creative Cloud using one of the available subscription plans. Since the first release of Photoshop CC, several updates have been released for Photoshop CC and Camera Raw. This edition of the book incorporates all the latest updates up until the 2015 release of Photoshop CC.

Photoshop installation

Installing Photoshop (Figure 1.2) is as easy as installing any other application on your computer, but do make sure any other Adobe programs or web browsers are closed prior to running the installation setup. You will be asked to enter your Adobe ID, or create a new Adobe ID account. This is something that has to be done in order to activate Photoshop and is done to limit unauthorized distribution of the program. Basically, the standard license entitles you to run Photoshop on up to two computers, such as a desktop plus a laptop.

Figure 1.1 This shows the Migrate Settings dialog that allows you to import custom preset settings created in older versions of Photoshop. Details of how to do this can be found in the 'Configuring Photoshop' PDF on the book website.

Figure 1.2 The Photoshop installer procedure is more or less identical on both Mac and PC systems. As you run through the installation process you will be asked to register the program by entering your Adobe ID or create a new Adobe ID account. If installing on a machine running an older version of Photoshop, you will also be asked if you wish to migrate saved user preset settings from the older program (see Figure 1.1).

New Welcome experience

Once Photoshop has launched you will then see the Welcome screen, which is shown in Figure 1.3 below. This has several tabs such as the New Features section. This contains tutorials to help you learn about some of the new features in Photoshop. The Create section (Figure 1.4) offers a list of new document presets plus an Open Recent list of documents you have opened most recently in Photoshop. At the bottom of the Create panel are links you can use to get further help or information about the program. To prevent the Welcome screen from appearing, there is a 'Do Not Show Welcome Screen On Launch' option in the Photoshop General Preferences.

Figure 1.3 The Welcome screen showing New Features.

Figure 1.4 The Welcome screen showing the Create options.

Default workspace

The default workspace setting for PC and Macintosh uses the Application frame shown in Figures 1.5 and 1.6. If you go to the Window menu and deselect 'Application Frame', you can switch to the classic layout where the panels appear floating on the desktop.

The Photoshop interface

The Photoshop CC interface shares the same design features as all the other CC creative suite programs, which makes it easier to switch from working in one CC program to another. You can also work with the Photoshop program as a single application window on both the Mac and PC platforms (Figures 1.5 and 1.6). This arrangement is more in keeping with the interface conventions for Windows, plus you also have the ability to open and work with Photoshop image documents as tabbed windows. Note that since the Application bar was removed in CS6, the Workspace options can be accessed via the Options bar. Meanwhile, the document layout options are now solely available via the Window ⇨ Arrange menu (circled).

Tools panel Tabbed window document Options bar Mac OS menu Photoshop panels Workspace options

Figure 1.5 This shows the Photoshop CC Application Frame view for Mac OS X (also known simply as 'osx'), using the default, dark UI settings. To switch between the classic mode and the Application Frame workspace, go to the Window menu and select or deselect the Application Frame menu item.

Tools panel Tabbed window document Windows OS menu Options bar Photoshop panels Workspace options

Figure 1.6 The Photoshop CC interface for the Windows OS. This has been captured using the middle light gray theme and the Photography workspace setting.

The Photoshop panels are held in placement zones with the Tools panel normally located on the left, the Options bar running across the top and the other panels arranged on the right, where they can be docked in various ways to economize on the amount of screen space that's used yet still remain easily accessible. This default arrangement presents the panels in a docked mode, but over the following few pages we shall look at ways you can customize the Photoshop interface layout. For example, you can reduce the amount of space that's taken up by the panels by collapsing them into compact panel icons (see Figures 1.27 and 1.28).

Custom settings

In the New Document dialog you can set a custom color as the background color. It includes a color swatch and Other... option, allowing you to choose a color via the Color Picker. The Advanced section also allows you to select a color profile and pixel aspect ratio.

Pixel Aspect Ratio

The Pixel Aspect Ratio is to aid multimedia designers who work with stretched screen video formats. If a 'non-square' pixel setting is selected, Photoshop creates a scaled document which previews how a normal 'square' pixel Photoshop document will display on a stretched wide screen. The title bar adds [scaled] to the end of the file name to remind you are working in this special preview mode. The scaled preview can be switched on or off by selecting the Pixel Aspect Correction item from the View menu.

Creating a new document

To create a new document in Photoshop with a blank canvas, go to the File menu and choose New... This opens the dialog shown in Figure 1.7, where you can select a preset setting type from the Preset pop-up menu followed by a preset size option from the Size menu. When you choose a preset setting, the resolution adjusts automatically depending on whether it is a preset intended for print or one intended for computer screen type work (you can change the default resolution settings for print and screen in the Units & Rulers Photoshop preferences). Alternatively, you can manually enter dimensions and resolution for a new document in the fields below.

The Advanced section lets you do extra things like choose a specific profiled color space. After you have entered the custom settings in the New Document dialog these can be saved by clicking on the Save Preset... button. In the New Document Preset dialog shown below, you will notice that there are also some options that will allow you to select which attributes are to be included in a saved preset.

Note that if you make a selection, such as Select All and follow this with Edit Copy, when you choose New Document it will do so using the same pixel dimensions as the selection. This also retains the same color space.

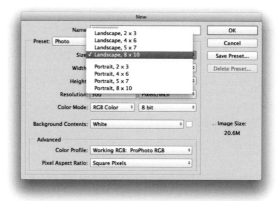

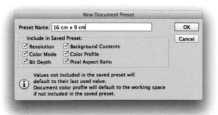

Figure 1.7 When you choose File ⇨ New, this opens the New document dialog shown here (top left). Initially, you can go to the Preset menu and choose a preset setting such as: Photo, Web or Film & Video. Depending on the choice you make here, this will affect the size options that are available in the Size menu (shown top right). If you use the New document dialog to configure a custom setting, you can click on the Save Preset... button to save this as a new Document preset (left). When you do this the new document preset will appear listed in the main preset menu (top left).

Tabbed document windows

Let's now look at the way document windows can be managed in Photoshop. The default preference setting forces all new documents to open as tabbed windows, where new image document windows appear nested in the tabbed document zone, just below the Options bar. In Figure 1.8 I have highlighted the tabbed document zone in yellow, where I had four image documents open. This approach to managing image documents can make it easier to locate a specific image when you have several image documents open at once. To select an open image, you simply click on the relevant tab to make it come to the front. When documents aren't tabbed in this way, you'll often have to click and drag on the document title bars to move the various image windows out of the way until you have located the image document you were after.

Of course, not everyone likes the idea of tabbed document opening and if you find this annoying you can always deselect the 'Open Documents as Tabs' option in the Workspace preferences (circled in Figure 1.9). This allows you to revert to the old behavior where new documents are opened as floating windows. On the other hand you can have the best of both worlds by clicking on a tab and dragging it out from the docked zone. This action lets you easily convert a tabbed document to a floating window (as shown in Figure 1.10). Alternatively, you can right mouse-click on a tab to access the contextual menu from where you can choose from various window command options such as 'Move to a New Window', or 'Consolidate All to Here'. The latter gathers all floating windows and converts them into tabbed documents. You can also use the N-up display options (see Figure 1.12) to manage the document windows.

With Mac OS X, you can mix having tabbed document windows with a classic panel layout. If you disable the Application Frame mode (Figure 1.5) and use the Open Documents as Tabs preference or the 'Consolidate All to Here' contextual menu command, you can still have the open windows arranged as tabbed documents.

Graphics display performance

If the video card in your computer has OpenGL and you have 'Use Graphics Processor' selected in the Photoshop Performance preferences and in the Advanced Settings you have 'Use OpenCL' checked, you can take advantage of the OpenCL features that are supported in Photoshop. For example, when enabled you will see smoother-looking images at all zoom display levels, plus you can temporarily zoom back out to fit to screen using the Bird's-eye view (page 59), or use the Rotate view tool to rotate the on-screen image display (see page 61).

Dual display setup

Those users who are working with a dual display setup will notice that new documents are opened on whichever display the current target document is on.

Reveal in Finder

Mac OS X users will also see a 'Reveal in Finder' option in the document tab contextual menu for pre-existing (saved) images (see Figure 1.10).

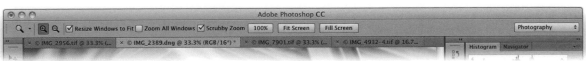

Figure 1.8 The default Photoshop behavior is for image documents to open as tabbed windows (highlighted here in yellow), docked to the area just below the Options bar. Click on a tab to make a window active and click on the 'X' to close a document window.

Figure 1.9 The Photoshop Workspace preferences.

Figure 1.10 This screen shot shows the two ways you can convert a tabbed document to a floating window, either by dragging a tab out from the tabbed windows zone, or by using the contextual menu.

Managing document windows

Documents can also be tabbed into grouped document windows by dragging one window document across to another (see Figure 1.11). You can also manage the way multiple document windows are displayed on the screen. For example, multiple window views are useful if you wish to compare different soft proof views before making a print (see Chapter 10 for more about soft proofing in Photoshop). With floating windows you can choose Window ⇨ Arrange ⇨ Cascade to have all the document windows cascade down from the upper left corner of the screen, or choose Window ⇨ Arrange ⇨ Tile to have them appear tiled edge to edge. With document windows (tabbed or otherwise) you can use the Window ⇨ Arrange menu to choose any of the 'N-up' options that are shown in Figure 1.12. This lets you choose from one of the many different document window layout options available from this menu.

Switching between windows

The ⌘ ` (Mac), ctrl ` (PC) shortcut can be used to toggle between open window documents and use ⌘ Shift ` (Mac), ctrl Shift ` (PC) to reverse the order.

Dragging layers between tabs

To drag layers between tabbed documents you need to select the move tool and drag the image (or layer) from the selected document to the tab of the target document. Wait a few seconds and then (very importantly) you have to drag down from the tab to the actual image area and release to complete the move.

Figure 1.11 Floating windows can be grouped as tabbed document windows by dragging the title bar of a document across to another until you see a blue border (as shown above). You can also click on the title bar (circled in red) to drag a group of tabbed document windows to the tabbed windows zone.

Figure 1.12 This shows the 'N-up' display options for tabbed document windows.

Synchronized scroll and zoom

In the Window ⇨ Arrange submenu (Figure 1.13), there are further menu controls that allow you to match the zoom, location (and rotation) for all document windows, based on the current foreground image window. The Match Zoom command matches the zoom percentage based on the current selected image, while the Match Location command matches the scroll position. You can also synchronize the scrolling or magnification by depressing the *Shift* key as you scroll or zoom in and out of any window view.

It is also possible to create a second window view of the image you are working on, where the open image is duplicated in a second window. For example, you can have one window with an image at a Fit to Screen view and the other zoomed in on a specific area. Any changes you make to the image can be viewed simultaneously in both windows (see Figure 1.13).

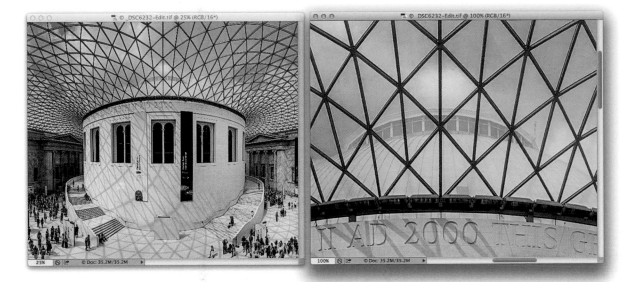

Figure 1.13 To open a second window view of a Photoshop document, choose Window ⇨ Arrange ⇨ New Window for (document name). Any edits that are applied to one document window are automatically updated in the second window preview.

Image document window details

The boxes in the bottom left corner of the image window display extra information about the image (see Figure 1.14). The left-most box displays the current zoom scale percentage for the document view. Here, you can type in a new percentage for any value you like from 0.2% to 1600% up to two decimal places and set this as the new viewing resolution. The Zoom status box also has a scrubby slider option. If you hold down the ⌘ (Mac), *ctrl* (PC) key as you click inside the Zoom status box you can dynamically zoom in and out as you drag left or right, and at double the speed with the *Shift* key held down as well (the zoom tool Options bar also offers a scrubby zoom option, which I describe later on page 58). In the middle is the Adobe Drive button that can be used to check in or check out a document that is being shared over an Adobe Drive linked server (Adobe Drive needs to be installed and enabled).

Figure 1.14 The document status is shown in the bottom left corner of the document window. ⌘ (Mac), *ctrl* (PC)-clicking inside the Zoom status box allows you to access the scrubby slider feature.

Adobe Drive (formerly Version Cue)

Current Adobe Drive status.

Document Sizes

The first figure represents the file size of a flattened version of the image. The second shows the size if saved including all layers.

Document Profile

The color profile assigned to the document.

Document Dimensions

This displays the physical image dimensions, as would be shown in the Image Size dialog box.

Measurement Scale

Shows measurement scale units.

Scratch Sizes

First figure shows amount of RAM memory used. Second figure shows total RAM memory available to Photoshop after taking into account the system and application overhead.

Efficiency

This summarizes how efficiently Photoshop is working. Basically it provides a simplified report on the amount of scratch disk usage.

Timing

Displays the time taken to accomplish a Photoshop step or the accumulated timing of a series of steps. Every time you change tools or execute a new operation, the timer resets itself.

Current Tool

This displays the name of the tool you currently have selected. This is a useful aide-mémoire for users who like to work with most of the panels hidden.

32-bit Exposure

This Exposure slider control is only available when viewing 32-bit mode images.

Save Progress

Shows the current background save status.

Smart Objects

Shows the current Smart Objects status.

To the right of this is the status information box, which can be used to display information about the image. If you mouse down on the arrow to the right of this box, you will see a list of all the items you can choose to display here (see Figure 1.15).

If you mouse down in the status information box, this displays the width and height dimensions of the image along with the number of channels and image resolution. If you hold down the ⌘ (Mac), *ctrl* (PC) key as you mouse down on the status information box, this will show the image tiling information.

⌘-click on this proxy icon to reveal the path to file from the disk volume (Mac only)

Figure 1.15 This shows the window layout of a Photoshop document as it appears on the Macintosh. If you mouse down in the status information box, this displays the file size and resolution information. If you hold down ⌘ (Mac), *ctrl* (PC) key as you mouse down in the status information box, this displays the image tiling information. Lastly, if you mouse down on the arrow icon next to the status information box, you can select the type of information you wish to see displayed there (the Status items are described on the right).

Title bar proxy icons (Mac only)

Macintosh users will see a proxy image icon in the title bar of any floating windows. The proxy icon appears dimmed when the document is in an unsaved state and is reliant on there being a preview icon saved with the image. For example, many JPEGs will not have an icon until they have been resaved. If you hold down the ⌘ key and mouse down on the proxy icon in the title bar you will see a directory path list like the one shown in Figure 1.15. You can then use this to navigate and select a folder location from the directory path and open it in the Finder.

Info panel status information

The status information box can only show a single item at a time. However, if you open the Info panel options shown below in Figure 1.16, you can check any or all of the Status Information items shown here so that the items that are ticked appear in the middle section of the Info panel. In addition to this, you can choose to enable 'Show Tool Hints'. These appear at the bottom of the Info panel and will change according to any modifier keys you have held down at the time, to indicate any extra available options.

Figure 1.16 If you go to the Info panel options menu (circled) and choose Panel Options… this opens the Info Panel Options dialog. Here, you can choose which Status items you would like to see displayed in the Status Information section of the Info panel. The above Info panel screen shot shows all the Status Information items along with the 'Show Tool Hints' info display.

View menu options

The View Extras items can also be selected via the View menu. To turn ruler visibility on or off, choose View ⇨ Rulers (⌘ R [Mac], *ctrl* R [PC]) and use the View ⇨ Show submenu to toggle the visibility of the Guides (⌘ ; [Mac], *ctrl* ; [PC]), or Grid (⌘ ' [Mac], *ctrl* ' [PC]). If a tick mark appears next to an item in the View ⇨ Show menu, it means it is switched on. Select the item in the menu again and release the mouse to switch it off.

Figure 1.17 The New Guide dialog.

Figure 1.18 This shows an image displaying the rulers and guides. To place a new guide first choose View ⇨ Rulers. You can then drag from either the horizontal or vertical ruler to place a new guide. If you hold down the *Shift* key as you drag, this makes the guide snap to a ruler tick mark (providing View ⇨ Snap is checked). If you hold down the *alt* key as you drag this allows you to switch dragging a horizontal guide to dragging it as a vertical (and vice versa). Lastly, you can use ⌘ H (Mac), *ctrl* H (PC) to toggle hiding/showing all extras items, like Guides (assuming you haven't assigned this shortcut to Hide Photoshop [see Figure 1.45]).

Rulers, Guides & Grid

Guides can be added at any time to an image document and flexibly positioned anywhere in the image area (see Figure 1.18). To add a new guide, the rulers will need to be displayed and you just need to mouse down on the ruler bar and drag a new guide out and then release the mouse to drop the guide in place. Once positioned, guides can be used for the precise positioning and alignment of image elements. If you are not happy with the placement of a guide, you can select the move tool and drag the guide to the exact required position. But once positioned, it is sometimes a good idea to lock all guides (View ⇨ Lock Guides) to avoid accidentally moving them again. You can also place a guide using View ⇨ New Guide… and in the New Guide dialog (Figure 1.17) enter an exact position for either the horizontal or vertical axis. The Grid (which is shown in Figure 1.23) provides a means for aligning image elements to a horizontal and vertical axis (to alter the grid spacing, open the Photoshop preferences and select Guides & Grid). If the ruler units need altering, just right mouse-click on one of the rulers and select a new unit of measurement. If the rulers are visible but the guides are hidden, dragging out a new guide will make all the other hidden guides reappear again.

Additional Guides features

Photoshop CC now includes two new submenu items in the View menu that relate to guides (see Figure 1.19).

New Guide Layout dialog

The View ⇨ New Guide Layout dialog can be used to create multiple guides in one step. Using the New Guide Layout dialog you can specify columns, rows, gutters and margins and save and custom layouts as presets. Figure 1.21 shows the New Guide Layout dialog using the default 8 column setting, which is shown below in Figure 1.22. You can select different column settings from the Preset menu (Figure 1.20).

Figure 1.19 The View menu showing the New Guide Layout and New Guides From Shape options.

Figure 1.21 The New Guide Layout dialog.

Figure 1.20 The New Guide Layout dialog Preset menu options.

Figure 1.22 An example of an image with a new guide layout added.

New Guides from Shapes

The New Guides From Shape option allows you to quickly create guides according to the edges of selected layers and selected shapes within a shape layer, as shown in the steps below. Hidden layers should always be ignored.

1 This shows a layout in Photoshop made up of two background gradients, two logo layers and an arrow shape layer.

2 In this step I selected the Photoshop icon layer group and chose View ⇨ New Guides from Shape. This added the guides shown here.

3 Next, I selected the Arrow shape layer group and again chose View ⇨ New Guides from Shape. This added more guides based on the arrow shape outline.

Figure 1.23 The Grid view can be enabled by choosing View ⇨ Show ⇨ Grid. When the Grid view is switched on it can be used to help align objects to the horizontal and vertical axis.

'Snap to' behavior

The Snap option in the View menu allows you to toggle the 'snap to' behavior for the Guides, Grid, Slices, Document bounds and Layer bounds. The shortcut for toggling the 'snap to' behavior is ⌘ _Shift_ _;_ (Mac), _ctrl_ _Shift_ _;_ (PC). When the 'snap to' behavior is active and you reposition an image, type or shape layer, or use a crop or marquee selection tool, these will snap to one or more of the above. It is also the case that when 'snap to' is active, and new guides are added with the _Shift_ key held down, a guide will snap to the nearest tick mark on the ruler, or if the Grid is active, to the closest grid line. Objects on layers will snap to position when placed within close proximity of a guide edge. Also, when dragging a guide, it will snap to the edge of an object on a layer at the point where the opacity is greater than 50%. Also note that when Smart Guides are switched on in the View ⇨ Show menu, these can help you align layers as you drag them with the move tool.

Pixel Grid view

The Pixel Grid view described in Figure 1.24 can only be seen if you have OpenCL enabled and the Pixel Grid option selected in the View menu. It is useful when editing things like screen shots and can, for example, aid the precise placement of the crop tool.

'Snap to' override

If you are placing a Guide close to an edge and the 'Snap to' function proves to be a problem, temporarily hold down the _ctrl_ key (Mac), or right mouse (PC). This will allow a Guide to be placed close to an edge, but not snap to it.

Figure 1.24 The Pixel Grid view can be enabled by going to the View ⇨ Show menu and selecting 'Pixel Grid'. When checked, Photoshop displays the pixels in a grid whenever an image is inspected at a 500% magnification or greater.

Figure 1.25 Photoshop panels can be collapsed with a double-click in the panel tab area (circled in red), while a double-click on the panel header (circled in blue) shrinks the panel to the compact panel size shown here. Or even smaller, if you drag the panel sides inward.

The Photoshop panels

The default workspace layout settings place the panels in a docked layout where they are grouped into column zone areas on the right. However, the panels can also be placed anywhere on the desktop and repositioned by mousing down on the panel title bar (or panel icon) and dragging them to a new location. A double-click on the panel tab (circled red in Figure 1.25) compacts the panel upwards and double-clicking on the panel tab area unfurls the panel again. A double-click on the panel header bar (circled blue in Figure 1.25) collapses the panel into the compact icon view mode and double-clicking on the same panel header expands the panel again. Some panels, such as the Layers panel, can be resized horizontally and vertically by dragging the bottom right corner tab, or by hovering the cursor over the left, right or bottom edge and dragging. Others, such as the Info panel, are of a fixed height, where you can only adjust the width of the panel by dragging the side edges or the corner tab.

Panels can be organized into groups by mousing down on a panel tab and dragging it across to another panel (see Figure 1.26). When panels are grouped in this way they'll look a bit like folders in a filing cabinet. Just click on a tab to bring that panel to the front of the group and to separate a panel from a group, mouse down on the panel tab and drag it outside the panel group again.

Figure 1.26 To group panels together, mouse down anywhere on the panel header and with the mouse held down, drag the tab across to another panel, or group of panels (a blue surround appears when you are within the dropping zone) and release the mouse once it is inside the other panels. To remove a panel from a group, mouse down on the panel tab and drag it outside the panel group.

Panel arrangements and docking

The default 'Essentials' workspace arranges the panels using the panel layout shown in Figure 1.5 (at the beginning of this chapter), but there are quite a few other different workspace settings you can choose from. It is also easy to create custom workspace settings by arranging the panels to suit your own preferred way of working and save these as a new setting. Panels can be docked together by dragging a panel to the bottom or side edge of another panel. In Figure 1.27 you can see how a thick blue line appears as a panel is made to hover close to the edge of another panel. Release the mouse at this point and the panel will become docked to the side or to the bottom of the other panels.

When panels are compacted (as shown in the bottom example in Figure 1.28), you can drag on either side of the panel to adjust the panel's width. At the most compact size, only the panel's icon is displayed, but as you increase the width of a panel (or column of panels), the panel contents expand and you'll get to see the names of the panels appear alongside their icons (see Figure 1.28).

Just remember if you can't find a particular panel, then it may well be hidden. If this happens, go to the Window menu, select the panel name from the menu and it will reappear again on the screen. It is worth remembering that the `Tab` key shortcut (also indicated as `⇥` on some keyboards) can be used to toggle hiding and showing all the panels, while `Tab` `Shift` toggles hiding/showing all the currently visible panels except for the Tools panel and Options bar. These are really useful shortcuts to memorize. So, if you are working in Photoshop and all your panels seem to have disappeared, just try pressing `Tab` and they'll be made visible again.

In the Figure 1.29 example, the tabbed image document fills the horizontal space between the Tools panel on the left and the three panel columns on the right. I have also shown here how you can mouse down on the column edge to adjust the column width (see the double arrow icon that's circled in red). Photoshop panels can be grouped into as many columns as you like within the application window, or positioned separately outside the application window, such as on a separate display (see 'Working with a dual display setup' on page 25).

Figure 1.27 As you reposition a panel and prepare to dock it inside or to the edges of the other panels, a thick blue line indicates that, when you release the mouse, this is where the panel will attach itself.

Figure 1.28 When panels are docked you can adjust the width of the panels by dragging anywhere along the side edge of the panels.

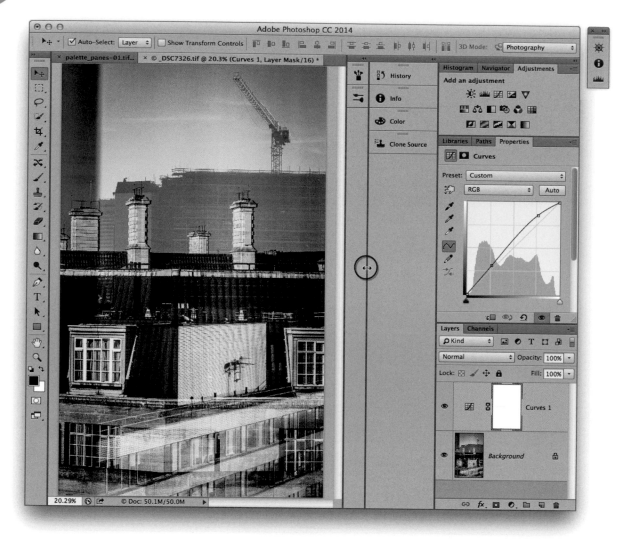

Figure 1.29 This shows a multi-column workspace layout with some of the panels grouped in a docked, compact icon layout, outside the main application window.

Closing panels

To close a panel, click on the close button in the top left corner (or choose 'Close' from the panel options fly-out menu).

Panel positions remembered in workspaces

Photoshop is able to remember panel positions after switching workspaces. When you select a workspace and modify the layout of the panels, the new layout position is remembered when you next choose to use that particular workspace.

Customizing the menu options

As the number of features in Photoshop has grown over the years, the menu choices have become quite overwhelming and this is especially true if you are new to Photoshop. However, if you go to the Edit menu and choose Menus..., this opens the Keyboard Shortcuts and Menus dialog shown in Figure 1.31, where you can customize the menu options and decide which menu items should remain visible. This Customize menu feature is like a 'make simpler' command. You can hide those menu options you never use and apply color codings to the menu items you do use most (so they appear more prominent). The philosophy behind this feature is: 'everything you do want with nothing you don't'. For example, in Figure 1.30 I applied a custom menu setting in which some new Photoshop CC menu items were color coded blue. You can easily create your own menu settings, but note that if you set up the Menu options so that specific items are hidden from view, a 'Show All Menu Items' command will appear at the bottom of the menu list. You can select this menu item to restore the menu so that it shows the full list of menu options again.

Help menu searches

Here is an interesting tip for Mac users who are running Mac OS X. If you go to the Photoshop Help menu and start typing the first few letters for a particular menu command, the Help menu lists all the available menu options. Now roll the mouse over a search result: Photoshop locates the menu item for you and points to it with an arrow.

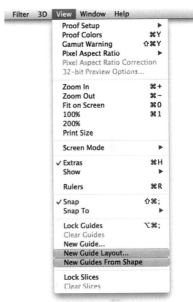

Figure 1.30 This shows a custom menu setting in use that color codes in blue some of the menu items that are new to this version of Photoshop.

Figure 1.31 The Keyboard Shortcuts and Menus dialog.

Creating workspace shortcuts

If you scroll down to the Window section in the Keyboard Shortcuts for Application Menus, you will see a list of all the currently saved Workspace presets. You can then assign keyboard shortcuts for your favorite workspaces. This will allow you to jump quickly from one workspace setting to another by using an assigned keyboard shortcut.

Customizing the keyboard shortcuts

While you are in the Keyboard Shortcuts and Menus dialog, you can click on the Keyboard Shortcuts tab to reveal the keyboard shortcut options shown below in Figure 1.32 (or you can go to the Edit menu and choose Keyboard Shortcuts…). In this dialog you first select which type of shortcuts you want to create, i.e. Application Menus, Panel Menus or Tools. You can then navigate the menu list, click in the Shortcut column next to a particular menu item and hold down the combination of keys you wish to assign as a shortcut for that particular tool or menu item. Now the thing to be aware of here is that Photoshop has already used up nearly every key combination there is, so you are likely to be faced with the choice of reassigning an existing shortcut, or using multiple modifier keys such as: ⌘ ⌥ Shift (Mac), or ctrl alt Shift (PC) plus a letter or Function key, when creating any new shortcuts.

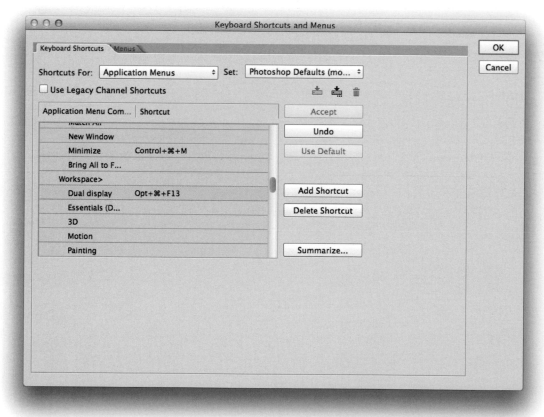

Figure 1.32 The Keyboard Shortcuts and Menus dialog showing the keyboard shortcut options for the Photoshop Application Menus commands.

Task-based workspaces

You can use workspaces to access alternative panel layouts, tailored for different types of Photoshop work, such as the Photography workspace example shown in Figure 1.35. You can also save a current panel arrangement as a new custom workspace via the Options bar Workspace list menu or by going to the Window menu and choosing Workspace ⇨ New Workspace… This opens the dialog box shown in Figure 1.34, which asks you to select the items you would like to have included as part of the workspace (the workspace settings can also include specific keyboard shortcuts and menu settings). The saved workspace will then appear added to the Options bar Workspace list (see Figure 1.33). Here, you will also be

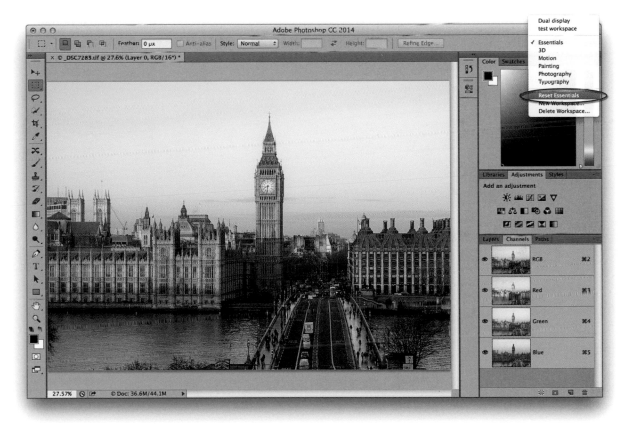

Figure 1.33 The Workspace list settings can be accessed via the Application bar menu (shown here), or via the Window ⇨ Workspace submenu. Workspace settings are automatically updated as you modify them. However, to reset a workspace back to the default setting, you can do so via the Workspace list menu (circled above).

able to choose 'Reset Workspace', to restore the workspace settings (this can be particularly useful if you have just altered the computer display resolution).

Another improvement has been to force all workspace settings to include panel locations and have them update as you modify the layout you are working in. This means if you select a workspace and fine-tune the panel layout or other settings, these tweaks are updated automatically. When you switch to another workspace and then go back to the original workspace, the updated settings are remembered (although you do have the option of reverting to the original saved setting). As you can see in Figure 1.34, saving keyboard shortcuts and menus is optional and the way things stand now, if you choose not to include these settings as part of the workspace, the menu and keyboard shortcuts used in the last selected workspace remain sticky. Let's say you save a custom workspace that excludes saving menus and shortcuts. If you switch to a workspace setting that makes use of specific menus or keyboard shortcuts and switch back again you can add these menu and shortcuts settings to the current workspace setting (until you reset).

Figure 1.34 The Save Workspace menu can be used to save custom panel workspace setups. These can be recalled by revisiting the menu and highlighting the workspace name. To remove a workspace, choose Delete Workspace… from the menu.

Figure 1.35 Here is an example of the Photography workspace in use.

Working with a dual display setup

If you have a second computer display, you can arrange things so that all panels are placed on the second display, leaving the main screen clear to display the image document you are working on. Figure 1.36 shows a screen shot of a dual display panel layout workspace that I use with my computer setup. In this example I have ensured that only the panels I use regularly are visible. The important thing to remember here is to save a custom panel layout like this as a workspace setting so that you can easily revert to it when switching between other workspace settings.

Figure 1.36 This shows an example of how you might like to arrange the Photoshop panels on a second display, positioned alongside the primary display.

Automating Photoshop

Why waste your time performing repetitive tasks when Photoshop is able to automate these processes for you? By using the Actions panel you can record steps in Photoshop as an action and use this to replay on other images. Figure 1.37 shows a screen shot of the Actions panel, where it currently displays an expanded view of the Default Actions set. As you can see from the descriptions, these actions can perform automated tasks such as adding a vignette to a photo or creating a wood frame edge effect. OK, these are not exactly the sort of actions you would use every day, but if you go to the panel fly-out menu you will see listed in the fly-out menu a number of action sets that are worth installing.

To run an action, you will usually need to have a document already open in Photoshop and press the Play button. It is also quite easy to record your own custom actions, and once you get the hang of how to do this you can use the File ⇨ Automate ⇨ Batch… command to apply recorded actions to several images at once. You can also go to the File ⇨ Automate menu and choose 'Create Droplet…'. Droplets are like self-contained batch action operations located in the Finder/Explorer. All you have to do is drag an image file to a droplet to initiate a Photoshop action process (see Figure 1.38). I explain later in Chapter 11 how to automate Photoshop and make efficient use of actions.

By saving and loading actions it is easy to share your favorite Photoshop actions with other users—all you have to do is to double-click an action icon to automatically install it in the Actions panel, and if Photoshop is not running at the time, this will also launch the program.

Figure 1.37 The Actions panel.

Allow tool recording

In the Actions panel fly-out menu there is an item called: Allow Tool Recording. When this is checked Photoshop allows you to record things like brush strokes as part of an action. There are some limitations to this feature, but providing the images you record and play back the action on have the same pixel dimensions, it will work as expected.

Figure 1.38 With Photoshop droplets you can apply a batch action operation by simply dragging and dropping an image file or a folder of images onto a droplet that has been saved to the Finder/Explorer.

Figure 1.39 On the left you can see the default single column panel view. However, you can click on the double arrow (circled) to toggle between this and the double column view shown on the right. Where tools are marked with a triangle in the bottom right corner, you can mouse down on the tool to see the other tools that are nested in that particular group.

Photoshop CC Tools panel

The Tools panel (shown in Figure 1.40) contains 65 separate tools. Clicking any tool automatically displays the tool Options bar (if it is currently hidden) from where you can manage the individual tool settings (see page 30). Many of the tools in the Tools panel have a triangle in the bottom right corner of the tool icon, indicating there are extra tools nested in this tool group. You can mouse down on a featured tool, select any of the other tools in this list and make that the selected tool for the group (see Figure 1.39).

You will notice that most of the tools (or sets of tools) have single-letter keystrokes associated with them. These are displayed whenever you mouse down to reveal the nested tools or hover with the cursor to reveal the tool tip info (providing the 'Show Tool Tips' option is switched on in the Photoshop Tools preferences). You can therefore use these key shortcuts to quickly select a tool without having to go via the Tools panel. For example, pressing **H** on the keyboard selects the hand tool and pressing **J** will select one of the healing brush group of tools (whichever is currently selected in the Tools panel). Photoshop also features spring-loaded tool selection behavior. If instead of clicking, you hold down the key and keep it held down, you can temporarily switch to using the tool that's associated with that particular keystroke. Release the key and Photoshop reverts to working with the previously selected tool again.

Where more than one tool shares the same keyboard shortcut, you can cycle through the other tools by holding down the **Shift** key as you press the keyboard shortcut. If on the other hand you prefer to restore the old behavior whereby repeated pressing of the key would cycle through the tool selection options, go to the Photoshop menu, select Preferences ⇨ Tools and deselect the 'Use Shift Key for Tool Switch' option. Personally, I prefer using the Shift key method. You can also **alt**-click a tool icon in the Tools panel to cycle through the grouped tools.

There are specific situations when Photoshop will not allow you to use certain tools and displays a prohibit sign (⊘). For example, you might be editing an image in 32-bit mode where only certain tools can be used when editing 32-bit images. Clicking once in the image document window will call up a dialog explaining the exact reason why you cannot access or use a particular tool.

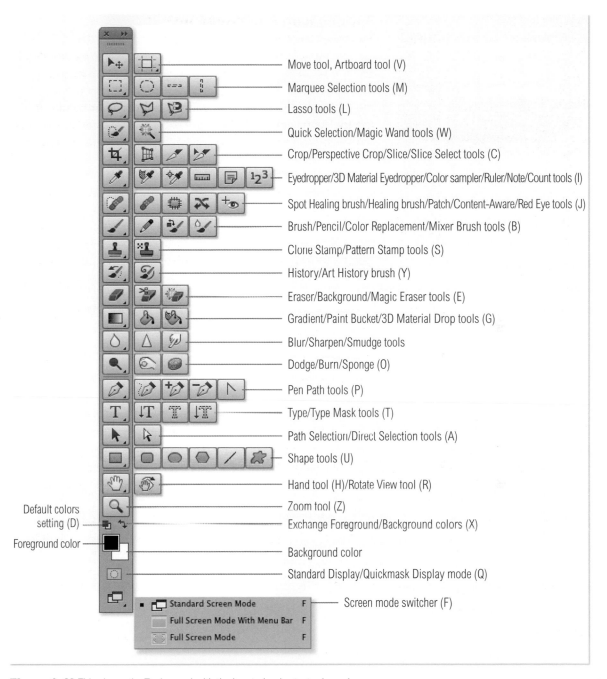

Move tool, Artboard tool (V)

Marquee Selection tools (M)

Lasso tools (L)

Quick Selection/Magic Wand tools (W)

Crop/Perspective Crop/Slice/Slice Select tools (C)

Eyedropper/3D Material Eyedropper/Color sampler/Ruler/Note/Count tools (I)

Spot Healing brush/Healing brush/Patch/Content-Aware/Red Eye tools (J)

Brush/Pencil/Color Replacement/Mixer Brush tools (B)

Clone Stamp/Pattern Stamp tools (S)

History/Art History brush (Y)

Eraser/Background/Magic Eraser tools (E)

Gradient/Paint Bucket/3D Material Drop tools (G)

Blur/Sharpen/Smudge tools

Dodge/Burn/Sponge (O)

Pen Path tools (P)

Type/Type Mask tools (T)

Path Selection/Direct Selection tools (A)

Shape tools (U)

Hand tool (H)/Rotate View tool (R)

Zoom tool (Z)

Default colors setting (D)

Exchange Foreground/Background colors (X)

Foreground color

Background color

Standard Display/Quickmask Display mode (Q)

Standard Screen Mode F Screen mode switcher (F)

Full Screen Mode With Menu Bar F

Full Screen Mode F

Figure 1.40 This shows the Tools panel with the keystroke shortcuts shown in brackets. The artboard tool is new to Photoshop CC. It is really more a tool for screen designers.

Hovering tool tips

In order to help familiarize yourself with the Photoshop tools and panel functions, a Help dialog box normally appears after a few seconds whenever you leave a cursor hovering over any one of the Photoshop buttons or tool icons. Note that this is dependent on having the 'Show Tool Tips' option checked in the Tools preferences.

Options bar

The Options bar (Figure 1.41) normally appears at the top of the screen, just below the Photoshop menu, and contains all the tool options associated with the current selected tool. However, it can be removed from its standard location and placed anywhere on the screen by dragging the gripper bar on the left edge (circled in Figure 1.41).

You'll see examples of the different Options bar layouts in the rest of this chapter (a complete list of the Options bar views can be seen in the Help Guide for Photoshop tools on the book website). Quite often you will see tick (☑) and cancel (⊘) buttons on the right-hand side of the Options bar and these are there so that you can OK or cancel a tool that is in a modal state. For example, if you are using the crop tool to define a crop boundary, you can use these buttons to accept or cancel the crop, although you may find it easier to use the *Enter* key to OK and the *esc* key to cancel such tool operations. As I mentioned earlier on page 19, you can use the *Shift Tab* shortcut to toggle hiding the panels only and keeping just the Tools panel and Options bar visible.

Tool Presets

Many of the Photoshop tools offer a wide range of tool options. In order to manage the tool settings effectively, the Tool Presets panel can be used to store multiple saved tool settings, which can then also be accessed via the Options bar (Figure 1.42), or the Tool Presets panel (Figure 1.43).

Figure 1.41 The Options bar, which is shown here docked to the main menu.

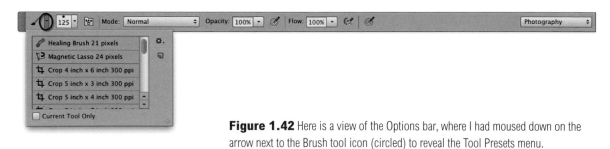

Figure 1.42 Here is a view of the Options bar, where I had moused down on the arrow next to the Brush tool icon (circled) to reveal the Tool Presets menu.

With Tool Presets you can access any number of tool options very quickly and this can save you the bother of having to reconfigure the Options bar settings each time you choose a new tool. For example, you might find it useful to save crop tool presets for all the different image dimensions and pixel resolutions you typically use. Likewise, you might like to store pre-configured brush preset settings, rather than have to keep adjusting the brush shape and attributes. To save a new tool preset, click on the New Preset button at the bottom of the Tool Presets panel and to remove a preset, click on the Delete button next to it.

If you mouse down on the Tool Presets options button (circled in Figure 1.43), you can use the menu shown in Figure 1.44 to manage the various tools presets. In Figure 1.43 the Current Tool Only option (at the bottom) was deselected which meant that all the tool presets could be accessed at once. This can be useful, because clicking on a preset simultaneously selects the tool and the preset at the same time. Most people though will find the Tool Presets panel is easier to manage when the 'Current Tool Only' option is checked.

You can use the Tool Presets panel to save or load pre-saved tool preset settings. For example, if you create a set of custom presets, you can share these with other Photoshop users by choosing Save Tool Presets... This creates a saved set of settings for a particular tool. Another thing that may not be immediately apparent is the fact that you can also use tool presets to save type tool settings. This again can be useful, because you can save the font type, font size, type attributes and font color settings all within a single preset. This feature can be really handy if you are working on a Web or book design project.

One important thing to bear in mind here is that since there has been a recent major update to the Photoshop painting engine, any painting tool presets that have been created in Photoshop CS5 or later will not be backward compatible with earlier versions of the program. Similarly, you won't be able to import and use any painting tool presets that were created in earlier versions of Photoshop.

Lastly, you can *ctrl*-click (Mac), or right mouse down on the tool icon in the Options bar and choose 'Reset Tool' or 'Reset All Tools' from the contextual menu. This will reset the Options bar to the default settings.

New Preset Delete
button button

Figure 1.43 The Tool Presets panel.

Figure 1.44 The Tool Presets options.

⬚	Rectangular marquee tool (M)
⬭	Elliptical marquee tool (M)
▭	Single row marquee tool
▯	Single column marquee tool
🔾	Lasso tool (L)
⯊	Freeform lasso tool (L)
⯊	Magnetic lasso tool (L)
🖌	Quick selection tool (W)
🪄	Magic wand tool (W)

The Paste Special menu commands

The standard Paste command pastes the copied pixels as a new layer centered in the image. The Paste Special submenu offers three options. The Paste In Place command (⌘ Shift V [Mac], ctrl Shift V [PC]) pastes the pixels that have been copied from a layer to create a new layer with the pixels in the exact same location. If the pixels have been copied from a separate document, it pastes the pixels into the same relative location as they occupied in the source image. Paste Into (⌘ ⌥ Shift V [Mac], ctrl alt Shift V [PC]) pastes the clipboard contents inside a selection with an unlinked layer mask, while Paste Outside pastes the clipboard contents outside a selection with an unlinked layer mask.

Figure 1.45 The first time you use the Macintosh ⌘ H keyboard shortcut, this pops a dialog asking you to select the desired default behavior: Hide Photoshop, or Hide Extras.

Selection tools

The Photoshop selection tools are mainly used to define a specific area of the image that you wish to modify, or copy. The use of the selection tools in Photoshop is therefore just like highlighting text in a word processor program in preparation to do something with the selected content. In the case of Photoshop, you might want to make a selection to define a specific area of the image, so that when you apply an image adjustment or a fill, only the selected area is modified. Alternatively, you might use a selection to define an area you wish to copy and paste, or define an area of an image that you want to copy across to another image document as a new layer. The usual editing conventions apply and mistakes can be undone using the Edit ⇨ Undo command (⌘ Z [Mac], ctrl Z [PC]), or by selecting a previous history state via the History panel. The ⌘ H (Mac), ctrl H (PC) keyboard shortcut can be used to hide an active selection, but note that on a Macintosh, the first time you use the ⌘ H keyboard shortcut, this will open the dialog shown in Figure 1.45, where you will be asked to select the desired default behavior: do you want this shortcut to hide the Photoshop application, or hide all extras?

The marquee selection tool options include the rectangular, elliptical and single row/single column selection tools. In Figure 1.46 I have shown the elliptical marquee tool in use and below that in Figure 1.47, an example of how you can work with the rectangular marquee tool. The lasso tool can be used to draw freehand selection outlines and has two other modes: the polygon lasso tool, which can draw both straight line *and* freehand selections, plus the magnetic lasso tool, which is like an automatic freehand lasso tool that is able to auto-detect the edge you are trying to trace.

The quick selection tool is a bit like the magic wand tool as it can be used to make selections based on pixel color values; however, the quick selection tool is a little more sophisticated than that and hence it has been made the default tool in this particular tool group. As you read through the book you'll see a couple of examples where the quick selection tool can be used to make quite accurate selections based on color and how these can then be modified more precisely using the Refine Edge command. For full descriptions of these and other tools mentioned here don't forget to check out the *Photoshop for Photographers Help Guide* on the book website.

Figure 1.46 A selection can be used to define a specific area of an image that you wish to work on. In this example, I made an elliptical marquee selection of the cup and saucer and followed this with an image adjustment to make the color warmer.

Figure 1.47 In this example I used the rectangular marquee tool to make a marquee selection of the door. I then applied a Hue/Saturation adjustment to modify the colors within the selection area.

Color Range tip

A Color Range selection tool can only be used to make discontiguous selections. However, it is possible to make a selection first of the area you wish to focus on and then choose Color Range to make a color range selection within the selection area.

Out-of-gamut selections

Among other things, you can use the Color Range command to make a selection based on out-of-gamut colors. This means you can use Color Range to make a selection of all the 'illegal' RGB colors that fall outside the CMYK gamut and apply corrections to these pixels only. To be honest, while Color Range allows you to do this, I don't recommend using Photoshop's out-of-gamut indicators to modify colors in this way. Instead, I suggest you follow the instructions on soft proofing in Chapter 10.

Skin tone and faces selections

There is a Skin Tones option available in the Select menu. You can use this to specifically select skin tone colors in an image. There is also a separate 'Detect Faces' checkbox (which is available when the Localized Color Clusters checkbox is activated). When Detect Faces is enabled it uses a face detection algorithm to automatically look for and select faces in a photo. It appears to be effective with all different types of skin colors. Checking the Detect Faces option in conjunction with a Skin Tones selection can often really help narrow down a selection to select faces only.

Color Range

Color Range is a color-based selection tool (Figure 1.48). While the quick selection and magic wand tools create selections based on luminosity, Color Range can be used to create selections based on similar color values.

To create a Color Range selection, go to the Select menu, choose Color Range… and click on the target color anywhere in the image window (or Color Range preview area) to define the initial selection (note, if you press the spacebar when launching the Color Range dialog the current foreground color is loaded as the sampled color). To add colors to a Color Range selection, click with the 'Add to Sample' eyedropper and keep clicking to expand the selection area. To subtract from a selection, click on the 'Subtract from Sample' eyedropper and click to select the colors you want to remove from the selection. You can then adjust the Fuzziness slider to adjust the tolerance of the selection, which increases or decreases the number of pixels that are selected based on how similar the pixels are in color to the already sampled pixels.

If the Localized Color Clusters box is checked, Color Range can process and merge data from multiple clusters of color samples. As you switch between 'sampling colors to add to a selection' and 'selecting colors to remove', Photoshop calculates these clusters of color samples within a three-dimensional color space. As you add and subtract colors Photoshop can produce a much more accurate color range selection mask based on the color sampled data. When Localized Color Clusters is checked the Range slider lets you determine which pixels are to be included based on how far or near a color is from the sample points that are included in the selection.

The selection preview options for the document window can be set to None (the default), Grayscale, a Matte color such as the White Matte example shown in Figure 1.49, or a Quick Mask. The skin tones selection has been improved to help reduce the number of false positives, though in most instances the difference between this and the original Photoshop CS6 behavior is quite slight. It is also possible to save Color Range settings such as sub selections (i.e. Reds, Yellows, Greens etc.) as presets and this also includes the ability to save skin tones, detect faces and fuzziness settings. By default Color Range presets are now saved to a Color Range folder in the Adobe Photoshop application Presets folder. The Color Range dialog also remembers the previously applied settings and applies these the next time the dialog is opened.

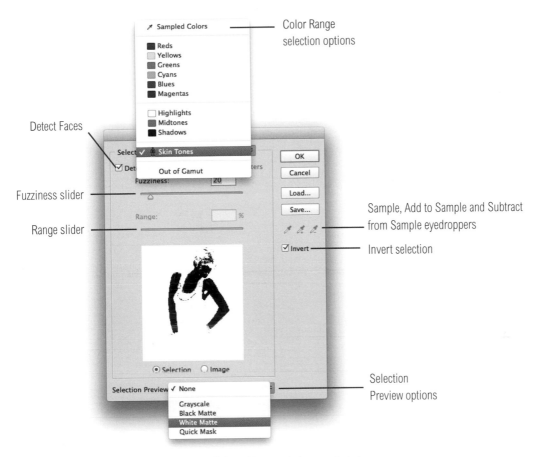

Color Range
selection options

Detect Faces

Fuzziness slider

Range slider

Sample, Add to Sample and Subtract
from Sample eyedroppers

Invert selection

Selection
Preview options

Figure 1.48 This shows the Color Range dialog with expanded menus that show the full range of options for the Color Range selection dialog.

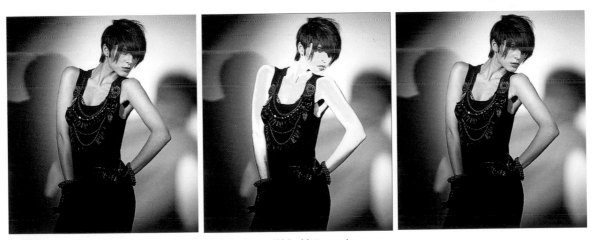

Figure 1.49 This shows a before image (left), Color Range White Matte preview (middle) and a color adjusted image (right) made using a Color Range selection.

Adjustable tone ranges

Color Range improvements in Photoshop CC offer greater control of Highlights, Midtones, and Shadows selections. Now, instead of being restricted to the use of 'hard-coded' value ranges, the exact range of tones and the partial selection of surrounding tones can be customized. In the case of the Highlights and Shadows selections there is a single slider with which to adjust the extent of a highlights or shadows selection. In the case of the Midtones you have two sliders with which to fine-tune the midtone range.

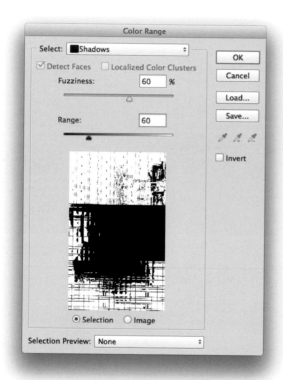

1 I opened the image shown here in Photoshop, went to the Select menu and chose Color Range… To start with I selected the Shadows option from the Select menu. Shown here is the default setting, which is the same as the previous, hard-coded range value used in Color Range. To reset the sliders here to the defaults, hold down *alt* key and the Cancel button will change to say 'Reset'.

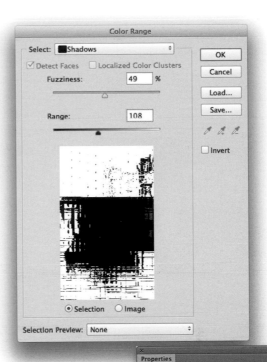

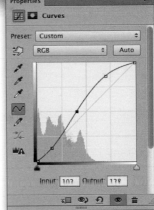

2 In Photoshop CC it is possible to edit the Fuzziness and Range values for a Shadows, Midtones or Highlights selection. In this instance I adjusted both sliders to fine-tune the shadows selection. With the selection active, I added a Curves adjustment layer and applied the lightening curve shown here to lighten the shadows.

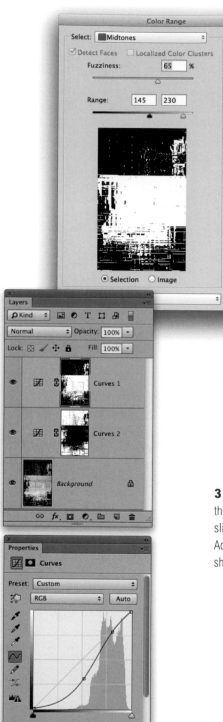

3 I then went to the Select menu again, chose Color Range… and this time selected the Midtones option from the Select menu. I then adjusted the Fuzziness and Range sliders to fine-tune the Midtones selection. After that I added another new Curves Adjustment layer, this time applying a darkening curve to create the final version shown here.

Modifier keys

Macintosh and Windows keyboards have slightly different key arrangements, hence the reason for me including double sets of instructions throughout the book, where the ⌘ key on the Macintosh is equivalent to the *ctrl* key on a Windows keyboard. You can use the right mouse button to access the contextual menus (Mac users can also use the *ctrl* key to access these menus) and, finally, the *Shift* key which is the same on both Mac and PC computers.

These keys are commonly referred to as 'modifier' keys, because they can modify tool behaviors. In Figure 1.50 you can see how if you hold down *alt* when drawing a marquee selection it centers the selection around the point where you first clicked on the image. If you hold down the *Shift* when drawing an elliptical marquee selection this constrains the selection to a circle. If you hold down *Shift* ⌥ (Mac), *Shift* *alt* (PC) when drawing an elliptical marquee selection, this constrains the selection to a circle and centers the selection around the point where you first clicked. The spacebar is a modifier key too in that it allows you to reposition a selection midstream. This can prove really useful. If you make a mistake when selecting an area, rather than deselect and try again, you can simply depress the spacebar key as you drag to realign the position of the selection.

The modifier keys mentioned above are all highlighted below in Figure 1.51.

Figure 1.50 These screen shots show Quick Mask plus marching ant selections created by dragging out from the center with *Shift* held down (top), with *alt* held down (middle) and *Shift* ⌥ (Mac), *Shift* *alt* (PC) (bottom).

Figure 1.51 This shows the modifier keys (shaded in orange), showing both the Macintosh and Windows equivalent key names. The other keys commonly used in Photoshop are the Tab and Tilde keys, shown here shaded in blue.

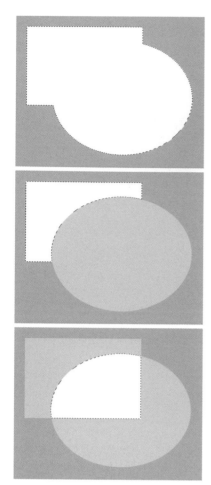

After you have created an initial selection the modifier keys will behave differently. In Figure 1.52 you can see how if you hold down the *Shift* key as you drag with the marquee or lasso tool, this adds to the selection (holding down the *Shift* key and clicking with the magic wand tool also adds to an existing selection). If you hold down the *alt* key as you drag with the marquee or lasso tool, this subtracts from an existing selection (as does holding down the *alt* key and clicking with the magic wand tool). And the combination of holding down the *Shift* *alt* keys together while dragging with a selection tool (or clicking with the magic wand) creates an intersection of the two selections. As well as using the above shortcuts, you will find there are also equivalent selection mode options in the Options bar for the marquee and lasso selection tools (see Figure 1.53).

Modifier keys can also be used to modify the options that are found elsewhere in Photoshop. For example, if you hold down the *alt* key as you click on, say, the marquee tool in the Tools panel you will notice how this allows you to cycle through all the tools that are available in this group. Whenever you have a Photoshop dialog box open it is worth exploring what happens to the dialog buttons when you hold down the *alt* key. You will often see the button names change to reveal more options (typically, the Cancel button will change to say 'Reset' when you hold down the *alt* key).

Figure 1.52 These screen shots show examples of Quick Mask plus marching ant selections that have been modified after the initial selection stage. The top view shows an elliptical selection combined with a rectangular selection with *Shift* held down, adding to a selection. The middle view shows an elliptical selection combined with a rectangular selection with *alt* held down, which subtracts from the original selection. The bottom view shows an elliptical selection combined with a rectangular selection with *Shift* *alt* held down, which results in an intersected selection.

Figure 1.53 The Options bar has four modes of operation for each of the selection tools: Normal; Add to Selection; Subtract from Selection; and Intersect Selection. These are equivalent to the use of the modifier modes described in the main text when the tool is in Normal mode.

Painting tools

The next set of tools we'll focus on are the painting tools, which include: the brush, pencil, mixer brush, blur, sharpen, smudge, burn, dodge and sponge tools. These can be used to paint or edit the image pixels. If you want to keep your options open you will usually find it is preferable to carry out your paint work on a separate new layer. This allows you to preserve all of the original image on a base layer and you can easily undo all your paint work by turning off the visibility of the paint layer.

When you select any of the painting tools, the first thing you will want to do is to choose a brush, which you can do by going to the Brush Preset Picker (the second item from the left in the Options bar) and select a brush from the drop-down list shown in Figure 1.54. Here, you can choose from the many different types of brushes, including the bristle shape brushes. The Size slider can be used to adjust the brush size from a single pixel to a 5000 pixel-wide brush. If a standard round brush is selected you can also use the Hardness slider to set varying degrees of hardness for the brush shape.

	Brush tool (B)
	Pencil tool (B)
	Mixer brush tool (B)
	Blur tool
	Sharpen tool
	Smudge tool
	Dodge tool (O)
	Burn tool (O)
	Sponge tool (O)

Round brush presets

There are just six round brush presets. These allow you to select hard or soft brushes with either no pressure-linked controls, the brush size linked to the amount of pressure applied, or brush opacity linked to the amount of pressure applied.

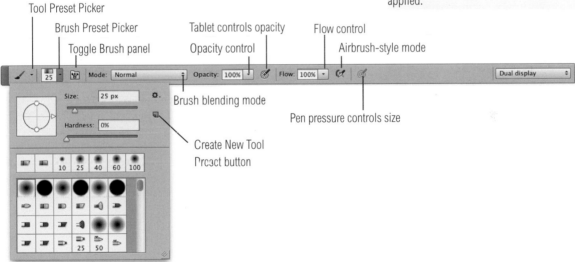

Tool Preset Picker

Brush Preset Picker

Toggle Brush panel

Tablet controls opacity

Opacity control

Flow control

Airbrush-style mode

Brush blending mode

Pen pressure controls size

Create New Tool Preset button

Figure 1.54 This screen shot shows you the Options bar for the brush tool. To display the brush preset list shown here, mouse down on the arrow next to the brush shape icon. You can then use the Size and Hardness sliders to modify one of the round brush settings and save as a new setting by clicking on the Create New Tool Preset button. Most of the painting tools offer a fairly similar range of settings and here you can see the pen tablet options, which allow you to set the pen pressure to control the opacity and/or the size of a selected painting tool.

Figure 1.55 There is no need to visit the Brush or Tool presets each time you want to change the size of a brush. You can use the right square bracket key **]** to make a brush bigger and the left square bracket key **[** to make it smaller.

Figure 1.56 You can combine the square bracket keys with the Shift key on the keyboard. You can use *Shift* **]** to make a round brush edge harder and use *Shift* **[** to make a round brush edge softer. Be aware this only applies when editing one of the round brush presets.

On-the-fly brush changes

Instead of visiting the Brush Picker every time you want to adjust the size or hardness of a brush, you will often find it is quicker to use the square bracket keys (as described in Figures 1.55 and 1.56) to make such on-the-fly changes. Also, if you *ctrl* right mouse-click on the image you are working on this opens the Brush Preset menu directly next to the cursor (Figure 1.57). Click on the brush preset you wish to select and once you start painting, the Brush Preset menu closes (or alternatively, use the *esc* key). Note that if you are painting with a Wacom™ stylus you can close this pop-up dialog by lifting the stylus off the tablet and squeezing the double-click button. If you *ctrl* *Shift*-click or right mouse + *Shift*-click on the image while using a brush tool, this opens the blending mode list shown below. These blend modes are like rules that govern how the painted pixels are applied to the pixels in the image below. For example, if you paint using the Color mode, you'll only alter the color values in the pixels you are painting.

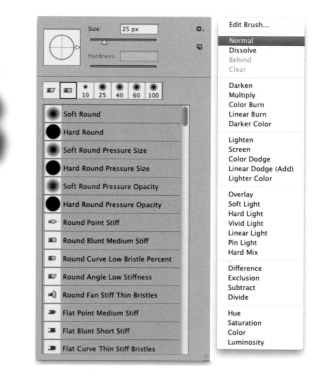

Figure 1.57 When using any of the paint tools in Photoshop, a *ctrl*-click or right mouse-click opens the Brush Preset menu (middle), while a *ctrl* *Shift*-click or right mouse + *Shift*-click reveals the brush blending modes list shown on the right.

On-screen brush adjustments

Providing you have the 'Use Graphics Processor' option enabled in the Performance preferences, Photoshop provides on-screen brush adjustments. If you hold down the `ctrl` `⌥` keys (Mac), or the `alt` key and right-click, dragging to the left makes the brush size smaller and dragging to the right, larger. Also, if you drag upwards this makes a round brush shape softer, while dragging downwards makes a round brush shape harder. You'll notice how the brush hardness is represented here with a quick mask type overlay. If you hold down the `⌘` `⌥` `ctrl` keys (Mac), or the `alt` `Shift` keys and right-click (PC), this opens the Heads Up Display (HUD) Color Picker where for as long as you have the mouse held down you can move the cursor over the outer hue wheel or hue strip (depending on the HUD Color Picker setting you have selected in the Photoshop General Preferences) to select a desired hue color and then inside the brightness/saturation square to select the desired saturation and luminosity. The point where you release the mouse selects the new foreground color. When you use the key combination described here to access the HUD Color Picker, you can hold down the spacebar to freeze the cursor position. For example, you can select a hue color from the hue wheel/strip, freeze the hue color selection and then switch to select a brightness/saturation value. Figure 1.58 shows examples of how the paint tool cursor looks for both the on-screen brush size/hardness adjustments and the Hue Wheel HUD Color Picker displays.

Non-rotating brushes

If you use the rotate tool to rotate the canvas, Photoshop prevents the brushes from rotating too. You can continue to paint with the same brush orientation at all canvas rotation angles.

Brush preview overlay color

If you go to the Photoshop Cursors preferences you can customize the overlay color that's used for the brush preview.

Brush panel selection

In the Brushes panel the last selected brush is highlighted plus you can access the most recently used brush presets in brush contextual menu and Brush Preset panel, providing you have Show Recent Brushes checked (circled blue in Figure 1.60).

Figure 1.58 You can dynamically adjust the brush size and hardness of the painting tool cursors on screen, or open the Heads Up Display Color Picker using the modifier keys described in the main text (providing the 'Use Graphics Processor' option is enabled in the Performance preferences).

Figure 1.59 In this example, I selected the round point stiff brush and adjusted the Angle Jitter in the Shape Dynamics settings and the foreground/background jitter in the Color Dynamics, linking both to the angle of the pen. I then set blue as the foreground color, orange for the background and used a combination of pen pressure and pen tilt to create the doodle shown here, twisting the pen angle as I applied the brush strokes.

Brush panel

Over in the Brush panel if you click on the Brush Presets button (circled red in Figure 1.60), this opens the Brush Presets panel with a brush presets list. You can then append or replace these brush presets by going to the panel fly-out menu and selecting a new brush settings group from the list.

So far we have looked at the Brush options that are used to determine the brush shape and size, but if you click on any of the brush attribute settings shown in Figure 1.60, the brush presets list changes to reveal the individual brush attribute options (see Figure 1.61). The brush attributes include things like how the opacity of the brush is applied when painting, or the smoothness of the brush. You can therefore start by selecting an existing brush preset, modify it, and then click on the Create new brush button at the bottom to define this as a new custom brush preset setting.

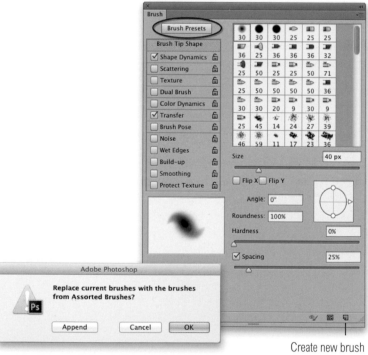

Create new brush

Figure 1.60 If you open the Brush panel, the default panel setting shows an Expanded View and lists the various brush presets in the right-hand section of the panel. If you click on any of the brush attributes in the list on the left, the right-hand section changes to reveal the various options settings (see Figure 1.61). If you open, or go to the Brush Presets panel menu, you can select any of the brush settings listed here, which will then ask if you want to Append or Replace the current list of presets.

Brush panel options

The following notes and tips on working with the Brush panel will apply to most, but not all, of the painting tools. To create your own custom brush preset settings click on any of the brush attribute items that are listed on the left-hand side of the panel.

The Jitter controls introduce some randomness into the brush dynamics behavior. For example, increasing the Opacity Jitter means that the opacity will respond according to how much pen pressure is applied and there is a built-in random fluctuation to the opacity that varies more and more as the jitter value is increased. Meanwhile, the Flow Jitter setting governs the speed at which the paint is applied. To understand how the brush flow dynamics work, try selecting a brush and quickly paint a series of brush strokes at a low and then a high flow rate. When the flow rate is low, less paint is applied, but as you increase the flow setting more paint is applied. Other tools like the dodge and burn toning tools use the terms Exposure and Strength, but these essentially have the same meaning as the opacity control. The Shape Dynamics can be adjusted to introduce jitter into the size, angle and roundness of the brush and the scattering controls allow you to produce broad, sweeping brush strokes with a random scatter, while the Color Dynamics let you introduce random color variation to the paint color. The Foreground/Background color control lets you vary the paint color between the foreground and background color, according to how much pressure is applied (see Figure 1.59). The Dual Brush and Texture Dynamics can introduce texture and more interactive complexity to the brush texture (it is worth experimenting with the Scale control in the Dual Brush options) and the Texture Dynamics can utilize different blending modes to produce different paint effects. The Transfer Dynamics allow you to adjust the dynamics for the build-up of the brush strokes—this relates particularly to the ability to paint using wet brush settings.

Pressure sensitive control

If you are using a pressure sensitive pen stylus, you will see additional options in the Brush panel that enable you to link the pen pressure of the stylus to how the effects are applied. You can therefore use these options to determine things like how the paint opacity and flow are controlled by the pen pressure or by the angle of tilt or rotation of the pen stylus. But the tablet

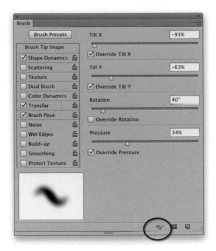

Figure 1.61 If you click on a brush attribute setting in the list on the left, the right-hand side of the panel displays the options that are associated with each attribute. Specific brush panel settings can be locked by clicking on the Lock buttons. If using a bristle tip brush shape, clicking the live brush tip preview button (circled above) enables the preview shown here.

Brush Pose

The Brush Pose options allow mouse users to set a stylus pose that is applied while painting. If painting with, say, a Wacom device, enabling the checkboxes (like those shown checked in Figure 1.61) overrides any tablet data to set a fixed pose. To see how this works, try selecting a dynamic tip brush and enable the live brush tip preview (circled above). Brush Pose settings can be saved with Brush and Tool presets.

Wacom™ tablets

Photoshop is able to exploit all of the pressure responsive built-in Wacom™ features. You will notice that as you alter the brush dynamics settings in the Brush panel, the brush stroke preview below changes to reflect what the expected outcome would be if you had drawn a squiggly line that faded from zero to full pen pressure (likewise with the tilt and thumb wheel). This visual feedback is extremely useful as it allows you to experiment with the brush dynamics settings in the Brushes panel and learn how these affect the brush dynamics behavior.

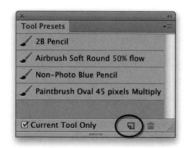

Figure 1.62 The Tool Presets panel. When you click on the New Preset button (circled) this opens the New Tool Preset dialog, where you can save and name the current tool settings as a new tool preset.

pressure controls can also be controlled via the buttons in the Options bar for the various painting tools (I've highlighted these tablet button controls in Figure 1.54).

Brush tool presets

When you have finished adjusting the Brush panel dynamics and other settings, you can save combinations of the brush preset shape/size, Brush panel attribute settings, and the brush blending mode (and brush color even) as a new Brush tool preset. To do this, go to the Tool Presets panel and click on the New Preset button at the bottom (see Figure 1.62). Or, you can mouse down on the Tool Preset Picker in the Options bar and click on the New Brush setting button. Give the brush tool preset a name and click OK to append this to the current list. Once you have saved a brush tool preset, you can access it at any time via the Tool Presets panel or via the Tool Preset menu in the Options bar.

Mixer brush

The mixer brush allows you to paint more realistically in Photoshop. With the mixer brush you can mix colors together as you paint, picking up color samples from the image you are painting on and set the rate at which the brush picks up paint from the canvas and the rate at which the paint dries out. The mixer brush can be used with either the bristle tips or with the traditional Photoshop brush tips (now referred to as static tips) to produce natural-looking paint strokes. The combination of the mixer brush and bristle tip brushes provides a whole new level of sophistication to the Photoshop paint engine. The only downside is that the user interface has become even more complicated. The brush controls and feedback are split between the Brush panel, the Brush Presets panel, the Options bar and the live brush tip preview. It's not particularly easy to pick up a brush and play with it unless you have studied all the brush options in detail and you understand how the user interface is meant to work. Fortunately, the Tool Presets panel can help here and the easiest way to get started is to select one or two of the new brush presets and experiment painting with these brush settings to gain a better understanding of what the new brush settings can do. In the meantime, let's take a look at the Options bar settings for the mixer brush that's shown in Figure 1.63.

The mixer brush tool has two wells: a reservoir and a pickup. The reservoir well color is defined by the current

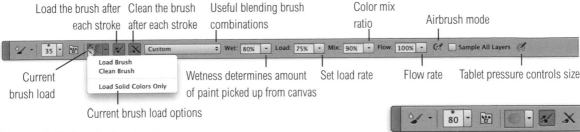

Figure 1.63 The mixer brush options.

Figure 1.64 The Load swatch displays the main reservoir well color in the outer area and the pickup well color in the center. Clicking on the mixer brush Current brush load swatch launches the Photoshop Color Picker.

foreground color swatch in the Tools panel or by *alt*-clicking in the image canvas area. This is the color you see displayed in the Load swatch preview. The pickup well is one that has paint flowing into it and continuously mixes the colors of where you paint with the color that's contained in the reservoir well. Selecting 'Clean Brush' from the 'Current brush load' options immediately cleans the brush and clears the current color, while selecting 'Load Brush' fills with the current foreground color again. The 'Load brush after each stroke' button does what it says, it tells the mixer brush to keep refilling the pickup well with color and therefore the pickup well becomes progressively contaminated with the colors that are sampled as you paint. The 'Clean brush after each stroke' button empties the reservoir well after each stroke and effectively allows you to paint from the pickup well only (Figure 1.64 shows an example of how the well colors are displayed in the Options bar).

The Paint wetness controls how much paint gets picked up from the image canvas. Basically, when the wetness is set to zero the mixer brush behaves more like a normal brush and deposits opaque color. As the wetness is increased so is the streaking of the brush strokes. The 'Set load rate' is a dry-out control. This determines how much paint gets loaded into the main reservoir well. With low load rate settings you'll get shorter brush strokes where the paint dries out quickly and as the load rate setting is increased you get longer brush strokes.

The Mix slider determines how much of the color picked up from the canvas that goes into the pickup well is mixed with the color stored in the main reservoir well. A high Mix ratio means more ink flows from the pickup to the reservoir well, while the Flow rate control determines how fast the paint flows as you paint. With a high Flow setting, more paint is applied as you paint. If you combine this with a low Load rate setting you'll notice how at a high Flow setting the paint flows out quickly and results in shorter paint strokes. At a lower Flow rate you'll notice longer (but less opaque) brush strokes.

Wet/Mix/Flow numeric shortcuts

Typing in a number changes the Wetness value. Holding down the *alt* *Shift* keys while entering a number changes the Mix value. Lastly, holding down just the *Shift* key as you enter a number changes the Flow value. Note, you should type '00' to set any of the above values to zero.

Mixer brush presets

Sampled fill colors are retained whenever you switch brush tips or adjust the brush tip parameters. You can also include saving the main reservoir well and pickup well colors with a mixer brush tool preset.

Windows stylus and mouse tracking

Stylus support on Windows OS for non-Wacom devices has been updated and in particular, targeting new tablet-based computers that use n-trig tablet technology. The mouse tracking code has also been updated to take advantage of modern operating system Application Program Interfaces (APIs). These changes include performance tweaks, which should speed up painting and other input device interactions.

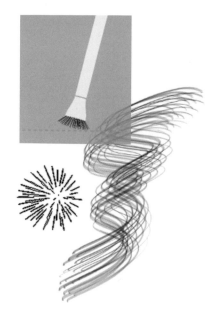

Bristle tip brush shapes

If you select one of the bristle tip brush shapes you can click on the Brush Tip Shape option in the Brush panel (Figure 1.66) to reveal the Bristle Qualities options. These brush tips can be used in conjunction with any of the Photoshop painting tools. When a bristle tip (as opposed to a traditional 'static' Photoshop brush tip) is selected you can also click the Bristle preview button (circled in Figure 1.66) to display the floating Bristle preview panel shown in Figure 1.65. As you adjust the slider controls in the Brush panel the Bristle preview provides visual feedback as to how this will affect the current bristle tip behavior.

Figure 1.65 This shows the live brush preview, which can be enabled by clicking on the button circled in Figure 1.66. It can be toggled in size, moved around the screen, or closed. The Brush preview can also be turned on or off via the View/Show menu (or use ⌘ H [Mac], ctrl H [PC]).

Dodge and burn tools

The dodge and burn tools have been much improved since Photoshop CS4. However, you are still limited to working directly on the pixel data. If you do want to use the dodge and burn tools, I suggest you work on a copied pixel layer. Overall, I reckon you are better off using the Camera Raw adjustment tools to dodge and burn your images, or use adjustment layers and edit the associated layer mask.

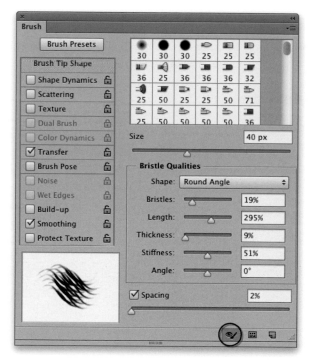

Figure 1.66 The Bristle tip Brush panel options. The Bristles slider determines the density of the number of bristles within the current brush size. The Length determines the length of the bristles relative to the shape and size of the selected brush. The Thickness determines the thickness of each bristle. The Stiffness controls the stiffness or resistance of the bristles. The Angle slider determines the angle of the brush position—this isn't so relevant for pen tablet users, but more so if you are using a mouse. Lastly, the Spacing slider sets the spacing between each stamp of the brush stroke.

Load/Replace Swatches from HTML

From the Swatches panel it is now possible to load swatches from an HTML page you are working on. As shown here, you use the Swatches panel menu to select the Load Swatches… or Replace Swatches… menu item and then select an HTML document to read from (this option is also available via other swatch pickers). This option will read color swatches from HTML, CSS and SVG files. It only loads colors that are unique to a document as opposed to every instance a color appears in a document.

The main benefit of this feature is that when working on a web page design you can now efficiently import precise HTML colors into Photoshop.

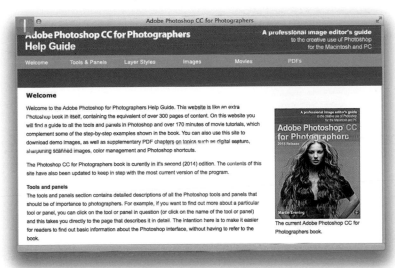

1 Here is a web page that I created in Adobe Dreamweaver and saved as an HTML file.

2 In Photoshop, I went to the Swatches panel, moused down to reveal the panel options menu (circled) and chose Load Swatches…

3 I then navigated to select the HTML document that was shown open in step 1.

4 This then added two colors from the web page design to the Swatches panel.

Hex Field

When working in RGB mode, the Hex Field is now selected by default in the Color picker (see Figure 1.67).

Figure 1.67 The Color Picker dialog with the Hex field auto-selected.

Adobe Color Themes panel

The Adobe Color Themes panel (Figure 1.68) restores Kuler functionality to Photoshop. Kuler was removed when Photoshop CC was first released due to the removal of Flash support from Photoshop. This panel provides the same level of functionality allowing users to explore lots of different color combination themes as well as create their own custom themes.

Setting a custom background color

In the New Document dialog the Background Content menu now features an Other... option. When this is selected it opens the Color picker, which allows you to select a custom color as the background color (see Figure 1.69).

Figure 1.68 The Adobe Color Themes panel.

Figure 1.69 The New Document dialog, showing the Other... background color option.

Automatically add colors to the Swatches panel

As you sample colors with the eyedropper tool, or via the Color Picker, this automatically adds color samples to the top row of the Swatches panel (Figure 1.70). This can be useful because it means you can make a series of color samples by clicking with the eyedropper tool and these will automatically be added to the Swatches panel ready for use in the same or another document. You don't have to explicitly save the swatches, it semi-permanently adds them to the swatches collection.

Figure 1.70 This shows the Swatches panel where the top row contains recently sampled colors.

	Paint bucket tool (G)
	Gradient tool (G)
	Rectangle tool (U)
	Rounded rectangle tool (U)
	Elliptical tool (U)
	Polygon tool (U)
	Line tool (U)
	Custom shape tool (U)

Tools for filling

The various shape tools, including the line tool, are mostly useful to graphic designers who wish to create things like buttons or who need to add vector shapes to a design layout. In Figure 1.71, you can see an example of how a filled, custom shape vector layer was placed above a pixel layer that had been filled with a radial gradient. The gradient tool may certainly be of interest to photographers. For example, you can use the Adjustment layer menu to add gradient fill layers to an image. Gradient fill layers can be applied in this way to create gradient filter type effects. You will also find that the gradient tool comes in use when you want to edit the contents of a layer mask. For example, you can add a black to white gradient to a layer mask to apply a graduated fade to the opacity of a layer.

The paint bucket tool is another type of fill tool and is a bit like a combination of a magic wand selection combined with an Edit ⇨ Fill using the foreground color.

Figure 1.71 In this example I added a radial gradient using a transparency to blue gradient. Above this I added a 35 mm filmstrip custom shape layer filled with black.

Tools for drawing

If you want to become a good retoucher, then at some stage you are going to have to bite the bullet and learn how to use the pen tools. The selection tools are fine for making approximate selections, but, as I show below in Figure 1.72, whenever you need to create precision selections or masks, the pen tool and associated path editing tools are essential.

The pen tool group includes the main pen tool, a freeform pen tool (which in essence is not much better than the lasso or magnetic lasso tools) plus modifier tools to add, delete or modify the path points. There are several examples coming up in Chapter 8 where I will show how to use the pen tools to draw a path.

	Pen tool (P)
	Freeform pen tool (P)
	Add anchor point tool
	Delete anchor point tool
	Convert point tool
	Path selection tool (A)
	Direct selection tool (A)

Figure 1.72 If you need to isolate an object and create a cut-out like the one shown here, the only way to do this is by using the pen and pen modifier tools to first draw a path outline. You see, with a photograph like this, there is very little color differentiation between the object and the background and it would be very difficult for an auto masking tool to accurately predict the edges in this image. With experience it shouldn't take you too long to create a cut-out like this.

Move tool (V)

Crop tool (C)

Perspective Crop tool (C)

Clone Stamp (S)

Pattern Stamp (S)

Spot Healing brush (J)

Healing brush (J)

Patch tool (J)

Content-Aware Move tool (J)

Red Eye tool (J)

Color Replacement tool (B)

Eraser (E)

Background Eraser (E)

Magic Eraser (E)

Image editing tools

The move tool can be used to move objects, while the crop tool can be used to trim pictures or enlarge the canvas area. This tool has undergone some major changes along with the addition of a perspective crop tool. You can read more about these in Chapter 4 on Image editing essentials.

The clone stamp tool has been around since the early days of Photoshop and is definitely an essential tool for all kinds of retouching work. You can use the clone stamp to sample pixels from one part of the image and paint with them in another (as shown in Figure 1.73). The spot healing and healing brush tools can be used in almost exactly the same way as the clone stamp, except they cleverly blend the pixels around the edges of where the healing brush retouching is applied to produce almost flawless results. The spot healing brush is particularly clever because you don't even need to set a sample point: you simply click and paint over the blemishes you wish to see removed. This tool has been enhanced with a content-aware healing mode that allows you to tackle what were once really tricky subjects to retouch. The patch tool is similar to the healing brush except you first use a selection to define the area to be healed and this is now also joined by a content-aware move tool that allows you to either extend a selected area or move it and at the same time fill the initial selected area. Incidentally, these tools have been much improved in this latest version of the program.

Providing you use the right flash settings on your camera it should be possible to avoid red eye from ever occurring in your flash portrait photographs. But for those times when the camera flash leaves your subjects looking like beasts of the night, the red eye tool provides a fairly basic and easy way to auto-correct such photos. Meanwhile, the color replacement brush is like a semi-smart color blend mode painting tool that analyzes the area you are painting over and replaces it with the current foreground color, using either a Hue, Color, Saturation or Luminosity blend mode. It is perhaps useful for making quick and easy color changes without needing to create a Color Range selection mask first.

The eraser tools let you erase pixels directly, although these days it is better to use layer masks to selectively hide or show the contents of a layer. The background eraser and magic eraser tools do offer some degree of automated erasing capabilities, but I would be more inclined to use the quick selection tool combined with a layer mask for this kind of masking.

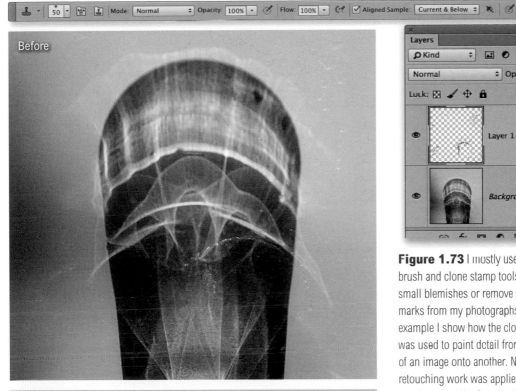

Before

After

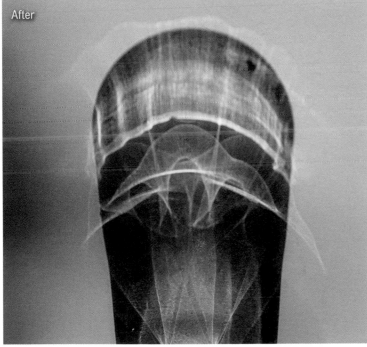

Figure 1.73 I mostly use the healing brush and clone stamp tools to retouch small blemishes or remove sensor dust marks from my photographs. In this example I show how the clone stamp tool was used to paint detail from one part of an image onto another. Note how the retouching work was applied to an empty new layer and the Sample: 'Current & Below' option selected in the clone stamp tool Options bar.

Nudging layers and selections

The keyboard arrow keys can be used to nudge a layer or selection in 1 pixel increments, or with the *Shift* key held down, by 10 pixel increments. A series of nudges count as a single Photoshop step in history and can be undone with a single undo (*⌘ Z* [Mac], *ctrl Z* [PC]) or a step back in history. Also, holding down the *Shift* key as you drag allows you to constrain the move direction to the horizontal, vertical or 45° angle.

Move tool

The move tool can perform many functions such as move the contents of a layer, directly move layers from one document to another, copy layers, apply transforms, and select and align multiple layers. In this respect the move tool might be more accurately described as a move/transform/alignment tool and you'll also see a heads up display that indicates how much you are moving something. The move tool can also be activated any time another tool is selected simply by holding down the *⌘* (Mac), *ctrl* (PC) key (except when the slice tools, hand tool, pen or path selection tools are selected). If you hold down the *alt* key while the move tool is selected, this lets you copy a layer or selection contents. It is also useful to know that using *alt* + *⌘ ctrl* (the move tool shortcut) lets you make a copy of a layer or selection contents when any other tool is selected (apart from the ones I just listed). If the Show Transform Controls box is checked in the move tool Options bar (Figure 1.74), a bounding box will appear around the bounds of the selected layer. When you mouse down on the bounding box handles to transform the layer, the Options bar switches modes to display the numeric transform controls.

Figure 1.74 The move tool Options bar with the Auto-Select layer option checked. Note you can select Group or Layer from the pop-up menu here.

Auto layer/layer group selection

The move tool Options panel has a menu that allows you to choose between 'Group' or 'Layer' auto-selection. When 'Layer' is selected, Photoshop only auto-selects individual layers. When 'Group' is selected, Photoshop can auto-select whole layer groups. If the move, marquee, lasso or crop tool are selected, a *⌘ ⌥ ctrl* [Mac], *ctrl alt* + right mouse-click [PC] selects a target layer based on the pixels where you click. When the move tool only is selected, *⌘ ⌥* [Mac], *ctrl alt* [PC] + click selects a layer group based on the pixels where you click.

Layer selection using the move tool

When the move tool is selected, dragging with the move tool moves the layer or image selection contents (the cursor does not have to be centered on the object or selection, it can be anywhere in the image window). However, when the Auto-Select option is switched on (circled in Figure 1.74), the move tool can auto-select the uppermost layer (or layer group) containing the most opaque image data below the cursor. This can be useful when you have a large number of layers in an image. Multiple layer selection is also possible with the move tool, because when the move tool is in Auto-Select mode you can marquee drag with the move tool from outside the canvas area to select multiple layers, the same way as you can make a marquee selection using the mouse cursor to select multiple folders or documents in the Finder/Explorer (see Figure 1.75).

Where you have many layers that overlap, remember there is a contextual mode for the move tool that can help you target specific layers (use *ctrl* right mouse-click to access the contextual layer menu). Any layer with an opacity greater than 50% will show up in the contextual menu. This then allows you to select a specific layer from below the cursor.

Client: ET Nail Art

Figure 1.75 When the move tool is selected and the Auto-Select box is checked, you can marquee drag with the move tool from outside of the canvas area inwards to select specific multiple layers or layer groups. If the Auto-Select Layer option is deselected, you can instead hold down the ⌘ [Mac], *ctrl* [PC] key to temporarily switch the move tool to the 'Auto Select' mode.

Align/Distribute layers

When several layers are linked together, you can click on the Align and Distribute buttons in the Options bar as an alternative to navigating the Layer ⇨ Align Linked and Distribute Linked menus.

Layer selection shortcuts

You can at any time use the ⌘ ⌥ *A* (Mac), *ctrl* ⌥ *A* (PC) shortcut to select all layers. But note that the move tool layer selection method will not select any layers that are locked. For example, if you use the Auto-Select layer mode to marquee drag across the image to make a layer selection, the background layer will not be included in the selection.

Zoom tool (Z)

Hand tool (H)

Eyedropper tool (I)

Color Sampler tool (I)

Ruler tool (I)

Rotate View tool (R)

Notes tool (I)

Count tool (I)

Navigation and information tools

To zoom in on an image, you can either click with the zoom tool to magnify, or drag with the zoom tool, marqueeing the area you wish to inspect in close-up. This combines a zoom and scroll function in one (a plus icon appears inside the magnifying glass icon). To zoom out, just hold down the *alt* key and click (the plus sign is replaced with a minus sign). You can also zoom in by holding down the spacebar + the ⌘ key (Mac) or the *ctrl* key (PC). You can then click to zoom in and you can also zoom out by holding down the spacebar + the *alt* key. This keyboard shortcut calls up the zoom tool in zoom out mode and you can then click to zoom out.

Zoom tool shortcuts

Photoshop uses the ⌘ *1* (Mac), *ctrl* *1* (PC) shortcut to zoom to 100% (or you can use ⌘ ⌥ *0* [Mac], *ctrl* *alt* *0* [PC]) and ⌘ *0* (Mac), *ctrl* *0* (PC) to zoom out to a fit to view zoom view. Another handy zoom shortcut is ⌘ *+* (Mac), *ctrl* *+* (PC) to zoom in and ⌘ *−* (Mac), *ctrl* *−* (PC) to zoom out (note the *+* key is really the *=* key). If your mouse has a wheel and 'Zoom with mouse wheel' is selected in the preferences, you can use it with the *alt* key held down to zoom in or out. If 'Use Graphics Processor' is enabled you can carry out a continuous zoom by simply holding down the zoom tool (and use *alt* to zoom out). Photoshop also supports two-fingered zoom gestures such as drawing two fingers together to zoom out and spreading two fingers apart to zoom in.

Hand tool

When you view an image close-up, you can select the hand tool from the Tools panel (*H*) and drag to scroll the image, and you can also hold down the spacebar at any time to temporarily access the hand tool (except when the type tool is selected). The hand and zoom tools also have another navigational function. You can double-click the hand tool icon in the Tools panel to make an image fit to screen and double-click the zoom

Figure 1.76 You can use the Zoom tool Options bar buttons to adjust the zoom view. If 'Use Graphics Processor' is enabled 'Scrubby Zoom' will be checked. This overrides the marquee zoom behavior – dragging to the right zooms in and dragging to the left zooms out.

tool icon to magnify an image to 100%. There are also further zoom control buttons in the zoom tool Options bar, such as 100%, Fit Screen and Fill Screen (Figure 1.76).

Bird's-eye view

The Bird's-eye view feature is available whenever 'Use Graphics Processor' is enabled in the Performance preferences. If you are viewing an image in a close-up view, you can hold down the **H** key and, as you do this, if you click with the mouse, the image view swiftly zooms out to fit to the screen and at the same time shows an outline of the close-up view screen area (a bit like the preview in the Navigator panel). With the **H** key and mouse key still held down, you can drag to reposition the close-up view outline, release the mouse and the close-up view will re-center to the newly selected area in the image (see Figure 1.77).

Figure 1.77 If a window document is opened with 'Use Graphics Processor' enabled and in a close-up view, you can hold down the **H** key and click with the mouse to access a bird's eye view of the whole image. You can then drag the rectangle outline shown here to scroll the image and release to return to a close-up of the image centered around this new view.

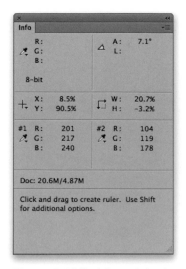

Figure 1.78 The Info panel showing an eyedropper color reading, a measurement readout, and two color sampler readouts below. Note, you can now have up to ten color samplers in the Info panel.

Figure 1.79 This shows the eyedropper wheel. The outer gray circle is included to help you judge the inner circle colors more effectively. The top half shows the current selected color and the bottom half, the previous selected color. The sample ring display can be disabled in the eyedropper options.

Flick panning

With 'Use Graphics Processor' enabled in the Photoshop Performance preferences, you can also check the Enable Flick Panning option in the Tools preferences. When this option is activated, Photoshop will respond to a flick of the mouse pan gesture by continuing to scroll the image in the direction you first scrolled, taking into account the acceleration of the flick movement. When you have located the area of interest just click again with the mouse to stop the image from scrolling any further.

Windows Multi-touch support

If you are using the Windows 7 or 8 operating system and have multi-touch aware hardware, Photoshop supports touch zoom in and out, touch pan/flicking as well as touch canvas rotation. This includes Windows 8.1 devices such as the Microsoft Surface Pro.

Eyedropper tool

The eyedropper tool can be used to measure pixel values directly from a Photoshop document, which are displayed in the Info panel shown in Figure 1.78. Photoshop also features a heads up display, which I describe in Figure 1.79. The color sampler tool can be used to place up to four color samplers in an image to provide persistent readouts of the pixel values, which is useful for those times when you need to closely monitor the pixel values as you make image adjustments. In Photoshop you can sample the current layer and below as well as with no adjustments (see Figure 1.80).

Ruler tool

The ruler tool can be used to measure distance and angles in an image and again, this data is displayed in the Info panel, such as in the example shown in Figure 1.78.

Figure 1.80 The eyedropper tool has sample options in the Options bar. You can sample 'Current & Below', 'All Layers no Adjustments', and 'Current & Below no Adjustments'. The sample size pop-up menu also appears when using the various eyedropper tools, such as black point and white point eyedroppers in Levels and Curves.

Rotate view tool

If 'Use Graphics Processor' is enabled in the Performance preferences, you can use the rotate view tool to rotate the Photoshop image canvas (as shown below in Figure 1.81). Being able to quickly rotate the image view can sometimes make it easier to carry out certain types of retouching work, rather than be forced to draw or paint at an uncomfortable angle. To use the rotate view tool, first select it from the Tools panel (or use the **R** keystroke) and click and drag in the window to rotate the image around the center axis. As you do this, you will see a compass overlay that indicates the image position relative to the default view angle (indicated in red). This can be useful when you are zoomed in close on an image. To reset the view angle to normal again, just hit the **esc** key or click on the Reset View button in the Options bar.

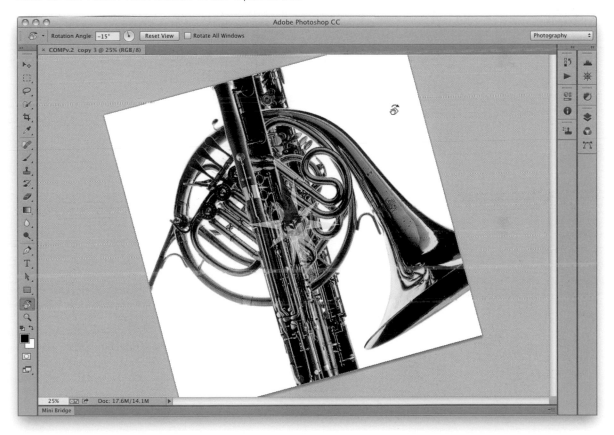

Figure 1.81 This shows the rotate view tool in action.

Photograph: Eric Richmond

Figure 1.82 The Notes panel.

Notes tool

The notes tool is handy for adding sticky notes to open images. You can use the Notes panel (Figure 1.82) to store the recorded note messages. This method makes the notes display and management easy to control. I use this tool quite a lot at work, because when a client calls me to discuss a retouching job, I can open the image, click on the area that needs to be worked on and use the Notes panel to type in the instructions for whatever further retouching needs to be done to the image. If the client you are working with is also using Photoshop, they can use the notes feature to mark up images directly, which when opened in Photoshop can be inspected as shown in Figure 1.83 below.

Count tool

The count tool is more useful to those working in areas like medical research where, for example, you can use the count tool to count the number of cells in a microscope image.

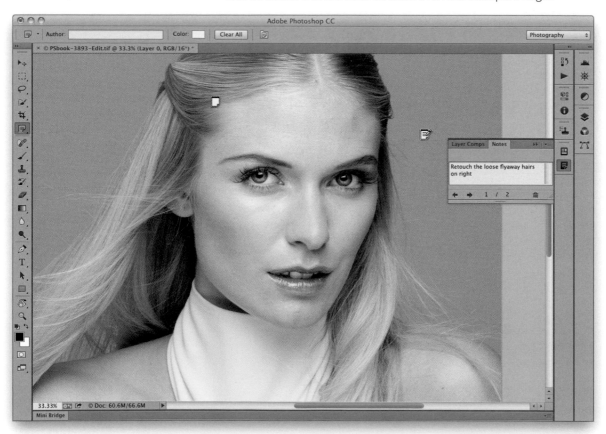

Figure 1.83 An example of the notes tool being used to annotate an image.

Screen view modes

In Figure 1.84 I have highlighted the Application bar screen view mode options which allow you to switch between the three main screen view modes. The standard screen view displays the application window the way it has been shown in all the previous screen shots and lets you view the document windows as floating windows or tabbed to the dock area. In Full Screen Mode with Menu Bar, the frontmost document fills the screen, while allowing you to see the menus and panels. Lastly, the Full Screen view mode displays a full screen view with the menus and panels hidden.

Full view screen mode

The Full Screen Mode with Menu Bar and Full Screen modes are usually the best view modes for concentrated retouching work. These allow full movement of the image, not limited by the edges of the document bounds. In other words, you can scroll the image to have a corner centered in the screen and edit things like path points outside the bounds of the document. Also note that the **F** key can be used to cycle between screen modes and *Shift* **F** to cycle backwards.

Figure 1.84 This shows examples of two of the three screen view modes for the Photoshop interface. Here you can see the Standard Screen Mode view (top) and Full Screen Mode with Menu Bar (bottom). The absolute Full Screen mode, which isn't shown here, displays the image against a black canvas and with the menus and panels hidden.

Blending modes

Layers can be made to blend with the layers below them using any of the 27 different blending modes that are in Photoshop. Layer effects/styles can be used to add effects such as drop shadows, gradient/pattern fills or glows to any layer, plus custom layer styles can be loaded from and saved to the Styles panel.

Drag and drop layers

You can drag and drop a file to a Photoshop document and place it as a new layer.

Working with Layers

Photoshop layers allow you to edit a photograph by building up the image in multiple layered sections, such as in the Figure 1.85 example below. A layer can be an image element, such as a duplicated background layer, a copied selection that's been made into a layer, or content that has been copied from another image. Or, you can have text or vector shape layers. You can also add adjustment layers, which are like image adjustment instructions applied in a layered form.

Layers can be organized into layer group folders, which will make the layer organization easier to manage, and you can also apply a mask to the layer content using either a pixel or vector layer mask. You will find there are plenty of examples throughout this book in which I show you how to work with layers and layer masks.

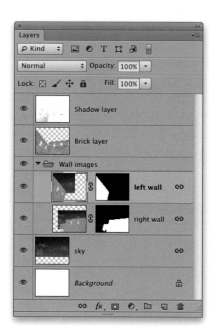

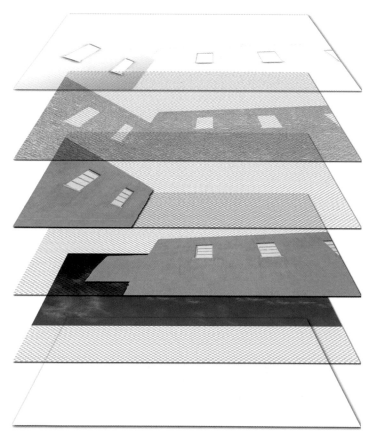

Figure 1.85 The above Layers panel view shows the layer contents of a typical layered Photoshop image and the diagram on the right shows a composite image broken down into its constituent layers.

Preset Manager

The Preset Manager (Edit ⇨ Presets ⇨ Preset Manager) lets you manage all your presets from within the one dialog. This allows you to keep track of: Brushes, Swatches, Gradients, Styles, Patterns, Layer effect contours, Custom shapes and Tools (Figure 1.86 shows the Preset Manager used to manage the Tool presets). You can append or replace an existing set of presets via the Preset Manager options and the Preset Manager can also be customized to display the preset information in different ways, such as in the Figure 1.87 example, where I used a Large List to display large thumbnails of all the currently loaded Gradient presets.

Saving presets as Sets

As you create and add your own custom preset settings, you can manage these via the Preset Manager. For example, this means that you can select a group of presets and click on the Save Set... button to save these as a new group of presets. Note that if you rearrange the order of the tool presets, the edited order will remain sticky when you next relaunch Photoshop.

Loading presets

If you double-click any Photoshop setting that is outside the Photoshop folder, this automatically loads the Photoshop program and appends the preset to the relevant section in the Preset Manager.

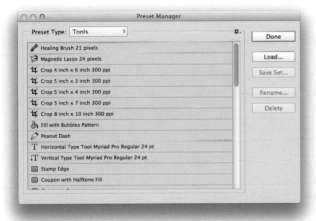

Figure 1.86 You can load and replace presets and choose how presets are displayed.

Figure 1.87 In the case of Gradients, it's nice to see a preview alongside each gradient. You can use the Photoshop Preset Manager to load custom settings that can be used to append or replace the pre-supplied defaults.

Figure 1.88 A previous history step can be selected by clicking on the history step name in the History panel. In its default configuration, you'll notice when you go back in history, the history steps after the one that is selected will appear dimmed. If you move back in history and you then make further edits to the image, the history steps after the selected history step will be deleted. However, you can change this behavior by selecting Allow Non-linear History in the History panel options (see Figure 1.89).

Figure 1.89 The History Options can be accessed via the History panel fly-out menu. These allow you to configure things like the Snapshot and Non-linear history settings. I usually have Allow Non-Linear History option checked—this enables me to use the History feature to its full potential (see page 71).

History

The History feature was first introduced in Photoshop 5.0 and back then was considered a real breakthrough feature. This was because, for the first time, Photoshop was able to offer multiple undos during a single Photoshop editing session. History can play a really important role in the way you use Photoshop, so I thought this would be the best place to describe this feature in more detail and explain how history can help you use Photoshop more efficiently.

As you work on an image, Photoshop is able to record a history of the various image states as steps and these can be viewed in the History panel (Figure 1.88). If you want to reverse a step, you can always use the conventional Edit ⇨ Undo command (⌘ Z [Mac], *ctrl* Z [PC]), but if you use the History panel, you can go back as many stages in the edit process as you have saved history steps.

The History panel

The History panel displays the sequence of Photoshop steps that have been applied during a Photoshop session and its main purpose is to let you manage and access the history steps that have been recorded in Photoshop. The history source column in the History panel will allow you to select a history state to sample from when working with the history brush (or filling from history). So, to revert to a previous step, just click on a specific history step. For example, in Figure 1.88 I carried out a simple one-step undo by clicking in the Source column for the last but one history step. Document saves are also now recorded in the History panel. This doesn't mean that history states are saved after you close a document of course, but it does mean that Photoshop will automatically store a history state each time you save, which will give you more options to revert to during an edit session.

One can look at history as a multiple undo feature in which you can reverse through up to 1000 image states. However, it is actually a far more sophisticated tool than just that. For example, there is a non-linear history option for multiple history path recording (see the History Options dialog in Figure 1.89). Non-linear history allows you to shoot off in new directions and still preserve all the original history steps. Painting from history can therefore save you from tedious workarounds like having to create more layers than are really necessary in order to preserve fixed image states that you can sample from. With history you don't have to do this and by making sensible use of

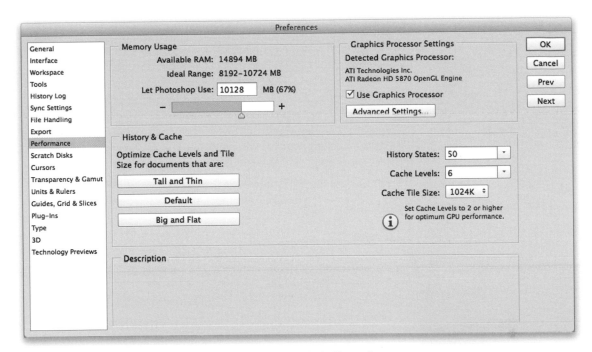

Figure 1.90 The number of recorded history states can be set via the History & Cache section of the Performance preferences dialog.

non-linear history, you can keep the number of layers that are needed to a minimum.

To set the options for the History panel, mouse down on the fly-out menu and select History Options… (Figure 1.89). By default, history automatically creates an 'open' state snapshot each time you open an image and you can also choose to create additional snapshots each time an image is saved. Basically, Snapshots can be used to prevent history states from slipping off the end of the list and becoming deleted as more history steps are created (see page 70). 'Make Layer Visibility Changes Undoable' makes switching layer visibility on or off a recordable step in history, although this can be annoying if turning the layer visibility on or off prevents you from using undo/redo to undo the last Photoshop step.

History settings and memory usage

When the maximum number of recordable history steps has been reached, the earliest history step at the top of the list is discarded. With this in mind, the number of recorded histories can be altered via the Photoshop Performance preferences (Figure 1.90). Note that if you reduce the number of history states (or steps) that are allowed, any subsequent action will

Figure 1.91 This shows the underlying tiled structure of a Photoshop image. This is a clue as to how history works as economically as possible. The history stores the minimum amount of data necessary at each step in Photoshop's memory. So if just one or two tile areas are altered by a Photoshop action, only the data change that takes place in those tiles is actually recorded.

History stages	Scratch disk
Open file	1360 MB
Add new layer	1360 MB
Healing brush	1670 MB
Healing brush	1670 MB
Marquee selection	1610 MB
Feather selection	1630 MB
Inverse selection	1660 MB
Add adjustment layer	1700 MB
Modify adjustment layer	1700 MB
Flatten image	1630 MB

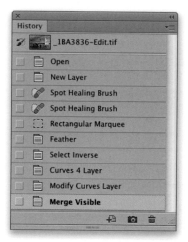

Figure 1.92 The accompanying table shows how the scratch disk usage can fluctuate during a typical Photoshop session. The image I opened here was 160 MB in size and 10 GB of memory was allocated to Photoshop. The scratch disk overhead is usually quite big at the beginning of a Photoshop session, but notice how there was little proportional increase in the scratch disk usage with each successive history step.

immediately cause all earlier steps beyond this new limit to be discarded.

Conventional wisdom would suggest that a multiple undo feature is bound to tie up vast amounts of scratch disk space to store all the previous image steps. However, this is not really the case. It is true that a series of global Photoshop steps may cause the scratch disk usage to rise, but localized changes will not. This is because the history feature makes clever use of the image cache tiling structure to limit any unnecessary drain on the memory usage. Essentially, Photoshop divides an image up into tiled sections and the size of these tiles can be set in the Performance preferences (see Figure 1.90). Because of the way Photoshop images are tiled, the History feature only needs to memorize the changes that take place in each tile. Therefore, if a brush stroke takes place across two image tiles, only the changes taking place in those tiles needs to be updated (see Figure 1.91). If a global change such as a filter effect takes place, the whole of the image area is updated and the scratch disk usage rises accordingly. A savvy Photoshop user will want to customize the History feature to record a reasonable number of histories, while at the same time be aware of the need to change this setting if the history usage is likely to place too heavy a burden on the scratch disk. The history steps example discussed in Figure 1.92 demonstrates that successive histories need not consume an escalating amount of memory. In this example, the healing brush work only affected the tiled sections. After the first adjustment layer had been added, successive adjustment layers had little impact on the scratch disk usage (because only the screen preview was being changed). By the time I got to the 'flatten image' stage the scratch disk/memory usage had begun to bottom out.

If the picture you are working with is exceptionally large, then having more than, say, ten undos can be both wasteful and unnecessary, so you should perhaps consider restricting the number of recordable history states. On the other hand, if multiple history undos are well within the scratch disk memory limits of your system, then why not make the most of them? If excessive scratch disk usage does prove to be a problem, the Purge History command in the Edit �□ Purge menu provides a useful way to keep the scratch disk memory usage under control. Above all, remember that the History feature is more than just a mistake-correcting tool, it has great potential for mixing composites from previous image states.

History brush

The history brush can be used to paint from any previous history state and allows you to selectively restore image data as desired. To do this you need to leave the current history state as it is and select a source history state for the history brush by clicking in the box next to the history step you wish to sample from. In Figure 1.93 you can see how I had set the 'New Layer' history step as the history source (notice the small history brush icon where the box next to this is currently checked). I was then able to paint with the history brush from this previous history state, painting over the areas that had been worked on with the spot healing brush and use the history brush to restore those parts of the picture back to its previous, 'New Layer' history state.

Use of history versus undo

As you will have seen so far, the History feature is capable of being a lot more than a repeat Edit ⇨ Undo command. Although the History feature is sometimes described as a multiple undo, it is important not to confuse Photoshop history with the role of the undo command. For example, there are a number of Photoshop procedures that are *only undoable* through using the Edit ⇨ Undo command, like intermediate changes made when setting the shadows and highlights in the Levels dialog. There are also things which can be undone using Edit ⇨ Undo that have nothing to do with Photoshop's history record for an image. For example, if you delete a swatch color or delete a history state, these actions are only recoverable by using Edit ⇨ Undo. The undo command is also a toggled action and this is because the majority of Photoshop users like having the ability to switch quickly back and forth to see a before and after version of the image. The current combination of having undo commands and a separate History feature has been carefully planned to provide the most flexible and logical approach. History is not just an "oh I messed up. Let's go back a few stages" feature, the way some other programs work; it is a tool designed to ease the workflow and provide you with extra creative options in Photoshop. A key example of this is the Globe Hands image that was created by Jeff Schewe. The story behind this image and its influence on the History feature is told in Figure 1.95.

Art history brush

The art history brush is something of an oddity. It is a history brush that allows you to paint from history but does so via a brush which distorts the sampled data and can be used to create impressionist type painting effects. You can learn more about this tool from the *Photoshop for Photographers Help Guide* that's on the book website.

Figure 1.93 A previous history state can be selected as the source for the history brush by going to the History panel and clicking in the box to the left of the history step you want to paint from using the history brush.

Filling from history

When you select the Fill... from the Edit menu there is an option in the Contents Use menu to choose 'History'.

Create new Create new
document snapshot

Figure 1.94 To record a new snapshot, click on the Create New Snapshot button at the bottom of the History panel. This records a snapshot of the history at this stage. If you *alt*-click the button, there are three options: Full Document, which stores all layers intact; Merged Layers, which stores a composite; and Current Layer, which stores just the currently active layer. Note if you have the Show New Snapshot dialog by Default turned on in the History panel options, the New Snapshot dialog appears directly, without you having to *alt*-click the New Snapshot button. The adjacent Create New Document button can create a duplicate image of the active image in its current history state.

Snapshots

Snapshots are stored above the History panel divider and used to record the image in its current state so as to prevent this version of the image from being overwritten and for as long as the document is open and being edited in Photoshop. The default settings for the History panel will store a snapshot of the image in its opened state and you can create further snapshots by clicking on the Snapshot button at the bottom of the panel (see Figure 1.94). This feature is particularly useful if you have an image state that you wish to store temporarily and don't wish to lose as you make further adjustments to the image. There is no real constraint on the number of snapshots that can be added, and in the History panel options (Figure 1.89) you can choose to automatically generate a new snapshot each time you save the image (which will also be time-stamped). The Create New Document button (next to the Snapshot button) can be used to create a duplicate image state in a new document window and saved as a separate image.

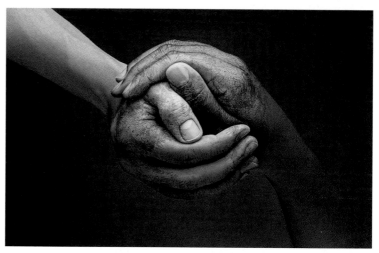

Figure 1.95 Photographer Jeff Schewe has had a long-standing connection with the Adobe Photoshop program and its development. The origins of the History feature can perhaps be traced back to a seminar where he used the Globe Hands image shown here to demonstrate his use of the Snapshot feature in Photoshop 2.5. Jeff was able to save multiple snapshots of different image states in Photoshop and selectively paint back from them. This was all way before layers and history were introduced in Photoshop. Chief Photoshop Engineer Mark Hamburg was suitably impressed by Jeff's technique and the ability to paint from snapshots became an important part of the History feature. Everyone had been crying out for a multiple undo in Photoshop, but when history was first introduced in Photoshop 5.0 it came as quite a surprise to discover just how much the History feature would allow you to do.

Non-linear history

The non-linear history option lets you branch off in several directions and experiment with different effects without needing to add lots of new layers. Non-linear history is not an easy concept to grasp, so the best way to approach this is to imagine a series of history steps as having more than one 'linear' progression, allowing the user to branch off in different directions in Photoshop instead of in a single chain of events (see Figure 1.96). Therefore, while you are working on an image in Photoshop, you have the opportunity to take an image down several different routes and a history step from one branch can then be blended with a history step from another branch without having to save duplicate files.

Non-linear history requires a little more thinking on your part in order to monitor and recall image states, but ultimately makes for a more efficient use of the available scratch disk space. Overall, I find it useful to have non-linear history switched on all the time, regardless of whether I need to push this feature to its limits or not.

Figure 1.96 The non-linear history option allows you to branch off in different directions and simultaneously maintain a record of each history path up to the maximum number of history states that can be allowed. Shown here are three history states selected from the History panel: (A) the initial opened image state, (B) with a Curves layer adjustment added and (C) an alternative version where I added a Black and White adjustment layer followed by a Curves adjustment layer to add a sepia tone color effect.

Corrupt files

There are various reasons why a file may be corrupt and refuses to open, but it often happens when images have been sent as attachments. Here, it is most likely due to a break during transmission somewhere, resulting in missing data.

Figure 1.97 The header information in some files may contain information that tells the operating system to open the image in a program other than Photoshop. On a Macintosh go to the File menu and choose File ⇨ Get Info and under the 'Open with' item, change the default application to Photoshop. On a PC you can do the same thing via the File Registry.

Figure 1.98 When files won't open up directly in Photoshop the way you expect them to, then it may be because the header is telling the computer to open them up in some other program instead. To force open an image in Photoshop, drag the file icon on top of the Photoshop application icon or an alias or shortcut thereof, such as an icon placed in the dock or on the desktop.

When files won't open

You can open an image file in Photoshop in a number of ways. You can open an image via Bridge, or you can simply double-click a file to open it. As long as the file you are about to open is in a file format that Photoshop recognizes, it will open in Photoshop and if the program is not running at the time this action should also launch Photoshop.

Every document file contains a header section, which among other things tells the computer which application should be used to open it. For example, Microsoft Word documents will, naturally enough, default to opening in Microsoft Word. Photoshop can recognize nearly all types of image documents regardless of the application they may have originated from, but sometimes you will see an image file with an icon for another specific program, like Macintosh Preview, or Internet Explorer. If you double-click these particular files, they will open in their respective programs. To get around this, you can follow the instructions described in Figure 1.97. Alternatively, you can use the File ⇨ Open command from within Photoshop, or you can drag a selected file (or files) to the Photoshop program icon, or a shortcut/alias of the program icon (Figure 1.98). In each of these cases this allows you to override the computer operating system which normally reads the file header to determine which program the file should be opened in. If you use Bridge as the main interface for opening image files in Photoshop, then you might also want to open the File Type Association preferences (see the Bridge chapter PDF on website) to check that the file format for the files you are opening are all set to open in Photoshop by default.

Yet, there are times when even these methods may fail and this points to one of two things. Either you have a corrupt file, in which case the damage is most likely permanent. Or, the file extension has been wrongly changed. It says .psd, but is it really a PSD? Is it possible that someone has accidentally renamed the file with an incorrect extension? In these situations, the only way to open it will be to rename the file using the *correct* file extension, or use the Photoshop File ⇨ Open command and navigate to locate the mis-saved image (which once successfully opened should then be resaved to register it in the correct file format).

Save often

It goes without saying that you should always remember to save often while working in Photoshop. Hopefully, you won't come across many crashes when working with the latest Macintosh and PC operating systems, and the fact that Photoshop can now carry out automatic background saves is a real bonus, but there are still some pitfalls you need to be aware of.

Choosing File ⇨ Save always creates a safe backup of your image, but as with everything else you do on a computer, do make sure you are not overwriting the original with an inferior modified version. There is always the danger that you might make permanent changes such as a drastic reduction in image size, accidentally hit 'Save' and lose the original in the process. If this happens, there is no need to worry so long as you don't close the image. You can always go back a step or two in the History panel and resave the image in the state it was in before it was modified. Incidentally, Photoshop CC now allows you to save multiple documents at once, placing them in a queue.

When you save an image in Photoshop, you are either resaving the file (which overwrites the original) or are forced to save a new version using the Photoshop file format. The determining factor here will be the file format the image was in when you opened it and how it has been modified in Photoshop. Over the next few pages I'll be discussing some of the different file formats you can use, but the main thing to be aware of is that some file formats do restrict you from being able to save things like layers, pen paths or extra channels. For example, if you open a JPEG format file in Photoshop and modify it by adding a pen path, you can choose File ⇨ Save and overwrite the original without any problem. However, if you open the same file and add a layer or an extra alpha channel, you won't be able to save it as a JPEG any more. This is because although a JPEG file can contain pen paths, it doesn't support layers or additional channels, so it has to be saved using a file format that is capable of containing these extra items.

I won't go into lengthy detail about what can and can't be saved using each format, but basically, if you modify a file and the modifications can be saved using the same file format that the original started out in, then Photoshop will have no problem saving and overwriting the original. If the modifications applied to an image mean that it can't be saved using the original file format it will default to using the PSD (Photoshop document) format and save the image as a new document via the Save As dialog (Figure 1.98). You can also

Graphic Converter

If you are still having trouble trying to open a corrupted file, the Graphic Converter program can sometimes be quite effective at opening mildly corrupted image files.

Closing unchanged files (Mac)

On the Mac ⌥-clicking the Close button on one open image will close all the others that have remained unchanged. Where images have had changes it will stop to ask whether you want to save these or not.

History saves

While there is an Auto-Save feature in Photoshop, it is still not possible to save a history of everything you did to an image. However, if you go to the Photoshop History Log preferences you can choose to save a history log information of everything that was done to the image. This can record a log of everything that was done during a Photoshop session and can be saved to a central log file or saved to the file's metadata.

The other thing you can do is go to the Actions panel and click to record an action. If you have the tool recording option enabled, such an action will record things like brush strokes and you may be able to fully record everything that was done to the image while it was edited in Photoshop.

choose to save such documents using the TIFF or PDF format. In my view, the TIFF format is a good choice for saving master images since this file format can contain anything that's been added in Photoshop.

Essentially, there are four main file formats that can be used to save everything you might add to an image such as image layers, type layers, channels and that also support 16-bits per channel. These are: TIFF, Photoshop PDF, the large document format, PSB and lastly the native Photoshop file format, PSD. As I say, I now mostly favor using the TIFF format when saving master RGB images. When you choose File ⇨ Close All, if any of the photos have been modified, a warning dialog alerts you and allows you to close all open images with or without saving them first. For example, if you make a series of adjustments to a bunch of images and then change your mind, with this option you can quickly close all open images if you don't really need them to be saved.

Background Saving

The Automatically Save Recovery Information feature can be enabled via the File Handling preferences. In case of a crash this will allow you to recover data from any open files that you were working on which had been modified since opening. Note that this feature does not auto-save by overwriting the original file (which could lead to all sorts of problems). What Photoshop does is to auto-save copies of whatever you are working on in the background using the PSD format. In the event of a crash, the next time you launch Photoshop it will automatically open the most recent auto-saved copies of whatever you were working on. If you refer to the configuring Photoshop PDF on the website you can read about how to configure the File Handling preferences to switch this option on and determine how frequently you wish to update the background save file.

Normal saves

As with all other programs, the keyboard shortcut for saving a file is: ⌘ S (Mac), ctrl S (PC). If you are editing an image that has never been saved before or the image state has changed (so that what started out as a flattened JPEG, now has layers added), this action will pop the Save As…dialog. Subsequent saves may not show the Save dialog. But if you do wish to force the Save dialog to appear and save a copy version, use: ⌘ ⌥ S (Mac), ctrl alt S (PC).

Using Save As... to save images

If the image you are about to save has started out as, say, a flattened JPEG, but now has layers, this will force the Save As dialog shown in Figure 1.99 to appear as you save. However, you can also choose 'File ⇨ Save As...' (⌘ Shift S [Mac], ctrl Shift S [PC]) any time you wish to save an image using a different file format, or, if you want, you can save a layered image as a flattened duplicate. In the Save As dialog you have access to various save options. In the Figure 1.96 example below, I was able to select the JPEG format when saving a layered, edited image. As you can see, a warning triangle appears to alert you if Layers (or other non-compatible items) can't be stored when choosing JPEG. In these circumstances, incompatible features like this are automatically highlighted and grayed out in the Save As dialog, and the image is necessarily saved as a flattened version of the master.

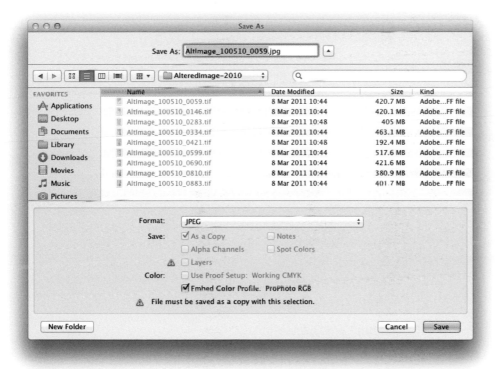

Figure 1.99 If the file format you choose to save in won't support all the components in the image such as layers, then a warning triangle alerts you to this when you attempt to save the document, reminding you that the layers will not be included. Note that the Mac OS dialog shown here can be collapsed or expanded by clicking on the downward pointing disclosure triangle to toggle the expanded folder view.

Maximum compatibility

Only the Photoshop PSD, PDF, PSB and TIFF formats are capable of supporting all the Photoshop features such as vector masks and image adjustment layers. The PSD format has been supported in Photoshop for as long as I have been using the program, but, as I say, remains poorly documented and poorly implemented outside Photoshop. This is the main reason why, for Photoshop (PSD) format documents to be completely compatible with other programs (such as Lightroom), you must ensure you have the 'Maximize PSD and PSB Compatibility' checked in Photoshop's File Handling preferences. The reason for this is because Lightroom is unable to read layered PSD files that don't include a saved composite within the file. If PSD images fail to be imported into Lightroom, it is most likely because they were saved with this preference switched off. Looking ahead to the future, it is difficult to say if PSD will be supported forever. What we do know though is that the TIFF file format has been around longer than PSD and is certainly a well-documented format and integrates well with all types of image editing programs. TIFF is currently still at version 6.0 and it is rumored it's going to be updated to v 7.0 at some point in the near future. Meanwhile, even the Adobe engineers are suggesting that PSD is close to its end, and are now recommending the use of TIFF.

File formats

Photoshop supports nearly all the current, well-known image file formats. And for those that are not supported, you will find that certain specialized file format plug-ins are supplied as free extras for Photoshop. When these plug-ins are installed in the Plug-ins folder they allow you to extend the range of file formats that can be chosen when saving. Your choice of file format when saving images should be mainly determined by what you want to do with a particular file and how important it is to preserve all the features (such as layers and channels) that may have been added while editing the image in Photoshop. Some formats such as PSD and PSB are mainly intended for archiving master image files, while others, such as TIFF, are ideally suited for many types of uses and, in particular, prepress work. Here is a brief summary of the main file formats in common use today.

Photoshop native file format

The Photoshop file format is a universal format and seemingly a logical choice when saving and archiving your master files since the Photoshop (PSD) format will recognize and contain all known Photoshop features. The main advantage of using PSD is that when saving layered images, the native Photoshop format is generally a very efficient format because it uses a run length encoding type of compression that can make the file size more compact, but without degrading the image quality in any way. LZW compression does this by compressing large areas of contiguous color such as a white background into short lengths of data instead of doggedly recording every single pixel in the image. The downside is that PSD is a poorly documented format. It arose at an early stage in Photoshop's development and remains, essentially, a proprietary file format to Adobe and Photoshop. The TIFF format is now generally considered a better format for archive work.

Smart PSD files

Adobe InDesign and Adobe Dreamweaver will let you share Photoshop format files between these separate applications so that any changes made to a Photoshop file will automatically be updated in the other program. This modular approach means that most Adobe graphics programs can integrate with each other more seamlessly.

Large Document (PSB) format

The PSD and TIFF file formats have a 30,000 × 30,000 pixel dimensions limit, while the PSD file format has a 2 GB file size limit and the TIFF format specification has a 4 GB file size limit. You need to bear in mind here that many applications and printer RIPs (Raster Image Processor) can't handle files that are greater than 2 GB anyway and it is mainly for this reason that the above limits have been retained for all the main file formats used in Photoshop (although there are some exceptions, such as ColorByte's ImagePrint and Onyx's PosterShop, which can handle more than 2 GB of data).

The Large Document (PSB) file format is provided as a special format that can be used when saving master layered files that exceed the above limits. The PSB format has an upper limit of 300,000 × 300,000 pixels, plus a file size limit of 4 exabytes (that's 4 million terabytes). This format is therefore mainly useful for saving extra long panoramic images that exceed 30,000 pixels in length, or when saving extra large files that exceed the TIFF 4 GB limit. You do have to bear in mind that only Photoshop CS or later is capable of reading the PSB format, and, just like TIFF and PSD, only recent versions of Photoshop will offer full file format compatibility.

TIFF (Tagged Image File Format)

The main formats used for publishing are TIFF and EPS. Of the two, TIFF is the most universally recognized image format. TIFF files can readily be placed in QuarkXpress, InDesign and any other type of desktop publishing (DTP) program. The TIFF format is more open and, unlike the EPS format, you can make adjustments within the DTP program as to the way a TIFF image will appear in print. It is also a well-documented format and set to remain as the industry standard format for archive work and publishing; also Camera Raw recognizes TIFF, but not PSD. Labs and output bureaux generally request that you save your output images as TIFFs, as this is the file format that can be read by most other imaging computer systems. Therefore, if you are distributing a file for output as a print or transparency, or for someone else to continue editing your master file, it is usually safest to supply the image using TIFF.

TIFFs saved using Photoshop 7.0 or later support alpha channels, paths, image transparency and all the extras that can normally be saved using the native PSD and PDF formats. Labs or service bureaux that receive TIFF files for direct output will normally request that a TIFF file is flattened and saved with the

PSDX format

PSDX is a special file format that has been developed for Photoshop Touch with tablet devices in mind and to provide better performance. Only a subset of PSD capabilities are available on tablet devices, so Photoshop Touch doesn't support things like Smart Objects, layer groups, layer styles, etc. Photoshop Touch can export your file as a PSDX. However, if you store your files in Creative Cloud, the PSDX to PSD conversion happens in the Cloud so that what you end up downloading will in fact be a PSD. You can also download the Touch Apps Plug-in for Photoshop, which then allows Photoshop to read the PSDX format.

TIFF and bit depth

Photoshop does allow for more bit depths when saving TIFF files. For example, BIGTIFF files can now also be read in Photoshop. The BIGTIFF format is a variant of the standard TIFF format that allows you to extend beyond the 4 GB data limit. The BIGTIFF file format is designed to be backward compatible with older TIFF readers in as much as it allows such programs to read the first 4 GB of data as normal. In order to read file data that exceeds this limit, TIFF readers need to be able to read the BIGTIFF format, which Photoshop can now do. Also, prior to Photoshop CS6, Photoshop could only read TIFF files that contained an even number bit depth, such as 2, 4, 6, 8, 10, etc., but could not read TIFF files that had odd number bit depths, such as 3, 5, 7, 9. It is only really files that come from certain scientific cameras and medical systems that create such files. Anyway, Photoshop now allows these files to be read.

alpha channels and other extra items removed. For example, earlier versions of Quark Xpress had a nasty habit of interpreting any path that was present in the image file as a clipping path.

Pixel order

The Photoshop TIFF format has traditionally saved the pixel values in an interleaved order. So if you were saving an RGB image, the pixel values would be saved as clusters of RGB values using the following sequence: RGBRGBRGB. All TIFF readers are able to interpret this pixel order. The Per Channel pixel order option saves the pixel values in channel order, where all the red pixel values are saved first, followed by the green, then the blue. So the sequence used is: RRRGGGBBB. Using the Per Channel order can therefore provide faster read/write speeds and better compression. Most third-party TIFF readers should support Per Channel pixel ordering, but there is just a very slim chance that some TIFF readers won't.

Byte order

The byte order can be made to match the computer system platform the file is being read on, but there is usually no need to worry about this and it shouldn't cause any compatibility problems.

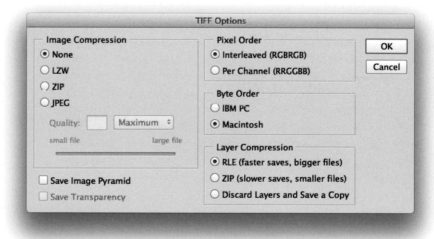

Figure 1.100 This dialog shows the save options that are available when you save an image as a TIFF.

Save Image Pyramid

The Save Image Pyramid option saves a pyramid structure of scaled-down versions of the full resolution image. TIFF pyramid-savvy DTP applications (and there are none I know of yet) will then be able to display a good quality TIFF preview, but without having to load the whole file.

TIFF compression options

An uncompressed TIFF will usually be about the same megabyte size as the figure you see displayed in the Image Size dialog box, but Photoshop offers several compression options when saving a TIFF. LZW uses lossless compression, where image data is compacted and the file size reduced, but without image detail being lost. Saving and opening takes longer when LZW is utilized so some clients will request you don't use it. ZIP is another lossless compression encoding, which like LZW is most effective where images contain large areas of a single color. JPEG image compression uses a lossy method that offers even greater levels of file compression, but again be warned that this option can cause problems downstream with the printer RIP if it is used when saving output files for print. If there are layers present in an image, separate compression options are available for the layers. RLE stands for Run Length Encoding and provides the same type of lossless compression as LZW, and ZIP compression is as described above. Alternatively, choose Discard Layers and Save a Copy, which saves a copy version of the master image as a flattened TIFF.

Flattened TIFFs

If an open image contains alpha channels or layers, the Save dialog (Figure 1.100) indicates this and you can keep these items checked when saving as a TIFF. If 'Ask Before Saving Layered TIFF Files' is switched on in the File Saving preferences, a further alert dialog will warn you that 'including layers will increase the file size' the first time you save an image as a layered TIFF.

JPEG

The JPEG (Joint Photographic Experts Group) format is the most effective way to compress continuous tone image files. JPEG uses what is known as a lossy compression method. For more about working with JPEG and other file formats for the Web, check out the Web Output PDF on the book website. Previously, the maximum number of pixels you could save as a JPEG was 30,000. However, Photoshop can now open and save JPEG documents up to 65,535 pixels in width or height.

Saving 16-bit files as JPEGs

For those who prefer to edit their images in 16-bit, it always used to be frustrating when you would go to save an image as a JPEG copy, only to find that the JPEG option wasn't available in the Save dialog File Format menu. The reason for this is because 16-bit isn't supported by the JPEG format. When you choose Save As… for a 16-bit image, the JPEG file format is actually available as a save option, whereby Photoshop carries out the necessary 16-bit to 8-bit conversion as part of the JPEG save process. This allows you to quickly create JPEG copies without having to temporarily convert the image back to 8-bit. Note, however, that only the JPEG file format is supported in this way.

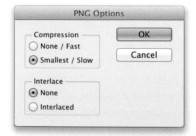

Figure 1.101 The PNG Save dialog. One of the advantages of PNG is that it is capable of storing transparency, which avoids the fudging that has to occur when using formats such as JPEG and GIF. For example, it is useful for creating overlays and watermarks for Lightroom.

PDF versatility

The PDF format in Photoshop is particularly useful for sending Photoshop images to people who don't have Photoshop, but do have the Adobe Reader™ or Macintosh Preview programs on their computer. If they have a full version of Adobe Acrobat™ they will even be able to conduct a limited amount of editing, such as the ability to edit the contents of a text layer. Photoshop is also able to import or append any annotations that have been added via Adobe Acrobat.

PNG

The PNG file format is one that is very popular for Web design and sometimes a useful substitute for the JPEG format. The PNG Save dialog is shown in Figure 1.101, where the file save options allow you to choose between 'None' or 'Smallest' compression. In Photoshop CC you can save metadata and ICC profiles when saving as a PNG, plus there is support for PNG files up to 2 GB in size.

Photoshop PDF

The PDF (Portable Document Format) is a cross-platform file format that was initially designed to provide an electronic publishing medium for distributing documents without requiring the recipient to have a copy of the program that originated the document. PDF files can be read in Adobe Acrobat or the Adobe Reader™ program, which will let others view documents the way they are meant to be seen, even though they may not have the exact same fonts that were used to compile the document.

Adobe PDF has now gained far wider acceptance as a reliable and compact method of supplying page layouts to printers, due to its color management features, and its ability to embed fonts and compress images. It is now becoming the native format for Illustrator and other desktop publishing programs and is also gaining popularity for saving Photoshop files, because it can preserve everything that a Photoshop (PSD) file can. Adobe Reader™ is free, and can easily be downloaded from the Adobe website. But the full Adobe Acrobat™ program may be required if you want to distill page documents into the PDF format and edit them on your computer.

Best of all, Acrobat documents are small in size and can be printed at high resolution. I can create a document in InDesign and export it as an Acrobat PDF using the Export command. Anyone who has installed the Adobe Reader program can then open a PDF document I have created and see the layout just as I intended it to be seen, with the text displayed using the correct fonts. The Photoshop PDF file format can be used to save all Photoshop features such as Layers, with either JPEG or lossless ZIP compression and is backward compatible in as much as it saves a flattened composite for viewing within programs that are unable to fully interpret the Photoshop layer information.

Figure 1.102 If you open a generic Acrobat PDF from within Photoshop choosing File ⇨ Open, you will see the Import PDF dialog shown here. This allows you to select individual or multiple pages or selected images only and open these in Photoshop or place them within a new Photoshop document.

Placing PDF files

The Photoshop Parser plug-in allows Photoshop to import any Adobe Illustrator, EPS or generic single/multi-page PDF file. Using File ⇨ Place (Embedded or Linked), you can select individual pages or ranges of pages from a generic PDF file, rasterize them and save them to a destination folder. You can also use File ⇨ Place (Embedded or Linked) to extract all or individual image/vector graphic files contained within a PDF document as separate image files. In these instances the dialog will be similar to that shown in Figure 1.102.

Adobe Bridge CC

The Bridge program provides you with an integrated way to navigate through the folders on your computer and complete compatibility with all the other Creative Suite applications (see Figure 1.103). The Bridge interface lets you inspect images in a folder, make decisions about which ones you like best, rearrange them in the content panel, hide the ones you don't like, and so on.

You can use Bridge to quickly review the images in a folder and open them up in Photoshop, while at a more advanced level, you can perform batch operations, share properties between files by synchronizing the metadata information, apply Camera Raw settings to a selection of images and use the Filter panel to fine-tune your image selections. It is very easy to switch back and forth between Photoshop and Bridge and one of the key benefits of having Bridge operate as a separate program is that Photoshop isn't fighting with the processor whenever you use Bridge to perform these various tasks. Bridge started as a file browser for Photoshop and has evolved to provide advanced browser navigation for all programs in the Creative Suite. Having said that, there isn't anything new in CC and the feature set remains unchanged.

Installing Bridge

Bridge CC is now provided as a separate download. Therefore, when you download Photoshop CC, you will need to remember to download the Bridge package separately and install afterwards. But do also see the notes on page 83 about getting Bridge CS6 to work with Photoshop CC.

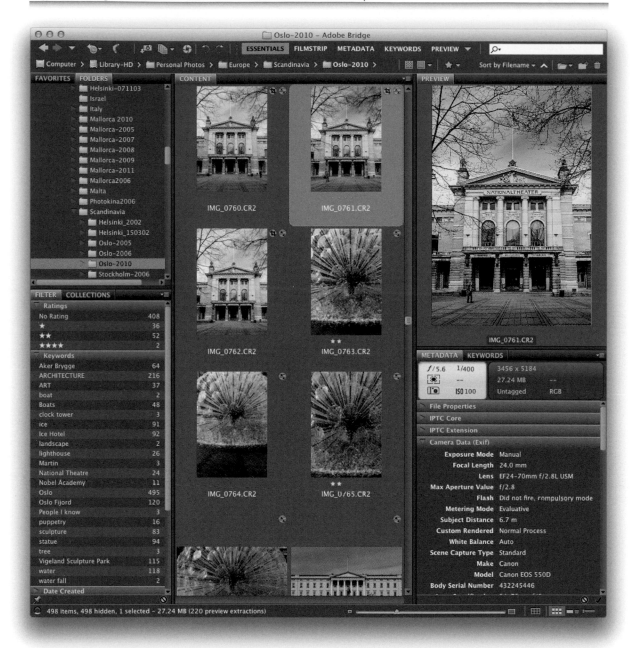

Figure 1.103 The Bridge interface consists of three column zones used to contain the Bridge panel components. This allows you to customize the Bridge layout in any number of ways.

The Bridge interface

Bridge can be accessed from Photoshop by choosing File ⇨ Browse in Bridge... or by using the ⌘ alt O (Mac), ctrl alt O (PC) keyboard shortcut. Once in Bridge you can use the same keyboard shortcut to return to Photoshop again, although to be more precise, this shortcut always returns you to the last used application. So if you had just gone to Bridge via Illustrator, the ⌘ ⌥ O [Mac], ctrl alt O [PC] shortcut will in this instance take you from Bridge back to Illustrator again.

You can also set the Bridge preferences so that Bridge launches automatically during the system log-in so that it is always open and ready for use. Bridge initially opens a new window pointing to the last visited folder location. You can have multiple Bridge windows open at once and this is useful if you want to manage files better by being able to drag them from one folder to another. Having multiple windows open also saves having to navigate back and forth between different folders. If you have a dual display setup you can always have the Photoshop application window on the main display and the Bridge window (or windows) on the other.

Image folders can be selected via the Folders or Favorites panels and the folder contents viewed in the content panel area as thumbnail images. When you click on a thumbnail, an enlarged view of the individually selected images can be seen in the Preview panel and images can be opened by double-clicking on the thumbnail. The main thing to be aware of is that you can have Bridge running alongside Photoshop without compromising Photoshop's performance and it is considered good practice to use Bridge in place of the Finder/Explorer as your main tool for navigating the folders on your computer system and opening documents. This can include opening photos directly into Photoshop, but of course, you can use Bridge as a browser to open up any kind of document: not just those linked to the Adobe Creative Suite programs. For example, Word documents can be made to open directly in Microsoft Word via Bridge.

Making Bridge CS6 work with Photoshop CC

The removal of the Output module and Export panel will annoy some, I am sure. But do bear in mind, if you happen to have an older version of Bridge installed, you can still use this in conjunction with Photoshop CC. If you want to do this, then first of all make sure you don't uninstall that earlier version!

From there, make sure you copy the latest Camera Raw plug-in from the CC Camera Raw plug-in folder to the CS6 one. You will also want to open the File Association preferences for Bridge CS6 and update these to open all the main Photoshop supported file formats (such as PSD, TIFF, JPEG, DNG and native raw formats) via Photoshop CC. However, be aware that as Photoshop CC evolves it is less likely to maintain this backward compatibility.

Custom work spaces in Bridge

The Bridge panels can be grouped in different ways and the panel dividers dragged, so, for example, the Preview panel can be made to fill the Bridge interface more fully and there are already a number of workspace presets which are available to use from the top bar. In the Figure 1.104 example you can see Bridge being used with the Filmstrip workspace setting.

Photograph: © Peter Andreas.

Figure 1.104 You can use the different workspaces to quickly switch Bridge layouts. This example shows the Filmstrip workspace in use, which is a good workspace to start with when you are new to Bridge.

Opening files from Bridge

There are a lot of things you can do in Bridge by way of managing and filtering images and other files on your computer. For now, all that you really need to familiarize yourself with are the Favorites and Folders panels and how you can use these to navigate the folder hierarchy. The Content panel is then used to inspect the folder contents and you can use the Preview panel to see an enlarged preview of the image (or images) you are about to open. Once photos have been selected, just double-click the images within the Content panel (not the Preview panel) to open them directly into Photoshop.

Slideshows

You can also use Bridge to generate slideshows. Just go to the View menu and choose Slideshow, or use the ⌘ L (Mac), ctrl L (PC) keyboard shortcut. Figure 1.105 shows an example of a slideshow and instructions on how to access the Help menu.

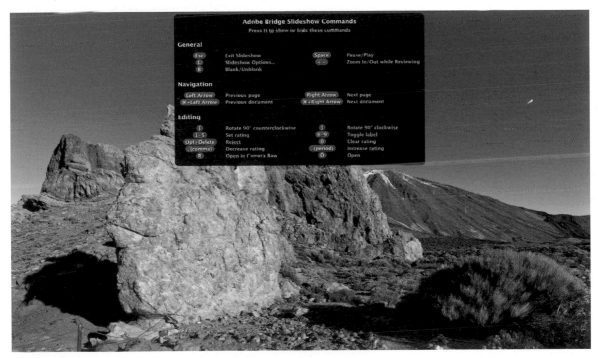

Figure 1.105 You can use the Bridge application View ⇨ Slideshow mode to display selected images in a slideshow presentation, where you can make all your essential review and edit decisions with this easy-to-use interface (press the **H** key to call up the Slideshow shortcuts shown here).

Camera Raw

Camera Raw (which at the time of writing is at version 9.0) offers a number of new features since the original Photoshop CC release. The Workflow options and Save dialogs have been much enhanced. New preview controls allow you to compare before and after versions more flexibly. With localized adjustments there is now a feather control for the spot removal tool and brush edit adjustments when using the graduated and radial filters. There are interactive adjustments on the Histogram and auto Whites and Blacks adjustments in the Basic panel. There is a Pet Eye removal option, auto straightening and a new Color Smoothness slider in the Detail panel controls. But best of all are the new Photo Merge features discussed in Chapters 6 and 8, which now allow you to create HDR or panoramic merges and save them to a DNG file.

DNG and transparency support

Camera Raw is able to read transparency in files and represent transparency as a checkerboard pattern (just like in Photoshop). Camera Raw can read simple, single layer files that are saved in the TIFF and PSD file formats as well as read transparency contained in HDR TIFF files and extract the transparency from multi-layered PSD files (providing the maximize compatibility option has been checked).

Opening photos from Bridge via Camera Raw

If you double-click to open a raw or DNG image via Bridge, this will automatically open via the Camera Raw dialog shown in Figure 1.106, where Photoshop will host Camera Raw. Alternatively, if you choose File ⇨ Open in Camera Raw… via the Bridge menu, this will open the file in Camera Raw hosted by Bridge. The advantage of doing this is that it allows you to free up Photoshop to carry on working on other images. If you choose to open multiple raw images you will see a filmstrip of thumbnails appear down the left-hand side of the Camera Raw dialog, where you can edit one image and then sync the settings across all the other selected photos. There is also a preference setting in Bridge that allows you to open up JPEG and TIFF images via Camera Raw too.

The whole of Chapter 2 is devoted to looking at most of the Camera Raw controls and I would say that the main benefit of using Camera Raw is that any edits you apply in Camera Raw are non-permanent and Photoshop CC offers yet further

major advances in raw image processing. If you are still a little intimidated by the Camera Raw dialog interface, you can for now just click on the Auto button (circled red in Figure 1.106). When the default settings in Camera Raw are set to Auto, Camera Raw usually does a pretty good job of optimizing the image settings for you. You can then click on the 'Done' or 'Open Image' button without concerning yourself too much just yet with what all the Camera Raw controls do. This should give you a good image to start working with in Photoshop and the beauty of working with Camera Raw is that you never risk overwriting the original master raw file. If you don't like the auto settings Camera Raw gives you, then it is relatively easy to adjust the tone and color sliders and make your own improvements upon the auto adjustment settings.

Full Screen mode

If you click on the Full Screen mode button in Camera Raw (circled below in blue), you can quickly switch the Camera Raw view to Full Screen mode.

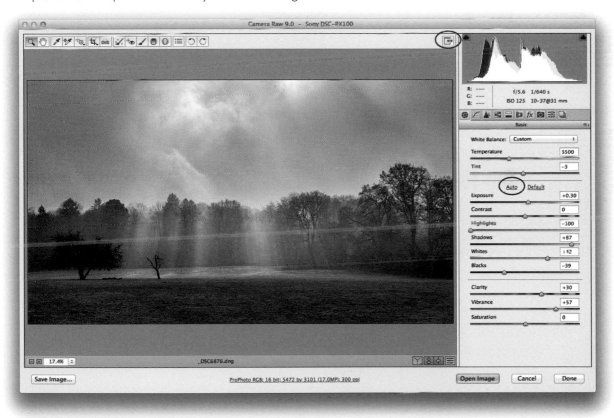

Figure 1.106 When you select a single raw image in Bridge, and double-click to open, you will see the Camera Raw dialog shown here. The Basic panel controls are a good place to get started, but as was mentioned in the text, the Auto button can often apply an adjustment that is ideally suited for most types of images. Once you are happy, click on the Open Image button at the bottom to open it in Photoshop.

Photoshop Online

Photoshop Online… is available from the Help menu and lets you access any late-breaking information along with online help and professional Photoshop tips.

Splash screen

If you drag down from the system or Apple menu to select About Photoshop…, the splash screen reopens and after about 5 seconds the text starts to scroll telling you lots of stuff about the Adobe team who wrote the program, etc. Hold down **alt** and the text scrolls faster. Last, but not least, you'll see a special mention of the most important Photoshop user of all… Now hold down **⌘** (Mac), **ctrl** **alt** (PC) and choose About Photoshop… Here, you will see the beta test version of the splash screen (Figure 1.107).

Figure 1.107 The beta splash screen.

Chapter 2

Camera Raw image processing

In the 18 or so years that I have been writing this series
of books, the photography industry has changed out of all
recognition. When I first began writing about Photoshop, most
photographers were shooting with film cameras, getting their
pictures scanned, and only a few professionals were shooting
with high-end digital cameras. In the last decade the number
of photographers who shoot digitally has grown to the point
where it is the photographers who shoot film who are now
in the minority. The vast majority of photographers reading
this book will therefore be working with pictures that have
been shot using a digital SLR or high-end digital camera that is
capable of capturing files in a raw format that can be read by
Adobe Camera Raw in Photoshop. This is why I have devoted
a whole chapter (and more) to discussing Camera Raw image
processing.

From light to digital

The CCD or CMOS chip in your camera converts the light hitting the sensor into a digital image. In order to digitize the information, the signal must be processed through an analog-to-digital converter (ADC). The ADC measures the amount of light hitting the sensor at each photosite and converts the analog signal into a binary form. At this point, the raw data simply consists of image brightness information coming from the camera sensor. The raw data must somehow be converted and it is here that the raw conversion method used can make a huge difference to the quality of the final image output. Digital cameras have an on-board microprocessor that is able to convert the raw data into a readable image file, which in most cases will be in a JPEG file format. The choice here normally boils down to raw or JPEG output. The quality of a digital image is therefore primarily dependent on the lens optics used to take the photograph, the recording capabilities of the CCD or CMOS chip and the analog-to-digital converter, but it is the raw conversion process that matters most. If you choose to process the raw data on your computer, you have much greater control than is the case if you had let your camera automatically guess the best raw conversion settings to use.

Camera Raw advantages

Although Camera Raw started out as an image processor exclusively for raw files, it has, since version 4.0, also been capable of processing any RGB image that is in a JPEG or TIFF file format. This means you can use Camera Raw to process any image that has been captured by a digital camera, including raw photos up to 65,000 pixels in any dimension or up to 512 megapixels in size, or a photograph that has been scanned by a film scanner and saved as an RGB TIFF or JPEG. Camera Raw allows you to work non-destructively, so anything you do when processing the image is saved as a series of instructions as to how to interpret that data; the pixels in the original file are never altered. In this respect, Camera Raw treats your master files like they were your negatives, allowing you to process images any way you choose without ever altering the original.

The new Camera Raw workflow

When Camera Raw first came out it was regarded as a convenient tool for processing raw format images, without having to leave Photoshop. The early versions of Camera Raw had controls for applying basic tone and color adjustments, but Camera Raw could never, on its own, match the sophistication of Photoshop. Because of this, photographers would typically follow the Camera Raw workflow steps described in Figure 2.1. They would use Camera Raw to do all the 'heavy lifting' work such as adjusting the white point, exposure and contrast and from there output the picture to Photoshop, where they would carry out the remaining image editing.

Camera Raw 9 in Photoshop CC offers far more extensive image editing capabilities and it is now possible to replicate in Camera Raw some of the things which previously could only have been done in Photoshop. The net result of all this is that you can (and should) use Camera Raw as your first port of call when preparing any photographic image for editing in Photoshop. Let's be clear, Camera Raw does not replace Photoshop. It simply enhances the workflow and offers a better set of tools to work with in the early stages of an image editing workflow. Add to this what I mentioned earlier about being able to work with JPEG and TIFF images, and you can see that Camera Raw is a logical place for any image to begin its journey through Photoshop.

If you look at the suggested workflow listed in Figure 2.2 you will see that Camera Raw 9 now has everything you need to optimize and enhance your photographs. It can also be

argued that if you use Camera Raw to edit your photos, this replaces the need for Photoshop adjustments such as Levels, Curves and Hue/Saturation. To some extent this is true, but as you will read later in Chapter 4, these Photoshop adjustment tools are still relevant for fine-tuning the images that have been processed in Camera Raw first, especially when you want to edit your photos directly or apply certain kinds of image effects that require the use of adjustment layers or additional image layers.

Does the order matter?

⇨ Set the white point
⇨ Apply a fine-tuned camera calibration adjustment
⇨ Set the highlight and shadow clipping points
⇨ Adjust the brightness and contrast
⇨ Adjust the color saturation
⇨ Correct for moiré
⇨ Apply basic sharpening and noise reduction
⇨ Apply a crop
⇨ Open images in Photoshop for further image editing

Figure 2.1 Camera Raw 1 offered a limited but useful range of image adjustments.

⇨ Set the white point
⇨ Apply a Camera Profile camera calibration adjustment
⇨ Apply a Lens Profile calibration adjustment
 (correct for distortion, chromatic aberrations and vignetting)
⇨ Apply an Upright perspective correction
⇨ Set the overall Exposure brightness
⇨ Enhance the highlight detail using the Highlights slider
⇨ Enhance the shadow detail using the Shadows slider
⇨ Fine-tune the highlight and shadow clipping points
⇨ Adjust the midtone contrast (Clarity)
⇨ Fine-tune the Tone Curve contrast
⇨ Fine-tune the color saturation/vibrance plus HSL color
⇨ Retouch spots using the clone or heal brush modes
⇨ Make localized adjustments (i.e. adjustment brush, radial/
 graduated filter)
⇨ Apply capture sharpening and noise reduction
⇨ Apply a crop and/or a rotation
⇨ Open images in Photoshop for further image editing

Figure 2.2 Camera Raw 9 has now extended the list of things that can be done to an image at the Camera Raw editing stage.

Camera Raw support

Camera Raw has kept pace with nearly all the latest raw camera formats in the compact range and digital SLR market, but only supports a few of the higher-end cameras such as the Hasselblad, Leaf, Leica, Pentax and Phase One cameras. Camera Raw currently offers support for over 500 raw camera formats, including most of the leading models, and is updated regularly every three months or so. As I mentioned here, you can also use Camera Raw to open JPEG and TIFF files. It is an RGB editor, so is designed to edit in RGB. However, CMYK files can be opened via Camera Raw, but these will be converted to RGB upon opening. For the full list, go to: helpx.adobe.com/photoshop/camera-raw. html. Camera Raw also supports the PNG file format. This has been done mainly with a view to providing PNG support in Lightroom. In terms of Photoshop Camera Raw use, such PNG support remains pretty much hidden at this point.

1/250 13 ☒+⅓ 100-0090

P ☐ ISO200
AWB ☒S 3, 0, 0, 0
RAW 24.3MB Adobe RGB
90/179 09/08/2011 12:42:07

Figure 2.3 The camera's on-board processor is used to generate the low resolution JPEG preview image that appears in the LCD screen. The histogram is also based on this JPEG preview and therefore a poor indicator of the true exposure potential of a raw capture image.

When you edit an image in Camera Raw it does not matter which order you apply the adjustments in. For example, Figure 2.2 shows just one possible Camera Raw workflow. Alternatively, you could start by applying a crop first and work your way through the rest of the list backwards. However, you are best advised to start with the major adjustments first, such as setting the Exposure in the Basic panel before you go on to fine-tune the image using the other controls. Plus it is best to apply an Upright correction early on before you apply other adjustments and especially before applying a crop.

Raw capture

If you are shooting with a professional digital back, digital SLR, or an advanced compact digital camera, you will almost certainly have the capability to shoot using the camera's raw format mode. The advantages of shooting raw as opposed to JPEG mode are not always well understood. If you shoot using JPEG, the files are compressed by varying amounts and this file compression enables you to fit more captures on to a single card. Some photographers assume that shooting in raw mode simply provides you with uncompressed images without JPEG artifacts, but there are other, more important reasons why capturing in raw mode is better than shooting JPEG. The main benefit is the flexibility raw gives you. The raw file is like a digital negative, waiting to be interpreted any way you like. It does not matter about the color space or white balance setting that was used at the time of capture, since these can all be set later in the raw processing. You can also liken capturing in raw mode to shooting with negative film, since when you shoot raw you are recording a master file that contains all the color and tone information that was captured at the time of shooting. To carry the analogy further, shooting in JPEG mode is like taking your film to one of those old high street photo labs, throwing away the negatives and making scans from the prints. If you shoot in JPEG mode, the camera is deciding automatically at the time of shooting how to set the white balance and tonal corrections, often clipping the highlights and shadows in the process. In fact, the camera histogram you see on the camera LCD is based on the JPEG interpretation capture data regardless of whether you are shooting in raw or JPEG mode (see Figure 2.3).

When shooting raw, all you need to consider is the ISO setting and camera exposure. But this advantage can also be seen by some to be its biggest drawback; since the Camera Raw

stage adds to the overall image processing, this means more time has to be spent working on the images, plus there will be an increase in the file size of the raw captures and download times. Therefore, some news photographers and others may find that JPEG capture is preferable for the kind of work they do.

JPEG capture

When you shoot in JPEG mode, your options are more limited since the camera's on-board computer makes its own automated decisions about how to optimize for tone, color, noise and sharpness. When you shoot using JPEG or TIFF, the camera is immediately discarding up to 88% of the image information that's been captured by the sensor. This is not as alarming as it sounds, because as you'll know from experience, you don't always get bad photographs from JPEG captures. But consider the alternative of what happens if you shoot using raw mode. The raw file is saved without being altered by the camera. This allows you to work with all 100% of the image data that was captured by the sensor. If you choose to shoot in JPEG capture mode you have to make sure that the camera settings are absolutely correct for things like the white balance and exposure. There is some room for maneuver when editing a JPEG, but not as much as you get when editing a raw file. In JPEG mode, your camera will be able to fit more captures onto a card, and this will depend obviously on the capture file size and compression settings used. However, it is worth noting that at the highest quality setting, JPEG capture files are sometimes not that much smaller than those stored using the native raw format.

Editing JPEGs and TIFFs in Camera Raw

Not everyone is keen on the idea of using Camera Raw to open non-raw images. However, the Camera Raw processing tools are so powerful and intuitive to use, why shouldn't they be available to work on other types of images? The idea of applying further Camera Raw processing may seem redundant in the case of JPEGs, but despite these concerns, Camera Raw does happen to be a good JPEG image editor. So from one point of view, Camera Raw can be seen as offering the best of all worlds, but it can also be seen as a major source of confusion. Is it a raw editor or what?

It's 'raw' not 'RAW'

This is a pedantic point, but raw is always spelled using lower case letters and never all capitals, which would suggest that 'raw' was some sort of acronym, like JPEG or TIFF, which it isn't.

Adobe Photoshop Lightroom

The Adobe Photoshop Lightroom program is designed as a raw processor and image management program for photographers. It uses the same Adobe Camera Raw color engine that is used in Photoshop, which means raw files that have been adjusted in Lightroom can also be read and opened via Camera Raw in Photoshop or Bridge. Having said that, there are compatibility issues to be aware of whereby only the most recent version of Camera Raw will be able to fully interpret the image processing carried out in the most recent version of Lightroom and vice versa. Lightroom does have the advantage of offering a full range of workflow modules designed to let you edit and manage raw images all the way from the camera import stage through to Slideshow, Book, Print or Web output. There is no differentiation made between a raw or non-raw file, and with the latest Process 2012, the same default settings are applied when a photo is first imported. When you choose to open a Lightroom imported, non-raw file (a JPEG, TIFF or maximum compatibility PSD) into Photoshop, Lightroom gives you the option to apply or not apply Lightroom edited image adjustments.

Perhaps the biggest problem so far has been the implementation rather than the principle of non-raw Camera Raw editing. In the Configuring Photoshop PDF (available on the book website) I make the point that opening JPEGs and TIFFs via Camera Raw was made unnecessarily complex in Photoshop CS3, but following the changes made in Photoshop CS4, this issue has been mostly resolved. The Camera Raw file opening behavior for non-raw files is now much easier to configure and anticipate.

On the other hand, if you look at the Lightroom program, I think you'll find that the use of Camera Raw processing on non-raw images works very well indeed (I explain the Lightroom approach to non-raw editing in a separate PDF that's also on the book website). It has to be said that editing non-raw files in Lightroom is much easier to get to grips with, since Lightroom manages to process JPEGs rather seamlessly (see sidebar).

Alternative Raw processors

While I may personally take the view that Camera Raw is a powerful raw processor, there are other raw processing programs photographers can choose from. Some camera manufacturers supply their own brand of raw processing programs which either come free with the camera or you are encouraged to buy separately. Other notable programs include Capture One (phaseone.com/en/software.aspx), which is favored by a lot of professional shooters, Bibble (bibblelabs.com) and DxO Optics Pro (dxo.com). If you are using some other program to process your raw images and are happy with the results you are getting then that's fine. Even so, I would say that the core message of this chapter still applies, which is to use the raw processing stage to optimize the image so that you can rely less on using Photoshop's own adjustment tools to process the photograph afterwards. Overall it makes good sense to take advantage of the non-destructive processing in Camera Raw to freely interpret the raw capture data in ways that can't be done using Photoshop alone. Plus you can also use Camera Raw as a filter to process non-raw images within Photoshop.

Camera Raw support

Camera Raw won't 'officially' interpret the raw files from every digital camera, but over 500 different raw formats are now supported and Adobe is committed to providing intermittent free Camera Raw updates that will usually include any new camera file interpreters as they become available. This generally happens about once every three months and sometimes sooner if a significant new camera is released. It used to be the case that these updates were provided just to add support for more cameras and fix a few bugs and/or improve integration with Lightroom. These days a Camera Raw update may well include major new features. For example, the Camera Raw 7.1 update for Photoshop CS6 included new defringe controls in the Lens Corrections panel and the ability to edit 32-bit HDR TIFF files. It is therefore always worth keeping a close check on any new Camera Raw releases to see if they contain important new features.

The update process is fairly straightforward, where standard installers for Mac and PC will automatically update Camera Raw for you. Note that whenever there is an update to Camera Raw there will also be an accompanying update for Lightroom and Adobe DNG Converter.

DNG compatibility

The DNG file format is an open-standard file format for raw camera files. DNG was devised by Adobe and there are already a few cameras such as Leica, Ricoh, Hasselblad and Pentax cameras that can shoot directly to DNG; there are also now quite a few raw processor programs that can read DNG, including Camera Raw and Lightroom of course. Basically, DNG files can be read and edited just like any other proprietary raw file format and it is generally regarded as a safe file format to use for archiving your digital master files. For more about the DNG format I suggest you refer to page 260 at the end of this chapter.

Camera Raw updates

In the past, Adobe's policy has been to provide ongoing Camera Raw support throughout the life of a particular Photoshop product. Since the move to the Creative Cloud and subscriptions services this means that customers using Photoshop CC will get continued access to all future Camera Raw (as well as program) updates for as long as they remain subscribed. Photoshop CS6 is still sold as a perpetual license product though and it is intended that the latest Camera Raw updates will still work with Photoshop CS6, except CS6 users will only be able to access support for new cameras. Features that have been added to Camera Raw since Camera Raw 7.4 are disabled for CS6 customers. Basically, it means perpetual license CS6 users only get continued new camera support.

At the end of this chapter I explain also how you can use the DNG Converter program to convert any supported raw camera format file to DNG. This allows you to create DNG files that can then be read by any previous version of Camera Raw.

Basic Camera Raw image editing

Working with Bridge and Camera Raw

The mechanics of how Photoshop and Bridge work together are designed to be as simple as possible so that you can open single or multiple images or batch process images quickly and efficiently. Figure 2.4 summarizes how the file opening between Bridge, Photoshop and Camera Raw works. Central to everything is the Bridge window interface where you can browse, preview or make selections of the images you wish to process. To open images, select the desired thumbnail (or thumbnails) and open using one of the following three methods: use the File ⇨ Open command, use a double-click, or use the ⌘ O (Mac), ctrl O (PC) shortcut. All of the above methods can be used to open a selected raw image (or images) via the Camera Raw dialog hosted by Photoshop. If the image is not a raw file, it will open in Photoshop directly. Alternatively, you can use File ⇨ Open in Camera Raw... or use the ⌘ R (Mac), ctrl R (PC) shortcut to open images via the Camera Raw dialog, this time hosted by Bridge. This allows you to perform batch processing operations in the background without compromising Photoshop's performance. If the 'Double-click edits Camera Raw Settings in Bridge' option is deselected in the Bridge General preferences, *Shift* double-clicking allows you to open an image or multiple selections of images in Photoshop directly, bypassing the Camera Raw dialog.

Opening single raw images via Photoshop is quicker than opening them via Bridge, but when you do this Photoshop does become tied up managing the Camera Raw processing and this in turn will prevent you from doing any other work in Photoshop. The advantage of opening via Bridge is Bridge can be used to process large numbers of raw files in Camera Raw, while freeing up Photoshop to perform other tasks. You can then toggle between the two programs. For example, you can be processing images in Camera Raw while you switch to working on other images that have already been opened in Photoshop.

Regarding JPEG and TIFF images, Camera Raw can be made to open these as if they were raw images, but please refer to page 126 for a fuller description as to how JPEG and TIFF files can be made to open in Camera Raw.

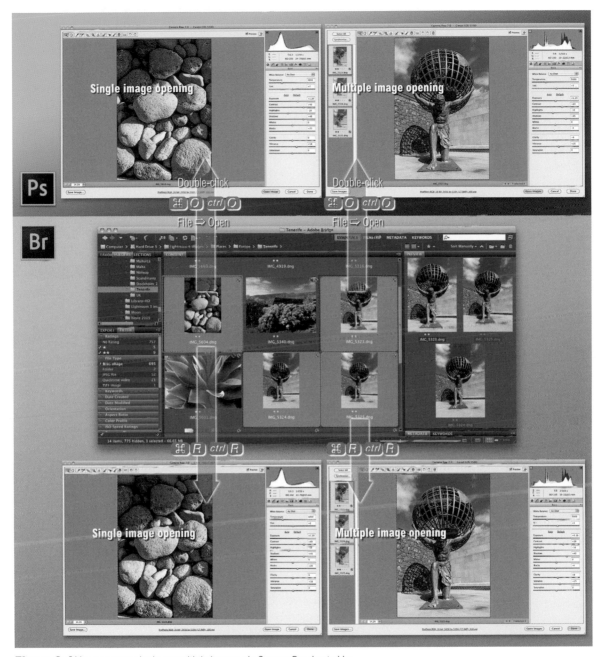

Figure 2.4 You can open single or multiple images via Camera Raw hosted by Photoshop using a double-click, File ➪ Open or ⌘ O (Mac), ctrl O (PC). Photoshop is ideal for processing small numbers of images. If you use ⌘ R (Mac), ctrl R (PC), Bridge hosts the single or multiple Camera Raw dialog. Opening via Bridge is better suited for processing large batches of images in the background.

Camera Raw tools

🔍 Zoom tool (Z)

This can be used to zoom in and zoom out of the preview image; double-click for 100%.

✋ Hand tool (H)

The hand tool can be used to scroll the magnified Preview image; double-click to Fit.

✐ White balance tool (I)

The white balance tool is used to set the White Balance in the Basic panel.

✸ Color sampler tool (S)

Allows you to place up to 9 color sampler points in the preview window (these are temporary and not stored in the XMP data).

☉ Target adjustment tool (T)

Mouse down on the Image in Camera Raw and move the cursor up and down to apply a targeted adjustment to the image.

⊟ Crop tool (C)

The crop tool can apply a crop setting to the raw image which is applied when the file is opened in Photoshop.

⊿ Straighten tool (A)

Drag along a horizontal or vertical line to apply a 'best fit', straightened crop.

✦ Spot removal (B)

Use to remove sensor dust spots and other blemishes from a photo.

⊙ Red eye removal tool (E)

For removing red eye (or pet eye) from portraits shot using on-camera direct flash.

✎ Adjustment brush (K)

Use to paint localized adjustments.

▮ Graduated filter (G)

Use to apply linear graduated localized adjustments.

◎ Radial filter (J)

Use to apply radial graduated localized adjustments.

☰ ACR preferences (⌘/ctrl–K)

Open the Camera Raw preferences dialog.

↺ Rotate counterclockwise (L)

Rotates the image 90° counter clockwise.

↻ Rotate clockwise (R)

Rotates the image 90° clockwise.

General controls for single file opening

Whenever you open a single image, you will see the Camera Raw dialog shown in Figure 2.5 (which, in this case, shows Camera Raw hosted via Bridge). The status bar shows which version of Camera Raw you are using and the make of camera for the file you are currently editing. In the top left section you have the Camera Raw tools (which I have listed on the left) and below that is the image preview area where the zoom setting can be adjusted via the pop-up menu at the bottom (which can now allow you to zoom in up to 1600%).

The histogram represents the output histogram of an image and is calculated based on the RGB output space that has been selected in the Workflow options. As you carry out Basic panel adjustments, the shadow and highlight triangles in the histogram display will indicate the shadow and highlight clipping. As either the shadows or highlights get clipped, the triangles will light up with the color of the channel or channels that are about to be clipped and if you click on them, will display a color overlay (blue for the shadows, red for the highlights).

Below that is the panels section, where you will always see the Basic panel selected by default each time you open an image via Camera Raw. The Basic panel allows you to apply basic tone and color corrections. Next to that is the Tone Curve panel, which can be used to apply a secondary, more refined tone adjustments using the parametric or point mode controls. The Detail panel contains controls for sharpening and noise reduction, while the HSL / Grayscale panel lets you fine-tune the hue, saturation, or luminance based on targeted colors, or convert to black and white. Then there is the Split Toning panel for adding split tone effects. The Lens Corrections panel can be used to apply lens and perspective corrections. The Effects panel allows you to add a post crop vignette, or add grain. In the Camera Calibration panel you can select different camera sensor profiles. The Presets panel can be used to save and access saved Camera Raw preset settings and lastly, the Snapshots panel can be used to save snapshot settings.

Full size window view

The Toggle Full screen mode button (**F**) can be used to expand the Camera Raw dialog to fill the whole screen, which can make Camera Raw editing easier when you have a bigger preview area to work with. Click this button again to restore the previous Camera Raw window size view.

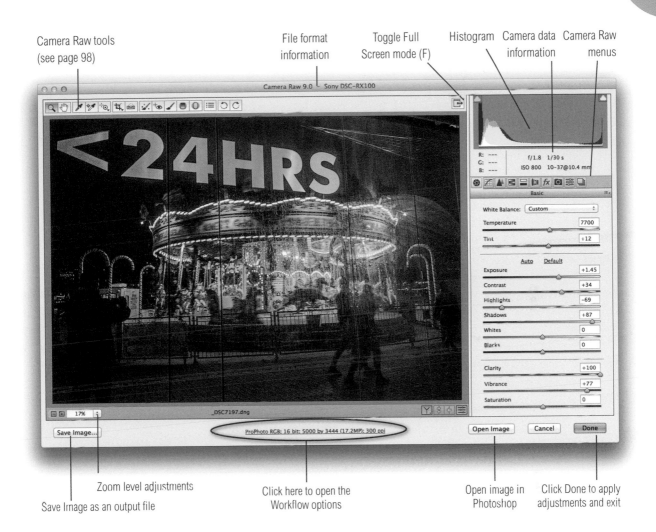

Camera Raw tools
(see page 98)

File format
information

Toggle Full
Screen mode (F)

Histogram

Camera data
information

Camera Raw
menus

Zoom level adjustments

Save Image as an output file

Click here to open the
Workflow options

Open image in
Photoshop

Click Done to apply
adjustments and exit

Figure 2.5 This shows the Camera Raw dialog (hosted by Bridge), showing the main controls and shortcuts for the single file open mode. You can tell if Camera Raw has been opened via Bridge, because the 'Done' button is highlighted. This is an 'update' button that you click when you are done making Camera Raw edits and wish to save these settings, but without opening the image. Otherwise, 'Open Image' is highlighted whenever Camera Raw is hosted by Photoshop.

If you click on the Workflow options (circled), this opens the Workflow Options dialog shown (see page 106), where you can adjust the settings that determine the color space the image will open in, the bit depth, cropped image pixel dimensions plus resolution (i.e. how many pixels per inch).

Figure 2.6 After editing an image via the Camera Raw dialog, you will see a settings badge appear in the top right corner of the image thumbnail (circled). This indicates that an image has been edited in Camera Raw.

Figure 2.7 If there is a process version conflict when selecting multiple files, there will be the option to convert all the selected files to the process version that's applied to the most selected image.

General controls for multiple file opening

If you have more than one photo selected in Bridge, you can open these all up at once via Camera Raw. If you refer back to Figure 2.4, you can see a summary of the file opening behavior, which is basically as follows. If you double-click (or use File ⇨ Open (⌘ O [Mac], *ctrl* O [PC]), this opens the multiple image Camera Raw dialog hosted via Photoshop (as shown in Figure 2.8) and if you choose File ⇨ Open in Camera Raw… or ⌘ R (Mac), *ctrl* R (PC), this opens the multiple image Camera Raw dialog hosted via Bridge.

The multiple image dialog contains a filmstrip of the selected images running down the left-hand side of the dialog and you can select individual images by clicking on the thumbnails in the filmstrip. In Camera Raw 9, the filmstrip has a menu that you can access by clicking on the fly-out menu circled in Figure 2.8. Here, you can choose 'Select All' (⌘ A [Mac], *ctrl* A [PC]) to select all the photos at once and use the *alt* S shortcut to synchronize the Camera Raw settings adjustments across all the images that have been selected, based on the current 'most selected' image. This will be the thumbnail that's highlighted with a blue border. The Synchronize dialog shown in Figure 2.9 then lets you choose which of the Camera Raw settings you want to synchronize. You can learn more about this and how to synchronize Camera Raw settings on page 255, as well as how to copy and paste Camera Raw settings via Bridge.

You can also make custom selections of images via the filmstrip using the *Shift* key to make continuous selections, or use the ⌘ (Mac), *ctrl* (PC) key to make discontinuous selections of images. Once you have made a thumbnail selection you can then navigate the selected photos by using the navigation buttons in the bottom right section of the Preview area to progress through them one by one and apply Camera Raw adjustments to individually selected images. If you have not yet enabled the 'Use Graphics Processor' option in the Camera Raw preferences (see page 127), you may see the yellow warning triangle shown in Figure 2.8, which indicates the preview has not completely refreshed yet.

Once a photo has been edited in Camera Raw you will notice a badge icon appears in the top right corner of the Bridge thumbnail (Figure 2.6). This indicates that a photo has had Camera Raw edit adjustments applied to it.

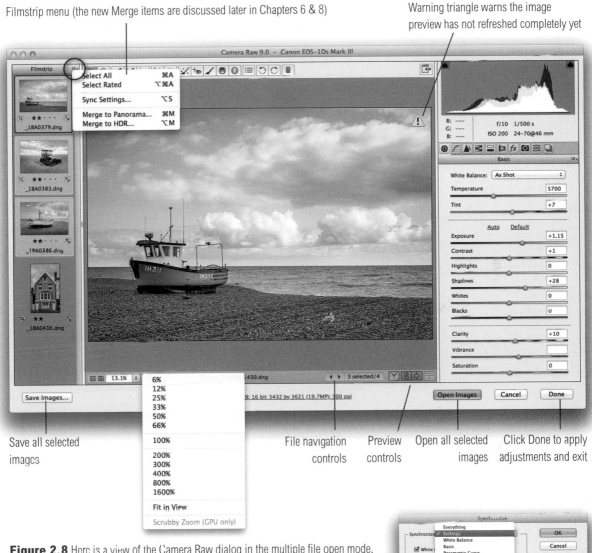

Filmstrip menu (the new Merge items are discussed later in Chapters 6 & 8)

Warning triangle warns the image preview has not refreshed completely yet

Save all selected images

File navigation controls

Preview controls

Open all selected images

Click Done to apply adjustments and exit

Figure 2.8 Here is a view of the Camera Raw dialog in the multiple file open mode, hosted in Photoshop (you can tell because the Open Images button is highlighted here). This screen shot shows a filmstrip of opened images on the left where all four of the opened images are currently selected and the top image (highlighted with the blue border) is the one that is 'most selected' and displayed in the preview area. Camera Raw adjustments can be applied to the selected photos one at a time, or synchronized with each other, by selecting 'Sync Settings…' from the fly-out menu. This opens the Synchronize dialog shown in Figure 2.9. Because images may now have different process versions, if you select multiple photos that use different process versions, the Basic panel will show a message like the one shown in Figure 2.7, requiring you to update the selected photos to the process version applied to the most selected image. Note that if you hold down the *alt* key as you do so, this will bypass the Synchronize dialog options and synchronize everything.

Figure 2.9 The Synchronize dialog.

Preview controls

The old preview checkbox has been replaced with new controls that allow you to quickly compare the current state of the image with a before, or checkpoint, state. Repeat clicking the preview mode button lets you cycle through the five available modes. To see the list shown in Figure 2.10, click on the preview mode button (⊡) and hold the mouse down. You can also use the **Q** key to advance to the next preview setting.

Note that zooming or panning in one pane view automatically zooms or pans on the other. And as soon as you use the crop, or straighten tool, this always takes you back to the full 'After' preview mode.

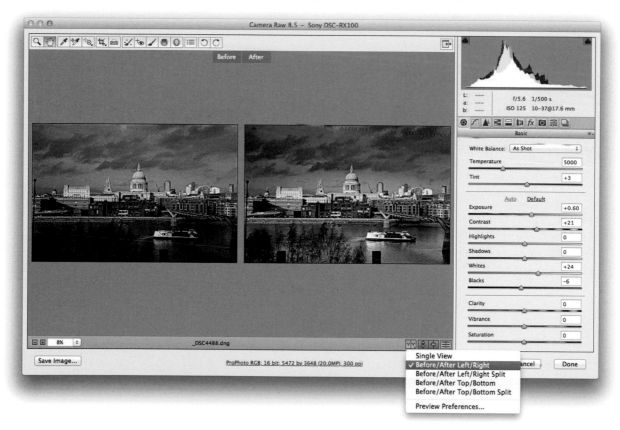

Figure 2.10 This shows the new preview controls menu for previewing the current state against a before, or checkpoint, view state. The five options are: Single View; Before/After Left/Right (as shown here); Before/After Left/Right Split; Before/After Top/Bottom; Before/After Top/Bottom Split.

Checkpoints

Anyone who has worked with the Compare view mode in Lightroom will be familiar with these preview controls and also the fact that you are able to create checkpoints mid-session to create an updated before preview to compare against.

The Swap button (⮀) can be used to swap the current image settings with the before or checkpoint state settings. What happens here is, when you click this, the settings in the image for the before state are actually updated (like creating a new snapshot). You can then click again on the Swap button to return to the previous working state and also use the P key to swap between the two states. To update the current checkpoint using the current settings, click the Checkpoint button (⭠), or use the alt P shortcut. You can also use the Toggle between current settings button (☰) to toggle the preview between the current settings and defaults for that panel, or use the ⌘ alt P (Mac) ctrl alt P (PC) shortcut.

Suppose you want to compare one image state against another. Once you arrive at a setting you wish to compare with, click the Swap button to make the current After state the new Before state. You can then load a pre-saved snapshot setting and load this as a new After preview to compare with the current Before checkpoint state; you can then click on the Swap button again to swap between these two states.

Preview preferences

The Preview Preferences can be accessed from the bottom of the menu shown in Figure 2.10. This allows you to enable/disable the various Cycle Preview Modes (when clicking on the Preview button or using the Q shortcut) and choose to show or hide the Draw Items listed below. The screen shots shown here were all captured with the Divider in side-by-side views and Divider in split views checked.

Figure 2.11 The Preview Preferences dialog, which can be accessed via the Preview options list shown in Figure 2.10.

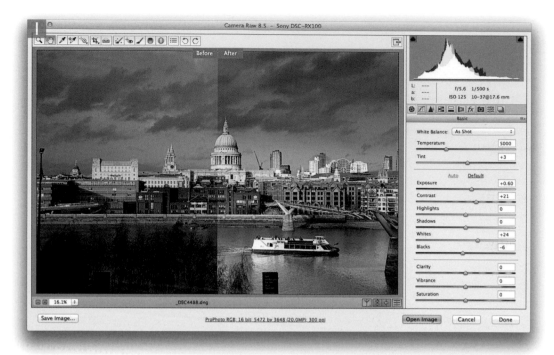

1 In this first step I selected the Before/After Left/Right Split preview.

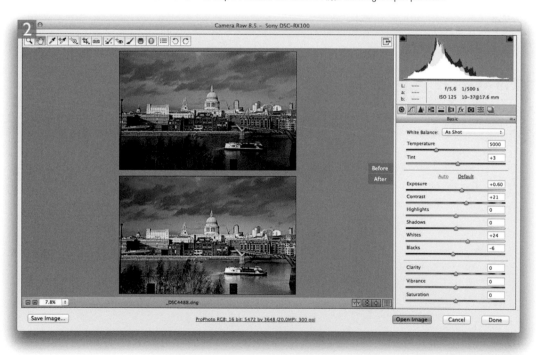

2 Here you can see the image previewed using the Before/After Top/Bottom preview.

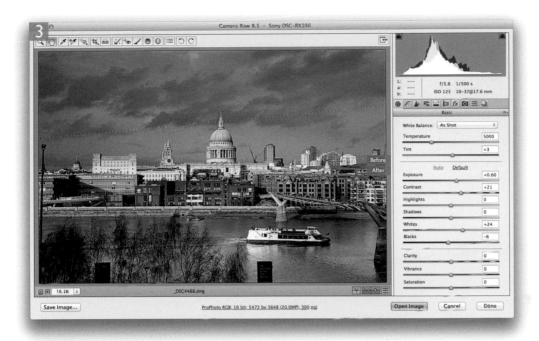

3 And this shows the Before/After Top/Bottom Split preview.

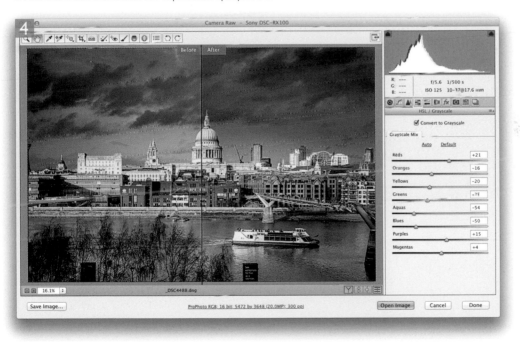

4 In this example, I returned to the Before/After Left/Right Split preview and clicked on the Checkpoint button (⬅) to update the Before preview. I then converted the image to black and white and was now able to compare this state with the full color edited checkpoint state.

Saving Workflow presets

The Workflow Options dialog allows you to save presets. For example, in Figure 2.12 you can see the Workflow Options dialog configured to use a SWOP Medium GCR profile as the preview space using a Relative Colorimetric rendering intent and saved as a preset setting. Saving presets allows you to quickly switch between different workflow options settings. These can also be accessed by right mouse-clicking the Workflow options.

Workflow options

Clicking on the blue hyperlink text (at the bottom of Figure 2.10) opens the Workflow Options dialog (Figure 2.12). This determines how files are saved, or opened in Photoshop via Camera Raw. The Color Space options allow you to choose any available profile space as the output space. This includes printer profiles, CMYK profiles, or the Lab space even. Ideally, this should match the RGB workspace setting you have established in the Photoshop color settings. Setting the bit depth to 16-bits per channel ensures the maximum number of levels are preserved when the image is opened in Photoshop.

In the Image Sizing options, you can set the pixel dimensions and resolution for the saved/opened images. Included here is a Percentage menu option, which means you can specify a percentage to resize an image by. Below that is the Output Sharpening section, where you can choose to sharpen the rendered image for print or screen output. These options are relevant if you are producing a file to go directly to print or for a website. If you intend carrying out any type of further retouching then leave this disabled. Lastly, you can choose to 'Open in Photoshop as Smart Object'.

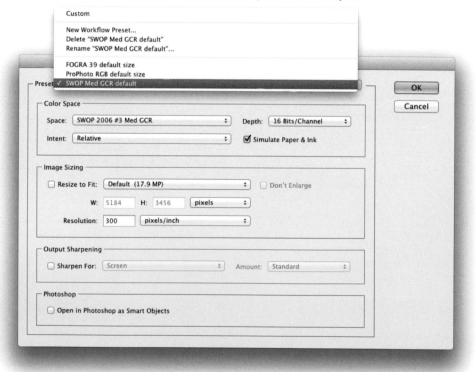

Figure 2.12 The Camera Raw Workflow Options dialog showing the Presets menu.

CMYK proofing

One of the more obvious benefits the Workflow Options dialog brings is the ability to soft proof in Camera Raw. Some of you will be aware that soft proofing was introduced in Lightroom 4, which lets you use the Develop module to very effectively preview how an image is likely to look when printed. The new Workflow Options dialog allows you to kind of do the same thing. It does not provide a total workflow solution the way Lightroom does, but when you select an output profile such as a CMYK profile this affects the way the preview image is displayed in the Camera Raw dialog, and you now also have the option to select a rendering intent and compare between the use of a Relative or Perceptual conversion. The Workflow Options dialog in Figure 2.13 is shown with a CMYK profile selected.

Essentially, when you select a specific CMYK profile the preview adjusts to show how the image you are editing in Camera Raw will look when output or saved as a CMYK TIFF, PSD or JPEG pixel image. When the Output options are configured in this way everything you adjust in Camera Raw is filtered through the prism of the selected CMYK output profile.

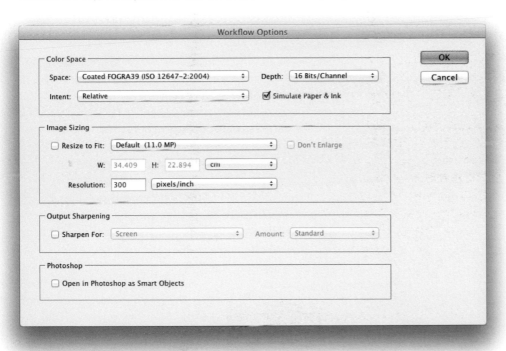

Figure 2.13 The Workflow Options dialog with CMYK profile selected.

You can also check the 'Simulate Paper & Ink' box to simulate how the image will appear when printed. The underlying image will still be edited as a full raw image. It is just the preview that is modified to provide a more realistic interpretation of the final output. The same thing applies when you select an inkjet printer profile. The Camera Raw preview aims to show the outcome when printing to a specified printer profile.

Output proofing and the computer display

The one thing to point out here with soft proofing in Camera Raw is that the accuracy of the soft proof view can only be as good as the monitor display you are using to view the image on. Most standard LCD displays have a native color gamut that is not that different from the sRGB color space. Consequently, a basic display isn't going to help you much when evaluating color output if the gamut of the display is smaller than that of the output space. However, even in these situations the soft proofing can still be valid in terms of judging the tone contrast. You will at least be able to get a sense of the tone appearance of the intended print output and modify the contrast accordingly. A better answer is to use a professional quality display that is able to match closely to the Adobe RGB gamut. That way you should be able to at least gauge CMYK color output reasonably accurately.

Saving soft proofed raw files as smart objects

Prompted by my colleague, Jeff Schewe, it became clear that you can take this one stage further. If you check the 'Open in Photoshop as Smart Objects' box at the bottom of the Camera Raw Workflow Options dialog (see Step 1 opposite), this allows you to open a raw image as a Smart Object in Photoshop. Now, if you happen to select a CMYK profile that matches the intended print output you can preview how your raw images will look when printed in CMYK. When you then save the smart object image as a TIFF, it can be placed directly into an InDesign layout. The following steps summarize such a workflow.

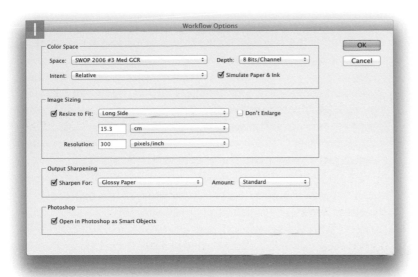

1 To begin with, I opened the Workflow Options and set the output space to the intended CMYK output space. I set the rendering intent in this case to 'Relative' and checked the Simulate Paper & Ink box. The long side image dimension was adjusted to match that of the page layout column width. In the Output Sharpening section I checked the Sharpen For box and chose 'Glossy Paper' from the menu using a 'Standard' Amount. I also checked the 'open in Photoshop as Smart Objects' box.

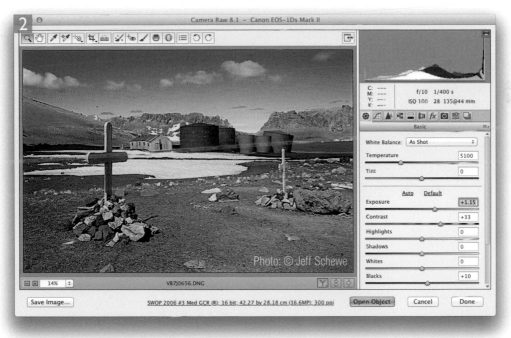

2 In Camera Raw the Open Image button now showed as 'Open Object'. I clicked this to open as a smart object in Photoshop.

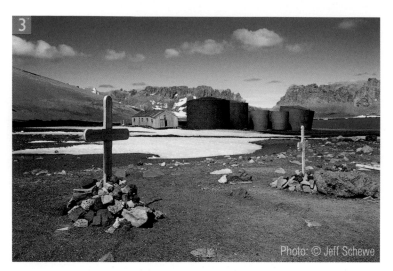

3 Here you can see the Layers panel view of the image opened in Photoshop as a smart object. I then saved the smart object image as a TIFF (which could be placed directly into an InDesign layout).

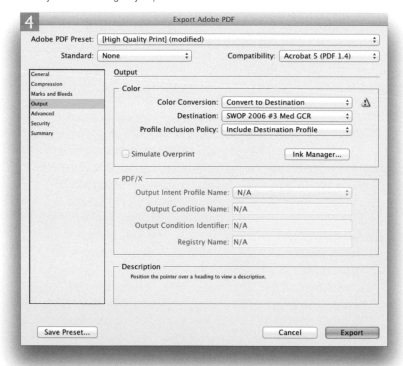

4 When exporting the layout from InDesign as a PDF, I went to the Output settings, selected the intended CMYK output space and chose 'Convert to Destination'. This meant that during the PDF export, the images such as the one shown in step 3 would be converted to CMYK directly from the original raw data.

Summary of the proposed soft proofing workflow

Let me now go back over the steps described on the previous two pages. The Workflow Options in Camera Raw were set to the CMYK profile of the intended CMYK output and the size settings were adjusted to match the column width of the intended InDesign layout. The rendering intent was set to Relative (because this tends to be the optimum rendering intent for most color images) and the Simulate Paper & Ink option was checked so the preview gave a reasonable indication of how the final image would look when printed.

In the Output Sharpening section I chose to apply a standard glossy paper output sharpening setting. Ideally, I would prefer to apply a custom Photoshop action that applied a more precise form of sharpening designed for CMYK printing. However, the paper sharpening settings offered here are the same ones used in the Lightroom Book module when output sharpening files for Blurb books that are printed on an Indigo press. Experience shows that this sharpening workflow, while not intended for CMYK repro, does appear to work well enough for this purpose.

The raw image was opened as a smart object in Photoshop, preserving all the raw data. The Camera Raw settings remained editable and the Camera Raw preview allowed me to make color and tone adjustments while being able to preview the CMYK outcome.

The smart object image could then be saved as a TIFF (preserving the Camera Raw data) and placed directly in an InDesign layout. It would still be possible to double-click the layout image to open it in Photoshop and double-click the smart object layer thumbnail to edit the Camera Raw settings.

At the PDF export stage the PDF settings were configured so that when the PDF generation took place, the original raw data was read, the Camera Raw adjustment settings applied and the image data resized to the desired pixel dimensions. Next, the image data was sharpened for output and converted to CMYK according to the settings configured in the Export Adobe PDF dialog, making sure the Camera Raw Output and PDF Export Output color settings both matched.

Soft proofing in practice

These few simple additions to the Workflow Options dialog have some interesting implications. The ability to select various output profiles is definitely a big step forward and gives photographers the option to edit their photographs while being able to preview the expected print outcome while working in Camera Raw. That much is easy enough to implement and get to grips with. The other thing we can now do is devise a non-destructive Camera Raw to print workflow in which the raw data remains completely editable right through to the final Export to PDF stage. This is seemingly a good thing to do, but comes at a cost. I would not choose to do this with the books I produce because of the sheer number of images involved. Saving raw images as smart objects will result in image files that are very large and always much bigger than a rendered TIFF that has been resized to match the required output size. This would work if the rendering intent is to be the same for all printed images. In practice I tend to use both Relative and Perceptual rendering intents when converting images to CMYK as well as different black generation profiles. Now, if it were possible to have a link between Camera Raw and InDesign whereby you could assign the rendering intent and profile in the Workflow Options and have these picked up at the Export to PDF stage, this would make such a workflow more practical. Maybe this will be on the cards for the future?

Opening raw files as Smart Objects

Staying on the subject of Smart Objects, while working in Camera Raw you can open a raw image in Photoshop and have the Camera Raw settings remain editable. Essentially, if you open a photo from Camera Raw as a Smart object, it is placed as a Smart Object layer in a new Photoshop document. This is almost like a hidden feature, but once discovered can lead to all sorts of interesting possibilities. There are two ways you can go about this. You can click on the Workflow options link to open the Workflow Options dialog and check the 'Open in Photoshop as Smart Objects' option (see Figure 2.14). When this is done *all* Camera Raw processed images will open as Smart Object layers in Photoshop. The other method is to simply hold down the *Shift* key to make the Camera Raw 'Open Image' button change to say: 'Open Object'.

It is also now possible to apply Camera Raw adjustments as a filter in Photoshop. This isn't the same as being able to place a raw image as a Camera Raw Smart Object, but it does give you the option to apply Camera Raw style edits to already rendered RGB images in Photoshop (see page 210).

Let's now look at a practical example in which I opened two raw images as Smart Object layers and was able to merge them as a composite image in Photoshop.

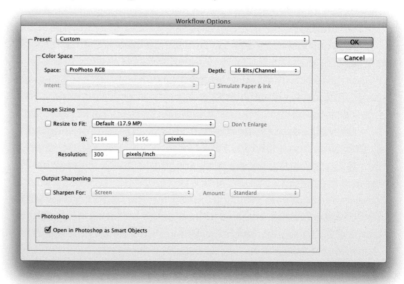

Figure 2.14 If you click on the Workflow options link this opens the Workflow Options dialog, where you can check the 'Open in Photoshop as Smart Objects' option. Alternatively, hold down the *Shift* key as you click the 'Open Image' button.

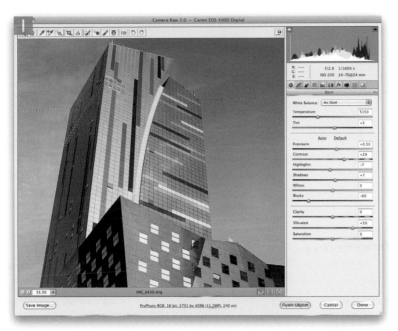

1 In this first step, I opened a raw image of a building and held down the *Shift* key as I clicked on the 'Open Image' button, to open it as a Smart Object layer in Photoshop.

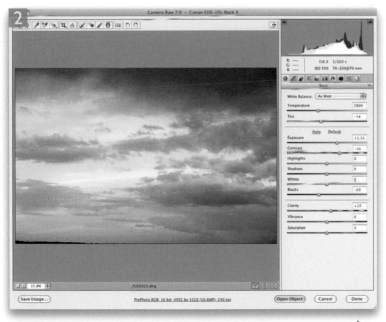

2 In this next step I selected a new image, this time a photo of a sky, and again held the *Shift* key as I clicked on the 'Open Image' button, to open this too as a Smart Object layer.

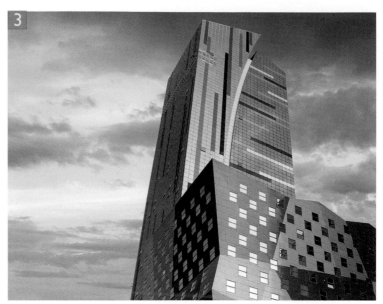

3 In Photoshop I dragged the Smart Object layer of the sky across to the Smart Object layer image of the building, to add it as a new layer. I then made a selection of the outline of the building and applied it as a layer mask to create the merged photo shown here.

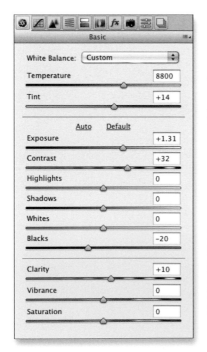

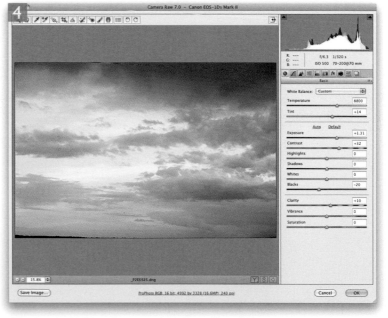

4 Because both of these layers were raw image Smart Objects, I was able to double-click the top layer thumbnail (circled in red in Step 3 above) to open the Camera Raw dialog and edit the settings. In this case I decided to give the sky more of a sunset color balance.

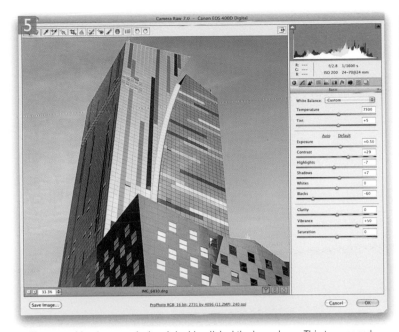

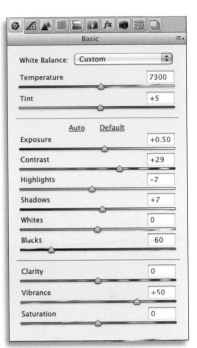

5 The same thing happened when I double-clicked the lower layer. This too opened the raw image Smart Object layer via Camera Raw and allowed me to warm the colors and add more contrast to the building.

6 This shows the Photoshop image with the revised Smart Object layers. The thing to bear in mind here is that all edits made to the Smart Object layers are completely non-destructive.

Saving photos from Camera Raw

When you click on the Save Image... button you have the option of choosing a folder destination to save the images to and a File Naming section to customize file naming. In the Format section you can choose which file format to use when rendering a pixel version from the raw master. These options include: PSD, TIFF, JPEG or DNG. If you have used the crop tool to crop an image in Camera Raw, the PSD options allow you to Preserve the cropped pixels by saving the image

Figure 2.15 Clicking on the Save Image... button opens the Save Options dialog. After configuring the options and clicking 'Save', you will see a status report next to the Save Image button that shows how many images remain to be processed. For more about the new DNG save options, see page 260 at the end of this chapter.

with a non-background layer (in Photoshop you can then use Image ⇨ Reveal All should you wish to revert to an uncropped state). The JPEG and TIFF format saves provide the usual compression options and if you save using DNG you can convert any raw, or non-raw original as a DNG file. The file save processing is then carried out in the background, allowing you to carry on working in Bridge or Photoshop (depending on which program is hosting Camera Raw at the time) and you'll see a progress indicator (circled in Figure 2.15) showing how many photos there are left to save.

If you hold down the `alt` key as you click on the Save… button, this bypasses the Save dialog box and saves the image (or images) using the last used Save Options settings. This is handy if you want to add file saves to a queue and continue making more edit changes in the Camera Raw dialog.

Saving a JPEG as DNG

Although it is possible to save a JPEG or TIFF original as a DNG via Camera Raw it is important to realize that this step does not actually allow you to convert a JPEG or TIFF file into a raw image. Once an image has been rendered as a JPEG or TIFF it cannot be converted back into a raw format. Saving to DNG does though allow you to use DNG as a container format for a JPEG or TIFF. For example, this means that you can now store a Camera Raw rendered preview alongside the JPEG or TIFF data, which will be portable when sharing such files with other (non Camera Raw aware) programs. Also, now that one can save using a lossy DNG format, on this level at least, there are some reasons for saving JPEGs using DNG.

Resolving naming conflicts

A save operation from Camera Raw will auto-resolve any naming conflicts so as to avoid overwriting any existing files in the same save destination. This is done by incrementing a number at the end of the filename when saving. This is important if you wish to save multiple versions of the same image as separate files and avoid overwriting the originals.

Color space and image sizing options

The Color Space section allows you to save a document using a profiled color space (Figure 2.16). Basically, you can preview a document in Camera Raw using a profiled color space (such as a CMYK space) and have the ability to export using that same color space.

When saving as a TIFF, PSD or JPEG, you can choose an image sizing setting that is independent of what has been set in the Workflow Options dialog. You can also choose to apply output sharpening when saving. Once configured you can save the combined Save settings as a preset (as shown below).

Figure 2.16 The new Camera Raw Save dialog.

Altering the background color

You can set the background color of the work area and toggle the visibility of the image frame. Right mouse-click outside the image in the work area to select the desired options from the contextual pop-up menu (see Figure 2.17).

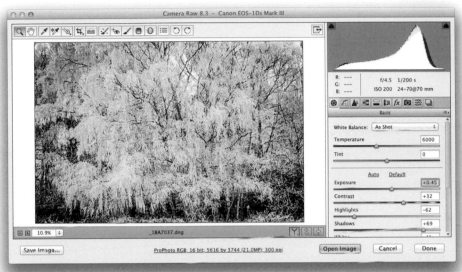

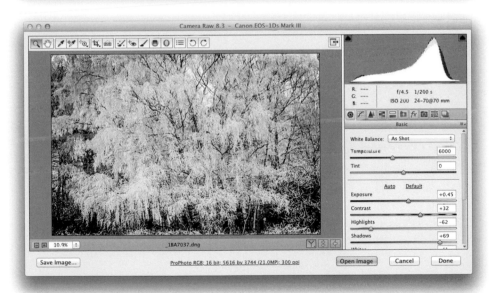

Figure 2.17 In these screen shots you can see examples of the Camera Raw interface using alternative background colors. In the top screen shot a White background was used and in the lower screen shot a Medium Gray color was selected.

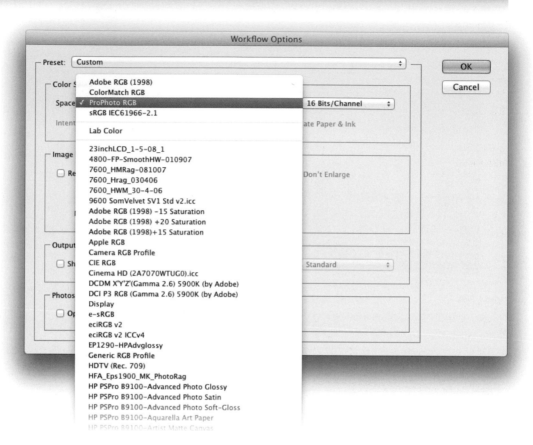

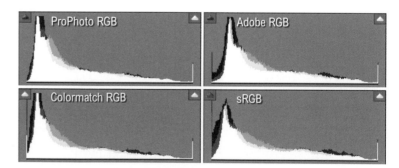

Figure 2.18 This Camera Raw histogram may vary depending on which color space is selected in the Workflow options.

The histogram display

The Camera Raw Histogram provides a preview of how the
Camera Raw output image histogram will look after the
image data has been processed and output as a pixel image.
The histogram appearance is affected by the tone and color
settings applied in Camera Raw, but more importantly, is
also influenced by the RGB space selected in the Workflow
options (see Figure 2.18). It can therefore be interesting to
compare the effect of different output spaces when editing a
raw capture image. For example, if you edit a photo in an RGB
space like ProPhoto or Adobe RGB and then switch to sRGB,
you will most likely see some color channel clipping in the
histogram. Such clipping can then be addressed by readjusting
the Camera Raw settings to suit the smaller gamut RGB
space. This exercise is particularly useful in demonstrating why
it is better to output your Camera Raw processed images using
either the ProPhoto or Adobe RGB color spaces.

Digital camera histograms

Some digital cameras provide a histogram display that enables
you to check the quality of what you have just shot. This too
can be used as an indication of the levels captured in a scene.
However, the histogram you see displayed is usually based on
a JPEG capture image. If you prefer to shoot using raw mode,
the histogram you see on the back of the camera will not
provide an accurate guide to the true potential of the image
you have captured (see also, Figure 2.3 on page 92).

Interactive histogram

The Histogram is interactive, meaning that you can click
on the histogram directly to apply basic tone adjustments.
More specifically, it allows you to click and drag to adjust the
Blacks, Shadows, Exposure, Highlights and Whites settings
(Figure 2.19). If using Process 2003 or 2010, it allows you to
adjust: Blacks, Fill Light, Exposure and Recovery. Now, I have
to say this feature was introduced early on to Lightroom 1.0
and seemed an interesting innovation at the time. It has to
be said that the zones referenced in the histogram are not
actually an accurate representation of the tones that are
being manipulated. I think in the end that it is just as easy to
click and drag on the sliders in the Basic panel. Where this is
advantageous is if you are working in one of the other panels,
say the Tone Curve panel. It means you can access these Basic
panel tone controls without having to switch panel views.

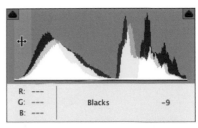

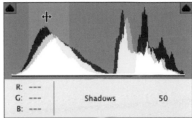

Figure 2.19 The interactive histogram.

Deleting images

As you work with Camera Raw to edit your shots, the Delete key can be used to mark images that are to be sent to the trash. This places a red X in the thumbnail. To undo, select the image and hit Delete again.

Image browsing via Camera Raw

In a multiple view mode, the Camera Raw dialog can be used as a 'magnified view' image browser. You can match the magnification and location across all the selected images to check and compare details, inspect them in a sequence and apply ratings to the selected photos.

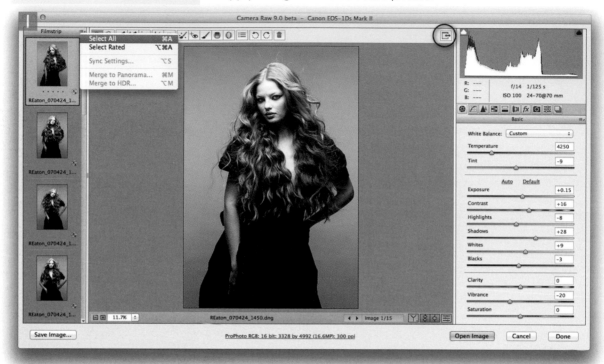

Selecting the rated images only

Use alt ⌘ A (Mac), alt ctrl A (PC) to select the rated images only. This means that you can use star ratings to mark the images you are interested in during a 'first pass' edit and then use the above shortcut to make a quick selection of just the rated images.

1 If you have a large folder of images to review, the Camera Raw dialog can be used to provide a synchronized, magnified view of the selected pictures. The dialog is shown here in a normal window view, but you can click on the Full Screen mode button (circled) to expand the dialog to a Full screen view mode. I then went to the Filmstrip menu and chose 'Select All'.

2 I next used the zoom tool to magnify the preview. This action synchronized the zoom view used for all the selected images in the Camera Raw dialog; I was also able to use the hand tool to synchronize the scroll location for the selected photos.

3 Once this had been done I could deselect the thumbnail selection and start inspecting the photos. This could be done by clicking on the file navigation controls (circled in the Step 3 image), or by using the keyboard arrow keys to progress through the images one by one. I could then mark my favorite pictures using ⌘ > (Mac), ctrl > (PC) to progressively increase the star rating for a selected image and ⌘ < (Mac), ctrl < (PC) to progressively decrease the star rating.

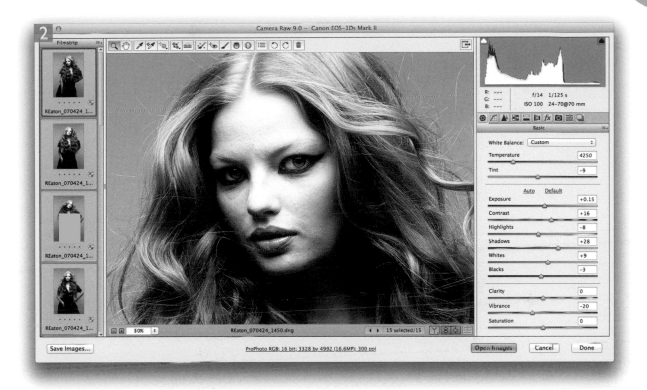

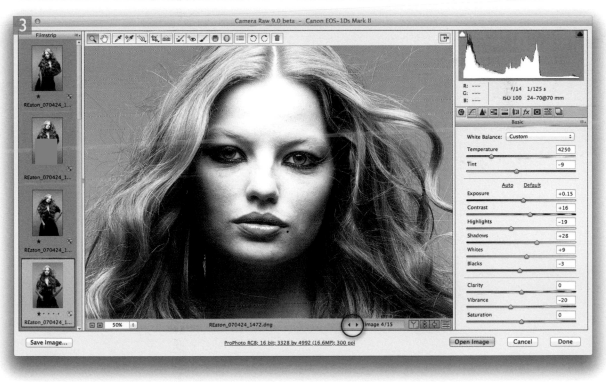

XMP sidecar files

Camera Raw edit settings are written as XMP metadata. This data is stored in the central Camera Raw database on the computer and can also be written to the files directly. In the case of JPEG, TIFF and DNG files, these file formats allow the XMP metadata to be written to the XMP space in the file header. However, in the case of proprietary raw file formats such as CR2 and NEF, it would be unsafe to write XMP metadata to incompletely documented file formats. To get around this, Camera Raw writes the XMP metadata to XMP sidecar files that accompany the image in the same folder and stay with the file when you move it from one location to another via Bridge.

Camera Raw preferences

The Camera Raw preferences (Figure 2.20) can be accessed via the Photoshop/Bridge menu (Mac), or Edit menu (PC). Within Camera Raw you can click on the preferences button (▤), or use ⌘ K (Mac), ctrl K (PC) to open the Camera Raw preferences. Lastly, there is a Camera Raw Preferences… button in Photoshop's File Handling preferences.

Let's look at the General section first. From the 'Save image settings' menu I suggest you choose 'Sidecar ".xmp" files'. TIFF, JPEG and DNG files can store the XMP data in the header, but if the XMP data can't be stored internally within the file itself, this forces the image settings to be stored locally in XMP sidecar files that accompany the image files (see also page 252).

Should you wish to preview adjustments with the sharpening turned on, but without actually sharpening the output, the 'Apply sharpening to' option can be set to 'Preview images only'. This is because you might want to use a third-party sharpening program in preference to Camera Raw. However, with the advent of Camera Raw's improved

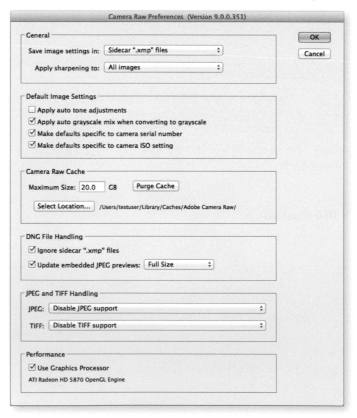

Figure 2.20 Camera Raw preferences dialog.

sharpening, you will most likely want to leave this set to 'All images' to make full use of Camera Raw sharpening.

Default Image Settings

In the Default Image Settings section, you can select 'Apply auto tone adjustments' as a Camera Raw default. When this is switched on, Camera Raw automatically applies an auto tone adjustment to new images it encounters that have not yet been processed in Camera Raw, while any images you have edited previously via Camera Raw will remain as they are.

The 'Apply auto grayscale mix when converting to grayscale' option refers to the HSL/Grayscale controls, where Camera Raw can apply an auto slider grayscale mix adjustment when converting a color image to black and white. The next two options can be used to decide, when setting the camera default settings, if these should be camera body and/or ISO specific (see page 157).

Camera Raw cache

When photos are rendered using the Camera Raw engine, they go through an early stage initial rendering and the Camera Raw cache stores a cache of this data so that when you next reopen an image that has data stored in the cache, it renders the photo quicker in the Camera Raw dialog. The 1 GB default setting is rather conservative. If you have enough free hard disk space available, you may want to increase the size limit for the cache, or choose a new location to store the central preview cache data. If you increase the limit to, say, 20 GB or more, you should expect to see an improvement in Camera Raw's performance.

DNG file handling

Camera Raw and Lightroom both embed the XMP metadata in the XMP header space of a DNG file. There should therefore be no need to use sidecar files to read and write XMP metadata when sharing files between these two programs. However, some third-party programs may create sidecar files for DNG files. If 'Ignore sidecar "xmp" files' is checked, Camera Raw will not be sidetracked by sidecar files that might accompany a DNG file and cause a metadata conflict.

However, there are times where it may be useful to read the XMP metadata from DNG sidecar files. For example, when I work from a rental studio I'll have a computer in the studio with all the captured files (kept as standard raws) and

Camera Raw cache

Whenever you open an image in Camera Raw, it builds full, high quality previews direct from the master image data. In the case of raw files, the early stage processing includes the decoding and decompression of the raw data as well as the linearization and demosaic processing. All this has to take place first before getting to the stage that allows the user to adjust things like the Basic panel adjustments. The Camera Raw cache is therefore used to store the unchanging, early stage raw processing data that is used to generate the Camera Raw previews so that this step can be skipped the next time you view that image. If you increase the Camera Raw cache size, more image data can be held in the cache. This in turn results in swifter Camera Raw preview generation when you reopen these photos. Also, because the Camera Raw cache can be utilized by Lightroom, the cache data is shared between both programs. Since version 3.6, the Camera Raw cache files have been made much more compact. This means that you can now cache a lot more files within the limit set in the Camera Raw preferences.

a backup/shuttle disk to take back to the office at my house from which I can copy everything to the main computer there. If I make any further ratings edits on this main machine, the XMP metadata is automatically updated as I do so. It then only takes a few seconds to copy just the updated XMP files across to the backup disk, replacing the old ones. Back at the studio I can again copy the most recently modified XMP files back to the main computer (overwriting the old XMP files). The photos in Bridge will then appear updated. So, if in the meantime the files on the studio computer happen to have been converted to DNG, it's important that the 'Ignore sidecar "xmp" files' option is now left unchecked, otherwise the imported xmp files will simply be ignored.

DNG files have embedded previews that represent how the image looks with the current applied Camera Raw settings. When 'Update embedded JPEG previews' is checked, this forces the previews in all DNG files to be continually updated based on the current Camera Raw settings, overriding previously embedded previews. It's important to point out here though that DNG previews created by Camera Raw can only be considered 100% accurate when viewed by other Adobe programs such as Lightroom or Bridge and even then, they must be using the same version of Camera Raw. While DNG is a safe format for the archiving of raw data, other DNG compatible programs that are not made by Adobe, or that use an earlier version of Camera Raw, will not always be able to read the Camera Raw settings that have been applied using the latest version of Camera Raw or Lightroom.

JPEG and TIFF handling

If 'Disable JPEG (or TIFF) support' is selected, all JPEG (or TIFF) files will always open in Photoshop directly. If 'Automatically open all supported JPEGs (or TIFFs)' is selected, this causes all supported JPEGs and TIFFs to always open via Camera Raw. However, if 'Automatically open JPEGs (or TIFFs) with settings' is selected, Photoshop will only open a JPEG or TIFF via Camera Raw if it has previously been edited via Camera Raw. When this option is selected you have the option in Bridge to use a double-click to open a JPEG directly into Photoshop, or use ⌘ R (Mac), ctrl R (PC) to force JPEGs to open via Camera Raw. But note that when you edit the Camera Raw settings for that JPEG, the next time you use a double-click to open, it will default to opening via Camera Raw.

Performance: Accelerated graphics (GPU)

The Performance section has a 'Use Graphics Processor' option. When this is checked it allows Camera Raw to use the Graphics Processing Unit (GPU) to speed up its interactive image editing when editing images. This option will be particularly helpful if you are using a high-resolution display, such as a 4K or 5K display (where the benefits will be most noticeable). The 'Use Graphics Processor' option is normally on by default (if your installed video card meets requirements), but you may need to visit this section of the Camera Raw preferences and check it in order to boost Camera Raw performance (note that the GPU options in Photoshop's Performance Preferences have no effect on Camera Raw). If you compare performance with this option enabled, the first thing you will notice is how the panning and zooming are both much faster. If you open a large image and choose to zoom in to a 100% view or higher, you'll soon notice how quickly you can scroll from one corner of the image to another. Without GPU support the Camera Raw preview performance will be identical to Camera Raw 8.x and you'll notice how the scrolling will tend to be slow and jerky. But when 'Use Graphics Processor' is enabled the scrolling should be noticeably smoother. If you look at what is happening more closely you will notice how the on-screen image initially loads a standard preview resolution image before rendering a full resolution preview. Also, when you are viewing an image close-up, Camera Raw pre-emptively loads and renders parts of the image that are just outside the current visible area. By doing so, Camera Raw is able to provide a smoother scrolling experience. You should also notice that when adjusting the sliders the preview response will appear to be a lot less jerky when 'Use Graphics Processor' is enabled. There is though a trade-off when implementing the GPU path. The main benefit is that it makes the interactive image editing faster, although at the same time there is more setup overhead required to accomplish this. Therefore, even though you may have GPU processing enabled, there may still be a slight delay when skimming through a bunch of raw images in Camera Raw. It should also be noted that you'll see more of a performance boost with some types of Camera Raw edits than others.

Graphics card compatibility

It is important to realize that the GPU performance boost will only be available for certain types of video cards (OpenGL 3.3 upwards) and only if you are using a 64-bit operating system – either Mac OS 10.9 and higher, or Windows 7 and higher. If the card you are using is compatible, the video card name will be shown in the Performance section of the Camera Raw preferences. If it's not, Camera Raw will show an error message. You'll also need to make sure your video drivers are up to date. On the Mac system, video drivers are updated whenever you carry out an operating system update, but on Windows the operating system is not always as accurate and may tell you that the outdated drivers you have installed are just fine. So in these instances, where PC users are experiencing problems, they may need to go to the manufacturer's website to download a dedicated video driver update utility.

Camera Raw can currently use only a single GPU. So if your computer has more than one video card this won't offer any improvement (although the performance boost from using just one should be significant). For best results the main requirement is that you have a compatible graphics card manufactured from 2010 onwards. You don't necessarily have to have the fastest card to get optimum performance, as a solid, mid-range card can be just as effective as a high-end card. Basically, to process large images, a video card with 2 GB memory should be suitable for Camera Raw processing, especially if you are working with a 4K or 5K display.

It should also be noted that the GPU acceleration described here only applies to processing carried out on the main display. Those users with multiple displays should be aware that performance on secondary displays will be unchanged regardless of whether they have 'Use Graphics Processor' checked or not.

Scrubby zoom

When 'Use Graphics Processor' is enabled there is also a Scrubby Zoom option available. To access, select the zoom tool, click on the Zoom menu (bottom left of the image preview) and select 'Scrubby Zoom' from the bottom of the menu (this allows you to toggle scrubby zoom behavior on/off). This option is actually enabled by default when 'Use Graphics Processor' is selected. Once enabled, click-dragging on an image with the zoom tool will allow you to zoom smoothly in and out.

Camera Raw cropping and straightening

You can crop an image in Camera Raw before it is opened in Photoshop, but note that the cropping is limited to the bounds of the image area only. If you press down the spacebar after dragging with the crop tool, this allows you to reposition the marquee selection. Release the spacebar to continue to modify the marquee area (incidentally, this same shortcut applies when dragging with the zoom tool to define an area to zoom in to). The crop you apply in Camera Raw is updated in the Bridge thumbnail and preview, and applied when the image is opened in Photoshop. However, if you save a file out of Camera Raw using the Photoshop format, there is an option in the Save dialog to preserve the cropped pixels so you can recover the hidden pixels later. You can use the Custom Crop menu option that's highlighted in Figure 2.22 to create a custom crop ratio (see Figure 2.21) and save this as a custom setting, which will then appear added to the crop menu.

To remove a crop, open the image in the Camera Raw dialog again, select the crop tool and choose 'Clear Crop' from the Crop menu. Alternatively, you can hit *Delete* or simply click outside the crop in the gray canvas area.

The Camera Raw straighten tool (which is next to the crop tool) can be used to measure a vertical or horizontal angle and at the same time apply a minimum crop to the image, which you can then resize accordingly.

Figure 2.21 This shows the Custom Crop settings that can be accessed via the Crop Tool menu (Figure 2.22). In this example I created a custom crop ratio with A4 metric proportions. This will then appear added to the Crop menu.

Auto straighten

You can automatically straighten a picture in the following ways. You can simply double-click on the straighten tool button icon in the Toolbar to auto-straighten an image. Or, with the straighten tool selected, you can double-click anywhere within the preview image. Alternatively, if the crop tool is selected, you can hold down the ⌘ key (Mac), or *ctrl* key (PC) to temporarily switch to the straighten tool, and then double-click anywhere within the preview image. Also, when using the crop tool or Straighten tool you can press *X* to flip the crop aspect ratio.

Figure 2.22 The Camera Raw Crop Tool menu includes a range of preset crop proportions. You can also add your own custom presets by clicking on Custom… (see Figure 2.21).

How to straighten and crop

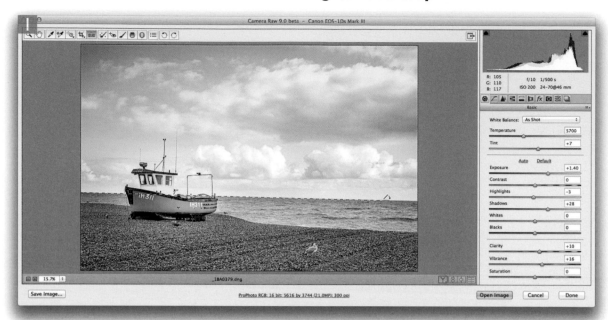

1 To straighten this photograph, I selected the straighten tool from the Camera Raw tools and dragged with the tool to follow the line that I wished to have appear straight.

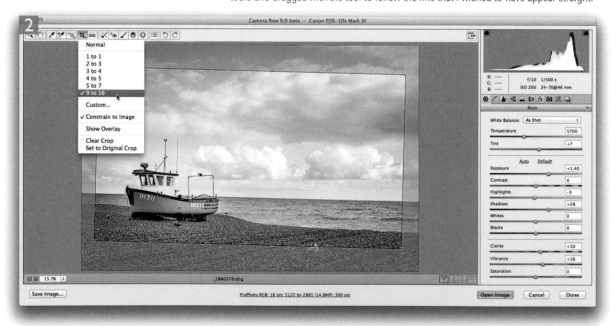

2 This action straightened the image. I then clicked on the crop tool to access the Crop Tool menu and chose a crop ratio preset.

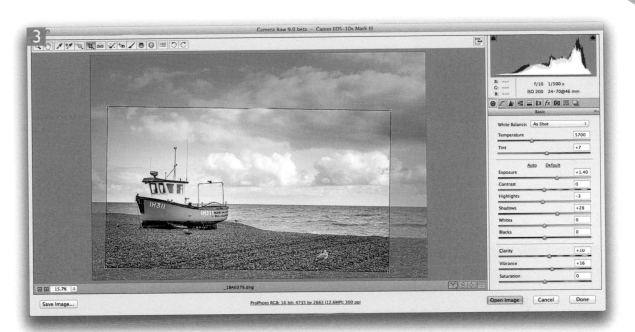

3 After selecting a 9:16 crop ratio setting, I dragged one of the corner handles to resize the crop bounding box as desired.

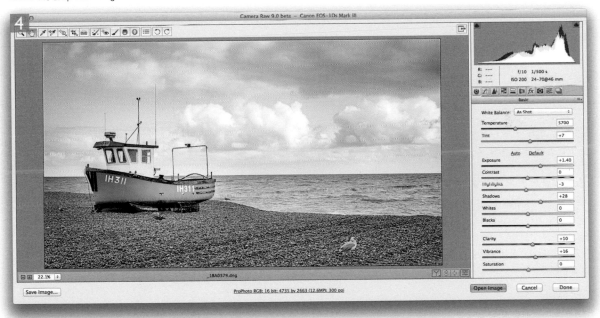

4 Finally, I deselected the crop tool by clicking on one of the other tools (such as the hand tool). This reset the preview to show a fully cropped and straightened image.

Figure 2.23 The Camera Raw Basic panel controls.

Figure 2.24 WhiBal™ cards come in different sizes and are available from RawWorkflow.com.

Basic panel controls

The Basic panel (Figure 2.23) is where you carry out the main color and tone edits to an image. Most photos can be improved by making just a few Basic panel edits.

White balance

Let's start with the white balance controls. These refer to the color temperature of the lighting conditions at the time a photo was taken and essentially describe the warmth or coolness of the light. Quartz-halogen lighting has a warmer color and a low color temperature value of around 3,400 K, while daylight has a bluer color (and a higher color temperature value of around 6,500 K). If you choose to shoot in raw mode it does not matter how you set the white point setting on the camera because you can always decide later which is the best white balance setting to use.

Camera Raw cleverly uses two color profile measurements for each of the supported cameras, one made under tungsten lighting conditions and another made using daylight balanced lighting. From this data, Camera Raw is able to extrapolate and calculate the white balance adjustment for any color temperature value that falls between these two white balance measurements, as well as calculating the more extreme values that go beyond either side of these measured values.

The default white balance setting normally uses the 'As Shot' white balance setting that was embedded in the raw file metadata at the time the image was taken. This might be a fixed white balance setting that you had selected on your camera, or it could be an auto white balance that was calculated at the time the picture was shot. If this is not correct you can try mousing down on the White Balance pop-up menu and select a preset setting that correctly describes which white balance setting should be used. Alternatively, you can simply adjust the Temperature slider to make the image appear warmer or cooler and adjust the Tint slider to balance the white balance green/magenta tint bias.

Using the white balance tool

The easiest way to set the white balance manually is to select the white balance tool and click on an area that is meant to be a light gray color (Figure 2.25). Don't select an area of pure white as this may contain some channel clipping, which could produce a skewed result. You will also notice that as you move the white balance tool across the image, the sampled RGB values are displayed just below the histogram, and after you click to set the white balance, these numbers should appear even.

There are also calibration charts such as the X-Rite ColorChecker chart, which can be used in carrying out a custom calibration, although the light gray patch on this chart is regarded as being a little on the warm side. For this reason, you may like to consider using a WhiBal™ card (Figure 2.24). These cards have been specially designed for obtaining accurate white point readings under varying lighting conditions.

Color temperature

Color temperature is a term that links the appearance of a black body object to its appearance at specific temperatures, measured in kelvins. Think of a piece of metal being heated in a furnace. At first it will glow red but as it gets hotter, it emits a red, then yellow and then a white glow. Indoor tungsten lighting has a low color temperature (a more orange color), while sunlight has a higher color temperature and emits a bluer light.

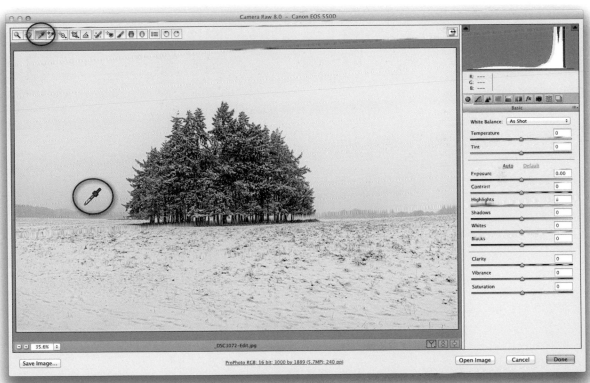

Figure 2.25 To manually set the white balance, select the white balance tool (circled), locate what should be a neutral area and click to update the white balance.

Single-clicking with behavior

The single-click behavior of the white balance tool remains unchanged.

Localized white balance measurements

The white balance tool can now be applied selectively when white balancing an image. Just click-and-drag with the white balance tool to define a rectangular pixel area. As you release the mouse, Camera Raw uses all the pixels within the marked rectangle to set the global white balance. This can be particularly useful for measuring white balance from a textured surface, such as in the example shown below.

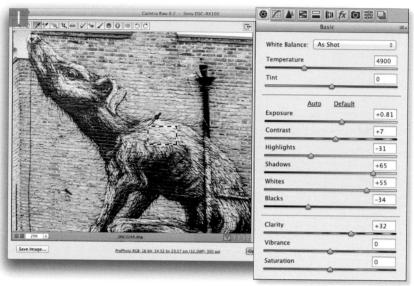

1 I opened this image in Camera Raw, which currently shows the 'As Shot' white balance setting. I selected the white balance tool and marquee dragged to sample the pixels within the area shown here to set the white balance.

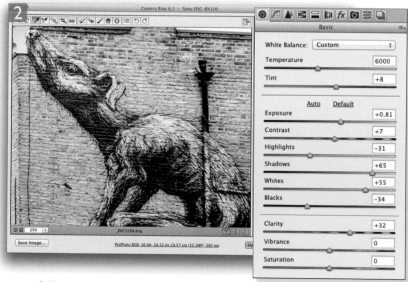

2 Here you can see the white balance corrected result.

The white balance tool also takes into account localized adjustments. For example, if you use the graduated filter to apply a warming white balance, when you click with the white balance tool it takes the localized Temp or Tint adjustments into account to ensure the pixels where you click are always neutralized.

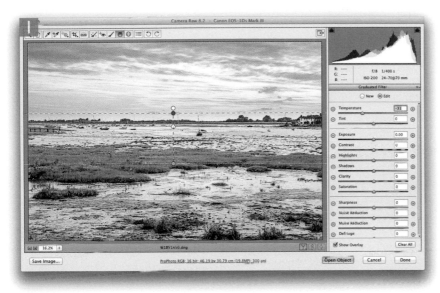

1 In this example, a cooling Temp adjusted graduated filter was applied to the lower half of the image.

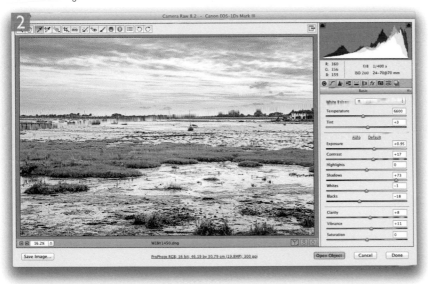

2 When I selected the white balance tool and clicked on the bottom half of the image it calculated a new white balance adjustment that took into account the locally applied white balance adjustment.

Independent auto white balance adjustments

You can set the Temperature and Tint sliders independently. It used to be the case that when you selected 'Auto' from the White Balance menu, this auto set both the Temperature and Tint sliders. Now, in Camera Raw, you can use _Shift_ + double-click on the Temperature and Tint sliders to set these independently of each other.

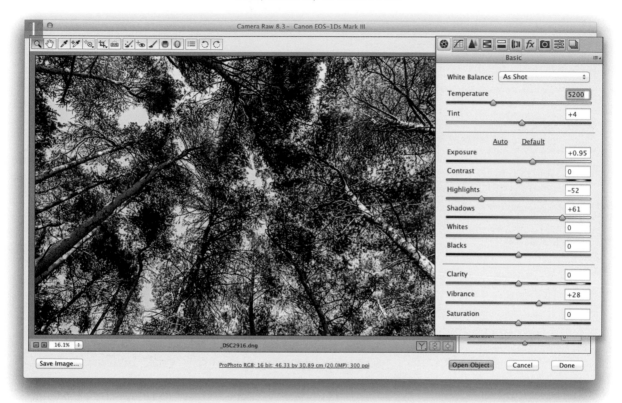

1 I opened this image in Camera Raw, which currently shows the 'As Shot' white balance setting.

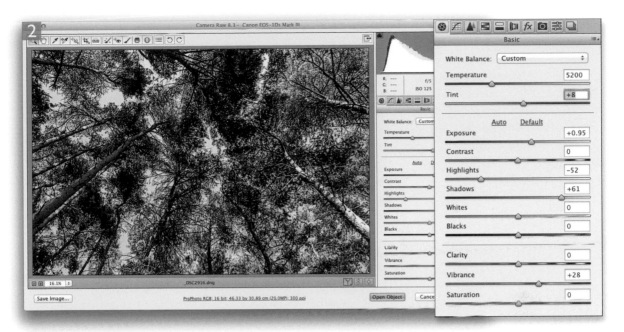

2 I held down the **Shift** key and double-clicked on the Tint slider. This auto-set the Tint slider only to the Auto calculated white balance setting.

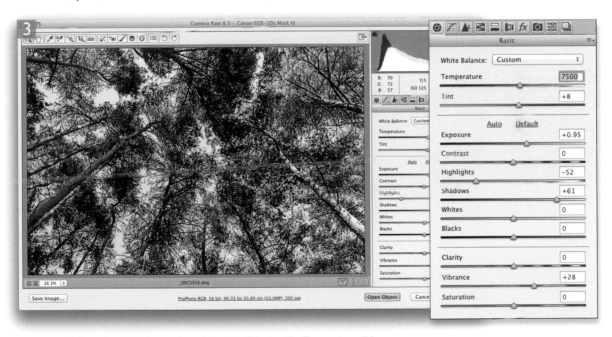

3 I then held down the **Shift** key again and double-clicked on the Temperature slider. This auto-set the Temperature slider only to the Auto calculated white balance setting. With both the Tint and Temperature sliders auto-adjusted, this now produced the same result as selecting 'Auto' from the White Balance menu.

High contrast image processing

The redesign of the tone controls means that contrasty images of high dynamic range scenes can be processed more effectively. As camera manufacturers focus on better ways to capture high dynamic range scenes, the raw image processing tools will need to offer the flexibility to keep up with such developments.

Process Versions

Version 1.0 of Camera Raw was first released in late 2002 as an optional plug-in for Photoshop 7.1. Between then and October 2008, with the release of Camera Raw 5 in Photoshop CS4, Camera Raw underwent many changes. Later versions had the benefit of more tools to play with, such as Recovery, Fill Light, Clarity, Vibrance and localized adjustments, but the underlying demosaic processing remained (almost) unchanged. An image that had been processed in Camera Raw 1.0 could be opened in Camera Raw 5.0 and still look the same. With Camera Raw 6.0 in Photoshop CS5, Adobe completely revised the way raw data was demosaiced, and also updated the noise reduction and sharpening, as well as fine-tuning the Recovery and Fill Light controls. It was therefore necessary to draw a line between the old and new-style processing and this resulted in the need for 'process versions'. In Camera Raw 6.0 you could use the Process 2003 rendering to preserve the Develop settings in all your legacy files (raw, TIFF or JPEG) more or less exactly as they were. Or, you could use the newer Process 2010 rendering to update your older files to the new processing method and take full advantage of the much-improved image processing capabilities in Camera Raw 6.0. Process 2010 was also applied by default to all newly-imported photos.

Camera Raw 7.0 in Photoshop CS6 saw the introduction of yet another new process version: Process 2012. This time the change was just as radical. This is because Process 2012 featured a new set of Basic panel tone adjustment slider controls where the line-up now includes: Exposure, Contrast, Highlights, Shadows, Blacks and Whites. Some of the names remain the same, but the Process 2012 sliders all behave quite differently compared to Process 2003/2010. I'll be explaining how these work shortly, but there are important reasons why it was felt necessary to introduce such changes. Firstly, Camera Raw had evolved a lot since it was first introduced. Initially, the Basic panel had just four tone control sliders: Exposure, Shadows, Brightness and Contrast. To this was added the Recovery and Fill Light sliders, by which time there was quite a bit of overlap between each of these sliders and the effect they would have on an image. For example, the Exposure, Recovery and Fill Light sliders all handled the highlights and shadows somewhat differently, but they would also have an effect on the image midtones and, hence, the overall brightness. Yes, there was the Brightness slider that could be used to adjust

the midtones, but there was also confusion in some users' minds over the role of Brightness versus the Exposure slider. The other thing that could be said was wrong with the old set of tone controls was the lack of symmetry between highlight and shadow adjustments. Those of you who are familiar with Process 2003/2010 Camera Raw processing will know that small incremental adjustments to the Blacks slider had a much more pronounced effect on an image compared with an Exposure or Recovery adjustment. The Process 2012 Basic panel tone sliders addressed these problems. The Exposure slider is slightly different in that it is now more of a midtones brightness slider rather than a highlight clipping adjustment. The Highlights and Shadows sliders have a more symmetrical response and can be used to adjust the shadow and highlight tones while leaving the midtones more or less unchanged (to be adjusted by Exposure). The Contrast slider can be used to compress or expand the entire tonal range and the Blacks and Whites sliders allow you to fine-tune the black and white clipping at the extreme ends of the tonal range.

Another thing Process 2012 addressed was the discrepancy in the Camera Raw tone settings between raw and non-raw images. Previously, raw images would default to a Blacks setting of 5, a +50 Brightness and +25 Contrast. For non-raw files such as JPEGs and TIFFs, the equivalent default settings were all zero. With Process 2012 the default settings were made identical for both raw and non-raw files alike. Apart from removing the mystery as to why these settings had to be different, it became possible to share and synchronize settings between raw and non-raw images more effectively. Lastly, the tone controls were revised with an eye to the future to provide the ability to handle high dynamic range images. For example, the Camera Raw 7.1 update allowed users to edit 32-bit HDR files just as if they were raw originals (see page 432).

Whenever you edit a photo that's previously been edited in an earlier version of Camera Raw using Process 2003 or Process 2010, an exclamation mark button will appear in the bottom right corner of the preview (Figure 2.26) to indicate this is an older Process Version image. Clicking on the button will update the file to Process 2012, which then allows you to take advantage of the latest image processing features in Camera Raw. Or, you can go to the Camera Calibration panel and select the desired Process Version from the Process menu shown in Figure 2.27. Here you can update to Process 2012 by choosing 2012 (Current). Should you wish to do so you can

Figure 2.26 This shows the Process Version update warning triangle. Note that you can *alt*-click to bypass the subsequent warning dialog.

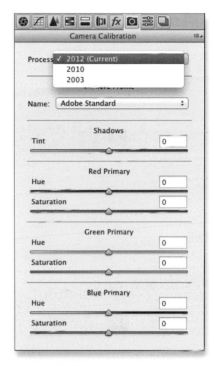

Figure 2.27 The Process Version setting can be accessed via the Camera Calibration panel.

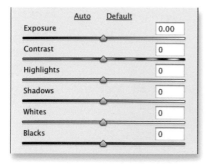

Figure 2.28 The Process 2012 tone adjustment controls.

use this menu to revert to a previous Process 2010 or Process 2003 setting. Note that Camera Raw will attempt to match the legacy settings as closely as possible when updating to Process 2012.

The Process 2012 tone adjustment controls

Now that I have outlined the new changes in Process 2012, let's look at the Basic panel tone adjustment controls (Figure 2.28) in more detail. You can adjust the sliders described here manually, or you can click on the Auto button to auto-set the slider settings. Note that in this edition of the book I only discuss the new Process 2012 controls. If you want to know how to master the Process 2003/2010 controls there is a 24-page PDF guide on Process 2010 image processing that you can download from the book website.

Exposure

With Process 2003 and 2010, as you adjusted the Exposure, Fill Light or Brightness sliders these would have an overlapping effect on the image's tonal values and each slider would affect the midtones in different ways. Consequently an adjustment made to any one of these sliders could affect the overall image brightness. With Process 2012, there is only one control for adjusting the overall brightness and that is the Exposure slider, which is essentially a blend of the old 2003/2010 Exposure and Brightness sliders.

The adjustment units remain the same, ranging from −4.00 to +4.00, but apart from that everything about this slider is different. Previously you would think of adjusting Exposure to set the highlight clipping point and perhaps adjusting the Exposure in conjunction with the Fill Light slider to find an ideal combination that applied an appropriate Exposure level of brightness while retaining sufficient detail in the extreme highlights. You can still hold down the *alt* key as you drag to see a threshold preview that indicates any highlight clipping, but I would urge you to rethink the way you work with the Exposure slider. Consider it primarily as an 'Exposure brightness' adjustment. If you now try to preserve clipping using the Exposure slider you'll quite possibly end up with an overdark image that you can't fully lighten with the Basic panel sliders alone. What you want to do is to concentrate on the midtones rather than the highlights as you adjust the Exposure slider and mainly use the Contrast, Highlights and Whites sliders to control the highlight clipping.

The Exposure slider's behavior is also dependent on the image content. Previously, with Process 2003/2010, as you increased the Exposure the highlights would at some point 'hard clip'. Also, as you increased the Exposure slider further, there was a tendency for color shifts to occur in the highlights as one or more color channels began to clip. With Process 2012, as you increase Exposure there is more of a 'soft clipping' of the highlights as the highlight clipping threshold point is reached. Additional increases in Exposure behave more like a Process 2010 Brightness adjustment in that the highlights roll off smoothly instead of being clipped. As you further increase Exposure you will of course see more and more pixels mapping to pure white, but overall, such Exposure adjustments should result in smoother highlights and reduced color shifts.

Contrast

The Process 2012 Contrast slider also behaves slightly differently. With any contrast type adjustment as you increase the contrast the dark tones get darker and the light tones get lighter, and as you reduce contrast the opposite happens. Meanwhile, the midpoint tones remain anchored. With Process 2003/2010 the midpoint was always fixed (see Figure 2.29). With Process 2012 the midpoint varies slightly according to the content of the image. So with low key images the midpoint shifts slightly more to the left and with high key images, it shifts more to the right. Consequently, the Contrast slider behavior adapts slightly according to the image content and should allow you to better differentiate the tones in the tone areas that predominate.

Basically, you need to think of the Exposure slider as the control for establishing the midtone brightness and the Contrast slider as the control for setting the amount of contrast around that midpoint. By working with just these two sliders you can fairly quickly get to a point where you have an image with more or less the right brightness and contrast. Everything you do from there on with the remaining sliders is about fine-tuning these initial adjustments. Highlights and Shadows help you reveal more tone detail either side of the Exposure midpoint and Whites and Blacks allow you (where required) to fine-tune the white and black clipping points.

One of the things that tends to confuse some people is the fact that as well as having the Contrast adjustment in the

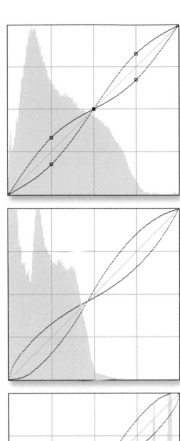

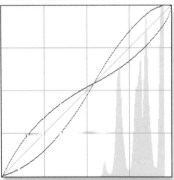

Figure 2.29 The Contrast slider in Process 2012 works slightly differently to its Process 2010 counterpart. With Process 2012 it automatically varies the midpoint setting depending on the image content. In the top Curve diagram the Process 2010 midpoint is locked in the center. With Process 2012 the midpoint can shift left or right depending on whether you are processing a low key or high key image.

Extreme Highlights/Shadows

As you play around with the Process 2012 controls you'll notice that the Highlights and Shadows adjustments have the potential to apply quite strong corrections when bringing out detail in the shadow and highlight areas. If you prefer a more natural look then you are advised to keep your adjustments within the ± 50 range. As you go beyond this, Camera Raw uses a soft edge tone mapping method to compress the tonal range. This technique is similar to that used when converting high dynamic range images to low dynamic range versions, such as when using the HDR Toning adjustment in Photoshop or the Photomatix program. As you increase the amounts applied in the Highlights or Shadows sliders you will start to get more of an 'HDR effect' look, though this will be nothing like as noticeable as the obvious halo effects associated with a typical HDR processed image.

Going in the other direction it is now possible to apply negative Shadows adjustments to darken the shadows— this can be useful where you wish to darken just the shadows to add more contrast. Similarly, you can apply positive Highlights adjustments in order to lighten the whites in images where the highlight tones need extra lifting.

The Highlights and Shadows controls also inform the Whites and Blacks how much tonal compression or expansion has been applied and the Whites and Blacks controls adjust their ranges automatically taking this into account.

Basic panel there is also a separate Tone Curve panel that can be used to adjust contrast. Basically, The Tone Curve panel sliders are useful for fine-tuning the image contrast *after* you have adjusted the main Contrast slider. Note that increasing the contrast does not produce the same kind of unusual color shifts that you sometimes see in Photoshop when you use Curves. This is because the Camera Raw processing manages to prevent hue shifts from occurring as you pump up the contrast.

Highlights and Shadows

The Highlights and Shadows sliders should be regarded as the 'second-level' tone adjustment controls that you apply after you have adjusted the Exposure and Contrast. Highlights and Shadows are essentially improved versions of Recovery and Fill Light. The important things to note here is that while they work at opposite ends of the tonal scale, they are symmetrical in behavior with their range extending just slightly beyond the midtone region. A Highlights adjustment won't affect the darkest areas and similarly, a Shadows adjustment won't affect the lighter areas. So, by using these two sliders it is easier to work on the shadow and highlight regions independently without affecting the overall image brightness. This is because the midtones will mostly remain unchanged (where they can be better governed by an Exposure slider adjustment). Overall, this is a better way of working because it is now clearer which control it is you need to grab when adjusting the highlights or shadows and the results are better too. For example, with Process 2003/2010, using a Recovery adjustment to restore more detail in the highlights would quickly flatten out and soften the highlight tones. Meanwhile, a Fill Light adjustment would have a much bolder effect on the shadows, but would also be influenced by the Blacks setting, which in turn would affect how far into the midtones a Fill Light adjustment would lighten. The Process 2012 Highlights and Shadows sliders are more consistent and easier to use.

You can also hold down the `alt` key as you drag a slider to see a threshold preview, which indicates any highlight or shadow clipping. I would say that a threshold preview analysis at this stage is more 'helpful' rather than essential.

Whites and Blacks

The Whites and Blacks sliders can be used to fine-tune the highlight and shadow clipping. In most instances it should be possible to achieve the look you are after using just the first four sliders, namely: Exposure, Contrast, Highlights and Shadows. Should you find it necessary to further tweak the highlight and shadows, you can use the Whites and Blacks sliders to precisely determine how much the shadows and highlights should be clipped, while preserving the overall tonal relationships in the image. These controls do offer less range. This is because they are primarily intended for fine-tuning the endpoints after the overall tonal relationships in the image have been established. As with the Highlights and Shadows sliders, you can hold down the `alt` key as you drag a slider to see a threshold preview and this will indicate any highlight or shadow clipping. At this stage a threshold preview analysis can be particularly useful. You can also rely on the highlight clipping indicator (discussed on page 146) to tell you which highlights are about to be clipped. It should be noted here that the direction of the Blacks slider adjustment is reversed in Process 2012 and the old zero value for the Blacks slider is now equivalent to a +25 adjustment. Previously, where you might have used a range of 0–5, you can now work with a range of +25–0, and it is now easier to fine-tune a blacks clipping adjustment. Also, the Blacks range is automatically calculated on an image-by-image basis (see sidebar).

Suggested order for the Basic panel adjustments

It isn't mandatory that you adjust the Basic panel sliders in a particular set order, although it is generally best to work on the sliders in the order they are presented from top to bottom. The first step should be to set the Exposure to get the overall image brightness looking right. After that you may want to use the Contrast slider to set the contrast. You can judge this visually on the display and maybe also reference the Histogram to see what type of Contrast adjustment would be appropriate. After that, use the Highlights and Shadows sliders to fine-tune the highlight and shadow regions. By this stage you should be almost there. Only if you feel it is necessary to improve the image further should it be necessary to adjust the Whites and Blacks sliders as well. I would suggest applying in this order to start with, but as you become more familiar with the controls there is no reason why you can't adjust these controls in any order you like.

Extreme Whites/Blacks

Working with the Whites and Blacks sliders you can correct for extreme highlights and shadows by adjusting them to reveal more detail. But you can also push them the other way in order to decrease shadow or highlight detail. For example, you might want to apply a positive Whites adjustment to deliberately blow out certain highlights. And you might also want to use a negative Blacks adjustment in order to make a dark background go completely black. See also the section on localized adjustments and how it is useful to apply such corrections via the adjustment brush. Note that images where the Blacks slider has been run up the scale using Process 2003/2010 will most likely appear somewhat different after a conversion. The Process 2012 Blacks slider tends to back off quite a bit.

Auto-calculated Blacks range

Previously, in Process 2003/2010, it was not always possible to crush the Blacks completely when editing a low contrast image. This was because the Blacks range was fixed. In Process 2012, the Blacks range is auto-calculated based on the image content. This means that when editing a low contrast image, such as a hazy landscape, the Blacks range adapts so that you should always be able to crush the darkest tones in the image. Also, the Blacks adjustment will become increasingly aggressive as you get closer to a –100 value. This means that you gain more range when processing such images, but at the expense of some loss in precision.

Highlight recovery technology

Camera Raw features an internal technology called 'highlight recovery'. This is designed to help recover luminance and color data in the highlight regions whenever the highlight pixels are partially clipped: in other words, when one or more of the red, green and blue channels are partially clipped, but not all three channels are affected. Initially, the highlight recovery process looks for luminance detail in the non-missing channel or channels and uses this to build luminance detail in the clipped channel or channels. This may be enough to recover the missing detail in the highlights. After that Camera Raw also applies a darkening curve to the highlight region only, and in doing so brings out more detail in the highlight areas. Note that this technology is designed to work for raw files only, although JPEG images can sometimes benefit too (but not so much).

Process 2012 notably provides improved highlight color rendering, which preserves the partial color relationships as well as the luminance texture in the highlights. You should find that highlight detail is rendered better. There is also less tendency for color detail to quickly fade to neutral gray.

Preserving the highlight detail

The Exposure slider's response correlates quite well with the way film behaves and you should also find that using Process 2012 provides you with about an extra stop of exposure latitude compared to editing with the Process 2003/2010 Exposure slider. As you apply Basic adjustments in Camera Raw, you will want to make the brightest parts of the photo go to white so the highlights are not too dull. At the same time though, you will want to ensure that important highlight detail is always preserved. This means taking care not to clip the highlights too much, since this might otherwise result in important highlight detail being lost when you come to make a print. You therefore need to bear in mind the following guidelines when deciding how the highlights should be clipped.

Where you should set the highlight clipping point is really dependent on the nature of the image. In most cases you can adjust the Highlights followed by the Whites slider so that the highlights just begin to clip and not worry too much about losing important highlight detail. If the picture you are editing contains a lot of delicate highlight information then you will want to be careful when setting the highlight point so that the brightest whites in the photo are not too close to the point where the highlights start to be clipped. The reason for this is all down to what happens when you ultimately send a photo to a desktop printer or convert an image to CMYK and send it to the press to be printed. Most photo inkjet printers are quite good at reproducing highlight detail at the top end of the print scale, but at some point you will find that the highest pixel values do not equate to a printable tone on paper. Basically, the printer may not be able to produce a dot that is light enough to print successfully. Some inkjet printers use light colored inks such as a light gray, light magenta and light cyan to complement the regular black, gray, cyan, magenta, yellow ink set and these printers are better at reproducing faint highlight detail. CMYK press printing is a whole other matter. Printing presses will vary of course, but there is a similar problem where a halftone dot may be too small for any ink to adhere to the paper. In all the above cases there is an upper threshold limit where the highlight values won't print. So, when you are adjusting the Highlights and Whites sliders, it is important to examine the image and ask yourself if the highlight detail matters or not.

Some pictures may contain subtle highlight detail (such as in Figure 2.30), where it is essential to make sure the important highlight tones don't get clipped. Other images may look like the example on the next page in Figure 2.31. Here, the light reflecting off a shiny metal surface creates bright, specular highlights and the last thing you need to concern yourself with is preserving the highlight detail. I would say that most images contain at least a few specular highlights and it is only where you have a photo like the one shown below, in Figure 2.30, that you have to pay particular attention to ensure the brightest highlights aren't totally clipped.

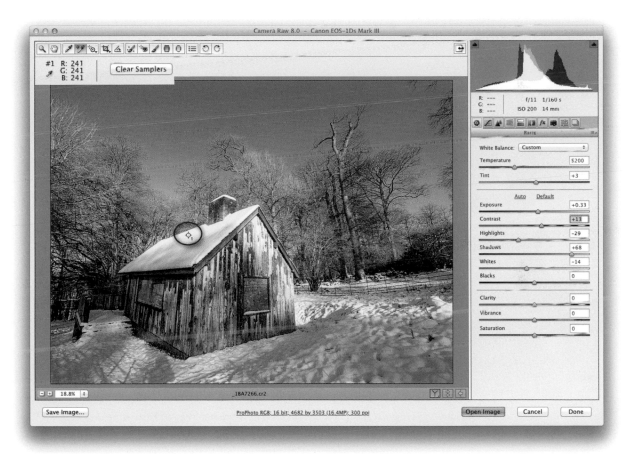

Figure 2.30 In this example it was important to preserve the delicate highlight tones To be absolutely sure that I didn't risk making the highlight detail areas too bright, I placed a color sampler (circled) over an area that contained important highlight detail. This allowed me to check that the RGB highlight value did not go too high. In this case I knew that with a pixel reading of 241,241,241, the highlight tones in this part of the picture would print fine using almost any print device.

White backdrops

For studio shots with a white background, you usually want the backdrop to reproduce as pure white. If you do this with the lighting you need to ensure the lighting ratios are balanced so that important detail in the subject highlights isn't clipped.

It is best not to overexpose the white background too much at the capture stage. One can always force the background tones to white when editing in Camera Raw by applying a positive Highlights and/or Whites adjustment (or by editing the image in Photoshop).

When to clip the highlights

As I say, you have to be careful when judging where to set the highlight point. If you clip too much then you risk losing important highlight detail. However, what if the image contains bright specular highlights, such as highlight reflections on shiny metal objects? The Figure 2.31 image has specular highlights that contain no detail. It is therefore safe to clip these highlights, because if you were to clip them too conservatively you would end up with dull highlights in your print. In this case the aim is for the shiny reflections to print to paper white. So when adjusting the Highlights and Whites slider for a subject like this, you would use the Exposure slider to visually decide how bright to make the photo and not be afraid to let the specular highlights blow out to white when adjusting the Highlights and Whites sliders.

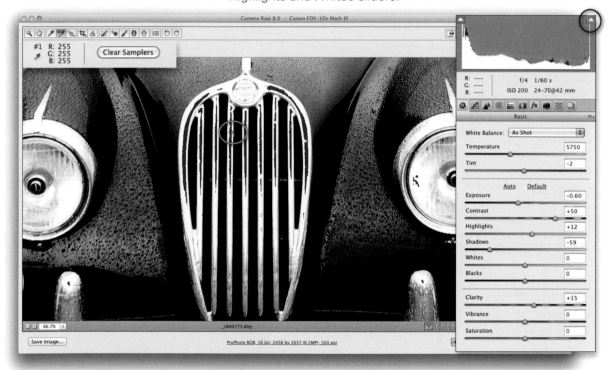

Figure 2.31 The highlights in this photograph contain no detail, so there is no point in trying to preserve detail in the shiny areas as this would needlessly limit the contrast. One can safely afford to clip the highlights in this image without losing important image detail and as you can see here, the color sampler over the shiny reflection (circled in blue) measures a highlight value of 255,255,255. With images like this it is OK to let the highlights burn out. Note that the highlight clipping warning is checked (circled in red) and the colored overlay in the preview image indicates where there is highlight clipping.

How to clip the shadows

Setting the black clipping point is, by comparison, a much easier thing to do. Put aside any concerns you might have about matching the black clipping point to a printing device, I'll explain how that works over the next two pages. Blacks slider adjustments are simply about deciding where you want the shadows to clip. The default setting is now 0 and this will usually be about right for most images. With some images, where the initial clipping appears too severe, you may want to ease the clipping off by dragging the Blacks slider more to the right, but it is inadvisable to lighten the Blacks too much. Some photos, such as the one shown below in Figure 2.32, can actually benefit from a heavy black clipping so that the dark areas print to a solid black.

Hiding shadow noise

Raising the threshold point to where the shadows start to clip is one way to add depth and contrast to your photos. It can also help improve the appearance of an image that has very noisy shadows.

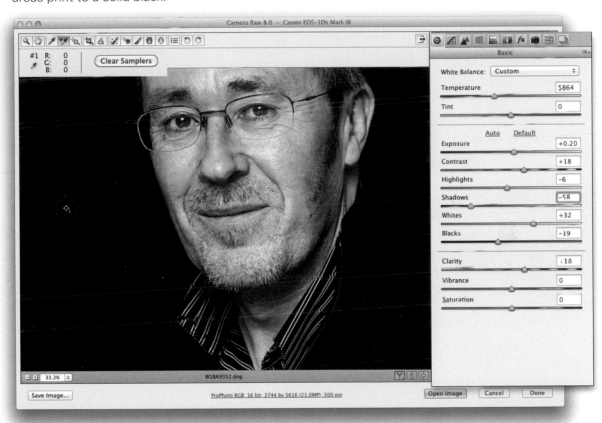

Figure 2.32 In this picture you can see that the Blacks in this photo are well and truly clipped. This is because I deliberately wanted to force any shadow detail in the backdrop to a solid black. As you can see, the color sampler over the backdrop in this picture (circled) showed an RGB reading of 0,0,0.

Is it wrong to set levels manually?

All I am suggesting here is that it is an unnecessary extra step to use Photoshop to set the black output levels to anything higher than the zero black after you have already set the black clipping at the Camera Raw editing stage (or have done so in Photoshop). If you do set the black output levels manually to a setting that is higher than zero you won't necessarily get inferior print outputs, providing, that is, you set the black levels accurately and don't set them any higher than is needed. And there's the rub: how do you know how much to set the output levels, and what if you want to output a photo to more than one type of print paper? You see, it's easier to let Photoshop work this out for you automatically. Some picture libraries are quite specific about how you set the output levels, but their suggested settings are usually very conservative and unlikely to result in weak shadows when printed to most devices. It is therefore probably better to oblige the libraries and just give them what they ask for. The only time when you may need to give special consideration to setting the shadows to anything other than zero is when you are required to edit an already converted CMYK or grayscale file that is destined to go to a printing press, where the black output levels have been set incorrectly. However, if you use Photoshop color management properly you are unlikely to encounter such scenarios.

Shadow levels after a conversion

You will sometimes come across advice saying that the output levels for the black point in an RGB image should be set to something like 20,20,20 (for the Red, Green, Blue RGB values). The usual reason given for this is because anything darker than, say, a 20,20,20 shadow value will reproduce in print as a solid black. Just to add to the confusion, different numbers are suggested for the output levels: one person suggests using 10,10,10, while another advises you use 25,25,25. In all this you are probably left wondering how to set the Blacks slider in Camera Raw, since you can only use it to clip the black input levels and there is no control for setting the black output levels so that they match these suggested output settings.

This is one of those areas where the advice given is more complex than it needs to be. It is well known that because of factors such as dot gain, it has always been necessary to make the blacks in a digital image slightly lighter than the blackest black (0,0,0,) before outputting it to print. As a result of this, in the early days of digital imaging, the only way to get a digital image to print correctly was to *manually* adjust the output levels so that the black clipping point matched the print device. Back then, if you set the levels to 0,0,0, RGB, the blacks would print too dark and you would lose detail in the shadows. Therefore the solution was to set the output levels point to a value higher than this (such as 20,20,20 RGB), so that the blacks in the image matched the blackest black for the print device. These are the historical reasons for such advice, because the black levels had to be adjusted differently for each type of print output including CMYK prepress files.

For the last 18 years or so, Photoshop has had a built-in automated color management system that's designed to take care of the black clipping at the output stage. The advice these days is therefore quite simple: you decide where you want the blackest blacks to be in the picture and clip them to 0,0,0, RGB (as discussed on the previous page). When you save the image out to Photoshop as a pixel image and send the image data to the printer, the Photoshop or print driver software automatically calculates the precise amount of black clipping adjustment that is required for each and every print/paper combination. In the Figure 2.33 example you can see how the black clipping point for different print outputs is automatically compensated when converting the data from the edited image to the profile space for the printing paper. Don't just take

my word, it is easy to prove this for yourself. Open an image (any will do), set the Channel display in the Histogram panel to Luminosity and refresh the histogram to show the most up-to-date histogram view (you can do this by clicking on the yellow warning triangle in the top right corner). Once you have done this go to the Edit menu, choose Convert to Profile and select a CMYK or RGB print space. You'll need to refresh the histogram display again, but once you have done so you can compare the before and after histograms and check what happens to the black clipping point.

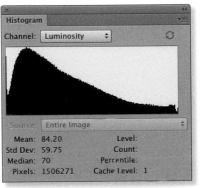

Original histogram – ProPhoto RGB

Figure 2.33 The Histogram panel views on the right show (top) the original histogram for this ProPhoto RGB image. The middle histogram shows a comparison of the image histogram after converting the ProPhoto RGB data to a print profile space for Innova Fibraprint glossy paper printed to an Epson 4800 printer. The print output histogram is overlaid here in green and you can see how the black levels clipping point has been automatically indented. The bottom example shows a standard CMYK conversion to the US Web coated SWOP profile (also colored green so that you can compare it more easily with the before histogram). Again, you can see how the black clipping point is moved inwards to avoid clogging up the shadow detail. Please note that the histograms shown here were all captured using the Luminosity mode since this mode accurately portrays the composite luminance levels in each version of the image.

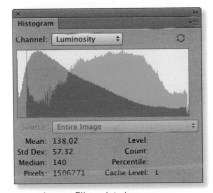

Innova Fibraprint glossy paper

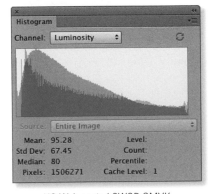

US Web coated SWOP CMYK

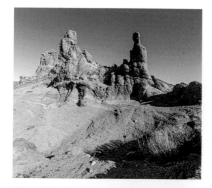

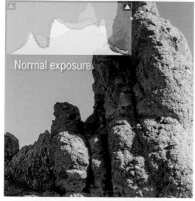

Normal exposure

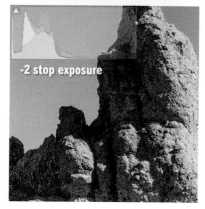

-2 stop exposure

Figure 2.34 This shows the difference the exposure can make in retaining shadow information. The darker the exposure, the fewer discrete levels that can be captured via the camera sensor. This will result in poorly recorded shadow detail. These close-up views compare the outcome when lightening an underexposed image to match the correctly exposed version.

Digital exposure

Compared to film, shooting with a digital camera requires a whole new approach when determining what the optimum exposure should be. With film you tended to underexpose slightly for chrome emulsions (because you didn't want to risk blowing out the highlights). With negative emulsion film it was considered safer to overexpose as this would ensure you captured more shadow detail and thereby recorded a greater subject tonal range.

When capturing raw images on a digital camera it is best to overexpose as much as it is safe to do so before you start to clip the highlights. Most digital cameras are capable of capturing at least 12 bits of data, which is equivalent to 4096 recordable levels per color channel. As you halve the amount of light that falls on the chip sensor, you potentially halve the number of levels that are available to record an exposure. Let us suppose that the optimum exposure for a particular photograph at a given shutter speed is f8. This exposure makes full use of the chip sensor's dynamic range and consequently there is the potential to record up to 4096 levels of information. If one were then to halve the exposure to f11, you would only have the ability to record up to 2048 levels per channel. It would still be possible to lighten the image in Camera Raw or Photoshop to create an image that appeared to have similar contrast and brightness. But (and it's a big but), that one stop exposure difference will have immediately lost you half the number of levels that could potentially be captured using a one stop brighter exposure. The image is now effectively using only 11 bits of data per channel instead of 12. This is true of digital scanners too. Perhaps you may have already observed how difficult it can be to rescue detail from the very darkest shadows, and how these can end up looking posterized. Also, have you ever noticed how much easier it is to rescue highlight detail compared with shadow detail when using the Shadows/Highlights adjustment? This is because far fewer levels are available to define the information recorded in the darkest areas of the picture and these levels are easily stretched further apart as you try to lighten them. This is why posterization is always much more noticeable in the shadows (see Figure 2.34). It also explains why it is important to target your digital exposures as carefully as possible so that you capture the brightest exposures possible, but without the risk of blowing out the highlight detail.

How Camera Raw interprets the raw data

Camera sensors have a linear response to light and unprocessed raw files therefore exist in a 'linear gamma space' (see Figure 2.35). Human vision on the other hand interprets light in a non-linear fashion, so one of the main things a raw conversion has to do is apply a gamma correction to the original image data to make the correctly exposed, raw image look the way our eyes would expect such a scene to look. The preview image you see in the Camera Raw dialog presents a gamma corrected preview of the raw data, while the adjustments you apply in Camera Raw are in fact applied directly to the raw linear data. This illustrates one aspect of the subtle but important differences between the tonal edits that can be made in Camera Raw to raw files and those that are applied in Photoshop where the images have already been 'gamma corrected'.

Camera histograms

As I have mentioned already in this book, the histogram that appears on a compact camera or digital SLR screen is unreliable for anything other than JPEG capture. This is because the histogram you see there is usually based on the camera-processed JPEG and is not representative of the true raw capture. The only way to check the histogram for a raw capture file is to open the image via Camera Raw or, indeed, any other raw processing program.

Figure 2.35 If you could inspect a raw capture image in its native, linear gamma state, it would look something like the image shown top left. Notice that the picture appears very dark. During the raw conversion process, a gamma curve correction is applied when converting the linear data so that the processed image matches the way we are used to viewing the relative brightness in a scene. The picture top right shows the same image after a basic raw conversion. As a consequence of this, the more brightly exposed areas will preserve the most tonal information and the shadow areas will end up with fewer levels. A typical CCD sensor can capture up to 4096 levels of tonal information. Half these levels are recorded in the brightest stop exposure range and the recorded levels are effectively halved with every stop decrease in exposure. The digital camera exposure is therefore quite critical. Ideally, you want the exposure to be as bright as possible so that you make full use of the Levels histogram, but at the same time be careful to make sure the highlights don't get clipped.

Basic panel image adjustment procedure

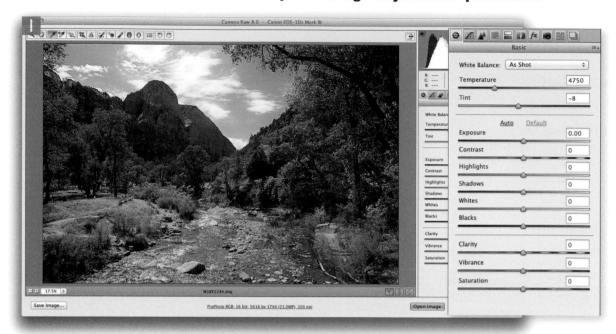

1 Here you can see the starting point for this image where the Basic panel settings were all set to their default values.

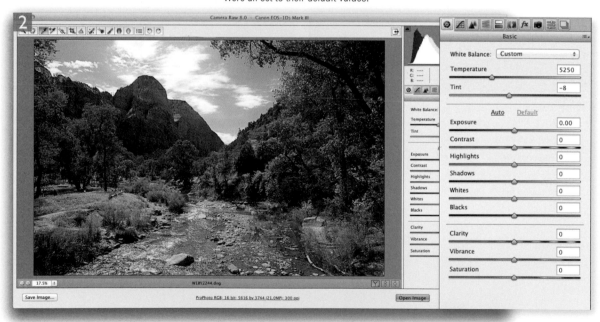

2 To begin with I manually adjusted the Temperature slider in order to make the image appear slightly warmer in color.

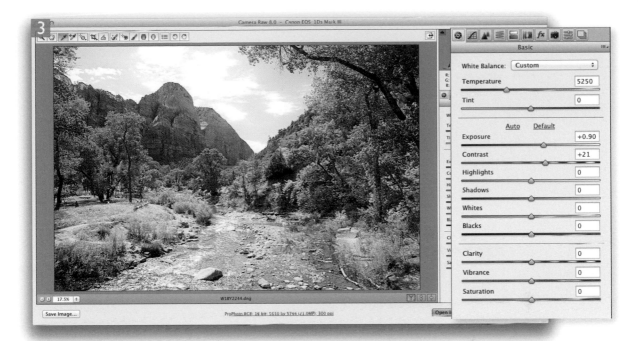

3 Next, I adjusted the Exposure and Contrast sliders to lighten the image and also to increase the contrast slightly.

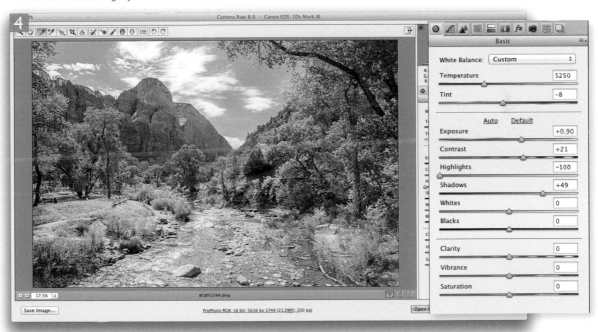

4 I then reduced the Highlights to restore more detail in the highlight areas and at the same time increased the Shadows to lift the darker areas.

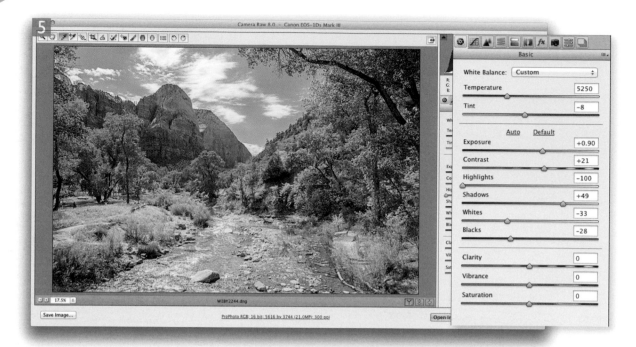

5 In this step I reduced both the Whites and Blacks sliders to fine-tune the white and black clipping points.

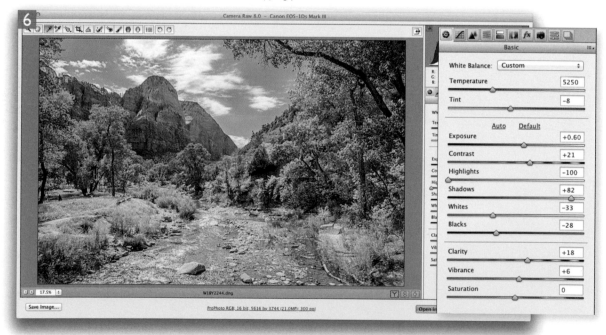

6 Finally, I readjusted the Exposure and Shadows sliders to rebalance the overall brightness of the photo. I also added some positive Clarity and Vibrance.

Auto tone corrections

Camera Raw has the useful ability to apply auto tone corrections. To do this, just click on 'Auto' (⌘ U [Mac], ctrl U [PC]) in the Camera Raw dialog (circled in Figure 2.36). An auto tone adjustment will affect the Exposure, Contrast, Highlights, Shadows, Whites and Blacks and is to some extent affected by the white balance setting. Auto tone adjustments work really well on most images, such as outdoor scenes and naturally lit portraits, but work less well on photographs that have been shot in the studio under controlled lighting conditions. So in these instances it is best not to use Auto.

Auto Exposure has also been improved recently, making it more consistent from image to image, as well as being more consistent across different image sizes that have been set in the Workflow options. For the most part the Auto Exposure results will appear to produce the same results as before, but with over-bright images the auto setting result will be noticeably tamer.

Auto Whites and Blacks sliders

The Whites and Blacks sliders also now support functionality akin to auto levels. You can Shift + double-click on either of these sliders to independently auto-set the Whites and Blacks adjustments. More specifically, when using this method, Camera Raw analyzes the image and computes the Whites or Blacks value needed to just begin to clip. This isn't quite the same as applying a standard auto tone adjustment, as the auto adjustment is recalculated based on all other adjustment settings that have been applied and also takes into account things like cropping and Lens Corrections and excludes from the auto calculation any pixels that are not currently visible. Therefore, if there are some bright highlights in your image, but these have been cropped, then these highlight areas will be ignored when you double-click the Whites slider to make an auto calculation (see the example that's shown on the following page).

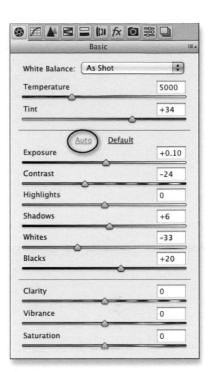

Figure 2.36 Clicking on the Auto button applies an auto adjustment to the Basic panel settings in Camera Raw. This auto-adjusts the Exposure, Contrast, Highlights, Shadows, Whites and Blacks settings. You can also use *Shift*+double-click to apply an auto setting to individual sliders.

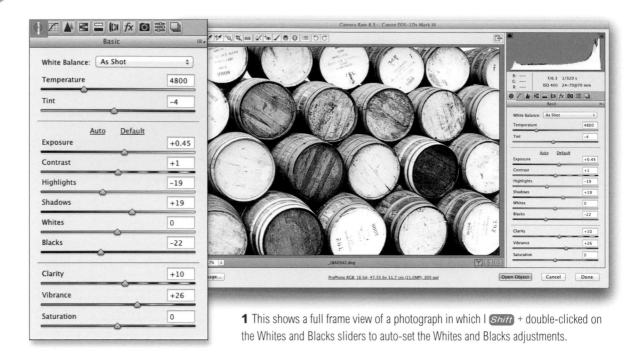

1 This shows a full frame view of a photograph in which I [Shift] + double-clicked on the Whites and Blacks sliders to auto-set the Whites and Blacks adjustments.

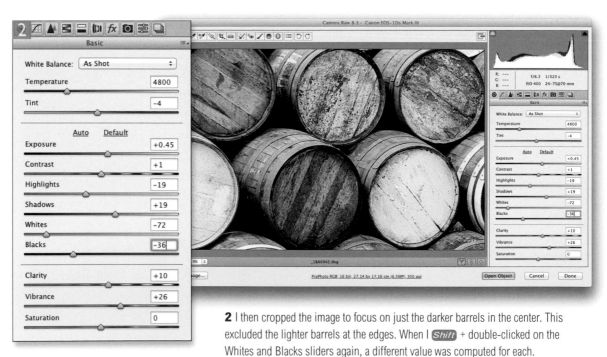

2 I then cropped the image to focus on just the darker barrels in the center. This excluded the lighter barrels at the edges. When I [Shift] + double-clicked on the Whites and Blacks sliders again, a different value was computed for each.

Camera-specific default settings

The Default Image Settings section of the Camera Raw
preferences allows you to make any default settings camera-
specific. If you go to the Camera Raw fly-out menu options
shown in Figure 2.37, there is an option that allows you to
'Save New Camera Raw Defaults' as the new default setting
to be used every time Bridge or Camera Raw encounters a
new image. On its own, this menu item allows you to create a
default setting based on the current Camera Raw settings (see
page 125) and apply this to all subsequent photos (except
where you have already overridden the default settings).
However, if the 'Make defaults specific to the camera serial
number' option is selected in the Camera Raw preferences,
selecting 'Save New Camera Raw Defaults' only applies this
setting as a default to files that match the same camera serial
number. Similarly, if the 'Make defaults specific to camera
ISO setting' option is checked, this allows you to save default
settings for specific ISO values. When both this and the

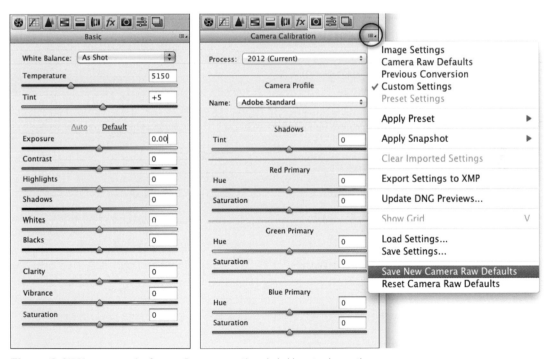

Figure 2.37 You can use the Camera Raw menu option circled here to choose the
'Save New Camera Raw Defaults'. This saves all the current Camera Raw settings as a
default setting according to how the preferences are set in Figure 2.20. The important
thing to bear in mind here is to ensure the Basic panel settings have all been set to
their defaults first.

previous option are checked, you can effectively have multiple default settings in Camera Raw that take into account the combination of the camera model and ISO setting.

You do have to be careful how you go about using the 'Save New Camera Defaults' option. When used correctly you can cleverly set up Camera Raw to apply appropriate default settings for any camera and ISO setting. However, it is all too easy to make a mistake, or worse still, select the 'Reset Camera Defaults' option and undo all your hard work.

The main thing to watch out for is that you don't include too many Camera Raw adjustments (such as the HSL/Grayscale panel settings) as part of a default setting. The best thing is to open a previously untouched image, apply a Camera Calibration panel adjustment plus, say, enable the Camera Profile and Lens Profile correction settings and save this as a camera-specific default. You might find it useful to adjust the Detail panel noise reduction settings for an image shot at a specific ISO setting and save this as a 'Make defaults specific to camera ISO setting'. Or, you might like to check using both Camera Raw preference options and setup defaults for different ISO settings with specific cameras.

Clarity

Adding Clarity to a photo can be thought of as adding sharpness, but it is more accurate to say that Clarity adds localized, midtone contrast. In other words, the Clarity slider can be used to build up the contrast in the midtone areas by effectively applying a soft, wide radius unsharp mask type of filter. Consequently, when you add a positive Clarity adjustment, you will notice improved tonal separation and better texture definition in the midtones. By applying a small positive Clarity adjustment you can therefore increase the local contrast across narrow areas of detail and a bigger positive Clarity adjustment increases the localized contrast over broader regions of the photo. Positive Clarity adjustments now utilize the new tone mapping logic that is employed for the Highlights and Shadows sliders. As a result of this, halos either side of a high contrast boundary edge should appear reduced.

All photos can benefit from adding a small amount of Clarity. I would say, a +10 value works well for most pictures. However, you can safely add a maximum Clarity adjustment if you think a picture needs it (such as in the Figure 2.38 example shown below). But note that in terms of strength, a maximum Clarity adjustment using Process 2012 is now roughly double what it was in Process 2010.

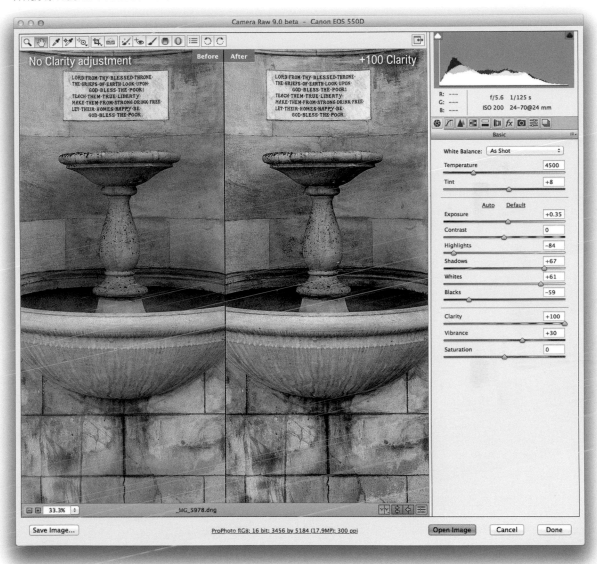

Figure 2.38 This screen shot shows an example of Clarity in action. The left half of the Camera Raw preview shows how the photo looked before Clarity was added and the right half of the preview shows the same image with +100 Clarity.

Negative clarity

Just as you can use a positive clarity adjustment to boost the midtone contrast, you can also apply a negative clarity adjustment to soften the midtones. There are two uses that come to mind here. Clicio Barroso and Ettore Causa suggested that a negative clarity adjustment could be useful for softening skin tones in portrait and beauty shots (see Figure 2.39). This works great if you use the adjustment brush tool (discussed on pages 226–238) to apply a negative clarity in combination with a sharpening adjustment. The other thing you can do is to use negative clarity to simulate a diffusion printing technique that used to be popular with a lot of traditional darkroom printers. In Figure 2.40 you can see examples of a before and after image where I used a maximum negative clarity to soften the midtone contrast to produce a kind of soft focus look. You will also find that this technique works particularly well with photos that have been converted to black and white.

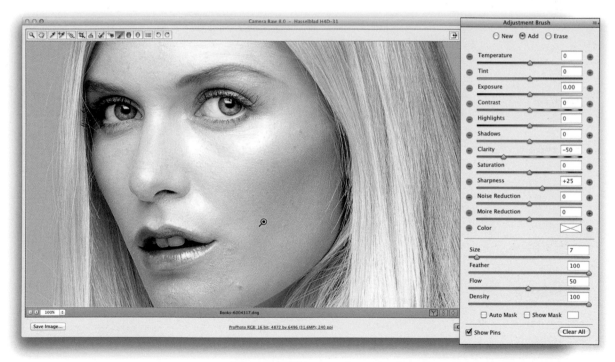

Figure 2.39 This shows the results of an adjustment brush applied using the combination of a −50 Clarity effect with a +25 Sharpness effect to produce the skin softening look achieved here. I applied this effect a little stronger than I would do normally in order to really emphasize the skin softening effect.

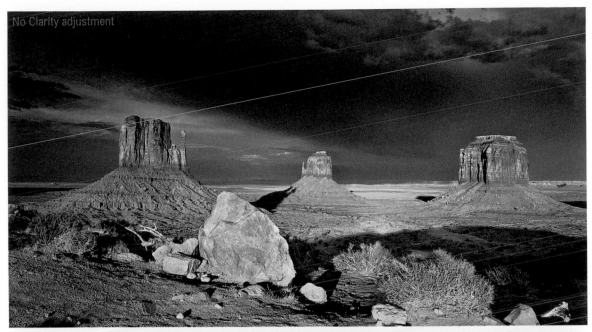

No Clarity adjustment

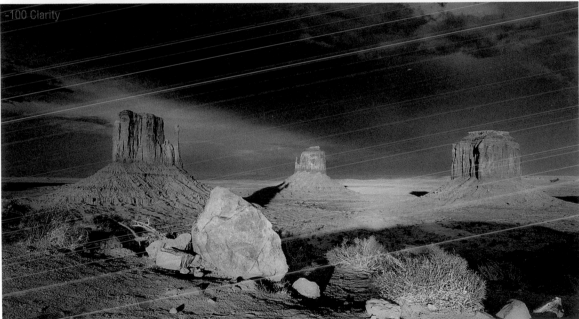

-100 Clarity

Figure 2.40 This shows a before version (top) and an after version (below), where I applied a –100 Clarity adjustment.

Vibrance and Saturation

The Saturation slider can be used to boost color saturation, but extreme saturation adjustments will soon cause the brighter colors to clip. However, the Vibrance slider can be used to apply what is described as a non-linear color saturation adjustment, which means colors that are already brightly saturated in color will remain relatively protected as you boost the vibrance, whereas the colors that are not so saturated receive a greater saturation boost. The net result is a saturation control that allows you to make an image look more colorful, but without the attendant risk of clipping those colors that are saturated enough already. Try opening a photograph of some brightly colored flowers and compare the difference between a Vibrance and a Saturation adjustment to see what I mean. The other thing that is rather neat about the Vibrance control is that it has a built-in skin tone protection filter which does rather a good job of not letting the skin tones increase in saturation as you move the slider to the right. In Figure 2.41, I set the Vibrance to +55, which boosted the colors in the dress, but without giving the model too 'vibrant' a suntan.

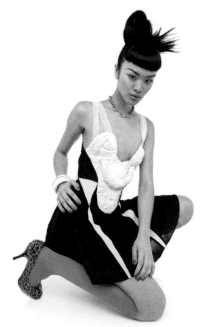
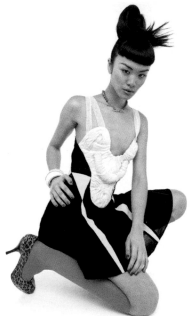

Model: Kelly @ Zone

Figure 2.41 Boosting the colors using the Vibrance control in the Basic panel.

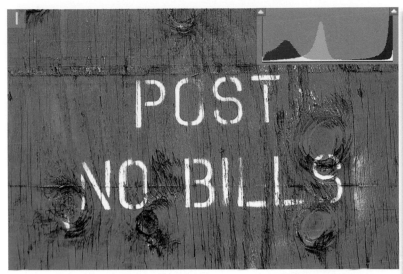

1 In this example you can see what happens if you choose to boost the saturation in a photo using the Saturation slider only to enrich the colors. If you look at the histogram you will notice how the blue channel is clipped. This is what we should expect, because the Saturation slider in Camera Raw applies a linear adjustment that pushes the already saturated blues off the histogram scale.

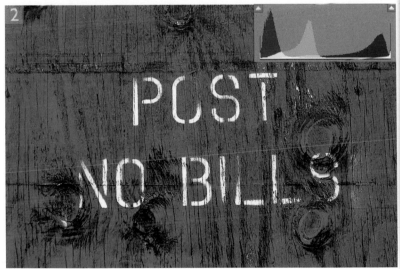

2 Compare what happens when you use the Vibrance slider instead to boost the saturation. In this example you will notice how none of the blue channel colors are clipped. This is because the Vibrance slider boosts the saturation of the least saturated colors most, tapering off to a no saturation boost for the already saturated colors. Hence, there is no clipping in the histogram.

Linear contrast in Process 2012

The default Tone Curve for Process 2003/2010 applies a Medium Contrast curve, whereas the Process 2012 default is 'Linear'. However, the Linear setting in Process 2012 actually applies the same Tone Curve kick to the shadows as the old Medium Contrast setting. Adobe simply recalibrated the underlying tone curve settings in Process 2012 so that Medium Contrast is now the new 'Linear' starting point. The important thing here is that the starting point in Process 2003/2010 and Process 2012 is actually the same. It's only the names and how the Tone Curve is represented in the Point Curve editor mode that have changed.

Tone Curve panel

The Tone Curve panel offers a fine-tuning contrast control that can be applied in addition to the tone and contrast adjustments made in the Basic panel. There are two modes of operation available here: parametric and point. We'll look at the parametric controls first. The starting point is a straight curve, though in actual fact, the underlying tone curve does actually apply a small amount of contrast (see sidebar). When editing a Tone Curve in parametric mode you use the Tone Curve panel slider controls to modify the curve shape. This is essentially a more intuitive way to work, plus you can also use the target adjustment tool (T) in conjunction with the parametric sliders to adjust the tones in an image. Note that you can use the T shortcut as a toggle action to access and use the Tone Curve target adjustment tool while editing in the Basic panel. Here is an example of how to edit the Tone Curve in the parametric editor mode.

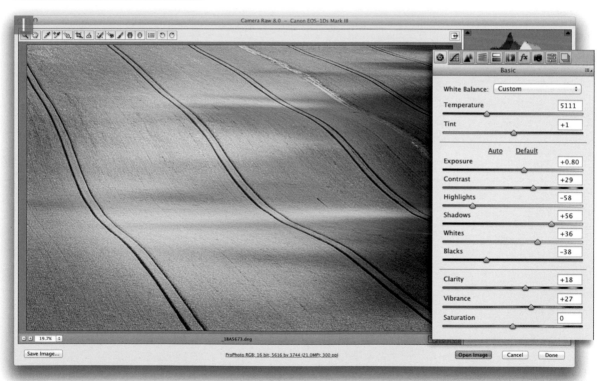

1 In this first example, the image was corrected using the Basic panel controls to produce an optimized range of tones that were ready to be enhanced further. I could have used the Contrast slider to boost the contrast more, but the Tone Curve panel provides a simple yet effective interface for manipulating the image contrast.

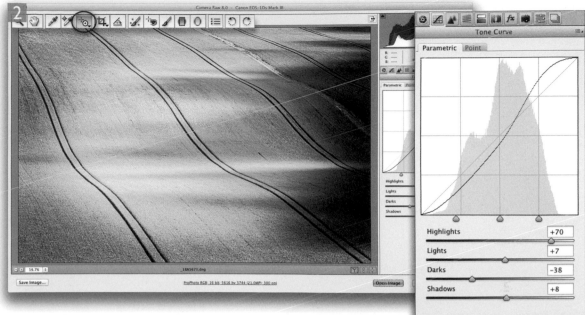

2 In the Tone Curve panel I selected the Parametric curve option. By adjusting the four main sliders I was able to apply a strong tone contrast to the photo. You can also apply these adjustments by selecting the target adjustment tool (circled) and then clicking and dragging up or down on target areas of the image.

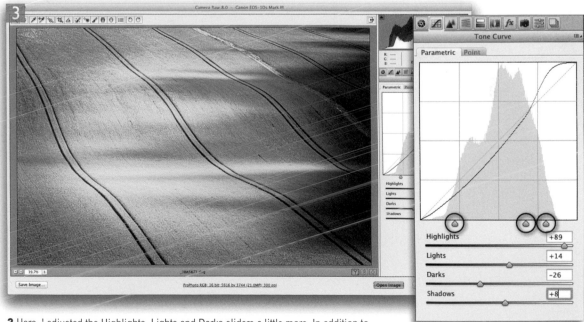

3 Here, I adjusted the Highlights, Lights and Darks sliders a little more. In addition to this, I fine-tuned the scope of adjustment for the Tone Curve sliders by adjusting the positions of the three tone range split points (circled).

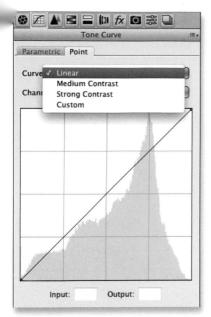

Figure 2.42 The Tone Curve panel, shown here in Point Curve editor mode with the default Linear tone curve setting.

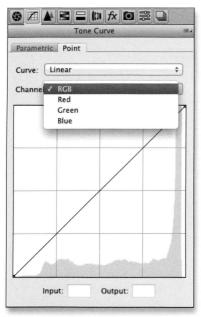

Figure 2.43 The Tone Curve panel, shown here with the RGB channel selected.

Point Curve editor mode

In the Point Curve editor mode, you can manipulate the shape of the Tone Curve as you would with the Curves adjustment in Photoshop. As I mentioned on the previous page, the default curve shape in Process 2012 is 'Linear', which is actually the same as the old Medium Contrast curve. If you want, you can use the Point Tone Curve panel mode to apply a stronger contrast base curve setting. Regardless of any adjustments you have already made in the parametric mode, the curve shape that's shown here uses the Curve setting selected from the Curve menu in Figure 2.42 as the starting point curve shape. I suppose you could say that the way the Tone Curve panel represents curves in Camera Raw is similar to having two Curves adjustment layers one on top of the other in Photoshop. In fact, if you also take into account the effect of the Contrast slider in the Basic panel, you effectively have three curves adjustments to play with. To edit the point tone curve, just click on the curve line to add points and drag to adjust the overall curve shape. You can edit curve points just like in Photoshop. When a point is selected, use the keyboard arrow keys to move the point around. Note that as you nudge using the arrow keys this pins an anchor point within the allowable curve range only. To select a new existing point, use *ctrl* *Tab* to select the next point up and use *ctrl* *Shift* *Tab* to select the next point down. You can delete a selected anchor point by ⌘ (Mac), *ctrl* (PC) + clicking it, hit the *Delete* key, or drag the point off to the side of the curve graph. Also, if you hold down the ⌘ (Mac), *ctrl* (PC) key while hovering the cursor over the image preview, you can see exactly where a tone will fall on the curve, and you can ⌘ (Mac), *ctrl* (PC)-click in the preview to place a point on the curve. Lastly, use the *Shift* key to select multiple points on the curve.

RGB Curves

When working in Process 2012, you will see a Channel menu, which allows you to edit either the RGB or individual red, green or blue channels (Figure 2.43). This allows you to apply fine-tuned color corrections. To some extent this does duplicate functionality available elsewhere in Camera Raw. Even so, RGB curves do let you apply unique kinds of adjustments, such as those seen in Figures 2.44 and 2.45. You can use it to apply strong color casts, you can correct images with mixed lighting and you can also achieve split tone effects that go beyond what can be achieved in the Split Toning panel alone.

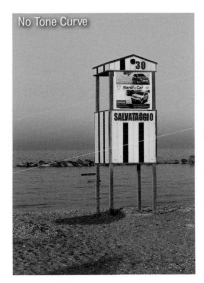
No Tone Curve

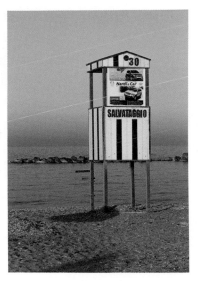

Figure 2.44 This shows two different RGB point tone curve adjustments. In the middle version, I applied an adjustment to cool the highlights and warm the shadows. In the version on the right, I deliberately applied a strong red/yellow cast.

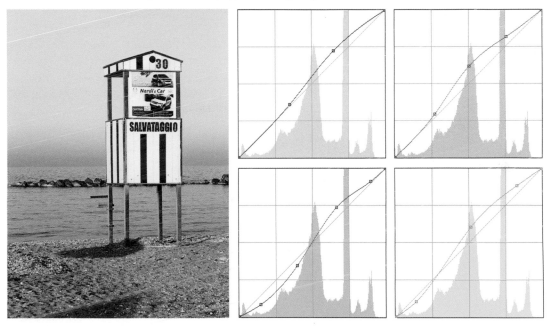

Figure 2.45 In this example I desaturated the image, taking the Saturation slider in the Basic panel to −100. I then applied the point tone curve adjustments shown here to apply a multi-color split toning effect.

Correcting a high contrast image

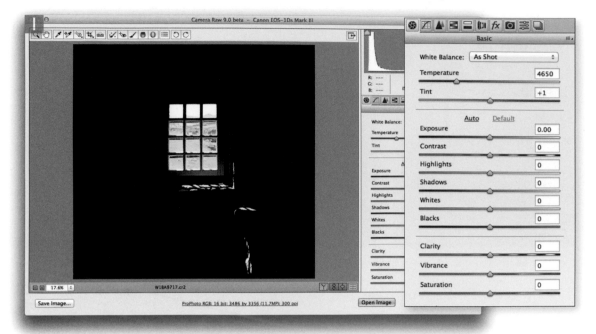

1 This photograph has a very wide subject brightness range, and is shown here opened in Camera Raw using the default Process 2012 settings.

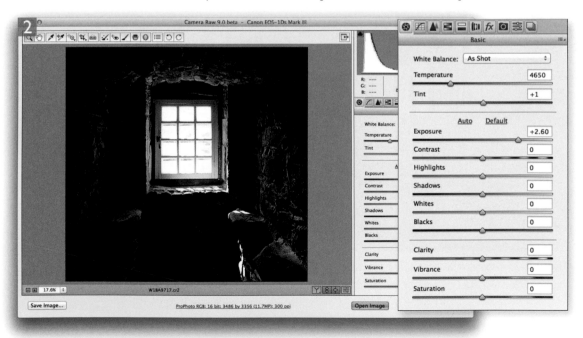

2 I began by adjusting the Exposure slider to brighten the image.

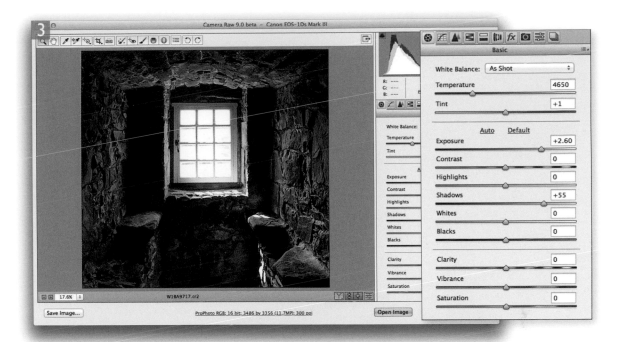

3 I next adjusted the Shadows slider, setting this to +55 to reveal more of the interior.

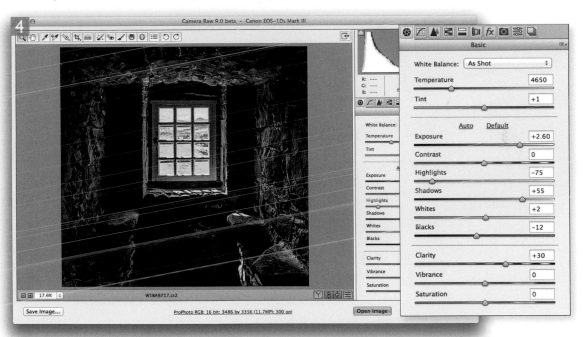

4 Lastly, I adjusted the Highlights slider to restore more detail of the view outside the window. I also fine-tuned the Whites and Blacks sliders and added more Clarity to boost the midtone contrast.

Camera Raw Detail panel

In case you are wondering, the following chapter contains a major section on working with the Detail panel.

HSL/Grayscale panel

The HSL controls provide eight color sliders with which to control the Hue, Saturation and Luminance. These work in a similar way to the Hue/Saturation adjustment in Photoshop, but are in many ways better and the response when using these sliders is more predictable. In Figure 2.46 I used the Luminance controls to darken the blue sky and add more contrast in the clouds, and I also lightened the rocks slightly. Try doing this using Hue/Saturation in Photoshop and you will find that the blue colors tend to lose saturation as you darken the luminosity. You will also notice that instead of using the traditional additive and subtractive primary colors of red, green, blue, plus cyan, magenta and yellow, the color slider controls in the HSL panel are based on colors that are of more actual relevance when editing photographic images. For example, the Oranges slider is useful for adjusting skin tones and Aquas allows you to target the color of the sea, but without affecting the color of the sky.

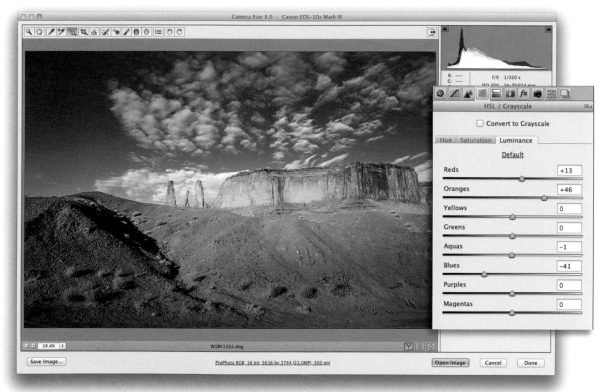

Figure 2.46 In this example, the Luminance sliders in the HSL/Grayscale panel were used to darken the sky and also to lighten the rocks.

Recovering out-of-gamut colors

Figure 2.47 highlights the problem of how the camera you are shooting with is almost certainly capable of capturing a greater range of colors than can be displayed on the monitor or seen in print. Just because you can't see them doesn't mean they're not there! Although a typical monitor can't give a true indication of how colors will print, it is all you have to rely on when assessing the colors in a photo. The HSL Luminance and Saturation sliders can therefore be used to reveal hidden color detail (see Figure 2.48).

Figure 2.47 This diagram shows a plot of the color gamut of an LCD monitor (the solid shape in the center) compared to the actual color gamut of a digital camera (the wireframe that surrounds it). Assuming you are using a wide gamut RGB space such as Adobe RGB, or ProPhoto RGB, the colors you are able to edit will certainly extend beyond what can be seen on the display.

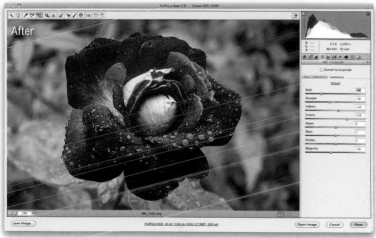

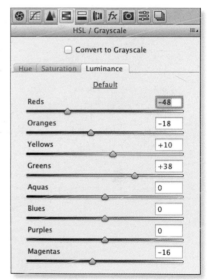

Tech note

The previews shown here are not simple screen grabs, but were mocked up using fully processed ProPhoto RGB images. You can judge the effectiveness of this adjustment by how well the lower one reproduces in print.

Figure 2.48 In the 'Before' screen shot view the pink rose appeared flat. In the 'After' example I applied a negative luminance adjustment to darken the red, orange and magenta colors to produce the improved 'After' version.

Grayscale conversions

To find out about how to apply grayscale conversions in Camera Raw, please refer to page 408 in the Black and White chapter.

Emulating Hue/Saturation behavior

In Photoshop's Hue/Saturation dialog, there is a Hue slider that can be used to apply global hue shifts. This can be useful if you are interested in shifting all of the hue values in one go. With Camera Raw you can create preset HSL settings where all the Hue sliders are shifted equally in each direction. Using such presets you can quickly shift all the hues in positive or negative steps, without having to drag each slider in turn.

Adjusting the hue and saturation

The Hue sliders in the HSL/Grayscale panel can be used to fine-tune the hue color bias using each of the eight color sliders. In the Figure 2.49 example, I adjusted the Reds hue slider to make the reds look less magenta and more orange. Photographs shot using a basic digital camera can often benefit from hue tweaks such as this to make the skin tones appear more natural.

The Saturation sliders allow you to decrease or increase the saturation of specific colors. In the Figure 2.50 example you can see how I used these to knock back specific colors so that everything in the photograph ended up looking monochrome, except for the grass and red wheel. Of course, I could have used the adjustment brush to do this, but adjusting the Saturation sliders offers a quick method for selectively editing the colors in this way. As with the Tone Curve, you can also use the target adjustment tool to pinpoint the colors and tones you wish to target and adjust.

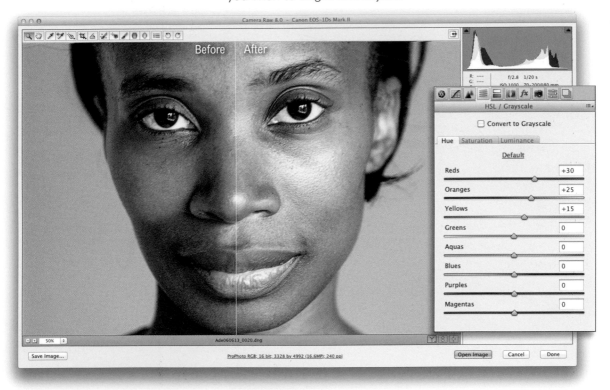

Figure 2.49 Here, I used a combination of positive Reds, Oranges and Yellows Hue adjustments to make the skin tones look less reddish.

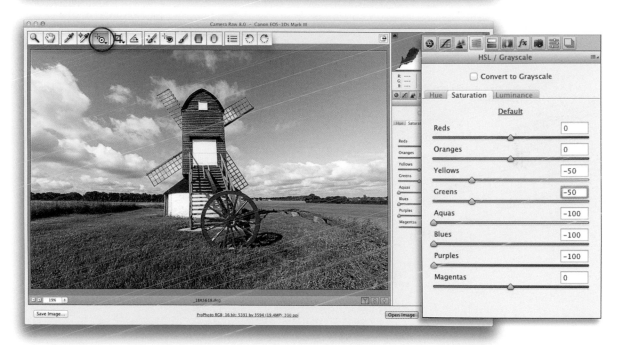

Figure 2.50 In this example, I have shown the before version (top) and a modified version (below), where I used the HSL/Grayscale panel Saturation sliders to selectively desaturate some of the colors in this scene. This can be done manually, or by using the target adjustment tool (circled) to target specific colors and drag downwards to desaturate.

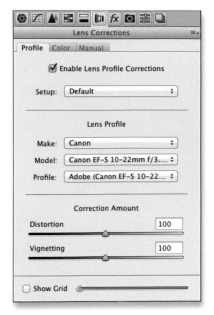

Figure 2.51 This shows the Lens Corrections panel Profile tab controls.

Lens Corrections panel

The Lens Corrections panel controls (Figure 2.51) can be used to help correct some of the optical problems that are associated with digital capture.

The Lens Corrections panel defaults to showing you the Profile tab mode shown in Figure 2.51, which allows you to check 'Enable lens Profile Corrections' for instant auto lens correction adjustments. This can be done for any image, providing there is a matching lens profile in the lens profile database installed with Photoshop and Camera Raw. If the lens you are using is not included in the camera lens profile database, you will need to use a custom lens profile. I'll come on to this shortly, but if we assume there are lens profiles available for the lenses you are shooting with, it should be a simple matter of clicking the 'Enable Lens Profile Corrections' box to apply auto lens corrections to any selected photo. When you do this you should see the 'Make' of the lens manufacturer, the specific lens 'Model' and lens 'Profile' (which will most likely be the installed 'Adobe' profile) appear in the boxes below. If these don't show up, then you may need to first select the lens manufacturer brand from the 'Make' menu, then the specific lens 'Model' and lastly, the desired lens profile from the 'Profile' menu. It is important to appreciate here that some camera systems capture a full-frame image, while compact SLR range cameras have smaller-sized sensors which make use of a smaller area of the lens's total coverage area. The Adobe lens profiles have mostly been built using cameras that have full-frame sensors. Therefore, from a single lens profile it is possible to calculate the appropriate lens correction adjustments to make for all other types of cameras in that manufacturer's range where the sensor size is smaller than a full-frame. Also note that when processing raw images, Camera Raw will prefer to use lens profiles that have also been generated from raw capture files. This is because the vignette estimation and removal has to be measured directly from the raw linear sensor data rather than from a gamma-corrected JPEG or TIFF image.

An auto lens correction consists of two main components: a 'Distortion' correction to correct for barrel or pincushion geometric distortion and a 'Vignetting' correction. The Amount sliders you see here allow you to fine-tune an auto lens correction. So, for example, if you wanted to have a lens profile correction correct for the lens vignetting, but not correct for,

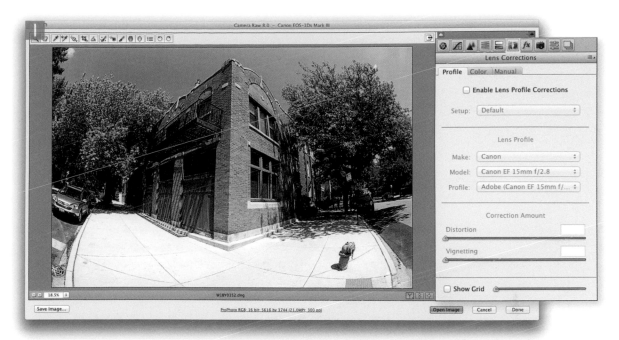

1 In this initial step you can see an example of a photograph that was shot using a 15 mm fisheye lens, where there is a noticeable curvature in the image.

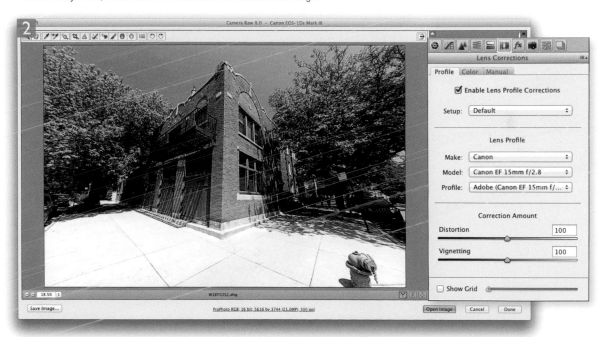

2 In the Lens Corrections panel I simply checked the Enable Lens Profile Corrections box to apply an auto lens correction to the photograph. In this instance I left the two Correction Amount sliders at their default 100% settings.

Figure 2.52 If the lens used is one that
applies a profile correction automatically,
you will see an alert message like the one
shown here. Some compact cameras rely on
software to correct for geometric distortion
and chromatic aberration. In fact, it has
always been conditional that Adobe read
and apply these behind the scenes when
reading the raw data. If you could see the
raw image without the correction you would
see quite a difference. But because these
are applied automatically there is no need
to apply a profile correction, hence the
message.

say, a fisheye lens distortion, you could drag the Distortion
slider all the way to the left. On the other hand, if you believe
an auto lens correction to be too strong or not strong enough,
you can compensate the correction amount by dragging either
of these sliders left or right.

The default option in the Setup menu will say 'Default'.
This instructs Camera Raw to automatically work out what
is the correct lens profile to use based on the available EXIF
metadata contained in the image file, or use whatever might
have been assigned as a 'default' Lens Corrections to use
with a particular lens (see below). The 'Custom' option will
only appear if you choose to override the auto-selected default
setting, or you have to manually apply the appropriate lens
profile. As you apply automatic lens profile corrections to
specific images you will also have the option to customize the
Lens Corrections settings and use the Setup menu to select
the 'Save new Defaults…' option. This allows you to set new
Lens Correction settings as the default to use when an image
with identical camera EXIF lens data settings is selected. After
you do this the Setup menu will in future show 'Default' as the
selected option in the Setup menu.

Accessing and creating custom lens profiles

If you don't see any lens profiles listed for a particular lens,
you have two choices. You can either make one yourself using
the Adobe Lens Profile Creator program, or locate a custom
profile that someone else has made. The Adobe Lens Profile
Creator program is available free via the Adobe website, or
you can use this direct link: tinyurl.com/kg538r7. The download
includes full documentation that explains how you should
go about photographing one of the supplied Adobe Lens
Calibration charts and generate custom lens profiles. It really
isn't too difficult to do yourself once you have mastered the
basic principles. If you are familiar with the Lens Correction
filter in Photoshop (see page 646) you will know how easy it is
to access shared custom lens profiles that have been created
by other Photoshop customers (using the Adobe Lens Profile
Creator program). Unfortunately, the Lens Corrections panel in
Camera Raw doesn't provide a shared user lens profile option,
so whether you are creating lens profiles for yourself or wishing
to install supplied lens profiles, you will need to reference the
directory path lists shown in the 'Where lens profiles are kept'
sidebar. Once you have added a new lens profile to the Lens
Profiles folder, you will need to quit Photoshop and restart

before any newly added lens profiles appear listed in the Automatic Lens Corrections panel profile list.

Note that images missing their EXIF metadata cannot be processed directly using the lens profile corrections feature. However, if you save a lens profile correction setting as a Camera Raw preset, it is kind of possible to apply such adjustments to any images that are missing the EXIF metadata by applying this preset via Camera Raw.

Some cameras that have built-in lenses, apply lens profile corrections automatically behind the scenes and Adobe are obliged to respect these. Camera Raw reads the camera manufacturer's own embedded lens correction metadata and applies a lens profile correction by default (an example of this is the Sony RX-100). In these instances, checking the Enable Lens Profile Corrections box will make no difference and a message at the bottom explains why (see Figure 2.52).

Lens Corrections: Color tab

The Lens Corrections panel contains a Color tab, which is specifically for making color lens corrections to do with chromatic aberration and color fringing (Figure 2.53).

Chromatic aberration

If you inspect an image closely towards the edge of the frame area, you may notice some color fringing where the different color wavelengths are not all focused at the same point. The effect is particularly noticeable in digital images because the camera sensor records three discrete color channels of information. This is known as latitudinal chromatic aberration. It will be most apparent around areas of high contrast and is particularly noticeable when shooting with wide angle lenses at a wide aperture. It's mainly a problem that's associated with cheaper lens optics, but can still sometimes be seen even with the best lenses. To correct for latitudinal chromatic aberration check the 'Remove Chromatic Aberration' box. When using Process 2012, the chromatic aberration data contained in a lens profile is ignored and Camera Raw carries out an auto correction based on an analysis of the image. As you can see in the Figure 2.54 example, this approach to removing chromatic aberration can work really well. One of the added advantages of this is that one can process images where a non-centrally-aligned lens has been used. For example, a photograph that's been shot using a tilt/shift lens where the central axis has been tilted can now be corrected more effectively.

Figure 2.53 The Lens Corrections dialog showing the Color tab controls.

Chromatic Aberration

Lens profiles will describe three aspects of a lens correction: Distortion, Vignetting and Chromatic Aberration. The lens Corrections panel has Distortion and Vignetting sliders in the profile tab section, while the chromatic aberration distortion data is actually now ignored and handled separately by checking the 'Remove Chromatic Aberration' option in the Color tab section. This carries out an 'analysis' method of correction, rather than using the data in the profile. Essentially, this correction kind of scales the size of the individual color channels that make up the composite color image so that any apparent 'color misregistration' towards the edges of the frame is corrected.

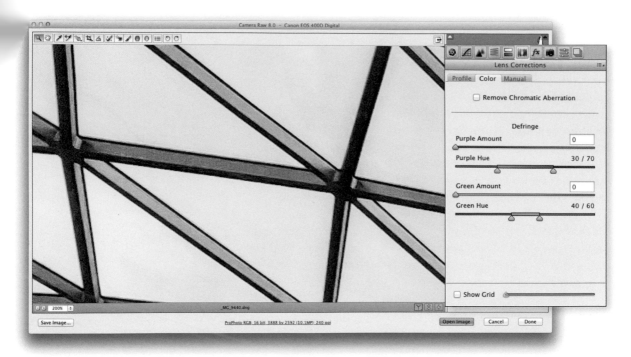

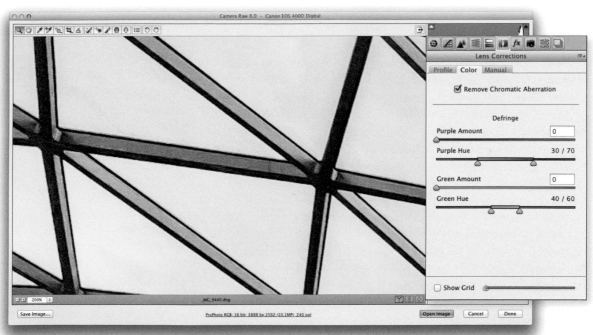

Figure 2.54 The top screen shot shows a 200% close-up view of an image where you can see strong color fringing around the high contrast edges. In the lower version I enabled the 'Remove Chromatic Aberration' option to remove the color fringes.

Defringe sliders

The Defringe controls are designed to fix axial (longitudinal) chromatic aberrations. These can also be caused by ghosting, lens flare, or charge leakage (which can affect some CCD sensors).

Unlike lateral chromatic aberration, which occurs towards the edges of the frame, these types of aberrations can appear anywhere in an image. It is something that can particularly affect fast, wide aperture lenses and is typically most noticeable when shooting at the widest lens apertures, where fringes will usually be at their most visible just in front of and just behind the plane of focus. These will typically appear purple/magenta when they're in front of the plane of focus, and green when they're behind the plane of focus. But even at the exact point of focus you may sometimes see purple fringes (especially along high contrast or backlit edges), which can be caused by flare. As you stop down a lens these types of aberrations usually become less noticeable.

The Defringe section consists of four sliders. There are now Purple Amount and Green Amount sliders for controlling the degree of correction and below each of these are Purple Hue and Green Hue sliders, which have split slider controls.

So, if we look at the two Purple sliders, the Purple Amount slider has a range of 0–20 and is used to determine the strength of the purple fringing removal. The Purple Hue slider can then be used to fine-tune the range of purple colors that are to be affected. What you need to be aware of here is that a higher Purple Amount setting will apply a stronger correction, but the downside is that at higher settings this may cause purple colors in the image that are not the result of fringing to also become affected by the Purple Amount adjustment. So, to moderate this undesired effect you can tweak the Purple Hue slider split points to narrow or realign the purple range of colors to be targeted. You can drag on either of the knobs one at a time, or you can click and drag on the central bar to align the Hue selection to a different purple portion of the color spectrum. If you need to reset these sliders then just double-click on each individual knob. Likewise, double-click the central bar to reset this to its default position. The minimum distance that may be set between the two sliders is 10 units.

The Green Amount and Green Hue sliders work in exactly the same fashion as the Purple sliders, except these two sliders allow you to control the green fringes. However, the

Reading old defringe settings

The Defringe controls found in Camera Raw 7.1 or later provide a new and more effective way to deal with all kinds of fringing artifacts. You will notice in the Manual tab section that the old Defringe menu has now been removed. It was probably not used that much anyway and rarely proved to be that effective. The new controls in the Color tab are a better substitute. Consequently, where an image has had a Highlight Edges or All Edges adjustment applied previously in Camera Raw, Camera Raw 7.1 or later will apply a Purple Amount value of 1, leaving all the other sliders at their default settings.

Figure 2.55 This shows the Lens Corrections panel where the ⌘ (Mac), *ctrl* (PC) key was held down. Here, you can see a white bar on the Purple Hue color ramp indicating where on the color ramp the sampled color lies.

default range for the Green Hue slider is set at 40 to 60 instead of 30 to 70. This is to help protect common green and yellow colors such as foliage colors.

The Defringe controls in use

The recommended approach is to carry out all your major tone and color edits first. Then make sure that you have turned on the profile-based lens corrections to correct for geometric distortion and vignetting. Once these steps have been taken, go to the Color tab of the Lens Corrections panel and check the 'Remove Chromatic Aberration' check box. You can then start using the global Defringe sliders to remove any remaining signs of fringing. Also, be aware that where the global controls are having an adverse effect on the rest of the image, you can always turn down the Purple/Green Amount sliders and use a localized adjustment with the Defringe slider set to a positive value to apply a stronger, localized adjustment. As with the Detail panel controls, the Lens Correction defringe controls are best used when viewing an image at 100% or higher.

You can also use the *alt* key as a visualization aid. These can greatly help the user see an emphasized overlay that gives a clearer indication of what effect the sliders are having and making the most suitable slider adjustments.

Use the *alt* key to drag on the Purple Amount slider to visualize purple fringe removal. This will cause the preview to reveal only the affected areas of the image. All other areas will be shown as white. This lets you concentrate on the affected areas and help verify that the purple fringe color is being removed.

Use the *alt* key to drag on either of the Purple Hue slider knobs to visualize the range of hues that are to be defringed. As you do this, the preview will show the affected hue range as being blacked out. As you drag on a slider you need to pay close attention to the borders of the blacked out area to check if there are any residual purple colors showing still. Obviously, the same principles apply when adjusting the Green Amount and Green Hue sliders with the *alt* key held down.

Eyedropper tool mode

When working with the Defringe sliders you can hold down the ⌘ (Mac), *ctrl* (PC) key as you roll the cursor over the preview window to reveal an eyedropper tool. This tool can be used to help set the Purple/Green Hue slider knobs. If the Caps Lock key is enabled, the eyedropper cursor will be shown as a cross hair. This can help you to pick the fringe pixels more accurately.

To use this tool it helps to be zoomed in extra close, such as at 200%, or even 400% . This will make the color picking more accurate and you will notice a little white bar appear on one or other color ramp as you hover the cursor over different parts of the image (see Figure 2.55). As you click in the preview this allows Camera Raw to analyze the pixels in the local area around where you click, which can result in one of four outcomes. Camera Raw detects that you clicked on a purple fringe and adjusts the Purple Amount and Purple Hue sliders to suit. Alternatively, Camera Raw detects that you clicked on a green fringe and will adjust the Green Amount and Green Hue sliders. Or, Camera Raw determines that the area you clicked on was too neutral, or was a color that falls outside the supported color range. In which case you will see one of the alert dialogs shown in Figure 2.56.

Figure 2.56 This shows the two possible error messages you might see when working with the eyedropper tool. The top one shows an alert pointing out that the sampled color is too neutral. The bottom alert dialog indicates that the sampled color falls outside the supported color range.

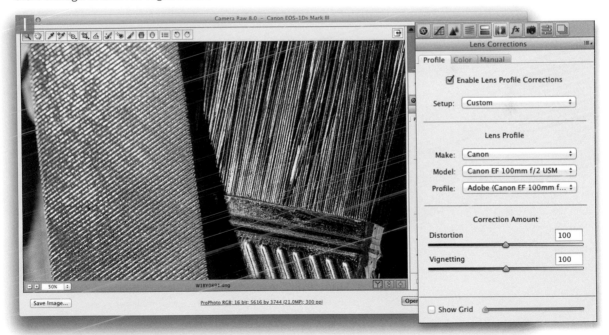

1 The first step is to apply all the main color and tone adjustments and to enable the lens profile corrections in the Lens Corrections Profile tab section.

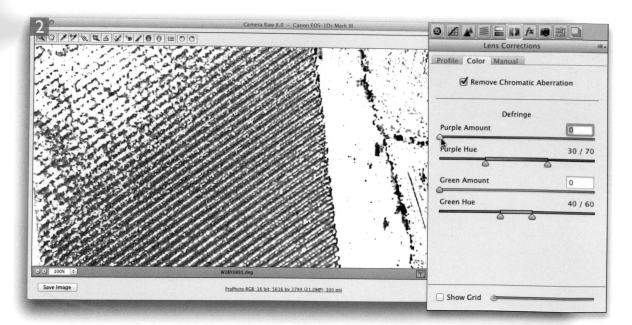

2 Here, I clicked on the Color tab to view the color controls. It is usually best to simply check the Remove Chromatic Aberration option to auto correct the image. I then held down the *alt* key and moused down on the Purple Amount slide to get a visualization of the extent of the purple fringed area, with everything else displayed white.

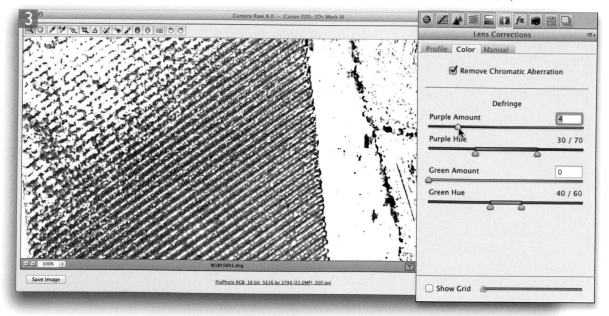

3 With the *alt* key held down still I dragged the Purple Amount slider till all of the purple fringing seemed to have been removed. Note that it may often help to use a close-up view beyond 100% when judging the effectiveness of such an adjustment.

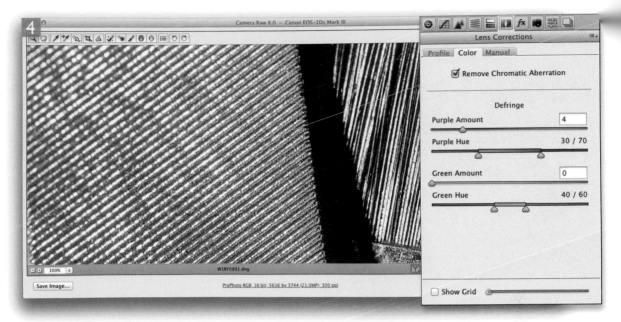

4 Next, I wanted to concentrate on the Green fringing. Here, you can see the extent of the green fringes in the areas that were behind the plane of focus.

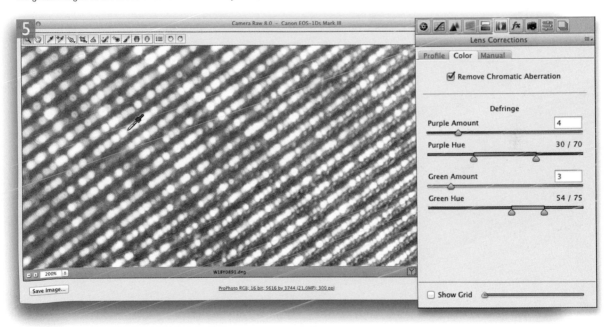

5 In this instance I used the eyedropper mode to determine both the Green Amount and Green Hue slider settings. I held down the ⌘ (Mac), *ctrl* (PC) key to change the cursor to an eyedropper and clicked on the green fringe area. This single step auto-set the Green Amount and Green Hue sliders.

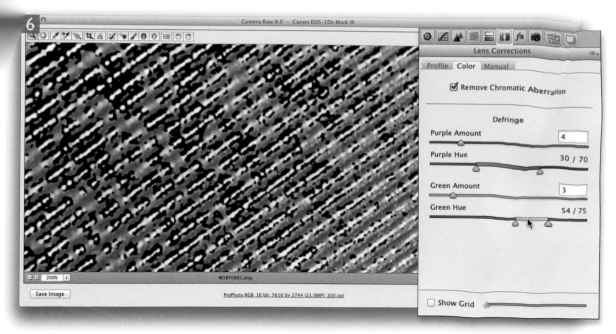

6 I held down the `alt` key and moused down on the Green Hue ramp to obtain a visualization of the green hues and the extent they were being adjusted. However, there was no need to tweak the hue ramp sliders—the auto correction worked fine as it was.

Localized adjustments: Defringe slider

The global Defringe controls should be all that you need to remove troublesome fringing. However, there may be times where it won't be possible to remove all visible fringing using the global Defringe sliders on their own. Or, it may be the case that when applying a strong global correction the adjustment you apply has an adverse effect on other areas. In situations like this it may be useful to apply a global adjustment combined with a localized defringe correction using either the adjustment brush, graduated filter or radial filter. Note that localized Defringe adjustments will remove fringes for all colors (not just purple and green) and therefore works independently from the global Purple Hue and Green Hue settings set in the lens Corrections panel.

The global lens corrections are available for all process versions, but in order to apply a localized adjustment the image you are processing must be updated to the latest Process 2012. The standard range goes from −100 to +100. A positive Defringe adjustment can be used to apply extra defringing where required, such as when working on specific problem areas in a picture. It may even be the case that with

some images a localized defringe adjustment is all that you need to apply. A negative, −100 defringe adjustment will of course completely remove any global defringing and can be used where you don't want to apply a defringe and wish to protect this area. One example of how you might want to use this would be to imagine a picture where, say, a strong purple defringe had been applied globally, which resulted in the edges of purple areas becoming desaturated. In a situation like this you could paint over the affected areas with the Defringe slider set to −100. This would allow you to restore some of the original color to these areas.

It should be noted that the localized defringe control is not as powerful as the global defringe controls. This is why it is often best to use the global Lens Corrections panel controls first and then use a localized adjustment to fine-tune as necessary. Also, be aware that there is no benefit to be gained in applying multiple localized defringe adjustments to improve upon what a single application can achieve.

Defringe and Process Versions

The Defringe slider is only available as a localized adjustment when an image has been updated to Process 2012. You do need to watch out though that once an image has been updated to Process 2012 and a defringe adjustment has been made you don't attempt to convert the image back to Process 2010 or Process 2003. If you do so this will cause the defringe effect to be zeroed. The pin you added will still be present, but there will be no defringe adjustment. If you then convert the image back to Process 2012 the adjustment mask will be preserved and you can restore the defringe effect by adjusting the Defringe slider setting.

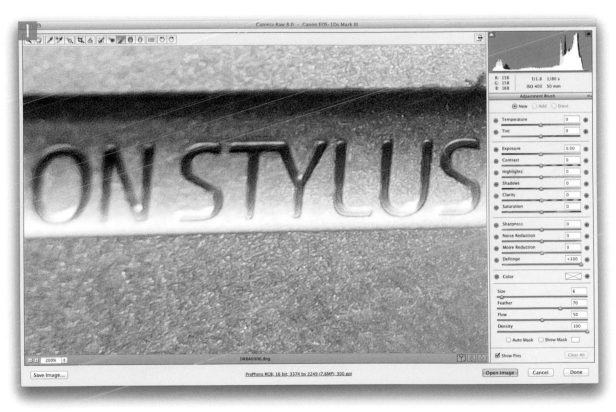

1 This shows a close-up view of an image with noticeable fringes.

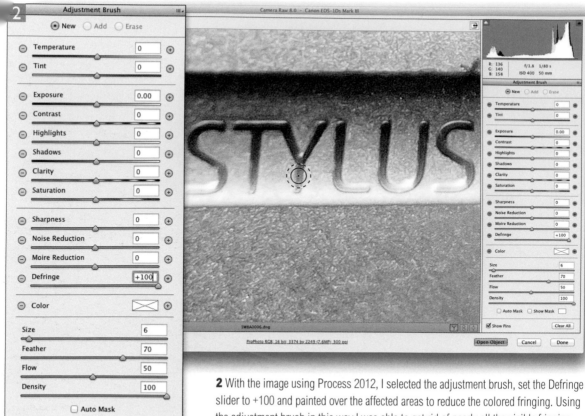

2 With the image using Process 2012, I selected the adjustment brush, set the Defringe slider to +100 and painted over the affected areas to reduce the colored fringing. Using the adjustment brush in this way I was able to get rid of nearly all the visible fringing and target the Defringe adjustment precisely, where it was needed most.

Lens Corrections: Manual tab

In the Manual tab section (Figure 2.57) you can apply automated Upright corrections, manual Transform and Lens Vignetting adjustments.

Upright corrections

Upright corrections are auto-calculated in Camera Raw based on an analysis of the image. By selecting one of the four options described here you can apply an instant auto transform correction in place of using the Vertical, Horizontal or Rotate sliders found in the Transform section below. The best way to use this tool is to check the 'Enable Lens Profile Corrections' option in the Profile tab section first before you apply an Upright adjustment and make sure you don't have a rotate crop applied or manual transform adjustments already applied to the image. The impact of a geometric correction is not always as major, but this should help you achieve the best results since

letting Upright work with a geometrically corrected image can make the line detection work better.

The Auto setting applies a balanced correction to the image, which rather than auto-selecting an Upright setting, uses a balanced combination of the options listed below. Essentially, it aims to level the image and, at the same time, fixes converging vertical and horizontal lines in an image. The ultimate goal here is to apply a suitable transform adjustment that avoids applying too strong a perspective correction. When selecting an Auto setting it mostly crops the image to hide the outside areas. However, if the Auto adjustment ends up being quite strong some outside areas may become visible as transparent pixels. It is worth pointing out here that Camera Raw now includes transparency support. This means such outer areas are displayed using the same default checkerboard pattern as in Photoshop and preserved as such whenever you export from Camera Raw using the PSD and TIFF formats (Camera Raw is also able to read transparency in DNG and TIFF files). If, on the other hand, you export as a JPEG, the transparent areas will be rendered solid white.

A Level adjustment applies a levelling adjustment only— this behaves like an auto straighten tool. The Vertical setting applies a level plus converging vertical lines adjustment. Lastly, there is a Full setting which applies a full level plus converging vertical and horizontal lines adjustment, and will allow strong perspective corrections to occur.

It may be that an Upright correction can end up looking too perfect. With architectural shots it is generally a good idea to allow the verticals to converge just a little. You might therefore want to combine an Upright correction with a manual transform, such as a positive Vertical adjustment. You might even consider saving an Upright auto correction plus a Vertical adjustment as a preset. And, if you find an Upright setting that you like, but an important part of the image ends up being cropped, you can also adjust the Scale slider to reduce the scale.

The Off setting can be used to turn off an Upright correction, while preserving the initial, pre-computed analysis of the image. You can also use **ctrl Tab** to cycle through the correction options and **ctrl Shift Tab** to reverse cycle. If you click on 'Reanalyze' this switches off the adjustment and clears the memory, so to speak. The Reanalyze option is there in case you wish to enable or disable a Lens Profile correction, which would otherwise affect the way an Upright pre-calculation is made. Or, if you forgot you needed to undo a rotated crop, you would want to click

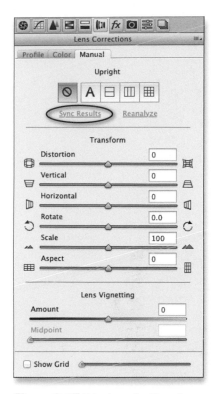

Figure 2.57 This shows the Manual Lens Corrections controls. Note that if a crop is currently applied to the image, you'll see a message informing you that an Upright correction will reset any crop that's active. If the image you intend to process cannot be corrected after clicking one of the Upright buttons, you'll see here a warning message saying 'No upright correction found'.

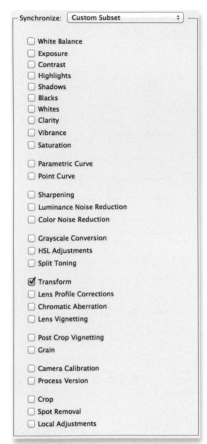

Figure 2.58 This shows the Synchronize Settings menu options for synchronizing Camera Raw settings. When the Transform option is selected this allows auto synchronization of Upright settings. One thing to note here is that whenever an Upright adjustment is enabled on the primary, most-selected photo, synchronizing the Transform setting will also force synchronize the crop as well.

on Reanalyze and then try running through the Upright options again (use *alt*-click to reset the Reanalyze button). As you click on any of the Upright options (except for Off) this automatically resets the Horizontal, Vertical, Rotate, Scale and Aspect Transform sliders, as well as resetting any crop that's active.

It is important to understand here that the underlying math behind Upright adjustments is doing more than just auto-set the Vertical, Horizontal and Rotate sliders in the Transform section. Behind the scenes there are angle of view and center of projection adjustments taking place and the vertical and horizontal adjustments involved in the Upright process are actually rather sophisticated. It's all to do with how the interaction of one rotation movement can affect another. Think what it's like when you adjust the tilt and yaw on a camera tripod head and you may get some idea of the problem.

Upright adjustments may also cause the image to appear stretched vertically or horizontally. An Aspect slider is therefore provided so you can compensate for such distortions and thereby keep the adjusted image looking more natural. At the bottom of the panel is a Show Grid option (use *V* to toggle), which can help you evaluate the effectiveness of an Upright correction. Next to this is a slider that allows you to adjust the fineness/coarseness of the grid scale. You can also use the *[]* keys to adjust the grid size and use *Shift [* (Mac), *Shift]* (PC) for bigger steps. Note that the Grid on/off setting and grid slider settings always remain sticky.

Synchronizing Upright settings

There are two ways to synchronize Upright adjustments. If you apply an Upright adjustment and use the Synchronize Settings menu to sync the settings and the Transform option is checked (Figure 2.58), this will apply an auto type of synchronization, similar to that which occurs when synchronizing an auto white balance setting. So, if you synchronize the settings in this way, each image will be synchronized in terms of having an Upright adjustment applied to it. But the way that adjustment is applied is auto-determined for each image.

If, on the other hand, you wish to synchronize the exact transform settings you will need to open a selection of images via Camera Raw in Filmstrip mode, apply the desired Upright transform to the first image and then click on 'Sync Results' (circled in Figure 2.57). For example, if you wanted to prepare a group of bracketed exposure images to create an HDR master you would want to use 'Sync Results' rather than 'Synchronize Settings'.

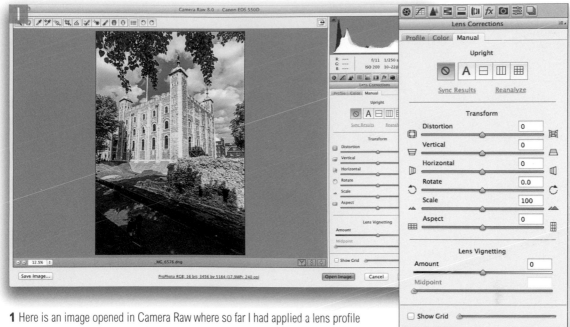

1 Here is an image opened in Camera Raw where so far I had applied a lens profile correction via the Profile tab section of the Lens Corrections panel. No Upright correction had been applied to this image yet.

 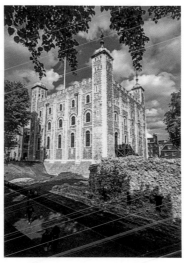

Figure 2.59 This shows the 'Constrain to Image' item in the Crop menu.

2 On the left you can see the outcome of a 'Full' Upright adjustment where Camera Raw carried out a full perspective plus levelling correction regardless of how strong the perspective adjustment would be. As you can see, this produced a very strong correction with outside areas visible (the transparent boundary). On the right is a Vertical adjustment, which aimed to level the horizon and correct the converging verticals. Where you do end up with transparency in an image you can select the 'Constrain to image' option from the crop tool menu (see Figure 2.59).

3 Here on the left is an Auto adjustment in which Camera Raw applied an adjustment that combined a level, horizontal and vertical adjustment in a more balanced way and On the right is a 'Level' adjustment, which aimed to straighten the horizon only. Of the five different outcomes the Vertical option from step 2 was the most natural-looking.

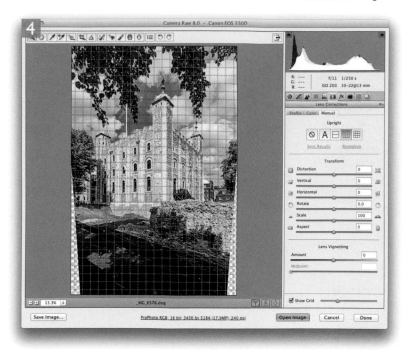

4 I checked the Show Grid box at the bottom of the Lens Corrections panel to enable the grid overlay. I could also adjust the slider to fine-tune the grid overlay scale.

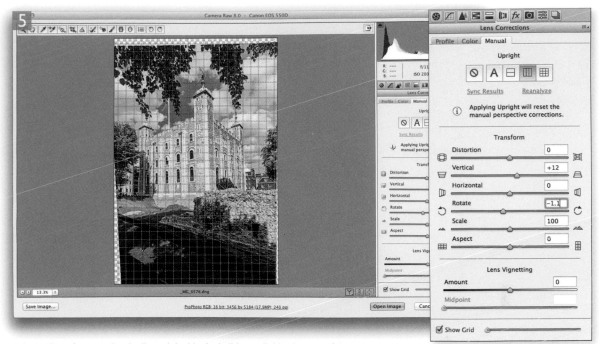

5 In the Transform section I adjusted the Vertical slider to dial back some of the keystone effect and also manually rotated the transform slightly.

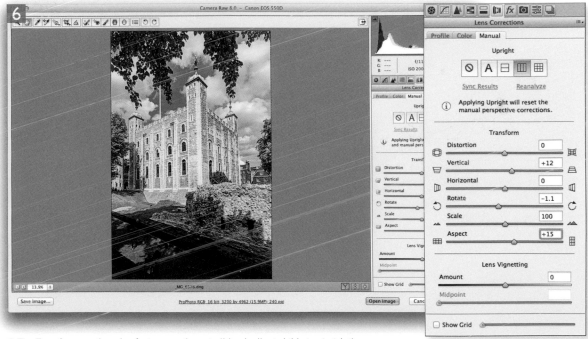

6 The Transform section also features an Aspect slider. I adjusted this to stretch the image more vertically. The end result is shown here with the image cropped.

Transform controls

The Transform controls can be used to fine-tune an Upright correction, or used in place of applying a manual transform adjustment. As I explained earlier, the way the Upright feature calculates its corrections cannot be replicated using the Transform sliders alone. However, there may be times when Upright can't make an appreciable improvement to the perspective and you will be better off using the manual Transform sliders. Sometimes you may find it helps to combine the two.

The Distortion slider can be used to apply a geometric distortion adjustment, which is independent of a distortion correction applied using a lens profile correction. The Vertical slider can be used to make keystone corrections and the Horizontal slider can similarly be used to correct for horizontal shifts in perspective, such as when a photo has been captured from a viewpoint that is not completely 'front on' to the camera. Note that you can click the Show Grid box (**V**) to toggle showing/hiding a grid overlay. The Rotate slider allows you to adjust the rotation of the transform adjustment. This is not exactly the same as rotating the image. So, while it is possible to use the Rotate slider to straighten a photo, I suggest that you should primarily use the straighten tool to make this type of correction first. The Scale slider allows you to adjust the image scale and, as I explained earlier, the Aspect slider can be used to adjust the aspect ratio of an image. As you adjust any of the above sliders you may end up with transparent areas around the edges of a transformed image. You have the option of using the 'Constrain to image' option from the crop tool menu (see Figure 2.59), or you can use Photoshop to fill these in for you (see page 542).

Lens Vignetting controls

If you wish to correct for the lens vignetting inherent in an image, it is always best to enable a lens profile correction and fine-tune the correction using the Vignetting slider. This assumes a lens profile is available though. Where there is none, or you are processing a scanned image, you can use the Manual tab Lens Vignetting controls. The Amount slider can be used to compensate for the corner edge darkening relative to the center of the photograph and the Midpoint slider can be used to offset the rate of fall-off. As you increase the Midpoint value, the exposure compensation will be accentuated more towards the outer edges.

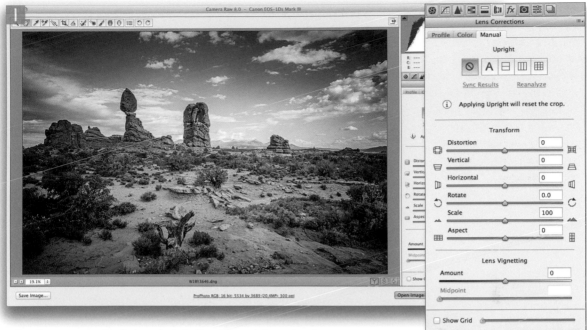

1 Here is an example of a photograph shot with a wide angle lens, where lens vignetting can be seen in the corners of the frame.

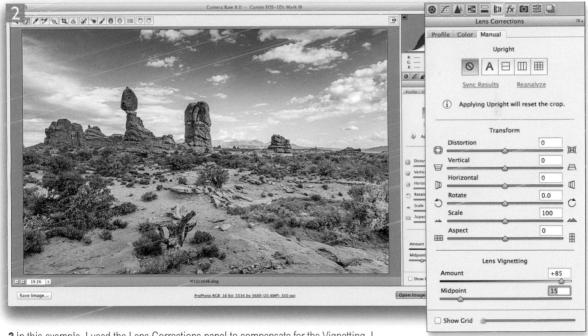

2 In this example, I used the Lens Corrections panel to compensate for the Vignetting. I set the Amount slider to +85 and adjusted the Midpoint to fine-tune the correction. The aim here was to obtain an even exposure at the corners of the photograph.

Combined effects

Now that we have Post Crop Vignetting controls as well as the standard Lens correction vignette sliders, you can achieve even more varied results by combining different combinations of slider settings, whether a photo is cropped or not.

Effects panel

Post Crop Vignetting control

A lot of photographers have got into using the Lens Vignetting controls as a creative tool for darkening or lightening the corners of their pictures. The only problem here is that the lens vignetting can only be applied to the whole of the image frame area. However, the Post Crop Vignetting sliders in the Effects panel can be used to apply a vignette relative to the cropped image area. This means you can use the Lens Vignetting controls for the purpose they were intended (to counter any fall-off that occurs towards the edges of the frame) and use the Post Crop Vignette sliders in the Effects panel as a creative tool for those times when you deliberately wish to lighten or darken the edges of a photo. The Post Crop Vignetting Amount and Midpoint sliders work identically to the Lens Corrections lens Vignetting controls, except you also have the option to adjust the Roundness and the Feathering of the vignette adjustment.

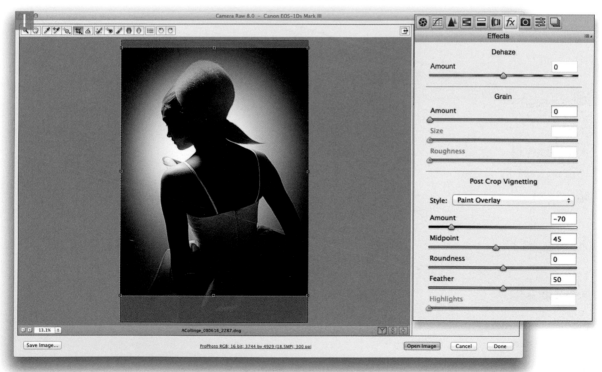

Client: Andrew Collinge Hair & Beauty.
Hair by Andrew Collinge artistic team,
Make-up: Liz Collinge.

1 In this first example I applied a –70, darkening vignette offset with a +45 Midpoint setting. This adjustment was not too different from a normal Lens Vignetting adjustment, except it was applied to the cropped area of an image.

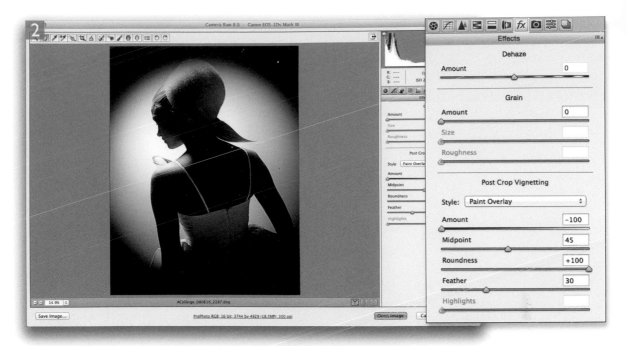

2 In this next version, I adjusted the Roundness slider to make the vignette shape less elliptical and adjusted the Feather slider to make the vignette edge harder.

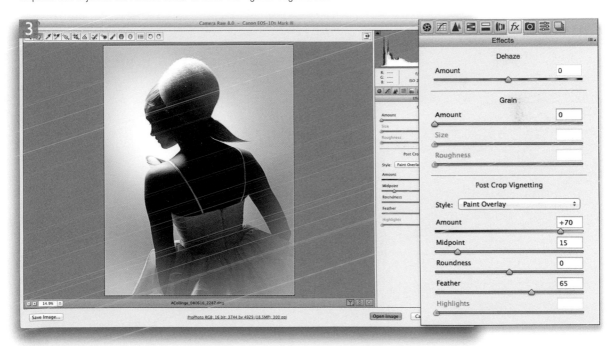

3 For this final version, I applied a +70 vignette Amount to lighten the corners of the cropped image, combined with a low Midpoint and a soft Feather setting.

Post Crop Vignette style options

So far I have just shown you the options for the Paint Overlay vignette style option. It wasn't named as such before, since this was the only Post Crop Vignette mode available in previous versions (Camera Raw 5 or earlier). When first introduced, some people were quick to point out that the Post Crop Vignetting wasn't exactly the same as a Lens Correction

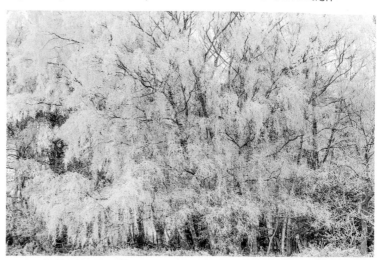

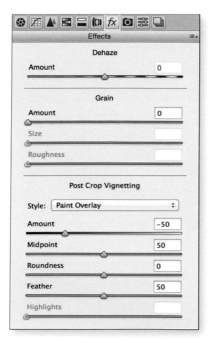

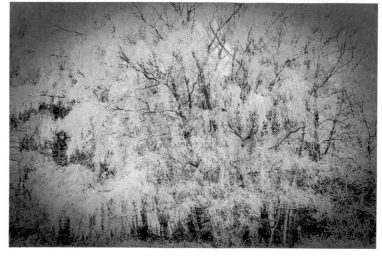

Figure 2.60 In this example I took a photograph of some frost-covered tree branches. Shown here is the before version (top) and one where I had applied a standard Paint Overlay style Post Crop Vignette using the settings shown here.

Vignette effect. You can see for yourself in the Figure 2.60 example how the Paint Overlay vignette applies a soft contrast, hazy kind of effect. This wasn't to everyone's taste (although I didn't always particularly mind it) and so Camera Raw 6 or later now offers you two alternative post crop editing modes which more closely match the normal Lens Correction edit mode, yet offer extra scope for adjustment. Where people were once inclined to use the Lens Correction sliders as a creative tool (because the Paint Overlay Post Crop effect was a bit wishy-washy), they should now think of using the Lens Correction panel for lens corrections only and use the Post Crop Vignetting sliders in the Effects panel to add different kinds of vignette effects. So let's now look at the post-crop options.

In the Paint Overlay mode example (Figure 2.61), the Post Crop effect blends either a black or white color into the edges of the frame depending on which direction you drag the Amount slider. The two new 'Priority' modes produce an effect that is now more similar to the Lens Correction effect since the darkening or lightening is created by varying the exposure at the edges. Of the two, the Color Priority (Figure 2.61) is usually gentler as this applies the Post Crop Vignette *after* the Basic panel Exposure adjustments, but *before* the Tone Curve stage. This minimizes color shifts in the darkened areas, but it can't perform any highlight recovery when you darken the edges.

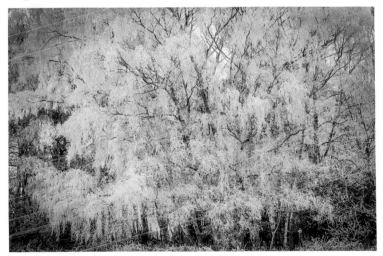

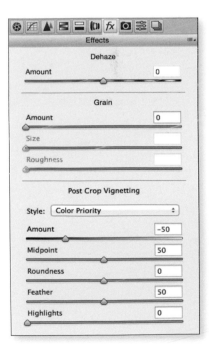

Figure 2.61 This shows an example of a darkening post-crop vignette adjustment in which the Color Priority style was used.

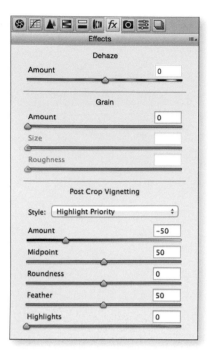

The Highlight Priority style (see Figure 2.62) tends to produce more dramatic results. This is because it applies the Post Crop Vignette *prior* to the Exposure adjustment. It has the benefit of allowing better highlight recovery, but this can lead to color shifts in the darkened areas.

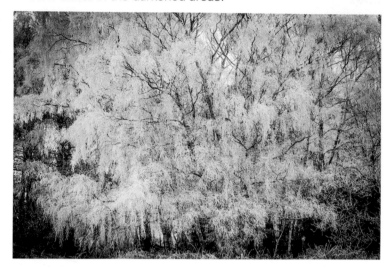

Figure 2.62 This shows an example of a darkening Post Crop Vignette adjustment in which the Highlight Priority style was used.

Highlights slider

You will notice there is also a 'Highlights' slider, which can be used to further modify the effect. In Paint Overlay mode, the Highlights slider is disabled, while in the Color Priority and Highlight Priority modes the Highlights slider is only active when applying a negative Amount setting. As soon as you increase the Amount to apply a lightening vignette, the Highlights slider will be disabled. As you can see in the Figure 2.63 and 2.64 examples, increasing the Highlights amount allows you to boost the highlight contrast in the vignetted areas, but the effect is only really noticeable in subjects that feature bright highlights. Here it had the effect of lightening the frost-covered branches in the corners of the image, taking them back more to their original exposure value. In these examples the difference is quite subtle, but I find that the Highlights slider usually has the greatest impact when editing a Color Priority Post Crop Vignette.

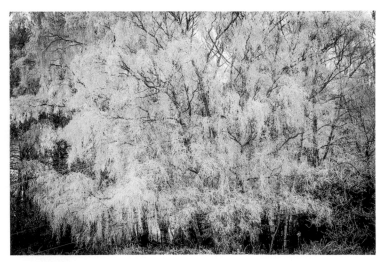

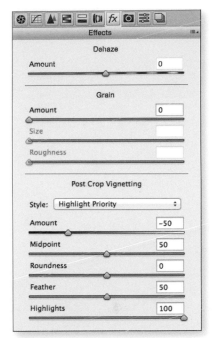

Figure 2.63 In this example I applied a Highlight Priority Post Crop Vignette style and added a 100% Highlights adjustment to the Highlight Priority vignette. In this instance, the Highlights slider adjustment made a fairly subtle change to the appearance of this Post Crop Vignette effect.

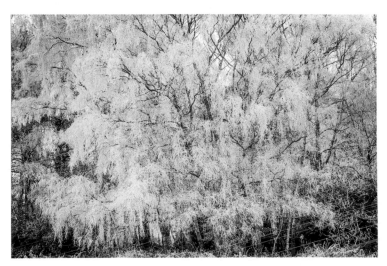

Figure 2.64 In this example I applied a Color Priority Post Crop Vignette style and added a 100% Highlights adjustment to the Color Priority vignette. If you compare this with the above example in Figure 2.63, you can see how a Highlights slider adjustment can have a more substantial effect on the Post Crop Vignette adjustment when used in the Color Priority mode.

Figure 2.65 The Effects panel showing the Grain sliders.

Figure 2.66 This shows the Effects panel with a Dehaze slider adjustment.

Adding Grain effects

The Effects panel also contains Grain controls (Figure 2.65). The Amount slider determines how much grain is added, while the Size slider controls the size of the grain particles. The default setting is 25 and dragging to the left or right allows you to decrease or increase the grain particle size. Note here that if the Size slider is set any higher than 25, then a small amount of blur is applied to the underlying image. This is done to help make the image blend better with the grain effect. The exact amount of blur is also linked to the Amount setting; the higher the Amount, the more blur you'll see applied. The Roughness slider controls the regularity of the grain. The Default value is 50. Dragging to the left will make the grain pattern more uniform, while dragging to the right can make the grain appear more irregular. Basically, the Size and Roughness sliders are intended to be used in conjunction with the Amount slider to determine the overall grain effect.

Dehaze slider

The Dehaze slider can be used to compensate for atmospheric haze in photographs, as well as mist, fog, or anything that contributes to the softening of detail contrast in a scene. In Figure 2.66 you can see the Effects panel with the Dehaze slider adjusted. You can use this slider by dragging to the right to apply a positive value to remove haze from a scene. Alternatively, you can drag the slider to the left to add haze to an image. The results you get are in some ways similar to adjustments made using the Clarity slider, but the effect is overall a lot stronger than what can be achieved using just Clarity on its own.

It is recommended that you set the white balance first prior to applying a Dehaze adjustment. I have also noticed how Dehaze slider adjustments to remove haze can also emphasise any edge vignetting in an image. You will therefore find it is best to make sure you apply a lens profile correction (or a manual vignetting correction) first to remove any lens vignetting before you apply a Dehaze slider adjustment.

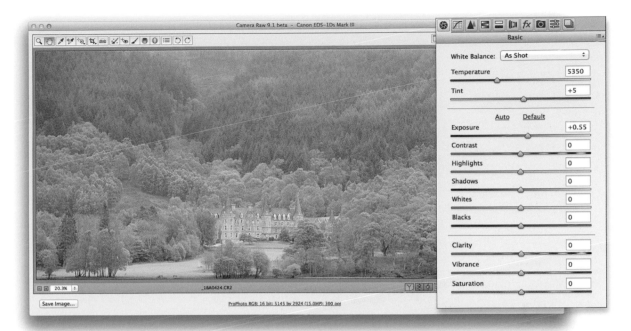

1 This shows a scene where the castle in the photograph was some distance away from the camera and the weather conditions were quite hazy. The only adjustment I applied here was to lighten the Exposure in the Basic panel settings.

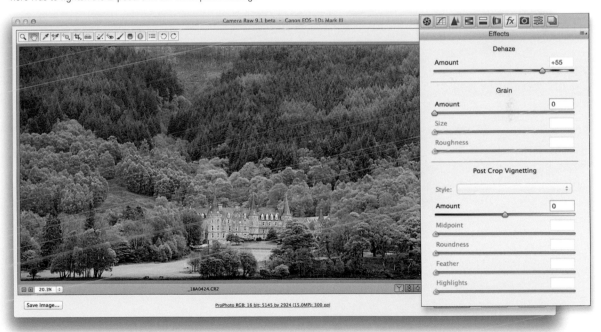

2 In this step, I went to the Effects panel and adjusted the Dehaze slider, setting it to +55, to cut through the haze to add more contrast and reveal more detail.

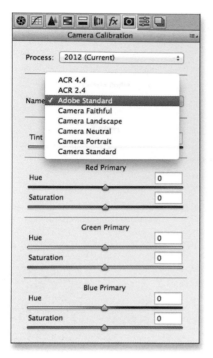

Figure 2.67 The Camera Calibration panel controls can be used to set the desired Process Version and fine-tune the Camera Raw color interpretation. The Camera Profile setting at the top can offer a choice of camera profile settings. These may include legacy settings such as ACR 4.3, etc. The default setting is 'Adobe Standard'.

ACR compatible cameras
The list of cameras that are compatible with the latest version of Camera Raw can be found at the Adobe website by following this link: adobe.com/products/photoshop/cameraraw.html.

Camera Calibration panel
The Camera Calibration panel (Figure 2.67) lets you choose which Process Version to use when rendering a raw file and also lets you select an appropriate camera profile, plus there are sliders for applying manual calibration adjustments. As I explained earlier, if you click on the warning triangle that appears in the bottom right corner of the preview section you can update an image from Process 2003 or 2010 to the latest Process 2012. You can therefore use the Camera Calibration panel to update the Process Version used or reverse this process and select an older Process Version should you need to.

Everyone wants or expects their camera to be capable of capturing perfect colors whether they really need to or not. What is perfect color though? Some photographers may look at a JPEG version of an image and judge everything according to that, while others, who shoot raw, may prefer the default look they get from a particular raw processing program. Apart from anything else, is the display you are using actually capable of showing all the colors your camera can capture?

Camera Raw is the product of much camera testing and raw file analysis, which has been carried out by the Camera Raw team. By selecting the 'Adobe Standard' camera profile in the Camera Calibration panel you can ensure you get the most accurate (or most suitable) color from your camera. Test cameras will have been used to build a two-part profile of each camera sensor's spectral response under standardized tungsten and daylight balanced lighting conditions. From this, Camera Raw is able to calculate a pretty good color interpretation under these specific lighting conditions, and also extrapolate beyond these across a full range of color temperatures. This method may not be as accurate as having a proper profile built for your camera, but realistically, profiling a camera is something that can only be done where the light source conditions are always going to be the same.

New Camera Raw profiles
You have to bear in mind that many of the initial default Camera Raw profiles were achieved through testing a limited number of cameras. It was later discovered that there could be a discernible variation in color response between individual cameras. As a result of this a wider pool of cameras were evaluated and the default profile settings were updated for certain makes of camera and in some cases newer versions of

the default camera profiles were provided. This is why you will sometimes see extra profiles listed that refer to earlier builds of Camera Raw, such as ACR 2.4 or ACR 3.6, etc. (see sidebar on 'New camera profile availability'). More recently, Eric Chan (who works on the Camera Raw engineering team) managed to improve many of the standard ACR profiles as well as extend the range of profiles that can be applied via Camera Raw. In Camera Raw 5 or later, the 'Adobe Standard' profile is now the default and this and the other profiles you see listed in the Profile menu options are the result of improved analysis as well as an effort to match some of the individual camera vendor 'look settings' associated with JPEG captured images.

Although 'Adobe Standard' is now the recommended default camera profile, it has been necessary to preserve the older profiles such as ACR 3.6 and ACR 4.4, since these need to be kept in order to satisfy customers who have, in the past, relied on these previous profile settings. After all, it wouldn't do to find that all your existing Camera Raw processed images suddenly looked different because the profile had been updated. Therefore, in order to maintain backward compatibility, Adobe give you the choice to decide which profile is best to use. If you are happy to trust the 'Adobe Standard' profile, then I suggest you leave this as the default starting point for all your raw conversions. The difference you'll see with this profile may only be slight, but I think you will find this still represents an improvement and should be left as the default.

Camera look settings profiles

The other profiles you may see listed are designed to let you match some of the camera vendor 'look settings'. The profile names will vary according to which camera files you are editing, so for Canon cameras Camera Raw offers the following camera profile options: Camera Faithful, Camera Landscape, Camera Neutral, Camera Portrait and a Camera Standard option. Nikon users may see Mode 1, Mode 2, Mode 3, Camera Landscape, Camera Neutral, Camera Portrait and Camera Vivid profile options. In Figure 2.69 you can see an example of how these can compare with the Adobe Standard profile.

The 'Camera Standard' profile is rather clever because Eric has managed here to match the default camera vendor settings for some of the main cameras that are supported by Camera Raw. By choosing the Camera Standard profile

New camera profile availability
Not all the Camera Raw supported cameras have the new profiles. These are mainly done for Canon, Nikon and a few Pentax and Leica models. So, you may not see a full list of profile options for every Camera Raw compatible camera, just the newer and most popular camera models.

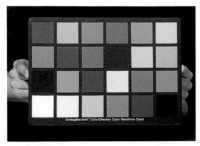

Figure 2.68 X-Rite ColorChecker charts can be bought as a mini chart or the full-size chart you see here.

Embedding custom profiles

If you create a custom camera profile for your camera and apply this to any of the images you process through Camera Raw, you need to be aware that the custom profile component can only be read if that camera profile exists on the computer that's reading it. If you transfer a raw file that's been processed in Camera Raw to another computer it will look to see if the same camera profile is in the 'CameraProfiles' folder. If it isn't, it will default to using the Adobe Standard profile. Which leads me to point out an important solution to this problem, which is to convert your raw files to DNG. The current DNG spec allows for camera profiles to be embedded within the file and thereby removes the dependency on the host computer having a copy of the custom camera profile that's been applied.

you can get the Camera Raw interpretation to pretty much match exactly the default color renderings that are applied by the camera manufacturer software. This means that if you apply the Camera Standard profile as the default setting in the Camera Calibration panel, Camera Raw applies the same kind of default color rendering as the camera vendor's software and will also match the default camera JPEG renderings. For years, photographers complained that Camera Raw in Bridge and Lightroom changed the look of their photos soon after downloading. The initial JPEG previews they saw that they liked would quickly be replaced by a different, Camera Raw interpretation. When the Camera Standard profile is selected you won't see any jumps in color as the Camera Raw processing kicks in. This is because Camera Raw is now able to match the JPEG rendering for these supported cameras.

Custom camera profile calibrations

While the Adobe Standard profiles are much improved, they have still been achieved through testing a limited number of cameras. You can, however, create custom standard camera profiles for individual camera bodies. Creating a custom camera calibration profile does require a little extra effort to set up, but it is worth doing if you want to fine-tune the color calibration for each individual camera you shoot with. This used to be done by manually adjusting the Camera Calibration panel sliders, but should now be done through the use of camera profiles. However, the sliders do have their uses still, as I'll explain shortly.

In the early days of Camera Raw I used to shoot an X-Rite ColorChecker chart and visually compared the shot results with a synthetic ColorChecker chart and adjusted the Camera Calibration panel sliders to achieve a best match. It was all very complex. Fortunately there is now an easier way to calibrate your camera equipment. You will still need to capture an X-Rite ColorChecker chart (Figure 2.68). These can easily be ordered online and will probably cost you around $100. You then need to photograph the chart with your camera in raw mode. It is important that the chart is evenly lit and exposed correctly. The best way to do this is to use two studio lights in a copy light setup, or, failing that, use a diffuse light source. Apart from that, it does not matter what other camera settings are used, although I would recommend you shoot at a low ISO rating.

Figure 2.69 This page shows a comparison of the different camera profiles one can now choose from and the effect these will have on the appearance of an image, which in this case was shot using a Canon EOS 1Ds MkIII camera.

Camera profiles and white balance

In the step-by-step example shown here I recommend creating a camera profile using a standard strobe flash lighting setup. This lets you calibrate the camera sensor for the studio lights you normally shoot with. The camera profile measurements can vary slightly for pictures that are shot using different white balance lighting setups. It is for this reason the DNG Profile Editor allows you to measure and generate camera profiles in the same way as the Camera Raw team do. For example, if you shoot the ColorChecker chart once with a lighting setup at a measured white balance of 6500 K and again at a white balance of 3400 K, you can measure these two charts using the DNG Profile Editor to create a more accurate custom camera profile.

DNG Profile Editor

In the quest to produce improved camera profiles, a special utility program called DNG Profile Editor was used to help re-evaluate the camera profiles supplied with Camera Raw and produce the revised camera profiles. You can get hold of a copy of this program by going to tinyurl.com/pq9d33j (Mac)/ tinyurl.com/q7c8h3p (PC). At the time of writing it is currently a version 1.04 product and available as a free download. There are a number of things you can do with this utility, but its main strength is that it allows you to create custom calibration profiles for individual cameras. You see, while the default camera profiles can be quite accurate, there may still be a slight difference in color response between your particular camera and the one Adobe used to test with. For this reason you may like to run through the following steps to create a custom calibration for your camera sensor.

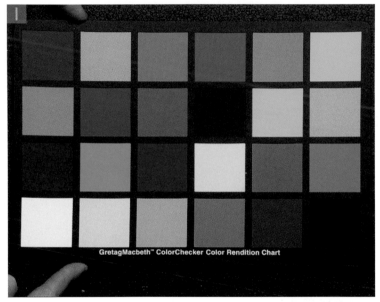

1 As I showed in Figure 2.68, you'll first need to photograph an X-Rite ColorChecker chart. I suggest you shoot this against a plain, dark backdrop and make sure it is evenly lit from both sides, and, for the utmost accuracy, is illuminated with the same strobe lights that you normally work with. It is also a good idea to take several photos and bracket the exposures slightly. If the raw original isn't exposed correctly you'll see an error message when trying to run the DNG Profile Editor. The other thing you'll need to do is to convert the raw capture image to the DNG format, which you can do using Adobe DNG Converter (see page 264) or by saving as a DNG file via the Camera Raw dialog.

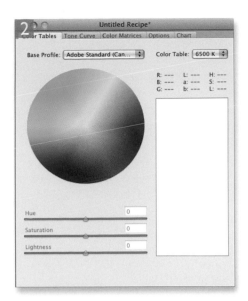

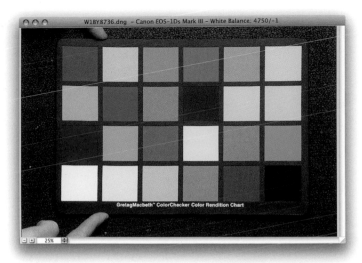

2 The next step is to launch DNG Profile Editor. Go to the File menu and choose File ⇨ Open DNG Image… Now browse to locate the DNG image you just edited and click Open. The selected image appears in a separate window. Go to the Base Profile menu and select the Adobe Standard profile for whichever camera was used to capture the ColorChecker chart.

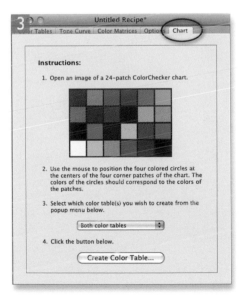

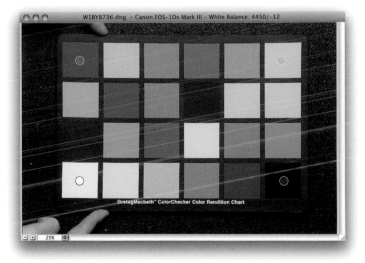

3 Now click on the Chart tab (circled) and drag the four colored circles to the four corner swatches of the chart. If you are just measuring the one chart, select the Both color tables option and click on the Create Color Table… button. If you are recording two separately shot targets at different white balance settings, use this menu to select the appropriate color table.

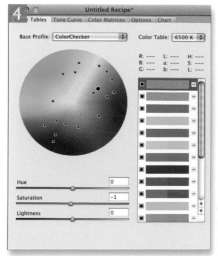

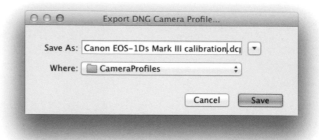

4 The camera profile generation process will be pretty much instantaneous. Once this has been done you can then go to the Edit menu and choose File ⇨ Export (name of camera) Profile, or use the ⌘ E (Mac), ctrl E (PC) shortcut and rename the profile as desired.

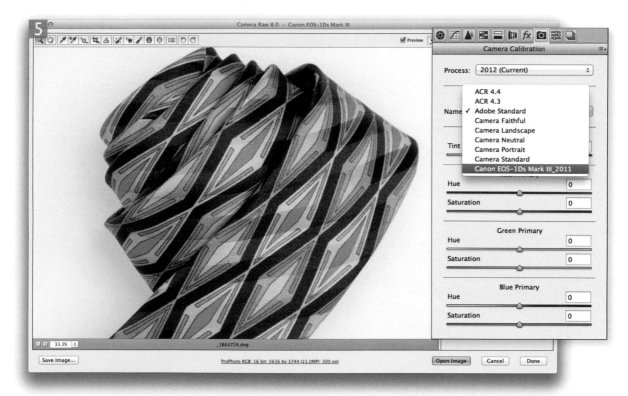

5 Custom camera profiles are saved to a default user folder but won't appear visible in the Camera Calibration panel profile list until you next launch Photoshop or Bridge and open a raw image via Camera Raw. Once you have done this you can select the newly created camera profile and apply it to any photos that have been shot using this camera.

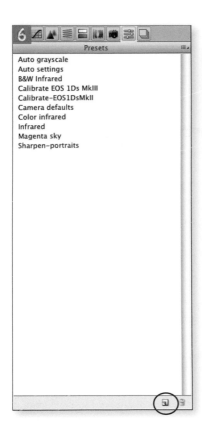

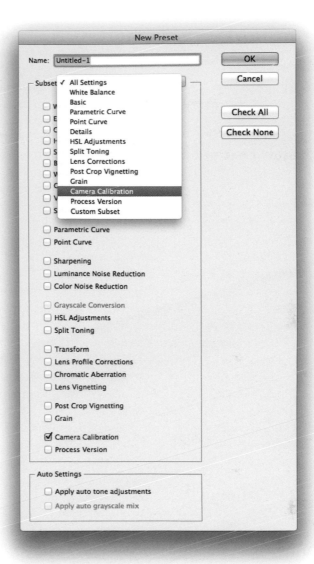

6 Here is an extra tip that is worth carrying out. You can save the camera profile selected in the Camera Calibration panel as a custom Camera Raw preset. In the example shown here I went to the Camera Raw Presets panel, clicked on the New preset button (circled) and in the New Preset dialog shown here, selected the Camera Calibration subset setting, so that only the Camera Calibration option was checked. Once I had done this I now had a camera profile preset setting that could easily be applied to any other photographs that had been shot with the same camera. One can also easily apply a setting like this via the Bridge Edit ⇨ Develop settings submenu.

Workflow options

You will notice that the workflow options (the hyperlink underneath the preview) is missing when using Camera Raw as a filter. This is because the workflow output settings are not needed when processing an image directly in Photoshop—it will already have been rendered to a specific RGB space and bit-depth.

Camera Raw filter tips

When using the Camera Raw filter you are limited to working with files no bigger than 65,000 pixels in either dimension. If the image you are editing happens to exceed this you will see a warning message. You can also apply the Camera Raw filter to targeted channels (as opposed to the entire composite channel). This means you can apply the Camera Raw filter to individual channels, such as the luminosity channel while working in Lab mode. However, when used this way certain features such as per-channel curves and split tone controls will be disabled.

Camera Raw as a Photoshop filter

You can now apply Camera Raw adjustments as a filter effect. You can do this directly in a destructive fashion, or ideally non-destructively by first converting to a Smart Object (Smart Filter) layer. This will allow you to re-edit the Camera Raw settings just as you would when editing a raw image. In the case of layered images you must distinguish whether you intend to filter a specific layer or all current visible layers. So, before creating a smart object do make sure you have the layer or layers you wish to process correctly selected. Some might argue that Camera Raw editing is already available for non-raw images, but it's important to point out that this was previously limited to flattened files saved in the TIFF or JPEG format.

Using Camera Raw as a Photoshop filter now gives you the opportunity to make full use of Camera Raw edits when working on any RGB or grayscale image. This may well benefit certain workflows. For example, when working with scanned images you can use Camera Raw to apply the capture sharpening. Or, maybe you'll feel more comfortable using the Camera Raw Basic panel tone controls instead of Levels or Curves to tone edit an image? There's also the benefit of being able to apply other Camera Raw specific adjustments such as Clarity to adjust the midtone contrast, or Camera Raw style black and white conversions.

There are limitations. For example, you can't expect to achieve the same range of adjustment control on a non-raw image when adjusting say the Highlights slider to rescue extreme highlight detail. Not all Camera Raw tools are made available when using Camera Raw as a filter. It didn't make sense to allow the saving of snapshots, because there is nowhere to save them when used as a filter in this way. The lens profile correction options are not available because you already have the Lens Corrections filter in Photoshop. There is also the overhead that comes from having to create a Smart Object, which inevitably leads to bigger saved file sizes. Above all, if you care about optimum image quality, you shouldn't skip carrying out the Camera Raw processing at the raw image stage. Camera Raw is most effective when it's used to edit raw images. The Camera Raw filter is basically a convenience when working in Photoshop as it can save you having to export an image or layer to apply the Camera Raw processing separately.

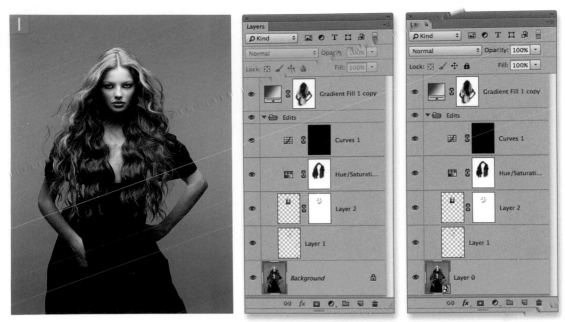

1 Here is a photograph that had been edited in Photoshop. In this first step the Background layer only was selected. I then went to the Filter menu and chose 'Convert for Smart Filters'. This converted the Background layer to a smart object.

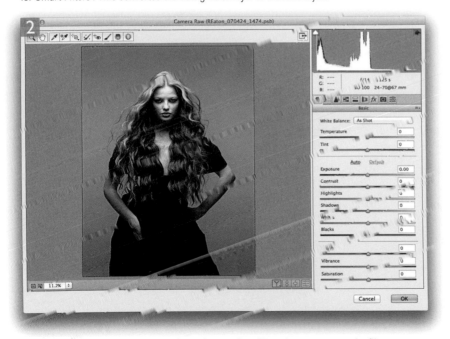

2 I went to the Filter menu and chose the Camera Raw Filter. As you can see, the filter was applied to the Background layer contents only as that was what had been selected in step 1.

3 I clicked the Cancel button to return to the original, layered image in Photoshop. This time I ensured all the visible layers were selected and chose 'Convert for Smart Filters' again. This created a smart object that contained all the layers.

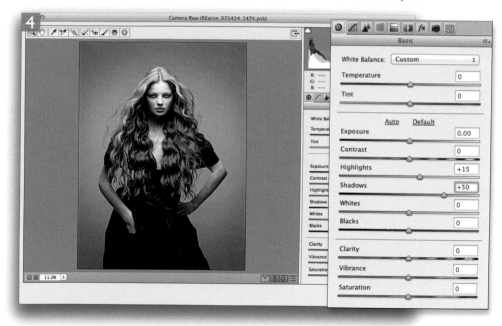

4 I renamed the smart object layer 'Merged composite' and chose the Camera Raw Filter, which would now be applied to a composite of all the layers contained within the smart object. In the Effects panel I added a post-crop vignette adjustment to darken the corners and in the Basic panel I adjusted the Highlights and Shadows.

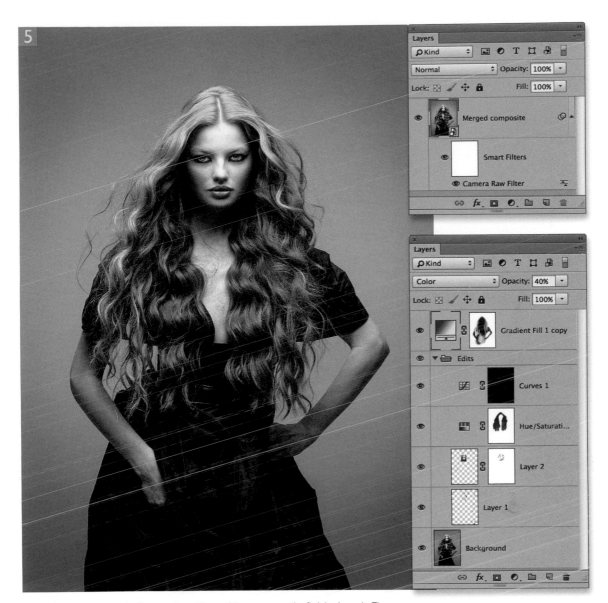

5 I clicked OK to apply the Camera Raw filter and here you see the finished result. The Layers panel shows the smart object layer with the Camera Raw filter applied. If I were to double-click the smart object thumbnail in the Layers panel this would open the expanded layers view, just like the one seen at step 1. As with all smart object editing, you can open a smart object to reveal the contents and continue editing the document. In this instance, if I were to change the Gradient Fill overlay layer and resave, this would update the smart object and the Camera Raw filter adjustments would also update accordingly.

Spot removal tool

You can use the spot removal tool (**B**) to retouch spots and blemishes. Whenever the spot removal tool is active you will see the Spot Removal options appear in the panel section on the right (Figure 2.70). From here you can choose between Heal and Clone type retouching. In Clone mode, the tool behaves like the clone stamp tool in Photoshop. It allows you to sample from a source area that will replace the destination area, without blending. In Heal mode, the tool behaves like the healing or spot healing brush in Photoshop, blending the sampled pixels with the surrounding pixels outside the destination area. Unlike earlier versions of Camera Raw the healing algorithm now used provides speedier healing performance as well as better image quality. However, adding multiple spots (and especially brush spots) may still slow down the overall Camera Raw performance.

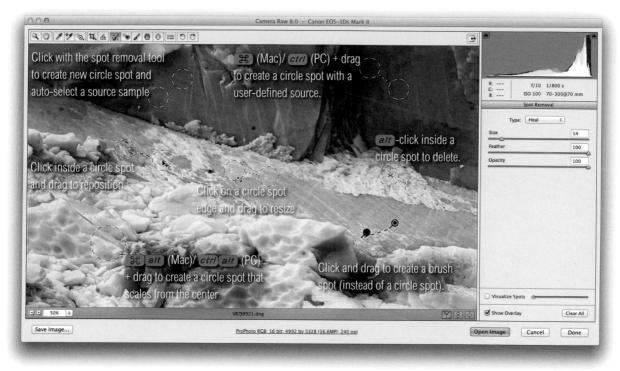

Figure 2.70 This screen shot shows the spot removal tool in action, with explanations of how to apply and modify the retouch circle spots. Brush spots are covered in more detail later on page 220.

Creating circle spots

Ideally you should carry out the spotting work at a 100% zoom setting. Whenever you click with the spot removal tool, this creates a new spot circle and auto-selects the most suitable area to clone from. This is a little like using the spot healing brush in Photoshop, except it works using either the Clone or Heal modes. If you don't like the auto-selection made you can use the **/** key to recalculate. This is because when you 'click only' with the spot removal tool it auto selects the area to sample from, but when you press **/** Camera Raw recomputes a new source area to sample from. This is useful where the initial auto-sample selection wasn't successful. Rather than manually override the source selection you can ask Camera Raw to take another guess, which may just work out better. The auto find source aspect of the spot removal tool is now able to cope better with textured areas such as rocks, tree bark and foliage. It also takes into account the applied crop. This means that if a crop is active the spot removal tool gives preference to sourcing areas within the cropped area rather than outside it. Basically, if an image is cropped, Camera Raw carries out two searches for a most suitable area to clone from: one within the cropped area and one outside. Preference is given to the search inside the cropped area when computing the auto find area. If somewhere outside the cropped area yields a significantly better result, then that will be used instead.

If you hold down the ⌘ alt (Mac), or ctrl alt (PC) key + click and drag, this allows you to create a circle spot that scales from the center. To manually set the source area to sample from you now need to hold down the ⌘ (Mac), ⌘ (PC) key + click and drag to define the source area. If you click to select an existing spot circle you can adjust both the destination or source point circles, repositioning them and changing the type from Clone to Heal or vice versa. You also have the option to adjust the radius of the spot removal tool as well as the opacity (the Opacity slider allows you to edit the opacity of your spotting work on a spot by spot basis). You can always use the **[]** keys to adjust the Radius, but it is usually simpler to follow the instructions in Figure 2.70 and drag with the cursor instead. You can click on the 'Show Overlay' box or use the **V** key to toggle showing and hiding the circles so that you can view the retouched image without seeing the retouch circles and use the Toggle Preview button (⌘ alt P [Mac], or ctrl alt P [PC]) to toggle showing/hiding the spot removal retouching.

Synchronized spotting with Camera Raw

You can synchronize the spot removal tool across multiple
photos. Make a selection of images in Bridge and open them
up via Camera Raw (as shown in Figure 2.71). Next, go to the
Filmstrip menu and choose 'Select All' to select all the photos.
If you now work with the spot removal tool, you can retouch
the most selected photo (the one shown in the main preview),
and the spotting work will automatically be updated to all the
other selected images.

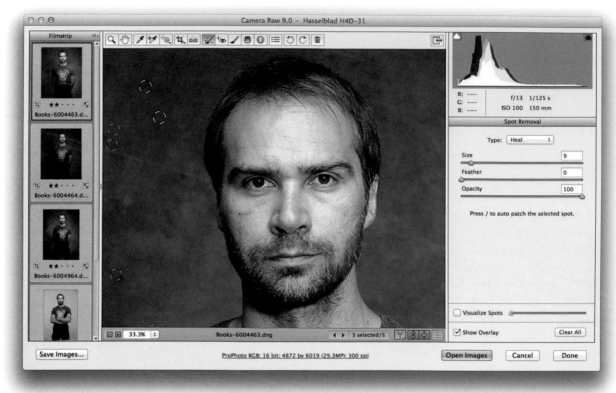

Figure 2.71 Here is an example of the Camera Raw dialog being used to carry out
synchronized spotting.

Spot removal tool feathering

The spot removal tool features a Feather slider (Figure 2.72).
This allows you to modify the brush hardness when working
with the spot removal tool in the clone or heal modes, applying
either a circle spot or brush spot. This is interesting because
while it has always been possible to adjust the brush hardness
in Photoshop when working with the clone stamp tool, there
has never been a similar hardness control option for the healing

brush. This is because the healing brush and spot healing brush have always had an internal feathering mechanism built in, so additional feathering has never been needed. Looking at what has been done here in Camera Raw the Feather slider control works well and is useful for both modes of operation. There is also another reason. With Lightroom 5 and Camera Raw 8, Adobe switched to using a faster healing algorithm in order to make brush spots retouching work speedier. However, as a result of this the blending isn't always as smooth as the previous algorithm. This was one motivation for adding a Feather slider. At the same time, the Feather slider does appear to offer more control over the spot removal blending and can help overcome the edge contamination sometimes evident when using the spot removal tool in heal mode, but with a fixed feather edge. The feathering is applied to the destination circle spot or brush spot and the Feather amount is proportional to the size of the spot, so bigger spots will use a bigger feather. Also, the Feather setting applied remains sticky across Camera Raw sessions.

You can hold down the *Shift* key as you use the square bracket keys to control the feather setting. Use *Shift* + *]* to increase the feathering and *Shift* + *[* to decrease. You can also hold down the *Shift* key as you right-mouse click and drag left or right to dynamically adjust the Feather amount.

Figure 2.72 The panel controls for the spot removal tool.

Spot removal tool fine-tuning

You can nudge both the destination and source circle/brush spots using the keyboard arrow keys. Use the ⌘ key (Mac), or *ctrl* key (PC) + arrow to nudge a destination circle or brush spot more coarsely and use ⌘ *alt* (Mac), or *ctrl* *alt* (PC) + arrow to nudge more finely. Use the ⌘ *Shift* keys (Mac), or *ctrl* *Shift* keys (PC) + arrow to nudge a source circle or brush spot more coarsely and use ⌘ *Shift* *alt* (Mac), or *ctrl* *Shift* *alt* (PC) + arrow to nudge more finely.

Finally, when you hold down the ⌘ *alt* (Mac), or *ctrl* *alt* keys (PC) and click in the preview and drag to adjust the cursor size, the size value is now reflected by the Size slider.

Visualize spots

The Visualize spots feature can be used to help detect dust spots and other anomalies. This consists of a Visualize Spots checkbox and a slider. When enabled, you drag the slider to adjust the threshold for the preview and this can sometimes make it easier for you to highlight the spots in an image that need to be removed. You can also use the comma and period keys (or think of them as the < and > keys) to make the slider value increase or decrease, and use the *Shift* key to jump more. Obviously, it helps to view the image close-up as you do this and when adjusting the slider the slider value remains sticky until you turn on Visualize spots to treat another image.

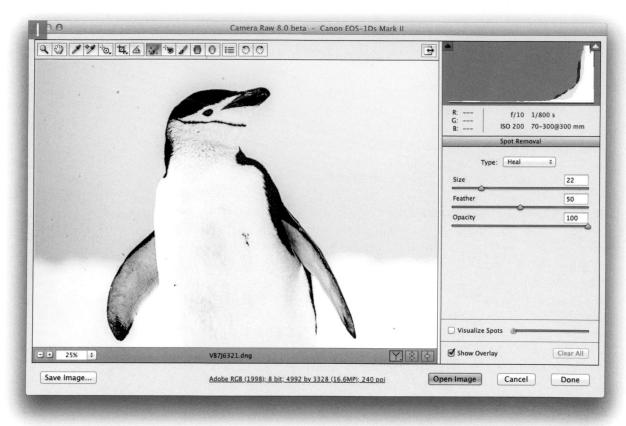

1 This shows an image that was shot with dirty camera sensor marks, which wasn't helped much by shooting a high key subject.

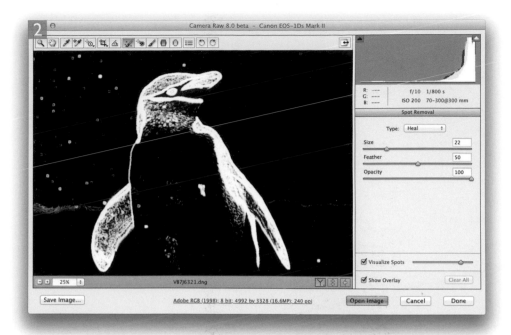

2 I checked the Visualize Spots box at the bottom of the Spot Removal panel options and adjusted the slider to obtain a suitable preview, one that picked out the spots more clearly.

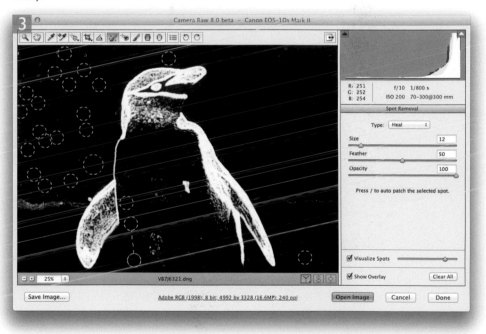

3 I then clicked with the spot removal tool to remove the spots that had been identified using this method.

Figure 2.73 When you click and drag with the spot removal tool this allows you to more precisely define the area you wish to remove.

Creating brush spots

Prior to Photoshop CC, a click and drag allowed you to manually determine the position of the sample area circle. Now in Camera Raw, clicking and dragging allows you to precisely define the area you wish to remove (see Figure 2.74). As you drag with the spot removal tool a red dotted outline will define the area you are removing and a green dotted outline define the area you are sampling from (see Figure 2.73). As with a basic click operation, the new click and drag method auto-selects the best area to sample from and you can use the [/] key to force Camera Raw to recalculate a new sample area.

If you click and drag with the **Shift** key held down this constrains the line to a horizontal or vertical direction. But if you click and click again with the **Shift** key held down this allows you to create a 'connect the dots' selection. Also, using a regular right-mouse click you can drag left or right to reduce or increase the cursor size.

With brush spots (where you click and drag), these are indicated by a pin marker. As you hover over the pin you will see a white outline of the brush spot shape. When you click to make a pin active the outline of the destination brush spot

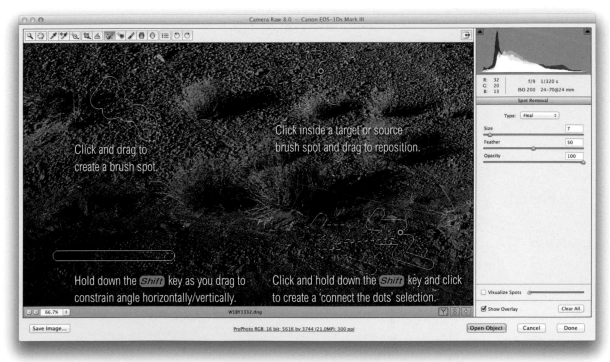

Figure 2.74 This screen shot shows the spot removal tool in action, with explanations of how to apply and modify brush spots.

will appear red and the corresponding source outline green. With brush spots it is not possible to manually resize the brush outline, but you can click on either pin marker or drag anywhere inside either brush stroke outline to reposition a destination or source brush spot.

Deleting spots

To delete a circle or brush spot, you simply select it and press the *Delete* key to delete the adjustment. Alternatively, you can hold down the *alt* key and click on an individual spot (as you do so the cursor changes to a scissor). Or, you can hold down the *alt* key and marquee drag within the preview area to select any spots you wish to delete. This will delete the spots as soon as the mouse is released. If you press down the spacebar after doing so, this allows you to reposition the marquee selection. Release the spacebar to continue to modify the marquee area.

Substitute zoom shortcut

You can use *⌘* *alt* *Shift* (Mac) *ctrl* *alt* *Shift* (PC) as a substitute zoom tool in Camera Raw when working with spot removal tool.

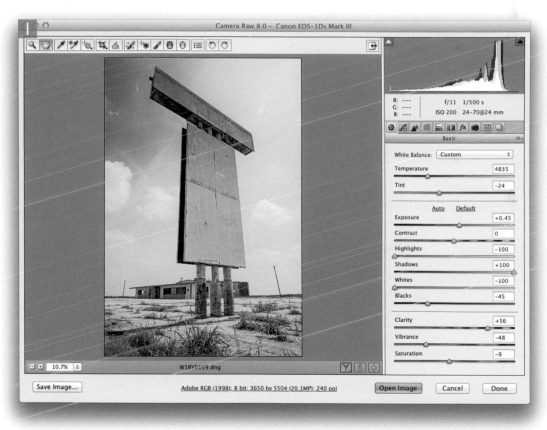

1 With this image I was interested in using the spot removal tool to remove a pole from the bottom right corner.

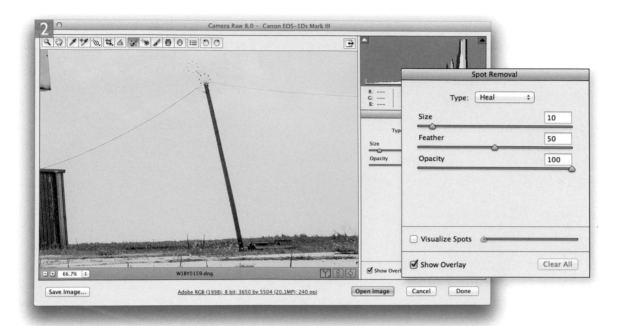

2 In this screen shot you can see that I had zoomed in on the image, selected the spot removal tool and clicked at the top of the pole. As with previous versions of Camera Raw, this applied a standard circle spot that auto-selected a source circle area.

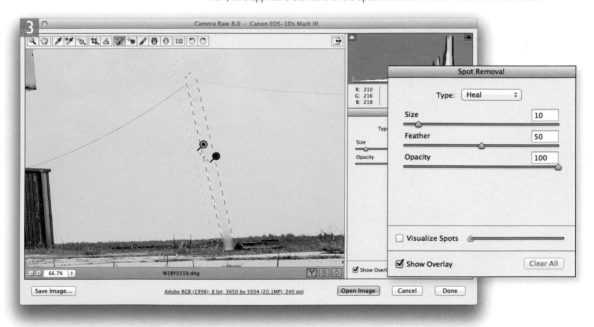

3 I then held down the *Shift* key and clicked at the bottom of the pole to apply a non-circular spot removal. In this screen shot the destination area is outlined in red and the auto-selected source area is outlined in green.

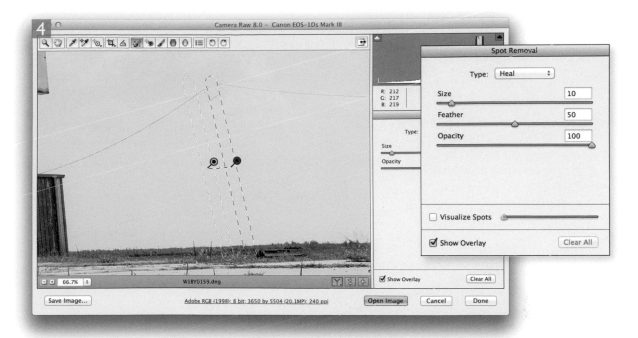

4 I obviously needed to adjust the source selection area, so I clicked on the green pin and moved this until I had found a nice match inside the red selected destination area.

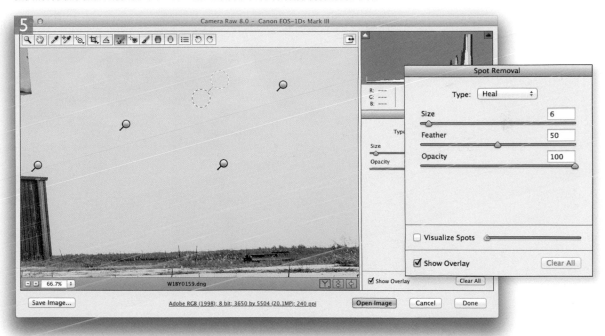

5 I carried on using the spot removal tool in this way to remove the cables and last of all, applied a standard spot circle to tidy up the last remaining bit of cable.

As with the spot removal tool, you can click on the 'Show Overlay' box to toggle showing and hiding the rectangle overlays (or use the **V** key).

Spacebar tip

When dragging with the red eye removal tool you can press down the spacebar to reposition the marquee selection. Release the spacebar to continue to modify the marquee area.

Red eye removal

The remove red eye tool is useful for correcting photos that have been taken of people where the direct camera flash has caused the pupils to appear bright red. To apply a red eye correction, select the red eye removal tool and drag the cursor over the eyes that need to be adjusted. In the Figure 2.75 example I dragged with the mouse to roughly select one of the eyes. As I did this, Camera Raw was able to detect the area that needed to be corrected and automatically adjusted the marquee size to fit. The Pupil Size and Darken sliders can then be used to fine-tune the Pupil Size area that you want to correct as well as the amount you want to darken the pupil by. You can also revise the red eye removal settings by clicking on a rectangle to reactivate it, or use the *Delete* key to remove individual red eye corrections. If you don't like the results you are getting, you can always click on the 'Clear All' button to delete the red eye retouching and start over again.

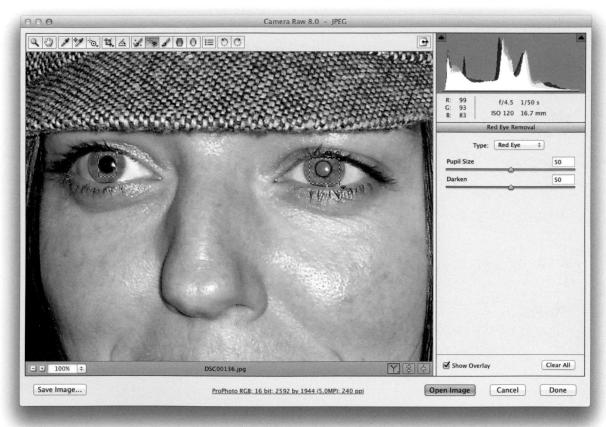

Figure 2.75 Here is an example of the red eye removal tool in action.

Red eye: pet eye removal

There is now a Pet Eye mode for the red eye tool (Figure 2.76), which is available as a menu option. This has been added because the red eye effect you get when using flash to photograph animals isn't always so easy to remove using the standard red eye tool. Corrected pupils can now be made darker to give you a more natural look. The Pet Eye controls allow you to adjust each pupil independently by adjusting the Pupil Size slider. You can also check the Add Catchlight box to enable adding a catchlight highlight, which you can then click and drag into position over each eye.

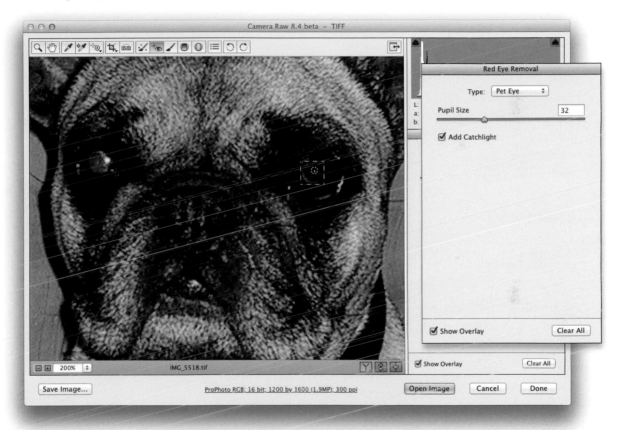

Figure 2.76 Here you can see I had selected the new Pet Eye option before using the red eye tool to marquee drag over the right eye of the dog in this photograph. Having selected the eye I adjusted the Pupil Size slider to darken the desired area.

Whites and Blacks adjustments

The Whites and Blacks are controls available for all the local adjustment tools (adjustment brush, graduated, and radial filter). Such adjustments are useful for fine-tuning the very lightest and darkest tone areas to reduce or add more contrast. It is recommended that you apply such adjustments after having applied the main tone adjustments and watch out in particular for any signs of clipping. These slider controls are discussed in more detail in a movie on the book's website.

Localized adjustments

The adjustment brush and graduated filter tools can be used to apply localized edits in Camera Raw. As with the spot removal and red eye removal tools, you can revise these edits as often as you like. But these are more than just dodge and burn tools—there's a total of 13 effects to choose from, as well as an Auto Mask option.

Adjustment brush

When you select the adjustment brush tool (**K**) the tool options shown in Figure 2.77 will appear in the Camera Raw panel section with the 'New' button selected (you can also use the **K** key to toggle between the Adjustment Brush panel and the main Camera Raw panel controls). Below this are the sliders you can use to configure the adjustment brush settings before you apply a new set of brush strokes.

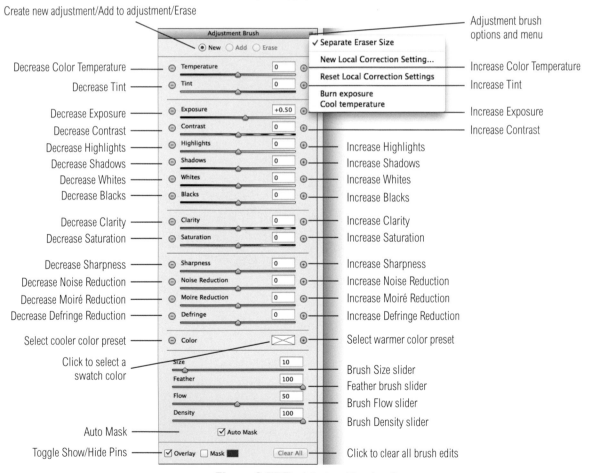

Figure 2.77 The Adjustment brush options.

Initial Adjustment brush options

To apply a brush adjustment, click on the New brush button at the top of the panel and select the effect options you wish to apply by using either the plus or minus buttons or the sliders. For example, clicking on the Exposure plus button increases the exposure setting to +0.50 and clicking on the negative button sets it to –0.50 (these are your basic dodge and burn settings). The effect buttons therefore make it fairly easy for you to quickly create the kind of effect you are after. However, using these buttons you can only select one effect setting at a time and all the other settings are zeroed. If you use the slider controls you can fine-tune the adjustment brush effect settings and combine multiple effects in a single setting.

Brush settings

Below this are the brush settings. The Size slider adjusts the brush radius, and you can use the [] keys to make the brush smaller or larger. It is also possible to resize a brush on screen. If you hold down the *ctrl* key (Mac), or use a right-mouse click (Mac and PC), you can drag to resize the cursor before you start using it to retouch the image. The Feather slider adjusts the softness of the brush and you can also use the *Shift*] keys to make the brush edge softer and *Shift* [to make the brush harder (you can also hold down the *Shift* key combined with a right mouse drag to adjust the feathering). Note that these settings are reflected in the cursor shape shown in Figure 2.78. The Flow slider is a bit like an airbrush control. If you select a low Flow setting, you can apply a series of brush strokes that successively build to create a stronger effect. As you brush back and forth with the brush, you will notice how the paint effect gains opacity, and if you are using a pressure-sensitive tablet such as a Wacom™, the Flow of the brush strokes is automatically linked to the pen pressure that you apply. The Density slider determines the maximum opacity for the brush. This means that if you have the brush set to 100% Density, the flow of the brush strokes can build to a maximum density of 100%. If on the other hand you reduce the Density, this limits the maximum brush opacity to a lower opacity value. For example, if you lower the Density and paint over an area that was previously painted at a Density of 100%, you can paint with the adjustment brush to reduce the opacity in these areas. If you reduce the Density to 0%, the adjustment brush acts like an eraser tool.

Hiding and showing brush edits

If you refer back to page 102 you will see an example of how you can compare the current image state with a previous checkpoint state. When carrying out localized adjustments it is useful to click on the Swap button (⇄) to toggle the localized adjustments on or off, or use the ⌘ *alt* *P* (Mac) *ctrl* *alt* *P* (PC) shortcut.

Figure 2.78 The outer edge of the adjustment brush cursor represents the overall size of the brush, while the inner circle represents the softness (feathering) of the brush relative to the overall brush size.

Localized adjustment strength

Localized adjustments have the same effective strength as their global adjustment counterparts. But note that all the effects have linear incremental, cumulative behavior except for the Temp, Tint, Highlights, Shadows and Clarity adjustments. These have non-linear incremental behavior, which means that they only increase in strength by 75% relative to the previous localized adjustment each time you add a new pin group.

Adding a new brush effect

Now let's look at how to apply a brush effect. When you click on the image preview, a pin marker is added and the Adjustment Brush panel shows that it is now in 'Add' mode (Figure 2.79). As you start adding successive brush strokes, these are collectively associated with this marker and will continue to be so until you click on the 'New' button and click to create a new pin marker with a new set of brush strokes. The pin markers therefore provide a tag for identifying groups of brush strokes. You just click on a pin marker whenever you want to add or remove brush strokes, or need to re-edit the brush settings that were applied previously. If you want to hide the markers you can do so by clicking on the Show Pins box to toggle showing/hiding the pins, or use the **V** key shortcut.

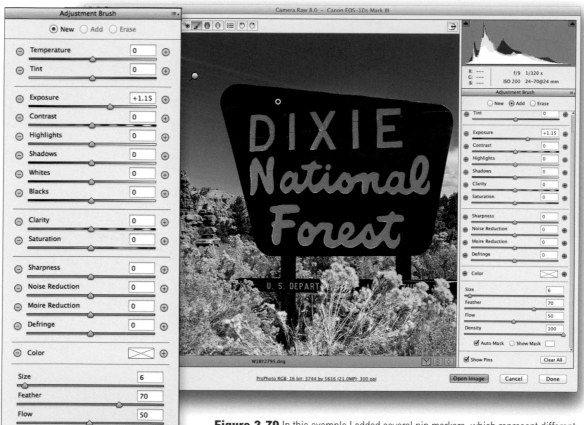

Figure 2.79 In this example I added several pin markers, which represent different groups of brush strokes. The one at the top was used to darken the sky and the one that is currently active was used to lighten the park sign with a positive Exposure value. Double-clicking a slider arrow pointer resets it to zero, or to its default value.

Resetting adjustments

There are two easy ways you can reset localized adjustment settings in Camera Raw. One method is to right-click on an adjustment pin and choose 'Reset Local Correction Settings' from the context menu. The other method is to click to select a localized adjustment pin and choose 'Reset Local Correction Settings' from the fly-out menu.

Adjustment brush duplication

Refinements have been made to the adjustment brush tool, bringing it more in line with the behavior of other localized adjustment tools in Camera Raw. When you add a brush adjustment you can click on the pin and drag to relocate the applied adjustment. There is a contextual menu for the brush pins (right-click on a pin to reveal), which allows you to duplicate a selected adjustment or delete (see Figure 2.80). There is also a shortcut (⌘ *alt* + drag [Mac], *ctrl* *alt* + drag [PC]), which you can use to clone an adjustment brush pin. Click on a brush pin with the above key combo held down and drag.

Figure 2.80 The adjustment brush contextual menu.

1 In this example, I applied an adjustment brush effect to the flower head in this picture to make it slightly bluer in color and also to lighten the Exposure and boost the Contrast and Clarity settings.

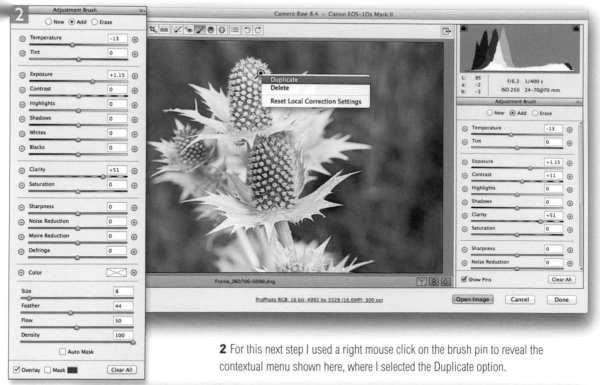

2 For this next step I used a right mouse click on the brush pin to reveal the contextual menu shown here, where I selected the Duplicate option.

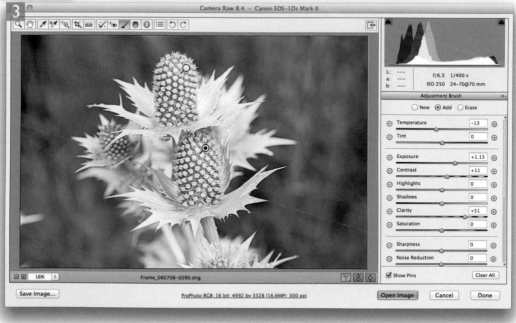

3 I was then able to click and drag on the duplicated pin to reposition it in the image. In this case I dragged to place it over the second flower head below.

Editing brush adjustments

To edit a series of brush strokes, just click on an existing pin marker to select it (a black dot appears in the center of the pin). This takes you into the 'Add' mode, where you can add more brush strokes or edit the current brush settings. For example, in Step 2 (over the page), I might have wanted to drag the Exposure slider to darken the selected brush group more. You might also want to erase portions of a brush group, which you can do by clicking on the Erase button at the top of the Adjustment Brush panel, where you can independently edit the brush settings for the eraser mode (except for the Density slider which is locked at zero). Alternatively, you can hold down the *alt* key to temporarily access the adjustment brush in eraser mode. When you are done editing, click on the New button to return to the New adjustment mode, where you can now click on the image to add a new pin marker and a new set of brush strokes.

Undoing and erasing brush strokes

As you work with the adjustment brush, you can undo a brush stroke or series of strokes using the undo command (⌘ Z [Mac], *ctrl* Z [PC]).

Previewing the mask more clearly

Sometimes it is useful to initially adjust the settings to apply a stronger effect than is desired. This lets you judge the effectiveness of your masking more clearly. You can then reduce the effect settings to reach the desired strength for the brush strokes.

Previewing the brush stroke areas

If you click on the 'Mask' option, you'll see a temporary overlay view of the painted regions (Figure 2.81). The color overlay represents the areas that have been painted and can also be seen as you roll the cursor over a pin marker.

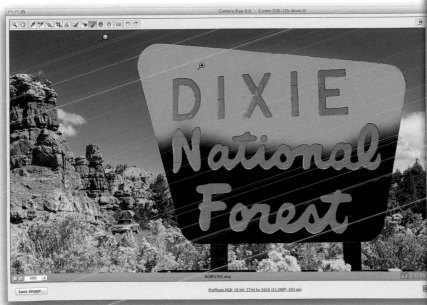

Figure 2.81 In this screen view, the 'Mask' option is checked and you can see an overlay mask for the selected brush group. Click on the swatch next to it if you wish to choose a different color for the overlay display.

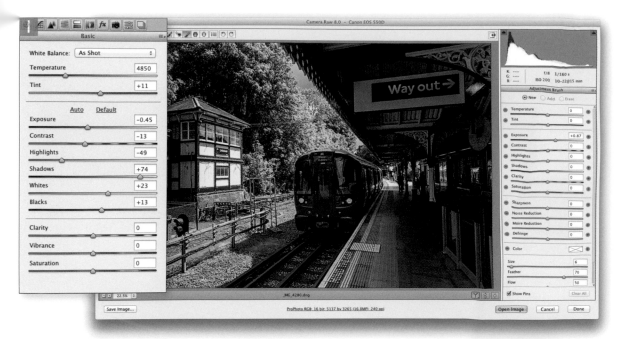

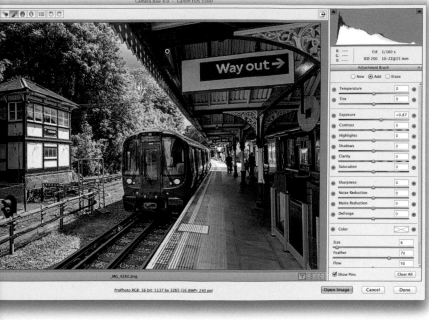

1 Here is a photograph where I had adjusted the Basic panel settings to optimize the image tones.

2 I then added a new brush group to lighten the shadows using a positive Exposure.

Auto masking

At the bottom of the Adjustment Brush panel is the Auto Mask option. When this is switched on it cleverly masks the image at the same time as you paint. It does this by analyzing the colors in the image where you first click and then proceeds to apply the effect only to those areas with the same matching tone and color (Figure 2.82). It does this on a contiguous selection basis. For example, in the steps shown here, I dragged with the adjustment brush in auto mask mode on the egg in the middle to desaturate the color. While the Auto Mask can do a great job at auto selecting the areas you want to paint, at extremes it can lead to ugly 'dissolved pixel' edges. This doesn't happen with every photo, but it's something to be aware of. The other thing to watch out for is a slow-down in brush performance. As you add extra brush stroke groups, the Camera Raw processing takes a big knock, but it gets worse when you apply a lot of auto mask brushing. It is therefore a good idea to restrict the number of adjustment groups to a minimum.

Figure 2.82 Quite often, you only need to click on an area of a picture with the color you wish to target and drag the adjustment brush in auto mask mode to quickly adjust areas of the picture that share the same tone and color.

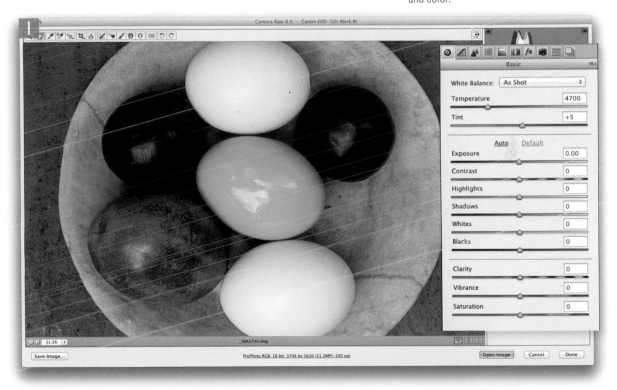

1 This shows a still life subject with just the Basic panel corrections applied.

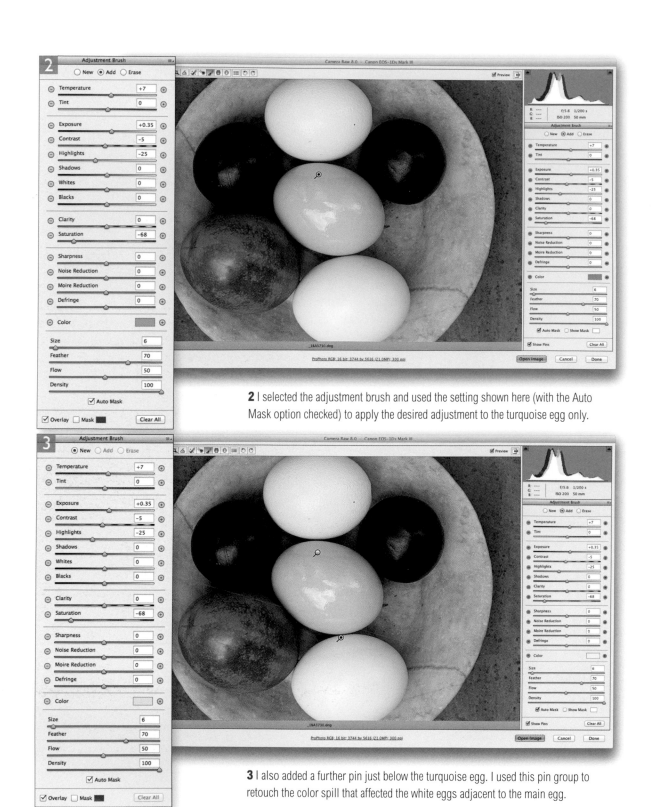

2 I selected the adjustment brush and used the setting shown here (with the Auto Mask option checked) to apply the desired adjustment to the turquoise egg only.

3 I also added a further pin just below the turquoise egg. I used this pin group to retouch the color spill that affected the white eggs adjacent to the main egg.

Darkening the shadows

With Process 2012 you now have a lot more tools at your disposal when making localized adjustments. I wanted to focus here though on the Shadows slider. In many ways the Shadows adjustment is a bit like the Fill Light control in Process 2010. As you raise the Shadows amount you can selectively lighten the shadow to midtone areas. However, with Shadows you can apply a negative amount in order to darken the shadows more. I see this as being particularly useful in situations like the one shown here, where you can use this type of regional adjustment to make a dark backdrop darker and clip to black.

Also, with the Highlights slider you can use negative amounts to apply localized adjustments to selectively darken the highlight areas and you can also use positive amounts to deliberately force highlight areas to clip to white. Therefore, you can use a positive Highlights adjustments to deliberately blow out the highlights in an image.

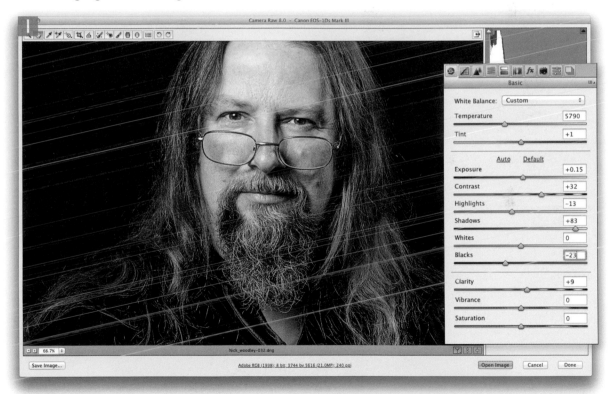

1 For this portrait I photographed my subject against a dark backdrop, which I wished to have appear black in the final image. As you can see, after carrying out preliminary Basic panel adjustments, there was still some detail showing in the backdrop.

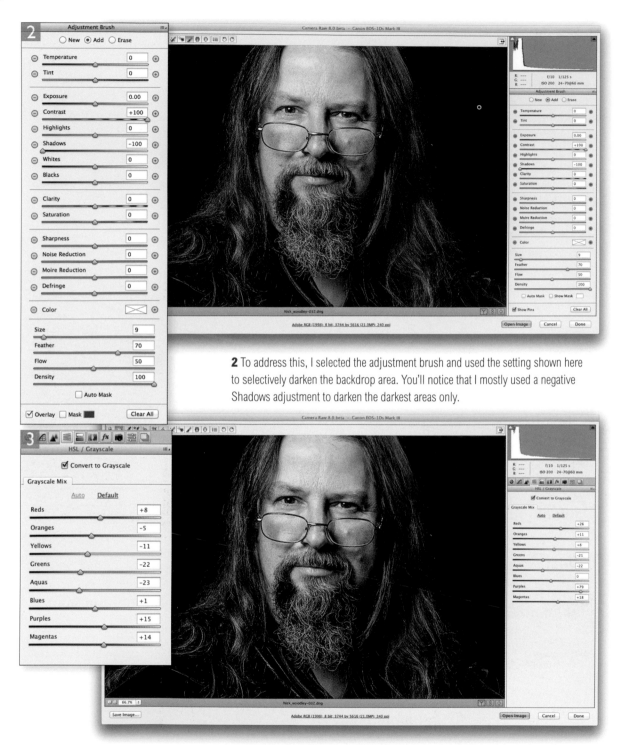

2 To address this, I selected the adjustment brush and used the setting shown here to selectively darken the backdrop area. You'll notice that I mostly used a negative Shadows adjustment to darken the darkest areas only.

3 Here is the final version, in which I converted the photo to black and white and added a split tone effect.

Hand-coloring in Color mode

The adjustment brush tool can also be used to tint black and white images and this is a technique that will work well with any raw, JPEG or TIFF image that is in color. This is because the auto mask feature can be used to help guide the adjustment brush to colorize regional areas that share the same tone and color. In other words, if the underlying image is in color, the auto mask has more information to work with. To convert the image to black and white, you can do what I did here and take the Saturation slider in the Basic panel all the way to the left. Alternatively, you can go to the HSL panel and set all the Saturation sliders to −100. The advantage of doing this is that you then have the option of using the HSL panel Luminance sliders to vary the black and white mix (see Chapter 5). After desaturating the image you simply select the adjustment brush and click on the color swatch to open the Color Picker dialog and choose a color to paint with.

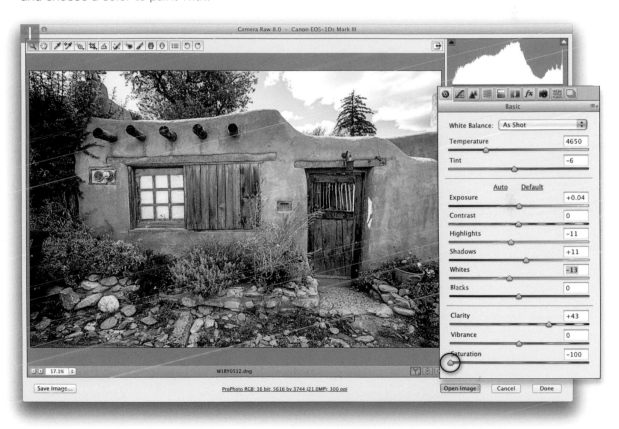

1 The first step was to go to the Basic panel and desaturate the colors in the image by dragging the Saturation slider all the way to the left.

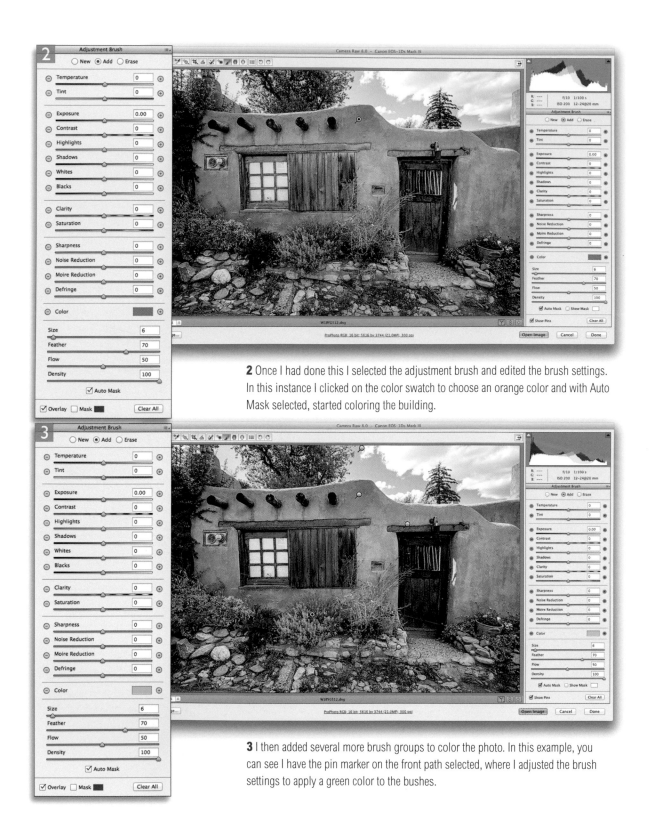

2 Once I had done this I selected the adjustment brush and edited the brush settings. In this instance I clicked on the color swatch to choose an orange color and with Auto Mask selected, started coloring the building.

3 I then added several more brush groups to color the photo. In this example, you can see I have the pin marker on the front path selected, where I adjusted the brush settings to apply a green color to the bushes.

Graduated filter tool

Everything that has been described so far with regards to working with the adjustment brush more or less applies to working with the graduated filter (Figure 2.83), which allows you to add linear graduated adjustments. To use the graduated filter tool, click in the photo to set the start point (the point with the maximum effect strength), drag the mouse to define the spread of the graduated filter, and release to set the minimum effect strength point. There is no midtone control with which you can offset a graduated filter effect, but you can use the **X** key to invert a graduated filter selection.

Graduated filter effects are indicated by green and red pin markers. The green dashed line represents the point of maximum effect strength and the red dashed line represents the point of minimum effect strength. The dashed line between the two points indicates the spread of the filter and you can change the width by dragging the outer pins further apart and move the position of the gradient by clicking and dragging the central line.

Toggle the main panel controls

You can use the **G** key to toggle between the Graduated Filter panel and the main Camera Raw panel controls.

Resetting the sliders

As with the Adjustment brush options, double-clicking a slider arrow pointer resets it to zero, or to its default value.

Angled gradients

As you drag with the graduated filter you can do so at any angle you like and edit the angle afterwards. Just hover the cursor over the red or green line and click and drag. If you hold down the **Shift** key you can constrain the angle of rotation to 45° increments.

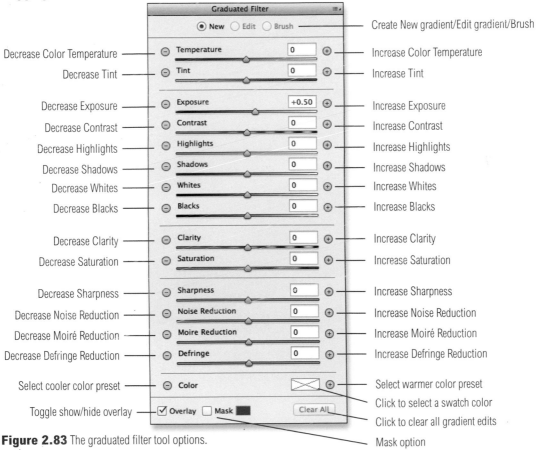

Figure 2.83 The graduated filter tool options.

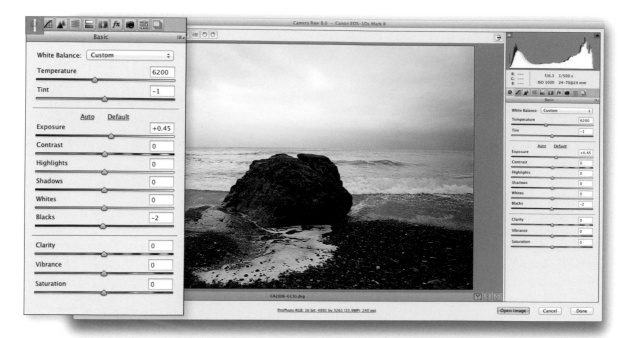

1 In this screen shot you see an image where all I had done initially was to optimize the Exposure.

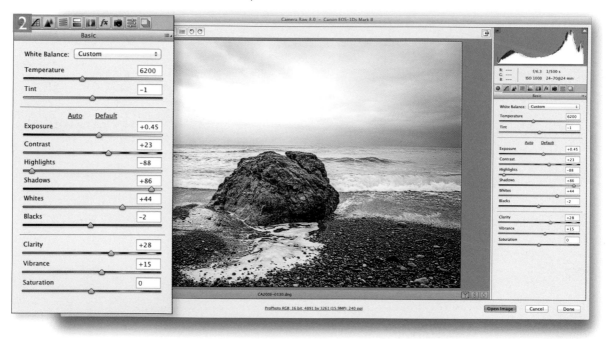

2 With the Process 2012 controls there is a lot that you can do to a photo like this just by adjusting the Highlights and Shadows sliders to reveal more detail in the sky and the rock in the foreground.

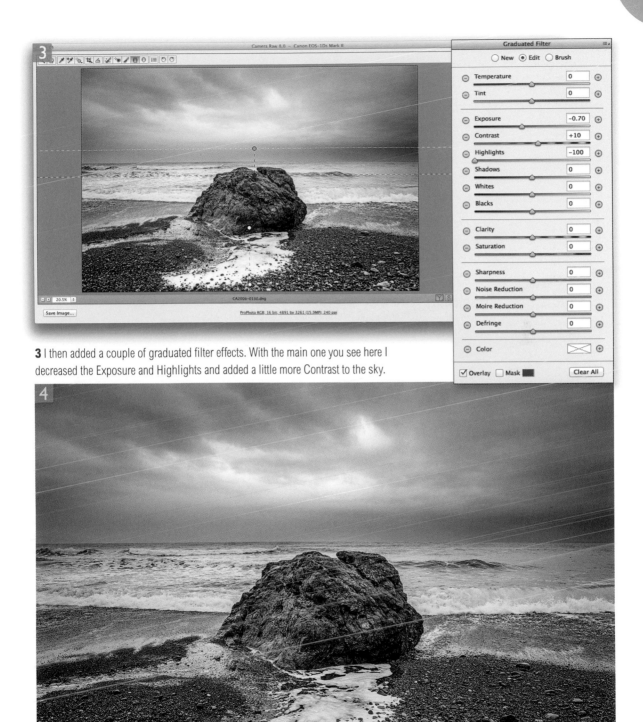

3 I then added a couple of graduated filter effects. With the main one you see here I decreased the Exposure and Highlights and added a little more Contrast to the sky.

4 Here is the final Camera Raw processed version.

Graduated color temperature adjustment

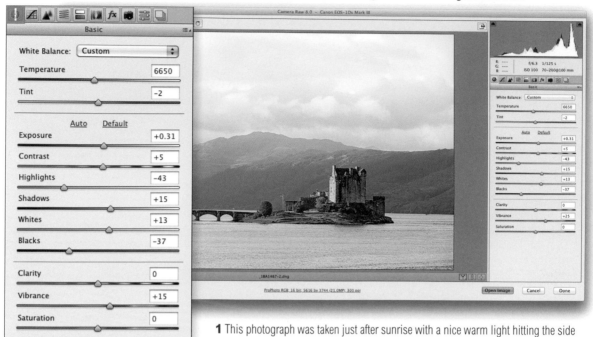

1 This photograph was taken just after sunrise with a nice warm light hitting the side of the castle.

2 Here, I wanted to add more color contrast to the sky and bring our more detail in the clouds. I selected the graduated filter tool and applied the settings shown here to the sky.

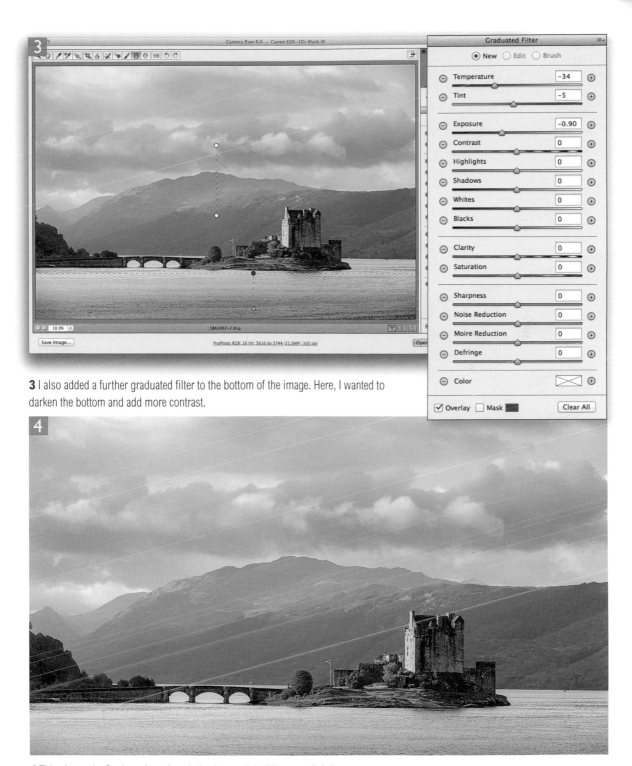

3 I also added a further graduated filter to the bottom of the image. Here, I wanted to darken the bottom and add more contrast.

4 This shows the final version where I also boosted the Vibrance slightly.

Figure 2.84 The Radial filter options.

Radial filter adjustments

Camera Raw also includes a radial filter to complement the 'linear' graduated filter. Essentially, the radial filter adjustment options (Figure 2.84) are exactly the same and you can use this tool to apply selective adjustments to the inner or outer area of a pre-defined ellipse shape. By default, the full effect adjustment is applied using the 'Inside' option where the effect starts at the center of the ellipse, and the zero effect is at the boundary and outside the ellipse. The strength of the effect tapers off smoothly between the center and the boundary edge. You can invert the adjustment effect by clicking the 'Outside' button, or use the X key shortcut to quickly toggle between the two. The radial filter also has a Feather slider control, which allows you to adjust the hardness of the edge and the Caps Lock key allows you to visualize the extent of feathering applied to the radial filter adjustment.

To apply a Radial filter adjustment you click and drag to define the initial ellipse area (you can press the spacebar as you do so to reposition). Once you have done this, use the handles to adjust the ellipse shape and drag the central pin to reposition the filter and narrow or widen the ellipse shape. To center a new radial adjustment hold down the alt key as you click and drag. If you want to preserve the roundness of the radial ellipse shape hold down the Shift key as you drag.

Use the ⌘ (Mac), or ctrl (PC) key + double-click to auto-center the ellipse shape within the current (cropped) image frame area and use ⌘ (Mac), or ctrl (PC) + double-click to expand an existing radial filter to fill the cropped image area. To clone an existing radial filter hold down the ⌘ alt (Mac), or ctrl alt (PC) keys as you click and drag on a radial filter pin. Lastly, double-click on a pin to dismiss the Radial filter edit mode and select the crop tool.

As I see it there are many creative uses for this new tool. You can use it to apply more controllable vignette adjustments to darken or lighten the corners. For example, instead of simply lightening or darkening using the Exposure slider, you can use instead, the Highlights or Shadows sliders to achieve more subtle types of adjustments.

As with the gradient filter, you can add multiple radial filter adjustments to an image. Once added, a radial filter adjustment is represented by a pin marker. As you roll over unselected pins the adjustment area will be revealed as a dashed outline.

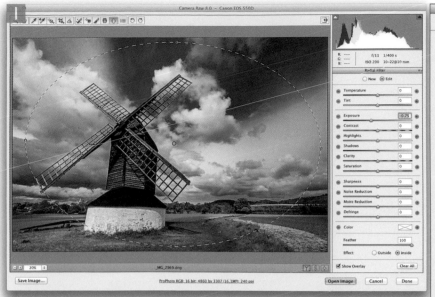

1 Here, I opened an image in Camera Raw and selected the radial filter tool. I ⌘ (Mac), or **ctrl** (PC) + double-clicked inside the preview area to add a new adjustment that filled the current frame area. I then set the Exposure slider to –0.75. By default, the adjustment was applied from the (green) center pin outwards.

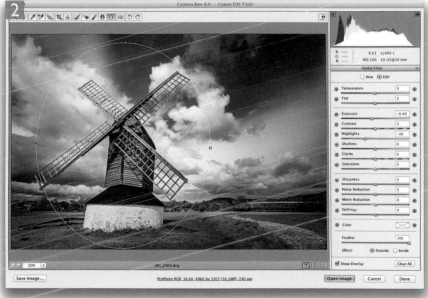

2 I used the **X** key to invert the effect, set the Exposure to a positive value of +0.40 and also applied a –0.30 Highlights adjustment. I then clicked on the side handles and adjusted these so that the effect was centered on the windmill.

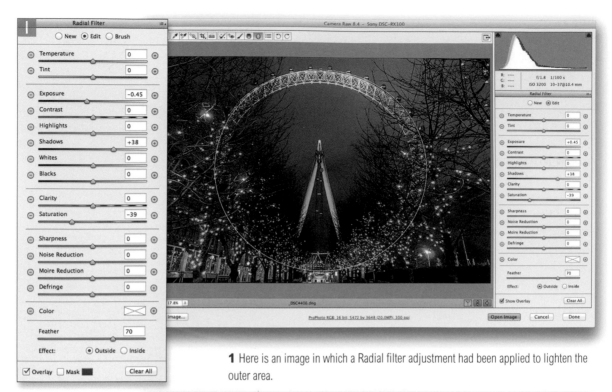

1 Here is an image in which a Radial filter adjustment had been applied to lighten the outer area.

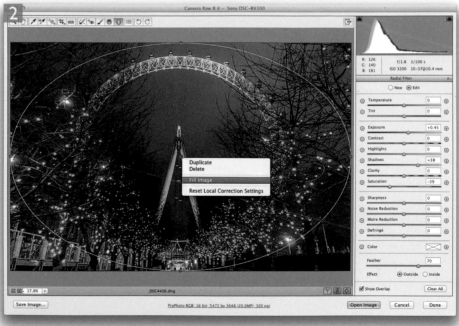

2 I then used a right mouse-click to access the contextual menu and selected Fill Image to expand the radial filter size to fit the bounds of the image.

Fill to document bounds

The contextual menu for the Radial filter includes an option that allows you to expand a Radial filter adjustment to fill the image bounds (see opposite). Just right mouse-click on a Radial filter pin and select 'Fill Image'. Note that double-clicking inside the ellipse overlay for a Radial filter adjustment achieves the same result.

Modifying graduated and radial filter masks

It is also possible to edit the graduated filter and radial filter masks. To start with you will notice that there is a Mask option at the bottom of the Graduated filter and Radial filter panels (see Figure 2.85) and next to this a color swatch, which you can click to choose any mask color you want.

After you have applied a Graduated filter, or Radial filter adjustment you can click on the Brush button at the top to reveal the brush editing options. These allow you to modify the mask for the filter adjustment. You can then click on the Brush + and Brush – buttons to add to or erase from the selected mask. There is an Auto Mask option to help limit the brush editing based on the pixel color where you first clicked and if you want to undo the mask editing you can click on the Clear button to undo your edits. You can also use the *Shift* + *K* shortcut to enter or leave the brush modification mode.

Figure 2.85 This shows the Brush edit controls for the Graduated filter options.

1 This photograph has been processed using the Basic panel controls to optimize for tone and color.

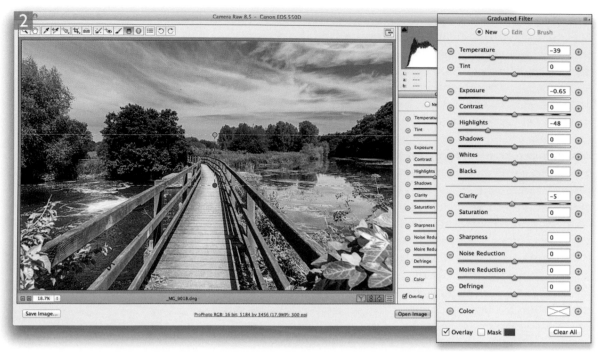

2 In this step I added a graduated filter effect to darken the sky and add more blue.

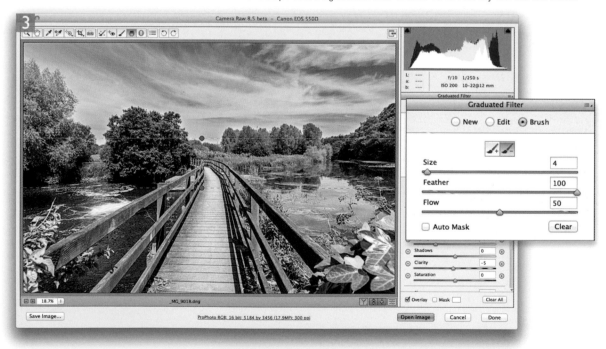

3 I then clicked on the Brush button to edit the Graduated filter mask. By switching between the subtract and add brush options I was able to edit the Graduated filter effect so that it had less impact on the trees.

Correcting edge sharpness with the Radial filter

Another thing the radial filter can be useful for is adding sharpness to the edges of a picture. If you own good quality lenses then this should not always be a problem as you would expect these to provide good overall sharpness. However, I do have a couple of lenses where the quality isn't always so great. In particular, I recently bought a little Sony RX-100 compact camera, which I shoot with a lot. I like the fact that this camera has a nice wide lens aperture and you can shoot in raw mode, but the edge sharpness is an issue compared to when shooting with prime lenses on a digital SLR camera. To address this I have found that you can use the radial filter to apply a Sharpness adjustment that gains strength from the center outwards. Now it has to be said that the fall off in sharpness towards the edges is more tangential in nature and a standard/radial sharpening boost isn't the optimum way to sharpen the corner edges. For example, DxO Optics Pro features a special edge sharpness correction that is built in to its auto lens corrections. Even so, the following example shows how you can make some improvements using this new feature in Camera Raw.

Edge sharpening presets

If you find this tip useful you might want to save a Radial filter adjustment as a preset and then simply apply the preset setting to other images shot using the same lens and at the same aperture range.

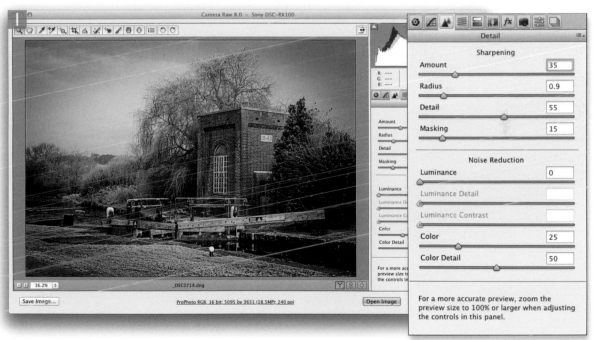

1 Here is a photograph that I shot using a Sony RX-100 compact camera. The image quality is good, though there is a noticeable fall-off in sharpness towards the edges of the frame. I went to the Detail panel and applied the sharpening settings shown here.

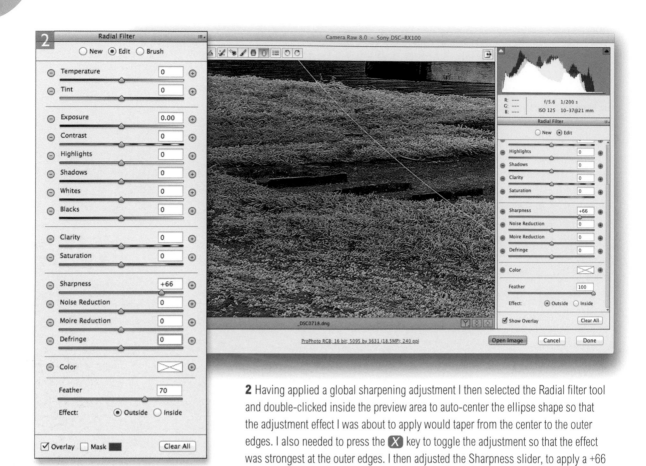

2 Having applied a global sharpening adjustment I then selected the Radial filter tool and double-clicked inside the preview area to auto-center the ellipse shape so that the adjustment effect I was about to apply would taper from the center to the outer edges. I also needed to press the **X** key to toggle the adjustment so that the effect was strongest at the outer edges. I then adjusted the Sharpness slider, to apply a +66 adjustment.

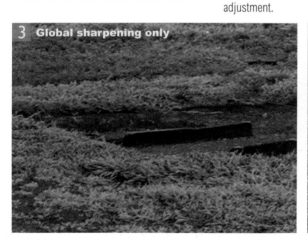

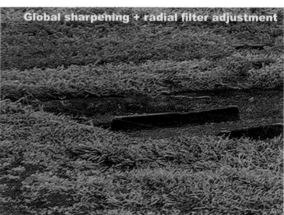

3 Here you can see a comparison of one of the corners of the image where the version on the left shows how the image looked before with the global sharpening only and on the right, how it looked with additional edge sharpening using the Radial filter adjustment.

Camera Raw settings menu

If you mouse down on the Camera Raw menu (circled in Figure 2.86) this reveals a number of Camera Raw settings options. 'Image Settings' is whatever the Camera Raw settings are for the current image you are viewing. This might be a default setting or it might be a custom setting you created when you last edited the image in Camera Raw. 'Camera Raw Defaults' resets the default settings in all the panels and applies whatever the white balance setting was at the time the picture was captured. 'Previous Conversion' applies the Camera Raw settings that were applied to the previously saved image.

If you proceed to make any custom changes while the Camera Raw dialog is open, you'll also see a 'Custom Settings' option. Whichever setting is currently in use will be shown with a check mark next to it and below that is the 'Apply Preset' submenu that lets you quickly access any pre-saved presets (which you can also do via the Presets panel that is discussed on page 253 onwards).

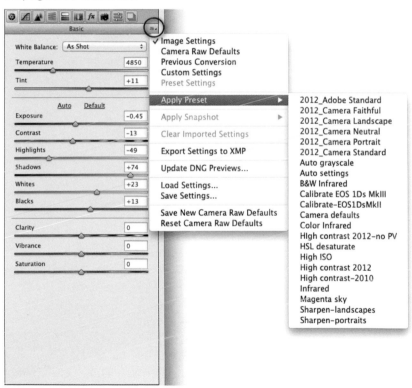

Figure 2.86 The Camera Raw menu options can be accessed via any of the main panels by clicking on the small menu icon that's circled here.

The Camera Raw database

The Camera Raw preferences gives you the option to save the XMP metadata to the Camera Raw database or to the XMP sidecar files (or the XMP space in the file header). If you choose to save to the Camera Raw database, all the Camera Raw adjustments you make will be saved to this central location only. An advantage of this approach is that it makes it easier to back up the image settings. All you have to do is ensure that the database file is backed up, rather than the entire image collection.

On a Mac, the Adobe Camera Raw Database file is stored in: Users/username/ Library/ Preferences. On Windows it is stored in: Settings\Username\Application Data\Adobe\CameraRaw. However, if you are working with Bridge and Lightroom, Lightroom will not be able to pick up any changes made to an image using Camera Raw via Photoshop or Bridge. You then have two options. You either have to remember to select the photos first in Camera Raw and choose 'Export Settings to XMP', or forget about saving image settings to the Camera Raw database and ensure that the 'Save image settings to XMP sidecar files' option is selected in the Camera Raw preferences.

Figure 2.87 When 'Update DNG Previews' is selected you can force update the JPEG previews in a DNG file, choosing either a Medium Size or Full Size preview. You can also choose to 'Embed Fast Load Data'.

Export settings to XMP

If you refer to the Camera Raw preferences shown in Figure 2.20 on page 124, there is an option to save the image settings either as sidecar ".xmp" files, or save them to the 'Camera Raw database'. If the 'sidecar ".xmp" files' option is selected, the image settings information is automatically written to the XMP space in the file header. This is what happens for most file formats, including DNG. In the case of proprietary raw files such as CR2s or NEFs, it would be unsafe for Camera Raw to edit the header information of an incompletely documented file format. To get around this the settings information is stored using XMP sidecar files, which share the same base file name and accompany the image whenever you use Bridge or Lightroom to move a raw file from one location to another. Storing the image settings in the XMP space is a convenient way of keeping the image settings data stored locally to the individual files instead of it being stored only in the central Camera Raw database. If 'Save image settings in Camera Raw database' is selected in the Camera Raw preferences you can always use the 'Export Settings to XMP' option from the Camera Raw options menu (Figure 2.86) to manually export the XMP data to the selected images. For example, if you are editing a filmstrip selection of images and want to save out the XMP data for some images, but not all, you could use the 'Export Settings to XMP' menu command to do this (see also the sidebar).

Update DNG previews

DNG files can store a JPEG preview of how the processed image should look based on the last saved Camera Raw settings. If you refer again to the Camera Raw preferences (Figure 2.20), there is an option to 'Update embedded JPEG previews'. When this is checked, the DNG JPEG previews are automatically updated, but if this option is disabled in the Camera Raw preferences you can manually update the JPEG previews by selecting 'Update DNG Previews…' from the Camera Raw options menu (Figure 2.86). This opens the Update DNG Previews dialog shown in Figure 2.87.

Load Settings… Save Settings…

These Camera Raw menu options allow you to load and save pre-created XMP settings. Overall, I find it preferable to click on the New Preset button in the Preset panel (discussed opposite) when you wish to save a new Camera Raw preset.

Camera Raw defaults

The 'Save New Camera Raw Defaults' Camera Raw menu option creates a new default setting based on the current selected image. Note that these defaults are also affected by the 'Default Image Settings' that have been selected in the Camera Raw preferences (see 'Camera-specific default settings' on page 157).

Presets panel

The Presets panel is used to manage saved custom Camera Raw preset settings.

Saving and applying presets

To save a preset, you can go to the Camera Raw fly-out menu and choose Save Settings… Or, you can click on the Add Preset button in the Presets panel (circled in Figure 2.88) to create a new Camera Raw preset. A preset can be one that is defined by selecting all the Camera Raw settings, or it can be one that

New Camera Raw defaults

The Save New Camera Raw Defaults option will make the current Camera Raw settings sticky every time from now on when Camera Raw encounters a new file. This includes images processed by Bridge. So, for example, if you were working in the studio and had achieved a perfect Camera Raw setting for the day's shoot, you could make this the new Camera Raw default setting. All subsequent imported images will use this setting by default. At the end of the day you can always select 'Reset Camera Raw defaults' from the Camera Raw options menu to restore the default Camera Raw camera default settings.

Figure 2.88 When the Presets panel is selected, you can click on the button at the bottom (circled) to add Camera Raw settings as a new preset. In this example I saved a High ISO preset using the New Preset settings shown in Figure 2.89. You can also use the Load Settings… and Save Settings… menu options to load and save new presets.

Camera Raw preset wisdom

Before you save a Camera Raw preset, it is important to think carefully about which items you need to include in a preset. When saving presets it is best to save just the bare minimum number of options. In other words, if you are saving a grayscale conversion preset, you should save the Grayscale Conversion option only. If you are saving a camera body and ISO-specific camera default, you might want to save just the Camera Calibration and Enable lens profile correction settings. The problem with saving too many attributes is that although the global settings may have worked well for one image, there is no knowing if they will work as effectively on other images. It is therefore a good idea to break your saved presets down into smaller chunks.

Camera Raw dialogs

An *alt*-click shortcut has been added to the Synchronize, New Preset, Save Settings, and Copy/Paste (Bridge) dialogs. What happens now is when you *alt*-click a checkbox item in one of these dialogs, it checks that box exclusively. Just *alt*-click again to toggle back to the previous checkbox state.

is made up of a subset of settings (as shown in Figure 2.89). Either way, a saved preset will next appear listed in the Presets panel as well as in the Apply Preset menu (Figure 2.86). Just click on a setting to apply it to an image. To remove a preset setting, go to the Presets panel, select it and click the Delete button at the bottom—the trash can next to the Add new preset button (see Figure 2.88).

Figure 2.89 The New Preset dialog can be accessed by clicking on the New Preset button (circled in Figure 2.88). You can choose to save All Settings to record all the current Camera Raw settings as a preset. You can select a sub setting selection such as: Basic, or HSL Adjustments, or you can manually check the items that you want to include in the subset selection that will make up a saved Camera Raw preset.

Copying and synchronizing settings

If you have a multiple selection of photos in the Camera Raw dialog you can apply synchronized Camera Raw adjustments to all the selected images at once. For example, you can ⌘ (Mac), *ctrl* (PC)-click or *Shift*-click to make an image selection via the Filmstrip, or click on the Select All button to select all images. Once you have done this any adjustments you make to the most selected photo are simultaneously updated to all the other photos too. Alternatively, if you make adjustments to a single image, then include other images in the Filmstrip selection and choose 'Sync Settings...' from the Filmstrip menu, this pops the Synchronize dialog shown in Figure 2.90. Here you can select the specific settings you wish to synchronize and click OK. The Camera Raw settings will now synchronize to the currently selected image. You can also copy and paste the Camera Raw settings via Bridge. Select an image and choose Edit ⇨ Develop Settings ⇨ Copy Camera Raw Settings (⌘ ⌥ *C* [Mac], *ctrl* *alt* *C* [PC]). Then select the image or images you wish to paste the settings to and choose Edit ⇨ Develop Settings ⇨ Paste Camera Raw Settings (⌘ ⌥ *V* [Mac], *ctrl* *alt* *V* [PC]).

Figure 2.90 When the Synchronize options dialog box appears you can select a preset range of settings to synchronize with or make your own custom selection of settings to synchronize the currently selected images.

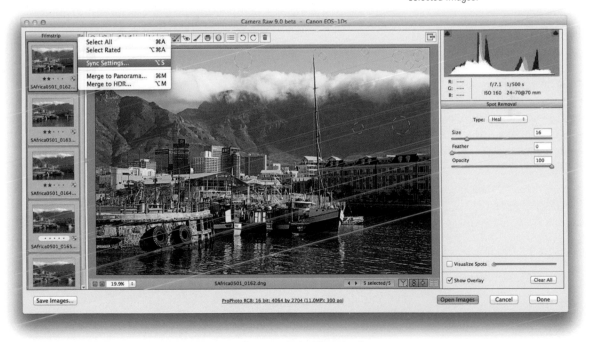

Figure 2.91 In this example, I made a selection of images via the Filmstrip, chose 'Select All', followed by 'Sync Settings', which opened the dialog shown in Figure 2.90.

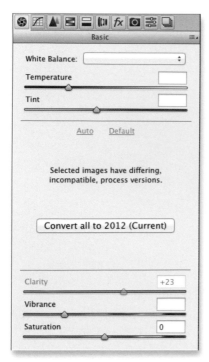

Figure 2.92 If there is a process version conflict when selecting multiple files, there will be the option to convert all the selected files to the process version that's applied to the most selected image.

Copying and pasting settings

Whenever you copy Camera Raw settings, Camera Raw utilizes the Basic panel settings associated with the process version of the selected image, and automatically includes the process version of the image in the copy settings. You can override this by disabling the Process Version box. But as you will gather from what's written here, it is not a good idea to not include the process version when synchronizing or copying settings.

Synchronizing different process versions

The Synchronize command will work as described, providing the photos you are synchronizing all share the same process version. If you have a mixture of process version images selected, the Basic panel will appear as shown in Figure 2.92, highlighting the fact that the selected images have differing, incompatible process versions. What happens next when you synchronize depends on whether you have the Process Versions box checked or not. If checked, it synchronizes the selected photos converting them to the process version of the most selected photo and updates them accordingly. If unchecked, it synchronizes just those settings that are common to the process versions that are applied to the selected images and ignores all the others (see Figure 2.93). Be aware that such synchronizations can produce unexpected-looking results. In any case, converting Process 2012 images to Process 2010 with the Process Version box checked can also produce unpredictable results.

Legacy presets

If the Process Version box is checked when saving a preset (see Figure 2.89), the process version is included when applying the preset to other images. If the photos you apply this preset to share the same process version, no conversion takes place, but if they don't share the same process version they'll have to be converted. If the Process Version box isn't checked when you create a preset, things again become more complicated. In this situation no process version is referenced when applying the preset. Therefore, if you apply a Process 2010 preset (without including the process version) to a Process 2012 image, settings such as Recovery or Fill Light won't be translated. Similarly, if you apply a Process 2012 preset (without including the process version) to a Process 2010 photo, settings like Highlights and Shadows won't be recognized either. Older presets that don't contain Basic or Tone Curve panel adjustments (other than White Balance, Vibrance and Saturation) will still work OK when applied to Process 2012 images. Where legacy presets do contain Basic or Tone Curve panel settings, they'll only continue to work effectively on images that share the same process version. Therefore, when creating new presets it is important to check the Process Version box. When you do this, if the image you apply the preset to has the same process version, the preset is applied as normal. If it has a different process version a conversion is carried out.

Synchronize Process 2010 from a Process 2012 master **Synchronize Process 2012 from a Process 2010 master**

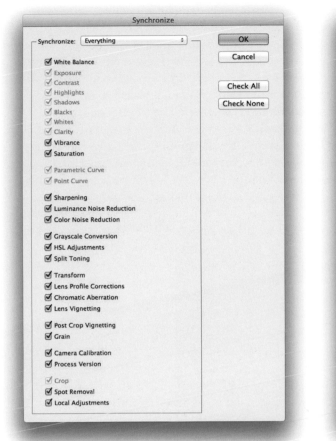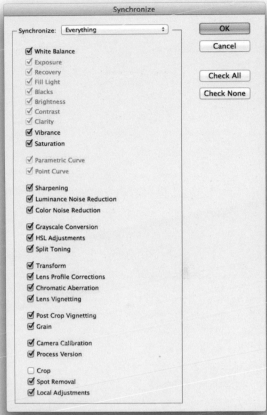

Figure 2.93 If there is a process version mismatch when synchronizing settings, the Process Version box determines what will happen. If checked, those photos with differing process versions will be updated to match the process version of the most selected image. If you attempt to synchronize Process 2010 images from a Process 2012 master, the adjustments that are new in Process 2012: Exposure, Contrast, Highlights, Shadows, Blacks, Whites, Clarity and Tone Curve will be applied by default, which is why the boxes next to the above settings are all checked and dimmed (meaning you can't edit them). Similarly, if you attempt to synchronize Process 2012 images from a Process 2010 master, the Exposure, Recovery, Fill Light, Blacks, Brightness, Contrast, Clarity and Tone Curve adjustments will be checked by default. If you deselect the Process Version box the above process version-specific settings will be disabled completely. When this is done only those settings that can be synchronized (without applying a process version conversion) will be synchronized, which in turn can lead to unpredictable results.

Lightroom snapshots

Working with Snapshots

As you work in Camera Raw you can save favorite Camera Raw settings as snapshots via the Snapshots panel. The ability to save snapshots means you are not limited to applying only one type of Camera Raw rendering to an image. By using snapshots you can easily store multiple settings or looks within the image file's metadata and with minimal overhead, since Camera Raw snapshots will only occupy a small amount of file space. I find snapshots are extremely useful and I use them a lot whenever I wish to experiment with different types of processed looks on individual images, or save in-between states.

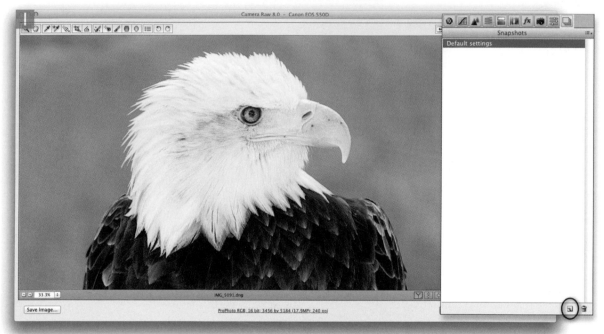

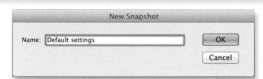

1 The Snapshots panel can be used to store multiple versions of Camera Raw settings. When you visit this panel you may sometimes see a snapshot called 'Import', which will be the setting that was first applied to the photo at the time it was imported. What you can do here is make adjustments to the photo using the Camera Raw controls and use this panel to create new saved snapshots. To begin with I clicked on the Add New Snapshot button (circled) to save this setting as a snapshot called 'Default settings'.

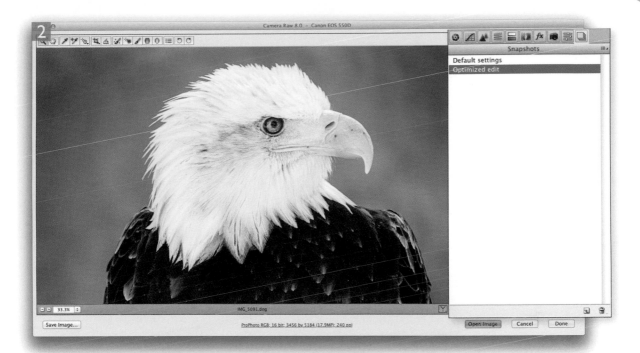

2 I then adjusted the Camera Raw settings to create an optimized adjustment and saved this as an 'Optimized edit' snapshot.

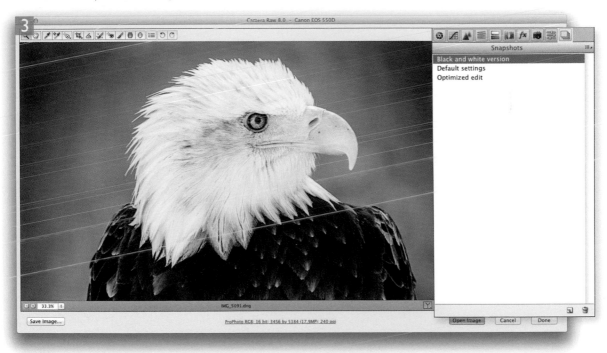

3 After that, I created a black and white version and saved this too as a snapshot.

Raw compatibility and DNG adoption

Eighteen years ago, Adam Woolfitt and I conducted a test report on a range of professional and semi-professional digital cameras. Wherever possible, we shot using raw mode. I still have a CD that contains the master files and if I want to access those images today I am, in some cases, going to have to track down a computer capable of running Mac OS 8.6, in order to load the camera manufacturer software that will be required to read the data! If that is a problem now, what will the situation be like in another 18 years' time? Over the last few years DNG has been adopted by many of the mainstream software programs such as Phase One Media Pro 1, Capture One, Portfolio and Photo Mechanic. At this time of writing, there are Hasselblad, Leica, Pentax, Ricoh, Casio and Samsung cameras that support DNG as a raw capture format option.

DNG file format

In the slipstream of every new technology there follows the inevitable chaos of lots of different new standards competing for supremacy. Nowhere is this more evident than in the world of digital imaging. In the last 20 years or so, we have seen many hundreds of digital cameras come and go along with other computer technologies such as Syquest disks and SCSI cables. In that time I have probably encountered well over a hundred different raw format specifications. It would not be so bad if each camera manufacturer were to adopt a raw format specification that could be applied to all the cameras they produced. Instead we've seen raw formats evolve and change with each new camera model that has been released and those changes have not always been for the better.

The biggest problem is that with so many types of raw formats being developed, how reliable can any one raw format be for archiving your images? It is the proprietary nature of these formats that is the central issue here. At the moment, all the camera manufacturers appear to want to devise their own brand of raw format. As a result of this if you need to access the data from a raw file, you are forced to use *their* brand of software in order to do so. Now, while the camera manufacturers may have excelled in designing great hardware, the proprietary raw processing software they have supplied with those cameras has mostly been quite basic. Just because a company builds great digital cameras, it does not follow they are going to be good at designing the software that's needed to read and process the raw image data.

The DNG solution

Fortunately there are third-party companies who have devised ways to process some of these raw formats, which means you are not always limited to using the software that comes with the camera. Adobe is the most obvious example here of a company able to offer a superior alternative, and at this time of writing, Camera Raw can recognize the raw formats from over 500 different cameras.

The DNG (digital negative) file format specification came about partly as a way to make Adobe's life easier for the future development of Camera Raw and make Adobe Photoshop compatible with as many cameras as possible. DNG is a well thought out file format that is designed to accommodate the many different requirements of the proprietary raw data files

in use today. DNG is also flexible enough to adapt to future technologies and has recently been updated to work with cameras that store proprietary lens correction data in the raw file. Because DNG is an open standard, the specification is freely available for anyone to develop and to incorporate it into their software or camera system. It is therefore hoped that the camera manufacturers will continue to adopt the DNG file format and that DNG will at some point be offered at least as an alternative file format choice on the camera.

DNG brings several advantages. Since it is a well-documented open-standard file format, there is less risk of your raw image files becoming obsolete. There is the potential for ongoing support for DNG despite whatever computer program, computer operating system or platform changes may take place in the future. This is less likely to be the case with proprietary raw files. Can you imagine in, say, 25 years' time there will be guaranteed support for the CR2 or NEF files shot with today's cameras?

DNG compatibility

When raw files are converted to DNG the conversion process aims to take all the proprietary MakerNote information that is sitting alongside the raw image data in the raw original and place it into the DNG. Any external DNG-compatible software should have no problem reading the raw data that is rewritten as a DNG. However, there are known instances where manufacturers have placed some of the MakerNote data in odd places, such as alongside the embedded JPEG preview. At one point this was discarded during the conversion process (but has now been addressed in Camera Raw 5.6 or later). Basically, the DNG format is designed to allow full compatibility, but is in turn dependent on proper implementation of the DNG spec by third parties.

Note that converting JPEGs to DNG won't allow you to magically turn them into raw files, but with the advent of lossy DNG, there are better reasons to now consider doing so. Where a JPEG has been edited using Camera Raw or Lightroom, when you save using the DNG format a Camera Raw generated preview is saved with the file. The advantage of this is that Camera Raw/Lightroom adjustments can now be seen when previewing such images in other (non-Camera Raw aware) programs.

Should you keep the original raws?

It all depends if you feel comfortable discarding the originals and keeping just the DNGs. Some proprietary software such as Canon DPP is able to recognize and process dust spots from the sensor using a proprietary method that relies on reading private XMP metadata information. Since DPP is a program that does not support DNG, if you delete the original CR2 files you won't be able to process the DNG versions in DPP. The only solution here is to either not convert to DNG or choose to embed the original raw file data when you convert to DNG. This means you retain the option to extract the CR2 raw originals any time you need to process them through the DPP software. The downside is you end up with bloated DNG files that will be about double in size.

Saving images as DNG

To convert images to DNG, you can either do so at the time you import photos from the camera, or when you click on the Save Image button in the Camera Raw dialog. This will open the dialog shown in Figure 2.94, where you can see the options available when saving an image using the DNG format.

Lossy DNG

With Camera Raw 7 or later it is possible to save DNG files using lossy compression while preserving most of the raw DNG aspects of the image, such as the tone and color controls. To do this you need to check the 'Use Lossy Compression' option. When this option is enabled you can also reduce the pixel dimensions of a raw image by selecting one of the resize options shown in Figure 2.94. Whenever you resize a DNG in this way the image data has to be demosaiced, but is still kept in a linear RGB space. This means that while the demosaic processing becomes baked into the image, most of the other Develop controls such as those for tone and color remain active and function in the same way as for a normal raw/DNG image. Things like Lens Correction adjustments for vignetting and geometric distortion will be scaled down to the DNG output size. The same is true for sharpening, where the slider adjustments for things like Radius are scaled down to the new downsampled size.

You do want to be careful about where and when you use lossy compression for DNG. On the one hand, 'baking' the demosaic processing is a one-way street. Once done, you'll never be able to demosaic the raw data differently. Will Adobe (or someone else) one day come up with an even better way to demosaic a raw image? Overall, I would say if you don't need to compress your DNG files, then don't—aim to preserve your raw files in as flexible a state as possible. On the other hand, I do foresee some uses. A lot of photographers like to use their digital SLR cameras to create time-lapse videos. Here I reckon it might be a good idea to archive the raw stills for such projects as lossy DNGs. Another benefit of lossy DNG is that I am now able to provide more images from this chapter as downsized DNGs for readers to experiment with.

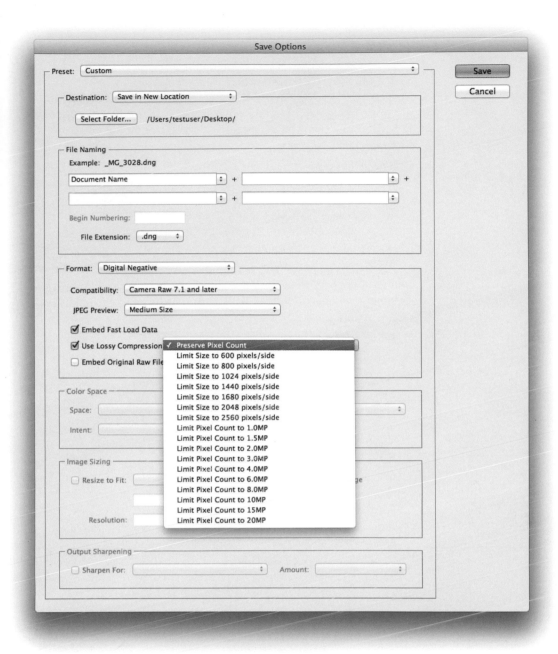

Figure 2.94 The Camera Raw Save Options dialog, showing the Lossy
Compression DNG options, including the pixel size menu choices.

DNG Converter

Adobe have made the DNG Converter program (Figure 2.95) available as a free download from their website: adobe. com/products/dng/main.html. The DNG Converter is able to convert raw files from any camera that is currently supported by Camera Raw. The advantage of doing this is that you can make backups of your raw files in a file format that allows you to preserve all the data in your raw captures and archive them in a format that has a greater likelihood of being supported in the future. I personally feel quite comfortable converting my raw files to DNG and deleting the original raw files. I don't see the need to embed the original raw file data in the DNG file since this will unnecessarily increase the file size. However, if you do feel it is essential to preserve complete compatibility, embedding the original raw file data will allow you to extract the original native raw file from the DNG at some later date. The advantage of this is it provides complete compatibility with the camera manufacturer's software. The downside is that you may more than double the size of your DNG files.

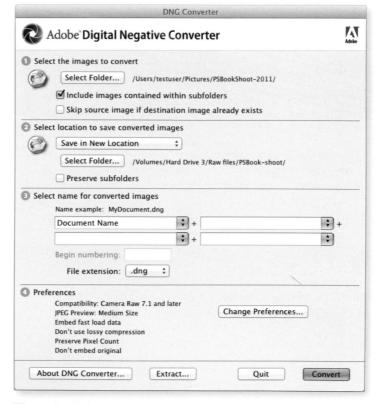

Figure 2.95 The DNG Converter program.

Chapter 3

Sharpening and
noise reduction

This chapter is all about how to pre-sharpen your photographs
in Photoshop and reduce image noise. Here, I will be
discussing which types of images need pre-sharpening,
which don't and what are the best methods to use for camera
captured or scanned image files.

In earlier editions of this book I found it necessary to go
into a lot of detail about how to use the Unsharp Mask filter
and the Photoshop refinement techniques that could be
used to improve the effectiveness of this filter. Now that the
sharpening and noise reduction controls in Camera Raw have
been much improved, I strongly believe that it is best to carry
out the capture sharpening and noise reduction for both raw
and scanned TIFF images in Camera Raw first, before you take
them into Photoshop. Therefore, the first part of this chapter
is devoted entirely to Camera Raw sharpening and noise
reduction.

Real World Image sharpening

If you want to learn more about image sharpening in Camera Raw, Lightroom and Photoshop then I can recommend: *Real World Image Sharpening with Adobe Photoshop, Camera Raw, and Lightroom* (2nd Edition) which is available from Peachpit Press. ISBN: 0321637550. The first edition was authored by Bruce Fraser. This new version is an update of Bruce's original book, now co-authored by Jeff Schewe.

Print sharpening

I should also mention here that this chapter focuses solely on the capture and creative sharpening techniques for raw and non-raw images. I placed this chapter near the beginning of the book quite deliberately, since capture sharpening should ideally be done first (at the Camera Raw stage) before going on to retouch an image. The output sharpening, such as the print sharpening, should be done last. For more about print output sharpening, please refer to Chapter 10.

When to sharpen

All digital images will require sharpening at one or more stages in the digital capture and image editing process. Even with the best camera sensors and lenses, it is inevitable that some image sharpness will get lost along the way from capture through to print. At the capture end, image sharpness can be lost due to the quality of the optics and the image resolving ability of the camera sensor, which in turn can also be affected by the anti-aliasing filter that covers the sensor (and blurs the camera focused image very slightly). With scanned images you have a similar problem, where the resolving power of the scanner sensor and the scanner lens optics can lead to scans slightly lacking in sharpness. These main factors can all lead to capture images that are less sharp than they should be.

When it comes to making a print, this too results in a loss of sharpness, which is why it is always necessary to add some extra sharpening, just before you send the photograph to the printer. Also, between the capture and print stages you may find that some photographs can do with a little localized sharpening to make certain areas of the picture appear that extra bit sharper. This briefly summarizes what we call a multi-pass sharpening workflow: capture sharpening followed by an optional creative sharpen, followed by a final sharpening for print.

Why one-step sharpening is ineffective

It may seem like a neat idea to use a single step sharpening that takes care of the capture sharpening and print sharpening in one go, but it's just not possible to arrive at a formula that will work for all source images and all output devices. There are too many variables that have to be taken into account and it actually makes things a lot simpler to split the sharpening into two stages. A capture image sharpening should be applied at the beginning, dependent on the source image characteristics and an appropriate amount of output sharpening should be applied at the end, dependent on the type of print you are making and the print output size.

Capture sharpening

The majority of this chapter focuses on the capture sharpening stage, which is also referred to as pre-sharpening. It is critical that you get this part right because capture sharpening is one of the first things you do to an image before you start to do any retouching work. The question then is, which images need

sharpening and of those that do need sharpening, how much sharpening should you apply?

Let's deal with JPEG capture images first. If you shoot using the JPEG mode, your camera will already have sharpened and attempted to reduce the noise in the capture data, so no further pre-sharpening or noise reduction should be necessary. Since JPEG captures are created already pre-sharpened there is no way to undo what has already been fixed in the image. I suppose you could argue that there are some cameras that allow you to disable the sharpening in JPEG mode and you could do this separately in Camera Raw, but I think this runs counter to the very reason why some photographers prefer to shoot JPEG in the first place. They do so because they want their pictures to be fully processed and ready to proceed to the retouching stage. So, if you are shooting exclusively in JPEG mode, capture sharpening isn't something you really need to worry about and you can skip the first section of this chapter.

If you shoot in raw mode it won't matter what sharpen settings you have set on your camera; these will have no effect on the raw file. Any capture sharpening must be done either at the raw processing stage or afterwards in Photoshop. It now makes sense to carry out the capture sharpening at the Camera Raw image processing stage *before* you open your images in Photoshop.

Capture sharpening for scanned images

Scanned images may have already been pre-sharpened by the scanning software and some scanners will do this automatically without you even realizing it. If you prefer to take control of the capture sharpening yourself you should be able to do so by disabling the scanner sharpening and use whatever other method you prefer. For example, you could use a third-party plug-in like PhotoKit Sharpener™, or follow the Unsharp Mask filter techniques I describe in the Image Sharpening PDF on the website. So long as you export your scanned images using the TIFF or JPEG format, you can also use the Detail panel controls in Camera Raw to sharpen them.

So what about all those techniques that rely on Lab mode sharpening or luminosity fades? Well, if you analyze the way Camera Raw applies its sharpening, these controls have almost completely replaced the need for the Unsharp Mask filter. In fact, I would say that the Unsharp Mask filter has for some time now been a fairly blunt instrument for sharpening

PhotoKit™ Sharpener

Bruce Fraser devised the Pixel Genius PhotoKit Sharpener plug-in, which can be used to apply capture, creative and output sharpening via Photoshop. The work Bruce did on PhotoKit capture sharpening inspired the improvements made to the Sharpening controls in Camera Raw. It can therefore be argued that if you use Camera Raw you won't need to use PhotoKit Sharpener capture sharpening routines. Adobe also worked closely with Pixel Genius to bring the PhotoKit Sharpener output routines to the Lightroom Print module. If you are using Lightroom 2.0 or later, you can take advantage of this. However, if you have Photoshop and Lightroom, PhotoKit Sharpener can still be useful for the creative sharpening and halftone sharpening routines it provides.

images, plus I don't think it is advisable to convert from RGB to Lab mode and back again if it's not necessary to do so. Compare the old ways of sharpening (including the techniques I described in my earlier books) with the Camera Raw method and I think you'll find that this is now the most effective, if not the only way to capture sharpen your photos.

Process versions

As I mentioned in Chapter 2, Process Versions updates for Camera Raw have seen new changes to the way raw images are handled. Since Camera Raw 6 and the introduction of Process 2010, there have been refinements to capture sharpening in Camera Raw. As a result of this, legacy photos processed via Camera Raw 5 or earlier and photos processed via Lightroom 2 or earlier are classified as using Process 2003. All photos that have been edited subsequently in Camera Raw 6 or later can now be edited using Process 2010 or Process 2012.

Improvements to Camera Raw sharpening

The latest versions of Camera Raw using Process 2010 or 2012, offer better demosaic processing, sharpening and noise reduction. The combination of these three factors has led to better overall image processing. Having said that, it should be noted that it is mainly only those cameras that use the three-color Bayer pattern sensors that are affected by this change. The demosaic processing for other types of sensor patterns such as the four-color shot cameras and the Fuji SuperCCD have not been modified. However, improvements have been made in the demosaic processing for specific camera models. For example, an improved green balance algorithm addresses the problem of maze pattern artifacts, which were seen with the Panasonic G1 camera and this may also improve the image resolution for some other camera models too.

Let me try and explain what exactly has changed and how Camera Raw is now different. We can start by looking at the two image examples shown in Figure 3.1, where the top image shows a photograph edited using Process 2003 and the bottom one shows the same image processed via Camera Raw using Process 2010 (the underlying demosaic processing is effectively the same in Process 2012). What you see here is a section of an image that's been enlarged to 400% so that you can see the difference more clearly. The first thing to point out is that the Process 2010/2012 demosaic process is more

Figure 3.1 This shows a comparison between a raw image processed in Process 2003 (top) and Process 2010 (bottom). Shown here is a magnified 4:1 comparison view.

Ideal noise reduction

The thing to understand here is that the ideal noise reduction in the demosaic process isn't where every trace of noise gets removed from the image. OK, so you might think this would be a good thing to achieve, but you would in fact end up with a photograph where the image detail in close-up would look rather plastic and over-smooth in appearance.

'noise resistant', which means it does a better job of removing the types of noise we find unpleasant such as color artifacts and structured (or pattern) noise. At the same time, the aim has been to preserve some of the residual, non-pattern noise which we do find appealing. The underlying principle at work here is that colored blotches or regular patterns tend to be more noticeable and obtrusive, whereas irregular patterns such as fine, random noise are considered more pleasing to the eye. The new demosaic process therefore does a better job of handling color artifacts and filters the luminance noise to remove any pattern noise, yet retains some of the fine, grain-like structure. The result of this precise filtering is images that are as free as possible of ugly artifacts, yet retain a fine-grain-like structure that photographers might be tempted to describe as being 'film-like'. The net result is that Camera Raw is able to do a better job of preserving fine detail and texture and this will be particularly noticeable when analyzing higher ISO raw captures.

The next component is the revised sharpening. Sharpening is achieved by adding halos to the edges in an image. Generally speaking, halos add a light halo on one side of an edge and a dark halo on the other. To quote Camera Raw engineer Eric Chan (who worked on the new Camera Raw sharpening), "good sharpening consists of halos that everybody sees, but nobody notices." To this end, the halo edges in Camera Raw have been made more subtle and rebalanced such that the darker edges are a little less dark and the brighter edges are brighter. They are still there of course but you are less likely to actually 'see' them as visible halos in an image. You should only notice them in the way they create the illusion of sharpness. The Radius sharpening was also improved. When you select a Sharpen Radius that's within the 0.5–1.0 range the halos are now made narrower. Previously the halos were still quite thick at these low radius settings and it should now be possible to sharpen fine-detailed subjects more effectively. You'll also read later how the Detail panel Sharpen settings are linked to the Sharpen mode of the Adjustment tools. This means you can use the adjustment brush, graduated filter or radial filter as creative sharpening tools to 'dial in' more (or less) sharpness. Lastly, we have the improved noise reduction controls which, compared to Process 2003, offer more options than before for removing the luminance and color noise from a photograph.

Sample sharpening image

To help explain how the Camera Raw sharpening tools work, I have prepared a sample test image that you can access from the book website. The Figure 3.2 image has been especially designed to highlight the way the various slider controls work when viewed at 100%. Although this is a TIFF image, it's one where the image has been left unsharpened and the lessons you learn here can equally be applied to sharpening raw photos.

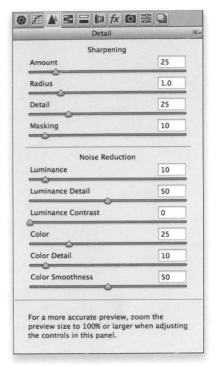

Figure 3.3 This shows the Detail panel in the Camera Raw dialog. Note that the Luminance Detail, Luminance Contrast, Color Detail and Color Smoothness sliders will only appear active if the image has been updated to Process 2010 or Process 2012.

Figure 3.2 The sample image that's used on the following pages can be found on the website. To open this photo via Camera Raw, use Bridge to locate the test image and use File ⇨ Open in Camera Raw, or use the ⌘ R (Mac) ctrl R (PC) keyboard shortcut.

Detail panel

To sharpen an image in Camera Raw, I suggest you start off by going to Bridge, browse to select a photo and choose File ⇨ Open in Camera Raw, or use the ⌘ R (Mac) ctrl R (PC) keyboard shortcut. The Sharpening controls are all located in the Detail panel in the Camera Raw dialog (Figure 3.3). If the photo won't open via Camera Raw, check you have enabled TIFF images to open via Camera Raw in the Camera Raw preferences (see page 124).

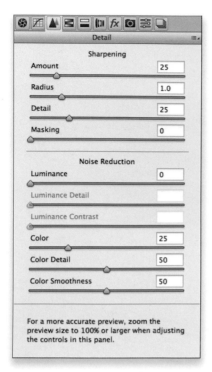

For a more accurate preview, zoom the
preview size to 100% or larger when adjusting
the controls in this panel.

Figure 3.4 This shows the default settings
for the Detail panel in Camera Raw when
processing a raw image.

Sharpening defaults

The Detail panel controls consist of four Sharpening slider controls: Amount, Radius, Detail and Masking. When you open a raw image via Camera Raw, you will see the default settings shown in Figure 3.4. But if you open a non-raw image up via Camera Raw, such as a JPEG or TIFF, the Amount setting defaults to 0%. This is because if you open a JPEG or TIFF image via Camera Raw it is usually correct to assume the image has already been pre-sharpened, so the default Amount sharpening for non-raw files is always set to zero. You should only apply sharpening to JPEGs or TIFF images if you know for sure that the image has not already been sharpened. Note that the TIFF image used in the following steps should normally open with zero sharpening and noise reduction settings.

The Noise Reduction sliders can be used to remove image noise and we'll come onto these later, but for now I just want to guide you through what the sharpening sliders do.

The sharpening effect sliders

Let's start by looking at the two main sharpening effect controls: Amount and Radius. These control how much sharpening is applied and how the sharpening gets distributed.

If you want to follow the steps shown over the next few pages, I suggest you download a copy of the Figure 3.2 image from the website and use Bridge to open it via the Camera Raw dialog. To do this use File ⇨ Open in Camera Raw, or use the ⌘ R (Mac) ctrl R (PC) keyboard shortcut. Then go to the Detail panel section (Figure 3.4). If you are viewing a photo at a fit to view preview size you will see a warning message that says: 'For a more accurate preview, zoom the preview size to 100% or larger when adjusting the controls in this panel', which means you should follow the advice given here and set the image view magnification in the Camera Raw dialog to a 100% view or higher. The test image I created is actually quite small and will probably display at a 100% preview size anyway. The main thing to remember is that when you are sharpening images, the preview display should always be set to a 100% view or higher for you to judge the sharpening accurately. In addition to this I should also point out that the screen shots over the next few pages were all captured as grayscale sharpening previews, where I held down the alt key as I dragged the sliders. If you are using Process Version 2003 you will only get to see these grayscale previews if you are viewing the image at a 100% view or bigger.

Amount slider

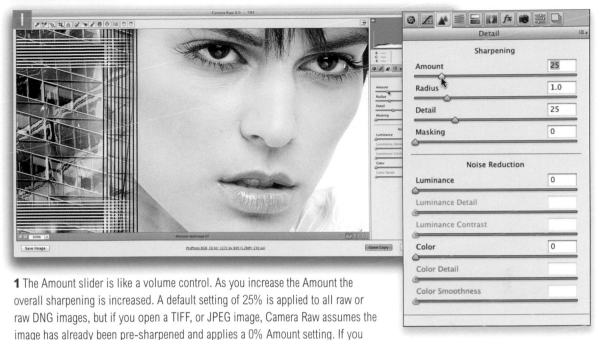

1 The Amount slider is like a volume control. As you increase the Amount the overall sharpening is increased. A default setting of 25% is applied to all raw or raw DNG images, but if you open a TIFF, or JPEG image, Camera Raw assumes the image has already been pre-sharpened and applies a 0% Amount setting. If you are editing the downloaded image you will need to set this to 25% to simulate the default shown here.

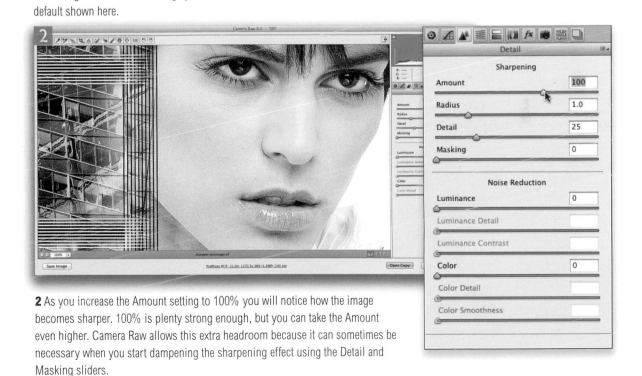

2 As you increase the Amount setting to 100% you will notice how the image becomes sharper. 100% is plenty strong enough, but you can take the Amount even higher. Camera Raw allows this extra headroom because it can sometimes be necessary when you start dampening the sharpening effect using the Detail and Masking sliders.

Radius slider

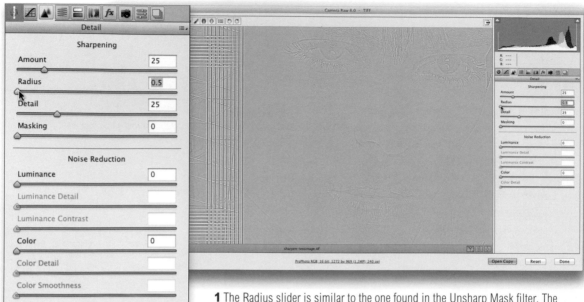

1 The Radius slider is similar to the one found in the Unsharp Mask filter. The Radius determines the width of the halos that are generated around the edges in a photo. A small radius setting can be used to pick out fine detail in a picture, but will have a minimal effect on the soft, wider edges in a picture.

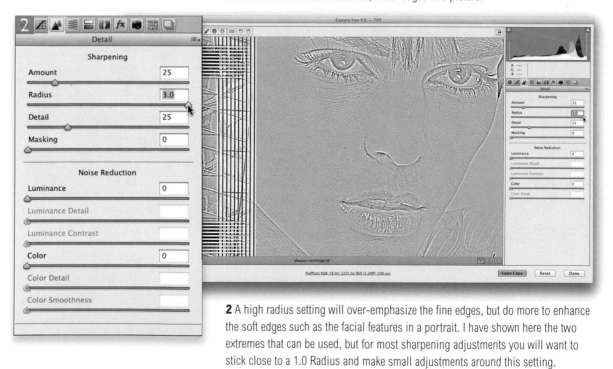

2 A high radius setting will over-emphasize the fine edges, but do more to enhance the soft edges such as the facial features in a portrait. I have shown here the two extremes that can be used, but for most sharpening adjustments you will want to stick close to a 1.0 Radius and make small adjustments around this setting.

The suppression controls

The Amount and Radius sliders control the sharpening effect. The next two sliders act as 'suppression' controls. These constrain the sharpening and target the effect where it is most needed.

Detail slider

The Detail slider acts as a halo suppressor/concentrator. For example, increasing the Detail allows you to increase the Amount sharpening but without generating too noticeable halo edges in the image. There has always been a certain amount of halo suppression built into the Camera Raw sharpening, but you can now use the Detail slider to fine-tune the Amount and Radius effects. One of the recent minor changes to Camera Raw sharpening means that Detail slider settings above 50 are more likely to exaggerate any areas that contain fine-textured detail (such as noise). As a result you may want to avoid setting the Detail too high when processing high ISO images. One way to cure this is to increase the Masking setting. With low ISO images it is certainly safer to use a high Detail setting. In fact, Eric Chan, who worked on the Camera Raw sharpening, points out he often uses a +100 Detail setting on his low ISO landscape images.

Detail slider settings

As you take the Detail slider below the default 25 value it acts as a halo suppressor that suppresses the amount of contrast in the halos. As you set the Detail slider above 25 it acts as a 'high frequency concentrator', which is to say it biases the amount of sharpening, applying more to areas of high frequency and less to areas of low frequency.

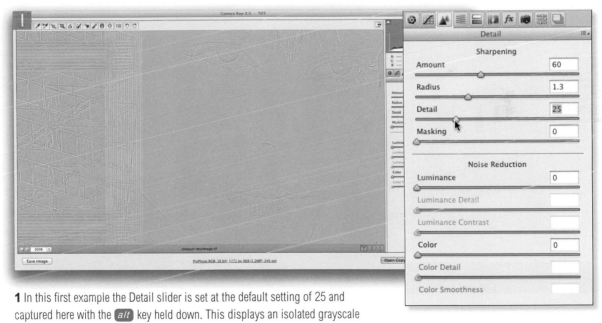

1 In this first example the Detail slider is set at the default setting of 25 and captured here with the *alt* key held down. This displays an isolated grayscale preview of the sharpening effect. At this setting the Detail slider gently suppresses the halo effects to produce a strong image sharpening effect but without over-emphasizing the fine detail or noisy areas of the image.

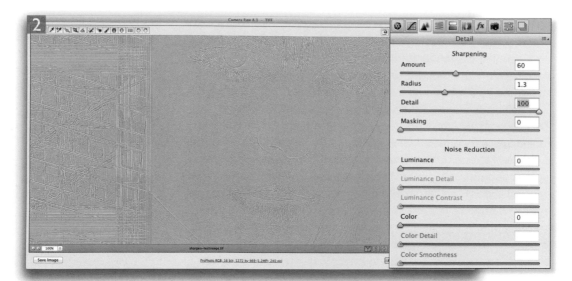

2 If you take the Detail slider all the way up to 100, the capture sharpening will be similar to a standard unsharp mask filter effect applied in Photoshop at a zero Threshold setting.

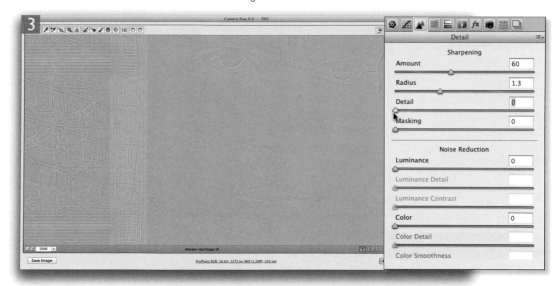

3 If, on the other hand, you take the Detail slider down to zero you can see how the image looks with maximum halo suppression. What we learn from this is how to set the Detail slider between these two extremes. For portraits and other subjects that have soft edges, I would recommend a lowish Detail setting of around 20–30 so that you prevent the flat tone areas from becoming too noisy. For images that have lots of fine detail I would mostly suggest using a higher value of 30–50, because you don't want to suppress the halo edges quite so much. With these types of photos you probably will want to add more emphasis to the fine edges.

Interpreting the grayscale previews

In the screen shots you have seen so far, I captured all these with the `alt` key held down as I dragged on the sliders. In the case of the Amount and Radius adjustments, holding down the `alt` key allows you to preview the effect these two adjustments have on the full color image by displaying a grayscale image which shows the sharpening effect as applied to the luminance information only.

One of the things that has long been known about the conventional Photoshop unsharp masking method is that a 'normal mode' unsharp mask filter effect sharpens all the color channels equally. It is mainly for this reason that people have in the past strived to sharpen the image luminance detail only, without actually sharpening the color information. This is what the 'convert to Lab mode, sharpen the Lightness channel and convert back to RGB mode' technique is doing. The same principle applies when using an Edit ⇨ Fade Unsharp Mask ⇨ Luminosity mode fade. With Camera Raw the sharpening is always applied to the luminance of the image, which is why you shouldn't see any unwanted color artifacts generated whenever you apply a sharpening effect. This explains the purpose of the grayscale preview for the Amount slider. It is designed to show you exactly how the sharpening is applied to the luminance of the photo, hiding the color information so that you can judge the sharpening effect more easily.

Radius and Detail grayscale preview

With the Radius and Detail sliders you are seeing a slightly different kind of preview when you hold down the `alt` key as you adjust these sliders. The grayscale preview you see here displays the sharpening effect in isolation as if it were a sharpening effect applied on a separate layer. For those of you who are well-acquainted with Photoshop layering techniques, imagine a layer in Photoshop that is filled with 50% gray and where the blend mode is set to 'Overlay'. Such a layer will have no effect on the layers beneath it until you start darkening or lightening parts of that layer. In Figure 3.5 you can see a mock up of what the Detail grayscale preview is actually showing you. It effectively displays the sharpening effect in isolation as light and dark areas against a neutral, midtone gray.

Figure 3.5 This is a Photoshop simulation of what the grayscale Radius and Detail previews in Camera Raw are showing you. Imagine the sharpening effect being carried out on a separate layer above the background layer with the blend mode set to Overlay. When using the Overlay blend mode, a 50% gray has no effect on the layer below. Any gray tone that's darker than 50% darkens the layer below and any gray that's lighter than 50% lightens it. If you consider a Camera Raw Detail panel grayscale preview in this context you will understand better that the low contrast preview image represents an isolated preview of the sharpening effect.

Figure 3.6 Here is another simulation of what the Camera Raw Masking slider grayscale preview is showing you. As you hold down the `alt` key and drag the Masking slider you are effectively previewing a layer mask that masks the sharpening layer effect. In other words, the Masking slider preview shown opposite is kind of showing you a pixel layer mask preview of the masking effect.

Masking slider

The Masking slider can be used to add a filter mask based on the edge details of an image. Essentially, this allows you to target the Camera Raw sharpening so that the sharpening adjustments are more targeted to the edges in the image rather than sharpening everything globally. As you adjust the Masking slider a mask is generated based on the image content, so that areas of the image where there are high contrast edges remain white (the sharpening effect is unmasked) and in the flatter areas of the image where there is smoother tone detail the mask is made black (the sharpening effect is masked). If you take the Masking slider all the way down to zero, no mask is generated and the sharpening effect is applied without any masking. As you increase the Masking, more areas become protected.

I like to think of the effect the Masking slider has on the Camera Raw sharpening as being like a layer mask that masks the layer that's applying the sharpening effect (see the Photoshop example shown in Figure 3.6). The calculations required to generate the mask are quite intensive, but on a modern, fast computer you should hardly notice any slow-down.

I should also mention here how the Masking slider was inspired by a Photoshop edge masking technique that was originally devised by Bruce Fraser. You can read all about Bruce's Photoshop techniques for Input and Output sharpening in an updated version of his book, which is now co-authored with Jeff Schewe: *Real World Image Sharpening with Adobe Photoshop, Camera Raw and Lightroom (2nd Edition)*. This book includes instructions on how to apply the edge masking technique that's referred to here. As I said earlier, because of how the sharpening controls have been updated in Camera Raw, the Detail panel slider controls now provide a much better capture sharpening workflow solution. For example, the original Photoshop edge masking technique (on which this is based) could only ever produce a fixed width mask edge. While you could vary some of the settings to refine the look of the final mask, it was still rather tricky and cumbersome to do so. With Camera Raw it is now much easier to vary the mask width because we now have a single slider control that does everything.

Masking slider example

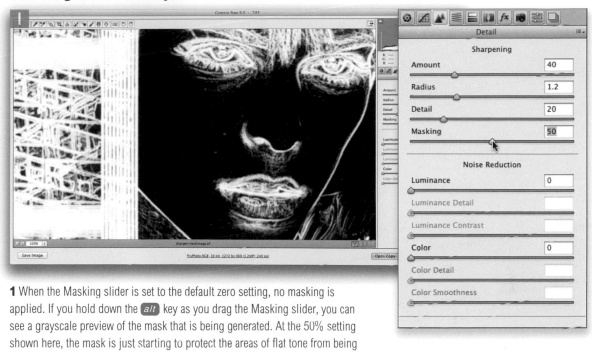

1 When the Masking slider is set to the default zero setting, no masking is applied. If you hold down the [alt] key as you drag the Masking slider, you can see a grayscale preview of the mask that is being generated. At the 50% setting shown here, the mask is just starting to protect the areas of flat tone from being sharpened.

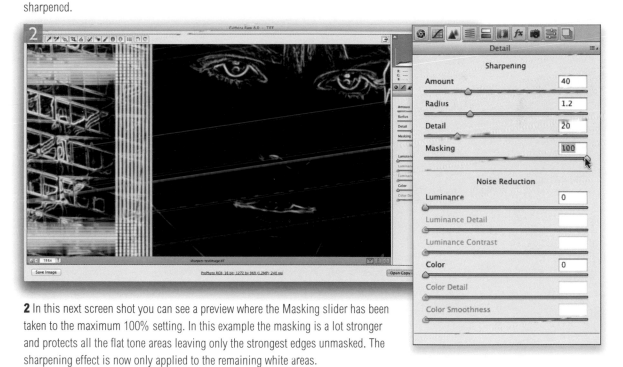

2 In this next screen shot you can see a preview where the Masking slider has been taken to the maximum 100% setting. In this example the masking is a lot stronger and protects all the flat tone areas leaving only the strongest edges unmasked. The sharpening effect is now only applied to the remaining white areas.

Some real world sharpening examples

Now that I have given you a rundown on what the individual Sharpening sliders do, let's look at how you would use them in practice to sharpen an image.

Sharpening portrait images

Figure 3.7 shows a 1:1 close-up view of a portrait shot where I used the following settings: *Amount: 35, Radius: 1.2, Detail: 20, Masking 70.* This combination of Sharpening slider settings is most appropriate for use with portrait photographs, where you wish to sharpen the important areas of detail such as the eyes and lips, but protect the smooth areas (like the skin) from being sharpened.

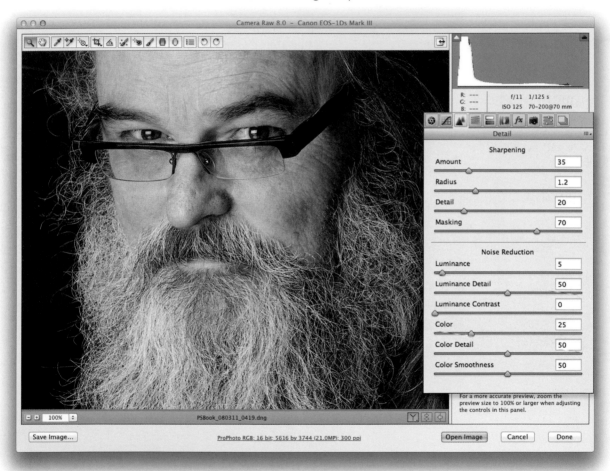

Figure 3.7 Here is an example of the sharpening settings used to pre-sharpen a portrait.

Sharpening landscape images

Figure 3.8 shows the settings that would be used to sharpen a landscape image. The settings used here were: *Amount: 40, Radius: 0.8, Detail: 50, Masking: 10*. This combination of Sharpening slider settings is most appropriate for subjects like the example shown below. You can include quite a wide range of subject types in this category and basically you want to use this particular combination of slider settings whenever you needed to sharpen photographs that contain a lot of narrow edge detail. Process 2010/2012 generates narrower halo edges whenever the Radius slider is applied in the 0.5–1.0 range. This has resulted in the ability to apply lower Radius settings to fine-detailed images that need a low radius, but without generating such noticeable halos.

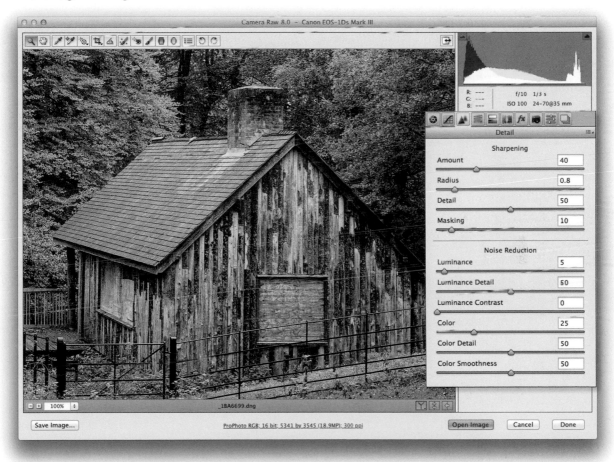

Figure 3.8 Here is an example of the sharpening settings used to pre-sharpen a landscape photograph.

Sharpening a fine-detailed image

Figure 3.9 shows an example of a photograph that contains a lot of fine-edge detail. In order to sharpen the fine edges in this picture I took the Radius down to a setting of 0.7. I also wanted to emphasize the detail here and therefore ended up setting the Detail slider to +90. This is a lot higher than one would choose to use normally, but I have included this particular image in order to show an example of a photograph that required a unique treatment. As with the previous example, I only needed to apply a very small amount of Masking since there were few areas in the photograph where I needed to hide the sharpening.

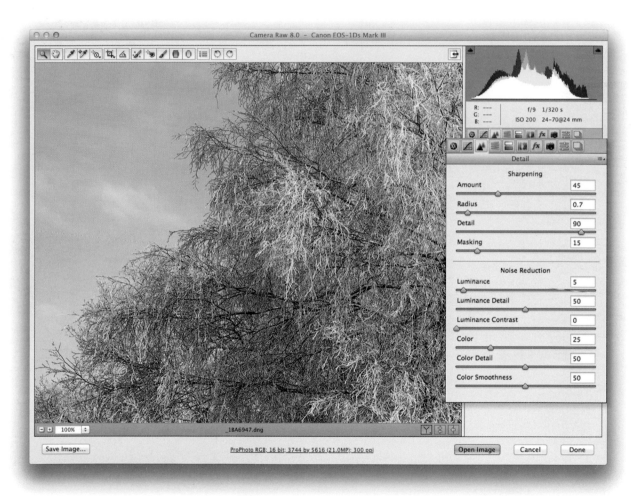

Figure 3.9 This shows an example of the Detail panel sharpening settings that were used to pre-sharpen a fine-detailed subject.

How to save sharpening settings as presets

You can save the sharpening settings as ACR presets and then, depending on what type of photo you are editing, load them as required. You could try using the settings in Figure 3.7, 3.8 or 3.9 to create sharpening presets that can be applied to other photographs.

Default sharpening settings

The standard default sharpening setting for raw images uses the settings shown earlier in Figure 3.4. This isn't a bad starting point, but based on what you have learned in the last few examples, you might like to modify this and set a new default. For example, if most of the work you shoot is portraiture, you might like to use the settings shown in Figure 3.7 and set these as a default and make this setting specific to your camera (see page 157).

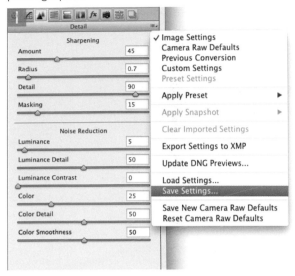

1 After configuring the Detail panel settings, go to the fly-out menu and choose 'Save Settings…'

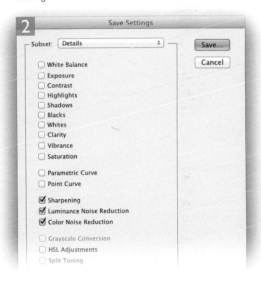

2 This opens the Save Settings dialog shown here. Choose the Details setting from the Subset menu and click the Save… button.

Settings folder location

On a Mac, the Camera Raw Settings folder location is: username/Library/Application Support/Adobe/Camera Raw/Settings. On a PC, look for: C:\Documents and Settings\ username\Application Data\Adobe\ CameraRaw\Settings.

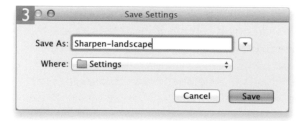

3 Now name the setting and save to the default Settings folder. Don't change the directory location you are saving the setting to here.

4 When you need to access a saved setting, go to the Settings panel in Camera Raw and click on a saved setting to apply it to the image. Since the setting selected here saved the Sharpening adjustments only, when selected this preset only adjusts the Sharpening sliders when it's applied to another image.

Capture sharpening summary

Hopefully this section has given you the confidence to now carry out all your capture sharpening in Camera Raw. Remember, the only images that should need pre-sharpening are camera shot raws or scanned TIFFs, although you can process any image in Camera Raw providing it is in a JPEG, TIFF, raw or DNG format and in an RGB, Lab or CMYK mode color space. Although in the case of CMYK images these will (behind the scenes) get converted to RGB internally before being processed in Camera Raw.

As I explained in the previous section, you should use the Camera Raw Sharpening controls to tailor the capture sharpening adjustment to suit the image content. Soft edged subjects such as portraits will suit a higher than 1.0 Radius setting combined with a low Detail and high Masking setting, Fine-detailed subjects such as the Figure 3.8 and 3.9 examples will suit using a low Radius, high Detail and low Masking setting. The aim always is to apply enough sharpening to make the subject look visually sharp on the screen, but without over-sharpening to the point where you see any edge artifacts or halos appear in the image. If you overdo the capture sharpening you are storing up trouble for later when you come to retouch the photograph.

Two Smart Object sharpening layers

An alternative approach is to use the 'Open raw files as Smart Objects' technique described on page 112 to open an image twice. You can then apply one set of Detail panel settings to one Camera Raw Smart Object layer and a different type of sharpening effect to the other Camera Raw Smart Object layer. You can then use a layer mask to blend these two layers so that you are able to combine two different methods of sharpening in the one image.

Selective sharpening in Camera Raw

With some images it can be tricky to find the optimum settings that will work best across the whole of the image. This is where it can be useful to use the localized adjustment tools to selectively modify the sharpness of an image. Basically, whenever you are using the adjustment brush, gradient filter, or radial filter tools in Camera Raw you can use the Sharpness slider to add more or less sharpness. In particular, with Camera Raw 6 or later, as you increase the Sharpness, the sharpness applied using a brush or gradient increases the sharpness 'Amount' setting based on the other settings already established in the Detail panel Sharpening section.

Negative sharpening

You can also apply negative local sharpening in the zero to −50 range to fade out existing sharpening. Therefore, if you apply −50 sharpness as a localized adjustment this means you can use the adjustment tools to disable the capture sharpening. As you apply a negative sharpness in the −50 to −100 range, you start to apply anti-sharpening, which produces something like a gentle lens blur effect.

Extending the sharpening limits

You can also go beyond the +100/−100 limit set by the Sharpness slider by applying multiple sharpness adjustments. To do this you need to create a new brush group using a new Sharpness setting and paint on top of an existing brush group.

How to apply localized sharpening

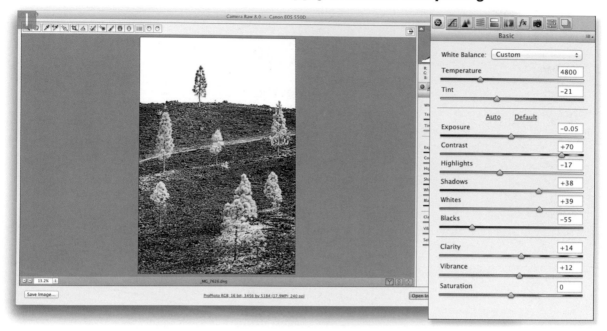

1 In this photograph I had the camera switched to auto focus mode. Although the trees at the top were fairly sharp, some of those at the bottom weren't.

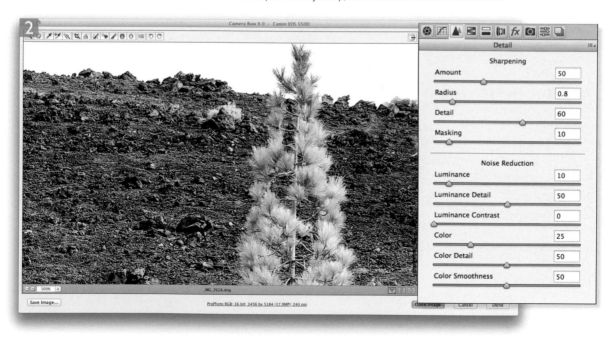

2 To start with I clicked to select the Detail panel and adjusted the Sharpening sliders to obtain the optimum sharpness for a tree near the top of the picture.

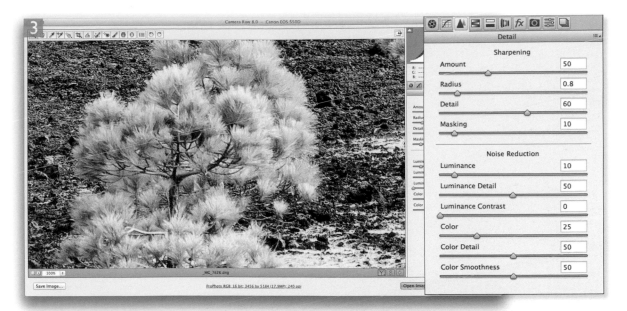

3 Here you can see a close-up view of a tree at the bottom, which even with the benefit of capture sharpening is clearly not as sharp as the one at the top.

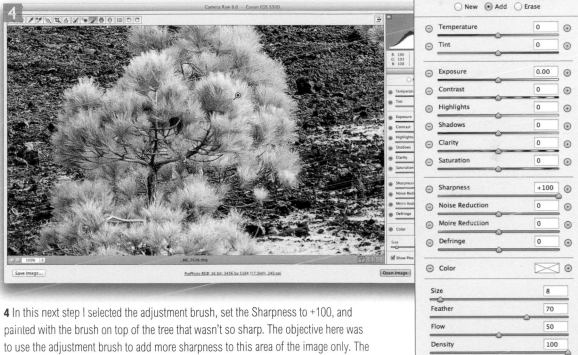

4 In this next step I selected the adjustment brush, set the Sharpness to +100, and painted with the brush on top of the tree that wasn't so sharp. The objective here was to use the adjustment brush to add more sharpness to this area of the image only. The Amount setting for the Sharpness slider effectively added an extra Sharpness amount using the same Radius, Detail and Masking settings as had already been applied via the Detail panel in Step 2.

Negative sharpening to blur an image

Here is an example of how to use a negative Sharpness amount to deliberately blur an image. Again, it is possible to apply multiple passes of negative sharpening, but the effect will eventually max out and, beyond a certain point and won't add any extra blurring. You can't yet apply what you might call a true lens blur effect in Camera Raw. Having said that it's still possible to be used effectively as a creative tool and there is one use where I think this technique would be particularly useful and that is when shooting a sequence of images to be incorporated into a time-lapse video. Rather than having to render every frame as a TIFF or JPEG and process each of these in Photoshop using the Lens Blur filter, doing this in Camera Raw can still be quite effective and offers the ultimate in flexibility.

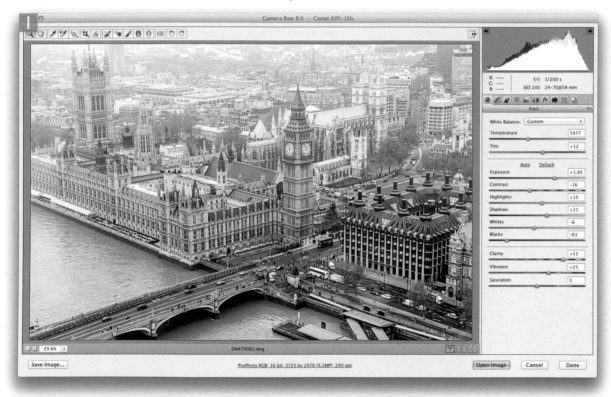

1 Here you can see a photograph opened in Camera Raw, where the aim was to apply a combination of negative sharpening effects and eventually synchronize the settings applied here to every frame in a sequence of photographs. You'll note that I also pre-applied a 16:9 ratio crop, to format the image for video output.

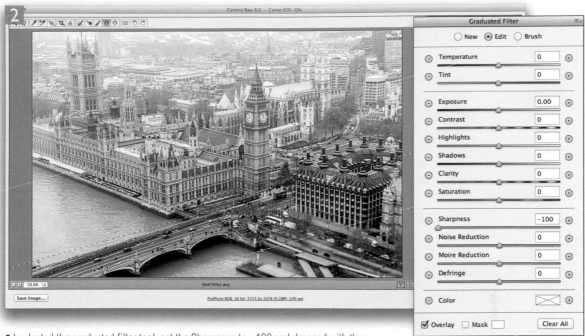

2 I selected the graduated filter tool, set the Sharpness to −100 and dragged with the tool to apply a negative sharpness, blurring adjustment. By repeating this process two or three times I was able to build a blurring effect in the bottom right corner.

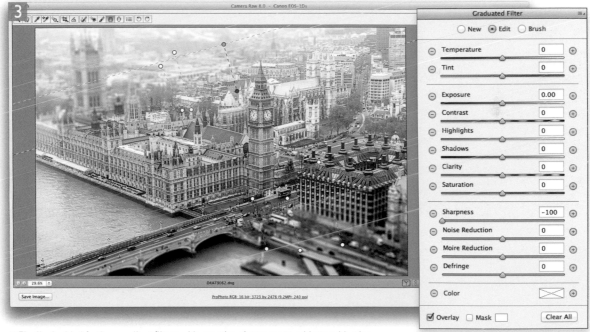

3 Finally, I added further gradient filters with negative sharpness to add more blurring to the top left corner.

Noise removal in Camera Raw

All images are likely to suffer from some degree of noise, but the amount of noise present will vary according to a number of factors. With digital images the noise seen will depend mainly on the quality of the camera sensor and what ISO setting the photograph was shot at. All camera sensors have a base level of noise even at the optimum, lowest ISO setting, and it is as the ISO is increased that the underlying noise becomes amplified and therefore more noticeable. Some sensors definitely perform better than others when used at higher ISO speeds and with the most recent digital SLR cameras we have seen a remarkable improvement in image capture quality at high ISO settings.

Another factor is exposure. On page 150 I showed how deliberately underexposing a digital photo can lead to shadow noise problems as you compensate by increasing the Exposure slider amount. In fact, the shadow areas are always the biggest problem. To determine how successful your camera is as at handling image noise, you should check how the shadows look. The Noise Reduction sliders in Camera Raw should be able to meet all your noise reduction requirements and there should be less need to rely on Photoshop or third-party products to carry out the noise reduction. Bear in mind that JPEG capture images will have already been processed in-camera to remove any noise. So, to take full advantage of Camera Raw noise reduction, you'll need to work with raw capture images. The other thing to bear in mind here is that the noise reduction and sharpening processes are essentially counteractive. As you attempt to reduce the noise in an image you'll inevitably end up softening some detail. The Camera Raw Process 2010 and 2012 controls have therefore been designed to make the noise reduction as targeted as possible to curing the problems of noise and with minimal softening of the image. Even so, in some instances you will still need to consider revising the sharpening settings.

Process Versions and noise reduction

Key to all this is understanding the effect the Process Version has on a raw image and the Detail panel controls. All images processed in Camera Raw prior to Camera Raw 6 will have used what is now referred to as Process 2003 rendering, which in turn limits the Noise Reduction slider controls so you can only adjust the Luminance and Color sliders. The improved noise reduction discussed here only applies to images

processed in Camera Raw 6 or later using the latest Process 2010 or 2012 rendering. Process 2003 images will need to be updated to Process 2010 or 2012 in order to take advantage of the new sharpening and noise reduction processing.

So let's look at what is special about the Process 2010 and 2012 rendering. The new demosaic process aims to filter the noise so as to reduce the luminance pattern noise and color noise component which we generally find obtrusive, but retain the random grain-like noise that we don't find distracting. The aim here is to filter out the good noise from the bad and provide, as a starting point, an image where the Camera Raw demosaic process preserves as much detail as possible. As the ISO setting is increased beyond whatever is the optimal ISO setting you then have the means to remove noise by adjusting the Noise Reduction sliders from their default settings. Extra help will still be required to further suppress the unwanted image noise which can be characterized in two ways: as luminance and color noise. This is where the Noise Reduction sliders in the Detail panel come in.

The noise reduction in Camera Raw is adaptive to different camera models and their respective ISO settings. The effective amount of noise reduction for the Luminance noise and Color noise amount settings therefore varies when processing files from different cameras as the noise reduction is based on a noise profile for each individual camera. The end result is that the noise reduction behavior feels roughly the same each time you adjust the noise reduction controls although the under the hood the values applied are actually different.

Removing random pixels

Camera Raw noise reduction is also able to remove outlying pixels, those additional, random light or dark pixels that are generated when an image is captured at a high ISO setting. Camera Raw can also detect any dead pixels and smooth these out too. You won't normally notice the effect of dead pixels, but they do tend to show up more when carrying out long time exposures. Even then you may only see them appear very briefly on the screen as Camera Raw quickly generates a new preview image.

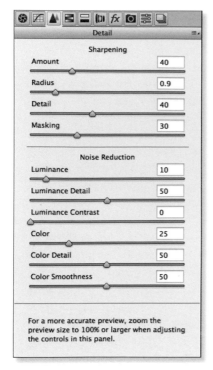

Figure 3.10 The Detail panel showing the Noise Reduction sliders.

Detail panel Noise Reduction sliders

The Noise Reduction controls are shown in Figure 3.10. The Luminance slider is used to smooth out the speckled noise that is always present to some degree, but is more noticeable in high ISO captures. The default setting is zero, but even with low ISO captures I think you'll find it beneficial to apply just a little Luminance noise reduction; in fact my colleague Jeff Schewe likes to describe this as the fifth sharpening slider and suggests you always include adding at least a little Luminance noise reduction as part of a normal sharpening process. Since Luminance noise reduction inevitably smooths the image, it is all about finding the right balance between how much you set the Luminance slider to suppress the inherent noise and how much you sharpen to emphasize the edges (but without enhancing the noise). Improvements made since Camera Raw 4.1 mean Camera Raw now does a much better job of reducing any white speckles in the shadows and the Luminance noise reduction was further improved in Camera Raw 6 to provide the smoothest luminance noise reduction possible.

Excessive Luminance slider adjustments can lead to a softening of edge detail. To help counter this, the Luminance Detail slider acts like a threshold control for the main Luminance slider. The default setting is 50 and the Luminance Detail slider sets the noise threshold of what the noise reduction algorithm determines to be noise. When this slider is dragged to the left you will see increased noise smoothing. However, be warned that some detail areas may be inappropriately detected as noise and important image detail may also become smoothed. Dragging the slider to the right reduces the amount of smoothing used and preserves more detail. This allows you to dial back in any missing edge sharpness, but it may also cause noisy areas of the image to be inappropriately detected as detail and therefore not get smoothed.

Luminance noise tends to have a flattening effect at the macro level where the underlying texture of the noise grain appears so smoothed out that in close-up the image has something of a plastic look to it. The Luminance Contrast slider therefore allows you to restore more contrast, but does so at the expense of making preserved noise blobs more noticeable. The smoothest results are achieved by leaving the Luminance Contrast slider at the default zero setting. However, doing so can sometimes leave the noise

reduction looking unnatural where the details may appear too smoothed out. Dragging the slider to the right allows you to preserve more of the contrast and texture in the image, but at the same time this can lead to increased mottling in some high ISO images. It is also worth pointing out here that the Luminance Contrast slider has the greatest effect when the Luminance Detail slider is set to a low value. As you increase the Luminance Detail the Luminance Contrast slider has less effect on the overall Luminance noise reduction.

Color noise

Color noise occurs due to the inability of the sensor in low light levels to differentiate color (because the luminance is so low). As a result of this we see errors in the way color is recorded and hence the appearance of color artifacts in the demosaiced image. The Color slider smooths out the color noise artifacts such as the magenta/green speckles you commonly see in noisy high ISO captures. For the most part you can now safely crank the Color noise reduction slider up towards the maximum setting. However, increasing the Color noise slider can also result in color bleeding, which results in the fine color details in an image becoming desaturated. This kind of problem is one that you are only likely to see with really noisy images that contain fine color edge detail, so it's not something you need to worry about most of the time. Where this does appear to be an issue, the Color Detail slider allows you to help preserve color detail in such images and as you increase the Color Detail slider beyond the default 50 setting you'll notice how it preserves more detail in the color edges. Take care when you use this slider, because as you increase the amount that is applied this can lead to some color speckles reappearing along the preserved edges. And in areas that have a strong color contrast you can see an over-sharpening of the color boundary edges. To understand more clearly the effect all of these sliders are having, you may want to zoom in to look at a 400% view.

Non-raw image noise reduction

In light of how effective the controls are now in Camera Raw and the fact you can use Camera Raw to process JPEG and TIFF images, I suggest you use Camera Raw as a primary means to reduce noise.

CMOS and CCD sensors

In recent years we have seen advances in sensor technology for digital SLR cameras, where the latest sensors are now able to capture images at incredibly high ISO settings without producing too much obtrusive noise once processed using a raw processor such as Camera Raw. At the highest ISO settings it is mostly only luminance noise that you have to remove. The reason why this has become possible is because these digital SLRs are using CMOS type sensors. However, the sensors designed for use with medium format cameras are mostly of the CCD type, which, while being very good in terms of color performance and sharpness, do not tend to respond well when the signal is amplified at higher ISO settings. To be honest, the sensors designed for use in medium format backs are best when used at the lowest ISO settings. However, Sony have recently created a 50 megapixel CMOS sensor for medium format cameras. I have tested this with the Hasselblad H5D-50C and Pentax 635Z camera systems and the sensor performance is exceptionally good, even at the very highest ISO settings.

Improved color noise reduction

Since Camera Raw 7, the quality of the color noise reduction has been improved at extreme color temperatures such as 3200K or lower in order to reduce the effects of color splotchiness.

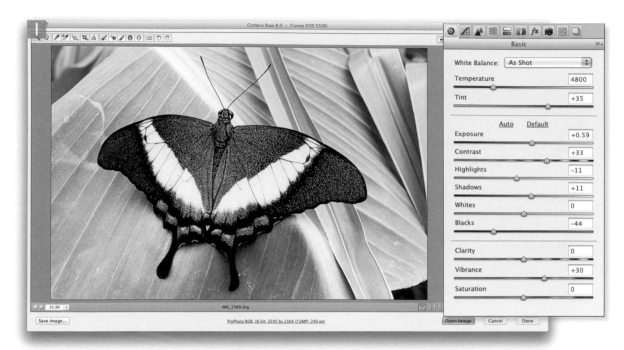

1 Here is a photograph that was shot at 3200 ISO and is a good example with which to demo the Process 2010/2012 color noise reduction.

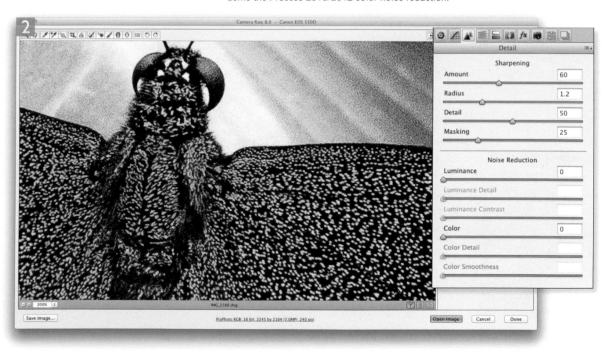

2 Here, I enlarged the image preview to 200% and set the Color slider to zero. As you can see, there were a lot of visible color noise artifacts in this image.

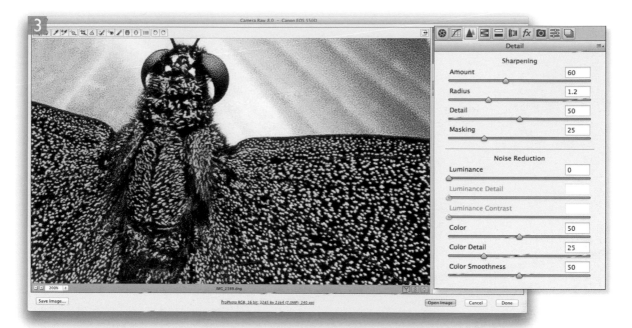

3 In this step, I applied a color noise reduction of 50. The Color Detail slider can do a good job resolving the problem of color edge bleed, commonly associated with color noise reductions. However, an excessive amount can cause edges with color contrast to appear unnaturally over-sharpened. Here, I applied a Color Detail setting of 25.

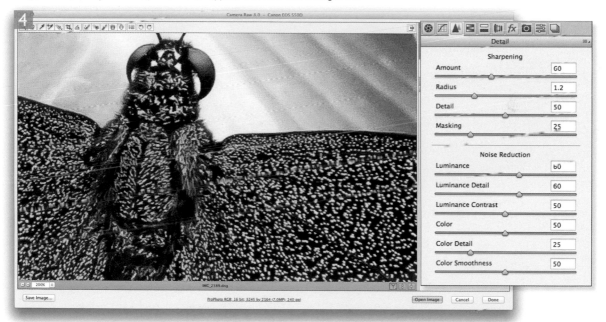

4 I then applied a Luminance noise reduction of 60 with a Luminance Detail setting of 60 and a Luminance Contrast setting of 50. This 'noise reduced' version is much smoother.

Color Smoothness slider

The Detail panel Noise Reduction section also includes a Color Smoothness slider. This can be used to help deal with color mottling artifacts (or large colorful noise blobs). These are usually caused by low frequency color noise and can be present in low as well as high ISO images, especially in the shadow regions. The default setting is 50. Dragging to the right can help make these disappear, though this will, at the same time, cause the image to appear smoother.

The example shown here was shot using a Canon EOS 1Ds MkIII camera at 100 ISO. I deliberately lightened the shadows to reveal the problem highlighted here. It is mainly some Canon cameras that seem to benefit most from this feature, although the most recent Canon models appear to have much improved noise handling across the board as well as at higher ISO settings.

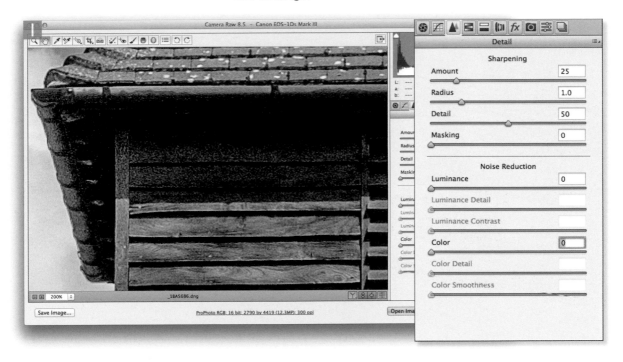

1 This shows a 200% close-up view of an image that was shot at ISO 100, but where there were clearly signs of color mottling in the shadow areas.

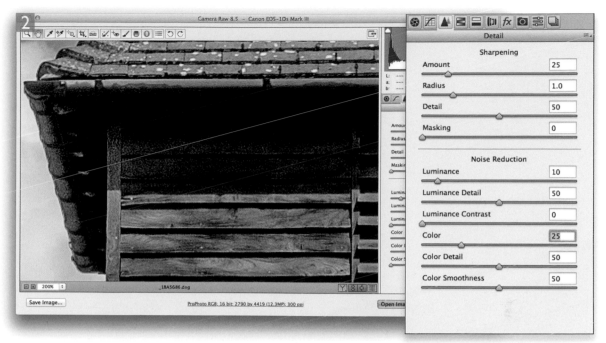

2 In this step I set the Luminance noise reduction to 10 and the Color slider to 25. This got rid of some of the color noise, but not all.

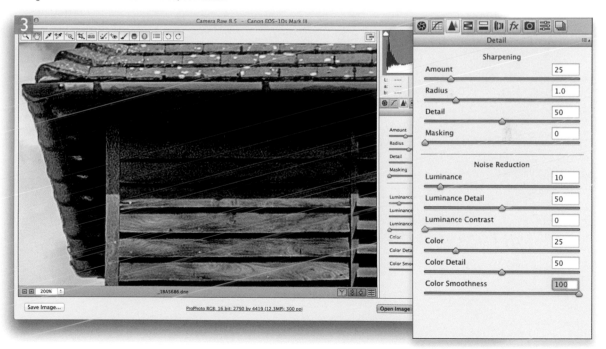

3 Setting the Color Smoothness slider to 100 smoothed out the mottling effect. This meant I didn't have to otherwise further increase the Color amount setting.

Adding grain to improve appearance of sharpness

Earlier, in the Camera Raw chapter, you may have got the impression that I'm not particularly keen about adding grain to images. Well, at least not when it's applied as a special effect. But the Grain slider can sometimes actually be useful when you are editing high ISO images and need to get rid of obtrusive noise artifacts. In the example shown here you can see how adding a small amount of noise can be used to compensate for some of the over-smoothing produced by the noise reduction process.

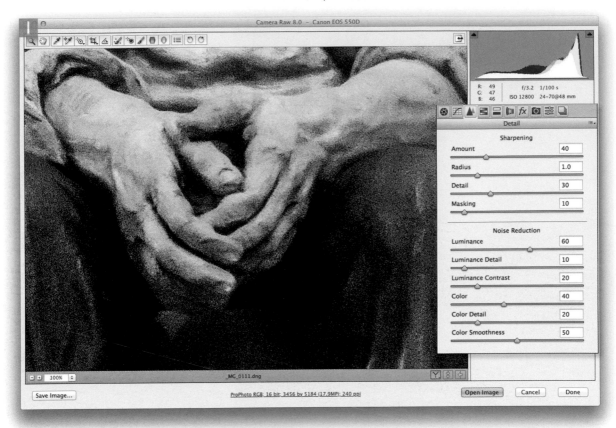

1 When editing this image it was necessary to apply the settings shown here in the Detail panel to help remove the luminance and color noise from the picture. Note the image is shown here at a 100% view.

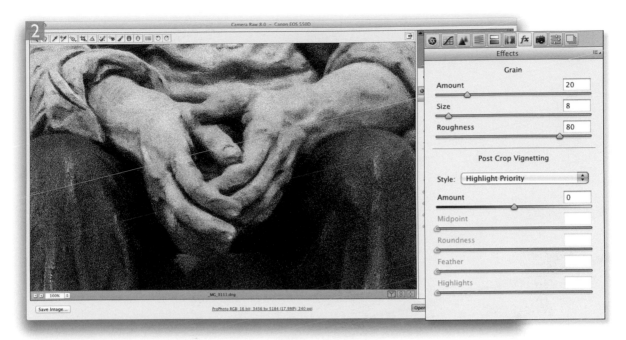

2 As a result of the noise reduction adjustment applied in Step 1, some of the image detail ended up becoming over-smooth. To counteract this I added a small amount of grain using the Grain slider in the Effects panel.

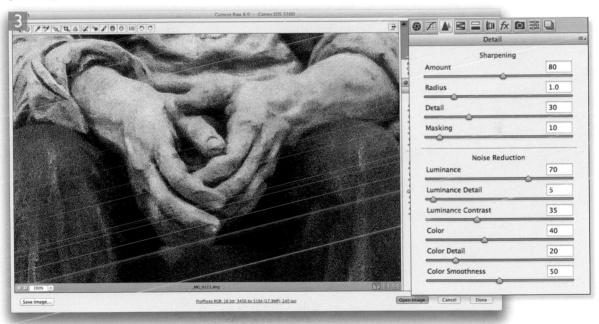

3 Finally, I returned to the Detail panel and readjusted the Sharpening sliders, in order to restore more sharpness in the final processed image (and also added more Clarity).

Localized noise reduction in Camera Raw

Camera Raw 7 and later features a Noise slider in the adjustment brush and graduated filter settings. As you increase the slider setting you can apply a localized adjustment that strengthens the noise reduction that's applied to the selected area. As with localized sharpening adjustments, this strengthening of the noise reduction effectively increases the amount setting for the Luminance and Color sliders, proportionally. Basically, you can use this slider adjustment to apply additional noise reduction where it is needed most, such as the shadow areas. I see this tool being useful where you have used a Camera Raw localized adjustment to deliberately lighten the shadows in a scene. Instead of bumping up the overall noise reduction it makes sense now to do so locally by increasing the Noise slider amount. Note that you can also apply negative amounts of noise reduction with the adjustment brush. For example, you might have an image where it is easier to apply a global adjustment that is heavy on the noise reduction and use a negative localized noise reduction adjustment to remove the noise reduction effect locally.

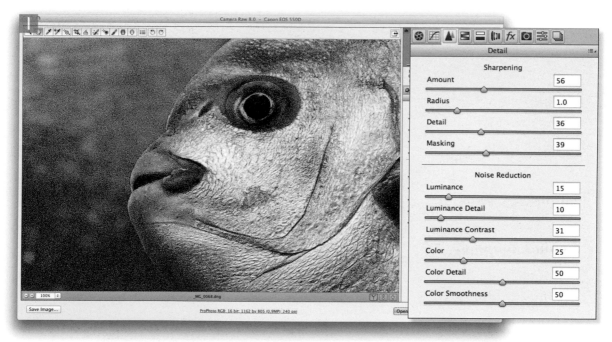

1 Here is a photograph that required localized lightening in the shadow areas. As you can see, I had already adjusted the Detail panel sliders to remove most of the image noise.

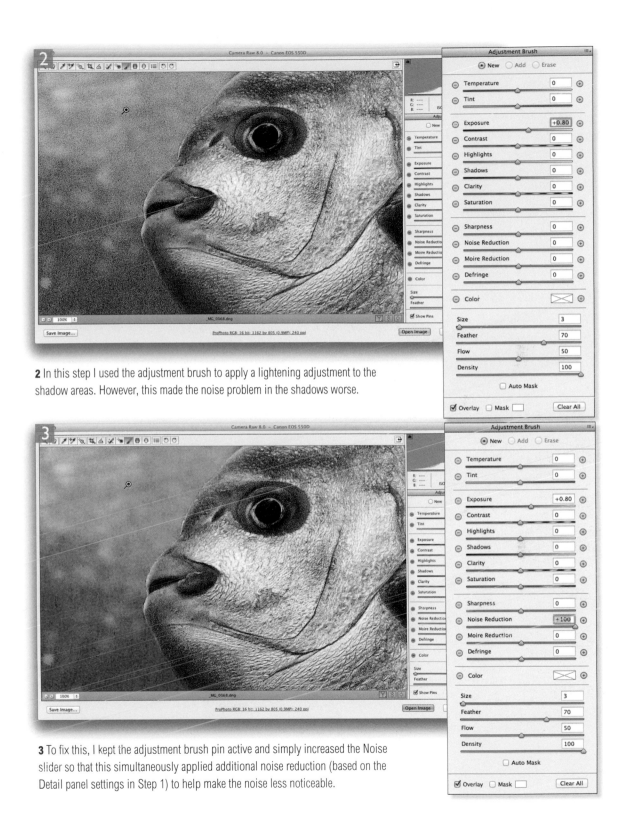

2 In this step I used the adjustment brush to apply a lightening adjustment to the shadow areas. However, this made the noise problem in the shadows worse.

3 To fix this, I kept the adjustment brush pin active and simply increased the Noise slider so that this simultaneously applied additional noise reduction (based on the Detail panel settings in Step 1) to help make the noise less noticeable.

Removing moiré at the shoot stage

One way to avoid the effects of moiré is to reshoot the subject from a slightly further distance and crop the image accordingly. Usually a small change in shooting distance is all that is required. The effects of moiré are much less of a problem now compared with the early days of digital camera technology.

Raw and JPEG moiré removal

Moiré removal is more effective removing luminance artifacts on raw images than JPEGs. This is because Camera Raw can take advantage of the higher resolution green channel (before color processing) to perform a fix. This is not possible with JPEGs as the green channel has already been fixed (color processed) and therefore 'polluted' the other three channels.

Localized moiré removal in Camera Raw

The term 'moiré' is used to describe image detail problems that are related to artifacts generated as a result of light interference. This can be due to the way light reflected from a fine pattern subject, such as a shiny fabric, causes interference patterns to appear in the final capture. What actually happens here is the frequency of the fabric pattern and the frequency of the photosites on the sensor clash and this causes an amplified moiré pattern to appear in the captured image—this is just a limitation of the sensor. These days digital SLR cameras mostly all have a high pass, anti-aliasing filter attached to the surface of the sensor, which is designed to mitigate some of the effects of moiré. However, there are some cameras where the sensors don't have high pass filters (such as the Nikon D800E and Canon 5DS R) and as a result of this you can end up seeing moiré-type effects when viewing an image close-up. Basically, if the camera lens is imaging fine-detail lines which correspond to less than one pixel width, this can cause a problem in the demosaic process. Therefore, it is really only certain types of subject matter photographed on the larger, medium format backs and above mentioned digital SLR cameras where the need to reduce moiré becomes necessary.

In the Camera Raw localized adjustments menus is a Moiré slider. As with the Noise slider, increasing the amount is designed to help reduce the effects of moiré (as seen in the example opposite). Here are some things to watch out for. Increasing the Moiré Reduction setting will allow you to apply a stronger effect and you can, if necessary, consider applying a double dose of moiré reduction to a local area. However, as you increase the effect you are likely to see color bleeding occur. In the accompanying example a moiré pattern could be seen in the brickwork. When I used a moiré reduction adjustment brush to remove the moiré, the brush referenced a broad area of pixels near where I was brushing in order to calculate what the true color should be. When retouching an image such as this it was important to use a hard edged brush to constrain the brush work and avoid the green colors of the foliage spilling over. Selecting the Auto Mask option can certainly help here. Also, when fixing different areas (such as the moiré on the air conditioning grills in this picture) you should consider creating a new brush pin to work on these areas separately. You'll notice that you also have the ability to apply negative amounts of moiré. This is there so that you can apply multiple passes of moiré reduction in which subsequent applications of negative moiré can be used to reduce the moiré reduction effect.

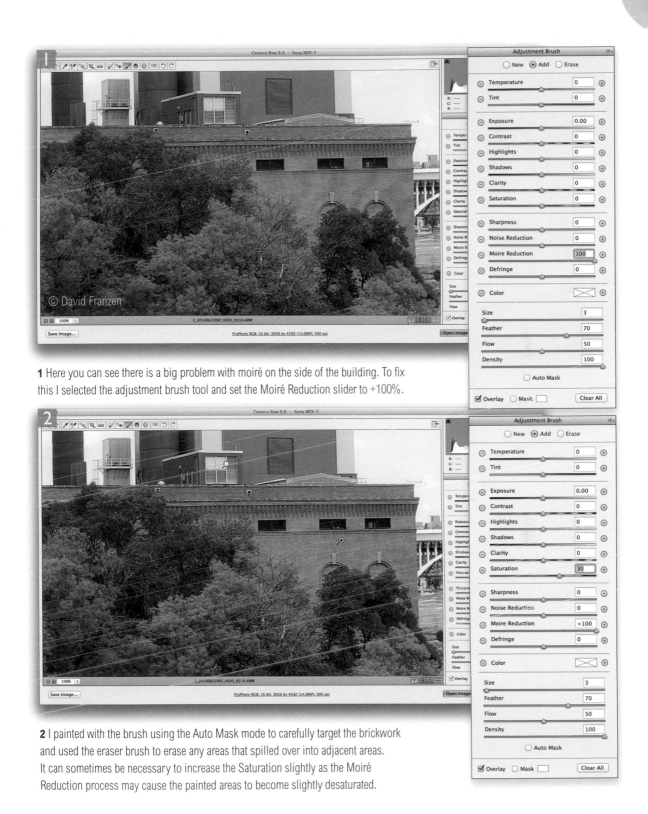

1 Here you can see there is a big problem with moiré on the side of the building. To fix this I selected the adjustment brush tool and set the Moiré Reduction slider to +100%.

2 I painted with the brush using the Auto Mask mode to carefully target the brickwork and used the eraser brush to erase any areas that spilled over into adjacent areas. It can sometimes be necessary to increase the Saturation slightly as the Moiré Reduction process may cause the painted areas to become slightly desaturated.

Localized sharpening in Photoshop

Smart Sharpen filter

So far we have seen how to apply localized sharpening in Camera Raw. Let me now show you a few ways this can be done directly in Photoshop. One method is to use the Smart Sharpen filter. Don't be too taken in by the fact that it's called a 'smart' filter. Some people figure this is a kind of 'super Unsharp Mask' filter to be used for general sharpening. If applied correctly, it can be used to sharpen areas where there is a distinct lack of sharpness, but if used badly may introduce noticeable artifacts (see Figure 3.11). However, there is a Reduce Noise slider in the Advanced options, which can play a key role in suppressing artifacts. The Smart Sharpen filter also runs very slowly compared with the Unsharp Mask filter and Camera Raw sharpening. Therefore, I generally consider Smart Sharpen to be more useful as a tool for 'corrective' rather than general sharpening.

Basic Smart Sharpen mode

The Smart Sharpen filter has three blur removal modes: the Gaussian Blur mode makes this work more or less the same as the Unsharp Mask filter. The Lens Blur mode is the more useful as it enables you to counteract optical lens blurring. Lastly, there is the Motion Blur removal mode, which can sometimes be effective at removing small amounts of motion blur from an image. After you have selected a blur removal method, you can use the Amount and Radius slider controls to adjust the sharpening effect.

In the example shown on the page opposite I first went to the Filter menu and chose 'Convert for Smart Filters', which converted the Background layer to a Smart Object layer. This allowed me to apply the Smart Sharpen filter as a 'smart filter', where I could edit the filter effect coverage by painting directly on the layer mask. An alternative option would be to duplicate the Background layer and apply the Smart Sharpen filter to that layer, but the advantage of the Smart Object/Smart filter layer approach is that the Smart Sharpen filter settings always remain editable.

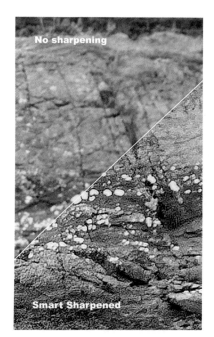

Figure 3.11 Take care when using the Smart Sharpen filter. An excessive amount of Smart Sharpen can lead to more noticeable artifacts like those seen in the bottom half of this screen grab.

Improved sharpen tool

The sharpen tool in Photoshop has been improved since CS5. The Protect Detail mode utilizes an algorithm that minimizes any pixelation when the sharpen tool is used to emphasize image details. The Protect Detail mode can therefore faithfully enhance high frequency image details without introducing noticeable artifacts, though I recommend using this tool set to the Luminosity mode in order to help reduce the risk of generating color artifacts (see Figure 3.12).

Figure 3.12 This shows the sharpen tool options, including the 'Protect Detail' mode.

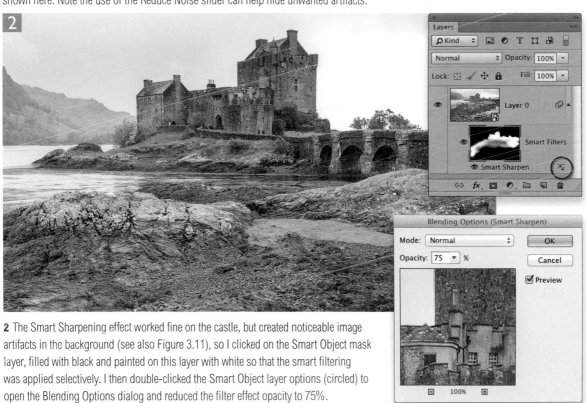

1 This shows a close-up view of a photograph where the main subject was slightly out of focus. I didn't want to apply any further global sharpening as this would have created artifacts in the background. I converted the Background image layer to a Smart Object and applied the Smart Sharpen filter in 'Lens Blur' mode using the settings shown here. Note the use of the Reduce Noise slider can help hide unwanted artifacts.

2 The Smart Sharpening effect worked fine on the castle, but created noticeable image artifacts in the background (see also Figure 3.11), so I clicked on the Smart Object mask layer, filled with black and painted on this layer with white so that the smart filtering was applied selectively. I then double-clicked the Smart Object layer options (circled) to open the Blending Options dialog and reduced the filter effect opacity to 75%.

You can save Smart Sharpen settings as you work by clicking on Presets menu circled below in Figure 3.13, and choose 'Save Preset…'

Legacy mode

If you click on the cog wheel in the Smart Sharpen dialog, there is 'Use Legacy' option. Checking this allows you to work with the Smart Sharpen filter using the old style Smart Sharpen processing should you wish (there is also a 'More Accurate' check box you can check here as well).

Advanced Smart Sharpen mode

Just below the Advanced mode section are two additional expandable sections: Shadows and Highlights. The controls in these sections act like dampeners on the main smart sharpening effect. The Fade Amount slider selectively reduces the amount of sharpening in either the shadow or highlight areas. This is the main control to play with as it will have the most initial impact in reducing the amount of artifacting that may occur in the shadow or highlight areas. Below that is the Tonal Width slider and this operates in the same way as the one you find in the Shadows/Highlights image adjustment: you can use this to determine the tonal range width that the fade is applied to. These two main sliders allow you to subtly control the smart sharpening effect. The Radius also works in a similar way to the Radius slider found in the Shadows/Highlights adjustment and is used to control the width area of the smart sharpening.

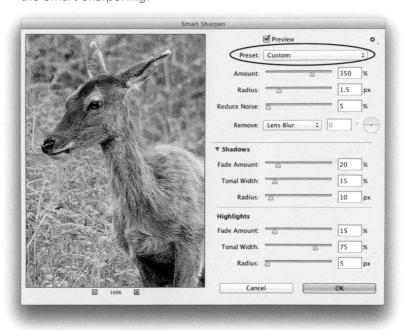

Figure 3.13 In this photograph I set the Smart Sharpen filter to Advanced mode and applied an Amount of 150% at a Radius of 1.5 using the 'Lens Blur' mode. Once I had selected suitable settings for the main Smart Sharpen, I clicked on the Shadow and Highlight tabs and used the sliders in these sections to decide how to limit the main sharpening effect. A high Fade Amount setting faded the sharpening more, while the Tonal Width determined the range of tones that were to be faded. Lastly, there was the Radius slider, where I could enter a Radius value to determine the scale size for the corrections.

Removing Motion Blur

The Motion Blur mode can be used to correct for mild camera shake or small amounts of subject movement in a photograph (see Figure 3.14). If you select the Remove Motion Blur mode, the trick here is to get the angle in the dialog to match the angle of the Motion Blur in the picture and adjust the Radius and Amount settings to optimize the Motion Blur correction.

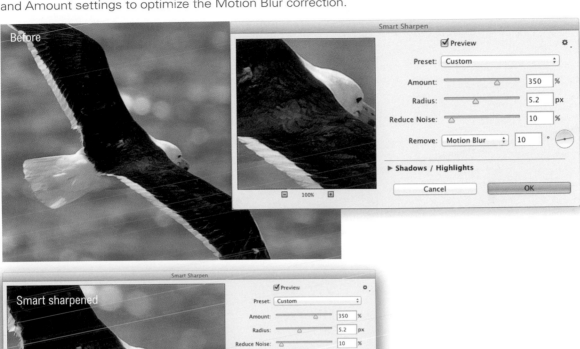

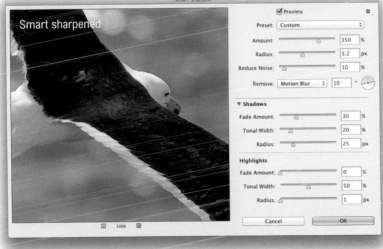

Figure 3.14 The Motion Blur method of smart sharpening is reasonably good at improving sharpness where there is just a slight amount of camera shake or subject movement. In this example I initially set the Amount, Radius and Angle to achieve the most effective sharpening and in Advanced mode I went to the Shadow tab to adjust the Fade Amount and Tonal Width settings so as to dampen the sharpening effect in the shadows. This helped achieve a slightly smoother-looking result.

Blur estimation tool (**E**)
Blur direction tool (**R**)
Hand tool (**H**)
Zoom tool (**Z**)

Figure 3.15 The Shake Reduction filter tools.

Shake Reduction filter

The Shake Reduction filter caused quite a stir when a sneak preview was first shown at the Adobe Max show in 2011. What it does is to correct the camera shake in a captured photo rather than work out how to refocus an out-of-focus image. The way it does this is to interpret the image and look for signs of camera shake, and, in particular, clues to the path that a camera moved during an exposure. For example, this will be most apparent in sharp pinpoint areas such as catch lights in the eyes. From this, the Stabilize plug-in is able to calculate a camera shake signature for the image and use this to work out how to reconstruct the scene without camera shake. It's like a software version of the image stabilizing control found on some lenses and cameras.

This can't be expected to work perfectly in every case as there is a lot of guess work going on here that is being computed by the plug-in. It works best where the source

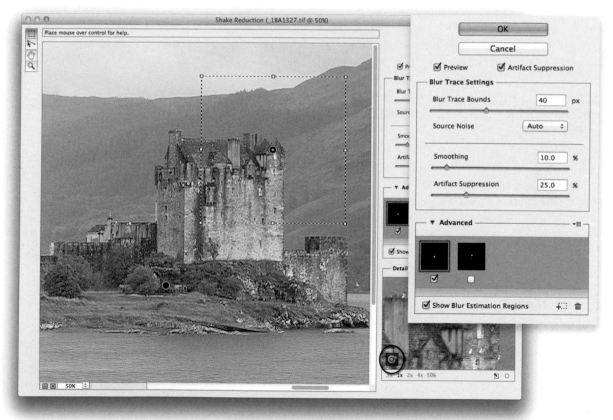

Figure 3.16 The Shake Reduction filter dialog. In this example, there is one blur trace active with an active blur trace region plus filled pin and one that's inactive (with a hollow pin).

image is essentially in focus, but was shot at a slow shutter speed and where camera shake is the only issue. In other words, without additional subject movement. This means the filter works best when processing static subjects, because if you shoot anything that's moving at a slow shutter speed you'll have the combined issue of camera shake plus subject movement to contend with. It will also work best if the source image is captured with a decent lens and camera sensor.

The Shake Reduction controls

The Shake Reduction filter controls are quite complex. Fortunately, when you open the filter it goes through an automatic routine of analyzing the image and applies auto-calculated settings for you, including the auto-placement of a blur estimation region, represented by a marquee area with a central pin. If you like the result this gives, then click OK to apply. If not, then you can override this auto-calculated starting point and refine the settings. These are shown in Figure 3.16. The Detail view at the bottom shows you a close-up view of the current blur estimation region and as you adjust the controls you'll see the results of that adjustment in the Detail view. If you want to relocate the blur estimation region, then simply click in the main preview window. This re-centers the loupe. As you do this though, you will see a refresh icon appear in the bottom left corner of the loupe view (circled in Figure 3.16). Click on this to refresh the preview.

In the Blur Trace Settings section there is a Blur Trace Bounds slider. This is initially set automatically, but you can adjust the amount here to increase or decrease the size of the blur trace area. The Source Noise menu is used to specify the noise content of the original image and defaults to Auto, but you can override this to choose Low, Medium or High. It is usually best to leave it set to 'Auto' though. The Smoothing slider can be used to control the sharpening-induced noise. In Figure 3.17 you can see the result of applying no Smoothing and with Smoothing. Below this is the Artifact Suppression slider, which can be used to suppress large artifacts. There is also a checkbox at the top of the panel controls that allows you to disable the Artifact Suppression and hides the Artifact Suppression slider. In Figure 3.18 'ringing' artifacts can clearly be seen in the 'Without' version. When the Artifact Suppression is applied using the correct amount, these can mostly be removed.

Figure 3.17 This shows the before and after effects of controlling the Smoothing

Figure 3.18 This shows the before and after effects of controlling the Artifact Suppression.

Figure 3.19 This shows the Advanced controls, showing the Advanced menu options and enlarge blur trace icon (circled).

Figure 3.20 This shows the 'Region Too Small' warning.

Figure 3.21 This shows an enlarged blur trace view.

Figure 3.22 This shows the contextual blur trace menu with 'Show Blur Trace on Image' and a blur trace overlaying the preview.

In the Advanced section there is an option to show or hide the Blur Estimation Regions in the preview area. This simply allows you to see the blur region outlines or not. Below that are the trace blur previews and here you can choose to turn individual blur regions on or off. Figure 3.19 shows a normal blur trace produced as a result of using the blur estimation tool (see the tools in Figure 3.15). Figure 3.23 shows a manual blur trace, produced by using the blur direction tool to manually define the camera shake blur. Note that in the Figure 3.16 example only one blur estimation blur trace is currently active and Blur Trace settings can be applied individually to each blur trace. If the blur estimation made is too small, then you will see the warning shown in Figure 3.20, which points out the blur estimation region is not big enough to calculate a blur trace from.

In Figure 3.19 you can see the Advanced section menu options. Here, you can save and load workspaces or blur traces. A workspace is the combination of the blur estimation regions plus their associated blur reduction settings. To save a blur trace, select one from the Advanced panel section and choose 'Save Blur Trace…' This will save the selected blur trace as a 16-bits per channel PNG format grayscale image (which you can then edit in Photoshop if you wish). Also, if you hover the mouse over a blur trace you can click on the enlarge blur trace icon (circled in Figure 3.19) to see a magnified blur trace view (see Figure 3.21). If you make a right mouse-click on a blur trace icon, you'll see a pop-up menu, from where you can choose 'Show Blur Trace on Image' (Figure 3.22). This overlays the Blur Trace on the image and allows you to adjust the Blur Trace Bounds slider to see how it grows or shrinks.

Repeat filtering

If you apply the Shake Reduction filter using an automatic settings adjustment, a repeat filter (using ⌘ F [Mac], ctrl F [PC]) will also apply an automatic adjustment. If custom settings were used to override the auto-calculated settings, a repeat use of the filter will use these same user-defined settings. However, if a repeat run is done on an image with different dimensions, the image will be reanalyzed and auto-corrected.

Smart object support

You can also apply Shake Reduction as a Smart Filter and make use of the masking to apply the filter effect selectively.

Blur direction tool

The blur direction tool allows you to manually specify the direction and length of a straight blur trace, but is only available when the Advanced options are expanded. It is purposely designed to let you apply a more aggressive style shake reduction to a specified area or areas. It's a tool you should therefore use in moderation and in conjunction with blur estimation region calculations to treat particularly tricky sections of an image (although you can use it on its own should you wish). A blur direction blur trace is represented using a lock icon (see Figure 3.23).

You can edit a manual blur trace in a number of ways. You can click inside the bounds of the blur trace that overlays the preview and drag to reposition it. If you click on either of the two handles you can manually drag to change the length or angle of the blur trace (see Figure 3.24). But note here that small changes made to the blur trace can have a significant impact on the result of the Shake Reduction adjustment. If you want to apply small, incremental adjustments you can use the bracket keys. Use [to reduce the blur trace length and use] to increase it. Also, you can use the ⌘ [(Mac), ctrl [(PC) shortcut to twist the angle anti-clockwise and use the ⌘] (Mac), ctrl] (PC) shortcut to twist the angle clockwise.

How to get the best results

To help improve the success of the filter, it is best to apply noise reduction first in Camera Raw (especially for the Color noise), avoid use of Clarity and Contrast and disable capture sharpening. I imagine the majority of candidate images for this filter will have been shot using a camera phone or cheap compact camera, as it is these types of cameras that will suffer most from camera shake. At the same time, the camera settings in low light conditions will mean the camera is capturing an image at a high ISO setting and at full aperture. Therefore, the plug-in is having to contend with processing an image that's not optimally in sharp focus and there will also be issues to do with sensor noise. That said, every bit helps of course. If you are aware of these limitations you should be pleased with its ability to at least make most pictures appear to look somewhat sharper than they did before, even if the results you get won't always be as dramatic as those shown in the demos.

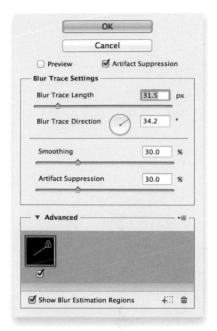

Figure 3.23 Here you can see the Blur Trace Settings for when a Manual blur direction is in force.

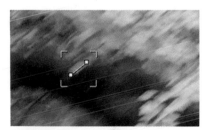

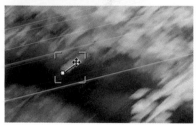

Figure 3.24 In the top view you can see the blur direction tool being applied to an image, where I dragged with the tool to follow the direction and length of the blur. The bottom view shows how you can edit a manually defined blur trace.

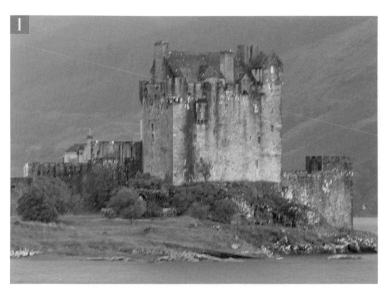

1 Here you can see the image I wished to improve. This was shot using a long focal length lens and there is noticeable camera shake in this picture.

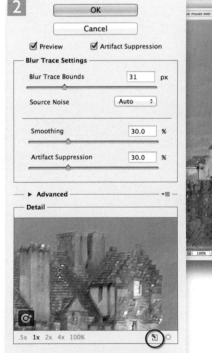

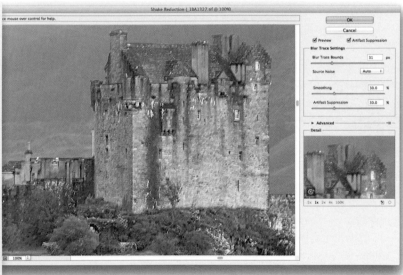

2 I went to the Filter menu and chose Sharpen ⇨ Shake Reduction. When this filter is opened it first auto-estimates the required blur size. It follows this by auto-estimating the required noise reduction (using the Auto setting). The Auto noise is a value calculated by the Shake Reduction algorithm (when set to 'None' it means it won't take noise into consideration). It will then auto-choose a blur trace estimate for the blur trace. The default Blur Trace size is determined by the image size and some image analysis, so it can be different from one image to another. After that, it will render a coarse preview followed by a fine preview. In many cases the result you see here should not need any further alteration to achieve a sharper result.

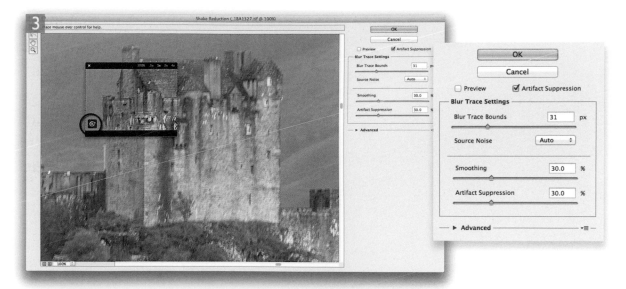

3 In the Detail section you can click on the Undock Detail button circled in Step 2 (or use the **Q** toggle shortcut) to undock the Detail loupe. This will snap to the preview area and allow you to drag and reposition on an area of interest. As you adjust the Blur Trace Bounds you will see a fast update within the Detail loupe view. When repositioning the Detail loupe, click the refresh button (circled) to recalculate.

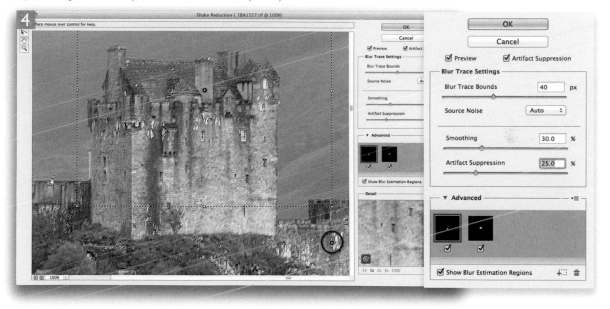

4 When the Advanced options are expanded, you can use the blur estimation tool (**E**) to define additional blur trace regions, which will then be added to the Blur Estimation Regions gallery. When two or more of these are defined (and made active), the overall blur estimations are blended together between these points. In this step I had two regions defined. In the first I modified the settings to increase the shake reduction effect.

Creating a depth of field brush

On page 304 I described how you could use the Smart Sharpen filter to remove the blurriness from parts of an image and selectively apply the filter effect through a layer mask. There is also another way you can reduce blur in a photograph and this technique is closely based on a technique first described by Bruce Fraser, in the *Real World Image Sharpening with Adobe Photoshop, Camera Raw and Lightroom* (2nd Edition) book. The only thing I have done here is to change some of the suggested settings, in order to produce a narrower edge sharpening brush. Basically, you can adapt these settings to produce a sharpness layer that is suitable for different types of focus correction.

This technique can be used to help make the blurred image detail *appear* to look sharper by adding a blended mixture of sharp and soft halos, which create the illusion of apparent sharpness. The method described here requires you to first create a duplicate of the Background layer and adjust the Layer Style options so that the filter effects you are about to apply are limited to the midtone areas only and the extreme shadows and highlights are protected.

You will notice that the first step involves changing the blend mode of the duplicate background layer to Overlay. This will initially make the image appear more contrasty, but you will find that once you have applied the Unsharp Mask followed by the High Pass filter, it is only the image edges that are enhanced by the use of this technique. In Step 3 you will notice I applied the Unsharp Mask filter at a maximum strength of 500%, with a Radius of 1.0 pixel and the Threshold set to zero. The purpose of this step is to aggressively build narrow halos around all the edge detail areas, and in particular the soft edges, while the High Pass filter step is designed to add wider, overlapping, soft edged halos that increase the midtone contrast. When these two filters are combined you end up with a layer that improves the apparent sharpness in the areas that were out of focus, but the downside is that the previously sharp areas will now be degraded. By adding a layer mask filled with black, you can use the brush tool to paint with white to selectively apply the adjustment to those areas where the sharpening effect is needed most.

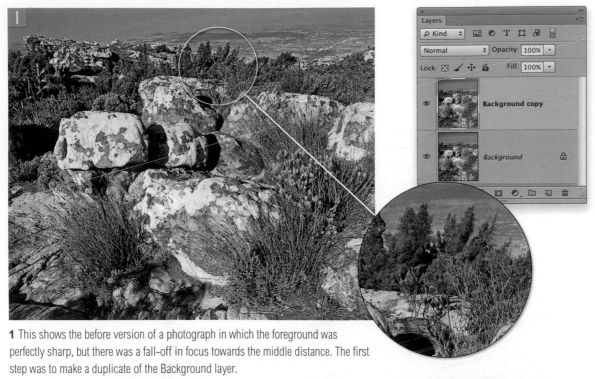

1 This shows the before version of a photograph in which the foreground was perfectly sharp, but there was a fall-off in focus towards the middle distance. The first step was to make a duplicate of the Background layer.

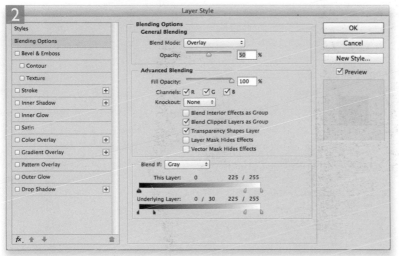

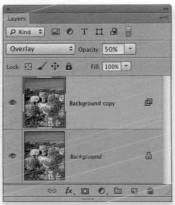

2 I then double-clicked the Background layer to open the Layer Style options and adjusted the settings as follows. The blend mode was set to Overlay and the layer Opacity reduced to 50%. The layer 'Blend If' sliders were adjusted as shown here to provide more protection for the extreme shadows and highlights.

Split slider adjustments

Blend If slider adjustments are covered later, but to achieve the split slider adjustment shown here, you need to hold down the *alt* key and click on one half of the slider arrow and drag to split it into two.

Adjusting the Depth of field settings

The Unsharp Mask and High Pass filter settings used here were designed to add sharpness to areas that contained a lot of narrow edge detail (such as the edges in a landscape). You will want to vary these settings when treating other types of photographs where you perhaps have wider edges that need sharpening. For example, Bruce Fraser's original formula suggests using an Unsharp Mask filter Radius of 4 pixels combined with a 40 pixel Radius in the High Pass filter.

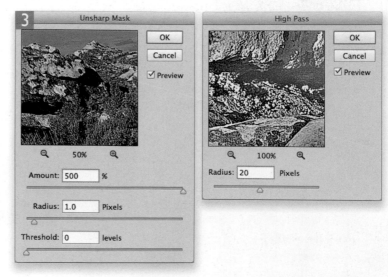

3 I clicked OK to the Layer Style changes and applied an Unsharp Mask filter to the Background copy layer, using an amount of 500% and a Radius of 1.0 pixel. This was followed by a High Pass filter (Filter ⇨ Other ⇨ High Pass) using a Radius of 20 pixels.

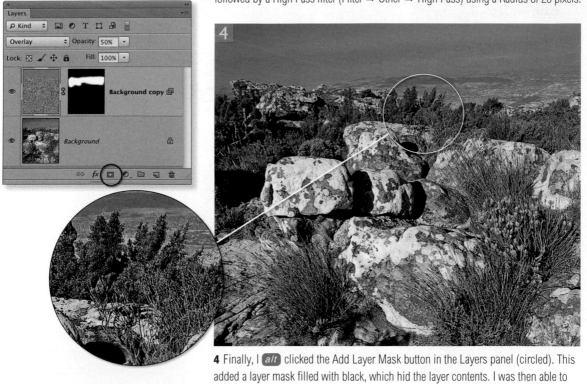

4 Finally, I *alt* clicked the Add Layer Mask button in the Layers panel (circled). This added a layer mask filled with black, which hid the layer contents. I was then able to select a normal brush and paint on the layer mask with white to reveal the depth of field sharpening layer and in doing so, add more apparent sharpness to the middle distance.

Chapter 4

Image editing essentials

So far I have shown just how much can be done to improve an image's appearance when editing it in Camera Raw, before you bring it into Photoshop. Some of the techniques described in this chapter may appear to overlap with Camera Raw editing, but image adjustments such as Levels and Curves still play an important role in everyday Photoshop work. This chapter also explains how to work with photos that have never been near Camera Raw, such as images that have originated as TIFFs or JPEGs. I'll start off by outlining a few of the fundamental principles of pixel image editing such as bit depth and the relationship between image resolution and image size. After that we'll look at the main image editing adjustments and how they can be used to fine-tune the tones and colors in a photograph.

Pixels versus vectors

Digital photographic images are constructed of pixels and as such are resolution-dependent. You can therefore only scale the finite pixel image information so far, before the underlying pixel structure becomes apparent. By contrast, vector objects, created in programs like Adobe Illustrator, are defined mathematically. So, if you draw a rectangle, the proportions of the rectangle edges, the relative placement on the page and fill color can all be described using a mathematical description. An object that's defined using vectors can therefore be output at any resolution and it does not matter if the image is shown on a computer display, a postage stamp or as a huge poster, it will always be rendered with the same amount of detail (see Figure 4.1).

Pixel-based image

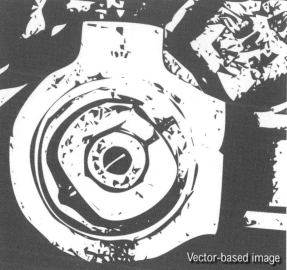

Vector-based image

Figure 4.1 Digital images are made up of a mosaic of pixels. This means that a pixel-based digital image will always have a fixed resolution and is said to be 'resolution-dependent'. If you enlarge such an image beyond the size at which it is meant to be printed, the pixel structure will soon become apparent, as can be seen here in the left-hand close-up view. Suppose though the above picture was converted to a vector path illustration to produce an abstract design. If a picture is constructed using vector paths, it will be resolution-independent. The mathematical numbers used to describe the path outlines shown in the example on the right can then be scaled to reproduce at any size: from a postage stamp to a billboard poster. As you can see in the comparison shown here, the pixel image starts to break up as soon as it is magnified, whereas the outlines in the vector-drawn image will reproduce perfectly smoothly at any size.

Photoshop as a vector program

Photoshop is mainly regarded as a pixel-based graphics program, but is in fact both a pixel and vector editing program. This is because Photoshop contains a number of vector-based features that can be used to generate things such as custom shapes and layer clipping paths. This raises some interesting possibilities, because you can create various graphical elements like type, shape layers and layer clipping paths in Photoshop, which are all resolution-independent. These vector elements can be scaled up in size in Photoshop without any loss of detail, just as they can with an Illustrator graphic.

Image resolution terminology

Before I proceed any further let me help explain a few of the terms that are used when describing image resolution and clarify their correct usage.

ppi: pixels per inch

The term 'pixels per inch' (ppi) should be used to describe the pixel resolution of an image. However, the term 'dpi' is also often used (inappropriately) to describe the digital resolution of an image, which is wrong because input devices like scanners and cameras produce pixels and it's only printers that produce dots. Even so, it's become commonplace for scanner manufacturers and other software programs to use the term 'dpi' when what they really mean is 'ppi'. Unfortunately this has only added to the confusion, because you often hear people describing the resolution of an image as having so many 'dpi', but if you look carefully, Photoshop and the accompanying user guide always refer to the input resolution as being in 'pixels per inch'. So if you have an image that has been captured on a digital camera, scanned from a photograph, or displayed in Photoshop, it is always made up of pixels and the pixel resolution (ppi) is the number of pixels per inch in the input digital image. Obviously, those using metric measurements can refer to the number of 'pixels per centimeter'.

lpi: lines per inch

This is the number of halftone lines or 'cells' in an inch (also described as the screen ruling). The origins of this term go back way before the days of digital desktop publishing. To produce a halftone plate, the film exposure was made through a finely etched criss-cross screen of evenly spaced lines on a glass plate. When a continuous tone photographic image was

Confusing terminology

You can see from this description where the term 'lines per inch' originated. In today's digital world of imagesetters, the definition is somewhat archaic, but is nonetheless commonly used. You may hear people refer to the halftone output as 'dpi' instead of 'lpi', as in the number of 'halftone' dots per inch, and the imagesetter resolution referred to as having so many 'spi', or 'spots per inch'. Whatever the terminology I think we can all logically agree on the correct use of the term 'pixels per inch', but I am afraid there is no clear definitive answer to the mixed use of the terms 'dpi', 'lpi' and 'spi'. It is an example of how the two separate disciplines of traditional repro and those who developed the digital technology chose to apply different meanings to these same terms.

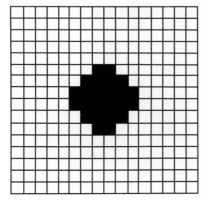

Figure 4.2 Each halftone dot is rendered by a PostScript RIP from the pixel data and output to a device called an 'imagesetter'. The halftone dot illustrated here is plotted using a 16 ×16 dot matrix. This matrix can therefore reproduce a total of 256 shades of gray. The dpi resolution of the imagesetter, divided by 16, will equal the line screen resolution. 2400 dpi divided by 16 = 150 lpi screen resolution.

exposed this way, dark areas formed heavy halftone dots and the light areas formed smaller dots, which when viewed from a normal distance gave the impression of a continuous tone image on the page. The line screen resolution (lpi) is therefore the frequency of halftone dots or cells per inch.

dpi: dots per inch

This refers to the resolution of an output device. For example, let's say we have an imagesetter device that is capable of printing small, solid black dots at a resolution of 2450 dots per inch and the printer wishes to use a screen ruling of 150 lines per inch. If you divide the dpi of 2400 by the lpi of 150, you get a figure of 16. Therefore, within a matrix of 16 × 16 printer dots, an imagesetter can generate individual halftone dots that vary in size on a scale from zero (no dot) to 255. It is this variation in halftone cell size (constructed of smaller dots) which gives the impression of tonal shading when viewed from a distance (see Figure 4.2).

Desktop printer resolution

In the case of desktop inkjet printers the term 'dpi' is used to describe the resolution of the printer head. The dpi output of a typical inkjet can range from 360 to 2880 dpi. Most inkjet printers lay down a scattered pattern of tiny dots of ink that accumulate to give the impression of different shades of tone, depending on either the number of dots, the varied size of the dots, or both. While a correlation can be made between the pixel size of an image and the 'dpi' setting for the printer, it is important to realize that the number of pixels per inch is not the same as the number of dots per inch created by the printer. When you send a Photoshop image to an inkjet printer, the pixel image data is processed by the print driver and converted into data that the printer uses to map the individual ink dots that make the printed image. The 'dpi' used by the printer simply refers to the fineness of the dots. Therefore a print resolution of 360 dpi can be used for speedy, low quality printing, while a dpi resolution of 2880 can be used to produce high quality print outputs.

Altering the image size

The image size dimensions and resolution can be adjusted using the Image Size dialog (Figure 4.3). This was recently updated in Photoshop CC to provide a new revised user interface, where it should be easier to understand what you are doing when modifying the Width, Height and Resolution settings. The image preview window shows you what the resized image will look like and can be made larger by resizing the dialog box. You can also click inside the preview and drag to pan the preview image; the Image Size dialog settings are now also sticky.

The Resample menu contains a Preserve Details option, which can offer improved image quality when enlarging an image. This, along with the other resample methods has been allocated a keyboard shortcut (see sidebar) to make it easy to toggle and compare different interpolation methods.

Resample method shortcuts

While the Image Size dialog is active you can use the following keyboard shortcuts to quickly access a desired resample method.

⌥ 1 : Automatic
⌥ 2 : Preserve Details
⌥ 3 : Bicubic Smoother
⌥ 4 : Bicubic Sharper
⌥ 5 : Bicubic
⌥ 6 : Nearest Neighbor
⌥ 7 : Bilinear

Megabyte image size
Dimensions units: pixels, inches, centimeters, etc.
Fit to menu: Custom, Original Size or Auto...
Settings gear menu: Scale Styles

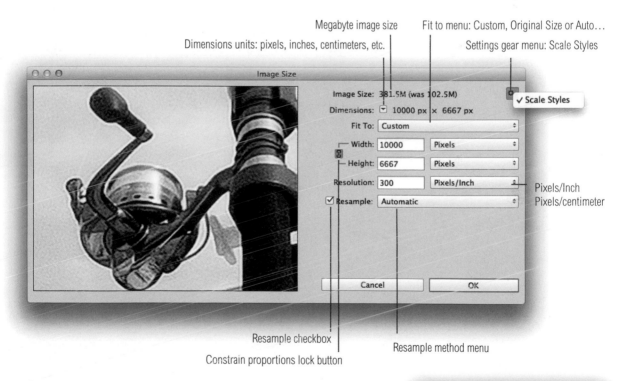

Pixels/Inch
Pixels/centimeter

Resample checkbox
Constrain proportions lock button
Resample method menu

Figure 4.3 The new Image Size dialog. You now need to go to the 'Fit To' menu and select Auto... to open the Auto Resolution dialog shown here. This can help you pick the ideal pixel resolution for repro work based on the line screen resolution.

Resolution and viewing distance

In theory the larger a picture is printed, the further away it is meant to be viewed. Because of this you can easily get away with a lower pixel resolution such as 180 or 200 pixels per inch when making a poster print output. There are limits, though, below which the quality will never be sharp enough at normal viewing distance (except at the smallest of print sizes). As my late colleague Bruce Fraser used to say, "in the case of photographers, the ideal viewing distance is limited only by the length of the photographer's nose".

When the Resample box is checked (as shown in Figure 4.3) you can resize an image by adjusting the values for the Width/Height fields, or by adjusting the Resolution. If you uncheck the Resample checkbox the Resolution field becomes linked to the Width and Height fields and you can resize an image to make it print bigger or smaller by altering the Width/Height dimensions, or the file resolution (but not the actual image document size). Therefore, any adjustment made to the Width, Height or resolution settings will not alter the total pixel dimensions and only affect the relationship between the measurement units and the resolution. Remember: the number of pixels = physical dimension × (ppi) resolution. You can put that to the test here and use the Image Size dialog as a training tool to better understand the relationship between the number of pixels, the physical image dimensions and resolution. The constrain proportions lock button links the horizontal and vertical dimensions, so that any adjustment is automatically scaled to both axes. Only uncheck this if you wish to squash or stretch the image when altering the image size.

Image interpolation

Image resampling is also referred to as interpolation and Photoshop can use one of seven methods when calculating how to resize an image. These interpolation options are all located in the Resample menu (see Figure 4.3) as well as appearing in the Options bar when transforming a layer (except for the new Edge-Preserving Upscale option).

I generally consider it better to 'interpolate up' an image in Photoshop rather than rely on the interpolation methods offered by other programs. Digital camera files are extremely clean and because there is no grain present, it is usually easier to magnify a digitally captured image than a scanned image of equivalent size. Here is a guide to how each of the interpolation methods works and which are the best ones to use and when.

Nearest Neighbor (hard edges)

This is the simplest interpolation method of all, in which the pixels are interpolated exactly using the nearest neighbor information. I actually use this method a lot to enlarge dialog box screen grabs by 200% for use in the book. This is because I don't want the interpolation to cause the sharp edges of the dialog boxes to appear fuzzy.

Bilinear

This calculates new pixels by reading the horizontal and vertical neighboring pixels. It is a fast method of interpolation, which was perhaps an important consideration in the early days of Photoshop, but there is not much reason to use it now.

Bicubic (smooth gradients)

This provides better image quality when resampling continuous tone images. Photoshop reads the values of neighboring pixels vertically, horizontally and diagonally, to calculate a weighted approximation of each new pixel value. Photoshop intelligently guesses new pixel values, by referencing the surrounding pixels.

Bicubic Smoother (enlargement)

This is the ideal choice when making pictures bigger, as it will result in smoother, interpolated enlargements. It has been suggested that you can also get good results using Bicubic Sharper when interpolating up before going directly to print. However, this ignores the fact that print sharpening should really be applied as a separate step *after* interpolating the image and the sharpening should ideally be tailored to the final output size (see Chapter 10). It is therefore always better to use Bicubic Smoother followed by a separate print sharpening step. This is because the smooth interpolation prevents any artifacts in the image from being over-emphasized and the sharpening can be applied at the correct amount for whatever size of print you are making.

Bicubic Sharper (reduction)

This method should be used whenever you need to reduce the image size more accurately. If you use Bicubic Sharper to dramatically reduce a master image in size, this can help avoid the stair-step aliasing that could sometimes occur when using other interpolation methods.

Bicubic Automatic

In the Photoshop preferences you'll notice how Bicubic Automatic is the default option. This automatically chooses the most suitable interpolation method to use when resizing an image. If you make a small size increase/decrease, it applies the Bicubic interpolation method. If upsampling to a greater degree, it uses Bicubic Smoother and if downsampling to a greater degree, it selects the Bicubic Sharper option. The same logic is also applied if you select the Bicubic Automatic option when transforming a layer.

Planning ahead

Once an image has been scanned at a particular resolution and manipulated, there is no going back. A digital file prepared for advertising usage may never be used to produce anything bigger than a 35 MB CMYK separation, but you never know. It is therefore safer to err on the side of caution and better to sample down than have to interpolate up. It also depends on how much manipulation you intend doing. Some styles of retouching work are best done at a magnified size and then reduced afterwards. Suppose you wanted to blend a small element into a detailed scene. To do such work convincingly, you need to have enough pixels to work with to be able to see what you are doing. Another advantage of working with large file sizes is that you can always guarantee being able to meet clients' constantly changing demands, even though the actual resolution required to illustrate a glossy magazine double-page full-bleed spread is probably only around 40–60 MB RGB or 55–80 MB CMYK. Some advertising posters may even require smaller files than this, because the print screen on a billboard poster is that much coarser. When you are trying to calculate the optimum resolution you cannot rely on being provided with the right advice from every printer.

Step interpolation

Some people might be familiar with the step interpolation technique, where you can gradually increase or decrease the image size by small percentages. This is not really necessary now because you can use Bicubic Sharper or Bicubic Smoother to increase or decrease an image size in a single step. Some people argue that for really extreme image size changes they still prefer to use the 10% step interpolation method, but I think the new Preserve Details algorithm and slider controls now beats that as the best way to interpolate an image upwards.

Preserve Details (enlargement)

These days most digital cameras are capable of shooting large enough files suited for most output requirements. However, if an image ends up being heavily cropped, or you are perhaps working with older images shot with a camera that had a low pixel count, you may find yourself needing to enlarge an image in order to meet some output requirements. The Preserve Details option works by upscaling the image in multiple steps of x1.5 magnification. At each step the image is divided into 7x7 pixel segments and the output step segments compared with the source. The new algorithm makes use of the high frequency information in the source to make the patches in the output appear as sharp as the source and so on at each stage. The calculation is also carried out in a color space similar to Lab in order to reduce color contamination and gain speed.

When this option is selected a Reduce Noise slider becomes visible. Since the Preserve Details upscaling process has a tendency to generate noise artifacts you can use this slider along with the Image Size preview to judge how much noise reduction should be dialled in to produce a smooth-looking result. As with all noise reduction, there will be a trade-off between edge sharpness and noise removal, so if you set the Noise slider too high you may end up with an over-soft result.

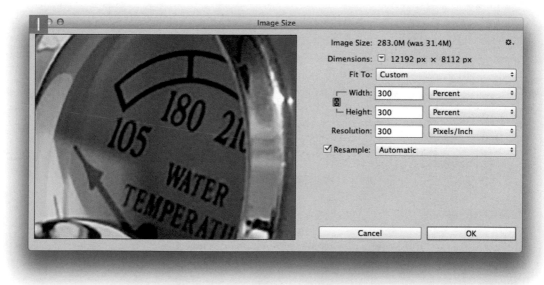

1 This shows a close-up section of a photograph that was shot using an 11 megapixel camera, where I used the Image Size dialog to enlarge by 300%. Here, the Bicubic Automatic option was selected, which in this instance would have auto-selected the Bicubic Smoother option to interpolate the image data.

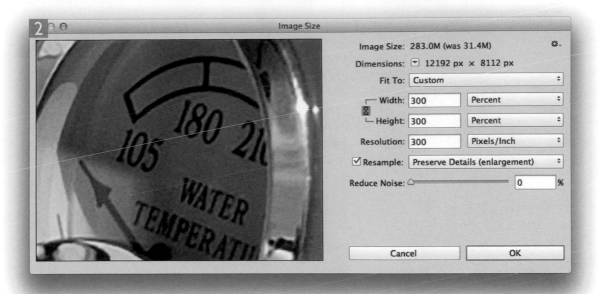

2 In Photoshop CC you can select the Preserve Details option when enlarging an image. If you compare the preview in this dialog with that shown is Step 1 you can see that the detail in the lettering is now crisper.

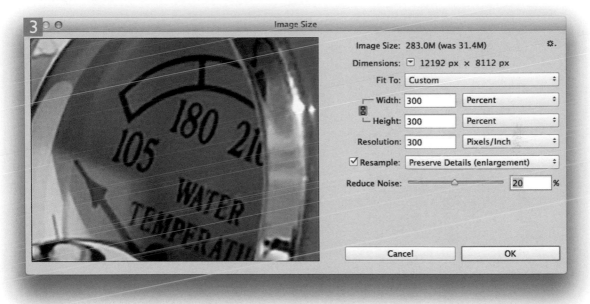

3 Although the Preserve Details option helped keep the details looking sharp, it did so at the expense of adding more noise to the image. To help combat this a Reduce Noise slider will appear when this option is selected. By increasing the Reduce Noise setting it is possible to reduce the noise that may result from detail enhancement.

Raw to pixel image conversions

Once a raw image has been rendered as a pixel image you cannot revert to the raw data version because the raw to pixel image conversion is a one-way process. Once you have done this, the only way you can undo something in the raw processing is to revert to the original raw image and generate a new pixel image copy. Although the goal of this book is to show you how to work as non-destructively as possible, this is the one step in the process where there is no going back. You therefore need to be sure that the photograph you start editing in Photoshop is as fully optimized as possible.

WYSIWYG image editing

If you want true WYSIWYG editing (what you see is what you get), it is important to calibrate the display and configure the color settings. Do this and you will now be ready to start editing your photographs with confidence. For more information about calibration see the Configuring Photoshop PDF on the book website.

Photoshop image adjustments

In Chapter 2 we explored the use of Basic panel adjustments in Camera Raw to optimize a photo before it is opened in Photoshop as a rendered pixel image. The following section is all about the main image adjustment controls in Photoshop and how you can use these to fine-tune your images, or use them as an alternative to working in Camera Raw, such as when editing camera shot JPEGs or scanned TIFFs directly in Photoshop.

If you intend bringing your images in via Camera Raw, it can be argued that Photoshop image adjustments are unnecessary, since Camera Raw provides you with everything you need to produce perfectly optimized photos. Even so, you will still find the information in this chapter important, as these are the techniques every Photoshop user needs to be aware of and use when applying things like localized corrections. The techniques discussed here should be regarded as essential foundation skills for Photoshop image editing. However you bring your images into Photoshop, you will at some point need to know how to work with the basic image editing tools such as Levels and Curves. So, for now, let's look at some basic pixel image editing principles and techniques.

The image histogram

The histogram graphically represents the relative distribution of the various tones (referred to as Levels) that make up a digital photograph. For example, an 8-bit per channel grayscale image has a single channel and uses 256 shades of gray to describe all the levels of tone from black to white. Black has a levels value of 0 (zero), while white has a levels value of 255 and all the numbers in between represent the different shades of gray going from black to white. The histogram is therefore like a bar graph with 256 increments, each representing how frequently a particular levels number (a specific gray value) occurs in the image. Figure 4.4 shows a typical histogram such as you'll see in the Histogram, Levels and Curves panels. This diagram also shows how the appearance of the graph relates to the tonal structure of a photographic image.

Now let's look at what that information can actually tell us. The histogram graphically shows the distribution of tones in a digital image. A low-key photograph (such as the one shown in Figure 4.4) will have most of the peaks on the left. Most importantly, it shows the positioning of the shadow and highlight points. When you apply a tonal correction using Levels

A digital image is nothing more than a bunch of numbers and it is how those numbers are interpreted in Photoshop that creates the image you see on the display. We can use our eyes to make subjective judgments about how the picture looks, but we can also use the number information to provide useful and usable feedback. Plus we have the Histogram panel, which is also an excellent teaching tool and makes everything that follows much easier to understand.

Figure 4.4 Here is an image histogram that represents the distribution of tones from the shadows to the highlights. Because this photograph mostly contains dark tones you will notice that the levels are predominantly located to the left end of the histogram. The height of each bar in the histogram indicates how frequently each levels value is represented in the image based on a 0–255 scale.

or Curves, the histogram provides visual clues that help you judge where the brightest highlights and deepest shadows should be. The histogram also tells you something about the condition of the image you are editing. If there are peaks jammed up at one or other end of the histogram, this suggests that either the highlights or the shadows have become clipped and when the original photograph was captured or scanned it was effectively under or overexposed. Unfortunately, once the levels are clipped you can't restore the detail that's been lost here. Also, if there are gaps in the histogram at this stage, it most likely indicates a poor quality original capture or scan, or that the image had previously been heavily manipulated.

Figure 4.5 The warning triangle in the Histogram panel indicates that you need to click on the Refresh button (circled) to update it.

The Histogram panel

You'll see a histogram whenever you work in Levels and Curves and there is also a separate Histogram panel (Figure 4.5), to provide feedback when working in Photoshop. With the Histogram panel, you can continuously observe the effect your image editing has on the image levels and you can check the histogram while making any type of image adjustment. The Histogram panel only provides an approximate representation of the image levels. To see a more accurate representation of the image levels, it is advisable to force Photoshop to update the histogram view, by clicking on the Refresh button in the top right corner (see Figure 4.5).

Throughout this book I like to guide readers to work as non-destructively as possible. Even so, anything you do to adjust the levels to make the image look better will result in some data loss. This is normal and an inevitable consequence of the image editing process. The steps on the page opposite illustrate what happens when you edit a photograph. You will notice that as you adjust the input levels and adjust the gamma (middle) input slider, you end up stretching some of the levels further apart and gaps may start to appear in the histogram. More importantly, stretching the levels further apart can result in less well-defined tonal separation and therefore less detail in these regions. This can particularly be a problem with shadow detail because there are always fewer levels of usable tone information in the shadows compared with the highlights (see Digital exposure on page 150). While moving the gamma slider causes the tones on one side to stretch, it causes the tones on the other side to compress more and these can appear as spikes in the histogram. This too can cause data loss, sometimes resulting in flatter tone separation.

The histogram can therefore be used to provide visual feedback on the levels information in an image and indicate whether there is clipping at either end of the scale. However, does it really matter whether we obtain a perfectly smooth histogram or not? If you are preparing a photograph to go to a print press, you would be lucky to detect more than 50 levels of tonal separation from any single ink plate. Therefore, the loss of a few levels at the completed edit stage does not necessarily imply that you have too little digital tonal information from which to reproduce a full-tonal range image in print. Having said that if you begin with a bad-looking histogram, the image is only going to be in a worse state after it has been retouched. For this reason it is best to start out with the best quality scan or capture you can get.

Basic Levels editing and the histogram

This image editing example was carried out on an 8-bit RGB image, so it should come as no surprise that the histogram broke down as soon as I applied a simple Levels adjustment (in the following section we are going to look at the advantages of editing in 16-bits per channel mode).

1 Here is an image that displayed an evenly distributed range of tones in the accompanying Histogram panel view.

2 When I applied a Levels image adjustment and dragged the middle (gamma) input slider to the left, this lightened the image and the Histogram panel on the right shows the histogram display after the adjustment had been applied. To understand what has happened here, this histogram represents the newly mapped levels. The levels in the section to the left of the gamma slider have been stretched and the levels to the right of the gamma slider have been compressed.

Bit depth

The bit depth refers to the maximum number of levels per channel that can be contained in a photograph. For example, a 24-bit RGB color image is made up of three 8-bit image channels, where each 8-bit channel can contain up to 256 levels of tone (see Figure 4.6), while a 16-bit per channel image can contain up to 32,768 data points per color channel, because, in truth, Photoshop's 16-bit depth is actually 15-bit +1 (see sidebar).

JPEG images are always limited to 8-bits, but TIFF and PSD files can be in 8-bits or 16-bits per channel. Note though that Photoshop only offers 8-bits or 16-bits per channel modes for standard integer channel images, while 32-bit support in Photoshop uses floating point math to calculate the levels values. Therefore, any source image with more than 8-bits per channel has to be processed as a 16-bits per channel

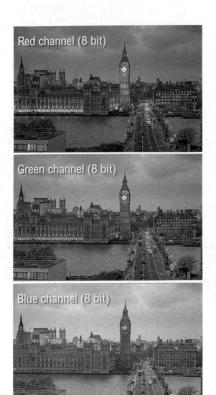

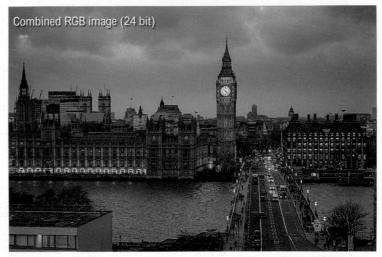

Figure 4.6 The bit depth of an image is a mathematical description of the maximum levels of tone that are possible, expressed as a power of 2. A bitmap image contains 2 to the power of 1 (2 levels of tone), in other words, black or white tones only. A normal Photoshop 8-bit grayscale image or an individual color channel in a composite color image contains 2 to the power of 8 (2^8) and up to 256 levels of tonal information. When three RGB 8-bit color channels are combined together to form a composite color image, the result is a 24-bit color image that can contain up to 16.7 million shades of color ($2^8 \times 3$).

mode image. Since most scanners are capable of capturing at least 12-bits per channel data, this means that scanned images should ideally be saved as 16-bits per channel images in order to preserve all of the 12-bits per channel data. You can check the bit depth of an image quite easily by looking at the document window title bar, where it will indicate the bit depth as being 8, 16 or 32-bit.

In the case of raw files, a raw image contains all the original levels of capture image data, which will usually have been captured at a bit depth of 12-bits, or 14-bits per channel. Camera Raw image adjustments are mostly calculated using 16-bits per channel, so once again, all the levels information that is in the original can only be preserved when you save a Camera Raw processed raw image using 16-bits per channel mode.

8-bit versus 16-bit image editing

A higher bit depth doesn't add more pixels to an image. Instead, it offers a greater level of precision to the way tone information is recorded by the camera or scanner sensor. One way to think about bit depth is to consider the difference between having the ability to make measurements with a ruler that is accurate to the nearest millimeter, compared with one that can only measure to the nearest centimeter.

There are those who have suggested that 16-bit editing is a futile exercise because no one can tell the difference between an image that has been edited in 16-bit and one that has been edited in 8-bit. Personally I believe this to be a foolish argument. If a scanner or camera is capable of capturing more than 8-bits per channel, then why not make full use of the extra tonal information? In the case of film scans, you might as well save the freshly scanned images using the 16-bits per channel mode and apply the initial Photoshop edits using Levels or Curves in 16-bits mode. If you preserve all the levels in the original through these early stages of the edit process, you'll have more headroom to work with and avoid dropping useful image data. Overall, it may only take a second or two longer to edit an image in 16-bits per channel compared with when it is in 8-bit, but even if you only carry out the initial edits in 16-bit *and then* convert to 8-bit, you'll retain significantly more image detail.

My second point is that you never know what the future holds in store for us. On pages 352–355 we shall be looking at Shadows/Highlights adjustments. This feature can be used to emphasize image detail that might otherwise have remained

If you use Camera Raw to process a raw camera file or a 16-bit TIFF, the Camera Raw edits will all be carried out in 16-bits. If you are satisfied with the results obtained in Camera Raw and you have managed to produce a perfectly optimized image, it can be argued there is less harm in converting such a file to an 8-bits per channel mode image in Photoshop. However, as I mentioned in the main text, you never know when you might be required to adjust an image further. Keeping a photo in 16-bits gives you the peace of mind, knowing that you've preserved as many levels as possible that were in the original capture or scan.

hidden in the shadows or highlight areas. It exploits the fact that a deep-bit image can contain lots of hidden levels of data that can be further manipulated to reveal more detail in the shadows or highlights. A Shadows/Highlights adjustment can still work just fine with 8-bit images, but you'll get better results if you open your raw processed images as 16-bit photos or scan in 16-bit per channel mode first.

Photoshop also offers extensive support for 16-bit editing. When a 16-bit grayscale, RGB, CMYK or Lab color mode image is opened in Photoshop you can crop, rotate, apply all the usual image adjustments, use any of the Photoshop tools and work with layered files. The main restriction is that not all filters can work in 16-bits per channel mode. You may not feel the need to use 16-bits per channel all the time, but I would say for critical jobs where you don't want to lose an ounce of detail, it is essential to make at least all your preliminary edits in 16-bits per channel mode. It should go without saying of course, but there is no point editing an image in 16-bit unless it started out as a deep-bit image to begin with. There is nothing to be gained by converting an image that is already in 8-bit to 16-bit.

In the steps shown opposite, I started with an image that was in 16-bits mode and created a duplicate version that was converted to 8-bits. I then proceeded to compress the levels and expand them again in order to demonstrate how keeping an image in 16-bits per channel mode provides a more robust image mode for making major tone and color edits. Admittedly, this is an extreme example, but preserving an image in 16-bits offers a significant extra margin of safety when making everyday image adjustments.

16-bit and color space selection

Photoshop allows you to edit extensively in 16-bits per channel mode. One of the advantages this brings is that you are not limited to editing in relatively small gamut RGB workspaces. If you edit using 16-bit, it is perfectly safe to use a large gamut space such as ProPhoto RGB because you'll have that many more data points in each color channel to work with (see the following section on RGB edit spaces).

Comparing 8-bit with 16-bit editing

1 Here, I started out with a full color image that was in 16-bits per channel mode and created a duplicate that was converted to 8-bits per channel mode.

2 With each version I applied two sequential Levels adjustment layers. The first (shown here on the left) compressed the output levels to an output range of 110–136. I then applied a second Levels adjustment layer in which I expanded these levels to 0–255 again.

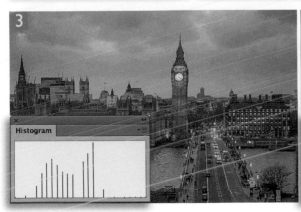

3 The outcome of these two sequential Levels adjustments can clearly be seen when examining the individual color channels. On the left you can see the image histogram for the 8-bit file green channel after these two adjustments had been applied and on the right you can see the histogram of the 16-bit file green channel after making the same adjustments. As you can see, with the 8-bit version there is noticeable banding in the sky and lots of gaps in the histogram. Meanwhile, the 16-bit version exhibits no banding and retains a smooth histogram.

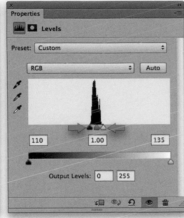

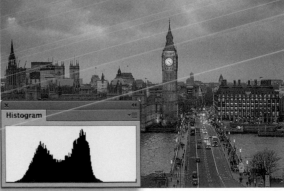

Figure 4.7 The Color Settings dialog.

The RGB edit space and color gamut

One of the first things you need to do when you configure Photoshop is to choose an appropriate RGB edit space from the RGB Working Spaces menu in the Edit ⇨ Color Settings dialog (Figure 4.7).

For photo editing work, the choice really boils down to Adobe RGB or ProPhoto RGB. The best way to illustrate the differences between these two RGB color spaces is to consider how colors captured by a camera or scanner are best preserved when they are converted to print. Figure 4.8 shows (on the left) top and side views of a 3D plot for the color gamut of a digital camera, seen relative to a wire frame of the Adobe RGB working space. Next to this you can see top and side views of a glossy inkjet print space relative to Adobe RGB. You will notice here how the Adobe RGB edit space clips

Figure 4.8 This diagram shows on the left, a top and side view of the gamut of a digital camera source space plotted as a solid shape within a wire frame shape representing the color gamut of the Adobe RGB edit space. On the right is a top and side view of the gamut of a glossy inkjet printer color space plotted as a solid shape within a wire frame of the same Adobe RGB space.

both the input and output color spaces. This can be considered disadvantageous because all these potential colors are clipped as soon as you convert the capture data to Adobe RGB. Meanwhile, Figure 4.9 offers a direct comparison showing you what happens when you select the ProPhoto RGB space. The ProPhoto RGB color gamut is so large it barely clips the input color space at all and is certainly big enough to preserve all the other colors through to the print output stage. In my view, ProPhoto RGB is the best space to use if you really want to preserve all the color detail that was captured in the original photo and see those colors preserved through to print.

The other choice offered in the Color Settings is the sRGB color space, but this is only really suited for Web output work (or when sending pictures to clients via email).

Is ProPhoto RGB too big a space?

There have been concerns that the ProPhoto RGB space is so huge that the large gaps between one level's data point and the next could lead to posterization. This might be a valid argument where images are mainly edited in 8-bits per channel throughout. In practice, you can edit a ProPhoto RGB image in 16-bits or 8-bits per channel mode, but 16-bits is safer. Also, these days you can use Camera Raw to optimize an image prior to outputting as a ProPhoto RGB pixel image.

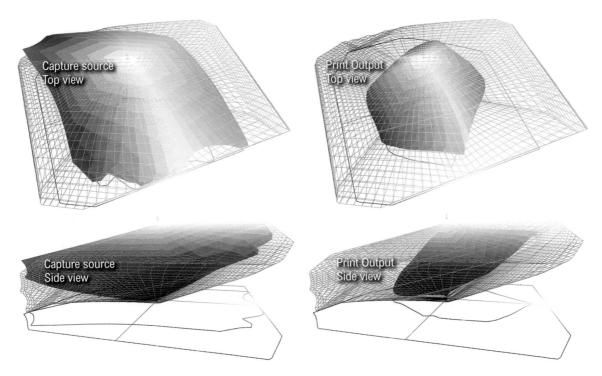

Figure 4.9 This diagram shows on the left, a top and side view of the gamut of a digital camera source space plotted as a solid shape within a wire frame shape representing the color gamut of the ProPhoto RGB edit space. On the right is a top and side view of the gamut of a glossy inkjet printer color space plotted as a solid shape within a wire frame of the same ProPhoto RGB space.

Figure 4.10 This shows the basic workflow for applying a normal image adjustment. Go to the Image ⇨ Adjustments menu and choose an adjustment type. In this example I selected Levels…, adjusted the settings and clicked OK to permanently apply this adjustment to the image.

Direct image adjustments

Most Photoshop image adjustments can be applied in one of two ways. There is the traditional, direct adjustment method where image adjustments can be accessed via the Image ⇨ Adjustments menu and applied to the whole image (or an image layer) directly. Figure 4.10 shows an example of how one might apply a basic Levels adjustment. Here, I had an image open with a Background layer, I went to the Image Adjustments menu and selected 'Levels…' (⌘ L [Mac], ctrl L [PC]). This opened the Levels dialog where I was able to apply a permanent tone adjustment to the photograph.

Direct image adjustments are appropriate for those times where you don't need the editability that adjustment layers can offer. They are also the only way to edit an alpha channel or layer mask, since you can't use adjustment layers when editing Photoshop channels.

Adjustment layers approach

With adjustment layers, an image adjustment can be applied in the form of an editable layer adjustment. These can be added to an image in several ways. You can go to the Layer ⇨ New Adjustment layer submenu, or click on the Add new adjustment layer button in the Layers panel to select an adjustment type. Or, you can also use the Adjustments panel to select and add an adjustment layer.

The Properties panel, in the adjustment controls mode, displays the adjustment controls. In the Figure 4.11 example you'll see I again started out with an image with a Background layer. I went to the Adjustments panel and clicked on the Levels adjustment button (circled in red). This added a new Levels adjustment layer above the Background layer and the Properties panel showed the Levels adjustment controls for this new adjustment layer.

There are several advantages to the Adjustment layer approach. First of all, adjustment layers are not permanent. If you decide to undo an adjustment or readjust the settings, you can do so at any time. Adjustment layers offer the ability to apply multiple image adjustments and/or fills to an image and for the adjustments to remain 'dynamic'. In other words, an adjustment layer is an image adjustment that can be revised at any time and allows the image adjustment processing to be deferred until the time when an image is flattened. The adjustments you apply can also be masked when you edit

the associated layer mask and this mask can also be refined using the Masks mode in the Properties panel. Best of all, adjustment layers are no longer restricted to a modal state where you have to double-click the layer first in order to access the adjustment controls. With the Properties panel you have the ability to quickly access the adjustment layer settings any time you need to. This also means you can easily switch between tasks. So, if you click on an adjustment layer to select it, you can paint on the layer mask, adjust the layer opacity and blending options and have full access to the adjustment layer controls via the Properties panel.

The beauty of adjustment layers is that they add very little to the overall file size and are much more efficient than applying an adjustment to a duplicate layer. Images that contain adjustment layers are savable in the native Photoshop (PSD), TIFF and PDF formats.

Adjustments panel controls

Figure 4.12 shows the default Adjustments panel view, where you can click on any of the buttons to add a new image adjustment. The button icons may take a little getting used to at first, but you can refer to the summary list on the page opposite to help identify them and read a brief summary of what each one does. If you have the 'Show Tool Tips' option selected in the Photoshop Interface preferences, the tool tips feature displays the names of the adjustments as you roll the cursor over the button icons.

Properties panel controls

Once you are in the Properties panel there are two modes of operation. There is the Mask controls mode, which I describe later on page 372, as well as an 'adjustment controls' mode. By default, the Properties panel displays the 'adjustment controls' mode when an adjustment layer is first created (Figure 4.13).

As you click on any other adjustment layers in the Layers panel to select them, the Properties panel updates to show the controls and settings for that particular layer. Note that double-clicking an adjustment layer opens up the Properties panel if it is currently hidden.

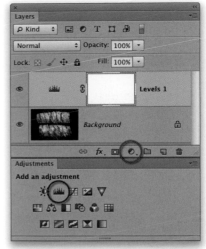

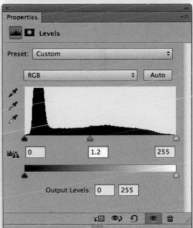

Figure 4.11 This shows the adjustment layer workflow. Go to the Adjustments panel and choose an adjustment type (in this example Levels, which is circled in red) and make the adjustment. This will then be added as a new adjustment layer. The adjustment controls themselves are displayed in the Properties panel. You can also mouse down on the Add Adjustment layer button in the Layers panel (circled in blue) to add a new adjustment layer.

Adjustment panel options

☼ Brightness/Contrast

A basic brightness and contrast tone adjustment.

Levels

To set clipping points and adjust gamma.

Curves

Used for more accurate tone adjustments.

Exposure

Primarily for adjusting the brightness of 32-bit images.

▽ Vibrance

A tamer saturation adjustment control.

Hue/Saturation

A color adjustment for editing hue color, saturation and lightness.

Color Balance

Basic color adjustments.

Black & White

For simple black and white conversions.

Photo Filter

Adds a coloring filter adjustment.

Channel Mixer

For adjusting the balance of the individual color channels that make up a color image.

Color Lookup

Adds a color lookup adjustment.

Invert

Converts an image to a negative.

Posterize

Used to reduce the number of levels in an image.

Threshold

Reduces the number of levels to 2 and allows you to set the midpoint threshold.

Selective Color

Apply CMYK selective color adjustments based on RGB or CMYK colors.

Gradient Map

Lets you use gradients to map the output colors.

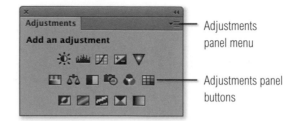

Figure 4.12 The Adjustments panel showing the adjustment buttons.

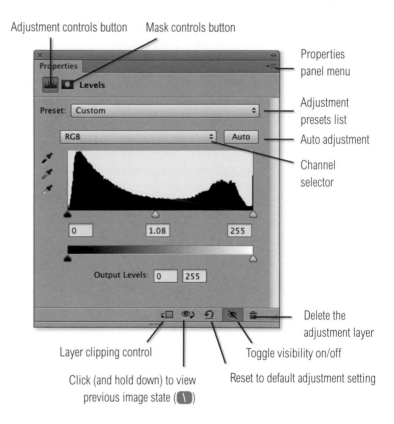

Adjustment controls button Mask controls button

Properties panel menu

Adjustment presets list

Auto adjustment

Channel selector

Delete the adjustment layer

Toggle visibility on/off

Reset to default adjustment setting

Layer clipping control

Click (and hold down) to view previous image state (⬛)

Figure 4.13 This shows the Properties panel with a Levels adjustment selected.

You can click on the Presets pop-up menu to quickly access one of the pre-supplied adjustment settings. Here, you might want to select each in turn, to see what each effect does, but without adding a new adjustment layer. Once you have configured a particular adjustment you can go to the Properties panel menu and choose Save Preset… to save as a custom adjustment setting. This will then appear appended to the Preset list as a custom setting.

The middle section contains the main adjustment controls for whatever adjustment you are currently working on.

At the bottom you have, on the far left, the adjustment layer clipping control button, which lets you determine whether a new adjustment is applied to all the layers that appear below the current adjustment layer, or are clipped just to the layer immediately below it. Next to this is a button for changing the preview image between the current edited state and the previous state. If you click on the button and hold the mouse down (or hold down the \ key), you can see what the image looked like before the last series of image adjustments had been applied to it. Next to this is a Reset button for canceling the most recent adjustments, but you can also use the undo command ⌘ Z (Mac), ctrl Z (PC) to toggle undoing and redoing the last adjustment and use the ⌘ alt Z (Mac), ctrl alt Z (PC) shortcut to progressively undo a series of adjustment panel edits. Next to this is an eyeball icon for turning the adjustment layer visibility on or off and lastly a Delete button. When you click on this it will delete the current adjustment layer. The Properties panel will remain open though and simply say 'No Properties' at the top.

Maintaining focus in the Properties panel

The Photoshop adjustment layers behavior has evolved such that adjustment layer editing is now no longer modal. This is mostly a good thing, but losing the modality means that you must first use the Shift Return keyboard command in order to enter a 'Properties panel edit mode' where, for example, pressing the Tab key allows you to jump from one field to the next. Simply press the esc key to exit the Properties panel edit mode.

Auto image adjustments

The Auto button sets the clipping points automatically. Use **alt**-click to open the Auto Options dialog (the Auto settings are covered later in this chapter).

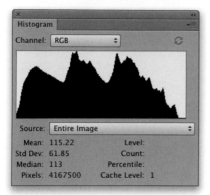

Figure 4.14 This histogram shows an image that contains a full range of tones, without any shadow or highlight clipping and no gaps between the levels.

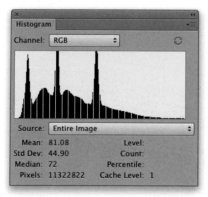

Figure 4.15 A histogram with a comb-like appearance indicates that either the image has already been heavily manipulated or an insufficient number of levels were captured in the original scan.

Levels adjustments

There was a time when every Photoshop edit session would begin with a Levels adjustment to optimize the image. These days, if you use Camera Raw to process your raw or JPEG photos, there shouldn't be so much need to use Levels for this purpose—you should already have optimized the shadows and highlights during the Camera Raw editing. However, it is important and useful to understand the basic principles of how to apply Levels adjustments since there are still times when it is more convenient to apply a quick Levels adjustment to an image, rather than use Camera Raw. The main Levels controls are shown below in Figure 4.16.

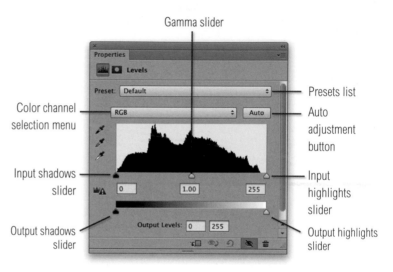

Figure 4.16 This shows a view of the Properties panel when adding a Levels adjustment. The Input sliders are just below the histogram display and you can use these to adjust the input shadows, highlights and gamma (the relative image brightness between the shadows and highlights). Below this are the Output sliders and you use these to set the output shadows and highlights. It is best not to adjust the Output sliders unless you are retouching a prepress file in grayscale or CMYK, or you deliberately wish to reduce the output contrast.

Analyzing the histogram

Levels adjustments can have a big effect on the appearance of the histogram and so it is important to keep a close eye on the histogram shown in the Levels dialog/Properties panel as well as the one in the Histogram panel itself. Figure 4.14 shows a nice, smooth histogram where the image was first optimized

in Camera Raw before being opened in Photoshop, while Figure 4.15 shows the histogram for an image that's obviously been heavily manipulated in Photoshop. In Figure 4.17 you can see a low-key image where the blacks are quite heavily clipped and most of the levels are bunched up to the left, while in Figure 4.18 the highlights are clearly clipped in this high-key image. As I explain below, it isn't necessarily a bad thing to sometimes clip the shadows or highlights in this way.

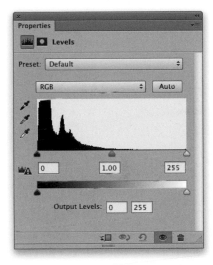

Figure 4.17 If the levels are bunched up towards the left, this is a sign of shadow clipping. With this image it was probably a good thing to let the darkest shadows clip.

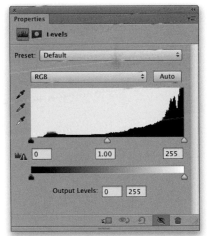

Figure 4.18 If the levels are bunched up towards the right, the highlights may be clipped. However, in this example it was desirable to let some of the highlights burn out to white.

Are Curves all you need?

I have become a firm believer in trying to make Photoshop as simple as possible. There are 22 different items listed in the Image Adjustments menu and of these I reckon that you can achieve almost all the image adjustments you need by using just Curves and Hue/Saturation. While Curves can replace the need for Levels, I do still like to use the Levels dialog, because it is nice and simple to work with, plus there are also a lot of tutorials out there that rely on the use of Levels. You are still likely to come across lots of suggestions on ways to tonally adjust images by various means. And you know what? In most cases these techniques can often be summarized with a single Curves adjustment. It's just that it can sometimes actually work out quicker (and feel more intuitive) to use a slightly more convoluted route. In Photoshop there is often more than one way to achieve a particular effect. To quote Fred Bunting: there are always those techniques that are "more interesting than relevant."

Better negative number support

When applying a Curves adjustment and editing an image in Lab color mode, it is now possible to enter triple digit negative numbers directly into the fields in the Curves dialog. Previously, you could only type in two digit negative numbers, or three digit positive number values.

Curves adjustment layers

Any image adjustment that can be carried out using Levels can also be done using Curves, except Curves allows you to accurately control the tonal balance and contrast of the master composite image as well as the individual color channels. You can target specific points on the Tone Curve and remap the pixel values to make them lighter or darker and adjust contrast in specific tonal areas.

As with all the other image adjustments, there are two ways you can work with Curves. There is the direct route (using the Image ⇨ Adjustments menu) and the adjustments layer method described here. I have chosen to concentrate on the adjustments layer Properties panel here first because I believe this method is more useful for general image editing.

Figure 4.19 shows the Properties panel displaying the Curves controls, where the default RGB units are measured in brightness levels from 0 to 255 and the curve line represents the output tonal range plotted against the input tonal range. The vertical axis represents the output and the horizontal axis the input values (and the numbers correspond to the levels scale for an 8-bit per channel image). When you edit a CMYK image, the input and output axis is reversed and the units are measured in ink percentages instead of levels. The Curves grid normally uses 25% increments for RGB images and 10% increments for CMYK images, but you can toggle the Curves grid display mode by *alt*-clicking anywhere in the grid.

Let's now look at the Curves control options. In the controls section you have a channel selection menu. This defaults to the composite RGB or CMYK mode, where all channels are affected equally by the adjustments you make. You can, however, use this menu to select specific color channels, which can be useful for carrying out color corrections (see Figure 4.20). The Auto button in Curves is the same as the one found in Levels. When you click on this, it applies an auto adjustment based on how the auto settings are configured (see Auto image adjustments on page 356).

If you double-click the eyedroppers, you can edit the desired black point, gray point and white point colors and then use these eyedroppers to click in the image to set the appropriate black, gray and white point values. There was a time in the early days of Photoshop where the eyedropper controls were important, but there are two reasons why this is less the case now. Firstly, you can accurately set the black and white clipping

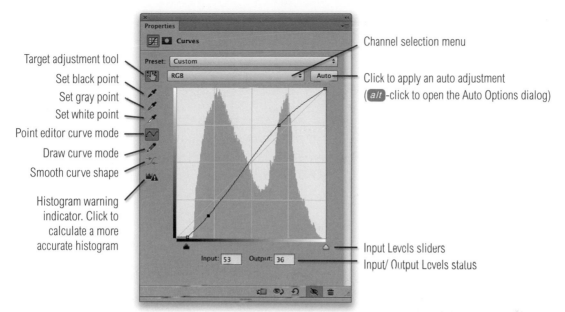

Channel selection menu

Target adjustment tool
Set black point
Set gray point
Set white point
Point editor curve mode
Draw curve mode
Smooth curve shape

Histogram warning
indicator. Click to
calculate a more
accurate histogram

Click to apply an auto adjustment
(*alt*-click to open the Auto Options dialog)

Input Levels sliders
Input/ Output Levels status

Figure 4.19 The Curves dialog represents the relationship between the input and output levels plotted as a graph. In this example, the shadow end of the curve has been dragged inwards (just as you would in Levels) to set the optimum shadow clipping point. You can control both the lightness and the contrast of the image by clicking on the curve line to add curve points and adjust the shape of the curve.

points in Camera Raw (as described on pages 146–148) and secondly, the color management system in Photoshop automatically maps the black point for you when you convert an image to CMYK, or uses the Photoshop Print dialog to make a color managed print output. However, the gray eyedropper can still prove useful for auto color balancing a photo.

The Input levels sliders work the same way as those in Levels and you can drag these with the *alt* key held down to access a threshold view mode (RGB and Grayscale Curves adjustments only). The Input and Output boxes provide numeric feedback for the current selected curve point so that you can adjust the curve points more precisely. You may sometimes see a histogram warning appear. This tells you that the histogram displayed in the grid area is not an accurate reflection of what the true histogram should be and if you click on this, it forces an update of the histogram view. The Curves dialog uses the Point curve editor mode by default, but there is also a pencil button for switching to a draw curve mode,

Figure 4.20 The default setting for Levels or Curves applies the corrections to the composite of the color channels. If you mouse down on the Channel menu, you can choose to edit individual color channels. This is how you use Curves to apply color adjustments.

Figure 4.21 When the cursor is dragged over the image, a hollow circle indicates where the tone value is on the curve.

which allows you to draw a curve shape directly. While in 'draw curve' mode the 'Smooth curve shape' button is made active and clicking on this allows you to smooth a drawn curve shape. Overall, you are unlikely to need to use the draw curve mode when editing photographic images.

On-image Curves editing

If you click on the target adjustment tool button to activate it and move the cursor over the document window, you will notice a hollow circle that hovers along the curve line. This shows you where the tones in any part of the image appear on the curve. If you then click on the image a new curve point is added to the curve (Figure 4.21). However, if you click to add a curve point and at the same time drag the mouse up or down, this also moves the curve up and down where you just added the curve point. This means when the target adjustment tool mode is active, you can click and drag directly on the image to make specific tone areas lighter or darker (see the step-by-step example shown opposite). For added convenience, there is also an 'Auto-Select Targeted Adjustment Tool' Properties panel menu option that automatically selects the target adjustment tool whenever a Curves adjustment layer is made active.

With both the eyedropper and the target adjustment tool methods, the pixel sampling behavior is determined by the sample options set in the Options bar. Figure 4.22 shows a view of the Options bar while the target adjustment tool is active. If a small sample size is used, the curve point placement can be quite tricky, because the hollow circle will dance up and down the curve as you move the cursor over the image. If you select a large sample size this averages out the readings and makes the cursor placement and on-image editing a much smoother experience.

Removing curve points

To remove a curve point select it and drag from the grid. Or, as you hover the cursor over an existing curve point on the curve line you can ⌘ (Mac), *ctrl* (PC)-click to delete it.

Figure 4.22 The target adjustment tool options bar showing the Sample Size options. For on-image selections it can be useful to choose a large sample size.

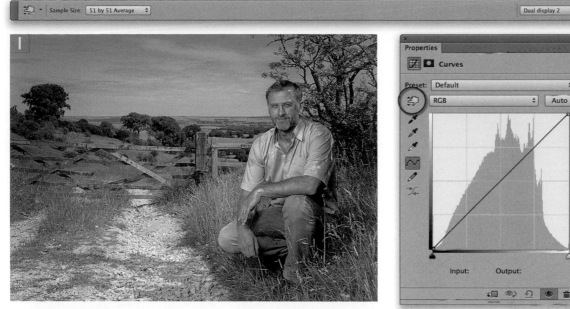

1 I deliberately chose a photograph that lacked contrast in order to demonstrate how the on-image curves editing works. To begin with I added a new Curves adjustment layer. I clicked on the target adjustment tool button (circled) and made sure that I had set a large sample size in the target adjustment tool options.

2 As I moved the cursor over the image I was able to click with the mouse to add new points to the curve. As I dragged the cursor upwards, this raised the curve upward and lightened the tones beneath where I had clicked. Likewise, as I dragged downwards I was able to darken those areas of the image.

Threshold mode preview

The Curves input sliders work exactly like the ones found in Levels. You can preview the shadow and highlight clipping by holding down the *alt* key as you drag on the shadow and highlight sliders circled in the Properties panel views shown in Figures 4.23 and 4.24.

Using Curves in place of Levels

You can adjust the shadow and highlight levels in Curves in exactly the same way as you would using Levels. For example, you have the Input shadows and Input highlights sliders and you can drag these inwards to clip the shadow and highlight levels (Figure 4.23). In Levels you alter the relative brightness of the image by adjusting the gamma slider, while in the Curves adjustment you can add a single curves point and move it left to lighten or right to darken.

Output levels adjustments

If you select a shadow or highlight curves point and move it up or down, you can adjust the output levels for the shadows or highlights. Figure 4.24 shows how to apply equivalent tone adjustments to the output levels in Levels and Curves, while Figure 4.25 shows some further examples of where the output levels have been adjusted.

Figure 4.23 The Levels and Curves panel settings shown here can both be used to apply identical adjustments to an image. In the Levels adjustment example I moved the shadows and highlight Input levels sliders inwards. You will notice that the Curves adjustment has an identical pair of sliders with which you can map the shadow and highlight input levels. In the Levels adjustment you will notice how I moved the gamma slider to the right, to darken the midtones. In the Curves adjustment one can add a point midway along the curve and drag this to the right to achieve an identical kind of 'Gamma' midtone adjustment.

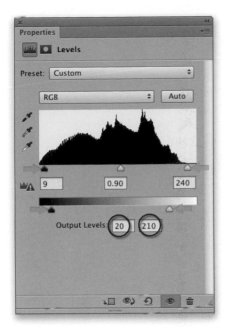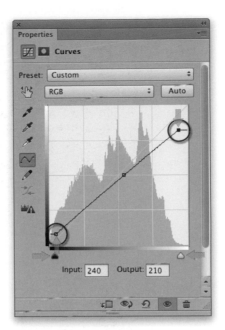

Figure 4.24 The Levels and Curves settings shown here will also apply identical adjustments. In the Levels adjustment I kept the input levels the same and adjusted the output levels to produce an image where the optimized levels were mapped to a levels range of 20–210. In the Curves dialog you can see the highlight point is selected and the curve point has been moved downwards to show a corresponding output value of 210 (the same value as the one entered in the Levels adjustment output levels).

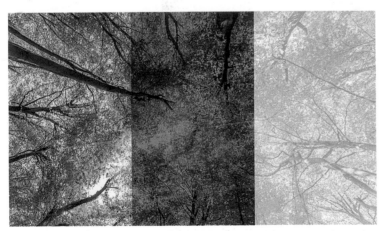

Figure 4.25 Setting the output levels to something other than zero isn't something you would normally want to do, except for those times where you specifically want to dull down the tonal range of an image. In the example shown here, the left section shows standard optimized levels, the middle section shows the same image with reduced highlight output levels and the right section shows the image with reduced shadow output levels.

Easier blend mode access

One of the main benefits of the adjustment layers approach is that you can switch easily between editing the adjustment controls in the Properties panel and adjusting the layer opacity and blend mode settings.

Figure 4.26 The Edit ⇨ Fade dialog.

Luminosity and Color blending modes

One of the problems you may encounter when applying Normal blend mode tone adjustments is that as you use Levels or Curves to adjust the tonal balance of a picture, the adjustments you make will also affect the color saturation. In some instances this might be a desirable outcome. For example, whenever you start off with a flat image that requires a major Levels or Curves adjustment, the process of optimizing the shadows and highlights will produce a picture with increased contrast and more saturated color. This can be considered a good thing, but if you are carrying out a careful tone adjustment and wish to manipulate the contrast or brightness, *but without* affecting the saturation, changing the blend mode to Luminosity can isolate the adjustment so that it targets the luminosity values only.

This is where working with adjustment layers can be useful, because you can easily switch the blend modes for any adjustment layer. In the example that's shown opposite, a Curves adjustment was used to add more contrast to the photograph. When this adjustment was applied in the Normal mode (as shown in Step 1), the color saturation was increased. However, when the same Curves adjustment was applied using a Luminosity blend mode, there was an increase in the contrast but without there being an increase in color saturation. Incidentally, I quite often use the Luminosity blend mode whenever I add a Levels or Curves adjustment layer to an image, especially if it has already been optimized for color. This is because whenever I add localized corrections I usually don't want these adjustments to further affect the saturation of the image. Similarly, if you are applying an image adjustment (such as Curves) to alter the colors in a photo, you may want the adjustment to target the colors only and leave the luminance values as they are. So whenever you make a color correction using, say, Levels, Curves, Hue/Saturation, or any other method, it is often a good idea to change the adjustment layer blend mode to Color.

If you happen to prefer the direct adjustment method, you can always go to the Edit menu after applying a Curves and choose Fade Curves… (⌘ *Shift* *F* [Mac], *ctrl* *Shift* *F* [PC]). This opens the Fade dialog shown in Figure 4.26, where you can change the blend mode of any adjustment as well as fade the opacity.

1 When you increase the contrast in an image using a Curves adjustment, you will also end up increasing the color saturation. Sometimes this will produce a desirable result because often photographs will look better when you boost the saturation.

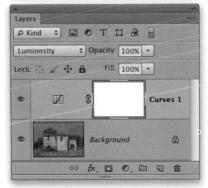

2 In this example I applied the same Curves adjustment as was applied in Step 1, but I changed the layer blend mode to Luminosity. This effectively allowed me to increase the contrast in the original scene, but without increasing the color saturation.

Locking down portions of a curve

As you go beyond adding one or two points to a curve, you need to be careful to keep the curve shape under control. Once you start adding further points to a curve, adjusting a point on one part of the curve may cause the curve shape to move, pivoting around the adjacent points. One solution is to sometimes lay down 'locking' points on the curve, as shown below in Figure 4.27.

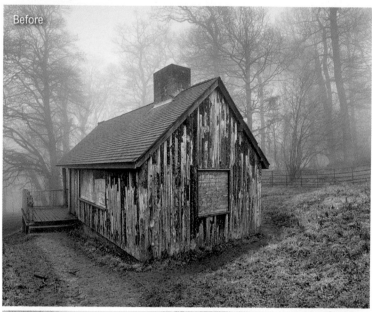

Figure 4.27 In this example I wanted to make the dark tones darker, but without affecting the mid to highlight tones so much. Here is what I did. I placed one curve point on the middle intersection point of the curve and another on the 75% intersection point. I then added a third curve point towards the toe of the curve and dragged downwards to darken the shadows and steepen the curve in the shadow to midtone areas. You will notice that because I had added the other two curve points first, adjusting the third curve point had little effect on the upper portion of the curve.

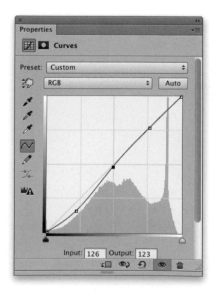

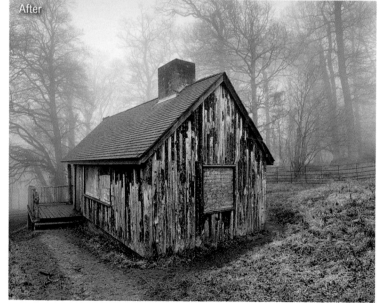

Creating a dual contrast curve

Now let's look at adding even more curve points. There are times where you may want to manipulate the contrast in two sections of the curve at once. For this you may need to place three or more points on the curve such as in the Figure 4.28 example shown below. This is where you need to be really careful, because it is all too easy to make some of the tones look solarized, or you may end up flattening them. Either way you risk losing tonal detail.

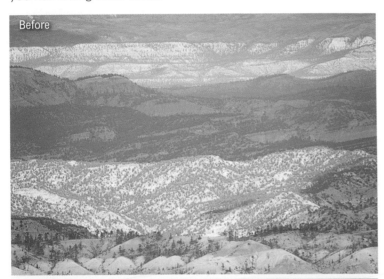

Before

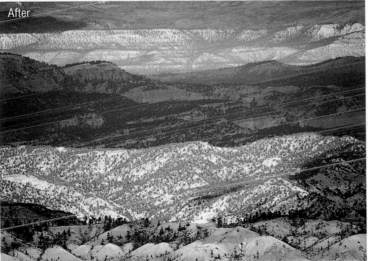

After

Figure 4.28 In this example I wanted to boost the contrast in the shadows and the highlights separately. To do this, I applied the curve shape shown here where you will see that by using six curve points I was able to independently steepen the shadow/midtone and highlight portions of the curve.

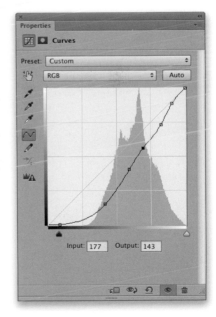

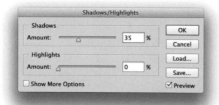

Figure 4.29 The Shadows/Highlights adjustment dialog is shown here in basic mode. Checking the Show More Options box will reveal the Advanced mode dialog shown in Figure 4.30.

Figure 4.30 In the Advanced mode, the Shadows/Highlights dialog contains a comprehensive range of controls. I would advise you to always leave the 'Show More Options' box checked so that you have this as the default mode for making Shadows/Highlights adjustments.

Correcting shadow and highlight detail

The Shadows/Highlights image adjustment (Figure 4.29) can be used to reveal more detail in either the shadow or highlight areas of a picture. It is a great image adjustment tool to use whenever you need to expand compressed image tones in an image, but it can be used to perform wonders on most photos and not just those where you desperately need to recover shadow or highlight detail.

The Shadows/Highlights image adjustment tool makes adaptive adjustments to an image, and works in much the same way as our eyes do when they automatically compensate and adjust to the amount of light illuminating a subject. Essentially, the Shadows/Highlights adjustment works by looking at the neighboring pixels in an image and makes a compensating adjustment based on the average pixel values within a given radius. In the Advanced mode (Figure 4.30), the Shadows/Highlights dialog has additional controls that allow you to make the following fine-tuning adjustments.

Amount

This is an easy one to get to get to grips with. The default Amount setting applies a 35% amount to the Shadows. You can increase or decrease this to achieve the desired amount of highlight or shadow correction. I find the default setting does tend to be rather annoying, so I usually try setting the slider to a lower amount (or zero even) and click on the 'Save As Defaults' button to set this as the new default setting each time I open Shadows/Highlights.

Tonal Width

The Tonal Width determines the tonal range of pixel values that will be affected by the Amount setting. A low Tonal Width setting narrows the adjustment to the darkest or lightest pixels only. As the Tonal Width is increased, the adjustment spreads to affect more of the midtone pixels as well (see the example shown in Figure 4.31).

Radius

The Radius setting governs the pixel width of the area that is analyzed when making an adaptive correction. To explain this, let's analyze what happens when making a shadow correction. If the Shadow Radius is set to zero, the result will be a very flat-looking image. You can increase the Amount to lighten the

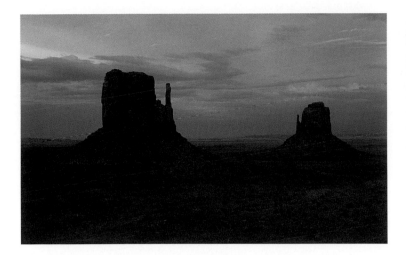

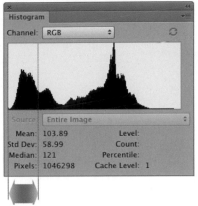

Figure 4.31 The Tonal Width slider determines the range of levels the Shadows/ Highlights adjustment is applied to. For example, if the Shadow adjustment Tonal Range is set to 40, then only the pixels which fall within the darkest range from level 0 to level 40 will be adjusted (such as the deep shadows in this photograph).

shadows and restrict the Tonal Width, but if the Radius is low or set to zero, Photoshop has very little neighbor pixel information to work with when trying to calculate the average luminance of the neighboring pixels. So if the Radius is set too small, the midtones will also become lightened. If the Radius setting is set too high this has the effect of averaging a larger selection of pixels in the image and likewise the lightening effect will be distributed such that most of the pixels get the lightening treatment, not just the dark pixels. The optimum setting is always dependent on the image content and the pixel area size of the dark or light regions in the image. The optimum pixel Radius width should therefore be about half that amount or less. In practice you don't have to measure the pixel width of the light and dark areas in an image to work this out. Just be aware that after you have established the Amount and Tonal Width settings you should adjust the Radius setting and make it larger or smaller according to how large the dark or light areas are. There will be a 'sweet spot' where the Shadows/ Highlights Radius correction is just right.

As you make an adjustment to the Radius setting you will sometimes notice a soft halo appearing around sharp areas of contrast between the dark and light areas. This is a natural consequence of the Radius function and is most noticeable when you apply large Amount corrections. Aim for a Radius setting where the halo is least noticeable or apply a Fade… adjustment after applying the Shadows/Highlights adjustment. If I am really concerned about halos, I sometimes use the history brush to selectively paint in a Shadows/Highlights adjustment.

HDR Toning adjustment

There is also an HDR Toning adjustment in the Image ⇨ Adjustments menu. This is described on page 424 and provides an alternative approach to applying Shadows/ Highlights type image adjustments.

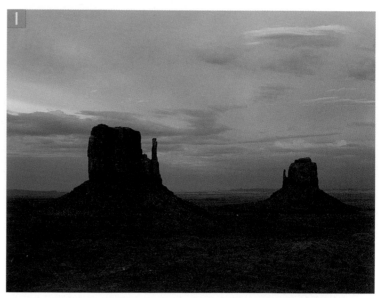

1 In this photograph there were a lot of dark shadows in the rock formations. Using the Shadows/Highlights adjustment it is possible to bring out more detail in the shadows, but without degrading the overall contrast.

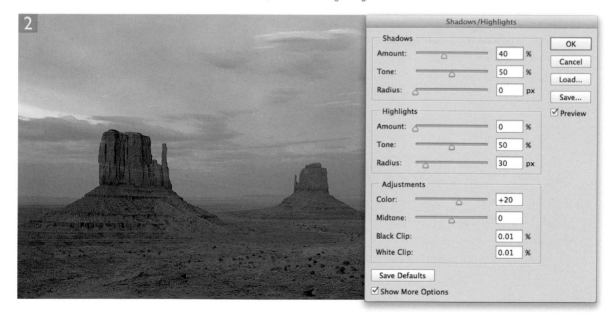

2 I went to the Image menu and chose Adjustments ⇨ Shadows/Highlights. I set the Amount to 40% and raised the Tonal Width to 50%. The Radius adjustment was now crucial because this determined the distribution width of the Shadows/Highlights adjustment. As you can see in this step, if the Radius is set to zero the image will look rather flat.

3 If you take the Radius setting up really high, this too can diminish the Shadows/ Highlights adjustment effect. It is useful to remember here that the optimum Radius setting is 'area size' related and falls somewhere midway between these two extremes. In the end, I went for a Radius setting of 130 pixels for the shadows. This was because I was correcting large shadow areas and this setting appeared to provide the optimum correction for this particular photo. I also increased the Midtone Contrast to +15. This final tweak compensated for some loss of contrast in the midtone areas.

Color Correction

As you correct the highlights and the shadows, the color saturation may change unexpectedly. This can be a consequence of using Shadows/Highlights to apply extreme adjustments. The Color Correction slider lets you compensate for any undesired color shifts.

Midtone Contrast

The midtone areas may sometimes suffer as a result of a Shadows/Highlights adjustment. Even though you may have paid careful attention to getting all the above settings perfectly optimized so that you successfully target the shadows and highlights, the photograph can end up looking like it is lacking in contrast. The Midtone Contrast slider control lets you restore or add more contrast to the midtone areas.

CMYK Shadows/Highlights adjustments
You can use a Shadows/Highlights adjustment on CMYK as well as RGB images.

Adobe Camera Raw adjustments
Shadows/Highlights adjustments can work great on a lot of images, but now that Camera Raw can be applied as a filter, you may like to explore using the Highlights and Shadows adjustments described on page 142. In many cases Highlights and Shadows adjustments in Camera Raw work better than using the Photoshop Shadows/ Highlights adjustment.

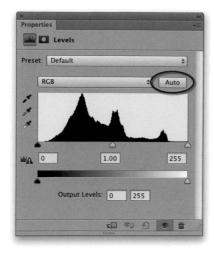

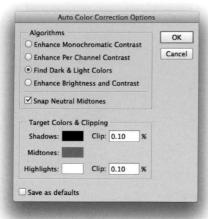

Figure 4.32 The Auto image adjustments can also be accessed when you click on the Options… button in the direct Levels or Curves dialogs, or *alt*-click the Auto button (circled) in the adjustment layer dialogs. If Snap Neutral Midtones is selected, Auto Color will neutralize these too. You can also customize the Clipping values to determine how much the highlights and shadow tones are clipped by the image adjustment.

Auto image adjustments

The Image menu contains three auto image adjustment options designed to provide automated tone and color corrections: Auto Tone, Auto Contrast and Auto Color (examples of these are shown in Figure 4.33).

The Auto Tone adjustment (⌘ *Shift* L [Mac], *ctrl* *Shift* L [PC]) works by expanding the levels in each of the color channels individually. This per-channel levels contrast expansion method will always result in an image that has fuller tonal contrast, but may also change the color balance. The Auto Tone adjustment can produce improved results, but not always. If you want to improve the tonal contrast, but without affecting the color balance of the photograph, then try using the Auto Contrast adjustment instead (⌘ ⌥ *Shift* L [Mac], *ctrl* *alt* *Shift* L [PC]). This carries out a similar type of auto image adjustment as Auto Tone, except it optimizes the contrast by applying an identical Levels adjustment to each of the color channels.

Lastly, there is the Auto Color adjustment (⌘ *Shift* B [Mac], *ctrl* *Shift* B [PC]). This applies a combination of Auto Contrast to enhance the tonal contrast, combined with an auto color correction that maps the darkest colors to black and the lightest colors to white and also aims to neutralize the midtones.

If you open the direct Levels or Curves dialogs you will see a button marked 'Options…' just below the Auto button. This opens the Auto Color Correction Options shown in Figure 4.32. If you are applying a Levels or Curves adjustment layer, then you can *alt*-click the Auto button in the Properties panel to open the Auto Color Correction Options dialog. The algorithms listed here match the auto adjustments found in the Image menu. Enhance Per Channel Contrast is the same as Auto Tone. Enhance Monochromatic Contrast is equivalent to Auto Contrast and Find Dark & Light Colors is the same as Auto Color. Notice however there is also a Snap Neutral Midtones option. When this is checked, a gamma adjustment is applied in each of the color channels which aims to correct the neutral midtones as well as the light and dark colors. A clipping value can be set for the highlights and shadows and this determines by what percentage the endpoints are automatically clipped. There is also an Enhance Brightness and Contrast auto adjustment that's only available as an auto option with Brightness/Contrast and Levels and Curves adjustment layer adjustments (see page 358).

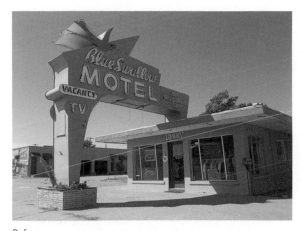
Before

Auto Tone (Enhance Per Channel Contrast)

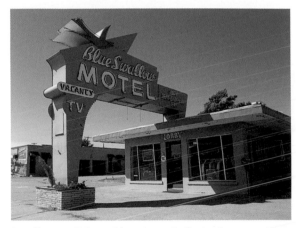
Auto Contrast (Enhance Monochromatic Contrast)

Auto Color (Find Dark & Light Colors + Snap Neutral Midtones)

Figure 4.33 This shows the three Image menu auto adjustment methods (with equivalent descriptions for how they are described in the Levels and Curves 'Auto Color Correction Options' dialogs). Auto Tone optimizes the shadow and highlight points in all three color channels. This generally improves the contrast and color balance of the image. Auto Contrast applies an identical tone balancing adjustment across all three channels that improves the contrast, but without altering the color balance. The Auto Color option maps the darkest and lightest colors to a neutral color (if the swatch colors shown in Figure 4.32 have been altered, you may see a different result). Lastly, I have shown an example of an Auto Contrast adjustment followed by a Match Color Neutralize adjustment.

Auto Contrast + Match Color Neutralize

Match Color corrections

The Figure 4.33 example shows a Match Color correction. This is a rather hidden feature, which I reckon only a few people know about. If you go the Image ⇨ Adjustments menu you will see an item called Match Color... In the dialog that's shown in Figure 4.34 you just need to check the Neutralize box to apply a Match Color neutralize adjustment. You'll find it's remarkably good at removing most color casts.

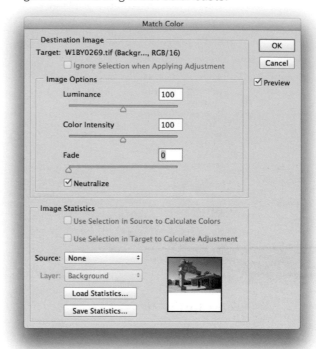

Figure 4.34 The Match Color dialog with the Neutralize box checked.

Enhanced Brightness and Contrast

Photoshop also has an 'Enhance Brightness and Contrast' auto option available in the Levels and Curves adjustment dialogs (see Figure 4.35). This auto correction is a bit more advanced than the other auto options and has now been selected as the default option whenever you click the Auto button in Levels or Curves.

Photoshop makes use here of a hidden database of Levels and Curves adjustments and makes a selection for you when you hit the Auto button (or, *alt*-click the Auto button in the Curves Properties panel and select Enhance Brightness and Contrast from the Algorithms menu). This is done by Photoshop analyzing the histogram and, based on this,

deciding which would be the most appropriate adjustment to select. In the case of Levels (and also Brightness/Contrast), Photoshop aims to clip the black and white points as necessary and applies an appropriate gamma adjustment. In the case of Curves, it selects an appropriate curve shape to apply, based on an analysis of the histogram levels distribution.

This feature is quite effective and can produce some pleasing results. It is not quite such a knock-out feature now as it would have been a few years ago. I think it's more likely that most photographers will want to use Camera Raw to auto process their raw capture images. But the one thing that has to be said when you apply this auto adjustment (as well as any kind of auto adjustment) is you do have the ability to edit the applied Levels or Curves settings before clicking OK to confirm the adjustment. Figure 4.36 shows a before and after example of an Enhance Brightness and Contrast auto Curves adjustment and how it added points to the curve.

Figure 4.35 This shows the Enhance Brightness and Contrast option selected in the Auto Color Correction Options Curves dialog.

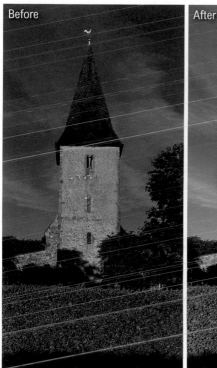

Figure 4.36 This shows a before and after example of an Enhance Brightness and Contrast auto Curves adjustment and the curve shape that it applied to this particular image.

Color corrections using Curves

Of all the Photoshop color correction methods described so far, Auto Color probably provides the best automatic one-step tone and color correction method. However, if you prefer to carry out your color corrections manually, I would suggest you explore using Levels or Curves color channel adjustments instead. Earlier I mentioned how you can set the highlight and shadow points in Levels and how to use a gamma adjustment to lighten or darken the image. Let's now take things one stage further and use this technique to optimize the individual color channels in an RGB color image.

On these pages I show how you can use the threshold mode analysis technique to discover where the shadow and highlight endpoints are in each of the three color channels and use this feedback information to set the endpoints. This is a really good way to locate the shadows and highlights and set the endpoints at the same time, because once you have corrected the highlight and shadow color values in each of the color channels independently, the other colors usually fall into place and the photograph won't require much further color correction.

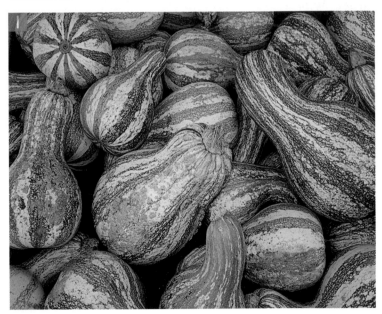

1 This JPEG capture photograph was taken with a basic digital camera and has an overall blue cast. The first step was to go to the Adjustments panel and click on the Curves button (circled) to add a new Curves adjustment layer.

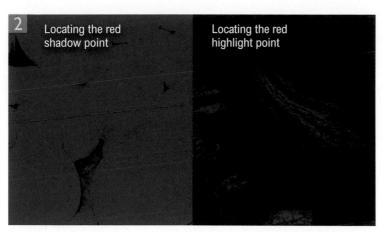

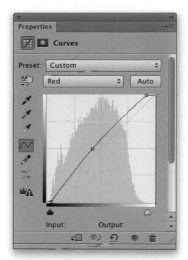

2 I went to the Channel menu, selected the red channel and adjusted the Shadow and Highlight input sliders until the red shadow and red highlight points just started to clip. If you hold down the `alt` key as you do this you will see the threshold display mode (shown here) which can help you locate the shadow and highlight points more easily. I then repeated these steps with the green and blue channels until I had individually adjusted the shadow and highlight points in all three color channels.

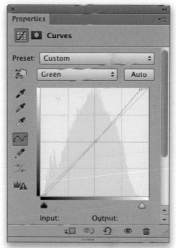

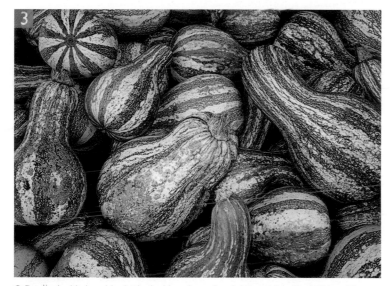

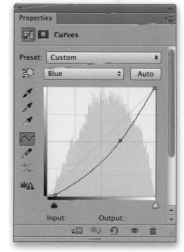

3 Finally, I added a midpoint in the blue channel and dragged it to the right to add more yellow. This technique of adjusting the color channels one by one can help you remove color casts from the shadows and highlights with greater precision. The trick is to use the threshold display mode as a reference tool to indicate where the levels start to clip in each channel and consider backing off slightly so that you leave some headroom in the composite/master channel. This then allows you to make general refinements to the Curves adjustment, ensuring the highlights do not blow out.

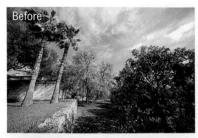

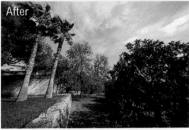

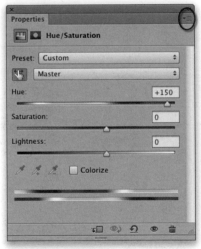

Figure 4.37 This shows an extreme example of how a Hue/Saturation adjustment can be used to radically alter the appearance of a photograph. As you move the Hue slider left or right the colors in the image are mapped to new values. You get an indication of this transformation by looking at the two color ramps at the bottom of the dialog. The top one represents the original 'input' color spectrum and the lower ramp represents how those colors are translated as output colors.

Hue/Saturation

The Hue/Saturation dialog controls are based around the HSB (Hue, Saturation, Brightness) color model, which is basically an intuitive form of the Lab Color model. When you select the Hue/Saturation image adjustment you can adjust the image colors globally, or you can selectively apply an adjustment to a narrower range of colors. The two color spectrum ramps at the bottom of the Hue/Saturation dialog box provide a visual clue as to how the colors are being mapped from one color to another. These hue values are based on a 360 degree spectrum, where red is positioned mid-slider at 0 degrees and all the other colors are assigned numeric values in relation to this. So cyan (the complementary color of red) can be found at either −180 or +180 degrees. Adjusting the Hue slider alters the way colors in the image are mapped to new color values and Figure 4.37 shows an extreme example of how the colors in a normal color image would look if they were mapped by a strong Hue adjustment. As the Hue slider is moved you will notice that the lower color ramp position slides left or right, relative to the upper color ramp.

Saturation adjustments are easy enough to understand. A positive value boosts the color saturation, while a negative value reduces the saturation in an image. Apart from the Master edit mode, you can choose from one of six preset color ranges with which to narrow the focus of a Hue/Saturation adjustment. Once you have selected one of these color range options, you can then sample a new color value from the image window, and this centers the Hue/Saturation adjustments around the new sampled color. Use a *Shift*-click in the image area to add to the color selection and an *alt*-click to subtract colors. There is an 'Auto-Select Targeted Adjustment Tool' Adjustment panel option available from the panel menu (circled in Figure 4.37), which when enabled, automatically selects the target adjustment tool when the adjustment layer is made active. In the case of a Hue/Saturation adjustment it automatically selects the Saturation slider and targets the appropriate color range.

When the Colorize option is checked, the hue component of the image defaults to red (Hue value 0 degrees), Lightness remains the same at 0% and Saturation at 25%. You could use this to colorize a monochrome image, but I think you will be better off using the Photo Filter adjustment to do this (see page 370).

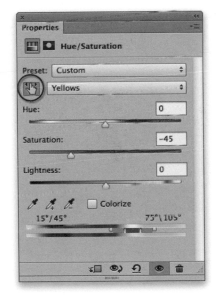

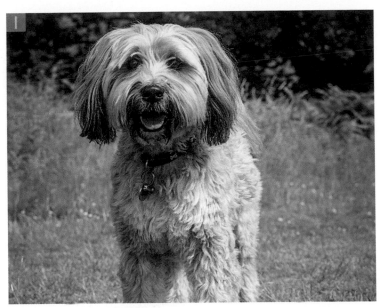

1 With this photograph I wanted to target the green background and make it less intense. One approach would be to add a Hue/Saturation layer, go to the target color group menu shown here, select 'Greens' and desaturate.

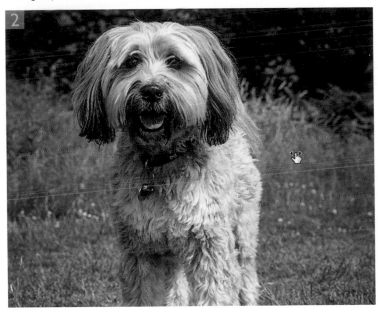

2 Another method (using a Hue/Saturation adjustment) would be to make the target adjustment tool active (circled) and carry out an on-image adjustment by dragging on the color area I wished to modify. This also selected the target color group from the menu, which happened to target the 'Yellows' rather than the 'Greens'. I was then able to click on the image and drag to the left to decrease the saturation.

Color selection shortcuts
The shortcuts for selecting the color groups in Hue/Saturation are as follows. Use _alt_ _2_ to select the master group, _alt_ _3_ to select the reds, and so on.

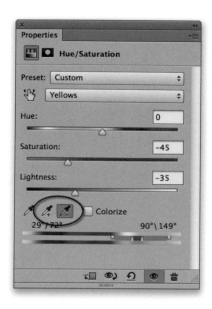

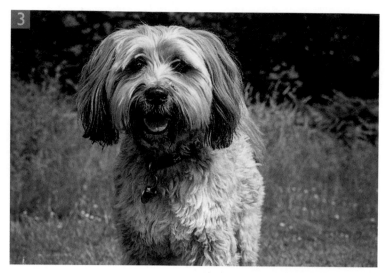

3 I was also able to use the eyedroppers (circled) to add to or subtract from the color range selection. For this step, I selected the minus eyedropper and clicked on the background to subtract some yellow/green colors from the selection. I also manually clicked and dragged the sliders in the color ramp at the bottom to fine-tune the color hue selection. The dark shaded area represented the selected color range and the lighter shaded area (defined by the outer triangular markers) represented the fuzziness drop-off either side of the color selection. I also adjusted the Lightness slider to darken the selected colors.

4 In this final step I painted on the adjustment layer mask with black in order to hide the Hue/Saturation mask and prevent this adjustment from affecting the warm tone colors of the dog. Painting with black on the adjustment layer mask restored the color in this region to how it was originally.

Vibrance

The Vibrance adjustment is available as a direct adjustment and as an Adjustment panel option (Figure 4.38) and allows you to carry out Camera Raw style Vibrance and Saturation adjustments directly in Photoshop. If you refer back to Chapter 2, you will recall that Vibrance applies a non-linear style saturation adjustment in which the less saturated colors receive the biggest saturation boost, while those colors that are already brightly saturated remain relatively protected as you boost the Vibrance. The net result is a saturation control that allows you to make an image look more colorful, but without the attendant risk of clipping those colors that are saturated enough already. As you can see in Figure 4.39 below, Vibrance also prevents skin tones from becoming oversaturated as the amount setting is increased. The Saturation slider you see here is similar to the Saturation slider in the Hue/Saturation adjustment, but applies a slightly gentler adjustment. It matches more closely the behavior of the Saturation slider in Camera Raw.

Figure 4.38 The Vibrance Adjustment panel.

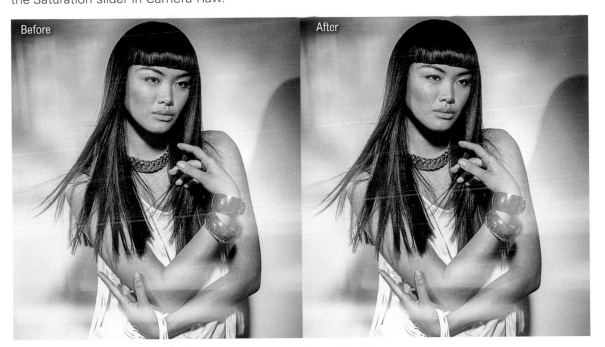

Figure 4.39 This shows a comparison between the before version (left) and the after version (right), in which I boosted the Vibrance by 80%. As you can see, this made the blue colors in the background appear more saturated. You will notice that the Vibrance adjustment also increased the saturation of the skin tones, but the saturation boost here is more modest compared to boosting the saturation with the Saturation slider.

Color Lookup adjustments

The Color Lookup adjustment was first introduced in Photoshop CS6, and provides a new kind of image adjustment that is suited to applying all kinds of varied image adjustment effects. It can use standardized ICC profiles (Abstract and Devicelink), or the less standardized 3D LUT formats (which are widely used in film and video). Basically, Color Lookup adjustments offer a way to package a lot of complicated adjustments into a single profile or LUT (lookup table). Credit should go here to Photoshop engineer Chris Cox, who built most of the 3D LUTs and profiles initially provided in Photoshop. These are not as simple as you might think. A lot of work went into their creation, including writing new code, and as many as eight internal tone and color adjustments are used to create the final effects.

This feature will be of particular interest to video editors because the film industry has for a long time relied on the use of special 3D LUT or Abstract profiles in order to color grade video. You will have seen this all the time in various movies, where the film has been given a certain type of moody color effect. Sometimes this has been done to help unify the color feel of different shots, while some films have incorporated a mixture of special effects. For example, Martin Scorsese's *The Aviator* used a special Technicolor™ colorizing effect, which I reckon the 3strip.look 3D LUT profile aims to simulate. On the page opposite you can see three examples of Color Lookup adjustments (Figures 4.41–4.43) that have been applied to the Figure 4.40 photo.

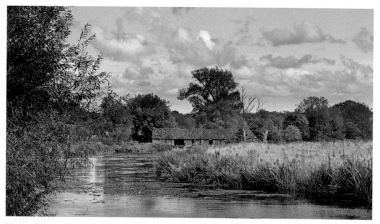

Figure 4.40 This shows the before version of the image to which I applied the Color Lookup adjustments shown on the right.

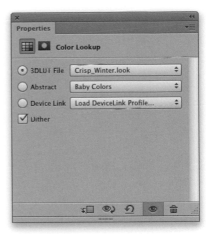

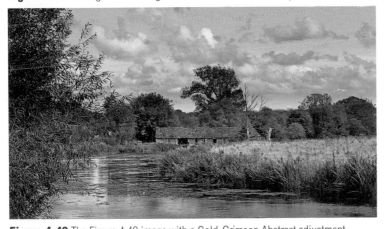

Figure 4.41 The Figure 4.40 image with a Crisp_Winter.look 3D LUT adjustment.

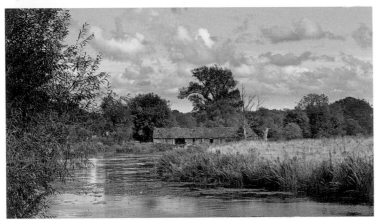

Figure 4.42 The Figure 4.40 image with a Gold-Blue Abstract adjustment.

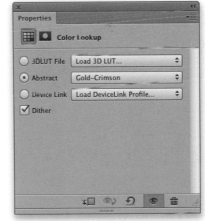

Figure 4.43 The Figure 4.40 image with a Gold-Crimson Abstract adjustment.

Color Lookup Table Export

You can generate your own Color Lookup tables via Photoshop for use in Photoshop, After Effects, and other image/video editing applications.

To do this, open an image, add some adjustment layers to give the image the desired look and then go to the File menu and choose Export ⇨ Color Lookup Tables... The dialog will prompt you to give the Lookup table a name plus an optional copyright string: i.e. '(©) Copyright' followed by your custom text. Selecting more grid points will result in higher quality tables at the expense of producing bigger files. In the export dialog you can save the look using the 3DL, CUBE, CSP or ICC profile formats (the first three are all 3D LUT formats).

Important things to be aware of here are that to export as a Color Lookup table the image you work on must contain a Background layer plus additional layers to modify the colors. This can include the use of color-filled pixel layers, gradients and patterns incorporating the use of conditional blending. However, for best results try using adjustment layers only to create the desired coloring effect, as the use of pixel layers may give unexpected results in the final exported Color Lookup table. Also, if you start with a Lab mode file, the export command can save an ICC abstract profile (which is the most generally used and most powerful of the formats). If you start out with an RGB document, then only the 3D LUT and RGB device link formats can be saved.

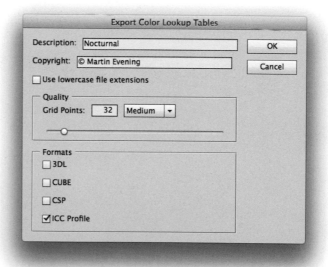

Figure 4.44 The Export Color Lookup Tables dialog.

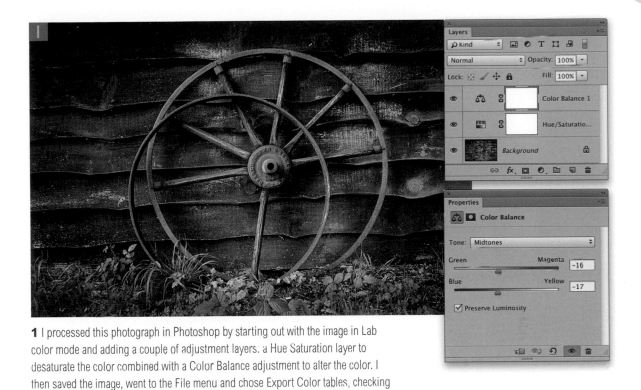

1 I processed this photograph in Photoshop by starting out with the image in Lab color mode and adding a couple of adjustment layers. a Hue Saturation layer to desaturate the color combined with a Color Balance adjustment to alter the color. I then saved the image, went to the File menu and chose Export Color tables, checking the ICC profile option (see Figure 4.44).

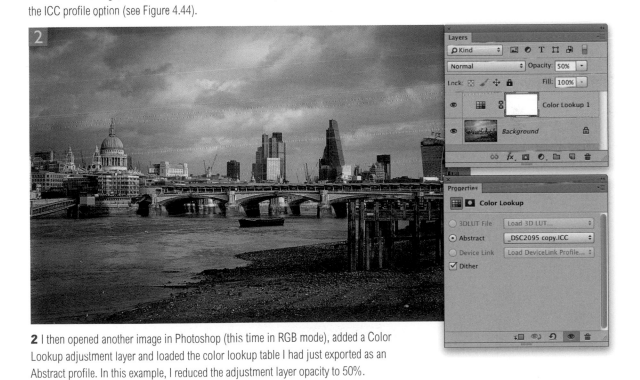

2 I then opened another image in Photoshop (this time in RGB mode), added a Color Lookup adjustment layer and loaded the color lookup table I had just exported as an Abstract profile. In this example, I reduced the adjustment layer opacity to 50%.

Color temperature and film

In the days of color film there were only two choices of film emulsion: daylight and tungsten. Daylight film was rated at 6,500 K and was used for outdoor and studio flash photography, while tungsten film was rated at 3,400 K and was typically used when taking photographs under artificial tungsten lighting. These absolute values would rarely match exactly the lighting conditions you were shooting with, but would enable you to get roughly close to the appropriate color temperature of daylight/strobe lights or indoor/tungsten lighting. Where the color temperature of the lighting was different, photographers would place color correcting filters over the lens to help balance the colors better. The Photo Filter in Photoshop kind of allows you to do the same thing at the post-production stage.

Photo Filter

One of the advantages of shooting digitally is that most digital cameras are able to record a white balance reading at the time of capture and use this information to automatically color correct your photos as you shoot. This can be done either in-camera (selecting the auto-white balance option) or by using the 'As Shot' white balance setting in Camera Raw when processing a raw capture image. If you didn't manage to set the color balance correctly at the time of capture and were shooting in JPEG mode then you'll be stuck with a fixed white balance in the image. But don't despair, because it is possible to crudely adjust the color balance in Photoshop using the Photo Filter adjustment, which is available from the Image ⇨ Adjustments menu, or as an image adjustment layer. The Photo Filter effectively applies a solid fill color layer with the blend mode set to 'Color', although you can achieve a variety of different effects by combining a Photo Filter adjustment with different layer blend modes. The Photo Filter offers a few color filter presets, but if you click on the Color button, you can select any color you like (after clicking on the color swatch) and adjust the Density slider to modify the filter's strength. Figure 4.45 shows a typical example where a Photo Filter adjustment might be used.

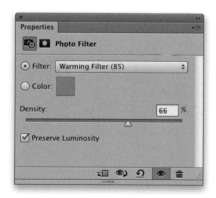

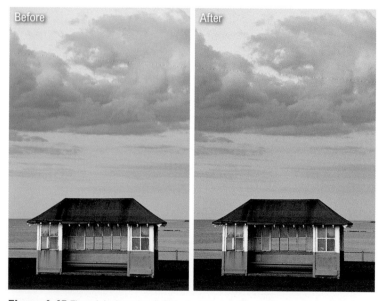

Figure 4.45 The original version (left) had a blue cast. To modify this photograph, I added a Photo Filter adjustment. I selected the Warming (85) filter and raised the Density from 25% to 66%.

Multiple adjustment layers

Once you start adding multiple adjustment layers you can preview how an image will look using various combinations of adjustment layers, and readjust the settings as many times as you like before applying them permanently to the photo. For example, you might want to use multiple adjustment layers to apply different coloring treatments to a photo. Instead of producing three versions of an image, all you need to do is add three adjustment layers, with each using a different coloring adjustment, and switch the adjustment layer visibility on or off to access each of the color variations (saving Layer Comps can help here, see page 556).

While it is possible to keep adding more adjustment layers to an image, you should try to avoid any unnecessary duplication. It is wrong to assume that when the image is flattened the cumulative adjustments somehow merge to become a single image adjustment. When you merge down a series of adjustment layers, Photoshop applies them sequentially, the same as if you had made a series of normal image adjustments. So the main thing to watch out for is any doubling up of the adjustment layers. If you find you have a Curves adjustment layer above a Levels adjustment layer, it would probably be better to try and combine the Levels adjustment within the Curves adjustment instead. Of course, when you use masked adjustment layers to adjust specific areas of a picture you can easily end up with lots of adjustment layers. However, if you place your image adjustment layers inside a layer group you can use the layer group visibility to turn multiple image adjustments on or off at once (see Figure 4.46). You can also add a layer mask to a layer group and use this to selectively hide or reveal all the image adjustment layers contained within a layer group.

To summarize, the chief advantages of adjustment layers are the ability to defer image adjustment processing and the ability to edit the layers and make selective image adjustments. It is important to stress here that the pixel data in an image can easily become degraded through successive adjustments as the pixel values are rounded off. This is one reason why it is better to use adjustment layers, because you can keep revising these adjustments without damaging the photograph until you finally decide to flatten the image.

Figure 4.46 This shows an example of how adjustments can be grouped together and a single mask applied to a combined group of adjustment layers.

Adjustment layer masks

As you have seen so far, adjustment layers are always accompanied by a pixel image layer mask. As with ordinary layers, these can be used to mask the adjustment layer contents. Whenever an adjustment layer is active, you can paint or fill the adjustment layer mask using black to selectively hide an adjustment effect and paint or fill with white to reveal again. You can also keep editing an adjustment layer mask (painting with black or white) until you are happy with the way the mask is working (see Figure 4.47).

Having the ability to edit an adjustment layer mask means you can apply such layer adjustments selectively. For example, although Photoshop has dodge and burn tools they are not really suited for dodging and burning broad areas of a photograph. They also have to be applied to a pixel layer directly, forcing you to create a copy layer if you wish to keep your edits non-destructive. If you want to dodge or burn a photo in order to darken a sky or lighten someone's face, the best way to do this is by adding an adjustment layer, filling the mask with black and painting with white to selectively reveal the adjustment layer effect. Working with adjustment layers is by far the best way to shade or lighten portions of a photograph. You have the freedom to re-edit the adjustment layer, to make the adjustment lighter or darker, and you can edit the layer mask to precisely control which areas of the image are affected by the adjustment.

Properties panel mask controls

The Properties panel in 'Masks mode' (Figure 4.49) can be used to refine the mask or masks associated with a layer (such as an additional vector mask). Layer masking is a topic I'll be discussing more fully in Chapter 8, but because it is relevant to masking adjustment layers, I thought it best to briefly introduce the Properties panel masking features here first.

Adjustment layers are added to the layer stack with a pixel layer mask, so the default mode for the Properties panel Masks mode shows the Pixel Mask mode options. If you click on the Vector Mask mode button next to it, you can add and/or edit a vector layer mask (see Step 4 on page 375). You can tell which mode is active because it will say Pixel Mask or Vector Mask at the top of the panel and the relevant mode button will have a stroked border.

Figure 4.47 This shows an example of a darkening adjustment layer applied to an image, but with a black to white gradient applied to the pixel layer mask to fade out the adjustment from the middle of the photograph downwards.

The Density slider can be used to adjust the density of the mask. When you have a mask applied to a layer or adjustment layer, where the mask is filled with black, this hides the layer contents completely. However, if you reduce the Density, this lightens the black mask color and therefore allows you to soften the mask contrast. So, when Density is set to 50%, a black mask color will only apply a 50% opacity mask and the lighter mask colors are reduced proportionally.

The Feather slider can be used to soften the mask edges up to a 250 pixel radius. Beneath this though is the Mask Edge… button which opens the Refine Mask dialog (Figure 4.48). Here you'll find you have even greater control over the mask edges and softness (these are described more fully in Chapter 8).

The Color Range button takes you to the Color Range dialog, which allows you to make selections based on color. This means that you can select colors to add to or subtract from a Color Range selection and see the results applied directly as a mask. Beneath this is the Invert button for reversing a masking effect. At the bottom of the panel are buttons that allow you to: convert a mask to a selection, delete the mask and apply it to the layer, enable/disable the mask and a delete button to remove a mask.

Figure 4.48 This shows the Refine Mask dialog.

Decimal place accuracy
The Feather slider in the Properties panel Masks mode (as well as elsewhere, such as in the Options bar for various tools) allows you to apply a Feather setting with up to 2 decimal places accuracy.

Figure 4.49 The Properties panel Masks mode controls.

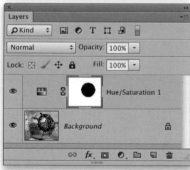

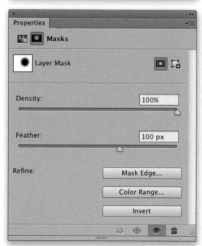

Editing a mask using the masks controls

1 Here, I applied a Hue/Saturation adjustment that applied a blue colorize effect. I then made an elliptical selection, selected the pixel layer mask and filled with black to reveal the original colors in the photograph.

2 I then went to the Properties panel in Masks mode and increased the Feather amount to 100 pixels to make the hard mask edge softer.

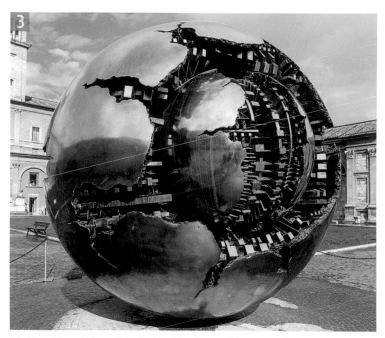

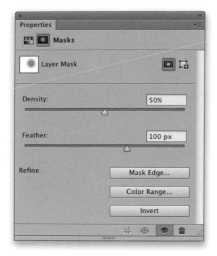

3 Let's say I wanted to soften the transition between the masked and unmasked areas. By decreasing the Density I could make the black areas of the mask lighter and thereby reveal more of the adjustment effect in the masked area of the image.

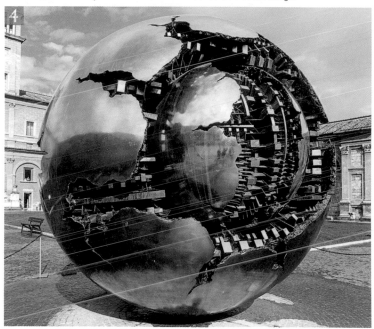

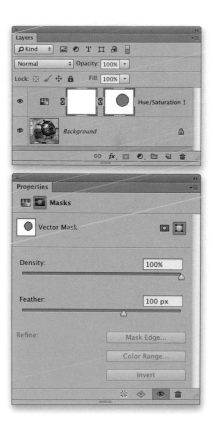

4 This technique is not just limited to pixel masks. In this step I started with a subtractive elliptical pen path shape, applied this as a Vector Mask and used the same Properties panel settings as in Step 2 to soften the vector mask edge.

Image Adjustments as Smart Filters

This latest version of Photoshop CC allows you to apply most of the regular image adjustments from the Image ⇨ Adjustments menu to smart object layers. Up until now it has only been possible to apply the Shadows/Highlights or HDR Toning adjustments to smart objects. Now, you can apply any of the adjustments in the Adjustments menu except for the Desaturate, Match Color, Replace Color or Equalize adjustments.

To create a smart object you can either go to the Filter menu and choose Convert for Smart Filters, or go the Layer menu and select Smart Object ⇨ Convert to Smart Object.

The ability to apply a wide range of image adjustments to smart object layers is the same as when you apply an adjustment layer, but is like adding an adjustment layer in a clipping group with an associated layer. One advantage of this approach is that when you apply an image adjustment to a smart object layer and move that layer the image adjustment or series of adjustments are automatically moved with the layer. When working with adjustment layers you have to remember to select and move the adjustment layers at the same time. Overall, this means you now have the option to create smart objects and combine adding filters and image adjustments, which in turn can share the same filter mask. Of course, if you wanted to maintain separate masking control of the image adjustments then it may be better to stick to using adjustment layers in these circumstances. However, there is of course a workaround that was suggested by Julieanne Kost as a means to apply independent layer masking to nested Smart Objects. For example, if you convert a layer to a Smart Object and apply a filter or adjustment you can mask it, as shown in the example opposite. If you then select the Smart Object layer and choose Layer ⇨ Smart Object ⇨ Convert to Smart Object again, you can nest this Smart Object in another Smart Object. This effectively allows you to mask Smart Object adjustments independently.

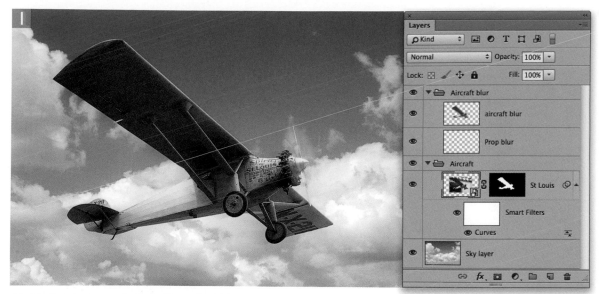

1 In this first step I opened a layered image in which the layer that contained the Spirit of St Louis airplane was a smart object layer. This meant that when this layer was selected I could go to the Image ⇨ Adjustments menu and apply any of the main 18 image adjustments from this menu. Here, I selected Curves.

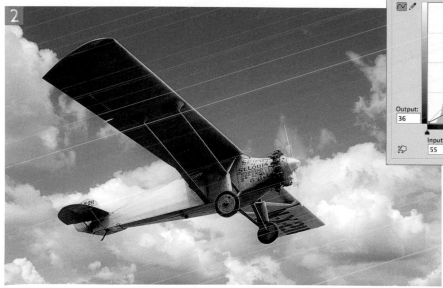

2 This opened the Curves dialog, where I applied the adjustment shown here. This adjustment targeted the smart object layer contents only, which was effectively the same as applying an adjustment layer in a clipping group. This particular smart object layer was also masked by a layer mask. You will notice in the Properties panel that there are controls for fine-tuning the Filter mask as well as the layer mask (or vector mask if one was applied).

Figure 4.50 This shows the Live Shapes Properties panel for the Ellipse shape tool.

Live shape properties

When you add an ellipse shape you will see the Live Shape Properties shown in Figure 4.50 and when you add a rectangle or rounded rectangle shape you'll see the Live Shape Properties shown in Figure 4.52. Here, it is possible to edit the corners of the rectangle shape. Note that the Properties panel only shows these options where an ellipse, rectangle or rounded rectangle path or shape layer is selected. If you click in the image with the rounded rectangle tool, this pops the dialog shown in Figure 4.51, where you can also set the corner radii.

This feature will mainly benefit graphic designer users, although the following steps show how it might also prove useful when editing photographs.

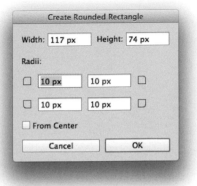

Figure 4.51 The Create Rounded Rectangle dialog.

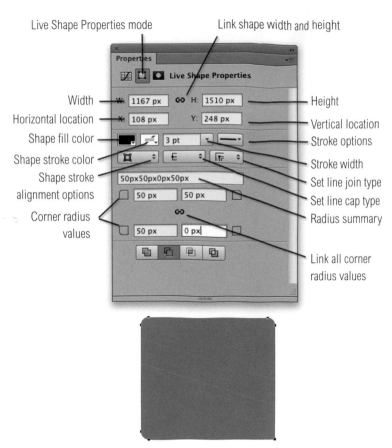

Figure 4.52 Here you can see the Properties panel showing the Live Shape options, where it is possible to edit the individual corner settings for a rectangle, rounded rectangle shape or path outline. Below the Properties panel is the shape outcome for a rectangle shape with these applied settings.

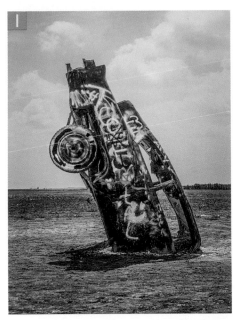

1 I began here with a photograph taken at Cadillac Ranch, just outside Amarillo, Texas. In the following steps I wanted to show how you can use the Properties panel to edit the corners of a vector mask.

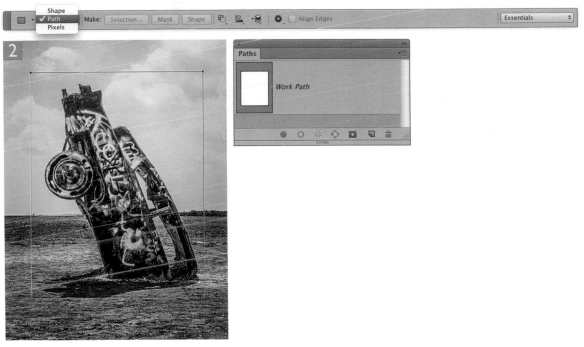

2 I first selected the regular rectangle tool in Path mode and defined a rectangle path outline. This added a new Work Path in the Paths panel.

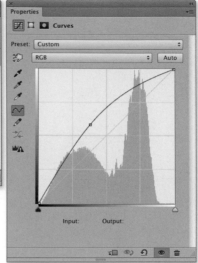

3 With the work path active, I added a new Curves adjustment layer, which also applied the active path as a vector mask. I then edited the Curve to apply a lightening adjustment.

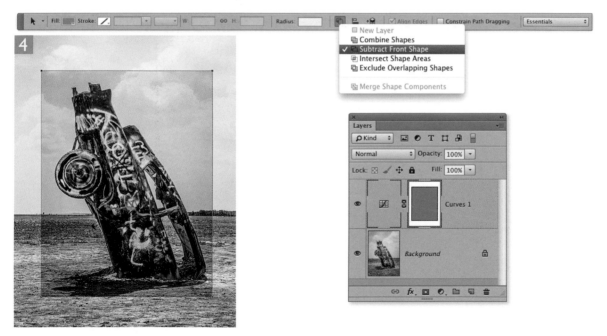

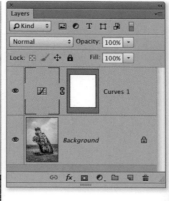

4 For this image I wanted the effect to be reversed, so I selected the path select tool, clicked to activate the path and selected Subtract From Shape from the menu shown here to invert the vector mask.

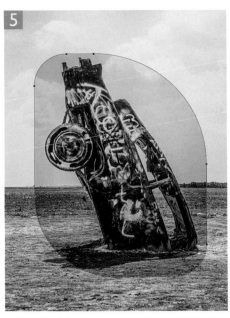

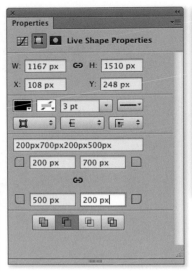

5 In the Properties panel I clicked on the Live Shape Properties button (between the Adjustment settings and Masks buttons) and proceeded to edit the corner settings. By doing so, I was able to control the shape for the original rectangular outline.

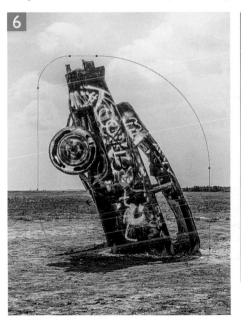

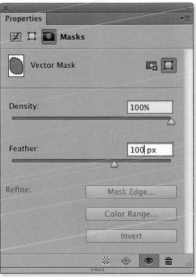

6 Lastly, I clicked on the Masks button to switch to the Masks mode for the Properties panel and adjusted the Feather setting to soften the modified mask edge.

Figure 4.53 This shows an image with the crop tool active, but no crop applied yet.

Figure 4.54 This shows the image being cropped, before confirming the crop.

Cropping

To crop an image, select the crop tool from the Tools panel. Note that when the crop tool is selected, the crop bounding box overlays the entire image (Figure 4.53). You can then drag any of the corner or side handles to adjust the crop. Or, you can click anywhere in the image area and drag to define the area to be cropped. As you crop an image the outer crop appears shielded (Figure 4.54). If you prefer, you can uncheck the Show Cropped Area option in the crop tool settings (Figure 4.57). Then, as you apply a crop (and switch to the crop mode) the Layers panel temporarily shows a crop preview layer. Don't worry. It doesn't mean any layers have been deleted—this is just a temporary preview (see Figure 4.55). As you drag a crop handle you'll notice how the underlying image moves as you adjust the crop and when a crop is active you can click and drag inside the crop area to reposition the image (and use the keyboard arrows to nudge the image). Both these behaviors make the Photoshop crop tool more like the one that's in Lightroom and (in my view) makes it easier to work with. Note there is also a single undo available when working in a modal crop and while the crop tool is in use you can click with the _Shift_ key held down to then define a new crop area.

Entering measurement units

You can constrain a crop to specific dimensions by using the W x H x Resolution option and enter the desired numeric units in the crop ratio field boxes plus the following abbreviations: Pixels (px), Inches (in), Centimeters (cm), Millimeters (mm), Points (pt) or Picas (pica).

Figure 4.55 The Layers panel view on the left shows an image in mid-crop where Delete Cropped Pixels is enabled and displays a Crop Preview layer. In this instance, an image that starts out with a Background layer will retain the Background layer after being cropped. However, if the Delete Cropped Pixels option is unchecked, a Background layer will afterwards become a Layer 0 layer.

Delete cropped pixels

If the Delete Cropped Pixels option is checked in the crop tool Options bar, the image will be cropped permanently and the Background layer preserved. But if the Delete Cropped Pixels option is unchecked it merely 'trims' the image, preserving the original image contents, including all the layers information, and a previous Background layer will be promoted to a normal layer (see Figure 4.55).

Crop ratio modes

You can mouse-down on the crop aspect ratio menu to select a crop 'Ratio' or 'W x H x Resolution' mode (see Figure 4.56), where you'll notice in the list below there is a nice, clear separation between the 'Ratio' and 'W x H x Resolution' preset settings. When the W x H x Resolution mode is selected, a Resolution field box appears in the Options bar (see Figure 4.57). You can then enter custom settings in the field boxes and clicking the 'Clear' button will clear all the current fields in the crop tool Options bar to reset the crop tool to its 'unconstrained' mode. Also, the last used settings are always remembered when exiting the crop tool.

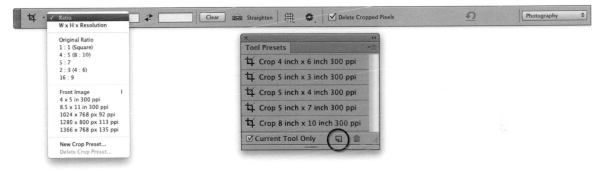

Figure 4.56 This view of the crop tool Options bar shows the Crop aspect ratio menu. You can select 'Ratio', 'W x H x Resolution', or one of the aspect ratio presets shown here. If you select the New Crop Preset… menu option this saves the settings as a new crop tool preset that will be added to the Tool Presets panel. Or, if you apply a crop and then click on the Add new preset button at the bottom of the Tool Presets panel (circled), this adds a new preset based on the current image size settings. Note that the ratio presets use ':' as a separator and W x H x Resolution presets use 'x' as a separator.

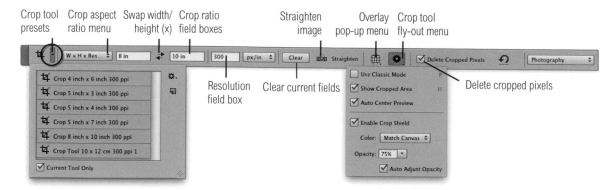

Crop tool presets | Crop aspect ratio menu | Swap width/ height (x) | Crop ratio field boxes | Straighten image | Overlay pop-up menu | Crop tool fly-out menu

Resolution field box | Clear current fields | Delete cropped pixels

Figure 4.57 Here are the primary options for the crop tool. If you mouse down on the triangle button next to the crop tool you will see listed any preloaded crop tool presets.

Landscape and portrait mode crops

When working in the W x H x Resolution mode, the value entered in the first entry field always corresponds to the width and the second value corresponds to the height. You then have the option to click on the double arrow button to swap these values around as necessary. So, you can click on the Swap width/height button to swap between a landscape or portrait mode crop and while a crop is active you can click on it to flip the crop between horizontal and vertical (or use the **X** key). When resizing a restricted aspect ratio crop box, you can also switch between the portrait and landscape orientations by dragging the bounding box from the corner.

Crop tool presets

Figure 4.57 shows the crop tool Options bar in normal mode before applying a crop. Here you can see the crop tool presets menu, which contains the same preset options that appear in the Tool Presets panel. This allows you to select a pre-saved crop preset setting that applies a crop with the required aspect ratio to crop an image and resize it to specific image dimensions and a specific pixel resolution setting. This is useful if you want to crop and resize an image to the desired pixel resolution in one go. As you drag on a corner or side handle the crop can be scaled up or down, preserving the crop aspect ratio. When a fixed crop aspect ratio is in force the crop proportions will remain locked.

If no crop tool presets are visible in the Crop tool presets list, try going to the Tool Presets panel and load the *Crop and Marquee.tpl* preset.

When saving a new crop tool preset the name of the tool (either crop tool or perspective crop tool) will be added as a prefix (see Figure 4.58).

Figure 4.58 This shows the Tool Preset dialog for the crop tool (left) and perspective crop tool (right).

Crop overlay display

Once you are in a modal crop state you'll have a choice of crop guide overlay options (Figure 4.59). The default 'Rule of Thirds' option is shown in use in Figures 4.53 and 4.54. This applies a 3×3 grid overlay, which can be useful when composing an image.

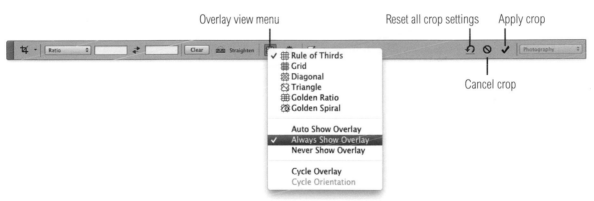

Figure 4.59 After you have dragged with the crop tool and before you commit to the crop, the tool Options bar will change (as shown here) to the crop modal state. To apply a crop, you can click on the Apply Crop button, double-click inside the crop area or hit the *Enter* or *Return* keys. To cancel a crop, click on the Cancel Crop button or hit the *esc* key.

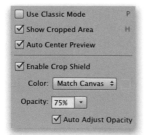

Figure 4.60 The Crop options fly-out menu.

There are other overlay options you can choose. The 'Grid' option can be helpful when aligning a crop to straight lines in an image and there are also further options such as Diagonal, Triangle, Golden Ratio and Golden Spiral overlay options. You can cycle between these overlay options using the O key and cycle between different crop overlay orientations using the $Shift$ O keyboard shortcut.

Crop tool options

The crop tool options (Figure 4.60) can be accessed from the crop tool Options bar (Figure 4.57). The 'Use Classic Mode' option (P) allows you to toggle between the default behavior where the image moves relative to the crop, or the old behavior where the crop bounding box only is moved. Note that some new functionality will be lost if you choose to revert to the Classic mode. The Auto Center Preview option allows you to toggle the 'image moving while resizing' behavior that keeps the crop box centered. The default settings have the crop shield enabled, applying a color that matches the canvas color at 75% opacity. But you can set this to any color you like, such as black at 100% opacity. The opacity can also be made to auto adjust when adjusting the crop position to reduce the opacity outside the bounding box area.

Front Image cropping

Selecting 'Front Image' (I) from the crop aspect ratio menu (see Figure 4.56) loads the current document full image size dimensions and resolution settings (there is also a Front Image button in the perspective crop tool Options bar).

Disable edge snapping

The edge snapping behavior can be distracting when you are working with the crop tool. This can easily be disabled in the View ⇨ Snap To submenu (or by using the $⌘$ $Shift$ $;$ [Mac], $ctrl$ $Shift$ $;$ [PC] shortcut).

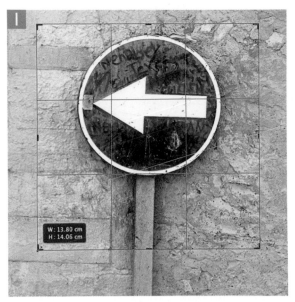

1 In the following steps the Show Cropped Area option was enabled in the crop tool options (see Figure 4.60). I selected the crop tool and dragged across the image to define the crop area. The cursor could then be placed over any of the eight handles in the bounding rectangle to readjust the crop.

2 Dragging the cursor inside the crop area allowed me to move the crop. I could also drag the crop bounding box center point to establish a new central axis of rotation.

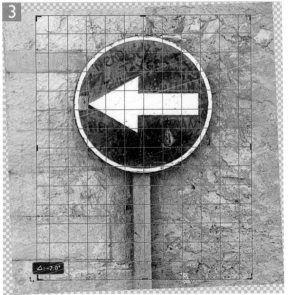

3 I could then mouse down outside the crop area and drag to rotate the crop around the center point, which can even be positioned outside the crop area. You normally do this to realign an image that is at an angle.

4 Here, I deselected the Show Cropped Area option from the crop tool Options bar (you can also use the **H** key shortcut to hide the outer shaded area).

Selection-based cropping

To make a crop based on a selection, all you need to do is select the crop tool (C) and the crop will automatically fit to the selected area. For example, you might want to ⌘ (Mac) ctrl (PC)-click a layer to make a selection based on a single layer and then execute a crop (as described below in Figure 4.61). You can also make a crop based on an active selection by choosing Image ➯ Crop. When you do this the crop tool automatically matches the bounds of any selection. Where a selection has an irregular shape, the crop is made to the outer limits of the selection and the selection retained.

Figure 4.61 Sometimes it is quicker to make a crop from a selection rather than try to precisely position the crop tool. In the example shown here, if I wanted to make a crop of the box containing the letter D, the quickest solution would be to ⌘ (Mac), ctrl (PC)-click on the relevant layer in the Layers panel and select the crop tool (C), or choose Image ➯ Crop.

Canvas size

The Image ⇨ Canvas size menu item allows you to enlarge the image canvas area, extending it in any direction. This lets you extend the image dimensions in order to place new elements. If you check the Relative box you can enter the unit dimensions you want to see added to the current image size. The added pixels are then filled using the current background color, but you can also choose other fill options (see Figure 4.62). It is also possible to add to the canvas area without using Canvas Size (see Figure 4.63 below).

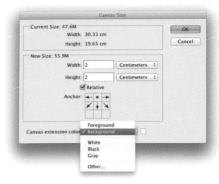

Figure 4.62 Canvas Size can be used to add pixels beyond the canvas bounds. In the example shown here, the image is anchored so that pixels are added equally left and right and to the bottom of the image only. When the Relative box is checked this allows you to enter the number of units of measurement you wish to add 'relative' to the current image size.

Figure 4.63 You can also use the crop tool as a canvas size tool. Make a full frame crop, release the mouse and then drag any one of the bounding box handles outside the image and into the canvas area. Double-click inside the bounding box area or hit *Enter* to add to the canvas size. If the starting point image has a Background layer, this step fills the added canvas with the current background color. In this example, the starting point is a non-Background layer, so adds transparency as more canvas is added. In the bottom image I used the content-aware scaling feature (discussed on page 392) to expand the image to fill the top and bottom of the new canvas area.

Big data

The Photoshop PSD, PDF and TIFF formats all support 'big data'. This means that if any of the layered image data extends beyond the confines of the canvas boundary, it is still saved as part of the image when you save it, even though it is no longer visible. If you have layers in your image that extend outside the bounds of the canvas, you can expand the canvas to reveal all of the big data by choosing Image ⇨ Reveal All (see Figure 4.64). Remember though, the big data can only be preserved providing you have saved the image using the PSD, PDF or TIFF formats. Also, when you crop an image that contains a normal, non-flattened Background layer and the 'Delete Cropped Pixels' box is unchecked, Photoshop automatically converts the background layer to a Layer 0 layer (and preserves all the big data).

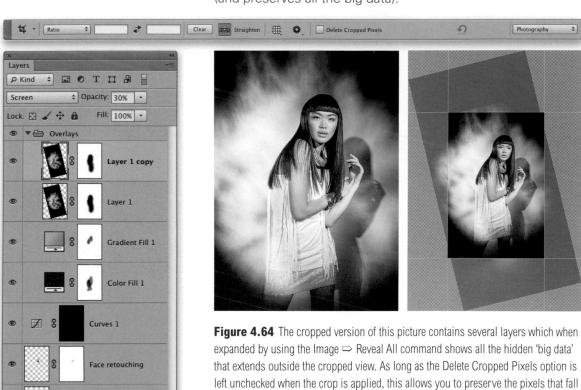

Figure 4.64 The cropped version of this picture contains several layers which when expanded by using the Image ⇨ Reveal All command shows all the hidden 'big data' that extends outside the cropped view. As long as the Delete Cropped Pixels option is left unchecked when the crop is applied, this allows you to preserve the pixels that fall outside the selected crop area instead of deleting them.

Client: Gallagher Horner. Model: Kelly @ Zone.

Perspective crop tool

The perspective crop tool can be used to crop and correct the converging verticals or horizontal lines in a picture with a single crop action. In Figure 4.65 I wanted to correct the perspective distortion seen in this photograph. Using the perspective crop tool I was able to accurately reposition the corner handles on the image to match the perspective of the shop front. You can either marquee drag with the tool as usual, or click to define the four corners of the perspective crop, after which you can drag on the corner and/or side handles to adjust the crop shape. Having done this you can click to confirm and apply the crop and, at the same time, correct the perspective. The perspective crop should work well in most cases, but you may sometimes need to apply a further transform adjustment to compensate for any undesired stretching of the image.

Modifying a perspective crop

When the perspective crop bounding box is active you can modify the crop shape by dragging the corner or side handles. If you hold down the *Shift* key as you drag a handle this constrains the movement to vertical or horizontal plane movement only. If you hold down the *alt* key as you drag a corner handle this allows you to resize the crop in both planes at once. If you hold down the *alt* key as you drag a side handle this allows you to expand the crop equally both sides at once.

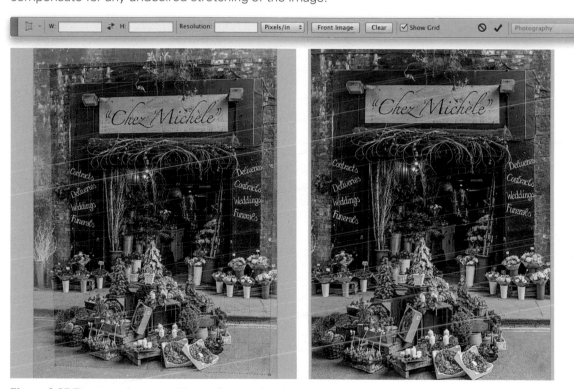

Figure 4.65 The perspective crop tool is great for correcting perspective. You will mostly find it easier to zoom in to gauge the alignment of the crop edges against the converging verticals. Here, it was also useful to check the 'Show Grid' option to help gauge the alignment correctly. Note also the 'Front Image' button. Clicking this loads the current document full image size dimensions and resolution settings, so that when you apply the crop the cropped image retains the same size (but may well appear stretched of course).

Edge detection success rate

The content-aware scale feature is very clever at detecting which edges you would like to keep and those you would like to stretch or squash, but it won't work perfectly on every image. You can't expect miracles, but if you follow the suggestions on these pages, you will pick up some of the basic tips for successful use.

What I have noticed though is it does appear to do a very good job of recognizing circular objects and can preserve these without distorting them. Russell Brown has done some very cool demos on working with this feature. You can check them out on his site: russellbrown.com/tips_tech.html.

Content-aware scaling

The content-aware scale feature can be used to rescale images by compressing flat portions of an image while preserving the detailed areas. It basically allows you to recompose photographs to fit different proportion layouts. Over the next few pages I have outlined some of the ways you can work with this tool and suggested some practical uses. For example, advertising and design photographers may certainly appreciate the benefits of being able to adapt a single image to multiple layout designs.

To use this feature, you will need an image that's on a normal layer (not a Background layer). Next, you need to go to the Edit menu and choose Content-Aware Scale (or use the ⌘ alt Shift C [Mac], ctrl alt Shift C [PC] shortcut). You can then drag the handles that appear on the bounding box for the selected layer to scale the image, making it narrower/wider, or shorter/taller. The preview then updates to show you the outcome of the scale adjustment and you can use the Options bar to access some of the extra features discussed here such as the Protect menu options.

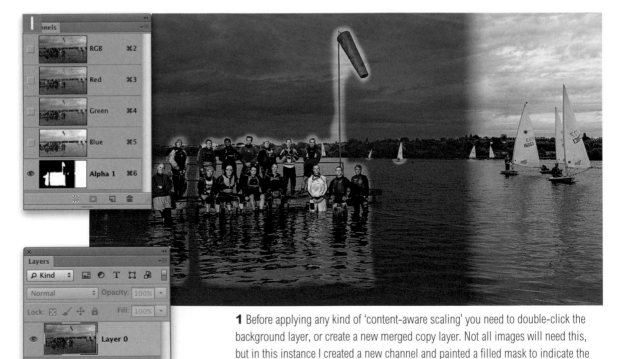

1 Before applying any kind of 'content-aware scaling' you need to double-click the background layer, or create a new merged copy layer. Not all images will need this, but in this instance I created a new channel and painted a filled mask to indicate the sections that should be protected.

2 This shows what the photograph looked like after I had used the Edit ⇨ Content-Aware Scale command to compress the image on the side as well as top and bottom. Note that the Alpha 1 channel mask created in Step 1 was selected in the Protect menu.

3 Here is the final result, in which there was now less gap between the jetty and the boats on the right. The people in the group now appeared relatively bigger in the scene. Whenever you scale an image using this method, you have to watch carefully for the point where important parts of the picture start to show jagged edges. When this happens, you'll need to ease off and consider scaling the image in stages instead. For example, with this image I applied a second pass content-aware scale to reduce the height of the wind sock mast.

How to protect skin tones

1 In this example I wanted to show how you can help protect someone's face from being squashed or stretched as you scale an image.

Amount slider

After you have applied a content-aware scale adjustment to a photograph (and before you click OK to apply it), you can use the Amount slider to determine the amount of content-aware scaling that is applied to the layer. If you set this to zero, no special scaling is applied and the image will be stretched as if you had applied a normal transform. You will note that I left the Amount slider setting at 100% in all the examples shown here, in order to demonstrate the full effect of the content-aware scaling.

2 In general, you will find that the content-aware scale feature does a pretty good job of distinguishing and preserving the important areas of a photograph and tends to scale the less busy areas of a photograph first, such as a sky, or in this case the mottled backdrop. However, if you click on the Protect Skin tones button (circled), this usually ensures that faces in a photograph remain protected by the scaling adjustments. As you can see here, I was able to stretch this picture horizontally so that the man in this photograph was moved across to the right. I was able to stretch the image quite a bit, but without distorting the face and body.

Photograph: © Jeff Schewe

How to remove objects from a scene

1 The content-aware scale feature can also be used as a tool to selectively remove objects from a scene. The results won't always be completely flawless, but it can still work pretty well where you wish to squash an image tighter and remove certain elements as you do so. To begin with it is important that the layer you are working on is a non-Background layer. You will need to either duplicate the Background layer or double-click to convert it to a normal layer. I hit the **Q** key to switch to Quick Mask mode (see Chapter 9) and painted on the image to outline the bits that I wished to remove. With the Quick Mask, white protects and black (which appears on the image as a red overlay) indicates the areas to remove.

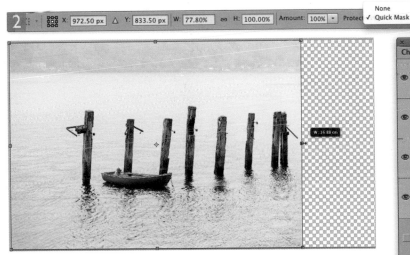

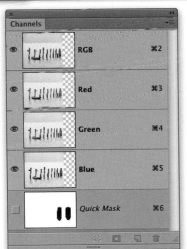

2 Next, I reselected the RGB composite channel in the Channels panel and selected the Edit ⇨ Content-Aware Scale command. From the Protect menu in the Options bar, I selected the Quick Mask I had just created, and as I scaled the image, the masked posts started to disappear. As before, it is important to watch carefully for jagged edges and not compact the image too much.

Straighten tool shortcut

When the crop tool is selected you can use the ⌘ (Mac) *ctrl* (PC) key to temporarily access the straighten tool. Or, if you are in the straighten tool mode, you can use the ⌘ (Mac) *ctrl* (PC) key to switch back to the crop box editing mode.

Image rotation

If an image needs to be rotated you can use the Image ⇨ Rotate menu to orientate a photo the correct way up, turn it 180°, flip it horizontally, or vertically even. To apply a precise image rotation, you can click to select the straighten tool from the crop tool Options bar (circled) and drag across the image as shown in Figure 4.66. Alternatively, if you wish to rotate an individual layer, make the layer active, select the ruler tool and drag to define the edge you wish to appear straight. Then click the Straighten Layer button in the ruler tool Options bar (Figure 4.67) to straighten.

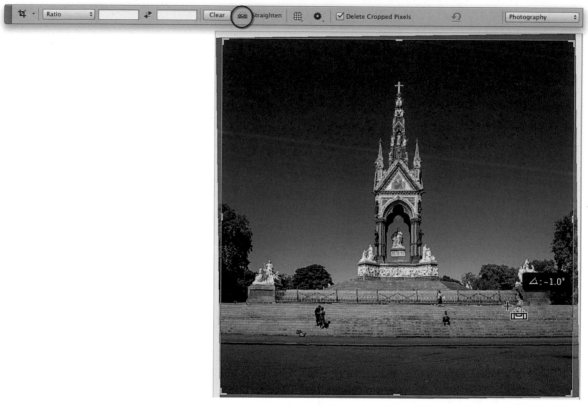

Figure 4.66 If an image doesn't appear to be perfectly aligned, click on the Straighten button in the crop tool Options bar and drag along what should be a vertical or horizontal edge in the photo. This will rotate the image so that it appears to be perfectly straight.

Figure 4.67 To straighten a layer, select the ruler tool and again, drag to define the edge that should be straight. Then in the ruler tool Options bar click on the Straighten Layer button to straighten the selected layer.

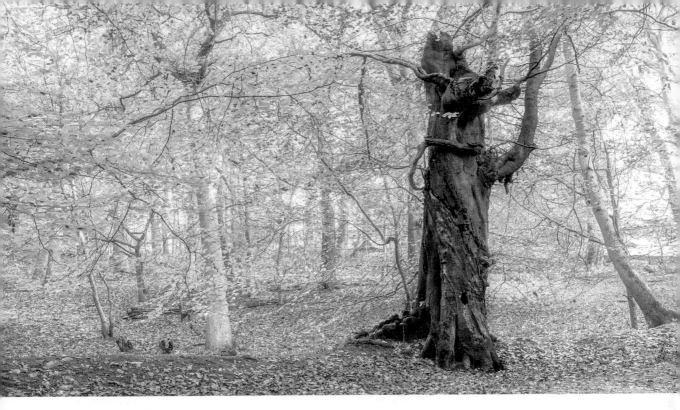

Chapter 5

Black and white

I was eleven years old when I first got into photography. My first darkroom was kept under the stairs of our house and, like most other budding amateurs, my early experiments were all done in black and white. Back then, very few amateur photographers were competent enough to know how to process color, so black and white was all that most of us could manage to work with. For me, there has always been something rather special about black and white photography and digital imaging has done nothing to diminish this. If anything, I would say that the quality of capture from the latest digital cameras coupled with the processing expertise of Photoshop and improvements in inkjet printing have now made black and white photography an even more exciting avenue to explore.

Black and white film conversions

Traditional black and white film emulsions all differ slightly in the way they respond to different portions of the visual spectrum (as well as the colors we can't see). This is partly what gives emulsion films their 'signature' qualities. So in a way, you could say that film also uses standard formulas for converting color to black and white, and that these too are like rigid grayscale conversions. You may also be familiar with the concept of using strong colored filters over the lens when shooting with black and white film and how this technique can be used to emphasize the contrast between certain colors, such as the use of yellow, orange or red filters to add more contrast to a sky. Well, the same principles apply to the way you can use the Black & White adjustment to mix the channels to produce different kinds of black and white conversions.

Figure 5.1 If you convert a color image to grayscale mode, Photoshop pops the dialog shown here which is basically advising you there are better ways to convert to black and white.

Converting color to black and white

When you shoot digitally, the most important thing to remember is always shoot in color. Wherever possible you are far better off capturing a scene in full color and using Camera Raw or Photoshop to carry out the color to mono conversion. Of course, if you shoot raw, the data will always be in color. Following on from that, you will need to use the most appropriate conversion method to get the best black and white results.

Dumb black and white conversions

When you change a color image in Photoshop from RGB to Grayscale mode, the tonal values of the three RGB channels are averaged out to produce a smooth continuous tone grayscale. The formula for this conversion consists of blending 60% of the green channel with 30% of the red and 10% of the blue. The rigidity of this color to mono conversion limits the scope for obtaining the best grayscale conversion from a scanned color original (see Figure 5.1). The same thing is true if you make a Lab mode conversion, delete the *a* and *b* channels and convert the image to grayscale mode, or if you were to simply desaturate the image. There is nothing necessarily wrong with any of these methods, but none allow you to make full use of the information that's contained in a color image.

Smarter black and white conversions

If you capture in color, the RGB master image contains three different grayscale versions of the original scene and these can be blended together in different ways. One of the best ways to do this is to use the Black & White image adjustment in Photoshop, which while not perfect, can still do a good job in providing you with most of the controls you need to make full use of the RGB channel data when applying a conversion. The Black & White slider adjustments will, for the most part, manage to preserve the image luminance range without clipping the shadows or highlights. These adjustments can be applied to color images directly, or by using the Adjustments panel to add an adjustment layer. The advantage of using an adjustment layer to apply a black and white conversion is that you can quickly convert an image to black and white and have the option to play with the blending modes to refine the appearance of the black and white outcome. Let's start though by looking at the typical steps used when working with the Black & White adjustment controls.

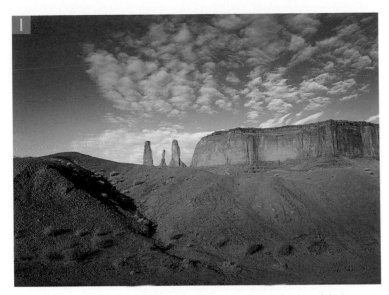

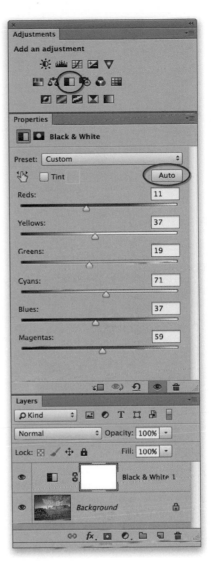

1 The following steps show a basic method for converting a full color original photograph to black and white. The Black & White image adjustment can be applied directly by going to the Image ⇨ Image Adjustments menu, or you can go to the Adjustments panel and click on the Black & White button (circled in red) to add a new adjustment layer.

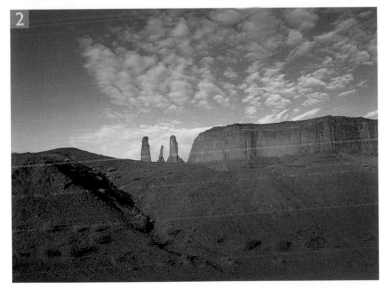

2 To begin with I clicked on the Auto button (circled in blue). This applied an auto slider setting based on an analysis of the image color content. The auto setting usually offers a good starting point for most color to black and white conversions and won't do anything too dramatic to the image, but is immediately a lot better than choosing Image ⇨ Mode ⇨ Grayscale.

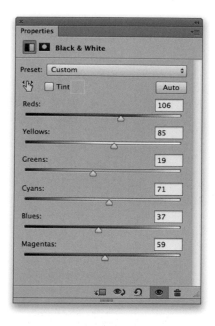

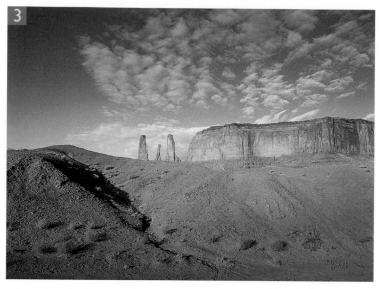

3 If you don't like the auto setting result, you can adjust the sliders manually to achieve a better conversion. In this example, I lightened the Yellows and darkened the reds slightly.

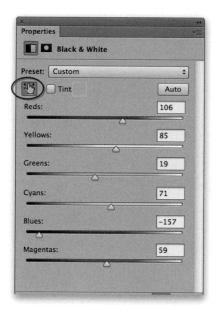

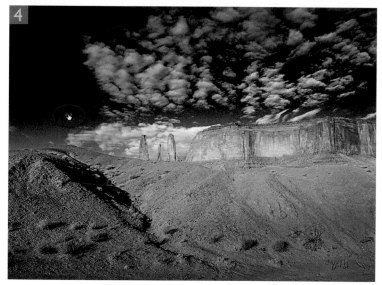

4 Lastly, I clicked on the target adjustment mode button (circled) for the Black & White adjustment. This allowed me to move the cursor over particular areas of interest (such as the sky) and drag directly on the image to modify the Black & White adjustment. This step selected the nearest color slider in the Black & White adjustment panel. Dragging to the left will make the tones beneath the target adjustment tool cursor go darker and dragging to the right, lighter. In the example you see here I managed to apply extra darkening to the sky.

Black & White adjustment presets

As with other image adjustments, the Black & White adjustment has a Presets menu at the top from where you can select a number of shipped preset settings. Figure 5.3 shows examples of the different outcomes that can be achieved through selecting some of the different presets from this list.

Once you have created a Black & White adjustment setting that you would like to use again you can choose Save Preset… from the Properties panel options menu (Figure 5.2). For example, I was able to save the slider settings shown here as a custom preset called 'Red Contrast'.

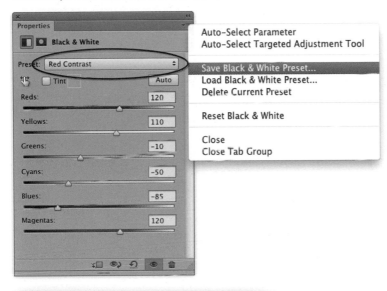

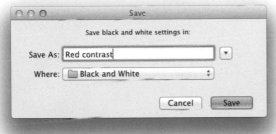

Figure 5.2 The slider settings shown here were saved as a 'Red Contrast' preset. Saved presets can be accessed by mousing down on the Presets menu at the top of the Black & White adjustment Properties panel (circled).

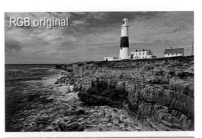

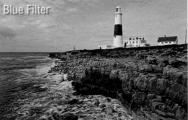

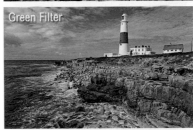

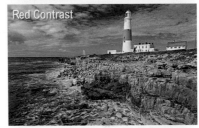

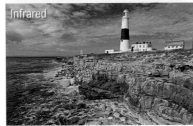

Figure 5.3 This shows some examples of different Black & White adjustment presets applied to a color image.

Split color toning using Color Balance

Although the Black & White adjustment contains a Tint option for coloring images, this only applies a single color overlay adjustment and I have never really found it to be that useful. It is nice though to have the ability to apply a split tone coloring to a photograph and one of the best ways to do this is by using the Color Balance image adjustment. This is ideal for coloring RGB images that have been converted to monochrome using the Black & White adjustment method, mainly because the Color Balance controls are intuitive and really simple to use. If you want to colorize the shadows, click on the Shadows radio button and adjust the color settings, then go to the Midtones, make them a different color, and so on. Note that it is best to apply coloring effects with the adjustment layer set to the Color blend mode. The advantage of using the Color blend mode is that you will be able to alter the color component of an image without affecting the luminosity. This is important if you wish to preserve as much of the tone levels information as possible.

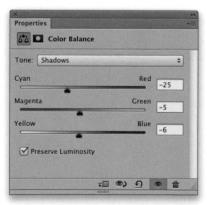

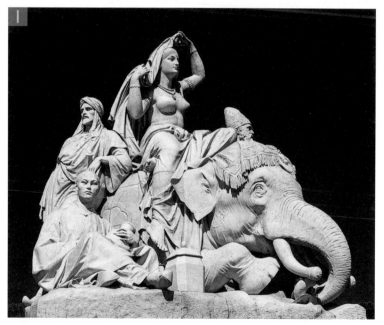

1 I started here with an RGB color image and converted it to monochrome using the Black & White image adjustment. I then added a Color Balance adjustment layer to colorize the RGB/monochrome image. To do this, I went to the Adjustment panel and selected the Color Balance adjustment. In the Properties panel I selected the Shadows option from the Tone menu and adjusted the three color sliders to apply a color cast to the shadows.

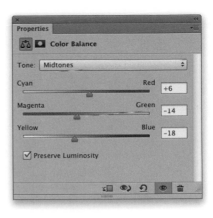

2 I then selected the Midtones Tone menu option and adjusted the color sliders to add a warm color balance to the midtones. You will notice that I had Preserve Luminosity checked. This helped prevent the image tones from becoming clipped.

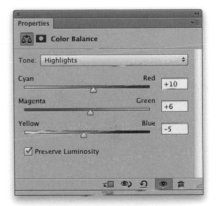

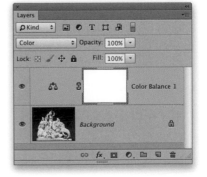

3 Finally I selected the Highlights option from the Tone menu and added a red/yellow cast to the highlights. I also set the adjustment layer blending mode to Color, which helped preserve all the image luminance information.

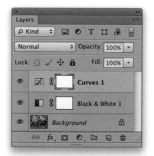

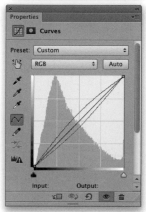

Split color toning using Curves adjustments

The Color Balance method is reasonably versatile, but you can also colorize a photograph by using two Curves adjustment layers and taking advantage of the Layer Style blending options to create a more adaptable split tone coloring effect.

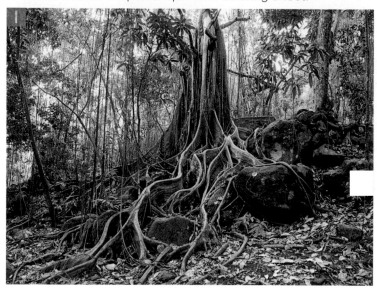

1 To tone this image, I first added a Curves adjustment layer above a Black & White adjustment layer and adjusted the channel curves to apply a blue/cyan color adjustment.

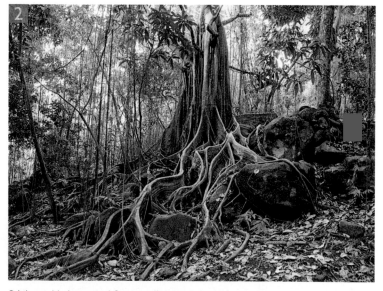

2 I then added a second Curves adjustment above the previous one and this time adjusted the channel curves to apply a sepia colored adjustment.

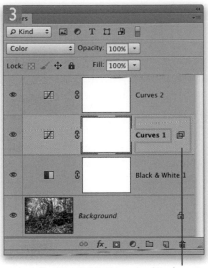

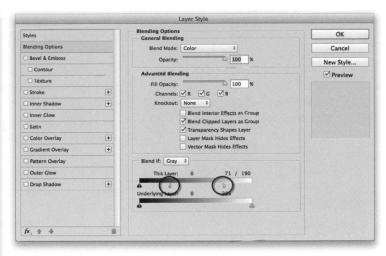

Double-click in this area of the layer to
open the Layer Style dialog.

3 I made the first Curves layer active and double-clicked to open the Layer Style
dialog shown here. I then *alt*-clicked on the highlight divider triangle in the 'This
Layer' 'Blend If' layer options. This enabled me to separate the divider, splitting it into
two halves (circled). This allowed me to control where the split between these two
points occurred.

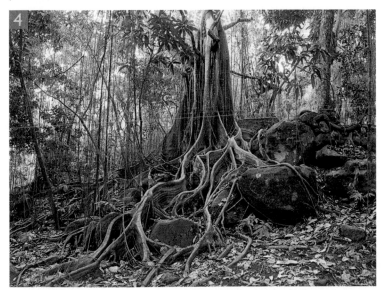

4 The advantage of this method is that you can adjust the layer opacity and l ayer
Style blending modes of each individual layer and this offers more flexibility when it
comes to deciding how best to color the shadows and highlights.

Photographic toning presets

If you click on the Presets menu, circled red in Step 2, or click on the gradient ramp options, circled blue in Step 2 (and then click on the presets options icon), you can add new sets of gradient map presets. Among these is a set titled 'Photographic Toning' (see Figure 5.4). This set of gradient maps has been specifically designed for creating split toning effects.

Figure 5.4 This shows the gradient map presets in the Photographic Toning set.

Split color toning using a Gradient Map

The coloring techniques shown so far allow you to apply split tone type coloring effects. Of these the Color Balance method is perhaps the easiest to use. However, another way to do this is to add a Gradient Map adjustment layer. When applied using the Normal blend mode the Gradient Map uses a gradient to map the tones in the image to new values. This in itself can produce some interesting effects when combined with standard Photoshop gradients. But if you set the Gradient Map adjustment layer blend mode to Color you can restrict the adjustment so that it can be used just to colorize the image. As you can see in Step 2, the gradient doesn't have to go from dark to light, what counts are the color hue and saturation values that are applied at each stage of the gradient. To edit the colors you just need to click on the gradient ramp to add a new color swatch and double-click a swatch color to open the Photoshop Color Picker and select a new color.

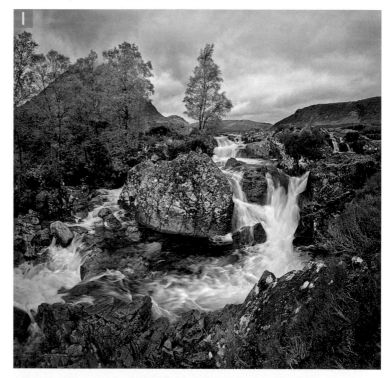

1 Here is a photograph that I wished to apply a duotone type effect to, but at the same time I wanted to keep this image in RGB mode.

2 I added a Gradient Map adjustment layer to the image and double-clicked the gradient in the Gradient Map adjustment Properties panel to create a new gradient setting.

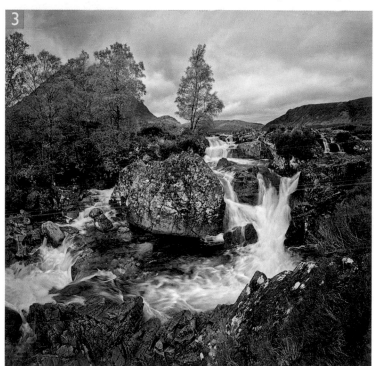

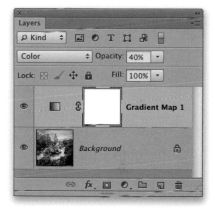

3 I set the Gradient Map layer blend mode to Color and in this instance reduced the layer opacity to 40% to produce the coloring effect seen here.

Camera Raw provides you with more sliders to play with than the Black & White adjustment. These allow you to adjust the in-between color ranges such as Oranges, Aquas and Purples. The Oranges slider is useful for targeting skin tones and the Aquas is useful for adjusting things like the sea. Having these extra sliders provides you with extra levels of tone control.

Camera Raw black and white conversions

You can also use Camera Raw to convert images to black and white. This can be done at the raw processing stage to a raw, JPEG, or TIFF image (providing the TIFF is flattened). Or, you can do so using the Camera Raw filter from the Filter menu.

If you go to the HSL/Grayscale panel and check the Convert to Grayscale box, Camera Raw creates a black and white version of the image, which is produced by blending the color channel data to produce a monochrome rendering of the original. Clicking 'Auto' applies a custom setting that is based on the white balance setting applied in the Basic panel, while clicking 'Default' will reset all the sliders to zero. You can manually drag the sliders to make certain colors in the color original lighter or darker, or select the target adjustment tool (circled in Step 2) to click and drag on the image to make certain colors convert to a darker or lighter tone. The overall tone brightness and contrast should not fluctuate much as you adjust the settings here and this makes it easy to experiment with different slider combinations. For example, if you want to make a sky go darker you can copy what I did in Step 2. Here, I selected the target adjustment tool, clicked on the sky and dragged to the left. This caused the Aquas and Blues sliders to shift to the left, darkening these tones. I would also suggest sometimes switching over to the Basic and Tone Curve panels to make continued adjustments to the white balance and tone controls as these can also strongly influence the outcome of a black and white conversion.

Pros and cons of the Camera Raw approach

In my view, Camera Raw black and white conversions have the edge over using the Black & White adjustment in Photoshop. This is because the slider controls are better thought out and the addition of the in-between color sliders (see sidebar) makes it possible to target certain colors more precisely. The target adjustment mode correction tool in Camera Raw also performs better than the one found in Photoshop's Black & White adjustment.

An important question to raise here is 'when is the best time to convert a photo to black and white?' If you do this at the early Camera Raw stage it limits what you can do to a photo should you then want to retouch the image in Photoshop. I find it is usually better to carry out the black and white conversion at the end of the editing process and

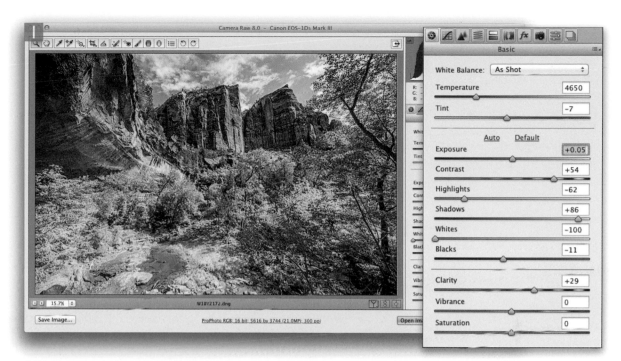

1 This shows a color image opened in Camera Raw.

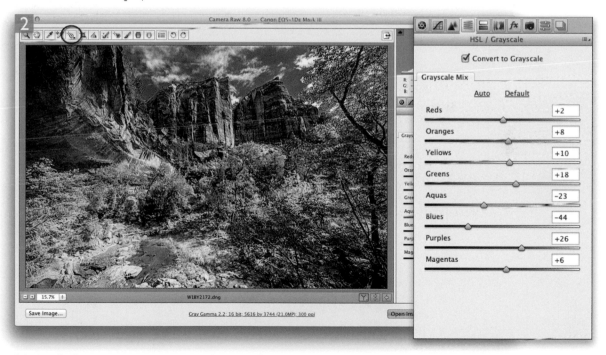

2 In the HSL/Grayscale panel I clicked on the Convert to Grayscale button and, with the help of the target adjustment tool (circled), clicked and dragged directly on the image to make adjustments that would increase the contrast in the clouds.

have the adjustment be reversible. This is not a problem in Photoshop, because if you add a Black & White adjustment layer, it is easy enough to toggle the adjustment on or off. If you want to use Camera Raw to make the black and white conversion, you need to somehow take the Photoshop-edited image back through Camera Raw again. Before Photoshop CC this meant saving a JPEG or flattened TIFF version and re-editing a derivative version of the master image via Camera Raw. But as I mentioned earlier, now that Camera Raw is available as a filter from the Filter menu, it is now much easier to apply a Camera Raw adjustment directly in Photoshop. I would recommend you convert the image layer or layers you wish to edit into a smart object first though, so the Camera Raw black and white edits remain non-destructive. Another option is to use Lightroom. Here, it is possible to re-import your Photoshop-edited images back into Lightroom and use the Develop module in Lightroom to apply a black and white conversion. The advantage of this approach is that both PSD and TIFF formats can be read and they don't have to be flattened—Lightroom doesn't have a problem processing layered PSD or TIFF format images.

HSL grayscale conversions

If you set all the Saturation sliders in the HSL panel to −100, you can then use the Luminance sliders in the HSL panel to make almost the same type of adjustments as in the Grayscale mode. One of the chief advantages of this method is you can use the Saturation and Vibrance controls in the Basic panel to fine-tune the grayscale conversion effect, which you can't do when using just the ordinary Grayscale conversion mode.

Camera Calibration panel tweaks

Another thing I discovered is you can also use the Camera Calibration panel sliders to affect the outcome of a Camera Raw black and white conversion. As you can see in the following steps, this can sometimes enable you to create stronger contrast effects than would be possible using the HSL / Grayscale panel sliders on their own.

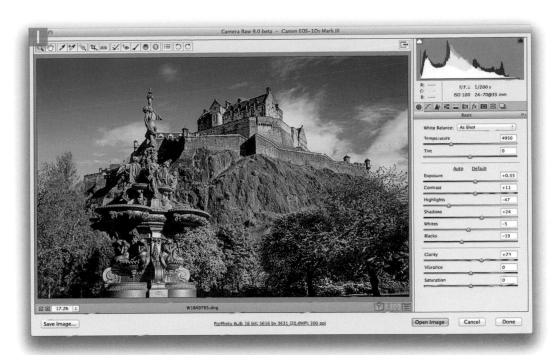

1 This shows a color image opened in Camera Raw, in which I applied some basic tone and color corrections.

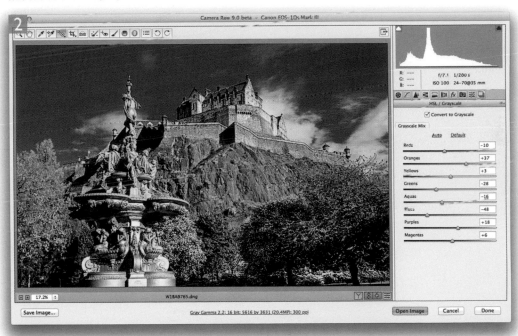

2 Here, I went to the HSL / Grayscale panel and checked the Convert to grayscale checkbox to convert the image to black and white.

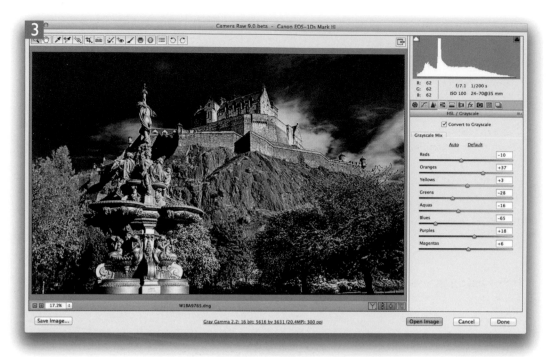

3 I then manually adjusted the Grayscale Mix sliders to make the sky darker.

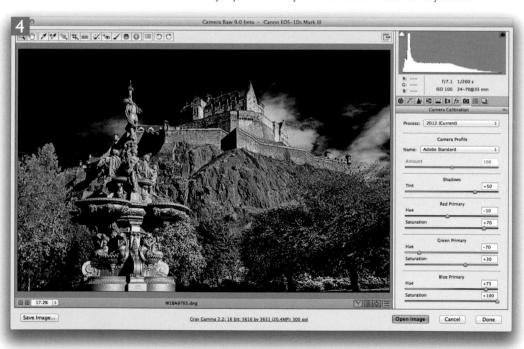

4 In this final step, I went to the Camera Calibration panel and adjusted the Tint Hue and Saturation sliders, as shown here to produce a stronger tone contrast effect.

Camera Raw Split Toning panel

After you have used the HSL/Grayscale panel to convert a photograph to black and white you can use the Split Toning panel to colorize the image. These controls allow you to apply one color to the highlights, another color to the shadows and use the Saturation sliders to adjust the intensity of the colors. This is how you create a basic split tone color effect. There is also the Balance slider, which lets you adjust the midpoint for the split tone effect. In Figure 5.5 I applied a warm tone to both the highlights and shadows and adjusted the Balance slider so that the split toning was biased more towards the highlights. The HSL/Grayscale and Split Toning controls are incredibly versatile and can work equally well with non-raw images.

Saturation shortcut

When dragging the Hue sliders in the Split Toning panel you can hold down the **alt** key to temporarily apply a boosted saturation to the split tone adjustment and thereby see more clearly the hue value you are applying. This works even when the Saturation sliders are set to zero.

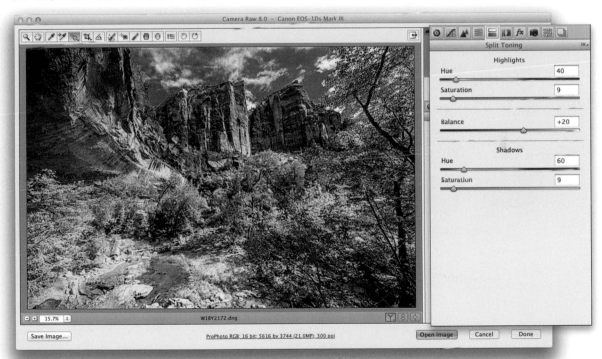

Figure 5.5 This shows an example of a Split Toning adjustment in Camera Raw.

Camera Raw color image split toning

Although the Split Toning panel is designed to be used with black and white images, these controls can be just as useful when editing color photos. While it is possible to apply split toning effects in Photoshop, the Split Toning controls in Camera Raw can produce similar results, but with less hassle.

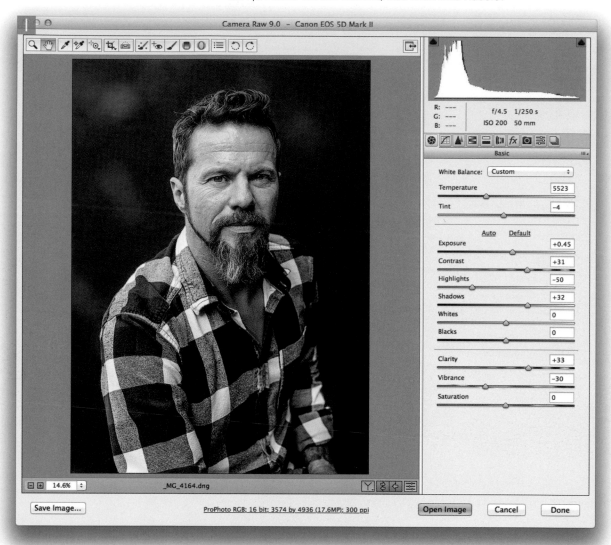

1 Here you can see a photo before I had applied a split toning effect. This started out as a full-color image, although I did apply a −40 Vibrance adjustment to desaturate the colors slightly.

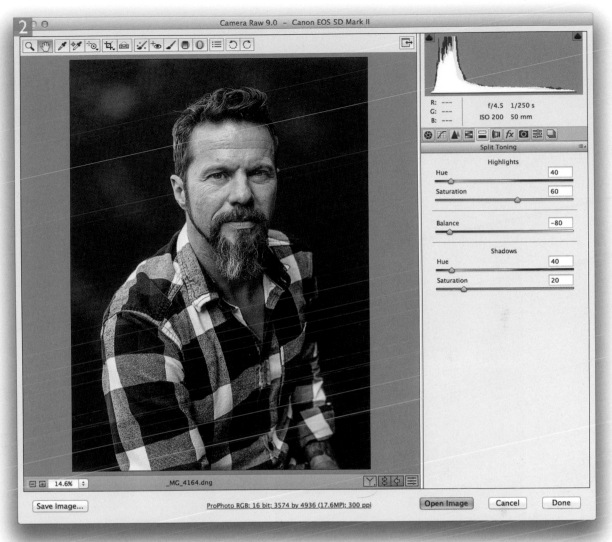

2 I then went to the Split Toning panel and adjusted the Hue and Saturation sliders to create the split toning effect shown here. Essentially, the Hue sliders allow you to independently set the hue color for the highlights and the shadows and the Saturation sliders let you adjust the saturation. As I mentioned on page 413, if you hold down the *alt* key as you drag on a Hue slider you'll see a temporary, saturated preview. This allows you to set the Hue slider for the desired color, without needing to adjust the Saturation slider first. The Balance slider can be used to adjust the balance between the highlight and shadow colors. This lets you offset the midpoint between the two. What is interesting to note here is that although the Hue values were the same for both the highlights and shadows, the Balance slider can still have a subtle effect on the outcome of any Split Tone adjustment.

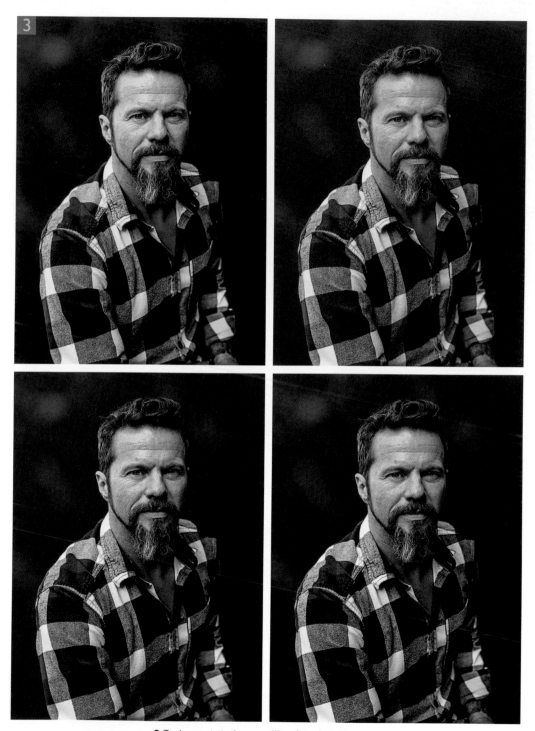

3 To demonstrate the versatility of the Split Toning panel, these four additional looks were created by further tweaking the Split Toning panel settings.

Chapter 6

Extending the dynamic range

For some time now, everyone has become preoccupied with counting the numbers of pixels in a digital capture as if this is the one benchmark of image quality that matters above all else. Size isn't everything though and it is really the quality of the pixel capture we should be concerned with most. The one thing people haven't focused on so much is the dynamic range of a camera sensor. Dynamic range refers to the ability of a sensor to capture the greatest range of tones from the minimum recordable shadow point to the brightest highlights and this is what we are going to focus on here in this chapter.

Other HDR applications

32-bit image editing is also used extensively to make the realistic CGI effects you see in many movies and television programs. These are created using a 32-bit color space to render the computer-generated characters. It is necessary to do this in order to make them interact convincingly with the real world film footage. What usually happens is a light probe image is taken of the scene in which the main filming takes place. This is a sequence of six or seven overlapping exposures of a mirrored sphere, taken to form an omnidirectional HDR image. The resulting light probe image contains all the information needed to render the shading and textures on a computer-generated object with realistic-looking lighting. Paul Debevec is a leading expert in HDR imaging and his website debevec.org contains a lot of interesting information on HDR imaging and its various applications.

High dynamic range imaging

High dynamic range imaging (HDR) is mostly about extending the dynamic range of the camera sensor to capture as wide a range of scenic tones as possible. Over the last few years digital camera sensors have improved significantly and some digital cameras are already capable of capturing a decent wide dynamic range. But in those situations where it is not possible to capture a sufficient range of tones with a single exposure the alternative is to blend an exposure-bracketed series of images together to create a single, high dynamic range image.

Right now there are a lot of photographers interested in exploring what can be done using high dynamic range image editing. For example, using the Merge to HDR Pro feature in Photoshop you can combine two or more images that have been captured with a normal digital camera, but shot at different exposures and blend these together to produce a 32-bit floating point, high dynamic range image. You can then convert this 32-bit HDR file into a 16-bit per channel or 8-bit per channel low dynamic range version, which can then be further edited in Photoshop. In Figure 6.1 I show some examples of what high dynamic range processed images can look like. You are probably familiar with the typical 'HDR look' where there are obvious halos in the picture. While some photographers seem to like this kind of effect there has been a backlash against the illustrated feel of such images. A couple of years ago I was asked to help judge the UK's Landscape Photographer of the Year competition. It was interesting to note that of all the obvious HDR-effect photographs, not one got short-listed into the final selection. That said, there may have been some HDR processed images that did make it through, because good HDR editing does not always have to be about creating an artificial look.

Basically, high dynamic range image editing requires a whole new approach to the way image editing programs like Photoshop process the high dynamic range image data. In fact, the Photoshop team had to rewrite a lot of the Photoshop code so that some of the regular Photoshop tools could be made to work in a 32-bit floating point image editing environment. Photoshop therefore does now offer a limited range of editing controls such as layers and painting in 32-bit mode. While the Merge to HDR Pro feature in Photoshop can be used do a good job, Camera Raw is now also a very effective tool for creating and processing high dynamic range images.

HDR essentials

Camera sensors record the light that hits the individual photosites and the signal is processed and converted into a digital file. I won't complicate things with a discussion of the different sensor designs used, but essentially the goal of late has been to design sensors in which the photosites are made as small as possible and crammed ever-closer together to provide an increased number of megapixels. Camera sensors have also been made more efficient so they can capture photographs over a wide range of ISO settings without generating too much electronic noise in the shadow areas or at high ISO settings. The problem all sensors face though is that at the low exposure extreme there comes a point where the photosites are unable to record any usable levels information over and above the random noise that's generated in the background. At the other extreme, when too much light hits a photosite it becomes oversaturated and is unable to record the light levels beyond a certain amount. Despite these physical problems we are now seeing improvements in sensor design, as well as in the Camera Raw software, which means it is now possible to capture wide dynamic range scenes more successfully in a single exposure and process them in Camera Raw (using Process 2012).

DxO Mark sensor evaluation

If you go to the DxO Mark by DxO Labs website (dxomark.com, or more specifically: tinyurl.com/7nwftam) you will find technical reports on most of the leading digital cameras. These evaluate the performance of sensors, indicating their optimum effective performance for ISO speed, color depth and dynamic range. For example, the latest Nikon D800 scores an impressive dynamic range of 14.3 EV, which is better than many medium format digital backs.

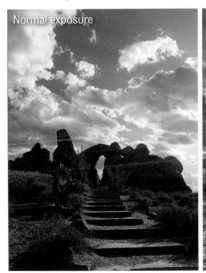
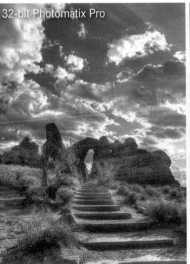

Normal exposure | 32-bit Photomatix Pro | 32-bit Camera Raw PV 2012

Figure 6.1 This shows a comparison of how a scene can be captured and processed in different ways. On the left is a normal exposure image of a wide dynamic range scene. In the middle is a merged, bracketed 32-bit image that was processed using Photomatix Pro. On the right is a merged, bracketed 32-bit image processed using the Process 2012 controls in Camera Raw.

Exposure slider

It is impossible to represent an HDR image on a standard computer display, which is why the Exposure slider is available for 32-bit images as a slider in the status box section of the document window (Figure 6.3). This allows you to inspect an HDR image at different brightness levels. Since the display you are using is most likely limited to a bit depth of 8 or 10 bits, this is the only way one can actually 'see' what is contained in a high dynamic range 32-bit image.

Alternative approaches

Other high dynamic range sensor technologies are in the pipeline. One method relies on the ability of a sensor to quickly record a sequence of images in the time it takes to shoot a single exposure. By varying the exposure time value for each of these exposures the camera software can extract a single high dynamic range capture. The advantage of this approach is that it might be feasible to capture a high dynamic range image using a fast shutter speed, although maybe not with a high speed strobe flash unit. So far we have seen a number of consumer digital cameras (and the iPhone) adopt this approach, but so far with limited success.

Bracketed exposures

As I mentioned earlier, if the camera sensor is unable to capture the full dynamic range of the scene, the alternative is to use bracketed exposures (see Figure 6.2). The aim here is to capture a series of exposures that are far enough apart in exposure value so that you can extend the combined range of exposures to encompass the entire scenic tonal range as well as extend beyond the limits of the scenic tonal range. The advantage of doing this is that by overexposing for the shadows you can capture more levels information and this can result in cleaner, noise-free shadow detail. Exposing beyond the upper range of the highlights can also be useful when trying to recover information in certain tricky highlight areas. Shooting bracketed exposures is the only way most of us can realistically go about capturing all of the light levels in any given scene and merge the resulting images into a single HDR file. When this is done right you have the means to create a low dynamic rendered version from the HDR master that allows you to reproduce most if not all of the original scenic tonal range detail.

Photomatix Pro

Photoshop's tone mapping methods are designed to help you create natural-looking conversions from an HDR to an LDR image. Photomatix Pro has proved extremely popular with photographers because it offers excellent photo merging, ghosting control, is better at merging hand held shots and above all, offers more extensive tone mapping options. Tone mapping with Photomatix Pro is much easier and also allows you to create those illustration-like effects that are often associated with a high dynamic range image look (which we should really call 'HDR to LDR converted images'). One

explanation for the difference between the Photoshop HDR conversion method and Photomatix Pro may be because Photoshop uses a bilateral filter for the tone mapping, while Photomatix Pro uses a Gaussian filter, which can produce more noticeable-looking halos. I quite like using Photomatix Pro because it is quick to work with and the tone controls are easy to master. However, I now mostly prefer to edit my 32-bit HDR images in Camera Raw because I find it is best for preserving the colors and producing more natural-looking results.

Displaying deep-bit color

It is hard to appreciate the difference between 8-bit per channel and 16-bit per channel images, let alone 32-bit images when all you have to view your work with is an 8-bit or 10-bit per channel display. However, display technology is rapidly improving and in the future we may see the introduction of displays that use a combination of LEDs and LCDs to display images at greater bit depths and over a higher dynamic range. Dolby already supply such specialist high dynamic range displays and the difference is remarkable. In the future, such displays may allow us to preview our images in greater tonal detail over a much wider dynamic range.

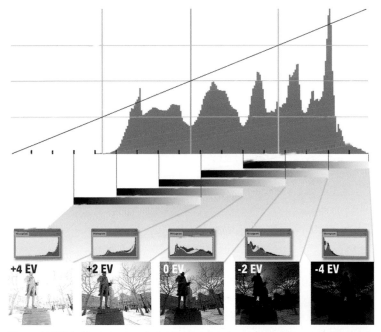

Figure 6.2 This illustrates how individual bracketed exposures when merged to form a single high dynamic range image can extend the histogram scale to encompass the entire luminance of the subject's scenic range.

Figure 6.3 This shows a 32-bit image with the Exposure slider shown in the status box.

Capturing a complete scenic tonal range

The light contrast ratio from the darkest point in a scene to the brightest will vary from subject to subject, but in nearly every case it will certainly exceed the dynamic range of even the best digital cameras. Our human vision is able to differentiate between light and dark over a very wide range. It is hard to say precisely how good our eyesight is, but it has been suggested that human vision under some circumstances might be equivalent to as much as 1,000,000:1, or 20 EV. Meanwhile, most digital cameras capture a tonal range that's far less than that. For the most part we have to choose our exposures carefully and decide in advance whether we wish to expose for the shadows, for the highlights, or somewhere in between. We also know from experience that you don't always need to record every single tone in a scene in order to produce a good-looking photograph. It is OK after all to deliberately allow some highlights to burn out, or let the shadows go black. However, if you wish to capture every level of tonal information in a scene, the only practical solution right now is to shoot a succession of bracketed exposures (see Figure 6.2). From this you can create a single image that is capable of capturing the entire scenic tonal range (see Figure 6.3).

Therefore, when capturing a high dynamic range image the objective is to make sure you capture the entire contrast range in a scene from dark to light. You can do this by taking spot meter readings and manually working out the best exposure bracketing sequence to use, and how many brackets are required. An alternative (and simpler) approach is to use a standard method of shooting in which you first measure the best average exposure (as you would for a single exposure) and bracket either side of that using either 3, 5 or 7 bracketed exposures at 2 EV apart. This may not be so precise a method, but a 5-bracketed sequence should at the very least double the dynamic range of your camera.

There are several benefits to capturing a high dynamic range. First of all you can potentially capture all the light information that was in the original scene and edit the recorded information any way you like. Secondly, a merged HDR image should contain smoother tonal information in the shadow regions. This is because more levels are captured at the bright end of the levels histogram (see 'Digital exposure' on page 150). Because of this the overexposed brackets will have more levels with which to record the shadow detail. When you successfully capture and create an HDR image, there should

be little or no noise in the shadows and you should have a lot more headroom to edit the shadow tones without the risk of banding or lack of fine detail that is often a problem with normally exposed digital photos.

HDR shooting tips

The first thing you want to do is to set up your camera so it can shoot auto bracketed exposures. Some cameras only allow you to shoot three bracketed exposures, others more. With the Canon EOS range you should find that by tethering your camera to the computer you can use the Canon camera utilities software to set the default to five or more exposure brackets. The bracketing should be done based on varying the exposure time. This is because the aperture must always remain fixed so you don't vary the depth of field or the parallax between captures. Next, you want the camera to be kept still between exposures. It is possible to achieve this by hand holding the camera and keeping it as still as possible while you shoot, but for best results you should use a sturdy tripod with a cable release. Even then you may have the problem of mirror shake to deal with (this is where the flipping up of the mirror on an SLR camera can set off a tiny vibration, which can cause a small amount of image movement during the exposure). However, this is mostly only noticeable if using a long focal length lens. It's really when shooting on a tripod that this can be a problem—if you shoot hand held, the vibration will be dampened by you holding the camera. So apart from using a cable release, do enable the mirror up settings on your camera if you can.

The ideal exposure bracket range will vary, but an exposure bracket of five exposures of 2 EV apart should be enough to successfully capture most scenes. If you shoot just three exposures 2 EV apart you should get good results, but you won't be recording as wide a dynamic range. As you shoot a bracketed sequence watch out for any movement between exposures such as people or cars moving through the frame, or where the wind may cause movement. Sometimes it can be hard to prevent everything in the scene from moving. Merge to HDR Pro and Camera Raw are capable of removing some ghosting effects, but it's best to avoid doing this if you can.

If you shoot three or five exposures and separate these by 2 exposure values (EV), this should allow you to capture a wide scenic capture range efficiently and quickly. You can consider

Really still, still life

The Merge to HDR Pro dialog can automatically align the images for you, but it is essential that everything else remains static. You might just get away shooting the HDR merge images with a hand held camera using an auto bracket setting, but if so much as just two of the pictures fail to register you won't be able to create a successful HDR merge. If you do resort to hand holding the camera, use a fast motor drive setting, raise the ISO setting at least two stops higher than you would use normally for hand held shooting and try to keep the camera as steady as possible (hand holding the camera should also absorb some of the mirror shake movement).

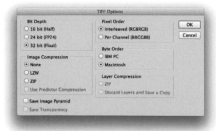

Figure 6.4 This shows the TIFF options when saving a 32-bit file as a TIFF.

narrowing down the exposure gap to just 1 EV between each exposure and shoot more exposures. This can make a marginal improvement to the edge detail in a merged HDR image, but also increases the risk of error if there is movement between any of the individual exposures.

HDR File formats

True high dynamic range images can only originate from a high dynamic range capture device, or be manufactured from a composite of camera exposures using a method such as the Merge to HDR pro option (which is described later in this chapter). Photoshop's 32-bit mode uses floating point math calculations (as opposed to regular whole integer numbers) to describe the brightness values, which can range from the deepest shadow to the brightness of the sun. It is therefore using a completely different method to describe the luminance values in an image.

If you want to save a 32-bit HDR image in Photoshop you are offered a choice of formats. You can use the Photoshop PSD, Large Document format (PSB), or TIFF format (see Figure 6.4). These file formats can store Photoshop layers or adjustment layers, but the downside is the file sizes will be at least four times that of an ordinary 8-bit per channel image. However, there are ways to make 32-bit HDR files more compact. You can use the OpenEXR or Radiance formats to save your HDR files more efficiently with compression and the OpenEXR format will very often be only slightly bigger than an ordinary 8-bit version of an image. The downside is you can't save Photoshop layers using OpenEXR, but this could still be considered a suitable format choice for archiving flattened HDR images, despite the fact it compresses the data compared to a full 32-bit per channel format such as PSB or TIFF.

How to fool Merge to HDR

Some people have asked if it is possible to take a standard single shot image, create versions of varying darkness and merge these together as an HDR image. The thing is, you can't fool Merge to HDR Pro since it responds to the camera time exposure EXIF metadata information in the file rather than the 'look' of the image. However, you can use the HDR Toning adjustment (Image ⇨ Adjustments ⇨ HDR Toning) to create a fake HDR look from a normal dynamic range image. The way it does this is to convert an 8-bit, or ideally a 16-bit per channel

image to 32-bits per channel mode and then pops the HDR Toning dialog shown in Figure 6.5, which allows you to apply HDR toning adjustments as if it were a true 32-bit HDR original. Note, this only works if you are editing an image that is in RGB or Grayscale mode and has been flattened first. This isn't true HDR to LDR photography, but it does provide a means by which you can create an 'HDR look' from photographs that weren't captured as part of a bracketed exposure sequence.

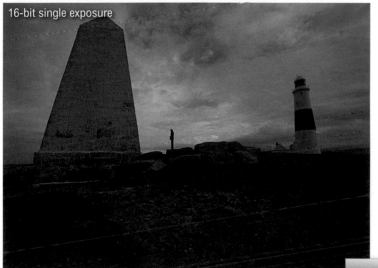

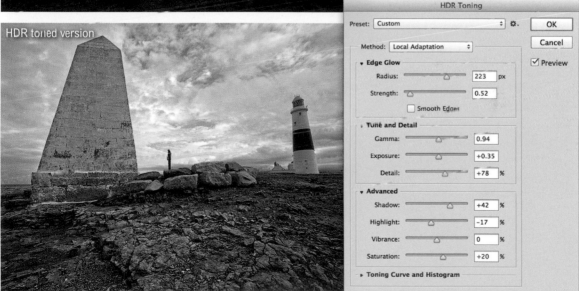

Figure 6.5 This shows an example of HDR Toning being applied to a normal 16-bit per channel image (top) to produce the fake high dynamic range effect shown here.

OpenEXR files and ICC profiles

Currently there is no accepted color management standard for the OpenEXR format. Therefore, when you open such images in Photoshop you need to have an idea about what would be the best profile to apply here, and assign this via the Missing Profile box that pops up when you open the image. In most cases it will be safe to assume this should be your regular RGB workspace (particularly if it was you who saved the OpenEXR file in the first place). While the document profile choices will say Adobe RGB or ProPhoto RGB, etc., the selected profile will use the color primaries of the selected workspace, but in a linear RGB space (which is the same for all 32-bit images opened in Photoshop).

Camera Raw Smart Objects

A Smart Object stores the raw pixel data within a saved PSD or TIFF image (you'll learn more about Smart Objects in Chapter 8). This means you have the freedom to re-edit the raw data at any time. Although it is possible to apply the technique shown here to JPEG images, this won't bring you any real benefit compared with processing a raw image original. The important thing to stress here is that this technique really applies to editing raw files only.

Basic tonal compression techniques

Blending multiple exposures

A simple way to extend the dynamic range of your capture images is to blend two or more exposures together using a simple mask. The approach described here in the following steps also brings you the benefit of being able to edit the individual Camera Raw Smart Object layers.

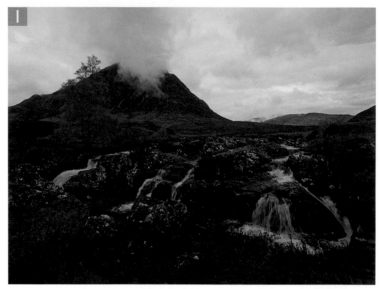

1 When shooting this landscape photo it was not possible to capture the entire scene using a single exposure. It needed one exposure made for the sky and another exposure made for the ground, with a difference of around 2 stops between the two. The photos you see here were captured in raw mode and only the default Camera Raw adjustments had been applied to each shot.

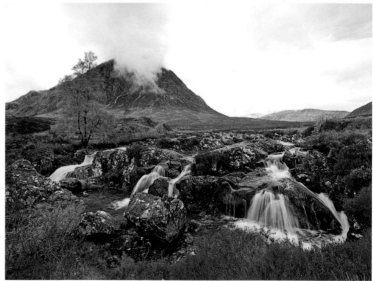

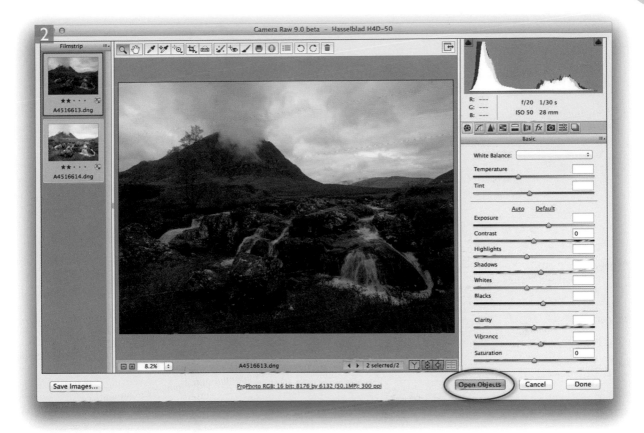

2 I began by opening these two raw images as Smart Objects. To do this. I opened the images via Camera Raw, held down the *Shift* key and clicked the 'Open Objects' button (circled) to open as Smart Objects in Photoshop. Note, this button usually says 'Open Images' and switches to say 'Open Objects' when the *Shift* key is held down.

3 After opening both raw images as Smart Objects I used the move tool to drag the darker exposure image to the lighter exposure image window, placing it as a layer (with the *Shift* key held down to keep in register). At this stage I could double-click the thumbnails to reopen the images in Camera Raw and re-edit the original settings.

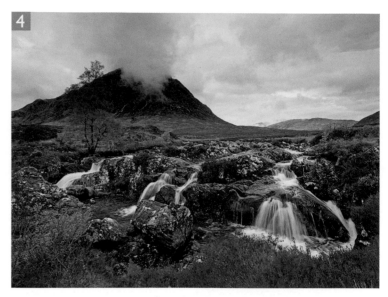

4 With the darker Smart Object layer selected I clicked on the Add Layer Mask at the bottom of the Layers panel (circled) to add an empty new layer mask. I then selected the gradient tool and added a white to black gradient. This faded the visibility of the top layer.

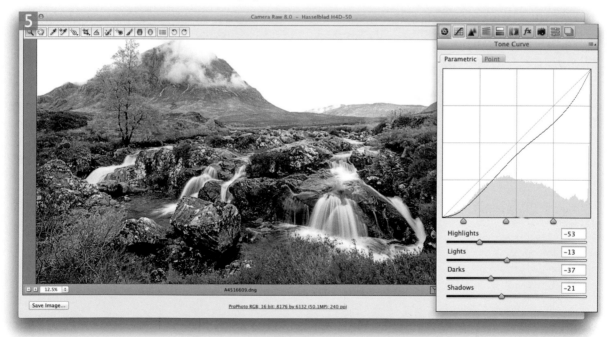

5 I then selected the bottom layer, double-clicked the thumbnail to open it in Camera Raw and made some further tweaks to the Tone Curve panel to add more tonal contrast. Once I was done I clicked OK to close the Camera Raw dialog.

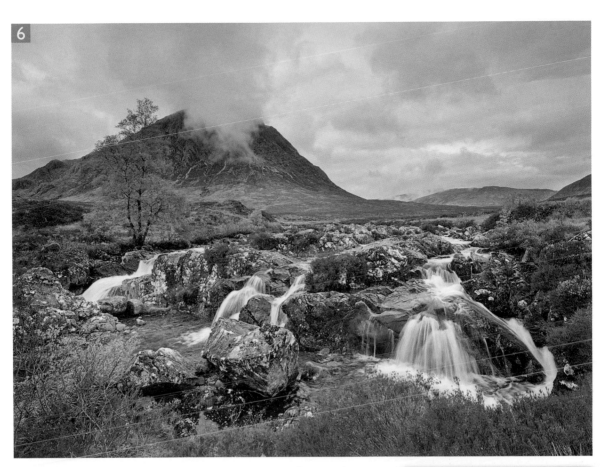

6 Whenever you update the Camera Raw settings it usually takes a few seconds after closing the Camera Raw dialog to see the changes updated in the Photoshop document window. To produce the final image shown here, I did a couple more things. I reopened the dark Smart Object layer and adjusted the white balance to make the image slightly cooler. I then also used the brush tool and painted with white and black on the associated layer mask to fine-tune the mask border edge. In some instances you might find it desirable to apply a mask that precisely follows the outline of the horizon. However, a lot of the time a soft edge mask will work fine. The effect I was trying to achieve here was somewhat similar to placing a graduated filter in front of the lens. Except when you do this in Photoshop you have the means to edit the mask edge as much as you like.

Camera Raw adjustments using Process 2012

You won't always be able to set up the camera on a tripod to shoot a series of bracketed exposures. However, the latest Process 2012 for Camera Raw does now provide you with the ability to effectively edit a raw image and compress the scenic tonal range without needing to rely on multiple exposures. Since using Process 2012 I have found less need to rely on Merge to HDR techniques. Quite often, all I need is one properly exposed raw image.

1 Here is a raw image that was processed using the default tone settings. Now, with this photo the camera was able to capture a full range of tones from the shadows to the highlights, but as you can see, it was missing contrast in the highlights, and the shadows were rather dark and lacked detail.

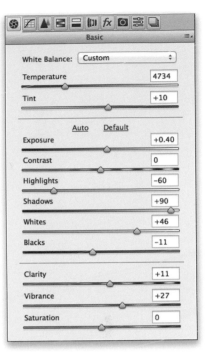

2 In the Camera Raw dialog I made sure I had updated to Process 2012 and adjusted the Basic panel sliders (shown here on the right) to achieve the best detail in the tower and the clouds. You will notice here that I mainly used a negative Highlights adjustment to darken the highlights and a positive Shadows adjustment to bring out more detail in the shadow areas. Having applied these major adjustments to compress the scenic tonal range, all I needed to do was fine-tune the Whites and Blacks sliders to set the highlight and shadow clipping. I also added some Clarity, which I generally find is necessary after compressing the tones in the original scene.

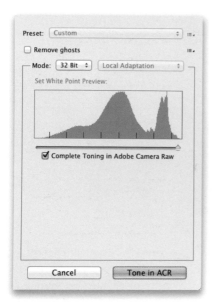

Figure 6.6 This shows a close-up view of the 32-bit mode panel in the Merge to HDR Pro dialog after merging a bracketed sequence of photos. When 'Complete Toning in Adobe Camera Raw' is checked, you'll see the 'Tone in ACR' button at the bottom.

Processing HDR files in Camera Raw

Camera Raw has the ability to edit TIFF 32-bit HDR files just as you would a regular TIFF or raw image. What this means is you can use the Basic panel controls in Camera Raw, or Lightroom to edit 32-bit HDR files (providing they have been saved as flattened TIFFs). If you have got accustomed to working with the latest Process 2012 tone controls, your editing experience working on HDR images will not be that much different from when working with regular raw, TIFF or JPEG images, except the dynamic range you'll have to work with will potentially be that much greater and the Exposure slider range will be increased to + or − 10 stops. In my view, working with the Camera Raw tone adjustments makes it easier to achieve the desired tone balance in an image. The other benefit from using Camera Raw as an HDR editor is you don't end up with the noticeable 'HDR look' you tend to get when processing HDR files to render low dynamic range versions. In other words, you can avoid getting the rather obvious halos (although some photographers do seem to like this kind of effect).

The Camera Raw options

One way to process an HDR image using Camera Raw is to create an HDR 32-bit file, or take an existing 32-bit image and force open it via Camera Raw. To do this the image must be flattened and saved using the TIFF file format. This is a good way to handle existing HDR 32-bit files. Alternatively, you can go to the file Handling preferences and check the 'Use Adobe Camera Raw to convert 32-bit files to 16/8 bit' option. Once this is done, when you open a 32-bit image in Photoshop and change the bit depth from 32-bit to 16-bit or 8-bit, this automatically pops Camera Raw in place of the HDR Toning dialog. In effect, it opens Camera Raw as a filter.

Lastly, you can convert to Camera Raw when you use Merge to HDR Pro to merge bracketed exposures to create a single HDR master. When the Merge to HDR Pro dialog opens and you are in the default 32-bit mode (see Figure 6.6), there is an option to 'Complete Toning in Adobe Camera Raw'. When this is checked, the OK button will say 'Tone in ACR'. Click this and you will be taken to the Camera Raw dialog in Camera Raw filter mode. Once you have finished editing the Camera Raw settings and clicked OK, the processed image will be a 32-bit image as a smart object layer, where you'll have the ability to open and re-edit the Camera Raw settings.

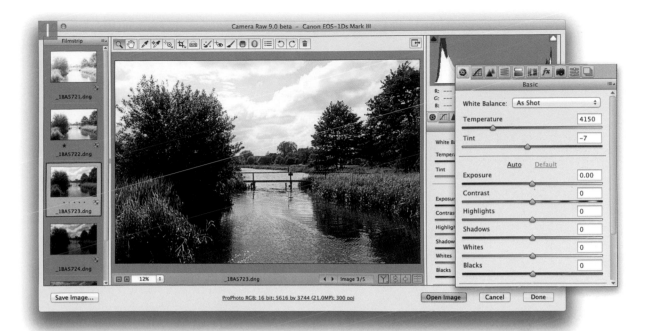

1 To begin with I opened five photos that were shot around two stops apart, where the camera was set to aperture priority mode and the shutter speed only was adjusted with each bracket. This ensured the aperture and depth of field would be consistent for each exposure.

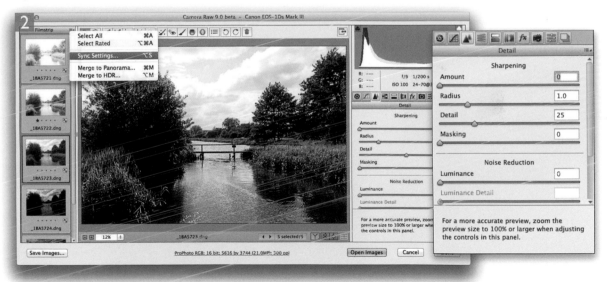

2 Before creating a merged HDR image I find it helps to disable sharpening of the raw master files. To do this, I went to the Detail panel and set the sharpening Amount slider to zero. Having done this, I selected all five of the photos I was going to merge and synchronized the settings.

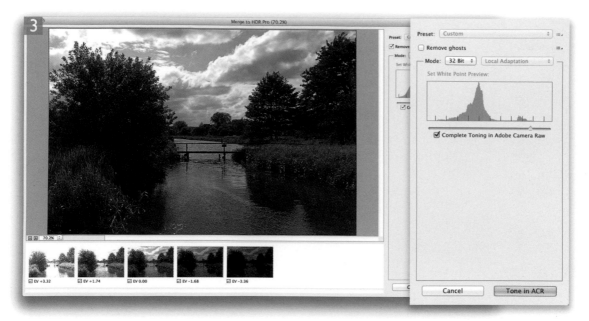

3 In Bridge I went to the Tools menu and chose Photoshop ⇒ Merge to HDR Pro… This opened all three images, blended them together and presented the Photoshop Merge to HDR Pro dialog shown here. You can use this dialog to tone map and convert the 32-bit data to 16-bit or 8-bit within Merge to HDR Pro. Instead I selected the 32-bit option, checked the 'Complete Toning in Adobe Camera Raw option' and clicked 'Tone in ACR' at the bottom.

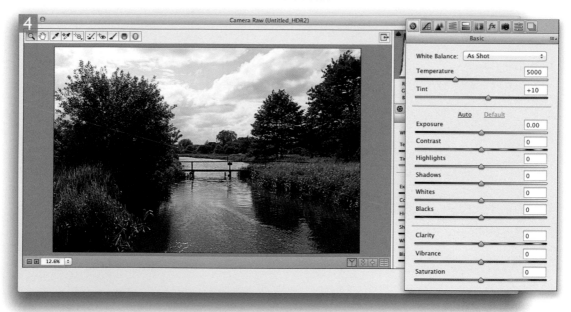

4 Here is how the saved image looked when previewed in Camera Raw with zero settings applied by default.

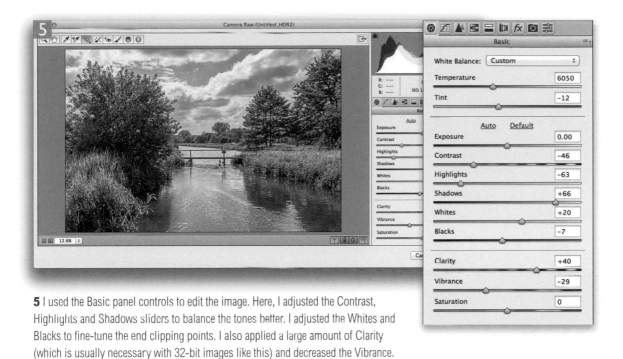

5 I used the Basic panel controls to edit the image. Here, I adjusted the Contrast, Highlights and Shadows sliders to balance the tones better. I adjusted the Whites and Blacks to fine-tune the end clipping points. I also applied a large amount of Clarity (which is usually necessary with 32-bit images like this) and decreased the Vibrance.

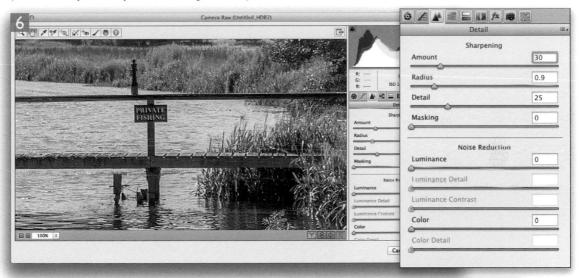

6 In this final version I went to the Detail panel and edited the Sharpening sliders to apply the desired capture sharpening (remember, I had disabled the sharpening prior to creating the original HDR master file). When I clicked OK you can see that this method created a smart object image in Photoshop, which meant the Camera Raw adjustments would remain editable.

Consistent file formats

When processing photos using the Photo Merge feature you are not able to mix raw and non-raw files.

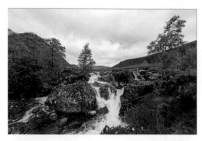

Figure 6.7 In this example I merged three bracketed exposures where there was movement in the clouds, the trees and water between each exposure. Selecting in this instance the 'Medium' Deghost option and with the Show Overlay option checked, highlighted the areas where the deghosting would be applied.

HDR photos using Photo Merge in Camera Raw

The Photo Merge feature in Camera Raw can also be used to produce a master HDR DNG file from raw or non-raw images. As when using Merge to HDR Pro, you need to start by selecting two or more photos of a subject that has been photographed at different exposure settings, where the aperture remains fixed and only the exposure time value varies.

The processing technique used in Camera Raw is slightly different. Consequently, you may find some results you get using the Camera Raw Photo Merge method will be better, but not always. For example, when using the Camera Raw Photo Merge HDR method there is some latitude to allow for small amounts of cloud movement between exposures providing the clouds have not moved too much. If there is more than a slight amount of movement you can select a Deghost option, but this can produce inferior results if there is no, or very little, movement. Also, the deghosting method used in Camera Raw may utilize more than one image to deghost the resulting HDR. When it works it is great, but it can sometimes lead to unwanted artifacts in the final image, so it is best to leave set to the default 'None' setting if you don't need it. As shown in Figure 6.7, with scenes that have moving content, such as water, you may want to increase the deghosting amount. You can get good results blending three or five exposure sequences, but it also works well when just two exposures are combined. In fact by using just two exposures you may actually get better results because you are extending the dynamic range, but without the risk of generating artifacts as a consequence of subject movement between exposures. For example, when photographing a landscape subject you might want to capture one exposure for the ground and another for the sky and blend the two using an HDR Photo Merge.

Creating Photo Merge DNGs

The image you see in the HDR Merge preview dialog will have an Auto Tone correction applied to it. So this should give you a reasonable idea of what the final Photo Merge DNG image will look like. Note that the full-size result will have default settings applied to it and will most likely look rather different. It is also important to be aware that the resulting DNGs from an HDR Photo Merge are saved as 16-bit floating point files, where the merged image consists of raw linear RGB data. The DNG files may therefore be quite large in size. You could argue that these

are not truly raw files, but a DNG produced this way is still mostly unprocessed and will allow you to make creative color and tone decisions when it is opened via Camera Raw.

What this means is that you still retain the flexibility to reprocess the resulting HDR Photo Merge DNG any way you like, just as you can with any raw image. For example, if new process versions become available, you will have the ability to make use of newer processing methods and always be able to fine-tune the raw settings, which arguably gives you more control over the final appearance of the image.

Exposure range

Merge to HDR raws created this way will have an increased Exposure range compared to normal. Exposure adjustments can be made within the −10 to +10 range.

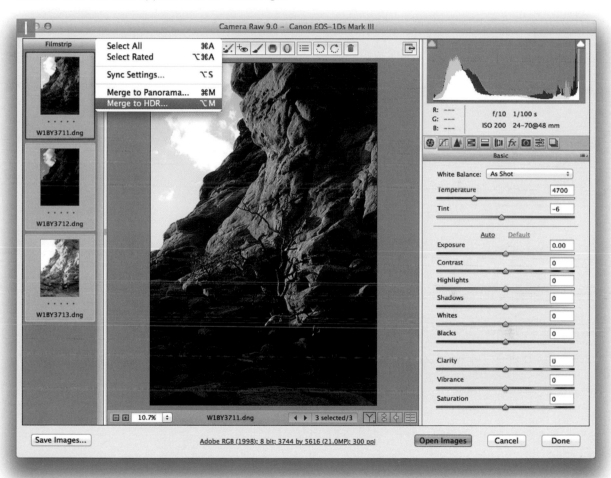

1 I selected three photographs that had been shot with the camera mounted on a tripod and bracket exposed, with 2 EV exposure difference between each shot. I opened these in Camera Raw, which opened in multiple image mode. I clicked on the Filmstrip menu and chose the Select All option. After that I selected Merge to HDR... (*alt* *M*). Holding down the *Shift* key as well (*alt* *Shift* *M*) opens in headless mode.

Headless mode

Opening in headless mode is a convenient way to bypass the following HDR Merge Preview dialog.

Merge preview dialog

Initially, you will see a fast preview in the Merge preview dialog whenever you change any of the merge options and a yellow warning icon will be shown in the top right corner of the preview. This will go away as a higher quality preview is built.

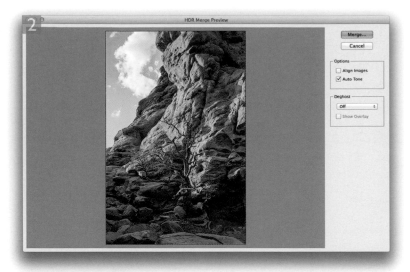

2 This opened the HDR Merge Preview dialog, where Deghost was set to 'Off', I checked the Auto Tone checkbox and unchecked Align Images. I then clicked the Merge button.

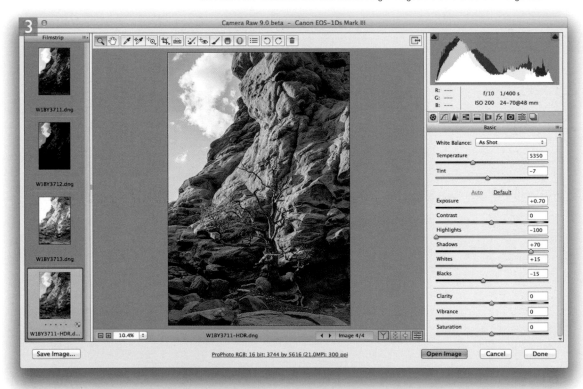

3 This created a merged HDR DNG image that was named using the filename of the most selected image in Step 1 with an -HDR suffix. It added the merged image to the Filmstrip and because Auto Tone was selected in Step 2, applied auto tone settings.

4 I was then able to further edit the HDR DNG image in Camera Raw as a raw image.
In this instance I applied some further localized image adjustments and also converted
the photo to black and white to produce the finished version shown here.

Merge to HDR Pro

The Photoshop Merge to HDR Pro command can be accessed via the File ⇨ Automate menu in Photoshop or via the Tools ⇨ Photoshop menu in Bridge. I usually find it best to open via Bridge, since the image alignment is applied automatically.

Response curve

Each time you load a set of bracketed images, Merge to HDR Pro automatically calculates a camera response curve based on the tonal range of images you are merging. As you merge more images from the same sensor, Merge to HDR Pro updates the response curve to improve its accuracy. If consistency is important when using Merge to HDR Pro to process files over a period of time, you might find it useful to save a custom response curve (see Step 3) and reuse the saved curve when merging images in the future.

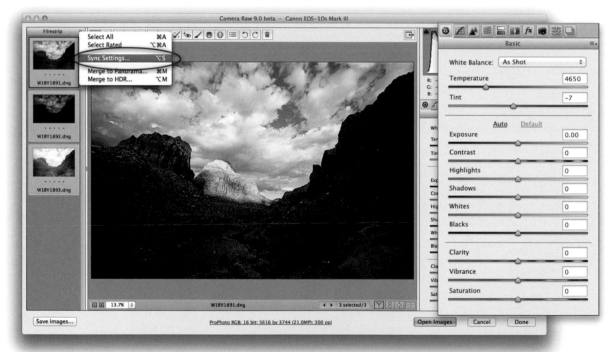

1 The original pictures were bracketed using different time exposures at two exposure values (EV) apart. I began by opening a selection of three raw digital capture images via Camera Raw. It was important that all auto adjustments were switched off. In this example, I made sure the Camera Raw Defaults were applied to the first image. I selected Synchronize… from the Filmstrip menu and chose to synchronize all settings across the other three selected images.

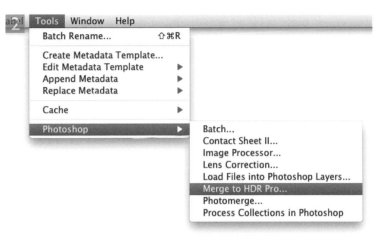

2 With the images selected in Bridge I went to the Tools menu and chose Photoshop ⇨ Merge to HDR Pro.

3 This shows the Merge to HDR Pro dialog in 16-bit mode. When the 8-bit or 16-bit mode is selected you will see the HDR toning options. These allow you to apply an HDR to LDR conversion in one step (the HDR toning controls are described more fully on pages 442–443). If you prefer at this stage to simply save the image as a 32-bit master HDR file, you should select 32-bit from the Mode menu, where the only option available is to adjust the exposure value for the image preview. There is also a fly-out menu in the Merge to HDR Pro dialog (circled below) where you can save or load a custom response curve.

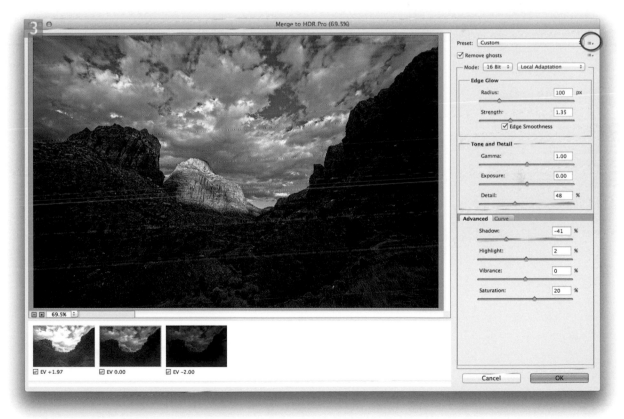

Merge to HDR Pro script

There is a 'Merge to HDR' script you can load from the Presets/Scripts folder that allows you to open files or folders of images to process via Merge to HDR Pro. It does not allow you to process layered files, although there are hooks present that could allow this to be scripted.

Exposure and Gamma

You can use the Exposure slider to compensate for the overall exposure brightness and the Gamma slider to (effectively) reduce or increase the contrast. The controls are rather basic, but they do allow you to create a usable conversion from the HDR image data.

Highlight Compression

The Highlight Compression simply compresses the highlights, preserving all the highlight detail. It can render good midtones and highlights at the expense of some detail in the shadows.

Equalize Histogram

The Equalize Histogram option attempts to map the extreme highlight and shadow points to the normal contrast range of a low dynamic range Photoshop image, but it's a rather blunt instrument to use when converting a high dynamic range image.

Tone mapping HDR images

After you have created a merged 32-bit per channel HDR image, you can save the HDR master using the PSD, PSB or TIFF formats to preserve maximum image detail plus any layers. Or, you can use the OpenEXR format, which as I explained earlier is a more efficient, space saving file format for storing 32-bit images. You can if you like skip saving the merged HDR image and jump straight into the tone mapping stage by selecting the 16-bit per channel or 8-bit per channel option in the Merge to HDR dialog. I think you will find though there are some definite advantages to preserving a master image as an HDR file. There is a real art to tone mapping an image from a high dynamic range to a normal, low dynamic range state and you won't always get the best results at your first attempt. It is a bit like the need to preserve your raw masters as raws and therefore makes sense to save an HDR file as a 32-bit master image first and then use Image ⇨ Mode menu to convert from 32-bits to 16-bits or 8-bits per channel. If the 'Use Adobe Camera Raw to convert 32-bit files to 16/8 bit' option is unchecked in the File Handling preferences, this pops the HDR Toning dialog (Figure 6.9), which offers four methods of converting an HDR image to a low dynamic range version (see the sidebars on the left and the section below). With each the aim is the same: to squeeze all of the tonal information contained in the high dynamic range master into a low dynamic range version of the image. Here I am just going to concentrate on the Local Adaptation method.

Local Adaptation

The Local Adaptation method is designed to simulate the way our human eyes compensate for varying levels of brightness when viewing a scene. For example, when we are outdoors our eyes naturally compensate for the difference between the brightness of the sky and the brightness of the ground. The difference in relative brightness between these two areas accounts for the 'global contrast' in the scene. As our eyes concentrate on one particular area, the contrast we observe in, say, the clouds in the sky or the grass on the ground is contrast that is perceived at a localized level. The optimum settings to use in an HDR conversion will therefore depend on the image content. Figure 6.8 shows a photograph of a scene with a high dynamic range. The global contrast would be the contrast between the palm tree silhouetted against the brightly lit buildings in the background, while the localized contrast would be the detail contrast within both the bright and dark regions of the picture (magnified here).

The Radius slider in the Local Adaptation HDR Toning dialog Edge Glow section (Figure 6.9) is said to control the size of the glow effect, but I prefer to think of this as a 'global contrast' control. Basically, the tone mapping process lightens the shadows relative to the highlights and the tone mapping is filtered via a soft edge mask. Increasing the Radius amount widens the halos. At a low setting you'll see an image in which there may be a full tonal range from the shadows to the highlights, but the image looks rather flat. As you increase the Radius this widens the halos, which softens the underlying mask and this is what creates the impression of a normal global contrast image. You can then use the Strength slider to determine how strong you want the effect to be. At a zero Strength setting the picture will again look rather flat. As you increase the Strength amount, you'll see more contrast in the halos that are generated around the high contrast edges in the image. The Edge Glow Strength slider can therefore be used to soften or strengthen the Radius effect, but you do need to watch for ugly halos around the high contrast edges.

When the Gamma slider is dragged all the way to the left, there is no tone compression between the shadows and highlights. As you drag the other way to the right, this compresses the shadows and highlights together. The Exposure slider can then be used to compensate for the overall exposure brightness. This slider adjustment can also have a strong effect as it is applied after the tone mapping stage rather than before.

The Detail slider works a bit like the Clarity slider found in Camera Raw and you can use this to enhance the localized contrast by adding more Detail. The Shadow and Highlight sliders are fine-tuning adjustments. These can be used to independently adjust the brightness in the shadows or highlight areas. For example, the Shadow slider can be used to lighten the shadow detail in the darkest areas only. HDR Local Adaptation conversions typically mute the colors so you can use the Vibrance and Saturation sliders to control the color saturation.

Finally, we come to the Toning Curve and Histogram. You can use this to apply a tone enhancing contrast curve as a last step in the HDR conversion. The histogram displayed here represents that of a 32-bit image, but you'll find the Histogram panel in Photoshop more useful when gauging the outcome of a conversion. When you are done you can click on the OK button for Photoshop to render a low dynamic range version from the HDR master.

Figure 6.8 Here is an example of a subject that has a wide dynamic range and strong global contrast.

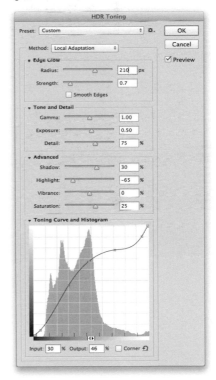

Figure 6.9 The Local Adaptation tone mapping method (also showing the Tone Curve and Histogram options).

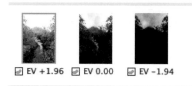

☑ EV +1.96 ☑ EV 0.00 ☑ EV −1.94

Figure 6.10 When removing ghosts you can select the image to base the anti-ghosting on.

Capture sharpening and HDR

As you apply HDR toning to a high dynamic range image, edge artifacts can start to appear. The things that cause this are heavy use of the Detail slider and edges where there is a sharp amount of contrast. Over the page you can see an example of how turning on the Edge Smoothing can help mitigate some of these effects. Beyond that, try not to go too crazy with the Detail slider, but you may also want to turn off the capture sharpening for the raw files before you generate a Merge to HDR Pro image. In Figure 6.12 you can see how doing this can make it easier for you to process certain types of images. If you do this you just need to remember to apply the required capture sharpening after you have created the HDR toned version.

Removing ghosts

It is important to minimize any movement when shooting bracketed exposures, which is why it is best to shoot using a sturdy tripod and cable release. Even so there remains the problem of things that might move between exposures such as tree branches blowing in the wind. To help address this the Merge to HDR Pro process in Photoshop utilizes a ghost removal algorithm which automatically tries to pick the best base image to work with and discards the data from the other images in areas where movement is detected. When the 'Remove Ghosts' option is checked in the Merge to HDR Pro dialog you'll see a green border around whichever thumbnail has been selected as the base image (Figure 6.10). You can override this by clicking to select an alternative thumbnail and make this the new base image. For example, if the moving objects are in a dark portion of the photograph then in these circumstances it will be best to select a lighter exposure as the base image. In practice I have found the ghost removal to be effective on most types of subjects, although moving clouds can still present a problem. Skies are also tricky to render because the glow settings can produce a noticeable halo around the sky/horizon edge. This problem can usually be resolved by placing the medium exposure image as a separate layer masked with a layer mask based on the outline of the sky.

How to avoid the 'HDR look'

It has to be said that HDR to LDR converted images can sometimes look quite freaky because of the temptation to squeeze everything into a low dynamic range. Just because you can preserve a complete tonal range doesn't mean you should. It really is OK to let the highlights burn out sometimes or let the shadows go black. The Photomatix Pro program has proved incredibly popular with HDR enthusiasts, and in the process spawned the classic 'HDR' look, which personally I think has been done to death now. However, Photomatix Pro can actually be used to produce nice, subtle tone mapped results, but I suppose people don't notice these types of HDR photos quite so much. The Photoshop approach also lets you produce what can be regarded as natural-looking conversions and I think you'll agree that the Figure 6.11 example shows how the HDR to LDR image process can result in a photo that looks fairly similar to a normal processed image, but with much improved image detail in the shadow regions.

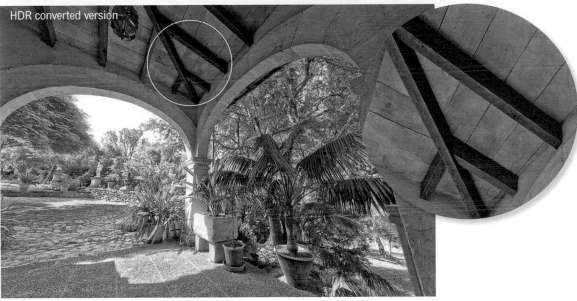

Single processed image

HDR converted version

Figure 6.11 The top photo here is a single edited image, shot using an optimum exposure processed via Camera Raw and output as a 16-bit file. Below you can see an HDR edited version that was converted to a 16-bit low dynamic range image. I tried to get the two images to match as closely as possible, but you should notice better tone and detail contrast in the roof rafters in the HDR converted version. The difference was more noticeable though when I examined the shadow areas. In the enlarged close-up views you can see there is much more image detail and virtually no shadow noise in the bottom image.

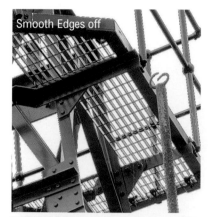

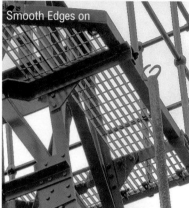

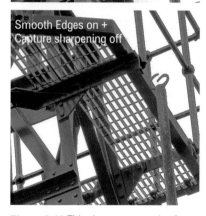

Figure 6.12 This shows an example of Smooth Edges off (top) and on (middle) and Smooth Edges on with capture sharpening off (bottom). Note that edge smoothing can decrease the contrast. To restore this, try boosting the Detail slider.

Smooth Edges option

When using the Local Adaptation method, there is a Smooth Edges option. When this is checked it can improve the image quality when toning HDR merged photos. Figure 6.12 shows before and after examples and how it can improve the appearance of the edges in a photo. I would say this is a problem you are more likely to notice when using a high Detail slider setting, where you can often end up seeing unwanted halos around high contrast edges. Applying edge smoothing won't help get rid of all types of artifacts and it can also influence the effect of the other HDR toning slider adjustments. So you may sometimes need to revisit these after applying the Smooth Edges option.

HDR toning examples

1 I began here with an HDR image that was produced by merging together a bracketed sequence of three photographs shot at 2 EV apart.

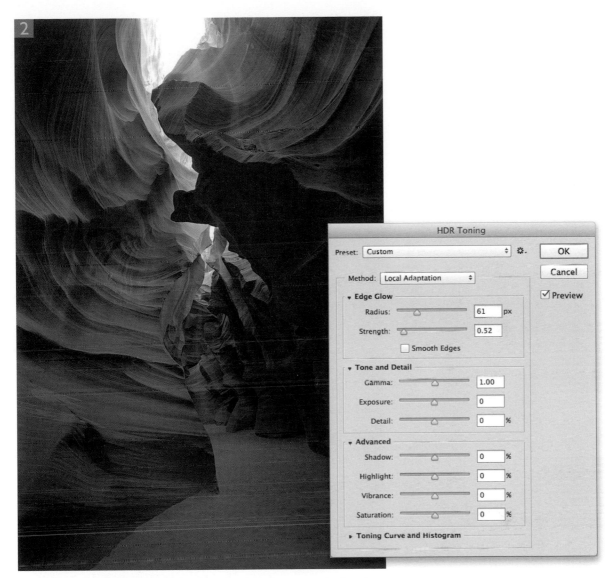

2 To convert a high dynamic range image into a low dynamic range version I went to the Image ⇨ Mode submenu and switched the bit depth from 32-bits to 16-bits per Channel. Providing the 'Use Adobe Camera Raw to convert 32-bit files to 16/8 bit' option was unchecked in the File Handling preferences, this opened the HDR Toning dialog shown here. Of the four tone mapping options available in this dialog, I find that the Local Adaptation method usually works the best. In this screen shot I left all the sliders at their default positions. Although the image doesn't look that great just yet, it is certainly quite an improvement upon how the default HDR converted image preview looked in earlier versions.

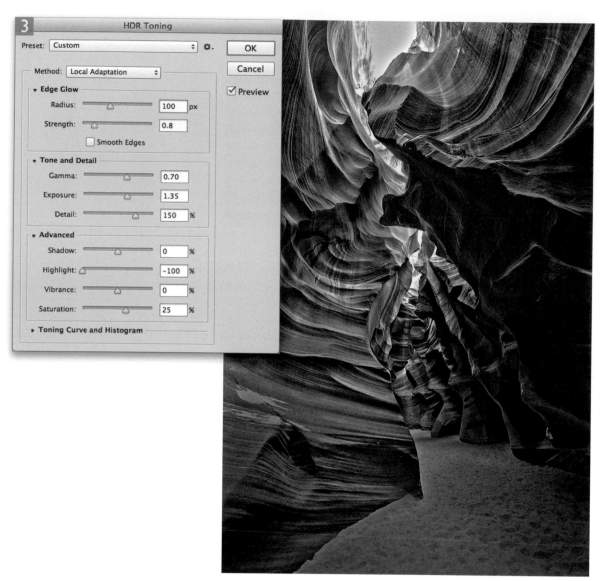

3 Here I adjusted the HDR Toning sliders to produce what might be called the 'illustration look' favored by some HDR photography enthusiasts. If this is the type of effect you are after I don't think the Photoshop HDR Toning adjustment is really as capable as, say, Photomatix Pro and nor is it as simple to configure. Looking at the settings shown here, I set the Radius slider to 100 pixels and raised the Strength to 0.80. I took the Gamma slider to 0.7, set the Exposure slider to +1.35 and the Detail slider to 150%. I then reduced the Highlight slider to −100% and increased the Saturation slightly, setting it to 25%.

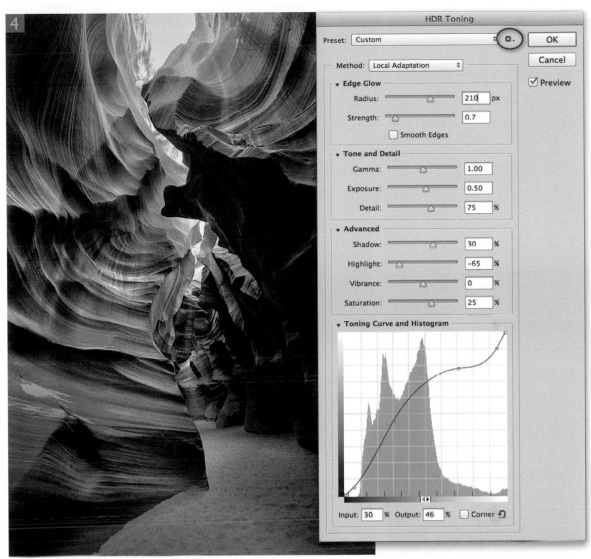

4 In this step I aimed to produce a more natural-looking result. To start with I set the Radius slider to 210 pixels. This was done to create much wider halo edges. I set the Strength slider to 0.7 and the Gamma slider to the default 1.00 setting. Exposure was reduced to 0.5. I also reduced the Detail slider to 75% and made some further tweaks to the Advanced slider settings below. I then adjusted the Toning Curve to fine-tune the final tone mapping (I find it helps to also refer to the Histogram panel in Photoshop as you do this). Lastly, I clicked on the HDR Toning options button (circled), selected Save Preset... and saved the Local Adaptation settings as a new preset, which might serve as a useful starting point for other HDR conversions of photos shot at the same location.

How to smooth HDR toned images

The following tutorial shows some additional things you can do in Photoshop to retouch an HDR tone mapped image and cure some of the problems created by the tone mapping process.

1 Here is an HDR, 32-bit image that was created from a bracket sequence shot 2 EV apart.

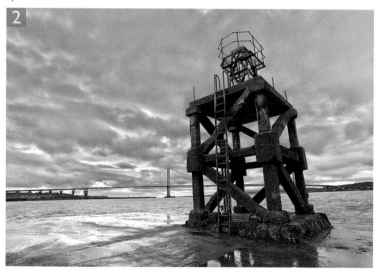

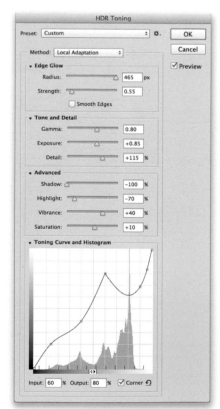

2 I chose Image ⇨ Mode 16-bits to open the HDR Toning dialog (with 'Use Adobe Camera Raw to convert 32-bit files to 16/8 bit' option unchecked in the File Handling preferences), where I applied the settings shown here. In particular, I made one of the curve points in the Toning Curve a corner point. When tone mapping HDR images it can be helpful to add a midpoint to the curve and make this a corner point. This then makes it easier to manipulate the tone curve shape, adjusting two or more portions of the tone curve separately.

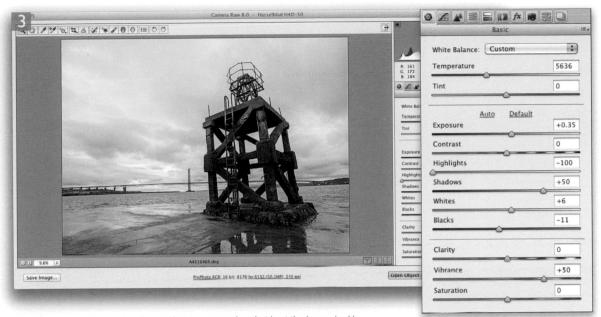

3 In the previous step, I aimed to apply a tone mapping that kept the image looking as realistic as possible. For example, I kept the Edge Glow Radius wide and the Strength low. HDR processing does tend to distort the colors though, so what I did here was to open the middle exposure image in Camera Raw and adjust the settings to try and match as closely as possible the HDR processed version.

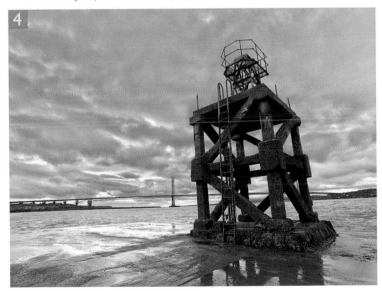

4 I then opened the image processed in Step 3 as a Smart Object layer, added this as a new layer above the HDR tone mapped version and set the blend mode to Color. This step helped cure some color banding in the highlight regions of the sky (I find this step useful for most Photoshop Merge to HDR Pro images).

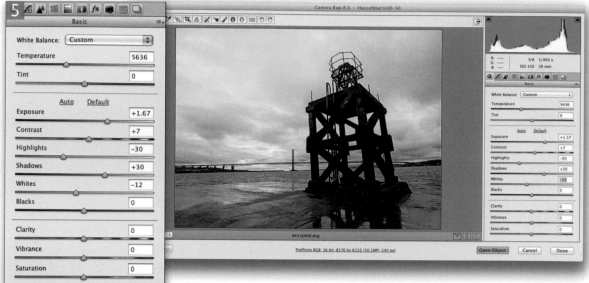

5 I was now happy with everything except the look of the sky. In the previous Step there were noticeable wide-edge halos. I now opened the darkest exposure image and lightened it to get the sky to look roughly as bright as the tone mapped version.

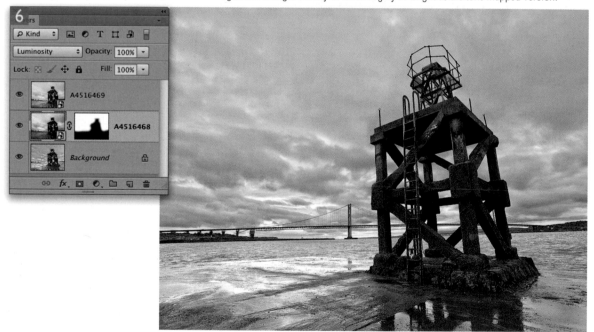

6 I then added this too as a Smart Object layer, sandwiched below the Color mode layer and set to the Luminosity blend mode. I added a layer mask filled with black and painted with white to reveal the layer contents in the sky areas only. The final version had all the benefits of HDR editing, but without the photograph looking as if it had been HDR processed.

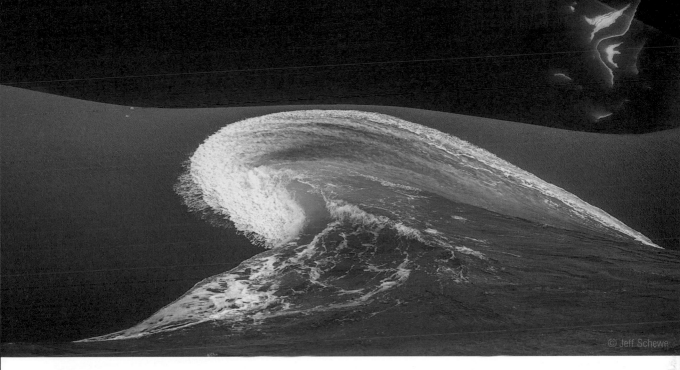

© Jeff Schewe

Chapter 7

Image retouching

Photoshop has become so successful that its very name
is synonymous with digital image retouching. Photoshop
retouching tools such as the humble clone stamp have been
around since the very early versions of the program and have
been used and abused in equal measure. The new retouching
tools that have been added since then mean that you can
now transform images almost any way you want. As my
colleague Jeff Schewe likes to say: "You know why Photoshop
is so successful? Because reality sucks!" Well, that's Jeff's
viewpoint, but then he does come from a background in
advertising photography where heavy retouching is par for the
course. The techniques described in this chapter will teach
you some of the basic procedures, such as how to remove
dust spots and repair sections of an image. We'll then go on
to explore some of the more advanced techniques that can be
used to clean up and enhance your photographs.

Figure 7.1 If you are carrying out any type of retouching work which relies on the use of the paint tools, a pressure sensitive graphics tablet and pen, such as the Wacom™ device shown here, is absolutely invaluable.

Basic cloning methods

At the beginning of any retouching session the clone stamp tool and healing brush are the most useful tools to work with. You can use these to carry out most basic retouching tasks before you proceed to carry out the more advanced retouching steps.

Clone stamp tool

To work with the clone stamp tool, hold down the `alt` key and click to select a source point to clone from. Release the `alt` key and move the cursor over to the point that you wish to clone to, and click or drag with the mouse. If you have the tool set to aligned mode, this establishes a fixed relationship between the source and destination points. If the clone stamp is set to the non-aligned mode, the source point starts from the same location after each time you lift the pen or mouse until you `alt`-click again to establish a new source point. When working with the clone stamp or healing brush I do find it helps to use a graphics tablet (like the Wacom™ device shown in Figure 7.1), as this can help you work more quickly and efficiently.

Clone stamp brush settings

As with all the other painting tools, you can change the brush size, shape and opacity to suit your needs. When working with the clone stamp I mostly leave the opacity set to 100%, since cloning at less than full opacity can lead to tell-tale evidence of clone stamp retouching. However, when smoothing out skin tone shadows or blemishes, you might find it helpful to switch to an opacity of 50% or less. You can also use lower opacities when retouching areas of soft texture. Otherwise I suggest you stick to using 100% opacity. For similar reasons, you don't want the clone stamp to have too soft an edge. For general retouching work, the clone stamp brush shape should have a slightly harder edge than you might use normally with the paint brush tools. When retouching detailed subjects such as fine textures, you might want to use an even harder edge so as to avoid creating halos. Also, if film grain is visible in a photograph, anything other than a harder edge setting will lead to soft halos, which can make the retouched area look slightly blurred or misregistered. If you need extra subtle control, lower the Flow rate; this allows you to build an effect more slowly, without the drawbacks of lowering the opacity.

1 The best way to disguise clone stamp retouching is to use a full opacity brush with a medium hard edge at 100% opacity. It is also a good idea to add a new empty layer above the Background layer, which you can do by clicking on the Add New Layer button (circled in blue). This lets you keep all the clone retouching on a separate layer, and it was for this reason I chose to have the 'All Layers' Sample option selected in the Options bar (circled in red) so that all visible pixels were copied to this new layer.

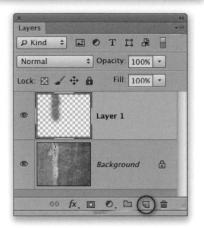

2 The Aligned box is normally checked by default in the Options bar. Here, I used the `alt` key to set the sample point on an undamaged part of the wall and was then able to click on the crack to set the destination point.

3 I then dragged to paint with the clone stamp. Photoshop retains the clone source/ destination relationship for all subsequent brush strokes until a new source and destination are established. In situations like this you may find the Clone Source panel 'Show Overlay' option proves useful (see page 458).

Pressure sensitivity

If you are using a pressure sensitive tablet such as a Wacom™ tablet, the default brush dynamics will be size sensitive, so you can use light pressure to paint with a small brush, and heavier pressure to apply a full-sized brush.

Healing brush

The healing brush can be used in more or less the same way as the clone stamp tool to retouch small blemishes, although it is important to stress here that the healing brush is more than just a magic clone stamp and has its own unique characteristics. These differences need to be taken into account so that you can learn when it is best to use the healing brush and when it is more appropriate to use the clone stamp.

To use the healing brush, you again need to establish a sample point by *alt*-clicking on the portion of the image you wish to sample from. You then release the *alt* key and move the cursor over to the point where you want to clone to and click or drag with the mouse to carry out the healing brush retouching. The healing brush works by sampling the texture from the source point and blends the sampled texture with the color and luminosity of the pixels that surround the destination point. The healing brush reads the pixels within a feathered radius that is up to 10% outside the perimeter of the healing brush cursor area. By reading the pixels that are outside the cursor area at the destination point, the healing brush is (in most cases) able to calculate a smooth transition of color and luminosity within the area that is being painted (always referencing the pixels within a feathered radius that is up to 10% outside the perimeter of the healing brush cursor area). It is for these reasons that there is no need to use a soft edged brush and you will always obtain more controlled results through using the healing brush with a 100% hard edge.

Once you understand the fundamental principles that lie behind the workings of the healing brush, you will come to understand why the healing brush may sometimes fail to work as expected. You see, if the healing brush is applied too close to an edge where there is a sudden shift in tonal lightness, it will attempt to create a blend with the pixels immediately outside the healing brush area. So when you retouch with the healing brush you need to be mindful of this intentional behavior. However, there are things you can do to address this. For example, you can create a selection that defines the area you are about to start retouching (maybe with some minimal feathering) and constrain the healing brush work so that it is carried out inside the selection area only.

This latest version of Photoshop CC offers speedier performance for the healing brush, spot healing brush and patch tool healing. This is most apparent when working with the healing brush as repairs are now carried out in real time.

1 I selected the healing brush from the Tools panel and selected a hard edged brush from the Options bar. The brush blending mode was set to Normal, the Source button set to 'Sampled' and the Aligned box left unchecked.

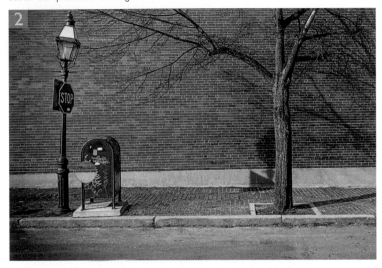

2 Before using the healing brush, I added a new empty layer and made sure the Sample options were set to 'All Layers' or 'Current & Below'. I *alt*-clicked to define the source point, which in this example was an area just to the right of the trash bin. I then released the *alt* key, moved the cursor over to where the bin was and clicked to remove it using the healing brush. Here is an example where having the Clone Source Show Overlay visible (see page 458) ensured the bricks were carefully aligned.

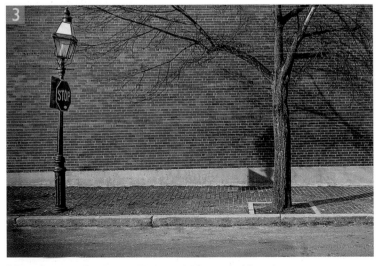

3 This shows the final image with the trash bin removed from the scene.

Figure 7.2 This shows how the clone stamp (or healing brush) cursor looks when using the Clone Source panel options shown in Figure 7.3, with the 'Show Overlay' and 'Clipped' options checked.

Figure 7.3 The Clone Source panel, shown here with the Show Overlay and Clipped options checked.

Choosing an appropriate alignment mode

You can use the clone stamp and healing tools in aligned or non-aligned modes (see Figure 7.4). I tend to find it is more convenient to use the clone stamp tool in aligned mode and the healing brush in non-aligned mode. This is because when you use the clone stamp you can preserve the relationship between the source and destination points, apply a few clones, then sample a new source point as you continue cloning over other parts of the photograph. You can even clone data from a separate document (as shown in Figure 7.5).

If you try to use the clone stamp over an area where there is a gentle change in tonal gradation, it will be almost impossible to disguise the retouching work, unless the point you are sampling from and destination point match exactly in tone and color. It is in these situations that you are usually better off using the healing brush. For most types of healing brush work I suggest you use the non-aligned mode (which happens to be the default setting for this tool). This allows you to choose a source point that contains the optimum texture information with which to repair a particular section of a photograph. You can then keep referencing the same source point as you work with the healing brush.

Basically, when the source area is unrestricted I suggest you choose the aligned mode for the clone stamp tool. However, when the source area is restricted and you don't want to pick up from other surrounding areas, choose non-aligned.

Clone Source panel and clone overlays

The Clone Source panel was mainly implemented with video editors in mind. This is because it can sometimes be desirable to store multiple clone sources when cloning in exact registration from one frame to another across several frame images in a sequence. The current version offers an improved overlay cursor view where if the 'Show Overlay' and 'Clipped' options are both checked, a preview of the clone source can be seen inside the cursor area. Figure 7.2 shows a detail view of the clone stamp being applied using the settings shown in Figure 7.3, where the 'Show Overlay' and 'Clipped' options were both enabled. You could choose to have the 'Show Overlay' option switched on all of the time, but there is usually a slight time delay while the cursor updates its new position and this can at times become distracting. I therefore suggest you only enable it when you really need to.

Figure 7.4 When you have the clone stamp tool selected and the Aligned box in the tool Options bar is unchecked, the source point remains static and each application of the clone stamp makes a copy of the image data from the same original source point.

Figure 7.5 In this example you can see how I was able to sample the sky image data from one image window and copy it to another separate image using the clone stamp. I just *alt*-clicked with the clone stamp in the source (sky) image, then selected the other image window and clicked to establish a cloning relationship between the source and destination image windows.

Ignore adjustment layers

When 'Ignore Adjustment Layers' is switched on, Photoshop ignores the effect any adjustment layers might have when cloning the visible pixels. Therefore, when the 'All Layers' sample option is selected this prevents adjustment layers above the layer you are working on from affecting the retouching carried out on the layers below.

Clone and healing sample options

The layer sample options (Figure 7.6) allow you to choose how the pixels are sampled when you use the clone stamp or healing brush tools. 'Current Layer' samples the contents of the current layer only and ignores all other layers. The 'Current & Below' option samples the current layer and visible layers below (ignoring the layers above it), while the 'All Layers' option samples all visible layers in the layer stack, including those above the current layer. If the Ignore Adjustment Layers button (circled) is turned on, Photoshop ignores the effect any adjustment layers above the selected layer are having on the image (see sidebar). Meanwhile, the spot healing brush only has a 'Sample All Layers' option in the tool Options bar to check or uncheck.

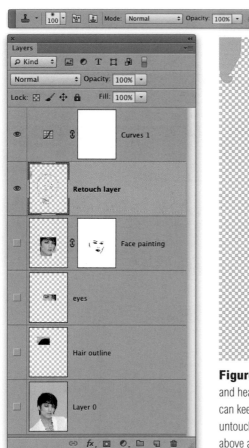

Figure 7.6 The layer sample options allow you to carry out all your clone stamp and healing brush work to an empty new layer. The advantage of this approach is you can keep all your retouching work separate and leave the original Background layer untouched. In this example the All Layers option allowed me to sample from layers above and below and carry out the retouching to a separate layer (which for the sake of clarity is shown here in isolation). Because the Ignore Adjustment Layers option was checked (circled above), Photoshop ignored the effect the Curves adjustment layer would have on the sampled pixels.

Better healing edges

Since the healing brush blends the cloned source data with the edges that surround the destination point, you can improve the efficiency of the healing brush by increasing the outer circumference size for the healing brush cursor. The following technique came via Russell Brown, who was shown how to do this by an attendee at one of his seminars.

If you change the healing brush to an elliptical shape, you will tend to produce a more broken-up edge to your healing work and this can sometimes produce an improved healing blend (Figure 7.7). There are two explanations for why this works. Firstly, a narrow elliptical brush cursor has a longer perimeter. This means that more pixels are likely to be sampled when calculating the healing blend. The second thing you will notice is that when the healing brush is more elliptical, a randomness is introduced into the angle of the brush. Try changing the shape of the brush in the way I describe below and as you paint, you will see what I mean.

Figure 7.7 To adjust the shape and hardness of the healing brush or spot healing brush, select the healing/spot healing brush tool and mouse down on the brush options in the tool Options bar. Set the hardness to 100% and drag the elliptical handles to make the brush shape more elliptical. Notice also that if you are using a Wacom™ tablet or other pressure sensitive input device, the brush size is linked by default to the amount of pen pressure applied.

Figure 7.8 The spot healing brush warning dialog. You'll see this if you accidentally try to sample a source point using the *alt* key.

Spot healing brush

As you will have noticed, the default healing tool in Photoshop is the spot healing brush. To use the spot healing brush you just click on the marks or blemishes you wish to remove. It then automatically samples the replacement pixel data from around the area you are trying to heal. If the spot healing brush is selected in the Tools panel and you try to use the *alt* key to establish a source point to sample from (thinking you have just selected the ordinary healing brush), you will be shown a warning dialog explaining there is no need to create a sample source when using this tool (Figure 7.8).

The spot healing brush tool has three basic modes of operation: Proximity Match, Create Texture and Content-Aware. These modes can be selected via the spot healing brush Options bar (Figure 7.9). In 'Proximity Match' mode it analyzes the data around the area where you are painting to identify the best area to sample the pixel information from. It then uses the pixel data that has been sampled in this way to replace the pixels beneath where you are painting. With the Proximity Match mode selected you can use the spot healing brush to click away and zap small blemishes. When you are repairing larger areas in a picture you will usually obtain better results if the brush size is slightly smaller than the area you are trying to retouch and you then click and drag to define the area you wish to repair. As you work with the spot healing brush you'll notice how it is mostly quite smart at estimating which are the best pixels to sample from. Sometimes though, the spot healing brush will choose badly, so it pays to be vigilant and understand how to correct for this. If you are removing marks close to an edge, it is usually best to apply brush strokes that drag inwards from the side where the best source data exists (see Figure 7.10). This is because in Proximity Match mode the spot healing brush intelligently looks around for the most suitable pixel data to sample from, but if you drag with the brush it looks first in the direction from where you dragged.

Figure 7.9 This shows the spot healing brush Options bar with the mode options menu made visible.

If the Proximity Match mode fails to work you may in some instances want to try using the Create Texture mode. Rather than sampling an area of pixels from outside the cursor it generates a texture pattern within the cursor area based on the surrounding area. It may just occasionally offer a better result than the Proximity Match mode, but you'll find that the Content-Aware mode does the same kind of thing only more successfully.

Healing blend modes

You'll notice in Figure 7.9 that there are a number of different blend modes available for when working with the spot healing brush (as well as the main healing brush). Most of the time you will find that the Normal blend mode works fine and you will get good results, but when retouching some areas you'll find the Replace blend mode may work more successfully, especially when using the Content-Aware mode (which is discussed next). The edge hardness can also be a factor here, but I find that by adjusting the softness of the brush when using the Replace blend you can get improved results. The Replace blend preserves more of the texture in the boundary edges and the difference is therefore more pronounced as you soften the edge hardness. When using the Content-Aware mode this can make a difference when painting up close to sharp edges. In the Normal blend mode you may still see some edge bleeding, whereas in Replace mode the edges are less likely to bleed. I generally find that for detailed areas such as when retouching out the wires that covered the rocks in the Figure 7.12 example, the Replace mode worked more effectively. The other blend modes include items such as Darken, Lighten, and Color. Now, if you refer to the later section on beauty retouching you can see how these might be useful where you wish to apply healing to an image so that, say, only the darker pixels or lighter pixels get replaced. This can be useful where you wish to minimize the amount of change that takes place in an image. For example, the Lighten blend mode would be an appropriate choice for getting rid of dark marks against a light color. By selecting the Lighten mode you should be able to target the retouching more effectively in removing the dark marks. Similarly, you could use the Darken mode to remove light marks against a dark background.

Figure 7.10 In Proximity Match mode, the spot healing brush works by searching automatically to find the best pixels to sample from to carry out a repair, but if you drag with the spot healing brush it uses the direction of the drag as the source for the most suitable texture to sample from. By dragging with the tool you can give the spot healing brush a better clue as to where to sample from. In this instance I could prompt it to sample from the area of clear skin that didn't have loose hairs.

Stroking a path

A really useful tip is to use the stroke path option in conjunction with the spot healing brush to apply a precisely targeted spot heal brush stroke. For example, to retouch the cables seen in the Figure 7.12 photo, you could try the alternative approach described below. Select the pen tool and use it to create an open path that follows the line of one of the cables. With the path still active, you can then go to the Paths panel options and choose 'Stroke Path'. This will open the Stroke Path dialog shown in Figure 7.11, where you can select the desired tool from the menu. If you were to select the Spot healing brush here and click OK, this will apply a spot healing brush stroke that follows the direction of the path.

Figure 7.11 This shows the Stroke Path dialog, which can be accessed via the Paths panel when a pen path is active.

Spot healing in Content-Aware mode

When working with the spot healing brush in the default Proximity Match mode you have to be careful not to work too close alongside sharply contrasting areas in case this causes the edges to bleed. The Content-Aware mode was added to the spot healing brush options in Photoshop CS5 and it intelligently works out how best to fill the areas you retouch when you use the spot healing brush. Note that the content-aware healing does make use of the image cache levels set in the Photoshop performance preferences to help speed up the healing computations. If you have the Cache limit set to 4 or fewer levels, this can compromise the performance of the spot healing brush in Content-Aware mode when carrying out big heals. It is therefore recommended that you raise the cache limit to 6 or higher.

Let's now look at what the spot healing brush is capable of when used in Content-Aware mode. In the Figure 7.12 example there were a number of cables and wires in this photograph that spoiled the view. By using the spot healing brush in Content-Aware mode I was able to carefully remove all of these to produce the finished photo shown below. Although the end result showed this tool could work quite well I should point out that you do still have to apply a certain amount of skill in your brush work and choice of settings in order to use this tool effectively. To start with I found that the Normal blend mode worked best for retouching the cables that overlapped the sky, since this blend mode uses diffuse edges to blend seamlessly with the surroundings. I also mostly used long, continuous brush strokes to remove these from the photograph and achieve a smooth blended result with the rest of the sky. When retouching the rocks I gradually removed the cables bit by bit by applying much shorter brush strokes and using the Replace blend mode. I find that you need to be quite patient and note carefully the result of each brush stroke before applying the next. You'll discover that dragging the brush from different directions can also influence the outcome of the heal blend retouching and you may sometimes need to carry out an undo and reapply the brush stroke differently and keep doing this until you get the best result. I also find that you can disguise the retouching better by adding extra, thin light strokes 90° to the angle of the first, main brush stroke and this too can help disguise your retouching work with the spot healing brush used in this mode.

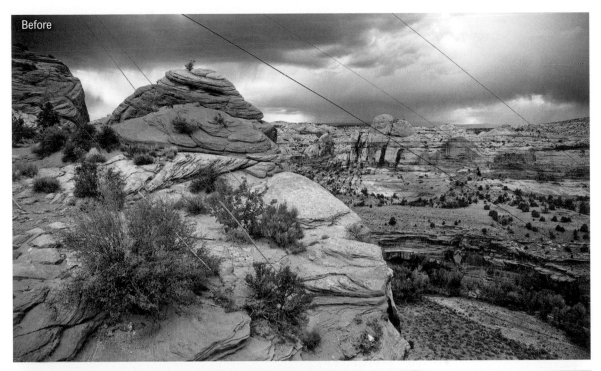

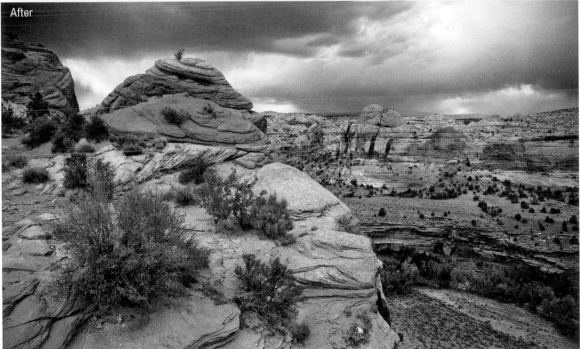

Figure 7.12 This shows a before version (top) and after version (bottom), where I had used the spot healing brush in Content-Aware mode to retouch the image.

Source and Destination modes

In Source mode you drag the patch tool selection area to a new destination point to replace the pixels in the original source selection area with those sampled from the new destination area. In Destination mode you drag the patch tool selection area to a new destination point to copy the pixels from the original source selection area and clone them to the new destination area.

Use Pattern option

The Use Pattern button in the Options bar lets you fill a selected area with a pattern preset using a healing type blend.

Patch tool

The patch tool uses the same algorithm as the healing brush to carry out its blend calculations, except the patch tool uses selection-defined areas instead of a brush. When the patch tool is selected, it initially operates in a lasso selection mode. For example, you can hold down the **alt** key to temporarily convert the tool to become a polygonal lasso tool with which to draw straight line selection edges. The selection can be used to define the area to 'patch from' or 'patch to'. It so happens you don't actually need the patch tool to define the selection; any selection tool or selection method can be used when preparing a patch selection. Once you have made the selection, select the patch tool to proceed to the next stage. Unlike the healing brushes, the patch tool has to work with either the Background layer or a copied pixel layer. What is useful though is the patch tool provides an image preview inside the destination selection area as you drag to define the patch selection. The patch tool in Normal mode has been improved to provide better patching. The processing time is also faster, and is in line with improvements made to Content-Aware fill.

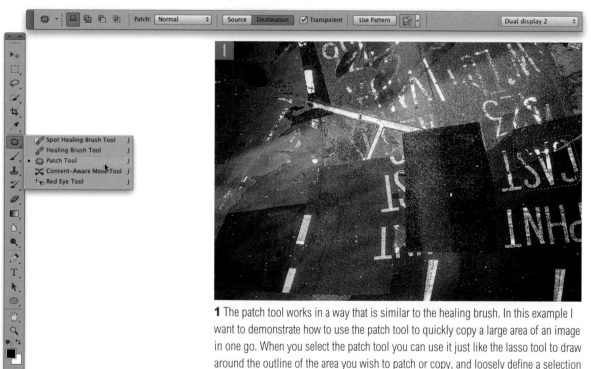

1 The patch tool works in a way that is similar to the healing brush. In this example I want to demonstrate how to use the patch tool to quickly copy a large area of an image in one go. When you select the patch tool you can use it just like the lasso tool to draw around the outline of the area you wish to patch or copy, and loosely define a selection area. However, as was mentioned in the main text you can use any selection tool method you like to define the selection as you prepare an image for patching.

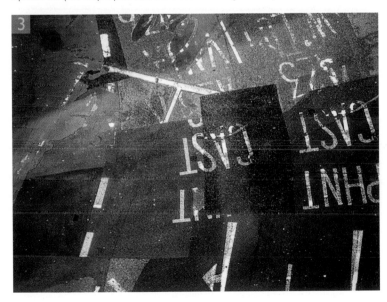

2 Having defined the area I wanted to copy, I made sure that the patch tool was selected (and was in Destination mode). I then dragged inside the selection to locate an area of the image that I wanted to patch. As I dragged the patch selection, I was able to position the road markings precisely where I wanted them to be placed. In this instance I reckoned it would work best if I had the Transparent box checked in the tool Options bar (see Step 1 plus also the sidebar and Figure 7.13).

3 As I released the mouse, Photoshop began calculating a healing blend, analyzing the pixels from the source area (that I had just defined) and used these to merge them seamlessly with the pixels in the destination selection area. The patch tool repair will usually work effectively first time. If it doesn't look quite right, I suggest deselecting the selection and use either of the healing brushes (or the clone stamp) to fine-tune the result.

Transparent mode

In Transparent mode you can use the patch tool in the Source or Destination mode to blend selected areas transparently. In Figure 7.13 below you can see a before and after example where the patch tool was applied using the patch tool in Destination mode with the Transparent option checked.

Figure 7.13 This shows an example of the patch tool applied in Transparent mode to copy an ice cube in a glass and have it blend transparently.

Content-Aware Fill

Structure: 1

Structure: 2

Structure: 3

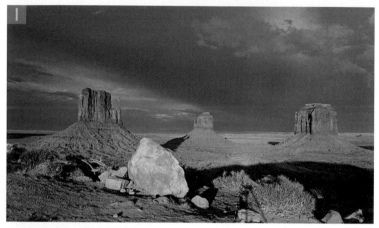

Structure: 4

Structure: 5

Figure 7.14 Examples of content-aware fill outcomes using different adaptation methods.

The patch tool and content-aware filling

Content-aware filling can be done by making a selection, choose Edit ⇨ Fill and fill using the Content-Aware fill mode (as shown below). There is also a Content-Aware mode when working with the patch tool. The following steps show a comparison between the use of the Edit ⇨ Fill command and the patch tool in Content-Aware mode. Note that when the Sample All layers option is checked, you can apply a patch tool content-aware fill to an empty new layer. Again, improvements made to patching in Photoshop CC 2015 should produce better results compared with previous versions.

1 This photograph was taken at sunset and you can see the shadow of the tripod and camera. To remove this from the photo, I first made a rough lasso selection to define the outline of the shadow.

2 I then went to the Edit menu and chose Fill... (or, you may find it easier to use the *Shift* *F5* shortcut). This opened the Fill dialog shown here where in the Contents section I selected 'Content-Aware' from the pop-up menu. When I clicked OK, this filled the selected area. You can see the result of this fill at the top in Figure 7.14.

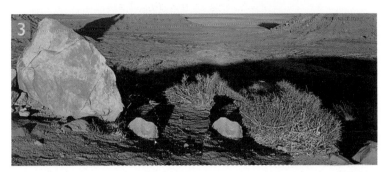

3 I undid the content-aware fill, selected the patch tool and in the patch tool Options bar chose the Content-Aware option. I added an empty new layer and with the 'Sample All Layers' option checked, dragged the selection to the left and released the mouse. With the selection still active, I was able to choose different Structure settings, finally settling on a Structure setting of 1. You can see the results of all the different Structure settings in Figure 7.14.

4 Here is the final version with the shadow successfully removed. To get this result I used a Structure settings of 1 and with Color set to zero.

Constraining the content-aware fill

To improve the effectiveness of a content-aware fill you can use a layer mask to hide areas of an image that you would rather the content-aware fill ignored when filling a selection. For example, if you start with a Background layer, double-click to convert this to a regular layer and add an empty layer mask to that layer. Then with black as the foreground color, paint with black to hide the bits you don't want the content-aware fill to pick up. Now make a regular selection and apply the content-aware fill. When you are done you can delete the layer mask to reveal the entire layer again.

Delete options

If you make a selection on a background layer, or a flattened image and hit Delete, you'll see the Fill dialog box. This allows you to choose how you wish to fill the selected areas and will have Content-Aware Fill selected by default. If you want to bypass this and apply the previous default behavior, you can use ⌘ *Delete* (Mac), *ctrl* *Delete* (PC) to fill using the background color.

Improved Content-aware fill

Content-aware processing has been improved in Photoshop CC 2015. There has been an overall improvement in terms of quality and speed. For example, content-aware is now around 10 times faster when working on really large repair areas and around 4 times faster when editing smaller images.

The thing to bear in mind here is that when you use the Content-Aware Fill feature you have no control over the Structure mode that's used. Even so, the Content-Aware Fill feature will work well in most cases. All you have to do is to make a rough selection around the outline of whatever it is that you wish to remove from a scene and let the content-aware fill do the rest. Photoshop can usually work out how best to fill in the gaps in the selection and construct a convincing fill by sampling pixel information from the surrounding area. If you don't get a satisfactory result straight off, there are a couple of things you can try doing to make it work better. For example, it is recommended you expand the selection slightly before applying a content-aware fill. You can do this by using the Refine Edge command or go to the Select menu and choose Modify ⇨ Expand. It can also help sometimes if you apply a content-aware fill more than once. As you apply subsequent fills you may see the filled area improve in appearance each time you do this. You might also like to try the constraining the content-aware fill trick described in the sidebar.

Structure control

If you choose the patch tool method described on the previous pages you have more control over the content-aware fill calculations. The main advantage you have here is that when you drag a patch selection you manually define which areas you would wish the content-aware fill to sample from. This can make a big difference to the final outcome.

The other thing you have control over is the Structure setting that you would prefer to use. In Step 3 on the previous page I dragged the patch tool selection to the left to indicate the area I would like the tool to sample from. After letting go with the mouse, Photoshop carried out a content-aware fill. I was then able to try out different Structure settings to see which worked best. For instance, when the Structure slider is set to 5, Photoshop uses a rigid sampling from the surrounding area and when it is set to 1, it tends to jumble things up more. The default setting is 3, which is probably a good starting-point to work with. In the previous example though, I found that the 1 setting happened to produce the best-looking result.

Content-aware move tool

The content-aware move tool works in a similar way to the patch tool in Destination mode, except it allows you to either extend a selected area or move it and fill the initial selected area. In doing this it offers you the same adaptation methods as provided for the patch tool in the content-aware fill mode (see the Options bar in Figure 7.15). You can cleverly adjust selected areas to make objects appear taller, shorter, wider, or thinner or to move selected items. Basically, the content-aware move tool allows you (in the right circumstances) to manually resculpt a photograph. We'll begin by looking at a move example using the content-aware move tool.

Figure 7.15 The content-aware move tool Options bar.

1 In this example I selected the content-aware move tool and drew a rough outline around the outside of the boat. I had created a new empty layer to carry out the content-aware move tool editing and the 'Sample All Layers' option was selected.

2 With the content-aware move tool in 'Move' mode I clicked inside the selection area and dragged a copy of the boat towards the middle of the photograph.

3 When I released the mouse this caused the original selection area to fill using a content-aware type fill and left a copy of the boat just to the left of the original.

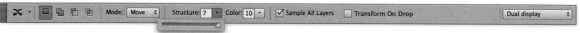

4 As with the patch tool, the content-aware move tool provides options for controlling the adaptation method. You can access these from the Adaptation menu shown above. To achieve the result shown in Step 3, the adaptation Structure was set to 7 and Color set to 10, but on the right I have shown the outcomes had I selected other options instead. As you can see, the Step 3 combination was the only suitable choice in this instance.

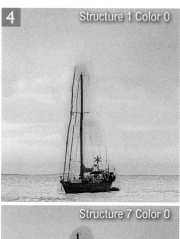
Structure 1 Color 0

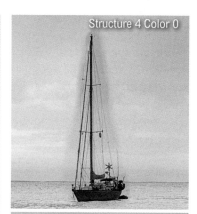
Structure 4 Color 0

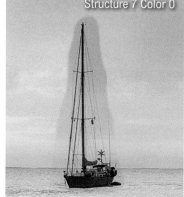
Structure 7 Color 0

Structure 7 Color 10

Border textures

The content-aware move tool tends to produce better-looking results when the surrounding area has a lot of texture detail to work with. To produce a good blend you should have at least 10% space around the surrounding edges for the content-aware move tool to work with.

Content-aware move tool in Extend mode

When the content-aware move tool is used in the Extend mode you can use it to move selected areas and have these blend with the original image, rather than fill the original selected area. For example, you can use this to make buildings taller or stretch someone's neck. The content-aware move tool also performs a content-aware type fill with its surroundings as you create a new blend. In the example shown below I used the content-aware move tool to extend the clouds in the sky. However, should you use this tool in Extend mode to make something more compact you will need to ensure the area on the side opposite to the direction you intend dragging is big enough to create a suitable overlap. This is because as you move the selection you need to have an adequate picture area to reference to cover up whatever it is you are making smaller.

Figure 7.16 This shows the cloud photo used in the steps below before applying the extend edit using the content-aware move tool.

1 I selected the Figure 7.16 image and used the content-aware move tool in Extend mode to select the outline of the clouds. I clicked inside the selection and dragged to the left.

2 As I released the mouse this dropped the copy selected area and blended it with the clouds below. In this instance I set the adaptation Structure to 1 and Color to 5.

Enhanced content-aware color adaptation

In the Fill dialog there is now a Color Adaptation checkbox. Shown here is an example of a basic content-aware fill combined with a color adaptation. And, in the Options bar for the patch tool and content-aware move tool there is also a Color setting. A zero setting means no Color adaptation occurs (just as before). As you increase this value more color blending occurs up to a maximum blend setting of 10 (an example of this is shown over the page). The content-aware algorithm generally has a preference for smoothness over texture. Increasing the Color adaptation further improves the smoothness and this method of filling and repairing is mainly useful when working on smooth graduated areas. A Color adaptation setting of 10 will tend to overcompensate, so the best setting options are usually within the 3–7 range.

1 In this example I wanted to show a simple way to remove the clouds from this photograph. I began by making a simple rectangular marquee selection of the clouds.

2 I then went to the Edit menu and chose Fill. In the Fill dialog shown here I selected the Content-Aware option. This filled the selection, removing the clouds, but left noticeable banding in the sky.

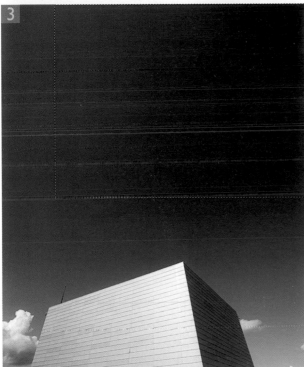

3 I undid the last step and repeated, except this time I checked the Color Adaptation option in the Fill dialog. This did a better job of filling the sky compared to without. It's not completely perfect, but shows the dramatic difference that can be achieved when this new option is enabled. Also, improvements have again been made in Photoshop CC 2015 to the content-aware algorithm to produce smoother results.

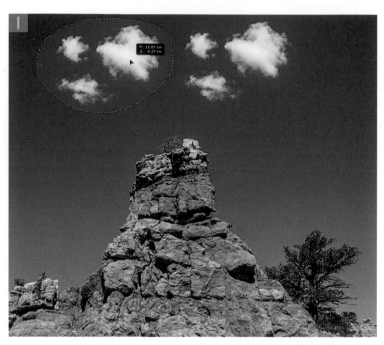

1 To demonstrate the power of the Color adaptation controls, I used the content-aware move tool in Move mode to move the cloud selection in this photograph.

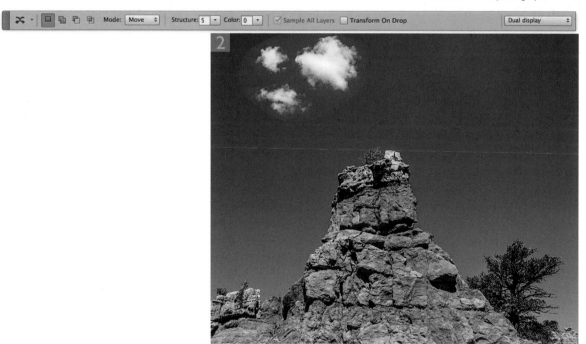

2 In this example the Structure was set to the default 5 setting with zero Color adaptation. This matched the legacy setting for this tool, but notice how the moved selection shows poor blending around the selection edges.

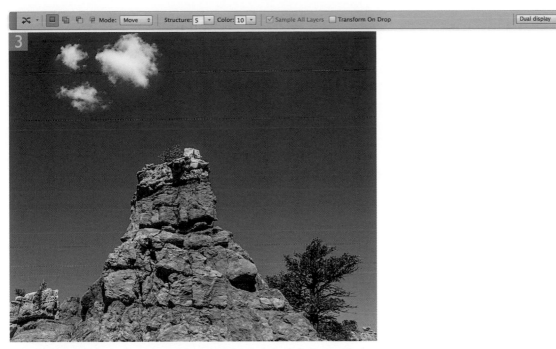

3 I then redid the last step, but this time set the Color setting to 10. However, this overcompensated with the cloud selection blending.

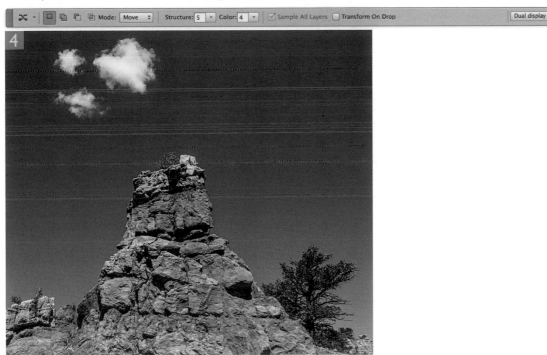

4 Here, I used the content-aware move with a Color setting of 4 to produce a much smoother-looking result.

Content-aware move with transformations

The following steps show how you can now apply transform adjustments as you carry out a content-aware move tool adjustment, whether you are using the Extend or Move mode.

1 To begin with I selected the content-aware move tool and clicked and dragged to define a rough outline of the guitar player.

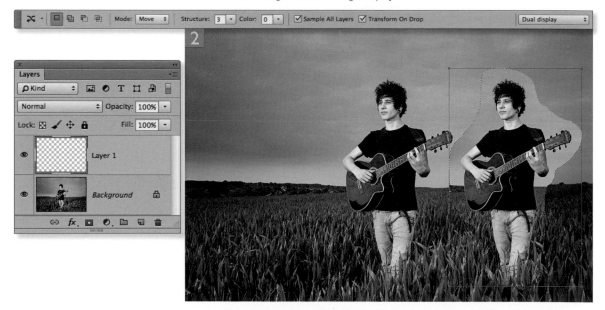

2 I added a new layer and checked 'Sample All Layers' and 'Transform On Drop' in the Options bar. I then clicked inside the selection with the content-aware move tool and dragged to the right. This created a temporary duplicate of the original selection.

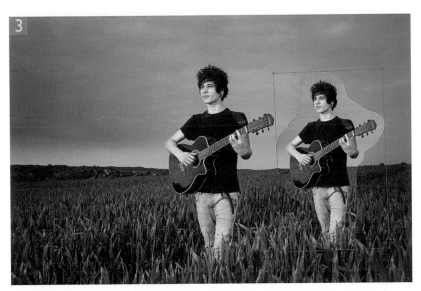

3 Because 'Transform On Drop' was checked I was able to scale the copied pixels and in this instance rotate slightly as well, making sure I matched the horizon line.

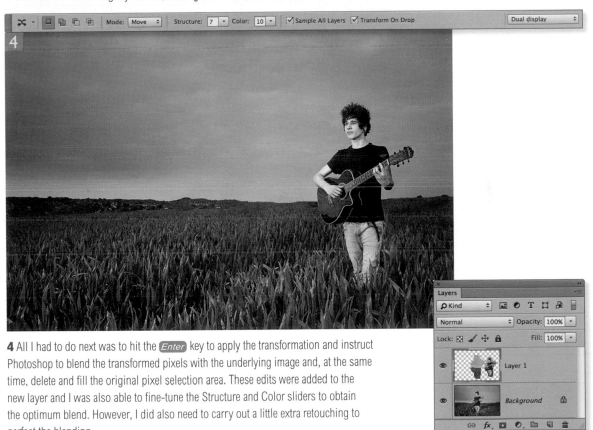

4 All I had to do next was to hit the ⟨Enter⟩ key to apply the transformation and instruct Photoshop to blend the transformed pixels with the underlying image and, at the same time, delete and fill the original pixel selection area. These edits were added to the new layer and I was also able to fine-tune the Structure and Color sliders to obtain the optimum blend. However, I did also need to carry out a little extra retouching to perfect the blending.

Working with the Clone Source panel

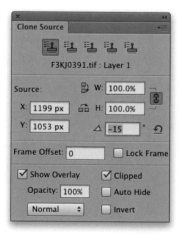

1 Here I wanted to show how you can work with the healing brush or clone stamp tools to clone at an angle. I added a new layer and sampled a side of the bowl with the healing brush.

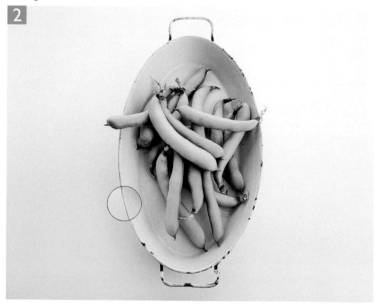

2 I then went to the Clone Source panel and adjusted the angle. The best way to do this is double-click to highlight the angle field, place the cursor over the area to be cloned and use the keyboard arrow keys to adjust the angle value up or down. You can also, hold down the *Shift* key to magnify the arrow key adjustment.

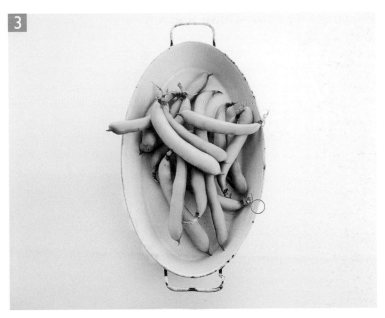

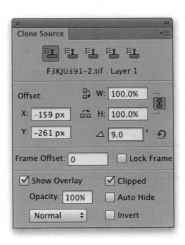

3 After making a first successful clone I found it was necessary to double-click the angle field again to make it active. I then positioned the cursor and once more adjusted the angle.

© Craig Robertson

4 Here you can see the finished result. Getting the angle just right each time was quite tricky, so some patience was required.

Perspective retouching

The Vanishing Point filter can be accessed from the Filter menu and allows you to retouch photographs while matching the perspective. I have provided here a quick example of how one might use the Vanishing Point filter to retouch out some road markings. For more details about working with this filter, there is a PDF you can download from the book website.

1 To begin with I selected a Background copy layer and chose Filter ⇨ Vanishing point and used the create plane tool (**C**) to define the road perspective. I selected the stamp tool (**S**), and with the Heal mode switched on, removed the unwanted road markings.

2 This shows how the road looked after retouching it using the Vanishing Point filter.

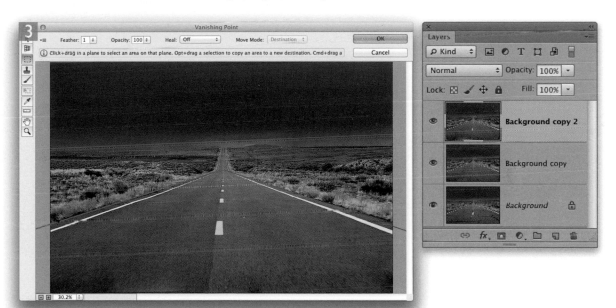

3 I applied the filter at the Step 2 stage and copied the Background Copy layer to make a new copy layer. To this I added a single yellow dash line in the middle of the road (which I had sampled from the original Background layer). I then opened the Vanishing Point filter a second time (note that the previously created perspective plane was still saved) and used the stamp tool in Heal mode again to clone the yellow dash down the middle of the road.

Getting the balance right

The main thing I show on these pages is how to use the paint brush to smooth the skin tones. I happen to prefer using the manual painting approach (rather than simply blurring the skin texture). This is because the painting method offers more control over the retouching. An important issue here is "how much should you retouch?" This is mostly down to personal taste. My own view is that it is better to fade any painting work that's done and let the natural skin texture show through. It is possible to retouch to produce a clean-looking image, while still keeping the model looking vaguely human.

Beauty retouching

Beauty photographs usually require more intense retouching, where the objective is to produce an image in which the model's features and skin appear flawless. This can be done through a combination of spotting and paint brush work.

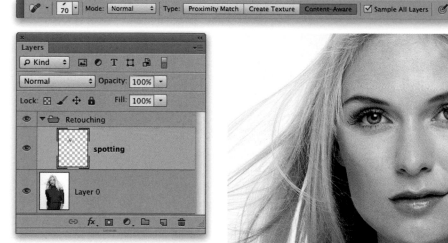

1 The top photograph here shows the before version and below that, how the same image looked after I had added a new empty layer and carried out some basic spotting work with the healing brush, where I cleaned up the spots and got rid of unwanted stray hairs.

2 After that I used the ⌘ ⌥ *Shift* E (Mac), *ctrl* *alt* *Shift* E (PC) command to create a merged copy layer at the top of the layer stack (based on a marquee selection) and worked with the paint brush on the merged layer. The trick here was to hold down the *alt* key to sample a skin tone color and gently paint using low opacity brush strokes with the blend mode set to 'Lighten'. This meant the paint strokes only affected those colors that were darker than the sample color. Similarly, I switched to 'Darken' mode where I wished to darken only those pixels lighter than the paint sample color. This selective method of painting can produce more controlled results compared with using the Normal blend mode.

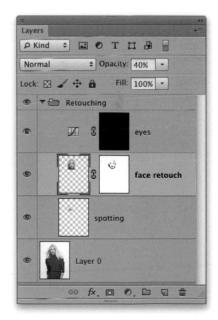

3 This shows the finished retouched version in which I faded the opacity of the painted layer to 40% and added a layer mask so that I could carefully mask the areas where the paint retouching had spilled over. Lastly, I made a lasso selection of the eyes and clicked on the Add Adjustment Layer button in the Layers panel to add a Curves adjustment based on the eyes selection. I then applied a lightening adjustment to lighten the eyes slightly.

Liquify tools

Forward warp tool (W)

Provides a basic warp distortion with which you can stretch the pixels in any direction you wish.

Reconstruct tool (R)

Can be used to reverse a distortion and make a selective undo.

Smooth tool (E)

Can be used to smooth out ripples in the mesh caused by multiple, small warp tool applications.

Twirl clockwise tool (C)

Twist the pixels in a clockwise direction. Hold down the *alt* key to switch tool to twirl in a counterclockwise direction.

Pucker tool (S)

Shrink the pixels and produce an effect similar to the 'Pinch' filter.

Bloat tool (B)

Magnify the pixels and produce an effect similar to the 'Bloat' filter.

Push left tool (O)

Push the pixels at 90° to the left of the direction in which you are dragging. Hold down the *alt* key to switch tool to push the pixels 90° to the right.

Freeze mask tool (F)

Protect areas of the image. Frozen portions are indicated by a quick mask type overlay. These areas are protected from any further liquify distortions.

Thaw mask tool (D)

Selectively or wholly erase the freeze tool area.

Hand tool (H)

For scrolling the preview image.

Zoom tool (Z)

Used for zooming in or zooming out (with the *alt* key held down).

Liquify

The Liquify filter is designed to let you carry out freeform pixel distortions. When you choose Filter ⇨ Liquify (or use the ⌘ *Shift* X [Mac], *ctrl* *Shift* X [PC] keyboard shortcut), you are presented with the Liquify filter dialog with its own set of tools and keyboard shortcuts, etc. To use Liquify efficiently, I suggest you first make a marquee selection of the area you wish to manipulate before you select the filter, and once the dialog has opened use the ⌘ *0* (Mac), *ctrl* *0* (PC) keyboard shortcut to enlarge the dialog to fit the screen.

Basically, you can use the Liquify tools to manipulate the image and when you are happy with your liquify work, click the OK button or hit *Enter* or *Return*. Photoshop then calculates and applies the liquify adjustment to the selected image area. The Liquify tools are all explained in the column on the left and Figure 7.17 provides a visual guide to what they can do. One of the main things to point out here is that Liquify is optimized to make use of the GPU (Graphics Processing Unit) and provide good overall responsiveness. As a consequence of this the turbulence and mirror tools were removed when Photoshop CS6 came out. This is because they couldn't be enabled to work with the GPU, but it's not such a great loss as people weren't using these particular tools much anyway.

The Liquify filter opens in a basic mode of operation (Figure 7.18), where initially only the forward warp, reconstruct, pucker, bloat, push left, hand and zoom tools appear in the tools section and there is just a simplified set of tool options. You will need to check the Advanced mode box if you want to access the full list of tools and other Liquify options (Figure 7.19).

The easiest tool to get to grips with is the forward warp tool, which allows you to simply click and drag to push the pixels in the direction you want them to go. However, I also like working with the push left tool, because it lets you carry out some quite bold warp adjustments. Note that when you drag with the push left tool it shifts the pixels 90° to the left of the direction you are dragging in and when you *alt* drag with the tool, it shifts the pixels 90° to the right. The key to working successfully with the Liquify filter is to use gradual brush movements and build up the distortion in stages.

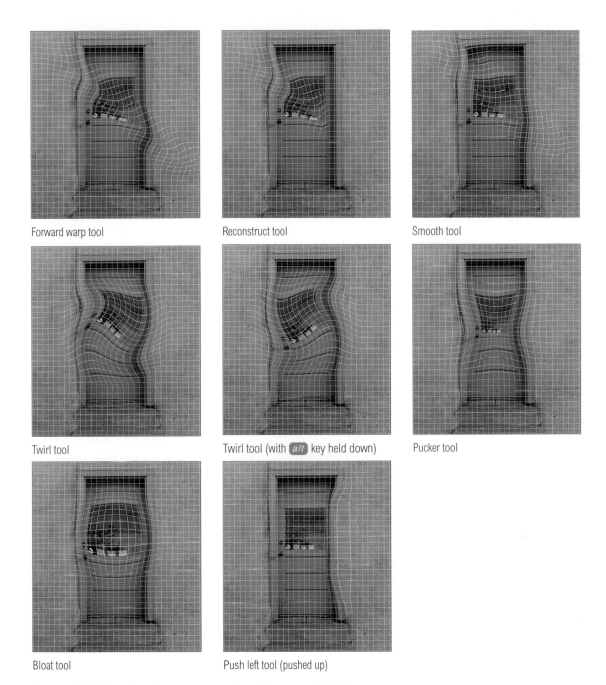

Forward warp tool

Reconstruct tool

Smooth tool

Twirl tool

Twirl tool (with *alt* key held down)

Pucker tool

Bloat tool

Push left tool (pushed up)

Figure 7.17 These illustrations give you an idea of the range of distortion effects that can be achieved using the Liquify tools listed on page 486.

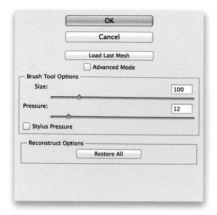

Figure 7.18 The basic Liquify settings.

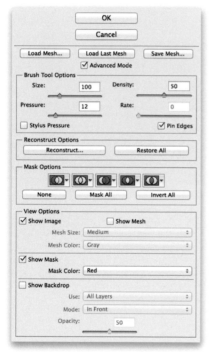

Figure 7.19 The advanced Liquify dialog options. There is a new Pin Edges option. When checked, this prevents the image edges from warping inwards.

Advanced Liquify tool controls

Once you have selected a tool to work with you will want to check out the associated tool options that are shown in the Advanced mode dialog in Figure 7.19. These tool options are applied universally to all the Liquify tools and include: Brush Size, Brush Density, Brush Pressure and Brush Rate. All tools (apart from the hand and zoom tool) are displayed as a circular cursor with a crosshair in the middle. You can use the square bracket keys **[** **]** to alter the tool cursor size and the rate of increase/decrease can be accelerated by holding down the *Shift* key. You can also adjust the cursor size by right mouse dragging with the *alt* key in the Preview area, or by using the scrubby sliders. The maximum brush size is 15,000 pixels. I highly recommend that you use a pressure sensitive pen and pad such as the Wacom™ system and, if you do so, make sure that the Stylus Pressure option is checked and that the Brush Pressure setting is reduced to around 10–20%.

Reconstructions

Next, we have the Reconstruct Options. If you apply a Liquify distortion and click on the Reconstruct button, this opens the Revert Reconstruction dialog shown in Figure 7.20. By setting the Amount to anything less than 100, you can decide by how much to reduce the current overall image liquify distortion—the reconstruction is applied evenly to the whole image and allows you to unwarp by however much you like. Note that as you do this the distortion will be preserved for any areas that have been frozen using the freeze tool. If you click on the 'Restore All' button the entire image is restored in one step (ignoring any frozen areas). There is also a reconstruct tool (*R*), which can be used to selectively paint over any areas where you wish to selectively undo a warp, and a smooth tool (*E*) that can be used to smooth out ripples in the mesh caused by multiple, small warp tool applications.

Don't forget that while inside the Liquify dialog, you also have multiple undos at your disposal. Use ⌘ *Z* (Mac), *ctrl* *Z* (PC) to undo or redo the last step, ⌘ ⌥ *Z* (Mac), *ctrl* *alt* *Z* (PC) to go back in history and ⌘ *Shift* *Z* (Mac), *ctrl* *Shift* *Z* (PC) to go forward in history.

Mask options

The mask options can utilize an existing selection, layer transparency or a layer mask as the basis of a mask to freeze and constrain the effects of any Liquify adjustments (Figure 7.21). The first option is 'Replace Selection' (). This replaces any existing freeze selection that has been made. The other four options allow you to modify an existing freeze selection by 'adding to', 'subtracting from', 'intersecting' or creating an 'inverted' selection. You can then click on the buttons below. Clicking on 'None' clears all freeze selections, clicking 'Mask All' freezes the entire area, and clicking 'Invert All' inverts the current frozen selection.

Figure 7.20 The Revert Reconstruction dialog.

Figure 7.21 If you mouse down on the arrow next to the mask options you can also load a mask from the pop-up menu. This can include saved alpha channels and this was how, for example, I was able to load the precision mask shown in Figure 7.22.

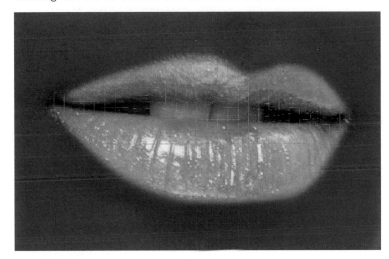

Figure 7.22 Freeze masks can be used to protect areas of a picture before you begin doing any liquify work. In the example shown here a freeze mask was loaded from a layer mask (see Figure 7.21). When you freeze an area in this way it is protected from subsequent distortions so you can concentrate on applying the Liquify tools to just those areas you wish to distort. Frozen mask areas can be unfrozen by using the thaw mask tool.

View options

The View options can be seen in Figure 7.23. The 'Show Mesh' option lets you see a mesh overlay revealing the underlying liquify distortion and the mesh grid can be displayed at different sizes using different colors. This can readily help you pinpoint the areas where a distortion has been applied. You can use the check boxes in this section to view the mesh on its own or have it displayed overlaying the Liquify preview image (as shown in the Figure 7.17 examples).

Figure 7.23 The Liquify View options.

The freeze mask overlay can be made visible or hidden by using the 'Show Mask' checkbox in the View options and this section also allows you to choose a mask color.

The Show Backdrop option is normally left unchecked. If the Liquify image contents are contained on a layer, then it is possible to check the Show Backdrop option and preview the liquified layer against the Background layer, all layers, or specific layers in the image. Here is how this option might be used. Let's imagine for example that you wished to apply a liquify distortion to a portion of an image and you started out with just a flattened image. You then make a selection of the area you wish to work on and make a copy layer via the selection contents using ⌘ J (Mac), ctrl J (PC). Once you have done this, as you apply the Liquify filter you can check the Show Backdrop checkbox and set the mode to Behind. At 100% opacity the Liquify layer covers the Background layer completely, but as you reduce the opacity you can preview the effect of a Liquify distortion at different opacity percentages. This technique can prove useful if you wish to compare the effect of a distortion against the original image or a target distortion guide (as in the step-by-step example included at the end of this chapter).

Saving the mesh

The Liquify dialog includes 'Save Mesh...' and 'Load Mesh...' buttons. These allow you to save your Liquify work as a mesh setting and reload this later. And there is also a 'Load Last Mesh' button.

When you save a mesh you have the option to work on the image again at a later date and reload the previous mesh settings. So, for example, if you have a saved mesh, this gives you the option to copy the original layer contents again, reapply the previously used mesh and re-edit the image contents in Liquify. Another thing you can do is to edit a low resolution version first, save the mesh and then reload and apply this mesh to the full resolution version later.

To reapply a Liquify filter using the last applied settings, go to the Filter menu and choose 'Last Filter', or use the ⌘ F (Mac), ctrl F (PC) shortcut.

Liquify performance

A number of improvements were made to the user interface in Photoshop CC and steps were also made to improve performance. Liquify now runs faster, maybe as much as 16 times faster, when working on large documents compared to Photoshop CS6. Also, zooming in on large documents is much faster now and aliasing has been removed when zooming levels at in-between full magnification views (i.e. at 33% and 66%).

Previously, the cursor ring and cross hairs showed different thicknesses in CS6 and this was due to differences in GPU cards. This problem has now been ironed out so that cursor rings and cross hairs are smoother and thinner, and the cross hairs are now made smaller on the Macintosh interface. You will also notice that the Photoshop preferences for cursors now determine the cursor appearance in Liquify as well. The brush slider responsiveness is now non-linear in behavior. In other words, the slider control feels more natural and this is especially noticeable when you use the bracket keys ([]) to adjust the cursor size.

Also, each tool in Liquify now remembers its own settings for size, density, pressure and rate. When you switch tools, the new tool will always remember its last-used settings.

Smart Object support for Liquify

Photoshop also provides Smart Object support for the Liquify filter. The reason why Liquify was not supported previously as a Smart Object was because this filter relied on the creation of a mesh, which would be automatically deleted once you clicked OK to apply a mesh edit. Now, when a document or layer is converted to a Smart Object, Liquify saves a compressed mesh within the document. This means that when you choose to re-edit a (smart object) Liquify filter setting the mesh can be reloaded. Note that while the mesh saved is compressed, this will still cause an image document to increase in size when saved.

On-screen cursor adjustments

Providing you have 'Use Graphics Processor' enabled in the Photoshop Performance preferences, you can now apply on-screen cursor adjustments in the Liquify dialog preview. This means if you hold down the `ctrl` `⌥` keys (Mac), or the `alt` key and right-click (PC), dragging to the left makes the brush cursor size smaller and dragging to the right, larger (and keeps the cursor position centered as you do so). If you drag upwards with these same keys held down you can decrease the brush pressure settings and dragging downwards will increase the brush pressure (see Figure 7.24).

If you hold down the `⌥` key the Cancel button changes to 'Reset'. But in addition now, if you hold down the `⌘` (Mac), `ctrl` (PC) key, the Cancel button changes to 'Default', which returns the controls to the 'factory original settings'.

Figure 7.24 In the Liquify dialog, if you hold down the `ctrl` `⌥` keys (Mac), or the `alt` key and right-click (PC), this reveals the on-screen cursor display. Drag left/right to make the cursor smaller or larger and drag up/down to decrease or increase the brush pressure setting.

Targeted distortions using Liquify

With the addition of the Puppet warp tool in Photoshop you may be wondering if we still need to use Liquify? After all, Puppet Warp does allow you to work on an image layer directly rather than via a modal dialog. Although I am a fan of the Puppet Warp feature, I do still see a clear distinction between the types of jobs where it is most appropriate to use Puppet Warp and those where it is better to use Liquify. In the example shown here, the Liquify filter was still the best tool to use because you can use the paint-like controls to carefully manipulate the mesh that controls the distortion. Plus you can also use the freeze tool (which is unique to Liquify) to control those parts of the image that you don't want to see become distorted. Every job is different and you'll need to decide for yourself which is the most appropriate distortion tool to use and which can best help you achieve the result you are after.

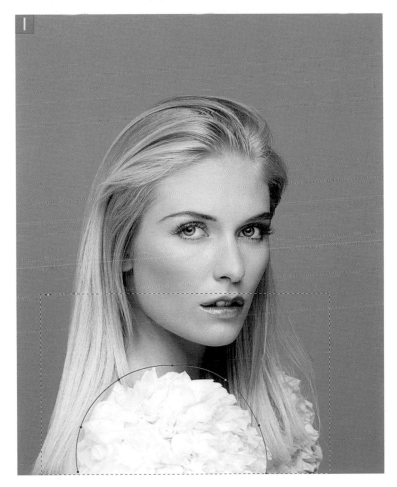

1 The objective here was to enlarge the rosette on the shoulder using the Liquify filter. This first step was to create a guide for subsequent Liquify work. I created an empty new layer (Layer 1) and used the pen tool to draw a path outline and stroked this path using the brush tool (see page 464). I then made a selection of the area of interest and used ⌘ J (Mac), *ctrl* J (PC) to copy the Layer 0 selected area. I then ⌘ (Mac), *ctrl* (PC)-clicked the copied layer to reactivate the selection. This is important as having a selection active forces Liquify to load the selected area only.

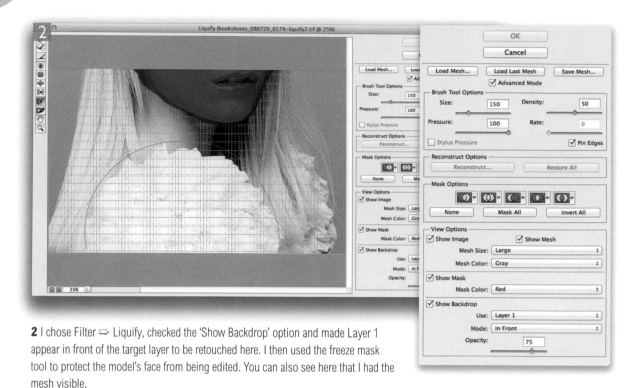

2 I chose Filter ⇨ Liquify, checked the 'Show Backdrop' option and made Layer 1 appear in front of the target layer to be retouched here. I then used the freeze mask tool to protect the model's face from being edited. You can also see here that I had the mesh visible.

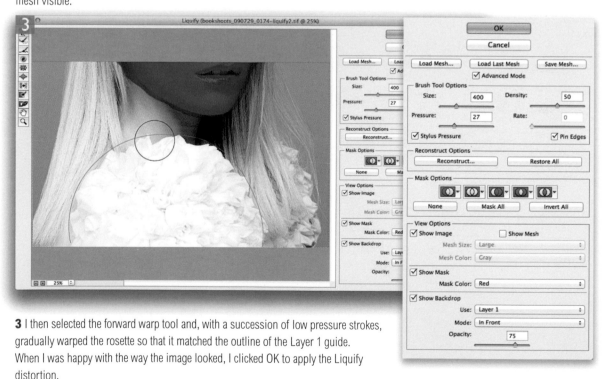

3 I then selected the forward warp tool and, with a succession of low pressure strokes, gradually warped the rosette so that it matched the outline of the Layer 1 guide. When I was happy with the way the image looked, I clicked OK to apply the Liquify distortion.

Chapter 8

Layers, selections and masking

For a lot of photographers the real fun starts when you can use Photoshop to create composite photographs and combine different image elements into a single photo. This chapter explains the different tools that can be used for creating composite photographs as well as the intricacies of working with layers, channels, mask channels and pen paths. To begin with, I shall focus on some of the basic principles such as how to make a selection and the interrelationship between selections, alpha channels, masks and the Quick Mask mode.

Figure 8.1 A selection is represented in Photoshop using marching ants.

Selections and channels

Whenever you read about masks, mask channels, image layer mask channels, alpha channels, quick masks or saved selections, people are basically talking about the same thing: an active, semipermanent or permanently saved selection.

Selections

There are many ways you can create a selection in Photoshop. You can use any of the main selection tools such as the lasso tool or the Select ⇨ Color Range command, or convert a channel or path to a selection. Whenever you create a selection, you will notice that it is defined by a border of marching ants (Figure 8.1). It is important to remember that selections are only temporary—if you make a selection and accidentally click outside the selected area with the selection tool, the selection will be lost, although you can always restore a selection by using the Edit ⇨ Undo command (\mathcal{H} Z [Mac], *ctrl* Z [PC]). As you work on a photo in Photoshop, you will typically use selections to define specific areas of an image where you wish to edit the image or maybe copy the pixels to a new layer and when you are done, you'll deselect the selection. If you end up spending any length of time preparing a selection, you'll maybe want to save such selections by storing them as alpha channels (also referred to as 'mask channels'). To do this, go to the Select menu and choose Save Selection… The Save Selection dialog box then asks if you want to save the selection as a new channel (Figure 8.2). If you select a pre-existing channel from the Channel menu you will have the option to replace, add,

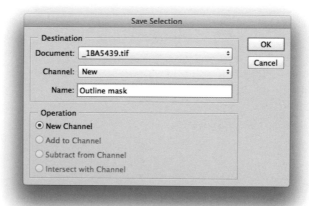

Figure 8.2 To save a selection as a new alpha channel you can choose Select ⇨ Save Selection and select the New Channel button option.

subtract or intersect with the selected channel. You can also create new alpha channels by clicking on the 'Save selection as a channel' button at the bottom of the Channels panel, which will convert a selection to a new channel. If you look at the Channels panel shown in Figure 8.3, you will notice how a saved selection has been added as a new alpha channel (this will be channel #6 in RGB mode, or #7 if in CMYK mode). You can also click on the 'Create new channel' button, then fill the empty new channel with a gradient or use the brush tool to paint in the alpha channel using the default black or white colors. Once you create a new channel it is preserved when you save the image.

To load a saved channel as a selection, choose 'Load Selection...' from the Select menu and select the appropriate channel number from the submenu. Alternatively, you can ⌘ (Mac), *ctrl* (PC)-click a channel in the Channels panel, or highlight a channel and click on the 'Load channel as a selection' button.

Recalling the last used selection
The last used selection is often memorized in Photoshop. Just go to the Select menu and choose 'Reselect' (⌘ *Shift* *D* [Mac], *ctrl* *Shift* *D* [PC]).

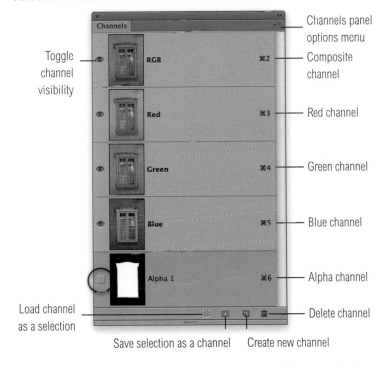

Toggle channel visibility — Channels panel options menu — Composite channel — Red channel — Green channel — Blue channel — Alpha channel — Delete channel — Load channel as a selection — Save selection as a channel — Create new channel

Figure 8.3 When you save a selection it is added as a new alpha channel in the Channels panel. Channels can be viewed independently by clicking on the channel name. However, if you keep the composite channels selected and click on the empty space next to the channel (circled), you can preview a channel as a quick mask overlay.

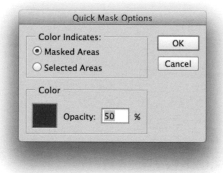

Figure 8.4 The top image shows an active selection and the bottom image shows the same selection displayed as a Quick Mask.

Figure 8.5 The Quick Mask Options.

The marching ants indicate the extent of an active selection and any image modifications you carry out are applied within the selected area only. Remember though, all selections are only temporary and can be deselected by clicking outside the selection area with a selection tool or by choosing Select ➪ Deselect (⌘ D [Mac], *ctrl* D [PC]). If you find the marching ants to be distracting you can temporarily hide them by going to the View menu and deselecting 'Extras'. Or, you can use the ⌘ H (Mac), *ctrl* H (PC) keyboard shortcut to toggle hiding/ showing the marching ants (though this is dependent on how you have configured the ⌘ H (Mac), *ctrl* H (PC) behavior [see page 32]).

Quick Mask mode

You can also preview and edit a selection in Quick Mask mode, where the selection will be represented as a transparent colored mask overlay (Figure 8.4). If a selection has a feathered edge, the marching ants boundary will only represent the selected areas that have more than 50% opacity. Therefore, whenever you are working on a selection that has a soft edge you can use the Quick Mask mode to view the selection more accurately. To switch to Quick Mask mode from a selection, click the quick mask icon in the Tools panel (Figure 8.6) or use the Q keyboard shortcut to toggle back and forth between the selection and Quick Mask modes. Whether you are working directly on an alpha channel or in Quick Mask mode, you can use any combination of Photoshop paint tools, or image adjustments to modify the alpha channel or Quick Mask content. If you double-click the quick mask icon, this opens the Quick Mask Options shown in Figure 8.5, where you can alter the masking behavior and choose a different color from the Color Picker (this might be useful if the Quick Mask color is too similar to the colors in the image you are editing).

Figure 8.6 The Quick Mask mode button is in the Tools panel just below the foreground/background swatch colors. Shown here are the two modes: Selection mode (left) and Quick Mask mode (right). You can toggle between these by clicking on this button. Double-click to open the Quick Mask Options shown in Figure 8.5.

Creating an image selection

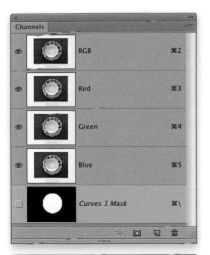

1 In this example I selected the elliptical marquee tool and dragged with the tool to define the shape of the cup and saucer. Note how you get to see a heads up display of the selection dimensions.

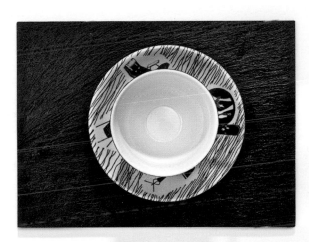

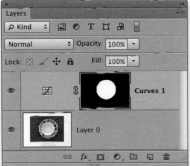

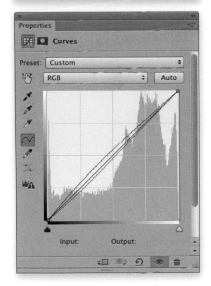

2 Now that I had created this selection I could use it to modify the image. With the selection still active, I added a new Curves adjustment layer (using the settings shown here in the Properties panel) to cool the cup and saucer. When you add an adjustment layer and a selection is active, the selection automatically generates a layer mask and the mask in this instance appears in the Channels panel as 'Curves 1 Mask'.

Reloading selection shortcuts

To reload a selection from a saved mask channel, choose Select ⇨ Load Selection… You can also ⌘ (Mac), ctrl (PC) + click a channel to load it as a selection. To select a specific channel and load it as a selection, use ⌘ ⌥ + channel # (Mac), ctrl alt + channel # (PC) (where # equals the channel number).

To select the composite channel, use ⌘ 2 (Mac), ctrl 2 (PC) and use ⌘ 3 (Mac) ctrl 3 (PC) to select the red channel, ⌘ 4 (Mac), ctrl 4 (PC) to select the green channel, ⌘ 5 (Mac), ctrl 5 (PC) to select the blue channel and subsequent numbers to select any additional mask/alpha channels that are stored in an image.

Modifying selections

You can modify the content of a selection using the Shift and alt modifier keys. If you hold down the Shift key you can add to a selection. If you hold down the alt key you can subtract from a selection and if you hold down the ⌥ Shift (Mac), alt Shift (PC) keys you can intersect a selection as you drag with a selection tool. The magic wand is a selection tool too, but here all you have to do is to click (not drag) with the magic wand, holding down the appropriate keys to add or subtract from a selection. Note that if you select either the lasso or one of the marquee tools, placing the cursor inside the selection and dragging moves the selection boundary position, but not the selection contents.

Alpha channels

An alpha channel is effectively the same thing as a mask channel and when you choose Select ⇨ Save Selection…, you are saving the selection as a new alpha channel. These are saved and added in numerical sequence immediately below the main color channels. Just like normal color channels, an alpha channel can contain up to 256 shades of gray in 8-bits per channel mode or up to 32,000 shades of gray in 16-bits per channel mode. You can select a channel by going to the Channels panel and clicking on the desired channel. Once selected, it can be viewed on its own as a grayscale mask and manipulated any way you like using any of the tools in Photoshop. An alpha channel can also effectively be viewed in a 'quick mask' type mode. To do this, select an alpha channel and then click on the eyeball icon next to the composite channel, which is the one at the top of the Channels panel list (see Figure 8.3). You will then be able to edit the alpha channel mask with the image visible through the mask overlay. There are several ways to convert an alpha channel back into a selection. You can go to the Select menu, choose Load Selection… and then select the name of the channel. A much simpler method is to drag the channel down to the 'Make Selection' button at the bottom of the Channels panel, or ⌘ (Mac), ctrl (PC)-click the channel in the Channels panel.

Modifying an image selection

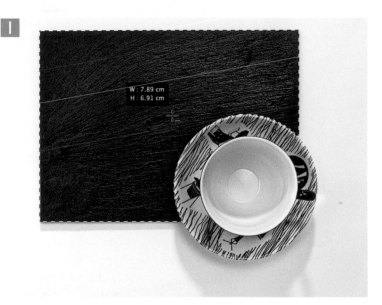

1 Here, I started off with a rectangular marquee selection. I then selected the elliptical marquee tool and dragged across the image with the *alt* key held down. This allowed me to subtract from the original rectangular marquee selection.

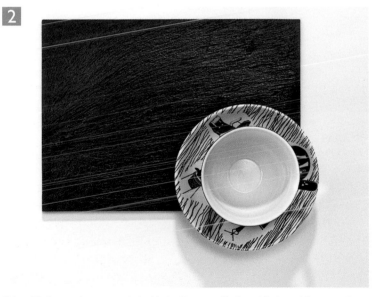

2 As with the previous example I added a Curves adjustment that used the current active selection to create the masked adjustment layer seen here. I then adjusted the Curves to make the place mat appear cooler.

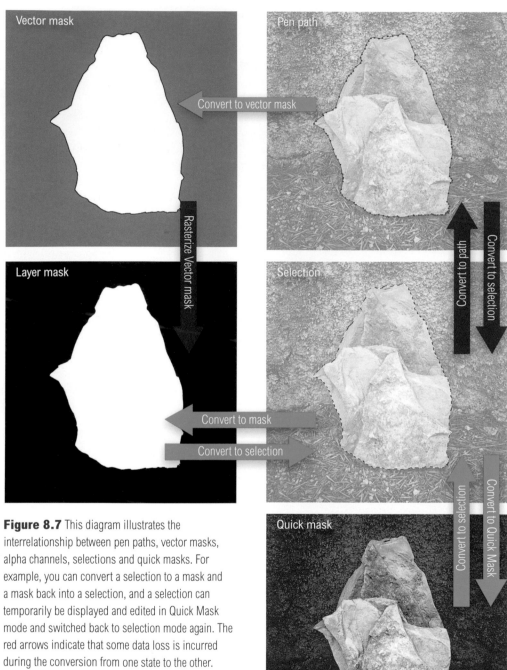

Figure 8.7 This diagram illustrates the interrelationship between pen paths, vector masks, alpha channels, selections and quick masks. For example, you can convert a selection to a mask and a mask back into a selection, and a selection can temporarily be displayed and edited in Quick Mask mode and switched back to selection mode again. The red arrows indicate that some data loss is incurred during the conversion from one state to the other.

Selections, alpha channels and masks

As was pointed out at the beginning of this chapter, there is an interrelationship between selections, quick masks and alpha channel masks. This also extends to the use of vector paths and vector masks (vector paths are discussed towards the end of this chapter). The accompanying Figure 8.7 diagram highlights these relationships in more detail.

Starting at the top right corner, we have a path outline that has been created using the pen tool in Photoshop. A pen path outline can be saved as a path and an active path can be used to create a vector mask, which is a layer masked by a pen path mask (see pages 601–610). A vector mask can also be rasterized to make a layer mask (a layer that is masked by an alpha channel). Meanwhile, a pen path can be converted to a selection and a selection can be converted back into a work path. If we start with an active selection, you can view and edit a selection as a quick mask and a selection can also be converted into an alpha channel and back into a selection again.

When preparing a mask in Photoshop, most people will start by making a selection to define the area they want to work on and save that selection as an alpha channel mask. This allows you to convert the saved alpha channel back into a selection again at any time in the future. The other way to prepare a mask is to use the pen tool to define the outline and then convert the pen path to a selection. If you think you will need to reuse the pen path again, such as to convert it to a selection again at a later date, then it is worth remembering to save the work path with a meaningful name, rather than the default 'Path 1' etc., in the Paths panel.

As I say, the business of using vector masks and layer masks is covered in more detail later on, but, basically, a layer mask is an alpha channel applied to a layer that defines what is shown and hidden on the associated layer. And a vector mask is a pen path converted to a vector mask that defines what is shown and hidden on the layer. There are good reasons for having these different ways of working and I provide a few practical examples in this chapter that show when it is most appropriate to use either of these two main methods to mask an image.

Converting vectors to pixels

In Figure 8.7 I mention that some of the conversion processes will incur a loss of data. This is because when you convert vector data to become a pixel-based selection, what you end up with is not truly reversible. Drawing a pen path and converting the path to a selection is a very convenient way to make an accurate selection. But, if you attempt to convert a selection back into a pen path again, you won't end up with an identical path to the one that you started with. Basically, converting vectors to pixels is a one-way process. Converting a vector path into a pixel-based selection is a good thing to do, but you should be aware that converting a pixel-based selection into a vector path will potentially incur some loss of data. More specifically, a selection or mask can contain shades of gray, whereas a pen path merely describes a sharp outline where everything is either selected or not.

Figure 8.8 The above illustration shows a graphic where the left half is rendered without anti-aliasing and the right half uses anti-aliasing to produce smoother edges.

Figure 8.9 The Feather Selection dialog can be used to feather the radius of a selection. Also, when going to the Select ⇨ Modify menu, the Smooth, Expand, Contract and Feather commands now have an 'Apply effect at canvas bounds' option. This prevents the setting being constrained by the document size limits.

Anti-aliasing

Bitmapped images are made up of a grid of pixels, where without anti-aliasing, non-straight lines would be represented by a jagged sawtooth of pixels. Photoshop gets round this problem by anti-aliasing the edges, which means filling the gaps with in-between tonal values, so that non-vertical/horizontal sharp edges are rendered smoother by the anti-aliasing process (Figure 8.8). Wherever you encounter anti-aliasing options, these are normally switched on by default and there are only a few occasions where you might find it useful to turn these off.

If you have an alpha channel where the edges are too sharp and you wish to smooth them, the best way to do this is to apply a Gaussian Blur filter using a Radius of 1 pixel. Or, you can paint using the blur tool to gently soften the edges in the mask that need the most softening.

Feathering

Whenever you do any type of photographic retouching it is important to always keep your selections soft. If the edges of a picture element are defined too sharply it will be more obvious to the viewer that a photograph has been retouched. The secret to good compositing is to make sure the edges of the picture elements blend together smoothly.

There are two ways to soften the edges of a selection. You can go to the Select menu and choose Modify ⇨ Feather (*Shift F6*) and adjust the Feather Radius setting (Figure 8.9). Or, if you have applied a selection as a layer mask, you can use the Feather slider in the Masks mode of the Properties panel to feather the mask 'in situ'. A low Feather Radius of between 1 or 2 pixels should be enough to gently soften the edge of a selection outline, but there are times when it is useful to select a much higher Radius amount. For example, earlier on page 374, I used the elliptical marquee tool to define an elliptical selection, applied this as a Levels adjustment layer mask and feathered the selection by 100 pixels in the Properties panel Masks mode. This allowed me to create a smooth vignette that darkened the outer edges of the photograph. The maximum feather radius allowed is 1000 pixels and Photoshop supports feather values up to two decimal places.

Layers

Layers play an essential role in all aspects of Photoshop work. Whether you are designing a Web page layout or editing a photograph, working with layers lets you keep the various elements in a design separate. Layers also give you the opportunity to assemble an image using separate, discrete entities and have the flexibility to make any edit changes you want at a later stage. You can also add as many new layers as you like to a document up to a maximum limit of 8000. The Photoshop layers feature has evolved in stages over the years, including new ways for selecting multiple layers and linking them together. First let's look at managing layers and the different types you can have in a Photoshop document.

Layer basics

Layers can be copied between open documents by using the move tool to drag and drop a layer (or a selection of layers) from one image to another. This step can also be assisted by the use of the _Shift_ key to ensure layers are positioned centered in the destination image. To duplicate a layer, drag the layer icon to the New Layer button and to rename a layer in Photoshop, simply double-click the layer name. To remove a layer, drag the layer icon to the Delete button in the Layers panel and to delete multiple layers, use a _Shift_-click, or ⌘ (Mac), _ctrl_ (PC)-click to select the layers or layer groups you want to remove and then press the Delete button at the bottom of the Layers panel. There is a 'Delete Hidden Layers' command in both the Layers panel submenu and the Layer ⇨ Delete submenu. In addition there is also a File ⇨ Scripts menu item that can be used to delete all empty layers (see Figure 8.10). Layer visibility can be controlled by toggling the eyeball icon next to each layer, or by using the ⌘ + comma (Mac) _ctrl_+ comma (PC) shortcut.

Image layers

The most common type of layer is a pixel image layer, which is used to contain pixel information. New documents have a default _Background_ layer and you can now convert a background layer to a regular layer by simply clicking on the Background layer lock icon. New empty image layers can be created by clicking on the Create new layer button in the Layers panel (Figure 8.14). They can also be created by duplicating the contents of a selection to create a new layer

Figure 8.10 This shows the File ⇨ Scripts menu, where there is also an item called 'Delete All Empty layers'.

Renaming layers

To rename a layer, double-click the layer name in the layers panel to highlight the text. Use _Tab_ to go to the next layer down and rename. Use _Shift_ _Tab_ to go to the next layer up.

Making Properties panel visible

There is an option in the Properties panel fly-out menu that forces Photoshop to open the Properties panel whenever you add a new vector shape layer.

Figure 8.11 The pen tool and shape tools include a Shape layer mode button for creating shape layer objects defined by a vector path.

Figure 8.12 Text layers are created whenever you add type to an image. Text layers can be re-edited at any time.

Figure 8.13 Adjustment layers are image adjustments that can be applied to individual or multiple layers within an image. Like other layers, you can mask the contents and adjust the blending mode and layer opacity.

within the same document. To do this, choose Layer ⇨ New ⇨ Layer via Copy, or use the ⌘ J (Mac), ctrl J (PC) keyboard shortcut. This copies the selection contents, so that they become a new layer. You can use this shortcut to copy multiple layers or layer groups. Also, you can cut and copy the contents from a layer by choosing Layer ⇨ New ⇨ Layer via Cut or use the ⌘ Shift J (Mac), ctrl Shift J (PC) keyboard shortcut.

Vector layers

Vector layers is a catch-all term used to describe non-pixel layers where the layer is filled with a solid color and the outline is defined using a vector layer mask. A vector layer is created whenever you add an object to an image using one of the shape tools, or draw a path using the Shape layer mode, or when you add a solid fill layer from the adjustment layer menu. Figure 8.11 shows an example of a vector layer, which is basically a solid fill layer masked by a vector mask.

Text layers

Typefaces are made up of vector data, which means that Text layers are essentially vector-based shape layers. When you select the type tool in Photoshop and click or drag with the tool and begin to enter text, a new text layer is added to the Layers panel. Text layers are symbolized with a capital 'T', and when you hit *Return* to confirm a text entry, the layer name displays the initial text for that layer, making it easy for you to identify (see Figure 8.12). Double-click in the text layer 'T' icon to highlight the text and make the type tool active (double-click the name area to rename the layer and double-click the clear area to open the Layer Style dialog).

Adjustment layers

Adjustment layers allow you to apply image adjustments as editable layers and you can toggle such adjustments on or off by clicking the layer eyeball icon (Figure 8.13). The chief advantages of working with adjustment layers are that you can re-edit the adjustment settings at any time and, use the paint, fill or gradient tools in the accompanying mask, to selectively apply those adjustments to the image.

Layers panel controls

Figure 8.14 shows an overview of the Layers panel controls for the layered image shown in Figure 8.15. The blending

mode options determine how a selected layer will blend with the layers below, while the Opacity controls the transparency of the layer contents and the Fill opacity controls the opacity of the layer contents independent of any layer style (such as a drop shadow) which might have been applied to the layer. Next to this are the various layer locking options. At the bottom of the panel are the layer content controls for layer linking, adding layer styles, layer masks, adjustment layers, new groups and new layers as well as a Delete layer button. Most of the other essential layer operation commands are conveniently located in the Layers panel fly-out menu options.

Layer visibility

You can selectively choose which layers are to be viewed by selecting and deselecting the eye icons. If you go to the History panel options and check 'Make Layer Visibility Changes Undoable', you can even make switching the Layer visibility on and off an undoable action.

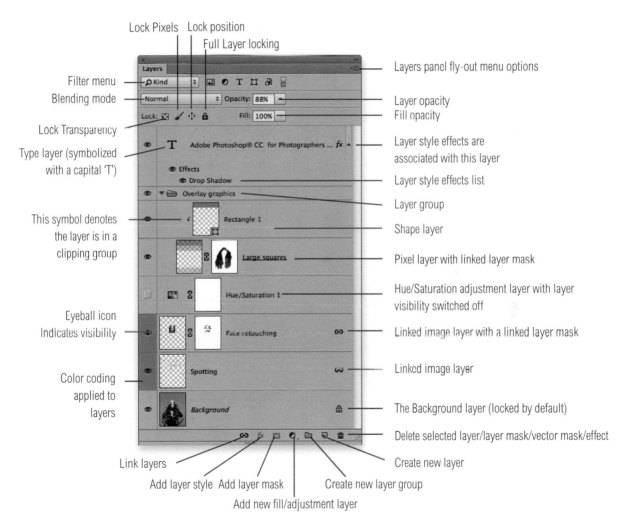

Figure 8.14 This shows an overview of the Photoshop Layers panel.

Figure 8.15 Here is an expanded diagram of how the layers in a book cover image file were arranged inside Photoshop. The checkerboard pattern represents transparency and the layers are represented here in the order they appear in the Layers panel.

Layer styles

You can use the layer style menu at the bottom of the Layers panel (see Figure 8.14) to apply different types of layer styles to an image, shape or text layer. This feature is really of more interest to graphic designers rather than photographers, but you'll find descriptions of the various layer styles in the online Help Guide.

Adding layer masks

You can hide the contents of a layer either wholly or partially by adding a layer mask, a vector mask or both. Masks can be applied to any type of layer: image layers, adjustment layers, type layers or shape layers. Image layer masks are defined using a pixel-based mask, while vector masks are defined using path outlines. Click once on the Add Layer Mask button to add a layer mask and click a second time to add a vector mask (in the case of shape layers a vector mask is created first and clicking the Add Layer Mask button adds a layer mask). You will also notice that when you add an adjustment layer or fill adjustment layer a layer mask is added by default. The layer mask icon always appears next to the layer icon and a dashed stroke surrounding the icon tells you which is active (see Figures 8.16 and 8.17).

The most important thing to remember about masking in Photoshop is that whenever you apply a mask you are not deleting anything; you are only hiding the contents. By using a mask to hide rather than to erase unwanted image areas you can go back and edit the mask at a later date. If you make a mistake when editing a layer mask, it is easy enough to correct such mistakes since you are not limited to a single level of undo. To show or hide the layer contents, first make sure the layer mask is active. Select the paintbrush tool and paint with black to hide the layer contents and paint with white to reveal. To add a layer mask based on a selection, select a layer to make it active, make a selection and click on the Add Layer Mask button at the bottom of the Layers panel, or choose Layer ⇨ Layer Mask ⇨ Reveal Selection. To add a layer mask to a layer with the area within the selection hidden, *alt*-click the Layer Mask button in the Layers panel, or choose Layer ⇨ Layer Mask ⇨ Hide Selection.

Lastly, the mask linking buttons referred to in Figures 8.16 and 8.17 allow you to lock or unlock a mask so that you can move the mask or layer contents independently of each other.

Figure 8.16 This Layers panel view contains two layers, and the selected layer is the one that's highlighted here. The dashed border line around the layer mask icon indicates the layer mask is active and any editing operations will be carried out on the layer mask only. There is no link icon between the image layer and the layer mask. This means the image layer or layer mask can be moved independently of each other.

Figure 8.17 In this Layers panel view, the border surrounding the vector mask indicates the vector mask is active and any editing operations will be carried out on the vector mask only. In this example, the image layer, layer mask and vector mask are all linked. This means if the image layer is targeted and you use the move tool to move it, the image layer and layer masks will move in unison.

Copying a layer mask

You can use the `alt` key to drag/copy a layer mask across to another layer in the same document.

Figure 8.18 The remove layer mask options.

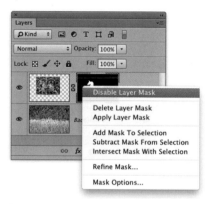

Figure 8.19 The layer mask contextual menu options.

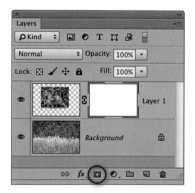

Figure 8.20 Click the Add Layer Mask button (circled) to add a layer mask where the contents remain visible. `alt`-click to add a layer mask filled with black, where the contents are hidden.

Viewing in Mask or Rubylith mode

The layer mask icon preview provides you with a rough indication of how the mask looks, but if you `alt`-click the layer mask icon the image window view switches to display a full image view of the mask (see Step 1 opposite). If you `⌥` `Shift` (Mac), `alt` `Shift` (PC)-click the layer mask icon, the layer mask is displayed as a quick mask type transparent overlay (see Step 2 opposite). Both these steps can be toggled.

Removing a layer mask

To remove a layer mask, select the mask in the Layers panel and click on the Layers panel Delete button (or drag the layer mask to the Delete button). A dialog box then appears asking if you want to 'Apply mask to layer before removing?' (Figure 8.18). There are several options here: if you simply want to delete the layer mask, then select 'Delete'. If you wish to remove the layer mask and at the same time apply the mask to the layer, choose 'Apply'. Or click 'Cancel' to cancel the whole operation.

To temporarily disable a layer mask, choose Layer ⇨ Layer Mask ⇨ Disable, and to reverse this, choose Layer ⇨ Layer Mask ⇨ Enable. You can also `Shift`-click a mask icon to temporarily disable the layer mask (when a layer mask is disabled it will appear overlaid with a red cross). A simple click then restores the layer mask again (but to restore a vector mask you will have to `Shift`-click again). Or alternatively, `ctrl` (Mac) or right mouse-click the mask icon to open the full list of contextual menu options to disable, delete or apply a layer mask (see Figure 8.19).

Adding an empty layer mask

To add a layer mask to a layer so that the layer contents remain visible, just click the Layer Mask button in the Layers panel (Figure 8.20). Or, choose Layer ⇨ Add Layer Mask ⇨ Reveal All. To add a layer mask to a layer that hides the layer contents, `alt`-click the Add Layer Mask button in the Layers panel. Or, choose Layer ⇨ Add Layer Mask ⇨ Hide All. This adds a layer mask filled with black.

Thumbnail preview clipping

If you use a right mouse-click on a layer thumbnail, this opens the contextual menu shown in Figure 8.21 where you can choose to clip thumbnails to the layer or document bounds.

1 This shows a composite image made up of a Background layer plus an additional pixel layer masked with a layer mask.

2 If you *alt*-click the layer mask icon, you can preview a layer mask in normal mask mode.

3 If instead you ⌥ *Shift* (Mac), *alt* *Shift* (PC)-click the layer mask icon, you can preview a layer mask in Quick Mask mode. The mask can be edited more easily in either of these preview modes. The backslash key (\) can be used to toggle showing the layer mask as a quick mask and return to normal view mode again.

Figure 8.21 There is a layer thumbnail contextual menu that allows you to determine whether the thumbnail preview clips to the document bounds (top) or to the layer bounds (below). This option affects the layer contents visibility in the Layers panel (but does not affect the associated pixel/vector layer masks). Once selected this option remains persistent for all document Layers panel views.

Density and mask contrast

The Density slider answers requests to have some kind of control over the mask contrast. A lot of layer masks will originate as black and white masks where the image adjustments or pixel layer contents are either at full opacity or hidden (the same is true of vector masks, of course). The Density slider allows you to preserve the mask outline, but fade the contrast of the mask in a way that is completely re-editable.

Properties panel mask options

Figure 8.22 shows the Properties panel Masks mode options menu, where you can use the menu options shown here to add, subtract or intersect the current mask with an active selection. Imagine you want to add something to a selection you are working on. You simply choose the 'Add Mask to Selection' menu option to add it to the current selection.

Figure 8.22 The Properties panel Masks mode panel controls are accessible from the menu circled in Figure 8.23.

Properties Panel in Masks mode

I have already shown a few examples of how the Properties panel in Masks mode can be used to modify pixel or vector layer masks and the Properties panel Masks mode controls are all identified in Figure 8.23 below. The pixel mask/vector mask selection buttons are at the top of the panel and can also be used to add a mask (providing a pixel or vector mask is already present). Below that are the Density and Feather sliders for modifying the mask contrast and softness. Next are the Refine buttons, which are only active if a pixel mask is selected. The Mask Edge… button opens the Refine Edge dialog, where, as you can see in Figure 8.24, you can further modify the edges of a mask. The Color Range… button opens the Color Range dialog, where you can use a Color Range selection to edit a mask. The Invert button inverts a pixel mask, but if you want to do the same thing with a vector mask you can do so by selecting a vector path outline and switching the path mode (see page 608). At the bottom of the panel there are buttons for loading a selection from the mask, applying a mask (which deletes the mask and applies it to the pixels) and a Delete Mask button.

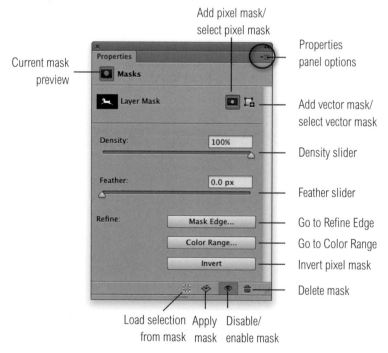

Figure 8.23 The Properties panel Masks mode controls.

Refine Edge command

The Refine Edge command uses a Truer Edge™ algorithm to enable complex outline masking and is available foremost as a Select menu item (⌘ ⌥ R [Mac], ctrl alt R [PC]) for modifying selections. When editing a selection the dialog says 'Refine Edge'. But if you are preparing a selection in order to create a mask, it makes more sense to use the Refine Edge command when you are working on an active layer mask. You can do this by clicking on the Mask Edge… button in the Properties panel Masks mode, or by using the above keyboard shortcut. Whichever method you choose the controls are exactly the same, except the dialog is called 'Refine Mask' when editing a layer mask. The Refine Edge controls offer everything you need to modify a selection or layer mask edge. At the bottom are the Output mask refinement controls for removing color contamination from a masked layer.

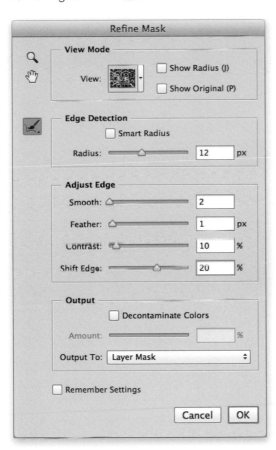

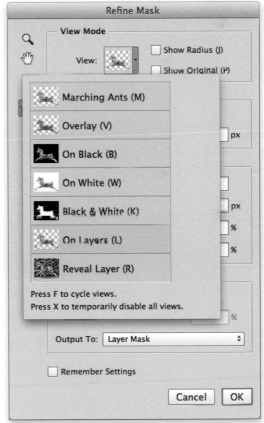

Figure 8.24 The Refine Edge dialog.

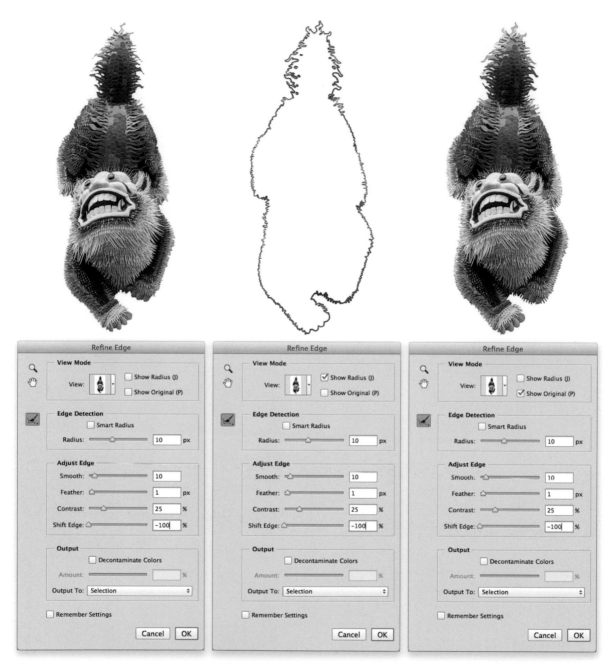

Figure 8.25 This shows examples of how the Radius and original image view modes might be used. Here you can see an image masked using the On White mask view mode. On the left you can see how the masked image looks using the current Refine Edge settings. In the middle is the preview with the Show Radius (**J**) option checked. This displays the refine edge boundary only. On the right is the preview with the Show Original (**P**) option checked. This allows you to view the masked image and compare the original version against the refine edge masked version (left).

View modes

When you first select Refine Edge, the initial view mode shows the layer masked against a white background, which isn't so helpful when editing a layer mask, but you can easily switch to the On Layers view by pressing *L* and once you have done this I suggest you click on the Remember Settings button at the bottom of the Refine Edge dialog to keep this as the new default setting. Without adjusting anything, click OK to close the dialog. The On Layers preview mode will then appear by default the next time you open Refine Edge. In the subsequent tutorial (on pages 520–525) I suggest you do all your main Refine Edge adjustments using the On Layers preview mode since this allows you to preview the adjustments you make in relation to the rest of the image. This and the other modes can be accessed from the pop-up menu shown in Figure 8.24 and you'll notice the keyboard shortcuts that are listed here, which will allow you to quickly switch between view modes. In the View Mode section, the Show Radius option (*J*) displays the selection border only for where the edge refinement occurs, while Show Original (*P*) allows you to quickly display the image without a selection preview (see Figure 8.25 for more details).

Edge detection

The Edge Detection section gives you some control over how the Truer Edge™ algorithm processing is used to refine the edge boundaries. This essentially analyzes the border edges in the image and calculates the most appropriate mask opacities to use, primarily according to the Radius setting you have applied. What you want to do here is to adjust the Radius setting to what is most appropriate for the type of image you are masking. If the edges to be masked are mostly fine, sharp edges, then a low Radius setting will work best. For example, a Radius of 1 pixel would be suitable for a selection that contained a lot of fine edges such as a wire fence. If the edges you wish to mask are soft and fuzzy, then a wider Radius setting will be most appropriate and it is suggested that you should aim to set the Radius here as wide as you can get away with.

Since a photographic image is most likely going to contain a mixture of sharp and soft edges, this is where the refine radius tool () comes in. This can be used to extend the areas of the edge to be refined. So if you have chosen a narrow Radius

Figure 8.26 You need a narrow thickness edge to refine sharp mask edges and a wider thickness to refine soft, wide mask edges. Here you can see the refine radius tool used at different thicknesses to manually edit a mask. You can set a narrow or wide Radius in the Refine Edge dialog and use the refine radius brush to modify that edge. Note that the edit brush work shows up as a green overlay in the Reveal Layer view mode.

Figure 8.27 This shows the erase refinements tool in use, which shows up as a red overlay when applied in the Reveal Layer view mode.

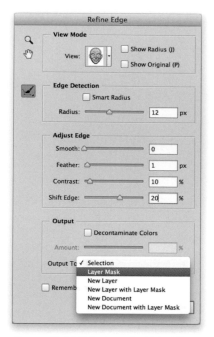

Figure 8.28 This shows the Output To menu options for the Refine Edge dialog.

setting, which would be appropriate for refining narrow edges, you can paint with the above tool using a wider brush diameter to paint over the softer edges and thereby apply the most suitable edge refinement algorithm along those sections of the border edge. As you modify the border you will want to select the refine radius tool and adjust the cursor size, using the square bracket keys ([]) to determine the brush size you need to work with. Once you have done that you can click and drag to paint along the edges to be refined (see Figure 8.26). Bear in mind that after each brush stroke, Photoshop needs to recalculate a new edge outline using the new algorithm and this may take a few seconds to complete, during which time you won't be able to edit the edge any further. It may seem a little off-putting at first, but I assure you that the time delay you may experience here is nothing compared to the amount of time you will be able to save through the use of this automated masking process. Holding down the alt key switches from the refine radius tool to the erase refinements tool (). Or, you can select this tool from the same tool menu as the refine radius tool, or use the Shift E key to toggle between the two tool modes. The erase refinements tool can be used to remove areas of the edge to be refined and basically undoes the refined radius mask editing. When working in the Reveal Layers mode, the refine radius painting shows as a green overlay and the erase refinement tool painting shows up as a red overlay (see Figures 8.26 and 8.27).

Smart Radius

The Smart Radius option can often help improve the mask edge appearance, as it automatically adjusts the radius for the hard and soft edges found in the border transition area. With hair selections in particular, you should find it helps if you aim to set the Radius slider as high as you can and check the Smart Radius option. I have found that this usually produces the best hair mask.

Adjust Edge section

In the Adjust Edge section there are four sliders. The Smooth slider is designed to smooth out jagged selection edges but without rounding off the corners. The Feather slider uniformly softens the edges of the selection and produces a soft edged transition between the selection area and the surrounding pixels, while the Contrast slider can be used to

make soft edges crisper and remove artifacts along the edges of a selection, which are typically caused when using a high Radius setting. When compositing photographic elements you usually want the edges of a mask to maintain a certain degree of softness, so you don't necessarily want to apply too much contrast to a mask here. Some images may need a high contrast, but you are usually better off relying on the Smart Radius option combined with the refine radius and erase refinements tools to refine such a selection/mask edge.

If you want to achieve a more aggressive smoothing you can combine adjusting the Feather and Contrast sliders. Simply increase the Feather slider to blur the mask and then increase the Contrast to get back to the desired edge sharpness.

The Shift Edge slider is like a choke control. It works on the mask a bit like the Maximum and Minimum filters in Photoshop. You can use this slider to adjust the size of the mask in both directions, making it shrink or expand till the mask fits correctly around the object you are masking. I usually find the Shift Edge slider is the most useful for adjusting the selection/mask shape, followed by the Feather and Contrast sliders, which I use when I wish to refine the mask further.

Refine Edge output

Lastly, we have the Output section (Figure 8.28), which determines how the masked image layer blends with the image layers below it. This step is crucial to making a successful mask, which may otherwise look wrong if the pixels around the outer edges of a mask (picked up from the original background) don't match those of the new background. Whenever you need to successfully blend a masked image layer with the other layers in a new image you can check the Decontaminate Colors option and then adjust the Amount slider in order to remove any of the last remaining background colors that were present in the original photo (see Figure 8.29). The best advice here is to only dial in as much decontamination as is necessary in order to achieve the most detailed and smoothest-looking blend.

The 'Output To' section allows you to output the refined selection in a variety of ways, either as a modified selection, as a layer mask, as a new layer with transparent pixels, as a new layer with a layer mask, or as a new document: either with transparent pixels or with a layer mask.

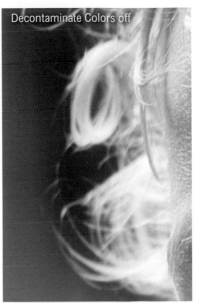
Decontaminate Colors off

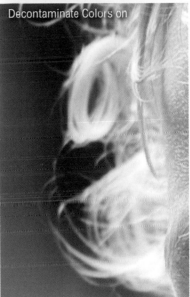
Decontaminate Colors on

Figure 8.29 Here you can see a close-up comparison between a Refine Edge edited masked layer (top) and below that, one where the Decontaminate Colors option was switched on to help improve the blend between the masked layer and the pixels in the layer below.

Quick selection brush settings

The quick selection brush settings are the same as for the other paint tools, except adjusting the brush hardness and spacing won't really have any impact on the way the quick selection tool works. If you are using a pressure sensitive tablet it is worth checking that the Pen Pressure option is selected in the Size menu, as this allows you to use pen pressure to adjust the size of the quick selection tool brush (see Figure 8.30 below).

Figure 8.30 This shows the quick selection tool brush settings where the Pen Pressure option has been selected from the Size menu. This links the quick selection tool cursor size to the amount of pen pressure applied.

Working with the quick selection tool

The quick selection tool is grouped with the magic wand in the Tools panel. It is a more sophisticated kind of selection tool compared with the magic wand and offers some interesting smart processing capabilities. Basically, you use the quick selection tool to make a selection based on tone and color by clicking or dragging with the tool to define the portion of the image that you wish to select. You can then keep clicking or dragging to add to a selection without needing to hold down the Shift key as you do so. You can then subtract from a quick selection by holding down the alt key as you drag. What is clever about the quick selection tool is that it remembers all the successive strokes that you make and this provides stability to the selection as you add more strokes. So, as you toggle between adding and subtracting, the quick selection temporarily stores these stroke instructions to help determine which pixels are to be selected and which are not. The Auto-Enhance option in the Options bar can help reduce any roughness in the selection boundary, as it automatically applies the same kind of edge refinement as you can achieve manually in the Refine Edge dialog using the Radius, Smooth and Contrast sliders.

Sometimes you may find it helps if you make an initial selection and then apply a succession of subtractive strokes to define the areas you don't want to be included. You won't see anything happen as you apply these blocking strokes, but when you go on to select the rest of the object with the quick selection tool, you should find that as you add to the selection, the blocking strokes you applied previously help prevent leakage outside the area you wish to select. In fact, you might find it useful to start by adding the blocking strokes first, before you add to the selection. This aspect of quick selection behavior can help you select objects more successfully than is possible with the magic wand. However, as you make successive additive strokes to add to a selection and then erase these areas from the selection, you'll have to work a lot harder going back and forth between adding and subtracting with the quick selection tool. In these situations it can be a good idea to clear the quick selection memory by using the 'double Q trick'. If you press the Q key twice, this takes you from the selection mode to the Quick Mask mode and back to selection mode again. The stroke constraints will be gone and you can then add to or subtract from the selection more easily since you will have now cleared the quick selection memory.

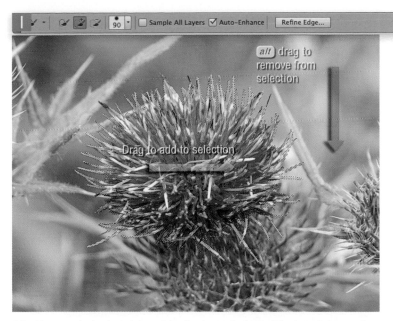

1 In this example, I selected the quick selection tool, checked the Auto-Enhance edge option and dragged to make an initial selection of the flower. Then, with the *alt* key held down, I dragged around the outer perimeter of the flower to define the areas that were to be excluded from the selection. I then continued clicking and dragging to select more of the flower petals to fine-tune the selection edge.

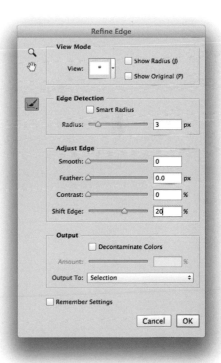

2 I clicked on the Refine Edge… button and selected the 'On White' mask option, which displayed the cut-out selection against a white background color. In the Edge Detection section I applied a 3 pixel Radius with the Smart Radius option checked. I also expanded the edge slightly, applying a +20% Shift Edge amount.

Combining a quick selection with Refine Edge

1 Here I wanted to demonstrate the capabilities of the Refine Edge/Refine Mask feature and show how, when used in conjunction with the quick mask tool, you can use it to mask tricky outlines such as fine hair. To demonstrate how this works, I have selected here a photograph that I took of my daughter, Angelica. This was a good example to work with since her blonde hair was backlit by the sun. There was a reasonable amount of tone and color separation between her and the background scenery and it certainly helped that the background was slightly out of focus. Overall, the conditions were pretty favorable for making a cut-out mask. Having said that, there were a number of areas where the tones and colors between the subject and the background matched quite closely and these would present more of a challenge.

To start with, I selected the quick selection tool from the Tools panel and applied a succession of brush strokes to select her outline. As is often the case, every now and then I had to hold down the ⟨*alt*⟩ key to switch to subtract mode in order to fine-tune the quick selection. There was no need for me to be too precise here, but it is usually helpful if you try to achieve the best quick selection you can. I then clicked the lock icon for the Background layer to convert it to a normal layer and was ready for the next step.

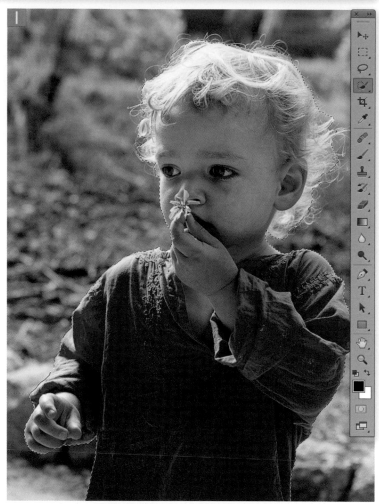

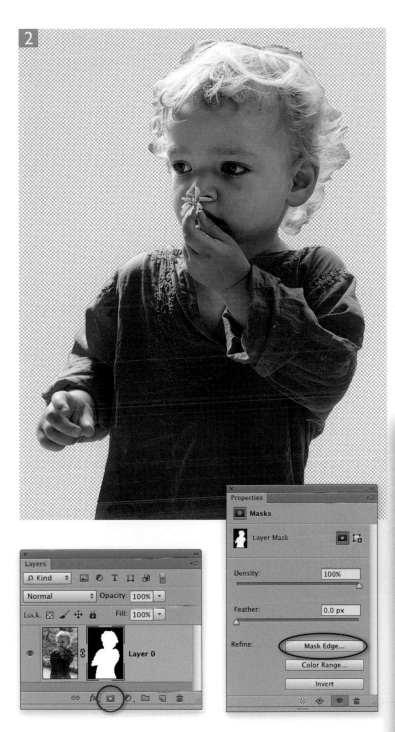

2 With the initial selection prepared, I clicked on the Add Layer Mask button in the Layers panel (circled) to add a layer mask based on the current selection. I then went to the Properties panel and clicked on the Mask Edge... button (or you could just go to the Select menu and choose Refine Edge...). This opened the Refine Mask dialog shown here, where to start with I selected the 'On Layers' (**L**) preview option and started adjusting the sliders to achieve a better mask edge. With the Smart Radius option checked, I set the Radius to 20 pixels and Contrast to 25% to improve the mask border edge. I kept the Smooth value low and increased the Feathering to 1.3 pixels to keep the mask outline edges reasonably soft.

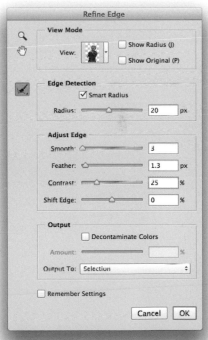

3 I could tell from the current state of the layer mask that while the body outline looked good, the biggest problem was (as always) how to most effectively mask the hair. In this screen shot the Refine Mask dialog was set to the Reveal Layer (R) preview mode. I selected the refine radius tool (circled) and started brushing over the outline of the hair. There are a couple of things to point out here. By working in the Reveal Layer preview mode, you can see more accurately where you are brushing, as the green overlay allows you to see which areas have been selected. You won't actually see the results of this masking refinement yet, but it helps using this preview mode in the initial stages. The second point is that the Refine Mask recalculates the mask edge after each single brush stroke, so you can't expect to apply a quick succession of brush strokes to define the mask, instead you do so by applying one brush stroke at a time. You'll also notice how Photoshop pauses for a few seconds while it carries out these calculations before it allows you to continue.

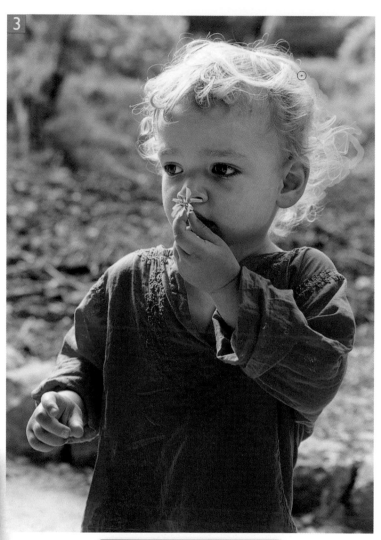

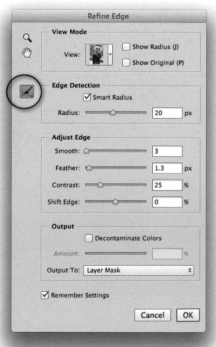

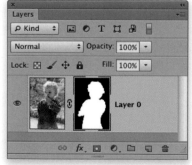

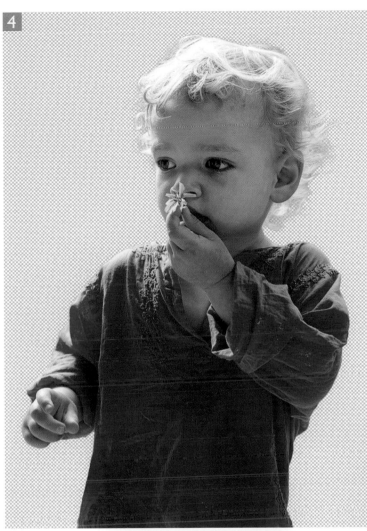

4 To refine the mask further, it was now best to revert to the 'On Layers' (**L**) preview option, as this allowed me to preview the mask edges against a transparent backdrop. At this stage I continued to work with the refine radius tool to perfect the edges of the hair outline. One can use the **alt** key to select the erase refinements tool (🪥) and remove parts of the mask, but in this instance I found the refine radius tool was the only one that was needed here. As in the previous step, you have to apply a brush stroke and then wait a few seconds for Photoshop to recalculate before applying any further brush strokes. I then adjusted the Shift Edge slider to contract the mask edge slightly and make it shrink more to Angelica's outline.

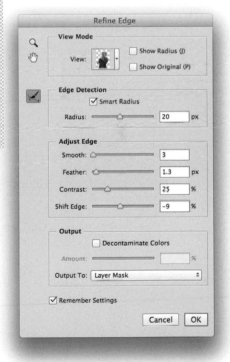

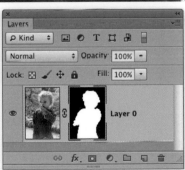

5 It was all very well looking at the masked image against a transparent background, but the real challenge was how the image previewed against backdrops of different color and lightness. To test this particular masked image, I selected the 'On White' (**W**) preview. By previewing the image against white I was able to get a better indication of how effective the mask was at separating the subject from the original background. As expected, I needed to check the Decontaminate Colors box in the Output section (circled) if the subject edges were to blend more convincingly with the white backdrop. As you can see, the mask was working quite well by this stage. However, I didn't want to decontaminate the layer just yet, so I unchecked this option for now.

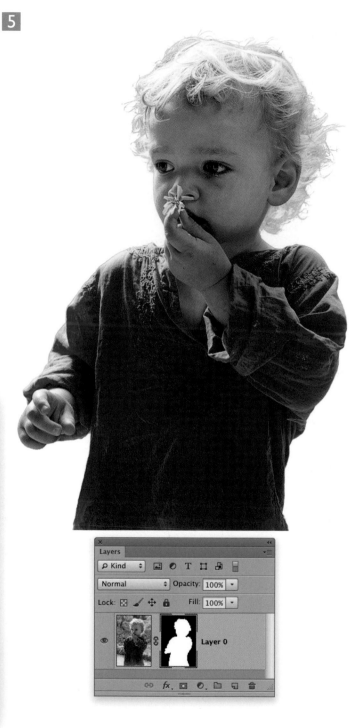

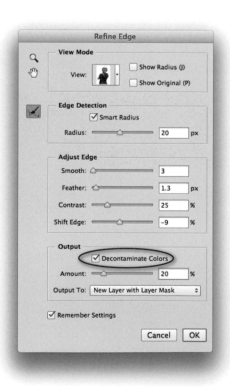

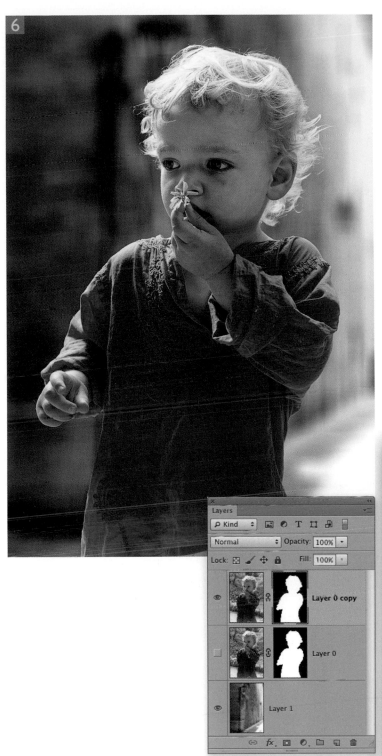

6 The real test though was how the masked layer would look when placed against a different background image. In this final step I took an out-of-focus backdrop image and dragged it across to the main image, placing this as a new layer below the current layer. I then reselected the masked layer of Angelica, and making sure the layer mask was active I opened the Refine Mask once more. Now, since the mask edges had already been modified I did not want to refine them any further, so I therefore set all the settings to zero. I did though want to check the Decontaminate Colors option in the Output section at the bottom. I was now able to preview the masked layer against the final backdrop and could tell how much to adjust the Amount slider. When I was happy with the way things were looking, I clicked OK to apply this final modification to the mask with the 'New Layer with Layer Mask' option selected in the Output To menu at the bottom of the dialog.

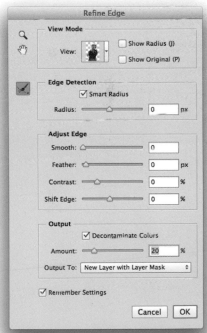

Tips when working with Focus Area

If the Focus Area selection needs improvement it is best to override the Auto option and adjust the In-Focus Range slider. If the In-Focus Range selection happens to include a lot of the out-of-focus background area this could be because the Focus Area selection is picking up noise. If this happens expand the Advanced options, deselect the auto option and gradually increase the Noise slider to see if this clears up the selection area. Basically, with higher ISO images you will need to increase the slider setting. However, sometimes when the Noise slider is set high, everything will be selected. So it is best to make small careful adjustments and if it's not looking right check the Auto option to reset to auto mode again.

Mercury Graphics Engine

The Mercury Graphics Engine has made a significant improvement in providing GPU acceleration for the Focus Area feature.

Focus area

The Focus Area feature in the Select menu is a selection tool that can be used to make selections based on focus. It can be used to make selections based on sharpness and is useful for cutting out objects shot against an out-of-focus background.

When creating a selection you have the option of overriding the Auto option and manually adjusting the In-Focus Range slider. This can help refine the selection. You can also click on the add and subtract tools to add to or remove from a focus area selection (just like you would when working with the quick select tool). The Focus Area selection will always have a hard edge, but this can be improved by checking the Soften Edge box. You can also modify by clicking the Refine Edge… button to open the Refine Edge dialog where you can fine-tune the selection edges as desired.

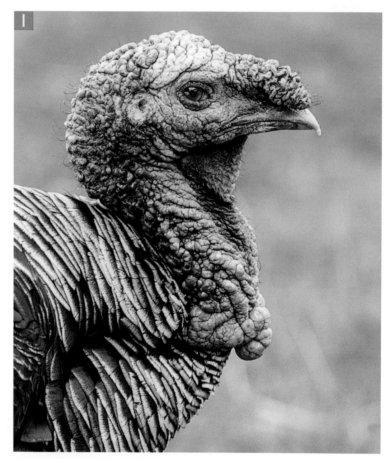

1 Here is a photograph of a turkey photographed using a long focus lens, where the background was out of focus.

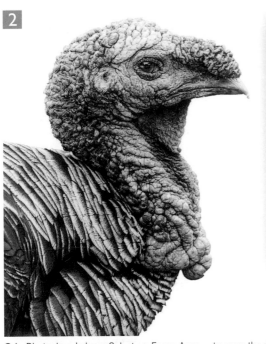

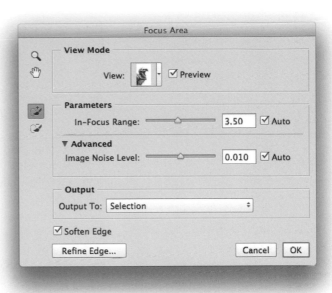

2 In Photoshop I chose Select ⇨ Focus Area… to open the dialog shown here with the default In-Focus Range Auto settings and the Soften Edge option checked.

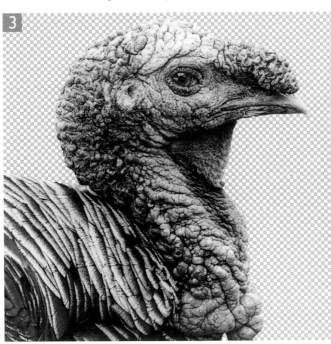

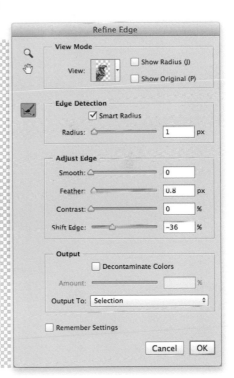

3 Finally, I clicked on the Refine Edge… button to go to the Refine Edge dialog where I was able to make further fine-tuned adjustments to the selection outline.

Ragged borders with the Refine Edge adjustment

The Refine Edge command is primarily designed as a tool for improving edge masks. However, Adobe engineer Gregg Wilensky, who worked on the Refine Edge feature, discovered how it can also be used to create interesting ragged-edge borders that look similar to those produced in the darkroom.

The main point to bear in mind here is that you primarily use the Radius slider to create the main effect and that a wide Radius will usually work best with the Smart Radius option disabled. Basically, the rough edges you see are actually based on the image itself so it is the image content that determines the outcome of the Refine Edge adjustment. The Feather, Contrast and Shift Edge adjustments can then be used to modify the main effect. In addition to this you can also select the refine radius tool and carefully paint along sections of the edge to further modify the border and generally roughen it up a little more. Above all you have to be patient as you do this and apply small brush strokes a little at a time, but the results you get can be pretty interesting.

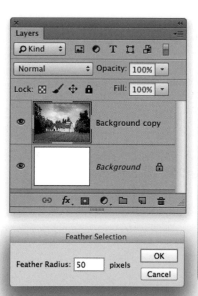

1 The first step was to make a copy of the background layer and fill the original background layer with a solid color, such as white. I then made a rectangular marquee selection, went to the Select menu and chose Modify ⇨ Smooth and applied an appropriate Sample Radius (in this case 50 pixels).

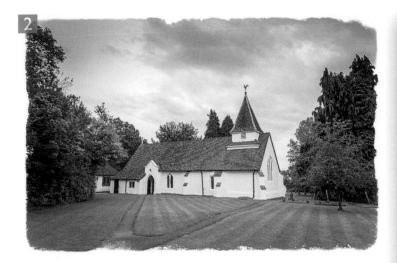

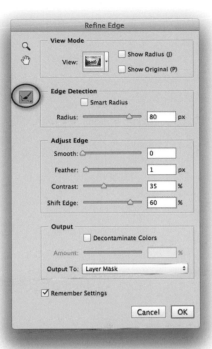

2 I then went to the Select menu and chose Refine Edge… (⌘ ⌥ R [Mac], ctrl alt R [PC]). The main controls I adjusted here were the Radius, to produce a wide border effect. The Contrast slider was used to 'crispen' the edges, Feather was used to smooth them slightly and a positive Shift Edge adjustment was used to expand the border edge. I also used the refine radius tool (circled) to manipulate some sections of the border to create a rougher border. In the Output To section I selected 'Layer Mask'. This automatically generated a pixel layer mask for the layer based on the current selection.

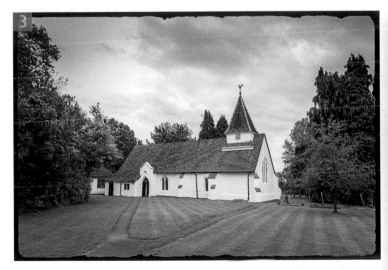

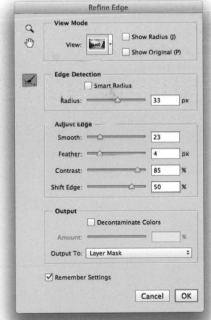

3 Here you can see an alternative border effect in which I started with a rounded marquee selection that was closer to the edges of the photo. This time I filled the Background color with black and used a 33 pixel Radius, a higher Contrast and a softer Feather adjustment to create a tighter border edge. As in Step 2, I also applied a few refine radius tool brush strokes to roughen the edge slightly.

Color Range masking

So far I have shown how to replace the background using the quick selection tool combined with Refine Edge/Refine Mask command. Let's now look at how to create a cut-out mask of a more tricky subject where the quick selection tool would not be of much use. Advanced users might be tempted to use channel calculations to make a mask. That could work, but there is a much simpler way. Color Range can also be considered an effective tool for creating mask selections that can be used when compositing images. In fact, I would say that the quick selection and Color Range adjustment are powerful tools that offer relatively speedy (and sophisticated) methods of masking.

1 This shows a photograph taken of a sailing ship mast against a deep blue sky. Obviously, it would be potentially quite tricky to create a cut-out mask of the complex rigging in this photo. One approach would be to analyze the individual RGB color channels and see if there was a way to blend these together using Calculations and create a new mask channel that could be used as a cut-out layer mask. A much easier way is to use the Color Range command. So to start with, I went to the Select menu and chose 'Color Range...'

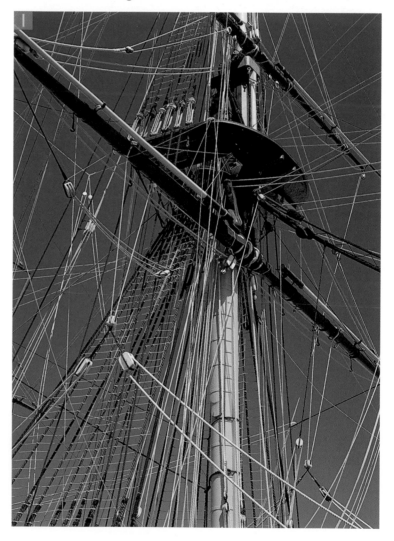

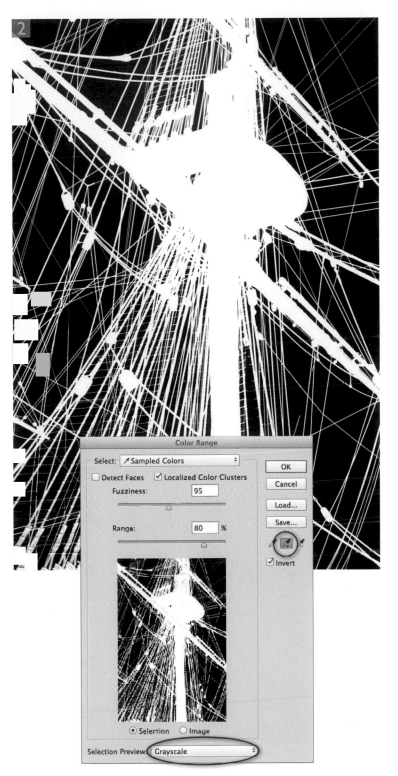

2 This opened the dialog shown below. With the standard eyedropper selected, I was able to simply click with the eyedropper anywhere in the image window to sample a color to mask with. In this instance I clicked in the blue sky areas to select the sky and checked the Invert box so that I was able to produce the inverted selection shown here. To create a more accurate selection, I checked the 'Localized Color Clusters' box and used the plus eyedropper (circled in blue) to add to the Color Range selection. You can click or drag inside the image to add more colors to the selection and also use the minus eyedropper (or hold down the *alt* key) to subtract from a selection. The Fuzziness slider increases or decreases the number of pixels that are selected based on how similar the pixels are in color to the already sampled pixels, while the Range slider determines which pixels are included based on how far in the distance they are from the already selected pixels. The Color Range preview is rather tiny, so you may find it helps to do what I did here, which was to select the Grayscale Selection Preview (circled in red) so that I could view the edited mask selection in the full-size image window.

3 Having completed the selection I clicked on the 'Add layer mask' button in the Layers panel to convert the active selection to a layer mask, which masked the Ship mast layer. I then wanted to blend the masked image with a photograph of a cloudy sky. This could be done by dragging the masked ship mast layer to the sky image, or as I did here, drag the sky image to the ship mast image and place the layer at the bottom of the layer stack. Shown here is the cloudy sky layer on its own with the layer visibility for the masked Ship mast layer switched off.

4 This shows a 100% close-up view of the masked layer overlaying the sky layer with the Ship mast layer visibility switched back on and the Ship mast layer mask targeted. In the Properties panel, I clicked on the Mask Edge... button to open the Refine Mask... dialog.

5 This shows the finished composite image, in which I used the Refine Mask controls to fine-tune the mask edges. As in the previous example, I selected the 'On Layers' view mode. I was then able to preview the Refine Mask adjustments on a layer mask that actively masked the Ship mast layer. I didn't have to do too much here. I disabled the edge detection by setting the Radius to 0 pixels, applied a Feather of 0.5 pixels and contracted the mask by –15%. I checked the Decontaminate Colors option and set the Amount slider to 20%.

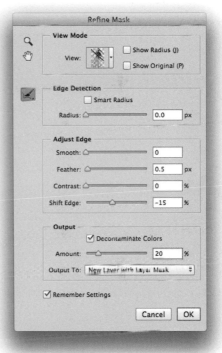

Layer blending modes

The layer blending modes allow you to control how the contents of a layer will blend with the layer or layers immediately below it. These same blend modes can also be used to control how the paint and fill tools interact with an image (you can also alter the blend mode for multiple selected layers). Here is a summary of all the blend modes currently found in Photoshop when blending together the two images shown in Figure 8.31.

Figure 8.31 The following pages illustrate all the different blending modes in Photoshop. In these examples, the photograph of Stonehenge was added as a new layer above a gray textured Background layer and the layer settings recorded in the accompanying Layers panel header screen shots.

Normal

This is the default mode. Changing the opacity simply fades the intensity of overlaying pixels by averaging the color pixels of the blend layer with the values of the composite pixels below (the opacity was set here to 80%).

Dissolve

This combines the blend layer with the base using a randomized pattern of pixels. No change occurs when the Dissolve blend mode is applied at 100% opacity, but as the opacity is reduced, the diffusion becomes more apparent (the opacity was set here to 80%). The dissolve pattern is random, which is reset each time the application launches. There is actually a good example of the Dissolve blend mode in use on page 643.

Darken

The Darken mode looks at the base and blending pixel values and pixels are only applied if the blend pixel color is darker than the base pixel color value.

Multiply

Multiply multiplies the base by the blend pixel values, always producing a darker color, except where the blend color is white. The effect is similar to viewing two transparency slides sandwiched together on a lightbox.

Color Burn

This darkens the image using the blend color. The darker the color, the more pronounced the effect. Blending with white has no effect.

Linear Burn

The Linear Burn mode produces an even more pronounced darkening effect than Multiply or Color Burn. Note that the Linear Burn blending mode clips the darker pixel values and blending with white has no effect.

Darker Color

Darker Color is similar to the Darken mode, except it works on all the channels instead of on a per-channel basis. When you blend two layers together only the darker pixels on the blend layer remain visible.

Lighten

This mode looks at the base and blending colors and color is only applied if the blend color is lighter than the base color.

Screen

Multiplies the inverse of the blend and base pixel values together to always make a lighter color, except where the blend color is black. The effect is similar to printing with two negatives sandwiched together in the enlarger.

Color Dodge

Color Dodge brightens the image using the blend color. The brighter the color, the more pronounced the result. Blending with black has no effect (the opacity was set here to 80%).

Linear Dodge (Add)

This blending mode does the opposite of the Linear Burn tool. It produces a stronger lightening effect than Screen or Lighten, but clips the lighter pixel values. Blending with black has no effect.

Lighter Color

Lighter Color is similar to the Lighten mode, except it works on all the channels instead of on a per-channel basis. When you blend two layers together only the lighter pixels on the blend layer will remain visible.

Overlay

The Overlay blending mode superimposes the blend image on the base (multiplying or screening the colors depending on the base color) while preserving the highlights and shadows of the base color. Blending with 50% gray has no effect.

Soft Light

This darkens or lightens the colors depending on the base color. Soft Light produces a more gentle effect than the Overlay mode. Blending with 50% gray has no effect.

Hard Light

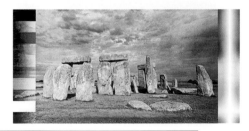

Hard Light multiplies or screens the colors depending on the base color. Hard Light produces a more pronounced effect than the Overlay mode. Blending with 50% gray has no effect.

Vivid Light

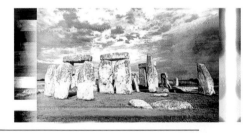

This applies a Color Dodge or Color Burn blending mode, depending on the base color. Vivid Light produces a stronger effect than Hard Light mode. Blending with 50% gray has no effect.

Linear Light

Linear Light applies a Linear Dodge or Linear Burn blending mode, depending on the base color. Linear Light produces a slightly stronger effect than the Vivid Light mode. Blending with 50% gray has no effect.

Pin Light

This applies a Lighten blend mode to the lighter colors and a Darken blend mode to the darker colors. Pin Light produces a stronger effect than Soft Light mode. Blending with 50% gray has no effect.

Hard Mix

Hard Mix produces a posterized image consisting of up to eight colors: red, green, blue, cyan, magenta, yellow, black and white. The blend color is a product of the base color and the luminosity of the blend layer.

Difference

This subtracts either the base color from the blending color or the blending color from the base, depending on whichever has the highest brightness value. In visual terms, a 100% white blend value inverts the base layer completely (i.e. turns to a negative). A black value has no effect and values in between partially invert the base layer. Duplicating a Background layer and applying Difference at 100% produces a black image. Difference is often used to detect differences between two near-identical layers in exact register.

Exclusion

The Exclusion mode is a slightly muted variant of Difference. Blending with white inverts the base image.

Subtract

This simply subtracts the pixel values of the target layer from the base layer. Where the result ends up being a negative value it is displayed as black.

Divide

This example doesn't really show you anything useful, but the Divide blend mode does have useful applications such as when carrying out a flat field calibration (see the website for more on how this blend mode can be used).

Hue

This preserves the luminance and saturation of the base image, replacing the hue color with the hue of the blending pixels.

Saturation

Saturation preserves the luminance and hue values of the base image, replacing the saturation values with the saturation of the blending pixels.

Color

Color preserves the luminance values of the base image, replacing the hue and saturation values of the blending pixels. Color mode is particularly suited to hand-coloring photographs.

Luminosity

This mode preserves the hue and saturation of the base image while applying the luminance of the blending pixels.

Photomerge layout options

Auto

In most cases I suggest you use the Auto option first to see what it does before considering the alternative layout options. Very often, Auto produces the best results.

Perspective

The Perspective layout can produce good results when the processed photos are shot using a moderate wide angle lens or longer, but otherwise produces rather distorted, exaggerated composites.

Cylindrical

The Cylindrical layout ensures photos are aligned correctly to the horizontal axis. This is useful for keeping the horizon line straight when processing a series of photos that make up an elongated panorama.

Spherical

This can transform and warp the individual photos in both horizontal and vertical directions. This layout option is more suitable when aligning multiple row panoramic image sequences.

Collage

This positions the photos in a Photomerge layout without transforming the individual layers, but does rotate them to achieve the best fit.

Reposition

The Reposition layout simply repositions the photos in the Photomerge layout, without rotating them.

Camera Raw lens corrections

When preparing images for stitching with Photomerge, it does not necessarily matter whether lens profile corrections have been applied in Camera Raw or not. However, Photomerge may do a better job if a good profile lens correction has been applied beforehand in Camera Raw.

Creating panoramas with Photomerge

The Photomerge feature allows you to stitch individual photos together to build a panorama image. There are two ways you can do this. You can go to the File ➪ Automate menu in Photoshop and choose Photomerge… This opens the dialog shown in Step 2, where you can click on the Browse… button to select individual files to process. If you have images already open in Photoshop, then click on the 'Add Open Files' button to add these as the source files. Alternatively, you can use Bridge to navigate to the photos you wish to process and open Photomerge via the Tools ➪ Photoshop submenu. Actually, there is now also a third way, which is to use the Photo Merge feature in Camera Raw. This is covered in the next section.

To get the best Photomerge results, you need to work from photographs where there is a significant overlap between each exposure. You should typically aim for at least a 25% overlap between each image and overlap even more if you are using a wide angle lens. For example, Photomerge is even optimized to work with fisheye lenses, providing Photoshop can access the lens profile data (see page 650), but with wide angle/fisheye lenses you should aim for maybe as much as a 70% overlap between each image. In the majority of cases the Auto layout option is all you will need to get good-looking panoramas, although the Cylindrical layout option is best to use for panoramic landscapes such as the example shown over the next few pages.

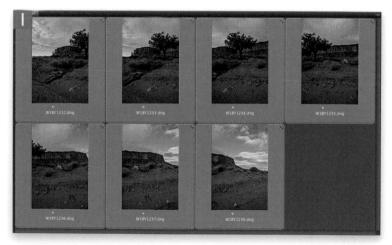

1 To create a Photomerge image, I started by selecting the seven photographs shown here in Bridge. I then went to the Tools menu in Bridge and chose Photoshop ➪ Photomerge…

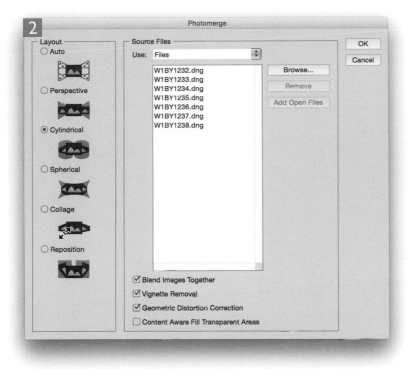

Blending options

The 'Blend Images Together' option completes the Photomerge processing because it adds layer masks to each of the Photomerged layers (see the Layers panel view in step 3). You can always choose not to run this option and select the Edit Auto-Blend Layers option later to achieve the same end result (see page 549). 'Vignette Removal' and 'Geometric Distortion Correction' are optional and can help improve the result of the final image blending, especially if you are merging photos that were shot using a wide angle lens. When the Geometric Distortion Correction checkbox is enabled, Photomerge aims to create a better stitch result by directly estimating the lens distortion in the individual image layers. Photomerge does not need to read the lens profile information except when it comes to handling fisheye lens photos.

2 This opened the Photomerge dialog, where you'll note that the selected images were automatically added as source files. Instead of using Auto, I selected the 'Cylindrical' layout option; I checked the three options at the bottom and clicked OK to proceed.

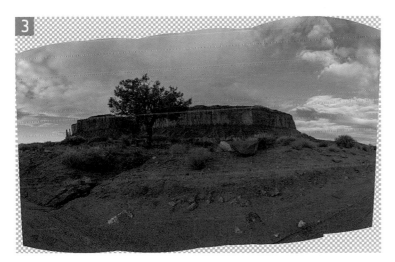

3 As you can see, this aligned the photos automatically and included a blend step to blend the tones and colors between the layers, followed by an auto layer mask step in which the individual layers ended up being masked so that each part of the Photomerge image consisted of no more than one visible layer.

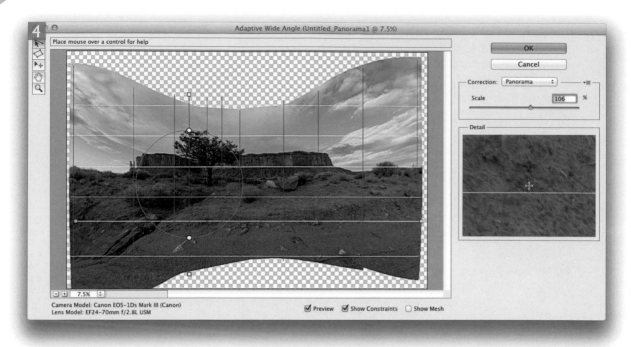

4 I merged all the layers in Step 3 and chose to apply the Adaptive Wide Angle filter. While some have thought of this filter as being specially designed for architectural photography, it also happens to be very useful when used on panorama landscape images. Sometimes the constrain area tool may be all you need. With this image I found it best to apply multiple constraint lines. For more about working with this filter, see page 652.

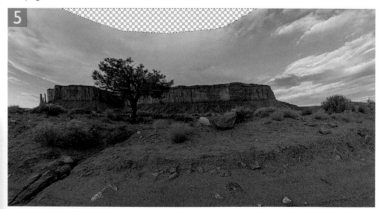

5 Typically you'll find that Photomerge panoramas will have missing gaps around the edges. It is quite easy to fill these in by using the Content-Aware Fill feature. I made a magic wand selection of the outer, transparent pixels. I then went to the Select menu, chose Modify ⇨ Expand and entered an amount of 5 pixels. I then went to the Edit menu and chose the Fill command, using the Content-Aware mode. This should successfully fill the selected area by sampling detail from the main image.

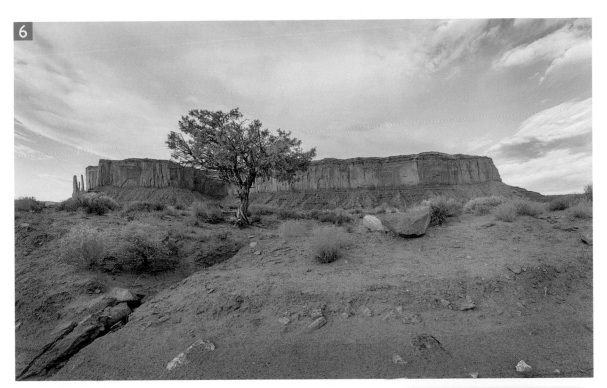

6 I was fairly pleased with the Step 5 result. But there are always small details that need some improvement. To achieve the finished step shown here I did a number of extra things. For example, you will have noticed that the composite image looked rather dark in the preceding steps. This was deliberate. You see, when using the Photomerge command, it does end up recalculating the brightness levels across the whole of the composite panorama area. In doing so this can cause the end points to become clipped. Even though the end points may not have appeared clipped in the original source layers, the Photomerge process can sometimes cause clipping to occur. To address this it is a good idea to soften the tone range in Camera Raw for all the images you are about to process so that you will have a safe margin of clipping, especially in the highlights. To create the final version shown above, I added a number of Curves adjustment layers. One was a masked layer that lightened the tree only, another applied a global contrast boost and lightening. Above that, I added a gradient masked layer to darken the sky and, finally, a vignette masked Curves layer to darken the edges.

The other thing I should mention here is that the images used to create this composite were all captured using an 22 megapixel digital SLR. The final composite seen here was approximately 8,370 x 4,490 pixels in size. This was roughly equivalent to a single 38 megapixel capture. Of course, I could also have checked the Content-Aware Fill Transparent Areas box in Step 2, which would have saved carrying out the Content-Aware Fill at Step 5.

Figure 8.32 The Camera Raw Photo Merge Panorama projection options.

Panorama Photo Merges in Camera Raw

The Photo Merge feature in Camera Raw is new and allows you to process multiple selections of images to create either a panorama stitch or an HDR image. Photo Merge saves these as demosaiced DNGs and as raw linear RGB data. Although the resulting images are partially processed you still retain the ability to apply Camera Raw edits and update to later process versions as they become available. Interestingly, Thomas Knoll included transparency support to DNG several years ago anticipating the possibility of carrying out Photo Merge processing at some point in the future with Camera Raw. Essentially, you can merge raw files to create an unprocessed master where you can then fine-tune the settings at the post-Photo Merge stage, adjusting things like the white balance and endpoint clipping. This is particularly helpful when using the Photo Merge feature in the Panorama mode. As I mentioned on the previous page, conventional Photoshop photomerge processing has a tendency to cause the highlight values to clip. You might carefully set the highlight end points at the pre-photomerge stage only to find them clipped in the resulting photomerge composite. The Photo Merge method in Camera Raw allows you to avoid this problem and maintain full control over the tones and avoid undesired clipping.

Creating Photo Merge panoramas

To create a Photo Merge panorama you need to open in Camera Raw a series of images that can be stitched together to form a panoramic view and then choose Select All, followed by Merge to Panorama… You will then be taken to a Panorama Merge Preview dialog, where you can select the desired projection method (Figure 8.32) and then click Merge. When carrying out a Photo Merge panorama the existing develop settings are applied as the initial develop settings to the resultant panorama DNG. However, you can quite easily apply any custom settings you like. Lens warp, vignette and chromatic aberration are applied to the images before stitching although settings that are not meaningful to the Photo Merge panorama process (such as local corrections and lens profiles) are ignored. The full-size merge is performed in the background so you can continue to edit other photos or start other merges while you wait. Photo merge panoramas created this way can also be processed using the Adaptive Wide Angle filter, just as in the previous example.

The panorama projection options

The Projection options are available in the Panorama Merge dialog (see Figure 8.32). The Cylindrical mode ensures the photos are correctly aligned to the horizontal axis. This mode is particularly appropriate when merging photographs that make up a super-wide panorama. It will ensure the horizon line is kept as straight as possible. The Perspective mode can produce good results when processing images that have been shot using a moderate wide angle lens or longer. With wider angle lens captures it can produce distorted-looking results. The Spherical mode transforms the photos both horizontally and vertically. This mode is more adaptable when it comes to aligning tricky panoramic sequences. So for example, where you shoot a sequence of images that consists of two or more rows of images, the Spherical projection mode may produce better results than the Cylindrical method.

Perspective projections

The Perspective projection is designed to work best with a sequence of images that capture a relatively small angle of view. If you use this method to merge a very wide angle view you may see an error message.

Merge preview dialog

Initially, you will see a fast preview in the merge dialog whenever you change any of the merge options and a yellow warning icon will be shown in the top right corner of the image. This will go away as a higher quality preview is built.

1 To begin with, I selected 6 photographs that had been shot in raw mode and photographed in a sweep to enable creating a photo merge panorama composite. I opened these in Camera Raw, chose Select All images and then selected Merge to Panorama… (⌘ M [Mac], ctrl M [PC]) from the Filmstrip menu. You can also hold down the Shift key as you do this, or use the ⌘ Shift M (Mac), ctrl Shift M (PC) shortcut to bypass the Panorama Merge Preview dialog shown in Step 2, and open in Headless mode.

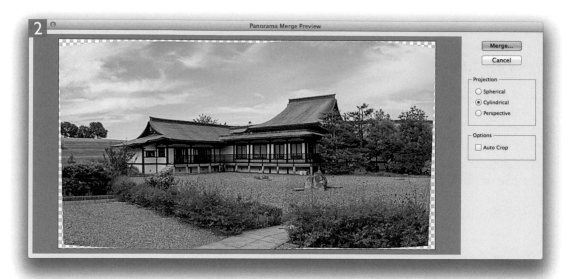

2 This prompted Camera Raw to analyze the raw image data of the selected files and generate a preview in the interim Panorama Merge Preview dialog shown here. This gave me the option to select the most appropriate projection method. In this instance I reckoned the Cylindrical option would produce the best result. I decided to leave the Auto Crop box unchecked. Also, if there are any source images that are unused in the resulting panorama, you'll see a warning message.

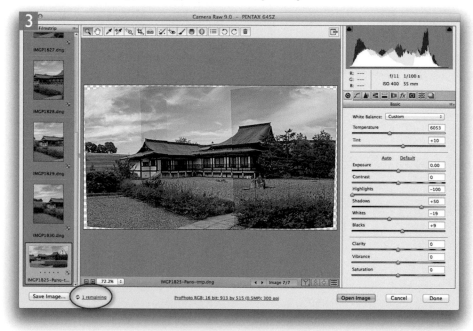

3 Having configured the settings in the Panorama Merge dialog, I clicked the Merge button. This initiated the Photo Merge process (to view status or cancel a merge, click on the link in the lower left area of the Camera Raw dialog [circled]).

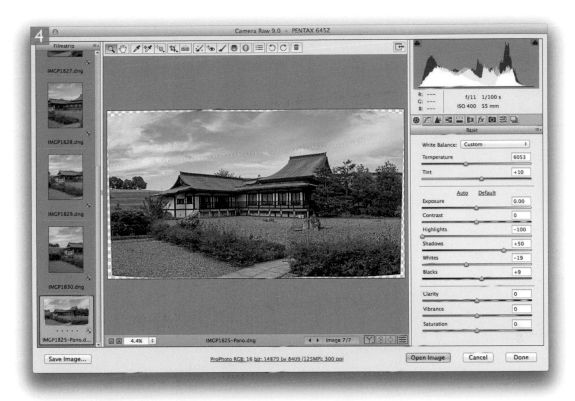

4 Shown here is the fully processed panorama merge. This composite retains the Camera Raw settings that were applied to the original, most selected image.

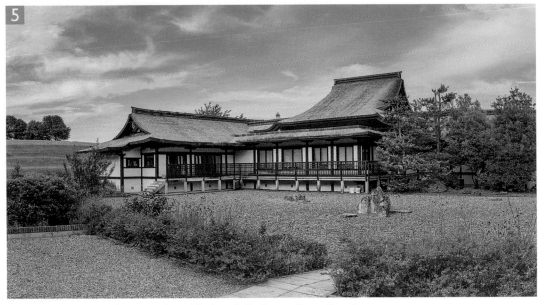

5 I was then able to crop the composite and further edit the Camera Raw settings to produce the modified version shown here.

Depth of field blending

The Edit ⇨ Auto-Blend Layers command allows you to blend objects that were shot using different points of focus and blend them to produce a single image with optimal focus.

1 I began by going to Bridge and selected a group of photographs that had been shot at different points of focus. These were photographed at a fixed aperture and with the camera mounted on a tripod. I then went to the Tools menu and chose Photoshop ⇨ Load Files Into Photoshop Layers.

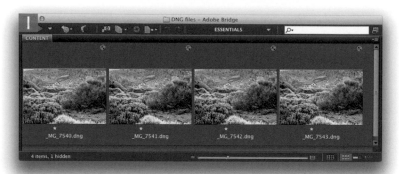

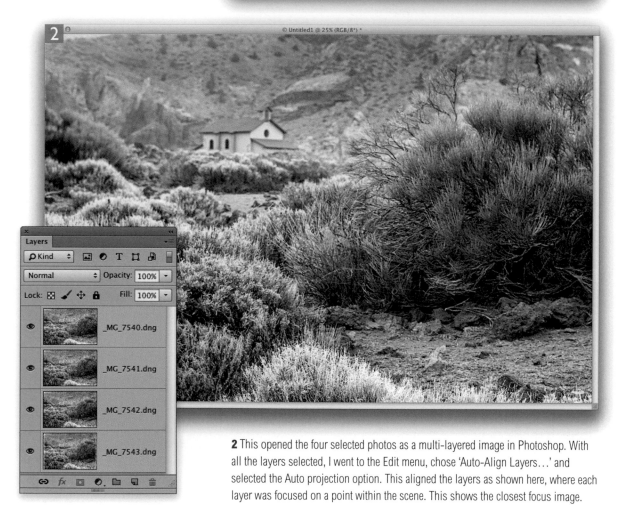

2 This opened the four selected photos as a multi-layered image in Photoshop. With all the layers selected, I went to the Edit menu, chose 'Auto-Align Layers…' and selected the Auto projection option. This aligned the layers as shown here, where each layer was focused on a point within the scene. This shows the closest focus image.

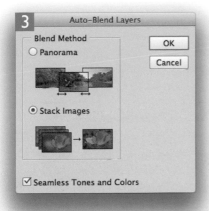

3 The next step was to merge the layered photos together, which I did by going to the Edit menu again and this time selected 'Auto-Blend layers…' I selected 'Stack Images' and made sure the 'Seamless Tones and Colors' option was checked.

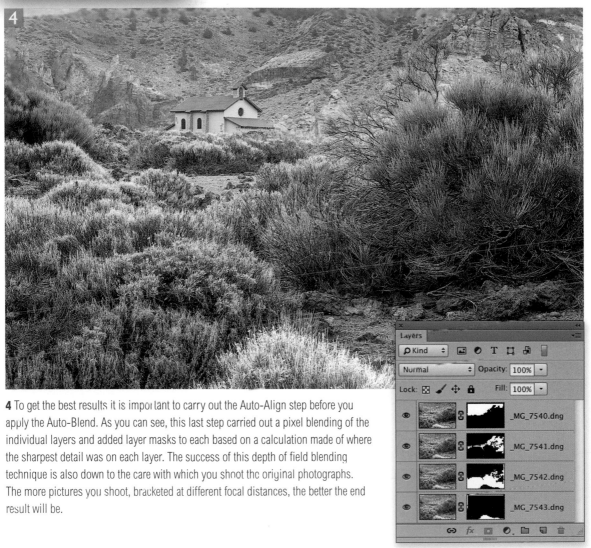

4 To get the best results it is important to carry out the Auto-Align step before you apply the Auto-Blend. As you can see, this last step carried out a pixel blending of the individual layers and added layer masks to each based on a calculation made of where the sharpest detail was on each layer. The success of this depth of field blending technique is also down to the care with which you shoot the original photographs. The more pictures you shoot, bracketed at different focal distances, the better the end result will be.

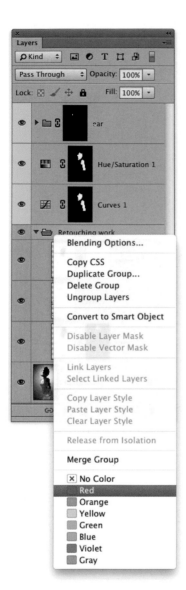

Working with multiple layers

Layers have become an essential feature in Photoshop because they enable you to do all kinds of complex montage work, but as the layers features have evolved there has been an increasing need to manage them more efficiently.

Color coding layers

One way to manage your layers better is to color code them, which can be done by selecting a layer and using the contextual menu shown in Figure 8.33 to pick the desired color label to color code the layer. You can also add and edit color labels on multiple layers at once.

Layer group management

Multi-layered images can be unwieldy to navigate, especially when you have lots of layers in an image. They can therefore be organized more efficiently if you place them into layer groups. Layer groups have a folder icon and the general idea is that you can place related layers together inside a layer group and the layer group can then be collapsed or expanded (the layer group icon reflects this). Therefore, if you have lots of layers in an image, layer groups can make it easier to organize the layers and layer navigation is made simpler.

If you click on the 'Create a new group' button in the Layers panel, this adds a new layer group above the current target layer, while ⌘ (Mac), *ctrl* (PC)-clicking on the same button adds a layer group below the target layer and *alt*-clicking opens the New Group from Layers dialog (see Figure 8.34). You can use Layer ➩ Group Layers. Or, simply select the layers in the Layers panel and use ⌘ G (Mac), *ctrl* G (PC) to place them into a layer group.

The Layer group visibility can be toggled by clicking on the layer group eye icon. It is possible as well to adjust the opacity and blending mode of a layer group as if it were a single layer, while the subset of layers within the layer group itself can have individually set opacities and use different blending modes. You can also add a layer mask or vector mask to a layer group and use this to mask the layer group visibility, as you would with individual layers. To reposition a layer in a Layer group, click on the layer and drag it up or down within the layer stack. To move a layer into a layer group, drag it to the layer group icon or drag to an expanded layer group. To remove a layer from a layer group, just drag the layer above or below the group in the stack (see page 552). You can lock all layers inside a layer group via the Layers panel fly-out submenu.

Figure 8.33 To color code a layer or layer selection, use a right mouse-click on a layer to access the contextual menu shown here and select a color from the bottom of the menu (the contextual menu varies depending on whether you click the layer thumbnail or just the layer).

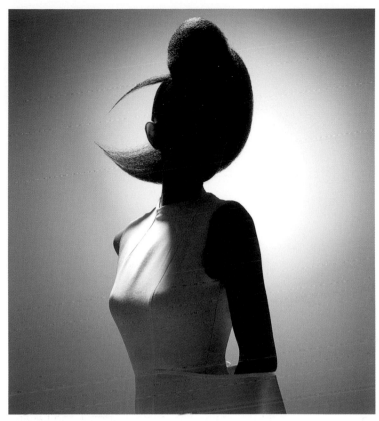

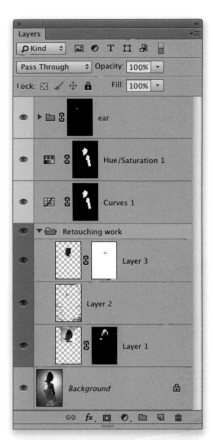

Figure 8.34 When a Photoshop document ends up with this many layers, the layer stack can become difficult to manage, but it is possible to organize layers within layer groups. In this example, I used a *Shift*-click to select the three retouching layers near the bottom of the layer stack. I then went to the Layers panel fly-out menu and chose 'New Group from Layers…' I named the new group 'Retouching work' and selected a red color to color code the layers within this group. Once I had done this, the visibility of all layers within this group could be switched on or off via the layer group eyeball icon and the opacity of the group could be adjusted as if all the layers in the group were a single merged layer.

Nested group layer compatibility

Since Photoshop CS5, a layer group, or multiple layer groups can be nested within a layer group up to ten nested layer groups deep. As a consequence of this, if a Photoshop CS5 (or later) image with more than five nested layer groups is opened in an earlier version of Photoshop, a warning dialog will be shown. In the case of Photoshop CS3 or CS4, you'll see a 'this document contains unknown data…' warning where you can choose one of the two options mentioned in the side panel in order to open the image.

Client: Andrew Collinge Hair & Beauty.
Hair by Andrew Collinge artistic team.
Make-up: Liz Collinge.

Nested layer group warnings

'Flatten' preserves the appearance of the document by reading the flattened composite data (provided Maximum Compatibility was switched on). The 'Keep Layers' option attempts to preserve all the layers but this may produce different-looking results.

Managing layers in a group

The following steps help illustrate the workings of the layer group management discussed on the preceding pages.

1 Layers can be moved into a layer group by mousing down on a layer and dragging the layer into the desired layer group.

2 The same method can be used when you want to move a layer group to within another layer group. Mouse down and drag the group to another layer group.

3 You can move multiple layers at once. Make a *Shift* select, or ⌘ (Mac), *ctrl* (PC) layer selection of the layers you want to move and then drag them to the layer group.

Instant layer grouping

Instead of choosing Layer ⇨ New ⇨ Group from Layers... and being shown the interim New Group from Layers dialog, you can simply select the layers you want to group and click on the New layer group button at the bottom of the Layers panel.

Collapse all layers

In the Layers panel menu there is a 'Collapse All Groups' menu item. You can use this to collapse all layer groups in a layered image document.

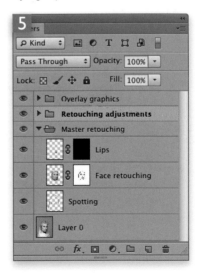

4 To remove a layer or layer group from a group, just drag it out of the layer group until you see a bold line appear on the divider above or below the layer group.

5 Here is a view of the Layers panel with the 'Retouching adjustments' group now outside and above the 'Master retouching' layer group.

Clipping masks

Clipping masks can be used to mask the contents of a layer based on the transparency and opacity of the layer or layer group beneath it. So, if you have two or more layers that need to be masked identically, one way to do this is to apply a layer mask to the first layer and then use this to create a clipping mask for the layer or layers above. Once a clipping mask has been applied, the upper layer or layers will appear indented in the Layers panel (Figure 8.35). You can alter the blend mode and opacity of the individual layers in a clipping group, but it is the transparency and opacity of the lower (masked) layer that determines the transparency and opacity of all the layers in the clipping mask group.

The main advantage of using clipping masks is that whenever you have a number of layers that are required to share the same mask, you only need to apply a mask to the bottom-most layer. Then when you create a clipping mask, the layer (or layers) in the clipping mask group will all be linked to this same mask. So for example, if you edit the master mask, the edit changes you make are simultaneously applied to the layer (or layers) above it.

How to create a clipping mask

To create a clipping mask, select a single layer or make a Shift selection of the layers you want to group together and choose Layer ⇨ Clipping Mask ⇨ Create. Alternatively, alt-click the border line between the layers. This action toggles creating and releasing the layers from a clipping mask group. Plus you can use the ⌘ ⌥ G (Mac), ctrl alt G (PC) keyboard shortcut to make the selected layer or layers form a clipping mask with the layer below.

Whenever you add an adjustment layer you can create a clipping mask with the layer below by clicking on the Clipping Mask button in the Properties panel. This allows you to toggle quickly between a clipping mask and non-clipping state (see Figure 8.36).

You can also create clipping masks at the same time as you add a new layer. In the example that's shown on the next few pages, you can see how I alt-clicked the 'Add New Adjustment Layer' button, which opened the New Layer dialog. This allowed me to check the 'Use Previous Layer to Create Clipping Mask' option (the same thing applies when you alt-click the 'Add New Layer' button).

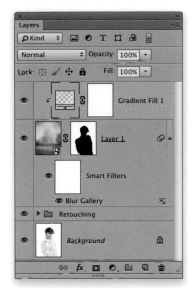

Figure 8.35 This shows an example of a clipping mask, where the Gradient Fill layer forms a clipping mask with the masked image layer beneath it. Note how the Gradient Fill layer in the clipping mask group appears indented in the layer stack.

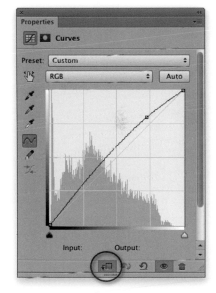

Figure 8.36 This shows the Clipping Mask button in the Properties panel that allows you to toggle between enabling and disabling a clipping mask with the layer beneath the adjustment layer.

Masking layers within a group

I use clipping masks quite a lot, but there is also another way that you can achieve the same kind of result and that is to make a selection of two or more layers and place them into a masked layer group (choose Layer ⇨ Group Layers). With the layer group selected, click on the Add Layer Mask button in the Layers panel to add a layer mask to the group. If you now edit the layer mask for the layer group, you can simultaneously mask all the layer group contents.

Clipping layers and adjustment layers

The following steps show how clipping masks can be used to group a fill layer with an image layer and how you can group two adjustment layers together so that they form a clipping mask.

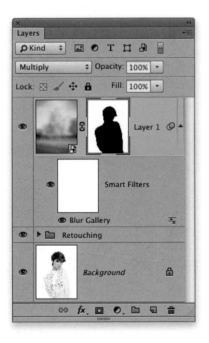

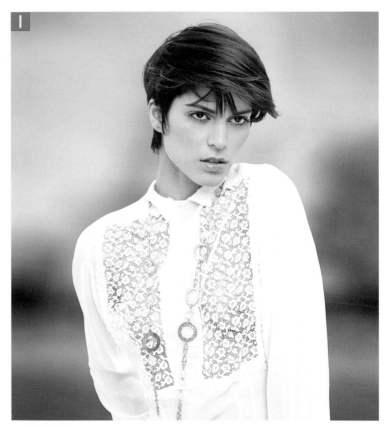

1 This shows a composite image in which I had carried out most of the retouching on the face and added a layer containing a new backdrop image. In this instance, the mask allowed the model image layer and retouching layers to show through from below.

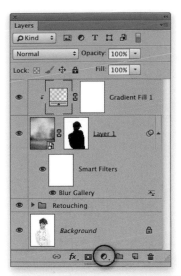

2 In this next step I added a linear Gradient Fill layer with a solid blue color fading to transparency. As you can see, when adding this new fill layer I created a clipping mask with the backdrop image layer. One way to do this was to hold down the *alt* key as I clicked on the 'Add New Adjustment Layer' button (circled). This opened the New Layer dialog shown here, where I checked 'Use Previous Layer to Create Clipping Mask'.

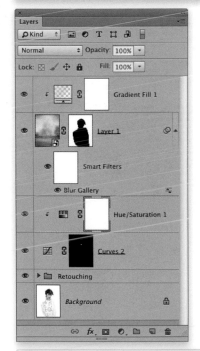

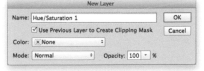

3 Lastly, I made a lasso selection of the model's eyes and added a new Curves adjustment to lighten them. I then did the same thing as in Step 2. I held down the *alt* key as I clicked on the 'Add New Adjustment Layer' button and chose a Hue/ Saturation adjustment. Again, I checked the 'Use Previous Layer to Create Clipping Mask' option. When I boosted the saturation in the Hue/Saturation layer, this adjustment was clipped to the same mask as the one used for the Curves adjustment.

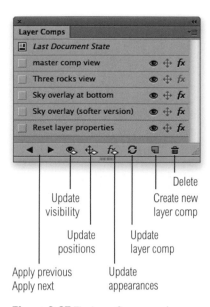

Update
visibility

Update
positions

Delete

Create new
layer comp

Update
layer comp

Apply previous
Apply next

Update
appearances

Figure 8.37 The Layer Comps panel.

Layer comp scripts

If you go to the File ⇨ Scripts menu you will find a number of script options. Layer Comps to Files… can be used to generate separate files from layer comps and Layer Comps to PDF… allows you to generate a PDF document based on the layer comps.

Layer Comps panel

As you work on a layered file you may find yourself in a situation where you are not sure which combination of layer settings looks best, or you may wish to incorporate different treatments within the one image document. In these kinds of situations the Layer Comps panel (Figure 8.37) can prove useful, because among other things, you can use it to store saved layer settings that can be contained within the document. This means you can experiment using different combinations of layer options and save these as individual layer comps. It is a bit like having the ability to save snapshots, except unlike history snapshots, layer comps are saved permanently with the file. You can save the current layer settings using the following criteria: you can choose whether to include the current layer visibility, the current position of the layer contents and, lastly, the current Layer Style settings, such as the blend mode, opacity or other blending options.

To save a layer comp setting, click on the 'Create new layer comp' button in the Layer Comps panel. This will open the dialog shown below in Figure 8.38. Here, you can give the new layer comp setting a name and select which attributes you wish to include. Once you have done this the new layer comp will be added to the Layer Comps panel list.

The Layer Comps panel uses icons to signify which attributes (visibility, position and appearance) have been saved for each layer comp. The buttons at the bottom allow you to update these attributes independently (for visibility, position and appearance), or update everything. There is also now a warning indicator icon if, for example, a smart object status invalidates other existing layer comps.

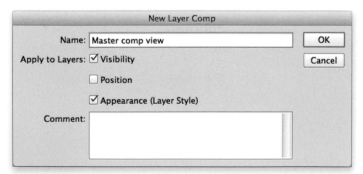

Figure 8.38 This shows the Layer Comps Options dialog. Here, you can see that I had just the Visibility and Appearance (Layer Style) options checked.

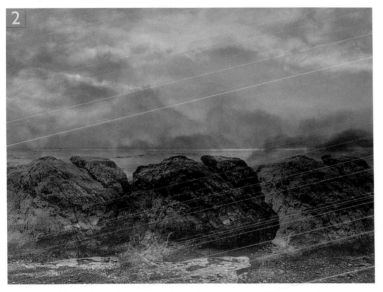

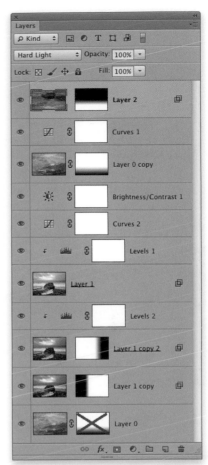

1 This shows a master layered file for a multi-layered image. As you can see, to produce the composite seen here, this image contains a variety of pixel and adjustment layers, which in turn used a number of different blending modes.

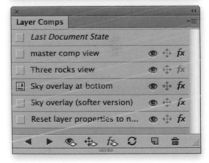

2 As I experimented with different versions of this composite, I saved each as a separate layer comp state. So in the example shown here, I created a layer comp in which all the layers were made visible and with a Hard Light blend mode set for the uppermost layer.

Layer linking

When working with two or more layers you can link them together, creating links via the Layers panel. Start by *Shift*-clicking to select contiguous layers, or ⌘ (Mac), *ctrl* (PC)-clicking to select discontiguous layers. At this point you can move the selected layers, apply a transform, or make the layers form a new layer group. However, if you need to make the layer selection linking more permanent, the layers can be formally linked together by clicking on the Link Layers button at the bottom of the Layers panel (circled in Figure 8.39). When two or more layers are linked by layer selection or formal linking, any moves or transform operations are applied to the layers as if they were one. However, they still remain as separate layers, retaining their individual opacity and blending modes. To unlink, select the layer (or layers) and click on the Link button to turn the linking off.

Selecting all layers

You can use the ⌘ ⌥ A (Mac), *ctrl* *alt* A (PC) shortcut to select all layers (except a Background layer) and make them active.

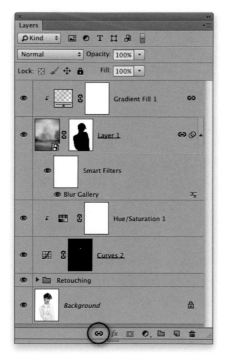

Figure 8.39 To link two or more selected layers, click on the Link button at the bottom of the Layers panel (circled).

Layer selection using the move tool

When the move tool is selected and the Auto-Select option is checked in the move tool options, you can auto-select layers (or layer groups) by clicking or dragging in the image (Figure 8.40), plus you can use the contextual menu to auto-select specific layers (Figure 8.41). You can also use ⌘ ⌥ ctrl (Mac), ctrl alt + right mouse (PC)-click to auto-select layers when the move, marquee, lasso or crop tools are selected.

Auto-Select shortcut

If Auto-Select Layer is unchecked, you can hold down the ⌘ (Mac), ctrl (PC) key to toggle auto-selecting layers or layer groups as you click or drag using the move tool.

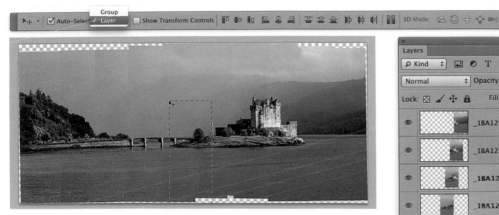

Figure 8.40 When Auto-Select Layer is checked, you can marquee drag with the move tool from outside the document bounds to make a layer selection of all the layers within the marqueed area, but the move tool marquee must start from outside the document bounds, i.e. you must start from the canvas area and drag inwards. In the example shown here, the Auto-Select and Layer options were selected and only the layers that came within the marquee selection were selected by this action.

Figure 8.41 When the move tool is selected, you can use the contextual menu to select individual layers. Mouse down on the image using ctrl (Mac), or a right mouse-click to access the contextual menu shown here and click to select a named layer. The contextual menu will list all of the layer groups in the document that are immediately below the mouse cursor. If there are any layer groups, the layers within the layer group will appear indented in the list.

Layer selection with the path selection tools

There is an option in the Option bar for the path selection and direct selection tools that allows you to select All Layers/Active Layers (see Figure 8.42). The All Layers mode retains the original Photoshop CC behavior. However, when Active Layers is chosen, the path selection tools will only be able to affect the layers that are currently active in the Layers panel. The steps shown on the following page help explain this more clearly.

Figure 8.42 This shows the Options bar for the path selection tool and the new pop-up menu offering a choice of All Layers/Active Layers.

Previously in Photoshop CC, when using the path selection or direct selection tools you could double-click on a vector path as a shortcut to switch to an isolation mode filter view of just that layer in the Layers panel. You could then double-click again on the path to toggle and revert to a full layer view again. This can still be done when you are in All Layers mode, but not if you have Active Layers selected. Flipping between these two modes can also be assigned a keyboard shortcut in the Tools section at the bottom of the list (see Figure 8.43).

Figure 8.43 If you go to the Edit menu in Photoshop and choose Keyboard Shortcuts… this opens the dialog shown here. If you select Shortcuts For: Tools and scroll to the bottom of the list you can assign a shortcut to toggle the new All Layers/Active Layers mode behavior.

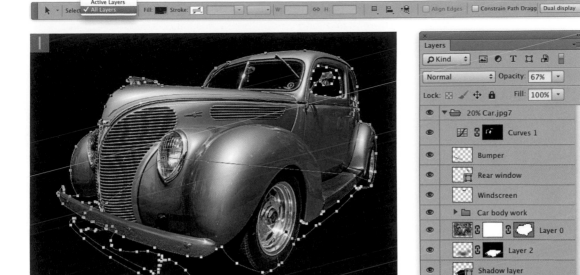

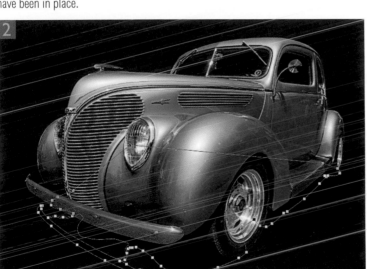

1 In this example the All Layers option was selected in the path selection tool Options bar. When I marquee dragged across the whole image with the path selection tool all the vector path layers became selected and with it the layers in the Layers panel associated with these paths. This was regardless of whatever layer selection might have been in place.

2 In this next example, just the three layers at the bottom were made active in the Layers panel. I set the path selection tool Options bar to Active Layers mode and marquee dragged across the whole image again. This time only the vector paths associated with the active layers in the selection made in the Layers panel became selected and the Layers panel selection remained unchanged.

Layer mask linking

Layer masks and vector masks are linked by default to the layer content and if you move a masked layer or transform the layer content, the mask is adjusted along with it (as long as no selection is active). When the Link button (⚭) is visible, you know the layer and layer mask are linked. It can sometimes be desirable to disable the link between the layer mask/vector mask and the layer it is masking. When you do this, movements or transforms can be applied to the layer or layer/vector mask separately. You can tell if the layer, layer mask or vector mask are selected, as a thin black dashed border surrounds the layer, layer mask or vector mask icon.

1 This photograph contained a clouds layer masked by the outline of the castle. The layer and layer mask are normally linked and here you can see a dashed border surrounding the layer mask, which means that the layer mask is currently active.

2 I then clicked on the link icon between the layer and the layer mask, which disabled the link between the mask and the layer. Now, when the layer was selected (note the dashed border around the layer thumbnail) I could move the sky layer independently of the layer mask.

Layer locking

The layer locking options can be found at the top of the Layers panel just below the blending mode options. Photoshop layers can be locked in a number of ways. To apply one of the locking criteria listed below, you need to first select a layer and then click on one of the Lock buttons. These have a toggle action, so to remove the locking, just click on the button again. This mechanism can also be used to lock/unlock multiple layers.

Lock Transparent Pixels

When Lock Transparent Pixels is enabled (Figure 8.44), any painting or editing you do is applied to the opaque portions of the layer only. Where the layer is transparent or semi-transparent, the level of layer transparency will be preserved.

Lock Image Pixels

The Lock Image Pixels option (Figure 8.45) locks the pixels to prevent them from being edited (with, say, the brush tool or clone stamp). If you attempt to paint or edit a layer that has been locked in this way, you will see a prohibit warning sign. This lock mode does still allow you to move the layer contents though.

Lock Layer Position

The Lock Layer Position option (Figure 8.46) locks the layer position only. This means that while you can edit the layer contents, you won't be able to accidentally knock the layer position with the move tool or apply a Transform command.

Lock All

You can select combinations of Lock Transparent Pixels, Lock Image Pixels, and Lock Layer Position, plus you can also check the Lock All option (Figure 8.47), or use the ⌘ / (Mac) *ctrl* / (PC) shortcut. When this option is selected, the layer position is locked, the contents cannot be edited and the opacity or blend modes cannot be altered. However, the layer can still be moved up or down the layer stack.

The above options mainly refer to image layers. When working with non-pixel layers you can only choose to lock the layer position or lock all.

Figure 8.44 This shows the Layers panel with an image layer selected. The Lock Transparent Pixels option prevents you painting in the layer's transparent areas.

Figure 8.45 Lock Image Pixels prevents you accidentally painting on any part of the layer.

Figure 8.46 Lock Layer Position prevents the layer from being moved when you edit it.

Figure 8.47 The Lock All box locks absolutely everything on the layer.

Generator: generating assets from layers

The Generator feature uses a customizable JavaScript-based platform and can be utilized to automatically create derivative files from the master image you are working on. To get set up you'll first need to go to the Photoshop Plug-ins preferences and check the Enable Generator box. This launches Generator so it is always running in the background. Following that you'll need to enable Generator for each image document you are working on. To do this, select File ⇨ Generate ⇨ Image Assets. This initiates Generator for the selected document and the setting remains sticky the next time you reopen the image. Once you have followed these steps you can follow specific layer naming conventions to determine how derivative files will be created. You see, Generator uses the layer or layer group naming to determine what derivative files are created and, more specifically, their attributes: such as the file format used, the quality setting and image size. Basically, you define the desired file output by the way you name the layers. For example, adding a file format suffix, such as .jpg, .png, or .gif, lets you indicate the file format you want the derivatives to be saved in. You can specify more precisely how the file is to be saved. If you add .png to a layer name, it will (by default) create a PNG 32 file. But if you wish, you can specify other PNG formats such as: *.png8*, or *.png24*. With JPEG you can specify the desired image quality setting (from 1 to 10) by adding a number. The default JPEG quality setting is 9, so adding *.jpg6* creates a JPEG file saved using a 6 quality setting. To specify the JPEG quality more precisely you can add a percentage value. So you can type *.jpg55%* to save a JPEG that uses a 55% quality setting. However, the .gif tag saves a basic alpha transparency GIF and there are no other options that can be specified using Generator.

Extended tagging

Other tags can be used to specify size by adding one of the following tags at the beginning of the layer name. To adjust the size by percentage you can type in a percentage scale value, such as *25%* or *33%* at the beginning of the layer name. To adjust the size to fit within specific dimensions, enter the desired unit dimensions. For example, 600 x 400 can be used to specify creating a file that fits within a 600 x 400 pixel size (Generator uses pixel values unless otherwise specified). So, you would need to add *in* (for inches), *cm* (for centimeters) and *mm* (for millimeters). Tags can be separated by commas when naming a layer to indicate that more than one type of file

should be generated (but each tag must be properly formatted with a valid file extension). For example, naming a layer *20% garden.png, 10in x 8in garden.jpg8* will create a 20% scaled PNG, plus a 10 inch x 8 inch JPEG file saved using a quality 8 setting. To cope with this the file naming in Photoshop now accommodates names up to 255 characters long.

Summary of how Generator works

Let me summarize what happens in the background when you use Generator. Whenever you work on a brand new image and File ⇨ Generate ⇨ Image Assets has been activated, assets are initially saved to a generic assets folder on the desktop, most likely named: Untitled-1-Assets. Whatever assets have been generated will be saved to this folder. Once a master file has been saved though, an assets folder is created alongside the parent file inside whatever folder directory you chose to save the file to. This assets folder uses the same name as the file it relates to. The original desktop assets folder (which was temporary) then disappears. All subsequent edits made to the open image will continue to generate updated assets, regardless of whether the master file has been saved and the parent file updated.

Generator uses

Generator is a feature that should be of interest to a lot of different types of Photoshop users. The following example shows a simple use of generator in which it was used to create a low res composite JPEG version of a layered image. This would continuously get updated as the file was worked on. A practical use for this type of workflow would be the ability to have instant access to a low res, composite version of the image you are working on, ready to email to a client. A photographer might also use Generator to generate image assets at dual pixel resolutions for inclusion in a Web layout optimized for high density pixel displays. Overall, I would say this feature was devised mainly with multimedia designers in mind. By using Photoshop CC in conjunction with the Edge Reflow CC program, designers can use Generator to work on a master file in Photoshop and generate Web asset files that are automatically updated in real time. For instance, designers at The Engine Co, have used Generator to write a plug-in for their Loom gaming engine. This allows them to update the user interface for a game in Photoshop while it is being played. Generator also allows designers to generate Retina resolution assets to accompany regular resolution versions. All in real time.

Adobe Edge Reflow CC
Adobe Edge Reflow CC is a new Web tool that can be used to create responsive Web designs that adapt content to different screen sizes. Using Edge Inspect CC, it is possible to extract the CSS code from an Edge Reflow project to work on in other code editors, such as Dreamweaver.

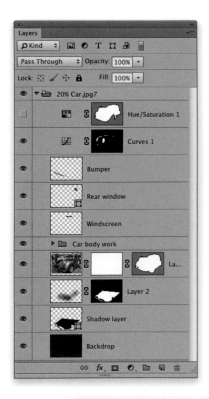

1 Here is an open image document where in the Plug-ins preferences I had checked Enable Generator. With the document open, I went to the File menu and chose Generate ⇨ Image Assets. I arranged all the layers into a single layer group and named this '20% Car.jpg7'. This naming specified creating a JPEG file resized to 20% of the original image's file size using a JPEG quality setting of 7.

2 I then saved the image and because Generator was enabled, this automatically created an assets folder identified using the file name of the original image. Inside this you can see it generated a reduced size JPEG version of the master image.

3 I then selected the masked Hue/Saturation layer below and clicked on the eyeball in the Layers panel to enable the adjustment. This changed the color of the car from green to mauve and the JPEG image stored in the accompanying assets folder was automatically updated (regardless of whether I had saved at this stage or not).

4 To check this was the case, I once again visited the file's assets folder and saw the JPEG version had been updated to show the car with the new, changed color.

Generator syntax

As mentioned in the main text, if you target a layer or layer group that uses Generator syntax, this can be used to influence how assets are exported. But the extended tagging must include a file format tag that matches the format that is being exported. For instance, if you name a layer group '30% Car.jpg70%' and export using JPEG, this will save a full resolution JPEG and alongside it a 30% scaled image saved as a 70% quality JPEG. If you were to export as a PNG, say, then the extended tagging will be ignored and just a full-size PNG file will be exported.

Export options

Photoshop CC has new export options for RGB mode images. These are available via the File ⇨ Save for Web menu and also via the Layers panel. This feature allows you to export your documents, layers, or layer groups faster and with fewer steps.

First, I suggest you go to the Export preferences (Figure 8.48), where you can configure what happens when you choose an export option. The Quick Export Default section allows you to choose which format the files can be saved in when applying a quick export and whether transparent pixels are to be preserved or not. In the Export Location section you can either have the option to be asked where to save asset files each time, or to always export to an assets folder next to the current document.

When you choose File ⇨ Save for Web ⇨ Quick Export as…, or go to the Layers panel menu and choose Quick Export as…, the assets saved will depend on what is selected in the document and whether Generator extended tagging has been utilized. In general, when you choose Quick Export, this exports a full resolution version of the image saved to the specified format. If a layer or layer group is targeted and extended tagging has been used in the naming, a full resolution version will get exported as well as one with the attributes specified using the Generator syntax.

If you want more control over the export process, choose File ⇨ Save for Web ⇨ Export as… This opens the Export Preview dialog shown in Figure 8.49, where you have complete control over the file format selection, the file format settings, the image size you wish to scale the export to as well as the canvas size. As with Quick Export, the export location depends on the settings configured in the Export preferences.

Exporting a layer

You can also export individual layers. To do this, target a specific layer or layer group and choose Quick Export As…, or Export As… from the Layers panel menu. In the case of a layer group, you will be exporting a merged version of the layers contained in the group. If you select a number of individual layers and choose Quick Export As…, you'll export separate files for each layer. If you choose the Export As… option you'll see a filmstrip of the selected layers appear down the left hand side of the Export Preview dialog, which allows you to see the layers listed. When you click Export…, again, all the layers will be exported as separate files.

Figure 8.48 The Export preferences.

File format options

Image size options

Canvas size options

Reset canvas to original size

Switch background color from light to dark

Figure 8.49 The Export Preview dialog.

Figure 8.50 This shows the Libraries panel where in the top screen shot I clicked on the top menu to select 'Create new Library…' The bottom panel shows how I was then asked to name the new library.

Creative Cloud Libraries

New to Photoshop, as well as to several other programs and apps in the Creative Cloud, is the Libraries panel. To access, choose Window ⇨ Libraries. This is a panel you can use to hold library collections of graphic assets, text styles, layer styles and colors (see Figure 8.50). As you work on a project you can click on the buttons at the bottom of the panel to add any of these items to build a library of design elements associated with a particular job. You can then save these as individual creative libraries, to be reused on other, similar projects. Libraries can be accessed and used on a single offline computer. However, they are also synced to your Adobe ID account, which means they can be easily shared with other machines that share the same user account. And as I mentioned at the beginning, library items can be shared across other Adobe programs. Essentially, this feature is like a super clipboard. Normally when you copy something only one item can be stored at a time in the clipboard memory. Using libraries you can use this as a place to store multiple design elements. In the Figure 8.51 example I used the Libraries panel to store a number of graphic assets that were associated with a house build project, along with a few custom color samples. When loaded I could simply drag and drop graphic elements from this panel, or click on a color sample to load this as the foreground color.

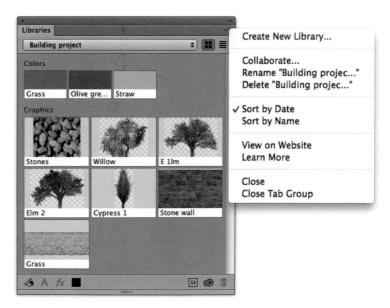

Figure 8.51 This shows the Libraries panel with Colors and Graphics elements added for a project I was working on.

Sharing libraries with other users

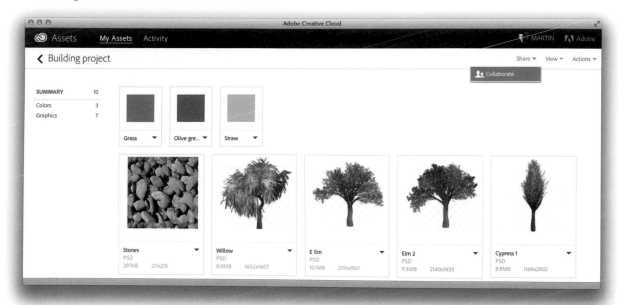

1 If you click on Collaborate… in the Libraries panel fly-out menu, this will take you to the web page shown here. In this example it opened the Building Project library assets I had opened in (Figure 8.51). You can then click on the Share menu and click on 'Collaborate' to invite other users to share a particular library. Note that you'll first need to go to the following link: tinyurl.com/qe6vq3s to set a cookie file that enables Library sharing on your creative cloud assets page. If you need to disable this feature go to: tinyurl.com/muergbe.

2 This shows the Collaborators pop-up window, where you can send emails to invite others to share specific libraries.

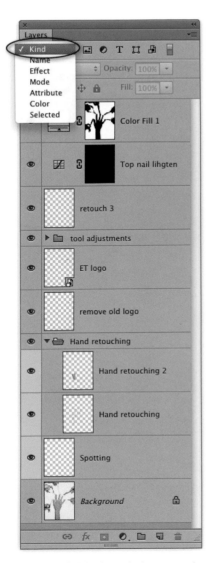

Figure 8.52 This shows the Layers panel for a multi-layered image and the filter layer options that are available.

Smarter naming when merging layers

When you merge a selection of layers together in Photoshop, the usual convention has been for the merged layer to take on the name of the uppermost layer in that layer selection. Now, Photoshop is a little smarter in that it ignores any of the default layer names such as 'Layer 1' or 'Curves' and uses the top-most, manually renamed layer to name the merged layer. It is a subtle change in behavior that makes some sense. However, a downside of this change (which was introduced to Photoshop CS6.1) is that some Photoshop actions can fail to work correctly as a result of this.

Layer filtering

Layer filtering can be used to determine what gets displayed within the Layers panel depending on the selected criteria. To filter the layers in an open document, select one of the filter options from the menu circled in Figure 8.52. Here, you can choose to filter the layers by Kind, Name, Effect, Mode, Attribute, Color or Selected. You'll notice there is also a switch in the top right of the Layers panel. This is colored red when a filter of any kind is active and you can click on the switch to toggle the layer filtering on or off. Note that none of the filtering options are recordable as actions.

When the default Kind option is selected you can filter using the following criteria: pixel layers, adjustment layers, type layers, Vector layers, Movie layers or Smart Objects (see the examples shown in Figure 8.53). If you filter by 'Name' you can search for any layers that match whatever you type into the text box. So for instance, in the bottom right example in Figure 8.53 I typed in 'retouching', which revealed all the layers with the word 'retouching' in their layer names. It so happens you can also use the Select ⇨ Find Layers menu command (⌘ ⌥ Shift F [Mac], ctrl alt Shift F [PC]) to carry out a layer filter search by 'Name'.

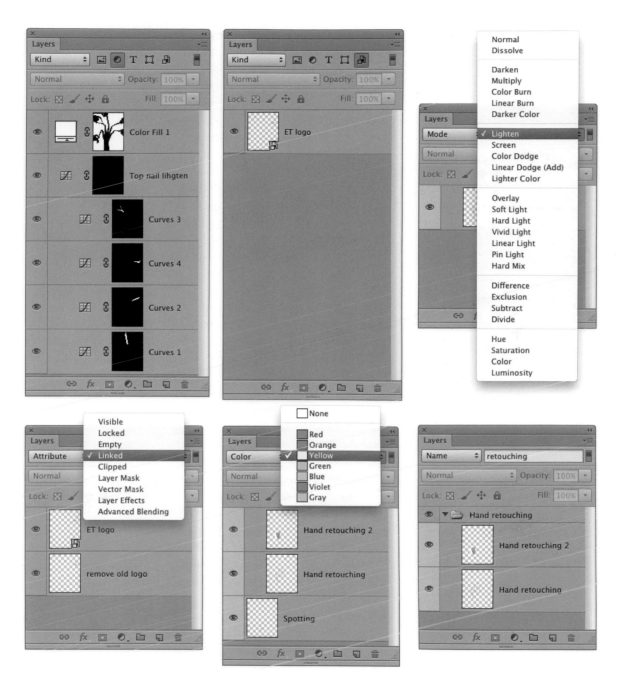

Figure 8.53 Here are examples of some layer filter searches. Top left shows a filter search by 'Kind', searching for adjustment layers only. Top middle, a search by 'Kind' for Smart Objects only. Top right shows a search by 'Mode' to filter by the Lighten blending mode. Bottom left shows an 'Attribute' search for layers that are linked. Bottom middle shows a 'Color' search for layers that are colored yellow. Bottom right shows a 'Name' search for layers that include the word 'retouching'.

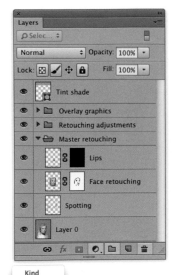

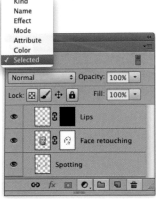

Figure 8.54 Invoking isolation mode.

Figure 8.55 The path selection/direct selection contextual menu.

Isolation mode layer filtering

Isolation mode is an additional layer filtering option that allows you to filter the active selected layers in a document. This means you can specify a subset of layers within a document and isolate them so that only these layers are visible in the Layers panel (although all other layers will remain visible in the document). Tool use then becomes restricted to just the selected layers, but you can add, duplicate, reorder or delete any of the visible layers while they are in the filtered state. You can modify an isolated layer selection by targeting a layer and choose 'De-isolate Layer' from the Select menu or contextual menu (use *ctrl* [Mac], or a right mouse-click to access).

To invoke the isolation mode, make a selection of layers active and enable the 'Isolate Layers' option via the Select menu, or select the Selected filter mode. To undo, select 'Isolate Layers' again, or click on the filter switch to disable the filtering. You can also invoke 'Isolate Layers' via the contextual menu for the move tool. In Figure 8.54 three pixel layers were active. When layer filtering was enabled using the 'Selected' mode only these three layers remained visible within the Layers panel.

When either the path selection or direct selection tools are active you can use *ctrl* (Mac), or a right mouse-click to access the contextual menu and choose 'isolate Layers' to enable/disable the isolation mode layer filtering (see Figure 8.55). Also, double-clicking on an active shape layer path using either of these tools automatically isolates the targeted layer. Double-click again to de-isolate the layer again (providing you are in All Layers mode [see page 560]).

Although tool usage is restricted to the selected layers only, when the move tool is selected and in auto-select layer mode, you can click with the move tool on the image to auto-add additional layers to an isolation mode filtered selection.

Whenever a layer filter is active most normal layer functions will remain active. This means that you can still edit layers, reorder or delete them. Layer filter settings aren't saved when you close a document, but the layer filtering settings do remain sticky for as long as a document remains open in Photoshop and any layer filters you apply will also be persistent for each individual document. Only one filter type can be active at a time, so it is currently not possible to apply multiple filter criteria to the layers in an image. And, when filtering a new document, you will always encounter the normal default layer filtering state when filtering for the first time.

Transform commands

There are a range of options in the Image ⇨ Image Rotation submenu (Figure 8.56). These allow you to rotate or flip an image. For example, you can rotate an image 180° where a photo has been scanned upside down.

The Transform commands are all contained in the Edit ⇨ Transform menu (Figure 8.57) and these allow you to apply transformations to individual or linked groups of layers. There are three main ways you can apply a transform. You can select a layer or make a pixel selection that you wish to transform and choose either Edit ⇨ Transform, or Edit ⇨ Free Transform. Also, whenever a layer plus one of the selection tools is selected, the Free Transform command is available via the contextual menu (just *ctrl* [Mac], or right mouse-click on a layer and select 'Free Transform'). Another option is to check the Show Transform Controls box in the move tool Options bar (Figure 8.58).

The main Transform commands include: Scale, Rotate, Skew, Distort and Perspective, and these can be applied singly or combined in a sequence before clicking *Enter*, or double-clicking within the Transform bounding box to OK a transformation. The interpolation method used when calculating a transform can be selected from the Interpolation menu in the modal Transform Options bar (see next page).

You can apply any number of tweaking adjustments before applying the actual transform and you can use the undo command (*⌘ Z* [Mac], *ctrl Z* [PC]) to revert to the last defined transform preview setting. You can also adjust the transparency of a layer mid-transform. This means you can modify the opacity of the layer as you transform it (this can help you align a transformed layer to the other layers in an image).

Of all the transform options, the Free Transform is the most versatile and the one you'll want to use most of the time. Choose Edit ⇨ Free Transform or use the *⌘ T* (Mac), *ctrl T* (PC) keyboard shortcut and modify the transformation using the keyboard controls as indicated on the following pages. When you are in transform mode, the Options bar offers you precision controls as well as other options.

Figure 8.56 The Image ⇨ Image Rotation submenu can be used to rotate or flip the entire image.

Figure 8.57 The Edit ⇨ Transform submenu can be used to transform or rotate individual layers or linked groups of layers.

Figure 8.58 The move tool Options bar also allows you to 'Show Transform Controls'.

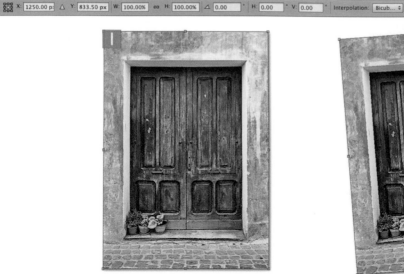

1 You can rotate, skew or distort an image in one go using the Edit ⇨ Free Transform command. The following steps show you some of the modifier key commands that can be used to constrain a free transform adjustment. You can place the cursor outside the bounding border and drag in any direction to rotate the image. If you hold down the _Shift_ key as you drag, this constrains the rotation to 15° increments. You can also move the center axis point to change the center of the rotation.

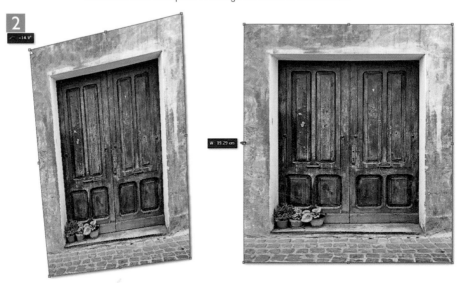

2 If you hold down the ⌘ (Mac), _ctrl_ (PC) key as you click any of the handles of the bounding border, this will allow you to carry out a free distortion. If you want to constrain the distortion symmetrically around the center point of the bounding box, hold down the _alt_ key as you drag any handle.

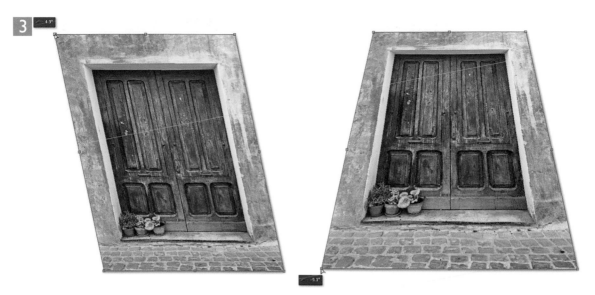

3 To skew an image, hold down the ⌘ ⌥ (Mac), *ctrl* *alt* (PC) keys and drag any one of the corner handles. To carry out a perspective distortion, hold down the ⌘ ⌥ *Shift* (Mac), *ctrl* *alt* *Shift* (PC) keys in unison and drag on one of the corner handles. When you are happy with any of the new transform shapes described here, press *Enter* or *Return* or double-click within the transform envelope to apply the transform. Press *esc* if you wish to cancel.

Repeat Transforms

After you have applied a transform to an image layer or image selection, you can get Photoshop to repeat the transform by going to the Edit menu and choosing: Transform ⇨ Again (the shortcut here is ⌘ *Shift* *T* [Mac], *ctrl* *Shift* *T* [PC]). This can be done to transform the same layer again, or you can use this command to identically transform the contents of a separate layer. I generally find the Transform Again command is most useful when I need to repeat a precise transform on two different layers, a similar object within the image, or on a separate image.

Interpolation options

The Interpolation menu allows you to select one of the following options: Nearest Neighbor, Bilinear, Bicubic, Bicubic Sharper, Bicubic Smoother, or Bicubic Automatic (but not 'Preserve Details'). These are exactly the same as the General preferences options and the options bar interpolation setting remains sticky while you are working in Photoshop.

Numeric Transforms

When you select any of the Transform commands from the Edit menu, or check 'Show Transform Controls' in the move tool options, the Options bar displays the Numeric Transform commands shown below in Figure 8.59. The Numeric Transform options allow you to accurately define any transformation as well as choose where to position the centering reference point position. For example, the Numeric Transform can commonly be used to change the percentage scale of a layer, where you just enter the scale percentages in the Width and Height boxes. If the Constrain Proportions link icon is switched off you can set the width and height independently. You can also change the central axis for the transformation by repositioning the white dot (circled) from its default center position. For example, if you click in the top left corner you can have all transforms (including numeric transforms) default to centering around the top left corner.

Figure 8.59 This shows the move tool Options bar in Transform mode. The same Options bar controls are seen when a selection is active and you choose Select ⇨ Transform Selection.

Transforming paths and selections

You can also apply transforms to Photoshop selections and vector paths. For example, whenever you have a pen path active, the Edit menu switches to show 'Transform Path'. You can then use the Transform Path commands to manipulate a completed path or a group of selected path points (the path does not have to be closed). You just have to remember you can't execute a regular transform on an image layer (or layers) until *after* you have deselected any active paths.

To transform a selection, choose Select ⇨ Transform Selection (note, if you choose Edit ⇨ Transform, this transforms the selection contents). Transform Selection works just like the Edit ⇨ Free Transform command. You can use the exact same modifier key combinations to scale, rotate and distort the selection outline. Or, you can use *ctrl* (Mac), or right mouse-click to call up the contextual menu of transform options.

Transforms and alignment

When you have more than one layer in an image, the layer order can be changed via the Layer ⇨ Arrange submenu (Figure 8.60), which can be used to bring a layer forward or send it further back in the layer stacking order. You can also use the following keyboard shortcuts. Use ⌘] (Mac), ctrl] (PC) to bring a layer forward and ⌘ [(Mac), ctrl [(PC) to send a layer backward. Use ⌘ Shift] (Mac), ctrl Shift] (PC) to bring a layer to the front and ⌘ Shift [(Mac), ctrl Shift [(PC) to send a layer to the back.

If two or more layers are linked, these can be aligned in various ways via the Layer ⇨ Align menu (Figure 8.61). To use this feature, first make sure the layers you want to align are selected, or are linked together, or in a layer group. The Align commands can then be used to align the linked layers using the different rules shown in the submenu list, i.e. you can align to the Top Edges, Left Edges, Bottom Edges, Vertical Centers, Horizontal Centers or Right Edges, and the alignment will be based on whichever is the top-most layer, left-most layer, etc. There is also a Distribute submenu, which contains an identical list of options to the Align menu, but is only accessible if you have three or more layers selected, linked, or in a layer group. The Distribute commands allow you to distribute layer elements evenly based on either the Top, Vertical Centers, Bottom, Left, Horizontal Centers or Right edges. So for example, if you had three or more linked layer elements and you wanted them to be evenly spread apart horizontally and you also wanted the distance between the midpoints of each layer element to be equidistant, you would select all the layers and choose Layer ⇨ Distribute ⇨ Horizontal Centers.

Rather than use the Layer menu options you can click on the Align and Distribute buttons in the move tool Options bar (Figure 8.62). Generally, I would say the Align and Distribute features are perhaps more useful for graphic designers, where they might need to precisely align image or text layer objects in a Photoshop layout.

Arrange, Align and Distribute shortcuts
Note here that all the Layer menu and Layers panel shortcuts are listed in a separate appendix which is available from the book website as a PDF document.

Figure 8.60 The Layer ⇨ Arrange submenu.

Figure 8.61 The Layer ⇨ Align submenu.

Figure 8.62 This shows the move tool Options bar in alignment/distribution mode. Note that the alignment options (shaded blue) will only become available when two or more layers are selected and the distribution options (shaded green) are only available when three or more layers are selected. Shaded in red is the Auto-Align Layers button. Clicking this is the same as choosing: Edit ⇨ Auto-Align Layers when two or more layers are selected.

Warp transforms

The Warp transform is provided as an extension of the Free Transform. Start by selecting the Free Transform option from the Edit menu and then click on the Transform/Warp mode button (circled in Figure 8.63) to toggle between the Free Transform and Warp modes. The beauty of this is that you can combine a free transform and warp distortion in a single pixel transformation. It has to be said that the magic of the Warp transform has been somewhat superseded by the Puppet Warp adjustment, but it is still nonetheless a very useful tool.

When the Warp option is selected you can control the shape of the warp bounding box using the bezier handles at each corner. The box itself contains a 3 × 3 mesh and you can click in any of the nine warp sectors, and drag with the mouse to fine-tune the warp shape. What is also great about the Warp transform is the way that you can make a warp overlap on itself (as shown on the page opposite).

You can only apply Warp transforms to a single layer at a time, but if you combine layers into a Smart Object, you can apply non-destructive distortions to multiple layers at once. For more about working with Smart Objects see pages 593–596.

Warp transforms are better suited for editing large areas of a picture where the Liquify filter is less able to match the fluid distortion controls of the Warp transform. However, as I just mentioned, the Puppet Warp (see pages 587–592) is also worth considering as an ideal tool for this type of image manipulation work.

Figure 8.63 To apply a Warp transform you need to select a layer or an image selection and choose Edit ⇨ Transform ⇨ Warp. Alternatively, choose Edit ⇨ Free Transform (⌘ *T* [Mac], *ctrl* *T* [PC]) and in the Options bar click on the Transform/Warp mode selection button (circled). Once this is selected, you will be in the default Custom warp mode, but you can also select from any of the preset warp mode options that are listed in the Warp menu on the left. When you select one of these preset options, you can adjust the warp settings using the Options bar controls. These allow you to control the Bend, Horizontal and Vertical percentage distortion.

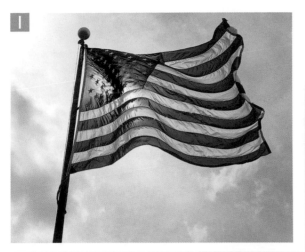

1 In this example I took a photograph of a US flag, separated out the flag from the flag pole on a separate layer and placed both these elements as individual layers above a separate sky backdrop and converted the Flag layer to a Smart Object.

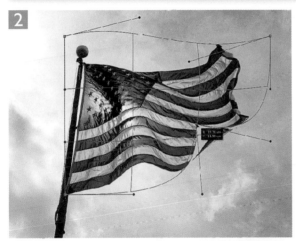

2 I then went to the Edit menu and selected Edit ⇨ Transform ⇨ Warp. The default option is the 'Custom' mode, where I had access to the bezier control handles at the four corners of the warp bounding box. These could be adjusted in the same way as you would manipulate a pen path to control the outer shape of the warp. Here, I was able to drag the corner handles and click inside any of the nine sectors and drag with the mouse to manipulate the flag layer, just as if I were stretching the image on a rubber canvas. You'll note how I was even able to adjust the warp so that the flag twisted in on itself to reveal the reverse side of the flag.

3 In Step 2 the warp preview in the bottom right corner had some sky area included with the warp. This is just how the preview is rendered when warping an image. You can see here how once the warp had been applied, the warped image appears as expected. Because the Flag layer remained as a Smart Object I could still continue to edit the Flag layer non-destructively.

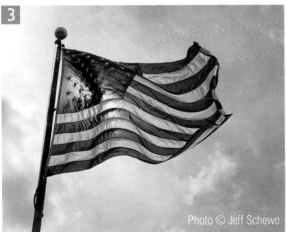

Photo © Jeff Schewe

Enable Graphics Processor

For the Perspective Warp feature to work, make sure you have 'Use Graphics Processor' enabled in the Photoshop ⇨ Performance preferences.

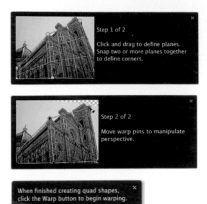

Figure 8.64 When you first select the Perspective Warp you will see these helpful animated help dialogs. They go away after the first time you use Perspective Warp.

Perspective Warp

Perspective Warp allows you to warp photos so that you can correct or manipulate the perspective. For example, it allows you to manipulate the perspective in parts of your image, while maintaining the original perspective in other areas.

You can find Perspective Warp under the Edit menu: Edit ⇨ Perspective Warp and it is particularly well suited to images of architectural subjects. For example, one way to use this tool is to correct the perspective of a building in a photograph, where you might wish to make a building's perspective look more correct, but without distorting everything else in the image. The thing is, this only works if the building in question is fairly rectangular in shape. Anything with a pitched roof isn't going to work, though the animated Perspective Warp help screens shown in Figure 8.64 demonstrate how this tool can be applied to some architectural photographs where the building shape is slightly irregular. You can also use the Perspective Warp feature to manipulate a layered object as I have shown over the following pages.

When you apply a Perspective Warp you will initially be working in the Layout mode (**L**) where the idea is to define the warp planes. You do this by clicking and marquee dragging to define the first warp plane and then clicking on the corner handles to adjust the shape. Subsequent warp planes can be added to define the other object planes and these will automatically snap-align to the edges of existing planes. Once you have done this you can click on the Warp button in the Options bar to access the Warp controls shown in Figure 8.65 below.

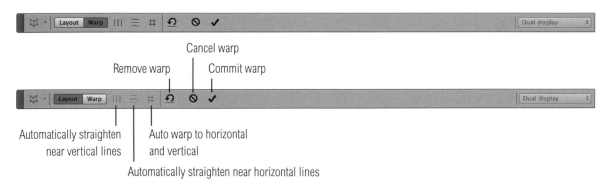

Figure 8.65 This shows the Perspective warp Options bar in Layout mode (top) (**L**) and Warp mode (**W**) below.

1 To illustrate how the Perspective Warp feature can work, I used the two photographs seen here. One is an empty room interior and the other, a photograph of a wooden box cabinet, which I had cut out using a pen path.

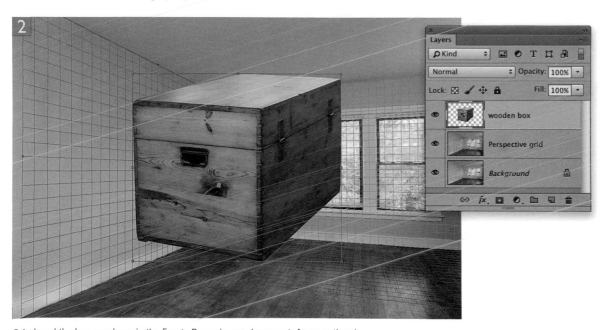

2 I placed the box as a layer in the Empty Room image document. As an optional step, I created a layer containing perspective grid guide lines, which I added here as a temporary layer and would use later to help guide the positioning of the box in the image.

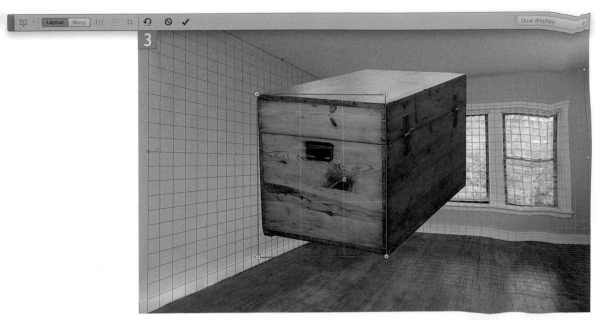

3 I went to the Edit menu and chose Perspective Warp. I began by marquee dragging over the box image layer to add the first quad plane.

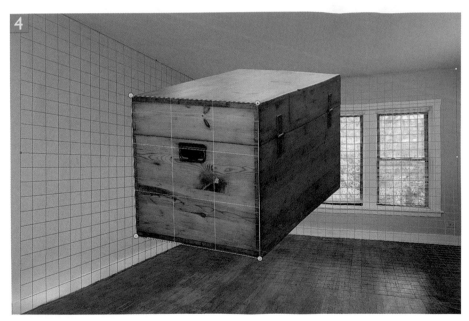

4 I then clicked on the quad plane corner pins to fine-tune their placement and align with the first plane of the wooden box. You can also use the keyboard arrow keys to nudge a selected quad pin.

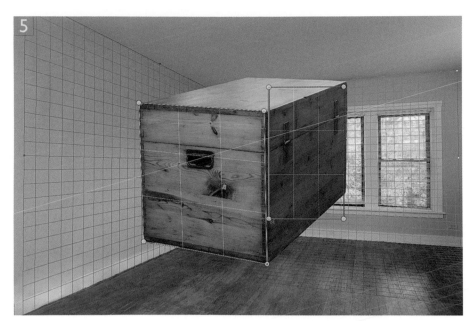

5 I then clicked and dragged to add a second quad plane. You will note as you do this how when the second plane edge meets the first the two edges are highlighted blue and the second plane snaps to the edge of the first. After doing this I fine-tune adjusted the corner pin positions of the second quad plane. You can hold down the ⌘ (Mac) *ctrl* (PC) key while drawing quads to place them close but without joining.

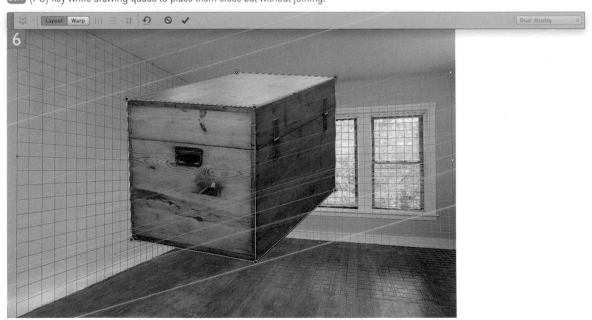

6 I added a third quad plane to define the top of the box. I then clicked on the Warp button (*W*) in the Options bar to prepare the layer for warping. You can also use the *H* key to hide the grids when working in the Warp mode.

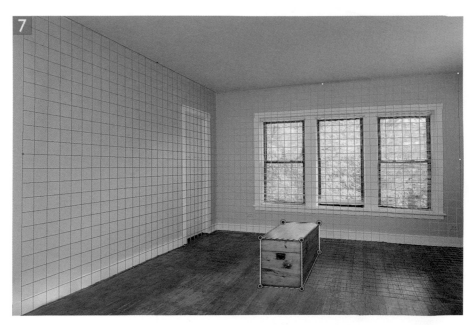

7 I clicked on the quad plane corner pins to move them and create a new perspective for the layer object. You will notice how if you hold down the *Shift* key as you click on a segment between two pins the segment turns yellow and will automatically snap to the horizontal, vertical, or a 45° angle (*Shift* click again to disable).

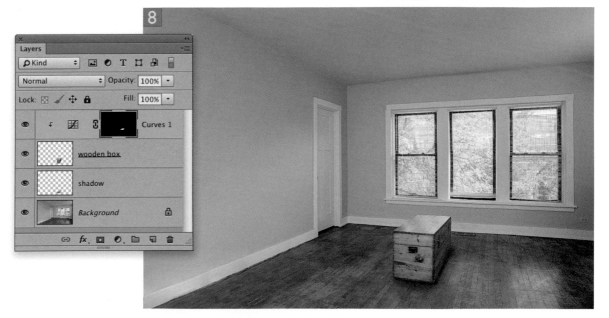

8 Lastly, I clicked Enter to OK the Perspective Warp adjustment. I then removed the perspective guides layer and carried out some further retouching to change the color of the top of the box and added some shading beneath it.

Puppet Warp

Whenever you are editing a normal, non-background layer the Puppet Warp feature will be available from the Edit menu. This is a truly outstanding feature for anyone who uses Photoshop to do retouching work. While the Liquify filter, Warp transform and Perspective Warp are great, the main benefits of working with the Puppet Warp tool are that the warp response feels that much more intuitive and responsive. As you edit the pins, the other elements of the photograph appear to warp in a way that can help the warping effect look more natural. The other advantage is you can edit the layers directly in Photoshop without having to do so via a modal dialog. Or rather it seems to be non-modal whereas in fact the Puppet tool is really still modal – it's just that you are able to work on a layer directly rather than via a dialog interface (as is the case with Liquify).

The only way to truly appreciate Puppet Warp is to watch a movie demo, such as the one on the book's website, or better still, try it out for yourself. The Puppet Warp tool Options bar (Figure 8.66) offers three modes of operation. The Normal mode applies a standard amount of flexibility to the warp movement between the individual pins, while the Rigid mode is stiffer and good for bending things like hands. The Distort mode provides a highly elastic warp mode which can be good for warping wide angle photographs. The Puppet Warp function is based on an underlying triangular mesh. The default Density setting is set to Normal, which is the best one to choose in most instances. The More points density option provides more precise warping control but at the expense of speed since the processing calculations are more intense. The Fewer Points setting allows you to work faster, but you may get unpredictable or unusual warp results. There is also a Show Mesh option that allows you to show or hide the mesh visibility.

The next thing to do is to add some pins to the mesh. These can be applied anywhere, but it is important you add at least three pins before you start manipulating the layer, since

Including soft edges

The Puppet Warp mesh is mostly applied to all of the selected layer contents, including the semi-transparent edges, even if only as little as 20% of the edge boundary is selected. And if this fails to include all the desired edge content you can always adjust the Expansion setting to include more of the layer edges.

Rigidity mode options Mesh density options Expansion control Show mesh Pin depth options Set pin rotation Remove all pins button

Figure 8.66 The Puppet Warp Options bar.

Multiple objects

If you have multiple objects on a layer, the Puppet Warp mesh is applied to everything on that layer. However, while the mode operation is global you can apply separate distortions to each of the layer elements.

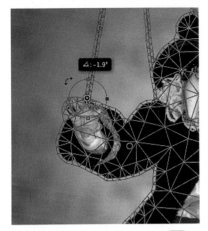

Figure 8.67 If you hold down the `alt` key and hover the mouse close to an already selected pin, this shows a pin rotation circle that you can adjust to twist the rotation of the selected pin.

Figure 8.68 This shows the pin contextual menu, which offers quick access to a list of useful options for modifying pins that have been added using Puppet Warp. (`ctrl`-click or use a right mouse-click to reveal the contextual menu shown here). 'Set Auto Rotation' can be used to reset the pin rotation.

the more pins you add, the more control you'll have over the Puppet Warp editing. The thing to bear in mind here is that as you move a pin, other parts of the layer will move accordingly, and perhaps do so in ways that you hadn't expected. This is the result of the Puppet Warp tool intelligently working out how best to distort the layer. As you add more pins to different parts of the layer you will find that you gain more control over the Puppet Warp distortions. The keyboard arrow keys can also be used to nudge the selected pin location, but if you make a mistake with the addition or placement of a pin you can always use the undo command (`⌘` `Z` [Mac], `ctrl` `Z` [PC]), or hold down the `alt` key to reveal the scissors cursor icon and click on a pin to delete it. Or, you can simply select a pin and hit the `Delete` key. In order to further tame the Puppet Warp behavior, you can use the Expansion setting to modify the area covered by the mesh, since this can have the effect of dampening down the Puppet Warp responsiveness. This can be considered essential if you want to achieve manageable distortions with the Puppet Warp. The default setting of 2 pixels allows for precise control over the warp distort movements, but this won't help with every image. In the Puppet Warp example shown over the next few pages I found it necessary to use a more expanded mesh, since without this the Puppet Warp distortions became rather unwieldy. This was especially noticeable when I tried setting the Expansion setting to 1 pixel or less. If you find that your Puppet Warp editing feels uncontrolled, try increasing the Expansion amount.

Pin rotation

The Rotate menu normally defaults to 'Auto'. This rotates the mesh automatically around the pins based on the selected mode option. However, when a pin is selected you can hold down the `alt` key and hover the cursor close to a pin, which reveals the rotation circle that also allows you to set the pin rotation manually (see Figure 8.67). Be careful though, because if you happen to `alt`-click a pin, this will delete it. As you rotate a pin, the rotation value will appear in the tool Options bar. This extra level of control allows you to twist sections of an image around a (movable) pinpoint as well as alter the degree of twist between this and the other surrounding pins. In the case of the puppet image example shown here, this gave me better control over the angle of the strings. See also Figure 8.68, which shows the pin contextual menu options.

Pin depth

The pin stacking order can be changed by clicking on the buttons in the tool Options bar. Where a Puppet Warp distortion results in elements overlapping each other, you can decide which section should go on top and which should go behind. You can either click on the move up or move down buttons shown in Figure 8.69, or use the **J** key to bring a pin forward and use the **[** key to send a pin backward (or use the pin contextual menu shown in Figure 8.68). Basically, this is a mechanism that allows you to determine whether warped elements should go in front of or behind other elements in a Puppet Warp selection.

Multiple pin selection

You can select multiple pins by **Shift**-clicking the individual pins. Once these are selected, you can drag them as a group using the mouse, or use the arrow keys to nudge their positions. You can **Shift**-click again to deselect an already selected pin from a selection. However, operations which affect a single selected pin, such as rotation and pin depth, are disabled when multiple pins are selected.

While in Puppet Warp mode, you can also use **⌘ A** (Mac), **ctrl A** (PC) (or the contextual menu) to select all the current pins and you can use the **⌘ D** (Mac), **ctrl D** (PC) shortcut to deselect all pins. Also, if you hold down the **H** key, you can temporarily hide the pins, but leave the mesh in view.

Smart Objects

If you convert a layer to a Smart Object before you carry out a Puppet Warp transform this will allow you to re-edit the Puppet Warp settings. You can also use the Puppet Warp feature to edit vector or type layers. However, if you apply the Puppet Warp command to a type or vector layer directly, the Puppet Warp process automatically rasterizes the type or vector layer to a pixel layer. Therefore, in order to get around this I suggest you select the layer and choose Filter ⇨ Convert to Smart Filters first, before you select the Puppet Warp command.

Now for a quick run through of the Puppet Warp in action, for which I chose to use an image of what else, but a puppet!

Move up Move down

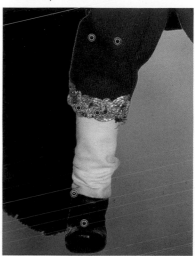

Figure 8.69 The pin depth controls allow you to move the selected pin positions on a Puppet Warp selection up or down. This allows you to control whether certain image areas slide in front or behind other areas of the image. The preview you see in the Puppet Warp edit mode will include the Extension area, but this won't be seen in the final render.

1 The first step was to have the puppet image as a separate layer. One can use the Puppet Warp tool on a complete layer, but it's really designed to function at its best when editing a cut-out layered object such as a type layer, vector layer or as a separate pixel image layer. Before doing anything else though, I converted the targeted layer to a Smart Object.

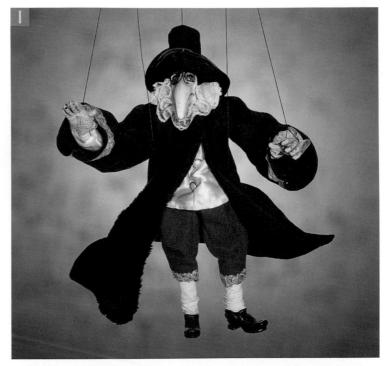

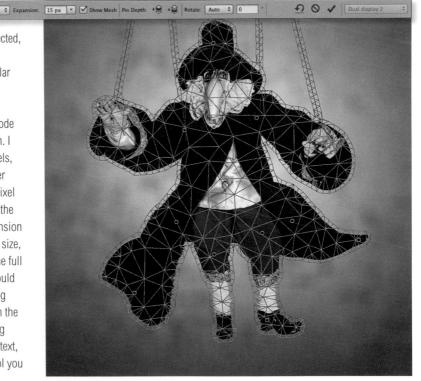

2 I made sure the puppet layer was selected, then went to the Edit menu and chose Puppet Warp. This step added a triangular mesh to the layer contents and the tool Options bar revealed the options for the Puppet tool. Here, I chose the 'Rigid' Mode and Normal Density option for the mesh. I also set the Expansion option to 15 pixels, as this would give me better control over the warp adjustments (at the default 2 pixel setting, the strings would bend all over the place). I should also point out the Expansion setting is dependent on the image pixel size, so although 15 pixels was correct for the full resolution version I edited here, you would need to use a lesser setting when editing the lower resolution test image that's on the website. I was then ready to start adding some pins. As I mentioned in the main text, the more pins you add, the more control you have over the warping effect.

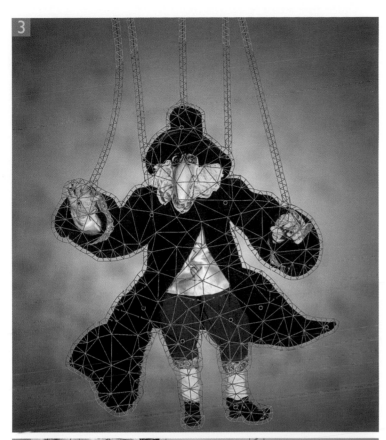

3 I was now ready to start warping the layer. All I had to do was to click to select a pin and drag to reshape the image. The interesting thing to note here is that as you move one part of the layer, other parts adjust to suit.

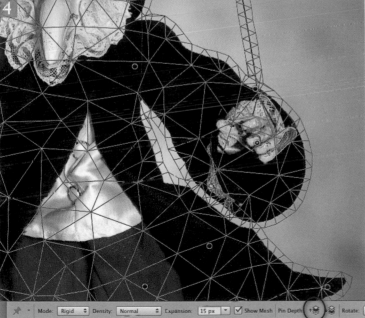

4 As I clicked and moved the pins I was able to create the desired distortion effect. In this close-up view you can see I had moved an arm so that it intersected one of the coat tails. In this instance it was necessary to click on the move upward pin depth button (circled) to bring the sleeve of the puppet's left arm in front of the coat tail.

5 What is particularly interesting with this image (and you'll notice this better if you work with the demo image that's on the book website) is how, as I moved different parts of the puppet's body, the puppet strings moved accordingly. In order to counter this, I clicked on the pins that were at the bottom and top of the strings and rotated them to remove the curvature and make the strings straighter.

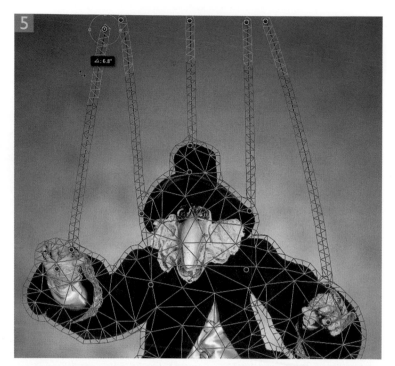

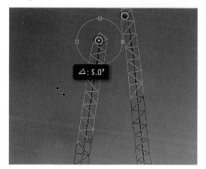

6 When I was done, all I had to do was to hit the (Enter) key. Now, because I had prepared this layer as a Smart Object you'll notice how the Puppet Warp adjustment was added as a Smart Filter in the Layers panel. This meant that if I wanted to re-edit the Puppet Warp settings, I could do so by double-clicking the Puppet Warp Smart Filter and carry on editing.

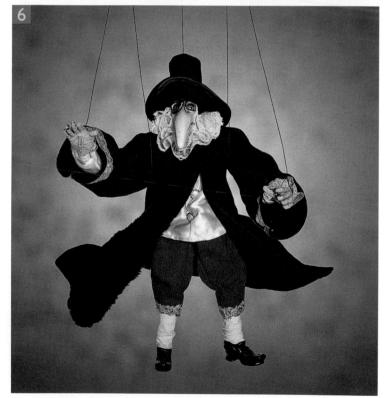

Smart Objects

One of the main problems you face when editing pixel images is that every time you scale an image or the contents of an image layer, pixel information is lost. And, if you make cumulative transform adjustments, the image quality can degrade quite rapidly. However, if you convert a layer or a group of layers to a Smart Object (Figure 8.70), this stores the layer (or layers) data as a separate image document within the master image. The Smart Object data is therefore 'referenced' by the parent image and edits that are applied to the Smart Object layer (such as a transform adjustment) are applied to the proxy only instead of to the pixels that actually make up the layer.

With Smart Object layers you can use any of the transform adjustments described so far plus you can also apply filters to a Smart Object layer (known as Smart Filtering), or apply image adjustments. What you can't do is edit a Smart Object layer directly using, say, the clone stamp tool or paint brush, but you can double-click a Smart Object layer to open it as a separate image document. Once opened you can then apply all the usual edit adjustments before closing it, after which the edit changes are updated in the parent document.

Smart Filters

If you go to the Filter menu, there is an option there called 'Convert for Smart Filters'. What this does is to convert a selected layer to a Smart Object and this is no different from choosing 'Convert to Smart Object' from the Layers panel fly-out menu. With Smart Objects you can apply most Photoshop filters, but not all (including some third-party filters). However, you can enable all filters to work with Smart Objects by loading the 'EnableAllPluginsforSmartFilters.jsx' script. I explain how this is done later on page 616.

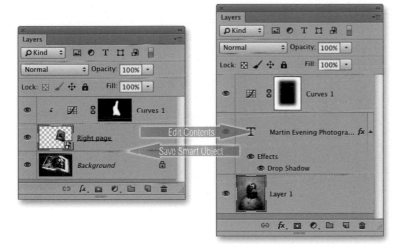

Figure 8.70 You can promote any layer or group of layers to become a Smart Object. A Smart Object becomes a fully editable, separate document stored within the same Photoshop document. The principal advantage is you can repeatedly scale, transform or warp a Smart Object in the parent image without affecting the integrity of the pixels in the original.

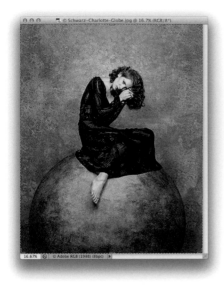

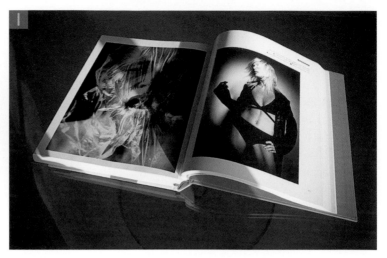

1 We'll now examine in more detail how you would use a Smart Object in Photoshop. Here is a photograph of a book that shows a couple of my promotional photographs, where let's say I wanted to place the photograph shown on the left so that it matched the scale, rotation and warp shape of the photograph on the right-hand page.

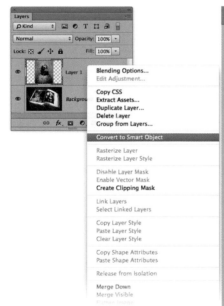

Quick tip

In these situations it is useful to remember that you can use the ⌘ O (Mac), ctrl O (PC) keyboard shortcut to quickly zoom out just far enough to reveal the transform bounding box handles.

2 I used the move tool to drag the photograph across to add it as a new layer and then went to the Layers panel options and chose 'Convert to Smart Object'. This action preserved all the image data on this layer in its original form. I then went to the Edit menu and chose Transform ⇨ Free Transform. Because the layer boundary exceeded the size of the Background layer, I had to zoom out in order to access the corner handles of the Transform box.

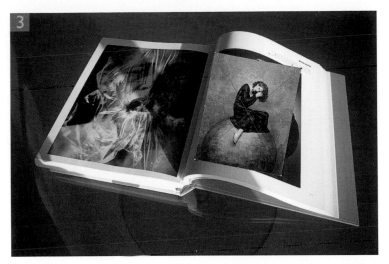

3 I then scaled the Smart Object layer down in size so that it more closely matched the size of the photograph on the page. I also dragged the cursor outside the transform bounding box, in order to rotate the photograph roughly into position.

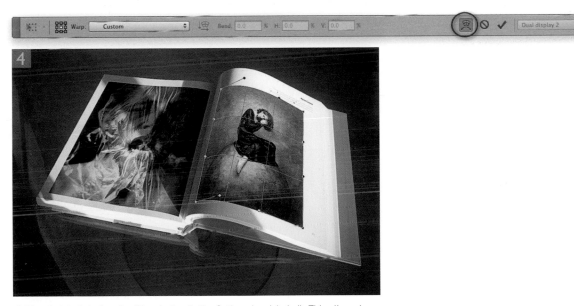

4 After that, I clicked on the Warp button in the Options bar (circled). This allowed me to fine-tune the position of the Smart Object layer, by using the corner curve adjustment handles to modify the outer envelope shape. I then moused down inside some of the inner sections and dragged them so that the inner shape also matched the curvature of the page.

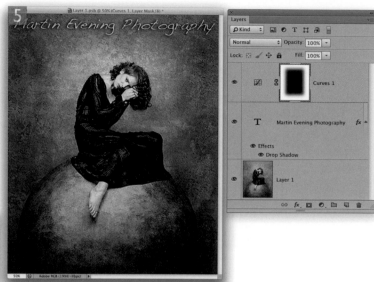

5 I was then able to edit the Smart Object layer any way I liked. To do this, I went to the Layers panel fly-out menu and selected 'Edit Contents'. (An alternative option was to simply double-click on the Smart Objects layer in the Layers panel.) In the example shown here, I added a text layer plus a Curves adjustment layer to darken the corners of the photo. I then closed the window, and as I did so this popped the prompt dialog shown here, reminding me to click 'Save' in order to save and update the master Smart Object layer.

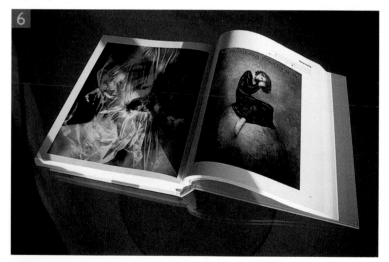

6 Here is the final image in which I added a Curves adjustment layer in a clipping group with the Smart Object layer so that the shading matched that of the original photograph on the page.

Linked Smart Objects

Photoshop now allows you to link to an external file that can be edited independently and updated in Photoshop. This will work with all the usual supported file formats, including raw files (with linked smart objects there is support for XMP sidecar files when linking to Camera Raw-edited files). You can therefore now have smart objects that are either embedded (as before), or linked. However, images that contain linked Smart Objects must be saved using the PSD format. The Layers panel displays these two kinds of Smart Objects using different icons, which are explained in Figure 8.71 below.

Creating linked Smart Objects

To create a linked Smart Object, you can *alt*-drag an image document from the Finder/Explorer, or from Bridge to an open image document in Photoshop. This places the dragged document as a layer, where you will see a placed image bounding box. Click *Enter* to confirm and create a linked Smart

Figure 8.71 This shows a Layers panel view of a layered image that uses Smart Objects. Here you can see that the Background layer was converted to an embedded Smart Object so that I was able to apply a Blur Gallery filter effect as a Smart Filter. The selected layer and the layer below it are linked Smart Object layers, which means the layer contents are linked to an external file. The Layers panel view on the left shows the normal 'updated' state. The one on the right shows a warning icon, which indicates the Smart Object file it links to is missing.

Figure 8.72 The images used to create the image below with linked Smart Objects.

Object. You will then see the Smart Object layer appear in the Layers panel as a linked Smart Object (see Figure 8.71). This particular image contained two linked Smart Objects, which are shown in Figure 8.72. The linked layers were created by _alt_-dragging the two bottom images to place these as linked Smart Objects.

If you go to the Status bar at the bottom of the application screen, or bottom of the image document window (Figure 8.73), there is a 'Smart Objects' option, which allows you to see the latest status for any Smart Objects in the current image. This indicates how many Smart Objects in an opened document are either missing or need to be updated. This is also available as a selectable option in the Info panel.

Once you have created a linked Smart Object, if you move or rename the parent image the relative linking within it will be retained. When you click on a Smart Object layer, the Properties panel (Figure 8.74) provides information about the current Smart Object layer status, allowing you to click on the Edit Contents button to edit the original Smart Object layer/image, or click on the Embed button to convert a linked Smart Object to a regular embedded Smart Object. You can change

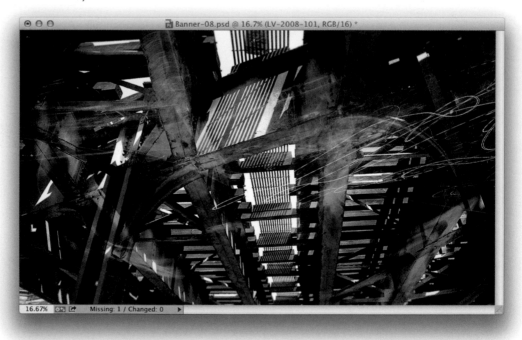

Figure 8.73 The status bar now has a Smart Objects option that shows the current status for linked Smart Objects.

a Linked Smart Object to an Embedded Smart Object by choosing Layers ⇨ Smart Objects ⇨ Embed Linked, or Embed All Linked. If you wish to reverse this process you can now also convert an embedded smart object to a linked package file. To do this, go to the Layers menu and choose Smart Objects ⇨ Convert to Linked…

Packaging linked embedded assets

To help users share files that contain Linked Smart Objects and make them portable, there is a Package… command available from the File menu. When you have an image open that contains Linked Smart Objects, this allows you to save a copy of the master to a packaged folder containing the master image plus a folder that contains the linked Smart Object files. The Package command currently packages image asset files only and does not yet include other assets such as fonts.

Resolving bad links

If a link is missing on opening you will see the dialog shown in Figure 8.75. This alerts you to any missing links Photoshop can't find. Maybe the linked Smart Object has been deleted? To update a bad link, click on the red question mark icon in the Properties panel and choose 'Resolve broken link…' from the menu. Alternatively, use a right mouse-click on the Smart Object layer in the Layers panel to open the contextual menu and select 'Resolve broken link…' from this menu. If you open a child Smart Object image directly, edit it and choose save, the parent image won't update until you force it to do so (which you can do for example, by going to the Properties panel).

Figure 8.75 This shows the missing assets dialog that will appear when opening a parent image and the linked Smart Objects can't be found.

Multiple instances of Smart Objects
To avoid redundancy, where there are multiple instances of Linked Smart Objects pointing to the same source file the Package operation only creates one copy of the Linked Smart Object source image.

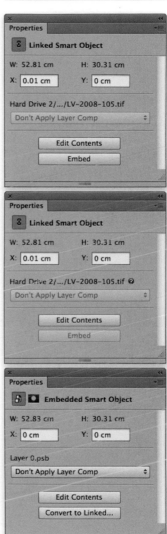

Figure 8.74 This shows Properties panel views for the status of Smart Objects. Top shows a linked Smart Object where you have the option to embed. Middle shows a linked Smart Object with a broken link and bottom shows an embedded Smart Object.

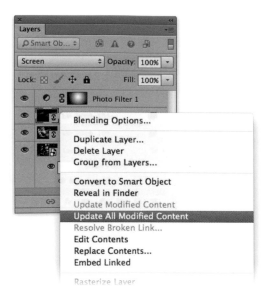

Figure 8.76 This shows the layers panel contextual menu for a selected layer with options for updating or replacing a linked Smart Object.

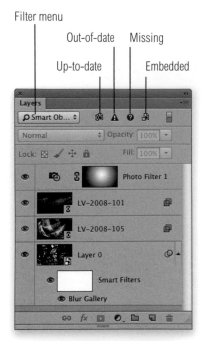

Figure 8.77 This shows the Layers panel view and Smart Object filter options. The buttons highlighted above show the following filter options: Up-to-date linked Smart Objects, Out-of-date linked Smart Objects, Missing linked Smart Objects and Embedded Smart Objects. The Layers panel view at the bottom shows an example of a Layers panel filter search where I filtered to show embedded Smart Objects only.

If you open a child Smart Object image by double-clicking the Smart Object layer, the parent image will update automatically.

You can also create Smart Object layers via the File menu. Choosing File ⇨ Place Linked allows you to select an external file and link it to a file saved using the PSD file format. Choosing File ⇨ Place Embedded will embed the file in the parent image. i.e the same behavior as used currently in Photoshop.

You can use the contextual menu (shown in Figure 8.76) to resolve broken links and update them. The update process only modifies the currently selected Smart Object (or duplicate thereof), rather than all linked Smart Objects. Choosing 'Update All Modified Content' updates all Linked Smart Objects in the document. You can use 'Replace Contents…' to change the source file used as a Linked Smart Object.

Layers panel Smart Object searches

The search feature in the Layers panel can be used to find both Linked and Embedded Smart Objects. Figure 8.77 shows the Smart Object filter options for the Layers panel. Basically, a search can be carried out to find up-to-date, out-of-date or missing Smart Objects, as well as Embedded Smart Objects.

Photoshop paths

If you need to define a complex outline you will usually find it quicker to draw a path and convert this to a selection rather than rely on selection tools like the magic wand or lasso, or painting on a mask.

The Paths panel is shown in Figure 8.78. The Fill path button fills the current path using the current foreground color. The Stroke path button strokes a path using a currently selected painting tool. The Load path as a selection button can be used to convert a path to a selection. If a path is selected, clicking the Add mask button adds a vector mask based on that path. Clicking the Create new path button creates a new empty path and you can remove a path by clicking the Delete path button.

Figure 8.79 summarizes how a pen path can be converted to a selection or a vector mask to isolate an object. An active selection can be converted to a path by clicking on the 'Make work path from selection' button. Alternatively, you can choose the Make work path option from the Paths panel fly-out menu.

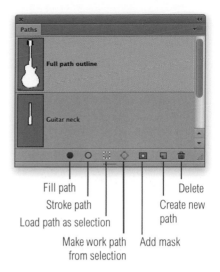

Figure 8.78 The Paths panel.

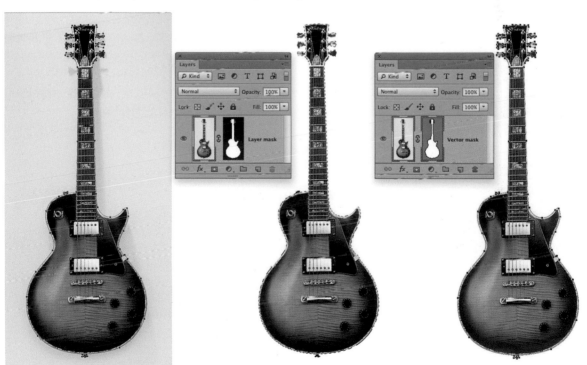

Figure 8.79 Make a path active and hit ⌘ *Return* (Mac), *ctrl* *Return* (PC) to convert a path to a selection. You can then click on the Add Layer Mask button in the Layers panel to add as a layer mask. To load a path as a vector mask, go to the Layer menu and choose Vector Mask ⇨ Current Path (or click twice on the Add Layer Mask button in the Layers panel).

Figure 8.80 In the past the Shape layers mode has been the default setting in the pen tool options. The Path mode is now the new default in Photoshop.

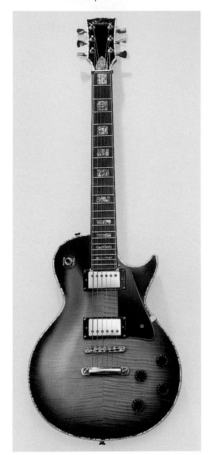

Figure 8.81 This is the path tutorial file, which can be found on the book website. In the first pen path drawing exercise all you need to do is to click with the pen tool to create a series of straight line segments that define the outline of the fretboard.

Pen path modes

The pen tool has three modes, of which there are only two you will really be interested in using. If the pen tool is in 'Shape layers' mode (Figure 8.80), when you draw with the pen tool this creates a vector mask path outline that masks a solid fill layer filled with the current foreground color. If you select the Path mode option this allows you to create a regular pen path without adding a fill layer to the document. You can of course use any path outline to generate a vector mask, so I usually suggest you keep the pen tool in the default 'Path' mode and leave it set like this. Note there are also Selection…, Mask and Shape buttons in the Options bar for converting a regular pen path.

Drawing paths with the pen tool

Unless you have worked previously with a vector-based drawing program (such as Adobe Illustrator), drawing with the pen tool will probably be an unfamiliar concept. It is difficult to get the hang of it at first, but I promise you this is a skill that's well worth mastering. It's a bit like learning to ride a bicycle: once you have acquired the basic techniques, everything else should soon fall into place. Paths can be useful in a number of ways. The main reason why you might want to use a pen path would be to define a complex shape outline, which in turn can be applied as a vector mask to mask a layer, or be converted into a selection. You can also create clipping paths for use as a cut-out outline in a page layout, or you can use a path to apply a stroke using one of the paint tools.

Pen path drawing example

To help you understand how to create pen paths let's start with the task of following the simple contours of the guitar that's illustrated in Figure 8.81 (you will find a copy of this image as a layered Photoshop file on the book website). This image contains a saved path outline of the guitar at a 200% view. The underlying image is therefore at 200% its normal size, so if you open this at a 100% view, you are effectively able to work on this demo image at a 200% magnification. The Background layer contains the Figure 8.81 image and above it there is another layer of the same image but with the pen path outlines and all the points and handles showing. I suggest you make this layer visible and fade the opacity as necessary. This will then help you to follow the handle positions when trying to match the path outlines. Let's begin by making an outline of the guitar fretboard

(as shown in Figure 8.81). Click on the corner sections one after another until you reach the point where you started. As you approach this point you will notice a small circle appears next to the cursor. This indicates you can now click on it to close the path. If you have learned how to draw with the polygon lasso tool, you will have no problem drawing this path outline. Actually, this is easier than drawing with the polygon lasso because you can zoom in if required and precisely adjust each and every point. To reposition, hold down the ⌘ (Mac), *ctrl* (PC) key to temporarily switch the pen tool to the direct selection tool and drag a point to realign it precisely. After closing the path, hit ⌘ *Enter* (Mac), *ctrl* *Enter* (PC) to convert the path to a selection, and click *Enter* on its own to deselect the path.

Now try to follow the guitar body shape (Figure 8.82). This will allow you to concentrate on the art of drawing curved segments. Note that the beginning of any curved segment starts by you dragging the handle outward in the direction of the intended curve (to understand the reasoning behind this, imagine you are trying to define a circle by following the imagined edges of a square box containing the circle). To continue a curved segment, click and hold the mouse down while you drag to complete the shape of the end of the previous curve segment (and predict the initial curve angle of the next segment). This is assuming that the next curve will be a smooth continuation of the last. If there happens to be a sharp change in direction for the outline you are trying to follow you will need to add a corner point. You can convert a curved anchor point to a corner point by holding down the *alt* key and clicking on it. Click to place another point and this will now create a straight line segment between these two points. Or, you can click and drag to create a new curved segment with a break in direction from the corner point. Now, if you hold down the ⌘ (Mac), *ctrl* (PC) key you can again temporarily access the direct selection tool and reposition the points. When you click on a point or a segment with this tool the handles are displayed and you can use the direct selection tool to adjust these and refine the curve shape.

If you want to try defining the entire guitar, including the headstock, you can practice making further curved segments and adding corner points (such as around the tuning pegs). These should be placed whenever you intend the next segment to break with the angle of the previous segment— hold down the *alt* key and drag to define the predictor handle for the next curve segment.

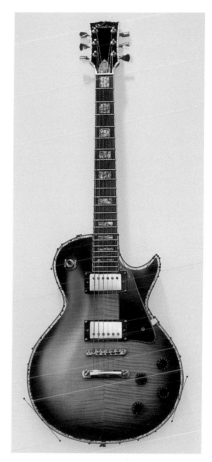

Figure 8.82 To draw a curved segment, instead of clicking, mouse down and drag as you add each point. The direction and length of the handles define the shape of the curve between each path point. When you create a curved segment the next handle will continue to predict a curve, continuing from the last curved segment. To create a break in the direction of a path, you'll need to modify the curve point by converting it to a corner point. To do this, hold down the *alt* key, click on the path point and drag to create a new predictor handle going off in a new direction.

Figure 8.83 Shown here are the main tools you need to edit any pen path. However, with the pen tool selected (left), you can access all of these tools without actually having to switch tools in the Tools panel. To add new continuing anchor points to an existing path just click with the pen tool. Instead of selecting the convert point tool (second along) you can use the *alt* shortcut and instead of selecting the direct select tool (third along), you can use the ⌘ (Mac), *ctrl* (PC) key. To add an anchor point to an existing path, rather than selecting the add anchor point tool (fourth along) you can simply click on a path segment. To delete an anchor point, rather than select the delete anchor point tool (fifth along), you can click on an existing anchor point using the pen tool.

Pen tool shortcuts summary

To edit a pen path, you can use the ⌘ (Mac), *ctrl* (PC) key to temporarily convert the pen tool to the direct selection tool, which you can use to click on or marquee anchor points and reposition them. You can use the *alt* key to convert a curve anchor point to a corner anchor point (and vice versa). If you want to convert a corner point to a curve, you can *alt* + mouse down and drag. To change the direction of one handle only, you can *alt* drag on a predictor handle. To add a new anchor point to an active path, you simply click on a path segment with the pen tool, and to remove an anchor point, you click on it again (these shortcuts are also shown in Figure 8.83). When an anchor point is selected and you need to position it accurately, you can nudge using the arrow keys on the keyboard and use the *Shift* key to magnify the nudge movement.

You can edit a straight line or curved segment by selecting the direct selection tool, clicking on the segment and dragging. With a straight segment the anchor points at either end will move in unison. With a curved segment, the anchor points remain fixed and you can manipulate the shape of the curve as you drag with the direct selection tool.

Rubber Band mode

There are a number of occasions where I find it necessary to use the pen tool to define an outline and then convert the pen path to a selection. In the end, the pen tool really is the easiest way to define many outlines and create a selection from the path. One way to make the learning process somewhat easier is to switch on the Rubber Band option, which is hidden away in the Pen Options on the pen tool Options bar (Figure 8.84). In Rubber Band mode, you will see the segments you are drawing take shape as you move the mouse cursor and not just when you mouse down again to define the next path point. As I say, this mode of operation can make path drawing easier to learn, but for some people it can become rather distracting once you have got the basic hang of how to follow a complex outline using the various pen tools.

Figure 8.84 The easiest way to get accustomed to working with the pen tool is to go to the pen tool Options bar, mouse down on the cogwheel icon and check the Rubber Band box (circled).

Multi-selection path options

In the Paths panel, it is possible to select multiple paths, more or less in the same way as you can select multiple layers via the Layers panel (see Figure 8.85). For example, you can use the _Shift_ key to select a contiguous range of paths from the paths panel to make them active, or you can use the ⌘ (Mac), _ctrl_ (PC) key to make a discontiguous path selection. If you then want to load a selection from a path you will need to select the target path, or paths, and click on the Load path as selection button in the Paths panel.

Figure 8.85 More than one path can be selected at a time in the Paths panel.

Multiple selected paths can be deleted, duplicated or moved. You can duplicate a path or multiple path selection by dragging it to the new path button in the Paths panel, or you can simply _alt_ drag a selected path (or paths) in the Paths panel to create duplicates.

The path selection tool and the direct selection tools are also multi-path savvy. Select the paths you wish to target via the Paths panel and then use the path selection and/or direct selection tool to select the targeted paths only as you drag on canvas. Let's say you have two paths selected in the Paths panel. You can then use the path selection tool or direct selection tool to target either or both selected paths via on-canvas dragging (see Figure 8.86 for a further example of how this works in practice).

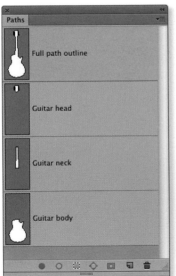

Figure 8.86 This shows an example of how the multiple path selection feature can be used. In the example shown here, three paths were first selected via the Paths panel: the guitar head, neck and main body. With these paths 'activated' via the Paths panel, I selected the path selection tool (**A**) and dragged on the image to select one or more of the activated paths. In the left-hand example I dragged to select the Guitar Body path only and make that selected. In the middle example I dragged to select the head and neck only. In the right-hand example, I dragged to select the head first, then held down the **Shift** key to drag and select the body as well, making both paths selected. To help make the above points clearer, I have shaded the selected paths in green.

The main thing to understand here is that clicking on a path or multiple paths in the Paths panel 'activates' them. To then 'select' a path or paths, click on a path outline in the image, or marquee-drag with the path selection or direct selection tool.

Selecting path anchor points

Refinements have been made to anchor point selection when working with the direct selection tool. As can be seen below in Figure 8.87, if you have a path selected with multiple anchor points activated, a mouse-click on an anchor point with the direct selection tool will make that single anchor selected and all the other points deselected. Previously, when you clicked with the direct selection tool the anchor point selection would be preserved. You can still retain this behavior. Let's say you make a selection of a few anchor points and wish to move them. What you do is click and hold with the mouse and drag. The anchor point selection will then be preserved. It is just when you single-click on an anchor point that it deselects all the anchor points.

Figure 8.87 If you have a path with multiple anchor points active and the direct selection tool is selected (left), if you click on a single anchor point this will be selected and all the other points deselected (right).

Hiding/showing layer/vector masks

You can temporarily hide/show a layer mask by *Shift*-clicking on the layer mask icon. Also, clicking a vector mask's icon in the Layers panel hides the path itself. Once hidden, hover over it with the cursor and it will temporarily become visible. Click it again to restore the visibility.

Vector masks

A vector mask is just like an image layer mask, except the mask is described using a vector path (Figure 8.88). A big advantage of using a vector mask is it can be further edited using the pen path or shape tools. To add a vector mask from an existing path, go to the Paths panel, select a path to make it active, and choose Layer ⇨ Add Vector Mask ⇨ Current Path. Alternatively, go to the Properties panel in Masks mode and click on the 'Add Vector Mask' button (see Figure 8.23 on page 512).

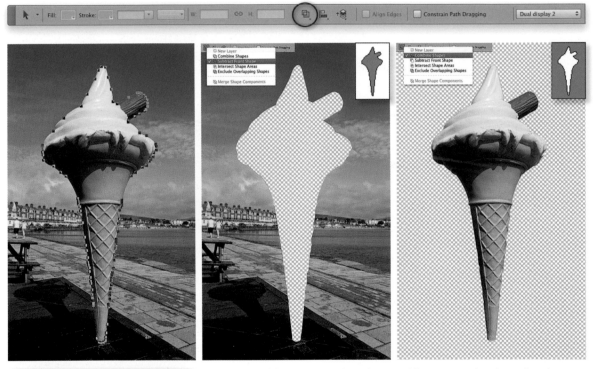

Figure 8.88 A vector mask can be created from a currently active path such as the active path in the image on the left. The path mode influences what is hidden and what is revealed when the path is converted to a vector mask. If a path is created in the 'Subtract Front Shape' mode (as in the middle example), the area inside the path outline is hidden (the gray fill in the path icon represents the hidden areas). If the path is created in the 'Combine Shapes' mode (as in the right-hand example) everything outside the path outline is hidden. However, it is very easy to alter the path mode. Select the path selection tool and click on the path to make all the path points active. You can then click on the path mode menu (circled in the Options bar) to switch between the different path modes.

Isolating an object from the background

Let's now look at a practical example of where a vector path might be used in preference to a pixel layer mask to mask an object. Remember, one of the benefits of using a vector mask is that you can use the direct path selection tool to manipulate the path points and fine-tune the outline of a mask.

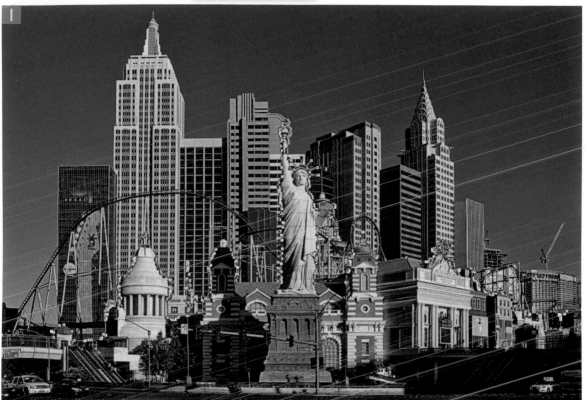

1 Here, I used the pen tool to define the outline of the buildings in the foreground. Note that the pen tool was in the Path mode (circled in the Options bar). Also, because I wanted to create a path that selected everything outside the enclosed path, I checked the Subtract Front Shape option before I began drawing the path. When the path was complete, I went to the Paths panel, double-clicked the 'Work Path' name and clicked OK to rename it as 'Path 1' in the Save Path dialog. This saved the work path as a new permanent path. It is important to remember here that a work path is only temporary and will be overwritten as soon as you deselect it and create a new work path.

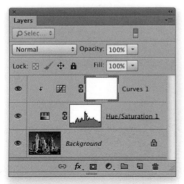

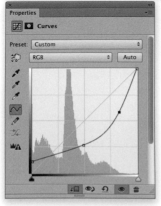

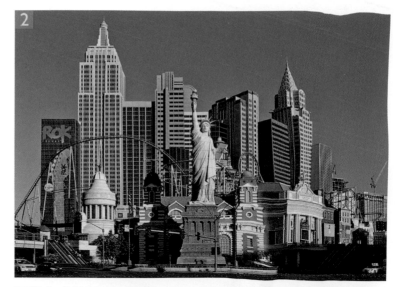

2 With the Path 1 active, I clicked on the 'Add New Adjustment Layer' button in the Layers panel and selected Hue/Saturation. I then set the Saturation to –90. As you can see, this applied a desaturating adjustment to the buildings in the background.

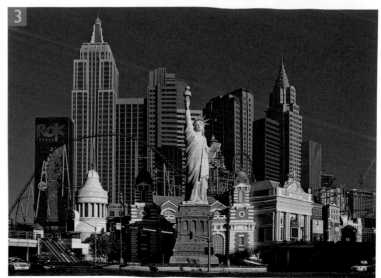

3 In this final step I added a Curves adjustment layer in a clipping group with the vector masked Hue/Saturation layer. With the Curves adjustment I applied a darkening effect, but which also lightened the shadows. I readjusted the Hue/Saturation adjustment layer and set the Saturation to –100 to remove all the color from the background.

Chapter 9

Blur, optical and rendering filters

One of the key factors behind Photoshop's success has been the program's support for plug-in filters. A huge industry of third-party companies has grown in response to the needs of users wanting extra features within Photoshop. Instead of covering all the hundred or more filters that are supplied in Photoshop, I have just concentrated here on those filters that I believe are useful for photographic work. In particular, I have concentrated on those filters that relate to blurring, optical and perspective corrections, plus rendering. I also show you ways you can use the Smart Filters feature to extend your filtering options.

Figure 9.1 The Noise ⇨ Add Noise filter can be used to add artificial noise to an image. It is particularly useful whenever you wish to disguise banding that may be visible after using the Gaussian Blur filter.

Filter essentials

Most Photoshop filters provide a preview dialog with slider settings that you can adjust, while some of the more sophisticated plug-ins (such as the Lens Correction filter) are like mini applications operating within Photoshop. These have a modal dialog interface, which means that whenever the filter dialog is open, Photoshop is pushed into the background and this can usefully free up already-assigned keyboard shortcuts. With so many effects filters to choose from in Photoshop, there are plenty enough to experiment with. The problem is that you can all too easily get lost endlessly searching through all the different filter settings. Here, we shall look at a few of the ways filters can enhance an image, highlighting those that are most useful. Most of the essential filters, such as those used to carry out standard production image processing routines are all able to run in 16-bit RGB mode. Some, however, are limited to 8-bit RGB mode processing. Lab mode images are similarly restricted in the filters available.

32-bit filters

A number of filters will also work in 32-bit mode including:
Blur: Blur, Blur More; Distort: Displace, Pinch, Polar Coordinates, Ripple, Shear, Spherize, Twirl, Wave, Zig-Zag;
Pixelate: Color Halftone, Crystalize, Facet, Fragment, Mezzotint, Mosaic, Pointilize;
Render: Fibers, Lens Flare; Sharpen: Sharpen, Sharpen More;
Stylize: Diffuse, Trace Contour;
Other: Custom.
Note when using the Diffuse filter in 32-bit mode, the Anisotropic option is grayed out.

Blur filters

There are now 16 different kinds of blur filters you can apply in Photoshop and each allows you to blur an image differently. You don't really need to bother with the basic Blur and Blur More filters, but what follows are some brief descriptions of the blur filters I do think you will find useful.

Gaussian Blur

The Gaussian Blur is a good general purpose blur filter and can be used for many purposes from blurring areas of an image to softening the edges of a mask. However, the Gaussian Blur can sometimes cause banding to appear in an image, which is where it may be useful to use the Noise ⇨ Add Noise filter afterwards (Figure 9.1).

Average Blur

The Average Blur simply averages the colors in an image or a selection. At first glance it doesn't do a lot, but it is still a useful filter to have at your disposal. Let's say you want to analyze the color of some fabric to create a color swatch for a catalog. The Average filter merges all the pixels in a selection to create a solid color and you can then use this to sample with the eyedropper tool to create a new Swatch sample color (see Figure 9.2).

Adding a Radial Blur to a photo

The Radial Blur can do a good job of creating blurred zoom effects. For example, the Zoom blur mode (shown in Figure 9.3) can be used to simulate a zooming camera lens. For legacy reasons the Radial Blur filter offers a choice of render settings. This is because the filter was devised before the age of GPU processing. For top quality results, select the Best mode. If you just want to see a quick preview you can always select the Draft mode option. Now that Photoshop features a new Blur Gallery Spin Blur filter effect, the Spin mode is less relevant.

Figure 9.2 The Average Blur can be used to merge the pixels within a selection to create a solid color which can then be used to take an accurate sample color measurement of the average color within that selection area.

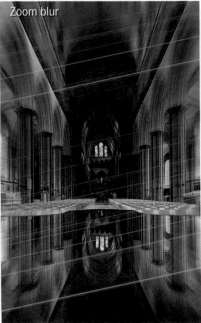
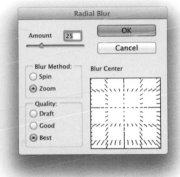

Figure 9.3 When using the Radial Blur filter in Zoom mode, you can create fast zoom lens effects such as in the example shown here on the right. You can also drag the center point in the filter preview dialog to approximately match the center of interest in the image you are about to filter. Note that I added a radial gradient to the Smart Filters mask to hide the blur effect in the center.

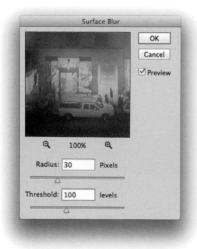

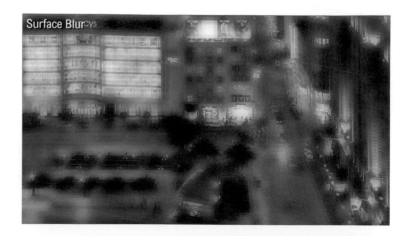

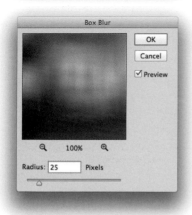

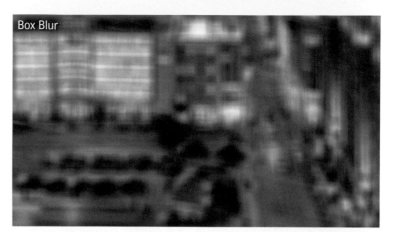

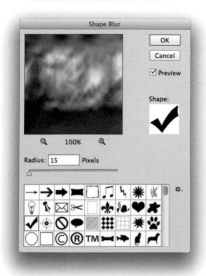

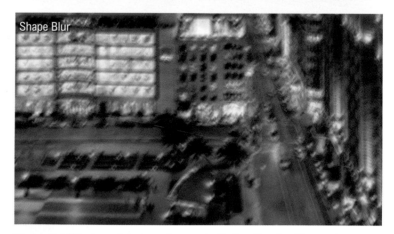

Figure 9.4 This shows from top to bottom, the Surface Blur, Box Blur and Shape Blur filters applied to the same image.

Surface Blur

This Surface Blur filter is like an edge preserving blur filter. The Radius adjustment is identical to that used in the Gaussian Blur filter, so the higher the Radius, the more it blurs the image. Meanwhile, the Threshold slider determines the weighting given to the neighboring pixels and whether these become blurred or not. Basically, as you increase the Threshold this extends the range of pixels (relative to each other) that become blurred. So as you increase the Threshold, the flatter areas of tone are the first to become blurred and the high contrast edges remain less blurred (until you increase the Threshold more).

Box Blur

The Box Blur uses a simple algorithm to produce a square shape blur. It is a fairly fast filter and is useful for creating quick 'lens blur' type effects and certain other types of special effects. The Box Blur is no match for the power of the Lens Blur filter, but it is nonetheless a versatile and creative tool.

Shape Blur

The Shape Blur filter lets you specify any shape you like as a kernel with which to create a blur effect and you can then adjust the blur radius accordingly. In Figure 9.4 (bottom image) I selected a tick pattern shape.

Fade command

Filter effects can be further refined by fading them after you have applied the filter. The Fade command is referred to at various places in the book (you can also fade image adjustments and brush strokes, etc.). Choose Edit ⇒ Fade Filter and experiment with different blending modes. The Fade command is almost like an adjustment layer feature, but without the versatility and ability to undo later. It makes use of the fact that the previous undo version of the image is stored in the undo buffer and allows you to apply different blend modes, but without the time-consuming expense of having to duplicate the layer first. Having said all that, the History feature offers an alternative approach whereby if you filter an image once or more than once, you can return to the original state and paint in the future (filtered) state using the history brush or make a fill using the filtered history state (provided Non-linear History has been enabled in the History panel options).

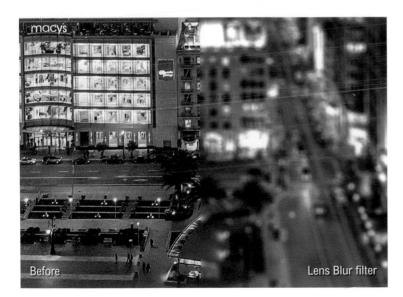

Before

Lens Blur filter

Figure 9.5 In this night-time scene there are lots of small points of light; you can use this image example to get a clear idea of how the Lens Blur filter Specular Highlights and Iris controls work, and observe how they affect the appearance of the blur in the photograph. Note that this image is also available from the book website for you to experiment with.

Enabling Lens Blur as a Smart Filter

Smart Filters are mainly intended for use with value-based filters only, such as the Add Noise or Unsharp Mask filter. They are not intended for use with filters such as Lens Blur because the Lens Blur filter can sometimes make calls to an external alpha channel, and if the selected alpha channel were to be deleted at some point, this would prevent the Smart Filter from working. However, so long as you are aware of this limitation, it is still possible to enable Smart Filters to work with filters like Lens Blur. You first need to go to the Adobe website and search for the following script: EnableAllPluginsforSmartFilters.jsx. This then needs to be placed in a suitable folder location such as Adobe Photoshop CC/Presets/Scripts folder. Then, go to the File ⇨ Scripts menu in Photoshop and choose Browse… This opens a system navigation window. From there you'll want to locate the above script. Once you have done this, you can click Load or double-click to run it, which will pop the Script Alert dialog shown in Figure 9.6. If you wish to proceed, click 'Yes'. The Lens Blur, as well as all other filters will now be accessible for use as Smart Filters. If you want to turn off this behavior, run through the same above steps and click 'No' when the Script Alert dialog shows.

Figure 9.6 The Script Alert dialog.

Lens Blur

If you want to make a photograph appear realistically out of focus, it is not just a matter of making the detail in the image more blurred. Consider for a moment how a camera lens focuses a viewed object to form an image that is made up of circular points on the film/sensor surface. When the radius of these points is very small, the image is considered sharp and when the radius is large, the image appears to be out of focus. It is also particularly noticeable the way bright highlights tend to blow out and how you can see the shape of the camera lens iris in the blurred highlight points. The Lens Blur filter has the potential to mimic the way a camera lens forms an optical image and the best way to understand how it works is to look at the shape of the bright lights in the night-time scene in Figure 9.5, which shows the image before and after I had applied the Lens Blur filter.

The main controls to concentrate on are the Radius slider, which controls the amount of blur that is applied to the image, and the Specular Highlights slider, which controls how much the highlights blow out. To add more lens flare, increase the Brightness slightly and carefully lower the Threshold amount by one or two levels and check to see how this looks in the preview area. The Iris shape controls (Blade Curvature and Rotation) should be regarded as fine-tuning sliders that govern the shape of the out-of-focus points in the picture. You can select from a menu list of different iris shapes and then use these sliders to tweak the iris shape. The results of these adjustments will be most noticeable in the blown-out highlight areas. If you want to predict more precisely what the Lens Blur effect will look like it is better to have the 'More Accurate' button checked.

Depth of field effects

With the Lens Blur filter you can also use a mask channel to define the areas where you wish to selectively apply the Lens Blur. This allows you to create shallow depth of field effects, such as in the example shown on the right. Basically, you can use a simple gradient (or a more complex mask) to define the areas that you wish to remain sharp and those that you want to have appear out of focus. You can then load the channel mask as a Depth Map in the Lens Blur dialog and use the 'Blur Focal Distance' slider to determine which areas remain sharpest.

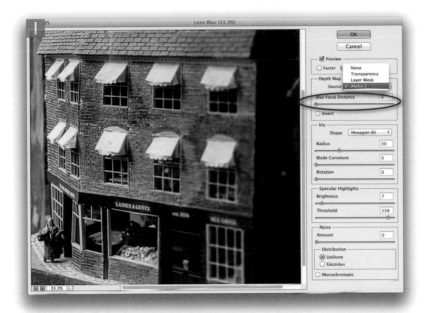

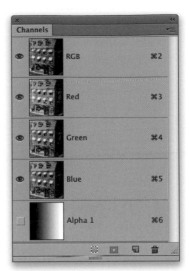

1 In this example, I created a linear gradient mask channel called Alpha 1, where the gradient went from white to black. I then loaded the Alpha 1 channel in the Lens Blur filter dialog to use as a depth map. With the Alpha 1 channel selected, I could now adjust the Blur Focal Distance slider (circled) to determine where I wanted the image to remain sharp.

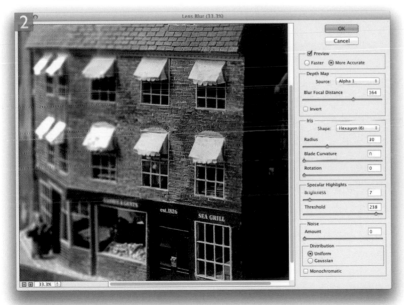

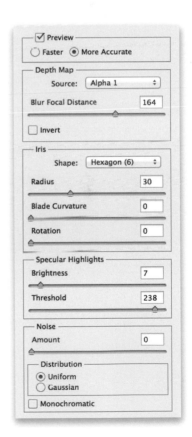

2 Another way to use a depth map is to click in the preview area to set the point where the image should be sharpest. Basically, the degree of Lens Blur is linked to the gray values in the Depth Map source channel.

Blur Gallery filter limitations

The Blur Gallery filters offer quite a lot of options for being creative, but there are some restrictions you need to be aware of. You can only apply this filter to RGB or CMYK images. It won't work on grayscale images, alpha channels or layer masks.

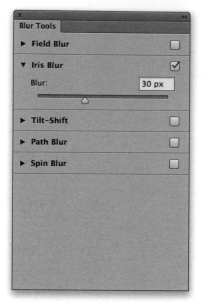

Figure 9.7 The Blur Tools controls. This and the panel below only appear when one of the new Blur Tools filters is selected.

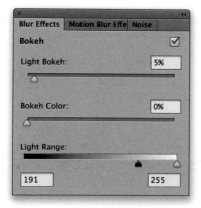

Figure 9.8 The Blur Effects controls.

Blur Gallery filters

The Lens Blur filter has enough slider controls to let you create a fairly realistic-looking Lens Blur effect, but it does suffer from certain limitations. Firstly, it can be quite slow to work with and therefore a painstaking experience to tweak the sliders in search of an optimum blur setting. The sheer number of sliders can also be considered quite intimidating, which may put some people off using this filter. While it is possible to create blur maps that can be used in conjunction with the Lens Blur filter, it is this aspect of its design that limits it from being accessible as a Smart Filter (though as I point out on page 616 it is possible to override this). The Blur Gallery filters offer a more simplified interface for applying Lens Blur effects. Overall these are a lot quicker to work with than the Lens Blur filter, have fewer controls to bother with and the blur effects can easily be edited. These are all available from the Filter ⇨ Blur Gallery menu and you'll note that when one Blur Gallery filter is active, the other four Blur Gallery filter modes are accessible too via the Blur Tools panel.

Iris Blur

Let me start first with the Iris Blur filter (Figure 9.7). The Blur slider controls the strength of the blur effect and allows you to apply much stronger blurs than you can with Lens Blur. In the Blur Effects panel below (Figure 9.8) are the Blur Effects controls. The term 'bokeh' refers to the appearance of out-of-focus areas in a picture when photographing a subject using a shallow focus (see Figure 9.9). What happens when you do this is that out-of-focus objects in a scene are focused as large, overlapping circles at the plane of focus. Objects that are in focus are also focused as overlapping circles, but an image is perceived to be sharp when those circles are small enough that they create the illusion of sharpness. The circles of confusion aren't actually circles. They are determined by the shape of the lens iris, which is usually pentagonal or hexagonal in shape. So, to create a bokeh-type effect in Photoshop, the Iris Blur filter applies a hexagonal iris shape blur to the image. The Light Bokeh slider lets you control the intensity of the bokeh effect by working in conjunction with the Light Range sliders to 'blow out' selected tonal areas and create bright, out-of-focus highlights. With the Lens Blur filter you have a Brightness and a single Threshold slider that control the appearance of the specular highlights. The Light Range control in the Blur Effects panel is a little more sophisticated.

There are two sliders: one for the highlights and one for the shadows. What happens here is the filter uses an inverse high dynamic range tone mapping to create a pseudo high dynamic range between the two slider points. By adjusting the shadow and highlight sliders, Photoshop can intensify the tonal range between these two points. This simulates a real-life subject brightness range and then applies the blur effect to the data. This is an important difference and is what helps make the Blur Gallery effects look more realistic compared with other blur methods. Basically, this gives you the flexibility to apply the bokeh effect to any tone area in the image you like and not just the highlights. For example, you can have a bokeh effect applied to the midtones or the shadows only. The Bokeh Color slider allows you to specifically intensify the color saturation of the bokeh effect. The default setting of zero will be best in most cases, but some shots may benefit from increasing the Bokeh Color slider amount.

Figure 9.9 This shows what a typical lens bokeh effect looks like.

Faster graphics processing

Blur Gallery filters are able to make use of what is known as 'Mercury Graphics' processing in Photoshop. If 'Use Graphics Processor' is enabled in the Performance preferences this can help speed up the time it takes to render the Blur Gallery previews in mouse-up mode as well as when processing the final render. Depending on the card this can make a big difference to final render times. You should also notice a more accurate preview while making blur adjustments or when moving a pin. However, this preview enhancement will only be noticed if using a graphics card that supports 1 GB of VRAM or higher. For example, Intel HD 4000 and AMD Trinity APU cards will support improved mouse-down previews.

Radius field controls

When using the Iris Blur filter you will see the radius field control shown below in Figure 9.10. This always appears centered in the image. You can click on any of the four outer ellipse handles to adjust the shape and angle of the radius field. There is also a radius roundness knob that you can drag to make the radius field rounder or squarer. If you click on the

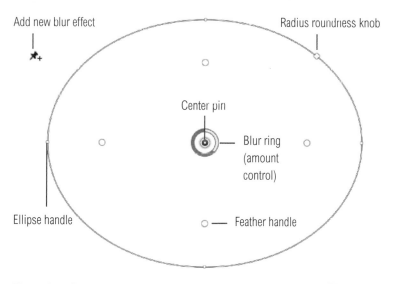

Add new blur effect

Radius roundness knob

Center pin

Blur ring (amount control)

Ellipse handle

Feather handle

Figure 9.10 The Iris Blur ellipse field controls. Note you can hold down **H** to hide the on-image display.

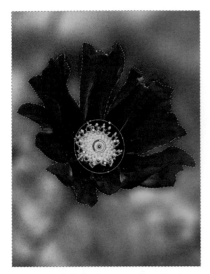

Figure 9.11 This shows an example of where the Selection Bleed amount was increased to allow the unselected area (the flower) to bleed into the selection area.

center pin you can drag to reposition the entire field radius. In between the center and the outer radius are the feather handles. You can drag on any of these to adjust the overall hardness/softness of the blur effect edge relative to the center or outer ellipse edge and if you hold down the *alt* key you can click and drag any of these four pins independently. Just outside the pin in the center is a blur ring. This indicates the blur amount applied to the effect. Click on the ring and drag clockwise to strengthen the blur effect and drag anti-clockwise to reduce the blur amount. As you move the mouse around the image you'll see an 'add new pin' icon. If you click, this adds a new blur effect providing radius ellipse controls to edit the settings for a new blur effect.

Blur Tools options

The Blur Gallery Options bar (Figure 9.12) provides additional controls. The Selection Bleed slider controls the extent to which areas *outside* the selection can bleed into the area that's selected (there must be an active selection for this to be enabled). In Figure 9.11 I selected everything but the flower and as I blurred the selected area, I set the Selection Bleed in the Options bar to 50%. This deliberately allowed the areas outside the selection to blend into the blurred area. To help make the edges look more convincing, only a small amount of bleed should be applied, but you can also use this as a way to produce creative edge bleed effects by applying a heavy blur with a high Selection Bleed value. The Focus slider lets you to control how much the focus in the center is preserved. At 100%, everything is kept sharp. As you reduce the amount the center becomes more out of focus. But when multiple Pins are placed this does allow you to preserve the non-blurred area for each specific pin (this is a per-pin setting). The 'Save Mask To Channels' checkbox lets you save an alpha channel that contains a blur mask based on the feathered area. This could be useful if you felt you needed to add noise later to a blur effect based on the same degree of feathering. Lastly, checking the High Quality checkbox will result in more accurate bokeh highlights.

Figure 9.12 The Blur Gallery Options bar. You can use the drop-down menu on the right to reset the Blur Gallery panel positions and settings. You can visit the Blur gallery menu (circled) to reset the Blur Gallery panels if necessary.

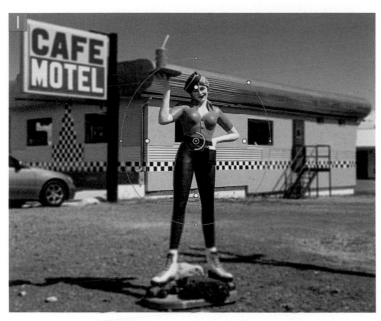

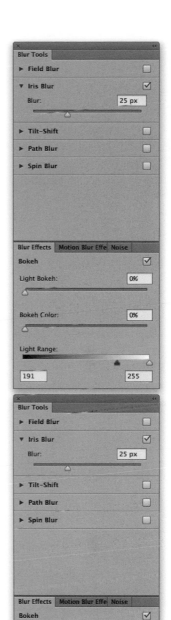

1 When applying the Blur Gallery filter in Iris Blur mode, the ellipse field controls will be shown, where you can edit the controls and adjust the Blur Tools settings.

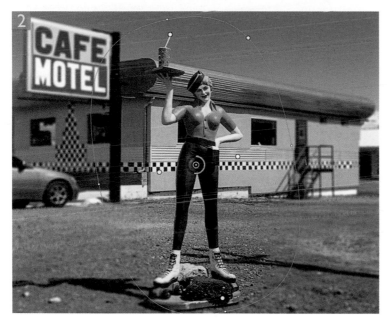

2 I dragged the outer ellipse handles to rotate and increase the size of the radius field, and dragged the Radius roundness knob to make the radius slightly squarer. I then held down the *alt* key to drag the inner feather handles to independently adjust the hardness/softness of the blur edge for all four corners. Lastly, I adjusted the Blur Effects panel sliders as shown here to create the bokeh effect seen here.

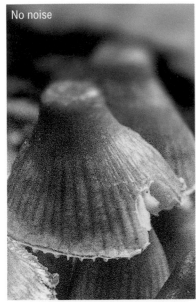

No noise

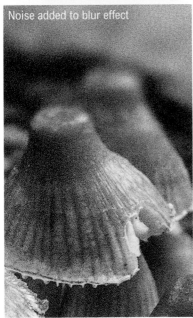

Noise added to blur effect

Noise panel

One of the problems you get when adding Blur Gallery effects to create the impression of shallow focus is that the blur effect will also blur the underlying noise structure of the image. Now, this is not such a problem if the image you are working on has no visible noise. But if you are editing a high ISO capture (like the example shown here), this is where the Noise panel can come in handy, because it allows you to generate noise that can be added just to the blurred areas.

When working with any of the Blur Gallery filters you simply go to the Noise panel shown. If the noise panel is not visible, choose Reset Blur Gallery from the workspace menu in the top right (see Figure 9.12). You can then check to add noise, select a noise method from the top menu (Gaussian, Uniform or Grain) and adjust the Amount slider to determine how much noise is added. In Grain mode, the controls are the same as those found in the Camera Raw Effects panel and you can adjust the Size and Randomness sliders. The Color slider controls the monochrome to color ratio (this can help you match the appearance of color noise present in the underlying image). Lastly, there is the Highlights slider. This can be used to reduce the noise in the highlight areas to achieve better highlight/shadow matching.

Figure 9.13 This shows a close-up view of the image shown here where the top view shows the outcome with no noise added and below where grain noise was added to the Blur Gallery effect.

1 This photograph was shot using the Canon EOS 550D at 6400 ISO. As one might expect, there is a fair amount of luminance and color noise visible in this image. It can be treated to some extent using the Detail panel, but not completely.

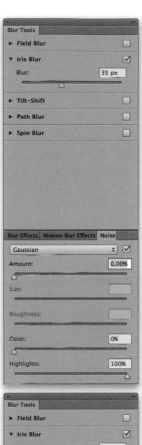

2 I went to the Filter menu and chose Blur Gallery ➩ Iris Blur. I manipulated the iris shape to achieve the desired shape and applied a 35 pixel blur. However, the blur effect also blurred the underlying grain in the image.

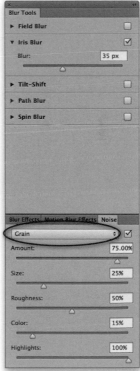

3 To correct this, I enabled noise in the Noise panel, set the mode to 'Grain' (circled) and adjusted the Amount slider to add more noise, adjusting the Size and Roughness. I then went to the Color slider and set this to 15% to make the added noise less monochrome. With the Highlights slider I left this set to 100%. Basically, these controls allow you to kind of mimic the appearance of the underlying grain in the photograph (a close-up of the before and after versions can be seen in Figure 9.13).

Figure 9.14 This shows an example of how tilt-shift distortion should be expected to work when a lens is tilted. In one direction the circles of confusion become more elliptical, stretching outwards from the center and becoming more elongated towards the corners. This can be simulated using a positive Distortion with the Tilt-Shift blur filter. On the opposite axis the distortion is circumferential. This can be simulated using a negative Distortion with a Tilt-Shift blur filter effect.

Multiple blur effects

Note that with both the Tilt-Shift and Iris blur effects the pins within each effect will interact with each other using what is essentially a Multiply blend mode. When multiple effects are combined the resulting blur radius fields from each effect are added together. Also at the same time, the areas of clarity are added together so that where there is an overlap the clarity is always preserved. This means you can easily combine different kinds of Blur Gallery effects to produce a 'merged' blur effect.

Tilt-Shift blur

The Tilt-Shift blur filter allows you to mimic both the blur and distortion effect you would get when shooting with a view camera that allows you to tilt the film plane and also the kind of effect you can get when shooting with a Lens Baby™ lens. You can also combine multiple Tilt-Shift blur effects with one or more other Blur Tools effects to achieve any kind of blur effect you want.

When you apply a Tilt-Shift blur you'll first see a pin in the center with two solid focus lines either side of the pin (Figure 9.15). These indicate the no-blur zone in which the image will remain in focus. Beyond this are the dotted feather lines. Between the focus and feather lines lies the transition zone where the image will fade from being in focus to out of focus, as set by the Blur slider in the Blur Tools panel. You can adjust the width of these lines by dragging anywhere on these lines. To adjust the Tilt-Shift blur angle, click and hold anywhere outside the central no-blur zone and drag with the mouse (you'll see a double-headed arrow cursor). To relocate a blur effect, click and drag inside the no-blur zone. To remove a blur effect, just hit the Delete key. New effects can be added by clicking anywhere in the image.

The Distortion slider can be used to add a distortion effect that radiates from the center pin outwards. So, if you apply a distortion and move the center pin from side to side you'll notice how the radial distortion effect adjusts as you do this, centering around wherever the center pin is placed (see Figure 9.14 for more details).

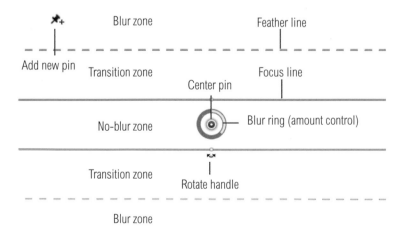

Figure 9.15 The Tilt-Shift blur controls. Note you can use [H] to hide these.

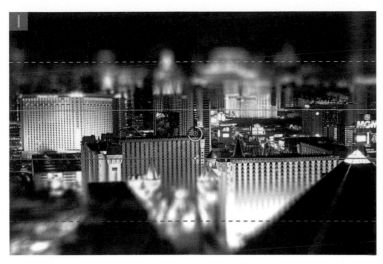

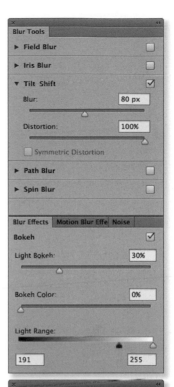

1 In this example I had placed a Tilt-Shift pin in the middle of the image. I increased the blur effect to 80 pixels and applied a maximum +100% Distortion. Both sides of the pin appear blurred, but by default the Distortion setting affected the bottom section only. As you can see, the positive distortion created stretched ellipses radiating from the center towards the bottom corners of the picture. If I were to reposition the central pin, the ellipses would reface to the new pin position.

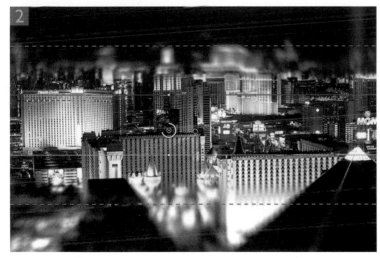

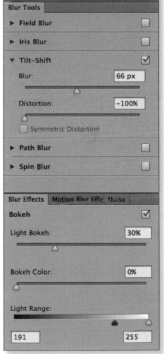

2 To distort the top half of the picture, I added a new pin next to the first. Here, I clicked and held the cursor just below the no-blur/transition zone line and dragged to rotate the Blur effect 180°. By default the same blur settings were applied to this second pin. All I did here was set the Distortion to −100% to create a circumferentially oriented distortion in the top half of the picture and adjusted the settings slightly. Alternatively, you can check the 'Symmetric Distortion' box to apply a mirrored distortion without needing to add a second pin. But note that a symmetric distortion always shares the same Distortion slider setting.

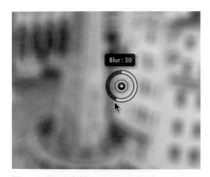

Figure 9.16 A blur amount display appears as you interactively click and drag on the outer blur ring.

Blur ring adjustments

The Blur ring has a central pin and, when activated, an outer ring, which indicates the blur amount applied to that pin. As you adjust the Blur slider you'll notice that the outer ring provides a visual indication of the blur amount that's been applied. It is also possible to click and drag on this ring to adjust the blur amount (see Figure 9.16).

Field Blur

The Field Blur effect can be used to apply a global blur effect. As with the Iris and Tilt-Shift blurs, you have a Blur slider in the Blur Tools panel and the usual set of Bokeh sliders in the Blur Effects panel below. You can use this filter to apply an overall lens blur type of effect, but as you can see in the accompanying example, by adding further pins it is quite easy to create different kinds of custom gradient blur effects.

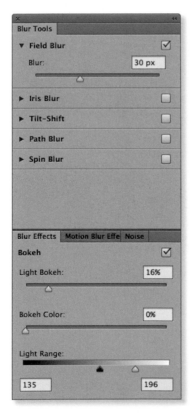

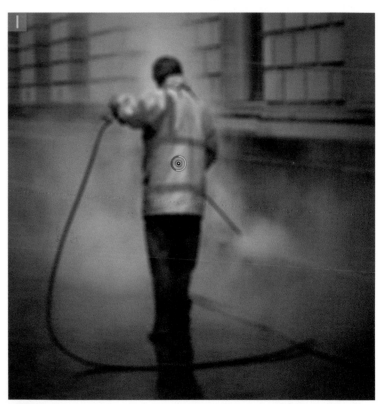

1 Here, you can see the Field Blur filter effect in action. When you first apply this filter you'll have a pin in the middle of the frame set to a default 15 pixel wide blur. What I did here was to increase this to 30 pixels to apply an all-over blur effect to the image.

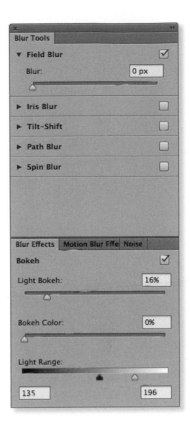

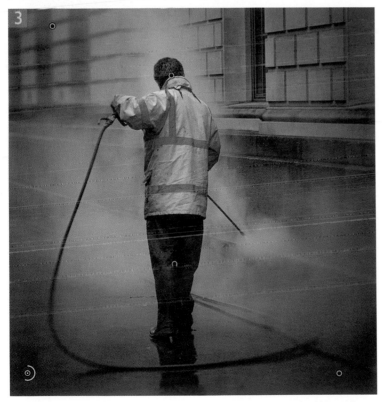

2 In this next step I moved the first pin to the top left of the picture and added a second pin in the center and set the blur amount to zero pixels. This created an area of clarity that counteracted the effect of the first pin. Essentially, when you have two pins placed like this, you can create a simple blur gradient.

3 You can keep on adding extra Field Blur pins to create more complex blur gradients. In this step I added an extra no-blur pin and two extra 30 pixel blur effect pins and dragged the pins to achieve the combined blur effect shown here.

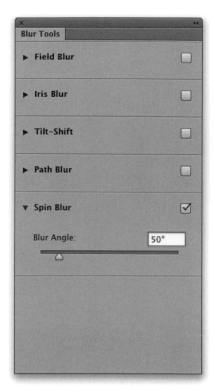

Figure 9.17 The Spin Blur controls in the Blur Tools panel.

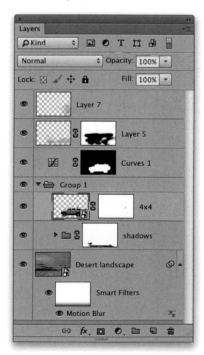

Spin blur

When the Spin Blur effect is selected you can apply a spin blur of varying intensity. The effect this filter can produce is similar to the Radial Blur filter in Spin mode, but because it is applied as a Blur Gallery filter you have a lot more interactive control over the final effect. For example, you can apply an elliptical shaped blur, recenter the blur effect and adjust the Blur angle (see Figure 9.17) while being able to see a live preview.

You can adjust the Spin blur by dragging the Blur Angle slider to increase or decrease the strength of the effect (or click and drag clockwise or anti-clockwise on the blur ring). You can then drag the handles to change the Spin blur size and shape, and drag the feather handles to adjust the feathering. You can reposition by click dragging anywhere inside the ellipse area and further spin blurs can be added by clicking anywhere else in the image area. You can also have them overlap.

The rotation center point can be adjusted by *alt* dragging the blur ring. This allows you to create spin blurs on objects that are viewed from an angle. To copy a Spin Blur, click inside a Blur ring, hold down the ⌘ key (Mac) *ctrl* key (PC) and then the *alt* key and with both keys held down drag to copy to a new location within the image. To hide the blur ring go to the View menu and deselect 'Extras', or use the ⌘ *H* (Mac) *ctrl* *H* (PC) shortcut.

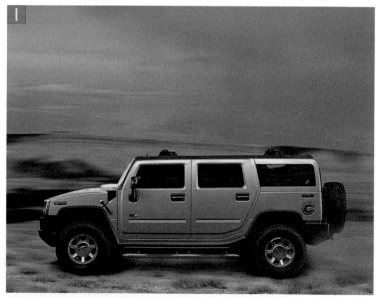

1 I created this image by taking a photograph of a 4x4 vehicle that was shot in a town, cutting it out and placing as a layer above a photograph shot in a deserted landscape.

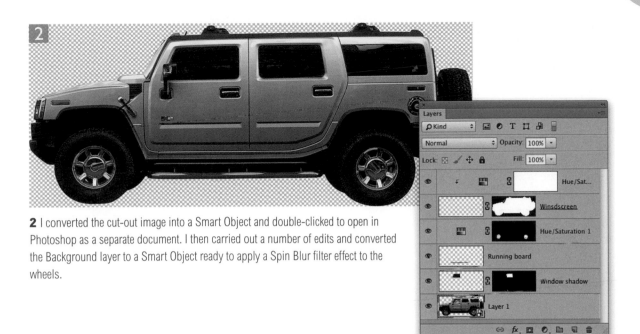

2 I converted the cut-out image into a Smart Object and double-clicked to open in Photoshop as a separate document. I then carried out a number of edits and converted the Background layer to a Smart Object ready to apply a Spin Blur filter effect to the wheels.

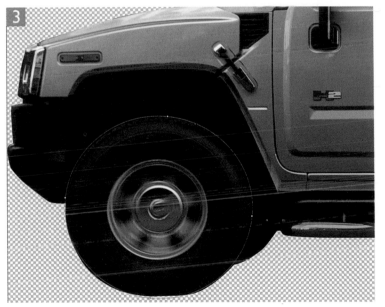

3 Next, I went to the Filter menu and chose Blur Gallery ⇨ Spin Blur… I dragged the Spin Blur ellipse over to the front wheel and manipulated the shape so that the Spin Blur ellipse matched the shape of the tire. I then applied a 35° Blur Angle via the Blur Tools panel Spin Blur section.

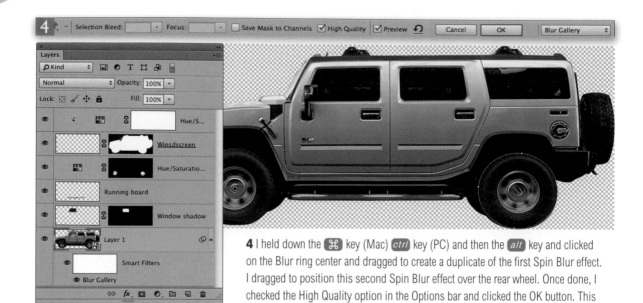

4 I held down the ⌘ key (Mac) *ctrl* key (PC) and then the *alt* key and clicked on the Blur ring center and dragged to create a duplicate of the first Spin Blur effect. I dragged to position this second Spin Blur effect over the rear wheel. Once done, I checked the High Quality option in the Options bar and clicked the OK button. This applied the Spin Blur effect as an editable Smart Filter to the 4x4 car layer.

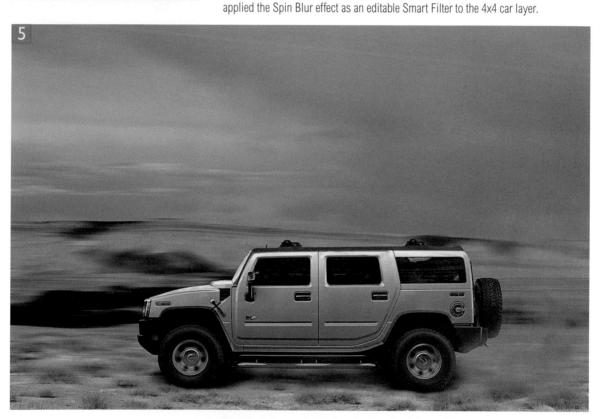

5 Lastly, I chose File Save to save the edited Smart Object layer and closed the Smart Object document window. The original image with the 4x4 plus landscape was now updated to show the vehicle with wheels that appeared to be in motion.

Path blur

The Path Blur tool can be used to create a motion blur effect along a user-drawn path. Basically, by adjusting the path shape you can manipulate the shape and direction of the motion blur to create an effect similar to camera shake, such as when photographing a moving subject and leaving the shutter set to a slow shutter speed. You can manipulate the curve shape to control the length and curvature of the Path Blur, click on the path to add more control points and click on existing curve points and drag to further modify the shape. *alt*-click on a Path Blur control point to convert it to a corner point, or convert a corner point back to a smooth point.

The path blur shape will have red blur direction arrows at either end point. You can click on a path blur shape end point, or a blur direction arrow and click and drag to determine the blur direction (the End Point Speed) and adjust the angle. The blur directional arrows also have a midpoint control you can click on and drag to further alter the shape of the blur direction. To disable an end point blur direction arrow, hold down the *⌘* key (Mac) *ctrl* key (PC) and hover over a path blur end point, you'll see a filled circle appear next to the cursor. Click on the end point to disable. Hold down the *⌘* key [Mac] *ctrl* key [PC] and click again to enable. If you hold down the *Shift* key you can click and drag a blur direction arrow at one end and simultaneously move the arrow at the other end as well.

It helps to understand here that the defined blur shapes at the two ends of a path are interpolated between the two end points. Also, as you add more path blur shapes to an image these will influence each other and it is this aspect of the Path Blur filter that provides lots of opportunities to produce creative blurring effects. To add a new path blur keep clicking to add more control points and press *Enter* or *esc* to end the path blur shape, or just click on the last control point. To reposition a path blur, hold down the *⌘* key (Mac) *ctrl* key (PC) and click on the blue path or a control point and drag to relocate. To remove a control point, select a path blur control point and hit the *Delete* key. To duplicate a Path blur, hold down *⌘* *alt* (Mac) *ctrl* *alt* (PC) as you drag a blue path or one of the control points.

The overall blur strength can be controlled by adjusting the Speed slider in the Path Blur section of the Blur Tools panel (Figure 9.18). There are two starting point modes here: Basic Blur and Rear Sync Flash (examples of which are shown on the next page). The Taper slider can be used to dampen the path

Figure 9.18 The Path Blur controls in the Blur Tools panel.

Extent of slider controls

The Speed and Taper sliders affect all path blur shapes equally. The End Point Speed slider is set for each blur direction arrow independently.

blur effect and adjust the edge fading from either end. The Centered Blur checkbox governs the way the blur shapes are calculated. This box is checked by default to ensure the blur shape for any pixel is centered on that pixel. This produces a more controlled behavior when editing path blur shapes. When it's unchecked it will sample from one side of any pixel only and the path blur will flow around a lot more as you edit the path blur shapes. As I just mentioned, the End Point Speed slider is linked to the length of the blur direction arrows, and the Edit Blur Shapes box allows you to view/hide the blur direction arrows. In the Options bar is a High Quality checkbox (Figure 9.19). Check this to produce high quality rendering to prevent any jaggedness appearing in a path blur effect.

Figure 9.19 The Blur Tools Options bar.

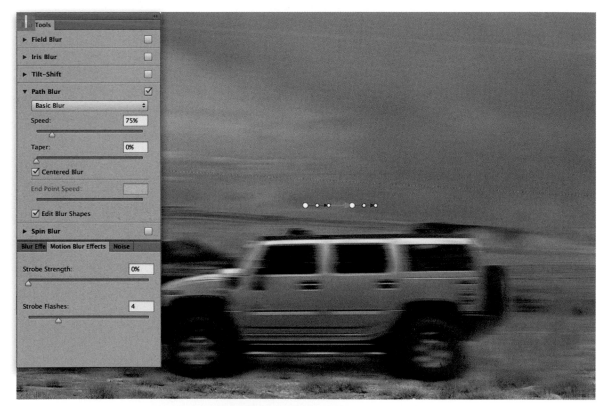

1 To show how the Path Blur can be used I continued editing a copy of the car layer Smart Object. In this step I applied a simple, linear Path Blur filter using a Speed setting of 75% and the Basic Blur mode.

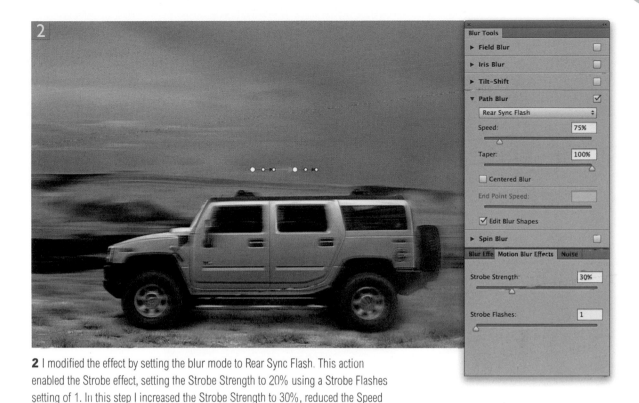

2 I modified the effect by setting the blur mode to Rear Sync Flash. This action enabled the Strobe effect, setting the Strobe Strength to 20% using a Strobe Flashes setting of 1. In this step I increased the Strobe Strength to 30%, reduced the Speed slider setting to 75% and increased the Taper amount to 100%.

Motion Blur Effects panel

The Motion Blur Effects panel (Figure 9.20) gives you the ability to create a multiple strobe/flash effect. You can adjust this to determine how much blur will show between flash exposures. In Basic Blur mode the Strobe Strength Slider is set to 0%, where there will be no strobe effect. As you increase the slider you create a more noticeable strobe effect with very little blur between exposures. This slider allows you to control the balance of the strobe light effect. Below that is the Strobe Flashes slider, which can be used to set the number of strobe flash exposures (from 1 up to 100).

Figure 9.20 The Motion Blur Effects panel.

1 In this example, I began by making a cut-out of the dancer featured in this photograph to isolate him on a separate layer and converted this layer to a Smart Object.

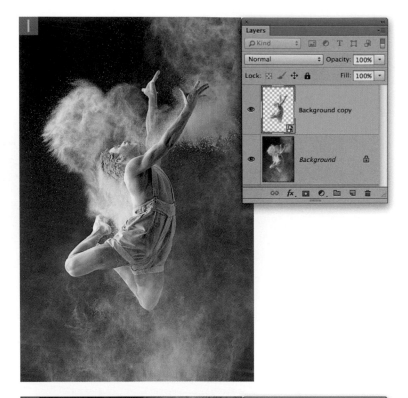

2 I then went to the Filter menu and chose Blur Gallery ⇨ Path Blur…This step shows the Path Blur filter applied using the default settings, with the Basic Blur mode selected and the Speed set to 50%.

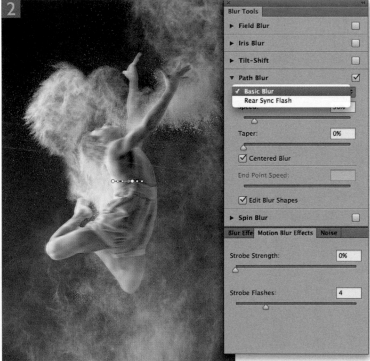

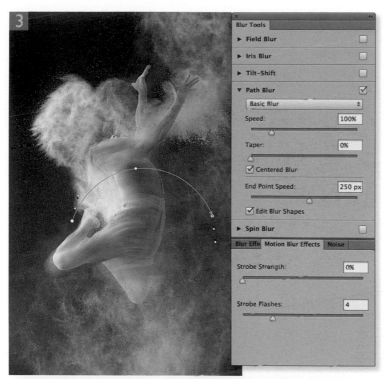

3 In this step I manipulated the path blur handles to create the arc shape seen here. I also edited the path blur end points and clicked and dragged the red handles to define the beginning and end blur directions. You will notice as you do this how the length of each of these red handles is also linked to the End Point Speed slider. I also increased the Speed amount, applying a 100% setting.

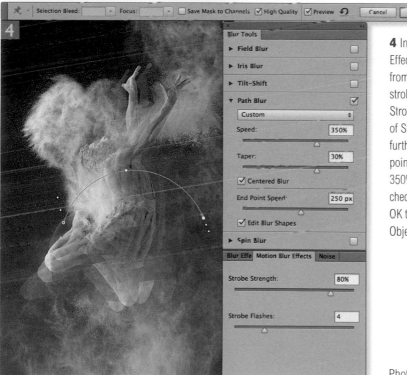

4 In this final step I went to the Motion Blur Effects panel and raised the Strobe Strength from the default zero setting to apply a strobe effect. In this instance I applied a Strobe Strength of 80% and set the number of Strobe Flashes to 4. In addition to this I further manipulated the two path blur end points and increased the Speed amount to 350%. In the Path Blur Options bar I also checked the High Quality box and clicked OK to apply the filter effect to the Smart Object layer.

Photograph: © Eric Richmond.

Smart Object support

Photoshop CC provides Smart Object support for all the Blur Gallery filters. Having the ability to apply the Blur Gallery filters to Smart Objects opens up a number of interesting opportunities. Most of all, it means you can apply Blur Gallery filters non-destructively and easily toggle the smart filter visibility on or off like any other smart filter effect. You can combine Blur Gallery filters with other filter effects and create different results by placing other filter effects above or below a Blur Gallery smart filter.

Blur Gallery filters on video layers

Interestingly, you can apply Blur Gallery filters to a video layer. This means you can easily apply effects such as a Tilt-Shift Blur filter to a video clip to produce the classic miniaturization effect (see opposite). One thing to be aware of is if you apply a Blur Gallery filter effect to a video layer as a smart object and check the 'Save Mask to Channels' option this will cause an alpha channel for each video frame to be saved to the Channels panel. Now, it so happens Photoshop only stores up to 99 channels and can therefore soon max out. So be sure to keep the 'Save Mask to Channels' option unchecked to prevent this happening.

Smart objects and selections

If you apply a Blur Gallery filter to a Smart Object layer with a selection that's active, the filter effect is applied to the whole layer and the active selection is used to create a smart filter mask (see page 638). However, it also means that the Selection Bleed is fixed at 100%—the Selection bleed setting appears grayed out in the options bar (see Step 2) and you won't be able to edit the Selection Bleed setting. To be honest, I am not sure why this should be the case, as it does seem to limit the effectiveness of converting a layer to a smart object and using a Blur Gallery filter in conjunction with a mask. In the example shown on the next page this suggests it is not always a good idea to convert a layer to a smart filter when using the Blur Gallery filters.

Applying a Blur Gallery filter to a video clip

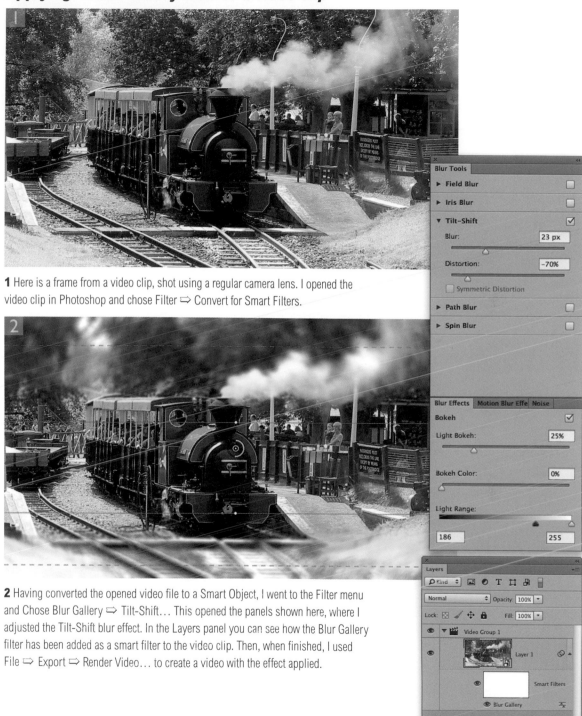

1 Here is a frame from a video clip, shot using a regular camera lens. I opened the video clip in Photoshop and chose Filter ⇨ Convert for Smart Filters.

2 Having converted the opened video file to a Smart Object, I went to the Filter menu and Chose Blur Gallery ⇨ Tilt-Shift… This opened the panels shown here, where I adjusted the Tilt-Shift blur effect. In the Layers panel you can see how the Blur Gallery filter has been added as a smart filter to the video clip. Then, when finished, I used File ⇨ Export ⇨ Render Video… to create a video with the effect applied.

Blur Gallery filter with a smart object plus mask

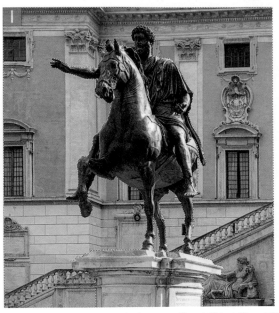

1 In this example I converted a layer to a Smart Object (Smart Filter) and loaded a selection that selected everything but the statue.

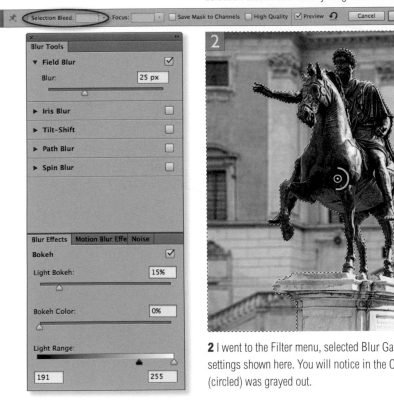

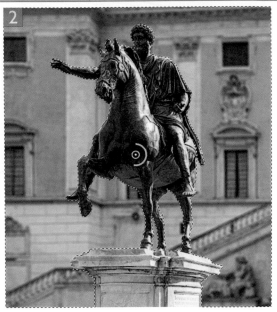

2 I went to the Filter menu, selected Blur Gallery ⇨ Field Blur... and applied the settings shown here. You will notice in the Options bar the Selection Bleed option (circled) was grayed out.

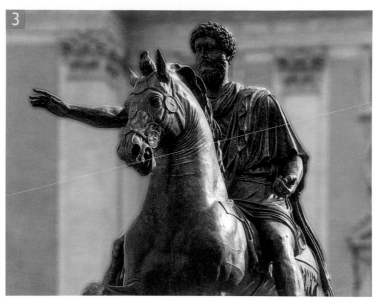

3 I clicked OK in the Options bar to apply the filter and the selection was converted into a mask that masked the Smart Filter layer. This did result in some selection bleed around the edges of the statue, but I was at least able to re-edit the filter settings.

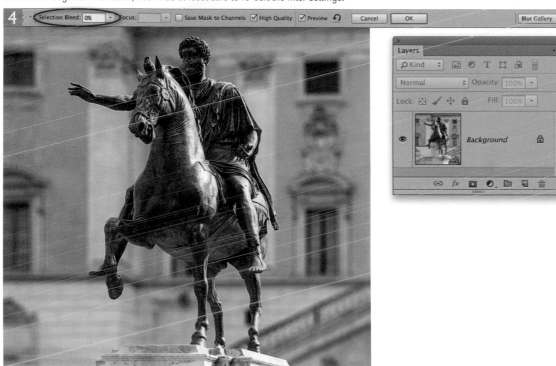

4 An alternative was to not process the image as a smart object. Here, I loaded the same selection as in Step 1 and applied the same filter settings to a Background layer with Selection Bleed set to 0% (circled). This method resulted in no edge bleed.

Smart Filters

For many years Photoshop users had requested the ability to apply live filters in the same way as you can apply image adjustments as adjustment layers. Smart Filters was the solution the Photoshop team came up with and this feature can be particularly useful when working with some of the blur filters discussed in this chapter, as you may very often need the ability to re-edit the blur amount. I have already shown a couple of examples earlier of Smart Filters in use, such as when applying the Spin blur and Motion Blur filters.

When you go to the Filter menu and choose Convert for Smart Filters, you are basically doing the same thing as when you create a Smart Object. So, if a layer or group of layers have already been converted to a Smart Object, there is no need to choose 'Convert for Smart Filters'.

You can switch Smart Filters on or off, combine two or more filter effects, mask the overall Smart Filter combination as well as adjust the Smart Filter blending options. These allow you to control the opacity and blend modes for individual filters. As I have shown below in Figure 9.21, you can group several layers into a Smart Object and filter the combined layers as a single Smart Object layer.

Double-click to edit a Smart Object

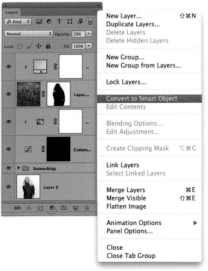

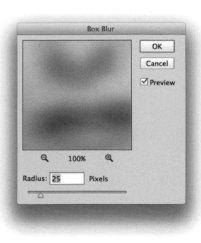

Smart Filter visibility Open Blending options

Figure 9.21 You can make a selection of more than one layer in a document and convert these into a Smart Object. From there you can add filter effects that are applied as Smart Filters to a composite version of all the selected layers. The multi-layered image can still be accessed and edited by double-clicking the Smart Object thumbnail.

Applying Smart Filters to pixel layers

Smart Filters are essentially filter effects applied to a Smart Object. The process begins with you converting a layer or group of layers to a Smart Object, or selecting a layer and choosing Filter ⇨ Convert for Smart Filters. Smart Filters allow you to apply most types of filter adjustments non-destructively and the following steps provide a brief introduction to working with the Adaptive Wide Angle filter as a Smart Filter.

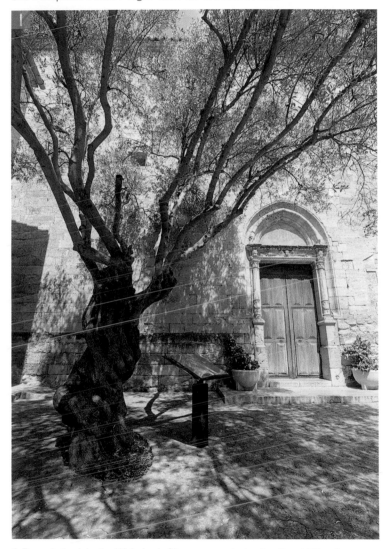

1 To apply the Adaptive Wide Angle filter as a non-destructive Smart Filter, the Background layer first had to be converted to a Smart Object. To do this I went to the Filter menu and chose 'Convert for Smart Filters'. This converted the Background layer into the Smart Object layer shown here in the Layers panel.

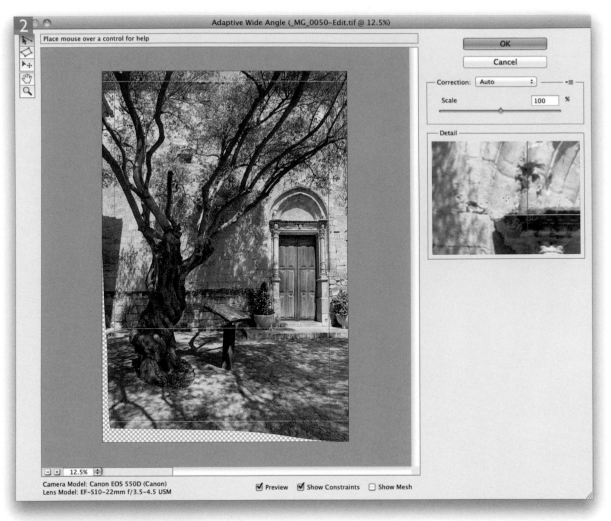

2 I then went to the Filter menu, selected the Adaptive Wide Angle filter and applied the adjustments shown here, where I used the Adaptive Wide Angle filter to correct the perspective in the original photograph. If you check the Layers panel you will notice that after I had applied the Adaptive Wide Angle filter, this added a Smart Filter layer to the layer stack. I could now click the filter name eye icon (circled) to switch this adjustment on or off.

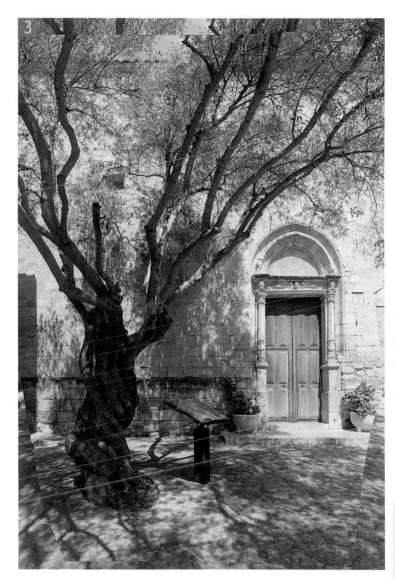

3 I then double-clicked on the Smart Filter blend options button (circled in blue). Here, I found it useful to select the Dissolve blend mode as this blend mode helped reveal the uncorrected version of the image behind the perspective-corrected version. I then double-clicked the Smart Object layer itself (circled in red). This popped the warning dialog shown on the right, which indicated that any subsequent changes I might make to the Smart Object image would need to be saved before closing the document window. It also reminded me that one should always save to the same location (in practice this should never be an issue if you always use the File ⇨ Save command rather than File ⇨ Save As…).

4 Here you can see the original Smart Object image document, but without the Adaptive Wide Angle filter. I could now edit this document as one would do normally. I added a number of layers which were used to selectively lighten or darken various parts of the photograph. When I closed the document window a dialog box prompted me to choose 'Save'. As I pointed out in Step 3, this must be done in order to save the Smart Object back to the parent document.

5 Here is the final version in which you can now see the result of the image adjustments applied to the Smart Object image combined with the Adaptive Wide Angle filter I had applied as a Smart Filter (filtering the entire image). In addition to this, I added a few layers including a retouch layer to neatly fill in the edges at the bottom, a Photo Filter layer to adjust the color slightly and a darken edges layer to vignette the image. The key lesson here is that nearly all of the adjustments I had just applied to this photograph, including the Adaptive Wide Angle filter settings, remained fully editable.

The chromatic aberration and vignetting adjustments are always applied relative to the center of the image circle. In the case of digital capture images the auto correction adjustments will work precisely so long as the source image has not been cropped. In the case of scanned images things get a little trickier since the auto corrections will only work correctly if the source image has been precisely cropped to the exact boundaries of the frame.

Video clip Lens Corrections

You can apply the Lens Correction filter to video clips by opening a video file in Photoshop and applying the Lens Correction filter as a Smart Object. This is quite a powerful feature and can greatly improve the appearance of your video footage. Providing that is, you have a lens profile for the camera and lens used, such as video recorded using a digital SLR camera.

Lens Corrections

The Photoshop Lens Correction filter appears at the top of the main Filter menu and has its own shortcut (⌘ Shift R [Mac] ctrl Shift R [PC]). You will notice there are two tabs in the panel and that the Auto Correction tab is shown by default (Figure 9.22). Here you'll find various options that are intended to fix common lens problems, starting with the Correction section. The Geometric Distortion option can be used to correct for basic barrel/pincushion distortion. Next we have the Chromatic Aberration option, which can be used to counter the tendency some lenses have to produce color fringed edges. Below that is the Vignette option, which can be used to correct for darkening towards the edges of the frame, which is a problem most common with wide angle lenses. Lastly, if you check the Auto Scale Image option this ensures the original scale is preserved as much as possible in the picture.

Basically, if you are about to apply an auto lens correction to an image that contains EXIF camera and lens metadata, the EXIF metadata information is used to automatically select an appropriate lens profile in the Lens Profiles section below. If the image you are editing is missing the EXIF metadata (i.e. it is a scanned photo) and you happen to know which camera and lens combination was used, you can use the Search Criteria section to help pinpoint the correct combination. It is important to appreciate here that the camera body selection is also important. This is because some camera systems capture a full-frame image (therefore making full use of the usable lens coverage area), while compact SLR cameras mostly have sensors that capture a smaller area. The lens correction requirements will therefore vary according to which camera body type is selected. Once you have selected the correct lens profile you can use the Preview button at the bottom of the dialog to toggle and compare a before and after view of the auto lens correction.

Custom lens corrections

In the Custom tab (Figure 9.23), the Geometric Distortion section contains a Remove Distortion slider that can correct for pincushion/barrel lens distortion. Alternatively, you can click to select the remove distortion tool and drag toward or away from the center of the image to adjust the amount of distortion in either direction. Overall, I find the Remove Distortion slider offers more precise control.

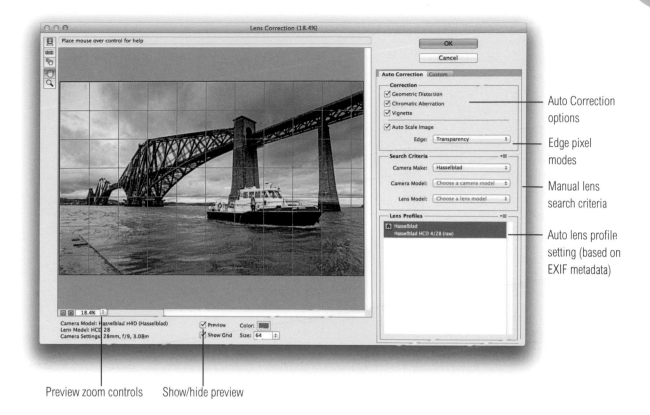

Auto Correction options

Edge pixel modes

Manual lens search criteria

Auto lens profile setting (based on EXIF metadata)

Preview zoom controls Show/hide preview

Figure 9.22 The Lens Correction filter dialog in the default Auto Correction mode.

The Chromatic Aberration section contains three color fringe fixing sliders for fixing the red/cyan, green/magenta and blue/yellow fringing.

The Vignette section contains Amount and Midpoint sliders, which are also identical to those found in the Camera Raw Lens Corrections panel and these can be used to manually correct for any dark vignetting that occurs at the corners of the frame.

The Transform section controls let you correct the vertical and horizontal perspective view of a photograph such as the vertical keystone effect you get when pointing a camera upwards to photograph a tall building, or to correct the horizontal perspective where a subject hasn't been photographed straight on.

You can adjust the rotation of an image in a number of ways. You can click and drag directly inside the Angle dial, but I mostly recommend clicking in the Angle field (circled in Figure 9.23) and using the up and down keyboard arrow keys

Edge pixels

As you apply Lens Correction Transform adjustments, the shape of the image may change. This leaves the problem of how to render the outer pixels. The default setting uses the Transparency mode, although you can choose to apply a black or white background. Alternatively you can choose the Edge Extension mode to extend the edge pixels. This may be fine with skies or flat color backdrops, but is otherwise quite ugly and distracting, although the extended pixels may make it easier to use the healing brush to fill these areas.

Lens Correction tools: remove distortion tool; straighten tool; move grid tool; hand tool; zoom tool

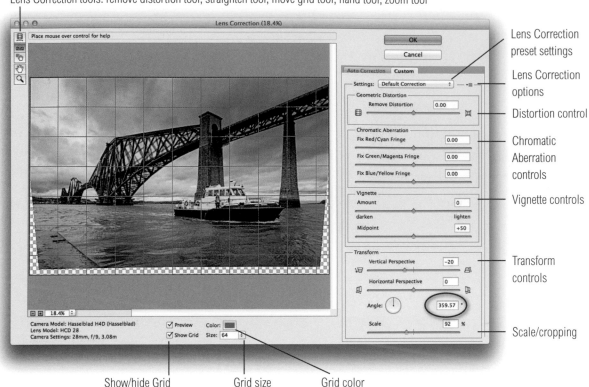

Show/hide Grid Grid size Grid color

Figure 9.23 The Lens Correction filter dialog in Custom mode.

to nudge the rotation in either direction by small increments. The other option is to select the straighten tool and drag to define what should be a correct horizontal or vertical line. The image will then rotate to align correctly.

The Scale slider can be used to crop a picture as you apply a correction. On the other hand you may wish to reduce the scale in order to preserve more of the original image (as shown in Step 2 on the page opposite). The grid overlay can prove useful for helping you judge the alignment of the image and you can use the move grid tool to shift the placement of the grid. The grid controls at the bottom of the Lens Correction filter dialog also enable you to change the grid color, adjust the grid spacing, and toggle showing or hiding the grid. Note that if you select the move grid tool this allows you to adjust the grid position by dragging in the preview window.

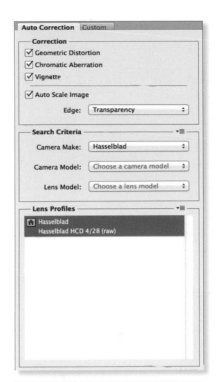

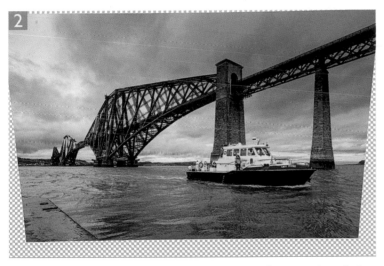

1 In this example I checked all the Auto Correction options to apply an auto lens correction to this photograph, which in this case was based on the EXIF metadata contained in the original photo.

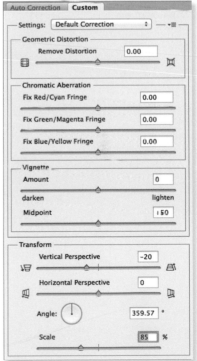

2 I then switched to the Custom mode and applied a custom lens correction to further correct for the perspective angle this photograph was shot from. Basically, I adjusted the Vertical Perspective slider and made a minor adjustment to the angle of rotation. You'll also note that I adjusted the Scale slider to reduce the scale size and preserve more of the image.

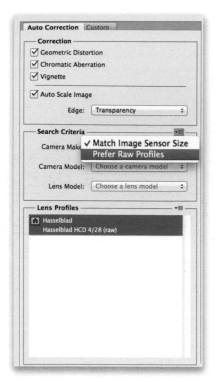

Figure 9.24 You can choose to prefer raw profiles via the Search Criteria section fly-out menu options in the Lens Correction filter dialog.

Selecting the most appropriate profiles

If the camera/lens combination you are using matches one of the Adobe lens correction profiles that was installed with Photoshop, then that is the only option you'll see appear in Lens Profiles (Figure 9.24). If no lens correction profile is available (because the necessary lens EXIF metadata is missing), you'll see a 'No matching lens profiles found' message. The Search Criteria Camera Make, Camera Model and Lens Model menus will then allow you to manually search for a compatible camera/lens profile combination. If you like, you can create your own custom profiles using the Adobe Lens Profile Creator program (see book website for details).

The Lens Correction filter can make use of profiles created from raw files or from rendered TIFF or JPEG capture images. This means that two types of lens profiles can be generated: raw and non-raw lens profiles. In terms of the geometric distortion and chromatic aberration lens correction, you are unlikely to see much difference between these two types. With regards to the vignette adjustment, here it does matter more which type of source files were used. In the case of raw files, the vignette estimation and removal is measured directly from the raw linear sensor data. Now, if the Lens Correction filter were able to process raw files directly this would result in more accurate lens vignette correction results. Since the Lens Correction filter is used to process rendered image files such as JPEGs and TIFFs, it is therefore better to use the non-raw file generated lens profiles, where available. It is for this reason that the Lens Correction filter dialog displays the non-raw lens correction profile by default and only shows a raw profile version if there is no non-raw profile version available on the system. The raw profile versions are therefore only available as a backup. However, if you go to the Search Criteria section and mouse down on the fly-out menu you can select the 'Prefer Raw profiles' option (see Figure 9.24). When this is checked the Lens Correction filter automatically selects the raw profiles first in preference to the non-raw versions. Overall I recommend you stick to using non-raw profiles as the default option for Photoshop lens corrections.

Adobe Lens Profile Creator

You can use the Adobe Lens Profile Creator 1.04 program to help characterize optical aberrations such as geometric distortion, lateral chromatic aberration and vignetting and build your own custom lens profiles. It is available as a free download. Go to the Lens Profiles fly-out menu and choose 'Browse Adobe® Lens Profile Creator Online...' This leads you to a page from where you can download the program. Basically you need to print out one of the supplied charts onto matte paper and then photograph it as described in the Creating lens profiles PDF on the book website.

Interpolating between lens profiles

The zoom lens characteristics will typically vary at different focal length settings. Therefore to get the best lens profiles for such lenses you may need to capture a sequence of lens profile shots at multiple focal length settings such as at the widest, narrowest and mid focal length settings. The Adobe Lens Profile Creator program can then use the multiple lens capture images to build a more comprehensive profile for a zoom lens. You can also build lens profiles based on bracketed focusing distances. For example, this might be considered a useful thing to do with macro lenses, where you are likely to be working with the lens over a wide range of focusing distances.

Lens Correction profiles and Auto-Align

The Auto-Align feature shares the same lens correction profiles as those used by the Lens Correction filter dialog. This is why you should mostly see much improved performance in the way the Auto-Align feature is able to stitch photos together. Adobe have also added caching support so that the Lens Correction and Auto-Align Layers dialogs open more speedily on subsequent launches after the first time you open either dialog.

Batch lens correction processing

You can batch process images to apply lens corrections by choosing File ⇨ Automate ⇨ Lens Correction… This opens a batch processing dialog where you can choose to configure the lens correction filter settings to batch process images and save them to a selected destination folder.

Non-raw profile variance

When it comes to applying lens corrections, you are much better off doing so at the raw processing stage, where raw lens profiles are the default. Raw profiles used at this stage are more consistent since they all start from a known baseline. Non-raw generated profiles are subject to a number of unknown factors. Non-raw profiles are still the best choice for use with the Lens Correction filter, but using Camera Raw and raw profiles is a better starting point.

Figure 9.25 When using the Adobe Lens Profile Creator program you can use the File menu to choose 'Send Profiles to Adobe' (⌘ ⌥ S [Mac] ctrl alt S [PC]). This allows you to share lens profiles you have created with other users.

Fisheye lens corrections

You will also see improved auto-alignment for fisheye photos that have been shot in portrait mode. However, for this to work properly it is necessary that all the source images are shot using the same camera, lens, image resolution and focal length. If these above criteria are not met, then you will most likely see a warning message.

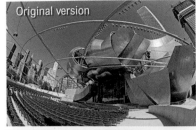

Original version

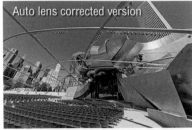

Auto lens corrected version

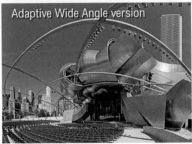

Adaptive Wide Angle version

Figure 9.26 Here you can see three variations of the same image. The top version shows the original fisheye lens photo with no lens corrections applied to it. The middle version shows the same image with an auto lens profile correction. The bottom version shows how the image looked after using the Adaptive Wide Angle filter with custom constraint adjustments.

Adaptive Wide Angle filter

So, if Camera Raw and Photoshop provide the ability to make automatic lens profile corrections, why do we also need an Adaptive Wide Angle filter? It does seem like an odd addition until, that is, you understand the logic behind this feature and why it can be so useful.

Essentially, the problem is this: how do you take a wide angle, spherical field of view and represent it within a rectangular frame? One approach is to preserve the spherical field of view without distorting the image. This is what fisheye lenses do. The other approach is to apply a perspective type projection, which will attempt to straighten the image so that straight edges in the scene appear straight. While some rectilinear lenses can be very good, the problem with a perspective projection is that objects will appear more stretched towards the edges of the frame. Round objects become egg-shaped and everything tends to look more stretched. I suppose in this instance you could sum up the problem as 'how do you squeeze a round peg into a square hole?' Artists over the centuries have overcome this problem by not observing true, camera lens-like perspective projections, where objects would appear distorted at the edges. They have sometimes combined multiple perspective projections in a single image, or adapted the perspective of some objects to avoid the effects of perspective distortion. They have effectively deviated from painting in true perspective.

In the world of photography we have so far been limited to what perspective projection lenses have been able to do at the point of capture and what programs like Photoshop can do in the post-processing. What's been missing until now has been the means to manipulate the field of view and determine precisely which lines should remain straight—something no camera lens can achieve. The Adaptive Wide Angle filter is the result of research which came out of Berkeley University California into *Image Warps for Artistic Perspective Manipulation* (Robert Carroll, Maneesh Agrawala and Aseem Agarwala). The clue here is in the title: this is an artistic tool that can be used to manipulate the appearance of a wide angle view such that you can take extreme wide angle photographs and apply constraint lines to create more natural-looking images, where the entire mapping is as shape-preserving as possible. This filter has a number of uses. It can be used to uniquely change the perspective composition of a scene

to produce an end result where the perspective looks more natural. It can be used to explore different artistic perspective interpretations, or it can be used to match the visual perspective in another scene. This could be particularly useful if you are required to blend two images together where it is necessary to get the perspective in one image to match more closely the perspective in the other—something that has been impossible till now.

If you want to test this filter out you should ideally do so using ultra wide angle images, such as those shot with a fisheye lens (see Figure 9.26) or an ultra wide perspective correcting lens, such as a lens with an effective focal length of 24 mm lens on a full-frame 35 mm SLR system or wider. You could try using this filter to edit other types of images, but is really intended as a correction tool for extreme wide angle photographs.

The Adaptive Wide Angle filter combines the technology utilized in the Lens Correction filter with Puppet Warp distortions. When using this filter it will not be necessary to apply a lens correction first via Camera Raw or Photoshop, and in fact, will work better if you don't. After all, since this filter can be used to make user-indicated distortion corrections, it is better to begin with an image that has had no distortion corrections so far applied to it, especially in the case of fisheye lenses, where it would be trickier to use corrected fisheye images as your starting point. This is because the Adaptive Wide Angle filter makes use of the Adobe Lens profiles to refine the lens distortion. As a consequence of this if you correct the lens distortion in Camera Raw first (or use the Lens Correction filter) this may potentially confuse the Adaptive Wide Angle filter. Generally speaking, the Adaptive Wide Angle filter is robust enough to cope with minor corrections, but if you choose to correct a fisheye image first using a Camera Raw lens profile correction, the Adaptive Wide Angle filter will have trouble processing the image correctly.

With photos that have been shot using a tilt-shift lens the user will have the opportunity to adjust the center of the optical axis and apply a certain amount of perspective correction at the time of capture. Such photos may still benefit from being processed using the Adaptive Wide Angle filter. However, it is absolutely paramount you have access to an accurate lens profile and the Auto mode selected in the Correction options.

Shoot raw, not JPEG

Some cameras may apply automatic lens corrections when you shoot in JPEG mode. It is therefore better to shoot in raw mode if you intend processing photos using the Adaptive Wide Angle filter.

Basically, the filter allows you to indicate which lines in a scene should be straight or horizontal/vertical. As these constraints are applied, the filter smoothly applies a Puppet Warp type adaptive warp projection to the image between the constraint lines and image boundary. In other words, you get to define which are the salient lines in the image that should appear straight and the image data is progressively warped to match the constraints you have applied and will continue to update as you add more constraints.

When correcting a fisheye lens image such as the one shown in Figure 9.26, it should not be necessary to apply many more constraint lines than one horizontal and two vertical constraints. Three constraint lines was all that was needed in this example to achieve the main distortion effect you see here. As it happens, I did end up adding a few extra constraints to fine-tune this particular image, but once the main key constraint lines had been added the adaptive wide angle adjustment was mostly complete.

How the Adaptive Wide Angle filter works

When you first open an image in the Adaptive Wide Angle filter it will search the lens profiles database to see if there is lens profile data that matches the image's lens EXIF metadata. If a lens profile is present the Correction section of the filter dialog will show 'Auto'. If not, you may want to see if one is available online. Go first to the Lens Correction filter and apply it to the same image. Click on the Search Online button. This will show a list of other user-created lens profiles that may possibly match. You can then select one of these and go to the Lens Profiles fly-out menu and choose 'Save Online Profile Locally'. This will then save the profile to the lens profile database on your computer and automatically be available the next time you open the Adaptive Wide Angle filter.

What the Adaptive Wide Angle filter does is it reads in the EXIF lens metadata, locates an appropriate lens profile and, based on this, assesses which is the best projection method to use. When the Preview box is checked, the preview shows an initial distortion correction that you can then refine further using the constraint controls. This initial preview will show what is known as a 'shape conformal' projection, as opposed to a perspective-accurate projection. With this type of projection the emphasis is on preserving shapes proportional to the distance from the viewer. As you add constraint lines you are essentially

overriding this projection and telling it to add more perspective. Essentially, the filter lets you selectively apply a perspective projection to the image.

As you apply constraints to the preview some parts of the image will be more squashed together and other parts will become stretched apart. The Scale slider can therefore be used to adjust the scale of the image relative to the dimensions of the original document.

Figure 9.27 This shows the Adaptive Wide Angle filter tools and their associated shortcuts.

Applying constraints

It helps to understand that because the Adaptive Wide Angle filter is able to use the Lens profile information for the lens the photo was taken with (based on your file's EXIF metadata) it therefore knows how to calculate to make all the edges straight. As I explained earlier, instead of applying a distortion correcting perspective projection the Adaptive Wide Angle filter applies a 'shape conformal' projection which helps avoid the effects of wide angle, perspective projection distortion. As you apply constraint lines to the image you are selectively overriding the shape conformal projection and telling the filter you want to apply a perspective type projection to this particular section of the image.

In use, you need to select the constraint tool (ⓒ) from the tools section (Figure 9.27) and drag along an edge to define it as a straight line. As you do this the constraint line will appear to magically know exactly how much to bend. Well, it's not magic really, as the filter already knows how much to bend based on the Lens Profile data. In the case of the Lens Correction filter the Lens Profile data is used to precisely remove the geometric distortion. With the Adaptive Wide Angle filter it doesn't straighten the lines unless you ask it to do so and it knows how much to bend the constraint based on the Lens Profile data. So, as you add constraints you'll see the lines in your image straighten. If you hold down the *Shift* key as you do so, you can both straighten an edge and make it a vertical or horizontal line. Where possible, the trick here is to use a minimum of two vertical constraints to apply vertical corrections left and right, plus a single horizontal constraint to match the horizon line. It is best to first align these constraints to known edges in the image preview and once you have done this it is easy enough to edit the constraint lines by clicking on the end points and dragging them to the edge of the frame. This is often crucial, because by doing so you are able to

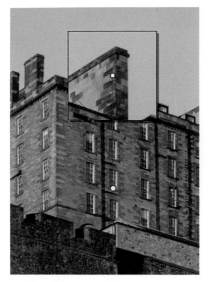

Figure 9.28 As you select a constraint handle to edit it, you will see a magnified loupe, as shown here. This is also available by holding down the Ⓠ key.

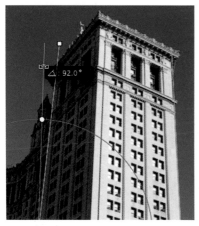

Figure 9.29 This shows a close-up section of a building where I had applied two vertical constraints to straighten the converging verticals. To keep the perspective looking natural, I edited the orientation of the constraints, setting the one on the left to 92° and the one on the right to 88°.

apply an even smoother correction across the entire width and height of the image area. You can hold down the Ⓧ key to switch to a magnified view (to 200% from a 100% view and 100% from smaller magnifications). Also, at views less than 100%, clicking and dragging a handle will show a 100% loupe view (see Figure 9.28). This can make precise placement easier. Once you have got these first three constraint lines to extend edge to edge, you should end up with a fairly satisfactory distortion where you'll only need to add further constraint lines where these are absolutely necessary. As you edit the constraints you'll probably notice how they may follow an odd kink here and there (this can be because the underlying mesh has so far been unevenly warped and the lens profile information guides the constraint line accordingly).

Rotating a constraint

If you click to select a constraint, you'll see two handles appear on the constraint line. If you click on one of these and drag you will see an overlaying circle and you can drag to apply an arbitrary rotation to the constraint. A green line appears as you do this and the edited constraint will afterwards be colored green (see Figure 9.29). This can be particularly useful when editing architectural photos where you wish to correct the converging verticals and remove a keystone effect. While it is possible to make the converging vertical lines go perfectly vertical, it may not always be best to force them to do so; allow them instead to converge just slightly. Therefore, when applying vertical constraints, you can adjust the orientation angle for each constraint line.

Saving constraints

Working with the Adaptive Wide Angle filter usually involves making a fair number of intricate adjustments. To keep the work you do in this filter editable you can save the constraints as a settings file. To do this, go to the Corrections menu shown in Figure 9.30 and select 'Save Constraints…' The constraint settings file is named the same as the image, which can make it easier to locate. When you need to load these constraint settings again you can then go to the same menu and choose 'Load Constraints…' But note that while a settings file can be shared with other images, it will only do so providing the embedded EXIF lens metadata matches exactly. The other

thing you can do is to convert an image to a Smart Filter before you apply the Adaptive Wide Angle Filter. If you do this, you can create and save a number of different correction settings for a particular photo. To help you avoid losing any work, if you exit the Adaptive Wide Angle filter by pressing the `esc` key, you will see a warning dialog that reminds you to apply or save the constraint settings first.

Constraint line colors

The constraint colors are colored as follows. Unfixed constraints are colored cyan, horizontals colored yellow, verticals magenta, fixed orientation constraints green and invalid constraints are colored red, indicating that the constraint you are trying to apply can't be calculated. When you go to the fly-out menu shown in Figure 9.30 you can open the Preferences shown in Figure 9.31. This allows you to edit the color swatches and choose new colors for the different constraint guide modes.

Polygon constraints

The polygon constraints tool (Y) can be used to define specific areas of a picture where you wish to apply a perspective correction. Just make a succession of clicks to define an area that you wish to see corrected. For example, if you were to click in all four corners of the preview area, the effect would be similar to applying a lens correction to the entire image. The polygon constraint tool is therefore useful for correcting areas of an image where there are no straight lines available to reference, or where you need to correct, say, a building facade or a large expanse of tiled flooring. You can also add horizontal/vertical oriented constraints to just outside the edges of a polygon constraint as a way to help control the overall polygon distortion.

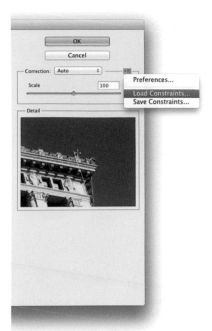

Figure 9.30 This shows the Adaptive Wide Angle filter Correction menu options that includes the Preferences, Load Constraints… and Save Constraints… options.

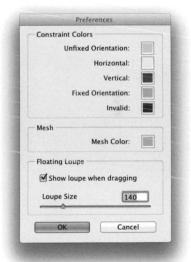

Figure 9.31 This shows the Adaptive Wide Angle preferences dialog, including a preference to set the size of the floating loupe (see Figure 9.28).

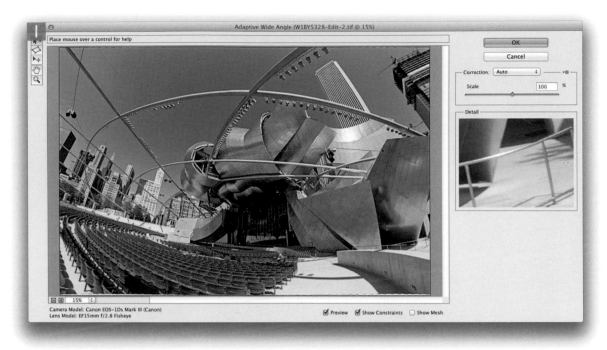

1 In this screen shot you can see a photograph that was shot with a 15 mm fisheye lens, opened in the Adaptive Wide Angle filter prior to making any corrections.

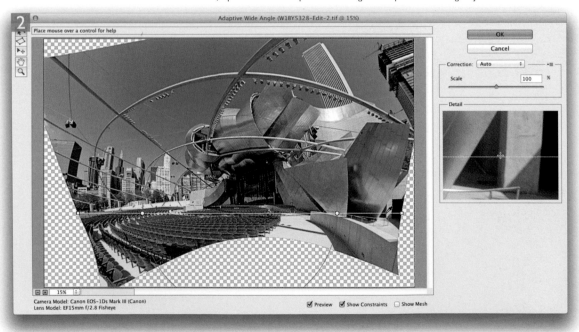

2 To start with, I selected the constraint tool and with the *Shift* key held down dragged across the horizon to correct the horizontal distortion at this point in the photograph.

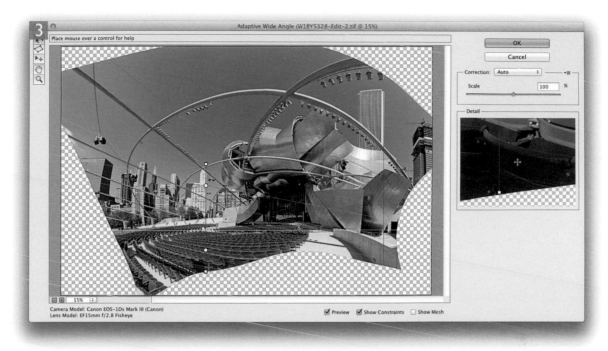

3 I again held down the **Shift** key and this time added a succession of vertical constraints to selectively correct for the vertical distortion. When I was done I clicked OK.

4 Here you can see the final, corrected version. If you refer back to Figure 9.26 you can also compare this with the original and a standard 'lens corrected' version.

Calibrating with the Adaptive Wide Angle filter

If you are dealing with images that have no EXIF lens data then the Adaptive Wide Angle filter will have nothing to work from. In these situations it is possible to calibrate the filter so that it is able to determine the curvature of the lens. As is shown in Figure 9.32, this is really a method that can only be applied to fisheye lenses. If you select the constraint tool and no EXIF lens data is detected, after you click to add a constraint this will produce a straight constraint line with a midpoint handle. What you have to do next is to click on the midpoint handle and drag to make the constraint line match a known vertical or horizontal line in the image (you can see this taking place in the Figure 9.32 example). After you have carried out the initial calibration you should find it quite easy to add further constraint lines to constrain the other edges.

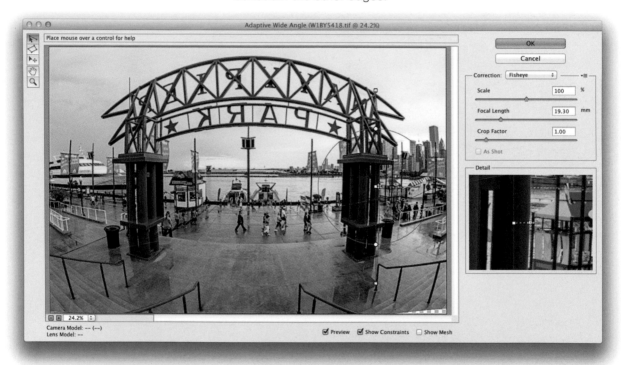

Figure 9.32 Calibrating a photo with no embedded EXIF lens data.

Editing panorama images

It is possible to use the Adaptive Wide Angle filter to correct panoramic images. However, for this to work, the panorama must be generated using Photomerge in Photoshop CS6 or later. This is because the filter relies on lens metadata information being added to the file as the panorama is generated, so it won't be able to process older panoramas in this way. When preparing a Photomerge panorama you need to make sure that you use just the Cylindrical or Spherical projection methods (see page 541). When you open a Photoshop CS6 or later panorama image via the Adaptive Wide Angle filter, you'll see it open in 'Panorama' mode.

The Adaptive Wide Angle filter can also be used in the way described here to process 1:2 full-spherical (180 degrees by 360 degrees) Photomerge panoramas. When editing a Photomerge file, the Adaptive Wide Angle filter needs to be able to read metadata information such as the focus length and where the center of the panorama is. This is all figured out as the images are stitched together in Photomerge. Note that checking the Geometric Distortion Correction checkbox box in Photomerge should not necessarily affect the Adaptive Wide Angle filter.

The following steps show how I managed to correct the distortion in such an image, where I had, rather ambitiously, shot the seven images that made up this panorama using an extreme wide angle lens. Up until now it would not have been possible to do much to correct the major distortion that can be seen in this stitched panorama.

Since first experimenting with the Adaptive Wide Angle filter I have come to the conclusion that it is useful for editing not just architectural photographs, but almost any Photomerge panorama that has been created in Photoshop. More recently, I have been shooting panorama stitch images using a 14 mm, rectilinear fisheye lens and post-editing the Photomerge panoramas using the Adaptive Wide Angle filter to tame the perspective (see Figure 9.33). The benefit of this approach is that one can capture a highly-detailed panorama that holds an extremely wide view yet not have it look like a typical, ultra wide angle photograph. The perspective view that you can achieve reminds me of the work of classical landscape painters, who, as I mentioned earlier, played fast and loose with perspective to create idealized landscape views.

Figure 9.33 This ultra wide angle panorama image was created from six photographs, all shot using a 14 mm lens.

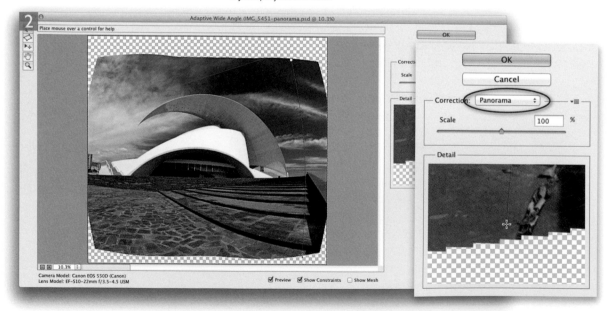

1 Here you can see a Photomerge image created in Photoshop using the Cylindrical layout/projection mode.

2 When I applied the Adaptive Wide Angle Filter to the image in Step 1, it opened using the Panorama correction method (circled). To begin with, I held down the *Shift* key to add a vertical constraint to the image.

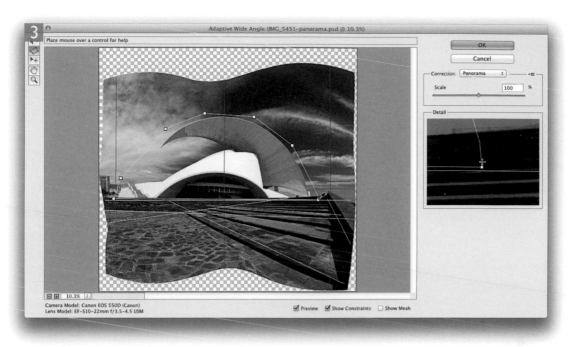

3 Following on from this, I added further vertical, horizontal and regular constraint lines to correct the distortion in the image. Since there weren't any straight lines to align to on the opera house, I used the polygon constraint tool to define the shape of the building. I hit *Enter* to close the polygon, which corrected the distortion inside the defined area.

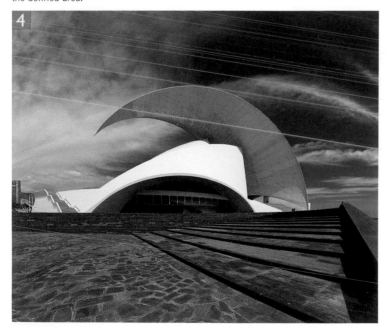

4 This shows the final, corrected version.

Flame filter

The ability to work with scripted patterns has been around in Photoshop for a while, but is now made more evident in the program through the addition of three new items in the Filter ⇨ Render menu: Flame, Picture Frame and Tree. Let's look at Flame first, which allows you to create realistic flame effects based on a user-defined path or paths.

When this render filter is applied well it can produce flames that look fairly realistic. You could say they pass a Photoshop version of the Turing test, where the end result can be good enough to convince viewers the added flames are real. The trick is to start by defining a path or paths that the flames can follow and know how to manage the slider controls to produce the desired flame effect. This filter is not compatible with Smart Objects, so you have to rely solely on the preview as you adjust the settings and click OK to see what the final outcome will look like. If you want to fine-tune the filter effect my suggestion is to undo the filter and reapply by holding down the `alt` key as you reselect 'Flame' from the top of the Filter menu. This reloads the filter with the last used settings. Readjust these and apply again. To save time you can choose a low quality render setting first and then reapply using a higher quality render setting. The following steps show how I was able to add some extra flames to a photograph of a freshly lit barbecue.

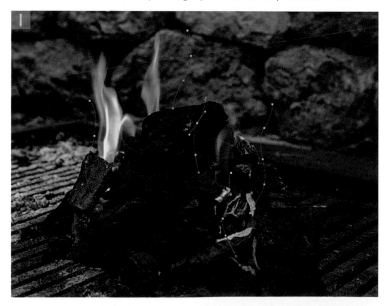

1 Here is a photograph of a barbecue fire about to catch light. To prepare this image to add more flames, I selected the pen tool and drew a number of open paths.

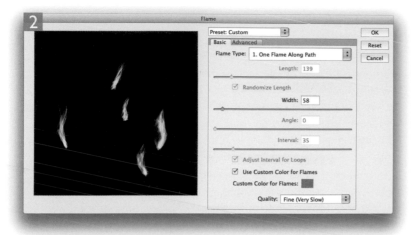

2 I added an empty new layer above the Background layer and chose Filter ⇨ Render ⇨ Flame… This opened the Flame dialog, where I entered the settings shown here to create the desired flame effect and sampled colors from the flames in the actual image.

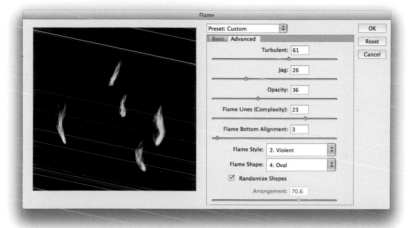

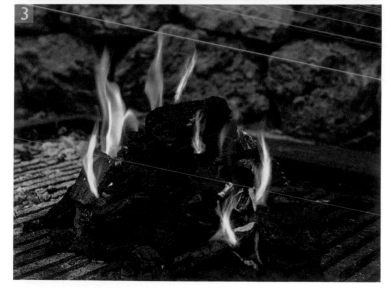

3 This shows the final image with the extra flames added to the separate layer.

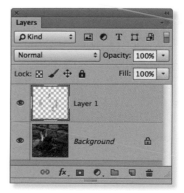

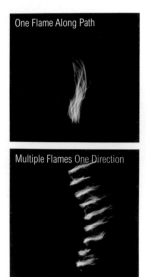

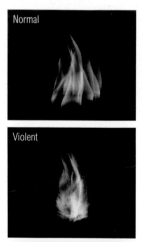

Figure 9.34 The Flame Type options include One Flame Along Path (top) and Multiple Flames One Direction (bottom).

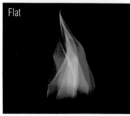

Figure 9.35 The Flame Style options include Normal (top), Violent (middle) and Flat (Bottom).

Flame filter controls

The flame effect can be modified by first selecting an option from the Flame Type menu (see Figure 9.34). The Length slider and Randomize Length check box will only become active when one of the multiple flame style options is selected. The Width slider controls the pixel width of the flame effect, while the Angle slider determines the flame angles when the following flame styles are selected: Multiple Flames One Direction, Multiple Flames Path Directed or Multiple Flames Various Angle. The Interval slider is active when any multiple flame style is selected. Increasing the Interval creates wider gaps between the flames. If the path forms a loop, checking the Adjust Interval for Loops option ensures the gap between the flames will be uniform or even. The flame effects are constructed with lines. Increasing the Flame Lines increases the complexity of the flame effect. The Turbulent slider determines how rough or how smooth the flame effect will be. A low Jag setting will produce a smoother effect and a higher setting appear more jagged. The Opacity slider can be used to control the brightness of the flame effect. It is important to ensure the flame effect is not too bright, or else the flame highlights will be clipped. One thing to watch out for is the way the Opacity slider also affects the flame shape as you adjust the slider. With the Flame Bottom Alignment slider, when this is set to zero, each of the lines that create the flame will be evenly aligned. As you increase the slider setting they will be more randomized.

There are three Flame styles: Normal, Violent and Flat, which are shown in Figure 9.35. As you can see these alter the characteristics of the flame effect. The Flame Shape menu has the following options: Parallel, To The Center, Spread, Oval and Pointing. These options determine the overall shape of the flame effect. The default color is very flame-like, but if you are attempting to match existing flames in a photograph you can do what I did in Step 2 on the preceding page, where I checked the Use Custom Color for Flames option. This popped a color picker, which allowed me to sample the flame colors in the photo and use these to generate flames that matched even more closely the real flames. The Quality menu allows you to select the desired render setting. When adjusting the sliders it can help to have this set to Draft mode. When it comes to rendering the final effect you can choose a higher quality setting. Lastly there is the Randomize Shapes button. When checked, the flame shape will be different every time a flame is created. When unchecked you can adjust the Arrangement slider to generate slightly different types of flame effect.

Tree filter

The Tree filter uses the same rendering script process as the Flame filter, but to generate different types of trees. Unlike the Flame filter the results are not quite good enough to look photo-realistic, but even so it is still quite impressive. But if you were to blur the results when adding to a blurred background, the rendered trees could look quite convincing. Otherwise, it is perhaps more a tool for illustrators. At the top of the dialog there is a Base Tree Type menu, where you'll find a list of 34 different tree types. You can then choose to adjust the Light Direction, the Camera Tilt to set the viewing angle, the Leaves Amount and Leaves Size. Below that are sliders to control the Branches Height and Branches Thickness.

The following steps show how I was able to use the Tree filter to create trees that would blend into a landscape photo.

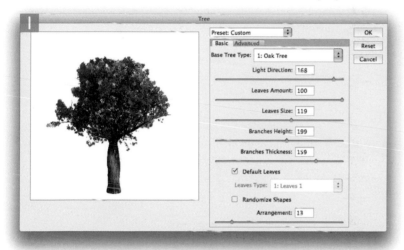

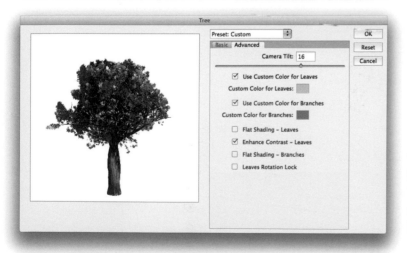

1 I added an empty new layer above the image layer and chose Filter ⇨ Render ⇨ Tree... This opened the Tree filter dialog, where I entered the settings shown here to build the desired tree shape.

2 I also clicked on the Custom Color for Leaves and Custom Color for Branches buttons to open the color picker shown here to sample colors from the trees in this photograph so that the leaves and branch colors would match.

3 This shows the finished result, where I also added a second tree and copied the shadows of the other trees to make these appear to match the rest of the scene. I also converted the rendered layer to a smart object and applied a very small amount of Gaussian Blur to soften the texture of the trees slightly so they matched all the other trees.

Tree filter checkbox options

Below the main dialog sliders are a number of checkboxes
(Figure 9.36). When the Default Leaves option is checked the
tree will be generated using the leaves linked to the selected
base tree type. If you uncheck this you can select other leaf
types in order to create your own custom hybrid tree type.
As was shown in the previous step-by-step example, you can
check the Use Custom Color for Leaves and Use Custom
Color for Branches options to set custom colors for both. The
Flat Shading – Leaves option and the Flat Shading – Branches
option apply a flat tone fill to either the leaves or branches. The
Enhance Contrast – Leaves option mostly adds more texture
contrast to the leaves. Leaves are normally rotated in three
dimensions. If you check the Use the Leaves Rotation Lock
option box, you can stop the leaves rotating three dimensionally.
This will produce more illustration-like results. Lastly,
when Randomize Shapes is unchecked, you can adjust the
Arrangement slider to apply different seed values to generate
different tree shapes.

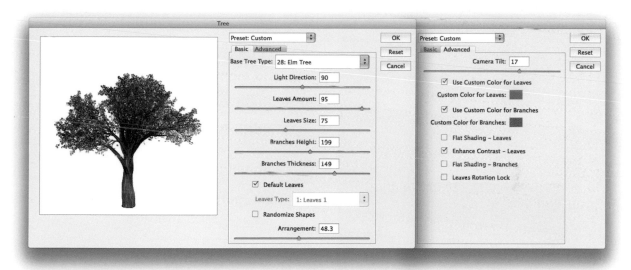

Figure 9.36 The Tree filter dialog

Full filter access

You'll notice that when the 'Show all Filter Gallery Groups and Names' option is deselected in the Photoshop Plug-ins preferences (the default setting) this limits the number of filters listed in the main Filter menu submenus. The Filter Gallery gives you access to the remaining 47 'artistic' filter effects, which are otherwise hidden.

Filter Gallery

To use the Filter Gallery, select an image (8-bit only), choose Filter Gallery from the Filter menu and click on the various filter effect icons revealed in the expanded filter folders. These icons provide a visual clue as to the outcome of the filter, and as you click on these the filter effect can be previewed in the preview panel area. This gives you a nice, large preview for many of the creative Photoshop filters. As shown in Figure 9.37, you can combine more than one filter at a time and preview how these will look when applied together. To add a new filter, click on the New Effect Layer button at the bottom. As you click on the effect layers you can edit the individual filter settings. To remove a filter effect layer, click on the Delete button.

Filter Gallery preview Collapse/expand filter effects Filter effect settings

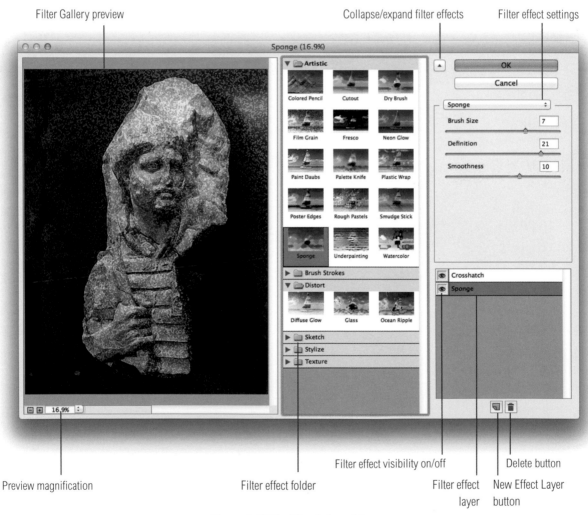

Preview magnification Filter effect folder Filter effect visibility on/off Filter effect layer New Effect Layer button Delete button

Figure 9.37 The Filter Gallery dialog.

Print output

This chapter deals with the print output process. Photographers reading this book will probably own at least one color desktop printer and the print quality that you can get from the latest inkjet devices has improved enormously over the last 15 years or so. To obtain the best quality print output, it is important to have a good understanding of the Photoshop Print and system print dialog interfaces and how to configure the settings. There are also other issues addressed in this chapter, such as how to use soft proofing, and how you ensure the colors you see on the display will be reproduced accurately in the final print.

Rather than go into all the details about different print processes, the different ink sets and papers that you can choose from, I have pared this chapter down so that it concentrates on just the essentials of inkjet printing. If you want to know more about Photoshop printing, there is a book I co-wrote with Jeff Schewe titled *Adobe Photoshop CS5 for Photographers: The Ultimate Workshop*. I can recommend *Mastering Digital Printing, Second Edition (Digital Process and Print)* by Harald Johnson, which provides an extensive overview of desktop printing and *The Digital Print – Preparing Images in Lightroom and Photoshop for Printing*, also by Jeff Schewe.

Print sharpening

One of the most important things you need to do before making a print is to sharpen the image before you send it to the printer. So I am going to start by looking at print output sharpening.

Earlier in Chapter 3, I outlined how you can use the Detail panel sharpening sliders in Camera Raw to capture sharpen different types of images. This pre-sharpening step is something that all images require. The goal in each case is to prepare an image according to its image content so that it ends up in what can be considered an optimized sharpened state and the aim is to essentially sharpen each photograph just enough to compensate for the loss of sharpness that is a natural consequence of the capture process.

Output sharpening is a completely different matter. Any time you output a photograph and prepare it for print—either in a magazine, on a bill board, or when you send it to an inkjet printer—it will always require some additional sharpening beforehand. Some output processes may incorporate automatic output sharpening, but most don't, so it is therefore essential to always include an output sharpening step just before you make a print output. So, how much should you sharpen? While the capture sharpening step is tailored to the individual characteristics of each image, the output sharpening approach is slightly different. It is a standard process and one that is dictated by the following factors, namely: the output process (i.e. whether it is being printed on an inkjet printer or going through a halftone printing process), the paper type used (whether glossy or matte) and finally, the output resolution.

Judge the print, not the display

It is difficult, if not impossible to judge just how much to sharpen for print output by looking at the image on a display. Even if you reduce the viewing size to 50% or 25%, what you see on the screen bears little or no resemblance to how the final print will look. The ideal print output sharpening can be calculated on the basis that at a normal viewing distance, the human eye resolves detail to around 1/100th of an inch. So if the image you are editing is going to be printed from a file that has a resolution of 300 pixels per inch, the edges in the image will need a 3 pixel radius if they are to register as being sharp in print. When an image is viewed on a computer display at 100%, this kind of sharpening will look far too sharp, if not downright ugly (partly because you are viewing the image much closer up than it will actually be seen in print), but the actual physical print should appear correctly sharpened once it has been printed from the 'output sharpened' version of the image. So, based on the above formula, images printed at lower resolutions require a smaller pixel radius sharpening and those printed at higher resolutions require a higher pixel radius sharpening. Now, different print processes and media types also require slight modifications to the above rule, but essentially, output sharpening can be distilled down to a set formula for each print process/resolution/media type. This was the basis for research carried out by the late Bruce Fraser and Jeff Schewe when they devised the sharpening routines used for PhotoKit Sharpener (see sidebar). These are elaborated upon in *Real World Image Sharpening with Adobe Photoshop, Camera Raw, and Lightroom* (2nd Edition), also by Bruce Fraser and Jeff Schewe (ISBN: 978-0321637550).

High Pass filter edge sharpening technique

The technique that's described on pages 674–675 shows an example of just one of the formulas used in PhotoKit Sharpener for output sharpening. In this case I have shown Bruce Fraser's formula for sharpening a typical 300 pixel per inch glossy inkjet print output. You will notice that it mainly uses the High Pass filter combined with the Unsharp Mask filter to apply the sharpening effect. If you wish to implement this sharpening method, do make sure you have resized the image beforehand to the exact print output dimensions and at a resolution of 300 pixels per inch.

PhotoKit Sharpener

PhotoKit Sharpener is available from pixelgenius.com, from where you can obtain trial versions of this and other Pixel Genius products. There is also a special discount coupon at the back of the book as well as from the book website, which entitles you to a 10% discount. PhotoKit Sharpener provides Photoshop sharpening routines for capture sharpening, creative sharpening and output sharpening (inkjet, continuous tone, halftone and multimedia/Web). The Camera Raw sharpening sliders are based on the PhotoKit Sharpener methods of capture sharpening, so if you have the latest version of Photoshop or Lightroom, you won't need PhotoKit Sharpener for the capture sharpening. If you have Lightroom, you will find that the output sharpening for inkjet printing is actually built in to the Lightroom Print module. Therefore, if you don't have Lightroom, you'll definitely find the PhotoKit Sharpener output sharpening routines useful for applying the exact amount of output sharpening that is necessary for different types of print outputs and at different pixel resolutions.

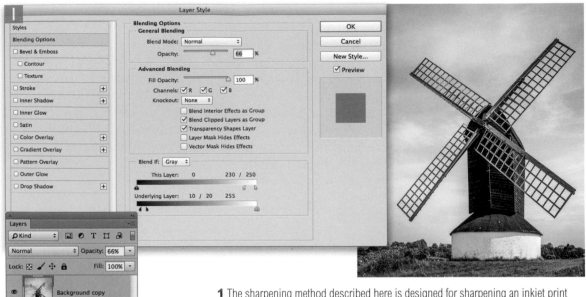

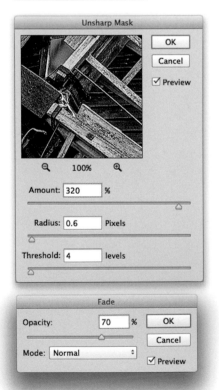

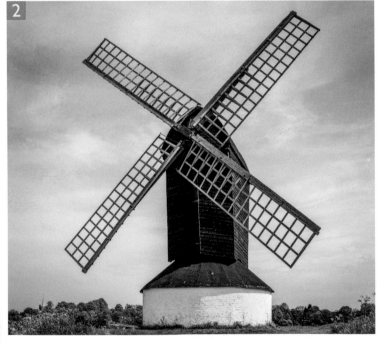

1 The sharpening method described here is designed for sharpening an inkjet print on glossy paper at 300 ppi. To begin with, I made a duplicate copy of the Background layer and set the layer opacity to 66%. I then double-clicked on this duplicate layer to open the Layer Style options and adjusted the Blend If sliders as shown here.

2 Next, I applied the Unsharp Mask filter to the layer using an Amount of 320, Radius of 0.6 and Threshold of 4. I then chose Edit ⇨ Fade, changed the blend mode to Luminosity and reduced the opacity to 70%.

Overlay blend mode

When the sharpening layer was set to the Overlay blend mode this resulted in an isolation of the High Pass filter sharpening effect. This is because, when a layer is set to the Overlay blend mode, a neutral gray color will have no effect on the image, only those colors that are lighter or darker than neutral gray will have an effect.

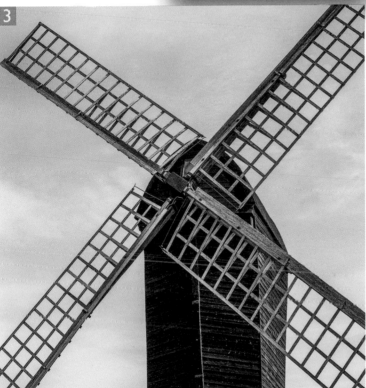

3 I changed the Layer blend mode from Normal to Overlay and went to the Filter menu, chose Other ⇨ High Pass filter and applied a Radius of 2 pixels. Here is a 1:1 close-up view of the sharpened image. Remember, you can't judge the sharpening by looking at the display, but you should be able to judge the effectiveness of the technique by how sharp the photograph appears here in print. Note that the sharpening layer here can be increased or decreased in opacity or easily removed and that the underlying Background layer remained unaffected by the preceding sharpening steps.

Gamut warning

The View menu contains a Gamut Warning option that can be used to highlight colors that are out of gamut. The thing is, you never know if a highlighted color is just a little or a lot out of gamut. Gamut Warning is therefore a fairly blunt instrument to work with, which is why I suggest you use the soft proofing method described here.

Print from the proof settings

When the Customize Proof condition is active and applied to an image, the Photoshop Print dialog can reference the soft proofed view as the source space. This means you can use the Customize Proof Condition to select a CMYK output space and the Photoshop Print dialog can allow you to make a simulated print using this proof space.

Soft proof before printing

Color management can do a fairly good job of translating the colors from one space to another, but for all the precision of measured targets and profile conversions, it is still essentially a dumb process. When it comes to printing, color management can usually get you fairly close, but it won't be able to interpret every single color or make aesthetic judgments about which colors are important and which are not. Plus some colors you see on the computer display simply can't be reproduced in print. This is where soft proofing can help. If you use the Custom Proof Condition dialog as described here, you can simulate on the display pretty accurately how a photo will look when printed. Soft proofing shows you which colors are going to be clipped and also allows you to see in advance the difference between selecting a Perceptual or Relative Colorimetric rendering intent. All you have to do is to select the correct profile for the printer/paper combination that you are about to use, choose a suitable rendering intent and make sure Black Point Compensation and Simulate Paper Color (and by default simulate black ink) are both checked.

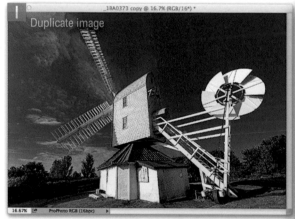
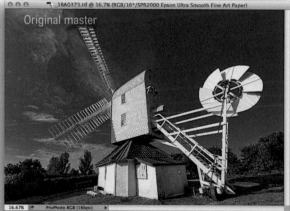

1 To begin with, I opened the image shown here, went to the Image menu and chose Duplicate... This created a duplicate copy image, which is shown here on the left next to the original on the right. In this screen shot you may already see a slight difference in tone contrast and color between the two. This is because I had applied the Customize Proof Condition shown in Step 2 to the original master image (seen here on the right).

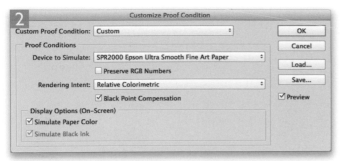

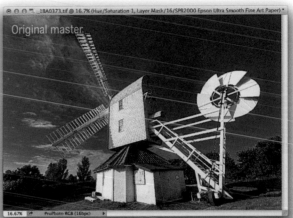

Simulate paper color

Simulate Paper Color may sometimes make the whites appear very blueish, which is most likely associated with optical brightener detection in the ICC profile. It is optional that you check this when carrying out a soft proof.

2 To soft proof the master image I went to the View menu and chose Proof Setup ⇨ Custom… Here I selected a profile of the printer/paper combination that I wished to simulate, using (in this case) the Relative Colorimetric rendering intent and with the Simulate Paper Color option checked in the On-Screen Display Options.

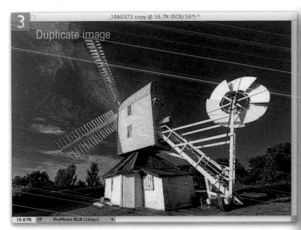

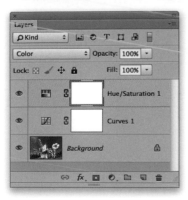

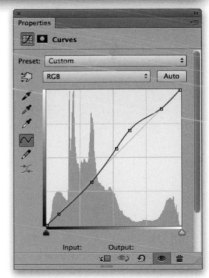

3 I now had a soft proof prediction of how the master file would print that could be viewed alongside a duplicate of the original image. The goal now was to add a Curves adjustment layer to tweak the tones (using the Luminosity blend mode) and a Hue/Saturation adjustment to tweak the colors (using the Color blend mode). A few minor adjustments were enough to get the soft proofed master to match more closely to the original (which I was comparing here to the Duplicate image on the left).

4 Here is the final version, which shows the corrected, soft proofed master image. When this corrected version was sent to the printer, I could expect the print output to match very closely to what was seen on the computer display. I recommend the correction adjustment layers be preserved by grouping them into a layer group. You will then be able to turn the visibility off before saving and only need to switch the layers back on again when you want to make further prints.

Managing print expectations

When you use soft proofing to simulate a print output your initial response can be 'eek, what happened to the contrast?' This can be especially true when you also include Simulate Paper Color in a soft proof setup. If we assume you are using a decent display and that it has been properly calibrated, the soft proof view should still represent an accurate prediction of the contrast range of an actual print compared to the high contrast range you have become accustomed to seeing on an LCD display (it's also a good idea to not have the luminance of the display set too high relative to the viewing environment, which may also lead to false expectations). One solution is to look away as you apply the soft proof preview so that you don't notice the sudden shift in the on-display appearance so much.

Making a print

There are just two Photoshop Print options: File ⇨ Print…
(⌘ P [Mac] ctrl P [PC]), which takes you directly to the
Photoshop Print dialog, and the File ⇨ Print One Copy
command (⌘ ⌥ Shift P [Mac] ctrl alt Shift P [PC]). You can
use 'Print One Copy' should you wish to make a print using the
current configuration for a particular image, but wish to bypass
the Photoshop Print dialog.

The Photoshop print workflow is designed to make the print
process more consistent between operating systems, as well
as more repeatable. The operating system Page Setup option is
accessed solely within the Photoshop Print dialog via the Print
Settings button, from where you can manage all the remaining
operating system print driver settings. Because both the Mac
and PC operating system print drivers are incorporated into the
Photoshop Print dialog, the process of scripting and creating
print actions is therefore more reliable (compared to earlier
versions of Photoshop).

Photoshop Print dialog

When you choose Print… from the File menu, this takes you
to the Photoshop Print dialog shown in Figure 10.1. A number
of improvements have been made to the Print dialog since
Photoshop CS6. You can resize the dialog as big as you like
to see an enlarged print preview and because of this you can
now get a much clearer preview of what the print output will
look like, especially when using the soft proof preview options.
Also, when the Print dialog is enlarged you can easily access all
the print controls at once from the panel list on the right. Solo
panel opening is possible by alt-clicking on a panel header. This
expands the selected panel contents and keeps all the others
closed. Plus you can click on a button to open the selected
printer Print Utility dialog. To begin with let's take a look at the
Printer Setup options.

Printer selection

If you have just the one printer connected to your computer
network, this should show up in the Printer list by default
(circled in Figure 10.1). If you have more than one printer
connected you can use this menu to select the printer you
wish to print with. Below that are the Print Settings and
print orientation buttons. Here, you need to click on the Print
Settings button to open the operating system print driver

Remembering the print settings

The settings you apply in the Photoshop
Print dialog are included with the
document after you click Print or Done
and then save the file. So, if you open a
document that you have printed before,
you'll get to see the last settings that were
used to print that document. If you open
a document which hasn't been printed
before, you get the last used print settings.
If you hold the spacebar as you select
File ⇨ Print, Photoshop ignores the Print
Settings that may previously have been
saved to that document. This allows you
to specify the print settings from a fresh
starting point. However, if your print
settings are for a printer that is no longer
available, everything gets reset to the
default settings.

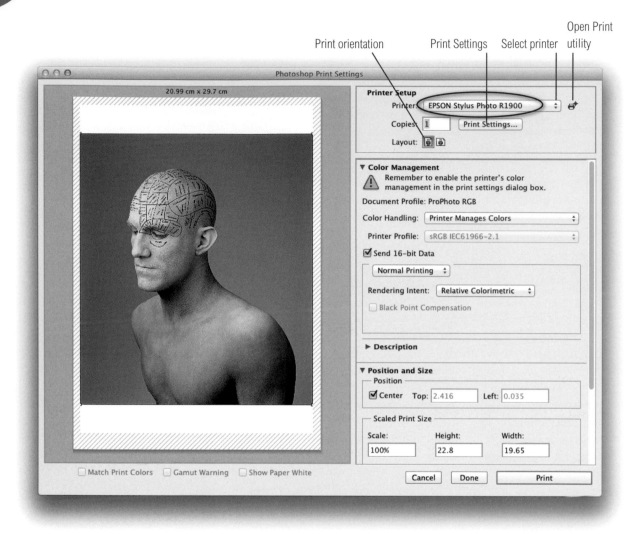

Print orientation Print Settings Select printer Open Print utility

Figure 10.1 The Photoshop Print dialog, with the focus on the Printer Setup options.

Preview background color

The outer background color matches the canvas color set in the Photoshop Interface preferences (see PDF on the book website). However, you can right-click on the outer background area to view the contextual menu and select a different background color if you like.

dialog for Mac or PC and configure the desired print settings, specifying the paper size you intend to print with as well as the media type. In Figure 10.2, you'll see screen shots of the Mac OS Print dialog showing how to select the correct printer model and an appropriate paper size. Figure 10.3 shows the Windows 8 dialog, where in the Advanced panel section you can go to the paper size menu (circled) and do the same thing. Once you are done, you can click on the Save or OK button to return to the Photoshop Print dialog.

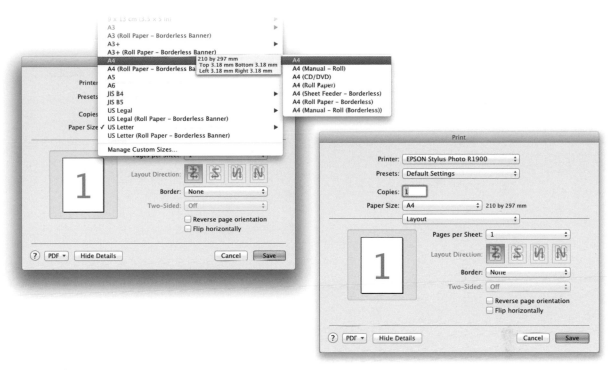

Figure 10.2 The Mac OS X Printer Settings, showing the paper size selection menu.

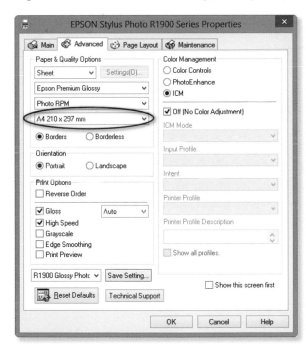

Figure 10.3 This shows the Windows 8 Printer Settings, with the Paper Size section circled.

No Color Management missing

The Color Management Color Handling options no longer include an option for printing with 'No Color Management'. This is due to the fact that updating the Mac code to Cocoa 64-bit made it problematic to retain the 'No Color Management' print route. This option was required for producing neutral target prints intended for reading and generating ICC profiles. However, you can download an Adobe Color Printer Utility from the Adobe website. This now allows you to print your print target files without applying color management. Here is the link to download: tinyurl.com/25onde3. Once you have used this to create custom profiles, these will need to be used with the 'Photoshop Manages Colors' option.

Color Management

Now let's look at the Color Management settings, which are shown in Figure 10.5, as well as close-up in Figure 10.4 below. In the Color Handling section you have the option to choose Printer Manages Colors or Photoshop Manages Colors. The former can be used if you want to let the printer driver manage the color output. If this option is selected the Printer Profile menu appears grayed out, as will the Black Point Compensation box, but it will be possible to select a desired rendering intent: either Perceptual or Relative Colorimetric (although not all printers will be able to honor this setting). It is also possible to select the 'Hard Proofing' option from the menu circled below when letting the printer manage the colors, but if this is your aim you should really choose the 'Photoshop Manages Colors' option instead to do this. Note, if you change printers in the Print dialog, the color management always switches to select 'Printer Manages Colors'. This default setting is most suitable for casual users of the Print dialog, but it's easy enough to change to 'Photoshop Manages Colors'.

When the 'Photoshop Manages Colors' option is selected the Photoshop Print dialog can be used to handle the print output color management. You will then need to mouse down on the Printer Profile menu. Here you need to select the printer profile that matches the printer/paper you are about to print with. It used to be the case that canned profiles were frowned upon as being inferior, but with the latest printer devices these are now very consistent in print output. Therefore, canned

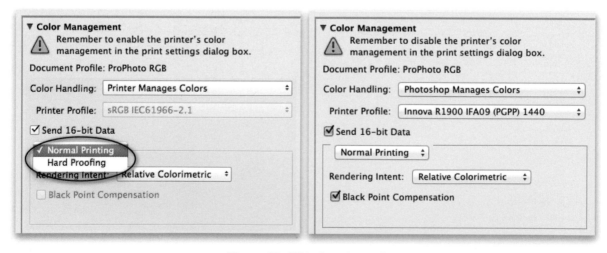

Figure 10.4 This shows the two Color Handling options: Printer Manages Colors or Photoshop Manages Colors.

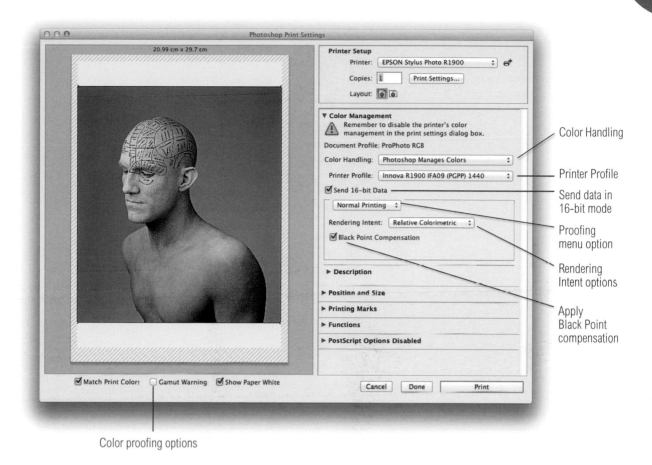

Color proofing options

Figure 10.5 The Photoshop Print dialog, showing the Color Management options.

profiles should work pretty well, so you will usually be advised
to use the manufacturer's own brand profiles for the papers
that their printers support.

When you select the printer model in the Print Settings this
filters the ICC profiles that are associated with the printer, so
these will appear at the top of the profile list (see Figure 10.6).
A set of canned printer profiles should be installed in your
System profiles folder at the same time as you install the
print driver for your printer. If you can't find these, try doing a
reinstall, or do a search on the manufacturer's website. Also,
the printer selection and profiles are sticky per document, so
once you have selected a printer and configured the associated
print settings, these will be saved along with everything else in
the document. It is therefore important to remember to always
save after clicking Done, or making a print.

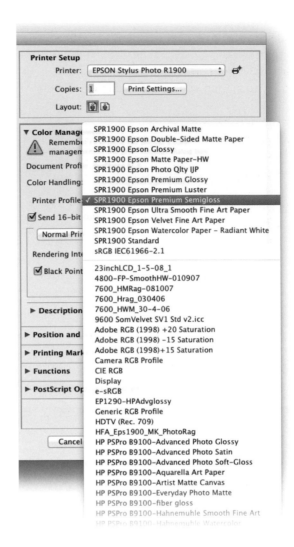

Figure 10.6 This shows the printer profile list, with the printer manufacturer profiles for the currently chosen printer placed at the top of the list.

Rendering intent selection

The rendering intent in 'Normal Printing' mode can be set to Perceptual, Saturation, Relative Colorimetric or Absolute Colorimetric. However, for normal RGB printing the choice boils down to a choice of just two settings. Relative Colorimetric is the best setting to use for general printing as this will preserve most of the original colors. Perceptual is a good option to choose when printing an image where it is important to preserve the detail in saturated color areas, or when printing a photo that has a lot of deep shadows, or when you are printing

to a smaller gamut output space, such as a fine-art matte paper. Whichever option you choose, I advise you to leave Black Point Compensation switched on, because this maps the darkest colors from the source space to the destination print space. Black Point Compensation preserves the darkest black colors and maximizes the full tonal range of the print output.

The Photoshop Print dialog preview can be color managed by checking the 'Match Print Colors' option (see Figure 10.5). You will notice that as you pick a printer profile or adjust the rendering intents you can preview on-screen what the printed colors will look like. When proofing an RGB output in this way you can also check the 'Show Paper White' option to see an even more accurate simulation, one that takes into account the paper color of the print media. There is even a Gamut Warning option, but as I pointed out on page 676, this isn't as useful as using the soft proofing method described earlier to gauge how your print output will look.

Hard Proofing

Earlier, in the Soft proof before printing section (pages 676–678), I described using the soft proof setup to predict how an RGB photograph might actually print via an inkjet or when printed in CMYK or any other print output space for which you have a profile. If the Hard Proofing option is selected in the Color management settings (circled), you can select a custom proof output space to simulate on a desktop printer and you'll see the options shown below in Figure 10.7.

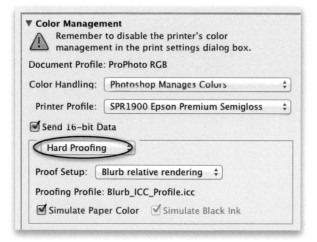

Figure 10.7 This shows the Color Management Hard Proofing options. In this example I used a custom proof setup created for Blurb book printing.

16-bit output

Image data is normally sent to the printer in 8-bit, but a number of inkjet printers now have print drivers that are enabled for 16-bit printing (providing you are using the correct driver and the 16-Bit Data box is checked in the Color Management section). There are certain types of images that may theoretically benefit from 16-bit printing and where using 16-bit printing may avoid the possibility of banding appearing in print, but I have yet to see this demonstrated. Let's just say, if your printer is enabled for 16-bit printing, Photoshop now allows you to send the data in 16-bit form (but only if the file you are attempting to print is in 16-bit, of course).

Overcoming dull whites

If you use the Hard Proofing option to produce a Hard Proof print output and you have the 'Simulate Paper Color' option selected, the whites may appear duller than expected when the print is made. This does not mean the proof is wrong, rather it is the presence of a brighter white border that leads to the viewer regarding the result as looking inferior. To get around this try adding a white border to the outside of the image you are about to print. You will need to do this in Photoshop by adding some extra white canvas. After making your print, trim away the outer 'paper white' border so that the eye does not get a chance to compare the dull whites of the print with the brighter white of the printing paper used.

Proof print or aim print?

If someone asks you to produce an RGB inkjet print that simulates the CMYK print process, you can use the 'Hard Proofing' option to create what is sometimes referred to as a 'cross-rendered aim print'. This is not quite the same thing as an official 'contract proof' print, but a commercial printer will be a lot happier to receive a print made in this way, as a guide to how you anticipate the final print image should look when printed on a commercial press, rather than one made direct from an RGB image using the full color gamut of your inkjet printer.

When the Hard Proofing option is selected you'll need to select a proof setup setting from the Proof Setup menu. This is how you configure a printer to simulate a specific CMYK output when making a print. You may already have configured a custom proof setup via the Custom Proof Condition dialog (see Figure 10.8). If not, you can go to the View menu, choose Proof Setup ⇨ Custom… and configure a custom setting. However, if a proof condition is already active for a document window (such as a standard CMYK preview or a custom proof setting) and you select the Hard Proofing option, this proof condition will be selected automatically. In the Photoshop Print dialog Color Management section (see Figure 10.8), the Simulate Black Ink is always checked by default, but you can also choose to check Simulate Paper Color when creating a hard proofing output. If you do this it is a good idea to ensure you include a white border when making a print (see sidebar).

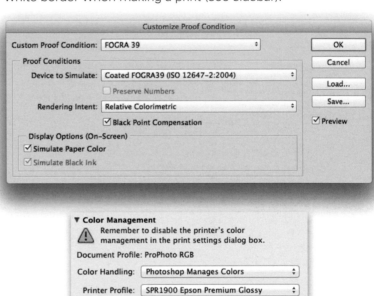

Figure 10.8 The View ⇨ Proof Setup ⇨ Custom Proof Condition dialog for screen viewing (top) and how these Custom Proof settings are interpreted in the Photoshop Print dialog Color Management section for print output (below).

Position and Size

You'll notice that the print preview is contained within a bounding box (Figure 10.9). You can position the image anywhere you like, by dragging inside the box, or scale it by dragging any of the bounding box handles. In the Position and Size section you can choose to center the photo, or precisely position it by entering measurements for the Top and Left margins. In the Scaled Print Size section, if the image overflows the currently selected page size, you can choose 'Scale to Fit Media'. This automatically resizes the pixel resolution to fit the page and the Print Resolution PPI adjusts accordingly. You can also enter a specific Scale percentage, or Height and Width for the image, but I don't advise you to do this unless you absolutely must. It is usually much better to resize the image in Photoshop first and print using a 100% scale size.

Heads up display in the Print dialog

As you drag the print preview you'll see a heads up display showing the precise position on the print page (see the move tool in use in Figure 10.10). Also, when dragging the preview corner handles the heads up display indicates the print dimensions.

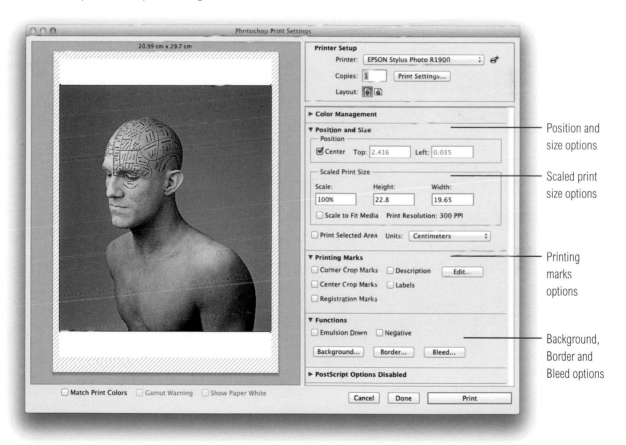

Figure 10.9 The Photoshop Print Dialog focusing on the remaining panel options.

Adjusting the print margins

If you hold down the *alt* key while dragging a margin for the print selected area, the opposite margin will move accordingly. So, if you *alt* drag the left margin, the right margin will move also. Hold down the ⌘ (Mac), *ctrl* (PC) key to have all four margins move to match the drag made on one margin.

Print selected area

With most printers the printable area is restricted in the margins and the trailing edge at the bottom that is usually wider than the side and top margin edges. You can see this in Figure 10.10, where the printable area margin is indented more at the bottom than it is at the top and sides. You can't adjust these of course, but if the Print Selected Area option is checked (circled below) you can adjust the cropped print margin sliders to apply a crop via the Print dialog within the printable area. Or, if you have applied a selection in the image first, this automatically adjusts the margin sliders to crop the image accordingly. The thing to make clear here is that you are determining the area within the page that can be printed, rather than cropping the actual image itself (even though the end result appears to be the same thing). You can also mouse down on the print preview and click and drag the image relative to the crop using the move tool shown here.

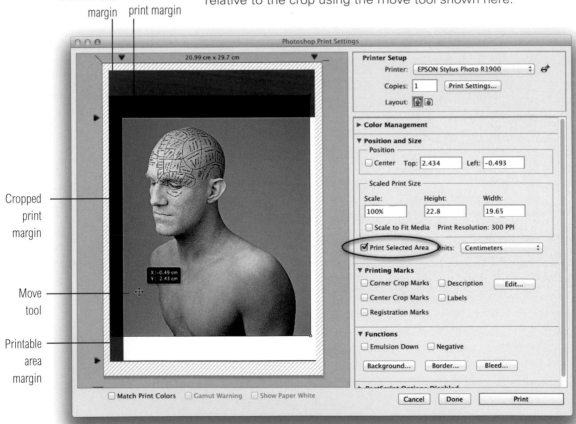

Figure 10.10 The Photoshop Print Dialog focusing on the Print Selected Area option.

Ensuring your prints are centered (Mac)

We would all love Photoshop printing to be simpler, but unfortunately there are no easy solutions and this is not necessarily Photoshop's fault. The problem is that there are a multitude of different printer devices out there and in addition to this, there are different operating systems, each of which has its own protocols as to how the system print dialogs should be organized.

Making sure a print is centered is just one of several problems that require a little user intervention. If you center a print in the Photoshop Print dialog, but it doesn't print centered, this is probably due to the default margin settings being uneven. The reason for this is that some printers require a trailing edge margin that is wider than all the other margins (see previous page). However, as I have shown in Figure 10.11 below, you can overcome this on the Macintosh system by creating your own custom paper size and margin settings.

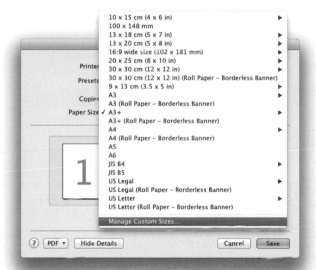
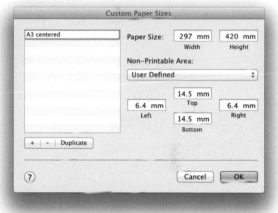

Figure 10.11 In Mac OS X, click on the Print Settings… button in the Photoshop Print dialog and choose Manage Custom Sizes… from the Paper Size menu. In the Custom Page Sizes dialog check the margin width for the bottom trailing edge margin for the selected printer. If you want your prints to always be centered, all you have to do is to adjust the Top margin width so that it matches this Bottom measurement. Set a Width and Height for the new paper size and save this as a new paper size setting and add 'centered' so you can easily locate it when configuring the Page Setup or Paper Size settings.

Figure 10.12 The Border option allows you to add a black border and set the border size.

Figure 10.13 The Bleed option works in conjunction with the Corner Crop Marks option and determines how far to position them from the edge of the printed image.

Printing Marks

In this section you can select any extra items that you wish to see printed outside the image area. The Corner and Center Crop Marks indicate where to trim the image, while adding Registration Marks can help a printer align the separate plates. Checking the Description box will print any text that has been entered in the File ⇨ File Info box Description field, though you can also click on the Edit... button next to this and enter description text directly via the Photoshop Print dialog. Lastly, check the Labels box if you want to have the file name printed below the picture.

Functions

Click on the Background... button if you want to select a background color other than white. For example, when sending the output to a film writer, you would choose black as the background color. You can click on the Border... button to set the width for a black border (Figure 10.12), but just be aware that the border width can be unpredictable. If you set too narrow a width, the border may print unevenly on one or more sides of the image. The Bleed... button determines how much the crop marks are indented (Figure 10.13).

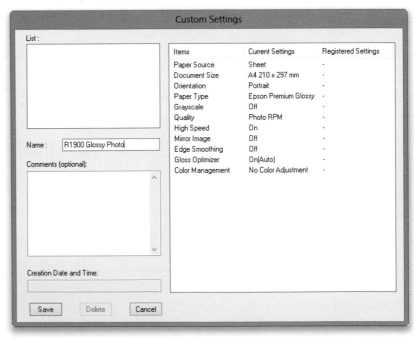

Figure 10.14 To save the PC system print settings as a preset, click on the Save Settings button in the Printer Properties dialog (see Figure 10.3) and click 'Save'.

Saving operating system print presets

Once you have established the operating system print dialog settings (as shown in Figures 10.2 and 10.3) for a particular printing setup, it makes sense to save these settings as a system print preset that can easily be accessed every time you want to make a print using the same printer and paper combination. To do this, apply the required print settings and save the settings via the Printer Properties/Print dialog and give the setting an appropriate name (see Figures 10.14 and 10.15).

Print output scripting

Since Photoshop CS5 the system print settings are applied *after* the Photoshop Print dialog. This means it is possible to record a Photoshop action in which you select the printer model, the media size, type and orientation plus the system Print settings, followed by the Photoshop Print dialog settings. Once recorded, you can use this action to make print outputs with the click of a button (Figure 10.17). So while it is a shame there is no current mechanism in Photoshop to create and save custom print settings, the ability to record the print output step as an action does at least provide one reliable method for saving the Photoshop print settings for future reuse. You can also convert such actions into Droplets (as shown below in Figure 10.16), where you can simply drag and drop a file to a droplet to make a print (I'll be discussing actions and droplets in Chapter 11).

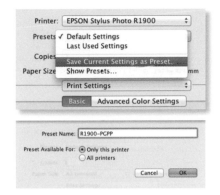

Figure 10.15 To save print settings on a Mac, choose 'Save Current Settings as Preset ...' via the system Print dialog Presets menu.

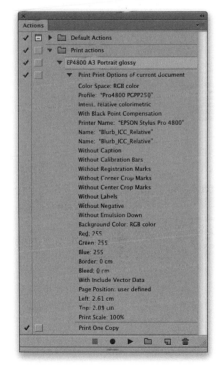

Figure 10.17 Photoshop actions can be used to record the complete print process. Once you have done this you can make further prints by simply replaying the action.

Print A5 Landscape glossy

Figure 10.16 You can automate the print process further. If you convert an action like the one shown in Figure 10.17 into a droplet, you can make it possible to simply drag and drop files to the droplet to initiate the desired print output. This allows you to bundle the printer model selection, the page setup, the media type and Photoshop print settings all into the one droplet/action.

Print quality settings

In the Print settings, a higher print resolution will produce marginally better-looking prints, but take longer to print. The High Speed option enables the print head to print in both directions. Some people prefer to disable this option when making fine quality prints, but with the latest inkjet printers, the high speed option shouldn't necessarily give you inferior results.

Configuring the Print Settings (Mac and PC)

The following dialogs show the Mac and PC Print Settings dialogs for the Epson R1900 inkjet printer (Figures 10.18 and 10.19). In both the examples shown here, I wished to produce a landscape oriented print on a Super A3 sized sheet of Epson glossy photo paper using the best quality print settings and with Photoshop handling the color management.

The system print settings dialog options will vary a lot from printer to printer. As well as having Mac and PC variations, you might have a lot of other options available to choose from and the printer driver for your printer may look quite different. However, if you are using Photoshop to manage the colors, there are just two key things to watch out for. You need to make sure you select the correct media setting in the print settings and that you have the printer color management turned off. This may mean selecting 'No Color Adjustment' in the Print Settings or Color Management sections and you should ignore any of the other options you might see such as: 'EPSON Vivid' or 'Charts and Graphs'.

Figure 10.18 This shows the Mac Print Settings for the Epson R1900 printer. In the Print Settings you will need to select a media type that matches the paper you are going to print with. Go to the Media Type menu and choose the correct paper. Next, you will want to select a print quality setting that might say something like 'Super-duper Photo' or 'Max Quality'. You may also need to locate an Off switch for the printer color management. This is because you do not need to make any further color adjustments. Note that with this particular driver it knows when you are choosing to print with the printer color management switched off and the 'Off (No Color Adjustment)' option is selected automatically. All you have to do now is click on the Save button at the bottom of the dialog to return to the Photoshop Print dialog from where you can click on the Print button to make a print.

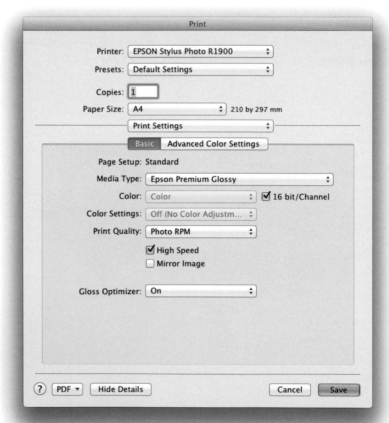

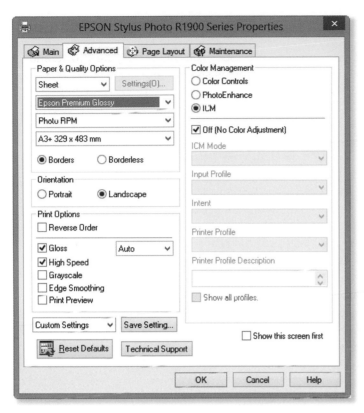

Figure 10.19 This shows the Windows 8 Print Settings for the Epson R1900 printer. Again, you will need to use the Media Type menu to select the correct paper to print with. For the Print Quality, select a high quality setting, such as the Photo RPM Quality setting selected here. In the Color management section I checked the ICM button and checked the Off (No Color Adjustment) box below to disable the printer-managed color management. Lastly, I clicked the OK button to return to the Photoshop Print dialog from where I could click on the Print button to make a print.

Photoshop managed color on Windows

When using 'Photoshop Manages Colors' on a PC system, the Photoshop Print dialog reads the JobOptimalDestinationColorProfile tag when selecting a default color profile. However, so far very few print drivers have got around to implementing this functionality. As and when such drivers do eventually ship, the printer will be able to better communicate with Photoshop as to which is the best profile, based on the media type you have selected.

Figure 10.20 Here is an example of an X-Rite color target that can be used to build an ICC color profile. The target file must be opened without any color conversion and sent directly to the printer without any color management and the print dimensions must remain exact. If it is necessary to resize the PPI resolution, make sure that the Nearest Neighbor interpolation mode is selected.

Replacing canned profiles

I don't have room to go into too much detail here, but on the Mac system at least, if you are familiar with using the ColorSync Utility, you can go to the Devices section, select a canned profile, click on the Current Profile name, choose Other… and select a custom profile to replace it with. This will allow you to promote a custom profile to appear in the filtered profile list for that printer.

Custom print profiles

As I have mentioned already, the profiles that are shipped with the latest inkjet printers can be considered reliable enough for professional print quality work (providing you are using the manufacturer's branded papers). If you want to extend the range of papers you can print with, then you will either have to rely on the profiles supplied by these paper companies or consider having a custom printer profile built for each paper type.

One option is to purchase a complete calibration kit package such as the X-Rite i1 Photo Pro 2 with i1 Profiler software. The other alternative is to get an independent color management expert to build a profile for you. There are quite a few individuals who are able to offer these services, such as Andrew Rodney, who is based in the US (digitaldog.net). A company called colourmanagement.net are also offering a special coupon to readers that entitles you to a discount on their remote printer profiling services (see back of book and book website for more details).

Remote profiling is a simple process. All you have to do is to follow the link to the provider's website, download a test target similar to the one shown in Figure 10.20 and follow the instructions closely when preparing a target print for output. The system print dialog settings used to produce the target print should also be saved so that exactly the same print settings can be used again when you then follow the steps outlined on pages 682–683. You will then need to send the printed target to the supplied address, where the patch readings will be used to build an ICC profile that represents the characteristics of a particular paper type on your individual printer. You'll usually receive back an ICC profile via email.

The important points to bear in mind are that you must not color manage the target image when printing. The idea is to produce a print in which the pixel values are sent directly to the printer without any color management being applied. With previous versions of Photoshop you could do all this directly within the Photoshop Print dialog. However, since the CS5 version, Photoshop no longer has a 'No Color Management' print option. As I mentioned earlier on page 682, you should look out for the new *Adobe Color Printer Utility* from the Adobe website. You can use this to print out non-color managed print targets for custom profiling.

Automating Photoshop

Getting to know the basics of Photoshop takes a few months, although it will take a little longer than that to become a fluent Photoshop user. One way you can speed up your Photoshop work is by learning how to use many of the various keyboard shortcuts. There are a lot of these in Photoshop, so it is best to learn a few at a time, rather than try to absorb everything at once. Throughout this book I have indicated the Mac and PC key combinations for the various shortcuts that are in Photoshop. While I have probably covered nearly all those one might use on a regular basis, there are even more shortcuts you can use. Most of these are listed in the Shortcuts table PDF, which is available from the book website. Or, you can go to the Keyboard Shortcuts dialog in the Photoshop Edit menu to see what's available.

Working with Actions

You can record a great many operations in Photoshop using actions. Photoshop actions are application scripts you can use to record a sequence of events that have been carried out in Photoshop and any actions recorded this way can then be replayed on other images. If there are certain image processing routines you regularly need to carry out when working in Photoshop, recording an action can save you the bother of having to laboriously repeat the same steps over and over again on subsequent images. Not only that, but you can also use actions to batch process multiple images.

A new action must always be saved within an action set in the Actions panel. Such action sets can then be saved and shared with other Photoshop users so that they too can replay the same recorded sequence of Photoshop steps on their computers.

Playing an action

The Actions panel already contains a set of prerecorded actions called *Default Actions.atn*. If you go to the Actions panel fly-out menu you can load other sets from the menu list such as: 'Frames', or 'Image Effects' (Figure 11.1). To test these out, open an image, select an action from the menu and press the Play button. Photoshop then applies the recorded sequence of commands to the selected image. However, if the number of steps in a complex action exceeds the number of available histories there will be no way to completely undo all the commands once an action has completed. As a precaution, I suggest you either take a Snapshot via the History panel or save the document before executing an action. If you are not happy with the result of an action, you can always go back to the saved snapshot in History or revert to the last saved version.

The golden rule when replaying an action is 'never do anything that might interrupt the progress of the action playback in Photoshop'. If you launch an action in Photoshop you must leave the computer alone and let Photoshop do its thing. If you click on the finder while an action is in playback mode this can sometimes cause an action to fail.

Photoshop Actions are always appended with the *.atn* file extension and saved by default to the Photoshop Actions folder inside the Photoshop Application Presets folder, but you can store them anywhere you like. If you want to install an action

Figure 11.1 Here is the Actions panel showing the panel fly-out menu options. You can easily add more action sets to the Actions panel via this list.

that you have downloaded or someone has sent to you, all you have to do is double-click it and Photoshop will automatically load the action into the Actions panel (and launch Photoshop in the process if the program is not already running at the time).

Recording actions

To record an action, you'll first need to open a test image to work with and you must then create a brand new action set to contain the action (or use an existing set, other than the Default Actions set). Next, click on the Create new action button at the bottom of the Actions panel (Figure 11.2), which adds a new action to the action set. Give the action a name before pressing the Record button. At this stage you can also assign a custom keystroke using the Function keys (F1–F15) combined with the Shift and/or ⌘ (Mac), ctrl (PC) keys. You will then be able to use the assigned key combination to initiate running a particular action. Now carry out the Photoshop steps you wish to record and when you have finished click the Stop recording button.

When recording a Photoshop action, I suggest you avoid recording commands that rely on the use of named layers or channels that may be present in your test file, as these will not be recognized when the action is applied to a new image. Also try to make sure that your actions are not always conditional on starting in a specific color mode, being of a certain size, or being a flattened image. If the action you intend recording is going to be quite complex, the best approach is to carefully plan in advance the sequence of Photoshop steps you intend to record. A Stop can always be inserted in an action, which will then open a message dialog at a certain point during playback (see page 701 and Figure 11.5). This can be used to include a memo to yourself (or another user replaying the action), reminding what needs to be done next at a certain stage in the action playback process. Or, if the action is to be used as a training aid, a Stop message could be used to include a teaching tip or comment.

As I mentioned already, if you want to save an action, it must be saved within an action set. So if you want to separate out an action and have it saved on its own, click on the Create new set button in the Actions panel to create a new set, drag the action to the set, name it and choose Save Actions… from the Actions panel fly-out menu (the action set must be highlighted, not the action). The following steps show how to record a basic action.

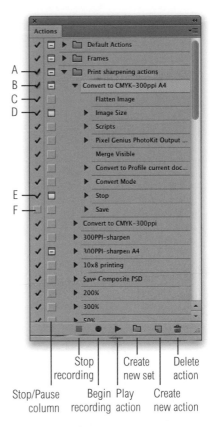

A: This Action Set contains inactive actions.
B: Indicates one or more action steps are inactive and contains a Pause.
C: An active step.
D: An active step with a Pause which will open a dialog box.
E: An active step with a Stop which will open a message dialog.
F: An inactive step.

Figure 11.2 The Actions panel column showing the different action state icons.

Descriptions of all actions

If you hold down the ⌘ ⌥ (Mac), ctrl alt (PC) keys as you choose Save Actions… this saves the text descriptions of the action steps for every Photoshop action currently in the Actions panel.

1 Here, I wanted to show a practical example of how to create an action, by showing how the print sharpening steps starting on page 674 could be recorded as an action. The first step was to create a new action set. To do this, I clicked on the Create new set button (see Figure 11.2), named this 'Print sharpening actions' and clicked OK.

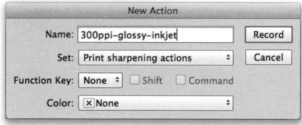

2 I then clicked on the Create new action button (circled) in the Actions panel, named this action '300ppi-glossy-inkjet' and clicked the 'Record' button.

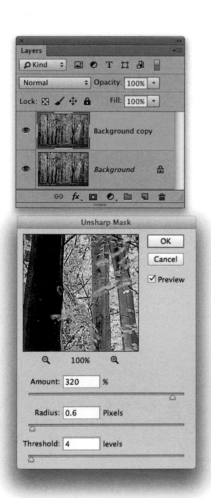

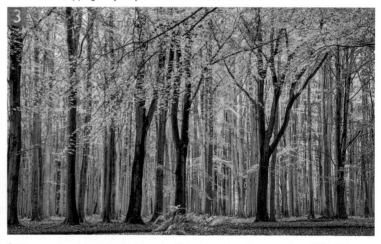

3 I then used a sample image to apply all the steps described on pages 674–675.

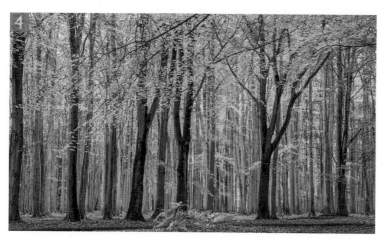

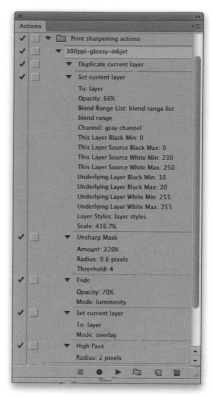

4 When I had finished recording all the steps, I clicked the Stop button to end the recording. In the Actions panel view shown on the right you can see a fully expanded list of all the steps, including the settings used. This action could then be applied to other images by clicking on the Play button, or could be applied as a batch action process. You can also switch the Actions panel to Button mode (Figure 11.3), which makes the actions playback selection even simpler.

Troubleshooting actions

If an action doesn't seem to be working, first check that the image to be processed is in the correct color mode. Many actions are written to operate in RGB color mode only, so if the starting image is in CMYK, the color adjustment commands won't work properly. Quite often, assumptions may be made about the image data being flattened to a single layer. One way to prevent this from happening is to start each action by using the _alt_ _._ shortcut (to select the top-most visible layer), followed by the Merge Visible to new layer shortcut (_⌘_ _⌥_ _Shift_ _E_ [Mac], _ctrl_ _alt_ _Shift_ _E_ [PC]). These two steps will add a new, flattened merged copy layer at the top of the visible layer stack. Some pre-written actions require that the start image fits certain criteria. For example, the Photoshop-supplied 'Text Effects' actions require that you begin with an image that contains layered text and with a text layer selected.

If you have just recorded an action and are having trouble getting it to work, you can inspect it command by command. Open a test image, expand the action to display all the items, select the first step in the action, hold down the _⌘_ (Mac), _ctrl_ (PC) key and click on the Play button. This allows you to play the action one step at a time. You need to have the _⌘_ (Mac), _ctrl_ (PC) key held down and keep clicking the Play button to

Figure 11.3 This shows the Actions panel in Button mode, where all you have to do is click on a button to initiate a recorded action (like the 300ppi-glossy-inkjet action circled above).

Recording ruler units

For actions that involve recording the placement of objects or drawing of marquee selections, it is a good idea to record setting the ruler units as part of the action. If you go to the Photoshop preferences and choose 'Units & Rulers', you can set the rulers to 'Percentage'. By recording this as part of an action, any subsequent placement of Photoshop guides, placement of the type tool or use of the marquee tools can be recorded relative to the proportions of the document. When you then replay an action, the action should work effectively no matter what the size or proportions of the image.

Volatile actions

One thing you have to be aware of is that although actions will remain stored in the Actions panel after you quit Photoshop, a newly installed or created action can easily become lost should you suffer a computer or program crash before you quit. Photoshop Actions can also become lost if you trash the Photoshop preferences or uninstall Photoshop. It is therefore always a good idea to take the precaution of saving any newly created or newly edited action sets so you don't lose them. These can be saved anywhere you like, but they ideally need to be stored in the Username/ Library/Application Support/Adobe/Adobe Photoshop CC/Presets/Actions folder (Mac), or Username\AppData\Roaming\ Adobe\ Adobe Photoshop CC\Presets\ Actions folder (PC), if they are to be seen listed at the bottom of the Actions panel fly-out menu (see Figure 11.1).

run through the remaining steps. If there is a problem with one of the action steps then double-click the relevant action step in the list to rerecord it. You will then need to make sure that action step is selected, keep the ⌘ (Mac), *ctrl* (PC) key held down again and click on the Play button to continue.

Limitations when recording actions

Most Photoshop operations can be recorded as an action, such as image adjustments, History panel steps, filters, and most Photoshop tool operations, although you should be aware that tools such as the marquee and gradient fills are recorded based on the current set ruler unit coordinates (see sidebar on recording ruler units). If you go to the Actions panel menu and check the 'Allow Tool Recording' item, this does allow things like brush strokes to be recorded as part of an action now.

Actions only record changed settings

One of the problems you commonly face when preparing and recording an action is what to do if certain settings are already as you want them to be. Actions only record a setting as part of an action if it actually changes something. For example, let's say you are recording an image size adjustment where you want the image resolution to end up at 300 pixels per inch, but the image is already defined in the Image Size dialog as being 300 pixels per inch. In these situations, Photoshop won't record anything. To resolve a problem like this you must deliberately make the image resolution something different before you record a 'set image resolution' step. Then, when you change the pixel resolution, this will get recorded. For example, while recording, you could go to the Image Size dialog and temporarily make the image, say, 200 pixels per inch (without resampling the image), then record setting the resolution to 300 pixels per inch. When you are finished recording, delete the 200 pixels per inch step from the completed action.

Background layers and bit depth

The lack of a Background layer can also stop some actions from playing. There is not always much you can do about this, other than to convert the current base layer to a Background layer by choosing Layer ⇨ New ⇨ Background from Layer before playing the action. This isn't always advisable since you wouldn't want to accidentally flatten all the layers in an important image. Alternatively, you could make a flattened duplicate of the current image and then run the action. You may

also want to check the bit depth of the image you are applying the action to. If the bit depth is 16-bit, not all Photoshop filters will work and you will need to convert the photo to 8-bits per channel mode first.

Layer naming

Action recordings should be as unambiguous as possible. For example, if you record a step in which a named layer is brought forward in the layer stack, in playback mode the action will look for a layer with exactly the same name. Therefore, when adding a layer include the naming of the layer as part of the action (but don't use Layer 1, Layer 2, etc., as this may only cause confusion with Photoshop's default layer naming). Also, use the main Layer menu or Layer key command shortcuts to reorder the layer positioning. Doing this will make your action more universally recognizable.

Inserting menu items

There are some things which can be added as part of a Photoshop action that can only be included by forcing the insertion of a menu item. For example, Photoshop doesn't record zoom tool or View menu zoom instructions. However, if you select 'Insert Menu Item' from the Actions panel fly-out menu, as you record an action, you will see the dialog shown in Figure 11.4. The Menu Item dialog will initially say None Selected, but you can now choose, say, a zoom command from the View menu and the zoom instruction will be recorded as part of the action, although frustratingly the image won't actually zoom in or out until you replay the action! I often use the Insert Menu Item as a way to record actions that open certain Photoshop dialogs that I regularly need to access, such as the various Automated plug-ins. This saves me having to navigate the Photoshop menus to access them.

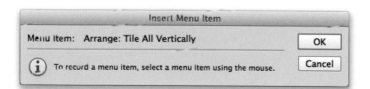

Figure 11.4 The Insert Menu Item dialog will initially say None Selected. You can then select a menu item such as Window ⇨ Arrange ⇨ Tile All Vertically, and click OK. When the Action is replayed the inserted menu item will be included in the playback list.

Tutorial Builder

Over on the labs.adobe website is an interesting tool called Tutorial Builder: labs.adobe.com/downloads/tutorialbuilder. html. Currently at version 3, this allows you to record steps carried out in Photoshop and compile these as ready made, step-by-step Photoshop tutorials. Also included is the code required to replay each step using the Touch SDK to replay the steps in Photoshop via a mobile device.

Stops and Pauses

When editing an action, you can insert what is known as a Stop. This allows you to halt the action process to display an alert message. This could be a useful warning like the one shown in Figure 11.5, which could be displayed at a key point during the action playback. If you click in the Stop/Pause column space to the left of the action step, next to a step where a dialog can be shown, you can instruct Photoshop to open the dialog at this point (see the red icons in the Stop/Pause column in Figure 11.2). This allows you to custom edit the dialog box settings when playing back an action.

Figure 11.5 The Record Stop dialog.

If there is a recorded 'Open' item, such as an ACR processing step in an action, checking 'Override Action "Open" Commands' overrides popping the ACR dialog for each image and simply applies the ACR processing. However, if you check this and there is no open step recorded in the action, this will prevent the action from running.

Batch processing actions

One of the great advantages of actions is having the ability to batch process images. The Batch dialog (Figure 11.6) can be accessed via the File ⇨ Automate menu, plus it can also be accessed via the Tools ⇨ Photoshop menu in Bridge. You first need to select an action set and action from the Play section and then you'll need to set the Source and Destination. The Source can be all currently open images, the selected images in the Bridge window, an Import source, or a specific folder, in which case, you'll need to click on the Choose… button below and select a folder of images. The following items in the Source section will only show if the Folder or Bridge options are selected. These allow you to decide how to handle files that have to be opened first in Photoshop before applying an action. Most of the time you will want to leave the 'Override Action "Open" Commands' unchecked (see sidebar). Only check the 'Include All Subfolders' option if you want to process all the subfolders within the selected folder. If you are processing a bunch of raw files and wish to override seeing the ACR dialog

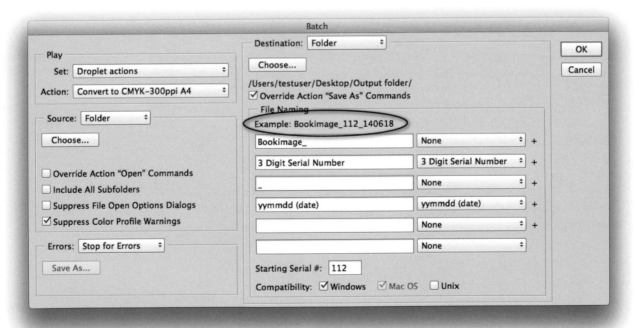

Figure 11.6 This shows an example of the Batch Action dialog set to apply a prerecorded action. The 'Windows' box has been checked here to ensure file naming compatibility with PC systems.

then do check the 'Suppress File Open Options Dialogs' option. Lastly, if you want to prevent the Missing Profile and Profile Mismatch dialogs appearing when you batch process images, check the 'Suppress Color Profile Warnings' option. As a consequence of doing this, if there is a profile mismatch, Photoshop checks what you did previously. If you previously chose to keep the image in its own profile space, then this is how the images will be batch processed. If there is no profile present, Photoshop checks to see if your previous preference was set to: Ignore, Assign a profile, or Assign and convert to the working space, and acts accordingly. If 'Stop For Errors' is selected, this halts the batch processing in Photoshop any time an action trips up over a file for some reason. You can prevent this by selecting the 'Log Errors to File' option instead. This allows the batch processing to complete, but creates a log report of any files that failed to process.

In the Destination section you have three options. If you choose 'None', Photoshop processes the selected files and leaves them open. If you choose 'Save and Close', Photoshop does just that and overwrites the originals, and if you choose 'Folder', you'll need to click on the Choose… button to select a destination folder.

Now it might so happen that the action you have selected to run the batch process with may contain a Save or Save As command that uses a specific file format and format settings, and this action step will contain a recorded Save destination. It might be the case that the Save destination is an important part of the action, but if the destination folder no longer exists, the action will fail to work (besides, you can specify a destination folder within the Batch dialog itself). So in the majority of instances, where the action contains a Save instruction, I recommend you check the 'Override Action: "Save As" Commands' checkbox. If the action does not contain a Save or Save As command, then leave this option unchecked.

If a folder is selected as the destination, you can use the file renaming fields below to apply a renaming scheme to the processed files. You can use any combination you like here, but if you select a custom file extension option this must always go at the end. A complete list of the file naming and numbering options are shown in Figure 11.7. These also let you define the precise numbering or renaming of the batch processed files. As you edit the fields, you will see an example of how the naming will be applied in the 'Example:' section (circled in Figure 11.6).

Customized file naming

It is easy to customize the File Naming with your own fields. In Figure 11.6, I created a batch process where the images were renamed 'Bookimage_' followed by a three digit serial number, followed by an underscore '_' and with the date expressed as: year; month; and day. Note that the numbering was set to start at '112'. So in this example the file name structure would be as follows: Bookimage_112_140618.

√ Document Name
 document name
 DOCUMENT NAME
 1 Digit Serial Number
 2 Digit Serial Number
 3 Digit Serial Number
 4 Digit Serial Number
 Serial Letter (a, b, c…)
 Serial Letter (A, B, C…)
 mmddyy (date)
 mmdd (date)
 yyyymmdd (date)
 yymmdd (date)
 yyddmm (date)
 ddmmyy (date)
 ddmm (date)
 extension
 EXTENSION
 None

Figure 11.7 The Batch interface naming and numbering options.

Migrating presets

The initial preset migration has been refined in Photoshop CC. To start with the preset migration no longer requires you to restart the computer and only migrates presets from the last installed version of Photoshop (instead of all previous installed versions). The preset migration now migrates settings from both the user library Presets folder as well as the Photoshop application Presets folder. It also migrates all active presets as well as any non-loaded presets that are around.

Exporting and importing presets

When you initially installed Photoshop, you may have noticed a dialog asking 'Would you like to migrate presets from the following versions?' In that dialog the most recent previous version of Photoshop appeared listed (see page 2). This allowed you to automatically import the preset settings that were contained in your old version of Photoshop. If you ignored this dialog and clicked 'No', you can go to the Edit menu in Photoshop and choose Presets ⇨ Export/Import Presets… This opens the dialog shown below in Figure 11.8. In Import Presets mode, select the Presets folder from your old version of Photoshop and click on an arrow to add selected presets to the list on the right (or click 'Add All'), then click 'Import Presets'. In Export Presets mode, select presets from the list on the left and click on an arrow to add these to the list on the right (or click 'Add All'), then click 'Export Presets'. This will allow you to create an 'Exported Presets' folder that contains a subset of presets folders, mirroring what was in the original Presets folder.

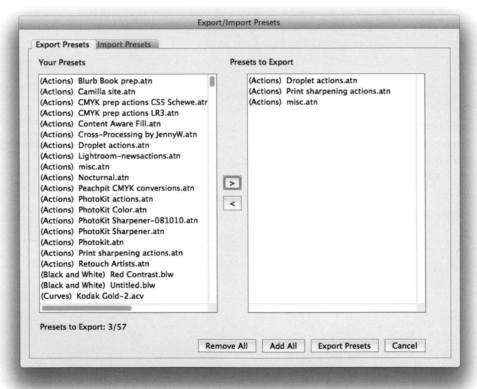

Figure 11.8 This shows the Export/Import Presets dialog.

Creating a droplet

Photoshop actions can also be converted into self-contained, batch processing applications, known as droplets, which can play a useful role in any production workflow. When you drag a document or a folder on top of a droplet icon this launches Photoshop (if the program is not already running) and initiates the action sequence contained within the droplet. The beauty of droplets is you only need to configure the batch processing settings once and they'll then be locked into the droplet. Droplets can be stored anywhere you like, although it makes sense to have them readily accessible such as in an easy-to-locate system folder (see Figure 11.9). Droplets can perform Save and Close operations (overwriting the original), or can be configured to save the processed images to an accompanying folder as a new version of the master image.

To make a droplet, go to the File ⇨ Automate menu and choose Create Droplet… Figure 11.10 shows the Create Droplet interface and you will notice that the Create Droplet options are identical to those found in the aforementioned Batch Actions dialog. Choose a location to save the droplet to and, if required, you can also choose a destination folder for the droplet processed files to be saved to. When you are done, click OK.

Cross platform droplets

You can name a droplet anything you like, but if a droplet is created on a Mac you'll need to add a .exe extension for it to be PC compatible. If you are a Mac user and someone sends you a droplet that was created using a PC, it can be made Mac compatible by dragging it on top of the Photoshop application icon first to convert it.

Figure 11.9 Photoshop Droplets (shown here with output folders).

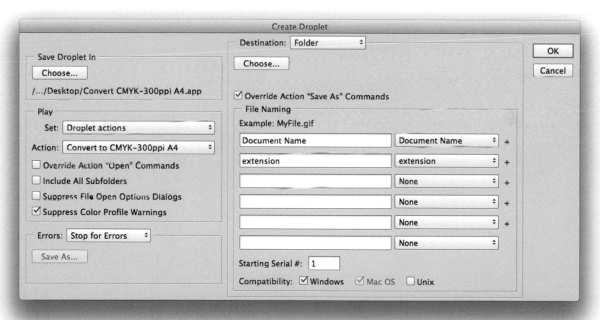

Figure 11.10 This shows the Create Droplet dialog.

Conditional Actions

The CS6.1 update introduced conditional actions, which can be inserted into regular actions.

Essentially what you can do is create a new action and choose 'Insert Conditional…' via the Actions panel fly-out menu. From there, you can choose a condition from the menu shown in Figure 11.11 to determine which action will be played if this condition is met. If not, you can choose an action from the Else menu to play instead. Only actions that are included within the current action set will be displayed in the 'Then' and 'Else' pop-ups. Note that if both menus are left set to 'None', no conditional action will be created because the resulting action would not do anything.

Figure 11.11 This shows the Conditional Actions dialog (top), plus all the available conditional action options (bottom).

Conditional action droplets

A conditional action can be included in batch or droplet operations. The following steps show how.

1 I went to the Actions panel, expanded an existing Action set and clicked on the Create New Action button to create a new action, called 'sharpen + convert CMYK'.

2 I then went to the Actions panel fly-out menu and selected 'Insert Conditional…'

Conditional mode change

The Conditional Mode Change dialog is available from the File ➯ Automate menu. You can choose to insert this into an action to create an action that can be used for batch processing (or in a droplet) to automatically convert files to a target mode color space. For example, if you go to the Actions panel you can create and record a new action and choose 'Insert Menu Item' and select File ➯ Automate ➯ Conditional Mode Change. Then select all the color modes you want to process as the source (excluding the Target mode) and select the Target mode below. In the Figure 11.12 example, I had open an image that was not in RGB mode and when recording the action, selected all color spaces except RGB as the source mode and selected RGB as the Target mode. I clicked OK and stopped recording. This action could then be used to batch process selected files to convert them to RGB color mode.

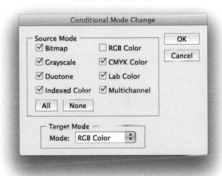

Figure 11.12 This shows the Conditional Mode Change dialog with the settings configured to convert non-RGB color files to RGB color.

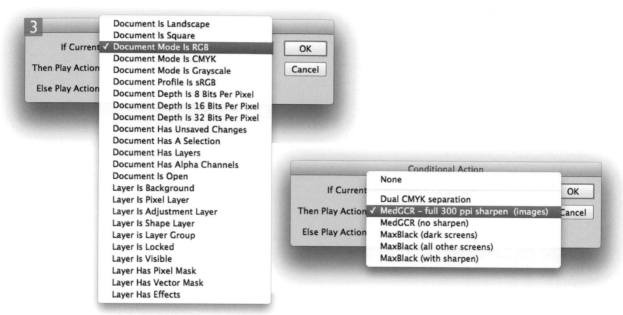

3 My aim here was to create a conditional action that was able to filter out the RGB images only to apply a 'convert from RGB to CMYK' action that also included an output sharpening step. In the 'If Current' menu I selected 'Document Mode is RGB'. Then, from the 'Then Play Action' menu I selected the appropriate action from the same parent Actions folder. I left the 'Else Play Action' menu set to 'None'.

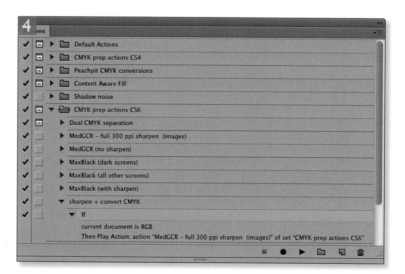

4 Here you can see an expanded view of the Actions panel after creating the above conditional action. The action that's being called here is one that was designed to process RGB images only, which would otherwise fail to run if applied to an image already in CMYK mode. So, using this inserted conditional item it would only process files that were in RGB mode and leave the CMYK files untouched.

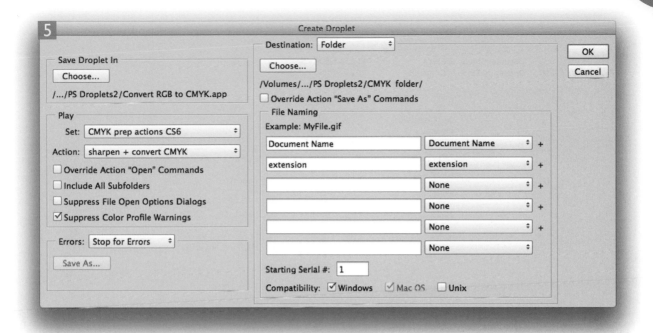

5 I was now ready to put the conditional action to use. I went to the File menu in Photoshop and chose Automate ⇨ Create Droplet… This opened the dialog shown here which I configured so that a new droplet was added to a special folder I keep all my droplets in and saved the processed files to a destination folder called 'CMYK'.

Convert RGB to CMYK CMYK

6 I clicked OK in the Create Droplet dialog to create the droplet and folder shown here. I was now able to test the new droplet. I made a selection of files that were a mixture of RGB and CMYK images. I dragged these across to the droplet and Photoshop knew to process all the RGB files and ignore the CMYKs. Without a conditional action a droplet like this would trip up on the CMYK files and display an alert message asking me if I wanted to stop or continue. With conditional actions you can avoid distracting dialog messages that would otherwise halt an automated batch process.

Preparing JPEGs for the Web

When you are preparing images that are destined to be shared by email or published via the Web, the Image Processor is a handy tool to use because you can not only resize the images as part of the image processing, but you can instruct the Image Processor to convert the image from its current profile space to sRGB, which is the ideal RGB space for general purpose Web viewing.

Image Processor Pro

The Image Processor Pro (Figure 11.13) is now made available as a separate downloadable script, which can be downloaded via the Adobe website. Once downloaded and installed, you will then need to go to the File ⇨ Scripts menu and select Browse… to launch Image Processor Pro. Meanwhile, the original Image Processor can also be accessed via the File ⇨ Scripts menu in Photoshop, or via the Tools ⇨ Photoshop menu in Bridge. Image Processor Pro though allows you to select a folder of images (or select all open images) to process, and select a location to save the processed files to. Image Processor Pro can then be configured to run a Photoshop action (if required) and save the processed files using a wide variety of file formats and simultaneously process to save the files in multiple file formats to separate folders. This can be very handy if you wish to produce, say, both a TIFF version at high resolution and a JPEG version ready to place in a web page layout.

With the standard Image Processor, you had the option to simultaneously save a JPEG, PSD and TIFF version and determine the output dimensions for each, but that was all. The more advanced controls in Image Processor Pro now allow you to configure sets of file outputs and apply individual processing instructions to each set. For instance, in Figure 11.13 you can see that Set 1 is configured to save a JPEG version, and there are options to determine the pixel dimensions, resolution and image quality. Furthermore, you can choose the output profile and select Photoshop actions to run either before or after image resizing. Meanwhile, Set 2 is configured for saving TIFF file versions. Here, you can also choose different file format options, resize the image and select the desired bit depth. With the PSD set there are options to include alpha channels, layers and whether you want to maximize file compatibility. Below the file format options is the File Naming section, where you can determine how the files are renamed for each individual set. The options here are similar to those found in the Batch processing and Create Droplet dialogs.

Lastly, there are plus and minus buttons you can use to add or remove sets. For example, you could configure Image Processor Pro to output three different types of JPEG output: maybe, one set of JPEGs resized for sending as email attachments, others saved ready for placement in a website and others as full-size images for placement in a layout. Once

the settings have been configured you can click on the Save…
button at the top to save as a configuration setting that can be
opened via the Load… button.

Figure 11.13 This shows Image Processor Pro, which can be configured to
process single or multiple images, apply Photoshop actions, add copyright info
and save the files to a designated folder location in one or more of the following file
formats: JPEG, PSD or TIFF. The destination folder will contain the processed images
and these will be separated into folders named according to the file formats selected.

Figure 11.14 The Photoshop Scripts menu.

Figure 11.15 An example of the Export Layers to Files... script dialog.

Figure 11.16 The Fit Image dialog.

Scripting

One of the most neglected aspects of Photoshop has been the ability to write scripts that automate the program. For most of us, the prospect of writing scripts is quite scary and I freely confess I am one of those who has looked at the scripting manuals and simply shuddered at the prospect of having to learn computer code. Steps have been taken though to make scripting more accessible to the general user. You can start by referring to the Photoshop Scripting Guide and other PDF documents about scripting that can all be found at: adobe.com/devnet/photoshop/scripting.html. You can also download pre-made scripts from the Adobe Add-ons website: creative.adobe.com/addons.

To start with, go to the Scripts menu in the Photoshop File menu (Figure 11.14). There you will see a few sample Scripts that are readily available to experiment with. Among these is a script called 'Export Layers to Files' (Figure 11.15). This can be used to generate separate file documents from a multi-layered image. Other scripts I like to use include the Load Files into Stack..., which I find useful when preparing images for stacks image processing or before choosing Edit ⇨ Auto-Align layers.

Automated plug-ins

A number of automated plug-ins are available via the File ⇨ Automate menu. These enable Photoshop to perform a complex set of procedures based on simple user input. Adobe has also made Automated plug-ins 'open source', which means it is possible for third-party developers to build their own Automated plug-ins for Photoshop.

Fit Image

Fit Image... (Figure 11.16) is a very simple Automated plug-in, which allows you to automate image resizing. To launch, choose File ⇨ Automate ⇨ Fit Image... It is well suited for the preparation of images for screen-based design work. You can enter the pixel dimensions you want the image to fit to, by specifying the maximum pixel width or height. Note that if you enter the same pixel dimensions for the width and height, Fit Image can be used to simultaneously batch process landscape and portrait format images. Scripts can be made to call other scripts, so it is often useful to include Fit Image within a more complex script, or as part of a recorded action sequence.

Index

Remote profiling for RGB printers

You have just been reading one of the best digital imaging books in the marketplace. Now you'll probably want to be sure your colour is as good as it can be, without too much back and forth when printing. Lots of print testing to achieve expected colour really does use up the ink and paper, but, more importantly it uses up the creative spirit. We'd like to offer you a deal on a printer profile. Just download the profiling kit from: www.colourmanagement.net/profiling_inkjets.html.

Our kit contains a detailed manual and colour charts. You post printed charts to us. We will measure using a professional auto scanning spectrophotometer. This result is then used within high-end profiling software to produce a 'printer characterisation' or ICC profile which you will use when printing. Comprehensive instructions for use are included.

You can read a few comments from some of our clients at: www.colourmanagement.net/about.html.

Remote RGB profiles cost £95 plus VAT. For readers of 'Adobe Photoshop CC for Photographers', we are offering a special price of £50 plus VAT. If our price has changed when you visit the site, then we will give you 30 percent off.

We also resell the colour management gear that you need: profiling equipment, LCD displays, print viewers, RIPs, printers and consumables etc. http://www.colourmanagement.net/profilegear.html.

Is your colour right? do you need to be sure? Have a read about our Verification Kit http://www.colourmanagement.net/prover.html. Normally £80 + VAT with UK postage, offer 50% discount. Overseas delivery by arrangement.

We also resell the colour management gear that you need: profiling equipment, LCD displays, print viewers, RIPs, printers and consumables etc. http://www.colourmanagement.net/profilegear.html.

Consultancy services

Neil Barstow, colour management and imaging specialist, of www.colourmanagement.net, offers readers of this fine book a discount of 15% on a whole or half day booking for consultancy (subject to availability and normal conditions).

Coupon code: MEPSCS7-10

Please note that the above coupons will expire upon next revision of Adobe Photoshop for Photographers. E&OE.

Rod Wynne-Powell

Rod, a fellow Adobe Prerelease Tester, continues to provide technical help and suggestions when tech-editing for this series of books. When he is not helping me, he finds time to train other photographers in Lightroom and Photoshop workflow, and recently one of his 'students' was asked by her colleagues what was it he had, to which the reply was "Gravitas and Patience" – seemingly they thought he had an App called 'Gravitas'!

He keeps abreast of the technologies that impinge upon photography, the Mac and Photoshop, which can prove invaluable, and he somehow manages to keep his hand in taking a wide range of photographs. The lessening amount of both retouching and consultancy work has resulted in a return to his roots – the taking of photographs, and a growing interest in Wildlife photography in particular.

Corporate photographer turned videographer Ben Rice refers to him as 'Doctor', and Rod's adoption of his firm's trading name stems from the most frequent of requests for help which began with "Rod, I have a problem…" – the only obvious response was to adopt the name of 'SOLUTIONS Photographic'.

Photograph and retouching: Rod Wynne-Powell

Email: rod@solphoto.co.uk
Blog: http://rod-wynne-powell.blogspot.com
Skype: rodders63
iChat: rodboffin
M: +44(0)7836-248126

SOLUTIONS Photographic

Now enters its twenty-ninth year, and provides consultancy and training, retouching to graphic designers, progress photography to construction companies, help with specifying Mac hardware and software to photographers, and diagnostics and remedial help when photographers face problems with their digital setups. He also can offer online help and training on an ad hoc basis.

Much of his training is tailored for one-to-one involvement as this has generally proved to be the most effective way to learn. Several photographers have availed themselves of his time for extended periods up to six days as far afield as Tuscany, Provence, Paris and Aberdeen, with follow-up sessions remotely using programs such as iChat, and Skype.

STEVIE NICKS

NICKS

VISIONS, DREAMS & RUMOURS

STEVIE NICKS

VISIONS, DREAMS & RUMOURS

Zoë Howe

OVERLOOK OMNIBUS

This edition published by Omnibus Press and distributed in the United States and Canada by
The Overlook Press, Peter Mayer Publishers Inc, 141 Wooster Street, New York, NY 10012. For bulk
and special sales requests, please contact sales@overlookny.com or write to us at the above address.

Copyright © 2015 Omnibus Press
(A Division of Music Sales Limited)
14/15 Berners Street,
London, W1T 3LJ, UK.

Cover designed by Fresh Lemon
Picture research by Jacqui Black

ISBN 978.1.4683.1066.5
Order No. OP56166

Every effort has been made to trace the copyright holders of the photographs in this book but one
or two were unreachable. We would be grateful if the photographers concerned would contact us.

Printed in Malta.

A catalogue record for this book is available from the British Library.

Cataloguing-in-Publication data is available from the Library of Congress.

Visit Omnibus Press on the web at www.omnibuspress.com

Contents

Prologue

23 May, 1997. Warner Brothers Studios, Burbank, California. A soundstage has been transformed into a mammoth concert venue; MTV's camera crew is ready to film the spectacle that is just moments away; backstage, one of the most important and intriguing bands in rock'n'roll history is preparing to play live together in front of thousands for the first time in 15 years. The MTV special will be titled *The Dance*. The band is Fleetwood Mac.

A petite woman with waist-length blonde hair, three days shy of her 49th birthday, glances nervously at the people around her; friends, ex-lovers, a quasi family – albeit a seriously dysfunctional one. So many complications, so much love and so much acrimony have gone down between these five people, and yet here they are, ready to go on stage as a unit once more after all this time. Drummer and founding member Mick Fleetwood, who at six foot five inches towers above her, bends down to kiss Stevie Nicks, the golden-haired, perennially mystical 'Queen Bee' of the group, on the head. She tentatively clasps hands with the guitarist Lindsey Buckingham, their jagged chemistry undiminished and crackling between them, and not for the last time this evening. The lights dim, a hush falls over the restless crowd. It's time. Fleetwood pounds out quarter notes on his bass drum, percussion shimmering like shards of glass. Stevie raises her shawl and the riff to 'The Chain', a song

that has never been more laden with significance to this band, begins, malevolent, mysterious. They are back.

Just two years previously, the idea of this seemed impossible to Stevie Nicks. Up until now, she had remained close to fellow singer-songwriter and keyboardist Christine McVie, but the third key writer in the group was not always 'friendly' towards Nicks. In fact, as Stevie at least used to see it, Lindsey Buckingham "just plain doesn't like me". Stevie and Lindsey, as you almost definitely don't need telling, were teenage sweethearts, collaborators, star-crossed lovers, creative rivals, sworn enemies. The fly in each other's ointment.

Even now the pair are locked in an ongoing dialogue through their songs, searching for closure. "You may be my love, but you'll never be my love..." crooned Stevie during an interview in 2013, quoting from her new song 'You May Be The One', adding wryly, "Guess who that one's about?" Yes, there's a thin line between love and hate. There's also an awareness inherent in the group that the fractured romance between Nicks and Buckingham is one of the most compelling elements of their live show, let alone their songwriting.

All the same, behind the sometimes stagey onstage glowers and finger-pointing is a genuine, unbreakable attachment between two people who still seem to yearn for something more, even if it's only during the time they are onstage. What we saw when Fleetwood Mac reconvened on stage for *The Dance*, and in particular when Stevie and Lindsey locked eyes, was quite real; even in rehearsals for the show, nothing like this had happened. There was something about singing those songs in front of an audience again that touched something deep within them both. The audience went wild, witnessing something so personal, a tender moment of not-quite closure for one of the most famous rock'n'roll love stories of all time. Fleetwood Mac obviously cottoned onto this. Boy, do they milk it now. But that's not to say there isn't still something true at the core. They've just blended reality with theatricality, and, for the fans, it works.

After the final threads of the toxic Fleetwood Mac tapestry separated completely in 1995, no one within the circle imagined they'd be beating a path to each other's door any time soon, although plenty were

hoping for a miracle. On being asked (repeatedly) as to the possibility of a reunion, Stevie opined that Buckingham might do it if offered "an exorbitant amount of money", but if she wasn't getting a good vibe from him, something that was rarely there anyway, it just wasn't worth it. Money obviously wasn't an issue; no matter how much of it had been inhaled, smoked or imbibed during the boom years, there was still more than enough to ensure she didn't have to go back to the tension and upset of working with the Mac, or Lindsey, again.

Safer as this option was, it was sad and unsatisfying; loose ends remained untied, and there was still a sense of longing for what might have been, if only creatively – and not just for the people involved, by the way. Lindsey himself has admitted he is a "different man" now, and thousands of Fleetwood Mac fans remain obsessed with the idea of Lindsey and Stevie not just getting along, but getting back together. There are websites, blogs and YouTube channels dedicated solely to collating and poring over footage and imagery of the pair during happier times, cooing over each other, sharing meaningful glances, embracing onstage, the scars left by decades of hurt having been picked at repeatedly during a show consisting largely of songs that lament or berate each other. Yes, there's an element of theatre there, this is what the audience wants to see, but when Stevie and Lindsey are onstage together, a love affair springs back to life, only this time there is a little more maturity and perspective. Maybe 'Mr and Mrs Intense', as Stevie has jokingly dubbed themselves, have reached a happy medium after all.

The Fleetwood Mac story – a saga of incongruity even before Stevie and Lindsey joined – was never over, even when each member of the band had supposedly closed the door on it. Stevie had always dreamed that, under different circumstances, they would reunite, and sure enough, those golden, binding threads that had become so frayed and ripped, slowly started to knot together.

Just weeks after the split of the 'final' Fleetwood Mac line-up in 1995 (bearing in mind that Stevie and Christine had left five years earlier, and Buckingham had quit in 1987) word was rife that Mick Fleetwood had started working with Buckingham on his solo album. Then Christine and John McVie came on board. The following year, Stevie even

recorded a duet with Lindsey for a movie (*Twisted*) and in May 1996, around the time of Stevie's birthday, the band reunited at a private Kentucky Derby gala at the home of Louisville actress/super-hostess Patricia Barnstable Brown. There they celebrated 20 years of *Rumours*, their seminal album post-Peter Green, and second album post-inclusion of Buckingham Nicks. The TV host Dick Clark was among the star-studded audience. (Presumably he'd forgiven Lindsey for puking in his office at the American Music Awards 30 years previously.) The idea of a tour was floated and, assuming Lindsey would be the hardest to convince, Christine McVie organised a dinner at her house, which turned out to be "the most blatant form of what you might call an intervention", as Lindsey remembers. "People got in a circle around me and said, 'You gotta do this thing'."

And so it began again, memories were dragged to the surface but conflict was at a minimum, love and caution prevailed, knowing which buttons not to press was key. Stevie and Lindsey were more stable in themselves than they had been for a long time; Stevie's addictions were in the past and Lindsey was now a family man, more settled and loving than his ex-partner had ever seen him. In each other's company, there was always the risk of falling into old patterns but, as Buckingham admitted, as long as they all kept an eye on themselves, the sweetness of the situation could shine through, fun could overtake friction, and a love that had never really disappeared would flourish, at least while the players were playing. "It's nostalgic," mused Buckingham. "You could cry over it if you let yourself. This was like the girl I used to live with again. No matter what, some kind of chemistry will always be there."

There is more to Stevie Nicks than Fleetwood Mac, and she's far from defined by a ruined rock'n'roll romance that will never go away, but that band, with its tragedies and mysteries and entanglements that would put Hollywood to shame, is what first brought her to the world's attention. All the same, her compelling presence, songwriting and unique voice – these are the elements that made sure she stayed in people's hearts for decades to come. As the pages turn and we journey through a fairytale life, with all the darkness and glamour that entails, we'll garner glimpses of inspiration, rock goddess lessons and nuggets

of advice from one of popular culture's most enduringly wise women. After all, Stevie Nicks often refers to herself as someone who has taken the falls so 'the little rock stars who come after' don't have to. They probably will all the same, but it's the thought that counts.

Just to be clear, I won't be referring to Ms Nicks as a 'white-winged dove' or a 'gold dust woman', as much as I love the imagery. Neither will I make any reference to Stevie 'going her own way'. Apart from anything else it seems cruelly ironic that so many sub-editors have blithely used this reference in the headlines of Stevie-related features considering 'Go Your Own Way' is a song that is less than kind about her, to say the least.

To be fair, 'Go Your Own Way' aside, (written, as it was, by a bitter, jilted Lindsey Buckingham) there's a reason why, when people try to describe Stevie Nicks, we link her immediately to song titles and her lyrics, all of which are miniature poetic autobiographies of who she was at the time, after all.

So who is Stevie Nicks? Who is behind the clichés, behind the mask, under all of those layers of chiffon and cashmere and gossamer dreams? Ask anyone and they'll have a different impression. Potent symbol of feminism as well as femininity. Mystical lady from the mountains. Soft-focus California dream girl. Hedonist. Witch. Strong and powerful. Frail and child-like. In need of solitude. In need of attention. Hard. Soft. Maybe she's all of these things. Maybe she's something else.

One of the most enchanting things about Stevie Nicks is that she *allows* us to be enchanted, she never gives away too much, all the while making you think she's giving you everything. Her songs are emotional, but many of her lyrics are cryptic, not confessional and literal like Lindsey's or Christine's. Her doe eyes are wide open but there's an aura around her, like the vines protecting the sleeping beauty; they won't let just anybody through. She's like a silent movie queen, prizing the mystery, and her fans thrive on the enigma – it keeps them held as if under a spell.

True, she allowed us into her home in her documentary *In Your Dreams*, but little is laid bare. There are no tights drying over bannisters, no tabloid magazines strewn on the coffee table. The home is a mask

in itself: Nicks really lives in a flat nearby which remains private. We are allowed just so close, and Stevie is very much at the controls, as she always has been. After an interview with *Vox* magazine in the nineties, unhappy with how the photographer had shot her abode, she organised a crew at her own expense to recreate her home at a Hollywood soundstage – all of her knick-knacks, her dolls, her trinkets were present, just lit more flatteringly for him to photograph again. Eccentric, yes... but who wants a rock star to be dull and predictable? We love them because they're more interesting than us, more free-thinking, independent and... yes, perhaps a bit strange.

Confusing rock star moments aside, Stevie is a role model for many and it's easy to see why: she is uncompromising, she puts creativity first, she has cracked the code of being sexy but not over-sexualised and, after 40 years in the rock'n'roll business, she has been there, done that, shed the tears, done the drugs, got the platform boots and is still here to tell the tale. So for those who sometimes wonder, 'what would Stevie do?' – and let's face it, who doesn't? – it's time to wrap yourself in velvet, fling a shawl over your lamp, light the candles (maybe have a fire extinguisher handy) and pour some Courvoisier into your tea; you're about to find out, Stevie-style.

PART I

Daughter Of The Desert

Chapter 1

"By the time I was five, I was a little diva."

Comfortable? Good. We're going in and we're taking it from the top. First of all, here are five key facts about Stevie Nicks' early years:

1) *Stephanie Lynn Nicks was born to parents Jess and Barbara on May 26, 1948 at the Good Samaritan Hospital in Phoenix, Arizona.*

2) *Barbara Nicks gave birth to Stephanie Lynn when she was just 20 years old, one year after marrying Jess Nicks. Jess would later become the chairman of meatpacking company Armour and Co., and executive vice-president at Greyhound Corp. The family would move around a lot – to Utah, California, Texas, New Mexico, Los Angeles... Despite this, Jess Nicks insisted his famous daughter always felt "like an Arizonan".*

3) *Jess loved the name Stephanie, but his first-born became known as Stevie because, as a small child, she just couldn't pronounce her name properly. It initially came out as 'Teedee' (her mother would still call her 'Teedee' and 'TC Bird' long into adulthood).*

4) *Stevie's favourite childhood memories stem from staying with her maternal grandmother in Ajo, Arizona. (Ajo means 'garlic' in Spanish, in case you were wondering.)*

5) *But it would be Stevie's paternal grandfather who would steer her firmly onto her life's path. Aaron Jess Nicks was a nomadic country & western*

singer who took the four-year-old Stevie with him when he went to perform in bars, teaching her to harmonise and sing the 'answers' when he sang call-and-response classics. The first song they sang together was 'Are You Mine?' by Red Sovine.

Stevie Nicks might have lived a peripatetic life, but Phoenix, with its sub-tropical desert climate and majestic mountain ranges, would always draw her back. Phoenix represented Stevie's roots, and in the rudderless life of a rock'n'roll star, having a sense of home and family is vital; Stevie still has a home in Phoenix to this day. The name of the place alone would provide an appropriate touchstone for Nicks as the years unfolded, that of a glorious bird, burning out only to rise back up from its own ashes, more spectacular than ever. Not a bad symbol for a rock star. While we're on the subject of symbolism, the zodiac indicates that Stevie was born under the sign of Gemini, a sign ruled by the element of air and the planet Mercury. The astrologically inclined may agree that these cosmic connections could explain her fascination with the heavens, mists and veils, her passion for diaphanous stage costumes and her life-long love of ballet and the idea of the body in flight. Her signature song, 'Rhiannon', chronicles the tale of a white witch 'taken by the sky', after all, and what are dreams and visions but ethereal flashes of the unconscious?

Music was in Stevie's life from the beginning – in her blood, no less – thanks to her grandfather AJ, a musical free spirit who lived up in the mountains. AJ supported himself by playing pool, but his heart lay in country & western music, and he was a gifted multi-instrumentalist: harmonica, guitar, fiddle – you name it, he could play it. His dream to succeed as a performer saw him leaving his family behind to ride the freight trains and play in bars around the country. Little Stevie was inspired by her bohemian grandfather, and the day he visited with a trunk-full of 45s was the day her path was set and she found her voice. They sat together on the floor of her bedroom, listening to records back to back. AJ would sing to Stevie, and soon they were harmonising and trying out duets; "sing like you mean it, granddaughter", AJ would

croon to the blonde-haired toddler by his side; "put your heart into it". Before long, they were inseparable, and AJ would take four-year-old Stevie with him to taverns across the mid-West where she would sing along with her grandfather and charm everyone, already quite the box-office draw. This was her first taste of success, of how she could affect an audience – not to mention make a little money: AJ would slip her 50 cents for her trouble.

The Nicks family moved to Los Angeles when Stevie was still very small, opening a Mexican-style bar where her mother would cook and the men of the family would hang out, but even after Stevie had started school the music flourished, and she was getting more and more confident, her talent radiating from her, very much in her element while singing to an audience. One of Stevie's favourite early memories was coming home from school and dropping in on the bar to find her father, her uncles and beloved grandfather in there, listening to music and singing together. "I can remember being there at about two in the afternoon," she recalled. "No one really in there... I remember singing with my granddad and feeling even at that young age that music was definitely going to be a part of my life."

AJ agreed. He knew he had a little star on his hands and decided he wanted to take his granddaughter on the road for a run of dates together. Jess and Barbara wanted to encourage Stevie too, but they weren't sure how wise it was to allow a five-year-old to go on tour and sing in bars. It was time to make a decision. Stevie's little brother Christopher had just been born and another move was on the cards – this time to Albuquerque, New Mexico – surely there was enough upheaval in their lives without their young daughter disappearing to perform like a miniature Vaudevillian for drunken strangers? The answer was 'no', an answer AJ did not wish to accept. After a huge row, he stormed out on the family, refusing to speak to them for two years. This sudden absence and bad blood broke Stevie's heart after having been so close to AJ; the first emotional storm of many to come.

Arguably, the arrival of Chris Nicks was a storm in itself, however. Stevie, the self-confessed 'little diva' was 'out of control', and her parents decided another child might bring a little balance to the family

and show Stevie she wasn't the only person in the world. It did not go down well and it would take some years for the siblings to really get on. "I hated Chris," she admits. "I would pull his hair and kick him... I'll be apologising to him for the rest of my life." As is often the way, her parents were typically far stricter with their first child than they were with their second, but as their only daughter she was still, as she once put it dreamily, "the star in my family's sky", and they encouraged her creativity and love of stories, fairytales, music and dance. Stevie collected shawls and swirled them around in her room, dancing and pretending to be Isadora Duncan, a ballet dancer whose free movement and emotional, joyous style would leave its stamp on Stevie's own way of moving. The idea of going to a strict ballet school where she couldn't express herself freely was anathema to her.

"I didn't want to study and kill myself; I knew I couldn't bluff my way through Russian ballet. So I had to figure out another way to do something wonderful without working at it." Stevie combined her passion for dance and obsession with popular music, dancing like a rock'n'roll ballerina to the Beach Boys, the Ronettes, Mahalia Jackson, spinning in front of her mirror, working out routines and 'stage shows' with the help of her little brother, whom she would pay 50 cents to dance with her. All of the elements of everything Stevie loved and would love for the rest of her life – music, performance, escapism, dressing up (maybe not so much little brothers) – were aligning.

By the time the now music-obsessed Stevie was 15 years old, in 1963, yet another relocation was due for the Nicks clan – this time, they would be heading back to Los Angeles. If Stevie ever felt a tinge of nostalgia about her old bedroom as the removal van pulled up, her mother Barbara would urge her to look to the future, not the past. "There's always a better house," she would assure her misty-eyed daughter as she eyed the floor she'd danced on and the window she gazed out of for one last time.

Stevie's bedroom was so important to her simply because she spent so much time in it; it was a sanctuary where she could read, contemplate and, most importantly, dream. Barbara and Jess were protective of their daughter, and she was kept inside far more than the average kid in the

sixties, but one advantage of this was that the fantasy world she created in her imagination would become so strong as to play a significant role in her future outlook. She believed absolutely in wishes and the power of the mind to make things happen, and would seek enchantment in the most mundane aspects of everyday life; even in the fact that she was extremely short-sighted. Without her glasses, the world was out of focus, turning a simple bare light bulb into a 'star' and treating her to 'amazing light shows' whenever she took off her spectacles. She later mused as to whether these early experiences of turning a disadvantage into something beautiful informed her mystical approach to everyday life. Trust Stevie Nicks to find magic in myopia.

School would take a little adapting to, largely because whenever Stevie started to get settled, the family had to move to another town. Being shy and having to meet new people so frequently wasn't the best combination, but Stevie had long since learned that if she wanted an easy life, she'd have to drop the anxiety – or at least hide it – and be flexible and friendly. She had to make friends quickly after all, or simply be on her own for the rest of the year until it was time to up sticks again, and these formative experiences served her well for the future. "I learned to get accepted quickly because I didn't have time to waste," she said. "To be snooty for six months until I decided to come down to earth and be a part of everything didn't work at all."

Arcadia High School, however, wasn't the easiest place to fit into; it was "hotsie-totsie, very cliquey, and lots of rich people went there". Stevie, on the other hand, was something of an oddball in comparison. Amid the trendy jocks and coiffed debutantes there was Stephanie Nicks. You couldn't miss her. "I dressed kinda crazy and I always had a big straw bag because I wanted to carry everything with me," she remembers. "If you talk to people that went to school with me, they would say, 'She was a little crazy, she loved her music and she was interesting'. I think I was very interesting to everybody."

Stevie might not have won over the popular kids in class to the extent that she was accepted into their gang, but she was confident enough in school to show off her talent for singing on a 'father–daughter' night. She and Jess, who also had a fine singing voice, chose to perform the

Roger Miller song 'King Of The Road', a song that could almost have been written about AJ. They rehearsed for a week and certainly gave an unforgettable performance, not least because Stevie got the giggles within seconds of starting to sing. "I was singing away," recalled Jess, "and Stevie was singing away, and she gets to laughing, and I get to laughing and I'll be damned if she didn't wet her pants right there on the stage!"

"I got the giggles during the first line, 'Trailer for sale or rent' and I was just hysterical," said Stevie. "He [gave] me this look, like, 'How could you do this to me?'" Wetting yourself onstage in front of your classmates... this actually would have been a great time to change schools, but no, Stevie would remain at Arcadia for another academic year, and it would be a year in which several important things would happen to Stevie:

1) *She would join her first band, The Changing Times – a vocal harmony group similar in style to the Mamas and the Papas, very much tuning in to the West Coast sound.*
2) *Shortly before her 16th birthday, a beehived Stevie was granted permission to take guitar lessons.*
3) *She would write her first song.*

Barbara and Jess weren't sure whether their daughter's fervent wish for a guitar was just a whim, so they paid for six weeks of lessons with a Spanish classical guitarist who rented a guitar to them for her to learn on. Stevie took lessons twice a week and by the time the course was up, it was clear to Stevie's parents that this was no passing fad. Because her teacher had plans to go to Spain to study, he agreed to sell the small classical Goya guitar Stevie had been learning on to Barbara and Jess, and they planned to present it to her on her birthday. Stevie adored it (she still has it to this day) and immediately sat down and started to compose a song. It was already bursting out of her: a ballad about a teenage love that had gone unrequited. Perfect inspiration for a first song, and as she turned 16 years old, it was like a rite of passage. The song was, as Stevie admits, "pretty goofy, but it had a chorus and two verses and it had an end. From that second onwards, I knew I wanted to be a songwriter."

The song was titled 'I've Loved And I've Lost, And I'm Sad But Not Blue' – meaning that she'd accepted that the boy she adored had rejected her affections and decided to go out with her friend instead. History would sadly repeat itself 15 years later, and, again, the heartbreak would lead to a poem that would lead to a song. Painful as it could often be, these upsetting times were – in the words of the poet Robert Graves – 'compost', and some beautiful blooms would burst forth as a result.

Stevie always wrote poetry; she was rarely seen without a pen in her hand, but this would be the first time she put her words to music. The boy she was writing about (who would no doubt be regretting his rejection of her a few years down the line) was "an incredible guy, and he ended up going out with my best friend. They both knew I was going to be crushed," she said.* The lyrics to Stevie's first song went thus: 'I've loved and I've lost, and I'm sad but not blue / I once loved a boy who was wonderful and true / But he loved another before he loved me / and I knew he still wanted her – 'twas easy to see.' "The words were incredibly trite," Stevie later said. "But I was so in love so it was totally stupid." By the time she had finished writing the song, Stevie was in floods of tears.

At least Stevie could admit that the tune was 'pretty', and she was instantly sold on how cathartic the songwriting process was, and how you could end up with something so rewarding despite feeling so down. Emboldened by the encouragement of her best friend Robin Snyder who praised its potential, Stevie would even perform the song in high school assembly, and from this point forth she was never seen without her guitar. It was decided. Stevie Nicks was going to be a songwriter, and so began an obsession that has lasted for five decades.

This early period was what gave her a "definite glimpse", as Stevie worded it, of things to come. She believed in her songwriting, which was crucial because she felt that not many other people did. But as long as she was happy, and Robin was by her side to spur her on, she knew

* A boy by the name of Dave Young, a quarterback on the school football team, was apparently Stevie's first 'proper' boyfriend, although pictures exist of him taking Stevie to senior prom, so no doubt this plaintive ballad is not about him.

she was developing a skill that would be hugely important to her. After all, she had no intention of working in an office, the idea of getting up at 8.30am to drive to a desk-bound job and a regular wage was repellent to her and she 'knew instinctively' that 'as a pretty little girl' with creative talent and obvious charisma, nine-to-five life was not going to work for her. Just a few years down the line she worked at a dental hygienist's clinic. She lasted three days and 'wanted to die'. 'I've Loved And I've Lost' was a glowing sign-post to the future.

Barbara and Jess were sympathetic to their daughter's ambition and commitment to her art – they knew there were worse things for a teenage girl to get up to – and if they could hear chords being strummed and the sound of that honeyed vibrato floating out of her bedroom, they never knocked on her door. They even let her miss dinner if she hadn't finished writing. If it meant that much to her, then it meant just as much to them, and they respected her dedication. "They could hear that I was working, at 16 years old, and would leave me alone," she said. But it wasn't just the writing that lit her up; Stevie was a natural performer and she wanted to share her songs with whoever would listen, which meant more performances at school assembly, appearances with folk groups, after-school clubs... any opportunity she could find to sing, she grabbed it. She'd found her vocation. "It's what I came here to do."

"There she goes," Barbara would note with understandable concern as she contemplated her daughter's future. "Down the same path as her grandfather." But Stevie's fate and that of AJ Nicks would be dramatically different.

Chapter 2

Three changes that happen to Stevie in this chapter:

1) She dyes her hair ivory blonde.
2) She meets Lindsey Buckingham.
3) She joins his band.

Life will never be the same again.

Another move was on the horizon, and where the family were going would offer Stevie plenty of opportunity to sing and perform amid kindred spirits. Jess Nicks' work would soon take them to San Mateo, California, where Stevie would attend the Menlo-Atherton High School in 1966. She was, as Mick Fleetwood put it, 'an instant hit', being voted runner up for Homecoming Queen in her first year there. Songwriting and poetry had balanced her, giving her confidence, expressiveness and poise, which marked her out amidst many of her more awkward teenage contemporaries. Add to that her beauty, balletic physical grace, easy charm and an inner core of determination, and there was nothing she couldn't achieve. She was altering her look too; a move that would create a seismic shift in the way she saw herself. Gradually, Stevie Nicks was honing herself into a mini rock'n'roll star: "I had my hair streaked at the

end of my tenth-grade year and got in a lot of trouble for it," she said. "They didn't just streak it blond... they streaked it silver. My hair was totally ivory. I was grounded for six weeks. But when my hair changed, everything changed. There was no way I was going back."

Apart from the shock hair-streaking incident, Stevie was generally still a 'good girl' at this point. She rarely troubled her parents (occasional strops notwithstanding – her pouting was legendary), she took her ambition seriously and still rarely went out. However, there was one weekly event she would attend just to get out of the house: a 'Young Life' church meeting for students. "Nobody went for church," Stevie admits. It was just something to do, an outlet for kids who liked to sing and play music and meet up on an otherwise dead Wednesday night. It was at one of these low key parties that someone caught Stevie's eye; a 'stunning' teenage boy with curly hair and intense blue eyes wandered in with his guitar, sat down and started to play 'California Dreaming'.

Stevie, immediately attracted to him, nonchalantly sidled over and joined in, singing the Michelle Phillips harmonies that she knew so well. "He was, I guess, ever so slightly impressed," recalled Stevie. The boy was playing it cool, but "he did sing another song with me, which let me know he did like it." The pair wouldn't see each other again for some time, but a connection had been made. The young guitarist with the emotive singing voice was called Lindsey Buckingham, and Stevie had fallen just a little bit in love with him.

Lindsey Buckingham, a year below Stevie at school, was a born Californian, growing up in the moneyed Bay-area community of Atherton. The youngest of three sporty brothers, Lindsey found his heart lay in music as opposed to athletics early on in life, playing along to his brother Jeff's Chuck Berry, Elvis Presley and Everly Brothers records on a toy Mickey Mouse guitar. It wouldn't be long until Lindsey was given a proper guitar by his parents, who had noticed his early talent. He never took a lesson, however; the fiercely independent young Lindsey preferred to teach himself by feel and by ear. Lindsey loved folk music and the finger-picking style used on the banjo, aping the playing of The Kingston Trio, a folk group local to Palo Alto, near where he lived. By the time he'd reached his mid-teens, Lindsey Buckingham was ready to join a band.

His first group at school was the Fritz Rabyne Memorial Band, named after a pupil at Menlo-Atherton as a joke – whether the real Fritz Rabyne, a diffident German boy still very much alive at the time, took this as a compliment will remain a mystery, but his chronic shyness and the sudden popularity of his name was not a good combination. "He moved away and we never heard from him again," said Fritz founder Javier Pacheco. "We hardly knew him to begin with!"

The band, eventually just known as 'Fritz', formed in the autumn of 1966 and started out with a line-up that included Jody Moreing on vocals, her cousin Calvin Roper on guitar, Bob Aguirre on drums, Javier Pacheco on keys and Lindsey himself on bass, rather than guitar. He would later explain that this was because he simply didn't take to playing the then 'fashionable heavy rock style' on guitar.

Pacheco took care of most of the songwriting duties and Fritz practiced regularly at Lindsey's house in Atherton. The band had potential, and when Moreing, later a successful singer-songwriter, and Roper had to go to college, an opportunity arose to inject some new blood into the line-up. On guitar, Fritz recruited a musician called Brian Kane, and when it came to finding a replacement vocalist, the band tried out several new female singers, but nothing gelled. Lindsey, perhaps unsurprisingly, remembered the pretty girl who stepped up to sing with him over a year earlier and suggested they give her a call. Bob Aguirre found Stevie's number and invited her for a try-out. Although not everyone in the band was convinced according to Aguirre (presumably referring to Javier Pacheco), "I knew right away. It worked." With Stevie, Fritz now not only had a new singer, but they had someone who could contribute new songs as well, hers having more of a country feel. Perhaps this is one of the reasons why there was some friction between Javier, who provided many of the songs, and Stevie. Even so, no one could deny that Stevie had something special about her that spelled success, and that was as threatening as it was promising. Stevie, on the other hand, would later admit that she "really had no idea what I was getting into when I said I would join Fritz." Still, it would provide the ideal training ground.

Fritz's first gig with Stevie was at the Quad at Stanford University. "A big deal," Aguirre told Fleetwood Mac fans in a Q&A in recent

years. "Stevie did a version of Linda Ronstadt's 'Different Drum' that brought the house down... we had to do it again by popular demand. The writing was on the wall."

Some reports claim Stevie joined Fritz in 1968, but according to Javier Pacheco, the new members arrived in the late summer of 1967. And, as Stevie Nicks recalls, "within two or three months we were opening for Hendrix, Janis Joplin, all the San Francisco bands." The chemistry was right, her voice and look was ideal and audiences loved her. Fritz was now no longer a school band, but one of the hottest groups in the Bay-area music scene and they had high hopes, rehearsing at least four times a week and putting huge energy into their shows. Stevie was already displaying a talent for theatricality, 'acting' out her songs and mesmerising the audiences with her performances. This didn't always go down well with the rest of the band, however.

Pacheco recalled that Stevie's emotional interpretations were certainly memorable, but to him, it simply seemed like a 'big put on', particularly when they performed the Buffy Sainte Marie song 'Codeine'. "Stevie doubled up and acted out withdrawal pains while she sang it," he remembers. "I used to complain about it... That was her showbiz side. But Stevie persisted and this always got noticed. People were moved by it. But she could also stir you with a simple country song as well."

Pacheco admits that, back when Stevie first joined the group and was finding her feet, he thought she was a shrinking violet who "couldn't cut it. As it became clear that she would be staying in the band, I became resigned to working around her vocal strengths and weaknesses," he later stated, with no small measure of snark. But as 'resigned' as he was, he would also tease her mercilessly. "Stevie became the victim, and I was the big bad wolf," he recalled. "I was critical of Stevie, but her songs did move me, [and] her first Fritz songs have stayed with me."

At around the same time as Stevie was doing her best to put up with the indignities to which Javier Pacheco was subjecting her, on the other side of the Atlantic, 5,437 miles away in London, a British blues band with the unusual name of Fleetwood Mac was being formed by guitar prodigy Peter Green. Like the already deified Eric Clapton, Green was

an acclaimed alumnus of John Mayall's Bluesbreakers, and he chose the name for his new band by blending the surname of the drummer, Mick Fleetwood, with that of the bass player, John McVie, both of whom were also former Bluesbreakers. Much was expected from this new line-up but only the boldest of clairvoyants could have looked into their crystal ball and predicted a future alliance between Fleetwood Mac and Fritz.

Sometimes, when being the only girl in a group of musos started to grate, Stevie would wonder why she stayed in Fritz. But in the years to come, she would look back and realise it was all unfolding exactly as it should have done. "It was preparation for Fleetwood Mac," she said. She also laid down her ground rules early: she was the singer. She was also a lady. There would be no heavy lifting, no helping out with carrying gear and no unloading the van. "I wanted to be a lead singer. I didn't want to carry a 21 lb Les Paul," she said.

Stevie's parents were anxious that Stevie should back herself up with some employable skills – she was a smart young woman and could turn her hand to so many things – and while Barbara and Jess loved that Fritz was going well and were always supportive of Stevie's dreams, they wanted to see her get her education too. "My mom said, 'I totally believe you're going to be a singer and a famous songwriter. But just in case, I need you to take typing and I need you to take shorthand. And if you go to college, we'll pay for everything.' And I went. I think that you should get the best education you can, and then if you want to go off and be a total entrepreneur space cadet, that's fine. But if you are called upon to take care of somebody or keep something together, you gotta have studied something." Stevie would also study Speech Communication at San Jose State University. Lindsey would join her the following year, majoring in art.

Unlike Moreing, Stevie stayed with the band when college came calling; if she had to commute every week to gigs and rehearsals, so be it. Admittedly, she couldn't commit to as many practices as before, and this would irk some of her bandmates who practiced for hours every day, but had to put up with enquiries about the band "with the little brownish-blondish haired girl..."

"Those guys didn't take me seriously at all. I was just a girl singer and they hated the fact I got a lot of the credit," remembered Stevie, who believed they didn't like her because she grabbed the spotlight. Actually, considering interviews given by her then bandmates in later years, it sounded like they were all rather attracted to her, but she was off limits or they behaved clumsily, and the 'look but don't touch' vibe ramped up the tension. "I think there was always something between me and Lindsey," Stevie told *Rolling Stone*, "but nobody in that band wanted me as their girlfriend because I was too ambitious for them. But they didn't want anybody else to have me either. If anyone else in the band started spending time with me, the other three would literally pick that person apart."

Part of the problem, as far as Javier was concerned, was the obvious connection between Stevie and Lindsey. Nothing was technically 'going on' between them at this point, but there was a serious frisson between them, and this split the band down the middle.

Bob Aguirre took Stevie out on a few dates early on, and, for all of Pacheco's gruff dismissals of Ms Nicks, he admits they could have been "more than friends" if it wasn't for his "silly machismo and arrogance... [I] missed my chance to get closer," he told fans in a frank online Q&A. "The main thing I regret is [that] Stevie and I did not become better friends, but just the opposite. She was 'on guard' with me." Boys, let this be a lesson to you – you may tease because you love, but pigtail-pulling rarely goes down well.*

The repeated commute up and down the peninsula for shows might have been a little time-consuming for the student Stevie, but it was worth it – speech communication was all very well, but Fritz's star was rising and they had become the go-to band for San Francisco support slots for all of the major names at all of the most prestigious venues. "We

* On the other hand, it does sound like there was also a tinge of cultural warfare between Pacheco and middle-class, comfortable Nicks. Pacheco observed that it probably wouldn't have worked out between them, what with her apparently having little experience of interacting with Mexican people beyond her family's 'maids and gardeners'.

played the Fillmore, Winterland, the Avalon, simply everywhere," said Stevie.

Fritz had the chance to watch and learn from headline acts such as Santana, Jimi Hendrix, Janis Joplin, Creedence Clearwater Revival, Jefferson Airplane and many other enduring rock icons, working their magic on stage as Stevie and her bandmates stood, transfixed, in the wings. One of her most treasured memories is the time that, during a Hendrix show, the guitarist himself looked over and declared, "I'm dedicating a song to that girl over there." "That was a moment of greatness," remembers Stevie proudly.

Jefferson Airplane singer Grace Slick made an impression on Stevie too, not least her powerful voice and 'slinkiness', which Stevie made a note of, learning from the best. This was the real education, never mind classes at San Jose State. And if this was the case, surely Stevie's greatest teacher at this point must have been Janis Joplin. When Fritz supported Big Brother & the Holding Company, Stevie was gripped by Joplin's performance, and how a 'plain', small and down to earth woman could suddenly go on stage and become a transcendent figure of such emotion and power.

"You couldn't have pried me away with a million dollar cheque," said Stevie. "I was glued to her. I said, 'If ever I am a performer of any value, I want to be able to create the same feeling that is going on between her and her audience'. Janis was tough but sang like a bird and could really hold that audience in her hand." This holy trinity of rock archangels – Grace, Janis and Jimi – taught Stevie the three qualities she would swiftly develop and prize within herself: sex appeal, attitude and humility.

Stevie might have adored Janis, but she didn't want to copy her completely, not least because Joplin's earthy character off stage was quite different to super-feminine Stevie's. Javier recalls Fritz sharing some of Joplin's Southern Comfort in the dressing room, and while they appreciated the headliner's gesture, they were somewhat shocked by Joplin's tough demeanour. "She could be very crude and unladylike, just like one of the guys," said Pacheco. "I don't think Stevie decided she wanted to be just like Janis after that initial meeting." Still, her cracked

charisma and emotional performances made their mark and would be added to the mix of qualities Stevie was mentally collecting and absorbing in order to make herself even more of a potent onstage presence.

It wouldn't just be the stars themselves that Stevie was observing, but some of the more stylish members of the audience. One woman in the crowd caught Stevie's attention during Joplin's set. "I saw this girl in the audience wearing a mauvy pink chiffon skirt and very high cream suede boots," recalled Stevie. "Her hair was kind of Gibson Girl – she had some pink ribbons – and I thought that's it." The woman was swathed in layers, a combination of bouffant Victorian beauty, free-flowing gypsy chic and elegantly ragged street urchin style. Stevie didn't mind admitting that she 'wanted to be her', and she would hold these images in her mind, looking out for items that fitted the image she wanted to create in markets and antique stores. One day she would have the opportunity to have exactly that look designed for her, but in the meantime, she would have to put up with off-the-peg threads. That didn't mean she couldn't look like a legend, however.

Stevie had done her homework; she knew that Janis and Grace bought their clothes at the hip Velvet Underground boutique in San Francisco and so, with her Goya guitar slung over one shoulder, Stevie would stride through the streets on a Saturday afternoon and kit herself out right there, just like her heroines. Bell bottoms, tunics, evening gowns, beautiful fabrics... the boutique was only small but it had everything Stevie needed to transform herself and, with money she'd saved from a job working part-time in a clothes store, she would "really splurge... I would carry my guitar in these clothes, and I would walk like a rock star – there was something about my posture and the ballet I had taken and I would be swathing through crowds of people thinking 'Do you know who I am?'" she laughs. "And I really believed it. It's like that thing, build it and they will come.* I was thinking, 'I am going to be a big star. Soon.' I believed you could plant the seed in people's heads." Long gone were the days of ingenue Stevie. She was rebranding herself

* A reference to the line: 'If you build it they will come' from the 1989 movie *Field of Dreams*.

18

into a rock goddess; it was just a matter of time until the rest of the world caught up and commenced worship.

Thanks to the plum support slots Fritz were playing in San Francisco, it wasn't long until Fritz themselves were attracting attention from managers and agents who could see their considerable potential. It wasn't just Stevie and Lindsey who were ambitious; the whole group were keen to make it, and they were soon signed by a new manager, David Forest. Forest was as dogged as they were – he went from fronting his own business to working with Creative Management Associates in LA, and he worked hard to try to secure a record deal for the band. However, the road to rock'n'roll stardom rarely runs smoothly, and while Stevie and Lindsey understood Los Angeles was the place to be, the rest of the band didn't take to it, preferring 'groovy San Francisco' to the 'plastic' City of Angels. The strain was starting to show, and the different agendas within Fritz were becoming harder to reconcile. Lindsey no longer wanted to play bass, Brian would rather have been playing the blues and, as Javier later revealed, "We were being manipulated by outside forces." He felt Forest had 'dragged' the band to LA because he was working there "and wanted to continue to control and/or profit from the group. Dave hid from us the fact that Bill Graham had shown interest in managing the group, so Forest made us believe that LA was our only viable option."

But this was not the only thing that would precipitate the break-up of Fritz after five years of hard work and 'musical apprenticeship', and draw two-fifths of the band to Los Angeles. The agent Todd Shipman was "trying to get traction for this band", remembers the producer Keith Olsen, then a starving engineer in Los Angeles. "[Shipman] started calling all the A-level producers asking if they'd be interested in going up and seeing them live in San Jose. When everyone turned him down, he went to the B-level producers – you see where this story is going – and nobody wanted to go. So he went to the C-level and, well, *they* didn't want to go. So he went to the D-list, which had my name on it.

"I said, 'Sure, free trip to San Jose!' Little did I know they were going to pick me up in the band van which had no seats. I got to sit with the drums in the back, and I got to help set up... I was young, I didn't care. But I saw the band that night and I thought, 'There's something

special here...' Lindsey and Stevie, when they sang together, they had this colour... Those voices were meant to sing together."

Keith felt instinctively that Stevie and Lindsey didn't need the rest of the band to succeed. However, he invited Fritz to come to Van Nuys in Los Angeles to cut a demo with him at the now legendary (but somewhat grubby) Sound City studio on Cabrito Road one quiet Sunday morning. It was a thrill to be asked, and, once they'd arrived at the innocuous-looking studio, the band's trepidation intensified thanks to a small hitch: the locks had been changed since Keith had last recorded there. All was not lost. Keith was nothing if not determined. "We broke into the studio by taking off the door. We came in, left the door on one side and recorded." Fair enough.

It was their first time in a proper studio and the resulting demo, naturally, was flawed but still strong. However, as Olsen listened to the track after the session, he realised that he loved it but... "something wasn't right. The band... there were too many weaknesses. I hate thinking about it or even talking about it now because they were such friends, but I said to Lindsey and Stevie, 'I'd love to continue to work with you but I think you would do better as a duo.' And, of course, that meant horrific consequences. These were the people they'd played with and I was suggesting that they break up the band; an awful thing to do, but that's reality sometimes. I was straightforward and honest and they said, 'Yeah, we'll think about it', and drove off."

Keith's conscience can rest easy – this wasn't the sole reason for the eventual split in 1971. The band was arguing more than ever and wanted to pursue different avenues, although this tempting glimpse of a possible future for Stevie and Lindsey would no doubt have been the tipping point. All you had to do was listen to the lyrics of Stevie's songs from just before that time to get a clear picture of how things were changing. Javier Pacheco remembers one of Stevie's songs was "right on the mark. The lyrics go: 'There's a deep sense of a funny kind of love...' Like a marriage after it has broken up. She was speaking of the coming downfall of Fritz. See, we were writing love and break-up songs to each other way back in 1970. This didn't just start with the Mac."

Chapter 3

S tevie and Lindsey might have told Keith they would discuss what he'd suggested, but there was little to think about; this was their dream becoming manifest, and Fritz was already starting to disintegrate. But Keith had not only set the Buckingham Nicks wheels in motion musically: it appears he inadvertently helped push their romance along as well. Stevie and Lindsey had retreated to the ramshackle but rock'n'roll orientated Tropicana Motel on Sunset Strip after Fritz's session at Sound City to talk over the possibilities, but talking would soon develop into something else.

"Why it happened between me and Lindsey was because we were so sad that we had to tell the three guys in the band that nobody wanted them, only us," Stevie explained in an interview with *Rolling Stone*'s Fred Shruers. "It just happened."

Much to Stevie's parents' chagrin, she and her collaborator-turned-boyfriend were making plans to quit college and live together permanently in LA, with a view to pursuing what so many had pursued before them. The idea of Stevie leaving her precious education behind was bad enough as far as her parents were concerned, but her decision to shack up with a boyfriend who was a musician was almost too much for them to take. And she used to be such a good girl...

The pair were almost ready to relocate when a bombshell hit. Lindsey's health had become poor, but he'd attempted to work through it. However, what first seemed like a dose of simple influenza turned out to be a bad case of mononucleosis (glandular fever), a painful and debilitating disease that leaves the sufferer no option but to lie flat and do nothing. Lindsey's main plan now was to recover in bed at his parents' house while trying not to die of boredom. This was a particular problem for Lindsey – he was fiercely creative but wouldn't have the energy to even lift his head for three long months. There were also just five TV stations to choose from.

Stevie, who often stayed over in the Buckinghams' living room, did her utmost to keep Lindsey entertained, bringing him food, playing records, telling him stories and trying to keep his spirits up. This experience of having to care for Lindsey as their relationship was still in its early stages bonded them even more. She "didn't mother him," recalls Keith Olsen, who remembers this frustrating period for Lindsey (and is especially sympathetic having suffered from mono himself). "She just poured her love out to him. It was such a love commitment." Music-wise, Lindsey insisted they should listen to the Everly Brothers, the Kingston Trio and the Beatles to study 'form' – Stevie would rather have listened to Aretha Franklin, Diana Ross and Joni Mitchell instead (Mitchell's 1970 album *Ladies Of The Canyon* being a particular influence on Nicks) but she followed Lindsey's determined guidance, until she 'burned out', at least.

One day Lindsey, still horizontal, asked Stevie to pass him his guitar. It was at this point that a change occurred that would inform how he played forever. "He didn't have enough strength to strum," explains Keith. "He only had enough strength to use his fingers. Now think about the way he plays guitar – it's all because of mono. He became this incredible super player who had a style all his own because of his illness. It was kind of a semi-flamenco finger-pick style but he's using the backs of his fingers really fast. He was able to figure out his soloing style because of that." Lindsey had always loved the finger-picking styles of bluegrass guitarists and banjo players in his youth, and this, combined with his often frenzied self-taught technique, helped him create a new sound altogether which would provide contrast to Stevie's mellifluous

voice as she harmonised with his more urgent, plaintive tenor. Lindsey had never provided any songs for Fritz, but something had unlocked. To Stevie's great relief, Lindsey's health slowly started to improve, and her love and support would be rewarded with the creation of a new song titled 'Stephanie', a pretty, romantic instrumental. Another song he wrote during this enervating period was far darker in mood. 'I'm So Afraid', later a hit single for Fleetwood Mac, is not just an angry, hopeless depiction of how Lindsey must have been feeling physically, but is a stark window into his fearful, neurotic psyche. 'I'll never change, I never will/ I'm so afraid of the way I feel...'

Lows were balanced by highs, and as Lindsey's strength picked up, so did their luck: Lindsey had recently been left a generous inheritance by an aunt he had never actually known, and as soon as he was able he used the money to buy an Ampex four-track tape recorder 'the size of a washing machine'. His father, Morris Buckingham, owned a coffee plant near the Cow Palace in Palo Alto, and he allowed Stevie and Lindsey to practice in the warehouse once the workers had gone home for the night.

The pair would write and work in that 'creepy' room from 9pm until dawn almost every night. "It was so scary that we locked ourselves in the room and didn't go out because it was a big warehouse," remembers Stevie. "If we heard things, we would just stay in there and keep the door locked."

Spookiness aside, the acoustics were good and it was here that Lindsey not only taught himself to use the machine and get just the sound he wanted, but the duo would record their first demos as Buckingham Nicks, with a mind to return to LA and secure a record deal. 'Frozen Love' was one of the many songs written during this creative time and, as Mick Fleetwood later observed, it is thanks to this period of hothousing that Lindsey developed his meticulous producer's mindset that he would become noted for in later years. Soon, all of those nights working in Mo Buckingham's cavernous coffee plant would pay off. With a clutch of finished demos, Stevie and Lindsey slung the four-track in the back of their rickety car, headed back to LA and knocked on Keith Olsen's door.

"Lindsey set it up in my house and said, 'Listen to this.' I was so blown away. Oh my God. I took those demos and I started to go around to sell them," says Keith. Stevie and Lindsey's voices were perfect together, Olsen already knew that; but they also had the songs that would take them to the next level. Gold dust.

Lindsey and Stevie signed up with Keith's company Pogologo Productions and agreed to split everything down the middle. "It was the good old days," adds Keith. Buckingham Nicks obviously had an album's worth of beautiful, unusual songs in them, the only obstacle was lack of budget. This wouldn't be a problem for long. While shopping the tracks around, Keith had approached David Shackler, former head of A&R at major label Polydor. Shackler was instantly smitten by Stevie and Lindsey's demos. He would, in turn, sign Buckingham Nicks to Anthem Records, a subsidiary of Polydor. The mission was on.

Stevie and Lindsey moved in with Keith Olsen in his 'little house on the hill' in Van Nuys as a temporary measure while they found their feet in LA and looked for their own place. Olsen generously even allowed them to borrow his prized new Corvette when their own car conked out yet again. This was a decision he would regret, to say the least. He can laugh about it now but...

"I was going away to New York to mix a James Gang show in Central Park. I had this little Corvette, it had maybe 350 miles on it, it was a stick shift and I had to drive down to get the guitarist Domenic Troiano. We all met back in the Valley." Keith got out of his car to wait with the rest of the band for the limousine to take them to the airport, only to see Stevie emerging from the house 'in her robe and furry slippers, hair in a towel.' She evidently needed to use the car. Stevie had never driven a stick shift before, but that didn't stop her. Keith and the James Gang looked on with interest as she attempted to make her way down the drive.

"She finally gets it going but it's making all these noises," recalls Keith. "Roy [Kenner], the singer of the James Gang, looks at me and says, 'You'll never see that car again.' I said, 'Oh no, she'll get the hang of it, she'll make it.'" And she did. The car wouldn't, however. By the time Keith and the James Gang reached New York, disaster had struck. Entering his hotel room, Keith was alarmed to see a light flashing on his

telephone, a message already waiting for him: "It's Lindsey. Call your house. It's *kind of* an emergency."

"I dial my house, and Lindsey picks up," continues Keith. "The first thing I say is 'Is everybody ok?' and he said, 'Yeah... But your car is in your neighbour's bedroom.' We're up quite a high hillside. Stevie had pulled the emergency brake and just left it in neutral, went click and got out of the car. It started to roll and about 40 minutes later there was a guy knocking on the door. 'Do you own a gold coloured car?' Stevie says, 'Well, sort of.' He said, 'It's in my bedroom.' It actually went off the cliff, rolled and went through his bedroom ceiling. It was the most unbelievable thing."

Olsen was clearly an understanding, supportive presence in their lives, but it was perhaps wise that Stevie and Lindsey were looking to move out, particularly as they would soon be in the studio together every day. Through Keith, the couple met Richard Dashut, a dark-haired, bearded maverick with a passion for British blues bands such as Fleetwood Mac, the Yardbirds and the Bluesbreakers, and a mischievous look in his eye. He'd started working at Sound City as a caretaker but within a week he was working with Olsen as an assistant engineer. Stevie and Lindsey got on well with him, and they were soon renting a place together in North Hollywood near Universal Studios. Through Dashut, Stevie would meet the musician Tom Moncrieff who would also stay with them from time to time, and remain a longtime collaborator of Stevie's for years to come.

And talking of Fleetwood Mac, after a promising start things had gone badly awry for the British blues band formed in 1967 by guitarist Peter Green. Though fundamentally unstable, they'd hit big with the beautiful instrumental 'Albatross', a UK number one in 1968, and two number twos, the ethereal 'Man Of The World' in 1969 and the riff-driven 'Oh Well' a year later. More to the point Green had emerged as a guitar great, his subtle textures and light touch contrasting sharply with the more exuberant styles of contemporaries like Clapton, Jeff Beck and Jimmy Page. Then, just as it seemed as if the Mac would join the superstar league, Green quit in circumstances that have never been fully explained, evidently disillusioned

by success, allergic to money and seeking a higher purpose in life. Some said he'd been reduced to begging on the streets of Richmond. A further blow occurred in 1971 when slide guitarist Jeremy Spencer abruptly upped sticks in LA during a US tour, electing to join a sinister religious sect known as the 'Children of God', another eerie development that brought forth credible suggestions that the group might be cursed. Bassist John McVie recruited his wife Christine, nee Perfect, to shore up the ranks but in the early seventies the ship was listing badly, a succession of singers and guitarists failing to refloat the group that rhythm section Fleetwood and Mac struggled to keep on course. Worse was to come.

Despite sharing the apartment, money was tight and Stevie had to pick up waitressing work to cover the rent while Lindsey stayed at home, practicing guitar and writing. This might seem a little unfair, but Stevie has always insisted she was largely happy with the arrangement. She was 'devoted to making it happen for him'. Plus Stevie felt secure in her own ambition; she had her '$50,000' education, she knew she'd be all right, and she could see the bigger picture. It was going to take all of her strength and grit to get them where they needed to be but someone had to do it, and other than a spot of dodgy telesales, Lindsey wasn't up for casual work. He and Richard would bounce cheques at coffee shops and spend a lot of time smoking strong 'opiated hash' with the singer-songwriter Warren 'Werewolves Of London' Zevon, who often dropped by. Still, the energy Lindsey put into developing their songs made it worthwhile, and they were both utterly determined; it was, as Stevie put it, 'our whole reason for getting out of bed.' The scenes at home were tense, however, and it was no wonder so much dope was smoked – albeit not by Stevie at this point. She was more interested in preserving her voice.

"I believed Lindsey shouldn't have to work," Stevie insisted in an interview with *Spin* in 2007. "I believed he should just practice guitar and become more brilliant every day. And as I watched him become more brilliant every day, I felt very gratified. I never worried about not being successful; I wanted to make it possible for him to be successful. When you feel that way about somebody, it's easy to take your own personality and quiet it down. I knew my career was going to work out

fine. I knew I wasn't going to lose myself." Occasionally Stevie would feel less generous on this subject, however, admitting to *Harpers Bazaar* with a twinkle in her eye that "Lindsey thought it would be selling out for him to work at a restaurant, so I did."

Stevie, writing in any scraps of spare time she could find, was working as a hostess at Bob's Big Boy burger bar – "I wasn't a waitress, I wasn't good enough!" – and using her charm to ease the way with difficult customers and earn good tips. The experience would stay with her and Stevie has subsequently always made an effort to be kind to waiting staff; she knows what they're going through, after all. "Whenever I'm helped in a restaurant these days I remember it," Stevie later said. "I'm glad, because I wouldn't like to have been in this roundabout if that made me forget the things that are truly of value."

Stevie also understood that she needed that time out at work every day to 'be independent' and maintain some kind of a routine. "When you're a tragic, starving artist, if you hang out at home you just get more tragic, so to go to that job for six hours a day was good. I said, 'You can sit around thinking about being famous, but somebody's gotta pay the rent, and it's obviously not gonna be you!'"

With hindsight, knowing that Lindsey would later complain about Stevie's relative lack of musicianship, and how much work he'd have to do to bring her songs to a standard he was happy with, it's hard not to consider how things would have turned out had Lindsey been the breadwinner while Stevie stayed at home and concentrated on developing her craft instead. Another vital female rock icon, Patti Smith, had a similar experience during her early 'starving artist' years in New York City while living with the artist Robert Mapplethorpe. Patti worked tirelessly to keep a roof over their heads while Robert stayed in his cocoon and developed his art. What about her art? Either way, Lindsey and Stevie were a team in every sense and, as Lindsey later said, not a little dismissively, "Whatever her music was, I was always this soul mate who knew exactly what to do with it."

The relationship between Nicks and Buckingham consisted of equal parts fierce devotion and an even fiercer creative rivalry, qualities that make their onstage presence completely compelling to this day. Decades

after they split, it seems the world is still rooting for Buckingham and Nicks, even though it's a love that can never be. It is surely rock's greatest and most difficult romance. At this point, however, Stevie and Lindsey couldn't have imagined that the world would be obsessed with their tumultuous relationship in years to come. They were just trying to get by, write enough material for the album and stay in love.

But the course was set, Sound City was happy to have them, and the record deal had been confirmed. An advance was paid by the label to cover studio time and living costs for everyone involved and finally they were having 'a taste of the big time', as Stevie put it.

Richard Dashut wasn't the only friend of Keith Olsen's that would help Buckingham Nicks make their debut album something special; Tom Moncrieff would be very much on board, initially on guitar and later on bass, as would a guitarist called Waddy Wachtel, with whom Olsen had worked since the late sixties, and who subsequently secured a deal with Polydor subsidiary Anthem himself. Keith was keen to bring Waddy ("another of those super-players who is so creative", as Keith describes him) and Buckingham Nicks together, as he knew his playing would suit their songs. They hit it off immediately – Waddy bonded with Stevie over Dolly Parton, and Lindsey over smoking weed. With fellow Pogologo signing Jorge Calderon on percussion, the Buckingham Nicks family was complete and they were ready to record.

The recording of *Buckingham Nicks* in the grimy but thrilling environs of Sound City made it all worth it; the musicians loved spending time together and they knew they were creating something beautiful. The opportunity for Stevie and Lindsey to play with musicians like Tom, Jorge and Waddy was also something they didn't take for granted. Plus they were making history – the legendary console at Sound City (now owned by Dave Grohl) was 'the first big giant Neve console in America', says Keith. "I demanded that we buy this console, because I owned a piece of Sound City at that time. The first day we plugged it in and turned it on, I cut 'Crying In The Night' with Buckingham Nicks. Very first thing recorded on there."

The album was scheduled for release in September 1973, with the track 'Don't Let Me Down Again' confirmed as the first single from

the record. The album would be dedicated to Stevie's grandfather AJ, although the cover wouldn't exactly be grandpa-friendly.

Knowing that the photo-shoot was looming, Stevie splashed out her last $111 on a beautiful, 'very sexy' white blouse to wear for the cover. It wouldn't be necessary, however. Waddy had suggested his brother Jimmy, now an art director, should be one of the photographers for the album artwork, and it was agreed Stevie could wear the blouse she was so proud of for some of the shots. Stevie felt she would 'win', that they'd love the blouse and how stunning she looked in it; pure angelic hippy chic. However, halfway through the session, "one of the photographers came over and said, 'OK, it's time to take off the blouse.'"

The plan was that the cover should feature a bare-chested Buckingham and Nicks in moody black and white. Stevie hated the idea, and apparently wept while the shots were being taken. These nude pictures represented "the most terrifying moment of my entire life," she later said, and Lindsey was not interested in her trepidation, reprimanding her for being childish and unreasonable. But from this point, Stevie promised herself she would never let herself be compromised again. Instead, she would be sexy as hell 'under 18 pounds of chiffon and velvet' and always retain her mystique.

Stevie's family were mortified by the cover when they saw it. "It was a big shock, let me tell you," Stevie's mother Barbara told *The Arizona Republic*. "I just told her, 'We're going to have to think about this before we show it to dad'. Stevie didn't want him to see it at all. But she was young then, and it's something she was talked into." AJ Nicks apparently wasn't too impressed with the album, according to Stevie, although, again, perhaps seeing his granddaughter ostensibly naked on the cover of a record might have been a little too much to take. Stevie, rather, believed there was more than an element of bitterness when it came to how AJ Nicks felt about little Stevie's big moment, and a sense of regret of what might have been had his own life as a musician taken a different turn.

To add insult to injury, the album was ultimately unsuccessful (except, curiously, in Birmingham, Alabama, where the disc apparently received a healthy amount of radio play). It failed to go gold, Polydor lost interest

and Buckingham Nicks were swiftly dropped. Stevie and Lindsey were devastated.

"It was hard when you practice that hard and you sound that good and everybody tells you that you should be doing something else," Stevie told *Creem*. "You want to say, 'Obviously we're not from the same planet, because I didn't sit with this guy for five years and sing like this for you to tell me that nothing we do is commercial.' Lindsey and I just couldn't understand how we could sing a beautiful song and nobody liked it. It was like, 'We don't belong here, nobody understands us.'"

However, it was time to shove despair aside and get back to work. Normal, or rather abnormal, service resumed; the writing and practising continued, Lindsey sparked up another doobie and Stevie found a new waitressing job, earning $1.50 per hour at Clementine's, an elegant LA restaurant with a 1920s theme. There was a lot of running around – Stevie was, she admits, probably in the best physical shape of her life – and the waitresses had to dress up as flappers, something the roguish Richard Dashut found quite hilarious. For dinner, Stevie would "try to find ways of making Hamburger Helper different..." which wasn't so hilarious, especially when Stevie came home to find that a stoned Lindsey had put her electric skillet on the stove, "and cooked the Hamburger Helper in the electric skillet, which meant we had no more electric skillet, and no more Hamburger Helper..."

Sometimes Stevie would bring home a slice of pizza to share between herself and Lindsey, barely enough sustenance to fuel the night ahead. "I'd get home from my waitress job, then we'd have dinner, and then we'd start working at nine at night to two or three. Then go to bed, get back up, he'd work on the music and I'd go and be a waitress."

Lessons learned by Stevie during this chapter:

1) *How to care for someone with a chronic illness.*
2) *How not to park a stick-shift.*
3) *How to keep your cool when faced with anger and rudeness in the workplace – you get better tips and normally get your way anyway. Excellent training for the music business too. Keeping your cool when faced with an angry Lindsey was an altogether different kind of challenge, however.*

Chapter 4

Three misconceptions you will find in this chapter:

1) *Buckingham Nicks were 'lacklustre'.*
2) *Lindsey Buckingham was going to have an affair while on tour with Don Everly (not necessarily with Don Everly).*
3) *Stevie would soon be leaving the music business altogether to go back to college.*

And three truths:

1) *Stevie was 'radical', Lindsey was a perfectionist. Both drove each other nuts.*
2) *A combination of a trip to Aspen and a bout of depression would produce one of Stevie's greatest songs.*
3) *Mick Fleetwood was about to ensure Stevie would not be leaving the music business to go back to college.*

After being dropped by Polydor, and feeling like "the world had ended", according to Stevie, it was time to get motivated again – they needed to play more gigs and showcase their talent if they were going to bag another record deal. Buckingham Nicks were admittedly somewhat picky about where they played – shunning offers to form a Top 40 show band to "play the steak and lobster circuit on the West

31

Coast", as Mick Fleetwood later described it; the money would have been more than welcome but the gigs were theirs "only if they'd play Top 40," explains Mick, "because nobody, they said, would pay to hear Buckingham Nicks play their own songs."

They didn't want to compromise themselves or lose their focus, but shows were thin on the ground, and the ones they did play weren't always a success. *Billboard*'s Nat Freedland caught them at LA's Troubadour, dismissing them as a "lacklustre male-female duo who... showed a couple of songs with chart possibilities. Keyboard and drums would help focus their on-stage guitar sound." Their debut appearance on the East Coast the following spring at New York's Metro saw them display "both problems and promise". *Billboard* praised their "strong vocal punch" but felt their "twin strength was undermined" by the addition of other musicians, presumably Waddy, Tom and Jorge.

"Buckingham handles both vocal leads and lead guitar, a role that seems to be a bit taxing," wrote *Billboard*'s reviewer. "Ms Nicks also encounters problems, chiefly in her solo style, which points up the occasional roughness of her voice and the strident quality to her top end that makes duets bracing, but proves less than fruitful when she takes the stage alone."

Rock Magazine's Dan Hedges saw something special in Buckingham Nicks, describing their sound as 'soaring' and berating Polydor's lack of support. "No, of course you've never heard of them," he wrote. "Thanks to their record company, few people have... Buckingham Nicks have created what may well be one of the finest American albums released over the last three or four years." Hedges went on to commend their haunting depth and inventiveness, a "welcome change of pace from [the] mindless bopping" that dominated the charts.

He was impressed by 'Crying In The Night' – 'the obvious choice for that all-important hit single' – and noted 'Crystal' and 'Frozen Love' for their ominous beauty. "With a bit of luck," Hedges concludes, "a few influential radio stations will pick up on them and, maybe then (no thanks to Polydor), people will discover exactly who Buckingham Nicks are. After that, who knows? There might even be a second album." And the rest. Never mind 'influential radio stations', Buckingham Nicks are

living testament to how one random, indirect encounter with the right person can change everything. But let's not get ahead of ourselves.

Waddy Wachtel had become firm friends with Stevie and Lindsey thanks to their time together in the studio and on the road, and he would spend hours playing guitar with Lindsey and smoking dope at their house. Stevie would often come home from work to find Lindsey, Waddy and Richard sprawled on the floor and staring at the ceiling. Stevie would have to lift up their legs in her attempts to tidy the place up. "Oh yeah," Waddy laughed in an interview with Black Cat. "She had to step over us, for sure." Stevie rarely found it amusing at the time.

"I was just living in a world with all of these guys and I wasn't relating to any of them," Stevie later recalled. "I was working and they were all practising guitar. I was a whole different kind of person, I was the mom, the camp director of the Cub Scouts..." Stoned Cub Scouts.

It wasn't easy to kick back and enjoy life when Stevie knew all too well that, despite her best efforts, poverty was creeping up on them again. In addition to the stress of trying to live two lives at once, she was often rewarded by 'a cold shoulder' when she returned home from work. "[Lindsey] wouldn't quite trust me about where I'd been or what I'd been doing. Rich and famous or starving and poor, we went through the same problems. He wanted me to himself but somebody had to earn some money."

When she wasn't working, the way Stevie wrote was completely different to Lindsey, and this also irritated him. Lindsey crafted a song from the foundations up, while Stevie went straight in with lyrics and melody, simple and quick, highly creative and unstoppably prolific. Put simply, she was a 'radical' and he was a perfectionist. "It needs to be perfect for Lindsey and so his perfection drives me crazy because I think he doesn't have any fun, and my radicalness drives him crazy because he thinks I'm not as good as I should be."

As a twosome, Lindsey and Stevie were, as Keith recalls, 'always on the edge' and Stevie has described this period as 'two years of solid depression'. The differences and the dramas... well, no one could do anything about that, but being poor just made them all the more tense. Olsen was keen to help, but the producer's well-meaning attempts to

offer the couple money were rebuffed by Stevie – she would only accept it if she could earn it.

"So I said, 'Stevie, do you wanna clean my house?' And she said, 'Sure!' It was really funny. She'd show up in that old Toyota, it was barely worth driving, and I'd open the door and here's this woman, one of the prettiest, most elegant people in the world, looking like Carol Burnett when she dressed as a maid. That happened maybe four times, but that money was the difference between eating and not eating."

Never mind eating; it was also during this period that Stevie first tried cocaine. It may be an unlikely image, that of a cleaning lady having a quick toot, but, for a joke, someone "had left a line of coke underneath something to see if I was a thorough house cleaner. And of course I was, and of course I found it."

Stevie and Lindsey might not have had the funds or the inclination at this stage to start hoovering up Columbia's finest on a regular basis, but they would soon be eating a little more frequently. Lindsey had just received the dream call, offering him the chance to tour for a month with Don Everly as the Everly Brothers, whom Lindsey had always revered. Evidently Don and Phil had fallen out to the extent that Phil was actually being 'replaced'. Stevie and Lindsey might have thought they had a complex relationship, but the Everlys were off the chart. Lindsey practiced the songs obsessively in preparation, and the proposed recording of Buckingham Nicks' follow-up album would just have to be postponed.

Stevie was more concerned that she was surplus to requirements – "Me and Lindsey were the original after-the-Everly-Brothers-Everly-Brothers!" – but she swallowed her pride, grabbed her beloved poodle Ginnie (a vital companion on this rather lonely trip), and drove Lindsey up to Aspen for two weeks of rehearsals before the reconstituted 'Everly Brothers' headed out on tour.

While Lindsey was away, Stevie decided to make the most of being in Aspen and stayed there for weeks, 'reflecting', linking up with a girlfriend who lived locally and taking inspiration from the awe-inspiring Colorado landscape. Stevie would read, write poetry, play with the dog... unfortunately this was before Stevie started to paint,

but Aspen was a much-needed change of scene, and the snow-capped hills and fiery autumn colours would plant lasting images in her mind. Aspen seemed so tranquil and fresh in comparison to dirty, fast-moving Los Angeles, and as Stevie gazed for hours at the mountains, fragments of song ideas came flickering through her mind. The sky and the snow were so clean and bright, almost mirror-like, but it was the reflective state this landscape would inspire in Stevie that would plunge her even further into contemplation.

Stevie's depression was coming to a head and she had plenty on her mind; money troubles aside, her beloved father Jess had been suffering from serious heart problems, forcing him to retire at just 49, and the weeks without Lindsey were lonely and paranoid. She also couldn't get over the fact that Lindsey was apparently living the high life with Don Everly, jamming with Merle Travis, Ike Everly, Roy Orbison, so many of their heroes – and she was in Aspen "with $40 and my dog and my Toyota that froze the day we got there. And we thought he was going to make lots of money. He didn't."

This was the first time Lindsey had been on tour without Stevie, and the anxiety this prompted would at least spark an idea for a song. 'Kind Of Woman' was a suspicious paean to how 'darling' Lindsey Buckingham was, and expressed Stevie's fear that another woman was going to snap him up while he was on tour. "I was imagining groupies with the black feathers and the rhinestones and the boots and black stockings, and I was dying," she said. "So 'Kind Of Woman' was, you know, 'You didn't mean to meet her.' Right, you're going to call me and tell me that?" (For all of Lindsey's faults, he insisted he was always faithful to Stevie.)

To compound Stevie's misery, when Lindsey returned to Aspen he was in a black mood, "very angry with me... and he left me". Why he was so furious is a mystery; whether it was because he hadn't brought back as much money as he'd hoped for and was taking it out on her, whether Stevie roasted him with her suspicions of infidelity or whether it was simply because Stevie was having a much-needed break after such a punishing year and, as a result, was not earning their keep for once, we don't know. What we do know is a fuming Lindsey took the

dog, got the car started and abandoned Stevie in Aspen, confused, cold and suffering from strep throat. Still, Stevie had reason to feel defiant. Temporarily.

"I had a bus pass because my dad was president of Greyhound," said Stevie. "So I said, 'Fine, take the car and the dog, I have a bus pass.'" Which would be all very well if it wasn't the day the Greyhound Buses went on strike. Stevie managed to find a phone, tearfully contacted her parents and "they unwillingly sent a plane ticket," she remembers, "because they didn't understand what I was doing up there in the first place." Stevie was wondering the same thing, and not for the first time. By the time she arrived back in LA, she was beside herself with distress and needed a friend; she certainly didn't want to go home to Lindsey. But again, from that pain, something beautiful and poetic would emerge.

"Stevie and Lindsey's relationship, as you know, was always turbulent," remembers Keith Olsen. "They'd argue and things were said between the two of them that would hurt each other deeply. Stevie came over to where I lived in Van Nuys at about midnight and pounded on my door, crying like crazy.

"She sat on the couch, crying that she and Lindsey had had this fight, 'Oh God, I can't take it, I don't know what to do.' I had to do this commercial the next day at 9am..." continues Keith. "So, I just said, 'Stevie, if you feel this way, get it out.' I got my guitar out and handed it to her and said, 'Go in the bedroom and write about it.' And that's what she did. I fell asleep on the couch."

While Stevie was in Keith's bedroom, images of Aspen rushed back to her as she wept angry tears. She'd gazed at the 'snow-covered hills', in awe of their silent, detached beauty, aware that one sharp shout in their presence could be deadly, "the whole mountain could come down on you." She held the guitar and mused upon this again, likening the image to her situation with Lindsey, a love that was not without its sense of dread and tension. One false move and the entire delicate balance would be thrown, with catastrophic results.

"Everything could tumble," she said, "When you're in Colorado and you're surrounded by these incredible mountains, you think 'avalanche'. It meant the whole world could tumble around us and

the landslide would bring you down." Words she had jotted down as poetry in Aspen were summoned, and Stevie wrote the song "in about five minutes", murmuring the words and the melody in Keith's room while he slept next door, and picking out a simple, affecting tune on his guitar. This song has come to represent Stevie's loving relationship with her father, and the fear she felt for him when she thought he was dying, but at the time, it was very much about Lindsey, the man she had "built her life around". It was about "taking your ego down," Stevie has said. Considering it had just been crafted by a woman torn by despair, the result was tender, warm and mature.

Keith Olsen: "She woke me up at 8 o'clock and said, 'I think I came up with something.' She played it to me, and it was 'Landslide'. Holy crap. The melody, the sentiment, the chorus... it was just perfect."

It is the beginning of 1974 and Fleetwood Mac seems to have reached the end of the road, so much so that manager Clifford Davis believes the group has imploded on him. While a state of confusion exists around the activities of the members of the real Fleetwood Mac, Davis, claiming he owns the rights to the group's name, recruits an entirely new band to become 'Fleetwood Mac' which embarks on a disastrous American tour. When it is over – prematurely since audiences soon smell a rat – the original members of Mac sue Davis who countersues, and the issue is eventually settled out of court. In the summer of 1974 the three remaining members of the group – Mick Fleetwood and John and Christine McVie – will relocate to Los Angeles, determined to somehow restore their identity after the disquieting business of the bogus group. As if they hadn't had enough to worry about along the way... something or someone is needed to break this curse.

Once the storm had passed, Lindsay and Stevie prepared to hit the studio again and record album two. Sound City had generously suggested they could cut the record there for free, "without a record deal, and shop it around to labels afterward," engineer Richard Dashut would tell Mick Fleetwood for his book *Fleetwood*. "This was unheard-of, but we had so much faith in what we were doing that some of it must have rubbed off."

Buckingham Nicks had plenty of material that they believed in and were keen to commit to vinyl; 'Monday Morning', 'So Afraid' and 'Landslide' were among the contenders, as was 'Long Distance Winner', one of many songs about "dealing with Lindsey," admitted Stevie. "How else can I say it? I bring the water down to you / But you're too hot to touch... [I'm] saying, 'I adore you... I'll stay with you, but you're still difficult.' It's just the age-old story: the inability to live with someone and the inability to live without them."

Stevie's parents were all too aware of how hard it could be for their little girl. They were always supportive: her father had always told her, "If you're going to do it, be the best, write the best, sing the best, and believe in it and yourself." But they were also increasingly shocked by how thin, sickly and unhappy their daughter had become. Was it worth it?

They knew Stevie was too determined for them to simply sweep her up and bring her home, but it was time to suggest an ultimatum: Stevie could continue trying to make it in LA for six more months, and should things not work out during that time, she would go back to college and be financially supported. Dejected and tired, Stevie agreed, but in the meantime, she and Lindsey really had to throw everything they had at this, their last ditch attempt at rock'n'roll success.

Business continued at Sound City. Buckingham Nicks, Waddy, Keith and Richard, the whole team were there, undeterred and eager to push forward and craft a new album that would grab the attention of the ideal label for them. But the winds of change were about to blow an unexpected situation their way. Buckingham Nicks might have been shopping for a label, but the tall, bearded man who'd just wandered into Sound City's reception was shopping for a studio.

"Mick Fleetwood came in to try and find a studio and a co-producer for his new album," remembers Keith. "The one right after *Bare Trees*. I played him some things that I'd done, and also I played him 'Frozen Love' by Buckingham Nicks." Lindsey Buckingham's ears pricked up when he heard their song being played loudly in the neighbouring studio, and he was surprised to see "this really tall guy stomping his feet to our song".

Fleetwood loved the song, loved the studio, and was impressed by the guitarist on the track, whose playing put him in mind of erstwhile Fleetwood Mac guitarist Danny Kirwan. Through the glass, Mick Fleetwood also spotted pretty, blonde Stevie wafting around and, unwittingly, she made quite an impression on him too.* Mick told Keith he liked the 'openness' of the studio, and booked it for the next Fleetwood Mac album, with Keith Olsen co-producing. Not a bad afternoon, all told.

Recording sessions were booked in for February, March and the first two weeks of April 1975, and Keith Olsen finally breathed out for the first time in months. The idea of recording with Fleetwood Mac was a buzz, but so was the thought of being able to make rent... so when guitarist Bob Welch decided to quit Fleetwood Mac, it wasn't just a bombshell for the band.

After three years in one of the most tempestuous, twisted bands in rock, Welch broke the news that he could take no more on December 31, 1974. Happy New Year. Bassist and founding member John McVie tried to convince Welch to stay, reminding him solemnly that 'it's rough out there' and that giving up Fleetwood Mac should not be done lightly. "It was a marriage," recalled Fleetwood. But Bob was determined and, as a result, the album would have to be shelved unless a solution could be found. Fleetwood Mac is nothing if not adaptable. Line-up changes were hardly unusual and Mick Fleetwood was in charge of keeping the wheels in motion.

"Mick calls me from the airport in LA," says Olsen. "He says, 'I have good news and bad news. Bob Welch has left the band and we won't be able to start the album in February.' I thought, 'Oh crap, I'm out of work, I'm going to have to go back on the hustle to find something for

* Interestingly, when Mick Fleetwood described the first time he crossed paths with Buckingham Nicks in his book *Fleetwood*, the focus is actually very much on Stevie, not Buckingham. The chapter is titled 'like a charmed hour and a haunted song' and opens with the Robert Graves quote from the White Goddess: *'Let the poet address her as Rhiannon, "Great Queen".'*

that time slot which I'm already too late for, I won't be able to pay my rent or my car payment...'

"I said, 'What's the good news?' He said, 'You know that guitar player? Would he want to join my band?' I said, 'You mean Lindsey? Lindsey and Stevie are kind of a set. You're going to have to take both.' Mick said, 'Well, do you think they would want to join my band?' And I said, 'I'll go and find out.'"

Whatever plans Keith and his date had for New Year's Eve were dropped. There would be no party, no dancing, no drunken kiss at midnight. Instead, they went straight to Lindsey and Stevie's house to put Fleetwood's proposal to them, and as hard as it might be to believe, they took some convincing. Stevie knew Fleetwood only really wanted Lindsey and, while it was encouraging that Fleetwood was potentially prepared to take them both, she was concerned about feeling like an also-ran. They were also reluctant to just drop their plans to try to make Buckingham Nicks a success after all of their hard work.

Keith Olsen continues: "For the next five hours, there's Lindsey, Stevie, myself and my date, who was sitting there thinking, 'God, this is really fun...' I sit there and try to convince them to join Fleetwood Mac. 'It's the best thing for your career...' and they're saying, 'But we're working on our new Buckingham Nicks album, it's going to be wonderful, we're going to pull in some of the players from the old Fritz band...' and here I am, second time around, trying to break up what they were doing."

While they mulled over the idea, the hours ticked by, 1975 arrived, bringing with it an incredible new era for Stevie and Lindsey if they could only see it. By 2am Olsen had managed to convince them to "try it for six or eight weeks". This would at least mean that a) they would be able to eat and b) so would Keith. The sessions could go ahead as planned and Fleetwood Mac would rise again. Keith's talented friends, in turn, would finally be in a band that had a chance of selling a decent amount of records.

"I thought, 'God, they could be on the road, they could make some money, they can expand their own personal art...' I just felt so good inside and they felt so tormented inside... That is exactly how it happened."

After Keith had left, Lindsey and Stevie were still ringing their hands over the situation. Lindsey was more reluctant than Stevie. He was convinced Buckingham Nicks was on the brink of real success with their follow-up album. "He was like, 'This record's happening'," remembers Stevie. "I said, 'Yes it is, but we are dirt poor and I don't want to be a waitress any more. If we don't do well in Fleetwood Mac then we'll quit, but let's save a bit of money, at least we'll be able to fix reverse in our car.' We always had to find a parking space where we could get out front-ways or we'd be stuck there all night..."

They needed another opinion from a trusted ally who knew their situation, musically as well as financially. Of course Keith wanted them to go for it, but Keith's financial situation was also riding on it as well. Waddy Wachtel had just returned from a tour with Linda Rondstadt when his phone started to ring. "It was Lindsey," he recalled. "He goes, 'Man, I gotta run something by you. Mick Fleetwood wants us to join Fleetwood Mac. I don't know if we want to do it. You know, we got Buckingham Nicks...'

"I said, 'Lindsey, the only mistake you are making right now is you're on the wrong phone call. I want you to hang up and call Mick Fleetwood and tell him 'Yes'.' I knew that was an in for them. Buckingham Nicks was going to be an uphill fight, but Fleetwood Mac already had a name. Let *them* be your back up band, man. So that's what he did."

As soon as she could, Stevie went out to buy all of the Fleetwood Mac records she could get her hands on to case out what they were getting themselves into. As *Peter Green's Fleetwood Mac, Then Play On* (the only Mac record Lindsey was really familiar with), *Heroes Are Hard To Find* and everything in between blared from their speakers, Stevie realised that however much they wanted to move forward as a duo, they could learn so much from working with Fleetwood Mac, even if they just stayed for the recording.

She also loved the music and was pleasantly surprised to pick up on the mystical bent that informed their records, undoubtedly courtesy of Peter Green himself. This instantly chimed with Stevie's own spiritual sensibilities. But she also needed to feel that Buckingham Nicks could bring something to the table and actually enhance Fleetwood Mac as

opposed to coasting along like passengers. She finally turned to Lindsey and said, "I think we can join this band, and not just be doing it for the money. We can add something."

It was time for Stevie to call her parents. Just half way through the six month limit they'd set, destiny had stepped in, a wish was granted, and Stevie and Lindsey's world would change completely.

Chapter 5

Stevie's early but enduring music industry power moves:

1) *You're a woman in a man's world. Resist pushiness to get your point across. Don't get bitter. You can still be strong and respected, but honey gets you further than vinegar.*
2) *But don't compromise yourself, and follow your instincts no matter what. Lesson learned after the Buckingham Nicks album cover fiasco.*
3) *Shoulders back, chin up and state your case looking groomed and confident. No 'crawling in like a worm'. Heaven forbid.*

As Stevie and Lindsey listened to the back catalogue of Fleetwood Mac, Mick Fleetwood settled down in a rather more salubrious area of California to play the Buckingham Nicks album to fellow Mac bandmates John and Christine McVie. The pair were impressed even though, as Christine reiterated, it was "really only the guitar-player we were interested in". Stevie was an afterthought – they were simply prepared to do what they had to do to secure Lindsey, who wouldn't budge without his partner. This is why, as Mick Fleetwood puts it, "She never forgave me." But Mick didn't hesitate when he received Lindsey's terms, and there would be no audition.

Mick's only concern was that Christine wouldn't take kindly to another woman joining the band. "Mick and John said to me, 'If you

don't like the girl then we can't have either of them, because they are a duo'," Christine said, admitting there was indeed some slight apprehension before meeting Stevie. She'd become so used to being the only woman in the band, but this was no alpha female neurosis – Christine was like one of the boys, and as it would turn out, it was a relief for Stevie to know there'd be another girl in the group. Stevie instantly saw Christine as a potential 'pal', not a rival, and they were different enough for this never to be an issue – Christine was as earthy, tough and cool as Stevie was ethereal and dreamy. Had they been too similar, the situation might have been different, but as Fleetwood remembers it, his delicately-posed question as to whether "no longer being the only lady" would be a problem was swiftly dismissed. "She just said, 'Do me a favour, as long as [we] hit it off everything will be fine', cause there's nothing worse than having a couple of ladies in the band who don't like each other." He might have been paraphrasing the last bit, but you get the idea. It was decided, and Mick called the group's lawyer Mickey Shapiro to make it official.

Not everyone took the news well. When Stevie told the rest of the Buckingham Nicks band, it was, as Tom Moncrieff remembers it, "devastating. We were working on a killer second album, Richard Dashut was engineering, but we had no money or support, or any real way to get any further. The owner of Sound City, Joe Gottfried, had agreed to 'spec' us the time ('cuz I 'spec I won't get paid'). He was a great guy," Tom says. "We thought we should have had a future, but joining Fleetwood Mac was the only realistic thing Stevie and Lindsey could do."

The way in which the following Fleetwood Mac episode unfolded ties in with the sense of 'depth and destiny' that has always been intrinsic with the band, according to Fleetwood. "We did everything on instinct. Nobody ever auditioned..." And it wasn't as if Lindsey didn't offer. In fact, he was a little bemused by the Mac's open door policy.

"John and Mick have always been open to having a lot of different people in the band, which is odd," Lindsey told *Rolling Stone*. "I would never be able to do that. I would think it was real important to keep an identity. I remember being a kid, if a new member joined a group,

I didn't like that at all. But that openness is what's kept them going for so long."

"That's one of the reasons nothing ordinary ever happened to this band," continues Mick. "Somewhere up there, I've always felt, was a little magic star, looking out for us." There was always a sense of the esoteric about Fleetwood Mac, and there's no doubt that Stevie and Lindsey would bring so much more than anyone could have imagined – it was a serendipitous, if unlikely union. But this magic star of theirs was evidently intent on making things awkward for them as well. As magic stars go, this one had a warped sense of humour. It would rarely be easy, or comfortable, emotionally at least, in Fleetwood Mac. But magical, yes, in many ways it would be. For Stevie, Fleetwood Mac would be like a fairytale on acid – exaggerated, indulgent, colourful – and Mick Fleetwood was the knight on a white charger, sweeping them up and away from destitution. Three months into her parents' kindly ultimatum, life had changed for the better. College was forgotten.

Arrangements were made for the band and their new members to meet up properly for the first time at El Carmen, a Mexican restaurant on West 3rd Street in Beverly Hills. Lindsey would meet Mick Fleetwood at his home in Fernwood, off Laurel Canyon, driving down together. John and Chris were heading down separately. Stevie, still in her flapper uniform after a day's waitressing, was already there when they arrived; "in two white Cadillacs, clunky, with big tail fins," remembers Stevie. "I was in awe."

Mick Fleetwood's grand entrance is something Stevie will never forget. She had always fantasised about English fairytale characters, lords and ladies, ancient royalty... and to Stevie, the eccentrically dressed Fleetwood, with his aristocratic manners and towering stature, was like "an English king. He was wearing a burgundy silk vest [waistcoat] with a watch-chain and a very long jacket that was nipped at the waist, and beautifully made pants. I was awestruck. I still am to this day of Mick's presence. The whole air around him is [of] power."

Christine and John swept in, Lindsey settled by Stevie's side and before long everyone was drunk on margaritas and having a ball. Fleetwood remembers "a lot of smiling". It felt right and Stevie, who had initially

felt understandably intimidated by her new bandmates' sheer level of fame, soon fitted in. "I fell madly in love with all of them immediately. They made me feel wonderful."

"We all really got on well," confirmed Christine. "Stevie was a bright, very humorous, very direct, tough little thing. I liked her instantly and Lindsey too." Christine and Stevie were "complete opposites at either end of the personality spectrum", but crucially the one thing they did have in common was a wicked sense of humour. "We have a good laugh," Christine told *Uncut Magazine* in 2003. "It is one of the primary reasons for anybody staying together, marriage, band, or whatever it is. The ability to laugh at things, and oneself, is really important."

Stevie was 27 but her childlike, exuberant demeanour and diminutive stature quickly marked her out as the 'baby sister' of the band. Nobody else had nabbed that role – Christine was five years older for a start, and had been in the business far longer. Stevie was as wide-eyed and adventurous as Christine was assured and down to earth. Stevie: "I thought it was very cool of a woman [not] to say, 'Oh, she's five years younger than me, I've worked for ten years on the road, killed myself, and here she is, our new front-woman!'" Christine was never interested in grabbing the limelight anyway, unlike their new recruits. Both Christine and Stevie had grit though, and together they were "a force of nature", Stevie said, remembering what she'd told Christine when she first joined the band. "We're pretty tough by ourselves but together, we can't be beat."

Stevie insisted to Christine that they "will never be pushed aside in a group full of men, and we weren't. When we walked in they were extremely gallant to us, and that's because we demanded it. Again, if you plant the seed, you can water it and make it happen. If you don't walk in with that attitude, you're just a doormat." Good advice.

There was, as there always seems to be with Fleetwood Mac, more than a little cosmic fortuity about the new development too – Christine's intuitive mother had cryptically left her daughter with the words "You will find it on Orange Grove..." before she passed away. Christine assumed she meant she was simply going to end up picking oranges in California, but when she met Stevie and Lindsey it all became clear: the couple lived on Orange Grove in Fairfax.

Fleetwood invited the newbies to have a jam the following day at 5pm (i.e. once the hangovers had worn off) in a garage on Pico Boulevard, Santa Monica, but the first full-scale rehearsal took place in the basement of their booking agents ICM in Beverly Hills. Stevie and Lindsey might have been nervous but the energy together was perfect, and Christine, John and Mick were stunned by their vocal sound, which instantly infused their existing songs with a new power.

"I started playing 'Say You Love Me'," remembered Christine. "And when I reached the chorus they started singing with me and fell right into it. I heard this incredible sound – our three voices – and said to myself, 'Is this me singing?' I couldn't believe how great this three-voice harmony was." The sound of their voices together turned her skin "to gooseflesh". For Fleetwood, those early rehearsals with Stevie and Lindsey reminded him of the energy of the Peter Green/Jeremy Spencer days. "I also found Stevie to be the most endearing combination of beatnik poet and cowgirl."

The inclusion of Buckingham Nicks was, as Mick Fleetwood's then wife Jenny Boyd put it, a "creative shot in the arm" – and Jenny had certainly seen Fleetwood's group undergo a few line-up changes in her time. Mick put the pair on a wage of $200 per week to start with. "We may have paid a little of their rent too," he recalled in his book *Fleetwood*, "but I can't remember. No one really had much money then, we were just surviving." It was all relative, of course – $200 a week was a lifeline to Stevie and Lindsey, who felt immediately rich. Just one week earlier they were eking out pizza slices. Fleetwood Mac may have been "just surviving" but they were surviving while driving Cadillacs and sinking margaritas. The fact remained, however, that, considering how successful they already were, they should have had more money at their disposal – but, as Fleetwood ruefully admitted, "everything was still in Bob Welch's name because we had no green cards that would let us earn money in the States. The $200,000 advance from Warner Bros to me, John and Chris went straight into Bob's bank account." Result? Welch was sent "one hell of a tax bill" for an album he wouldn't even be on.

Still, the money they apportioned for Stevie and Lindsey would make an instant difference to their lives. "I had hundred-dollar bills

everywhere," says Stevie, who recalls pinning the notes up onto the walls of their apartment 'for fun'. "Since we hadn't spent any money in five years, we didn't even know how to spend money. And I was washing hundred-dollar bills through the wash and finding them crumpled and detergented out, and hanging them on the line with the rest of our stuff." It wouldn't take long for Stevie to learn how to spend some serious cash, however: Stevie ditched the apartment they'd been sharing with Richard for a new one on Hollywood Boulevard. She would soon get rid of the old Toyota and buy a 280 SL Mercedes convertible with a glamorous red interior. *Then* she really felt like a rock star. But something else that would quickly change was the fact that, while she had been 'the caretaker' of so many people since moving to LA, suddenly people were taking care of her.

Plans for the next album, the eponymous *Fleetwood Mac* (referred to by those in the inner circle at the time as 'The White Album'), were underway. Christine was writing songs at her home with John in Malibu, and Stevie and Lindsey, already armed with songs galore in demo form, headed over to run them past the rest of the band. After the assembled Macs had made themselves comfortable, Christine unveiled 'Sugar Daddy' and 'Warm Ways', to much approval. Then it was time for Stevie and Lindsey to show off their wares. Neither party had any need for apprehension – the songs were, as far as the rest of the band were concerned, 'tremendous' and fully formed. Lindsey had been "labouring over the harmonic guitars of 'I'm So Afraid' since at least 1971", according to Fleetwood, so it was no surprise that the demos were rather more than rough musical sketches.

'Monday Morning' and 'Landslide' were also on the tapes, and it was proposed that Fleetwood Mac should also record a new version of 'Crystal', which had featured on *Buckingham Nicks*. 'Crystal' was written by Stevie with her father and grandfather in mind, but she insisted Lindsey take the vocals as he interpreted it so beautifully. It was a strong song, and the lyrics were pure Stevie – *'do you always trust your first initial feeling?'* – and they were keen to hear how it would sound with more production. Another song Stevie presented to Fleetwood Mac was 'Rhiannon', a mysterious song that would soon come to define

Nicks, not to mention light a fire under Fleetwood Mac's live shows, for more than 40 years to come. Stevie's demo was gentler and more sensitive than the song we know today, but that bright intensity and 'bird in flight' feeling, musically expressed by the lilting, rise and fall vocal melody in the chorus, was there at its core from the start.

The idea for 'Rhiannon' was sparked when Stevie was looking for reading matter to pass time in an airport three months earlier, possibly while waiting for her flight back to LA from Aspen around Hallowe'en 1973. Stevie picked out the supernatural novel *Triad* by Mary Leader, and was very taken with two of the names in the story – that of Branwen, the female protagonist, (after whom Stevie would name an Afghan hound) and Rhiannon, Branwen's long-dead cousin who comes back to haunt her. Initially she "just thought it was a pretty name", but something about it inspired her on a deeper level. Within ten minutes, a song had formed. The lyrics, almost channeled, were about a compelling white witch, "taken by the sky", enchanting all who encountered her on a starless night; *'who will be her lover?'*

"It's just about a mystical woman [who] finds it hard to be tied down," she explained in 1976 in an interview with the broadcaster Jim Ladd. "What the band got really well was that uplifting of wings feel, you know... when you see a seagull and she's lifting up. Well, that's Rhiannon. She's moving up." And so was Stevie.

Later, however, Stevie would discover that the character she'd conjured, apparently from her imagination, actually existed in ancient Celtic mythology: Rhiannon was a Welsh 'witch', a goddess who appears frequently in the Mabinogion – eleven prose stories collected from Welsh manuscripts that date back to the Middle Ages. "Rhiannon is the maker of birds and the goddess of steeds," Stevie explained of her findings. "She's the protector of horses. Her music is like a pain pill. When you wake up and hear her birds singing her little song, the danger will have passed. I realise that somehow I had managed to pen a song that went very much along with the mythical tale of Rhiannon." And so, on her first album with Fleetwood Mac, Stevie's precious 'Welsh witch' would find a home, administering an uplifting musical 'pain pill' to all who listened.

With the songs chosen and everyone 'in love' with each other (this wouldn't last), Fleetwood Mac soon decamped to Sound City with Keith Olsen and Richard Dashut for the recording of *Fleetwood Mac*. "When we got into the studio, the magic started to happen, it really did," remembers Olsen. Lindsey fazed the band with his creativity (and occasionally irritated them with his strong ideas) and Stevie danced and whirled around the studio. "I had a feeling audiences were going to devour her," said Fleetwood, already, no doubt, rather smitten.

The making of *Fleetwood Mac* that chilly February was largely smooth, by Fleetwood Mac standards at least. Everyone was excited by the sheer 'newness' of it all... although that's not to say there wasn't tension. There would be some considerable clashing of egos between Lindsey and John, who didn't like taking orders from someone who had just joined the band. Lindsey was full of ideas, a natural producer, but perhaps he didn't have the best bedside manner when suggesting rhythms to Mick on the drums, and bass lines to McVie. John McVie was not only very protective and defensive of what he did, he was also 'a consummate game-player' as Fleetwood puts it, and in addition was often rather drunk. McVie would often stop Lindsey in his tracks during moments of over-confidence and bossiness with the words: "Hang on, you're talking to McVie here." Maybe John's own ego needed checking, or maybe Buckingham was too eager to recruit potential students onto his 'egg-sucking for grannies' course, who knows? It must have been inwardly not a little amusing to Stevie to see how others responded to Lindsey's forceful manner.

Still, Lindsey knew what he wanted, and more often than not, he was right. The tracks were sounding phenomenal, although the music had changed: at one point John McVie looked at the two American flower children harmonising before him, turned to Olsen and said, "We used to be a blues band..." Keith looked back at him and retorted: "Yes, but now it's a much shorter trip to the bank."

Two vibrant new writers had joined the fray, and the resulting combination brought together gritty British rock and the sunshine of the West Coast with an added twang of country, courtesy of Stevie. They were becoming closer in sound and stature to the Eagles than the

Bluesbreakers, and while Fleetwood Mac might never have had a US hit single up to this point, this would soon change thanks to their new magic ingredient – Buckingham Nicks.

Fleetwood Mac would pay tribute to the past, however, with the song 'World Turning', which had developed from the stem of an old Peter Green song; the band just jammed it and let it evolve in the studio. This track was only added because there weren't quite enough songs on the album, but its presence would provide a meaningful bridge between two very different Fleetwood Macs. Much of the development of this track would be down to Christine McVie and Lindsey, and Stevie was apparently more than a little rocked when she walked into the studio to see them singing it together. Stevie and Lindsey had never written together like that.

Stevie Nicks was three years away from hitting her 30th birthday, but she was still, in many ways, an innocent. Up to this point she barely drank or smoked, while Christine alone would be downing champagne within minutes of entering the studio, a cigarette ever-present in her free hand. There was also plenty of cocaine in the studio, indeed it was the first time really that any of them had gone for coke in a big way, but as Fleetwood puts it, "a toot now and then relieved the boredom of long hours in the studio." Presumably no jigsaws were available. But seriously, the proliferation of marching powder also suppressed their appetites, which was just as well – there was barely time to take a break to eat. They just worked and developed their studio tans.*

Long hours indeed would be spent recording 'Rhiannon'; the only really difficult track on the album to lay down. "The others were easy," Olsen said. "Like five takes, and the feel just kept getting better." But, as Stevie describes the character of her signature song, Rhiannon is "hard to tie down"; maybe that counts for capturing and pinning the song down on tape too.

* A studio tan = not a tan. It was generally assumed that if a rock star looked tanned and healthy, their career was on the skids. They should be too busy working in a dark studio with no windows, or partying hard all night, to spend time lying about on the beach.

"It was one of those songs that took over a day to get the basic track, and we're on analogue tape," explains Keith. "The first pass was kind of magical but had too many mistakes. The second pass was pretty good, but didn't have the magic and from there it went downhill. But I kept those two."

By the end of the night, they still didn't have 'Rhiannon' the way they wanted it, and resolved to try again the following afternoon (never morning) when everyone was vaguely fresh. But Keith stayed back in the studio. He wanted to try something out.

"I started editing two-inch tape," he says. "And I just looped some sections – looping was done with a big physical loop of tape, and it would be transferred over to another machine. So if you listen to the end of 'Rhiannon', you will hear the mini scar in the cymbal crash that happens every time it loops around. There were, like, 14-15 cuts to put together that track. It was hard. Really hard." But it was worth it. By the time the band were back in the studio the following day, one of the strongest songs on the album – Stevie's song – had been transformed. The best of the previous day's parts had been blended to show off Stevie's luminous vocal, the haunting harmonies, the chiming keys and Lindsey's now iconic guitar parts at their finest. Listen to it now and try not to get the shivers. It's not possible. (If you don't get the shivers, however, maybe check your pulse.)

Part of the song's splendour would be sealed in the mixing stage. Engineers Richard Dashut and Ken Caillat would mix the radio edit of 'Rhiannon', and, after accidentally addressing Stevie as 'Lindsey', Caillat was put under further pressure when Stevie took him aside and told him: "This has to be a great mix. This song is very special to me." Then she turned away, before turning back to add, "It's magic." She may well have been right; the song was so good, Ken admitted later, that it "almost mixed itself". As they worked, Stevie whirled and pirouetted around the studio, her arms aloft, apparently in an altered state. "She believed she had magical powers," says Ken. "She probably thought she was chanting up a good mix from Richard and me." It must have worked: by the time their work was complete, everyone was dancing, not just Stevie.

While the band worked, Mick Fleetwood, then acting as the band's manager, was having to field anxious calls from the label. Warner Brothers were sceptical about the band's tenth studio album after so many changes, so much trouble, so many cancelled shows and diminishing sales. But Fleetwood wasn't just delivering lip service in his attempts to reassure them – he genuinely believed the album was going to be their biggest yet. The joke within Warners was that Fleetwood Mac albums paid the lighting bills, generally 300,000 unit sales, nothing spectacular. The band knew *Fleetwood Mac* would be different, however, and Fleetwood was so adamant about it that he personally visited the office of then Warners boss Mo Ostin, accompanied by lawyer Mickey Shapiro, to demand either support or the freedom to find a more appropriate label. Fleetwood Mac had been on Warners' Reprise roster for years, but they needed their label to understand that what was coming would likely revolutionise how the band was regarded, not to mention their finances. Warners would be able to leave the lights on all night on what the Mac were about to pull in.

There was a nasty moment when the master tapes were briefly misplaced, but once they were found in a stack of tapes that were to be erased (best not to think about that too much), the individual members of the group were given copies of the record to take home and listen to in their own time. When Stevie took her copy back to the apartment and played it, curtains drawn, candles lit, she realised that she and Lindsey had accomplished what they set out to do when they first agreed to join Fleetwood Mac. "I said, 'This is a really nice album. There are some really pretty songs on it… And the voices sound beautiful, and… yes, we have added something. We have enhanced Fleetwood Mac.'"

PART II

On The Wings Of An Albatross

Chapter 6

Three influences on Stevie Nicks' style:

1) Eye make-up: Greta Garbo.
2) Clothes: California sunshine, fairy queens, children's books.
3) Hair: Victorian society beauty meets Lillian Gish in San Francisco.

As soon as the album was complete and the band members were happy with it, Fleetwood Mac went on an extensive tour; a venture that, again, Warners was not behind. The label didn't understand why the band would tour in May when the album was out in July — what was the point of going out on the road with no product to sell? Plus, this was a band not known for its stability. Warners shrugged their shoulders and refused to front the band any money for the tour, but Mick Fleetwood booked the dates anyway, all the while planning to dump Warners in favour of another major label, such as CBS or Arista.

The way they had been treated latterly was demoralising and, now Fleetwood Mac was practically a new band with exciting prospects, the feeling was that, should the future be as bright as they anticipated, Warners didn't deserve a piece of that particular pie after having been so lackadaisical. "Our low status in those days was confirmed when our label took out an ad in *Billboard*," recalled Mick. "In the photograph

Stevie was identified as Lindsey and vice versa. We were not amused."
I should think not.

Despite Warners' low expectations, the tour would snowball into a phenomenal success; the Mac initially played 3,000 capacity venues, opening for Loggins & Messina*, but by the end of 1975 they had played 90 punishing but triumphant headline shows in front of 20,000 people. The new mix of voices, personalities and songs would be a revelation for fans, and ultimately proved to the band – and the label – that they'd been right all along.

The tour certainly went well in terms of profile, but on a personal level, a feeling of anxiety prevailed, and it radiated from everyone for different reasons. Christine and John's marriage would not last the course, and Lindsey and Stevie, always a troubled couple, were constantly tugging at the seams of their relationship. Certain members of the crew were also feeling the strain: on Stevie and Lindsey's insistence, Richard Dashut had been appointed Fleetwood Mac's live sound engineer instead of then tour manager John Courage, who had been taking care of this duty quite happily for years.

Richard appreciated the gig and his friends' loyalty but he had never mixed live sound before and was extremely nervous. John Courage, meanwhile, was not impressed by the new development and encouraged the road crew to 'show him what the road's really like', leaving Richard to fend for himself in a Winnebago alongside some of the band's toughest roadies ("like cut-throat bikers on acid"). Before they embarked Courage rather cruelly instructed the other technicians to "keep him up all the way to El Paso", the first date of the tour on May 15. He would be duly kept up for 48 hours, smoking dope and "consuming mounds of blow… I was a zombie when it was time to work". To compound matters, Richard, being such a close friend of Stevie and Lindsey's, would occasionally travel with the band in limousines. This didn't exactly engender a sense of crew solidarity. "The road crew loathed me," he admitted. "One night I was initiated with a thoroughly wrecked room, but I was too tired to complain."

* Successful pop-rock duo Kenny Loggins and Jim Messina.

There was more than a little casual sexism on the tour for Christine and Stevie to contend with too, and the sound of "get those broads off the stage" barked by Loggins & Messina's road manager Jim Recor (no doubt with a twinkle in the eye, but still...) was not unusual. Aside from wives or groupies, most of the crew were unused to having women on tour. While tensions were rife between the now disintegrating couples in the band, the general touring mood for Fleetwood Mac had nevertheless improved with the advent of Stevie and Lindsey, which is certainly saying something, as it was far from a relaxed expedition. But, as John Courage put it: "They were young, good-looking, friendly and fun to be with. Bob Welch was serious and moody and he went through depressing times with us. But now I saw John and Chris and Mick enjoying themselves again."

Musically, the shows were strong and the tour proved an ideal testing ground for the new songs, a brave move in an era when unreleased material was rarely performed live. Still, old school fans were not disappointed, and appreciated Lindsey's version of Peter Green's iconic 'Oh Well'. These were big shows for Stevie and Lindsey to play, but Loggins recalls watching from the wings and being struck by new girl Stevie's "innate awareness of how to work a large audience," he says. "Stevie has always impressed me as a unique artist and individual." Yes, Fleetwood Mac's new front woman was a natural, and this would be yet another reason for the growing agitation between herself and Lindsey. Buckingham was not happy that his girlfriend, whose simple but beautiful songs he had transformed into 'hits', had been "singled out as the star".

Stevie's charisma, voice and energy mesmerised the audience, particularly when the time came to unleash 'Rhiannon', which was "very, very weird" to sing live, according to Stevie. It would build to a raging, frenzied crescendo, quite different from the recorded version, and Stevie appeared to be transported to another plane as she performed it. "It's a real mind-tripper. Everybody, including me, is just blitzed by the end of it." Mick Fleetwood described Stevie's passionate performance of the song as "like an exorcism". Nearly 40 years on, the atmosphere 'Rhiannon' creates has hardly changed. It would always be,

as Stevie says, a 'heavy' part of the set. But no matter how much energy it takes out of her, she never tires of singing it.

Stevie always talked about Rhiannon as if she were a real person in her life, a kind of ever-present *anam cara* whose intensity she has to keep at bay while performing the other songs in the set. "She just has to wait, that's all there is to it." Stevie was also protective of 'Rhiannon' to the point that she was against the idea of the song being released as a single. "I thought, 'What if my Rhiannon falls flat on her face?' It's not my choice to release her as a single, she is a mythological goddess [and] a brilliant, brilliant character..." said Stevie in 1997. "She simply is not for sale and has never been." This is all very well, but while 'she' might not have been for sale, the song definitely was, and it gave the band their first US hit to boot in February 1976, earning Ms Nicks a lot of money.

The sheer scale of the shows was daunting and relationship difficulties were making Stevie feel increasingly alone, but she was going onstage armed with her precious songs and the spirit of Rhiannon urging her on. Cocaine also helped, something Courage ensured no member of the band was without. After their faithful tour manager had counted down the minutes until it was time for the band to face the crowd, they would line up and hold out their wrists, onto which Courage, or JC as he was known, distributed a toots-worth of the emboldening powder to see them onto the stage. As Stevie herself has noted, coke was viewed as a purely recreational drug at the time – she never imagined the damage it could inflict upon her, both mentally and physically. It was just as essential and routine a part of the backstage ritual as putting on her silent movie-star eye-makeup (and lots of it – what looked like too much close up was often just the right amount from the point of view of the audience), doing her ballet stretches and fixing her long, curly hair. For the 1975 tour, Stevie opted mostly for floaty, flowery printed chiffon tops and jeans. It would be a while until she took on her 'Rhiannon' look of black chiffon, handkerchief skirts, shawls and a top hat. However, the vision was already in her mind, and she pre-empted her own adoption of this look with the line 'black robes trailing' in 'Sisters Of The Moon', a song she was working on during this tour. Before long, that image of a witchy rock goddess would be a Fleetwood Mac mainstay. Her 'uniform'.

By the time *Fleetwood Mac* was released on July 11, 1975, the band had flown to Detroit, taken in the Mid-West and North-East of the US, and more dates were being added all the time. The album would set a record at the time for the most weeks on the chart before reaching the top, and by the following year, it would still be in the Top 10, selling over five million copies and winning the group five platinum discs and a gold one in the UK. The press praised it – although some journalists took time to get used to Stevie's 'harsh' voice in comparison to Christine's more silvery tones, a criticism that upset Stevie to the point she even considered quitting. The comments hadn't just pricked her ego; they reignited her paranoia that she was only there because of Lindsey, and that she wasn't really wanted. However, Mick and Christine did their best to reassure her, and her harmonies, particularly on Christine's song 'Over My Head', were duly praised, the single going straight into the Top Ten in November. Her own song, 'Rhiannon' would surpass even this on release the following February.

Both fans and press were rightly excited for the future of Fleetwood Mac and, as far as the band was concerned, the new members were 'blossoming' and this period on the road would seal them as a unit, musically at least. Away from the audience's adoring gaze, Stevie and Lindsey were fighting more than ever, and while Stevie often took refuge in Christine's company, Lindsey was largely out on his own socially, dedicating his time and considerable energy to composing instead – to the extent that Mick Fleetwood had to "drag him out of his hotel room to have some fun". He would spend days on end with his tape recorders, working feverishly on songs. He was struggling with demons and neuroses, and it wasn't easy for him to be in a band that had existed successfully without him before he came along. He might have been the dominant partner in Buckingham Nicks, but this was Fleetwood Mac, and Lindsey didn't have the reins. At least if he kept writing and recording, he could pour his frustration into something productive.

Still, no one could deny the huge positive changes that had affected both Lindsey and Stevie: within just a few months of joining Fleetwood Mac, they had gone from destitution to fame – and not just in

Birmingham, Alabama, where *Buckingham Nicks* had been such a cult hit.* It was confusing for them, an experience that, in a way, would strengthen their intense bond while onstage, but at the same time their partnership was becoming more and more damaged. The whole tour was, to put it mildly, something of a culture shock.

The sudden level of attention frightened Stevie, and witnessing her new bandmates' raw individual pain on a daily and nightly basis was jarring: John McVie's heavy drinking and despair over his failing marriage to Christine led to disturbing behaviour, for example. Stevie recalled huddling with Christine in her hotel room as John paced the hotel corridors "just screaming her name," said Stevie. "It was horrible."

Similarly there were times, certainly, that Stevie felt Christine was her "only friend" on the road, and vice versa. As soon as the press saw there were now two women in Fleetwood Mac, the questions started (and have never really stopped); they wanted a cat-fight, at least a little bitching. They wouldn't get it. Arguably Stevie and Christine's friendship ended up being the most successful out of the many relationships borne of – and killed by – Fleetwood Mac. It lives on, just as strong as ever.

As Christine observed, humour was a vital part of what made it work from the start, and they weren't competitive, although Stevie later claimed she'd heard tales that Christine was indeed occasionally jealous of Stevie. All the same, "Christine never let me know, not one comment of: 'I could really have done without you.' I'm sure there were times when I'm flying around the stage in my gossamer chiffon where she (thought) to herself, 'Wow, what's this? Fairy school?' Never once did she make me feel like that. She knew from the beginning I was real sensitive and that I love her so much that anything she'd say to me would cut like a knife."

* In fact, just after joining the band, Buckingham Nicks were offered a headline show in Birmingham, which the Mac allowed them a night off to play. Stevie and Lindsey appeared in front of 6,000 fans and were treated like heroes – rock stars, indeed. After years of obscurity in LA, this was something of a shock, but this was merely practice for the levels of adulation to come, levels that would often reach 'scary' heights as far as Stevie was concerned.

The strain of heavy touring coupled with emotional conflict (and drugs) would have taken its toll on anybody, however, and it soon led to Stevie becoming thin, tired and ill with frequent throat problems. Mick Fleetwood often saw her "melting into a corner wrapped in a shawl with a cup of tea, writing..." He was concerned to see her losing weight she didn't have to spare in the first place, but remembered her being "sweet and funny". She was putting a brave face on, as was Mick, whose marriage to Jenny Boyd was also in the balance.

This gruelling tour – 90 dates in total – was the final straw for all of their respective relationships, and considering two of those relationships were within the band, Fleetwood Mac could have been forgiven for wanting to split up for the sake of their sanity, but there was no discussion of parting. Stevie herself seriously considered leaving from time to time during this tour, however, particularly after her parents came to the Phoenix show. They just couldn't hide their horror at how drawn and skinny their usually bubbly, curvaceous daughter had become. She often had to be persuaded to eat and look after herself, and would tell Mick in later years: "When I joined I hadn't a clue it would be like this. I didn't know Chris and I would be sleeping on amps in the back of trucks. But I've decided I'm going to make it through and that no one's going to say, 'Oh, she can't cope.'" Again, she used the frequent periods of waiting around in venues to focus her feelings into songwriting, writing poems and songs such as 'Sisters Of The Moon' in her notebook backstage, transforming her "blues into something creative and beautiful", as Fleetwood puts it.

'Sisters Of The Moon' was inspired by the sometimes traumatic nature of being on tour, or more specifically, this first tour with Fleetwood Mac. It was hard, there were no limousines, not yet anyway, and she just wasn't used to the lifestyle. Ever the drama queen, not only did she think "that I might die", she started to romanticise her own tragic potential. She told radio interviewer Jim Ladd: "I walked out in front of a mirror and looked at myself and I was sick, I went, 'Oh, poor sad little thing. She must be dying.'

"I stood back and said, 'But you don't want to die and neither do I, so we must change this now. Soul, be my sister, I'm not going out on

some cloud without you, and you look like you're on your way out. We'd better put this back together and realise that this is not such a frail creature.' So, [the lyric] 'intense silence as she walked in the room' was me looking at myself. And 'the people they love her...' that's after the gigs; there are a million people and you're being pulled every way... 'and they like to wrap her in velvet' like some sort of weird corpse? Not me. Do it to other rock'n'roll stars, baby, but I'm not doing that. I love life too much. But I was letting myself sink and sort of getting off on the fact I was so frail and blonde and pale."

She was starting to romanticise her own tragic potential, but it was when her parents stepped in and questioned what was happening that "it clicked. There was something about my parents saying, 'Are you crazy? Where is that little girl that we love? Is she gone?'"

It's not hard to imagine the 'intense silence as she walked in the room...' however: the anxiety, paranoia and sense of isolation Stevie must have felt despite being suddenly surrounded by more people than ever. The people who 'loved her' were 'still the most cruel' – fans, the press, in some cases, the band. 'Some say illusions are her game...'

Female friendships, the 'sisterhood', were becoming ever more vital to Stevie on the road. 'She asked me: 'be my sister'...' (both 'she' and 'me' referring to Stevie herself) is just an open-hearted request not only to her own 'soul' or self, an appeal to take care of herself a little better, but also for a friend with no agenda. Not an easy thing to find at this level of fame and success. 'Friends' would be everywhere in the shape of hangers on and chancers, naturally. But as well as her strong kinship with Christine, the support Stevie gained from the presence of her old schoolfriend Robin Snyder, who joined her on the road as her vocal coach, was something that gave her strength. Robin, stable, beautiful and down to earth, didn't just help her friend to protect her voice from being worn ragged by relentless shows; she was also one of the only people who really knew Stevie.

Alongside Robin, other female friends were included in the sacred Stevie circle, most notably Mary Torrey and Christi Astbury, two long-haired, pretty blondes. Before long one of the most noticeable things about Stevie Nicks backstage at a Fleetwood Mac show would be her

entourage of young women who were all curiously of a certain type – a Stevie type. They all looked as if Stevie had dressed them up like dolls from her own wardrobe. Perhaps it was a tactic to confuse the press. Either way, Kenny Loggins remembers noticing this shimmering little army "floating through the backstage area" with amazement.

"My first impression of touring with Fleetwood Mac was seeing Stevie and her acolytes... She seemed to collect talented, young, beautiful girls who would then dress like her and follow her around all the time. I'd never seen anything like it." It was as if having 'mini-mes' around her gave her confidence; there was a protective, self-esteem-boosting perimeter wall around her at all times. It also helped having neutral parties around when Lindsey was in a bad mood – he was less likely to tear into Stevie if there was an audience of devotees witnessing the proceedings. Lindsey was, as Stevie herself put it, 'scary' when he got angry.

Mick Fleetwood's own protectiveness and awareness of Stevie's vulnerability betrayed his affection for her at this early stage. He loved how 'silly' they could be together, and admits they're both 'old drama queens' (less of the 'old' please, Michael) but there was clearly more to it, and the super-sensitive Lindsey picked it up before even Mick did.

On one occasion, when Mick did get Lindsey out of the hotel to 'have fun', he ended up being hit by a bombshell. The pair got stoned after a gig in Texas, and finally Lindsey had started to relax. But suddenly he turned to Mick and said, "It's you and Stevie, isn't it?" "I remember this hitting my psyche like a bolt of lightning," Mick wrote in *Fleetwood*. "I really didn't understand. I could only stammer, 'Whaddaya mean?' But he didn't answer. The moment passed and it was never mentioned again."

But Mick even questions himself about his soft spot for Stevie at this stage – and he doesn't really have an answer: "Did I fall for her right away? I don't know, but she immediately felt like a soul mate." He was as transfixed as anyone when she worked her magic onstage. However, Mick kept his feelings to himself – and from himself, if his book is anything to go by – for as long as he could. Not only was his own marriage fractured, seemingly beyond repair, his mental health

wasn't doing too well either. Keeping mind, body and spirit together in circumstances such as these was not easy.

Another complication, because there obviously weren't nearly enough on this tour, was that Loggins & Messina's tour manager Jim Recor had also become unsurprisingly attracted to Stevie. Presumably once he'd managed to get over the fact there were 'broads on the stage', he was struck by her presence, beauty and grace, which shone out in bold relief against the usual entourage of hairy roadies and sweaty male musicians (Christine McVie being the other obvious exception here). Jim's own relationship with his wife Sara, a model (and later a close friend of Stevie's herself. Confused yet? This is nothing...) was breaking down, and confiding in someone as magnetic as Stevie, let alone travelling with her for the best part of a year, would not help matters.

The long-awaited final date of the tour was December 22, 1975, and in the spirit of rock'n'roll decadence, Richard Dashut and John Courage (now evidently reconciled) played Dodgems with their two rented station wagons in the icy Holiday Inn car park, smashing them into each other as the band looked on with jaded amusement. They had Christmas off, and they'd earned it. They already had a gold disc for the album and had proved themselves to Warners. Stevie and Lindsey were taken off their wage and made partners in the band. Fleetwood Mac was officially reborn.

But as *Fleetwood Mac* steadily climbed the charts, behind the scenes there had never been so much turmoil. The McVies' marriage was over, with Christine now enjoying the attentions of the Mac's dangerously charming lighting director Curry Grant. Stevie and Lindsey, meanwhile, were barely hanging on by a thread; the writing was on the wall, although there was already the dreadful awareness that, if they did split up, they'd still have to see each other every day anyway. Neither of them would abandon Fleetwood Mac.

Meanwhile, Jenny Boyd had felt utterly abandoned in Topanga with the kids while Mick was working, and their failing marriage and his damaged lifestyle led to what Jenny herself describes as a "major-league breakdown... When I felt a little better, I told Mick that if we didn't separate I might do myself in. There was almost no reaction." Mick was obviously on the verge of a meltdown himself.

Whatever happened, come heartbreak, divorce, breakdowns, fights, illnesses, addictions and betrayals... for better or worse, Fleetwood Mac always had, and always would, come first. John McVie might have told Bob Welch it was 'a marriage', but it was obviously much more of a commitment than that. It was bigger than all of them, charging unstoppably like a wild-eyed giant, trampling innocents in its wake. The people within the band took their fun where they could, and extreme lows were matched by seemingly impossible highs, in every sense. If nothing else, they just had to keep moving forward. Soon after New Year 1976, one year after Stevie and Lindsey joined the band, Fleetwood Mac started work on their next album. None of them would survive unscathed.

Chapter 7

Rumours. One of the greatest albums of all time, and, for the band, almost an entire year of pain, torture, heartbreak and spite being administered in daily doses in a confined space.

Things we will have learned by the end of this chapter:

1) *That Courvoisier, honey and tea go together very nicely, thank you.*
2) *That Sly Stone had a secluded sunken room in his studio for... erm... thinking, probably. The entrance was a massive pair of furry lips.*
3) *The enthusiastic use of cocaine was not confined to the humans present.*

In 1976 punk first truly broke, crackling outwards from New York and London via the Ramones, Television, the Sex Pistols, Adam Ant... but despite the rumblings of the more local nascent punk movement in Los Angeles, Fleetwood Mac would be unperturbed by the growing craze that encouraged rock fans to hack off their hair and throw out all of their old records. The effects of punk are larger in memory than they were at the time, after all, and a majority of Mac fans would be hanging on to their treasured platters, waiting with baited breath for news that the band would be rolling into a town near them. No, the aggression and hardline purity of punk would not cause any difficulties for Fleetwood Mac. There was enough aggression – passive and otherwise – within the band itself. They had enough to worry about.

Cutting edge groups such as The Clash and Talking Heads would, however, make a certain Fleetwood Mac songwriter prick up his ears in time, inspiring an attempt to shrug off the full-fat West Coast AOR vibe of their music in favour of something harder and leaner. But at this point, Fleetwood Mac was lyrical soft rock heaven to the hilt, and the three writers – Christine, Stevie and Lindsey – had been busy respectively working on new material matching that very description for the next album, the album that would later be titled *Rumours*.

As soon after New Year as possible, the band members, who had barely recovered from the *Fleetwood Mac* tour, reconvened to jam and rehearse ideas before heading to the studio. Mick had found a truly sinister place to practice: a dilapidated house in Florida with an unsettling atmosphere. Nature had already started to take over this empty place; there were frogs in the pool – "where we half expected to see William Holden floating face down", quipped Mick Fleetwood, in reference to the opening shots of *Sunset Boulevard*. Whether he had selected this location as a joke or not is unclear, but putting an already unhappy band in a deeply unhappy house would only engender further emotional bleakness. Lindsey would start to write the sour, feather-spitting 'Go Your Own Way' here with Stevie in mind. That should give you some idea of the vibes.

Studio sessions were booked from January 28, although they wouldn't be using Sound City this time. Mick Fleetwood felt it prudent to throw the group into a new situation, away from the stagnant and the familiar. It was healthy, perhaps, to change the scene during a "time of enforced creativity". So he booked a studio called the Record Plant in Sausalito, near San Francisco; a wooden, windowless place. Fleetwood had booked it out for nine weeks, which was somewhat optimistic. Making this album would actually take the band the best part of a year, not including overdubs, and recording took place in several different studios from North Hollywood to San Francisco to Miami, despite most of the band simply wanting to record at their homes. The whole process was, as Stevie describes it, 'horrifying'.

During the time Fleetwood Mac took to make this record, their second with Stevie and Lindsey, Keith Olsen had made albums with

"[Arista Records boss] Clive Davis, The Grateful Dead, Santana, Foreigner, Pat Benatar, Rick Springfield, one after another, album after album while they were still working on *Rumours*. It's one of those things I'm happy I'm not involved with – when albums take over three months, you get lost…" Richard Dashut and LA-based engineer Ken Caillat were brought in, the house engineer being sacked for "being too into astrology". Interestingly Mick would give Dashut and Caillat a Chinese I Ching coin for luck, however. You evidently had to choose your oracle carefully around this lot.

Having Dashut on board was vital for both Stevie and Lindsey; he was an ally for them both and indeed close to the whole band, but while he was a sympathetic presence, he managed to remain largely neutral and good-humoured, which is more than can be said for the rest of the collective. As a result, Dashut became band confidante. By the end of the sessions, his ears would be more bent than a nine-bob note, especially once Stevie got going.

She was, as Ken Caillat remembers, the "cutest little hippie chick", (often adding in his book *Making Rumours* that fame would change her personality quite dramatically, as well it might) but you'd need to have some time on your hands if you dared ask her how she was doing. According to Caillat, Ms Nicks would unleash a volly of information about herself, no details omitted. Conversations such as these would, invariably, be one-sided but, let's face it, she was a star now. This kind of behaviour was par for the course, especially now that she'd just walked out on Lindsey and was desperate for someone to confide in. The relationship wasn't technically 'over' yet, but after the strain of the last tour, they'd had a huge fight at their flat and Stevie had had enough, grabbing her favourite things and leaving.

"I don't even remember what the issues were," Stevie told *Rolling Stone's Writers Notes* in later years. "I just got to the point where I wanted to be by myself. It wasn't good anymore, wasn't fun anymore, wasn't good for either of us. I'm just the one who stopped it." Before they'd joined Fleetwood Mac, Buckingham had always taken care of the music while Stevie worked to keep them alive, but now Stevie was considered a major songwriter in her own right – and she was grabbing

a lot of the attention on stage too. Stevie and Lindsey's romance was already rocky by the time they joined the group, and Stevie would sometimes wryly comment that the obsessive Lindsey loved his guitar more than he loved her. But she was now being celebrated as a star herself, and she found that, in many ways, she just didn't need him as much as she did before. Neither of them had been "any comfort to each other" on the road, as Stevie put it, and the irritation was mutual. "I was frustrated. There was no love, everybody was too nervous."

The idea of being together every day in the studio after the most recent blow-up was not an appealing one, but they had no choice. It was devastating but, as Stevie noted, "devastation leads to writing really good things". At least Stevie and Christine could ensure there would be a few hours each day that would not be spent in the company of John and Lindsey. The studio had accommodation, and while the boys of the company opted to stay there, the ladies chose to rent neighbouring condominiums by the harbour in Sausalito.

At her apartment, Stevie could attempt to relax, write to her parents, gossip with friends, stare out of the window at the water (the only panes of glass in the studio had engineers on the other side) and, very importantly, prepare her clothes for the day ahead. Let it be known that the chiffon-clad rock queen image was no stage act. This was now Stevie Nicks *all the time*, particularly in the studio, where she always looked stunning. The great care Stevie took over her outfits was at least partly because she was playing a part even offstage, and the costume, or uniform as she refers to it, will have given her confidence, almost like a suit of armour. Unlike John McVie, who was perfectly happy in a pair of shorts, both Stevie and Lindsey, with his silk kimonos, velvet jackets and Byronic white shirts, knew the power of the right look and no mirror would go unchecked when Stevie or Lindsey were around.

They weren't the only ones in Fleetwood Mac to have a strong sense of the sartorial, of course: Christine wore fashionable gypsy-esque threads, head-scarves and boots, Mick preferred a more theatrical Victorian style with billowing sleeves, waistcoats, pocket watches and knickerbockers; alongside Stevie and Lindsey they were like a

rock'n'roll tapestry of archaic characters, knights, ladies, black-hearted princes... and then there was John, who just "looks like he's going to the beach" as Stevie once observed. Part of what was interesting about the band members' respective images was that they were so different. As Stevie herself attested, it wasn't enough to play music onstage, you had to give the audience something visual to enjoy as well. It went back to Vaudeville, Broadway... there was importance placed on entertaining all of the senses. Their audience would witness the show with their eyes as well as their ears, after all.

Mick never visited Stevie or Christine at their apartments, assuming it must have been "out of bounds to men". Not strictly true. Lindsey himself would occasionally swing by over the course of the next few months, "sleeping over", according to Stevie. These star-crossed lovers might have complained they could never have a clean break from each other, but they didn't help matters by hooking up out of sheer attachment, love and a bid to break the unbearable pressure. Richard Dashut recalled that almost everyone, "to relieve the tension, looked for sexual release, but even that didn't help. The only refuge was the music." What was about to transpire was "the craziest period of our lives". It would be a unique situation for an album to be recorded in, but one that ultimately made it even more compelling.

Always together, always upset, sarcastic barbs flying, substance abuse, not enough rest and increasing pressure from the label, anxious the album should match up to if not better *Fleetwood Mac*... not only was it a huge achievement that such a stunning album would be produced under such stress, but it was also something of a miracle no one disappeared, had a coronary or committed a murder. *Rumours* was never just about showcasing beautiful songs. It was a narrative laid bare for all to read, a soap opera, a tangled movie plot that would ensnare anyone who listened.

On the first morning of recording, Caillat recalls driving to the studio, his beagle Scooter by his side, and he observed ominous-looking storm clouds gathering as he approached Sausalito. Portentous indeed. Even Scooter would have to deal with some angst; he was about to meet Stevie's poodle Ginny, and his high-octane friendliness

would unfortunately be as unwelcome to Ginny as it was to Stevie.*
Meanwhile, roadies bustled past, bringing in the daily haul of booze:
Heineken, champagne, Courvoisier and honey for Stevie... Alcohol was
generally eschewed by the technicians because it made it difficult to do
their job, and coffee was the order of the day, or at least it was at first.
Cocaine would soon take its place. Stevie would drink and smoke pot.
"She had the most time on her hands of anyone and was always looking
for the right inspirational input," writes Caillat in *Making Rumours*.

The Record Plant might as well have been chosen by Mick with
one person alone in mind, subliminally at least. It had 'Stevie Nicks'
written all over it. A wooden building nestled at the bottom of a steep
hill, it was hard to find, hidden by trees like 'a secret haven' as Caillat
observed. The only thing identifying it as the right place was the giant
number – 2200 – painted on the wall by the front door, which also
featured a carved 'band' of wooden animals playing instruments in a
forest, like something out of a fantastical Kit Williams illustration. It was
a rabbit warren to get lost in. Hobbit holes sprang to mind. The whole
idea of the studio was to make it a 'getaway', far from the rest of the San
Francisco music industry.

It would, however, become a prison in its own way. At the same time
as the Mac's sessions there, the Eagles were recording in an adjacent
studio – two bands with destinies very much entwined even if they
didn't connect at this point. Some have opined that this claustrophobic
period holed up and coked up, 'trapped' in this dark, secret studio, was
one of the key inspirations behind *Hotel California,* which was recorded
right there. The studio door opened out onto the street, glaring sunlight
suddenly streaming in every time it was opened, a sudden, rude sense
of the outside world rushing into this strange, stuffy twilight world of
darkness and music and no small amount of mental torment.

Weeks would go by without sleep. From time to time, they thought
they were all going insane. "They had brought amazing songs to the

* Ginny would, however, be very exuberant from time to time herself, if rumours of
the dog's penchant for cocaine are to be believed. No wrap of the stuff could be left
unattended when Ginny was around.

table," says Dashut. "But the sound needed to be coherent and arranged. One theory as to why [the album] took so long was that, because of the amount of cocaine being snorted, what felt like their 'best work' one day sounded dreadful the next, and everything would start again."

Something that would please Stevie, however, would be the fact that the mics they were using had been used previously on Joni Mitchell's live album *Miles Of Aisles*. Joni was a heroine in Stevie's eyes. No one was allowed to approach her room when a Mitchell album had just been released. Stevie would be in there, lying on the floor, blasting the much anticipated record out of her trusty speakers, and was *not* to be disturbed. Any connection to Joni had to be a positive sign. Other than that, good omens were thin on the ground.

Thankfully, Stevie found somewhere to retreat. In the studio just next door, owned by Sly Stone, there was a dubious-looking 'pit' which contained a black velvet bed, surrounded by drapes. The entrance was two giant red furry lips, and Mick Fleetwood for one found it "revolting, bordello-like". It was often occupied by coke-chopping hangers-on whom nobody seemed to recognise, but Stevie, who had far less to do than the others in the studio, often treated it as a little den, a secret place where she could think and write and get away from the others once the strangers and opportunists had left. And for all its porno chic, Fleetwood himself admits that some of the band "went in there to pray from time to time".

It would be in Sly's pit that "in about five minutes" Stevie conjured the song 'Dreams', although it was originally known as 'Spinners', simply because it reminded the band of a song by the band of the same name. She'd brought in her Fender Rhodes, set herself up in the darkness of the pit, and "it just flowed out". This slow, sad song detailed tenderly but honestly a kind of dialogue between herself and the subject of the song – clearly Lindsey. The lyrics instantly take us to the heart of the conflict: the desire for freedom and yet the crushing loneliness, 'remembering what you had and what you lost...' This may not have only been a dig at Lindsey, however, but a confession of her own turmoil too. But there would be comfort and trust in a kind of spirituality, those intuitive *'crystal visions'* Stevie is so fond of (although 'I keep my visions to myself' perhaps hints that Lindsey had heard one too many of these

crystal visions for his liking), and some sense of anticipated healing, if not a resolution, by the end of the song. 'When the rain washes you clean, you'll know...' is a reference to a Native American belief that the spirit is set free when the rain falls.

Having recorded her demo on cassette, Stevie was apprehensive about playing it to the rest of the band; she knew the themes within the song would resonate with them all. As it turned out, "everybody really liked it and we recorded it right away". Lindsey knew exactly what the song was about, of course, and even later would damn it with faint praise, describing it as "an interesting outcome for something that didn't have a lot of variety in terms of its chord structures, but tons of variety in terms of its melodic left and right turns..."

Stevie admits her songs always start as simple sketches; she'd present them to the band and then they would be arranged. This was rarely easy; handing over her songs meant handing over her control, and apart from anything else, all of her songs were personal and precious to her. "I pretty much give it to them and say, 'Do with it what you may,'" she said. "I'm always there saying, 'Well, I'm not sure I like your way of doing it,' but on this particular album everything they did on my songs, I couldn't have done them better, even if I had the [musica] knowledge." It would normally be Lindsey doing the lion's share of the work on Stevie's songs; another thing that vexed him. It was bad enough seeing Stevie get so much credit, but the fact he was still expected to develop her tracks created even more resentment. "So you don't want to be my wife, my girlfriend," he said in an interview in later years, evidently still chagrined, "but you want me to do all that magic stuff on your songs. Is there anything else that you want, just, like in my spare time?" Ouch.

As far as Lindsey was concerned, he had extra work to do because Stevie wasn't a musician; she just swanned in when she fancied with a song she wanted them all to hear, expecting a pat on the head. But as far as Stevie was concerned, she wasn't a musician because those formative years when he was practicing guitar, she was keeping a roof over their heads. Nevertheless, the fact remained that, while Lindsey was so intrinsically tied to Stevie that he always knew how to work with her songs, sometimes he simply wouldn't do it. "He could take my songs and do what I would

do if I had musical talent," Stevie said in an interview with *USA Today*. "When he wasn't angry with me, that is. That's why there's seven or eight great songs, and 50 more where he wasn't happy with me and didn't help me. Lindsey would say, 'I don't want this song on the record,' and I'd say, 'I hate you!' and I'd be out the door and at home making up speeches I wanted to deliver to him the next day..." Part of Lindsey's many-faceted irritation with Stevie was that her songwriting, despite her lack of technical musicianship, came so easily. As Ken Caillat noted, "She only knew about three chords, and she could make 30 songs out of them."

It was difficult for Stevie to take criticism from Lindsey as a band member, as it was almost impossible to separate valid artistic appraisal from his anger concerning their situation. "It made for some hurtful times," he admitted, "and you had to push through anyway." But there were occasions when Stevie wanted to criticise his guitar parts when something wasn't working, or tear him off a strip for not getting it right, but in turn those would be the times that "he would really need comfort from me," Stevie said. "For me to say, 'It's all right. Who cares about them?' You know, be an old lady (wife)... [but] I was *also* pissed off because he hadn't gotten the guitar part on. So I'm trying to defend their point of view and at the same time trying to make him feel better. It doesn't work. I couldn't be all those things."

In the studio, Stevie invariably had to find something to do when the others were arranging their parts; she often sat behind Richard and Ken, smoking what was left of one of Lindsey's joints or sipping tea with a splash of Courvoisier (medicinal purposes, naturally). Stevie might have been the star on stage but she often felt in the way in the studio. Even as she danced and shook her tambourine with its trailing black ribbons, she knew that it would be Mick's tambourine parts that would be used, not hers. As Ken Caillat remembers it, she was mostly just trying to keep herself entertained, and her tambourine was always dampened with gaffer tape, as it would be on stage. It is the eternal problem for a singer – what do you do with your hands when you aren't actually singing? Stevie had found a solution, and it suited her whimsical, gypsy image perfectly.

'Dreams' was, to say the least, a contrast to 'Go Your Own Way', an embittered 'kiss-off' aimed directly at Stevie in a major key but with a

driving, almost brutal groove. The song that would end up on the album would be nowhere near as furious as the version that was first presented to the band. Caillat remembers being "surprised at the intensity of his vocal, almost angry... [it] was pretty raucous."

Lindsey would claim that 'loving you isn't the right thing to do...', hurting Stevie profoundly with the line 'shacking up's all you wanna do...' insinuating a certain amount of promiscuity on Stevie's side which, she insists, "he knew wasn't true. It was just an angry thing he said". Saying it privately is one thing, proclaiming it on a record for the world to hear was another, and it would sting all the more that Stevie not only had to listen to it, she had to sing harmonies on the track, not to mention every night on tour when the time came.

But, snipes aside, Lindsey also exposed the fact he was still in love with her – 'if I could, baby, I'd give you my world...' – and he was apparently confused as to why 'everything turned around'. But he was laying the blame at her feet and taking the high road, something that must have infuriated Stevie all the more. Stevie and Lindsey were communicating to each other through their songs, as they would continue to for decades to come, working out their pain in their own manner, jabbing each other musically, taking hits right to the heart. They knew each other too well, and were deft at pushing the exact buttons required for maximum emotional carnage. But in hindsight, Stevie also accepted that this was also just their way of processing their feelings, like keeping a journal or confiding in a soul mate. This was just that little bit more public...

"I write philosophically, he writes angry," she shrugged. "As a songwriter, I have to respect that he's gonna write about what's happening to him, and so am I." And so was Christine, although her songs were a little lighter in tone*... she was in love with Curry Grant,

* Although, *Rumours* being a revealing emotional map of Fleetwood Mac's volatile year, it has been speculated that Christine's third contribution, 'Oh Daddy', was a contemplative ode to Curry, whose womanising was understandably wearing her down by this later stage. The final lines, 'And I can't walk away from you baby / If I tried' were provided by Stevie. Christine latterly claimed 'Oh Daddy' was written for Mick Fleetwood, in the light of his struggling marriage to Jenny Boyd, however.

which definitely took her mind off John, with whom she barely spoke unless she had to ask which key a song was in. 'Don't Stop (Yesterday's Gone)', the kindest, most positive, forward-looking song on the record, was written for him however, although 'You Make Loving Fun' was famously and rather brazenly written for Curry, making the situation all the more awkward. Still, John had put Christine through more than enough anguish with his drinking, which by all accounts transformed his usually sweet 'crazy big brother' demeanour into something that was ultimately impossible to live with. It was frankly about time someone in Fleetwood Mac had some fun.

Chapter 8

Decided to travel back in time to get to know Rumours-era Stevie?

Do say: "I can't believe they left off 'Silver Springs'."

Don't say: anything that even sounds like the words 'shacking up'.

February 1976. The scene outside the studio was like a Christmas card and Stevie, wrapped up in layers, stayed in the warmth of the Record Plant, sipping her hot Courvoisier and honey, a Vicks inhaler never far from her grasp. (Rare was the day that Stevie wasn't complaining of a cold or a sore throat.) Lindsey had a new song to suggest, but he had to be careful to only play the chords when Stevie was around. The lyrics would only spark another argument, after all, but he couldn't hide them forever.

The band sat around Lindsey while he strummed frenetically, a vigorous, chugging groove like an unstoppable train. He kept those lyrics a secret for as long as he could, unable to even reveal the name of the song, which just became known as 'Strummer' for want of something to call it. The song was 'Second Hand News', and no, the lyrics were not kind to Stevie: '…I ain't gonna miss you when you go / Been down so long / I've been tossed around enough…' and again, like torture, Stevie would eventually have to provide backing vocals, singing these very words and knowing exactly to what, and whom, they referred.

Stevie, understandably, was keen for the band to record another of her own songs now, and the following day would be the turn of the powerful, poignant 'Silver Springs'. This was a track written specifically for the album, as opposed to being an earlier Buckingham Nicks-era song, of which there were many. The evocative name was simply inspired by "a freeway sign that said Silver Spring, Maryland" which Stevie spotted when the band were on the road. A magpie for a pretty name with a touch of poetry to it, Stevie jotted it down in her notebook, even using the name 'Miss Silver Spring' to check into hotels now and again. The real Silver Spring was named after a local river that was flecked with the mineral mica, and sparkled in the sunlight. To Stevie, it was a fresh, flowing, celestial image to cleanse the soul of heartache, just like the rain in 'Dreams' and the beating wings of 'Rhiannon'.

'Silver Springs' was another musing upon the disintegration of Stevie's romance with Lindsey. But while it was replete with sadness and even anger, there was no spite, as there was in 'Second Hand News', and as a song it was reflective rather than driving, like Lindsey's tracks. There is, however, an echoing of the sentiment of one of the more tender, frustrated lyrics in Lindsey's 'Go Your Own Way': 'I know I could have loved you but you would not let me,' is a direct emotional match for 'If I could, baby I'd give you my world; how can I if you won't take it from me?' As Stevie said, "It wasn't quite over", because he was still visiting her from time to time, yet at the same time it really was. However, as long as they kept communicating to each other in song, never getting closure, on some level they would never break away from each other completely, not even at the time of writing. Of course it's not over. Come on. It's Stevie Nicks and Lindsey Buckingham. The Romeo and Juliet of rock'n'roll.

'Silver Springs' is, as Stevie rightly says, "a real heartbreaker", and builds in intensity, exposing her own volcanic emotions. 'I'm so angry with you,' Stevie says, explaining the sentiment behind the lines, 'you'll never get away from the sound of the woman who loves you...' "You will listen to me on the radio for the rest of your life, and it will bug you. I hope it bugs you... As far away as Lindsey goes from me, he'll never get away from my voice." Lindsey might have challenged her to beat it

in 'Go Your Own Way' but these final lines of 'Silver Springs' keep him locked in, almost like a curse. It's symbolic that 'Silver Springs' would end up being the B-side to 'Go Your Own Way'; they were knitted tightly together even on vinyl, doomed to 'bug' each other for the rest of all time.

The song was beautiful but recording it started inauspiciously; Record Plant owner Chris Stone had wandered in with his friend Jimmy Robinson, who worked with him. A joint was passed around between the boys before work continued on 'Silver Springs', but before long everyone dispersed, everyone having had a toke from the joint feeling increasingly ill and discombobulated. The joint contained angel dust. "It ruined them for the rest of the day," said Caillat. Fortunately for Christine and Stevie, they hadn't smoked with Robinson, but there was nothing happening and no point in staying any longer at the studio that day. They would resume the following day – Friday, February 13 – which the more superstitious of you might have your own theories about.

The angel dust incident wasn't the only time the Mac would get inadvertently even more trashed than intended. Stevie's best friend Robin came by to visit the studio with some home-baked hash brownies, which were bound to go down well. Despite her repeated warnings regarding the considerable strength of these cakes, they were eaten with alarming gusto. The result was that, again, "not a note was played and the engineers went home," writes Caillat. "John and Stevie spent hours huddled in a corner, giggling like mad over a copy of *Playboy*."

'Silver Springs' would be further enhanced with experimental sounds courtesy of Ken Caillat, who added to the song's sparkle by using tape delay for 'an ethereal sound', and setting up a lavalier mic to pick up the sound of Lindsey's pick on the metal strings of his Strat. The result was 'a delicate, glasslike, musical box-type sound', very much evocative of 'blue-green colours flashing', 'shining autumns' and the mica shimmering away in that beautiful river in Maryland. Joint in hand, Stevie stepped up to the microphone which had been set up with a foam pop filter to get the ideal vocal sound. Ken instructed her to allow her lips to slightly touch the filter. The result was a "smooth, strong vocal," he explains. "We all knew this track was a winner."

1976 was still young but the process of making the new album was already starting to pall; there were too many superfluous elements – entourages, drugs, expensive food that was never touched – which were holding things up and costing the band even more money, not that they noticed the latter at the time. It would have been all right if it was more of an enjoyable experience for everyone. Mick Fleetwood could see that a change of air and a bit of leg-stretching was required, and just as everyone was on the verge of losing their minds in the confines of the Record Plant, he pulled together a ten-day European tour – Stevie and Lindsey's first time to Europe with the band. Stevie would stay close to her friends, who were now ubiquitous, giving Lindsey a wide berth. It was during this short stint, which took in a visit to Paris, that Stevie really saw the European drinking culture close at hand. It would have been rude not to join in. "Very easy to do over there, everybody there drinks like it's water," she said. "When I joined Fleetwood Mac, I was twenty-seven years old and I never drank, and these people were used to getting on an airplane at nine in the morning and ordering a double Bloody Mary."

Other live shows would punctuate the year, chiselling the band out of the studio, but that isn't to say these sessions were all gloom, however; brief bursts of jollity did occasionally burn through the fog of ill feeling. Mick would often try to lighten the mood with an impromptu skit, for better or worse... anything to raise a smile (although it was more likely to raise Lindsey's blood pressure, as he mostly just wanted to get on with it). The band members, on the rare occasions they wanted to be together outside of the studio, would also sometimes break for dinner at the Chinese restaurant Kowloon, six miles south-west of the studio on Pico Avenue. Kowloon was famous for its extremely strong cocktails, such as Mai Tais, and Lindsey's favourite, Scorpions, which were sipped out of tureens with straws. The drunker they got, the more the tureens slipped, tipping into the menu and eventually soaking everyone's laps with alcohol. "We called this getting 'Kowlooned'," says Ken Caillat, who experienced many a dowsing there himself, and Lindsey himself was often inspired to kick off a food fight. Whenever Stevie went, she "wore a plastic cover-up which she would zip up, leaving only her face exposed." Wise indeed.

Another favourite restaurant to hang out in was Agatha's, where Lindsey would eventually succumb to the friendly charms of a brunette waitress with hair as curly as his. While Stevie might have been "the one who stopped it", discovering this would leave her bereft, she couldn't deal with him; but the thought of him finding pleasure in someone else's company was too much to bear and there would be frequent tearful rows in the studio. The incongruity of seeing Stevie and Lindsey blissfully singing the harmonies to 'You Make Loving Fun' side by side on tall stools before viciously turning on each other as soon as the take was complete was bizarre, and the acrimony would take its toll on everyone. This was apparently the first real indication to Ken Caillat that they were having problems. He'd witnessed Lindsey flirting with other women at Agatha's in the evenings, but simply assumed they had an open relationship. Unfortunately the fighting infected the atmosphere to the extent that the usually civil McVies started arguing too. Eventually both women walked out.

One of the many benefits of renting an apartment downtown was that Stevie and Christine were a little closer to civilisation, a little further from the madness and, crucially, were able to frequent some glamorous shops. It was still relatively new for Stevie not to have to avoid going into stores at all, being so poor she couldn't bear to expose herself to temptation. Life had changed. She could now do – and buy – what she wanted. And by God, she did.

As well as fashionable clothes, shawls and make-up, Stevie and Christine would buy "little beautiful coke bottles that you wore around your neck," recalls Christine. "Gold, turquoise, with diamonds... it was an aesthetic thing... The boys would be doing huge rails of coke while Stevie and I would [have] our little bottles with tiny coke-spoons that we'd wear on delicate chains." It was, "ladylike, more refined," concurs Stevie, admitting that it was actually acceptable at the time too. The payback would be "a complete bitch", however.

For Stevie, the ritualistic nature of drug paraphernalia tied in perfectly with "the candles, the incense, all that stuff". In her imagination, sparked by the romantic draw of cocaine and everything that surrounded it, a powerful character was coming to life like an exotic homunculus.

Drawing the shades in her apartment, lighting a candle and some sticks of Nag Champa incense, Stevie meditated on new ideas, humming quietly, words and couplets darting about in her head as the sweet smoke surrounded her like an aura. The following night in the studio, she would retreat to Sly Stone's overtly seductive hide-out with her Fender Rhodes and a cassette-recorder, eventually emerging with a compelling demo. 'Gold Dust Woman' was ready to be unveiled for the first time.

'Gold dust' naturally refers to that expensive powder that kept disappearing up rock stars' nostrils amongst other places (according to oft-dismissed rock'n'roll rumours), but Stevie herself has insisted the song wasn't 'entirely' about cocaine – which, by the way, Stevie rarely bought; it was just 'around'. The lyrics also referred to her anger (dragons), fear (black widows) and an underlying anxiety of what effects sudden wealth, fame and power could have on a person. Stevie had had an insight of just how overwhelmingly 'big' it could get; she just didn't assume it would grip her in the way that it would. The 'Gold Dust Woman' is the character and the story Stevie created to project those fears of the future onto, but it – she – was also a mirror that offered a grim flicker of the future. 'Take your silver spoon,' Stevie would sing, referring to the tiny cocaine spoon that dangled around her neck, 'and dig your grave...' her lilting country twang providing an eerie contrast to the lyrics.

"I had a serious flash of what this stuff could be, of what it could do to you," Stevie told *Spin* in 1997. "And I really imagined that it could overtake everything, never thinking in a million years it would overtake me."

The line 'rulers make bad lovers' refers to how powerful they had all become, how possible everything was, but also what that could potentially do to them in the long run. "I was definitely swept away about how big Fleetwood Mac was and how famous I suddenly was," she admitted. "I might be a ruler, but maybe I'd be a lousy lover," it being generally accepted that excessive cocaine use doesn't always make for the most fulfilling of sexual experiences either. Drugs weren't the whole story in 'Gold Dust Woman', however. The words also referred to 'groupie-type women', the femme fatales, manipulators and hangers-

on who stared daggers at Stevie and Christine, but were all smiles whenever a male member of the Mac came into the room.

Stevie had taken a historical, fairy-tale image – a powerful, formidable 'ancient queen' – and blended it with chemical abuse, broken love, shattered illusions and the wreckage of celebrity. This was your warning against too much of a good thing, although it's not as if it would curtail the band's frequent need for the white stuff. In fact, the evening was wearing on, and when Stevie entered the studio with her tape to play it to the rest of the band, they all broke for a 'bump' so they could feel perky enough to give it their attention and learn the parts despite the late hour.

By the time the demo had been played, everyone "realised this was a very special song" said Ken Caillat. The demo was free from the ghostly wails and smashed glass percussion that augment the track we know and love, of course, but it was clear it could "take some very unusual sounds" to make it even more atmospheric and unnerving. Lindsey was already somewhat freaked out by it. "It's an evil song," he said. "Very dark, and I'm guessing that the acrimony was directed at me." Stevie has always insisted she was never into witchcraft, but this song, coupled with her black clothes and love of the moon and Welsh witches, would be enough to convince the world she had considerable cosmic power and was not to be messed with.

After a 'transcension' into the small hours, they were getting somewhere and the song was already very different from the original demo, which was "harder and more rock'n'roll" as Ken remembers it. Lindsey played his Stratocaster through the Leslie, a sound Stevie loved, and she wanted to sing the work vocal in the studio with the band, so a directional mic and baffles were set up. After something to eat, a little cocaine, a joint and a splash of Courvoisier, Stevie was ready to sing the first vocal take at around 3am. The studio was fully lit, which didn't suit the eerie mood of the song, and Stevie started to become more and more inhibited with every take. Eventually it was agreed that a change in atmosphere was required. The lights were dimmed and Stevie sat on a chair, wrapped herself in a cardigan and arranged her supplies around her – Vicks inhaler, tissues, a bottle of Calistoga mineral water and a carton of lozenges to ease her throat.

Jim Grissim from *Crawdaddy* was there, having just interviewed Stevie, and he watched the whole process unfold. "The song required a lot of power and an equal measure of feeling," he observed. "Stevie had achieved an astonishing command of the material and on the eighth take she sang the song straight through, nailing it perfectly." By the end of the take, as Ken Caillat remembers it, "Stevie was howling like a witch on fire." This would arguably be one of the most compelling tracks on the whole record. It would be matched in power by 'The Chain', the song that opened side two of the original vinyl album.

"'The Chain' is really my song," Stevie would say. "We split [the royalties] five ways but the fact is I wrote most of those words and most of that melody."

The song had an awkward start in life; the rest of the band had been trying to work out why the groove they were working on wasn't happening, Stevie asked if she could help and while she was rebuffed, they soon realised the melody and chorus that she'd come up with on her own worked perfectly with the parts they were sketching into life. "If Stevie hadn't had that melody and those words, it would never have happened," insists Ken Caillat. "That's another example of how undervalued she was by the band at this point."

Richard Dashut has described *Rumours* as an 'aural collage' – there would be so many overdubs that the tapes actually started to wear out – but 'The Chain' is the ultimate composite track, and its title pays tribute to this. But it is also a clear nod to the symbolic emotional chains of Fleetwood Mac, unbreakable and strong, for better or worse. Stevie had come up with a melody on the piano, and, feeling there was something there and sharing it with the band, the other writers worked with her to develop it. She had also written another song with many of the words that would end up on 'The Chain'. And so these elements came together to provide the foundation of a shadowy song that, lyrically, would be almost frightening in its passion, again, like a curse – 'damn your love, damn your lies...'

Soon 'The Chain' would be more than just a great song; by the mere process of working it through as a band, it would be part of a healing process, uniting them and reminding them of what they had. Lindsey

and Mick worked out the beginning, a simple bass-drum beat interlaced with the mysterious, Oriental sound of the Dobro guitar. They added the original chords from the chorus of a song called 'Keep Me There', Christine and Stevie thrashed ideas out on the piano, and John worked out a bass solo which "we all loved," Stevie remembers. "It's like, the monsters are coming!" It would be the first song written by the whole band and, while the sentiment was that of an intense, damaged love, it was a poignant conclusion of togetherness during the fractious year that would birth their album – originally titled *Yesterday's Gone* (a reference to 'Don't Stop'), but ultimately taking the title *Rumours*.

Whether flirtatious, confessional or downright confrontational, everyone's songs together simply sounded "like a bunch of rumours", as John McVie noted. It was the perfect title, and it also wryly referred to the flurry of sensationalist gossip about them in the music business and the press, members of which had gleefully cottoned on to their romantic complications and were now making all sorts of claims about who was now sleeping with whom.

"They said Stevie was sleeping with me..." wrote Mick Fleetwood (perish the thought). "Christine had run off with Lindsey, Stevie was seeing John and me on alternate Wednesdays, Stevie was leaving, Stevie had left months ago and this was why the album had been delayed, Stevie practiced black magic and led a coven of witches in the Hollywood Hills... So rampant were the rumours that sometimes we heard them fifth-hand and had to call each other to make sure we were still sane and in touch." Fleetwood Mac elected to use the British spelling of 'rumours' when the time came, presumably in tribute to the Londoner who came up with it. It was scheduled for release in September 1976. That wasn't going to happen.

Albums weren't supposed to take this long. To put it into some kind of context, The Beatles recorded their first album in one day, all bar four tracks they'd already recorded, and Iggy Pop's *Lust For Life* took eight days to make, although, granted, there weren't quite as many people involved as there were in Fleetwood Mac. The Eagles, at least, would have been able to sympathise to a degree, their own autobiographical album *Hotel California* taking a painful nine months. The making of

Rumours would leave even the generally cheerful Richard Dashut something of a broken man – and they weren't even half way through yet. He described the process as "boredom punctuated by sheer terror". There were occasional moments of joy, "but not many".

"There were tears," he admitted. "I don't think there was a time when any of us didn't cry. There was a lot of anger, yelling..." By March, Richard and Ken Caillat had "lost all ability to keep the band sane", as Caillat himself admitted. The drugs and associated paranoia were out of control and the daily start time was getting later and later. As soon as the group could take no more, Mick Fleetwood commanded them to 'transcend', push through and keep playing into the night. These 'transcensions' were frequent occurrences, but only tended to be participated in by the "coked up crazies", says Ken, meaning Stevie, Mick and Christine. John and Lindsey were rarely up for unnecessarily late nights – once the clock started to tick towards 3am, Lindsey's tactic would be to say he was going to the bathroom... and just leave. But they didn't always have a choice, and the intake of cocaine was largely motivated by the need to stay up and work.

Before long the band's body clocks were so confused, they were getting up at 8pm to go to the studio and work through the night. A familiar scene would be Mick bending over the mirror for a 'toot', huge eyes flashing and a wide grin appearing on his face. "The woods are lovely, dark and deep," he would recite. "But we have promises to keep, and miles to go before we sleep..." The verse he was paraphrasing, a favourite no doubt memorised during his public school days, belonged to the Robert Frost poem *Stopping By Woods On A Snowy Night*. I think Frost was referring to a different kind of snow, but whatever works.

There would be a 'banquet' every night, like a Roman bacchanal, a drawn-out, drugged-up mess, according to studio owner Chris Stone. "The band would come in at night, party till one or two in the morning and then, when they were so whacked out they couldn't do anything, they'd start recording." In the meantime, hangers-on continued to party while the band tried to work. One favourite dealer of Mick's was going to be credited on the artwork for supplying them so freely, but he was executed before the album was released. That's right. Executed.

Christine would later refer to the whole affair as a 'trauma'. And it wasn't nearly over yet.

The band would take a few well-earned weeks off, leaving the Record Plant several thousand bad vibes heavier, the walls still ringing with a confusion of vicious rows and potent music. Something else Stevie would leave behind was her romantic partnership with Lindsey, once and for all. "We were just finishing up the end of our songs in Sausalito and I said 'We're done, I think this is over,'" she said in an interview with Oprah Winfrey in later years. They were both devastated (Stevie and Lindsey, that is, although no doubt Oprah was sad too), but they had to take time away from each other, because, as Stevie insisted, "No matter what it takes, our breaking up is not going break up this band. I'm not going to quit and neither are you..." And so another layer of bitterness started to harden – Lindsey Buckingham, according to Stevie, would never get over the fact that their relationship's demise was hastened by joining Fleetwood Mac.

"Lindsey always blamed Fleetwood Mac for the loss of me," she said. "Had we not joined we would have continued with our music but we probably would have gotten married, had a child... We were still young enough, destiny could have taken us another way. But destiny took us straight into Fleetwood Mac."

Chapter 9

The Eagles' Don Henley arrives on the scene.

Three things he was good at:

1) Being charming.
2) Spending money.
3) Movin' on.

1976 might have been the year of disintegrating relationships for every member of Fleetwood Mac, but there were new romances brewing. This would be the year Lindsey Buckingham met Carol Ann Harris, who worked at the Producers' Workshop where *Rumours* would be mixed, a studio on Hollywood Boulevard ("between sleazy theatres playing *Dick City* and *Squirm*," recalls Fleetwood). Harris had long, blonde wavy hair and big searching eyes, not unlike Lindsey's last girlfriend, although she was something of a hard act to follow. Stevie wouldn't find it easy being around Carol for obvious reasons, and Carol herself would note the constant tension between Stevie and Lindsey, as if they weren't yet over each other. But Stevie herself had found new love: Don Henley, founding member, drummer and singer of the Eagles, a band Stevie had always loved. "He was cute, elegant, sexy. Such an interesting guy," she told *Spin*. She didn't have the best first impression of him, however.

During the hot, hazy summer of 1976, Fleetwood Mac would open for the Eagles on a smattering of US shows. The Mac and the Eagles had neighbouring dressing rooms on the first of these shows and, when Stevie entered to get ready for the show, she was confronted with a bouquet of roses with a card: "The best of my love... Tonight? Love Don", in a cheesy reference to the Eagles' 1974 hit 'The Best Of My Love'. Stevie hadn't even met Don yet and was apoplectic at the crass proposition. She hadn't noticed John and Mick, who had bought the flowers and written the card, giggling like a pair of naughty schoolboys in the corner. Just as Stevie was on the point of rushing out to find Don and tell him exactly what she thought of his invitation, Christine quickly took her aside to explain that Henley wasn't to blame. "It was a while before Stevie felt like talking to either of us again," said Mick.

Quite unlike the false impression she'd had of him, Don was a Southern gentleman and his irresistible charm would impress Stevie when they met. They had so much in common already, and, after crossing paths as inevitably they would on several occasions, it didn't take long for Don to pick up the phone and initiate something more. Lindsey, meanwhile, was observing everything as it happened. "I could see it coming," he said. "It's strange, it's one thing to accept not being with someone, and it's another to see them with someone else, especially someone like Don, right? A big star in another group."

"It was 1976, right after [we] really made it, and the Eagles had been famous for a long time," remembers Stevie. "So he found a very different girl in me than in most of the women he was used to hanging out with, and we had a very special relationship because of that."

Don's star power and wealth was considerable – there would be 'cranberry Lear jets' sent to pick Stevie up and many other extravagances – all very nice, but subtlety and timing was not his strong point. The Eagles had started recording at Criteria Studios in Miami, and soon Fleetwood Mac would do the same. The Mac stayed at an idyllic house on the water. "It's romantic, it's pink, it's like Mar-a-Lago*," she said. "Anyway, he sends a limousine driver over with a box of presents for

* A beautiful estate on Palm Beach, Florida, now owned by Donald Trump.

me and they're delivered right to the breakfast room where everyone's eating." And when she says 'presents', we're talking vast bouquets of flowers and fruits, an expensive stereo and a selection of "fabulous records..." all being loaded onto her breakfast table by the driver. "And I'm going, 'Oh no, please, this is not going to go down well.' Lindsey is not happy..." Perhaps that was the idea.

Ostentatious displays of affection aside, the fact that Don was "a big star in another group" was a plus – there was an empathy, rather than the imbalance there would have been between a rock star and a groupie, which is the sort of situation it's fair to assume Stevie is referring to with her earlier comment on "the women he hung out with". These two were on the same level.

Henley also taught her how to spend money like a star. "He didn't set out to do that, I just watched him," she said. Taught by the best, it would seem. Henley thought nothing of buying a huge new house or a flashy car. The earlier mention of a Lear jet should tell you all you need to know. One fine example of how well Stevie had learned from her paramour occurred in 1983 when, one night, "me and a bunch of my friends were up all night doing cocaine and watching that movie *Risky Business*. That's one of my favourites." She saw the 1979 Porsche 928 driven by Tom Cruise in the film, and decided she wanted it. "And I just made a call and that Porsche was delivered. I said, 'I want the same Porsche that's in *Risky Business*.' And I bought it that morning." In rose, apparently.

As Lindsey came to terms with seeing Stevie and Don together, he realised it didn't "bum him out" as much as he thought it might. At least, that's what he told the press, and possibly himself. In reality, it must have been difficult and confusing, but he relished the opportunity "to be Lindsey Buckingham" again, not just one half of a duo. Lindsey would even concede that "someone like Don is good for her... The whole breakup has forced me to redefine my whole individuality – musically as well." He also told *Rolling Stone* that, once the loneliness lifted, he was "surprised we lasted as long as we did."

Seeing another successful musician outside of the band had its disadvantages too, however, especially in the sexist seventies music

industry. Stevie remembers: "I was up at Don's house having dinner with him and his manager, Irving Azoff (later Stevie's own manager). Glenn Frey of the Eagles walked in, looked at me and said, 'Spoiled yet?' Like, no mention of Fleetwood Mac. I was not even in the league of a singer. I was nothing more than a girl. My claws went out and I wanted to get out of there." Stevie, who would later call Glenn 'witchy' – a compliment in Stevie-land – admitted she 'loved' him and that this was in the past, but this little experience was one she wouldn't forget. "Going out with a very famous man, a rock'n'roll singer, and have people not relate to me like I even had a job..."

Stevie would also date songwriter JD Souther briefly, another who was "very, very, very chauvinistic" and who in his time had cheated on girlfriend Linda Ronstadt with none other than Joni Mitchell. Stevie found JD "wonderful but very Texas". She realised that if she wanted any of these relationships with famous men to work, she had to refrain from ever talking about her own professional life to shield their fragile egos. "It didn't help my status with the man to bring up anything I did, so I didn't. And then you start saying, 'But I work too. I'm happening. I write songs, but you aren't giving me a break.'" Cut to today, and Stevie is a happy singleton. It's not hard to see why.

September would see a return to LA, to the smog, and to another studio where a 'mutilation' would take place. Yes, 'Silver Springs' might have been 'a winner', but it was also too long – eight minutes in total, potentially taking up the space of two songs on the vinyl record. Ken would have to sit with Stevie for hours trying to cut some of the many verses. "While we worked, tears ran down her face," recalled Ken, who describes Stevie's words as 'her obsession'. "[She sobbed] 'These lyrics mean so much to me, they're part of the story and we can't cut them...'" However, when it was explained that it was that or risk losing the song from the album, she agreed, although, after several hours of hacking at her precious song, she was drained and emotional. The only other option would have been to lose one of her other songs, as it just wouldn't have been fair on the other writers to have such a long track on the album unless she was prepared to lose another of her own. Her eventual agreement was helped along by the understanding that she

would receive fewer royalties should she opt for keeping 'Silver Springs' in its entirety and drop another song.

"As soon as she realised this, it was as if a miracle had occurred," Ken Caillat writes. "The tears went away and she stopped resisting most of my edits. She was a business woman!" They successfully chopped 'Silver Springs' down to 4.33 but, as it would later transpire, even this wouldn't be enough. They had just 22 minutes per side, and there was also concern regarding "how it would flow with the rest of the songs," said Ken. Fate stepped in when Stevie unfortunately elected not to come into the studio one day, and, while she was absent, someone voted 'Silver Springs' off the album altogether in favour of recording another of Stevie's songs to replace it. Lindsey suggested 'I Don't Want To Know', a song from the Buckingham Nicks days, a bright, uptempo duet boasting tight, Everly Brothers-like harmonies. The band recorded the basic track without Stevie. All it needed was her vocal.

When Stevie swept in the following day, she was bemused that the band had recorded another of her songs without even consulting her – surely this meant she now had more songs on the LP than anyone else? Not exactly... It was time to break the bad news. Lindsey had nominated Mick to tell her because his situation with her 'was already fragile', and Mick was the band leader, after all. After a band meeting, he agreed, telling the others that he'd "let her know that we've all tried, but there's no other way to make this record perfect. She'll just have to trust us." Sales for *Fleetwood Mac* were rocketing, their attorney Mickey Shapiro had informed them, and the pressure increased to make *Rumours* the best it could be – they were already superstars, but two hit albums in a row would change their lives. Therefore, they had to be ruthless. The modus operandi was to make the record all-killer-no-filler, every song had to be a potential single. But 'Silver Springs' was hardly filler, and Richard and Ken in particular were regretful about the decision. Not as much as someone else was about to be, of course.

Mick approached Stevie as if he was walking towards an incendiary device. He gently suggested they go out into the parking lot. "I knew it was serious," remembers Stevie, "because Mick never asks you to go out into the parking lot for anything." He explained that the general

consensus was that they wanted to use 'I Don't Want To Know' instead of 'Silver Springs', which was still too long and not upbeat enough to fit with the other songs. Stevie protested that she didn't want 'I Don't Want To Know' on the album, to which Mick reasoned, "Well, then don't sing it." Detonation was mere seconds away.

"I started to scream bloody murder," Stevie admitted in an interview with the BBC. "Probably said every horribly mean thing that you could possibly say to another human being." Stevie insisted she was one fifth of the band and she had a right to boycott 'I Don't Want To Know' – her own song, after all – but it was made clear that she could either get on with it and sing, put up with having just two songs on the album or leave. Angry and upset, Stevie eventually cooperated and sang it "with a gun to her head". But no one could deny that, as Richard Dashut said, "'Silver Springs' was the greatest song never to make it onto an album." The decision to put it on the B-side to 'Go Your Own Way' was further insult to injury.

Other songs of Stevie's that were recorded but not included on *Rumours* were 'Think About It' and 'Planets Of The Universe' – she was, as Ken recalls, "a little dismayed" they weren't selected but she was building up a fine stash of work should she choose to release a solo album. It was restrictive for a writer as prolific as Stevie to have to provide just three songs per Fleetwood Mac album.

Warners were getting edgy: the album release had been postponed to February 1977 and they wanted reassurance. Mick Fleetwood organised a listening party, where only 'Dreams' and 'Go Your Own Way' would be revealed. By the end of 'Dreams', the studio executives were swaying to the music, and as 'Go Your Own Way' concluded they were even applauding. They asked for more, but Fleetwood told them they would just have to wait. He thought it best to quit while they were ahead. But the suits were already confident that, as they'd hoped, the next Fleetwood Mac album would match, even surpass *Fleetwood Mac* in sales and acclaim.

Mixing would continue at Studio B in the Producers' Workshop, where Lindsey and studio manager Carol Ann Harris quickly became an item. Harris remembers the first time she met Stevie very well, describing

her as "a tiny hummingbird... brushing past in a blaze of colour on a cloud of patchouli and ylang ylang. I'd never seen anything so bright and dynamic before." Carol watched Lindsey's irritation around her, the chemistry still crackling between them, and also observed with slight surprise the reaction Mick Fleetwood always had around Stevie, straightening up in his seat, winking at her, flirting... Surely not?

During this period, the shoot for the album artwork was arranged and the romantic, classical shot of Mick and Stevie on the cover would cause some controversy, if only within the Mac. The photographer Herbie Worthington, who had also shot the cover of *Fleetwood Mac*, ran the shoot and focused very much on Stevie and Mick to create a visual extension of the *Fleetwood Mac* cover image, which featured Mick towering over John McVie. Mick's pose would be similar on both covers, upright and aristocratic, and on the cover of *Rumours,* Stevie Nicks, bedecked in gossamer chiffon and wearing her black ballet slippers, entwined around him, arms apart like wings. Between Mick's legs were his trademark dangling wooden balls*, and in his hand was a crystal ball into which Stevie was gazing, 'crystal visions' indeed. Mick had wanted something 'special' and 'Shakespearean', an enigmatic work of art that would capture people's imaginations for years to come. However, the rest of the band were put out that Herbie was concentrating on just two members, rather than reflecting the group. The photographer wasn't trying to promote anyone over anybody else, and there would be a group shot on the back, but Lindsey in particular was not pleased.

Contact sheets were sent to the band by December. Herbie had already chosen his favourite image from the session, and was pleased when the general consensus was to select the same one. Lindsey, however, "has never forgiven me for not being on the *Rumours* cover," he said. "[He] came up and said, 'I wish I could have been on my own cover.' That's

* Fleetwood explains his balls: "At one gig in the early days, I came back from a toilet break with the lavatory chains, a ball attached at each end, wrapped around my waist. I did a solo, hitting the balls into the microphone, just to make the lads laugh. Talk about spontaneous expression! The funny part is, my balls never went away."

showbiz." Would it have been less of a problem if it had been Mick and Christine on the cover? Who can say?

After a brief but much-needed Christmas break in Phoenix, Stevie reunited with the band in Hollywood before New Year to add the finishing touches to *Rumours*; by January 4, 1977, everything was complete. Fleetwood Mac would celebrate finishing the making of *Rumours* at a French restaurant on Melrose, but Stevie would be conspicuous by her absence, as Lindsey was there with Carol Ann on his arm. They'd both had their romances since splitting up, but it was the first time he'd started seriously dating someone. Life after Stevie Nicks. Inconceivable. And, given the circumstances, impossible.*

Still, it was time to celebrate at last, and Stevie wasn't just walking away as soon as the work was done. She was planning a party of her own. Fleetwood Mac were exhausted but thrilled to have finally finished *Rumours* and yet they were still largely oblivious to just how strong this album was. Ken Caillat had given everyone a tape, and Stevie could think of no better way to hear the songs they'd all grown rather tired of than in the company of friends.

The party was arranged to take place at Stevie's brother Chris's house in Whitley Terrace, above the Hollywood Bowl. There they could also enjoy an impromptu screening of *Snow White And The Seven Dwarfs*, because Warners had given Stevie a copy of the Disney animation. Ever the child at heart. By 7pm, the drink was flowing and pot was being smoked. Ken Caillat, as instructed, had brought his Revox two-track

* Stevie and Lindsey were outwardly still seen as a team in many respects, and another album that would be released in 1977 was Walter Egan's *Fundamental Roll*, a record that featured Buckingham Nicks on co-production duties and backing vocals (particularly, in Stevie's case, 'Magnet And Steel' which would hit the Top Ten). Egan, a singer-songwriter from New York, loved Buckingham's guitar work on *Fleetwood Mac*, and, on Keith Olsen's urging, invited him and Stevie to work on his debut solo album. The three would become friends, but during the period *Fundamental Roll* was being made back at Sound City, the friction between Lindsey and Stevie simply became unbearable. Egan found himself refereeing their arguments (and also admits to 'falling quite hard' for Stevie), and soon the pair were having to turn up separately in order for anything productive to happen at all.

machine, connected it to the stereo and rewound the tape while the assembled illuminati and members of the inner circle settled down with their drinks. It was a pleasant surprise for the band to hear the songs with fresh ears, not to mention a revelation to the other guests. Everyone applauded and whistled, and Fleetwood Mac lapped up the adulation. If this was a sign of things to come, they had nothing to worry about. Nearly a year in the studio for less than 40 minutes' worth of songs.

But what songs. They had gone beyond what they had set out to do – make an album that could outshine *Fleetwood Mac*, on which every track could be a hit. It was an instant classic; everybody in the room knew it. And yet, they were, as Ken put it, "still so close to the album [they had] no idea what they had created."

Chapter 10

Everyone has different memories of the same things. There are some prime examples of this in the following chapter:

Photographer Annie Leibowitz was sure she provided the band with copious amounts of drugs for their now iconic Rolling Stone shoot. Stevie can only remember champagne. (Maybe it was all the drugs.)

An intimate moment would occur between the estranged Buckingham and Nicks. One remembers it lasting for hours. The other, 15 minutes. Either way, "people were getting uncomfortable".

Stevie insists she and Christine were 'rock'n'roll nuns'. No comment.

Some 800,000 copies of *Rumours* were shipped to dealers in February 1977, the biggest advance order in Warners' history. No doubt helping to boost sales was the compelling sense of intrigue swirling around the band, a complex psychodrama that gripped both the public and the press, who had just never seen anything quite like it. Journalists delighted in concentrating on the personal traumas within Fleetwood Mac and, outwardly, the band were generally good-humoured about it; in reality they were uncomfortable with the idea of presenting their raw emotional wounds to the rest of the world to pore over. But the soap

opera was part of them now, and always would be. It was also priceless PR, and they were required to work it. *Rolling Stone* wanted to run a frank interview with the band to coincide with the release of the album. The piece, written by Cameron Crowe (also the man behind films such as *Almost Famous*), would be titled 'True Life Confessions', and the band would be photographed for the cover by none other than Annie Leibovitz. Stevie was now receiving constant reminders that she'd made it, but this was a significant one. *Rolling Stone* was one thing. Being on the cover, another altogether. Shot by Leibovitz? Fleetwood Mac were entering a new stratosphere.

The shoot took place at a rented room in LA (although Carol Ann Harris has claimed it took place at Lindsey's house), and the group turned up, stepping over cables and manoeuvring around lights, needling each other and making straight for the champagne that Annie had wisely elected to provide. In Annie's memory, she'd brought "huge amounts of drugs" which they all consumed with enormous enthusiasm and before long everyone was "out to lunch". Stevie only recalls the champagne (although how anyone recalls anything from this day at all is amazing in itself). Either way, everyone caned it, and with good reason: Annie, tough, tomboyish and imaginative, had just told Fleetwood Mac to get into bed with each other.

It was a courageous, funny idea. It was also raunchy, oozing with sex, partner-swapping, incestuousness, not to mention a sense of 'hands-up' humour in the face of pain and romantic complication. The rest of the world was amused by the stories about them, why shouldn't they show they could laugh at it all too? Well, they weren't ready to. Still, Annie pushed them straight into the deep end without water wings, with interesting results. Stevie claims this shoot sparked the attraction between herself and Mick, although it would appear Mick at least had been smitten for some time.

"When Annie said she wanted us to lie down together on a big bed," said Stevie, "it was like, 'Hmm, hope you have a backup idea.' I said, 'OK, but I can't be in bed next to Lindsey.' So I curl up next to Mick for the next three hours while Annie is suspended over us on a platform." Again, there are slightly different versions of the course of

events, probably because most of the people involved were out of their tree. Carol Ann Harris claimed the shoot took no more than an hour. Whatever, time is a liquid concept; liquid being the operative word in this case.

Stevie, looking like a little girl in a peach satin 1930s nightgown, dubiously wandered to the giant mattress that Annie had brought. The band members had been dawdling, perhaps understandably, but as Harris recalls, the esteemed photographer would simply bark at them to come in once the set was ready. Time was money. "Come on, you guys," she shouted. "Quit fucking around in there, I need you in here now."

Christine was not keen to be next to John in the picture, their divorce was still fresh; so she was placed in the arms of a bare-chested Lindsey while a bejeaned John was consigned to the other side of the mattress, alone and reading a copy of *Playboy*. In the middle was the lanky Fleetwood, covered partially by a thin white sheet, with a curled up Stevie smiling mischievously by his side. Lindsey admitted that "the idea for the photo wasn't all that funny", because the animosities in the band, particularly between himself and Stevie, were still very close to the surface. However, after 'compartmentalising' their feelings (Fleetwood Mac are big on psychobabble) to get through the session, something happened. There are two versions of what that was, but the end result is the same – there was an intimate coming together of Stevie and Lindsey. The only matter of dispute is how long that intimacy lasted.

Here's Stevie's version, courtesy of *Rolling Stone*: "Lindsey and I got to talking about how amazing it was that not so long ago I was a waitress and he didn't have a job, and now we were on the cover of *Rolling Stone* with this huge record. And we lay there for two hours talking and making out. Finally, Annie had to tell us to leave, because she had rented the room for only so long. But in one afternoon she put Lindsey and me back together and also planted the seed for Mick and me... You want to know the power of Annie Leibovitz, there you go."

And Lindsey's: "We had this moment of not being able to avoid all that had been lost. We embraced for about 15 minutes, and Mick finally came over and said that people were starting to get uncomfortable."

Stevie is, as even the most devoted fan would surely agree, prone to the occasional exaggeration, but the important thing is that there was a moment of tenderness after all of the hurt. Carol Ann Harris was in the next room, by the way.

The band had been rehearsing for the *Rumours* tour since the beginning of February 1977 at Rat, a small studio in the San Fernando Valley. Soon they would transfer to the large sound stage (Soundstage B) at SIR studios on Sunset Boulevard, struggling to work every day for a month through howling wind and rain. It was a tough period for Stevie; Lindsey Buckingham was back to his usual impatient self with her.

To cope with his moods, Stevie simply found herself getting smaller and smaller, "mouse-like, [I] would never dare offer a suggestion," she said. "It was like a living nightmare... everything about me seemed to bug him: my laughter, the way I could deal with a lot of difficult things, [it] all made him want to cringe. So I changed when I was around him." At least Stevie could retreat to her loyal coterie of whispering ladies in waiting, who offered comfort and company which, in turn, created an atmosphere that excluded everyone else. It was like a group of bridesmaids, or schoolgirls sharing secrets, talking behind their hands, sweeping hither and thither behind the Queen Bee.

The glamorous Carol Ann Harris had been invited to rehearsals by Lindsey, which, as Lindsey no doubt predicted, would cause Stevie no small discomfort. John McVie's new girlfriend Julie Reubens tried to make Carol Ann feel welcome, but, while she had the right look, there was no way she was going to be invited to join Stevie's loyal gang, who eyed her with suspicion.

Stevie would, according to Carol Ann, attempt to make sense of Lindsey's interest in her by assuming it was because of their similarity, which wasn't hard to see. Stevie also learned that they shared a birthday – May 26. Carol Ann wrote in her book *Storms* that Stevie took her aside during a break to tell her so, apparently adding, "You must be so much like me that it's almost mystical. No wonder Lindsey would go for you." Carol Ann "didn't know whether to laugh or scream", but sardonically offered that "John Wayne also was born on May 26..." If this was Stevie's way to tentatively connect with Carol Ann, it had been

rejected. If it was her way of trying to understand Lindsey's attraction by blatantly suggesting it was just because he was trying to find another Stevie, it had been flatly ridiculed. But for all Carol Ann's amused wariness of Stevie, she concedes that her beauty was breathtaking and once she started to sing, even in rehearsals, the power was overwhelming. Stevie had become a fantasy figure for men and women alike, a combination of vulnerable child and powerful sex symbol, not that Stevie felt particularly comfortable with it herself.

"It annoys her," Christine said in a TV interview at the time. "People are happy to put her in the role of 'sex goddess, starter of trends...' [but] she's totally unaware. She goes on stage and does what she does... as she says, she has nothing else to do with her hands. My hands and feet are occupied. She's free to do what she does and it contributes in a very positive way to the band."

The upcoming tour would see Stevie's onstage style come into its own, and it was an extension of her *Rumours* cover look. Gone altogether were the jeans and floral tops of the *Fleetwood Mac* tour. With the help of designer Margi Kent, who helped her design her 'uniform' for the *Rumours* artwork, she now had a capsule wardrobe that gave a nod to the character she had created in 'Rhiannon', and gave her greater stature. At just 5 ft 1, platforms – sometimes with heels as high as seven inches – were a must, usually in tan, cream or lilac, and were made by local Italian bookmaker di Fabrizio. Stevie's hallmark top hat – found in a thrift store in Buffalo on the *Fleetwood Mac* tour – would also give much needed height. With these staple items, she never had to worry about not knowing what to wear. Plus black "looks great on blondes", she noted, and was also a classic slimming colour to wear, not that Stevie needed to think about that.

Stevie's diaphanous skirts would move easily as she danced, and if there was air-conditioning or a breeze at one of their outdoor shows, they would flow hypnotically around her. And then there were the capes and piano shawls which, again, would give Stevie a bigger presence onstage as she raised her arms like wings. The effect was similar to that of the Victorian modern dance pioneer Loie Fuller, who used voluminous fabrics in a similar way, swirling and moving like a butterfly, and, crucial in Stevie's case, visible from afar. One of Stevie's favourite capes, even

today, is her fringed, sequinned 'Gold Dust Woman' cape, created by Kent in gold chiffon. It looked ethereal but had the strength to withstand show after show, and wearing a shawl that was specifically designed for that powerful song only seemed appropriate – ceremonial, almost. It also helped to be able to put it aside afterwards, as if it could contain all of that dark energy that had been whipped up during the song, keeping it separate from the rest of the characters Stevie would inhabit during the course of a set. Before long, a Fleetwood Mac audience would be filled with Stevie-alikes, wafting about in drifty layers and top hats, going wild to 'Rhiannon'.

The *Rumours* tour began on February 24 in Uniondale, New York. Fleetwood Mac would now be playing 10-15,000 capacity halls; the Jefferson Coliseum in Birmingham, Alabama selling out within one hour because of the community's enduring love of Buckingham Nicks. The anticipation surrounding the tour was heightened by the fact that, by the end of February, *Rumours* had gone Platinum, one million copies sold within its first month of release.* To celebrate, the band partied for two days straight just before leaving for the tour, but in all the excitement, Stevie had forgotten she'd left her contact lenses in for 48 hours straight, wearing off her cornea. Short-sighted at the best of times, Stevie now could barely see at all. For the first show, she had to be carried by piggyback to the stage by John Courage, desperately tried to avoid the spotlight hitting her eyes and was soon ordered by a doctor to have her eyes bandaged for several days. As Carol Ann remembers it, the opportunity to take advantage of Stevie's temporary lack of sight was too much to resist for some – even her adoring handmaidens.

"They dressed her in outrageous outfits – 'You look really pretty today', we'd all grin – they put food and drink just out of her reach and set booby traps. Very childish, but we laughed like idiots." With friends like these... Still, it will have cheered Stevie to know that within days of setting off on tour, her own song 'Dreams' would be released, hitting

* At its peak *Rumours* would earn Fleetwood Mac a gold disc twice a month, and platinum once a month. A year later it was still selling nearly 250,000 copies every week.

the top of the charts by April; the only time Fleetwood Mac would go to number one in the US.

By the time the band played the Berkeley Community Theatre in San Francisco, Stevie's eyes had started to heal. It was a home crowd for Buckingham Nicks and both Stevie and Lindsey felt the pressure even more than usual. John Courage counted down the minutes from ten until the Mac had to be onstage while Stevie tipped her head upside down to brush her long home-permed locks, slicked on some extra lipstick, necked a vitamin pill and waited, giggling as Mick pranced towards her, his wooden balls clacking as he thrust his pelvis unambiguously in front of her. Lindsey glowered, and Carol Ann watched them both, wondering if her prince still had feelings for Stevie.

The show at San Francisco was mesmerising and the crowd loved it. However, Stevie was bereft, throwing herself onto a couch backstage and sobbing. Robin Snyder, always at hand, rushed up to console her as she wailed that the show was a disaster, she'd missed a cue in 'Rhiannon' and Lindsey had to cover for her. Lindsey meanwhile was nursing his hands, bleeding from his furious finger-picking, his face uncertain. It's fair to say that cocaine might have had something to do with their constant uneasiness, but both Stevie and Lindsey were devoted to the limelight, and it mattered to them perhaps more than anyone else in the band how they came across onstage.

Every night, Courage would pour the usual amount of cocaine onto the back of every wrist before the show, the bottle-caps of coke lined up in the wings for whenever anyone needed a bump, and yet, as Nicks insists, "We really were tame back then. We had to behave. We'd play a gig, get on an aeroplane right after the show and leave for the next place. And we were watched like hawks. We had security outside each of our rooms so Chris and I were almost like travelling rock'n'roll nuns." Yes, it was difficult for men to get anywhere near Chris and Stevie, which, from the way Stevie talks about it, was a reality that had its pros and cons. She spent a lot of time in her room just writing her journal, little notes in envelopes that she'd keep to look at in years to come. She had her friends, she had Christine – everybody else she'd give a wide berth. For the time being.

"We were cool onstage," she added, in conversation with *The Guardian*'s Tim Jonze. "But offstage everybody was pretty angry. Most nights Chris and I would just go for dinner on our own, downstairs in the hotel, with security at the door."

On April 1, Fleetwood Mac flew to the UK to start the European leg of the *Rumours* tour. Mick and John's concerns that they'd been 'forgotten' or abandoned by their die-hard blues fan base were quickly allayed – the band was greeted with enthusiasm, not to mention a raft of new fans won over by Stevie and Lindsey. This was a homecoming for Fleetwood Mac, and for those who had been sceptical about the dramatic change within the group. "We showed them our new tricks and changed their minds," said Mick.

The UK tour started right at the heart of England in Birmingham, near where Christine McVie was brought up. The flight was interminable, the food was dreadful and the weather was... well, English, really. To exacerbate the low mood, any warmth Stevie and Lindsey had shared during the *Rolling Stone* shoot had cooled considerably. "We hardly spoke," Stevie remembers. "We would get on and off the same plane without interacting at all."

The band became even sulkier when they reached the hotel, which wasn't as luxurious as they'd hoped. Yes, Fleetwood Mac might have essentially been a British band, but they'd been away for too long, they had a bigger following in the States now and while their fans were pleased to see them, their status in the UK just wasn't the same. *Rumours* entered the chart at number 34, eventually reaching the top by the following January. Stevie and Lindsey were a little shocked that the first date in the UK was at the Birmingham Odeon, which had a capacity of just over 2,000. They had been selling out 20,000 capacity venues back in the US.

To make matters worse, Carol Ann noted that the Odeon was "a decrepit theatre which looked at least 100 years old."* Stevie kicked up a stink when she realised she had just one rack to hang her many

* I thought Americans liked history. Anyway, it was actually built in 1937, which made it a youthful 40 years old.

wardrobe changes on backstage, Mick was whining for more cocaine and John McVie was just trying to get the radiator to work. The normally good-humoured tour manager John Courage was at the end of his tether, being the focus of all of the complaints, but somehow everyone got what they needed; the acoustics of the venue were perfect and the show was strong, perhaps the best on the UK leg of the tour.

Stevie might have been fearing a return to the bad old days of roughing it on her first tour with the Mac, but it wasn't all bad food and dirty hotel rooms – in fact, it would be on this leg of the tour that the band visited Eric Clapton's Italian-style villa near Ewhurst in rural Surrey, about 35 miles south west of London. The much admired Pattie Boyd, formerly Mrs George Harrison and now Eric's lady-in-residence, was still technically Mick's sister-in-law (Mick's marriage to Jenny famously wavered between on and off), and the whole band decamped after a show to Clapton's sumptuous home. According to Harris, meeting Clapton was, for the American contingent, tantamount to meeting John Lennon, but as awe-struck as they were to meet the legendary guitarist, they soon settled in once the drugs and booze started to flow. The boys played darts while getting increasingly wasted (you can imagine how this ended) and Stevie hot-footed it up to Pattie's luxurious bedroom for some 'girl talk'.

Eventually they came back down to find that Eric had brought down some more guitars and a jam session was about to kick off with another guest, none other than the late lamented Small Faces bassist and songwriter Ronnie Lane. As the snow fell outside and candles were lit, Stevie joined in with harmonies while the assembled rock royalty played the mournful 'While My Guitar Gently Weeps'. It was beautiful, if slightly awkward, considering the circumstances: 'While My Guitar Gently Weeps' was written by George Harrison, best friends with Clapton and also Pattie's beau in times past. Next up was Clapton's yearningly romantic 'Layla', written for Pattie before their affair was out in the open. So, yes. Awkward. Still, it was the seventies; and at least, when it came to complicated domestic arrangements, the Mac were in extremely good company.

Eric Clapton wasn't the only blues guitar hero that Stevie and the group would encounter during their visit to London, as none other than Pete Green, the group's long lost founder, showed his face at the hotel

where they were staying. Looking a bit down at the heel, he arrived with a ghetto blaster on his shoulder, blaring disco music, and knocked on their doors at night. On being granted entry, he sat on the end of their beds in silence. "Sadly he wasn't the Peter Green he must have been when writing 'The Green Manalishi'," said Stevie. 'The Green Manalishi', composed during Green's last months with the band, was inspired by a hallucination of a barking green 'dead' dog, and evokes a sense of dread and mysticism. It's not hard to see why it's one of Stevie's favourite Green-era Mac songs. "I always do those cries in the background when we do that song live. That makes feel connected to him," she explained. "He was very far away when I saw him. I tried talking to him, but he didn't want to talk, especially not about music and definitely not about Fleetwood Mac. He only wanted to watch."[*]

Culturally some of the differences in Europe were hard to take for Stevie and Lindsey – in some parts of the UK they felt as if they were in the dark ages, and the show they would play at the Pavillon de Paris, on the northern edge of the French capital, would literally make them sick. It was a huge space that had previously been used as a slaughterhouse, being as it was in the city's meatpacking district. There had been a bull-fight at the venue the night before Fleetwood Mac's show, the idea of which was bad enough but the stench of blood was still in the air, making everyone nauseous and turning Stevie 'positively green'. But, as always, the band rose to the audience's roar of approval as soon as they hit the stage. According to Mick Fleetwood, Stevie herself is an "audience addict" and as she worked her magic, teetering on her platform boots in front of the giant moon projection, her spell was cast on yet another converted audience. France has a deep love of the blues and rock'n'roll, but they took the new Fleetwood Mac very much to their hearts.

[*] Seven years earlier, Green's mental health had declined alarmingly when, at a party in Munich, he had his drink spiked with acid. The fall-out would see Green having to undergo electro-convulsive therapy, so it is little wonder Stevie found him to be 'far away'. Later in 1977, the year Stevie met him, Green would be arrested for threatening his accountant Clifford Davis with a shotgun, insisting that he stop sending Green royalties, which he considered 'dirty money'.

What was predictably hard for Stevie on this tour was that, every single night, she not only had to hear Lindsey sing 'Go Your Own Way', she had to sing the choruses with him. That 'shacking up' line stood out in bold relief and, "every time those words would come out onstage, I wanted to kill him," she said. "It was like, 'I'll make you suffer for leaving me.' And I did. It put me back in the place where Lindsey and I were when he wrote that song: back at our apartment [where he was] really angry with me. I had to revisit the world of the big fight every time he sang it."

One thing that would give her strength on stage in the light of all of this angst was a special gift from Don Henley, who had tapped into her love of myths and English legends. It was a pendant that depicted Merlin the magician that she wore as a good luck charm. Considering her kinetic stage performance, whirling and spinning, it was amazing the charm didn't fly off. There was a show when it nearly went – she came offstage to find it hanging by the chain from her waist – but it didn't fall off. "I feel that he's there. It didn't want to leave me," she said. Which is more than can be said for Henley when the time came to step up to the plate a little later down the line.

Stevie was treated like a queen by Don at first; after having endured years in the roles of 'Mr and Mrs Intense' with Lindsey, when Don and Stevie did manage to score some time together, he showed her a very good time. But Henley was not keen on commitment, and while Stevie had always dreamed of family life as a young woman, she realised quickly that it would not be a possibility with him. This was sadly no surprise to the Eagles crew, who knew him to swing from 'the ultimate Southern-charm gentleman' to 'distant and unreachable' when the chips were down. According to Marc Eliot's *Take It To The Limit*: "It was a pattern so familiar that it had become a running joke. Henley's favoured method of seduction became known as 'Love 'em and Lear 'em'," in reference to his penchant for picking up the object of his temporary desire in a Lear jet. During Henley's 'distant' patches, Stevie would direct her loneliness into writing and kept those she could rely on – her girlfriends – closer than ever on the road.

Chapter 11

"I love that people dress up like me – because I do that… I dress up like me."
Stevie Nicks

The *Rumours* tour was increasingly high octane and exhausting, so, to combat the fatigue and boredom, Fleetwood Mac ramped up the luxury: riders became more extravagant, travel was always first-class (no more sleeping on top of amps) and any sense of the whimsical or the eccentric was encouraged whole-heartedly to alleviate the dull down-time on the road. One example of this was the giant inflatable penguin that had recently joined the entourage, specifically to float above the band at outdoor gigs; though prone to erratic behavior, at its magnificent best it rose to a full 70 feet tall. John McVie had always been fond of penguins, to the extent that they became the band's mascot. You'd find the tuxedoed little chaps lurking on the corner of album sleeves, printed on flight cases or emblazoned on Access All Areas passes. The inflatable was a bridge too far for some, however. When Mick Fleetwood's family attended a show, his father looked up at the huge bobbing inflatable, and then looked back at his grinning son. "Penguins don't fly," were his simple but crushing words. Oh well, as Peter Green might say.

The major show for Fleetwood Mac during the summer of 1977 was undoubtedly Bill Graham's Day On The Green at the Oakland

Coliseum, California, on May 7. They would play on the opening day of this outdoor festival, sharing the bill with the Doobie Brothers, Gary Wright and the Steve Gibbons Band. Every year the festival brought together the cream of the rock crop, but this year was particularly strong: on the days that followed Fleetwood Mac's show, the crowd would be treated to sets from the Eagles, the Steve Miller Band, Heart (with whom Stevie would later strike up a friendship), Peter Frampton, Boz Scaggs, The Beach Boys... it was a rock fan's wet dream.

Fleetwood Mac chartered a private Viscount 40 propjet from Van Nuys Airport to get to the show, and Stevie immediately commandeered a cosy area at the rear where she and her girlfriends snuggled up together and snoozed under a blanket. John, Mick and Lindsey sank beer after beer with John Courage and Christine sat with the band's super-together secretary Judy Wong,* quaffing champagne and chain-smoking. Richard Dashut and Ken Caillat boarded the plane, and as Ken wandered towards Stevie's den, Judy warned him off. "It's kind of Stevie's area," she explained carefully, no doubt having first-hand experience of witnessing the cold front that could be expected by anyone venturing into her 'area' uninvited. Ken later commented on "Stevie's fan club", as he referred to them, with some suspicion. "In the future, Stevie would have more and more 'friends' around her," he said. "They would take control of her appointments and we wouldn't be able to reach her when we needed to. Finally, we wouldn't be able to reach her at all."

The Day On The Green concert series was relatively new, running since 1973, but it soon became an essential on the West Coast rock'n'roll calendar. On May 7, 1977, the great and the good of California cool

* Judy Wong was the subject of erstwhile Mac guitarist Danny Kirwan's song 'Jewel-Eyed Judy'. Kirwan has his own troubled story. Loved by Peter Green for his passion ("so into it that he cried as he played"), he ended up being fired after struggling increasingly with alcoholism, and later lived rough on the streets. Just before being sacked, Kirwan had a fight with guitarist Bob Welch that turned ugly and precipitated his departure. Welch, a sufferer of depression himself, would commit suicide at the age of 66 in 2012. Peter Green was not the only casualty within the Mac family.

were there to check out Fleetwood Mac. The crowd was 75,000-strong, the biggest audience Stevie and Lindsey had ever faced. Stevie: "I was standing in the middle of the stage thinking, 'This is the big time'." The show might have been in broad daylight – scuppering Curry Grant's atmospheric lighting – but the Mac created a potent atmosphere of neurotic energy, particularly during Buckingham's malevolent version of 'Oh Well', with Stevie hurtling across the stage with her tambourine, dancing wildly like a clockwork doll wound up just a few notches too tight. They quite simply weren't like anybody else on the bill, or any other bill for that matter. For Stevie, the show was one of the defining Mac concerts of the seventies, and the seventies was a defining decade. There was something about it that had "a magic that really isn't there now", not just for Fleetwood Mac, but for all of the major rock bands who reigned during that era.

Stevie's designer Margi Kent joined the band on the road to develop further costume ideas for her employer. She worked alongside Curry Grant, "because if I did special costumes, we wanted to build according to the vibe of the lighting", she said. "Believe me, in those days every day was a story. They travelled around like a family, whether they were getting along or not, it's still a family." Margi would become a close confidante of Stevie's – to be in charge of her look was to be in an intimate position of trust, after all – and Stevie loved her, continuing to work with her to this day. She would even dedicate 'Landslide' to Margi during some of these early shows, an honour indeed.

During this tour, a witch's hat would be introduced into Stevie's ever-expanding wardrobe. It looked perfect silhouetted against the Hallowe'en moon projected behind the drum riser, and, with her mystical demeanour and black robes, would add to the ever-rumbling speculation that Stevie was actually a bonafide sorceress.

Critics were less concerned as to whether she was a practising Wiccan or not than they were by her vocal performance. There was always a seductive crack in Stevie's voice, but it was now becoming so hoarse it was affecting her range and tone. The ubiquitous cocaine and champagne backstage (and sometimes onstage) had their uses; they gave Stevie false courage to step out in front of thousands when she was at her

most nervous, and pepped her up, "like taking one of your mom's diet pills", giving her the energy to cope with her myriad professional and romantic pressures, fittings, interviews, shows... but soon she couldn't go forward without it. Those tempting bottle-caps filled with cocaine would be in the wings at every gig. Already high, "Stevie tripped off stage right during every single break to change shawl and snag a bottle cap of blow", according to Carol Ann Harris. At the end of the concert, everyone was presented with their own wrap of coke to take with them to the hotel to get them through the night. This may explain why Stevie's purse was always brimming with pills such as Quaaludes – she needed something to bring her down and allow her a few hours' sleep.

The effect on Stevie's voice was becoming critical – the constant use (and chemical abuse) meant her voice was changing and getting lower. Robin, a voice therapist, was on hand to help her train and control her voice without strain, but it had little effect. Stevie's singing during this time would be described, unkindly, by *Rolling Stone*'s Peter Herbst as "growled incantations to rival Regan's (from *The Exorcist*), without Regan's exquisite control". He also commented on her 'sulkiness' between songs and physical instability; at one point 'frantic roadies' had to leap forward to prevent her from falling off the stage altogether.

Even so, fans were undeterred and 1977 was a huge year for Fleetwood Mac; a *Rolling Stone* poll awarded them the accolade Artist Of The Year, *Rumours* would be proclaimed Best Album, Stevie's song 'Dreams' would be voted Best Single and Nicks herself was nominated in the female vocalist category. *Rumours* also went to number one Stateside on May 21, displacing *Hotel California* by the Eagles. It would stay at the top of the charts for eight months.

Such fame thrilled and frightened Stevie in equal measure. In September 1977, the band would be hailed once more at the prestigious Don Kirschner Rock Awards, scooping honours for Best Group and Best Album, partying briefly and then heading home. Even after all of the acclaim and applause, Stevie, driving home separately with her brother Chris, felt 'lonely' and 'scared'. No matter how many people Stevie surrounded herself with, she couldn't shake the feeling of isolation. Being with family helped, although she had little time to see her parents

and many months often slipped by between visits. At least having Chris nearby when she was in LA gave her something of an anchor.

The band could not have survived the tough, drug-addled *Rumours* tour without several much-needed breaks to punctuate the year. In some cases they were only a few days, in others Fleetwood Mac would be able to decompress for a month. During one break, Stevie decided to do a little mansion-shopping. The only problem was that Lindsey and Carol Ann had the same idea... and were interested in the same house in the Hollywood Hills. Rock star problems, eh? Stevie got there to view it first, to her ex-lover's fury. It was a beautiful day, "the scent of jasmine in the air..." as Carol Ann remembers it. "I gazed at the pink bougainvillea cascading down the walls and entry gates of old Spanish-style mansions..." Well, she was jolted out of her reverie when Lindsey parked the car outside the big white Spanish house they were due to see... and they heard Stevie's voice floating down from the balcony. She'd arrived an hour earlier with Robin in tow, and was tickled to see an unsmiling Lindsey below her, Carol Ann standing wanly by his side. After enquiring as to whether Stevie's realtor was 'Satan', Lindsey discovered to his considerable chagrin that Stevie had been given the listing via his own realtor. Much teasing later, and insistence from Stevie that this was 'a girl's house' anyway, Lindsey relented. The triumph clearly warmed Stevie's cockles, because she invited them both – yes, Carol Ann was surprised too – back to her rental nearby. Stevie had to get ready for a photo-shoot that was taking place in her house, but her brother Chris was there, as was an abundant stash of marijuana and coke. In a convoy of BMWs, off they went.

Stevie's home was not dissimilar to the house she'd just been viewing, built in the Spanish style, large and airy and protected by iron gates. The grounds were grazed by large statues of pink flamingoes and the outside walls were covered with trailing blossoms. Once inside, Carol Ann gazed in wonder at the tasteful opulence. There were lamps covered with silk scarves giving off a soft, coloured glow, Persian rugs strewn over polished wooden floors and, naturally, "candles everywhere, sitting on delicate tables next to photographs of Stevie and nearly everyone in the Fleetwood Mac family..."

Carol Ann Harris recalls in her book *Storms*: "The room was furnished with light wicker furniture that was almost buried under pillows covered in Laura Ashley fabric. Hanging from the ceiling was a wicker swing that moved gently in the warm breeze. In one corner stood a baby grand piano [with] a shawl thrown over it... and on a glass coffee table lay a large leather book titled *Magical Beings*. It was a room for Rhiannon and I loved it." Chris appeared, joints were rolled, Stevie brought out the marching powder and then scurried off to change for her shoot. For the first time, Stevie had shown some cordiality to Carol Ann, although she still rarely felt comfortable with her around. Even so, there would be moments of closeness in the coming years. Mostly it would be tricky as hell, of course, but one theory for Stevie's temporary friendliness was that she was in love. Yes, a curveball was heading Fleetwood Mac's way that would risk causing irreparable damage – and this was a group that had weathered more knocks than a front door.

Mick Fleetwood has said that his relationship with Stevie Nicks started in LA, just before they set off on the final leg of the *Rumours* tour that took in New Zealand, Australia and Japan in December 1977. And yes, Stevie was seeing Don Henley while Mick was still married to Jenny Boyd. Considering the already ridiculous levels of relationship tensions within the band, this was a disaster and Stevie herself was 'horrified'. Drugs and booze dissolved that extra level of propriety, however, and their feelings for each other temporarily over-rode however devastated they were. Being together all of the time, taking comfort in each other... the boundaries had never been more confused.

During that rainy, muggy autumn, just before the final stint of the tour began, Mick would sneak away from home to be with Stevie and they would drive up and down Mulholland Drive together in his car. To make matters even more complex, Mick's parents were staying with him, and this much-needed level of secrecy gave the situation an even more "supercharged aura of romance", as Mick put it. By the end of the first night of the tour in Auckland on November 6, it had become a full-blown affair.

It was, according to Stevie, "the biggest surprise", and she still refers to him as one of her "great, great loves". But it would anger the band and,

once the news was out, hurt many people deeply, none more than Jenny Boyd. "I loved these people," said Stevie, referring to the Fleetwoods. "I loved this family. It couldn't possibly have worked out, and it didn't." Mick and Stevie understood each other though. They laughed together, took solace in each other and were together almost all of the time. Both of them were fairly pickled too, and Mick in particular was in a state of some fragility. In addition to his out-of-control lifestyle and failing marriage, he was suffering from hypoglycaemia, and, while anaesthetising himself heavily, he was also trying to manage the band. Worse than all of this, however, was the fact that his father had just been diagnosed with cancer.

Mick and Stevie were 'in love'; this wasn't just lust or sadness or opportunism, and their affection for each other lit up their otherwise somewhat traumatic days. But, with the clarity of hindsight, Stevie would later state in an interview with Oprah Winfrey that, "Mick and I would have never had an affair if we hadn't been... coked out. We were the last two people at a party and guess what? It's not hard to figure out what happened, and it wasn't a good thing, it was a doomed thing, caused pain for everybody, and led to nothing." Looking back at pictures of herself during that period, Stevie admitted that she thought she looked "beautiful" at the time, but now simply sees a woman who looks "unattractive and high".

We are granted a window into the band's mood at this time thanks to an hour of 'fly-on-the-wall' film (viewable on YouTube) shot during the Japanese dates on this tour. Fleetwood Mac are interviewed (often while drunk) as well as observed by a roaming camera. "What do you find interesting now?" asks the interviewer (also seemingly inebriated). Stevie Nicks smiles but clams up: "It's too personal..." When asked about Mick Fleetwood, she states wryly that he "loves attention. LOVES it." But Stevie is kind and light-hearted in the footage, and doesn't object to a camera being in her face while she tries to put on her make-up before the show. She flirts outrageously with the crew, singing the vaudeville classic 'Shine On Harvest Moon' with them post-show, hugging and talking with one tech quite intimately and proclaiming a few moments later (when she spots the camera): "I'm having such fun with the crew... they're so much more fun than the band!"

The young Stevie, who was already proving a talented singer and performer thanks to the encouragement of her grandfather, country and western singer AJ Nicks.

A beehived teenage Stevie working the sultry look in a high school photograph. Arcadia High School, 1965.

Stevie joined the Fritz Rabyne Memorial Band at the Menlo Atherton High School in California in 1967, and the band swiftly built up a following in San Francisco, supporting major acts including Janis Joplin, Jefferson Airplane and Jimi Hendrix. Here, Fritz band-mate Lindsey Buckingham poses by Stevie's side, and not for the last time.

Stevie attends the 20th Annual Grammy Awards ceremony with her devoted mother Barbara Nicks at the Shrine Auditorium in Los Angeles, California on February 23, 1978. Fleetwood Mac's *Rumours* would win the Album Of The Year category. RON GALELLA/WIREIMAGE

Fleetwood Mac in 1976. From left to right: Mick Fleetwood (drums), John McVie (bass), Christine McVie (keys, vox), Lindsey Buckingham (guitar, vox) and Stevie Nicks (vox). AP/PRESS ASSOCIATION IMAGES

Warner Brothers bosses Mo Ostin and Joe Smith join Fleetwood Mac (and Bugs Bunny) as they are presented with a gold disc for *Fleetwood Mac*, the first Mac album to feature Stevie and Lindsay Buckingham. JAMES FORTUNE/REX

Stevie recording a vocal take for the album *Fleetwood Mac* in 1975, Mick Fleetwood and Lindsey Buckingham in the background.
FIN COSTELLO/REDFERNS

Stevie with the man who briefly became her husband in January 1983: record executive Kim Anderson. Kim was the widower of Robin Snyder Anderson, Stevie's closest friend. RON GALELLA/WIREIMAGE

John McVie and Stevie display their contrasting sartorial styles onstage. MARVIN LICHTNER/TIME LIFE PICTURES/GETTY IMAGES

Producer Jimmy Iovine and Stevie attend the 10th Annual American Music Awards together. Iovine started working with Nicks on her first solo album *Bella Donna*, released in 1981. RON GALELLA/WIREIMAGE

A true 'girl's girl', Stevie always surrounded herself with female friends when on the road. RICHARD E. AARON/CAMERAPRESS

A wide-eyed Stevie charms the press on a cruise-boat in the harbour of Rotterdam, Holland, during the *Tusk* world tour, 1980.
BARRY SCHULTZ/SUNSHINE/RETNA/PHOTOSHOT.

We see a little girl from the audience approach her after the rest of the crowd has gone, the young fan having found Stevie's ring, which had flown off her finger during the show. Stevie is thrilled and the child is rewarded with a hug, a kiss and Stevie's own black poncho. Robin is by Stevie's side on every date of the tour, providing support and humour right up to the moment Stevie steps out in front of the crowd. "Every night she's at the side of the stage," says Stevie. "And I say, 'Oh, I'm so tired,' and she says, 'Oh, it's ok, I can probably do it,' and she probably could!"

Lindsey Buckingham is given less screen time in this documentary, but what we do see is him storming into the dressing room exclaiming: "I'm sick of playing! Hate it! We need a vacation." Yes, they do. They had never worked so hard. But by the time 1978 dawned, they would all be multi-millionaires. Stevie, as a principal songwriter, was earning big money, her lifestyle utterly different to how it was three years previously. Everyone would celebrate the end of their tour in December with a mammoth pre-Christmas shopping spree, and Stevie gave a gala New Year's Eve party at her house to honour their incredible year, and the year to come. AOR was healthier than ever – *Never Mind The Bollocks* by the Sex Pistols might have been welcomed by rock critics as it grabbed headlines through shock value and stripped back three-chord immediacy, but punk had little chance of stealing Fleetwood Mac's commercial thunder. Nevertheless, its angry, wipe-the-slate-clean influence would creep into their next album via the restless energy of new wave disciple Lindsey Buckingham.

Rumours-era beauty tips a la Stevie Nicks:

1) *Look to old school Hollywood for make-up inspiration, but especially the European actresses, such as Marlene Dietrich and Greta Garbo, highlighting the eyelids and brushing darker colour in the sockets.* "I'd always done my eyes like that. To me, Marlene and Greta are just totally glamorous without people saying they were sex symbols," Stevie said in an interview in 1977. "They were just wonderful, classic women. Katharine Hepburn too."

2) *And once the party / show / day is over, take all of that make-up straight off. Exhausted? Trashed? Doesn't matter! "I have always taken very good care of my skin," Stevie once insisted to Oprah Winfrey. "Even on the days you are just very, very drunk and everybody else goes to bed with their make-up on, not me." Stevie would also advise steering clear of sun exposure and cigarettes, although her recent claims that she 'never' smoked are at odds with her earlier claims that she was a 'chain-smoking mess' in the eighties, but no matter. The point is, don't smoke.*

3) *Steam. During the* Rumours *tour, Stevie's voice took a pounding, and as we know, she was susceptible to colds. On the advice of a fellow rocker, she invested in a facial sauna into which she plunged her face before each show in a bid to clear her sinuses. The by-product of this would be that her pores would be purified and her complexion left dewy. "It may not help my voice but I'll have terrific skin," she joked. "Mr Boz Scaggs told us it's the only thing that got him through his show every night…" "And he doesn't even sing…" added Robin. Curious.*

4) *Ballet exercises. Every day, Stevie would stretch to keep her limbs lean and prevent injuries during the show. She would also do ballet exercises to Lindsey's demo tapes, although as soon as he added lyrics (usually negative) the feel changed and she'd have to abandon them. But the main thing is that ballet takes focus and discipline, and the results are worth it. Before one concert in Japan, she challenged Richard Dashut to get his leg up on the barre, which he managed with some pain (he was wearing tight jeans) before staggering away, muttering: "That's all right, I didn't want to have kids anyway…" The other advantage of ballet is, as Stevie says, it's a meditation. "It's so physically difficult, that if you're worried about anything, and you do this for 15 or 20 minutes even, you can't think about anything else."*

Fewer worries = fewer wrinkles.

5) *And speaking of fewer worries, keeping a journal is a must when it comes to Stevie-style solutions. It gets all of your concerns out on the page – privately, as opposed to on Facebook – and is cheaper than therapy. Plus it might give you a good laugh a few years down the*

line. Stevie journals constantly, also creating tour diaries that she binds together like a scrapbook and gives to everyone at the end of each tour. (Well, she did say she didn't have as much to do as everyone else.) "I tell people all the time that they should keep a journal, even if it's just, 'I had a terrible day today and I don't want to talk about it, love Stevie,' or 'I dreamt last night…' Even if it's just three sentences, because at the end of five or six days, you would have created a habit and you will find over a month that you have a whole story growing."

You might even get a song out of it too.

Chapter 12

There were several men in Stevie Nicks' life around this time. In true Stevie style, let's take a look at the astrological compatibility between them...

Stevie (Gemini) and Mick Fleetwood (Gemini): Gemini is the sign of the cosmic twins, so we have two sets of twins here – which technically means there are four people in the relationship already and that's not counting Jenny Boyd or Sara Recor. Crowded. But fun, not to mention simpatico to the nth degree.

Stevie and Don Henley (Cancerian): Cancerians are home-lovers – Don's the one building houses and buying gorgeous new homes, so that's no surprise. Cancerians love to spoil their sweethearts (and we know Don loved to do that) but the two signs move at different paces – Cancer can be slow and languorous, but Gemini is like quick-silver. Just look at the way Stevie moves onstage if you need visual proof. Cancerians can also be 'crabby', unsurprisingly. Crabbiness + an easily hurt Stevie = not a great combination in the long run.

Stevie and JD Souther (Scorpio): Scorpios are sexy and intense, which would appeal to Stevie's fierce sense of dreamy romanticism, but they can also be dark and heavy, which stifles light and airy Geminis who don't like to be tied down. These two did have 'an incredible time' though... Both have tons of energy but, ultimately, the flightiness of Gemini would

irritate Scorpio, while the fixed, stubborn nature of Scorpio often scares a self-respecting air sign off. It's a 'no'.

Stevie and Lindsey Buckingham (Libra): Two mercurial, attractive, sharp and witty signs who share an element – air. There are two distinct sides with both of these signs – Gemini = twins and Libra = scales. There's a profound understanding between these two soul mates, who mirror each other's desires and needs – which sounds about right. It's supposed to work between these signs anyway but whatever happens, the bond is hard to break.

S tevie, Christine and Lindsey had all been working on new songs for the next album; expectations were high and Warners wanted another *Rumours* – which had scooped a Grammy in February 1978 and was still at number one in the US charts. Stevie wrote compulsively, not just because she was expected to, but for herself.

Christine referred to Stevie affectionately as "the mad songwriter", and Stevie was inclined to agree. "I thought, 'They're right. I am mad. There's no place for another song.'" But she had amassed so much material, there was only one thing for it; it was time to consider the option of a solo career, an option that had been suggested to her by more than one record executive, keenly aware of her appeal and potential as an artist in her own right. Stevie didn't want to leave the band but she did want to express her creativity and use her songs, many of which she would present to Fleetwood Mac only to have them rebuffed anyway. The wheels were already quietly in motion for a side project, which would soon exist, not always harmoniously, alongside the Mac.

Meanwhile, Lindsey had been fired up by punk, having caught live shows by bands such as The Clash while in London. Witnessing the spirit, attitude and simplicity of the new movement, Lindsey looked back at his own band with more objective eyes, and he saw that Fleetwood Mac were just one of the many groups seen as pompous, indulgent dinosaurs by the punks. Lindsey didn't want to be any of those things, and saw an urgent need to push the Mac up and out of the rock'n'roll rut, even if he had to force them. There were three writers in the band,

but Lindsey wanted to use punk as an influence on their follow-up to *Rumours*, and, as we can now hear from listening to *Tusk*, if Stevie and Christine didn't follow suit... well, that was just too bad, and as a result, the writing styles on this record had never been so diverse.

Lindsey knew *Rumours* would be hard to follow, so, with his own songs at least, he would go in a totally different direction. By the middle of the *Rumours* tour, Lindsey had already written a fierce clutch of songs, including 'That's All For Everyone', 'Not That Funny' and 'What Makes You Think You're The One?' He was also tired of using his 'best ideas' to improve Stevie's and Christine's songs. Instead, he would concentrate on "broadening the [band's] palette," and if it took aggression on his part to chisel the rest of the band out of 'complacency', so be it — he wasn't exactly known for his soft-soaping bedside manner anyway. The way he used punk as an inspiration was more in terms of attitude than as a direct musical influence however; the grooves he was coming up with were less 'punk' and, at times, more of an angry, stabbing bluegrass-meets-ELO vibe. He was experimenting, and in the true nature of the new wave, he was free to make mistakes and think laterally, rather than stick to an old formula. If it ain't broke... then break it anyway.

Sessions for the next album were arranged to take place at the Village Recorder studio in Santa Monica, a former Masonic temple previously used by sometime Beatles guru the Maharishi Mahesh Yogi in the sixties as a centre for transcendental meditation. Any lingering vibes of serenity were soon to be well and truly dissipated now the Mac were booked in. But before recording got underway, there was time to grab a few weeks' holiday before the band had to reconvene. Stevie was desperate to get away and rest while she could, so, with Christi, Robin and new best friend Sara Recor by her side, she flew to Maui in Hawaii, where she planned to do little more than simply lie in a hammock and stare at the sea and the sky, studded with more stars than she had ever seen — more stars than you could see in smoggy LA anyway.

Sara and Stevie had become friends against all odds; Sara was married to Jim Recor, with whom Fleetwood Mac had worked while touring with Loggins and Messina. Stevie and Jim had, as we know, struck up an affectionate friendship, but apparently no more. After meeting Stevie

for the first time on Jim's urging, Sara coolly enquired as to whether Stevie was "Jim's little road friend?" Despite this somewhat excruciating introduction, Stevie would later become firm friends with Sara. They had plenty in common beyond a similar taste in men. "After a while I didn't care about what might have happened between my husband and Stevie," Sara had told Carol Ann Harris. "It was pretty much over between Jim and I. At the very least Jim had a crush on her, but who wouldn't?"

Together, they rented a house in Maui, a favourite destination for the members of Fleetwood Mac. It was tranquil, peaceful and separate from their chaotic lives in California or on the road, so it wasn't surprising that Stevie would 'bump into' Mick Fleetwood. Mick had escaped there too, ostensibly to spend some time alone to sort his head out, but the fact Stevie was there too may well have been a clincher. Mick was having a meltdown due to pressure and fear – fear of the future and of what was going to happen to his beloved, cancer-stricken father. Both of Mick's parents were in LA staying with Jenny at Mick's family home, seeking holistic alternatives to aggressive chemotherapy. Mick would soon return home to give his family the support they so desperately needed from him, but he was in need of help himself. In the meantime, Jenny had to take on much of the emotional heavy lifting.

While in Maui, Stevie would meet a young woman with whom she would build a lifelong bond. During an evening at the Blue Max club, Stevie's attention was caught by a striking brunette singer called Sharon Celani who had stepped onto the stage to sing 'Poor, Poor Pitiful Me', a song written by Stevie and Lindsey's old friend Warren Zevon and made famous by Linda Ronstadt. Sharon's voice impressed Stevie, who was already considering who she would want around her when – not if – she launched her own career and formed her own band outside of Fleetwood Mac. "I walked up to Sharon and said, 'My name is Stevie Nicks. I know you love being in Hawaii but... if I ever have a band, if I ever do a record will you consider coming and singing with me?' And I didn't know this girl, this could have been an unpleasant person that I'd just nailed myself into a relationship with. I didn't know. I took it solely on the way that she sang 'Poor, Poor Pitiful Me'."

123

But Stevie, who then joined Sharon onstage for a number herself, would find that her instinct was correct about Sharon – who naturally said 'yes' in response to what was tantamount to being casually offered the chance of a lifetime. From Stevie's point of view, she just loved the idea of having two backing singers to work with, not just on one record, but for all of her future work. The other singer to join the fray would be Lori Perry, whom Stevie and Lindsey had met through her husband producer Gordon Perry and Keith Olsen – the man all roads seem to lead to – in the early 1970s. A dream team was being formed. Having two girls to sing with, as well as gossip and spend time with, was ideal for Stevie. The musicians she wanted to pull around her for her own music were all male, and Stevie was a true 'girl's girl', after all.

Once the various Mac-members were back in LA, Lindsey and Carol Ann decided to have a barbecue at their home in June Street, a "death row inmate's last meal", according to Carol Ann – they both knew the rest of the band would be shocked by the songs Lindsey had been working on in the home studio he'd constructed, and no small amount of hostility was anticipated. His new short haircut alone had not gone down well on the whole – the detachment from the rest of the band that it represented went far beyond the visual. With the new coiffure, a rejection of his usual satin kimono tops for well-cut suits and dark make-up now lining his electric blue eyes, Lindsey had transformed himself, with Carol Ann's help, from poetic romantic lead to abrasive, sexy rock'n'roll Mephistopheles. He was shrugging off the tired hippie culture and impatiently waiting for the rest of the band to follow suit.

Everyone came to the party except Stevie, but Carol was wrong to assume it was down to the fact she was avoiding her. If she was avoiding anyone, it was Jenny. It all became clear when Carol Ann spotted a tearful Mrs Fleetwood lingering on her own at the party, and took her aside. Jenny knew Mick's infidelities were nothing new – anyone who has read the memoir *Fleetwood* will know he was utterly at the mercy of the demands of 'the old veal viper' – but groupies were one thing. An affair with Stevie, a veritable member of the family, was another.

But the situation within and around the band generally had also reached such a stage that Jenny was now more worried about her daughters than anything else, and the amount of hedonism to which they were potentially exposed. She wanted to take her girls back to the UK and away from Mick and the damaging Fleetwood Mac scene. Jenny also told Carol Ann that "Mick was terrified that Lindsey would go ballistic when he found out he and Stevie were sleeping together." Lindsey's anger was widely feared... but when Mick finally sat Lindsey down and told him, the reaction was a simple "Oh. OK."

"I didn't feel betrayed by Mick," Lindsey insisted to *The Independent*'s Lucy O' Brien in 1998. "Quite honestly I'd have been surprised if it hadn't happened. Stevie and I had long since parted company and she'd had several boyfriends in between." All sounds so reasonable and easy-going, doesn't it? But the inevitable hurt would bubble volcanically beneath a sardonic exterior. Jenny herself was angrier with Mick than she was Stevie, but seeing 'the other woman' at John McVie's wedding to Julie Reubens that April would be the moment that pushed her over the edge. The feeling at the wedding was one of magnanimity – it even took place at Christine McVie's Hollywood home, suggesting a certain level of noblesse oblige. But then Stevie arrived, and committed the ultimate wedding faux pas: she was wearing white.

One might think that the mere presence of Stevie Nicks at one's nuptials alone would guarantee an unfortunate upstaging of the bride, but for some reason, she went that step further. *Rolling Stone* reported that she was a "vision in white" – again, that's Stevie, not the bride – and she graciously accepted the many compliments flooding her way with quips and humble brags: "Thank you... it should be nice for what I paid for it." This was apparently too much for Jenny Fleetwood. The pair were later heard by Carol Ann having it out in Christine's walk-in wardrobe, Jenny pleading with Stevie to think of the children, Stevie trying to defend herself. Robin Snyder, alerted by the sudden conspicuity of Stevie's absence, found them and swooped in, calming Stevie down and gently extricating her. Oh, Fleetwood Mac. They could never just have a nice, normal day during which no one got hurt, could they? No.

"Talking about Tusk *without* Rumours *is like talking about aftershocks without an earthquake."*

Rob Trucks, author of *Tusk* (33 1/3)

Work began on the album that would be *Tusk* in May 1978, the beautiful early summer weather seeming like an auspicious sign, not that the band and crew were going to see much of the outside world for a while. The band was called for 3pm (early for Fleetwood Mac) at Studio D, the Village Recorder, where they would record on a state of the art console, designed specifically to suit their needs. The idea for this album was that they would have their own studio built with a view to save money. Fleetwood Mac were gifted at many things, but economising was not one of them.

Their studio, which lay behind an unmarked iron door, was private, luxurious and comfortable. They knew if they were staying for any length of time, their second home would have to be exactly as they wanted it. Champagne was flowing from day one – not something that suggests a particular desire to stick to a tight budget. The decor in the studio was opulent; there were little stars on the domed ceiling in the listening room, plump sofas, remote-controlled baffles and beer on tap. There were also the usual tables covered in the most expensive gourmet salads, sandwiches and cheese boards, none of which would be necessary because all the band wanted was cocaine. There was plenty of that too. Hangers-on would come and go, perhaps to a lesser extent than on *Rumours*, but one new member of the inner circle would be a Beach Boy, hard partier and all-round big kid Dennis Wilson, now seeing Christine McVie. He was pretty expensive too.*

Despite the call time of 3pm, Stevie turned up around 5pm, much to Buckingham's chagrin. He was already tense because the songs he had written and intended to use for this album were a departure from their

* Dennis Wilson once expressed his love for Christine by booking gardeners to transform her back garden into a heart-shaped paradise for Valentine's Day. She was thrilled by the gesture. She was less thrilled when he then handed her the bill for it.

previous work together, and he knew his ideas would meet resistance. He also had no intention of compromising. Warners might have wanted *Rumours Part Deux*, but in Lindsey's opinion, *Rumours* had been a step into fresh, uncharted territory, therefore *Tusk* would have to be just as brave and innovative, if not more so, and the plan was to make it a double album. He decided to let Christine and Stevie play their demos first to ease everyone in before delivering the punch with angry songs such as 'Not That Funny' and 'What Makes You Think You're The One?' with its stabbing ELO-inspired piano chords – brilliant but bitter, radiating strangulated fury and barely repressed contempt (towards Stevie, no doubt) with blatant lyrics such as 'What makes you think I'm the one / who will love you forever?'

When Stevie finally did turn up, Ginny the poodle scampering along at her feet and a gaggle of 'girl fans' helping her with her many bags, Carol Ann Harris remembers her grand arrival: one befitting the "queen of rock she most definitely was... dressed in a flowing dress made of antique scarves, with jade and gold bracelets jangling against her thin wrists... It was an entrance that would have made Elizabeth Taylor proud..." Booze and chatter soon flowed as the ice broke and the vibe softened a little – until Mick discovered someone had crashed into his prized new (uninsured) sports car while he was inside. There would be plenty to distract him, however. Stevie's studio outfits, each more ravishing than the last, were, by all accounts, for Mick's benefit. Stevie's songwriting on this album reflects their affair, which changes as the time spent making *Tusk* passes. The relief and fun of 'Angel' would morph into sadness, almost grief, in 'Storms'.

With plans to make the album something of an epic affair, the writers in the band had an opportunity to include more of their work – a great relief to Stevie. But despite this extra scope, the process of making the record was agonising from the start. There was less sense of cohesion than ever between the band members, not just artistically but physically: Stevie would ensure she was only there if she was needed, learning from the experience of having sat around killing time during the last two albums, and even John McVie would end up recording his parts separately so he could go sailing, the one way he could get far away

from the band and not be on call. At one point even Lindsey announced he wanted to record some tracks at home. Being in the studio wasn't exactly an attractive proposition for anyone: Lindsey, essentially at the helm of the project, was more divisive and controlling than ever, and no amount of gourmet sandwiches or champagne could soften the effects of that. His manner towards Stevie was, as she had predicted it would be, often harsh, sarcastic and cold; Lindsey might have found new love in the arms of the gentler, perhaps more submissive Carol Ann, but that wouldn't make it easier between the two former lovers, and Stevie's writing would often bear the brunt of Lindsey's jabs. He was pulling away from her stylistically, apart from anything else – but just because his writing was changing didn't mean hers would be, nor would Christine's.

"*Tusk* was mainly Lindsey's conception, dream, everything he ever wanted to do," Stevie told *The Record*'s Michael Goldberg in 1982. "Everybody just figured that for whatever his reasons were, it was important that he do that and we just sort of sat back and let him do it. I don't mean to sound blase or anything. I was there. I just didn't have very much to do with it. Because if I had had much to do with it, it wouldn't have been a double album and it wouldn't have been crazy."

Fortunately for Stevie, she found she could escape from the studio a little more frequently than the others, which gave her time to record a duet with Kenny Loggins, with whom Fleetwood Mac had recently toured. Nicks loved duets, and she loved Loggins' music. She didn't need her arm twisting, although if she had known what a disciplinarian he was going to be, she might have thought twice. "I call him 'Slave Driver Loggins'," she quipped. "He cracked the whip on me for two days to get that particular performance. And I was downright angry at points where I was going, 'I'm not going to do this,' and he said, 'Yes you are.' He's a real good producer, he got exactly what he wanted." The outcome was the soft-rock ballad 'Whenever I Call You "Friend"', which would be included on Loggins' album *Nightwatch*.

"I think I pushed her harder than she was used to in the studio," admits Kenny. "I just wanted to make a difficult song seem easy and fun, and she certainly delivered that." To be fair, Kenny was "always

impressed with how dedicated she was, how savvy she was to her marketplace and her audience, and what a hard worker she was at all times. The girl really knew what she wanted and was not afraid to go after it." There were no two ways about it, Stevie was a star – and she knew how to work it in every way. Not only was she always flanked by her entourage, "it seems she had a full-time on-staff photographer just to catch her when she was in the mood to pose..."

Chapter 13

Stevie Nicks' songwriting modus operandi was to be a kind of troubadour, articulating universal emotional themes and going straight to the heart of the experiences we all have through poetry and song.

"I said a long time ago that I was going to write the truth. I'm going to make these songs experiences that I know every one of you has had, and when you hear that song, you click into it and you'll know exactly what I was talking about. Those are the people I write for, the people who need somebody to write down what's happening to all of us."

Stevie's songs on *Tusk* – 'Sara', 'Sisters Of The Moon', 'Angel', 'Beautiful Child' – all had hit potential and would arguably turn out to be the strongest on the record, although Lindsey would have contested that *he* was generally responsible for bringing both her and Christine's songs up to 'hit' standard. As usual, Stevie had to screw up her courage when presenting her work to Lindsey. No one had the balls to criticise Lindsey's songs, however. He radiated an intimidating aura that warned off anyone who might question his musical decisions. As Stevie said, it was just easier to sit back and let him take the reins.

Stevie already had 'Sisters Of The Moon' to bring to the table, the song she had started writing on her first major tour with Fleetwood Mac. The upbeat 'Angel' was initially Stevie's attempt to "write a rock'n'roll

song," she admitted in a documentary about the album in 1980, but it soon took on a life of its own. "It started out being much sillier [but] it didn't end up being silly at all. When I started it I thought, 'This is good for me, since I write so many intense, serious, dark songs...' I wanted to write something that was up. It starts out that way but there is a definite eeriness..." In the studio, she stamps her peep-toe platform-clad feet to the music and sings her vocal, swishing her skirts by her sides, the energy building as the song progresses.

The band sipped on Margaritas as they worked, but no cocktails could dull Stevie's edginess around fractious Lindsey, especially when she had to work with him on the harmonies of 'Angel' – yet another song at least partly inspired by him – at the grand piano. The song features typical Stevie themes – dreams, the wind, charmed hours, haunted songs, angels, yet more dreams, but there are also direct references to feelings tied to a past relationship: "When you were good, you were very, very good... I still look up when you walk in the room... and we both pretend..." The lines will have come from her notepads of poetry, thoughts and moments jotted down, and so there may be flashes of Mick, of Don, even (a cad, yes, but when he was good...). But at its core the song really is about Lindsey, whom, despite everything, she still has to stop herself from automatically "reaching out" to. It's about the love that might have been, and a new understanding that was proving hard to achieve.

The 'pretending' in 'Angel' may also refer to the affair with Mick and the need for discretion despite the fact everyone now knew what was going on. Overseeing this ménage-à-quatre would be the spirit of Rhiannon, as well as an indirect nod to family shining through in the line 'So I close my eyes softly / Till I become that part of the wind...' "There's a man in the story of Rhiannon and his name is Arawn, the great lord of darkness, the man who possesses the power to take or give life, but he only takes life... because of pain," Stevie explained in an interview with broadcaster Jim Ladd in 1979. "Aaron is my father's name, and also my brother's [middle] name, and my grandfather's name. So Arawn is many things to me." Of the lyric, Stevie expands with a reference to the ancient story: "And so Arawn touched the twins with

his hand so that they would sleep. And in that sleep there will be no pain. And in that nonexistence of pain there will be happiness, because it was only given with great love. And this was in a haunted song, and a charmed hour, and this was the angel... of my dreams."

Stevie's transcendent song 'Sara', meanwhile, would braid her feelings for Mick, her protective 'great dark wing', and her then best friend Sara Recor. One night in July, as the scent of jasmine floated through the window, blossoms warmed by another balmy day of California heat, Stevie refreshed her make-up, lit the candles and sat at the piano, sketching out a song from some simple chords, singing softly over the top, her notepads of self-penned poetry lying open nearby. When it came to writing or drawing, Stevie always ensured the atmosphere was just right when she "felt the power"; candles and incense are always present, but she often does her hair and make-up to make for a sense of ceremony, maybe even changing her outfit, so that "when I do sit down to create, all the channels are open." The channels were certainly open tonight, so to speak. By the time the song was finished, it encompassed "a vast bunch of people" in her life, and she "fell in love" with the track she'd created, and everything, everyone, it represented.

The demo Stevie would record of 'Sara', with Tom Moncrieff on bass and singer Annie McLoone on strong, echoing harmonies, was over seven minutes long. In fact, the *original* version was over a quarter of an hour long and consisted of a wordy 16 verses. Stevie had a lot to say, and 'Sara' was veering more towards an epic saga than a pop song as a result. The process of chopping it down to size would be as hard as ever – "It got edited down to 14 minutes, down to 11 minutes, down to nine minutes, down to seven minutes, down to four minutes and 40 seconds," she remembers. "I was at the point where I went, 'Is the word Sara even going to be left in the song?'" – but a longer demo, with Stevie on piano and vocals, would be revealed in later years on the enhanced *Tusk* release. On listening to that magical early recording, one hears Stevie uttering the words "I wanna be a star! I don't want to be a cleaning lady..." before she launches in. One thing you can say for Stevie Nicks: no matter how wealthy she became, she never forgot those lean years.

'Sara' was, as Stevie states, her "most personal song" – personal not only to herself but to Fleetwood Mac and what they were all going through – but while writing always had a strong therapeutic benefit, Stevie actually found she had more 'fun' writing this than almost all of her other songs to date. "I knew 'Sara' would be popular because I loved writing [it]," she said. It was hypnotic, soft and veiled in a mist of melancholy, but part of Stevie's enjoyment in writing 'Sara' was thanks to the simple healing process of wallowing, a feeling encapsulated in the evocative line: 'Drowning in the sea of love, where everyone would love to drown...'

"[It's] self-indulgence," Stevie admitted in later years, explaining the lyric with a chuckle. "Don't we all love to lay face down on our bed and go, 'I'm so miserable, don't bug me, I want to hurt! Don't even bring me tea...!'?* I love to walk around in the throes of passionate miserability. I made that word up years ago. I don't like to suffer and I hate pain but I want to suffer to the point that I go to the typewriter and write down all of my marvellous philosophy as to why I'm suffering – I love that part of it."

As Stevie worked on the song at her home, with Sara herself by her side, Mick would turn up in his bright red Ferrari to develop the brush work Stevie wanted to accompany what had already been recorded for the demo. It took him three days to get it right but, as Fleetwood himself put it, "The result was, in many ways, the ultimate Fleetwood Mac song of that era, the late seventies, breathless, ethereal, almost ecclesiastical and somehow reverent, as Stevie pays tribute to her muse."

Despite the title, the 'muse' was not just Sara. Ms Recor would, understandably, believe the song to be Stevie's dedication to her but no, as Stevie said in later years, "[Sara] likes to think it's completely about her, but it's really not. It's about me, about her, about Mick, about Fleetwood Mac..." There is also what sounds like a knowing reference towards Stevie's first meeting with Lindsey – "I think I had met my match... he was singing...". Everyone who meant something

* I was with her up until "Don't even bring me tea...".

profoundly to Stevie seems to be featured in this song. It's no wonder it was so long at first.

'Sara' also reached out to Don Henley; the line 'When you build your house, call me home...' referred to the charming Eagle himself, as the building of a fabulous home for Henley was indeed underway. And, as Stevie recalls, "I was in it before it was finished." But it would not be 'home' to her.

'Sara' was a special name for Stevie and was always "the poet in my heart, for sure." It was a name she loved to sing, and 'Sara' would almost become another musical spirit, just like 'Rhiannon', to accompany her invisibly onstage. There was a spiritual connection, almost commitment, to this name, and the uncharacteristically ambiguous nature of the lyrics led to some speculation on the song's release the following December, not least when Stevie explained that, if she ever had a little girl, she would name her 'Sara'.

But when questioned about the song himself in later years, Don Henley would later cause ructions by blurting out a shockingly personal piece of information in an interview with *GQ*. "I believe to the best of my knowledge [Stevie] became pregnant by me," he said. "And she named the [unborn] kid Sara, and she had an abortion and then wrote the song of the same name to the spirit of the aborted baby." Whether true or not, this blunt, all too public treatment of such a delicate subject was staggering. Stevie herself refused to comment beyond revealing that Henley "had to make many an apologetic phone-call" before they could be friends again.

Indiscreet as his statement was, one can see from the lyrics how Don got there – "Now it's gone, it doesn't matter what for... there's a heartbeat and it never really died" – and a devastating decision such as this would explain the 'passionate miserability' that gently washes over the whole song. Stevie herself has indicated there was indeed more than one 'lost child' in her life.

Summer had morphed muggily into autumn, and Hallowe'en, normally Stevie's favourite time of year, was just around the corner. Stevie adored dressing up, in case you hadn't noticed, as did the whole of Fleetwood Mac, who had something of a gothic, twisted fairy tale

about themselves. But Hallowe'en 1978 would mark a change in Stevie's life. Yes, there would be dressing up, there would be a party at Lindsey's, there would be booze and blow and rollerskating and loud music... but there would also be a moment at which someone's feelings were transferred irrevocably from one beautiful woman to another. Stevie needed her great dark wing more than ever, but he was already preparing to build a nest elsewhere.

As the witching hour struck, Sara Recor arrived at the party, looking as glamorous as ever. She caught Mick Fleetwood's eye as she went to find Stevie. There was no more than a perceptible flicker between the two individuals, but something was already brewing.

It was around this time that Sara could almost always be found at Stevie's house. Her marriage to Jim had passed the point of no return, and Stevie's glorious home was the ideal sanctuary. The two women adored each other despite the fact Jim had, as we know, been a little in love with Stevie himself in the past. Sara and Stevie played music together, sang and larked about, referring to themselves as 'The Twang Sisters' as they sang country songs to entertain people and make each other laugh.

Another who was frequently at Stevie's house during this time was Mick. Sara was secretly attracted to him from the moment she first met him and the feeling was evidently mutual, the chemistry between them growing every time Mick came round to visit Stevie. When, one day, they found themselves alone in Stevie's house, Mick invited Sara to go for a drive, taking her to the little house he had bought for Jenny – now vacant – on Little Ramirez Canyon. No one said this was going to be classy. He'd told Sara he and Stevie were over (although apparently Stevie herself hadn't yet been informed of this development) and this was the prompt Sara needed to allow her bottled up feelings for Mick to pour out, and vice versa. Everyone in the Mac camp was insecure and in need of approval, love and comfort; they would hold onto each other as the emotional sea around them became choppier, often with scant regard for boundaries.

The thrill of new love aside, this new situation was messy to say the least. Both Mick and Sara loved Stevie, both felt bad about Jenny, and then there was Jim, with whom Mick was still friends. Jim would be

remarkably civilised about it, giving Mick his blessing. Stevie's position was obviously a little different. She might have been seeing Henley, but what she saw as the simultaneous loss of Mick and her closest friend Sara would break her heart. As always, out of the pain would come some of Stevie's most heartrending songwriting, her private emotions exposed through her lyrics. One of the songs that lays bare Stevie's reaction to this break-up would be 'Storms'.

When Stevie brought in a demo of this sensitive song, ringing with tenderly expressed heartache, she broke down when Lindsey elected to attack it almost immediately. All of Stevie's songs are personal, but to pour acid on 'Storms' was tantamount to harpooning a dove. Carol Ann was in the room and watched him "going over her new song bit by bit, pointing out how this part was crap, the next part needed to be raised or lowered by two octaves and this section desperately needed a new melody line – he tore it apart. By the time he finished... he smiled and said, 'I like it, Stevie, it just needs some work, that's all.'" Stevie bit back, and, as Carol Ann remembers, "The end result was always the same: a vicious battle over her music... without fail the parts that Lindsey didn't like were the parts that Stevie loved. Their angry debates quickly escalate to a screaming match, with stomping around [by Lindsey] and tears [from Stevie]." Stevie already felt betrayed and hurt by her lover and her friend – and again, she would have to see that ex-lover in the studio every day, just as she had when she broke up with Lindsey during *Rumours* – but to have her work berated, work that so honestly conveyed her hurt, was just too much.

Lyrically, perhaps Lindsey took it personally; there are references to wondering how much she really cared about the subject of the song, inferences to a love gradually fading out of her life, but he may also have been subliminally punishing Stevie for having loved someone else so much that she could write a song like this – a raw composition clearly musing over Mick, a fact that will no doubt have been painful for Lindsey to accept. 'Every night you do not come / Your softness fades away...' creates an image of an extra-marital relationship: her lover isn't always able to be there with her. 'She said, "Every night he will break your heart..."' is possibly a reference to a warning from Jenny Boyd, delivered

during their argument in Christine McVie's closet on John and Julie's wedding day. Tellingly, Stevie's lyrics in this song also allude for the first time to a kind of acceptance that her life as a touring musician simply cannot include a relationship without there being some measure of angst. She has loved before, but in the past she "did not deal with the road".

'Storms' is one of the songs Stevie is most proud of, referring to it as a "beautiful poem" full of wisdom and understanding, not just of Mick's motives but her own feelings. It was about coming through the other side. "It was probably one of the most terrible times of my life getting over the idea that Mick and I weren't going to be together," she has said. The storms in the title, of course, refer to Stevie's own tempestuousness. She wants to 'give something warm' to her friend as they part, but 'I've never been a blue, calm sea'. Nevertheless, as Stevie maintains, her relationship with Mick could never have worked, too much pain had already been caused by it and, while Fleetwood Mac seemed to be the incredible unbreakable band, this might just have been the catastrophe to shatter it once and for all. 'Beautiful Child', Stevie's fifth song on *Tusk*, also detailed the love affair with Fleetwood, their age difference (the 'beautiful child' being Stevie, naturally), the confusion and the awareness of how wrong it all was, mingled with an inability to let go. 'I'm tall enough to reach for the stars / I'm old enough to love you from afar...' lyrics evidently speaking as Mick, and written, presumably, before his feelings for Sara became known, when the only major problem between Mick and Stevie was that theirs was ultimately a forbidden love.

In the studio post-split, Stevie and Mick were largely silent with each other* – yet another Fleetwood Mac cold war – and while obviously

* However, Mick would still gallantly leap to Stevie's defence whenever her honour was at stake, most notably when, in August 1979, LA punk band The Rotters released a single called 'Sit On My Face, Stevie Nicks', which was played frequently on the rock radio station KROQ until Fleetwood himself "demanded that they stop playing it," *Creem* reported in their story about the debacle (cheekily titled 'The Best Seat In Town'). "Further verbal lickin's from Fleetwood Mac's legal busybodies convinced the station to drop the tasty tune from their playlist," wrote *Creem*, before adding: "C'mon now, Mick. Was it REALLY that offensive to you, or is this just another case of SOUR GRAPES?"

extremely upset, Stevie refused to speak about what had happened with anyone, feeling understandably betrayed and less able to trust than perhaps she'd ever felt before. The band worked on. It didn't help that the decision to name the album *Tusk* was inspired by one of the many pet names Mick Fleetwood used in reference to his own penis. It was one thing having Mick posing around with unambiguous wooden balls dangling between his legs, but to basically name an album after his own genitals, particularly after having just proved that they were often in charge when it came to decision-making, was the height of poor taste in Stevie's eyes. She even threatened to quit the group over it, but of course, she didn't, and of course, the name *Tusk* stayed. In the meantime, the general vibe in the studio wasn't helped by Lindsey's 'decor'. "Lindsey had tusks on the wall and all these weird Polaroids. I thought this must be what hell is like. With speakers," said Stevie.

The title track itself, with its distinctive staccato riff, was born of a simple groove Lindsey Buckingham used to play during sound-checks while Richard Dashut got the mix they wanted. It was Mick Fleetwood's suggestion that they develop the riff into a song – the song that would be the album's first single – and this may explain why 'Tusk' is heavy on the drums, with Lindsey Buckingham's double-tracked octave-apart vocal soft and viper-like over the top during the verses before bursting into the chorus, all feral shouts and primal screams. It sounded fierce, but it needed something extra, something that the Mac had never done before.

While brainstorming in the studio, something reminded Mick of a holiday he had spent in Barfleur, France. One Sunday morning he awoke (rather earlier than he'd have liked to, the fact it was morning at all should tell you that) to the strident sound of a brass band marching around the town square below. Once he'd accepted that they weren't going to go away, Mick watched from his window and was inspired by the festive atmosphere the brass band had created, and how their presence was bringing everyone together – people were appearing in their droves to hear and see them. Remembering that feeling, Mick put it to the rest of the band that it would be fun to recreate that marching band sound and atmosphere... only in a much, much bigger way. With

the help of the University of Southern California's Trojan Marching Band, Fleetwood Mac would take over the Dodger Stadium in LA to record the single and, famously, the video for 'Tusk'. Fleetwood didn't just want the band to play, he wanted them to have the space to march as well, and there would be plenty of room for that.

John McVie was the only Mac-member absent – he preferred to be in Tahiti instead – so he was represented by a cardboard cut-out. It was a relief for the band to be out of the studio, and recording in the open air and the sunshine was a unique situation. Stevie, in her summer dress, did a spot of baton-twirling as the band played, and she and Robin roller-skated around the vast space during down time. The video concludes with the band playing as they march around the track; their only audience – Fleetwood Mac themselves – watch from the stalls and cheer them on, Stevie waving her straw hat in the air with excitement.

There was, as Stevie has observed, something tribal about the song, and indeed the album, which chimes with Mick's own connection with Africa and his fascination with African drumming. Tapping into that tribal quality led to the band themselves becoming like 'warriors' in their mind-set, which Stevie believes is the reason that the almost interminable process of making the album didn't see them all off completely. "*Tusk*, was very native, very African," Stevie told ABC Australia's Molly Meldrum. "Mick thinks he is a Watusi warrior and... he and I would sit and write for days, it was like. these are the sacred steps back up to the top of the sacred mountain of this jungle... That's what *Tusk* was. Everything on *Tusk* was very warrior-esque, which is probably one of the reasons why 13 months didn't kill us all; we went to another kind of world for *Tusk*."

It would be experiences such as the recording of the 'Tusk' single and video that would make the process a little more fun and diverse, although while Stevie admits she enjoyed making *Tusk* more than *Rumours,* there were elements that also drove her crazy – having to be there at 2pm every day, for example: crack of dawn in Rock Star Land. What made this call-time even harder to face was the fact that, once in the studio, much time would be wasted, from her point of view, on 'blues jams' that went on for hours, work-outs that didn't involve her

anyway. The prospect of this was rarely conducive to dragging herself out of her perfumed bed chamber.

"We had a digital person that I never understood the whole [time] why he was there," she said. "I called him 'Mr Didge'. For 13 months we went to the studio every single day at two o'clock... and you are not late for a Fleetwood Mac session – they come and get you and kill you. So [you're there] from two o'clock in the afternoon – which is a horrifying time of day to even be up – until eight or nine the next morning, and then it's like, 'Let's jam! Let's play the blues! Da da da da-da!!' And you can't leave [the room] because you're part of this band..."

Quibbles aside, the work was strong, not to mention abundant, but Mick was concerned a split was on the cards, not least because of the starkly different styles of songwriting that were now etched in very bold relief. Stevie and Christine's songs were especially radio-friendly, but Fleetwood was still uneasy – Warners had told him they'd have to sell 500,000 copies just to break even, the way they were spending – and Lindsey, meanwhile, felt betrayed by the general lack of enthusiasm. Every writer in the band was respectively honing their own voice, so was this going to lead to disinterest in the band and a flurry of solo projects that would take over and tear them asunder? Whatever was on the cards, *Tusk*, for all its compelling qualities, would lack a unified voice and this was an indication of things to come. Meanwhile, the expenses had rocketed and *Tusk* would go down in history as the most expensive album produced up to that point, reportedly costing over $1 million (although this claim was a myth, according to Mick Fleetwood, who insists the Eagles broke that record. Those Lear jets won't pay for themselves). Still, figures were neither here nor there – the fact was Fleetwood Mac had gone way over the top.

"When we moved out of the studio it looked like [a] house that we'd lived in," Stevie giggled. "There had to be 350,000 Polaroids plus stuffed animals hanging upside down, you know, rabbits*... Everything that we all owned, yarn and crocheting stuff, and paints. We had all our art supplies..." It was chaos, but after over a year in a confined space, they

* Essential studio staple, rabbits.

had to create their own corners inside of that, a corner that felt like home, otherwise they'd lose their minds. There was also so much equipment in the studio that, by the end of the 13 months it had taken to make *Tusk*, it would take an entire week and a large truck to shift it all back out again.

The bills were mounting, and the intention to make it a double album would mean it was also expensive for fans. Warners were not convinced by the idea at all. The record industry was in the midst of a slump and Mo Ostin feared *Tusk* lacked commercial appeal, but Lindsey was determined, no matter whether anyone else in the band agreed. Christine McVie and Stevie had wrinkled their noses in bemused disdain as Lindsey whacked a Kleenex box in the toilet (not a euphemism) to get just the percussion sound he needed – and Lindsey's experiments were not all that welcome on their watch at the time either, even if Stevie has said that, with hindsight, she can appreciate *Tusk* much more than she did while they were making it. It was ahead of its time, but listening to the same songs for over a year was "a drain", she admits, and would make it hard for anyone to view the music objectively.

Lindsey had been trying to push Fleetwood Mac forward, to "shake people's preconceptions of pop" – a noble quest, but this, and his statement that selling copies was not his priority, didn't instil the label with confidence. Stevie shared Warners' view that it would be expecting too much of fans to part with $16 in one fell swoop, and the label considered releasing the album as separate discs "to soften the blow" of the cost. Price wouldn't be a problem at all, however, when the Westwood One rock radio station elected to play the entire album on air, allowing people to tape it. Fleetwood was furious, but Stevie Nicks was, according to Ken Caillat, rather more concerned with the cover of the album and the 'Tusk' single, which came out on September 19, 1979 (and went straight into the top ten in both the UK and US), just under a month before the album's release. The dilemma of who would end up being 'showcased' on the cover, a la *Fleetwood Mac* and *Rumours,* was avoided altogether on both lead single and album because the image used would be that of Ken Caillat's dog Scooter, biting the leg of his master's jeans. Stevie wasn't a fan of Scooter at the best of times, but this was a bridge too far.

"[Stevie] wasn't happy about that at all," said Ken. "Of course, she'd been fine being only one of the two band members on the cover of *Rumours*. She hadn't suggested that Lindsey, Christine and John be included on that cover." Rather more worryingly, Ken suspects that, when the decision regarding the cover art was made, Stevie "put a hex on Scooter. Then when he died four years later in 1983, Stevie said, 'I'm glad, Ken. Your dog had that album cover that should have been mine.'"

Chapter 14

An extract of Stevie's velvet-covered journal from the time of the Tusk *tour: "One more time, on the plane. Lindsey is his usual asshole self. I am coming to the conclusion that Lindsey and I are at an end. So sad to see good love go bad... Seattle. Worried about Christine. Wishing some spiritual guidance would come from somewhere. Where are the crystal visions when I need them?"*

Work on *Tusk* had been hard, and the upcoming tour would be even harder, but just before *Tusk* was released and during the intense period of tour rehearsals, there would be a brief moment during which the band emerged into the light to be given the mother of all pats on the back: on October 10, 1979, Fleetwood Mac would be honoured with the 156th star on the Hollywood Walk Of Fame.

It was a surreal situation. The band first had to congregate inside the famously tacky Frederick's of Hollywood lingerie store on Hollywood Boulevard while hundreds of fans waited outside. At least this would give the frazzled band something to laugh about. Frederick's staff even presented them with 'commemorative underwear' – well, it would be rude not to – while *Rumours* blasted through the speakers outside. Finally the big moment arrived, heralded by 100 USC Trojans charging through the shop playing 'Tusk'.

When the Mac finally sloped out into the street, looking every inch the cool, consummate rock stars, drinks in hand, they were invited to the podium to address the excited devotees before them. Mo Ostin thanked Fleetwood Mac for basically making them a ton of cash; John McVie, looking insouciant in sunglasses, deadpanned: "Thank you all for being... er... Americans..." and Stevie couldn't resist blessing the crowd for "believing in the crystal vision. Crystal visions do come true," she said dreamily. It was a little closer to what fans probably wanted to hear, but Stevie's little speech made Carol Ann and Lindsey snigger like naughty school-children. "We knew she was saying it from the heart," said Carol Ann. "But it was just so Stevie to throw out her 'crystal vision' line at every opportunity that we both cringed – and quoting it against a backdrop of push-up bras and fuck-me heels..." That evening, a star-studded gala party was held in Beverley Hills to celebrate the Mac's achievement. It was a classic rock star shindig and everyone who was anyone was there (even the often reclusive Beach Boy Brian Wilson turned up). Never mind 'crystal vision', double vision would have been more appropriate.

Once the hangovers had worn off, Fleetwood Mac would resume rehearsals for the *Tusk* tour at the Sunset Gower studio complex. Mick Fleetwood remembers the soundstage, previously used by Busby Berkeley and Fred Astaire back in the golden era of Hollywood, as "immense, old, damp" – the walls rang with history, and it was twice the size of the studio used for the *Rumours* tour rehearsals. The constant chilliness did nothing for Stevie's respiratory health – fragile at the best of times – and even her dog Ginny developed a wheezy cough. Colds would abound, and self-medicating was in full flow.

The members of the Mac were frequently bored or simply exhausted, but ennui was, as always, balanced up by the kind of luxuries that would make Henry VIII feel quite at home. "Everything was being done on a scale that made the *Rumours* tour look like a poor man's road trip," said Carol Ann, who would visit Lindsey during the rehearsals and look on in wonder at the extravagance required to make day-to-day living bearable for the band. There was a Japanese masseuse; a daily banquet that was largely ignored, as always (Stevie had recently had root canal

treatment anyway); the crew expanded, equipment was updated and two black tents were added to the stage plot. Every night, one would be erected on either side of the stage. One contained Stevie's many wardrobe changes, while both would contain plenty of blow for the band to enjoy without even having to leave the stage during the concert. The rehearsal site itself was so large, Christine could easily cycle around the room on her bike, her dog chasing after her, without even coming close to crashing into anything.

Meanwhile, Lindsey noodled on his guitar, and Stevie rushed around in high heels and leg warmers, returning to the safety of her ubiquitous gaggle of girlfriends whenever she had the chance, even during songs. That support network was more vital than ever as rehearsals were tough, most of the Mac were reluctant to be there at all, and there was now a new level of competition for Stevie to cope with. Her powerful, 'white witch' stage persona that reliably grabbed the spotlight on stage was now under threat from a rival in the shape of the new-look Lindsey Buckingham, who, with the help of his eyeliner, darkened, angry brows and sharpened cheekbones (thanks to a little contouring make-up) now looked "completely Satanic", according to Carol Ann Harris. He was giving Stevie a run for her money, and he'd certainly get plenty of attention during the *Tusk* tour, often for all the wrong reasons. That 'Satanic' look was, by accident or design, reflecting his inner demons, and those demons were planning to accompany him live on stage, with some disastrous results.

It was no secret to the world that Fleetwood Mac had had their problems, but Stevie now insisted in interviews that their troubles were in the past, assuring journalists with a smile that "Fleetwood Mac is the rock in my life. We realised we could come through anything. The band is strong." And they were, unbreakably so, but that didn't mean that, away from the public gaze, the Fleetwood Mac family was even close to functioning healthily. At least people were now talking less about the band's personal relationships and more about the music. For now.

The time spent making *Tusk* marked the longest the band had ever been in the studio, and similarly the *Tusk* tour would be an epic odyssey,

145

a year on the road taking in 113 shows between October 26, 1979 (at the Pocatello Mini Dome, Idaho) and September 1, 1980 at the magnificent Hollywood Bowl, taking in the rest of the States, Japan, Oceania and Europe along the way. The *Tusk* tour saw Fleetwood Mac at the peak of their excess, setting a new level of rock star extravagance. There were limos for everyone – stage crew included – and commercial flights were abandoned altogether in favour of well stocked private airliners. This wasn't unusual rock'n'roll behaviour once an act reached a certain level. Led Zeppelin had hired the flying 'shag-carpeted gin palace' that was known as the Starship, after all. It was simply practical, there was less waiting around and any chances of offending anyone or getting arrested were minimised. One of the planes chartered by Fleetwood Mac was Caesar's Palace's 'Chariot', a private Boeing 707 which was previously a passenger jet, and had also last been used by the Zep themselves a year earlier, as the Starship had been permanently grounded due to engine trouble. Caesar's Chariot was fitted with comfortable, overstuffed seating, there was a bar (obviously) and private rooms. There was also, famously, a Hammond organ. All the essentials, basically. It would cost $2,500 per day to hire the plane.

Mick Fleetwood has always maintained that this was the tour that nearly "killed the band" – and it would notably be the final tour with the profligate Fleetwood himself as manager – but they were going out in style if that was the case. Every whim was met, the masseuse was always on hand, the champagne and cocaine were already staples – it's almost pointless even mentioning them now. No one was going to be suffering from substance withdrawal and, thanks no doubt to the excess of many lovely things, the dressing rooms post-show were always crammed with people and record executives (mostly people too), including Danny Goldberg and Paul Fishkin, co-owners of new label Modern Records. Modern Records had recently signed Stevie exclusively as a solo artist. Stevie and Paul had also spent some time together romantically (in fact Goldberg has asserted that Stevie had dumped Fishkin for Fleetwood). He was "sweet and wonderful and understands [the lifestyle] as well as anyone," Stevie mused in an interview with *People*, although she would add, perhaps by way of warning, "I'm not interested in playing around

but I do get terribly lonely on the road..." Just as well he "understands', then.

Fishkin first met Stevie Nicks at a Warners Bros convention in 1976 where, on the first night of the event, she was going to play the *Rumours* album to the company for the first time. "She was sitting with George Harrison and I was introduced to her," remember Fishkin. "I hardly knew who she was, she wasn't a 'star' yet." Paul would make a lasting impression on Stevie by being in the right place at the right time that night, rescuing her from a potential dousing from over-excited Warners executives. Her new hero.

"The guys were about to throw her in the pool," Fishkin told Robert Llewellyn in his 'Carpool' series of interviews. "They were having a big party for the opening night of the convention, and she turned to me and said, 'I'm terrified of water'. So I was the big protector, I saved her." As a reward, Stevie invited Fishkin up to her suite with a handful of other executives – this isn't going where you think it is – and played them the album. "We were the first ones to hear it, it was before she'd played it at the convention. I remember dancing around, over the beds, it was crazy, an incredible moment." The pair would remain friends after this memorable first meeting, and Modern Records was formed in 1978 essentially *for* Stevie's solo career, the distribution deal being firmed up with Atlantic in June 1979. While much of the real work would go on hold as Stevie "completed her recording and touring obligations to Fleetwood Mac", by the time she was ready, everything would be in place. This was a development that Stevie would be keeping from Mick Fleetwood for the time being, believing that the news might not be well-received. Fleetwood Mac required commitment, and Mick was already panicking that the band members were pulling away from each other. His concerns were hardly allayed when, at the LA press conference for the tour, the majority of journalists wanted to know whether Stevie was leaving, or whether the band were likely to break up. Was this their final hoorah? This may have been one of the reasons Mick was throwing money at everyone and everything to make sure they had the best time they could possibly have.

One story from this tour that would go down in history, much to Stevie's considerable irritation, was the tale that Stevie and Christine

demanded their hotel rooms be painted in their favourite pastel colours in advance of their arrival – pink, in Stevie's case. This has been heartily refuted by Ms Nicks. "I never had to have a pink room! I'm not even a pink person," she retorted. Not denying any other pastel colours there, one notes.

Still, even if it was true, it's almost possible to see some kind of rock star logic in having a thread of continuity when travelling from city to city, hotel room to hotel room, for an entire year. (Yes vocalist Jon Anderson, for example, required his own teepee to be erected in every dressing room for this same reason.) But Stevie insists that "all I wanted, and this is what I got, was the presidential suite at hotels. We were elegant people and we wanted a place to sleep after the show that was beautiful... From the first day I joined Fleetwood Mac, we got a first class ticket and a limousine picked us up. So it's their fault that I'm like this!" If there was just one presidential suite available, Stevie and Christine would flip a coin. The boys in the band didn't get a look in, although it's fair to say they probably weren't roughing it either. That said, what with Stevie knowing she would be away for so long, there was a little tightening of the purse strings (whether that was the intention or not) when she sold her fabulous Hollywood home – dubbed 'Fantasyland' by frequent visitors – in favour of a smaller beachfront condo.

That aside, everything else was getting bigger and bigger on Planet Mac and, with Mick Fleetwood acting as bursar, any hopes of breaking even had gone straight out of the window. But while the tour would not be a financial success, the *Tusk* shows were staggering to witness, so huge and impressive that, once the band had hit the stage, they were rendered as small as "toys, puppets," observed *NME*'s Richard Gabel. This wouldn't mean they or their performances were in any way lost; there was something about Fleetwood Mac that meant they were perfectly at home in vast venues. "The space gives them grandeur, since they command it with amplification and volume. They must be Gods," Gabel breathlessly concludes. But the difference between the sometimes playful backstage Stevie, dancing about with a plastic brush sticking out of her hair, and the poised rock queen on stage, was stark. The audience was rapt as Stevie told her stories through song, the energy building

until it appeared almost as if she was speaking in tongues, particularly in 'Sisters Of The Moon', her mysterious chanting and gibberish were "like soothsayer's words", as the always entranced Mick Fleetwood remembers it.

'Rhiannon' was as dramatic and spell-binding as ever, even casting a spell over its own creator, it would seem. On this tour, Stevie seemed transfigured by the energy she'd conjure up in the form of Rhiannon, a form so strong and powerful it would apparently be champing at the bit to take her over all through the show, to "carry me off". "[But] Rhiannon just has to wait," Stevie told *Rolling Stone* rather matter-of-factly. "That's all there is to it." Stevie would show *Rolling Stone* photographic evidence of her temporary transfigurations. "This is Rhiannon, without a doubt," she said, handing over a photograph of herself performing the song – a picture that apparently looked nothing like her. "You see, it turns." She then pulled out another photograph, this time one of herself with Lindsey onstage. "This is the killer. The pale shadow of Dragon Boy, always behind me, always behind me." The journalist observed that she was speaking "almost to herself, in a hoarse whisper" at this point. "Carried off" indeed. So Lindsey was now Dragon Boy. The 'dragon' in 'Gold Dust Woman' represented anger, so that would certainly make sense.

Lindsey Buckingham's fearsome new look was pulling focus, but so was the way he was performing his songs, screaming with fury, sending the crowd wild. Stevie had her own characters onstage, but Lindsey's stronger persona seemed to have an emboldening effect – he would charge towards the front of the stage, his solos infused with new energy and his behaviour becoming... well, a little insane. There was now a war onstage between the white witch and the prince of darkness. His high levels of tension reflected the fact that he was being held responsible for the band's new direction on *Tusk,* and the mixed reaction it garnered. The passing of Lindsey's father, Morris Buckingham, only added to Lindsey's disordered state.

The final shows of the decade took place on home turf at San Francisco's Cow Palace, close to Morris Buckingham's old coffee plant where, back in the day, Buckingham senior had allowed Stevie and

Lindsey to work on their songs through the night. Stevie would dedicate the final show to Morris. Just over a week earlier, on December 5, 1979, Stevie's treasured 'Sara', the album's second single, was released, peaking at number seven in the US charts. Given the circumstances and the changes the band members had undergone, even since the conception of the song, it was often difficult and emotional for Stevie to sing it live. It was as if she was re-opening those wounds again and again, and soon she would have to take a hiatus from singing 'Sara' onstage until a little more time had passed.*

The band spent Christmas with their loved ones (i.e. not each other), reconvening in February 1980 for their first shows of the new decade that took place in Japan before they moved on to Australia. While the band were technically 'off' during January 1980, work was already underway for *Bella Donna,* Stevie's debut solo album, and it was time to let Mick Fleetwood know about it. According to Fleetwood, the letter he received from Stevie was "full of portents, news and admonitions." She wasn't just telling him she had her own career to think about now, she was taking the opportunity to deliver some home truths and go into a bit of a paranoid stream of consciousness to boot, noting that "it is a fearful time. Things are becoming less exciting and more real." Stevie also expressed her fears regarding what was happening politically; the diplomatic crisis between the US and Iran was at its height, with 52 American hostages held at the US Embassy in Tehran; the Soviet army

* 'Sara' would be at the centre of further consternation, albeit for different reasons, the following year. A certain Carol Hinton of Rockford, Michigan, attempted to sue Nicks for plagiarism, claiming she had sent a song called 'Sara' to Warner Bros in the latter part of 1978. The lyrics bore some similarities – both apparently sharing the line 'drowning in the sea of love' – but Stevie proved she had recorded her demo in July 1978, some months earlier than Hinton's supposed submission. Eventually Hinton dropped the suit, accepting Nicks had not plagiarised her work. Regarding the ordeal, Stevie told *Rolling Stone* in 1981: "I never said she didn't write the words she wrote. Just don't tell me I didn't write the words I wrote. Most people think the other party will settle out of court, but she picked the wrong songwriter. To call me a thief about my first love, my songs, that's going too far." It was "just a farce", Mick Fleetwood observed.

was moving into Afghanistan… and, Mick recalls, Stevie informed him "that I was a cheap bastard, so she was sending the girls in our office an extra \$250". The letter was signed 'Katherine DeLongpre'*, one of her many pseudonyms and characters ('Lily' being another). These names were masks to hide behind, useful when putting your feelings in writing, should the letter ever fall into the wrong hands.

"Tragedy and music make for great writing," Stevie would say, in reference to her letter-writing and feverish journal-keeping. She will have had plenty to get out of her system once the tour had resumed, because, by March 1980, Lindsey's rage was spilling over like molten lava. After touring the US and Japan, Fleetwood Mac hit Australia. They greedily fell upon every substance they could possibly inhale, having just arrived from Japan where recreational resources were somewhat limited. This post-withdrawal binge, plus the simple reality of having to spend every day with each other, was a combination that would affect both Lindsey and Stevie in different ways, neither of them positive. The situation was a ticking time-bomb, and by the time they were to play Melbourne's Festival Hall on March 11, Lindsey was ready to explode. The way his behaviour was turning was almost as if he was possessed by something mischievous and malevolent, and, unsurprisingly, he was targeting Stevie. It was hard enough having to be in the same room or on the same flight as 'someone who hates you' but Lindsey's fury was now starting to bleed into the show.

The band, coked up and looking elegantly wasted, hit the stage, greeted by the usual roars. While it was not unusual to see Lindsey glaring at Stevie during her songs, Lindsey, who had apparently been drinking heavily, stepped up his hostility, determined to upstage her. At one point he lay down on his back and continued to play, writhing about and grinning up at an enraged Stevie as she screeched at him for

* Katherine, or Catherine, de Longpre was a 17th-century French saint widely known for her kind-hearted largesse towards those less fortunate than her. Her disposition is likely have resonated with Stevie, who is known to be extremely generous and thoughtful. (As demonstrated by the extra cash she wanted the 'girls in the office' to have.)

ruining 'Rhiannon'. Despite Stevie standing over him yelling, Lindsey remained exactly where he was for three songs. But this wouldn't be the worst of his actions that night. As Stevie delicately placed her glittering shawl over her head and the opening beats to 'Sisters Of The Moon' kicked in, with an evil glint in his eye, Lindsey grabbed one of Stevie's spare shawls from the wings and whirled around, lampooning her performance.

"Stevie was rigid with furious indignation," remembers Carol Ann. "She made it through the song and abruptly walked off stage and didn't return. The show was over. Not one band member talked to Lindsey backstage, but he didn't seem to care." On top of the prodigious amount of drinking Lindsey had been doing, he had also been suffering from fits and had been prescribed Dilantin, an anti-epileptic drug which controlled his seizures. Taking both in combination was not recommended. Aware that not just Stevie, but the entire band and crew were unhappy with him, Lindsey attempted to control his runaway behaviour for the next few shows. Stevie must have been dreading what he was going to do next, but he played well and kept himself to himself.

But just as Fleetwood Mac were allowing themselves to relax a little, confident that the latest storm had passed, on March 20, the 59th show on the tour at the Athletic Park in Wellington, New Zealand, Lindsey lost control completely. Pulling his jacket over his head and twirling around in a repetition of his cruel send-up of Stevie's dancing, this time, during 'Rhiannon', Lindsey proceeded to ruin the night and put his own position in jeopardy by resorting to behaviour that would put his previous sarcastic imitations in the shade.

He'd been "hitting the old scotch bottle a little too hard before the concert," remembers Mick Fleetwood. "And halfway through he snapped. First I noticed he was playing out of tune, then he started to clown around and mimic Stevie… [and] he was playing anything except 'Rhiannon', laughing like a madman."

"I thought, 'Well, that's not working for me,' but I didn't do anything," Stevie would add. "This must have infuriated him, because he came over and kicked me. I'd never had anyone be physical with me in my life. Then he picked up a black Les Paul guitar and he just frisbee'd

it at me. He missed, I ducked – but he could have killed me." The kicking continued as Stevie desperately tried "to salvage her number", Fleetwood remembers. And all in front of 60,000 traumatised fans.

Carol Ann Harris was watching, horrified, from the wings. "The kick[s] seemed to stun her. Stevie frantically tried to stay away from his steel-toed cowboy boots and the whole show fell apart." Lindsey's own memory of this night is hazy, but for everyone else, it was hard to forget. "I'm not sure that happened," Buckingham told *The Guardian*'s Tim Jonze in later years. "Oh, it happened, all right," confirmed Christine McVie.

Everyone was "freaked out", as Fleetwood recalls and there would be no encore. The crowd yelled for more but their heroes would not return, all of them now running "at breakneck speed back to the dressing room to see who could kill [Lindsey] first", remembers Stevie. Bodyguards waded in to attempt to prevent the inevitable. Stevie was flying towards Lindsey, who was "slumped miserably on a bench", as Fleetwood puts it, but Christine was faster. Stevie has often credited the tough, practical Christine for absorbing much of the ugly side of being on the road with the Mac, and she would certainly be doing that tonight. Lindsey rose as an irate, tight-lipped McVie charged towards him, and before he could say anything she had struck him hard across the face. Then she threw her drink at him just to underscore the point. "Don't you ever do this to the band again," she hissed before storming out to cool off.

"I think he's the only person I ever, ever slapped," Christine told *Rolling Stone* in later years. "I just didn't think it was the way to treat a paying audience, aside from making a mockery of Stevie like that. Yes, she cried. She cried a lot." The tour would continue but there was serious discussion behind the scenes of sacking Buckingham and replacing him with their old friend Eric Clapton, a fellow survivor of the British blues wars of the sixties.

Lindsey himself looks back on those shows philosophically, admitting that the band's temptation to let him go was "well-founded", and that he had behaved unprofessionally. "Stevie and I could never quite find each other after *Tusk*," said Lindsey in later years, a note of therapy-speak creeping through. (Although who wouldn't need therapy after

years in Fleetwood Mac?) Their broken relationship had been like a marriage in Lindsey's eyes, and one within which he had the upper hand. Lindsey didn't react well to not getting his own way, although his attitude would change once he had a family in later years. But at this point in the story, the torture of having lost Stevie but never being able to really move on was working its way out in all sorts of ways that were rarely constructive.

"You have to understand that this was someone I met when I was 16," explains Lindsey. "I was completely devastated when she took off. And yet, trying to rise above that professionally, I produced hits for her, I had to do a lot of things for her that I really didn't want to do. If I kicked her onstage, that was… something coming through the veneer. There has been a lot of darkness." The word 'darkness' has come up more than once in connection to the ongoing saga of Stevie and Lindsey. On being asked if she would ever get back together with Lindsey, Stevie once dismissed the idea, insisting she would never want to go back to "that darkness".

This extensive tour kept barrelling along, no matter how hurt, tired or trapped the members of the group felt, and the amount of drugs needed to dull the pain would cause problems in all sorts of ways, not least because, thanks to their growing and not unfounded reputation as one of the world's most hedonistic bands, once they'd hit Europe in May, they were stopped by customs officers. After Stevie and Christine were subjected to humiliating body-searches, tour manager John Courage put his foot down and changed their transport plans. For the European leg of the *Tusk* tour, they would be travelling by private train through Germany and into France and Holland. This was all very well, and the train itself was luxurious and comfortable, but the Mac rather went off it when they realised that the lounge car of their train, with its gold light fittings, wooden interiors and velvet drapes, had once belonged to Adolf Hitler, and it came complete with an elderly attendant who had served the Führer himself. They all stayed in their own sleeping quarters after discovering that little piece of living history.

A stop-off in Switzerland was eventful, according to the memory of the late Montreux Jazz Festival boss Claude Nobs. The week Fleetwood

Mac descended on the lake-side town, the weather was gloriously warm, so it was with some concern that hotel staff were informed of smoke rising from the chimney of, no doubt, the presidential suite after the band had checked in to their glamorous new digs. It may have been Switzerland, but it was hardly the right weather for getting a blazing fire going in the hearth. It wasn't difficult to tell whose room it was coming from, for those on the inside track. Stevie Nicks loved a good fire (a safe one, anyway), and it was quite normal for her to have fires burning in every room in the house, no matter what the weather was like outside. She'd crank up the air conditioning if she had to, but those fires inspired her and created the right atmosphere for songwriting. (Her mother would despair of her fuel bills, but Stevie didn't care.)

Meanwhile, a member of the hotel staff was sent up to the room to ensure all was well, but after knocking on the locked door, there was no response. There was simply an eccentric fire-loving superstar inside who was spending some quality time with her stash of coke, and did not wish to be disturbed, but the porter didn't realise that. As black smoke continued to billow from the chimney, the fire brigade was soon called and, legend has it, as the door of the room was broken down, Stevie immediately threw the mountain of coke straight onto the fire in a panic, the powder igniting in a bright blue flash.

Drugs were one thing on the road, but sex was another. Stevie has, to Christine McVie's own slight bewilderment, claimed that both women in the band were like 'rock'n'roll nuns'. This might sound unlikely, but the point she so often makes on this subject is that the double standards in the music industry were off the charts – and it was all the more noticeable when you were in a mixed-gender band. The cliched image of a rock star was generally that of a promiscuous, hedonistic male. That was "the romantic idea", Stevie grumbled to *The Guardian's* Tim Jonze. But what about female rock stars? Why was the same behaviour seen in such a completely different way? Even now, female artists who live in exactly the same way as male rock stars are regarded with disapproval, while the men are revered all the more. But the other reason it was difficult for Christine and Stevie to have male companions with them on tour was because the situation was far from straight-forward; you

had two estranged couples in one band – three if you count Stevie and Mick. "[Boyfriends] would just get stomped on," says Stevie. "For me to have a guy out on the road with us, and have Lindsey glaring at him the whole time? Or for Christine to have a guy and John flip him off?"

The European shows were as huge as the American extravaganzas. On the first day of June, the Mac played an outdoor show at Munich's Olympic Horse Riding Stadium, supported by Bob Marley & the Wailers in front of a wildly excited crowd. But the warmth and affection the band had had for fans during the *Rumours* tour had transformed, in many cases, into impatience and fatigue, sentiments neatly encapsulated by the badges Ken Caillat had made for everyone for the *Tusk* tour. The buttons proclaimed the words: 'Tell Your Story Walkin'', as if to say "move along, I've no time for you, whatever you have to say, say it on your way out." It was a weary example of the dark, cynical humour needed to get everyone through each day. Richard Dashut, so frequently the glue in the Fleetwood Mac family, had decided to leave and it felt as if things were falling apart for good.

The *Tusk* tour concluded at the Hollywood Bowl on September 1, 1980. Despite being so close to their respective homes, John Courage insisted the band stayed at L'Ermitage hotel in Beverley Hills, banning them all from going to their own homes. He needed them on the spot, and gathering them together for the show once they'd dispersed would be like herding cats. The concert was, naturally, a huge success; all of their Hollywood friends turned out for them, and the after-tour party was as Saturnalian as ever. However, the fact remained that the tour had barely broken even despite the hard graft and massive, sold-out shows. Mick Fleetwood had just been trying to keep everybody happy, but his thriftless attitude meant that no one had actually made any money. Three weeks after the end of the *Tusk* tour, a meeting would be held at Mick's home to discuss it. But this was far from just a 'band meeting'. The respective Macs were accompanied by their lawyers. Mick tried to defend himself – and his 10 per cent – but Stevie had a new manager of her own, the super-sharp Irving Azoff (who also managed the Eagles) and he was, "ruthless as he took charge of the inquisition", Carol Ann Harris remembers. "He told Mick there would be no in-house

managing of his new client, Ms Nicks [and] he made it clear that Mick had done a horrific job of looking out for the band's best interests over the past two years." From now on, Mick would just be the drummer; no doubt a relief for everyone, not least Mick himself (the loss of that 10 per cent notwithstanding).

The band, not surprisingly, "felt we deserved a break," Christine said. "And we took that break. We took a *long* break." A break from each other, yes, but side projects beckoned. Everyone was desperately in need of a fresh creative outlet, and Stevie for one would be working harder than ever. The seed of her solo career had been tended in the dark for long enough. It was time for it to bud.

PART III

Bella Donna

Chapter 15

Interpretations of the title of Stevie Nicks' debut solo album Bella Donna*:*

1) Beautiful woman
2) A term of endearment often used by Stevie
3) A poisonous herb, also known as Deadly Nightshade

"The title is about making a change based on the turmoil in my soul. You get to a certain age where you want to slow down. The title song was a warning to myself and a question to others. I'm thirty-three years old, and my life has been very up and down in the last six years."

Stevie Nicks, *Rolling Stone*, 1981

By the end of the *Tusk* tour, Stevie Nicks was, by her own admission, in terrible shape. "I was so tired and sung out. I was so 'Landslide-ed' out and so 'Rhiannon-ed' out that I thought if I had to do that set one more time I was going to go nuts." Paul Fishkin and Stevie had already started Modern, a record company that would be "special", with "high principles", as she put it. Stevie's romance with the dark-haired, rakish Fishkin – "the one man in my life who was truly good" – had foundered but their friendship and professional collaboration would continue and, with the utmost belief in Stevie and her work, he and co-conspirator Danny Goldberg "set the Ferris wheel in motion."

While Stevie knew Fleetwood Mac wouldn't feel comfortable with the development, she – and her Modern Records cohorts – felt strongly that it was the right thing to do, and at the perfect time. One of the reasons Mick Fleetwood insisted *Tusk* should be a double album was so the writers of the band had room to stretch; Mick was anxious they would be tempted to move on if they weren't given a little more space. Now he felt his fears had become a self-fulfilling prophecy. Everyone in the band was worried, 'angry', even, when Stevie told them her news. They believed it would harm Fleetwood Mac whether Nicks was successful in her venture or not.

Naturally Stevie herself was terrified of 'tanking', but if she wasn't allowed to express her creativity more fully, she risked sinking into a serious depression. Stevie had always felt like "the baby sister, the one that is left out. That's what I used to get upset about. They were not even close to using my full potential." Her bandmates questioned her decision, but she simply explained she was looking for "an outlet for my songs," and reassured them that she did not want to leave.

Nicks was exhilarated by the prospect of finally being able to open out her ideas rather than having to limit them, shelve them or watch them being taken apart and rearranged for Fleetwood Mac; she'd be the focus in the studio and she'd also be free to explore the influences that were close to her heart and in her bones, like country music. But a solo career would also relaunch Stevie as a different kind of 'brand'. Up until now she had been just another dimension of Fleetwood Mac, and a rather floaty, flakey one at that.

Paul Fishkin and Danny Goldberg (also 'besotted' with Stevie, albeit silently so) saw her in a different context, and were amazed that she had such little clout in the Fleetwood Mac infrastructure. Fishkin believed her to be one of the 'hottest female artists' around and knew she could easily be taken seriously as a solid rock singer if she was given the opportunity. "She was a rocker, her whole thing was Janis Joplin," Fishkin reminds us. This was one of the most exciting moments in Stevie's life so far – being able to step away from the Mac and think, "What do *I* want to do next?" She might have felt like 'the White Queen' on the chess board, being moved around by the hands of fate

before, but Stevie was finally in charge. The next step was finding the right people to have around her in order to make her new project the best it could be.

Stevie had been writing and working on demos throughout the *Tusk* tour, and had a sketch in her head of what she wanted for her new album. What Stevie *really* wanted was for *Bella Donna* to be just like a Tom Petty record. Stevie had been a huge fan of Tom Petty & the Heartbreakers, ever since she'd heard their eponymous debut album. It was in November 1976, while Fleetwood Mac were still working on *Rumours*, and Tom's "Florida swamp-dog voice", Mike Campbell's guitar and Benmont Tench's keyboards had Stevie smitten. "Tom had the same influences we had – the Byrds, Neil Young, Crosby, Stills and Nash – but he dropped in lots of serious old blues. And Tom is such a great singer and so charismatic onstage. I became such a fan that if I hadn't been in a band myself, I would have joined that one."

Stevie desperately wanted Tom Petty to produce *Bella Donna*, or at the very least write her some material, and as she was surreptitiously working on her game-plan during the *Tusk* tour, she approached him with the idea. Stevie and Tom had plenty in common, as far as she could see, but at first Petty could only see the differences – and he was somewhat dazzled by this "larger than life" star, a "Cecil B. DeMille movie" personified. "She was this absolutely stoned-gone *huge* fan," Petty recalled in an interview with Paul Zollo for the book *Conversations With Tom Petty*. "And it was her mission in life that I should write her a song. We [the Heartbreakers] didn't quite know whether to like Stevie or not, because we saw this big corporate rock band, Fleetwood Mac – which was wrong, they were actually artistic people – but in those days, nobody trusted that sort of thing and we kept thinking, 'What does she want from us?'"

But Tom loved Stevie's singing voice, and eventually agreed to produce a song for her. Stevie was impressed by him from the off. "He was pretty much what I expected. There's not a fake bone in his body," she said. But Tom wasn't used to working with 'girls', not least one with a Hollywood entourage – and he'd definitely never worked with anyone like Stevie Nicks. "It was a completely different world

from anything I had seen. She was very sweet and we *liked* her. But she had a whole different work ethic than we had, and there were a lot of hangers-on."

After working on one track, Tom gently informed Stevie that he would be 'too busy' to help her out with the production of the album. What he could do, on the other hand, was put Stevie in touch with Jimmy Iovinc, who had produced Petty – as well as Patti Smith, John Lennon and Bruce Springsteen – and would be a good foil for Stevie in the studio. Tom and Stevie would soon become close themselves, of course. "She would come to my house and just hang out and play records. We'd sit around and play the guitar and sing..." This would be the beginning of a lasting and creative friendship. And yes, Stevie would eventually get that song from Petty. No Nicks mission goes unaccomplished, or had you not noticed? She would also nab the Heartbreakers, who would play on the album themselves, amongst a roll-call of top LA session musicians and, at last, 'the girls' – Sharon Celani and Lori Perry – Stevie's backing singers. This would be their debut recording together, and Stevie had been sending them demo tapes so they could practice the songs, whether they were in different cities to one another or not. They were all dedicated to making the new sound that Stevie craved for her album, that of a female "Commodores", as Stevie put it. She had brought Sharon with her on the *Tusk* tour as her dresser to get her accustomed to life on the road and they had all remained in close contact with each other as the plans for *Bella Donna* unfolded. Everything had long been in preparation and nothing was happening by accident. But Stevie was also nervous about going into the studio alone – Sharon and Lori gave her confidence and created a buffer, which was all the more necessary when Stevie discovered that the tough, serious-minded Jimmy Iovine would not tolerate the usual Fleetwood Mac 'party' atmosphere during sessions, and friends were largely banned from the studio.

Stevie would have to alter her whole way of life if she was going to work with Iovine, and the process would see her evolving emotionally, a metamorphosis Stevie herself would welcome. She was already 33, but after having been cosseted and indulged for so long, she realised

there was so much more to life when you make your own decisions and 'fend for yourself'. Stevie was fed up of being treated like a child, but if she wanted that to change, she'd have to behave like an adult. No one had expected it of her before, so there was no reason to grow up. She was vulnerable, child-like, a princess, a star whose every whim was met, a romantic who played with make-up and dressing up boxes, was fascinated by children's stories and had, as every rock star did, everything done for her. Stevie had also shied away from being a 'women's libertarian', believing the feminist cliché to be tantamount to 'pushiness' – she found it easier to deal with men in the music business with wide-eyed softness and a girlish smile.* But now someone demanded maturity from her, and Stevie rose to it, realising that being older was actually "wonderful", she told music writer Liz Derringer. "You see things clearer. You don't have to get so crazy. You're a woman, not a child. You're the only one who's here and no one is going to save you. My mom has been telling me that for years. And I call her sometimes and she'll say, 'I wish you'd let somebody take some of this pressure off your little bitty shoulders for a moment, Stevie.' And that's what I did. I gave it to Jimmy. I said, 'Here it is, here's the pressure, here's my weird life, here's how crazy it is. Now figure out how to make this album.'"

Stevie and Jimmy arranged to work together after being introduced by Tom Petty towards the end of the *Tusk* tour, but Jimmy Iovine would need some convincing. Stevie was excited to meet him, but he made it clear that she would have to knuckle down and 'be a soldier'. If she wasn't prepared to do that, they simply would not be working with each other. Iovine believed Stevie had probably been spoiled in Fleetwood Mac, protected like a 'baby egg'. He warned her that, if they were to assemble a crack team of session musicians around her, Stevie would have to rise to it and then some. "It's not a part-time job," he insisted. "You can't trick the band, they have to believe it. If they feel like this is a hobby of yours, they're going to treat it like a hobby. If that's what you want to do, I'm not interested." She had much to prove

* Stevie has since confirmed that she is and always has been a feminist.

– not just to her audience, but to him. Jimmy required commitment from her, and the excesses she was used to in the studio would not be tolerated. The languor of Los Angeles, reflected in the months, years even, one could spend in a California studio while the weed was passed along the line and also-rans lurked, waiting for crumbs, was nowhere to be seen. Stevie had a fast-talking young New York producer on her hands with no patience for pampered rock princes and princesses. There was work to be done.

"He said, 'I know you're used to being the midnight cat queen that comes in whenever you feel like it and completely wreck the studio... this is not how you are going to do this album. For a start, you only have three months, and in the second place, I don't want to waste my time with a cartoon.' I just thought, 'Wow, I guess he doesn't think I'm that big of a deal, he's threatening to leave and we haven't even started the album yet!'"

This was the first time anyone had spoken to Stevie Nicks quite so directly, and it shocked her into getting focused. After taking a deep breath, she quietly assured Jimmy that this was all she had wanted to do since she'd started writing songs. She was looking forward to recording in a different, more immediate way anyway, and was aiming for more of a live feel after the painstaking production of *Tusk*. That said, she was also "scared to death, because I didn't know whether I was able to conform to this new disciplinary way of life..." But Jimmy Iovine would be the perfect person to guide her through and get the album cut in time, because, by the time they started work, she really did only have three months – not a long time in Fleetwood Mac's world. Admittedly, Stevie had plenty of work prepared in demo form, but Iovine had to finish work on Tom Petty's latest album *Hard Promises* before he could start working with Stevie, while Fleetwood Mac had recording sessions booked for their next album, *Mirage,* in Spring 1981 – and, as Stevie herself has said, when Fleetwood Mac tell you they need you to be somewhere, you go. Not that that's a situation many of us will have been in.

Stevie would hardly be languishing as she waited the long six months until her sessions could get underway, however. While waiting for

Iovine, inspired by his hardline work ethic, she rented a house for her and the girls to move into and practice together every night. The Heartbreakers' Benmont Tench, who would be credited as the album's musical director, would visit and play the grand piano as they worked through the songs, Stevie high-kicking in time like a rock'n'roll gypsy ballerina, and by the time October swung around and Stevie could finally sweep through the doors of LA's Studio 55 with Jimmy, "we were so ready to make that record. It just goes to show you what you can do if you want to." Still, while Jimmy was working with Tom and the weeks passed by, Stevie was starting to feel "very edgy... No one really knew where I was. I was also starting to feel very unimportant and very sorry for myself. I was ready to begin *Bella Donna* and it seemed like it would just never happen." But Jimmy had *Bella Donna* in his mind while he completed *Hard Promises*, and he also had something else on his mind as well; due to the close, almost conspiratorial relationship between artist and producer, Stevie and Jimmy soon became intimate.

Some of the songs Stevie had already written for the album included 'How Still My Love', 'After The Glitter Fades' and the country-inflected 'Think About It', which Stevie had saved after it had been rejected from *Rumours*. "Stevie knew," said Ken Caillat, "that regardless of whether she was performing her songs with Fleetwood Mac or on her own, she would certainly be expanding herself as a solo artist. 'Fine with me if the band doesn't want my songs, I'll just do them by myself!'" And for those songs, their time had come.

Stevie would make copies of her demo cassettes for "everybody in my life, there must be thousands of them out [there]", so almost all of the songs she had earmarked for *Bella Donna* and beyond had been run past Fleetwood Mac first. There were just two exceptions. "They were welcome to anything I wrote," Stevie said in later years. "Except, I would say, 'Bella Donna' and 'Edge Of Seventeen'. 'Bella Donna' was written to be the meaningful word of this album, and I couldn't give them that." The title track, in some ways, would echo some of Stevie's sentiments as explored in 'Sisters Of The Moon' – a beautiful, exhausted woman who is on the verge of fading away, her 'face becoming thin' as her life in the 'fast lane' took its toll.

"The woman was so tired, that the woman could have disappeared," said Stevie, referring to the lyrics in 'Bella Donna', although 'the woman' – i.e. her – had made some progress over the past few years. This version of her own self was, at least, not 'dying', as she'd dramatically feared during the *Fleetwood Mac* tour. Her armour was tougher now, but the fatigue and pressure was still great. "It was just too difficult for me. I never thought my face would become thin, I have a lot of trouble losing weight as it is, and I became thin and unhappy. All the wonderful things that money could buy could not change the way you feel inside when you're by yourself in a hotel room at night." But in 'Bella Donna', Stevie's words soothe her own psyche. 'Ooh, my Bella Donna... Come in out of the darkness.' She had answered her own prayer in 'Sisters Of The Moon' – her soul had become her sister.

Once Stevie entered the studio during the warm, foggy October of 1980, part of what would make *Bella Donna* a success was the 'family' of hand-picked musicians Stevie gathered around her. One was her old friend Waddy Wachtel. "She and I hadn't seen each other in years, but she wanted me there," he said in an interview with *Black Cat*. "I was thrilled. That's where I met Jimmy Iovine and [engineer] Shelly Yakus, a well as the basis of her first touring band, Benmont Tench and Roy Bittan." The multi-instrumentalist Bittan, also known as 'The Professor', was another redoubtable talent, a key member of Bruce Springsteen's E Street Band since 1974. All in all, over 20 musicians would play on *Bella Donna*. Their presence motivated Stevie to work even harder. It was all about "the right people in the right room together," she said. "You have to look good with Russ Kunkel, Waddy [Wachtel], Roy [Bittan] and Mike [Campbell] of the Heartbreakers. With Tom Petty and Don Felder out there you're certainly not going to stand up there and be terrible. You're going to do the very best you can from the first time you sing. You don't want to look like a jerk in front of all these guys!"

Another feature of the album would be a duet with Don Henley on the ballad 'Leather And Lace', which the pair had recorded in demo form back when they were dating. A tender expression of foreplay – 'give to me your leather, take from me my lace' – 'Leather And Lace' seemingly reflects an erotic moment of courtly love. Written originally by Nicks

for Waylon Jennings and Jessi Colter's duet album of the same name but never used, Stevie took it back for herself. This was a good decision – it would be the second single from *Bella Donna*, and a top ten hit in the *Billboard* Hot 100 on its release in October 1981. The star power of Don Henley didn't hurt, but as Henley himself was initially sceptical as to whether Stevie had the discipline to pull off her own solo album, or the strength to 'break away' from Fleetwood Mac, so this duet – and its subsequent success – was satisfying to Stevie in more ways than one. With Jimmy's help, Stevie would soon be showing all of her doubters what she was capable of away from the Mac. "I have my own life," as she sings in 'Leather And Lace', "and I am stronger than you know."

To have Don on her album was "the greatest compliment anybody could give me", Stevie told *Rolling Stone*. "I have striven to live up to the songwriting of Don Henley and Glenn Frey, Jackson Browne and Joni Mitchell. I learned a long time ago that I'd have to work very hard to get even a blink from any of them, not as a woman or a performer, but as a writer." Stevie's male contemporaries were 'pretty chauvinistic', and she would often struggle to be taken seriously. "They resent my success," she once said. "I see it in their eyes, 'How did this dingbat manage to get everything she wants?'" She just had to shrug it off and keep going, building up the bubble in which she lived to shield her from outside forces that threatened to distract her or upset her balance.

There would be no drifting off or 'indulgence' on these sessions. Stevie had to match Jimmy Iovine's rod of iron with the best performances she had in her. In fact, the intense, determined Iovine would get "the most incredible performances" out of everyone, even if he had to drive the musicians up the wall to get results. "By doing that he made you feel like, 'OK, I'll show you,'" Stevie said. "Once he was in the middle of the room while we were recording. He had his headphones on and all of a sudden he turned the beat of the song around. He [looked] at [drummer] Russ Kunkel and motioned him to change the tempo. And I'm watching Russ start to play what Jimmy's saying and I'm blown away. My eyes can't believe that they're seeing this guy [Iovine] bouncing around the room looking like some kind of little elf, telling all these famous guys what to do. And they're following his every move."

Iovine had the energy, the ideas and the power to get what he needed musically out of anyone, and for all of his hard-line tactics, Stevie had fun in the studio. It was a completely different way of working for her, and she was loving the space – physically and mentally – Jimmy had created for her album to take shape. They spent hours in the studio together, danced around to her songs, Stevie would tease him and Jimmy would allow his softer side to come through, encouraging her as he brought up the vocal on 'After The Glitter Fades'. "Does it sound good enough?" Stevie asked him after a take. "Sounds beautiful," he assured her. (That gentle side was relatively rare, however. Stevie would have to draw the line when it came to 'protecting' her backing singers from his domineering manner. Her efforts would be swiftly curtailed with the bark: "Shut up and let me work with them.")

'After The Glitter Fades', from the Buckingham Nicks-era, is a poignant, observant ballad exploring the theme of the music industry and Hollywood as one who was once an outsider ('Well, I never thought I'd make it here in Hollywood...') and is now a 'rock'n'roll woman' going through all of the extreme peaks and troughs that such a life entails. And is the heartache worth it? Always. 'Even though the living is sometimes laced with lies, it's all right...'

Written before joining Fleetwood Mac, Stevie had predicted her own future – not just the success, but the listlessness – with this song. Just a few years after writing 'After The Glitter Fades', everything Stevie touched would indeed appear to turn to gold, and while sometimes dazed by drugs and exhaustion, 'the dream keeps coming even when you forget to feel'. But sometimes the dream would become a nightmare, and soon a tragedy would strike, leaving the music world, and beyond, stupefied, grief-stricken and paranoid. December 1980 would be a frightening time to be a rock star.

Chapter 16

BBC news report, December 8th 1980: Former Beatle John Lennon has been shot dead by an unknown gunman who opened fire outside the musician's New York apartment. The 40-year-old was shot several times as he entered the Dakota, his luxury apartment building on Manhattan's Upper West Side, opposite Central Park, at 2300 local time. He was rushed in a police car to St Luke's Roosevelt Hospital Center, where he died. His wife, Yoko Ono, who is understood to have witnessed the attack, was with him.

The death of John Lennon, assassinated by Mark Chapman on that cold December night, sent shockwaves throughout the entire world, but for those who had been close to him, the devastation was unimaginable. Lennon had been a close friend of Jimmy Iovine's, and they worked together on the former Beatle's album *Menlove Avenue* (released posthumously in 1986). Stevie remembers Jimmy talking about Lennon "many times; about [their] incredible friendship, how John had taken Jimmy in and taught him to record. He was his teacher... and I was entranced because I could not imagine these two together." Jimmy adored John Lennon – to work with the man who had kick-started his love of music was a huge thrill, but getting to know him was, as Stevie described it, a "real-life fairytale" – although what they really had in common was a little more earthy.

The pair had been 'talking casually' together during a flight when Lennon asked Iovine: "Why'd you get into music?" "So I thought about it – *okay, okay, I got to fucking answer this question right!* – and said, 'John, I saw you guys on *Ed Sullivan* and it was incredible. My friends, everybody felt the same. And then I saw the Rolling Stones a little later and I thought, I want to be part of this...' He goes, 'That's cool.' And I said, 'John, why did you do it?' And he says, 'To get laid.' And I felt completely ridiculous, because that's why I did it!"

On the dark day that Stevie and Jimmy received the news of Lennon's murder, "a terrible sadness set in over the house." Jimmy was torn up with anger, misery and confusion, to the point that nothing Stevie could say would help. Stevie also had her own anxieties – as someone very much in the public eye, there was suddenly the feeling that it could have happened to her, or any of her famous friends. After realising Jimmy wanted to be alone with his grief, Stevie left for Phoenix, still her home and the home of her extended family. There, her ailing uncle, also called John, was on his deathbed, and she would sit by his bedside holding his frail hand, his son – yet another John – sitting on the floor nearby. As always, through heartache came inspiration; her uncle's failing health, and the loss of John Lennon, would jointly spark what would become Stevie Nicks' signature song – 'Edge Of Seventeen', opening with the memorable words: 'Just like the white-winged dove...'.

"The line: 'And the days go by like a strand in the wind...' that's how fast those days were going by during my uncle's illness, and it was so upsetting to me." She would visit frequently until, one day, "sometime right about sunset, he turned his head slightly to John, and then to me, and his hand slowly let go of mine. I did run out into the hallway, but no one was there... and the white-winged dove took flight..." The white-winged dove, naturally, would represent a spirit set free, inner peace finally taking over... but Stevie would later realise the white-winged dove was originally indigenous to the Arizona desert, a pigeon-like bird often seen perching on cacti – so there was another resonant connection to home in this song.

The title, 'Edge Of Seventeen', would come from Stevie's 'patchwork' songwriting style and magpie-like ability to pluck jewels from the

most everyday of sources. The name of this song was given to Stevie, accidentally, by Tom's first wife Jane. Making conversation, Stevie asked Jane how old she was when she first met her husband. "She said, in her very Florida swamp accent, 'I met him at about the age of 17.' I thought she said, 'At the *edge* of 17.' I just went... 'Oh, Jane. This is fantastic.' And I just wrote it right down. I said, 'I'm going to use that in a song.' I was really good friends with her, so she dug it."

Stevie sat at the piano and poured her emotions into writing the song; she knew her uncle would have wanted her to use her mourning constructively and write, rather than sit around and cry. But despite its motivation, musically the song Stevie wrote would be far from melancholy. 'Edge Of Seventeen' was, as Waddy Wachtel observed, "magic, explosive". It had an electrifying sense of tension and strength. There was nothing wallowing about it, although there is a yearning quality in Stevie's vocal.

"I cried in the middle of the bridge," she told *Vox*. "About 'the sea never expects it when it rains but the sea changes colour, but the sea does not change'... And so with the slow graceful flow of age, I went forth with an age-old desire to please. It was like, 'well we have to keep going now'. And I wanted that song to have all that energy of us going on." And that energy was 'written into' the track, to the extent that, every time Stevie sings it, she "goes back to that week. In my mind, my little time-space, I'm back in the house finding out that news... That's why I can sing 'Edge of Seventeen' just like I wrote it yesterday."

Recording 'Edge Of Seventeen' with her band made Stevie feel supported, however, and she was humbled by the effort they poured into it, their 'heart and soul'. "It was like they held my elbows so I could stand really tall and sing that song for my uncle and for John Lennon... And understand that we were doing what both of them would have wanted us to do."

It would take two nights to get the track recorded and the plan for the arrangement was to muster a similar feel to The Police's 'Bring On The Night' – something they certainly achieved. The groove was suggested by drummer Russ Kunkel, and it would be Waddy who played that now famous one-note riff; it was tough on the wrist but

he refused to use an echo effect, playing every stroke himself. He had to admit that, when it came to this track, he "didn't know what the hell we were doing", although he "dug it", which is, of course, the main thing. Waddy hadn't heard 'Bring On The Night' but understood what was required musically, and duly delivered. So it was with some horror when he later realised just how similar the intros to the two songs actually were. "I had the radio on, and on comes what sounds like 'Edge of Seventeen' – and all of a sudden, there's Sting's voice! I thought, 'We ripped them off completely!' I called Stevie that night and said, 'Listen to me, don't ever do that again!'"

'Edge Of Seventeen' was a showcase for Lori and Sharon's voices, lighter and airier than Stevie's rich, rasping contralto, like silver to gold, and, having practiced so diligently with Stevie around the piano, they now instinctively came to know what harmonies were required and when. They also knew when their glorious leader was feeling insecure or lonely, and they would back Stevie up when she wanted to stay late at the studio even if the rest of the band were desperate to sleep. Nicks is a workaholic, and Sharon and Lori knew how much she needed them to stay on the same track as her, even when no one else would or could.

Stevie needed constant reassurance, but that in turn would be rewarded with loyalty and generosity, to put it mildly. She required 'praise' from those around her, as Danny Goldberg recalled, "but she put considerable energy into making [them] feel important" and on an equal footing. Stevie went to some effort – albeit in vain – to try to get her designer Margi Kent an 'in' with *Vogue* magazine, and she was so devoted to her friends that she had a clutch of 24-carat gold crescent moon pendants made, so she could distribute them among those she loved. Jimmy Iovine refused to wear one. According to Danny Goldberg, the highest compliment Stevie could pay would be to say you were "very Rhiannon", and the macho Jimmy wasn't too keen on that either. "I am *not* very Rhiannon..." he protested. But back to Sharon and Lori. Stevie explains:

"They make my life easier. If I get tired and drop out, they pick it up for me. If I don't want to sing alone when I'm recording, then one of them just quietly sings along, smiles and acts happy. I have to have

people around me that love to sing and work, otherwise I feel like Alice in Wonderland because I don't relate to anybody, and nobody relates to me.

"The girls stay [late at the studio], even though they also want to sleep, because they'll know that maybe I'll write that special song, or that special emotional thing we wanted to get on tape will be gotten for the rest of our lives – we all feel it's a 'rest of our lives' proposition that we're talking about here." And it would be.

Stevie would work as long as she had to, 'zoning out' at the piano, almost channelling in order to produce the kind of songs that could match up to 'Rhiannon'. Helping her along were, according to Stevie, "spirits from the air". Another more earthly form of assistance was on hand thanks to the odd slug of brandy – something Jimmy Iovine wasn't especially approving of – and voice coach / right hand woman Robin was generally nearby to administer a much needed 'toot' of cocaine when Stevie needed to keep up the momentum, as we hear on a sneaked recording (audible on YouTube) of Stevie working on a demo of the song 'Julia' with Shelly Yakus at the dead of night. Shelly is clearly exhausted but Stevie is determined to write on, huskily murmuring her lyrics – all 'riding through the snow' and 'horses that run like the wind' – as she plays the song on the piano, eventually puncturing the magical mood by announcing, "I want a toot! This is important!" to Robin. The song was driving her crazy, but she couldn't go to bed until she'd conquered it.

There is just one note causing her a problem, "it fucking haunts me!" she yells, before surmising that there is "somebody up there who wants me to do something with this fucking note... Stupid thing. I'm sorry, Shelly," she adds with a smile in her voice. "You have to understand that I'm neurotic. I'm not only neurotic but I'm schizophrenic too..." "Good combination..." replies Shelly wryly. Her frustration is tangible; she'd written the song just the night before and played it for Robin "perfectly". This is just a window into how much every single song Stevie writes means to her.

Tom Petty might not have been producing but Jimmy Iovine 'desperately' wanted him to write a single for the album – he wasn't

confident that there was one as yet, and to include a duet with a star like Petty would work on every level. Having spent time together, drinking wine and singing at his home, Tom knew he and Stevie could "make a pretty good sound" together, so, after a little urging from Jimmy, Tom sat down at home with his guitar and Stevie's voice in his head, and wrote the poignant 'Insider'. It took him a day to complete and the result was, as Petty observed, "one of my best songs [up] to that point. I loved it." He loved it a little too much to give it away, however. Petty duly took it to Jimmy Iovine, who "flipped. He thought it was incredible... he said, 'God, when I asked for a song, I didn't expect this!'"

Stevie was conflicted about the idea of using a song that wasn't hers on her debut solo album, but she loved Tom, and she would love 'Insider', which was replete with Nicks-esque lyrics involving 'dangerous backgrounds' and 'dark angels'. For a Tom Petty super-fan like Stevie, having a duet with the man himself on her record was always going to be special. However, after the pair recorded their vocals, and the hallmark sound of the Heartbreakers was added, Petty was getting "a little depressed about giving away this song. It *hurt* me when I did the track and the vocals." Eventually Tom had to tell Stevie he just was too attached to it to give it to her. He wanted his song – their duet – on *Hard Promises*.* "She said, 'Well, I can relate to that. I completely understand. I'll take something else.'"

That 'something else' would be the song 'Stop Draggin' My Heart Around', written by Petty and Mike Campbell. Stevie fell in love with it when she heard it – although it wasn't actually written with her in mind. The track was already in existence, and, as Petty remembers, "all they did was take [it] and overdub Stevie onto it." Tom sang the chorus and bridge with Stevie and it took just a few hours to lay down the vocals, Stevie working out the lyrical expression and dynamics by writing down dashes and exclamation points on her lyrics pad. (When

* Stevie's vocals would also appear alongside Sharon Celani's on Petty's 'You Can Still Change Your Mind'. So Stevie got her wish of 'joining' the Heartbreakers.

she asked Tom if he does the same thing, he simply replied: "I barely got through school.")

With those two distinctive voices over the inimitable sound of the Heartbreakers, no one was surprised when 'Stop Draggin' My Heart Around', released in July 1981, soared into the top ten on the *Billboard* Hot 100, while *Bella Donna* itself would rocket straight to number one the same month. "[The song] was a huge hit," admitted Petty. "But we [the Heartbreakers] were on a Stevie Nicks album..."

The main problem would be that Petty's own single 'A Woman In Love (It's Not Me)' missed out on being the hit it could have been, as it was scheduled for release just weeks before 'Stop Draggin' My Heart Around'. "It was an awkward position for us because ['Stop Draggin' My Heart Around'] was billed as Stevie Nicks with Tom Petty & The Heartbreakers. Radio programmers didn't want to have two Tom Petty & the Heartbreakers songs around the same period, especially while one was getting this extreme amount of airplay."

On the upside, working together on the song would firm up Tom and Stevie's friendship, and it would only build over the years to come – a small blip thanks to the press notwithstanding. The paparazzi and tabloid press weren't generally interested in rock stars but Stevie was a little different – she was sexy, adventurous, beautiful and mysterious – and column inches were often filled with speculation about her love life, linking her with almost every man she was seen within six feet of. Stevie was irritated that she was being painted as "the siren of the North", whoever that was, and insisted she was a "very quiet lady" who liked to be at home. All the same, the press intrusion and rumour mill would mean Stevie and Tom would have to give each other a wide berth for a while, which upset her enormously.

Something that had everybody talking was the rapport between Petty and Nicks, a rapport that was somewhat different to the connection between Nicks and Lindsey Buckingham. The reason for this was largely because they weren't and had never been involved in the biblical sense, according to Stevie. "I think we'll write together eventually," she told *Bam Magazine*. "You see, Tom and I aren't in love with each other, or haven't been in love and out of love. We're just good friends so we

probably could write together. Lindsey and I have so much behind us that it would be difficult to sit down and get into lyrics. As it is he asks me, 'Who's that one about? What are you talking about in that line? What does that mean?'" And who could blame him? Although almost anybody would be able to answer Lindsey's first two questions with "You" and "You".

"Even when we were lovers, we were never really best friends," Lindsey said. "We've always competed, ever since we started going out together back in 1971." And that competition continued apace outside of Fleetwood Mac too; while Stevie had been working on *Bella Donna*, Lindsey had been furiously completing his own debut album *Law And Order*. Stevie wished him well – apart from anything else, she knew that if her album was a bigger hit than his, there would be hell to pay.

"I love Lindsey," she insisted. "And I wanted Lindsey to make it. If his album is more successful than my album, I would be so glad… I was saying, 'let it go straight to the top', because it only makes my life easier when Lindsey is happy." *Law And Order* would be released on October 3, 1981, Lindsey's 32nd birthday, hitting number nine in the US charts. Four days later, *Bella Donna* would go platinum. Happy birthday… The rivalry was as dogged as ever and, if this was a race, Stevie was in the lead in terms of star power, and she always would be – no matter how hard Lindsey worked.

It wasn't just about her songwriting, it was about her look – she was the perfect pastel-shade, strong-yet-soft-focus icon for the new decade. Her vibrant imagination and visual appeal also meant Stevie was attracting attention from other areas of show business, and there had already been plans to make a *Rhiannon* movie, for example. While mission *Rhiannon* was afoot, Danny Goldberg was sent to meet Evangeline Walton, the fantasy author who had written novels including 'The Song Of Rhiannon', part of the series based on the ancient Welsh Mabinogion manuscripts that Stevie had drawn on for inspiration. Walton, based in Tucson, Arizona, was in her seventies at the time, and Danny was taken aback to note that her skin was bright purple – as a child she had been prescribed silver tincture to ease a bronchial disorder. Being very pale-skinned, she had absorbed the tincture which turned her skin grey,

darkening to a vibrant plum colour as she aged. But she was bright and happy, and listened to Danny with great interest, graciously agreeing that Stevie could use her stories, expecting nothing unless the film actually went ahead. Danny carefully explained that Stevie's plans were "a little tenuous". "Don't worry dear," responded Walton with a twinkle in her eye. "All true artists are a little neurotic."

A meeting with Columbia bore little fruit when it was discovered they wanted to dump the Welsh mythology and just use Stevie's songs for a remake of the Kim Novak classic *Bell, Book And Candle* instead, but the treatment, thanks to Danny Goldberg's dogged efforts, was eventually bought by United Artists. Paul Mayersberg, who wrote the screenplay for the David Bowie movie *The Man Who Fell To Earth*, was brought on board and, while *Rhiannon* was ultimately never made, Stevie was just happy to be receiving professional attention (and payment) away from the Mac. Danny would be receiving his own 'Stevie moon' necklace for his efforts.

Another Stevie moon pendant would, of course, be given to Margi Kent, whose intuitive designs for Stevie's costumes both on tour and for album artwork provided another way for Stevie to express herself and strengthen her image. For the *Bella Donna* cover shoot, with her favourite photographer Herbie Worthington once again at the helm, the outfit Stevie wears is "the same as the one I wore on *Rumours*, except it's opposite, it's white," she explained to *High Times*. "It's a strange turn-around that I've come from black to white..." Coming in out of the darkness, a la 'Bella Donna', no doubt.

The change is also likely to have been connected to the fact that the 'Stevie is a witch' gossip had now gone haywire, and, as a result, she was attracting some unsavoury attention. Stevie loved wearing black but she eventually had to ask Margi to design a wardrobe-full of new stage clothes in cheery colours, her 'Easter egg' outfits as she called them, so that the rumours could die down. As to whether she would 'cast black spells' on people, Stevie retorted: "I don't do that. That's stupid, and anyone that [thinks that] that is making up their own character [that] has nothing to do with me. I love good witches. I like the good witch of the north, Glinda. Glinda is my friend, not the other

one. I don't want them around. My love of that fantasy fairy-tale thing is the good part."

It was also Margi Kent's job to ensure that Stevie's stage look for Fleetwood Mac did not threaten to upstage the rest of the band – particularly with Lindsey being so sensitive about who was getting the most attention at that time. "We would specifically tone it down because Stevie was getting way too much air time," Margi laughed in an interview with *District MTV*. "We had to keep it politically correct, it's hard for her not to stand out because she's a very dramatic performer, but we had to scale back. She had to be respectful of everybody's position in the band, she is a band member and she feels that way." But, when Stevie would finally tour to promote the record, in the autumn of 1981, "we went crazy," remembers Kent. "Everything was colours, textures and feathers."

The outfit on the front of *Bella Donna* was longer than that of Stevie's *Rumours* costume, and instead of ballet slippers, Stevie would be wearing her now trademark suede platform boots, made by "my little Jewish cobbler who's seventy years old. A five-foot one-inch-tall person needs six inches. I get far on these boots. They are very out of style and I don't care. I love them." Stevie also hunted down the perfect platforms whenever she was on tour, scouring flea markets and boutiques, finding them in rose-pink, lilac, grey... pretty, soft colours. "We searched London," she recalled, "and I found one pair that was like a size five, and I wear a five and a half or six, but I bought them anyway. I stuffed my little feet into them." Before long Stevie had amassed 25 pairs, and one show would see her change platforms three or four times.

The *Bella Donna* costume represents Stevie's enduring desire to 'give a fairytale' to people, and the large white bird she is holding (Max, a pet belonging to her brother Chris) also connects with that. Fairytales, myths, dolls, puppets... even the Muppets – Stevie loved them all and they all resonated with her mission to encourage more escapism in a dark and difficult world. "If that's the only thing I can do, well, that's fine."

The German artist Sulamith Wülfing was also a great influence on Stevie's style. Stevie had collected her books, filled with luminous

pictures of fairies, angels and trolls, since the early seventies. Flicking through the pages, "on the road, late after concerts..." gazing at the fantastical images gave Stevie great comfort, and eventually she taught herself to draw just by looking at Wülfing's illustrations. "I think she's probably a lot like me," said Nicks of Wülfing. "The world kind of scares her and freaks her out, and she just wants to do this one thing, and she did it."

Prior to the release of *Bella Donna* in the summer of 1981, Fleetwood Mac would be getting together to record *Mirage*. Everyone had interrupted their own projects to fly to France for the sessions, and rather grudgingly so at that. Meanwhile, Stevie had promised herself she would keep her lip buttoned regarding her solo work – she knew if she allowed her excitement to spill over it would not go down well.

After the intensity of working on *Bella Donna* and an extra two months working on demos for the next Fleetwood Mac album, spending springtime in the French countryside might have sounded idyllic, but the reasons for recording at the Chateau d'Herouville were not. Mick had declared himself a resident of Monaco for tax reasons, and the Chateau was the only viable option financially. And so, with debts up to their ears, rumours of a split swirling around them and trepidation prickling through their veins, the five members of Fleetwood Mac severally made the long journey to Herouville, 60 miles outside of Paris. Mick Fleetwood, finishing his own solo album *The Visitor*, would meet them there with Richard Dashut.

The dilapidated 18th century house had been converted into a studio and had seen the likes of David Bowie, Pink Floyd and Iggy Pop pass through its mouldering doors, not to mention Elton John, who had named his 1972 album *Honky Chateau* after it. The album included the single 'Rocket Man' and was hugely successful, so maybe the Chateau had enough enchantment to help the Mac create their best album to date. That was the idea, anyway. It was time to return to the *Rumours* formula after Lindsey had been allowed off the leash for *Tusk*.

Carol Ann Harris' appraisal of the Chateau was that it was "icky. Damp, spider-and-ant infested, almost no modern amenities..." They were all used to being spoiled, and admittedly the luxuries had become

essentials – they made the tensions between each other easier to bear. But the food provided was good and the Chateau also had, according to Carol Ann, "an ominous, supernatural feel." Which surely made it perfect for Fleetwood Mac. The press were convinced the next Fleetwood Mac album would never come out, so a bit of supernatural assistance would not have gone amiss, ominous or nay.

Mick Fleetwood arrived "as the sun was rising on the day we were to begin recording," he wrote. "We drove down the long tree-lined lane and saw Stevie peering out of the leaded-glass window, looking like Queen Guinevere in the misty early light. It was as if she were waiting for us, being the dawn-type lady that she is." Very poetic, and Mick certainly knows Stevie Nicks better than most of us, but a 'dawn-type lady'? Maybe if she'd stayed up all night. Nowadays Stevie just makes sure she's up by 11am "for my soaps", although no doubt it would be dawn somewhere. But we digress. The missing piece of the Mac jigsaw had arrived, the spirit of *Rumours* was being drawn upon and the adventure of the Fleetwood Mac album no one believed would ever appear had begun.

Some pearls of Stevie wisdom for female musicians and songwriters:

1) *Sometimes competition is good. "I'm not jealous of my background singers. Unless I am unsure of myself and when that happens, then good, I hope someone lets me know by making me jealous. That keeps me on my toes. I'd better be better, or I'll be off the stage! If I even think someone is getting close then I start to run, so it works for me."*

2) *Feeling creatively stifled? Make like Ms Nicks, throw your favourite things into a duffel bag (make sure it contains a note pad and pen) and 'take off' somewhere. A change of scene can shift things along. Stevie would frequently do this whenever being in that fabulous Hollywood mansion or Marina Del Rey dream home started to grate.*

3) *Stay focused. Just because you might be doing something else, doesn't mean you can't still develop your own work too – you just have to make sure you don't have tunnel vision. If the muse is there, don't ignore it. When Stevie worked with the Heartbreakers on Hard Promises, any time there was a break when her services weren't required, "immediately*

she'd go over to a piano and start working on songs," remembers Petty. "That girl likes to write!"

4) *Read. Take the opportunity for a bit of time out on the tour bus or in the studio when you can and escape with a book — you're resting your wired mind, but reading will inspire your own writing in turn. Stevie Nicks enjoyed the suspenseful fiction of Taylor Caldwell, for example, but she wasn't that fussy. "I just read anything that comes in my way that's interesting. I pick up bunches of little old poetry books. I love serenity since I don't have much of it in my life."*

5) *To quote a lyric of Christine McVie's, "don't stop". Keep singing, writing, playing. Be obsessive and be the best. "I plan to be out there singing when I am a seriously older woman. I think my voice will still be good, because I'm not going to let it go. The people that can't sing anymore are the people that went away for five years and then just decided to come back. And you just can't make a comeback. Comebacks are no good. You have to just keep singing." Preach.*

6) *And finally: "Women in rock'n'roll should go right ahead and do it because if you can make it, there's nothing like it."*

Chapter 17

When the darkness encroaches, get inside the Stevie bubble. Swap TV for Cocteau movies. Swap sensible clothes for dress-up. Swap newspapers for Lewis Carroll. Exchange social media for a phone-call. Put movie-star make-up on just to play the piano. That goes for you too, boys.

Stevie Nicks to Playboy *magazine: "I can't do what I do if I don't retain some innocence and spirituality. You'd see a definite change in my lyrics if I became hardened. I'm not interested in existing on that critical level most people live on."*

Fleetwood Mac's modus operandi for *Mirage* was to make an 'updated version' of the sound of *Rumours*, the album that had served them all so well. Admittedly, they were older now and had different preoccupations, and the rich seam of fury that ran through *Rumours* belonged to *Rumours* alone, but to go into the studio with the atmosphere of that album in mind was certainly the idea. Meanwhile, the charts were dominated by the likes of Blondie, the Pretenders, Michael Jackson and Diana Ross – artists with a serious core of rock or soul but a strong pop sensibility. Fleetwood Mac were unsure whether they could move on from simply being seen as the kings and queens of 1970s rock – as Lindsey had been trying to encourage for some time – and they did. The dream team of Richard Dashut and Ken Caillat would be working with them again,

money would be treated with a little more respect and the whole album would take a relatively short time to record. One of the reasons for this, perhaps, was the fact that everyone was just itching to get back to their own projects and their own lives, none more so than Stevie, who would be joined for a while at the Chateau by Jimmy Iovine.

As well as having to witness the pair's canoodling, Lindsey was irritated to see Jimmy advising her all the while. It was hard enough for Stevie and Lindsey to see each other with new partners, but the fact Iovine was a prestigious producer who was driving Stevie in a different direction would grate on a professional level as well as a personal one. Stevie had hoped that the fact everyone was now developing their own careers away from the Mac would bring greater balance, make everyone 'happier' and also potentially take the heat off her a little – "If we're both doing a solo project, then you're not going to be angry with me..." she said at the time. But Lindsey, for one, felt frustrated that, every time he was about to start work on new solo material, the band would steam in and so he would have to use the ideas he had for his own projects for the Mac recordings instead. And yes, he would still be 'angry' with Stevie, not least because, as always, less was expected of her in the studio than of him – and thus she wouldn't have to give as much to the Mac as he would, as producer, arranger and writer.

Stevie's focus was split, the press and the public's hopes were highest for her solo career even though Lindsey, Mick and Christine were working on side projects themselves and, as Lindsey saw it, this caused Stevie to change, and her commitment to waver. She was, apparently, "flexing some emotional muscles that she feels she can flex now that she's in a more powerful position," Lindsey said to *The Record*'s David Gans. "There's a certain amount of leeway in how you can interpret Stevie's behaviour, but there's no denying that her success is making her feel she can pull things she wouldn't have felt comfortable pulling before. Most of them aren't particularly worthwhile but she's venting something, loneliness, unhappiness or something." Her 'baby sister' schtick no longer seemed to wash now either – what had once been seen as charming vulnerability was now regarded by critics such as Gans himself as "childish" and "awkward". Buckingham simply opined that

she felt "out of her depth", being the only one who wasn't technically a musician. Stevie herself would insist that her loyalty to the Mac never faltered at all, however, insisting that the "special knowledge" as referred to in her pre-Mac song 'Crystal' now came to represent to her the unspoken awareness within the band that they would never leave each other. Even so, while she might not have been 'leaving', she was elsewhere in spirit.

A polite silence was maintained regarding Stevie's own solo work, in her presence at least. "They knew if they ripped [it] apart, I wouldn't give them any more songs," Stevie said. "Remember, 'Dreams' – which is just me – is the only gold single that Fleetwood Mac ever had." Behind her back, it was a little different. Lindsey felt Stevie's writing was supposedly "flaky", and sniggeringly referred to 'Stop Draggin' My Heart Around' as 'Stop Draggin' My Career Around',* later publicly dismissing Stevie's work as "a little hard to take seriously". Miaow. In the meantime, however, they had a job to do, and they had to do it together. At least the strange charms of the Chateau would distract them from each other for a while.

The Chateau had an interesting history; once used as a courier relay station between Versailles and Beauvais, it would be painted by Van Gogh, who was buried nearby, and it was once a residence of the Romantic-era composer Frédéric François Chopin. Music was already in its bricks, but the house's rock'n'roll heritage was even more fascinating. Converted into a residential recording studio by Gigot composer Michel Magne in 1962, ten years later it would be the site of the oddest Grateful Dead gig the band had ever played. The Dead were booked to play a free outdoor festival nearby, but the heavens opened and the event was rained off. The band, staying at the Chateau, decided to play at the house itself, and anyone who happened by was welcome to come and join the party. "We didn't even play to hippies," remembered frontman Jerry Garcia. "We played to a handful of townspeople in Auvers. The

* 'Weird Al' Yankovic would parody the song himself in 1983 with the track 'Stop Draggin' My Car Around'.

chief of police, the fire department… Everybody had a hell of a time – got drunk, fell in the pool…"

David Bowie later arrived to work on *Pin Ups* and *Low* with Tony Visconti and Brian Eno, all of them convinced the place was haunted by the ghosts of Chopin and his mistress George Sand, to the extent that the Thin White Duke himself refused to sleep in the master bedroom. Fortunately there were 29 other rooms to choose from.

"There was some strange energy in that chateau," Tony Visconti confirmed in an interview with *Uncut*. "The master bedroom had a very dark corner, right next to the window ironically, that seemed to just suck light into it. It was colder in that corner too. I took the bedroom because I wanted to test my meditation abilities. It felt like it was haunted as all fuck, but what could Frédéric Chopin or George Sand really do to me, scare me in French? Eno claims he was awakened early every morning with someone shaking his shoulder. When he opened his eyes no one was there." This might have been handy as an alternative to an alarm clock, but knowing that most rock stars don't like to commence work until the more civilised time of two or three in the afternoon, one can see how this early wake-up call might not have been appreciated. Perhaps Frédéric just didn't approve of how Eno used the keyboards.

Bedrooms aside, there were other areas of the house that could tell some intriguing stories if only the walls could speak, not least around the main staircase. The Bee Gees recorded the soundtrack to *Saturday Night Fever* there, thanks to its natural reverb, but they were not the first artistes to utilise that part of the house. "So many pornographic films [were] made at the Château," said Robin Gibb. "The staircase, where we wrote 'How Deep Is Your Love?', 'Stayin' Alive', all those songs, was the same staircase where there've been six classic lesbian porno scenes filmed. I was watching a movie one day called *Kinky Women Of Bourbon Street**, and all of a sudden there's this château, and I said, 'It's the Château!' These girls, these dodgy birds, are having a scene on the staircase that leads from the front door up to the studio. There were

* The film was actually called *The Kinky Ladies Of Bourbon Street*, but to be fair to Robin, the title was probably the least memorable thing about the movie.

dildos hanging off the stairs and everything. I thought, 'Gawd, we wrote 'Night Fever' there!'"

The Mac put their own stamp on the place by having the rooms they were using redecorated (not with dildos) and it was a romantic, atmospheric place to record; no doubt the esoteric side of the house's background appealing to Stevie's love of the unknown. The band weren't especially worried about hostility from the 'other side', even if soft rock, increasingly the musical direction Fleetwood Mac were heading, wasn't Chopin's thing. No, there was enough earthly aggravation to keep them occupied, and Carol Ann Harris recalls being quite disturbed by the raging arguments that would occur "every night" in the studio. Meals, on the other hand, were eaten together albeit in silence, and whenever there was an opportunity to go for a walk in the vast, wild grounds around the house, they would take it – and walk as far away from each other as possible. On one occasion, as Mick Fleetwood prepared to go for a ride on the stunning mare that lived in the stable, Stevie swept out of the house and mounted it before he could hop on himself, cantering off into the distance, "her long cape billowing behind her". No doubt growing up in Arizona imbued her with something of the cow-girl.

Ken Caillat's dog Scooter might have gone to the great dog basket in the sky, but the engineer had brought his new puppy 'Pal' with him, and the grounds of the Chateau were perfect for a pooch to play in. During down time, it made a change to be able to leave the studio and be refreshed by cool French air rather than choked by LA smog, so as often as they could, Ken and Richard Dashut headed out to play with the model helicopters that they'd just bought. One day, as Richard and Ken went outside to do a spot of flying, Richard commented that he hadn't seen Pal for a while. The dog had been locked into Lindsey's rented Peugeot the night before, and by the time Ken found him and flung open the car door, he saw that the puppy had basically chewed through the interior of the car. "All the headliner had been torn into shreds and was hanging down like a kelp forest with the light from the dome light streaming through," Ken recalls. "Dashut hit the ground rolling with laughter..." No doubt this didn't exactly help to lift Buckingham's mood.

The songs Stevie brought to the table for *Mirage* included 'Straight Back', written just after the *Bella Donna* sessions and detailing the wrench of leaving LA and Jimmy to go back to Fleetwood Mac: a sanguine comparison between her solo career and the band. An earlier Nicks composition that also made the cut was 'That's Alright', a sweet, uplifting country ballad with a lachrymose twist. Stevie had attempted to get 'That's Alright' on a Mac album ever since she joined the band, but it was never deemed to have the right feel. The song, originally titled 'Designs Of Love', was written before Stevie and Lindsey moved to Los Angeles for the first time, and is a departure from the other tracks on *Mirage*, of which many by Lindsey harked back to a fifties, Bobby Vee feel (notably 'Oh Diane' and, in parts, the emotive 'Book Of Love'), while Christine's inclusions tapped straight into the early eighties soft-rock vibe, with super-smooth, prismatic songs like 'Hold Me' and the inoffensive 'Love In Store'. Buckingham and Nicks' songs always had an edge that Christine's didn't, to these ears certainly, but McVie certainly knew how to write a radio-friendly hit.

Another song Stevie presented to the collective was 'If You Were My Love', written just after she had concluded her sessions with Tom Petty & the Heartbreakers for *Bella Donna*. "I had so much fun that I was really bummed out when it was over," Stevie lamented. "That's when I wrote that song." Interestingly, the song is written to a potential lover, as the title indicates, and the line, 'Well, they say everyone must remain faithful...' betrays a possible crush. Whatever, the song would be rejected from *Mirage*, as would the unusually defiant 'Smile At You'. This song was written at Stevie's home 'El Contento', a pink Spanish-Moorish property in the Hollywood Hills that in the 1920s put a roof over the head of silent movie beauty Vilma Banky. Stevie loved it, not least because she was fascinated by the shadowy history of Banky, but Stevie also found it conducive to write and reflect there because Tom Moncrieff had built her a studio to focus and work on demos. Her time at El Contento was, appropriately, a happy one. If she wasn't in the studio, according to Danny Goldberg, she would be in the kitchen "making tacos" or in the living room, hunched over her precious Bösendorfer piano, one of her first major purchases when the royalties rolled in.

Some have hinted that 'Smile At You' was refused by Lindsey when he discovered she had written it with Tom Moncrieff's assistance, although Moncrieff himself maintains he has no memory of working on the song at all, and Stevie would simply explain that it was a "bitter" song, and they weren't really in that place when they were making *Mirage*. Either way, Moncrieff, who was staying at El Contento at the time, had often helped Stevie develop her work when Lindsey just couldn't face it. Lyrically, 'Smile At You' gives a rare glimpse of Stevie's own 'flaming' fury for once; most of her dedications to Lindsey were kind and philosophical rather than barbed; that was more his style. Whatever the motive for shelving the song, it wouldn't turn up on a Fleetwood Mac record until 'Say You Will' in 2003, which is a shame: the inclusion of this song might have given *Mirage* the grit so many Mac fans felt this album lacked.

As always, there would be no shortage of material from Nicks, and, just as reliably, Stevie would have to stifle her hurt whenever one was passed over. "Stevie writes constantly," observed Christine McVie. "And all her songs are like babies to her even though some of them are rubbish." Christine was becoming impatient that Stevie didn't sit down and finish one song rather than "cranking them out all the time".

Still, for every few songs that were 'rubbish', there would be a 'Gypsy' – Nicks' defining moment on *Mirage*, and possibly of the decade. 'Gypsy', written in 1979 and saved from the *Bella Donna* sessions, was a song that, once recorded, would be described by Mick Fleetwood as one of Fleetwood Mac's "greatest works of art. It crystallises that period of the early 1980s when we were looking back on our youth." Even Buckingham considers 'Gypsy' their "best collaboration" musically.

'Gypsy' takes us wistfully into Stevie Nicks' past, lifting the veil on her broke but happy years in San Francisco; queuing up for rock shows outside the Fillmore Auditorium, rifling through the racks of beautiful clothes at the Velvet Underground boutique and dreaming of stardom. This song was a tribute to those psychedelic days, and how little Stevie had really changed. "Every place I live still looks pretty much like my apartment in San Francisco," Stevie said in an interview with *The Record*. "The clothes I wear... that doesn't change. I love long dresses,

I love velvet, I love high boots. I love the same eye makeup. I still have everything I had then."

A sensitive soul, Stevie once decided to cheer herself up by moving into one of the smaller rooms in her 'English' house in Doheny, recreating her old room in San Francisco: pulling her mattress onto the floor, moving her speakers, plants and 'junk' into a room "about as big as [a] sofa... I just lived in there for about three months," she told the broadcaster Jim Ladd in 1982. "It was really like living back in my apartment before I joined Fleetwood Mac. I'm very comfortable living in one little room with my bed on the floor and lace tacked up at the windows." There was a comfort in tapping into the 'gypsy that remains', as Stevie put it, and cocooning herself in nostalgia; those formative years in San Francisco would always have a special place in Stevie's heart. There are references to Robin Snyder's 'bright eyes', and the line 'lightning strikes, maybe once, maybe twice' refers to the treasured friendship Stevie had found with Robin. "One time in your life you find a very good friend," explained Stevie. "And maybe if you're incredibly lucky, you might find a second. [The lyric] 'It all comes down to you' means you have to look very hard." As much as it is inspired by Robin, this song must also be connected to Lindsey too, Stevie's soul mate, both of them navigating life together at that time, both of them 'facing freedom with a little fear', side by side. The line: 'she is dancing away from you now...' must have cut Lindsey deep. But this lyric would also take on a devastating new resonance in the near future.

Once the album was complete, a *Mirage* listening party was held at the Chateau, to which the band invited a select group of lucky listeners including tennis stars John McEnroe and Vitas Gerulaitis, who were competing at Wimbledon that year. The band played ping-pong with them and stayed up all night playing the record over and over again. After weeks of tension, it felt good to play the tapes to new ears; the songs were light-hearted, soft and... well, rather anodyne. They tried to cast the *Rumours* spell once again, but there was one thing missing. "Passion," Christine admitted in later years. That hot-blooded anger that had spiked *Rumours* with a ferocious, sharp-toothed *je ne sais quoi* had transmuted into frosty detachment.

★ ★ ★

1981 was the year of the music video – for the first time this new, glossy, brightly-coloured medium had found its home in the groundbreaking new music video channel MTV, and artists were able to express themselves and reach out to fans more widely. The posters pinned to the walls of a thousand bedrooms were coming to life. Australian director Russell Mulcahy was considered a leading proponent of the music video during the eighties; he was the man behind Buggles' 'Video Killed The Radio Star' promo, meaningfully the first pop video broadcast on MTV, and, naturally, when Fleetwood Mac started to talk about having their own videos made for the *Mirage* singles – due for release in 1982 – he was top of the list, as was Steve Barron, who had already directed videos for Adam & the Ants ('Antmusic'), the Human League ('Don't You Want Me?', 'Love Action') and Simple Minds ('Promised You A Miracle'). These artists, all pop titans of the new era, were considerably younger than Fleetwood Mac. Maybe Mulcahy and Barron could sprinkle a little visual stardust on them and ensure they could stride confidently into this glitzy new decade, taking their place alongside the younger stars with ease and shaking off any 'seventies rock dinosaur' allusions once and for all.

For the 'Hold Me' video shoot, Barron and his crew took the band to the Mojave desert where a series of surrealist Magritte-inspired tableaux were set up. The set included jagged spikes of broken mirror sticking out of the sand (surely an inauspicious sign in itself), mountains of discarded guitar parts and John McVie and Mick Fleetwood gooning about as archaeologists. Christine, meanwhile, searches for Lindsey in the desert and sings plaintively to camera while the 'mirage' itself – Stevie, clad in trailing red silk – preens on a *chaise longue* and is painted by Lindsey, before struggling doggedly across the sand in her platform boots with the canvas under her arm, which she was not particularly happy to do. In fact, it sounds as if none of the band were particularly happy to do anything. They were hot, they were exposed and they couldn't stand each other. Producer Simon Fields remembers the shoot being "a fucking nightmare".

"It was 115 degrees on this sand dune," remembers Stevie. "No one in Fleetwood Mac even saw the other scenes that anybody did, because if you walked out of your trailer for five minutes, you died of

asphyxiation because it was so hot..." Stevie's friends would tease her for getting the easy job, but she insists it was far from luxurious. "I'm lying on that chaise longue, and it's 115 degrees, and they're saying, 'We need you to look dreamy,' you know... I'm going to look dreamy and then I'm going to die!"

It was not, however, just the heat that was causing tempers to prickle. "[They] were, um, not easy to work with," Barron said carefully. "Four of them – I can't recall which four – couldn't be together in the same room for very long. They didn't want to be there. Christine McVie was about ten hours out of the makeup trailer. By which time it was getting dark." Fields also was not having a good time. Despite the cute and cuddly comedy archaeologist look, John McVie was steaming drunk and "tried to punch me," recalls Fields. "Stevie Nicks didn't want to walk on the sand with her platforms. Christine McVie was fed up with all of them. Mick thought she was being a bitch, he wouldn't talk to her." Another day in Paradise.

Hanging around for hours and being bossed about was not Fleetwood Mac's favourite way of spending three days – Stevie alone had plenty of that to contend with as it was – but the video shoot for 'Gypsy' would also be painful as it interrupted Stevie's first serious attempt at kicking cocaine, no doubt on the urging of strait-laced Jimmy Iovine. A stint at a rehab centre would have to be abandoned as Russell Mulcahy's shoot had been scheduled and could not be changed.

Again, the band were not comfortable in each other's company, but Mulcahy seemed to know how to deal with them. "It was like the best mom in the world," Stevie enthused later. "I wish we could find a producer like Russell for Fleetwood Mac..." (Take that, Lindsey.) However, Mulcahy had to be strong with the group, warning them not to "mess with me", according to Nicks. He also impressed Stevie because of his commitment to reflecting 'Gypsy' visually, which he went to great lengths to do. The result would be completely over the top, featuring Stevie as a pouting, bubble-haired ballerina, Stevie as a nymph, skipping theatrically through an enchanted forest, glitter raining down upon her, Stevie as a 1930s ingenue navigating her way through the grime and glamour of Hollywood...

The 'Gypsy' video would be long – over five minutes long, in fact. It would also be the most expensive music video ever produced at the time and required several locations, many dancers and myriad costume changes, which will have appealed to Stevie. Mulcahy, having heard the song and its story, spent several hours Chez Nicks where he "looked at my closet and he looked at my crystal balls and all my stuff that I have," remembers Stevie. Knick-knacks, dolls, dresses and trinkets would all find their way into the video, which sees Stevie in her cluttered, comforting little bedroom practising her ballet, a dream-like, Vaseline-smeared image that soon becomes a black and white 1930s Hollywood movie, with the members of the band as the stars. The result would be the first ever 'World Premiere Video' to be screened on MTV come the single's release in 1982, but, again, this would be a difficult shoot thanks to the interpersonal difficulties within Fleetwood Mac. Stevie was exhausted and desperate for cocaine – a bottle of which had been brought to her in secret before being discovered and confiscated before she could even have a toot. She also wasn't thrilled to have to dance with – and be kissed and caressed by – Lindsey during one of the scenes. The sight of her former love with another woman at breakfast might have made her "absolutely ill", but similarly she "didn't want to be anywhere near him".

"I certainly didn't want to be in his arms," she said. "If you watch the video, you'll see I wasn't happy. And he wasn't a very good dancer." The following scene in which Stevie rushes out into the rain-swept street after their awkward dance nearly saw her "decapitated" as one of the rain machines swooped a little too low. This would have been history repeating itself, in Stevie's opinion. She is convinced that, in a past life*, she had been "put to death, like Marie Antoinette", because she has great trouble putting her head back, even in "the beauty parlour, I can't put my head back in the sink for a shampoo."

* Another past life of Stevie's was apparently that of a monk, which, she says, makes sense because she loves "creeping about and being quiet".

This does somewhat raise a question around the cover of *Mirage* itself, featuring Christine, Lindsey and Stevie in Lindsey's arms as if in mid-dance, Stevie's head thrown back dramatically. "I hated posing for that more than life," Stevie insisted. In the near future, when she was required to throw her head back again during the video for her single 'If Anyone Falls', the director "had to call in a back-up singer to do it. I called her my stunt neck."

<p style="text-align:center">★ ★ ★</p>

Bella Donna was released in July 1981 – an instant hit, and a record that would rise swiftly up the charts. But Lindsey Buckingham believed that the immediate triumph of her debut solo album would not assuage the emptiness she continued to try to fill with drugs, romance and escapism. "Stevie has never been very happy," he said. "And I don't think the success of her album has made her any happier. In fact it may have made her less happy."

Stevie, on the other hand, believed he was simply jealous, and his resentment would lead to the usual hurtful, insulting behaviour. "He wasn't ever able to revel in any kind of joy for my success for *Bella Donna*," recalls Nicks in an interview with *The Times*' Chrissy Iley. "He would always start an argument – 'We're really not here to discuss your solo records, Stevie.' I gave him a signed copy of *Bella Donna*. He left it leaning against the recording studio wall for a month. I took it back, crossed his name out, and gave it to somebody else." It obviously still meant so much to Stevie that Lindsey approved of her work, and a snub like this mortified her, particularly seeing as so many lines on the album were about him.

Critically acclaimed, publicly lauded, *Bella Donna* was a tour de force. *Rolling Stone* magazine proclaimed Stevie the 'Queen of Rock'n'Roll', and by September 1981, the album had reached the top of the *Billboard* chart. But on the very day *Bella Donna* was proclaimed number one, Stevie received a distressing phone call about her closest friend. Robin Snyder had been diagnosed with leukaemia. She was the only one who could calm Stevie down in any circumstances, the one who had listened

to every song Stevie had written since the age of 16, the one who knew how to protect Stevie's greatest asset – her voice – and now, at the age of just 33, she was dying. Stevie "just went crazy", and a black cloud of grief and fear now overshadowed what would otherwise have been a time of celebration. There was an upsetting irony in the fact that, when explaining the concept of 'Bella Donna' to Waddy and the band in the studio the year before, Stevie took great pains to clarify that the song was serious, it was not just about an attractive girl per se, but a beautiful woman who was becoming worn ragged by the rigours of rock'n'roll. It detailed Stevie's own fears for the future if she didn't slow down. The 'bella donna' character was suffering. Now Robin, who had been by Stevie's side on the road and in the studio since day one, was suffering for real.

"[This] should have been the time when I was the most happy and self-confident," said Stevie. "But I felt the most helpless, because all the money in the world couldn't save this woman's life."

Chapter 18

'Lightning strikes...'

Stevie's promotional dates for *Bella Donna,* titled the White-Winged Dove tour, would begin on November 27 in Houston, Texas, continuing until mid-December. Under the unbearable pall of Robin's illness, and reminded of her own warnings to herself in her album's title track, Stevie would take a different tack to touring this time. She was in charge now, after all. Stevie told press before embarking on the dates that the White-Winged Dove tour would be nowhere near as extensive as the average Fleetwood Mac odyssey. Nobody would "die from touring", she promised.

Stevie's own health problems had forced her to 'slow down', having been diagnosed with bronchial spasmodic asthma. "Everything that I do is wrapped up in my lungs," she admitted, so it made sense to take a little more care. "I need rest real bad," she told *Playboy.* "I also need some exercise. I don't want to be this romantically fragile character everyone thinks I am. The image is fine, but not if you have to go to hospital for it. For my asthma, I have to take these miserable pills that make you feel like someone put something weird in your Perrier." She was getting older, a process she intended to respect. Or that was the intention, at least.

Stevie and her band would take in Houston, Dallas, Oakland, Tempe and would conclude with five nights at the Fox Wilshire Theatre in Los Angeles on December 13, with the show being recorded for an HBO special. The set featured Stevie's best-known Fleetwood Mac songs, including 'Gold Dust Woman', 'Sara', 'Angel', 'Dreams' and show-closer 'Rhiannon', a glittering haul of *Bella Donna* songs, of course, and 'Gold & Braid', which she had developed with Tom Moncrieff, and one that remains a fan favourite to this day.

The entire process would be an utterly different experience for Stevie – she was on her own, at least in the sense that she was now the main focus on stage, the sole reason fans had bought their tickets. The responsibility was great, and Stevie was extremely nervous. In Fleetwood Mac, nobody minded if you wandered off stage to powder your face or brush your hair. But with Lori and Sharon by her side, bolstering her while she sang, Margi's new designs draping her form and some of her favourite musicians behind her, Stevie was free to fly with confidence. Wild-haired guitarist Waddy Wachtel, who had been in Stevie's life since she had first moved to LA, was bursting with pride as he witnessed his friend truly transform into a rock star in her own right.

"It was extraordinary to see Stevie become this rock'n'roller," he told *Black Cat.* "Because when I met her she was this little folk girl. One night I said to her, after we did the first show of her tour, 'Stevie, you really impressed me. Standing on stage with you, you are a rock'n'roller, my girl.' She thought I was kidding. 'Get outta here!' she said. But I was totally serious. She's incredible."

Waddy's defining moment with Stevie would arguably be that iconic, scratchy riff on 'Edge Of Seventeen'. He had valiantly refused the use of an echo effect when it came to playing it in the studio, but onstage he realised that this song could be rather more labour intensive, not least because Stevie often used the opportunity, while he played the introduction, to have a quick breather. "I'd be standing there, playing that riff for around three minutes, before she'd even start singing," he laughed. "By the end of the tour I was able to break walnuts with my right hand."

A particularly special moment would be Stevie's show at the Oakland Coliseum, a favourite venue of hers and a place she had long fantasised

about playing as a solo artist. As the lights went down and more than 10,000 lace-clad fans anticipated the entrance of their heroine, a mature gentleman in a dapper grey suit approached the microphone. "Ladies and gentlemen," he began. "Please welcome my daughter, Stevie Nicks."

It was, as *The Record* reported, "an emotional moment" for both father and daughter, and indeed everyone present, and once Stevie had hit the stage, she told the audience – "This is the big one for me." Stevie later admitted that the first time she asked her father Jess Nicks to introduce her onstage he "almost had a heart attack". But Jess, now a concert promoter himself, stepped up for his daughter. There was already showbusiness in his genes, as we know… "He went on the road with us for a month, [but] he thought my organisation could have been run a little better, so he went home," Stevie laughed. "Bye, dad!"

Margi Kent had designed an entire new wardrobe for Stevie for the tour – feathers, lace, chiffon, colourful saris, everything Stevie loved ramped up to the highest degree; finally there was no one she had to worry about upstaging. While the black clothes of yore had been jettisoned (for now), fans were pleased to see that Stevie's swirling shawls were still an important part of her stage-wear. "Over the years they've become really superstitious things for me," Stevie later said. "They're like special good luck charms."

"The princess on-stage is my combination of [Russian prima ballerina and style icon] Natalia Markarova and Greta Garbo and the elegant rock'n'roll that I love… it's hard to be a fairy princess 50 per cent of the time and just be a nice lady the other half. But I like my real self better," she would tell *Rolling Stone*, although the 'real self' and the 'fairy princess' would often merge, and the sense of the spiritual and the mystical was always important for Stevie, giving her strength and, ultimately, defining her. Her intense gaze was also commented on as if Stevie was a seer who could gaze into the very depths of one's soul. The reality was more likely to be that Stevie's eyesight was very poor, and she was probably just trying to focus.

Even though the 'witchy' threads had been put into mothballs, Stevie's mysterious 'wise woman' quality would mean that some fans were worshipful to the extreme. One night, Stevie emerged from the

stage door after another triumphant show to find a weeping girl waiting for her. "I can never walk away from someone in tears," Stevie told *Playboy*. "She said, 'Will you sign my arm?'" Innocently, Stevie agreed; if it was going to cheer a wailing fan up, where was the harm? But to Stevie's horror, the girl returned the following night and proudly displayed her arm, which was now tattooed with Stevie's name, just as Stevie herself had signed it.

"I grabbed her and told her, 'Don't ever have someone cut into your arm with my name. It's stupid and I'm not happy about it.' Her reaction was more tears. Another night, one of her friends asked me to sign her arm. I told her, 'I'm not touching your arm. And if I ever find out that you got my name tattooed on you anyway, I'll sue. Don't put that on me. I'm not here to bring pain. I'm here to bring you out of pain.' It bummed me out. I felt like I'd come out the wrong door."

Another difficulty for Stevie was that, now she was a bona fide star, simple things such as going out for dinner with her girlfriends were almost impossible without being approached, or worse. It was symptomatic of the gulf between how men and women were, and in many cases still are, perceived.

"It's fine for the guys," Stevie complained, "but if we [girls] go down to Le Dome for a drink or to the Rainbow for spaghetti, we're classified as loose, roaming women. Me and some of the other female singing stars, like Ann and Nancy Wilson (Heart) and Pat Benatar can't just go out boogying with our girlfriends."

Stevie was now too recognisable to go out without being mobbed, but she had also been "securitied up to my neck" for seven years, so the idea of going out alone was actually frightening. She wasn't used to it anymore and, ultimately, came to accept her fate, holding wild parties in her home instead.

"People say [the security] is for my safety," Stevie conceded, before giving a rather disconcerting conclusion: "Women are getting raped all the time. And I don't need to get raped, because I'd never get over it. That's when my songs would stop. That's when my belief in the world would die. I know it happens, but it happening to me is another story. It tends to take away one's spontaneity."

That Stevie imagines the trauma of rape would necessarily be any more shattering for her than it would be for any other woman is hard to reconcile, but one can only assume the narcissistic world of a then coke-addled rock'n'roll star is a place where not everything makes sense, and the feelings of whoever is at the centre of it are simply deemed more important, more sensitive and more worthy of protection than anyone else's. Stevie, at that time, was also "edging towards an emotional crisis", as she put it, becoming more and more dependent on cocaine in a bid to cope with her increasing work-load and the misery of Robin's sickness. Her life was in a state of confusion.

At least there were some 'truly spectacular moments' on the White-Winged Dove tour. At the end of the final show in Los Angeles, an emotional Stevie was practically bent double trying to carry the hundreds of bouquets flung at her during the show. As Stevie herself observed, the mere fact that no one had been heard to shout "Where's Don? Where's Tom Petty? Where's Lindsey?" was a success in itself. By the end of 1981, Stevie had never felt more like a star. She had also never felt more in need of care. She had her friends, her dogs and cats and her dazzling two-fold career, but she still occasionally hankered for family life, wishing she had "a little girl, even a little boy". Even so, Stevie also knew her relative sense of freedom was something she couldn't give up easily, and that included serious relationships too. Perhaps this was also her way of protecting herself after having been hurt.

Stevie had written that 'the sea of love' was where everyone aspired to drown themselves, and her life had been bursting with romance, but now "I need to get to know Stevie again," she said. "I need to be able to paint all night without making someone feel horrible because he's waiting for me to come to bed." Stevie was conscious of the fact that her chosen path would often leave a partner hanging as she skipped around the world, or turned up late at night too tired to pay him any attention. On the other hand, the men who did understand her career were also those who invariably wouldn't commit, or who would break her heart. The sea of love could be turbulent and cruel. Whether or not her motive for shying away from domesticity in its traditional sense was due to an underlying fear of loss, Stevie felt it best to steer clear of the

water altogether and use her head, not her heart, for the time being. Besides, her love and warmth was needed elsewhere.

★ ★ ★

1982 crawled to its feet under a cloud of foreboding and sickness – Stevie's priority was cheering Robin up but she was feeling justifiably bereft herself. There was no escaping the inevitable: Robin had months to live.

Despite the terminal diagnosis, Robin and her partner Kim Anderson did their best to live their lives, deciding to marry soon after the shattering results came through. Robin would even become pregnant – a legacy for Kim, the Warner Bros rep she had met while touring with Fleetwood Mac. Robin was given the option of terminating the pregnancy and prolonging her own life, but she refused.

During the spring, Stevie whisked Robin to the tranquil sands of Hawaii to give her a break and create some lighter memories during this, the final year of her life. Once back in California, Robin would be cared for at the City Of Hope Cancer Center. The treatment was aggressive and before long, she had lost so much weight she was unrecognisable. Seeing her friend like this was unimaginably hard for Stevie and, at first, Stevie would visit the centre "high on coke" and having drunk "half a bottle of brandy on the way there, because I couldn't stand it. She said to me, 'Don't come back until you're not high'."

Robin's courage and fortitude inspired Stevie, who found herself wanting to paint and draw more in a bid to channel her grief more prolifically. Jimmy Iovine rushed out and found whatever he could to sate Stevie's artistic urges – namely some "stupid little kindergarten paints and some paper" – and, with a glass of water by her side for her brushes (and a glass of wine for herself) Stevie started to render the image of a mystical pyramid, her first painting. Not only was art a way of escaping the pain and entering a meditative state, but it gave her a chance to create pictures for Robin to have on the walls of her hospital room, to lift her spirits and assure her she was always with her in her heart, even if she couldn't be there in person.

"When you paint or draw something, you carry it around for days or months or years," Stevie explained. "If you have a dog or a cat, they'll seek out that painting to sleep on because it has your essence in it. So I started to draw so I could pin something up on her wall and be with her, knowing this wasn't a letter I'd just jotted out, or a song, but an image that would constantly occur when she looked at that, that would say, 'She's here'." Stevie's artwork would be heavily influenced by the fantasy illustrations of German artist Sulamith Wülfing as we know, and the bright, celestial images will have no doubt brought great comfort to Robin. Knowing there was at least something she could do for her ailing friend will have consoled Stevie alike, who otherwise was at a loss to know what she could do to help.

On June 18, the radio-friendly Fleetwood Mac album *Mirage* was released, spending 18 weeks in the US Top Ten, and for the first time since *Rumours* returning the band to number one, where it would remain for five lucrative weeks, having knocked British rock band Asia's eponymous album from pole position. However, the circumstances around the Mac – and the album – were such that no one in the inner circle felt especially excited by it; Lindsey had lost his mojo after being reined in post-*Tusk* and simply shrugged his shoulders on *Mirage*, taking a wilfully "passive role", as he put it. For all of its strengths, that lack of Buckingham electricity showed. Many critics and fans felt the album was a little too soft and pedestrian for their liking. It is the oddball tracks, such as Lindsey's 'Empire State', an ambiguous, whispered love song to New York from a true blue West Coast boy, and, of course, 'Gypsy', that really carry the record aloft. Nevertheless, the album would go double-platinum, the first single 'Hold Me' peaked at number four in the US, becoming one of the band's biggest hits in America, and Stevie's 'Gypsy', released in August, would reach the respectable position of number 12.

The launch party for *Mirage* was held a month after the release of the record itself, which came out a whole year after Fleetwood Mac left the Chateau, due to overdubs and remixes at the hands of Lindsey Buckingham and Richard Dashut. One wouldn't want to suggest that everything about *Mirage* reflected the dearth of energy in the studio,

but the reality was that everyone's priorities were elsewhere. A party is a party, however, and a typically decadent jamboree would occur at the SIR soundstage in Hollywood as a gale howled outside. More than 200 people turned up at the cavernous site to drink champagne under the flashing disco lights, and the various members of Fleetwood Mac regarded each other civilly, with Lindsey even inviting the band and their partners back to his place in Bel Air.

Stevie insisted on riding back with Carol Ann (which surprised her, let alone everyone else) while suggesting Jimmy and Lindsey should drive back together too – no doubt her intention was to spend a little quality time with the devil's dandruff*, which Jimmy didn't approve of her using. This was her first hit of the night, and she must really have wanted it to have chosen to ride with the girlfriend of her ex.

But, according to Carol Ann, as the radio blared and their blonde locks flew about in the wind, Stevie opened up to her, shedding a tear over how brave Robin was in the face of cancer, and complaining affectionately about Jimmy Iovine telling her what to do all the time. She "wanted to please him... he's a lot like Lindsey". Carol Ann laughed and agreed that being with Lindsey was no walk in the park. "I've learned that everything I do is watched – and if he's in a mood to disapprove of something then I find out quickly... Sometimes I feel as though I need to ask permission for every move I make," Carol Ann confided. Stevie sympathised, adding warmly (according to Carol Ann) that "all of my girlfriends and I are sisters of the moon. I've given every woman I love a little half-moon necklace to wear. I'd give you one too, but it would drive Lindsey crazy..." Yes, I'm sure that was the only thing stopping Stevie from giving such a meaningful gift to someone she generally had an uneasy relationship with at best.

Parties aside, the sense of lethargy around *Mirage* would spill over into the promotional tour, which ran from the beginning of September to the end of October 1982. At just two months long, it didn't last anywhere near as long as the average epic Mac tour and would take in

* I've mentioned cocaine so many times in this book so far I'm running out of alternative names for it.

only key American cities. "I'm not that excited about touring myself," Buckingham told *The Record*'s David Gans bluntly. Warners executives no doubt read this interview with their heads in their hands.

Everyone knew Lindsey preferred tinkering in the studio at the best of times, but now there was an added pressure. "People have been waiting for us to break up for years, and the subject's coming up again," he continued. "The most likely one to disappear is Stevie, but there's no way of telling whether she wants to go off and not be a part of the band... at other times it's the opposite." "Would Fleetwood Mac survive her departure?" asked Gans. "Why not?" retorted Mick Fleetwood. After all, there had been plenty of line-up changes within the band, gifted musicians and compelling personalities moving in and out of the ranks like pawns on a chess-board. Was 'White Queen' Stevie really any different?

Stevie had always flatly denied any suggestions she might be planning to dump Fleetwood Mac, but Paul Fishkin, protective of Stevie as an artist and as a friend (and an asset), publicly asserted that, ultimately, "If it came down to her making a decision in terms of her career or their career, I know which direction I would push her in." Having essentially two lives was time-consuming, energy-draining and complex, not to mention something of a conflict of interests. Also, as far as those in the Nicks camp could see, the Mac were not making Stevie especially happy, while at the same time her presence in the band was only enhancing their work and their stage show.

Money certainly wouldn't be a problem on the *Mirage* tour. The band would be paid $800,000 to play a single set on September 5 at the inaugural US Festival in California on a bill that included Jackson Browne and Jimmy Buffett, but the vast pay-checks did little to boost morale. Nor did the great quantities of drugs and alcohol that were available to them at all times. From the moment Fleetwood Mac arrived at the amphitheatre in Houston, Texas, for the first show of the tour, it was, as Carol Ann Harris remembers, "immediately apparent that this tour was nothing like the *Rumours* or *Tusk* tours."

Footage of the *Mirage* tour displays a band that is almost out of control. Lindsey and Stevie scream their harmonies at each other in 'The Chain', eyeing each other with what can only be described as mutual loathing.

During his solo on 'Sisters Of The Moon', Lindsey appears to barge Stevie with his guitar, prompting Stevie to take comfort from her fans who reach out with flowers and hungry hands, as if she were some kind of weeping Madonna. On one clip she is indeed weeping, tears streaming down her face. Carol Ann recalls that many of the shows were not up to their usual standard, but unlike the early days, when the slightest mistake would have had Stevie on the verge of a panic attack, or Lindsey flying into a rage, the band "had little to say about it. Everyone headed for the drinks table, picked up powder-filled bottle caps and changed into their street clothes to head back to the hotel." They were numb, preoccupied and, frankly, with the exception of Mick and John, nobody wanted to be there. The news that was just around the corner was the tipping point that ensured this tour would be swiftly curtailed.

On October 5, the tragedy Stevie had been dreading came to pass. Just days after giving birth three months prematurely to a baby boy, Robin Snyder Anderson died. Stevie went into a tailspin, tearfully calling Lindsey's hotel suite on the day she received the news – he had known Robin nearly as long as Stevie, after all.

There was no time to reflect or grieve, and almost everything would prove a trigger for Stevie to burst into tears. A song on the radio, a picture, a scent... but most evocative for Stevie would be the material she had written herself – 'Gypsy' in particular would be a song Stevie would have to have a break from for a while. There was so much of Robin woven into that song as it was, and now this brave 'breathtaking' woman was dancing away from her, leaving her memory with those who loved her, just as the lyrics stated. It was too close to the bone.

"[Robin] walked me through life, taught me how to sing, how to use my voice. She made sure before she left this planet that I was all right. As I questioned [whether there] would be life after Fleetwood Mac, I certainly questioned would there be life after Robin," Stevie said. She would find that, of course, there was, "except that it's not the same, not near as special."

Understandably, discussions were soon underway within the band to abandon any further plans to tour *Mirage,* and by the end of October, Stevie, Lindsey and Christine informed Mick and John that they would

not continue after the scheduled US tour dates concluded in November. "There would be no European or Far East tour," confirmed Carol Ann Harris. "With *Mirage* at number one for two straight months, the band was over it. They wanted a long break from Fleetwood Mac, and they couldn't give a damn about record sales..."

The tour was too short, in Mick Fleetwood's opinion, and failed to do the album justice. "As soon as we left the road, *Mirage* died after five weeks at number one," he noted, John Cougar's *American Fool* steaming in to take its place. However, some things are more important than promoting a record. Mental health, for example. Stevie, for one, was self-medicating furiously, plans were already in motion for her next solo album, and she also desperately needed time to get over the anguish of losing her closest friend. But she also needed to figure out what the future would hold for Robin's baby Matthew. Stevie was his godmother, after all.

The caption to Stevie Nicks' 'Rhiannon' painting, dedicated to Robin Snyder Anderson:

'Rhiannon' was started at the onset of Robin's Leukaemia — last August — she died last Tuesday — She was originally finished for Patrick at the City of Hope — she died while she was still in her grey stage — I finished her in brilliance upon Robin's death — because Robin was brilliant — May she be a patron of driving this disease away — it cannot live this cancer — amongst Rhiannons [sic] bright colors — she was a bright light girl — and we will fight on white light —

S. Nicks, 1982

Chapter 19

1983: Stevie Nicks by numbers –
 1 wedding
 3 singles in the US Top 40 ('Stand Back', 'If Anyone Falls',
 'Nightbird')
 1 platinum album
 1 divorce

"When Stevie passed 30 and had not gotten married, I honestly did not think she ever would," Jess Nicks told local glossy *Arizona Living*, "When a woman goes that long being single, and particularly when she's hugely successful, usually her career is so important that she won't get married. So at 34, when she did get married, it was quite a shock to her mother and me." As it was to the rest of Fleetwood Mac and, indeed, Stevie's fans. Stevie's fairytale wedding on January 29, 1983 would not cause ructions because of jealousy, nor because she had inevitably spliced herself with a charismatic fellow rock star who was destined to let her down. It was because the man she married was Kim Anderson, husband of her best friend Robin who had died just three months earlier.

The intentions behind the bizarre nuptials were honourable if misguided – Stevie, as godmother, felt responsible for frail, premature

baby Matthew and was anxious to support Kim during his darkest hour. She also needed help herself; Stevie was often hysterical, lying on the floor in the night, screaming and crying, beating her fists. Robin's death was, she has said, "the worst thing that ever happened to me. The only person that could comfort me was him, and the only person that could comfort him was me."

"I was determined to take care of that baby, so I said to Kim, 'I don't know, I guess we should just get married.' It was a terrible, terrible mistake. We didn't get married because we were in love, we got married because we were grieving and it was the only way that we could feel like we were doing anything." The decision was 'split-second', informed not just by the need to take positive action and care for the child, but also by the fact that, rather more unsettlingly, Stevie was so present in Kim's life, and so similar to Robin in many respects, "a little part of him thought that I was her reincarnate," she said.

There would even be moments during the months ahead when, Stevie admits, "He thought I *was* her. When the light was down, he wasn't sure whether it was Stevie or Robin. I would say something and turn away and he would think she had come back." Both of these mourning souls were evidently suffering from their own personal breakdowns while trying to be strong and find a way through it for the sake of the child.

But Stevie was also "falling in love with this little baby that basically Robin had died for. We decided to get married, and nobody understood. Nobody. My parents thought it was the most crazy thing, and they thought I was nuts anyway..."

Stevie's family felt that, while Kim was 'pleasant', the marriage was a bad idea. It was also too soon after Robin had died. While the belief that she had to marry Kim was simply borne of bewildered despair and wanting to do the right thing, it was regarded by some as being in rather poor taste. And apart from anything else, it was upsetting to the Nicks family that Stevie's wedding should not be an event celebrating the fact she had ostensibly found 'the one', but a bittersweet, confused declaration of friendship and support. As her father said, "When she makes up her mind to do something, nobody can change it," and, as Stevie saw it, she was stepping up for Robin's sake.

When Stevie called her friends with the news, nobody knew how to react, but everybody was united in their discomfort. "I remember calling Don Henley and saying, 'Don, I'm getting married to Kim. Will you come to the wedding?' He said, 'No,' and hung up. Then he called back a couple of days later and said, 'All right, I'll come,' and that is the same reaction I got from every person I called."

The bride wore symbolic black lace over white and a dazed smile, the ceremony took place on the beach at sundown outside Stevie's new home in the Pacific Palisades, and the couple were married by Philip Wagner, the same minister who had given comfort to Robin as she was dying. Robin had been a member of the Hiding Place Church, a community of born-again Christians who "emphasise the supernatural in its worship". Wagner had been "trepidatious" about marrying Kim and Stevie – "I had to know where Stevie was at with the Lord," he told *Rolling Stone* – but a simple ceremony went ahead despite the circumstances. There were no "thees and thous", according to Wagner, just "a little five-minute thing about their relationship to the Lord, and little miracles happening. Then we did some quick vows, they exchanged rings, and we had a little communion."

Paul Fishkin was in attendance, loyal as ever, the only person who "understood the emotional trauma" of the entire fifteen months, according to Stevie. She felt questioned and judged by everyone else. Christine McVie and Mick Fleetwood ventured to the ceremony. Lindsey gave it a wide berth.

The development sent the whole band reeling, and Lindsey in particular was horrified. While unhinged behaviour was, as Carol Ann had observed, "the rule instead of the exception" in the world of the Mac, this was "beyond the pale", she wrote in *Storms*. "But when I thought of the grief Stevie had shared with me on the night of the *Mirage* party, I could only speculate that it was this grief that was responsible for a type of temporary insanity..."

Once the rice had been thrown and the unhappy couple returned home, attempting to process what was happening, Stevie threw herself immediately into work. And 'immediately' is no exaggeration: she wrote the dynamic 'Stand Back' on her wedding night, having been inspired

by hearing Prince's new song 'Little Red Corvette' on the radio as they drove to Santa Barbara for their 'honeymoon'. A demo was recorded at the hotel that evening, and a collaboration was just a phone call away...

<p style="text-align:center">★ ★ ★</p>

As always, writing songs and honing existing work for the new album was ongoing in the run-up to the sessions, as was the recording of demos. Sharon Celani, who had moved into Stevie's house (the library, to be precise) had to be on hand at all times should inspiration strike.

"Sharon's always been a real big help to me for songwriting," Stevie said in a radio interview at the time. "Sometimes I can write the song but I can't get it together to run up and down stairs and plug the tape recorder in, find a tape that doesn't have anything on it, figure out why the tape recorder doesn't work... why there's no batteries in the house, it's the middle of the night and I'm having a nervous breakdown because this is an important epic song I'm trying to write here and nothing works..." So Sharon's role went far beyond that of back-up singer and confidante – she would soon be the one in charge of the tape recorder, ready to press 'record' when the moment was right to capture the goods.

Recording for Stevie's second solo album *The Wild Heart* would take place variously at A&R in New York, the Goodnight studio in Dallas, Sunset Sound in Los Angeles and the familiar turf of The Record Plant and Studio 55, with the stoic Jimmy Iovine once more at the helm. The process was economical, time wise, but Stevie would have little opportunity to be at home with Kim and Matthew. This might not have been such a bad thing – as we know, it was confusing for Kim to have Stevie around and more often than not he "would not let me take care of Matthew" anyway, which rather defeated the object of having got married in the first place.

When asked about how motherhood was working out for one so frequently away, Stevie glossed over the subject, saying that Matthew has "his own little path" and that he was going to be all right. He had a nanny, Bridget, who looked after him, which was just as well, because "I

wasn't allowed to even go into the nursery unless [Kim] ok'd it," Stevie later revealed and, unsurprisingly, this strange version of domestic life was only going to get more peculiar. "He changed the phone numbers, nobody was allowed to come over unless he [approved] it," Stevie told BBC Radio 1's Nicky Horne. "He became so possessive of me that he wouldn't let me out of the house." Sessions for *The Wild Heart* couldn't come too soon.

The album, dedicated to Robin, would be a therapeutic process for Stevie and once again, she gathered her favourite musician friends around her, including Tom Petty, Benmont Tench, Roy Bittan, Waddy, Don Felder, Michael Campbell, Lori and Sharon. Mick Fleetwood would be present, adding drums to the track 'Sable On Blond' and collaborating with Stevie on synths, and co-writing several songs* would be the Texan singer-songwriter Sandy Stewart, "an incredible writer and incredibly funny, nice person."

Sandy came to Stevie's attention when someone handed a tape of Sandy's melodies to Stevie one day. Nicks was "so inspired, I wrote the lyrics to ['If Anyone Falls'] and 'Nothing Ever Changes' that night. From that day onward, Sandy and I considered ourselves kind of the Rodgers & Hammerstein of rock. If someone can write a track that I really love, I'll be glad to write a song to it, because I've got about 800,000 pages of words…"

Stevie was impressed by Sandy's sound, and had been keen to tap into the dominant trend of synth-pop sweeping the charts. Culture Club, Prince, Kim Carnes, Ultravox… all were utilising synthesisers but in a style less stark than the electronic music of the previous decade. To hear Stevie's spiked-honey voice against a wall of velvety synths would be a jolt for those who simply had her pegged as a 1970s relic, clinging to what had worked in the past. Stevie embraced modernity and innovation, she just wanted to merge it with her own unique style rather than completely reinvent herself.

Both the evocatively titled 'Sable On Blond' and 'Wild Heart' had been written the previous year, just after Stevie moved into her

* 'If Anyone Falls', 'Nothing Ever Changes' and 'Nightbird'.

"horrifyingly bad, awful, terrible house in the Pacific Palisades". The Palisades is a glamorous, affluent beachside area north of Los Angeles and, as we know, Stevie was a stone's throw from the ocean, but there was something about the place she couldn't love, not least the fact that she came back from her *Bella Donna* tour, spent and desperate for the respite of home, to find there was no heating. "And I was all alone with no phones, like a mountain woman." Thank goodness she had all of those shawls.

What would Stevie Nicks do in a situation like this? "I freaked out..." Yes, and? "And I wrote 'Sable On Blond' and the verses to 'Wild Heart'. Me and my piano." That's more like it. 'Sable On Blond' was a "serious statement", according to Stevie. The song threw a spotlight on her feelings about maturing, learning to be alone, "to be one colour" after surrounding herself with people and noise and work, blocking out her emotions with drugs. She needed a place where she could just live with herself and train herself to be stronger. It wasn't easy, but drawing on the legend of Excalibur, Stevie explained: "The sword is there for protection, but you don't call upon it unless it's absolutely necessary. During that period in my life, I was learning how not to call on the sword." The sword could well represent cocaine. However, it may also represent the wrong type of man. She was still surrounded by dashing rock'n'roll 'highwaymen' who were all too easy to fall in love with.

And so this brings us to the song 'Wild Heart'. Its fierce warmth is mingled with sadness, a characteristic of many of Stevie's songs. But this one represents the anxieties and fears Stevie was battling with all the more clearly, "all the darkest places of your mind", as Stevie put it, rather tellingly. "It definitely takes you through your nervous breakdown, and through your recovery and through your survival."

Stevie would record a demo with Sandy Stewart, Sharon and Lori, and the result was, in Stevie's words, "a killer". It had to be if it was going to lend its name to the album itself. If the song wasn't strong enough, Stevie would have simply had to change the album title, but "I played it for Tom Petty and he said, 'This is an epic.'"

Now that Stevie had proved herself with *Bella Donna*, she insisted on more of a 'party' atmosphere in the studio, and the presence of friends

was more welcome than it had been during the previous album process. Iovine no doubt loosened his grip a little, particularly as he could see how important it was for Stevie to have the people she loved around her at this point in her life.

"*Bella Donna* was really intense," Stevie told Mary Turner for *Off The Record*, "because it was an unproven white-winged dove who could have crashed into the side of the mountain; everybody was hesitant about it, so I was really dedicated." That isn't to say Nicks wasn't just as committed to *The Wild Heart*, but the pressure was also lifted considerably thanks to the storming success of its predecessor. The turnaround would be relatively swift, however; the release date for the album would be June 10, 1983, which certainly focused the mind.

When it came to the mood of the album, Stevie visualised a direct thread between the characters of this and her previous release: 'Bella Donna' was coming of age and venturing out with more courage – which Stevie herself was doing musically as a solo artist. "It's like Bella Donna's heart is wild all of a sudden," Stevie told *Rock Magazine*. "She's surer of herself now, so she's taking more chances." Where *Bella Donna* was reflective and poetic, *The Wild Heart* would be, as its name suggests, "strong and emotional, no holds barred".

The themes of pain, death and rebirth would loom large, for obvious reasons. Mortality and change were on Stevie's mind. "This album is more rock'n'roll," Stevie would later state. "Which is good for me – it certainly keeps you young. If you can't rock and roll, you're old." No one could have predicted Robin would have been taken at such an early age, and the ordeal had opened Nicks' eyes and shown her she needed to make the most of her life, to "rock a little", as she often said, as opposed to too much, or worse, not at all.

One song destined for *The Wild Heart*, stashed away from previous years, would be 'Beauty And The Beast', written on the road with Fleetwood Mac during the *Tusk* tour. It was inspired both by Mick Fleetwood, around the time of their affair, and Jean Cocteau's dream-like 1946 movie *Beauty And The Beast,* a favourite film of Stevie's. The story itself resonated strongly. "Beauty And The Beast surrounds me," Stevie explained. "Everybody I know is either being the Beauty or the

Beast." At the heart of the fairy story was a sense of "desperation", Stevie observed. At the time of writing the song, she was witnessing Mick Fleetwood's sadness as his father was dying of cancer. After the tour visited Dallas, Mick flew straight to his father's bedside after the show, arriving 45 minutes before he passed away.

Stevie's friend and sometime producer Gordon Perry had a studio in Dallas, and the day after the show, Stevie went there and recorded a demo of 'Beauty And The Beast' on the piano. The studio was 'magical' and church-like, and the experience of recording the song there for the first time is a moment that Stevie has always held close to her heart. There was a reverence that suited the sentiment of the song. "Everybody has to remember how special everybody is... this is the story of Beauty and the Beast: how special we are to each other."

'Beauty And The Beast' would be at the centre of one of Stevie's most lavish sessions yet. "I'm someone who's oblivious to being able to do anything in the studio in a mere three hours," Stevie quipped, although she treated the session with the gravitas she felt it deserved, walking in in a long black gown, a glass of champagne in her hand as she greeted the musicians and approached the microphone.

"I wanted them to feel like they were the most special orchestra that ever existed," Stevie said. "They don't even have any idea what they gave me, how precious it is."

The pensive 'Nightbird' is Stevie's direct dedication to Robin's memory, and lyrically it has a connection to 'Edge Of Seventeen' (which refers to the 'call of the nightbird' Stevie heard after her uncle John passed away). In the song, Stevie speaks of not having been 'ready for the winter', for the sadness that was to come, and plaintively addresses the spirit of her departed friend, asking her, "When I call, will you walk gently through my shadow?"

The song was written with Sandy Stewart in Stevie's living room, taking just two hours to complete, "with her synthesiser and me pacing". All of Stevie's songs are special to her, and all of them would go on to have a life of their own once she had presented them to the world. But 'Nightbird' had a particularly serious purpose; Stevie hoped that, through this song, she would play her part in helping to beat cancer.

"Maybe 'Nightbird' will inspire somebody to do some research," Stevie said. "Maybe it will make somebody be a doctor. Maybe some kid will go, 'I'm gonna do cancer research and I'm gonna beat leukaemia'. That's what I hope Sandy and I did with 'Nightbird'."

The cover of *The Wild Heart* itself would also pay tribute to Robin in its threefold depiction of Stevie. Shot by Herbie Worthington, who had become part of the Nicks extended family and one of many people on her payroll, the concept was to portray different dimensions of Stevie, dressed in a floor-length, hooded black cape against a warm, dark background. The crouching Stevie shows her private and often lonesome side, and to the right there is the stronger side of Stevie, the star, upright and regal. But the spectral, faded figure in the centre looking down at the more contemplative Stevie represents Robin's spirit.

The Wild Heart would see a return of Tom Petty, whose song 'I Will Run To You' featured on the record as a duet. Tom and Stevie's collaborations were always stellar, their cracked, slightly wasted-sounding rock'n'roll timbres mingling together perfectly and, as Tom's then wife Jane put it, if only they would work together more, she could be "sleeping in mink". "Jane is on my side," confirmed Stevie. "Tom and I are a duo extraordinaire, and I don't have much interest in going around looking for some other guy to sing with." Bye for now, Don.

'I Will Run To You' merged that classic Heartbreakers sound with subtle synths, a blend of present and future. Lyrically, the line 'I will follow you down...' echoes Bob Dylan's 'Baby, Let Me Follow You Down'; Dylan was a hero of both Nicks and, more obviously, Petty alike.

Petty and Nicks spent a lot of time together and because Stevie respected him so much, the 'swampy Floridian' felt confident enough to tell Nicks the truth, rather than regard her with awe. He loved her and was amused by her idiosyncrasies. "It's like when you've got a sister in the family nobody wants to talk about much," he said dryly. "Someone you love but who's a little bit... er... different."

"He'll say I'm like a plane that doesn't have any radar," said Stevie. "He says to me, 'You're not living in the real world', and I'm saying, 'Do you live in the real world?' and he's going, 'Well, I live in more of a real world than you do, for sure.'" But there was a logic to not living in

the real world, in creating a more solipsistic existence that shuts out that which can only bring further anxiety to a thin-skinned individual like Nicks. The problem was that, in this case, the plane wasn't only lacking a radar, it was spiralling towards an emotional Bermuda Triangle.

Prince was another artist who noted Stevie's lifestyle with concern – she was, after all, a "drug addict", as she put it, while he was as "straight as an arrow". They would get on well, however, and share a "special" friendship – one which didn't involve going to bed, Stevie would insist, despite the inevitable rumours. But Prince was "a strange and beautiful guy", there was no doubt about that.

Prince had just returned from touring his massively successful 1982 album *1999* when he received a call from Ms Nicks. Iovine had been setting up the studio at Sunset Sound, Los Angeles, to record 'Stand Back', the song inspired by Prince's own 'Little Red Corvette', and Stevie wanted to see if the man himself would join the session. Stevie hummed the melody down the phone to him and within an hour His Purpleness was in the studio with her. "He listened again, and I said, 'Do you hate it?' He said, 'No,' and walked over to the synthesisers, was absolutely brilliant for about 25 minutes, and then left. He was so uncanny, so wild, he spoiled me for every band I've ever had because nobody can exactly re-create – not even with two piano players – what Prince did all by his little self." Electronic drums were used, Toto guitarist Steve Lukather was brought in to add a guitar part and that Prince magic would ensure 'Stand Back' would be the most successful single from the album, later being nominated for a Grammy. The sound of that heavy bass and voluminous synth against Stevie's husky voice would soon be heard booming out of many a nightclub, an underground hit as well as a mainstream smash.*

Prince had just one piece of advice for Stevie: sex up your lyrics. Prince's own lyrical content was always notorious for its explicit

* 'Stand Back' reached number five in the *Billboard* charts and continues to receive extensive airplay to this day. Prince, however, would not be credited on the album, although officially Prince is a 'co-writer', according to the US Copyright Office.

sexuality, while Stevie's words were often obscure, never literal. As Stevie explained, a sudden injection of overt raunchiness into her lyrics would make no sense because "that's not the way I am in real life. I am not a person who walks naked through the house. I will always have something beautiful on, and it will enhance me. I believe there is a certain amount of mysticism that all women should have. Even in my journals, I don't ever write about sex."

And before Prince could protest any further, Stevie concluded the argument by stating: "You have to write about sex, so you must not be intrinsically sexy. I don't have to write about sex because I am intrinsically sexy. That shut his mouth right up." In your face, Prince. Stevie was a sex symbol by default, but she hadn't forgotten the one time she had bowed to pressure and gone topless on the cover of *Buckingham Nicks* – it left her embarrassed and the record barely sold any copies anyway. Stevie just had to be herself.

To Prince's credit, he cared deeply for Stevie and ran rings around her when she suffered one of her many bouts of the flu, plumping her pillows and tidying up around her. "He would bring me cough medicine," Stevie recalled to *The Telegraph*'s Craig McLean, "and then I'd ask for another spoon of it, and he'd go, 'I didn't come here to start you on a new drug!' So I realised that was not gonna work out: we're two really famous rock'n'roll stars, and I'm a drug addict and he's not, so these paths are not gonna meet well. But if I needed Prince I'm sure he would come and help me."

Stevie disliked making music videos, but in the age of MTV, if she wanted to continue to be seen as a happening young star, she had to comply. Still, the whole process wasn't 'impulsive' enough. "It's being told to do it over and over again... It focuses in on your performance and also every little line on your face. I don't sing because of the way I look. I sing because I love the music. I don't like my body being put under a microscope. Unfortunately, if you're doing film, you have to do it. That's why I'll never be an actress."

There are actually two 'Stand Back' videos in existence – one of which was a no-expense-spared *Gone With The Wind*-inspired promo directed by Brian Grant, a colleague of Russell Mulcahy and a favourite

director of the band Queen. This video showed Stevie riding on a white mare towards the manor before throwing off her hat and cape and stomping through the drawing room with a grace not quite matching up to that of Vivien Leigh.

There are scenes of a ball, with a handsome man approaching her to dance (later echoed in the video for Stevie's hit 'Rooms On Fire'), more galloping and some depictions of Civil War violence, extras galore. The video would never be aired because Stevie felt she looked fat. No longer in her twenties and having imbibed enough champagne to sink the Queen Mary, Stevie was still uncommonly beautiful but had started to feel more conscious of how she looked, particularly after insensitive photographers had observed she had "put a little weight on around the chin". (It is unlikely Mick Fleetwood or Lindsey Buckingham would ever be addressed in this way.) Still, the 'Scarlett' version, as is it known, would eventually turn up on the DVD supplement of Stevie's 2007 collection *Crystal Visions – The Very Best Of Stevie Nicks*.

"I re-did 'Stand Back' with Jeffrey Hornaday, who choreographed *Flashdance*," explained Stevie. "This sent me into waves of panic because I am not a dancer and I am certainly not like what's-her-name in *Flashdance*." She had nothing to fear. Stevie not only had her ballet chops to back her up, but to help her she brought in the dancer Brad Jeffries, to whom she became so fond that he would star in many of Stevie's other videos, such as 'If Anyone Falls' and later 'Rooms On Fire' as the love interest.

Brad was just the latest addition to the Stevie entourage, also appearing with Stevie and the band when they performed 'Stand Back' that year on *Saturday Night Live*, hurling himself onstage mid-song and engaging in a wild dance routine with Stevie, who, incidentally, throws her head back repeatedly (as she does in the video) defying the 'I was beheaded in a past life so I can't put my head back' argument. The official video for the hit 'Stand Back', reflecting *Flashdance* and even *West Side Story* with its gang of strutting dancers, was filled with mirrors and developed into a veritable pea-souper of whirling dry ice. "It's wonderful," enthused Stevie. "And Brad, who choreographs all my videos to this day, puts up with a lot from me because he knows that I'm sweet and he doesn't want

to hurt my feelings, you know? It's difficult because I'm a rock'n'roll singer..."

As 'wonderful' as it thankfully turned out, the making of the 'Stand Back' video did not run smoothly; Jeffrey Hornaday and Jimmy Iovine clashed significantly, according to Danny Goldberg's book *Bumping Into Geniuses*. After seeing an edit of the 'Stand Back' video, Jimmy put together a list of changes on Stevie's behalf and presented them to Hornaday, who didn't take kindly to the criticism. However, when Stevie entered the studio and watched the edit, she listed exactly the concerns that Jimmy had brought up, which caused the director to start arguing with Stevie "about the merits of his 'vision'". Goldberg remembers, "Jimmy jumped up... and insisted, 'There is no argument. This is Stevie's record. This is Stevie's video. You do what Stevie wants.' Taken aback by Iovine's hostile tone, Hornaday answered, 'Fuck you, man.'" The contretemps concluded with Jimmy punching Jeffrey Hornaday in the face. Behind the leg-warmers and the dry ice, the world of the pop video is a volatile place. Approach with care.

★ ★ ★

"One day when I walked into Matthew's room, the cradle was not rocking. It was always rocking whenever I'd walk in, and I knew Robin was there. One day it wasn't rocking and it was very dark and the baby was very quiet. And I said, 'Robin wants this to end – now.'"
Stevie Nicks to *The Guardian*'s Craig McLean, March 2011.

The *Wild Heart* tour was soon to begin at the end of May, and there were still scenes to complete for the 'Stand Back' video. During a Friday night at home, Stevie went through her closets selecting extra outfits for the video and some of the costumes she wanted to use on tour, as her wardrobe mistress was coming by to pick them up. It was perfectly routine, but Kim, who had been gradually unravelling over the past few months, refused to let the wardrobe mistress in altogether. "I saw this man turning into an absolute madman," said Stevie. "It was like he was building a fort around me. So on Saturday I went to finish the filming of 'Stand Back' – we were leaving on Monday – and I came back on

Saturday night and he screamed and yelled at me and I screamed and yelled at him... and I said I want a divorce. I'm not Robin, I can't replace her, I wish I could but I can't." The marriage, borne of altruism and grief, had turned into a full-blown nightmare; it wasn't healthy for anyone concerned and the time had come to face reality. Stevie admits it was about "ten days after" the wedding that she realised she'd made a mistake. Her friends and family had seen that long before they'd exchanged vows, but had been powerless to change her mind.

For some years, Stevie would not hear from Kim at all. "I suppose that Matthew will find me when he's ready, I mean I am, next to Robin, his mommy," Stevie mused. "But Kim and I can't deal with each other at all. So when [Matthew's] old enough, I have all of his mother's things and I have her life on film for 14, 15 years, I have us on tape singing, I have a beautiful book that I wrote the year she died, a roomful of stuff for him. I have his mother to give back to him when he's ready."

Chapter 20

Andrew Means, Arizona Republic: Is there anything Fleetwood Mac can give you now that you don't have as a soloist?

Stevie Nicks: A headache.

*T*he *Wild Heart* tour would certainly live up to its name. An extensive North American road trip of four legs, starting in Vegas in May, and ending in November at the Carolina Coliseum, it would whisk Stevie away from the turmoil of her divorce and throw her straight into the arms of a new man whom she would later describe as the love of her life. As Stevie remembers, "Everyone around me was in love. On the tour everyone was either getting divorced or falling in love, they'd get on the plane and see someone and fall in love instantly…" Stevie was no different and besides, her relationship with Jimmy Iovine had morphed into a strictly professional one – their lifestyles were just too disparate and La Nicks was sorely in need of some TLC.

Mick Fleetwood, occupied with his side project The Zoo, and the subsequent 1983 release *I'm Not Me,* decided against being in Stevie's touring band for *The Wild Heart,* giving the opportunity to drummer Liberty DeVitto, who promptly fell in love with (and later married) Stevie's friend Mary Torrey. Stevie herself, for all of her romantic tendencies, didn't believe in 'love at first sight'. Or she didn't until this tour.

Don Henley's fellow Eagle Joe Walsh was booked as the support act on *The Wild Heart* tour. A successful solo artist in his own right since his 1973 breakthrough album *The Smoker You Drink, The Player You Get*, he had wittily captured the rock star lifestyle with sharp self-awareness in his 1978 hit 'Life's Been Good': the Maseratis, the mansions, the destroyed hotels, parties and paranoia are all there; the lyrics explaining that "I can't complain but sometimes I still do..." and concluding: "It's tough to handle this fortune and fame / Everybody's so different, I haven't changed." Listen to this song and you'll get a pretty clear idea of what life was like for Joe, Stevie, Don and the whole Hollywood rock'n'roll scene of that era. That's if you weren't there to witness it firsthand, of course.

Now Walsh had a brand new album out, *You Bought It – You Name It*, tying in perfectly with Stevie's promotional tour. Joe was charismatic, funny and unconventional, and while Stevie was no stranger to larger than life rock stars (or just Eagles per se), during the tour, Stevie walked into the bar of the Mansions Hotel in Dallas after a show, and spotted him sitting alone. "I walked across the room... He held out his hands to me, and I walked straight into them." She "crawled into his lap, and that was that... I remember thinking, 'I can never be far from this person again... he is my soul.'" Some fans have rather unkindly questioned how a beauty like Stevie would choose someone as 'weird-looking' as Joe (don't shoot the messenger – I personally think he is raffishly handsome, onstage guitar-face notwithstanding). Stevie did once state that, when she walked into the bar, she wasn't wearing her glasses. But surely when someone is your 'soul', looks just don't come into it anyway, and Joe himself has subsequently referred to Stevie as a 'soul mate' himself, albeit a soul mate that wouldn't always get treated too well.

Joe would be a more than welcome distraction from the difficult year Stevie had had, although she worked hard at making the tour work, possibly harder than ever. Rather than the process getting easier, thanks to having already gone out on the road alone with *Bella Donna*, it was "probably getting more difficult," Stevie admitted to *Arizona Living*. "The *Bella Donna* tour was something like eleven concerts – that was fun and it went by really fast. This one is really fun, but every night I've become

more aware that I'm singing every song. I'm very used to having a lot of songs off [with Fleetwood Mac] so I can fix my makeup, comb my hair, wipe my face and just touch up a little bit. And now I can't. I'm in such a hurry that sometimes I run to the side of the stage and I'm not even sure what I'm running there for. So it's a lot more work, physically."

Stevie was also exercising and losing weight, having been bothered by how she looked on recent photos, but her increased physical fitness also meant she didn't run out of energy during the show. "I have to stay in really good shape," she said. "In the long run, of course, it's going to make me a much stronger person because it's forcing me to take good care of myself. Otherwise I could never get through that two-hour set." It could only be a good thing that Stevie was now in better shape than she had been previously, but privately, Stevie was, as Mick Fleetwood observed, "on a slow downward spiral".

Fleetwood could see how exhausted Nicks was, how she was pushing herself hard and working like a woman possessed. "I think she suffered physically. She was running two gigs and two lives, separate lives that were equally as powerful and it took a hell of a lot out of her to retain that loyalty to Fleetwood Mac and not go, 'See ya'." It was a year since the last Fleetwood Mac album and no one was exactly beating a path to the studio to work on the next one – no one had time – but Mick was anxious that the band should not fizzle out. On the other hand, he knew he'd have a fight on his hands if he were to persuade Stevie's management to free her up for the Mac. She was doing very nicely on her own, after all, and Fishkin had already been quite clear "which direction [he] would push her in", if it came down to making a choice. It was a delicate situation.

Stevie's tour was already well underway by the time *The Wild Heart* hit the charts, then dominated by Michael Jackson's *Thriller* album. *The Wild Heart* couldn't compete with the King of Pop, but it would go double platinum, and while it would not be as lauded as *Bella Donna*, it was a "masterpiece", in Stevie's eyes. It didn't matter what the critics said (she refused to read reviews anyway – bad reviews, like horror movies, haunted her for weeks), Stevie was proud of it, not least because of what it represented to her. "Freedom," she declared. "It sets me free

from Fleetwood Mac. It sets me free from Stevie Nicks. It sets me free from the person who drives me. You always have to please somebody. It is letting me go. This is two records now, so the first record wasn't just a fluke accident. I can go and do whatever I want now and no one is going to be saying to me: 'You still aren't a proven solo artist.'"

It is just as well Stevie didn't bother about reviews, because some of them were not kind, labelling the record 'pedestrian' and 'rambling', although this was nothing in comparison to some of the live reviews she received on this tour. Her fans were enchanted but *The LA Times*' Steve Pond had little patience for the Stevie show. "Her frequent dying swan routines [are] laughable, her barely coherent, giggle-laden comments embarrassing," he wrote. "But there's always a market for earnest silliness masquerading as poetic insight. She's not cynical or manipulative but apparently baffled and honestly touched by the emotion she inspires. All this doesn't make the spectacle any easier to enjoy, just harder to dismiss."

Stevie wasn't writing or performing for the benefit of the critics, it was all for her fans; as far as they were concerned, she was delivering exactly what they wanted. Punishing schedule aside, there were pleasurable moments on this tour for Stevie and her band, who just enjoyed hanging out together, playing music and introducing each other to the new artists who had caught their attention. This was one of the reasons Stevie brought together a band of people she loved being with: there would be no scurrying off to individual corners after the show, no silences, no awkwardness, as there always was on tour with the Mac.

Sharon, Lori and fellow backing singers Marilyn Martin and Carolyn Brooks, who had joined the throng to fill out the sound, would regularly practice their parts and try new harmonies around the piano during down time, not least so they could be prepared should Stevie ever lose concentration or pull the rug from under them onstage. "Sometimes Stevie will do something creative and different," Lori said, diplomatically. "Which forces [us] to either not sing or change our parts."

"I'm very impulsive," agreed Stevie. "So if I decide to take the upper third part harmony and then immediately sing the low part, I do it. That's the way I am, so these girls are put through a serious wringer every night to follow me."

One of Stevie's favourite moments on tour would be arriving at the new venue, empty, cavernous and echoey. There was always the opportunity to put on a favourite mixtape and blast it through the PA, filling the hall with sound. Roxy Music, Lionel Ritchie, Hall & Oates, The Commodores, Jackson Browne, Maniac, Prince and Michael Jackson were all artists Stevie loved to listen to. She'd practice her pointe exercises backstage to her Tom Petty tape (with 'TP' painted on the case in nail polish), allow Waddy to play her some AC/DC and listen to The Police during the moments before she hit the stage.

"That song 'Every Breath You Take', we open the show with it," she explained. "It gets me out of the dressing room as soon as I hear it. I don't want to miss any of it, he is talking to me! As long as I don't have to know him, just listen to him singing, that's fine. Thank you Sting!" The way Stevie talks about the intense, moody Sting possibly hints at another rock star crush – at least from afar. He gave her "palpitations", after all... "I've seen him but I never talk to him. I talk to Stewart (Copeland), to Andy (Summers) and the road manager, but I never talk to Sting and after I saw that video, I know why. You would not want Sting to ever be mad at you," Stevie giggled in a radio interview.

In the meantime, Stevie and Joe Walsh were keeping their relationship under wraps, which made it all the more thrilling. "It was a very great secret," she said in an interview with BBC Radio 1, before tenderly adding, "It was love." Although they didn't officially announce they were together – Stevie had only just gone through a divorce, after all – those who knew her could already see he was bringing out the generous and often fiercely protective side of her nature.

"I yelled at people at his sound checks. Someone would say, 'Joe destroyed the dressing room last night,' and I'd just say, 'Fix it.' (laughs) I bought him incredible silk shirts and leg warmers that he wore, I took really good care of him, and I think that's probably what scared Joe the most, I was too in tune with him, and he was out of tune with everything." Or... it might have been the leg-warmers. The main problem, however, was that they were both drowning in their addictions, clinging to each other for support but aware that they would drag each other further into the depths of dependency. "We were busy

being superstars, and everyone was doing way too many drugs," Stevie said in later years. "But I was so in love with him."

On September 25, Nicks, Walsh and Kenny Loggins appeared as 'Stevie Nicks and Friends' for a fund-raiser at the Compton Terrace Amphitheater, a venue in Phoenix owned by Jess Nicks, who was now running the promotion company Compton Terrace Concerts★. Having suffered from heart troubles himself, Jess Nicks had become involved with the American Heart Association and organised events to raise money for the cause. He'd already booked Fleetwood Mac for previous fund-raisers, raising tens of thousands of dollars, and now, post-retirement, had set up Compton Terrace, named after the late William Edward Compton, erstwhile programme director at KDKB radio who had given generous airplay to Buckingham Nicks during the early seventies. Nicks, Loggins and Walsh gave their time for free, and, as well as the show being a benefit for the American Heart Association, the City of Hope hospital would also receive a donation in Robin's honour.

It was a moving event to witness, not to mention take part in, and emotions were already running high. Just a few days previously, *The Wild Heart* tour had taken in Denver, Colorado. Colorado, with its tranquil 'snow-covered hills', always seems to be a rich source of inspiration for Stevie but the song that would spring from this particular visit would have an especially emotional resonance. Stevie had always felt that Joe had 'a lot of pain' which he concealed deftly with his clowning and partying. But on this September day in 1983, Stevie would discover what the source of that pain was. She tells the story:

"I guess I had been complaining about a lot of things going on on the road," Stevie explained. "And Joe decided to make me aware of how unimportant my problems were.

"He rented a jeep and drove me to Boulder, which is like an hour and a half [away], and told me this story on the way of a little girl that

★ No doubt after being dissatisfied by how things were being run on the White-Winged Dove tour, Jess Nicks was also involved in the smooth-running of *The Wild Heart* tour too.

was killed in an accident on her way to nursery school. His little girl. And he drove up to this park* and I knew he was going to show me something that was going to freak me out, because I was already totally upset by the time we got to Boulder. We walked across this park and there was this little silver drinking fountain, and it said, 'To Emma Kristen, for all those who can't, or aren't big enough to get a drink.'" Joe explained that this had been his daughter's favourite park, and that his tribute, nestling under a tree, was inspired by the time Emma once reached up to drink from a fountain only to find she was too tiny. A light snow was falling, and as Stevie approached the fountain, she burst into tears.

"Something about this story touched me so deeply that I went home to my house in Phoenix, I walked into the front entryway, where my Bösendorfer piano is, I sat down and wrote this song in about five minutes." The song would be titled 'Has Anyone Ever Written Anything For You?', and, when Stevie told her parents the emotional story behind the song, even Jess Nicks had to excuse himself from the room in order to shed a tear. This song was Stevie's way of responding to what Joe had shared with her, because there was "nothing I could say to someone who had suffered a loss like that."

Walsh had tragically lost his eldest daughter when she was just three, in 1974, and he would write 'Song For Emma' that year. "So he wrote a song for her, and I wrote a song for him," Stevie concludes. "Thank you, Joe, for the most committed song I ever wrote... But more than that, thank you for inspiring me in so many ways. Nothing in my life ever seems as dark any more since we took that drive."

The line 'poet, priest of nothing' in the song refers to Joe, and "all the rock stars in the world that I know; they're all poets, and they're all priests of nothing, and they're all legends," Stevie explained, adding that very few of them handle their fame very well. "'Priests of nothing' means they don't try hard enough. So whenever I get involved with any of them I tend to become their manager, their agent... 'why don't we get out your piano? Why don't we write a song? Let's arrange this!'

* North Boulder Park.

I know that if I can just lure them to the piano, with like a glass of wine, they'll be home-free and so will I, because I get to watch them be brilliant, and probably write something, and they will be knocked out because they'll be doing what they do. They forget they have a job, you know?"

As for Stevie herself, she is "a priestess of way too much. My problem is the other extreme: how many rooms could you clean, meals could you cook, children to take care of, shows you should do, fittings you should go for, make-up hours... you know? I try to fit the impossible into 24 hours, and all of the 'priests of nothing'? They're sleeping."

Beyond anyone else Stevie had loved so far, beyond Lindsey, Don, Mick, Paul, Jimmy or any of the other men to whom she had been meaningfully connected, Joe was the one man Stevie would have considered marrying, and eventually he would be the one to break her heart. "There was nothing more important than Joe Walsh, not my music, not my songs, not anything." Not long before they met, there was nothing more important than her songs, so this statement is profoundly telling.

But despite the care Stevie took of him – perhaps even because of it – Joe never quite treated Stevie the way she wished to be treated. On her favourite holiday, Hallowe'en, Joe blew Stevie out, choosing to work on his new computer instead. She felt "replaced. If computers are going to replace me in a man's life..." well, then it just wasn't going to work. (Although Stevie herself often complained she couldn't find a man who wouldn't mind if she stayed up all night working on her art rather than coming to bed.) Stevie received a further slap in the face when Walsh, after being probed mercilessly by shock jock Howard Stern about his relationship with Nicks, simply said, after a Pinteresque pause, that he had loved Stevie "as a sister. She's like a soulmate... we were seeking refuge in each other's presence. We were on the road, we had careers. We were both lonely..." Only Joe can know what he really felt, addled as he was by drugs, but the fragile Stevie was lovestruck, and felt as if the world had ended whenever he let her down.

"I remember days of misery waiting by the phone," Stevie recalled. "Me in my house, with him saying, 'I'm going to visit you.' I would

kick everyone out because I just wanted to be with him, and not a phone call, nothing. [I put up with it because] I was in love with him. I wouldn't now. But we were doing a lot of drugs and drugs make you needy. I don't know what my relationship with Joe would have been like sober."

Neediness aside, drugs also make you unreliable at best. Walsh probably meant what he said when he was saying it, at least. But for Joe, getting too close to Stevie Nicks was also potentially dangerous for both of them considering their lifestyle, and Nicks was not oblivious to that. "We were a couple on the way to hell."

Chapter 21

Keith Olsen's favourite memory of recording with Stevie Nicks?

"Anytime Stevie would just walk out into the studio and sing — there was always an honesty and colour, [it was] a peek into her heart... she would sometimes let you in and expose her soul."

During *The Wild Heart* tour, Stevie had, as always, managed to find time to write and record demos for her next album — there was plenty to write about, after all. The third solo Nicks record would be trendy and upbeat, with synth arrangements reminiscent of the Art Of Noise at times and a very different feel from *The Wild Heart*.

The initial plan was to simply call it *Rock'n'Roll*. She was the queen of it, after all. But the record would not be 'rock'n'roll' in the traditional sense, and Stevie decided on a working title of *Mirror, Mirror*, an obvious nod to her fascination with the trippy, magical children's story *Alice's Adventures In Wonderland*. It also conjured a sense of self-reflection, an activity Stevie was often engaged with, and there was also the subliminal reference to cocaine.

Eventually the record would be titled *Rock A Little*, however; a name that, at this point, had great significance. Stevie would explain when asked about the title that "'Rock A Little' means perseverance. [It] means cool out, rock a little all the time and you won't die." Once

again, Stevie was telling herself what she needed to do. She just wasn't listening to her own advice.

Stevie had written the title track three years previously, and the song was originally inspired by the ocean, and its often unsettling power. Stevie's beach-side home was a dwelling that rocked, in more ways than one. "The beach was always shaking and I always thought it was an earthquake," she admitted. "Scared me to death every night. So I had to learn to know not to pack my bags and run out the back."

Stevie was, of course, also using the sea as a metaphor for herself with this album – the ocean was unpredictable; sometimes tranquil, sometimes raging, but even when it was 'calm', the house would 'rock a little', never quite still or stable. 'Rock A Little', like 'Bella Donna', was another warning to Stevie from her own heart.

Songs were pouring out of her, and with Fleetwood Mac still on hiatus, solo projects were flourishing across the board. Christine McVie was preparing to release her eponymous second solo album in January 1984, featuring guest appearances from the likes of Eric Clapton and Steve Winwood, while Lindsey Buckingham's album *Go Insane* would be released in July 1984, an intense, clenched fist of a record largely documenting his inevitable break-up with Carol Ann Harris.

There was an ominous shadow hanging over Hollywood as 1983 came to a close. In addition to drug problems, broken relationships, meltdowns and, for some, financial issues, there would be the tragic loss of another dear friend: Dennis Wilson. On December 28, just weeks after celebrating his 39th birthday in typically sybaritic style, Dennis was hanging out at Marina Del Rey, not far from Stevie's condominium. He had been drinking heavily for hours, and, as the day wore on, a wasted Dennis decided to dive into the freezing water to look for some personal items – including a photograph of one of his ex-wives – that had been flung overboard during a drunken evening on his old yacht Harmony three years earlier.

Dennis reappeared triumphantly with the photograph, but told concerned friends he was going down again for a box he knew was there. He never emerged. The people he was with suspected a practical joke, which wouldn't have been out of character, but his body was

brought up by divers some hours later. New Year was cancelled, and on January 4, 1984, Wilson was buried at sea* off the California coast, as per his wish. From his prison cell, Charles Manson, with whom Dennis had become temporarily embroiled during the late sixties, claimed Dennis' death was a result of having neglected his priorities to him. "Dennis Wilson," he said, "was killed by my shadow..." California dreaming was not to be recommended if you weren't prepared for some serious night terrors.

Dennis had become close to Fleetwood Mac during his two-year relationship with Christine, who adored him and had written the song 'Only Over You', featured on *Mirage,* for him. Their engagement was broken off in 1981 when his spending and womanising became too much to bear, but the Beach Boy remained loved by the Mac as a friend and an artist. Lindsey in particular revered Wilson and the Beach Boys, and would honour his memory with the track 'D.W. Suite' on *Go Insane.*

As the hard-living Californian rock elite mourned the death of their sweet, wild friend, many will have privately mused on the fact that it could easily have been any of them. There was fear behind the Aviators and a hollow anxiety at the bottom of the glass that wouldn't go away no matter how many times it was refilled. This news had to serve as a wake-up call, and indeed this would be the year Stevie herself would eventually make her first steps towards beating her own habit once and for all. It would also be around this time that Stevie hinted she was tempted by the thought of "gracefully slipping out of" the music industry altogether to concentrate on painting and developing her ideas for children's story-books. It was an attempt to stay in touch with innocence, light and clarity in a world – her world – that was rapidly turning dark.

★ ★ ★

* Non-veterans of the Coast Guard and US Navy are not permitted to be buried at sea unless cremated, however Dennis' burial was allowed thanks to the intervention of then president Ronald Reagan.

Stevie was itching to get back into the studio with her band and Jimmy Iovine, and Jimmy, not convinced by the musical direction Stevie wanted to take, was back on the prowl trying to find songs for Stevie to use as singles. One anthemic number that had been pitched for Stevie's attention – by Bernie Taupin, no less – was the song 'These Dreams'. Stevie rejected it and it went on to be a number one hit for Heart that very year.*

Cue a phone call to Tom Petty. Unfortunately, this time he didn't have any songs to give, although he felt Iovine's pain. Stevie had embraced the synth-pop sound ubiquitous in the 1980s, but many of the old guard were not so keen. Petty felt "music [had] really turned to shit. People were *trying* to do something, but it was all these fakey keyboard sounds."

Iovine wasn't pleased when Petty told him he had no material "left over" for Stevie, but Petty had an idea up his sleeve. "[Jimmy] said, 'I'm frustrated, I'm trying to find writers. Who do you think would be a good writer?' And I said, 'You should try this guy Dave Stewart. He's in England. I don't know him, but he seems consistent as a writer.'" 'Fakey keyboard sounds' notwithstanding, Petty had to concede that the Eurythmics' hit 'Sweet Dreams (Are Made Of This)' was a great song, and Dave Stewart – one half of Eurythmics with Annie Lennox – clearly had some form.

"The next thing I know, the phone rings, and it's Dave Stewart," remembers Petty. "He says, 'Hey, I'm here, and Jimmy told me I got the gig from you. I've come over to write some stuff for Stevie and other people. Why don't you come down?'" The Eurythmics were also in the US to play some shows, and it was at an after-party held

* Heart's sibling front women Ann and Nancy Wilson would become friends with Stevie, dropping in on her home in Phoenix when their tour hit Arizona. There they played dress up, took drugs and marvelled at how the star's own home was, basically, "a shrine to Stevie Nicks". "Her home was filled with pictures of her," they remembered. "We spent most of the night digging through her closets trying on clothes with her. It was fun to be girls together. When it came to drugs, though, we couldn't keep up with Stevie. At some point, we had to leave to sleep."

at Stevie's home that Dave Stewart first encountered Ms Nicks. Dave apparently didn't realise who she was at the time, but their meeting would be unforgettable, even inspiring a song – although, ironically, Stevie would not get the benefit of it for her album. The track 'Don't Come Around Here No More' would be recorded by Dave and Tom Petty instead.

The night before Stewart and Nicks first met, Stevie had had a monumental argument with Joe Walsh over the phone, culminating in Joe hanging up on her. Believing their relationship was over, Stevie pushed thoughts of Joe aside as she regarded Stewart, with his dark glasses and insouciant Sunderland accent, with no small interest, and the feeling was mutual. Stewart asked Nicks if she was in a relationship. The answer she gave was 'no'. Stevie and Dave had plenty in common – for a start, both of them were hugely successful writers who had survived dramatic, often toxic romantic relationships with their musical partners; Annie in Dave's case, Lindsey in Stevie's.

After disappearing into her bathroom together to snort cocaine, nature took its inevitable course and Stevie and Dave staggered off to bed. But after waking up at 5am to find a troubled Stevie pacing about (and, surreally, trying on Victorian clothing), Dave suggested getting together again but Stevie, still in love with Joe, refused, uttering the now immortal words, "Don't come around here no more." In the cold light of day, Stevie had panicked. "I threw him out of bed and started dressing him," she told Chrissy Iley for *Elle*. "All this leather! All these chains I was threading through!" The whole fiasco was "very *Alice In Wonderland*," Dave observed.

With those now famous words of rejection still ringing in his ears, Dave promptly started writing, eventually recording 'Don't Come Around Here No More' with Petty at Sunset Sound – Stevie had booked a session with the boys but failed to show. Yet another example of the importance of turning up (the 'Silver Springs' debacle being another memorable one).

As Stevie remembers it, "Dave wrote that song for me and we took it in with Jimmy Iovine, then we called Tom and he came down. I went home because I was tired and when I came back the next day it was all

written, and it was fantastic. Being a huge Tom Petty fan, I listened and said, 'So, what, I'm going to rewrite this song and write better words than Tom Petty did?' I was very pissed off, and at the same time, very much enamoured with the song. I knew this was going to be the second coming of Tom Petty."

"The girls that sing with her had turned up for the session," explained Tom. "[So] Dave said, 'Let's get them out here and see what they can do.'" So the song, inspired by a kiss-off from Stevie Nicks, would feature the voices of her close friends Sharon Celani and Marilyn Martin, while the subsequent video would be *Alice In Wonderland*-themed, even featuring cellos being played with pink flamingoes instead of bows. (Stevie had had pink flamingo statues 'grazing' in her grounds.)

Joe and Stevie were soon back together, but Dave Stewart felt a strong kinship to Nicks; this may have been a one-night stand but he always remembered her, and in later years they would come together again, finally collaborating musically in earnest. Stewart's fondness for Nicks is detailed quite openly in his later song 'Stevie Baby', from his 2011 album *The Blackbird Diaries*: 'It took one second, just one kiss / To realise all the things I'd miss. / I play *Rock A Little* just to reminisce / I never thought we'd meet again like this...' But this was all to come.

The next 18 months of Stevie's life would be devoted to making the new album, a journey which would take time to find its compass and would feature more collaborations than ever before, possibly pointing at Stevie's own lack of focus – she was drifting away from reality and, seemingly, no one, not even Jimmy Iovine, had been able to tether her. One collaboration that had worked well for her in the past was 'Stand Back', which featured Prince, but the pint-sized megastar would not be available this year – being as it was the year his film *Purple Rain* was unveiled for the first time. Stevie, dressed in a white beaded gown, would be at the premiere on July 27, 1984, as would Lindsey Buckingham, Little Richard, Lionel Richie, 'Weird Al' Yankovic, and frankly everyone who was anyone in American pop culture at that time.

The album of the soundtrack would go platinum 13 times and the semi-autobiographical film, starring Prince himself and the Revolution, broke new ground. However, it was dark, often uncomfortable viewing.

Warners had turned the option down because it was too "outrageous", and Stevie herself "freaked out" during the scene in which Prince's character slaps Apollonia Kotero, and had to go and recover in the bathroom, remaining there until the film was over.

Unfortunately, Prince noticed she had left her seat, and approached her afterwards, putting her on the spot. When Stevie explained how the scene had made her feel, he simply looked at her as if "it killed him", and it would be some time until they would speak again. "It's a shame really," Stevie mused. "We were alike in so many ways. For one thing, we both liked wearing black chiffon around the house…"

★ ★ ★

For *Rock A Little* – at this point still known as *Mirror, Mirror* – Stevie suddenly decided to "move everyone to Dallas to record, with very little preparation." Stevie had been enchanted by Gordon Perry's converted church studio Goodnight Dallas, where she had recorded the piano demo of 'Beauty And The Beast' (and first met Gordon's then wife Lori, subsequently married to Stevie's brother Chris Nicks). Stevie wanted to recreate that special atmosphere for her third solo long-player.

"This was one of my bad planning moves," Stevie admitted. "I prepared, I mean the [songs were] written, but all the rock'n'roll stars arrived and Jimmy Iovine, you know, I put him in a very weird position. He had to go in and say, 'Well, I don't really know the songs either but we're going to play!' We were there for about a month and we ended up coming out with about six tracks that we could go back to that are really good."

Tracks 'we could go back to' was a diplomatic way of saying that many would have to be recorded again. Stevie was a little disappointed with how things were turning out, and Jimmy Iovine was reaching the end of his rope. 'Musical differences' aside, cocaine was now running the show and ruling Stevie's daily life. Jimmy wasn't the only one who found it hard to stand helplessly by and watch someone he loved sink deeper into addiction. Stevie understood why Iovine elected to leave (although elsewhere she has stated that she fired Jimmy after the

'Don't Come Around Here No More' incident). "It wasn't fun for him anymore," she said. "It got a little bit too crazy." "Drugs were getting in the way," confirmed Lori Perry Nicks. "They weren't the unit they were previously." Paul Fishkin admitted too that "we all started getting nervous about [the escalating drug use]." But Stevie would not listen to reason. Not yet.

Keeping some of the tracks they had worked on together, Stevie contacted her friend Keith Olsen, who would take over as producer at his own studio Goodnight LA, next door to their old stamping ground of Sound City in Van Nuys. The release date of *Rock A Little* would be pushed back from late 1984 to November 1985, and the process of making this album was not a little tense at times.

"Stevie asked me [to produce] during the time I was working with Joe Walsh," explains Olsen. "We thought that doing something together would be like 'old times', even though we knew that 'old times' were gone forever."

Olsen and Walsh also went back a long way, back to the days of the excellent blues-rock outlaws The James Gang in the late sixties, and now they would be working together on Joe's latest solo record *The Confessor*, an album that would feature the guitar-playing of Waddy Wachtel.

Stevie herself would be a guiding presence on *The Confessor**, recorded at around the same time at Goodnight LA. "She rode shotgun with me," Walsh told DJ Howard Stern. "[She] gave me some direction, she's really good at the craft of songwriting." It often became incestuous on those LA studio complexes, and a little cross-pollination was rarely a bad thing when the artists were of this calibre. It was up to Olsen to make sure all sessions ran as they should, "musicians arriving on time, doing their thing and leaving... some of the time that didn't quite work out..."

* *The Confessor* is about the twelve-step drug rehabilitation programme, a process Joe would have to undergo himself. One of the people he had to 'make amends' to, as one does on the programme, would be Stevie.

Rock A Little would feature Stevie's song for Joe, 'Has Anyone Ever Written Anything For You?', a track that would become a collaboration with Keith Olsen himself. Keith takes up the story:

"Stevie had gotten sick and her doctor had told her to rest – period. So I went to her house and kind of just hung with her to make sure she rested and really did take care of herself. While I was there, I was playing her piano and her Kurzweil keyboard, and kept landing on this section of her song to give it another section that I thought it needed [basically a bridge] and a key change.

"I just kept playing this over and over and she heard it from her room, came out and hummed along a melody that just made it so special. [Stevie] agreed with me to put this bridge and key change into the song. (I always wanted to title the song 'I'd Rather Be Alone'.)"

When it came to selecting songs for *Rock A Little*, a number of the original tracks and demos Stevie had been developing would not be used, and it took time for the record to find its way. "For some reason it wasn't right... like, it was right but it was as if you had the wrong pair of shoes," Stevie explained. "I just wanted to do this kind of year-and-a-half of trying to understand why I didn't feel that it was right. I understand now why it wasn't, which isn't really something I can tell you, but it is right now."

"Stevie writes lots of sketches," adds Olsen. "Some good, some normal, some great... it's my job to wade through them and find the gems, then develop them."

A duet with Don Henley was one of the songs that wouldn't make the cut. Jimmy Iovine had, as always, been determined to have songs on Stevie's album written by others despite Stevie's wishes, and one of those songs would be 'Reconsider Me', written by Warren Zevon. "Of course, I love Warren because I've known Warren since before Lindsey and I joined Fleetwood Mac," Stevie said. (Warren was one of the musicians who got stoned at Stevie and Lindsey's back in the day.) "Jimmy thought it was a very important song for me to do. He thought it was like 'Stop Draggin' My Heart' was in a way. It was that kind of a career-changing song. And, of course, you couldn't tell me anything in 1985 and I just didn't want to do another person's song, you know?

"In the end, I did record it and then when all the songs were recorded in the end, a couple of songs had to go; I pulled it because it wasn't one of my songs." Stevie also had to admit she wasn't a "'reconsider me' kinda gal" anyway. Still, the track would surface again in later years when Modern/Atlantic Records were working with Stevie on collating the box-set *Enchanted*.

Tennessean guitarist Billy Burnette, son of rockabilly singer Dorsey Burnette, would also be brought on board temporarily to work with Stevie but again, because the song they worked on was not an original, the song would be shelved. Stevie and Billy first met at UCLA, where Mick Fleetwood's The Zoo were playing one night; Stevie and Billy liked each other instantly. Billy was already friends with Mick and John, and he would later join Fleetwood Mac himself when Lindsey left the band. He was clearly simpatico and Stevie invited Billy to the studio to try something out. Stevie wanted to sing the first song her beloved grandfather had taught her, the jaunty call-and-response Red Sovine number 'Are You Mine?', a song Sovine himself made famous as a duet with Goldie Hill in the fifties. It meant the world to Stevie to get it just right and pay tribute to AJ Nicks, who had started her on her journey three decades earlier with this song.

"I don't remember exactly why I asked Billy to do that," mused Stevie. "I guess because of his country roots. We did a really beautiful duet on it, but since I didn't write it and Billy didn't write it, it didn't go on the record, because it would have taken the place of another song that I did write." Their work together on this would not go to waste, however, and they would perform 'Are You Mine?' on tour.

Some covers would make it through, as would a selection of co-writes. 'If I Were You', 'Sister Honey', 'I Can't Wait', 'The Nightmare' and 'Imperial Hotel' were all collaborations, while 'Some Become Strangers' was written by David Williams, Amy Latelevision and Peter Rafelson and 'Talk To Me' by Chas Sandford. While Stevie felt conflicted about using songs written by others, if they reverberated with her, it "doesn't matter one bit. It simply saved me from having to sit down and write it," she said to *Innerview* broadcaster Jim Ladd. *Rock A Little* would be the first Stevie Nicks album to feature such a high percentage of

other people's work, but the opportunity to sing material written by others gave Stevie the chance to tap into her theatrical side and take on a different character. "If I can relate to you, then I can become you and see through your eyes. When I sing Tom's songs, I *become* Tom; I become more Floridian and gator-like and have more of a drawl."

'Talk To Me', a power-pop contemplation on how emotional wounds can fester if communication breaks down, was sourced by Jimmy Iovine and, while Stevie wasn't instantly sold on it, it "made itself my song," Stevie said. "It sort of sang to me, it said to me something that I was going to write anyway that night, it was exactly my thoughts." Stevie took a little time to settle in with the vocals on this track, although the A-list session drummer Jim Keltner, who had been recording overdubs next door, popped in and gave her some encouragement, being her 'audience' while she worked. Whatever he said clearly had a good effect – Stevie nailed it in two takes.

The track would be released as the first single from the album, going gold no less. Writer Chas Sandford certainly knew how to craft a winning single, being the creator of John Waite's smash hit 'Missing You', and there are definitely echoes of that song in 'Talk To Me'.

'The Nightmare' was a song co-written with Stevie's own brother Chris, and lyrically, the song proved to be, as Stevie put it, "the final statement on how I felt about real unconditional love. As a woman, if you give out the vibe, then people will flirt with you, but boy, when you are in love with somebody, you don't flaunt or offer yourself. So in the nightmare, the fact is it didn't work, but I wouldn't trade a second of it. I'll never again settle for anything that is any less than that feeling."

Keith Olsen once insisted that Joe Walsh and Stevie didn't write about each other but it's hard to imagine that there isn't a little bit of Joe in here, a window into Stevie's strong feelings for him, and an unwitting glimpse of the real nightmare that was to come. Either way, some of Nicks' sweetest poetry is contained within this song: 'Thrown down through the arms of sleep / She fell through the ivory morning / Deep into the waters / Of the one she called love... You cannot know the dream / Till you've known the nightmare.' There are whispers of the past in this song too, including some favourite themes and

lyrical references to previous songs, including 'Sisters Of The Moon' ('the moon and her sisters...') and 'Storms' ('I'd like to leave you with something warm...')

Stevie found it especially difficult to pick the singles from *Rock A Little*, but 'I Can't Wait', co-written with Rick Nowels and Eric Pressly, would be the second. Rick Nowels and Stevie had known each other "since he was 13 and I was 18, there's no one I've known longer than that except Robin." But there was no nepotism behind Stevie's decision to record this track; Rick was already an established writer and when Stevie took the tape he had given her home, ran a bath, put the tape into her bathroom stereo and turned up the volume, she "went crazy. [I] played 'I Can't Wait' all night long, made up the words, danced around to it, saw the video in my head and went in the next night [to the Village Recorder, LA] without anybody else's permission and did the vocal that's on the record right now. That's the only time I ever sang this song."

One of the tracks produced by Jimmy Iovine before his departure, 'I Can't Wait' would be released in 1986, with 'Rock A Little (Go Ahead Lily)' on the B-side. 'I Can't Wait' is surely another song that, lyrically, reflects Stevie's frustration with Joe Walsh. As the title suggests, the song is about being kept waiting by a lover, and the lyrics perfectly depict how Stevie was feeling at that time: 'She wonders how many more hours her heart will feel broken... Blame it on something at first sight...' The song begins with Stevie howling 'I love you', the statement more like a strident, almost desperate rallying cry than a sentimental confession.

When Stevie first listened to the backing track, it was "about the most exciting song that I had ever heard." She loved the punchy percussive rhythms and "electric" sense of vitality. While she "pretended not to be that knocked out" at first, the track, not to mention the final result, would be something Stevie remains proud of to this day. "Some vocals are magic and simply not able to beat," she wrote in her *Timespace* liner notes. "Now when I hear it on the radio, this incredible feeling comes over me, like something really incredible is about to happen." Not least the receipt of a large cheque for radio-play, not that that would have been particularly incredible for Stevie.

Another co-write would be 'Sister Honey' (also the name of one of Stevie's paintings), written with the guitarist Les Dudek, who had played with the Steve Miller Band, Boz Scaggs and the Allman Brothers, all contemporaries of Fleetwood Mac who had been working the same rock'n'roll circuit for years.

Les was in Stevie's living room one evening, guitar at the ready, when he cranked up the volume and started to play the chords we now know to be the foundation of 'Sister Honey'. Stevie was hooked immediately. "I just went, 'All right, baby!' The entire canyon is ringing with 'Sister Honey'."

"You get that sparkle in the room with someone who's playing great, and they're not paying a hell of a lot of attention to you because they're playing their thing, and you just draw back and go, 'OK, I'm going to blow your mind now.' And the guitar player or the piano player or your mom or your dog look up and go, 'All right!'"

Sensing things were going well, Les suggested Stevie use some of his own lyrics in the song. He handed her some lines, starting with the words 'strange fascination, some kind of temptation...' "I went, 'You're not serious? I don't have to sing these, right?' [But] just because I love Les, I thought, 'All right, I'll do it for you...'" So 'Sister Honey''s lyrics are pure Stevie with the exception of the second verse. From Stevie's point of view, there is a sense of a return to her fading connection to Lindsey Buckingham once again. "Come back, solemn stranger, it's your last chance... she's almost gone now..." The lines – "even if you don't need her, tell her you need her / She needs you, brother..." hint poignantly at Stevie's insecurity at this point, particularly around Walsh, who would soon be out of her love-life for good.

The self-penned tracks that made the cut would be typically autobiographical. 'I Sing For The Things', for example, would be a sentimental portrait of the 'things' that money can't buy her, the dreams and 'chains': a reference to the song 'The Chain', and the often troubled love and permanence of Fleetwood Mac – she is 'chained' to the band but her dreams struggle against that. But 'I Sing For The Things' also praises the sense of romance that has the power to render all of the material luxuries in her life worthless.

"We already have so many things," Stevie said, "When I start to have several things that are similar, I can't choose. That makes me want to run away." In terms of 'things', Stevie herself would rather treasure the few items that she loved, that brought her comfort and made her feel rooted, such as her favourite skirt, her boots; signature items that each had a story. (You wouldn't find Stevie Nicks wandering around an antique store murmuring to her assistant, "Do I have one of those?" a la Michael Jackson.)

The title track, 'Rock A Little', would be "shared with my father", Stevie said. It was as much inspired by the thunderous ocean as it was by her own dad, who spurred her on when she faltered. "It came from my dad saying to me, 'We don't care how you feel, you have to go up there and do a show now,'" Stevie explained. The lyric 'hit it, Lily' refers to the fact that Stevie's loved ones used the name 'Lily' as a pet name for her. "My dad would say, 'Go ahead, Lily, hit it, rock a little, get up, if you don't feel good, go home.' So this whole thing came about as a statement, it doesn't really matter what your problems are, what really matters is you have to go up and go out there onstage."

The video for 'I Can't Wait', directed by Marty Callner, would be a dramatic affair, featuring wind machines, lots of marching up and down a giant white staircase, black skirt-swishing and tambourine-bashing a la 'Rhiannon' and a strange prison cell that contains a wild Stevie, dancing and pacing within the oppressive four walls like a caged lioness. The energy is compelling but Stevie looks back on this video with genuine regret: she is clearly high, as she was all for all of the videos she shot in this era, but perhaps most obviously so here.

"I look at that video, I look at my eyes, and I say to myself, 'Could you have laid off the pot, the coke, and the tequila for three days, so you could have looked a little better?' It just makes me want to go back into that video and stab myself." For some years now, Stevie had been relying on drugs to give her energy, and drugs to bring her down, pills to help her sleep and powders to help her wake up and work the next day. The spiral had started long ago, and Stevie had already started to lose people she loved because of it. Stevie also missed her family, whom she felt she had to avoid more than she'd have liked to, again, because

Lindsey Buckingham and Stevie performing onstage during the often nightmarish *Tusk* tour in 1979. Stevie and Lindsey's personal war raged both on and off stage. RICHARD E. AARON/REDFERNS

Stevie raises her wings and prepares to take flight with Fleetwood Mac. She quickly found having winged, diaphanous costumes gave her small frame greater physical presence onstage. RICHARD E. AARON/REDFERNS

Stevie and Mick Fleetwood (not pictured) join former Fleetwood Mac guitarist Bob Welch for the star-studded California Jam 2 at Ontario, California, March 18, 1978 NEAL PRESTON/CORBIS

Fleetwood Mac pose for photographers backstage at the 5th American Music Awards held at the Santa Monica Civic Auditorium on January 16, 1978 in Santa Monica, California, where they were honoured for their album *Rumours*. MICHAEL OCHS ARCHIVES/GETTY IMAGES

Fleetwood Mac and their road manager John Courage pose with promoter Bill Graham before hitting the stage for the *Day On The Green* concert in Oakland, California, hosted by Graham himself, April 26, 1976. NEAL PRESTON/CORBIS

Stevie in hypnotic mode during a backstage shoot, 1985, Los Angeles, California. Some say her intense gaze was largely down to being extremely short-sighted. Either way, the camera loves it. DONALDSON COLLECTION/MICHAEL OCHS ARCHIVES/GETTY IMAGES

Stevie and best friend Robin Snyder Anderson.

Fleetwood Mac at the unveiling of their star on Hollywood's Walk of Fame, Hollywood Boulevard, 1980. Somewhat comically, they'd had to wait inside the notoriously trashy lingerie store Frederick's of Hollywood before greeting the public. NEAL PRESTON/CORBIS

Stevie in contemplative mood on a carousel horse. Perhaps she'd have preferred the ghost train. NEAL PRESTON/CORBIS

Stevie and her beloved backing singers Sharon Celani and Lori Perry perform together onstage, during the *Bella Donna* tour, 1981. Sharon and Lori continue to sing with Stevie to this day NEAL PRESTON/CORBIS

Tom Petty and Stevie belt out 'Stop Dragging My Heart Around', their hit duet from *Bella Donna*. LYNN GOLDSMITH/CORBIS

Stevie would often use choreographers to create high concept pop videos that tapped into her love of ballet. NEAL PRESTON/CORBIS

Stevie was always deluged with bouquets of flowers from adoring fans at both Mac gigs and her solo shows. Here she is at the Rock N' Run benefit at UCLA, California. RICHARD E. AARON/REDFERNS

Stevie, Mick Fleetwood and Billy Burnette of Fleetwood Mac perform on stage, Ahoy, Rotterdam, June 14, 1988. PAUL BERGEN/REDFERNS

of her cocaine dependency. Her sense of isolation was palpable, and her need for reassurance more keen than ever.

"My family is so important to me," Stevie told ABC Australia's Molly Meldrum, a note of disconnection and panic in her voice. "Last night, in the middle of the night I started to cry because I miss my brother, and I needed to call him, and I didn't have any phone numbers because I don't have a book. I just needed for somebody to tell me that it's all OK. My family is very, very important to me, and you are important to me, and all the people that come to see me are important to me…"

Chapter 22

'Just leave a message… maybe I'll call.' (Joe Walsh, 'Life's Been Good')

No amount of adulation and support could soften Stevie's latest crisis. Joe Walsh had left her, having accepted an offer to tour Australia with The Party Boys, a predominantly Australian supergroup with a rolling line-up of musicians that at various times also featured UK and US stars, including Alan Lancaster of Status Quo, Eric Burdon of The Animals and metal vocalist Graham Bonnet. Joe would stay in Australia for some time after the tour was through in 1985, forming a touring band with Waddy Wachtel called The Creatures From America.

Interestingly, the live Party Boys album Walsh appeared on, released that year, would be titled *You Need Professional Help*. This he most certainly did, as did Stevie. This was purportedly one of the main reasons Walsh chose to leave LA for Australia – to get away from Nicks and the party scene that he was afraid would kill him. Joe also admitted he couldn't give Stevie what she wanted, and that ultimately "[neither] of us could have committed to a lasting relationship in the state we were in". Stevie believed he simply "got scared". They were "complete, perfect" as a couple; a crazy, dysfunctional couple anyway. But Stevie also knew what she was prepared to give up for him: her beloved career, her lifestyle. He was unlikely to do the same for her.

Stevie was in the studio one night, getting ready to cut some new songs with Waddy. Joe had been away for weeks and, while he knew that Stevie didn't have much time in the studio that evening, he came down to hang out at about midnight and "completely screwed up the session", said Stevie.

"It would have been fine any other night but I was angry that Joe had done that. He had everybody dying laughing because he tells 100 jokes and people were rolling on the floor, everybody was drinking and I'm going, 'This is not fair, he is not being sensitive at all to this situation. You know I would give up anything for you, I might even give up my damned career for you' – maybe, if I thought he was serious enough...

"I had a limousine that night because I didn't know what time it would finish and I didn't want to hold anybody up, so I said, 'Do you want to go home? What do you want to do?' and he looked at me and said, 'Actually, I didn't tell you this but I'm leaving for Australia tonight and I have to pack. So I'm just going to get a ride home with Waddy.'"

Stevie's heart sank, and as she finally walked towards the door, she said, "I don't like where this relationship is going, because it's not going anywhere and I don't want to do it any more." Walsh promptly called her bluff. "He said, 'If you walk out that door, you basically cease to exist.' I just didn't stop walking."

It was a harsh, bitter end to a romance that had been so important to Stevie, and it was of small comfort to her when she later received a message from Walsh via a mutual friend: "He told my friend he'd gone to Australia because he's a coward. He said, 'Tell Stevie I'm going because both of us are doing so much coke that one of us is going to die.'" So many relationships are borne of being 'drug buddies', and the boundaries can become confused, but whether Stevie's 'love' was truly requited or not, the bond would have been all the stronger because of cocaine, and to break an addiction often means breaking off a friendship for the greater good.

Stevie admittedly was convinced she was not long for this world herself, and, had she continued the way she was going, there's a good chance she would have fulfilled that prophecy, whether Joe was there or

not. She had spent approximately $1 million on cocaine, the drug that had famously burned a hole in her nose so large she professed she could loop a belt through it, or at least a ring... "a gold ring... with diamonds!" she added, jokingly, ever stylish and decadent even when it came to something as gruesome as this. It was harder to find humour in the day-to-day reality of what that meant. Stevie was suffering frequently from nose-bleeds and black-outs. It had to be said, Walsh had a point, but to make that point, he had to break Stevie's heart, maybe even being deliberately cruel to make it easier for Stevie to turn her back on him. But it would be a break that would sadly never quite mend. 'How will we feel 20 years from now?' Stevie asked in 'I Can't Wait'. For her part, she wouldn't feel all that different. The blaze of passion might have diminished to glowing embers, but the love was still there.

"It took me a long, long time to get over it – if I ever got over it," Stevie said in an interview with *The Telegraph* in 2007. "There was no other man in the world for me. And it's the same today, even though Joe is married and has two sons. He met somebody in rehab and got married. And I think he's happy."

Rock A Little was finally finished by the summer of 1985, and would be released in November. It had cost over $1 million to record, so it's just as well that Stevie was happy with it and was already champing at the bit to head out on tour before starting on record number four. *Rock A Little*, in Stevie's words, was "a whole tapestry of energy from a lot of different brilliant people, whom I very much respect, woven into this pattern that I hope people will understand." In reality, not everyone did understand, and while the record went platinum, reviews were mixed. *Rolling Stone* expressed a concern that Stevie was "slipping out of touch... the real shame is that Nicks could make a good record again, if she'll only take her advice and rock a *little*."

As usual, Stevie ignored the critics and was proud of her record. She even contacted Joe Walsh, for whom she still hankered, to play it to him. It may have just been an excuse to see him and attempt to rekindle their relationship, but after tentatively suggesting she could come over, Stevie was thrilled when Joe agreed. After a final tweak of her outfit, a spritz of perfume and a primp of her super-sprayed hair, Stevie jumped

into a limousine and was driven to Joe's house, which was several hours away. Crushingly, he opened the door only to flatly tell her he didn't have time after all. It was yet another rejection, and a furious Stevie promptly wrote a song about it, 'Long Way To Go', stating that it was a "long way to go to say goodbye / I thought we already did that..." This angry song, which would be included on the album *The Other Side Of The Mirror*, was also something of a confessional: "You were high in my life / Obsessive was my love / Worth it was my time / Oh no, you are fading out." But Stevie's memories of Joe Walsh would never quite fade to silence.

★ ★ ★

In January 1986, four years after *Mirage*, Fleetwood Mac finally reassembled to make a new album, *Tango In The Night*. Interestingly, it was noted that Stevie's management company Frontline 'agreed' on Stevie's behalf that their artist would indeed be recording with them. Once Stevie would have dropped everything for the band, but now her cooperation was subject to her own increasingly busy schedule; she had an epic tour lined up for 1986, taking in the States and Australia. Also, now that Mick was no longer managing Fleetwood Mac, everyone had their own managers, for better or worse. The members of the band had become disconnected, but in one sense this was no bad thing. Having had the chance to grow and develop away from the Mac hothouse, not just as artists but as individuals, everyone felt as ready as they ever would to work together again, although some were more enthusiastic than others.

The process of making *Tango* started well, with Lindsey stating that it "made us feel like a band again, for the first time in a long time." Buckingham and Richard Dashut took on production duties and recording started at Rumbo Recorders in LA. However, by the time Lindsey's own home studio, 'The Slope', was built, the bulk of the work would be produced there, with Lindsey very much at the helm of the operation. There would be no more meandering jams into the small hours, no more late starts...

"We would start about 1pm [and] shut down about 11," Lindsey said. "If people looked like they were having too good a time, I would walk in in my bathrobe..."

"It wasn't like he'd laid down any rules," added Stevie. "He just had very good intentions to take as little time as possible to do wonderful work and not be staying up all night playing [the] Rolling Stones, which we've been known to do... for days... The fact that it was in his own home, maybe it wasn't as much fun but we got an awful lot more done, and quicker." Stevie had to be honest, she was reluctant to go into the studio with Lindsey again, but she was tentatively pleased with how restrained his behaviour was so far.

Behind the smiles, however, there was turmoil. Of course there was. This is Fleetwood Mac. Mick Fleetwood had gone bankrupt, Lindsey was quietly fed up that, yet again, the songs he would have used on his own solo album would now be absorbed into *Tango In The Night,* John would just rather have been at sea and Stevie was otherwise engaged, joining sessions for *Tango* in earnest as late as January 1987. More worryingly, she was also now constantly high and risking permanent mental and physical damage as a result, her body already sending her signals loud and clear, with ever more frequent nosebleeds, falls and black-outs. Stevie visited a doctor to receive the alarming, but perhaps unsurprising news that she was veering ever closer to a brain haemorrhage, or even an early grave. "[He said], 'It could be the next time you do cocaine. It won't be pretty.' It absolutely scared me to death."

It was imperative that Stevie stopped doing coke immediately, but the reality was that she was almost in love with the drug, describing it in her typically fanciful way as "being swept up on a white horse by a prince. There was no way to get off the white horse and I didn't want to." And so, despite the knowledge that her addiction was life-threatening, Stevie elected not to dismount from her deadly steed straight away. Stevie was with Fleetwood Mac for three weeks in the studio, leaving them with the rather pained, emotional song 'When I See You Again', before her own tour took her away from them. As Lindsey Buckingham recalled, "They weren't a great three weeks. I didn't recognise her at all. She

wasn't the person I had known and moved to LA with." It had been some time since Lindsey had seen Stevie, and he had never seen her so dead-eyed and disconnected.

"Cocaine is not a creative drug," Nicks conceded in later years. "It will not help you to create a masterpiece. What it will do is help you put the tiredness at the back of your mind." There was no point in being alert but mentally absent, however, let alone artistically restricted. Still, the drug gave Stevie fake courage, not only onstage but as a writer. In some cases, the songs that would appear while Stevie was on coke would be lyrically all too blatant and literal, but, fooled by the chemicals coursing through her system, she would forge ahead unstoppably. "You were likely to say more, to write down more, to give away more of the secret or to maybe say too much... You think it's making you better and in the long run it's not. It's taking away the actual essence of what you started out to do."

Coke also allowed Stevie to cram more activity into her life than was strictly healthy. Just weeks before her *Rock A Little* tour was due to commence, instead of resting or working on with Fleetwood Mac, she jetted off to Australia to spend time with Tom Petty and Bob Dylan on their True Confessions tour when Tom's wife Jane didn't want to go. After suggesting Tom buy Jane diamonds or even "a fucking Porsche", because, unbelievably, an invitation to go on tour with Petty and Dylan was a hard sell, Stevie shrugged and went instead. There she hung out, joined in with after-party singalongs around Benmont Tench's piano, and even appeared onstage herself, and an onstage cameo playing the tambourine soon turned into something much more.

"When they finished their set, nobody really noticed that I was there, and then they went off and I didn't know what to do, so I went off too," Stevie remembered in an interview with Jim Ladd. "When they turned around and went back on, they said, 'Come back.' Tom knew it was going to be wonderful, they both motioned over to me to sing on 'Knockin' On Heaven's Door', so I did. In the next chorus [Bob] turned to me and let me sing the choruses by myself.

"It was incredible, there's no way to explain what it would be like to someone like me, who went to Woodstock and decided that was what

I wanted to do... to stand on a stage with Bob Dylan and Tom Petty, it makes everything else that goes on that I don't love that much worth it..."

The crowd loved seeing Stevie onstage with their heroes, although Australian government officials weren't so impressed when they discovered she was technically performing without a work permit. Stevie revealed to *New York Magazine's* Jada Yuan that she was told: "'If you even walk on that stage and go ping!, you can never come back to Australia. Not on a vacation, not with Fleetwood Mac, not with friends.'" As if this wasn't enough Petty-related drama, Stevie had recently managed to "accidentally pilfer" a tape of melodies that had been written for Petty, later adding lyrics to one and then innocently playing it for the man himself at a later date during a phone conversation. "All I can hear is Tom screaming." Oops.

Stevie was looking forward to kicking off what would be her longest and most colourful solo tour yet. She shrugged off concerns from loved ones and perceptive journalists, describing herself as a "road warrior", and embarked on the *Rock A Little* tour with her band, starting at The Summit in Houston, Texas on April 11, 1986. They would tour Australia too, the first time Stevie had performed in a solo capacity outside of the US. But the *Rock A Little* road-trip was problematic. Stevie defied her doctor's warnings and continued to take cocaine and drink heavily, and the effects took their toll on her body and mind as well as decimating her performances.

Once word got out about the hole in Stevie's nose that was currently "the size of a dime", rumours spread that Stevie was having to get her fix via other, rather undignified means. Stevie has dismissed the famous speculation that she had to have the drug blown up her derriere by an assistant as "an absurd statement. It's not true," she told *Q Magazine* in 2001, although the damage to Stevie's septum "didn't stop me doing cocaine one bit." Stevie decided not to have her nose fixed in case it changed her voice. "It's so painful. I curse the day I ever did cocaine. Nothing really works right in my head now. That hole goes against God's plan... I'm stuck with it forever, and it slowly deteriorates... If it's doing that to your nose imagine what it's doing to your head, brain, and the workings of your entire body."

The use of cocaine up to that point, however, and no doubt the hole itself, meant that Nicks' voice had noticeably changed on her studio recordings, becoming huskier and more nasal and her range was increasingly limited. Live, these changes were all the more noticeable, as was her persona, now morphing into something even wilder and less controlled.

Vocal discrepancies could be hidden to a certain extent by Stevie's trusty backing singers, who covered the high notes for her, but while the ever-loyal fan base layered up the lace and trooped out to her concerts in force, cheering as loud as ever, the critics weren't convinced. Watching through their fingers, they observed her unsteady dancing, frequent skips off stage for costume changes (and the rest) and strange mumblings between songs. Elements of the Stevie they knew and loved were still there, but something had cracked and the shows veered into sad and even grotesque territory, reminiscent of Vegas-era Elvis Presley, increasingly broken and bloated but performing as best he could, a caricature of himself. There would also be cruel jibes about Stevie's shape in the press, cutting, as she was, a more matronly figure these days. More frighteningly, there were times when Stevie stumbled and fell onstage, "near overdoses" and incidents when "we had to just scrape her off the floor", as Paul Fishkin remembers. Stevie had become like one of her own marionettes, relying on expert puppeteers to pull and push her into position. Without them, she sank.

The Chicago Tribune's Daniel Brogan was concerned that Nicks was "riding an expressway to creative oblivion and self-destruction", while the show "provided a graphic picture of what bad shape she is in. Years of hard living have reduced her voice to a wretched rasp… she spent much of her 90-minute set spinning and whirling on and off the stage, often leaving her bewildered-looking band to pick up the pieces."

It was after this very show in Chicago that, as Mick Fleetwood recalls, there was "an intervention". Stevie often insists she "decided to go to Betty Ford… Nobody came and threw me in a van and took me, it was my decision," but Stevie's management Frontline felt urgently that she should clean up, while Fleetwood, who played percussion on the tour, had watched Stevie "running herself into the ground, drinking, doing

a lot of cocaine..." and was seriously concerned she would hurt herself badly. Stevie's father Jess Nicks concurs, remembering that it was "after repeated attempts to help her" that they finally flew out to convince his daughter in person to go to rehab.

"She resisted when we confronted her with it," Jess Nicks told Cox News Service's Linda Romine. "She was concerned it would be publicised and be detrimental to her career. We spent most of the night with her and convinced her it was for her help... It's tough, [but] Christ, the career means nothing to the parents when it comes to the health of your children." Stevie herself remembers Jess asking her, "How could you possibly even consider putting me through not having you for the rest of my life?" When you put it like that...

Stevie agreed to check in to the Betty Ford Clinic in Palm Springs after her tour, apparently using cocaine for the last time in August at the magnificent Red Rocks Amphitheater, Colorado. This show symbolically ended with the release of 25 white doves, one of which refused to leave Stevie's hand. The crowd went insane as Stevie giggled in disbelief at what could only be an omen, and she gently placed the bird in Mick Fleetwood's hat, later to be kept by Stevie as a pet (the dove, not the hat).

Stevie is especially fond of her Red Rocks concert; it was a vast venue and a powerful show and, should anyone be unfamiliar with Stevie Nicks, the lady herself has recommended that the concert film *Live At Red Rocks* is the perfect place to start. It has to be said, however, that this film, and in particular Stevie's encore of 'Edge Of Seventeen' on *Live At Red Rocks*, displays the singer at her most extreme, her performance frenzied to the point of being alarming.

Nicks has always reflected on her addiction with courage and honesty, and is philosophical about how bad it became, even stating that she "wouldn't change it", if offered the chance to go back and do things differently. "I think it all happened for a reason," she said. "But I got through it, I was so lucky. I would never lecture anybody, because I don't think that's the way to get to people... The ones who did make it pretty much cherish the fact we are alive, but it is difficult to accept this whole life in a different way, because for

so long it was lived under that dream-cloud, dream-child world of different kinds of drugs."

Stevie used the name 'Sara Anderson' when she checked into the clinic that October; 'Sara' being, as we know, a special name for Stevie in so many ways, and 'Anderson' being Robin's surname – and her own married surname, of course. It's not difficult to see why Nicks chose the name 'Sara'. Like 'Rhiannon', the name itself had a presence and a meaning to her that had manifested into an unseen guiding force, and Stevie needed all of the psychic protection she could muster to see her through the doors of the centre and through a tough but ultimately successful 28-day programme of rehabilitation.

There were 6am wake-up calls, daily chores, and Stevie shared her room with an elderly female alcoholic. Also undergoing treatment alongside her would be the country singer Tammy Wynette, and "one of James Taylor's backing singers". Stevie herself was, she admits, a "chain-smoking, coffee-swilling mess" when she arrived there, and she also over-ate to compensate for what she was missing. Hours would be spent in therapy, scraping away at the layers of hurt that had built up, getting to the heart of why the problem had even started in the first place.

"You don't have treatment as such," Stevie explained, "but meetings with your counsellor and with everyone together. You cry and you tell all your secret stories. In three days you are out of pain and crying for a purpose. You are hopeful, but never really happy." The life of a rock star often doesn't allow much space for really paying much mind to others – one becomes so used to being the centre of attention, the draw, that many stars don't feel the need to listen to other people. This was another reason being in rehab really was enlightening for someone like Stevie. In group therapy, she had to listen, and found the stories of her new comrades, many of whom were even richer than herself, very moving. These were people who'd had it all and betrayed it by going too far and throwing it all away for the sake of their addiction. Their confessions touched her, and, crucially, motivated her to be more careful. "When you have to sit down and write on a piece of paper, 'I am not special, I am dying', that's a real serious thing to swallow," she said.

It would be during this period that Stevie really learned why she took coke – it was to give her the energy to do more than any human being could, or should, handle. More than was necessary, in many cases. She was an over-achiever, and it was killing her. The irony was that, because she had split her focus and was doing too much, the extra work Stevie was managing to complete was sometimes of dubious quality. "The important things I had to do got done anyway," she said. "And all that extra time allowed me to do a bunch of stuff not that well. You know, you get crazy and say, 'Well, I'm gonna write three songs tonight. I'm gonna sit at my typewriter and I'm gonna write ten pages of my future book…' You don't have to do that. What I learned at Betty Ford is that it isn't necessary to go non-stop, seven days a week."

One assignment she had to accomplish at the clinic was to write an essay on the difference between being a rock star and a human being. This she found especially difficult, tellingly; she had allowed her rock star life to define her. This *was* reality to her.

Stevie's time at Betty Ford was an often tortuous month of necessary soul-searching – something Stevie was already quite adept at, one might presume, though this time she was coming through the other side, with the help of professionals, rather than indulging herself. Naturally, this experience would give rise to a surge of fresh creative inspiration. 'Welcome To The Room… Sara', a song that would appear on *Tango*, is like a journal-entry from this time, the title a direct quote from the therapists who greeted 'Sara' as she walked into her first session. 'This is a dream, right?' she asks in the lyrics, still incredulous that she is there at all.

The line 'You can take all the credit…' is apparently a sarcastic swipe at Frontline Management, who had insisted on her attending rehab. 'Frontline baby…' she wrote. 'Well, you held her prisoner…' The issues Stevie worked through in the safety and privacy of the clinic would soon appear on the page, and ultimately the record. And, lest we forget, one of those issues would be Joe Walsh's chilly treatment of her… 'In the never forgotten words of another one of your friends, baby / When you hang up that phone / Well, you cease to exist…'

As always, Stevie's lyrics are a patchwork quilt of vignettes, thoughts jotted down, little moments surfacing from memory as if murmured

during a troubled sleep. By the end of the month, Stevie would be awake, more awake than she'd been for a very long time, if only for a moment. Something far more damaging than cocaine was about to crash into her life that would lead her by the hand into a sleep-walking half-life for eight long years.

Chapter 23

Stevie musings and some Nicks-piration:

Children often predict their future. Not only did Stevie write a song called 'Rose Garden' as a teenager, describing an imagined golden future that would soon become real for her, the concept for the 'Rhiannon' costume was born long before you might think. "In fourth grade, I wore a black top hat, a black vest and skirt, a white blouse, black tights and black tap shoes with little heels. I did a tap dance to Buddy Holly's 'Everyday' with my friend Colleen. I had a definite knowledge of how I wanted to look even then." Might that tap dance ever be showcased on stage with Fleetwood Mac? One can only hope.

Ms Nicks had a major reality check when she went solo, and she didn't mind admitting it. "Fleetwood Mac took care of me, they took care of everything. I was a spoiled rotten princess. Now I feel like a hard-working princess, because I am called upon now to do a lot more." Important note: we are most certainly still a princess.

"When I stop singing I'm gonna have a garage sale like you're not gonna believe. We're talking chiffon, chiffon, and more chiffon." I think we all know that's not going to happen.

For Stevie, ditching cocaine was liberating. Once a gleaming white emblem of Stevie's freewheeling rock'n'roll lifestyle, the

drug had long had Stevie in its grip, locking her into an expensive routine that now resembled an obsessive compulsive disorder. "It [became] like, 'I can't get out of bed without doing some coke. I can't go shopping without doing some coke. I can't go to a movie without doing some coke...'" It was a relief to be unshackled from this faceless dictator. Stevie generally hated being told what to do, so it struck a nerve when a close friend noted that cocaine was in fact telling her what to do every few minutes – go to the bathroom for another hit.

Stevie wasn't supposed to talk about the Betty Ford Clinic, but she acknowledged it was an "amazing place" that had made it easy for her to turn her life around. She felt excited about the future rather than over extended and frazzled. No longer did she hanker for the fragile, mythical image of seventies Stevie, the one that was close to fading out altogether. Stevie had lost too many heroes, although there had always been a conflict about how she felt about this. "A part of me said 'I want to go down with them also.'

"[But] another part of me said, 'Isn't it too bad that Jimi Hendrix isn't still here? What would he be doing now? Isn't it sad that Janis Joplin is not still here?' I wish Oscar Wilde had lived another 20 years, but he was a notorious drug addict. There would be no more work from Oscar Wilde, no more work from Jimi Hendrix, Janis Joplin... That's what made me say, 'I don't want to be one of the ones that people are sad about because they're no longer with us.'"

It was a monumental effort, finally chiselling the monkey from her back, but what was to follow would render this fresh start obsolete. Concerned friends and management still didn't believe Stevie was out of the woods, and were especially worried about how much she drank. Stevie felt better than ever after leaving Betty Ford but "the powers that be were terrified I was going to start doing [cocaine] again. And everybody thought I should go to AA," she told *The Telegraph*'s Mike Brown, even though, she insists, she was not an alcoholic. "In order to get out of that, the next best thing in everybody else's eyes was for me to go see a shrink. I really didn't want to go. But I finally said, 'all right, to get all of you off my back...'"

The doctor Stevie visited did not inspire confidence; he exhibited 'groupie-like' tendencies and was eager to have Stevie in his office so he could hear some pop-star gossip and be cool by association, which Stevie saw through immediately. More seriously, he wrote out a prescription for the tranquilliser Klonopin, also known as Clonazepam, to ease any anxiety Stevie might be suffering from. "I didn't want to do it," Stevie says. "He said, 'You're nervous.' And I was nervous; I'm a nervous person. So I finally just said, 'all right.'" And so, Stevie, who was not actually depressed, was put on strong anti-depressants for the next eight years of her life... and one of the long-term side-effects of taking this drug would be, ironically, depression. Agreeing to this would be one of the worst decisions Stevie Nicks had ever made – far worse than taking cocaine – but the effects would take time to show.

Post-rehab, Stevie went straight into recording with Fleetwood Mac. It was about time, as far as the rest of the band were concerned. Over the past year, while the Mac had been working on *Tango In The Night*, they had been sending tapes of what they'd recorded to her home in Phoenix, and Stevie, in turn, had been sending them demos to develop in her absence. However, even when she did have breaks in the *Rock A Little* tour, Stevie was nervous about turning up. She was, as Mick Fleetwood remembers, "dreading that Lindsey, in his producing capacity, would be sarcastic toward her, but he made an effort not to be as much of a martinet as he was with the rest of us." At first.

"It is wonderful that this experience of Fleetwood Mac has turned into such a wonderful thing," Stevie gushed at the time. "Something changed, because everyone is going out of their way to be sensitive to everybody else. Nobody yells at me for leaving town for over a month, and of course, being as hyper-over-sensitive as I am, I was ready for them to yell at me, and they didn't." Stevie would relay a rather different version of how things played out in the studio in later years, however.

Moments of good behaviour aside, there was undeniable friction, a friction that had been present even when the band first decided to get back together to record two years earlier. The members of the Mac had turned up to visit Stevie at a charity concert she was performing at

alongside Don Henley in September 1985 at the Universal Amphitheater in LA. The benefit was for Mulholland Tomorrow, an environmental group protesting against proposed housing developments in the Santa Monica Mountains. Backstage, the Macs circled each other awkwardly – it was the first time they had all been in the same space together since the end of the *Mirage* tour. As one observer noted, "The tension was so thick you could choke on it." It was hardly better in the studio.

Stevie put her hands up: "It was me that was causing [the problems], because Lindsey was the head guy and I was making him erratic. When I was not there, they all got on fine. But when I walked in it was like, 'Thanks for stopping by. We heard you were busy with your solo tour. Thanks for bailing on us.' That's the first thing I got. I don't have time for that abuse. I felt like, 'If you don't get off my back, I'm going to injure you badly.'" Happy days.

Lindsey Buckingham revealed his frustrations to writer Rob Trucks: "By the time we got to *Tango In The Night*, everyone was just a mess. I was probably the least, maybe Christine and myself, but you know, victims of the excesses that fame has to offer, victims of buying into all of our own press, shall we say... but mainly victims of choices we made in terms of lifestyle. Stevie in particular was not very focused. She was out there doing solo work. She wasn't there."

Be that as it may, Stevie would still feel stung when Christine, normally her greatest ally, coolly said in an interview that Stevie "phones her part in. She asks what songs we plan on doing and what songs we want her to do. The rest is decided between Mick, Lindsey and me." Stevie then noticed a quote from Lindsey Buckingham enthusing about the rapport he had with Christine, a connection which had existed "before we had even met", no less. Lindsey knew how insecure Stevie was on this subject; Stevie had felt put out when she saw Lindsey and Christine intimately working together on songs in the studio during the *Tusk* era. Lindsey was expert at pushing Stevie's buttons.

One reason, surely, for Stevie's reluctance to spend time in the studio was that she associated recording studios with hoovering up truckloads of cocaine. Now she was clean, this would be the first time in nearly a decade that Stevie Nicks would go into the studio with Fleetwood Mac

and not indulge. It can't have been easy, especially being the one with the least to do.

When Stevie did turn up, there were often huffs and atmospheres. Sometimes her input was not required, sometimes it was, but she often felt rejected, as if she were a child being waved away after trying to bother the busy grown-ups. "There've been many times when Stevie might come out in the studio and try and sing along, and we'd tend to say, 'Don't do that right now, let us work this out first.'" said Christine. "Now she'll just go, 'There's no need for me to be here.' She does feel left out."

Stevie admitted it was "lonely on the other side of the mirror", or at least on the other side of the glass in the studio. "Five hours go by and they don't even remember I'm there," she grumbled. But whatever irked her could, as always, be channelled into her own material somehow, and this detachment would be a theme on Stevie's *Alice In Wonderland*-esque record *The Other Side Of The Mirror,* her next solo album. While she sat moodily watching the others work, Stevie was determined to make her next release better than anything she'd done before.

During these moments of isolation, sometimes Stevie would close her eyes and think of Robin, the kindred spirit who had been by her side so often in the studio. Stevie still felt her presence and believed herself to be guided by her, particularly when it came to vocal takes. "She'll go, 'That's a really good song,' or 'That vocal was perfect!' She was a speech therapist so sometimes I feel her like the teacher up there shaking her finger at me saying, 'You need a few more hours sleep every night...'"

Ultimately *Tango* would be a creative tour de force despite the inherent ill feeling – the album included strong material such as Lindsey's phenomenal 'Big Love' and Christine McVie's 'Everywhere' and 'Little Lies', her best work in years. The entire album would be a far greater success than *Mirage* and a personal triumph for Lindsey, who had worked hard on the production in his home studio with Richard Dashut. Stevie brought the hypnotic 'Welcome To The Room... Sara' to the table, as well as 'When I See You Again' and the radiant 'Seven Wonders', another co-write with her *Wild Heart* collaborator, synth-queen Sandy Stewart.

'Seven Wonders' was born of one of Sandy's demos, played to Stevie at her home in Phoenix. When Stevie heard the song, she wanted it instantly, and had to ask whether Sandy intended to use it for herself. "She said, 'When I wrote it I thought about you...'" remembers Stevie in an interview with Timothy White for *Rock Lives*. "So I said, 'Well, what do you think about Fleetwood Mac?' She said, as any wise songwriter would say, 'Absolutely. Go ahead.'"

Sandy also contributed lyrics to the song, although they wouldn't be used. Stevie explains, "The only reason for that was because we thought we'd written down exactly as I sing them, the exact words to 'Seven Wonders'. The spontaneity of that early take made it truly special.

"Sandy unfortunately didn't get me the real words before that, so I sang those words... and then I saw the real words and I tried to sing the real words, which are in fact very different. I couldn't do a vocal again like that first time I walked up to the mic and sang 'Seven Wonders'. There is something in that vocal that is real special, and it's because I hadn't really thought about the song much. It was my first time singing 'Seven Wonders', so when you hear it, you know that it was really the first time I was hearing it too."

After hearing Stewart sing the song first, Stevie misunderstood some of the words, hence the line 'All the way down to Emmeline', which has mystified fans for years. The original line was 'All the way down you held the line', but the use of a name like 'Emmeline' is typical for Stevie, so accustomed are we to hearing her throw in women's names – 'Sara', 'Lily' – and thus we look for the clues she scatters in her songs. In this case, it seems to have simply been a phonetic red herring, but it does also sound as if Stevie is murmuring the name 'Sara' during the breaks between the chorus and verses. Another belief is that Stevie is singing 'Aaron', which would also make sense: it is a family name close to her heart, as we know. Sandy Stewart's working title for the song is rumoured to have been 'Aaron' too, which may have had a hand in catching Stevie's attention.

Stevie preferred to record her vocals alone and away from the band, increasing the gulf between them. For all of *Tango*'s luminous charms, Stevie felt it didn't sound like Fleetwood Mac, not least because she

"couldn't really be heard" on the record, and just three of her songs were included, while the other writers were all over it. Songs such as 'Everywhere' lacked Stevie's trademark harmonies; Christine argued that she had *wanted* her to sing on them, but the bald fact was that she had barely been there. The matter was resolved with overdubs*, layering Stevie's vocals into the mix of the album. Her voice is not especially perceptible on 'Everywhere', although her mellifluous tones contrast perfectly against Lindsey's sharp tenor in the backing vocals for 'Little Lies', sweet and sour. But the damage was done. Stevie Nicks felt "mistreated".

"We put as many things of hers on there as we could," Lindsey insisted in an interview with writer Rob Trucks. "But if you say it took ten months to a year, I'm not exaggerating, we saw her all of two weeks. And so we had to try to cheat things, we had to try to create things out of thin air for her."

Stevie, naturally, didn't see it like that, and decided to wield her power and make a point. "It got so bad I said, 'I'm going to do a solo record,' much to Mick and Lindsey's horror. From that moment on, I got treated much worse. However, they couldn't be too awful to me, because they knew they couldn't go out on the road without me. I had platinum records and sold-out tours, why did I need to be treated like this?"

The singles were selected – 'Big Love' being the first release in March 1987 – and videos were shot, a process Stevie in particular couldn't bear, especially since being criticised for putting on a few pounds. But she appeared, swishing her ra-ra skirts and walking arm-in-arm with Christine in the video for 'Little Lies', snapping her fingers and gazing into camera, her glamorous, steam punk outfits and voluminous blow-dry incongruous with the bucolic farmland setting. Lindsey, meanwhile, wore a suit, and managed to pout and lip-synch simultaneously. This

* The press were desperate to know who was providing the female 'grunts' on 'Big Love', speculating that it was surely Stevie, or a new girlfriend of Lindsey's. Wrong on both counts – it was Lindsey providing all of his own sex noises, sampled through a variable-speed oscillator to change the pitch.

was no easy feat, especially when the words being mimed were 'tell me, tell me lies', words that require the lips to be pulled back rather than pushed forward. Still, this was the eighties, and pouting, quite frankly, came first.

The video for 'Everywhere', another Christine song that would become a number one hit, was very Stevie in essence: a silvery full moon, a Tudor romance, highwaymen riding through the night... but other than Christine herself, the video featured lavishly costumed actors instead of the band. The potent 'Big Love' promo, on the other hand, was radically modern in approach, a multi-faceted affair costing $250,000 (or twice that, according to Mick Fleetwood); it variously featured the whole band but was really all about Lindsey, thrusting back and forth as he played guitar and made bedroom eyes at the camera.

The promo for 'Seven Wonders', Stevie's sole single from *Tango*, would be a more traditional video in the sense that it focused on the band 'playing' onstage, as it were. We find ourselves on a rosy, theatrical set to find Fleetwood Mac performing in an empty theatre, surrounded by Grecian ruins. Stevie struts among her bandmates and clicks her fingers as she sings, equal parts gypsy queen, flamboyant conductor and circus ring-leader. There are moments of awkward humour here, as Lindsey goons and Mick grins. The director also plays on the 'Stevie / Lindsey romance' element, even though said romance had long since died after ingesting its own poison and was now starting to smell funny. The pair dutifully lock eyes and touch hands, but there is sarcasm in Lindsey's kohl-rimmed eyes, and nervousness in Stevie's.

Interestingly, there would be no image of the band on the album cover, just a lush homage to Rousseau by the Australian artist Brett-Livingstone Strong, a painting that was already on display in Buckingham's house. The lack of any Mac members at all on the front of the record perhaps points to the fact that there was little unity in the ranks, and the image chosen will certainly have been decided upon by Buckingham. But the resulting release in April 1987 would be deemed a return to form, and it would become the band's biggest seller since *Rumours*. *Tango* would spend more than ten months in the US top 40, selling a staggering three million copies and being certified triple

platinum, but it was an even bigger hit in the UK, hitting the top of the album charts three times during 1987 and 1988 (and the competition was strong – Michael Jackson's *Bad* was also jostling for pole position). In the UK, *Tango* would be certified 8x platinum. But it would also be the last studio album to feature the definitive Fleetwood Mac line-up. Lindsey Buckingham had had enough.

Plans were underway for the first Fleetwood Mac tour in five years to promote *Tango* (although the tour itself would be called *Shake The Cage*). There was just one person disinclined to get back out on the road. Lindsey. He hadn't missed touring, hated the pressures that went with it and, to his mind, he had been distracted from his own work enough. In fact, he went so far as to state this publicly in an interview with the rock magazine *Creem*, to the rest of the band's outrage. "It was like he was giving his notice in the press," said Mick Fleetwood.

An emergency band meeting was called, taking place at Stevie's house that July. The plan was to persuade Lindsey to support the album they – he especially – had worked so hard on. He could even honour the tour and then leave the band if that was his wish.

Everyone was dreading the meeting, and as they settled down in the paradoxically calm atmosphere of Stevie's living room, Lindsey protested he was too "fried", and didn't want to expend all of his energy on the road with the Mac when he had an album of his own to make. He'd given more than enough of himself to the band already. But Mick was determined – he needed to make money after all and a confrontation ensued. Lindsey dug his heels in. "[He] wasn't prepared to do me any favours," admitted Fleetwood. But Lindsey was feeling pressured and with good reason.

As the heat started to rise, Stevie defused the situation with a little coquettish teasing. "We can have a great time out there," she soothed. "Let's do it for old times' sake, just once more." She paused, her cheeks turning pink (surely she had only just stopped short of saying "For me?") and Lindsey smiled for the first time that evening. A breakthrough had seemingly occurred, and after Stevie assured him that things would be different this time and that "it won't be a nightmare", Lindsey agreed to mull it over.

Stevie's soft-soaping had apparently worked. The message came through to the rest of the band, via Warner Brothers boss Mo Ostin, that Lindsey would tour with Fleetwood Mac for 10 weeks. Immediately arrangements were put in place for rehearsal time, tour dates were booked and anticipation was building, although Christine McVie, who had joked that she would "break Lindsey's arms" if he refused to tour (rendering him somewhat useless if he did change his mind), couldn't quite relax, having "sensed" that this was still the last thing Lindsey wanted to do. And she was right. Suddenly Lindsey pulled out with little explanation beyond that he simply couldn't cope.

It wasn't difficult to see why. In an interview in later years, Lindsey had to admit that "everybody's level of craziness was at the max at that point... and if things are crazy in a studio, it's usually times five on the road. I hit the wall. It was a survival move, pure and simple. I never regretted it for a minute." Manager Dennis Dunstan called Stevie's house with the news, precluding it with the words one never wants to hear: "Are you sitting down?"

Publicly, Buckingham released the following statement: "In 1985, I was working on my third solo album when the band came to me and asked me to produce the next Fleetwood Mac project. At that point, I put aside my solo work, which was half finished, and committed myself for the next 17 months to produce *Tango In The Night*. It was always our understanding that upon completion of the album I would return to my solo work. Of course, I wish them all the success on the road."

The band was furious and demanded another meeting, this time at Christine's house on August 7, 1987. What would unfold was, as Mick described, "a real showdown", and he'd seen a few in his time. The gloves were off. There would be no blushes or cajoling, nudges and persuasion this time. Strangely, it would also only be at this point that, according to a Stevie Nicks interview in 1993, she really felt she and Lindsey had broken up for good, which Lindsey Buckingham found "interesting", especially considering how many "men she went through".

Lindsey protested, saying he'd "given 12 years of his life" to the band and couldn't "do it all anymore". The word 'all' was an inflammatory one. He was referring to the rest of the band as if they were mere

passengers while he was the nucleus, but this aside, Chris and Stevie's songs would generally receive more radioplay than Lindsey's. The situation was turning ugly and Stevie cracked, reminding Lindsey that "there are other people in the room besides yourself."

It wasn't as if Stevie hadn't considered leaving the Mac herself, indeed she had, many times, but she was always conscious that such a move meant potentially putting a lot of people out of work – not just the band but the crew and entourage. Lindsey just wanted to move on, but his former partner was shell-shocked, bursting into tears and hissing, "You've broken my fucking heart on this." She tried to bar his path but Lindsey, a coiled spring at the best of times, coldly pushed her aside, snarling "get this bitch out of my way, and fuck the lot of you." He was unwilling to listen to any more, but Stevie was not letting him go without a fight. Literally. The scene to follow would be a "physically ugly" one, according to John McVie.

"That was in the courtyard of my house," Christine McVie remembers. "There was a bit of a physical fight, and she wasn't beating him up. It wasn't nice."

Stevie ran outside as Lindsey marched towards his car, but as she grabbed onto him, he hit out, allegedly slapping her in the face and pushing her against the hood of his car, causing Dennis Dunstan and Stevie's manager Tony Dimitriades to have to restrain him as he screamed "get that woman out of my life, the schizophrenic bitch!" This was, hands down, the worst fight Stevie and Lindsey had ever had.

Lindsey has often said he "doesn't remember" quite what happened on that afternoon at Christine's house, which is fair enough – it doesn't sound like an especially memorable day, after all. However, he has conceded that "it was an unpleasant situation... But you have to ask yourself, if someone is beating on your chest because they don't want you to leave, isn't that kind of flattering?" Way to make lemonade out of that lemon, Mr Buckingham.

Lindsey later claimed that his intention initially was to eschew the tour, not leave the band; but he had now slapped, screamed and intimidated his way straight out of the group that had made him a star. Stevie admitted that, while part of her hoped he would change his mind

at first, she was ultimately happier now he had gone. Both of them now had a chance to heal, and the band played on, just as it always did in the face of adversity and line-up changes. It was interesting that, after so many years of wondering if or when Stevie would leave the group, Lindsey would be the first to go. However, as Buckingham said, "Later Stevie would say, 'You know, I should have left when you left.'"

Chapter 24

Stevie Nicks: "I don't think if you live a normal, suburbanite life that you could write songs. What would you write about? Tragedy, unfortunately, for all people in rock'n'roll, brings you up to your highest level of creativity."

Roger Scott, broadcaster: "Ordinary people get upset as well..." (Interview for Tyne Tees TV)

Within days of Lindsey's explosive departure, there was an unusual celestial alignment which took place on August 17 and 18, 1987. This alignment was known as the Harmonic Convergence, and, according to Mayan cosmology, the date marked the end of the 'cycles of hell', supposedly corresponding with a shift in the earth's energy – 'from warlike to peaceful'. Interesting timing indeed. Thousands gathered at sacred points across the world to meditate, such as Sedona in Arizona, just two hours from Stevie's birth-place and, significantly for Stevie herself, surrounded by ancient red rocks that seemed to glow in the sunlight. The rocks had formed from sandstone and limestone left by a receding sea aeons ago. Iron oxide subsequently covered the sandstone forming a rust and creating the glorious 'red rocks' that people flocked to be near during the convergence.

Stevie herself took the cosmic relevance of these two days seriously, inviting the band to her opulent home in Paradise Valley, Arizona,

and ceremoniously making a wish. She meditated on her desire that Fleetwood Mac "would be able to come back and go out in the fashion that we came in," she said. "We would not go out a dying band or slip gracefully away if we decided to quit."

The possibility of the band calling it a day was, according to Stevie, not out of the question. But, in the meantime, dates had been booked and the show had to go on. Fleetwood Mac and their management pondered over the possibilities for Lindsey's replacement, and the music industry speculated over who might get that plum gig, with names such as Waddy Wachtel, Don Henley and Peter Frampton being thrown around. Ultimately it would take two guitarists to replace Lindsey, the knowledge of which no doubt will have brought Buckingham some pleasure. The two musicians to be hastily brought into the fold would be LA session star Rick Vito and the Mac's old pal Billy Burnette.

The decision would be made quickly and the 'audition' brought back memories of how Stevie and Lindsey first joined the band. "We went to dinner," remembers Stevie. "I walked into the restaurant and Billy Burnette was sitting there, and Rick Vito was sitting there and Mick Fleetwood and his manager Dennis Dunstan. I sat down and they introduced me to Rick – I'd known Billy for a long time – [and] everybody just started to smile..."

The following day Rick and Billy joined the band for a rehearsal in a small space in Venice, LA. After playing through a handful of songs, Mick was heard to shout, "Yeah, you're in!" The eleventh line-up of the band was sealed. This entire debacle had sent shockwaves through the music press, and while people were still dealing with the fact that Lindsey had left, the concept that the band would be carrying on was even harder to compute for some. But Fleetwood Mac was defiant in the face of what had happened, and the questions being levelled at them. Stevie haughtily stated that there was no reason for everyone else to quit just because Lindsey had. And as for the new line-up, the proof would be in the performances. If rehearsals were anything to go by, Stevie was convinced they were going to be just fine.

"I knew instantly that as soon as we stepped onto the big stage this was going to be wonderful," she said. "It sounds like Fleetwood Mac. If you

walk outside and listen from the parking lot, the first thing you would say would not be 'Ah, I don't hear Lindsey...'" And this was crucial, especially to Stevie. Mick, John and Christine were used to musicians coming and going, but for Stevie, her entire experience of Fleetwood Mac was interwoven with Lindsey's. Mick remembers her feeling privately unsure as to whether the tour would work, whether there could even be a Mac without Lindsey, but soon she was convinced, not least because Rick and Billy were significantly 'more compassionate' to her than her former beau ever had been.

To be fair, they were the new boys and they were keen to fit into the megastar rock band they now found themselves in, but Stevie was thrilled that, in direct contrast to the past, Vito and Burnette were "very interested in what I do, they're interested in my songs, they come up to my house and work with me... That's something Lindsey and I never did because he never wanted to be that close to me anymore," she said in an interview with the BBC. "We would always get back on the subject of why we broke up 12 years ago. After 12 years it's hard for me to remember why we broke up, or for that matter why we even went together." When inevitably asked by journalists about Lindsey around this time, Stevie simply stated that she "gave [him] up. He's a thing of my past. I hope he finds what he's searching for, and I hope he's happy, and I wish him well. And there's nothing left to say." Wishful thinking, perhaps. As Stevie fans know, their heroine has never stopped talking, or indeed writing, about Lindsey.

The first four-month leg of the tour was scheduled to commence on September 30, 1987 at the Kemper Arena, Kansas City, and the band chartered a 727 to whisk them there in the decadent style with which they had become accustomed. Burnette and Vito fitted in well, and, as Stevie insisted at a press conference, "They are not just fill-in guys. They are in the group," before adding pointedly, "And everybody is playing as one unit now. Neither Billy nor Rick are freaking out on stage trying to get all their licks in."

Stevie put her all into the Shake The Cage dates, even asking for rehearsals during the tour to work on harmonies for 'Little Lies', and, while her costumes had a little of the 'wedding cake' about them,

according to one reviewer, she looked beautiful, swirling her talismanic shawls as the audience expected. Most importantly, Stevie's voice was generally on good form, even though her throat still caused her problems, to the extent that 'Rhiannon' often had to be left off the set list. 'Big Love' and 'Tango In The Night', the title track to the very album the band were on tour promoting, would also unfortunately have to be jettisoned, being Lindsey's songs.

Fans had little idea quite how heroic Stevie's performances were – not only were they seeing her sing coke-free for the first time in years, she was suffering from a chronic fatigue syndrome called Epstein-Barr. This, combined with her use of Klonopin, was causing increasing problems, which is all the more lamentable as Stevie was finally starting to really enjoy being in Fleetwood Mac without Lindsey breathing down her neck. In fact, everyone was more relaxed, John McVie had recovered from his drinking problem and, for Stevie, Fleetwood Mac had now become "a pleasure thing. It makes everything else all right."

Nicks was diagnosed with Epstein-Barr shortly after having breast implants removed; many hadn't realised she'd had cosmetic surgery in December 1976, but, a year into her tenure with Fleetwood Mac, the sudden attention was making her more conscious than ever of her looks. Stevie believed her body to be out of proportion – "I thought my hips were too big and I had no chest..." – and in a bid to look better on stage, she went under the knife. "I'd advise against having [implants]," she said later. "You will have to take them out and that leaves you scarred.

"I was in and out of hospital, at the doctor's three times a week, taking acupuncture, having IVs to clean the toxic silicone out of my body, it was awful. Once you have [Epstein-Barr], you have it always. I don't have the symptoms right now. If you get all depressed and worn out, it comes back. It has a lot to do with your state of mind."

The illness was making Stevie crave rest, and she was sleeping as much as she possibly could, much to the bemusement of many of the people around her. The protective and avuncular Mick – still the band's 'Daddy', as Christine called him – spotted what was happening and promptly cancelled their final shows and the Australian dates scheduled the following March, allowing Stevie to go home and rest until the

European leg of the tour drew *Shake The Cage* to a close with a magnificent finale at Wembley Arena in June 1988.

Other than emerging to appear with Fleetwood's Zoo on New Year's Eve in Aspen (where they rang in 1988 with Eddie Van Halen, of all people), Stevie obeyed doctors' orders and hibernated, warmed by the blazing fires in her hearths, the candlelight that surrounded her and the devoted friends who rallied round. But while Stevie recuperated, she also had time to contemplate her next move as a solo artist, a move that would get underway once the European tour had been completed. Fleetwood Mac had agreed to have a break once *Shake The Cage* had rumbled to a close, providing the perfect opportunity for Stevie to take her time with her new album *The Other Side Of The Mirror*.

Stevie's manager Tony Dimitriades already had a producer in mind: the English songwriter and producer Rupert Hine. He was a gentle, instinctive soul with humour and vision, just like Stevie, and his success rate was impressive; he'd already written and produced for Kevin Ayers, Tina Turner, The Thompson Twins, The Waterboys, Howard Jones, Chris De Burgh and many other hugely popular artists of the day and Tony had a feeling Hine could be the one to take Stevie forward. After speaking to Nicks herself, Dimitriades contacted Hine and arranged an introductory lunch for the pair, so they could get a sense of whether a potential collaboration would work. Tony warned Rupert that Stevie did have a bit of a habit of falling in love with her producers. Hine, bemused, thought to himself, "Well, I'm not sure that's going to happen."

★ ★ ★

After settling in at Le Dome on Sunset Boulevard, Stevie and Rupert started talking in earnest, Stevie's warmth and charm putting Rupert immediately at ease. "I remember liking her very much simply because when she spoke, it was only about the things that matter," Rupert remembers. "It wasn't about the things I'd done."

Dimitriades and Stevie's colleagues at Atlantic Records had engineered the meeting with the knowledge that Hine had "written big commercial

hits", he said, "Although I don't think like that. Having commercial success is always second only to doing the best thing you can do in terms of writing a song that is completely communicative and successful unto itself. If you get that right, you have automatically increased the chances of success tenfold." It was clear Rupert and Stevie were on the same wavelength already, but what he was about to say next would be the clincher.

With regard to the production of the record, Rupert asked where Stevie would like to record. She had already mentioned several studios she had liked, but before she could repeat herself, Hine clarified the question. "I said, 'No, where would you like to record on Planet Earth?' She looked at me, almost incredulous," said Hine. "I said, 'Leave studios out of it. Where can you imagine recording?' Knowing Stevie a little, I thought it might be somewhere in Wales, the 'Rhiannon' factor, or perhaps somewhere exotic. She said, 'Can we do it at my house?' I said, 'I don't even have to see your house to say 'yes'.'" Rupert was known for doing whatever it took to get the results that were required, and there would be no boundaries. Anything could happen.

As far as Stevie was concerned, he was hired "before we even started talking about music. The night I met Rupert Hine was a dangerous one. He was different from anyone else I had ever known... He was older, and he was smarter, and we both knew it. It seemed that we had made a spiritual agreement to do a magic album." Evidently Tony's warning was already proving correct: Stevie was already attracted to Rupert and they hadn't even looked at the menu yet.

Soon after their auspicious first meeting, Tony contacted Rupert to confirm it was all systems go, as far as Stevie was concerned, and sessions for her fourth solo album were duly arranged at her California home. 'Home' was a large mock Dutch castle way up in the Hollywood Hills, a building that radiated a sense of dark fantasy and spooky glamour. The rent was an equally glamorous $25,000 per month. For Stevie, it was the ideal setting, and the sense that anything was possible with this new, innovative producer, thrilled her. She really was on the other side of the mirror here – now she even had a moat between herself and the so-called 'real world'.

The Dutch castle, now used largely for movie and video shoots*, was pure Hollywood let's-pretend: despite the suits of armour and antique paintings, it was built in 1974. Still, between the fusty faux medieval decor and Stevie's wild imagination, it might as well have dated back to the Dark Ages. Rupert, having been given the grand tour by the palace queen herself, was especially taken by the ballroom, and suggested making the record in there. (Stevie remembers it as the "formal dining room"; either way it was a great big room.) Ms Nicks agreed, of course, and the console was set up right underneath a spectacular chandelier, which hung from the middle of the ceiling.

"It was great until one day something went wrong with the plumbing in the bathroom above," says Hine. "All of this water was dripping, equally majestically, down the chandelier and onto the console. I would love to have had a film of that. It was so surreal." Fortunately there was no lasting damage as members of Stevie's entourage leaped in to cover the console with plastic. It was simply "funny", Rupert remembers. "One of the many surreal things that happened during those 18 months." To add to the oddness of the sessions, Stevie often glanced up at the walls to see "all these old, expensive pieces of art looking at us... we were never alone."

As they settled into working together, Stevie realised instantly that she had made the right decision in hiring Rupert Hine. Early on, Stevie had expressed how she wanted her songs to communicate as directly as possible, to resemble her demos, in a way. She had been told too many times by friends that they preferred the demo versions of her songs to those that took half a million dollars to produce, so this time Stevie decided to do things a little differently.

"It's important that what I'm saying comes through," Stevie explained in an interview for *Tyne Tees*. "In this record, [Rupert] did what I

* It is now rather unfortunately known as 'the house that porn built', being as it is a popular location for adult movie shoots, with its grottos, waterfalls and ostentatious bedrooms. However, on a more savoury note, Stevie would shoot her video to 'Rooms On Fire' here, and the house – and Johnny Depp – would feature in Tom Petty's promo for 'Into The Great Wide Open'.

asked, he let me put my demo feeling through. In other words, if I was to sit down and play the piano not very well and sing one of my songs not that well, it might [just] hit you because you understand what I'm trying to say. As soon as they put harps and violins and incredible guitar on it, you lose that." Stevie's songs were extensions of herself, precious and personal – it was that quality that people connected with; the fewer bells and whistles, the better.

That's not to say this album would be under-produced – this was the eighties, let's not forget – but there was a freshness to it, and little standing between the listener and the song. That directness was what Stevie wanted, and, judging by the response of so many of her fans, that's exactly what was achieved. Rather than hunt down another writer to provide 'hits', as was Jimmy Iovine's obsession, making Stevie feel a little put out in the process, Rupert was more of an 'enabler', helping Stevie complete some of the many songs already in her canon.

This album would take considerable time to complete – it would finally hit the shelves in May 1989 – but one theory for this would be that Stevie simply wanted to take her time with it, although on a darker note, her worsening reaction to her daily dose of Klonopin can't not have slowed her down. She was effectively sedating herself while still trying to work and be creative. Nevertheless, she was enjoying working in a new way in the comfort of her own space, and as Rupert sat up late with Stevie as she wrote down her thoughts or tinkered on the piano before finally going to bed, it would soon transpire that the pair of them could write together very naturally. Rupert was fascinated by how Stevie developed songs and never wanted to get in the way of it by insisting her tracks be morphed into something with more obvious commercial potential.

"Stevie's audience wants the most authentic Stevie they can get," Rupert explains. "And that doesn't mean someone coming in and saying, 'I've got an idea for a much more dazzling chorus...' That would be horrible for her, and I'm not the kind of person that would do that. So writing together unfolded when we were together. I would play the piano and she would start singing from a [note] pad. Very organic." Co-writes with Rupert would include 'Alice', 'Fire Burning' and 'Two

Kinds Of Love', a song that would develop into a duet with the singer Bruce Hornsby, whose haunting hit song 'The Way It Is' in 1986 had caught Stevie's attention.

Stevie would also work with songs sent over from Heartbreaker Mike Campbell, who wrote with Tom Petty and, occasionally, would have a song that wouldn't be quite right for Tom – in the case of this album, 'Whole Lotta Trouble' and 'Fire Burning'. "He'll send them over to Stevie," says Rupert, "and with the ones she likes, she reaches for her pad and just starts singing this beautiful writing, never thinking ahead, like, 'maybe these two lines will suit the chorus', she just keeps going from the top of the page until the tape runs out. This, I've seen other people be completely confused by. I love it because it's what I call 'fishing'. At any moment, the music and words [can] combine to be greater than the sum of their parts. Something rings a bell inside you and you go, 'Oh, I like that.' I think she appreciated having someone sitting by her side going, 'I get it.'" This compassionate understanding was like a balm to Stevie's spirit.

Having a British producer must also have resonated nicely with her fascination with the UK and, of course, the album's very English inspiration, *Alice In Wonderland*. But Lewis Carroll's character was not the only Alice entwined with this record; *The Other Side Of The Mirror* would be dedicated to Stevie's characterful grandmother Alice, or 'Crazy Alice', as Stevie liked to call her. Alice sadly died before the album would be released; on the 'other side of the mirror' for real, as Stevie observed.

Working intimately with Rupert and having moved everyone into her home* would create a strange but inviting greenhouse atmosphere;

* Stevie's favourite photographer Herbert Worthington III, always on hand to capture a pose when his employer was in the mood, was on the payroll and also living in the Coach House at Stevie's expense. Stevie liked to keep a tight quasi-family around her at all times, a circle that included real family: brother Chris Nicks was in charge of Stevie's merchandising. One can't help but feel that part of Stevie's escapism from 'reality' involved creating a world that only contained a select number of co-habitants, kept close – and on a retainer – at all times.

there was plenty of room to roam, but it was a matter of time, and not much time, before Stevie and Rupert's relationship moved beyond the professional. Stevie was already captivated with Rupert and, as he puts it, "she was very quick to make a declaration of how she felt."

"It always seemed to me that whenever Rupert walked into one of these old, dark castle rooms, that the rooms were on fire," Stevie reminisced dreamily in her sleeve notes for *Timespace,* and her feelings would not go unrequited.

Rupert: "Stevie's so open it's almost impossible not to fall for her. She's never provocative, just completely herself. You fall for that honesty. That magical quality, which is the phrase everybody uses, is simply because she is true to who she is. If she cared about how she came across, visually or ideologically, she wouldn't have it. It's all real." The connection between them was sensed by those around them, and, as Stevie remembers, everyone "respected [our] space".

It was only when Stevie had presented 'Rooms On Fire' to Rupert, and he was focusing on the arrangement of the track, that she casually revealed the inspiration behind it. "She said, 'You know this is about you, right?' I could only think of the words to 'You're So Vain': 'you probably think this song is about you...' I thought, 'Wow, it's kind of the reverse of that.' It made it quite difficult to finish. I haven't thought about that for a while..."

The sparkling 'Rooms On Fire', which would significantly be the first single from the album and Stevie's first ever UK Top 20 hit, would be a co-write with her childhood friend Rick Nowells, and detailed the potent attraction she felt for Rupert with a raw honesty; the lyric "she laughed, and she cried and she tried to taunt him..." denoting a certain amount of seductive teasing to draw him in, not that she will have needed to try very hard.

The song unveils a heartfelt, slightly child-like fantasy: that of a superstar who has made the choice not to get married or have children until one night everything changes. Stevie attends a party, one of those 'everlasting, horrifying' celebrity shindigs that Nicks, certainly since kicking cocaine, now tried to honour with only a brief appearance. She tells the story:

"A man comes into the room. I don't see very well so I have a sixth sense, [so] even though I can't see him very well I feel something. I close my eyes for a second and he walks over to me. I look up and he's there.

"He asks me to dance," Stevie continues, "and we end up getting married and I end up having a little baby girl and we live together for 20, 25 years. The sad thing is that I waited for him all my life and then he dies before me. I wait for him for the rest of my life and he comes back after I am very, very old and gets me. And takes me with him back to wherever he comes from."

In the wildly kitsch video for 'Rooms On Fire', filmed at the castle, a serious Stevie floats slowly down the red staircase in a long scarlet gown to attend what appears to be her own ball; she is the Red Queen indeed, albeit with a touch of Cinderella mingled with more troubling shades of Norma Desmond. One can imagine this is the sort of thing Stevie does regularly anyway, descending the staircase to greet her devoted entourage, dressed to the nines, wondering, like a pensive princess, what the day will bring.

She meets the man of her dreams, he takes her by the hand and they slow-dance by the pool. She is then seen dancing in a dazzling haze with the baby she had always hoped in her heart for (played by her god daughter), and there are cutaways of Stevie as we all imagine her to be: a mystical woman, chiffon flying in the wind as she stands on her balcony; a writer, working at the white grand piano, or poring over her diary with a fire in the hearth and a picture of herself nearby.

She cuts a contemplative figure in the video, sad-eyed as she sings, but despite her health problems Stevie Nicks still knew how to party, and it was time to celebrate her favourite time of the year: Hallowe'en. Stevie invited all of her friends to the castle and dressed up as Scarlett O'Hara from *Gone With The Wind*, having found the perfect red dress in her temperature-controlled costume chamber. Her 'belle of the ball' status was, naturally, assured. And did Rupert go as Rhett Butler? Not exactly. "I went as Biggles, the first world war flying pilot – pretty silly but good fun. Mick Fleetwood came as Jesus Christ on a donkey. A real donkey. They don't do things by halves."

Just days later, the rock band U2 rolled into town to premiere their *Rattle And Hum* film at the Chinese Theater on November 4, 1988. ("That was my only time in *People* magazine," said Rupert, who turned up on Stevie's arm.) There would be an after-party at the Paramount soundstage, but, in addition, Stevie wanted to throw her own celebration for the band at the 'castle' of which she was so proud, with an A-list Hollywood set. Rupert watched in amazement as the castle was swiftly decorated and further beautified for the event. Rupert had only been in a relationship with Stevie for a few weeks, and had no idea what to expect.

"There was all this buzzing around, and I said, 'What can I do?' And she said, 'You can just welcome the guests in your lovely English way.' So I thought, 'Well, that doesn't sound like very hard work.'"

Rupert stood, poised by the door, although he was convinced he would be wasting his time for at least another two hours. Stevie had told her invitees to come at 7pm but, in the UK at least, party-goers tend to roll up a little later. Not in Tinseltown, baby. Let's face it, it's a party at Stevie Nicks' castle. Why would anyone want to miss a minute of it?

"On the dot of 7pm, the bell rang," remembers Rupert. "I opened the front door and I saw what I thought was one of those Hollywood lookalike entertainers. 'Jack Nicholson' was in the doorway. So I said, 'Jack!' and he shook hands and said, 'Yeah, how are you?' He went off to get a drink and I was looking at him thinking, 'This is too weird.'

"Lori, Stevie's sister-in-law, said 'Wow, Jack was on time, wasn't he?' It was really Jack. 7pm, first to arrive at a party for U2 at Stevie Nicks' house – I didn't think for a minute anyone outside of the music world would be turning up. I'd just let Jack Nicholson in... holy shit, this is a whole different level to what I'm used to. And there was a whole succession, John McEnroe came in with Tatum O'Neal, Cher... I'd just spent ten years making records in Buckinghamshire and now I'm in Hollywood with these ludicrously heavyweight A-list people turning up at Stevie's party."

Rupert's favourite memories of working with Stevie aren't those of glittering soirees, red-carpet events or even working on an album in an enchanted castle with someone he just happened to have fallen in love

with. It was simply the way she talked to him, perfectly naturally, in song.

"We'd go out to dinner and she'd suddenly just start singing to me straight into my ear, things that she was either thinking or just little ideas. That was one of the strongest memories – hearing Stevie's voice away from the studio and away from the stage, only able to really tell me what she was thinking by singing."

PART IV

Never Break The Chain

Chapter 25

Elements required to recreate that 1989 Stevie look. Men who are not cross-dressers may wish to skip to the next bit.

Red ball gown — worn not only on the cover of The Other Side Of The Mirror but out and about at parties, premieres... You'll be needing a selection: one with gold embroidery, one with short, ruched sleeves, another with long trailing lace... Stock up.

Permed blonde hair — but get a stylist to do it. Stevie home-permed her hair with the popular brand 'Lilt' for years, but you are not Stevie Nicks and will probably get it wrong. Plus even La Stevie herself suffered dry-looking locks from time to time as a result of heavy processing. Conditioner is a must.

Blusher — forget the natural look, you want people to know it's there, so go for bright pink and don't hold back.

Flower fascinators — pin them in your giant 1980s hairdo and strike a pose, baby.

Elements required to recreate the 'Stevie's Dream Man' look of this era:

Foppish, floppy hair that will flap around excitingly as you tango with the object of your desire, or tumble appealingly over your eyes. Study the chap in the 'Rooms On Fire' video, or some pictures of nineties-era Hugh Grant.

If you have no hair, just pop on a toupee. Stevie is very short-sighted and probably won't notice.

A suit – you have to look sharp if you're going to court Ms Nicks. We're not going for an effortless look here, or 'I just fell out of bed and then roly-polyed straight into a hedge' chic. Stevie needs to see that you're going to put as much energy into looking good for her as she does. Just ensure the suit is fire-retardant. (All those candles.)

Expression – Practice your best man-of-mystery smile. No teeth, mind, just an enigmatic curl of the lips. Perhaps a raffish raise of the eyebrow. Looking good.

Dance skills – I'm afraid so, and, before you ask, the 'funky gibbon' won't cut it, nor will a half-baked attempt at 'The Hustle'. Go traditional and learn how to do the Viennese waltz if you want to sweep Stevie off her feet.

As ever, if one wishes to read Stevie Nicks' 'autobiography' – and I know that thousands do – in the meantime, one only need listen to her songs. All of them are based on her life, and there is no fiction, although there may be a touch of poetic licence here and there. But Nicks has often insisted she is not 'a storyteller': the tales she tells in her songs are based on truth. The material on *The Other Side Of The Mirror* is no different, taking us from innocence past and the thrill of fear surrounding life's turning points ('Ghosts'*) to a bitter recrimination of a lover ('Long Way To Go'), the still-flickering flame of a past love (in the unambiguously titled 'I Still Miss Someone (Blue Eyes)' – almost certainly about the estranged Lindsey Buckingham and his denim-blue peepers) and, of course, the electric charge between Stevie and Rupert in 'Rooms On Fire'.

* The arrangement of the chorus on 'Ghosts', a song Stevie described as a 'hymn', is reminiscent of Tom Petty's 'Free Fallin'', released four months after *The Other Side Of The Mirror* in October 1989. Stevie would later cover 'Free Fallin'' herself for the soundtrack of *Party Of Five* in 1996.

Stevie also included a cover – 'Cry Wolf', originally released in 1987 by Laura Branigan – and, as we know, a duet with Bruce Hornsby: 'Two Kinds Of Love', a song Stevie wrote while on tour with Tom Petty and Bob Dylan the previous year, containing revealing lyrics that describe the subject of the song, her 'famous friend' as a 'great temptation'. So many handsome princes, so little time.

Stevie was keen to work with Hornsby but when it transpired that the two artists' schedules didn't quite click, there was only one thing for it. "We got on a Concorde to New York," says Rupert. "We recorded it and Concorded it straight back again. It's very typically Stevie. We had one night in New York but I think Stevie still brought about six suitcases..."

This was when Rupert picked up a nifty time-saving device from the seasoned traveller that was Nicks. "On her luggage she has a big 'X' on the side in gaffer tape," he said. "So whenever you arrive at any airport, because she'd always have about a dozen suitcases, she would just say to the porters, 'Anything with an X on it is mine,' so she or her assistants wouldn't have to stand around working out where the luggage was. You could see it from 50 feet away." Top superstar travelling tip there.

The session with Bruce was a little tense, but the result was stellar. It was hard to put a finger on the reason behind the strange mood in the studio; one theory is that it simply wasn't the kind of song Hornsby would write himself, so it took a little while to find its centre. But there is also a school of thought that Hornsby wasn't too pleased to be on the same track as the saxophonist Kenny G, whose playing is considered by some to be the height of eighties *fromage*. But Stevie loved Kenny's playing – likening it to a fluttering human voice – and she also adored him as a friend. Frankly, Stevie didn't care what anyone else thought. It was her album, and she wasn't interested in being trendy. This is one of the reasons Stevie Nicks has endured as an icon over the decades. She has always stayed true to her own heart; a strength necessary in the music industry where one often finds oneself very much alone in various ways.

One of the more serious moments on the album that would shed a light on Stevie's inner toughness would be 'Doing The Best I Can

(Escape From Berlin)'. "That's the story of my life, especially the last three years," said Stevie. "I get tired of people telling me their opinions of what I do. I want to say: 'You have no idea the responsibility I feel toward people and the guilt that I carry around, how much I want to please everybody. It's difficult, it's ageing. 'Doing The Best I Can' says, 'get off my back', basically."

Rupert: "It was quite dark for Stevie. I wanted to make that track very strong and sinewy. I enjoyed arranging that song, and enjoyed that she enjoyed it too. She always sings along when you're listening back to things – even if her voice is already on it, she always sings, which I find very charming."

One of Stevie's favourite tracks on the album would be 'Alice', a reflection of the mind-bending children's story that inspired the record and a nod to her 'crazy' grandmother, but "there is much of Alice in Stevie Nicks", insisted Stevie, referring to herself in the third person, as very famous people are occasionally prone to do. There is also plenty of Fleetwood Mac in 'Alice', and the song describes the protagonist running back and forth between the looking glass and reality.

In December 1988, shortly after Fleetwood Mac released their *Greatest Hits* compilation (featuring 'Rhiannon', 'Gypsy', 'Dreams' and 'Sara' from the Nicks back-catalogue), Rupert Hine flew to the UK to get his own studio ready for Stevie, who would be arriving the following month. Farmyard Studios, where Rupert had recorded all of the albums he had worked on throughout the eighties so far, was situated in Little Chalfont, Buckinghamshire, and this would be where the mixing and overdubs for *Mirror* took place.

Stevie instantly loved the studio's charm; this definitely had the 'Rhiannon factor'. "It was like being in a cottage in Wales," remembered Stevie. "It was a little spooky... the atmosphere was like nothing I had ever experienced." Romance aside, the result would also be Stevie's only hit album in the UK. "All those great albums with Tom Petty and Don Henley... they were big in America but never really translated to Europe," concedes Hine.

Sadly it would be at this point that Rupert and Stevie's whirlwind relationship came to an end, but ultimately friendship and mutual respect

would endure, and Stevie's time with this eccentric super-producer would leave her "a changed woman. And now, long nets of white cloud my memory," she says in her *Timespace* liner notes, quoting 'Rooms On Fire' to infer that time has made her forget some of the finer details of what happened. Well, they do say happiness is good health and a bad memory. The main thing is that, "now I remember the rooms, the music, and how truly magic the whole thing was."

★ ★ ★

The Other Side Of The Mirror was released in May 1989 shortly after first single 'Rooms On Fire' hit the shops, with the album reaching number 10 in the *Billboard* charts, and number three in the UK. Stevie had flown back to Los Angeles after leaving Rupert in England, but while plans for a three-month US and European tour were put in motion, Stevie was not feeling particularly inclined to do anything other than snuggle into her comfiest chair, draw the blinds and watch TV. Thanks to Klonopin, Stevie was starting to lose interest in her work during the very year she should have been riding at her highest. She couldn't even be bothered to write. This was a sign that things really were serious.

 "[The doctor] kept upping my dose," Stevie said. "1988 into '89, I'm now not even writing songs any more. I was living in a beautiful rented house in the Valley, and just pretty much staying home. Ordering take-in and watching TV. And I've gained 30lb and I'm 5ft 1in tall, and I'm so miserable."

 Because of the emotional gloom caused by the drug, Stevie would then supplement the Klonopin with barbiturates to try to lift her mood. Unfortunately, the doctor's decision to increase her dose of Klonopin may well have been a result of the fact that Stevie *was* suffering from increased anxiety this year; in June, her mother Barbara Nicks would undergo open-heart surgery. Stevie rushed to her hospital bedside in Phoenix, Arizona – "my beautiful desert" (always very much in touch with her Wild West roots) – and the five weeks that followed were "the most emotionally trying of my life". Stevie would dedicate the programme for the upcoming tour to her mother, for her courage and

"her wild, wild heart". The dedication would be signed by both Stevie and Christopher Nicks.

Dosed-up and depressed, Stevie barely remembers her tour for *The Other Side Of The Mirror*, which took place between August and November 1989, and in a promotional interview she admitted blankly that "a lot of the time I'm not happy". This would be the first time Stevie Nicks toured Europe as a solo artist, but in the main, the shows were not to her usual high standard and reviews were unkind; after a show in Stockholm, Sweden, one critic went so far as to say the performance was an "insult to her fans". In the case of many of the concerts on this tour, the support acts – including Richard Marx and Philadelphia band The Hooters – received more love from the crowd than the headliner, many of whose fans walked out during her set.

It was difficult for Stevie to muster the energy to slim down when she was feeling so under par, but eventually she would reassess her lifestyle and start exercising, buying a treadmill and pounding away as she watched *Miami Vice* and *Star Trek* to pass the time.

Fleetwood Mac would soon set to work on their next album, *Behind The Mask,* their first since Lindsey's departure. Not only were they now lacking a major songwriting presence as well as a strong singer and guitarist, they were without their usual producer in Buckingham. Enter Greg Ladanyi, a record producer and songwriter who had worked with friends of the Mac – including Warren Zevon, Toto and Don Henley – and he came highly recommended. Sessions were booked at the Village Recorder, but recording would also take place in Phoenix for the convenience of the increasingly ailing Stevie, who had now started to shake noticeably and was spending as much time as possible trying to start writing again. These were, as Stevie calls them, "lost years". "For eight years, I didn't do anything worth remembering." Stevie also started to make bad decisions, hiring and indeed firing the wrong people, subsidising the many people in her entourage whom she felt so dependent on day to day, and disengaging from the life that had once been so exciting.

"Did you ever see that movie *The Never-Ending Story*? There is a character in that film, a blob called The Nothing. Well, I turned into The Nothing. If I didn't spend those years on medication, I would have

done two or three great albums... But I have nothing from those eight years. It ruined my life. It took my soul."

Fortunately for Stevie, she had so many reams of poetry and ideas banking up that she could still provide four songs for *Behind The Mask*, three of which were co-writes: 'Love Is Dangerous' and 'The Second Time' were both collaborations with Rick Vito, and 'Freedom' was co-written with Mike Campbell. 'Affairs Of The Heart' is the only song on the record credited solely to Nicks.

Behind The Mask would take little time to record compared to the Mac's previous albums, and, as usual, Stevie was not always required to be present, but the style of the album would be unremitting AOR, and lacked the dark tension and mystery that had always been so appealing about their previous output. The cover of the album, created by photographer Dave Gorton, was an odd depiction of a scene by a house under a thunderous sky, a band of five musicians play together *al fresco* while a young woman, with tumbling brown-blonde locks and a white tulle dress, stands in the foreground, her arms folded and her face serious, almost disappointed. Mick Fleetwood said that no one in the band wanted to be on the cover, but it's not surprising that many fans would assume this to be a portrayal of the Mac, with the sulky 'Stevie' character standing significantly apart.

The record, released in April 1990, topped the UK album chart and was hailed by *Rolling Stone*, who loved the new line-up, proclaiming Vito and Burnette to be the "best thing to have happened to Fleetwood Mac", and compared *Behind The Mask* to *Rumours* in the sense that the songs so deftly communicated the writers' respective emotional pain. But it would not be universally loved; *AllMusic* damned it as the "least inspired" of the Mac's output, and while making it had been 'fun', Stevie, fatigued and unsure of whether this was still the band she wanted to be in, was teetering ever closer to the brink of leaving the group altogether. "I've been close to leaving ever since I joined," she said, before adding, "but so has everybody else." But this would be the final Fleetwood Mac album for Stevie until *The Dance* in 1997.

Publicly, Stevie presented a positive front: "In comparison to all of our other albums, this was extremely easy to record. It's not that we didn't take as much time, it's more that the time that we did take was quality

time. Being in the studio with two brand-new personalities made it a lot more like being in a new band." Making the record was nowhere near as 'gruelling' as it had been in the past, and Stevie's songs were strong, particularly the country blues-tinged tracks she had written with Vito. Still, many thought *Behind The Mask* suffered from Lindsey's absence*. Despite the refreshing lack of drama with the new line-up, this loss would also be felt, privately, by Stevie Nicks. It wouldn't be long before Stevie decided she just "couldn't continue to be in a Fleetwood Mac that didn't have Lindsey in it."

★ ★ ★

The world tour for *Behind The Mask* – titled simply *The Mask* – would be the longest yet for Fleetwood Mac, taking the band on the road from March until December 1990. Rather than concentrate on material from the new album, the shows provided more of a 'greatest hits' package "high on concert pomp and circumstance," wrote *Billboard*. "The camaraderie of old friends and familiar music from the past."

But this would also be a tour tinged with sadness; after the recording of *Behind The Mask*, both Christine McVie and Stevie Nicks decided this would be their last Fleetwood Mac tour, although they still were happy to record with the band. The ladies were losing their mojo with the Mac, as were some fans and critics. What was described as an "amicable split" had transpired after a "series of heartfelt conversations", according to the Mac's publicist. Stevie Nicks was advised by her own management not to go on the road with the band at all, but she refused to let them down.

"The people who surround me felt that the loss of Lindsey was devastating to the band, and that the band could never be what it was, and I had this solo career that could be a lot more successful if I had a little more time and a little more rest," Stevie told Nicky Horne in an interview for BBC Radio 1.

"For my health and state of mind, they thought it would be better for me to have just one career, like most people. Since they didn't manage

* His appearance on the title track notwithstanding.

Fleetwood Mac they didn't really care about [them]. That angered me, because I did care about Fleetwood Mac. I would never walk away unless I had no choice."

The announcement would be made public shortly before the final date on December 7, 1990 at the Forum, Los Angeles, where the band would be joined, poignantly, by Lindsey Buckingham for 'Landslide', 'Go Your Own Way' and 'Tear It Up'. The timing of the news raised eyebrows in the media – Mick Fleetwood's tell-all autobiography *Fleetwood: My Life And Adventures In Fleetwood Mac*, written with Stephen Davis, had just been published, detailing, amongst other things, his doomed tryst with Stevie Nicks.

Had the book's revelations pushed Stevie and Christine out of the band? This was the question on everyone's lips, but the fact of the matter was a) Stevie and Christine hadn't actually read the book when they decided they wanted out and b) when Stevie *did* read it, she insisted she had no issue with how Mick had written about their affair. Indeed, his reminiscences came over as misty-eyed and sentimental rather than sordid or shocking.

"As far as what I wrote about me and Stevie," Mick told reporters, "I don't think she had a problem. We were very much in love. I think she wished that I had written more." Stevie herself later confirmed that she "wasn't displeased by anything Mick said. It was a great love affair; something I would never trade in a million years." She would even go so far as to say that, not only does she still regard Mick Fleetwood as one of her three "great loves", she wasn't ruling out the possibility that they might end up together again. "Maybe when we're real old," she mused to journalist Peter Castro. "It's possible. I'll always love Mick. It's a wild thing to say, but no one could ever take that away from me."

The reason Stevie was leaving the band was because she needed to devote her energies to her solo career, although she found it hard to take in that she was really moving on – she would conduct interviews, purportedly her last as a member of Fleetwood Mac, through sobs. In her heart she really didn't believe it was 'the end'.

Even so, the plans Stevie had for the future would, if fulfilled, leave little time for the Mac. While she had often talked of having come to

terms with the fact that family life was not on the cards, a part of her still yearned for a child; she talked about having 'accepted' her fate so frequently, it certainly sounded like a lady who was perhaps protesting too much from time to time. And so, during *The Mask* tour, Stevie revealed not only that she was collating her first box-set, titled *Timespace*, but, come January, she wanted to adopt a baby girl and become a single mother. On Klonopin.

"I don't regret the rest of it at all, but I do regret the fact I didn't stop to have a baby," she told *Chatter*'s Peter Castro when reflecting on her life of "rock'n'roll adventures". "I'm ready for it, and I'm good with children. And then I just may have one myself after that, if the right man walks into my life. I'll probably call her Lillian* Rebecca. She'll be loved, and she'll be the most important thing in my life – more than music, Fleetwood Mac, solo albums or anything else."

Christine's reasons for moving on from the band were quite simple – she'd come to the end of the line, had bought a farmhouse back home in the UK and wanted to spend time there, painting, writing and relaxing. She had also suffered the loss of her father, and needed time away from the Mac, and the road, to reassess her future. The past few years with the new line-up, Christine admitted, had been a lot of fun, but "when the time comes for a change, you feel it."

"I would have to say this is our biggest challenge, in no uncertain terms," Mick Fleetwood told Stephen Hochman for the *LA Times* once the news went public. "But without sounding blase, it's a decision that's come in a pleasant way, and it's understandable. Each, for their own reasons, basically wants more time to herself. And, God knows, both of them have given so much to Fleetwood Mac through the years."

They had indeed, and soon the group would be taking even more from Stevie, this time very much against her will.

* 'Lillian' was a nod to Lillian Hellman, a writer with whom Stevie had always identified. It would also remind her of Robin – when the 1977 film *Julia* was released, based on the writing of Hellman, Stevie would pretend she was Lillian, played by Jane Fonda, and Robin the title character Julia, portrayed by the English actress Vanessa Redgrave. The 'Julia' character also has a child called Lily, which is one of Stevie's pet names.

Chapter 26

*"We will probably go down in history as the most eclectic of bands. I'd like
to be remembered as a notoriously eclectic person: a collector and a dancer
and a singer and a songwriter and a fairy-dust spreader."*

Stevie Nicks to *Us Magazine*, 1990

The future stretched out in front of Stevie, a future free from
Fleetwood Mac, free for her to tune her focus and concentrate
entirely on what *she* wanted to do. Yes, Stevie had agreed to the possibility
of recording again with the band, but still the separation felt like 'a
divorce'. Once the shock wore off and, during the New Year of 1991,
Nicks had a chance to really process what was happening, the conflict
and sadness transformed into tentative excitement and relief, not least
because never again would she have to feel 'guilty' about doing her own
thing, with the band "waiting for [her] like anxious cats".

Feeling the way she did in terms of her health, it would be a while
until Stevie could find the motivation to record another solo album;
every time she tried to come off Klonopin, her hands would shake so
violently that she feared she had Parkinson's, and so the daily sedation
continued. However, the planning of her collection *Timespace* was a
positive outlet, and it was therapeutic to reflect on the past ten years as

she collated some of the most meaningful moments from her solo back catalogue.

It was the right thing to do at this point in her life, it was independent of the Mac and she had more than enough songs – published and as yet unpublished – to include. Atlantic Records had suggested a 'greatest hits', but, as Stevie said in the revealing and extensive self-penned liner notes, "It's really my favourite songs, my 'space in time,' the personal hits in my heart. [And] I figured if I was going to pull them out, it was time to explain why they were written." The title *Timespace* is also an invented word that Stevie loves to use, often referring to the 'timespace' of a situation she was once in, inferring that the memory is not only of its time, but the place, and mental 'space', it was in as well.

The album would also include new material, including a song written for Stevie by Jon Bon Jovi and Billy Falcon, which bore the rather un-Stevie title, 'Sometimes It's A Bitch'. The inclusion of this song proved that, as powerful a star as Stevie Nicks was, she still didn't have final say over her own output, and backed down despite feeling strongly about not just the song but the title. The word 'bitch' was not a word Stevie enjoyed singing. It was just not her style. However, Stevie's record company practically bullied her into including the song, stating unequivocally that her "career would be over" if she didn't.

"I don't have any reason to hate Jon Bon Jovi," Stevie protested in an interview with Spencer Bright for *Vox*. "He wrote me a song that was a wonderful thing to do. I knew that just me singing it wasn't going to go over well with my fans, which it hasn't. But [my management] exerted all the pressure you could possibly exert, they scared me to death. So I did the song, and is it a big hit? No, it's not." Stevie should have been allowed more creative control and to follow her instincts. She might have been spaced-out at this stage, but this was not her first rodeo, and Stevie Nicks knew a thing or two about 'hits'.

The lyrics of 'Sometimes It's A Bitch' were clearly inspired by Stevie, even if they might have been a little sub-Nicks and indelicate – 'I've run through rainbows and castles of candy / I've cried a river of tears from the pain' – but 'sometimes it's a bitch / sometimes it's a breeze' just didn't feel right at all. Singing a cover, unless it was a very special song

that really struck a chord, or described how she was feeling anyway, was something Stevie was not always happy to do at the best of times.

Timespace would also feature Stevie's duet with Tom Petty 'Stop Draggin' My Heart Around', 'Leather And Lace', 'Edge Of Seventeen', of course, and previously unreleased songs including 'Love's A Hard Game To Play' (written by Bret Michaels and Pat Schunk) and 'Desert Angel', co-written with Mike Campbell and dedicated to those serving in the Gulf War that was currently raging.

Stevie Nicks, like so many, was deeply disturbed by what was happening in Iraq, and started writing humble, heartfelt letters of support to the troops. Stevie's earnest, imaginative missives will no doubt have brought comfort and welcome distraction to those who read them. As she wrote in her song, "I was born in the desert / So I know how it feels out there." Admittedly she wasn't being shot at, but the sentiment was keenly appreciated. She "sends the sanctuary" of her own starlit desert surroundings out to those at war, expressing "how much we love you" and also sincerely reaching out to those left behind, the mothers, daughters, wives. "Where is my father? / Where has he gone?"

In one letter, Stevie chose to share the story of Rhiannon, the goddess – and song – that had 'healing' powers, a musical 'pain pill' that had so often helped Stevie transcend the madness. "I once, a very long time ago, wrote a song about [Rhiannon]," Stevie wrote, continuing the story as if she were Wendy in *Peter Pan*, telling the lost boys a heartening fairy story before they turned out the lights. "Rhiannon was a queen in a world far above us called The Bright World," she continued, "where all the colours were brighter, and everyone had a special sort of glow around them... It is said that in times of war, or strife, or pain, her song can be heard... It is said that the legend is true, so I send you the energy from my golden cross and the three singing birds of Rhiannon to comfort you and to keep you safe."

'Rhiannon' itself would not be featured on *Timespace*, but of Stevie's material released under the Fleetwood Mac umbrella, 'Silver Springs' was a song Stevie desperately wanted to include. It was so significant to her, especially as she had 'gifted' it to her mother, who otherwise would

not accept presents from her wealthy daughter. The song 'belonged' to Barbara Nicks, who also opened an antiques emporium under the name 'Silver Springs'.

The problem was that Mick Fleetwood also wanted 'Silver Springs'. It was his intention to include it on *25 Years – The Chain**, the four-CD Fleetwood Mac box-set he and John McVie were currently collating for a December 1992 release. Stevie knew she had to consult Mick, something she was dreading, particularly after they had wrangled over this very song back in 1976, when Mick had told Stevie it was being excluded from *Rumours*. But she duly called him, leaving an ominous message on his answering machine.

"I said, 'Mick, I need you to call me. If you don't, it's going to be disastrous.' He didn't call," Stevie said, in a frank interview with BBC Radio 1's Nicky Horne. "I finally tracked down his manager. I said, 'I want 'Silver Springs'. You tell Mick that if I don't have those tapes by Monday, I am no longer a member of Fleetwood Mac.' He said, 'OK, give me until 10.30, I'll find Mick, don't do anything yet.' At about 10.15, Dennis [Dunstan] called back and said he had tracked Mick down." Mick's response? "Over my dead body."

Stevie Nicks was always well aware she had 'little power' in Fleetwood Mac, but the one thing she could do was remove herself from the band altogether. She made it clear that any hopes of her collaborating on a Mac album in the future were now dashed, and that Mick had "ruined Fleetwood Mac's future. I don't know [why]. I don't think that, unless he sits down and tells me, I will ever know. Knowing Mick as well as I know him, he will never tell me." Stevie officially left the group in the summer of 1991, just two months before the release of *Timespace*. Rick Vito was soon to follow, citing "personal reasons", swiftly bagging a record deal with Modern Records, Stevie's own label.

Nicks was furious that, after "15 years of fighting like a dog to keep this band together", enduring more than any self-respecting artist rightly should, in her opinion, it should end like this. "I could have

* On the collection would be the previously unheard 'Paper Doll', a reggae-tinged track written by Stevie Nicks and Rick Vito during the *Behind The Mask* sessions.

dropped out when Lindsey went, but I chose to juggle two careers. When they went to Hawaii after a tour, I went straight into the studio and I toured. When I finished my album I went straight into the studio with Fleetwood Mac, and they were angry because I was late. So I was constantly under the gun of them being angry because I was doing something else and not completely Fleetwood Mac."

Nicks still 'adored' Christine and John, although she flatly stated she never wanted to perform with Mick Fleetwood again despite their previous intimacy, not just as lovers but as friends and performers. As for Stevie's feelings about Lindsey, not much had changed. They were still "about as compatible as a boa constrictor and a rat." She couldn't imagine them speaking again, let alone working together. And yet, at the same time, Stevie still had to admit that, "Fleetwood Mac goes on like a miniseries. It's one of those *Gone With The Wind* things that goes on and on. I never really know what's going to happen... I never burn bridges but right now I don't think I'll work with them."

Once compiled and sequenced, *Timespace: The Best Of Stevie Nicks*, her first retrospective, was released on September 3, 1991, ultimately going platinum in the US, gold in the UK and spending an impressive four weeks at number one in New Zealand. She supported the album with a tour, titled tellingly, *Whole Lotta Trouble*, after the track she wrote with Mike Campbell. Joining her on tour would be her old friend Les Dudek on guitar, with whom she had so enjoyed working on *Rock A Little*.

And so, in a show of defiance after leaving the Mac, and no doubt under continued pressure from her label, Stevie Nicks packed her costumes, her make-up and her medication and embarked on an extensive US tour, taking her from July 9, at the Woodlands Pavilion in Houston, Texas, to November 14, at the legendary Whiskey A-Go-Go in LA. Stevie did love being on tour, no matter how tired she was. She couldn't stay still for very long, and the energy she received from her super-tight band and the sheer adulation from her most devoted fans would keep her going. As the ribbons trailed from her mic-stand and Stevie hollered and purred, swathed in some of her most spectacular outfits yet – all plunging sweetheart necklines, glitter and giant puff

sleeves – Stevie mesmerised the crowds with her undiminished presence and glamour, even if her backing singers still had to cover some of the high notes at times.

Stevie returned home with her entourage (which once again included Sara Recor, who had separated from Mick Fleetwood – no doubt she and Nicks would have plenty to talk about) to enjoy a quiet Christmas in Phoenix, Arizona, and make plans for the coming year. In the meantime, Lindsey Buckingham was still working on his solo album, the one he'd been working on since he left Fleetwood Mac in 1987, and readying it for its eventual release in the summer of 1992. *Out Of The Cradle* was recorded with Richard Dashut and featured many co-writes with the producer, as well as a Rodgers & Hammerstein cover ('This Nearly Was Mine'), a version of 'All My Sorrows' by the Kingston Trio, the group Lindsey had so loved as a youth, and a fiery song that echoed a sentiment on *The Other Side Of The Mirror*, practically sharing a title: the 'Big Love'-esque 'Doing What I Can'. This epic 16-track album would also connect Lindsey with his old Fritz band-mate Bob Aguirre, with the closing track a twinkling co-write between the two, 'Say We'll Meet Again'. Be careful what you wish for, Lindsey.

★ ★ ★

In 1992, it transpired that the Fleetwood Mac song 'Don't Stop' was being used by US presidential candidate Bill Clinton as the rousing theme tune for his campaign. So when he won the election, succeeding George H. W. Bush, Clinton could think of nothing better than having Fleetwood Mac themselves perform the song at his inaugural ball on January 19, 1993. The fact the group had technically disbanded didn't stand in his way. He was President. He could do what he wanted.

Stevie was in the full throws of Klonopin addiction by now, and heavier than ever at 175 pounds, but despite her reluctance to take the spotlight, she couldn't say no to Clinton, and the rest of the definitive Mac line-up felt similar, although Lindsey took a little convincing. It had been five years since he'd been in the same room as the group, more than a decade since they'd performed together live, and Buckingham was wary of throwing

himself straight back into the toxic situation he'd worked so hard to get out of, especially as the final parting was a less than peaceful one. Even after all of this time, it would take the President of the United States to get Lindsey to appear on stage with them again, much to Stevie's incredulity. Nicks herself had only recently stated she never wanted to perform with Mick Fleetwood again, and yet here she was. Some opportunities are just too good to miss – and it was just one song, after all. "I called [Lindsey] and said, 'If you cheat me out of this honouring moment, I'll never speak to you again,' so he did it." They didn't particularly speak at the time anyway, to be fair.

On that cold January night, the band made their way to the Capital Center in Landover, Maryland, to perform for the man who was about to become America's 42nd President. It was, as *Ultimate Classic Rock*'s Stephen Lewis wryly noted, a "summit", and testament to the politician's "tactful ability to finesse broken relationships." It would take more than Clinton's smooth charm to permanently fix the Mac, but that night Mick Fleetwood recalls looking at his band-mates before they went onstage, to be watched live on TV by millions. "John and Chris were holding hands. Lindsey was holding Stevie's hand. That really got to me."

The crowd were howling with excitement and Fleetwood Mac rocked, giving a flawless performance as they played in the round to thousands of people, and millions more in their homes. It was a special moment, not least because it was fascinating to see them play together again, and looking so excited to be doing so. They certainly didn't look as if they were playing under duress.

Stevie chose to wear her classic black chiffon and her top hat, Lindsey was in a baggy suit, smiling at Stevie as he sang, looking like a man who couldn't quite believe what he was doing. The audience, including the whole Clinton clan, looked on, smiling, dancing and clapping along with this progressive anthem that had meant so much to them, for quite different reasons, during the presidential campaign. Stevie glanced over at Lindsey for the line, "I never meant any harm to you." She still looked a little blank from the sedatives, as she would, but the Mac magic was weaving around the audience and everyone on stage, unifying everyone, if only temporarily. It was a night filled with hope.

The performance took an even more memorable turn when they were accompanied onstage by the entire Clinton family – "Bill, will you join us, please?" requested Christine, cool as a cucumber and as if she did that sort of thing every day – and even Michael Jackson, who sang along next to Stevie as the song played out and a full-scale (but quite civilised and very smartly dressed) stage invasion occurred, including Aretha Franklin in a full white gown Stevie would have been proud of, and actress Sally Field, who appears to be making eyes at the dashing Lindsey Buckingham. Earlier in the evening, there had also been performances from Elton John, Aretha herself, Barbra Streisand, Michael Jackson, Bill Cosby, Jack Lemmon and Chevy Chase to name but a few. Clinton had star power himself now, but, just like John F. Kennedy, he always had the ability to attract the showbiz element, and Stevie herself would become a regular presence at Clinton administration events. (Although a little later down the line Nicks herself admitted in an interview with David Letterman that, perhaps, "Clinton isn't old enough, I think he needs to be more experienced. He's my age, and I have trouble figuring out who's going to go on which bus, he's got to decide on, you know, Russia...")

"[The inaugural gala] was something I don't think any of us will ever forget," Stevie told Howard Cohen of *The Miami Herald* afterwards. "Walking out [on stage]... and knowing that we were walking out because Bill Clinton wanted us. You couldn't feel more special than we did that night." For Stevie, one of the stand-out memories of that night would be when Clinton walked onstage to join the Mac. "I started to move towards him and he got this terrified look on his face. I just handed him my tambourine and said, 'Go to it, Mr President.' And he did – he rocked out." What was amusing was that the tambourine Stevie had handed Clinton was dampened, as it always was, with gaffer tape. It looked beautiful, with its long flowing ribbons, but its only function was to give Stevie something to do with her hands while she wasn't singing. Nicks was a little embarrassed when she realised Clinton was trying to get a sound out of the instrument to no avail. Still, at least he had something to do with his hands.

Despite the undeniable exhilaration Fleetwood Mac clearly felt onstage together, in the cold light of day little had changed. Lindsey,

according to Stevie, was still "not able to have any kind of relationship with me. I just bug him to death. Everything I do is abrasive to him. He's scary when he gets mad." They would return to their cold war, and it was then that Stevie truly believed that her role in "that particular Shakespearean drama" really was over. But what was especially sad was that, because of her addiction, she now felt largely indifferent.

Her sister-in-law Lori Perry Nicks, who, with husband Chris and daughter Jessica, was living with Stevie at her Paradise Valley home, was heartbroken to see her friend like this. "There was nothing anybody could really do. She was very sad for a long time. There was nothing that she could find in life that really mattered very much to her." It was a cruel contrast after the thrill of that enchanted night in Maryland, a glimpse of how things had been, and how they might just be again.

Little could happen of any value or substance until Stevie finally wrenched herself free from prescription drugs, however. Inertia aside, the physical effects were becoming increasingly worrying, but while this destructive habit had been developing insidiously for eight years, it would take something major, something dreadful, to shock Stevie into going into rehab and kicking Klonopin out of her life for good.

<p style="text-align:center">★ ★ ★</p>

Stevie had been collating work for her sixth solo album, *Street Angel* – her first since leaving Fleetwood Mac – as best she could since 1992. It was a slow process, but at least she felt as if she was moving forward. "I think it is a good time in my life," Nicks said at the time, unconvincingly. "I was very excited to begin this record. I started in my house with [former Eagle] Bernie Leadon and [guitarist] Andy Fairweather Low, and we just started playing songs. By the time we went into the studio, we had become like a little band, and it was very happy because it was more fun for me."

British super-producer Glynn Johns was hired to work with Stevie on the album, a man who had famously worked with The Beatles, Bob Dylan, The Band, The Rolling Stones, The Who and many, many other iconic artists. This wouldn't mean he and Stevie were the best

fit, however, with Glynn appreciating a rather more 'cut and dried' approach which was at odds with Stevie's generally more fluid, heart-led way of working.

Many of the songs on this album were out-takes from previous records, thanks to the writer's block Stevie had been suffering from, but the pressure was on to release at least something – the main reason for leaving Fleetwood Mac was to concentrate on developing her own career, after all. Now here she was, free from the Mac, and, as she described it, she was "vegetating". It was a relief that there was plenty of material to work with, but whether it would add up to a make a hit album was another matter entirely.

The tracks 'Love Is Like A River' and 'Listen To The Rain' were *Rock A Little* off-cuts, 'Rose Garden' was a song Stevie had written as a teenager while the pre-Mac 'Destiny' was recorded but rejected from *The Wild Heart*. The record would also include a bevy of Nicks/Campbell co-writes, including 'Blue Denim' (another paean to Lindsey Buckingham's eyes), 'Kick It' and 'Greta'. There would also be a cover of Bob Dylan's 'Just Like A Woman', featuring the man himself on harmonica, a Sandy Stewart song, written with Dave Mundy, titled 'Unconditional Love' and the Trevor Horn/Betsy Cook track 'Docklands'.

In short, it would be something of a patchwork quilt, and it didn't bode well that it consisted mainly of songs that, under different circumstances, would have previously been far from Stevie's first choice. The self-penned title track, a duet featuring David Crosby, was pretty and intriguing, telling the story of an unreachable homeless young woman, a "Charles Dickens character with your top hat and scarf", reflecting Stevie's own favourite style that she'd persuaded Margi Kent to recreate ("like an urchin on the wharves of London"). But as much of a departure as this record was in terms of theme, mood and writing, it was rather prosaic and not a patch on Stevie's previous work. "Fun" aside, even Stevie herself wasn't a fan of it, and she blames the result on her addiction to the "soul-sucking" Klonopin. "That's what everybody heard when they listened to that record," Stevie said. "They heard that I really didn't care."

The drug might have dulled Stevie's edges, but an incident was around the corner that would force her to wake up, setting off the chain reaction needed to close the door on her dependency, no matter what it took. While hosting a baby shower at her home, Stevie cracked open a bottle of Lafitte Rothschild, took a sip, and blacked out, cracking her head on the fire-place.

"The girls said they found me lying on the carpet," Stevie told *Us Magazine*. "They got me up to bed. Later I looked at myself in the bathroom mirror and saw I had some blood on the side of my head. I'm one of those people who doesn't injure themselves. I was horrified to see that blood. I hadn't had enough wine. I knew it was the Klonopin." Stevie is sure "some little spirit" must have tapped her on the shoulder and made her see what was happening before her problem went even further. "Having a little bit of the spiritual is ultimately better than having none," Stevie said. "I believe there have been angels with me constantly through these last 20 years, or I wouldn't be alive."

Once she had recovered from her fall, now convinced the prescribed drug she took every day was 'killing' her, she decided to conduct an experiment on the willing Glenn, her trusty personal assistant. She sat him down and asked him to take the same dosage of Klonopin she'd been taking, just to see the effect it had. "I said, 'It won't kill you, because it hasn't killed me, but I just want to see what you think'," Stevie told *The Telegraph*'s Mike Brown. "Because Glenn was terribly worried about me – everybody was. I was taking two in the morning, two in the afternoon and two more at night. At that point if I could find a Percoset, because I'm so miserable, I'd take that, or I'd take a Fiorocet [barbiturates] – anything."

So Glenn agreed to take exactly the same medications that Stevie had been taking up to this point, his employer keeping a close eye on him. At one point he was given the task of setting up a stereo in Stevie's living room. After half an hour, Stevie popped in and found him "just sitting there", unable to fix the stereo or even move from the spot. "He was almost hallucinating," Stevie remembers. "It was bad. I called up my psychiatrist and said, 'I gave Glenn everything you've prescribed for me.' And the first words out of his mouth were, 'Are you trying to kill

him?' And the next words out of my mouth were, 'Are you trying to kill me?'"*

Stevie called her management to announce that she wanted to go to rehab and get every trace of Klonopin out of her system, the drug that had stolen away her 'precious forties', the drug her 'powers that be' had led her towards so she could keep working. The irony was not lost on her. 'Work' had become almost impossible. "It's very Shakespearean," Stevie said. "It's very much a tragedy." "She was in dreadful pain," adds Paul Fishkin. "But she just willed herself to do it."

"I spent 45 days in [hospital]," Stevie said. "When you go on those tranquillisers, you'd better start saving your money so you can afford to go into rehab and stay for two months." Better still, if your doctor suggests Klonopin, just "run screaming from the room."

And so, Nicks admitted herself to the Daniel Freeman Memorial Hospital in Venice Beach and 'nearly died'. Her hair went grey and fell out, her skin flaked off and she had a headache from the withdrawal symptoms from the day she arrived to the day she left. The agony of this lengthy detox was almost unbearable, far harder than kicking a cocaine addiction. Stevie had brought in as many favourite items as she could to comfort her during two long months of torture. One was a picture of her niece Jessica. "I kept saying, 'I'm so sorry I'm not going to be there for you. I'm so sorry I'm not going to be able to teach you.'"

The temptation was always there to "call a limo, go to another hospital and ask for Demerol because I was in so much pain," but instead Stevie stoically persevered, choosing life – and quality of life – over complacency and substance addiction. Stevie watched others come and go; the heroin addicts would be there for "12 days, three days of psychotherapy and they're gone, and I'm still there". The entire ordeal was like someone opening a door "and pushing me into hell... But I did it."

* For those of you concerned about Glenn the human guinea-pig, please be reassured that he was fine, and the experiment was only 'for one day'.

Chapter 27

Stevie Nicks to chat show host Rosie O'Donnell: "I said [to myself], 'I am never going on stage weighing 170 pounds.'"

Rosie: "Stevie, just so you know, 170 pounds is my goal weight."

After checking out of rehab, Stevie returned home to Phoenix. She had let her LA rental go after an earthquake had struck the previous year, but Los Angeles was also full of associations she needed to distance herself from. "[It was] not a good time," Stevie said, in an interview with *The Guardian's* Craig McLean. "I was freaked out. In rehab, when you're leaving, the last thing they say to you is, 'Don't get married, don't sign contracts, don't buy a house, don't sell a house. Nothing heavy.' Because your judgment is impaired. And you need to go out there and find out who you are, not on tranquillisers."

So, retreating to the desert she loved, Stevie licked her wounds before returning her attention to *Street Angel,* a record Stevie would dedicate to her niece, Jessica James Nicks, the little girl whose sweet face Nicks had gazed upon every day in the clinic. Stevie was still 'very much grieving' over her lost years and creativity. And soon she would be mourning for *Street Angel.* She loved the songs – regarding them, as many songwriters do, as her 'children' – but the new album failed to match the quality of its predecessors by rather a long way.

After the inevitable departure of Glynn Johns, much of the production had taken place under the watchful eye of producer Thom Panunzio, a comrade of Tom Petty's, while Stevie had been away. When Stevie emerged, *Street Angel* was not only far from how she'd have liked it to be, it was also "unfixable. [It was] a terrible record," she admitted. Nicks tried to improve the recording by adding over-dubs, even re-recording some of the material, but the fact was she also had bigger things on her mind. The ordeal she had just undergone, if nothing else, had given her a new perspective. "You're lucky you're still alive," she mused. "Lucky to live in this incredible house, lucky you didn't lose your fortune or scare all of your friends away..." She was also four years away from celebrating her half century. Makes a girl think...

Street Angel, released in May 1994, would be certified Gold, her only solo album so far not to go Platinum in the US, and as she embarked on a three-month promotional tour, Stevie became increasingly downcast by the reaction in the media, who were apparently nearly as disappointed as she was. There was also a sense of impatience with her persona, a persona she had arguably long since outgrown. As *Rolling Stone*'s Kara Manning observed, Stevie's "child woman personality has served her 20 years, [and] it's overdue for the doe-eyed innocent to get tough. Refusing to spit and kick like Bonnie Raitt or Kim Gordon, she trembles instead, a little girl made helpless by uncaring men and her own isolation."

To be fair to Stevie, this, of all times, was when she really did need her friends to rally round, and one friend in particular stepped up to the plate. Heartbreaker Mike Campbell had always been a close ally of Stevie's; 'very generous' and supportive, not just in terms of giving her melodies but as an understanding presence in her life. Realising how hard it would be for Stevie after coming out of rehab, facing the same faces, throwing herself back on the road and suddenly encountering thousands upon thousands of fans, Campbell, who had written with Stevie on *Street Angel*, stayed close to the fragile Nicks; Stevie hints in the film *In Your Dreams* that he, indeed, was the mystery man she "made out across America" with on the

tour bus, according to Stevie, a "forbidden romance" that, she insists, saved her life.*

The *Street Angel* tour would be Stevie's first to use a bus, rather than a private jet. It was time to cut costs. "[It's] a difference between $700 a day or $5,000 a day," she admitted. Stevie made sure she was comfortable, however, decking the coach out with veils to sleep under, the plumpest of feather pillows and a king-size quilt she retreated to once she finally was ready to sleep at "five or six in the morning". There would also need to be a special place on the bus for all of the thousands of gifts she received from fans: teddies, jewellery, flowers, all of them thrown at the feet of Ms Nicks, all of them accepted with sincere grace. The toys would be taken to Phoenix and given to hospitals or children's charities, and the flowers Stevie would keep, drying them to make potpourri, putting a handful into small velvet bags and handing them to the crew at the end of the tour.

Stevie looked big but beautiful on the tour, her long blonde hair a voluminous mass of crimped waves (she braided her locks into hundreds of tiny plaits before she slept to create the effect) that gave her fuller shape a little more proportion. Fans were as supportive and adoring as ever, praising her performances and enjoying the appearance of guitarist Rick Vito, who accompanied her on a rendition of 'The Chain'. However, it irritated Stevie that the critics seemed more inclined to concentrate on her weight, saying, with understandable bitterness, "I guess talent no longer matters."

Seeing pictures of herself at her heaviest had broken her heart, as did some of the vile comments made in the press about how she looked. Unfair as it was, being judged on her weight rather than her songs, she made a decision. "I just wouldn't go on stage and perform any more if I didn't lose the weight. It was just too hard to have everybody expect

* Nicks would write a song about this tryst, titled 'For What It's Worth', which would emerge later on the 2011 album *In Your Dreams*. As Stevie matured, her lyrics seemed to become far less cryptic – perhaps time really did make her bolder as she noted in 'Landslide' – either way, the lines in 'For What It's Worth' are unambiguous: "You said even if I left my girlfriend...", "only a few around us knew..."

me to be a different way and not be able to get back to that. I was very depressed about it." Worse than the reviews were the shocked and disappointed faces she encountered wherever she seemed to go – she wasn't the 'Stevie Nicks' they wanted to see. She almost felt as if she had to apologise.

By the end of the tour, Stevie resolved to "make [*Street Angel*] go away completely. I have never listened to it since", and her fuller figure depressed her, to the extent she even considered getting a regular job in which she was no longer scrutinised for her looks. It was hard – having been regarded as such a beauty in her youth, this contrast was all the press could talk about. Had she always been plain, perhaps people would have only focused on her work. But the two elements – her fairy-queen looks and her music – were forever intertwined. It was time to make some changes, and Stevie promised herself that she would "never forget this feeling".

One member of her management had already been sacked by Stevie after he warned she would ruin her career if she didn't lose weight (although she shifted the pounds anyway) and, to further add to the sense of portent, her contract with Atlantic was nearing its end – she was obliged to provide one more album for them – and there was nothing on the horizon so far. With that in mind, Stevie did what any self-respecting rock star would do: she became a recluse; drawing, writing and exercising, dancing in her ballet room (complete with 'fabulous ballet barre' carved for her by a fan) and spending hours on the treadmill with the TV on, her high heeled boots having been temporarily replaced with platform Reeboks.

But as Stevie worked hard to pull herself up and out of her funk, Mick Fleetwood was pushing on, some say ill-advisedly, with yet another version of Fleetwood Mac. This time they had Bekka Bramlett taking the 'Stevie Nicks' role, and Mick accepted an offer to open for REO Speedwagon on the *Can't Stop Rockin'* tour, a development that left the estranged members of the definitive Mac understandably dismayed. "It was really disturbing when they wound up on a nostalgia tour triple-bill package as the middle act between Pat Benatar and REO Speedwagon," said Lindsey Buckingham. "Mick could rationalise it,

because continuing the band was the same thing he had done after Peter Green had left." But this new phase was in danger of devaluing the band's legacy, and many critics and fans agreed. The sight of the undoubtedly talented Bekka Bramlett strutting onstage instead of Stevie prompted many audience-members to, as one witness put it, "go their own way – out to the parking lot."

Slowly Stevie started to build herself up again, recording new demos with her backing singers and emerging into the outside world. On one occasion, when Tom Petty was playing at the Ritz-Carlton nearby, Stevie ventured out to have dinner with him. What followed was "one of the quintessential lectures of my life". During their meal together, Stevie agonised over her regrets during her time on Klonopin – "I had done many things in those eight years that I was not proud of, that were not me, things that I would never do..." – and begged Tom to write her some material, because, despite repeated attempts, it appeared that the well had all but dried up. Petty was having none of it.

"He said, 'You know what? Everybody makes mistakes. You can't blame yourself for the Klonopin – you didn't go out on the streets looking for that. That's just a nasty thing that happened to you, so now get over it. You're upset 'cause you're 20 pounds overweight – lose it, you can do it. That's not your problem.

"Your problem is knowing and remembering that you're a great songwriter. I'm not going to help you write songs, I don't have to help you. You need to go home to your piano and sit down and do what you love to do. You never married, you never had children because your love is songwriting, and what in the world is up with you telling me that you need me to help you write songs?'"

Stevie had to admit that, had anyone else attempted to address her so directly, she would have stormed out. But Stevie loved and respected Tom, and the feeling was mutual. It was the 'kick in the butt' she needed, and she promptly went home, set up her surroundings to be suitably atmospheric and sat down at her piano. One of the songs to emerge from this time would be 'That Made Me Stronger' – a tribute to Tom's strong but friendly advice. This, and much of the material Stevie produced from this point, would appear on Stevie's 2001 album *Trouble*

In Shangri-La, a title that succinctly illustrated Stevie's life; an unreal kind of paradise that was spiked with anxiety.

One seam of trouble that had run through Stevie's life was about to reappear in a rather more palatable form, proving that time heals, history repeats and hell does sometimes freeze over. The following year would see Stevie Nicks and Lindsey Buckingham – yes, the pair who were never going to speak again – duetting on Nicks' stand-alone song 'Twisted' for the soundtrack to the Helen Hunt movie *Twister*. The track would also feature Mick Fleetwood on drums – they were just two fifths away from a full-scale reunion – and this would be one of the sessions that would push the band towards reconvening in earnest. This time they didn't even need to be urged by the President of the United States. Things were different now, and everyone had had a chance to grow as individuals, beat their demons – or at least go some way towards doing so – and find the love for each other again.

"I was always available to give this another try," Stevie added. "In an eerie sort of way it felt as if we had only been apart for a year. Some things you just never forget. [Lindsey's and my] voice are just good together and we know it. I love my solo career, don't get me wrong. But it will never be quite as exciting as Fleetwood Mac."

★ ★ ★

In March 1997, a slim, healthy Stevie Nicks turned up to rehearse with Fleetwood Mac for two shows for MTV that would be filmed at the Warner Brothers soundstage in California. There were plans afoot for a live video and album – titled *The Dance* – and the entire lavish affair would be filmed before a huge, and justifiably excited, audience. A short tour would follow. Stevie's mother Barbara was excited for the band, not least because they now had a second chance at seeing the world together. (They were 'so screwed up' before, they simply slept all day.)

Once the offer had come through from MTV the previous year, Stevie, already on a roll with her weight loss thanks to that treadmill and the Atkins diet (she'll only touch a carb if it's 'killer'), also decided to quit smoking for good. At her most addicted, she had smoked three

packs of Kools daily, but she needed to make sure her voice was as strong as it could be for *The Dance*. The night before Stevie gave up, on New Year's Eve 1996, she decided to binge on booze and cigarettes – "about 500" – to make her feel so wretched she would never want to smoke again. Nicotine patches would get her through in the meantime.

Stevie would also knuckle down and work on her voice with 40 minutes worth of exercises every day under the initial supervision of a vocal coach, and as for indulgences, a cup of Paradise Tea (and maybe a shot of tequila before hitting the stage) would have to suffice. The former party queen of the LA rock scene was now 49, and she knew she had to stay healthy if she wanted to continue doing what she loved long into the future. "That's my first priority now," she said. "To be in shape so I can walk on the stage and be great." The Mac would, as it always had, take precedence over any romantic involvements for Stevie; she had started seeing someone at the time, but he would ring her up during rehearsals, pull her focus and question her as to when he could expect her home. "All of a sudden it's defensive," Stevie told *Salon Magazine*'s Michael Ryder. "And I'm thinking 'you're endangering what I do'. That's just the way I am." He had to go.

Another priority for Stevie was to stay on the right side of Lindsey Buckingham, but it appeared he had softened since their previous encounters. He was more fulfilled, having been able to use his own ideas for his own output without being under the Mac cosh, was "reoriented" and, most importantly, had "finally got some closure on Stevie after having to be around her all those years".

Everyone had been 'at their worst' during their final sessions together for *Tango In The Night* ten years earlier, but as the rehearsals happened, Lindsey observed Stevie's behaviour and realised he wasn't the only one who had evolved. Stevie was also making an effort to be more open to Lindsey, and Lindsey in turn was 'kinder' in his dealings with her. "This was the girl I used to live with," he said rather touchingly, "and it was no longer bittersweet, it was sweet." Yes, it would still be "an emotional minefield", he would add, remnants of past grudges and hurts still close to the surface and, as Mick Fleetwood observed as the days went on, "there are places you don't go and buttons you don't push",

but the most important thing was that the circle had been completed and they all knew they were exactly where they were supposed to be.

"We decided to do this a long, long time ago," said Stevie, specifically of herself and Buckingham. "We decided to search for the pot of gold together and we never gave up until we got it. So now, that's a pretty great thing. Now the two of us can link arms and walk out on stage and say we worked very hard for this."

"It's nice to think I might go to my grave being Lindsey's friend and not a thorn in his side for all eternity…"

And so, on May 23, after six weeks of rehearsal, Fleetwood Mac hit the stage at the Burbank Studios in California. They had all come a very long way as artists and as people, and, at seemingly the perfect time, they had reunited. The stars had aligned; if ever there was a 'harmonic convergence', this was it. As the opening beats to 'The Chain' kicked in and Stevie raised her arms in silhouette to the sky, the spell was cast once again.

Performing their greatest hits (and a few new songs) onstage in front of an ecstatic audience was, Stevie admitted, "trippy. We really didn't think that we would ever do that again," but the result was "as magic as it gets." For the first time in 15 years, they were back onstage together playing a full Mac set, but it was the first time in at least 20 years that they'd all been quite this happy to perform onstage with each other. There were plenty of smiles, meaningful glances and flirtatious exchanges. Everyone looked healthy and sharp, the familiar gleam was still in Mick Fleetwood's bug-eyes, John had, happily, eschewed his trademark shorts and was looking dapper, Christine was stylish, coiffured and slender, Lindsey was besuited as always and the slimmed-down Stevie's California-girl looks had matured beautifully, the look in her eyes reflecting greater warmth now she was clean. Stevie nervously 'flubbed' the start to 'Dreams', but didn't seem to care, in fact she liked the fact that the audience could see that just because you were a 'star' didn't mean you didn't make mistakes or act like an 'airhead' from time to time. Moments such as these tend to break the ice and connect the audience to the person on stage all the more – and everyone in the house was rooting for her after all.

Naturally, one of the most engaging elements of the Fleetwood Mac story is the relationship between Stevie and Lindsey, and this concert would seemingly deliver to fans exactly what they wanted to see, although that was never the motive at the time. The pair appeared to be singing to one another, but in contrast to previous shows on previous tours, they were not exchanging angry curses and furious looks. Quite the opposite. After Stevie and Lindsey's touching acoustic duet of 'Landslide', a song that took both of them back to old, if not happier, times, there was an embrace and a coy: "Thank you, Lindsey..." "Thank you, Stevie." But during the performance of 'Silver Springs'... well, no one could quite believe what they were seeing, and what unfolded onstage was not planned. "In six weeks of rehearsal, it was never like that... Only on Friday night did we let it go into something deeper."

As the song progressed, Stevie turned to Lindsey and just sang with all of her might as he watched her and took it, as if she was casting a hex upon him, her finger pointing at him as she sang, "You'll never get away from the sound of the woman who loves you..." Since that night, some might say Stevie and Lindsey play up the emotional warfare of their relationship on stage – a relationship that has developed its own persona and has arguably become a member of the band in its own right – but what happened on the MTV Special was real and unexpected, even for Stevie herself.

Nicks would subsequently sing 'Silver Springs' to Lindsey "almost every day" on the tour that would follow, which was, she had to confess, somewhat cathartic. "Lindsey and I get to say things we wouldn't get to say to each other in real life," she said in an interview with *Miami Herald* during the tour. "It's like a release. Even now, we don't talk much, so when those songs come around and are directly involved with our relationship it's very therapeutic to work that stuff out."

The Dance tour, lasting from September to November, coincided with the 20th anniversary of the release of *Rumours* and was a gratifyingly successful venture, as was the live *The Dance* album, featuring that incendiary performance of 'Silver Springs' and earning the group several Grammy nominations. Stevie believed that the band now "plays way better than we did in the beginning" and also agrees the material chosen

for *The Dance* album displayed new arrangements that surpassed the originals in many cases; 'Rhiannon' being just one example – opening with an extended introduction of just voice, keys and percussion as Stevie takes on the role of the troubadour, telling the tale of the man who 'still cried out' for the enigmatic protagonist.

New tracks on the record, such as Lindsey's soft-hearted 'Bleed To Love Her', boast lyrics that seem all too clearly to point to Stevie at her most mystical and capricious. "Once again she calls to me, then she vanishes in thin air..." There's a sense of affectionate ribbing in this song, as well as genuine, enduring love, and even longing. It certainly appeared that at least a part of Lindsey was 'still crying out' for her, and vice versa. After all of these years, they were still writing about each other, and would continue to do so. Stevie would be writing songs about Lindsey even as they toured together for *The Dance*.

Thanks to the nature of simply being on the road together – i.e. trapped in confined spaces with little else to do – Stevie and Lindsey would finally start to talk properly, chipping away at the thick ice that had formed over their shared past.

They had, according to Lindsey, "some really good talks", even going some way to sorting out their differences, or at least accepting them. It wasn't easy. "We've known each other all our lives and yet we're still trying to figure out what's going on," lamented Lindsey. "Obviously [there's] a lot of love as a sub-text. But where is that love? How do we get in touch with that? For all of us, the decisions we make now are going to determine how we are as people until we die. Stevie and I are trying to look at it... with care."

Meanwhile, there was someone else in the group who was feeling uneasy. *The Dance* tour would only take in key US cities, never making it to Europe or Canada as hoped, because Christine just didn't want to be on the road. She missed England and wanted to retire, and this news, broken during the US dates to the rest of her band-mates, would hit Stevie the hardest. Nicks was emotional enough as it was, and it wasn't unusual for her to burst into tears onstage after Christine's announcement. "It happened at a certain part in 'Sweet Girl'," she explained, the song that celebrated "dancing across the stages of the

world", as Stevie has spent her life doing. The lyrics also asked, 'What do you want to do?' For Christine, she just wanted to go home, and Stevie was devastated. "I was just thinking about how Christine didn't want to go back out on the road and it upset me, I was thinking of her as 'Sweet Girl'. I have to be careful because I'm real emotional and I could go that way every night if I let myself."

As the tour came to a close shortly before Thanksgiving 1997, everyone said goodbye to each other again, leaving each other slightly different people to the way they'd found each other. But there was dissatisfaction. The tour had gone so well, the album was a hit, it felt as if they were starting something again… only to suddenly stop. "It's like, 'Well, now what?'" said Stevie. "I feel bad for Mick, because I would have liked it to have gone its karmic wheel; when you do a record, there's a certain kind of life that it has, and I feel that we should have gone to Europe. We should have finished the tour. But I don't think that we should've risked Christine's sanity. It wasn't worth that."

The question was often raised as to whether the band could simply continue without Christine McVie. As far as Stevie was concerned, "without her, it won't ever go back together". This assertion would be proved wrong just five years down the line. In the meantime, both public and press were in raptures over *The Dance* triptych of album, TV special and tour, and there was no doubt about it, Stevie had stolen the show. "Let's face it," said *Rolling Stone*. "That Fleetwood Mac tour was all about Stevie Nicks…"

Wheels were already in motion for Nicks' new album and a solo collection, the planning of which had been postponed because of the Fleetwood Mac tour. Stevie was a little wary of dropping her own work for the sake of a Mac venture that could suddenly fall apart or suffer another dramatic Lindsey Buckingham exodus, but as it happened, the timing was serendipitous: thanks to *The Dance*, interest had never been higher and the new, 'improved' Stevie Nicks had won everyone over with her performances with the Mac.

After the disappointment that was *Street Angel*, she was keen to present something to the world that reflected her more positively. Nicks' contract with Atlantic Records was coming to an end, and Warners'

Reprise label had been in touch to suggest she release a box-set to see out her old contract before moving on and working on a new solo album.

"Atlantic decided that they would like to box up all of the songs that I loved," Stevie explained in a radio interview with DJ Chuck Nowlan. "It was better to do it this way because, it wouldn't have been so good to have to muscle together solo records from different record companies. So this way, you know, my whole solo life is on Atlantic and now it's all in a perfect little box where everybody can have what they want out of it."

Stevie holed up at home with her closest friends, including her assistant Karen Johnston and old friend Sara Recor, to devise the track-list for what would be a three-disc collection spanning her whole career as a solo artist. Stevie remembers: "We said, 'Okay, everybody make your own list: what would you like to see on the boxed set off each record?' And there were some things that weren't on anybody's list, and there were other things that we kind of fought back and forth about. It took a good 10 days to work it around to exactly what songs would go.

"These songs played a big experience in our lives. Sara's been my friend since 1978; they're my really close friends who were there at the end of the seventies when all this started, when the idea came to go and do a solo career. That was a big deal when I decided to do that, because it did upset Fleetwood Mac. These ladies watched it all go by... So when we went through all these songs, it was like we were going through home movies. They bring up all the experiences that were happening."

Like *Timespace*, Stevie wanted the box-set to include liner-notes written by herself, unseen photographs and even some pages from her famous journals. The release would be titled *Enchanted,* a suggestion of Chris Nicks' that Stevie fell for instantly. After the success of the Fleetwood Mac tour – particularly her part within it – the album could only soar.

Fascinating fact 1: Stevie at this stage owned two Yorkshire terriers. Their names? Sara Belladonna and Sulamith India Grace.

Fascinating fact 2: Stevie Nicks' favourite record for inspiration: Joni Mitchell's 1974 album Court And Spark.

Fascinating fact 3: Stevie Nicks first really fell in love with lace when she visited the Antiquarius antiques emporium in London. NB. Despite her love of lace blouses, she is not a 'doily' person.

Fascinating fact 4: Ms Nicks has personalised stationery with an image of a top hat and tambourine in the top right corner, and a gypsy-like woman with flowing locks (guess who!) in the bottom left corner. She's been known to write notes to her fans on this pretty paper and have them scanned onto the site The Nicks Fix, because she's nice like that.

Chapter 28

Celeb Stevie-worshippers include Smashing Pumpkins frontman Billy Corgan, Florence Welch from Florence + The Machine, Courtney Love – who was empowered by listening to Bella Donna during her days as an erotic dancer in Japan – and designer Anna Sui, who created a line heavily inspired by Stevie's style. "She's the iconic California woman," says Sui. "Everyone has their version of her."

As for Courtney, Stevie knows her and loves her straight back. "She's like my wild child. I don't have a whole lot in common with [her], but I really like her, and I want her to be great. And I know this life is hard, so maybe I'm here to give her advice every once in a while – 'don't make this mistake or this mistake.'… Like I can tell her, right?"

*E*nchanted would be like a treasured photo album, a highly personal scrapbook filled with 'tumultuous songs', hits, rarities, B-sides and gems that had long languished in Atlantic's vaults up until now. "There is a memory and an experience that goes with each song," Stevie said, adding that the process of preparing for the box-set and going way back into her repertoire to select the right songs was like "seeing all of my experiences spread out over the floor."

Putting together this extensive retrospective would find Stevie occasionally having to accept, with humour, the quixotic naiveté and defiance of her youth. "I wish at certain places that I had put a little more time and effort in, or that I had listened to people who said, 'This is not that good of a vocal. Either do it over or let's see what else we have in all these tracks,' and I would stand up: 'No, it has to be the first vocal! It's the true thing.' Which we all say in the beginning; you say stuff like, 'It has to be the virgin part!' You find out all these years later it totally sucked and they were totally right."

Stevie was always prepared to be open with herself and her fans, and in the album's liner-notes, she was ready to reveal more secrets and opportunities for Stevie anoraks to feverishly read between the lines in search for clues. Sometimes Stevie was opaque, sometimes she was blatantly honest, but everything, from her love for Lindsey to the relationship with Prince that never was, would be touched upon.

"There isn't a song in here that isn't about something intense," said Stevie. "To hear all [of them] in a group, I didn't even realise that my life was that intense. When I proof-read all the words for the songs, I went, 'Wow, even I'm amazed that you're still alive.'"

"'Thousand Days' was written about my non-relationship with Prince," she told *Billboard*'s Timothy White (adding that he still hadn't actually "set up his payment on 50%" of their co-write on 'Stand Back'.) The song recalls an all-night recording session with Prince at his home in Minneapolis during which Nicks smoked a joint or two, an old habit of hers of which Prince staunchly disapproved, before falling asleep on his kitchen floor.

"Prince and I were just friends," Stevie would confirm in later years, quashing the widespread speculation that Stevie had a purple paramour during the eighties. "I think he would have been happy to have a relationship. But I wanted a musical relationship, and I had smartened up, even then. You'll break up and never speak again. But he wasn't interested in just that... I like him, but we were so different there was no possible meeting ground." So that clears that one up then. Who's next? Ah yes, Don Henley...

Enchanted would feature Stevie and Don's duet 'Leather And Lace' from *Bella Donna* as well as the previously rejected Warren Zevon-penned track 'Reconsider Me', featuring Don and Stevie once more. This track would be selected as *Enchanted*'s first single. According to Stevie in later years, not only did Stevie not wish to include this song on *Rock A Little,* the record Jimmy Iovine had originally sourced the melodious track for, but her reluctance to sing it actually sparked the final argument between the pair before Iovine threw his hands up and stormed out on Stevie, and the album, for good. Stevie was at her most obstreperous and coke-addicted during this period, and not only was the idea of singing someone else's song on her album unappealing, she didn't like the sappy sentiment of the track one bit. Stevie Nicks beseeching someone to 'reconsider' her? Please. In Stevie's opinion, every song on the record had to represent her, whether the writing was her own or not.

"[Jimmy] thought it was going to be a key song in my career," recalled Stevie. "But I really don't like to do other people's songs that often. That's why I write my own songs. I was pretty crazy at that point in my life, and you couldn't tell me anything. And I said to him, 'I would never ask somebody to reconsider loving me.' Well, he thought that was the biggest bunch of crap he'd ever heard, so we had a big fight about it and that's just about the last time Jimmy and I ever worked together."

All the same, the track had been recorded and duly put out to pasture for over a decade. It was time to bring it out of mothballs and, as Iovine had predicted, 'Reconsider Me' was a winner. Those who knew the Stevie story were intrigued to hear her crooning with ex-lover Don. Those who didn't just loved the sound of their voices together, a Mac and an Eagle, two figures who were always destined to appeal to each other creatively as well as carnally; with songs such as 'Witchy Woman' and 'Journey Of The Sorcerer' in their canon, the Eagles radiated dark Wild West vibes just as much as Stevie.

Another Henley/Nicks collaboration to feature on *Enchanted* would be 'The Highwayman'. This, and 'Leather And Lace', had been developed from demos recorded in 1977 while they were seeing each

other, so these were two duets that had not been engineered by Jimmy Iovine, despite both of the tracks having been included on *Bella Donna*. 'The Highwayman' was inspired by Alfred Noyes' romantic poem of the same name, which tells the gripping tale of a star-crossed secret affair between a highwayman and an innkeeper's daughter. Stevie's lyrics reflect the galloping meter of the Noyes original. "And she... out in the distance / Sees him against the sky / A pale and violent rider /A dream begun in wine."

For Nicks, the 'highwaymen' in her life were figures such as Don and the Eagles; they were dashing rock'n'roll marauders, and she had to be a highway-woman to keep up with them. You didn't really think Stevie was going to cast herself as an innkeeper's daughter, did you? (Even if her father had once run a bar in LA.) Yes, Outlaw Stevie was an equal and could match any Eagle desperado that she came across. And, as we know, she certainly came across a few.

Speaking of which, the male lead in the B-side 'One More Big Time Rock'n'Roll Star' ('just what I need...' she grumbles) sounds familiar. With regard to the lyrics, as Nicks said in an interview with *The Boston Globe* at the time, "It's such a rock-star thing to send flowers. It's sick to send a $150 arrangement of flowers and think that that's going to make it OK." Hello again, Don. That hot/cold 'Love 'em and Lear 'em' attitude strikes again.

Another duet to turn up on *Enchanted* would be 'Whenever I Call You "Friend"' with Kenny Loggins (or 'Slave Driver' Loggins, as Stevie jokingly referred to him) from way back in 1978. The track, a true-blue seventies soft-rock love song, was included on Loggins' album *Nightwatch*, but evidently Nicks was given permission to feature it here too. Musically, it was a departure from Nicks' usual style but, as Loggins puts it, "It seemed like she could sing just about anything and make it a hit. Hers was a rambling, free-form lyrical style that she would then arrange into a musical form."

Stevie's duets remain some of her most classic moments as far as Loggins is concerned. She had spent years harmonising and blending her voice with Lindsey's, and it showed. "My favourite stuff of hers was when she teamed up with Tom Petty," adds Kenny. "I thought their

voices were great together. Her duet with Don Henley ['Leather And Lace'] was pretty great too."

Naturally, the Nicks/Petty track 'Stop Draggin' My Heart Around' would feature on *Enchanted*, and there would also be a glimpse of Lindsey Buckingham, thanks to the inclusion of Stevie's Buckingham Nicks-era song 'Long Distance Winner'. Naturally, Buckingham would be present in all sorts of other ways too, not least because so much of Stevie's writing has always centred around him. The track 'Gold And Braid', a live favourite developed with Tom Moncrieff and shelved during the *Bella Donna* sessions, is "about Lindsey wanting more from me in our relationship. But wanting to know everything about someone, which goes hand in hand with being in love, was never something I've ever wanted to share with anybody. Professionally, everybody always wanted me to be their idea of what I should be. I'd flat-out look at people and say, 'You know, I'm not gonna do what you want, so why do you bother?'"

'Gold And Braid' takes us back to a time when one of Lindsey's main problems was how Stevie was onstage, in comparison to how he would have liked her to be. Back when Buckingham Nicks first joined Fleetwood Mac and started touring, Stevie, as Lindsey's partner, was "acting too sexy on stage, with my dancing and all that. But I like doing that. [I] told him: 'I can't be your Stevie up there.' I'm not telling *him* how to act. It bothered him when the audience would go crazy about me.

"I always took the line a performer should decide for him/herself what he/she wants to do on stage," Stevie continued. "Other people shouldn't interfere in that. Lindsey didn't agree. He's the kind of man that likes timid women, very introverted, serious. I like talking to people. Sometimes I'd go to the edge of the stage to say 'hi' to the people who, after all, did come for me." Perhaps Stevie's blithe assumption that the audience had largely 'come for her' irritated Lindsey too. Still, the lyrics to 'Gold And Braid', a song written when the couple were very much at war, resolve her feelings and reach out to him. "I never did not love you, I never did run from you..."

Another favourite on the box-set would be 'Ooh My Love', a very Stevie-story about a 'trapped princess' who is terrified of the outside world, and, of her earlier songs, the paranoid 'Kind Of Woman' would appear, detailing Stevie's fears of Lindsey straying. Fellow *Bella Donna* track 'After The Glitter Fades' was also selected, a song written before the glitter glittered, indeed, in 1972, shining a light on Lindsey and Stevie's early days in LA and their love of singing together. (Stevie had originally wanted Dolly Parton to sing this track but was, at the time, unable to reach the megastar.)

The box-set takes us from pre-Buckingham Nicks, with 'It's Late', a favourite of Stevie's grandfather AJ's, and 'Rose Garden', to more contemporary releases, including a pensive cover of a Sheryl Crow song, the blues-inspired 'Somebody Stand By Me', part of the soundtrack for the 1995 Drew Barrymore vehicle *Boys On The Side*. Disc three of *Enchanted* was very much a cornucopia of Stevie's movie songs, while the first two discs were selections from her solo albums.* *Enchanted* would hit the shelves, amid much anticipation post-Mac reunion tour, on April 28, 1998**, exceeding initial sales projections for the first week (shifting 56,000 units) and remaining a fan favourite to this day. The final track, a minimal piano version of 'Rhiannon', draws the curtain on the collection.

A 37-date US tour kicked off a month later on May 27 in Hartford, Connecticut, one day after Stevie's 50th birthday. Nicks celebrated her half-century in style and was lavished with 'fabulous presents', naturally. "I got a diamond pendant and a diamond ring," she boasted

* Stevie and Sheryl Crow also recorded two Nicks songs for the 1998 Sandra Bullock movie *Practical Magic* – 'If You Ever Did Believe' and a new, Stevie-led version of the Buckingham Nicks song 'Crystal'. Crow was an artist who tapped into Stevie's love of country music and Nicks would come to regard her as "the little sister I never had," while Sheryl hailed Stevie's unique combination of "beauty, mystery, talent and power". Love-in alert.

**This would also be the year that Fleetwood Mac were inducted into the Rock'n'Roll Hall of Fame, and in addition to this honour they were given the Outstanding Contribution accolade at the BRIT Awards, presented to them by the producer Sir George Martin.

mischievously, as well as 50 silver roses from Don Henley, no less. Don't get too excited – they'd just recently worked together for Henley's Walden Woods conservation benefit at LA's Wiltern Theatre, and no doubt Ms Nicks had dropped a few hints about her big day (only joking, Stevie) in his earshot.

The Walden Woods organisation was formed in 1990 to preserve the land around Walden Pond in Concord, Massachusetts, where *Walden* author Henry David Thoreau lived and worked. For the benefit, titled 'Stormy Weather', a bevy of brilliant female artists including Joni Mitchell, Björk, Natalie Cole, Gwen Stefani and Sheryl Crow appeared, as did, of course, Stevie Nicks, who strode on in a sensational red ball gown and performed Etta James' 'At Last' to a jubilant crowd. Backstage, the stars mingled and Stevie and Sheryl Crow made a beeline for each other. They had previously met at the Grammy Awards after-show party for *Boys On The Side*, but, as Stevie said, "It wasn't until we both did [the] charity benefit for Don Henley that we sat down and talked properly about recording together. I thought, 'If it doesn't work out at least we'll each have a new friend.'" Stevie knew she wanted to write with Sheryl on her next solo album, *Trouble In Shangri-La*, the record she had put on hold when Fleetwood Mac reunited the year before. All in good time.

After the benefit, Stevie and her band threw themselves into rehearsals for the *Enchanted* tour, with Nicks telling everyone, "Well, this is our big chance to be 'enchanted'. When I do my next record it's definitely on a much more serious vein [sic]..." This tour would indeed be rather more fun than usual, not least because Stevie was promoting a box-set rather than a conventional solo album, freeing her up to sing what she wanted onstage.

On this tour, Stevie would also address her audiences far more than she normally would, sharing nuggets of information hitherto unknown – providing a live version of her revealing liner-notes, perhaps – such as the background to her early track 'Garbo'. The song was actually inspired by the "infamous *Buckingham Nicks* album cover..." After having been snapped at by Lindsey – "don't be paranoid, don't be a child..." – Stevie had wondered to herself whether the Hollywood stars

before her had ever felt similarly upset at having to do things against their will, "for art, for music..." said Stevie with a sardonic smile. She wrote 'Garbo' straight after the photo session that had caused her so much anxiety.

Clean, energetic, and with a full schedule ahead of her, not to mention some rather splendid new diamonds, this was the perfect 'enchanted' start to a new phase in Stevie's life, and she was feeling – and looking – better and stronger than ever, having evolved from waif-like gypsy urchin to wise woman of rock. Ms Nicks was no longer a rock'n'roll princess; now she was a queen. In some people's eyes, she was also, still, a witch; and not even a white witch, but a Satanic, black magic-conjuring occultist. Stevie had lost count of the number of times she tried to explain that her interest in the metaphysical was strictly positive, and that her witchy costume onstage was exactly that – a costume – but the ignorant few saw the image and ran with it.

May 28 was a travelling day on the *Enchanted* tour, but as the band and crew made their way from Connecticut to Detroit, a news story was breaking about a ludicrous incident way down South, in Huntsville, Alabama. The previous Sunday, a group of students had been chastised just moments before their baccalaureate service. The reason? They wanted to sing Stevie's song 'Landslide', deeming it an appropriate song with its lyrics about growing older. The music minister at Huntsville High School disagreed, banning the students from performing the song altogether on grounds of Satanism. But of course.

"The music minister said the leader of Fleetwood Mac is a witch and a Satan worshipper," said Emily McDowell, who had intended to sing 'Landslide'. "I was in shock. So I pointed out the fact that I was a Christian and I wasn't singing the song to go against God."

All the uninitiated had to do was listen to Stevie's lyrics and look at the work she was doing to see that she was clearly not a 'Satanist'. In fact, her principles fitted the 'Christian' ideal rather more than those belonging to many in the church. There was always a strong sense of 'service' in her attitude towards her music and her performances – she wanted to 'bring magic' to people's lives; she wanted her lyrics to show them they weren't alone. In addition, Nicks generously gave time and

funds to numerous charities, was sincerely moved (and not just to tears, to action) by those in need and, in the light of both of her parents' heart problems, Stevie donated 25 cents from every ticket sold on her *Enchanted* tour to the Arizona Heart Institute Foundation, raising funds and awareness in one fell swoop. The donations went towards research, the 'Heart Healthy Lessons For Children' programme and the building of a research and education centre on the Arizona Heart Hospital campus in Phoenix.

Stevie was the ideal poster girl for the charity. As her father Jess Nicks, then the chairman for the Heart Institute's International Council, explained: "I've had open-heart surgery twice, her uncle had open-heart surgery twice, her mother had open-heart surgery once, and her grandmother died of heart disease. [Stevie is] a prime candidate for heart disease." Stevie Nicks has a prolapsed heart valve herself, and considering her previous lifestyle, it is amazing the cocaine abuse alone didn't put her coronary health in serious jeopardy.

As Stevie toured *Enchanted* she would be protected by her usual coterie of friends and colleagues, which was just as well – rock stars are vulnerable at the best of times but in July 1998, it transpired that a certain fan had become dangerously infatuated with Stevie. Now, it's hardly surprising that quite a number of fans are completely besotted with Stevie Nicks. Maybe you are yourself. Yes, you, the one reading this. I'm not judging; you're among friends here. But this particular fan didn't just want to listen to *Bella Donna* and maybe catch his heroine on tour. A recently released man from the West Pines mental institution in Denver, Colorado, preferred the idea of kidnapping Nicks altogether, believing she was, yes, a witch who could 'heal him' and help him to "get along with others and find a woman to marry". His intention was not to hurt her, only to "abduct and impregnate her". If he neglected to take his medication, he had the potential to become very aggressive.

Ronald Anacelteo, a 'self-proclaimed homosexual', he had been diagnosed with schizophrenia and, noting that Nicks was on her *Enchanted* tour, had turned up to see her play only to be banned from entering. Having banged on about Nicks constantly while he was in

hospital, clinic staff had alerted the police when they learned he had bought tickets to two Stevie shows, with the hope of getting as close to her as he could in order to receive the healing he needed. He readily admitted that if he had the opportunity, he would kidnap her in order to "make babies", having been taken in by a vile homophobic church campaign that proclaimed gay people required 'healing' to make them straight. Stevie, naturally, took legal advice and had a restraining order brought out against him, barring him from all of her concerts, studios she was likely to be working in and, of course, her home.

It was a frightening time and the Nicks entourage was on red alert, not least because Stevie's troubled admirer had also worked out where she lived. Trouble in Shangri-La indeed. The entire ordeal was symptomatic of the very theme Stevie had chosen for her next solo album – the unique extremes and fears, the darkness under the glitter, the issues that arise from fame and fulfilled dreams that can be too hard to handle.

Fortunately, Stevie would be safe; it wasn't such a bad thing that she was rarely alone – and at least the ordeal would go some way to take her mind off the news she had recently received about Lindsey Buckingham. On July 8, Stevie's former lover had had his first child with partner Kristin Messner, a boy called William Gregory. The news was bittersweet even though Stevie had, as Buckingham himself rather crassly put it, "been through" an abundance of men, and stated that she knew they were "over" when Lindsey walked out after *Tango In The Night*, some years after she actually left him.

But still, he occupied a huge place in her heart and her mind, and perhaps their earnest talks, renewed closeness and fiery onstage passion during *The Dance* had given Stevie hope that they might end up together after all – she would later admit, with a chuckle, that when she saw him behaving with such uncharacteristic gentleness with his new family, she would say to herself, "Oh Stevie, you made a mistake..." During an interview with MTV.com's Kim Stoltz, Stevie bravely confessed that the day she knew her romance with Lindsey was over was "the day his first child was born. I knew that was it... that was the definitive thing." Stevie was still clearly nursing the embers of the love of a lifetime.

The *Enchanted* tour concluded on August 14, 1998 at A Day In The Garden, Woodstock, with Stevie flying in on a helicopter over the hordes of people to whom she would soon be singing. "It was so incredible!" she enthused to the audience as the rain clouds rolled in over Bethel, New York. Despite the dramas that had punctuated the dates, a youthful, bright-eyed Stevie hit the stage with a wide-open smile and a pitch-perfect voice. However, during that final show at Woodstock in the open air, Stevie broke down as she performed her encore number 'Has Anyone Ever Written Anything For You?' The crowd wept with her as she struggled through, the meaning of the song, written for Joe Walsh and the loss of his daughter, still so close to the surface. But it was also clear that Stevie, in her euphoria mingled with sadness, was still fragile. This was her first sober solo tour. She was finally seeing and engaging with just how much love there really was out there for her.

"Can we do this again?" Stevie asked the audience, as she tearfully closed the final *Enchanted* show, before adding tellingly: "It would be so good for me." The crowd howled their approval as she bit her lip, her eyelashes wet. This was immersion therapy – night after night Stevie had been immersed in the unquestioning love of her fans, unimpeded by the usual hazy wall of drugs and alcohol. In her lonely moments, when she remembered she had no cocaine as a crutch, no future with Lindsey, no children of her own, that helped.

Chapter 29

A date for your Stevie Nicks diary (you have a Stevie Nicks diary, right?):

Every May in Manhattan there is a drag parade called 'Night Of A Thousand Stevies', and, at the time of writing, this glamorous caper is approaching its 25th anniversary in 2015. Everyone dresses up according to the given Nicks-related theme, and, one day, 'The Goddess herself' has promised to turn up in disguise. "Not one of you will know it's me until I walk onstage and sing 'Edge of Seventeen'," she said enigmatically. See you down the front.

1999 beckoned and work on *Trouble In Shangri-La* had been postponed for long enough. Nicks had started writing and recording demos for it back in 1994; 'Love Is' and 'Trouble In Shangri-La' were early contenders and provided "the beginning and the end" of the album, according to Stevie, and 'That Made Me Stronger' – that nod to Petty's pep-talk – was another song from this period just bursting to be heard. Meanwhile, the 'trouble' to which Stevie refers in the album title would not only symbolise her (ultimately successful) fight against her own demons, in contrast with her 'fairytale' life, but the many stars struggling away on their apparently diamond-studded path.

"If you're in show business, there is a price," she said. "You get to have Shangri-La, but people just go crazy. It's not [as] wonderful as

everybody thinks sometimes. [The title track was written] in the last few months of the O.J. Simpson trial*; it wasn't really about them, it was just about how people make it to the top of their field and can't seem to handle it. I've seen so many people screw up paradise, including myself."

All in all, it would take several years until *TISL* would emerge into the sunlight, having lain dormant thanks to the Fleetwood Mac reunion and *Enchanted*. However, anticipation for the release was high: it would be the first Nicks solo album to feature new work since *Street Angel*, therefore it would also be her first solo album recorded drug-free, and that clarity would make a considerable difference to the quality of the finished product. As soon as Stevie had recovered from the *Enchanted* tour, she resumed project *Shangri-La*, lining up a crack team of producers and musicians that would include new pal Sheryl Crow, who contributed the song 'It's Only Love', most of the Heartbreakers, of course, and the producer and songwriter John Shanks, who had previously worked with Melissa Etheridge, Bonnie Raitt and Joe Cocker. The 13-track album would eventually be released one year into the new millennium – Stevie never did like to be rushed.

The flamboyant John Shanks was, as one friend observed, "a bit of an LA professional, perhaps not the best fit". To be fair, Stevie had actually earmarked Sheryl Crow to produce the whole record, but clashing commitments meant she "produced as much of it as she could and then had to go and do her own thing," Nicks explained to chat show host Rosie O'Donnell. "Then she came back and helped with a little more of it, and really has been my saving grace. She's like my angel." Small world that the music business is, 1999 would see Sheryl in the studio with Prince to sing on his album *Rave Un2 The Joy Fantastic*, as well as

* Ex pro footballer and actor O.J. Simpson was tried on two counts of murder after the deaths of his ex-wife, Nicole Brown Simpson, and a waiter, Ronald Lyle Goldman, in June 1994. The case has been described as the most publicised criminal trial in US history. Simpson was acquitted after eight months. At the time of writing, Simpson is incarcerated in a Nevada prison after being jailed in 2008 for armed robbery and kidnapping.

making her acting debut in *The Minus Man* alongside then boyfriend Owen Wilson. Meanwhile, back in Shangri-La, Mike Campbell stepped in on production, as would Rick Nowels, Shanks, of course, and Stevie herself.

To Sheryl, Stevie has always been "one of the few people who takes care of me. If I'm sick, Stevie will come over with a cashmere blanket; that's how she is. She's a big rock star, and she doesn't need to drop everything, but she cares about people," she told *The Independent*, going on to quash any assumptions that Nicks could possibly be competitive, egotistical or anything other than sweet. "When I was first Grammy-nominated she was very supportive. Other female artists seemed to ignore me but Stevie didn't have any of that.

"Stevie can never know how much of an inspiration she's been to me," Sheryl continued. "Her singing style... she came out of blues and country, and when I first heard it, it validated what I liked. To me she was the greatest female songwriter of her generation, and I don't know of anybody today who gets so lost in the mystery and power of their music."

That's not to say Crow and Nicks shared the same traits or tastes – Stevie loved shawls and frills while cowgirl Sheryl had more androgynous tastes, and, in the studio, Stevie found Sheryl to be rather more organised than her, while Sheryl observed that Stevie didn't always look after herself, preferring coffee to water, even if her voice started to dry out. Sheryl's main observation during sessions, however, was that Stevie had previously been in the studio with male producers, who, in many cases, "want to make her into something that is maybe not as intimate as what she sees her music as being".

Whether Crow noticed this from the point of view of a fellow female artist contending with the same issues in her own career, or simply as a sensitive person on the same wavelength, Stevie loved that Sheryl "gets it, she understands the life of a woman in rock'n'roll. There's no room for playing games with her or saying, 'You don't understand what I'm going through.' She understands and that's brought us closer than I can explain."

Normally there were few people Stevie could really relate to, but both women had had a similar path: finding solo fame at 29, taking care of everyone on the road and acting the 'matriarch'... Now Stevie had

a female friend with whom she had plenty of experiences in common and was on the same level – another star in her own right rather than an employee, or someone who would inevitably defer to her. Nicks whisked Sheryl to Hawaii for a holiday in a luxurious rented abode, just as she had done with Sara Recor, Sharon and Lori and all of those she felt close to. "She knows how to live," laughed Sheryl. The friends took a catamaran and "sailed to Molokai for 10 days", remembers Stevie. "It was great, because nobody was going to mess with Sheryl and me together. We were like Thelma and Louise."

The pair would record Nicks' early song 'Sorcerer' as a duet, and the track would be released as the album's second single (the Shanks-penned 'Every Day' being the first). Sheryl challenged Stevie to "explore different parts of my voice", and, for Nicks, the process was reminiscent of singing with Lindsey. The resulting version of 'Sorcerer', with its sensual, confident country-rock arrangement, shone, stomped and rang out just as Stevie had hoped it would. After thirty years of being knocked from pillar to post – performed live by Buckingham Nicks, considered then rejected for *Tusk*, recorded with Marilyn Martin on backing vocals for the 1984 movie *Streets Of Fire* – 'Sorcerer' had found a home, and this song would be one of the highlights of the album.

Stevie also wanted to include two more vintage songs, one the mysterious, mandolin-led 'Candlebright', a track born in 1970 that reflected the nomadic streak of this curious 'lady from the mountains', before she even *was* a nomad. "I'd never lived away from my parents when I wrote that song. I had no idea what was coming. But I think that song is a pretty amazing premonition, because it really is about how I would always travel and basically keep the light in the window so I could find my way back." And Stevie expresses that gypsy-like tendency even when she isn't on tour. Why do you think she has more than one house? When she needs fresh surroundings, she simply throws her favourite things in a bag and moves on, "for no special reason".

'Candlebright' is another strong moment on *Trouble In Shangri-La*, although, as far as many die-hard fans were concerned, you could rarely

go wrong with any of Stevie's output. There was always a sense of familiarity thanks to the fact that she generally used the same chords and phrasing, always fond of the notes that took her rasping voice from 'fah' to 'mi' to 'do' on the 'do-re-mi' scale. (Sing it and you'll see what I mean.)

While perhaps the effect on fans was subliminal, this was something that had inevitably been noted by the musicians around her, particularly Stevie's musical director Waddy Wachtel. He found it frustrating at first, but soon realised the repeated use of the same chord progression was actually Stevie's secret weapon when it came to introducing unfamiliar work live – something artists are rarely wont to do if they want to hold their audience's attention.

Waddy: "I said one night on tour, 'Once again you amaze me... normally if one plays new songs for people, they go, 'We don't want to hear that.' But *your* songs, because they embrace those same chords, you're in. It's so funny because it's always been like a criticism between her and I: 'Stevie, you gotta get off those fucking chords!' But afterwards, I had to say: 'Well, I'm wrong again!' It's a comfort factor for her fans. It's a security blanket."

Like 'Candlebright', 'Planets Of The Universe' would be another song to be brought into the light after twenty years waiting its turn, a *Rumours* reject dating back to when Nicks and Lindsey Buckingham's relationship was imploding. This was no 'Dreams', however and, lyrically, 'Planets' presented something of an issue; while Stevie normally managed to remain admirably magnanimous in her dedications to Lindsey, this song contained a verse written in the heat of the moment that addressed her ex-lover a little "too spitefully", Nicks confessed. Therefore, the version on *Trouble In Shangri-La* does not include the bitter lines that command Lindsey to "take your leave"... "don't condescend to me..." before stating: "I wish you gone / And I don't care / I don't care / I don't care..."* Protesting too much, naturally, but either way, Stevie

* The full-length version of this song would also appear on a six-track single release in 2001. Also, it would be on 'Planets' and 'Bombay Sapphires' that Stevie would play keyboards for the first time on one of her records.

wanted to neutralise the poison on this, the third single from *Trouble*, even if it was obvious that the story behind the song was now ancient history anyway. (The full unedited version would be included on the 2004 reissue of *Rumours*.)

However, the more recent track 'Fall From Grace' would show that, while much of the ire had dissolved, confusion and dissatisfaction raged on between Nicks and Buckingham. 'Fall From Grace', written on *The Dance* tour the previous year, asked quite openly, as the protagonist sits alone in her hotel room: "Was I so wrong? Why am I always so intense?", trying to pluck answers from the air. She was experiencing a melancholy sense of *deja vu*, "in this same place I sit / The same place as before..."

The dramatic, revealing 'Thrown Down' was also written during this time, chronicling how the estranged lovers had again become confidants on the tour. (This song would not, ultimately, be included on *Shangri-La*, turning up later on the 2003 Fleetwood Mac album *Say You Will*.)

The lyrics to 'Thrown Down' describe how "he fell for her again, she watched it happen..." – as did everyone else – and goes on to note "how difficult it had been to be without her." (One must assume these words were inspired by real conversations and not a blatant lack of modesty.) The barricade had been 'thrown down' after many years and changes had passed between them, and "maybe now he could prove to her", Stevie sings in the chorus, "That he could be good for her / And they should be together." Stevie might have been known for her often obtuse poetry but there was nothing cryptic about that. These words were like the jottings in a love-struck teenager's diary. Was it fantasy? Reality? A little of both, maybe... and it's uncertain as to where Lindsey's wife Kristin fits in to all of this. Admittedly, she must have accepted that, in a strange way, "Lindsey and Stevie are always going to be an item of sorts," as Mick Fleetwood put it. "They have an unsquashable alliance whether they like it or not." And at the moment, it appeared, they quite liked it.

"Lindsey and I have come through this whole thing," Stevie said breezily. "He lives ten minutes from me. I can jump in the car and go over there." Would that be wise? Or appreciated? Who can say? But their cautiously salvaged friendship meant the world to them, they

had been through so much together and nothing, no one, could take that away from them. For *Trouble In Shangri-La*, Ms Nicks also invited Lindsey himself to play on the unambiguously titled 'I Miss You' (the first time Buckingham had played on a Stevie record). "Time and distance never matter," Stevie crooned. No further questions, m'lud.

'Fall From Grace', meanwhile, would meet with some opposition from John Shanks, who felt it had too many verses. Many Nicks songs do have an abundance of stanzas, having started out as poems, but Shanks wanted Stevie to get ruthless, just as she'd had to be with her beloved 'Silver Springs' three decades ago. Chopping down her creations was always painful.

One day, however, some avenging angels came to the rescue. Sheryl Crow had invited her actress friends Laura Dern and Rosanna Arquette into the studio as Nicks was agonising over 'Fall From Grace'. The women saw the original draft of the lyrics and loved the words so much, they rounded on Shanks, forcing him to change his mind.

With Stevie it was, as the more empathetic producer Rupert Hine has observed, never about the rules, the technical side, or indeed about "musical masturbation, [rather] she wants the song to communicate. Sometimes the mechanics of verses and choruses and bridges and middle-eighths can be a bit wearing for her. I think she's had less successful relationships with producers when they've been more bothered by that side of it." 'Fall From Grace', to Stevie, is the perfect leveller to 'Edge of Seventeen' in terms of energy and it's interesting that, on this most feminine of albums in terms of who collaborated on it, it should be a strong band of ladies to protect one of Stevie's cherished songs.

As always, collaborations and duets would loom large on Stevie's album, but this time, most of the team-ups would be with other women. Perhaps inspired by her sisterly new friendship with Sheryl Crow, Stevie invited singer-songwriter Sarah McLachlan to provide piano, guitar parts and backing vocals on the track 'Love Is'. (McLachlan also drew the dragon that makes up the 'S' in Stevie's name on the album cover.)

Stevie likes to have the radio on as she drifts off to sleep and she first discovered McLachlan's music when she was drifting off one night only to be "pulled out of sleep" by the sound of Sarah's haunting voice and

dark, passionate lyrics. Now wide awake, Stevie listened for the DJ to announce who the track was by. All he said was "That was a new thing from Sarah that's called 'Possession'." Stevie takes up the story:

"So I wrote down: 'Sarah. Possession.' The next morning I said to my assistant, 'You have to go get this record that's called 'Possession'. I don't know if that's the name of the album or the song. All I know is that this lady's name is Sarah...' which, of course, is my favourite name."

It was meant to be. As Stevie concluded, Sarah has been "a total part of my life ever since". There was no doubt that Sarah McLachlan was talented, but she had something else, something that Stevie had seen back in the late sixties at the Fillmore in San Francisco. "[Your] music reminded me of how I had felt about Janis [Joplin]," Stevie told Sarah. "I thought, 'Somehow this woman reminds me of the incredible music that came out of San Francisco when all of us were so knocked out to be alive.' I thought, 'Wow. She's ticked into an incredible thing here. Somehow she's new, yet she must be a very wise, old soul, because she's put it all together now, but she's still a little antique.'" A compliment indeed.

Stevie would also invite Dixie Chicks singer Natalie Maines to lend her vocals to the song 'Too Far From Texas', a Sandy Stewart track. Stevie contacted Natalie through Sheryl because, "of course, Sheryl Crow knows everybody in the world," joked Stevie. "If you need anybody, call Sheryl – she'll have a number."

After listening to Sandy's song with Sheryl by her side at home in Phoenix, Stevie turned to her friend and said, "What do you think? Do you think Natalie and I could sing this?" Sheryl suggested sending the song to Natalie. "Within two days, me, Natalie, Sheryl Crow on bass, Waddy Wachtel, Mike Campbell, Benmont Tench and Steve Ferrone went into Michael's home studio, and basically it's like Natalie and Stevie and Sheryl and the Heartbreakers, without Tom," chuckled Stevie. "We replaced Tom with us."

A break in the proceedings would be called for in January 2001. President Bill Clinton was leaving office, handing America over to the Republican George W. Bush, the eldest son of George H. W. Bush,

who had preceded Clinton back in 1993. Hillary Clinton had organised a farewell party, and, to "complete the cycle", as Lindsey Buckingham said, invited Fleetwood Mac to play – as a surprise – at the ball. Just after Christmas 2000, during that post-turkey lull when nothing much happens, the band received the call from the White House.

Fleetwood Mac had just two weeks to get their heads together and prepare for the performance, which would take place on January 6, 2001. They hadn't played together for three years. Lindsey picked up the phone and called Stevie. "I said, 'Jeez, do you think we can pull this off? We need to rehearse, right?' They wanted an hour, so we figured we could rehearse for three days and put together just the workhorses for the set, which we did. Christine's lack of presence wasn't really felt too much. We have some singers who filled in those parts and it went very smoothly. We were involved in a small way in ushering in his administration, so it was nice to kind of complete that cycle."

Stevie knew it would be a high security event, but was still amazed by just how hard it was to get into the White House (although little did Stevie know she would soon have her very own flag on Capitol Hill in honour of her charity work). The Mac played eleven songs, sticking to the hits, and Stevie was touched when she glanced over to see Bill Clinton dabbing his eyes during 'Landslide', its lyrics no doubt especially poignant to him at this stage in his life. It was a more reflective song than the strident 'Don't Stop' of the Clinton campaign of yore, he *was* getting older... and, come to think of it, maybe the word 'landslide' wasn't exactly what he wanted to hear in the light of the current situation. His own victory over Bush senior had indeed been a landslide, but as the song describes, changes were afoot, anxiety abounded and a new season was underway, making America feel distinctly chilly.

★ ★ ★

Back to work, and the eccentric pop singer Macy Gray would be the latest voice to appear on *Trouble In Shangri-La*, although Stevie admitted she wasn't her first choice. Stevie was looking for an unusual, high but husky vocal for her song 'Bombay Sapphires' (*not* inspired by gin, she

has insisted, having included the 's' on the end in an attempt to clear up any confusion. It didn't work.) and originally wanted to feature her old crush Sting, but "chickened out".

"The only reason Macy is on the record is because we're managed by the same people," said Stevie a little bluntly. OK then. Nicks was clearly in a better mood when she was called upon to provide quotes for the album press release in 2001, however, gushing about Gray's "wild, intense vibe. She walks into the room and it's like everything starts to move. She's like a walking tornado. She's a total blast. We had a great time working on the song. Our voices blended so well together."

Away from the party line, Stevie Nicks admitted in an interview with NPR's Ann Powers that "some people cannot sing harmony..." Macy Gray was, apparently, one of those people. "I wanted her to sing the harmony and she said, 'Stevie, I can't do it.' So I had to go out and sing the harmony without the melody, and then she went out and sang in unison with me, in order to get her to sing the higher harmony. She was like so irritated with herself. I'm like, 'It's fine, it's fine.' It's amazing and she sounded great, but we had to work really hard on it, because that's not what comes to her. She wants to sing straight melody." Macy Gray ain't no backing singer.

The 'Bombay Sapphires' we hear on the final cut was the third version that had been recorded, and this one was produced by Stevie Nicks. "It was easy," shrugged Stevie in an interview with VH1.com, "because it was exactly what I wanted to do. It was done in one night. I really did have a vision for that song, and [on earlier attempts to record it] nobody else saw my vision. The first time it was too R&B, the second time it was too Wagner, dirge-like. The third time it was back to its little funky reggae self." As for the title, well, 'Bombay Sapphires' was inspired by actual sapphires from Bombay. (Again, *not* liquor – and Stevie would never write about gin anyway, because "it makes you *mean*.") "It's a blue-grey kind of star sapphire," Stevie explained. "It's the colour of the ocean." Or the colour of, say, the glass bottle used to contain a certain brand of gin, the name of which escapes me at this moment.

Despite the wrangles, 'Bombay Sapphires' would be Stevie's favourite track on the album; it conveyed a message she wanted to share with the

A mid-Eighties Stevie in all her voluminous, if glassy-eyed, glory. MIRRORPIX

The post-Lindsey Buckingham line-up of Fleetwood Mac. Rick Vito is on the far left, while Billy Burnette stands between Stevie and John McVie. Vito and Burnette joined the band in 1987, their tenure lasting until 1991. THE LIFE PICTURE COLLECTION/GETTY IMAGES

Stevie and Don Henley perform at the Concert for Artists' Rights at the Forum in Inglewood, California, February 26, 2002. KMAZUR/WIREIMAGE

Stevie Nicks steps out with British producer Rupert Hine. The pair worked together on Stevie's 1989 solo album *The Other Side Of The Mirror*. TOM WARGACKI/WIREIMAGE

A straight-haired Stevie poses in one of her favourite top hats – an enduring part of her 'Rhiannon' costume.

US President Bill Clinton shakes hands with Michael Jackson as Fleetwood Mac perform 'Don't Stop' for the inauguration festivities in Maryland in 1993. AFP/AFP/GETTY IMAGES

Fleetwood Mac after being inducted into the Rock and Roll Hall of Fame in 1998. The thirteenth annual Rock and Roll Hall of Fame induction dinner also honoured Santana, The Eagles, The Mamas and Papas, Lloyd Price and Gene Vincent. JON LEVY/AFP/GETTY IMAGES

One of many emotional moments on stage between Stevie Nicks and Lindsey Buckingham during Fleetwood Mac's televised reunion concert, *The Dance*, at Warner Brothers Studios, May 23, 1997, Burbank, California. NEAL PRESTON/CORBIS

Rod Stewart and Stevie perform at Philips Arena in Atlanta, Georgia on March 24, 2012. The show was part of their co-headline *Heart And Soul* tour. RICK DIAMOND/GETTY IMAGES

Stevie and musical soul mate Sheryl Crow perform at the 10th anniversary celebration of the National Breast Cancer Coalition in New York City, March 6, 2002. LAWRENCE LUCIER/GETTY IMAGES

Stevie performs during the Epicurean Charitable Foundation's fifth annual benefit concert in her beloved Las Vegas, Nevada, December 8, 2006. ETHAN MILLER/GETTY IMAGES

Stevie, second from right, and from left, Charles Kelley, Hillary Scott and Dave Haywood, of the musical group Lady Antebellum, perform on stage at the 49th annual Academy of Country Music Awards at the MGM Grand Garden Arena, Las Vegas on Sunday, April 6, 2014. CHRIS PIZZELLO/INVISION/AP

Stevie with Tom Petty & The Heartbreakers. Stevie has always been proud of her longstanding association with The Heartbreakers, and was thrilled when Petty presented her with a platinum brooch proclaiming her 'the only girl' in their band. TIM MOSENFELDER/CORBIS

Dave Grohl and Stevie perform at the premiere of Grohl's documentary *Sound City* at the Hollywood Palladium on January 31, 2013 in Los Angeles. The film celebrates the history of the Sound City studio, where Buckingham Nicks cut their first record with producer Keith Olsen.
KEVIN WINTER/GETTY IMAGES

Glamorous and poised as ever, Stevie Nicks is the proud and deserving recipient of the BMI Icon Award at the Beverly Wilshire Four Seasons Hotel in Beverly Hills, California on May 13, 2014. LESTER COHEN/WIREIMAGE

world: "You don't have to stay in a bad situation – you can see past the problem and to the 'white sand and ocean...'" This line would be inspired by a trip to Hawaii two years earlier, where Stevie retreated to take stock of the changes in her life. She found that "if you take yourself to a great environment, you can just about get over anything." True, not everyone can whisk themselves off to a luxury resort when they're feeling glum, but we can always use our imaginations (in the meantime).

"I was looking outside one day and it was like I was almost seeing my past as something I really wanted to leave behind for a while," Stevie said. "I was looking *past* the past, out to the ocean and how beautiful it was and how white and inviting the sand was... For me, it was very important that that song be on the record."

Moving on was very much a core theme for Stevie at this time, especially after having been so involved in retrospective work over the preceding three years. "The box-set really was all about the past, and the Fleetwood Mac reunion was all about the *Rumours* songs..." Stevie said. "I felt a necessity to go into the future. Because when you're in a great old band that still exists, you can always live on that. Or you can go ahead and do your own thing [alongside] that."

Much of the album would be recorded in intimate studios such as Mike Campbell's, but Stevie always loved to use her home as much as possible, and the album cover itself would display the glorious sunset view from Stevie's "back yard", as she refers to it. (The words 'back yard' conjure up images of the terraced houses in the British soap opera *Coronation Street*. Stevie Nicks' ocean-facing 'back yard' is not *quite* the same.)

The image, taken by former lover Neal Preston, is of Stevie with her back to the camera, looking out over the view, the colours heightened as the 'magic hour' just before twilight descends. In actual fact, the picture of Stevie to grace the cover was meant to have been taken from the front, but Preston snapped a quick Polaroid for lighting as Stevie walked through the archway and onto the platform that jutted nerve-rackingly over the sea below from a considerable height.

"After the whole session was over and everyone had gone home, [the Polaroid] was lying on a desk and I picked it up and went, 'Oh, this is it!'

We don't even need to go through the rest of the film.' And there was not a picture in the rest of the film that would have worked.

"I said, 'Every little girl at three is going to want to be her, and every 90-year-old woman is going to want to be her too, because that really is a fairytale princess image.'" And it was; with her long hair and peach chiffon flowing in the breeze, her platformed feet in motion, there is a hint of Rapunzel gazing at the horizon from her tower – although *this* Rapunzel looks as if she is about to take flight and glide into the sunset – no rescuer required, thanks.

Back on Earth, the album itself would soar; released on May Day 2001, an auspicious date*, the record would enter the *Billboard Top 200* at number five, something that had evaded Stevie's releases since *The Wild Heart* in 1983. Stevie would have been immensely proud of *Trouble* anyway, but it didn't hurt that it would be certified gold within six weeks of its release, and even prompted the usually critical Lindsey Buckingham to break tradition; not only did he praise the album, he proclaimed it the best solo album Stevie had ever made. Well, he was on it himself, after all.

Stevie's favourite item: her precious Tiffany blue lamp. She even wrote a song about it – 'Blue Lamp' (which turned up on Enchanted, *left over from the* Bella Donna *sessions). A gift from Stevie's mother, as we know, it dates back to the time Buckingham Nicks first joined Fleetwood Mac and "symbolises the light that shines throughout the night", as Stevie puts it. "Because Fleetwood Mac was a definite light at the end of the tunnel." Stevie has kept that lamp switched on for decades. "It was the first really beautiful thing that I got. I ended up carrying it back from Phoenix to Los Angeles on the plane and they didn't want to let me on with [it], and I said, 'Well, you're gonna have to run over me, 'cause we're not going without the lamp.'"*

* The ancient festival of Beltane is celebrated on or around May Day. This holiday marks the halfway point between the spring and summer solstices and would be a day of feasts, fires and rituals to encourage growth, abundance and fertility, hence the dancing around the phallic maypole.

Chapter 30

Some advice from Stevie: "Don't fall in love with a rock star. They're out there on the road and they're meeting lots of girls. Eight months into a tour when you're in Omaha, and there is nobody there and you're lonely, you just can't ask them to sit in their room and watch a movie. That's the way of the beast, you know?" Alternatively, ask the manager to re-route the tour so it doesn't hit Omaha.

Another album to be released on May 1, 2001, alongside *Trouble In Shangri-La*, was Destiny's Child's *Survivor*, which featured the hit single 'Bootylicious', a song very much made by the fact that it samples the one-note riff from 'Edge Of Seventeen'. The story behind how Destiny's Child came to use the sample is a subject of some dispute; Beyonce claims to have heard 'Edge Of Seventeen' while on an aeroplane, the riff putting her in mind of a "voluptuous woman" with attitude. She started humming along, eventually writing a song around it that celebrated the curvaceous female form, the lyrics a reaction to the constant media scrutiny over her weight. That's one version of the story.

The other version is that producer Rob Fusari had the idea of using the riff from 'Eye Of The Tiger', but after not being able to secure it, used the 'Edge Of Seventeen' riff instead. He wasn't happy when he heard Beyonce cheerily claiming credit, and rang Destiny's Child manager

(and Beyonce's father) Mathew Knowles to complain. The upshot was that Knowles "explained to me, in a nice way, [that] 'People don't want to hear about Rob Fusari, producer from Livingston, N.J. No offence, but that's not what sells records. What sells records is people believing that the artist is everything.' And I'm like, 'I understand the game. But come on, I'm trying too. I'm a squirrel trying to get a nut, too.'"

Stevie only realised her song had been sampled when, during an interview with Barnes & Noble, the journalist asked whether she had heard it. Stevie was thrilled – she kept up with MTV and VH1, so Beyonce Knowles and co. were no strangers to her. "I love Destiny's Child," she enthused. "I'm totally honoured! I think these girls can really sing, so they're OK in my book." On learning that, during the chorus, the words "I don't think you're ready for this jelly/My body too bootylicious for you, babe," are sung, Stevie was mock-shocked. "Oh my goodness," she squealed. "I'll try not to turn into my mother, Barbara, and give them a quick call."

She wouldn't have to. During the week of *Survivor* and *Trouble In Shangri-La*'s release, Stevie was promoting her album on *The Rosie O'Donnell Show*, while Destiny's Child were up the hall rehearsing for *Saturday Night Live*. During a break, Stevie and Destiny's Child got talking, and the result would be a cameo performance from Stevie Nicks herself in the 'Bootylicious' video, being filmed in LA later that week. Stevie, looking at least 15 years younger than her actual age, is seen strutting on the spot with a guitar around her neck, playing the riff normally taken care of by Waddy Wachtel, greeting the camera with a mean glare and a pout.

Nicks, visible for just a few fabulous seconds, had fun on the shoot and would maintain an enduring admiration of Beyonce, later proclaiming her "great. She's got her alter ego [Sasha Fierce], but Beyonce the girl, the woman, is very sweet and nice and polite. She's a good role model. She's not skanky. I'm glad we have her." Stevie doesn't dish out compliments like that to everyone, as those who recall her reaction to Britney and Madonna's publicity stunt smooch, or Nicki Minaj's attitude problem on *American Idol*, will testify. All to come, dear reader, all to come.

May 2001 was a particularly special month for Stevie; not only would she celebrate her birthday (as, to be fair, she did every year), and release a solo album she was proud of, but a circle was being completed. The remastered, expanded version of *Rumours* would be released on May 29, and the track list would include 'Silver Springs'. Better late than never. No doubt the public response to Stevie's astonishing live rendition of the song on *The Dance* didn't hurt.

"It's incredible," said Stevie. "Because they're putting the old 'Silver Springs' back where it should have been all the time." Stevie and the rest of Fleetwood Mac had been summoned to the Valley to hear the record and, "I really didn't want to go," said Stevie. "I've heard *Rumours*, I do [the songs] every time I'm onstage but they said, 'No, you have to OK it.' So I sat in the studio, and I swear I cried three different times because I heard things that I [haven't] heard since the day we were in the studio doing them, because in stereophonic sound you can only put so much, so a whole lot of that great stuff is like mush, and you can't hear it. On this you can hear all of the incredible instrumentation that went onto that record." It was a triumphant moment for Stevie and the new *Rumours* would be a hit, especially in the light of *The Dance* – yes, the MTV Special had taken place three years previously but the effect of it cannot be underestimated. The world wanted more classic Fleetwood Mac magic, and it would have been rude to refuse. This explosion of Mac love would clear the way for a new Fleetwood Mac album to boot.

The *Trouble In Shangri-La* tour commenced on July 6 in Burgettstown, Pennsylvania, after high profile appearances on the *Late Show With David Letterman* and *The Tonight Show With Jay Leno*, on which Stevie was joined by Sheryl Crow, as she would be on tour. Sheryl subtly slunk onstage to provide backing vocals on 'Gold Dust Woman', joining Stevie on six songs from the album and performing a solo spot with her own song 'Every Day Is A Winding Road' as Stevie refreshed her make-up and brushed her hair as it did battle with the humidity.

Sheryl was "part of the band", as Stevie put it and the tour, augmented with this star guest, was a hit, grossing more than $13.3 million. "It was fun musically to have Sheryl there," said Waddy Wachtel. "She's a total pro. I like her a lot." It helped Stevie to have Sheryl around, and Sheryl

in turn would draw a lot of support from her new mentor, although she found Stevie to be "way too tough on herself," particularly in terms of how she looked in a climate that was somewhat cruel to women who dared to get older. "Stevie should tell herself the wonderful things that she tells me," Sheryl insisted. "It's hard to be in the public eye, and getting older isn't easier for any of us gals. Stevie's still gorgeous, though, and I get frustrated with her because she doesn't realise it."

The set-list for the tour – initially a balance between *Trouble* tracks and old favourites – changed as the tour progressed from July to October, and the alterations were not always to Stevie's liking. "I started out with five or six songs [from the new album] in the set, but by the last concert, not one was in the set. That was heart-breaking." It was Waddy Wachtel's job to make sure the songs for the live show had sufficient impact to keep the energy up – not only for the fans' sake, but the band. Three months worth of playing the same songs every night risked becoming a little routine, and nobody becomes an artist because they like a routine.

"Getting the Petty tune ['Stop Draggin' My Heart Around'] to open – that was my insistence," said Waddy. "It gave us a great way to go. When she walks out on that stage, I want her to be comfortable. She's got to feel like singing, feel like entertaining, feel like smiling – or no one is going to be smiling," he added ominously.

Waddy was also pushing to mix the set up a little with the inclusion of a loved but lesser-used song from Stevie's bursting canon of hits; "something unique, something you don't do often," he beseeched Nicks. "Like 'Bella Donna'... then we listened to it and went 'Too much work! Too hard.... Did we actually used to perform this?'" Back to Plan A.

Another of Waddy's myriad duties would be to keep the band in check – and that included making sure backing singers Sharon and Lori didn't overdo it when it came to 'moves'. "I'd say, 'Girls, cut that shit out! Keep that fuckin' arm of yours down or I'll cut it off!' (laughs). This is *not* a disco.' I can't look over at my singers and see them flailing around, you know?" Let that be a lesson to any budding backing singers out there. If you see a skinny, bespectacled man with long curly hair

and a sleeveless tank top charging towards you with an angry look on his face, stop dancing, start running.

If you believe in self-fulfilling prophecies, or simply the magnetic power of the words we choose – which Stevie of all people surely must – perhaps the appealingly descriptive 'Trouble In Shangri-La' was not the best name to use. This tour, as successful as it was, would indeed be beset by trouble, ranging from sound problems to ill health. By mid-August, Nicks had already cancelled eleven shows on account of acute bronchitis.

"Stevie was sick a lot in the beginning," remembers Waddy in an interview with *Black Cat*. "It was very tough. [And] the monitors sucked for her. Every night it was: 'I don't feel good,' or 'The monitors stink,' and she wasn't having fun." Morale was sinking. When the front person is unhappy, everyone is unhappy. Thankfully Lori Perry Nicks knew what to do.

"[Lori] saved our asses, basically, on that tour," continues Waddy. "She said, 'Turn Stevie's vocal down!' As soon as it was turned down, everything started to focus."

Stevie and her assistant Karen Johnston would fly with Waddy Wachtel and a chosen few by private plane from show to show while the rest of the band would be on a tour bus. But if Stevie thought she'd had some drama on this tour, it was nothing in comparison to the genuine disaster that was about to strike. As Waddy gravely recalls: "We were out there when the world blew up." On September 11, 2001, Stevie Nicks was travelling from Toronto, Canada, to Rochester, NY. On September 11, Stevie "became a New Yorker."

"Part of my heart went down with those towers..." A line from Stevie Nicks' journal on the tenth anniversary of 9/11.

After the show in Toronto on September 10, Waddy started to feel unwell. In order to protect Stevie's health in case he was infectious, it was decided that Waddy would not be flying with Nicks to New York. In fact, he decided to stay the night in Toronto to rest, promising to meet the band and crew in Rochester on the 12th, the day of the show.

But as the night wore on, Waddy started to feel inexplicably uneasy. "I went to bed kind of uncomfortable. And woke up much more uncomfortable, like we all did." As morning broke in Toronto, Waddy received a phone call telling him to turn on the television. And so, the catastrophic events that had struck Wachtel's birthplace that day were replayed before his very eyes, the destruction, the devastation... and the shockwaves of that tragedy would reverberate across the planet to this day. Suddenly Waddy remembered that Stevie was in New York herself, having touched down at 2.30am. Despite repeated attempts to reach her, "you couldn't get hold of anybody in New York."

When Stevie landed in the small hours of September 11, the sky was clear after a heavy electric storm. As she stepped into the limousine at the airport, she couldn't have anticipated what the day would bring, but she was fairly sure it would incorporate sight-seeing, luxury shopping and generally enjoying her day off. "It's always a romantic drive for me... like something wonderful could happen." As the limo finally purred up to the entrance of the historic Waldorf Astoria Hotel at around 4am, Stevie was excitedly visualising her show that was scheduled to take place at the iconic Radio City Music Hall that week, "one of my favourite places to play."

The Waldorf itself was a source of fascination for this dyed-in-the-wood West Coast girl, and as she took in the 'great arched windows' and the stunning decor, she wished those walls could reveal the secrets of the many guests who had passed through that foyer, the movie stars, the dignitaries, the royalty... As Stevie and 'the girls' settled into their suite, gossiped, drank coffee and unpacked, the sun rose and filled the room with dazzling pink light. Stevie gazed out of the window onto the streets below, now already full of cars and people on their way to work. She was tempted to go out for breakfast and start getting busy with the platinum card, but reluctantly decided to get a little sleep instead. Wise decision. "I went to bed, dreaming of going out later, maybe finding a little diamond something..."

Stevie drifted into a much-needed slumber only to be woken urgently several hours later by her assistant Karen. It was shortly after 9am, moments after a hijacked jet had hit the south tower of the World

Trade Center just six miles from the Waldorf. Eighteen minutes earlier, at 8.45am New York local time, a hijacked 767 commercial jet had flown into the north tower. In shock, Stevie Nicks jumped from her bed and ran to the window. "Suddenly I felt like I was in the middle of history.

"Looking down at that same street – no cars, no cabs, and no people," she reminisced in her journal. "Just empty. Not beautiful – just frighteningly silent. No way out – just fear." And there really would be no way out. The hotel "went into lock down," Stevie wrote, adding that "it is the President's hotel, so lockdown is something they do well." At one stage, hotel guests realised there was a "military escort on our wing. That whole period nearly drove me into a mental home," Stevie admitted.

All anyone could do was watch, weep and wait as office workers jumped to their death to escape the blazing towers less than 30 minutes away, smoke and dust billowed through the city streets and panicking citizens ran for their lives. It's testament to the images we are so frequently exposed to in popular culture that the scenes looked sickeningly familiar; it was as if we'd seen it all before in a disaster movie. Stevie and her entourage flicked through every international news channel, watching the horrifying footage and wondering what was going to happen next. Naturally, the shows in Rochester and at Radio City Music Hall would be cancelled, and during those three days, all Stevie could do was remain in her suite, watch the news, put wet towels up at the windows to keep out the stench of burning metal, write and peer out as the sun set on New York each day through the unnatural haze.

"The sunsets were extra beautiful," adds Stevie wistfully in her journal. "Like smoke on stage makes the lights more beautiful. After that, soon after that actually, I developed an allergy to dust and smoke. I don't use smoke on my stage anymore." As soon as she was able to emerge from her hotel room, she reached out to New Yorkers in person, delivering lunch to a group of fire fighters at Ground Zero. Stevie's big-hearted decision to share her perceptions and feelings at this dreadful time by publishing pages of her journal would also bring comfort to many, as would the fact she continued her tour once she'd left New York for

Atlanta. It wasn't as if she hadn't considered abandoning the rest of the dates altogether, but, "my parents and friends like Tom Petty and Don Henley kept saying, 'People paid to see your show, and if they're willing to go out in this frightening world, don't you dare come home.' It was hard to walk on stage and not burst into tears. All my songs suddenly seemed to be about 9/11."

One of the most significant songs Stevie wrote shortly after this time was 'Illume', which would be included on Fleetwood Mac's next album *Say You Will* in 2003. "It's just about making it, you know," Stevie would explain. "I was sitting there, thinking about those horrible tragedies, and the candle was lit, and my heart was still so heavy, and I didn't know quite what would happen, and we were all like that, confused.

"I didn't set out to write a September 11 song, it just happened. I also wrote one called 'Get Back On The Plane,' and a song called 'The Towers Touched The Sky,' but it was just too depressing." Mick Fleetwood would describe 'Illume' as Stevie's "modern-day 'Gold Dust Woman'" after listening to her rudimentary demo. Nicks wasn't sure whether the groove was too simple, but Fleetwood reassured her. "It has that Edith Piaf element coming through, where the singer's relationship with the lyric is incredibly personal and powerful," he said.

The remaining shows on the *Trouble In Shangri-La* tour would take on a sombre tone, and it was during this dark period that Sheryl Crow really witnessed the intense restorative properties of Stevie's music up close, as fans shed tears and looked to Nicks for solace. That healing extended to Stevie herself too – the power of her heartfelt song craft, or her "heart songs" as she refers to them, helped to bring her through the trauma. Once she and the band finally arrived back in Los Angeles to play to a home crowd, Stevie was so relieved to be back she could have cried.

"When we played in LA, it was like a church revival," Crow told *The Independent* the following year. "You could feel it in the air. It was right after September 11 and Stevie had people in the palm of her hand. She gave [them] a lot of strength that night. Stevie says that her songs go out and work on her behalf. And they do, because they are very healing for

people. I've yet to make that peace with my work because it doesn't have that depth. But if I ever wrote something as good as 'Landslide', say, I'd just get in my car, drive to Tennessee and have kids. I'd feel completely sated."

Chapter 31

Fascinating Stevie fact 1: Ms Nicks' house contains a crystal ball, a moon-and-stars light given to her by her god-daughters (Mick Fleetwood's daughters Amy-Rose and Lucy), a doll in a birdcage, a painting of a gypsy who 'rules the room' and is possibly getting younger, in reverse Dorian Gray-style, and, most importantly, a 'fainting couch'.

Fascinating Stevie fact 2: Nicks would sell her gated home on Chautauqua Boulevard in Pacific Palisades ostensibly because she didn't want to have to worry about the state of the pool or the gardens while on tour. But, according to the Hollywood rumour mill, she wanted out because she believed the property to be haunted.

Fascinating Stevie fact 3: When Stevie was being made-up for a Rolling Stone cover shoot with Annie Leibovitz in 1981, she popped a tape of her then new song 'Wild Heart' into the stereo and sang exuberantly along with it, Lori harmonising by her side as Stevie's make-up artist Liza attempted to beautify her employer even further. Somebody filmed it – Nicks herself is not aware of whom – and put it on YouTube. It has become, she admits, "quite a little phenomenon". Watch it. It's adorable and, at the time of writing, has had over 1 million views.

As 2001 drew to a close, Mick Fleetwood was keeping a close eye on Stevie Nicks and Lindsey Buckingham, hoping they would soon put their solo careers aside for a while in order to return to Fleetwood Mac and start recording their first studio album together in 15 years. Stevie was enthusiastic, John preferred not to be in the studio and persuading Lindsey to do anything 'Mac' was always a little tricky. Christine, meanwhile, would remain in England, working on her own solo projects.

"Christine deserves, like everyone else does, to do whatever the hell she wants," said Fleetwood, while Nicks made it publicly clear that "if we thought there was any chance she would come back we would have waited to do this record."

"You can't make people do stuff," said Stevie. "[But] Mick and I are going to make this happen. We're the strong ones and we're going to push this through if it kills us." Fortunately it would be a little easier than that. Before long, Mick and Lindsey were already back in the studio, preparing for *Say You Will*.

Work was already surreptitiously underway when, on December 6, Mick and Lindsey joined Stevie for a 'Stevie Nicks and Friends' benefit show for the Arizona Heart Association, alongside Don Henley and some of the many pals who had appeared on *Trouble In Shangri-La* – including Sheryl Crow and Dixie Chick Natalie Maines. Sheryl impressed Stevie once again, being the first star to say an unequivocal 'yes' to playing on the bill. As soon as she agreed, others followed. "Sheryl did a benefit for my father and the Heart Association, so my family loves her as much as I do. We raised enough to build a hospital. Now that's girl power," said Stevie.

Mac power would be deployed too, of course, when Stevie invited Lindsey onstage – introducing him as "someone who is very special" to her – for 'Landslide'. The crowd witnessed a loving moment between the pair when Stevie held his hand, and Lindsey kissed her head. Mick Fleetwood then joined the pair (gooseberry, much?) and the audience would be delighted further when Lindsey announced that, "Mick and I have been spending a lot of time together because Fleetwood Mac are working on a studio album right now." Once the crowd – now going

nuts – eventually calms down, Buckingham adds solemnly that one must "learn to be responsible for yourself, and then you can take care of others... We're learning how to do that again." The idea would be that the chemistry would thus remain, while the baggage would largely be left behind (or at least squashed into a metaphorical cupboard).

Yes, that was the *idea*. The reality was as it always had been with Fleetwood Mac when they hit the studio: highly creative, sometimes enjoyable but often excruciatingly uneasy and resulting in a mix of material that would, in many cases, polarise the band members. Now they were missing a key writer, and, while the most radio-friendly tracks on the album would be those written by Stevie, *Say You Will* was, like *Tusk*, very much Lindsey's record, appearing at times as simply a vehicle for indulging his wish to make experimental, angry music that wouldn't always be easy to listen to.

Mick clearly wanted everything to work between all of the personalities, organising sessions in a comfortable rented house in Bel Air instead of a conventional studio, running around after Stevie as if pandering to a confident child when she strides in late with a large 'spirit-catcher', brought from her home in Phoenix to bring luck to the proceedings. John McVie simply wanted to be on his boat, the possibility of spending more time in the studio with the band holding little enthusiasm for him. "Back in the studio, *love* to be there," he says sardonically in *Destiny Rules*, the Candlewood Films documentary of the making of *Say You Will* for VH1. "150 replays of the same track..."

Stevie had been working hard for *Say You Will* in her own time, having written 17 potential tracks before she had even completed her *Trouble In Shangri-La* tour, but the 9/11 attacks on New York had left her "world forever changed", as she told her bandmates, and as a result she wanted more time to write new material. She was given four weeks, and knuckled down at home with her typewriter and her piano, honing four songs at first, recording them as demos and bringing them to the studio once her month was up. 'Illume' was one track. Another would be the upbeat title track 'Say You Will', (which would, when recorded, feature the dulcet tones of Stevie's niece Jessica and John McVie's daughter Molly). 'Silver Girl', dedicated to Sheryl Crow and "all the

rock'n'roll women", and 'Thrown Down'– "I'm talking to you," said Stevie as Lindsey listened – completed the initial four. Stevie turned to look at Buckingham to gauge his reaction, only to realise he was in tears. Then that set her off. "I cried, we all cried, and then we set to work," said Stevie somewhat matter-of-factly.

"If you write a few more songs like that, we'll make this a double album yet," says Lindsey, and the room soon breaks into applause. Stevie bows theatrically... rather a different atmosphere to the scenes she described having to endure during the seventies, which saw her staying out of the way, compromising her songs, feeling unwanted or tolerated. But as she leaves at the end of the day, Stevie says to Mick, and not for the first time, "I had no rest... but I wrote four songs," as she reaches up to embrace him, like a little girl in need of approval. To this day it still matters to Stevie what the others in the group think, whereas Lindsey appears to remain more self-assured, sometimes to the point of bullishness. Nicks was getting better at sticking up for herself and her songs, especially thanks to that hugely successful solo career, but little had changed when it came to people criticising Buckingham's work. Nobody dared.

Emotions ran high, not least because, as Lindsey laid down backing vocals to Stevie's songs, he found it strange "singing about myself" again. "He continues to be a well of inspiration, which is terrific," said Nicks dryly, although not all of the songs she provided for *Say You Will* were drawn from that abundant source. 'Illume', as we know, was inspired by 9/11 but the idea for the track 'Say You Will' was also partly borne of a film Stevie had seen about the legendary Cuban jazz trumpeter Arturo Sandoval, which resonated with her on various levels. "I just loved the way that through all the pain, they managed to [make] music and stay happy and keep love alive," observed Stevie. "Dancing and rhythm and music... how healing it was. That was really my inspiration for that song." 'Say You Will' is about second chances, softening the pain of the past and seeking peace through music.

Stevie's song 'Running Through The Garden', on the other hand, was inspired by a combination of *The Twilight Zone*, Nathaniel Hawthorne story *Rapaccini's Daughter* and a strange, beautiful picture of a girl that

Christine had drawn for her. "It's her, it's the girl in the song," Nicks insists. Written in 1985 with Benmont Tench, Gary Nicholson and Ray Kennedy, 'Running Through The Garden' is "the story of a girl who's raised in this beautiful Italian villa," Stevie explains. "Her dad is this gardener and he's raised all these poisonous plants, and she became poisonous. If anybody were to kiss her, they would die. She could never leave because she's addicted to the poison." This deadly garden and its doomed prisoner takes the concept of 'Bella Donna' even further; 'Running Through The Garden' presents us with a toxic plant and a beautiful woman combined. (Originally the track was to be titled 'Rapaccini's Daughter' but, because of publishing rights, Stevie chose the alternative title.)

The symbol of the garden, 'running towards what you know is wrong', and the plaintive apology for the inevitable entrapment of the man who comes near, clearly paints a picture of Stevie at the time she wrote those lyrics in the mid-eighties. The 'poison' may well represent the cocaine that ruled her life at that time, and it is little wonder that Hawthorne's story spoke to Stevie – when the gardener and his daughter attempt to leave the garden and breathe the pure air away from their dangerous grounds, they start to fade. The garden could well represent Fleetwood Mac – a dark, toxic, co-dependent situation that was often damaging, but almost impossible to leave. A poignant, intimate track of Stevie's – 'Goodbye Baby' – would close the album, many fans speculating that the protagonist is expressing her heartbreak over a terminated pregnancy. 'Don't take me to the tower and take my child away,' she sings. '...I who went to sleep as two / woke up as one.'

One Stevie track on *Say You Will* that we know to be about Lindsey is, of course, the powerful 'Smile At You', written in the seventies with Tom Moncrieff, the title belying the song's furious lyrics. 'Smile At You' had been rejected from *Mirage* on account of the fact that they "weren't in that place any more". Does that mean they were back in 'that place' again now? Possibly. It's more likely that it was just a great song that needed to be heard after nearly four decades in the dark. Its rancour was as potent as ever, however, and Stevie's biting vocal take would be like pure fire, as Lindsey's silvery backing vocals weave

around a malevolent, percussive groove. For this writer's money, 'Smile At You' is one of the strongest moments on *Say You Will*.

Lindsey's material here seems to swing between compellingly strange and experimental and very reminiscent of past Mac glories; the opening guitar riff for the admittedly excellent 'Miranda' is almost the same as that of 'Big Love', while the chord progression on 'Steal Your Heart Away' puts one in mind of a slower (and friendlier) 'Go Your Own Way' at times, and even the guitar part on Stevie's 'Destiny Rules' is appealingly similar to his finger-picking on 'The Chain'.

'Bleed To Love Her', debuted on *The Dance*, is uncharacteristically warm and sweet for Lindsey, despite the extreme passion denoted in the title, as if the idea of 'bleeding' to love someone was quite normal. If this is too affectionate for you, the spiteful 'Come' will certainly redress the balance. Allegedly written about Buckingham's former girlfriend Anne Heche, who would later go on to marry TV host Ellen DeGeneres, 'Come' sneers nastily, 'Think of me, sweet darlin' / Every time you don't come.' Stevie wasn't happy about the inclusion of this song at all, feeling it was far too controversial. They had never addressed sex so blatantly on their records and this was, perhaps, an unpalatable way to do it. Still, such is the artist's dilemma. Are you creating for the sake of your audience, or yourself?

There would be moments of fun during sessions for *Say You Will*, and occasionally work would be pushed aside in favour of reminiscing, but largely, or at least once the veneer of good behaviour had worn off, old tensions started to raise their heads. Lindsey, as ever, made the point that his songs were complete, having intended them for inclusion on a solo album – now, yet again, they were being absorbed by Fleetwood Mac, so maybe that gave him leeway to be, at times, very un-Mac indeed. Stevie, on the other hand, insisted that *her* songs were written very much with the band in mind, as if they were "in the room" with her. Changes and cuts suggested by Buckingham would be sullenly rebuffed – "would you say that to Bob Dylan?"

Lindsey also made a point about the fact they had to work on Stevie's songs "for six months" before they could add his tracks and overdub her vocals, insinuating that Nicks' material needed a lot of attention.

Therefore it sounded all too familiar when, after the album was complete in 2003, Buckingham publicly complained that "she's yet to say: 'Good work on my songs, Lindsey...'" It was a sulky snipe that harked back to his issues from 30 years earlier, after they'd first broken up, and yet he still had to arrange and produce her work. Stevie was shocked, to say the least. "Did he say that? My God. All I can say is he worked his butt off. I give him all the credit."

In a bid to lighten the mood, as Lindsey worked and Mick and John sat, slumped and awkward, on the sofa, Stevie frivolously invited the cameras into the kitchen to show them the treasures that lay within. It was a veritable land of temptation – red liquorice laces, Fritos, Doritos... "It's a boys' kitchen, full of great stuff," Nicks told *Rolling Stone*'s Jancee Dunn. "I just say to myself, 'You can never eat this, or you will weigh 170 pounds at the end of this project.'"

Another attempt to "inject some humour into this recording", something she evidently felt was desperately needed, saw Stevie bringing in a 'Big Mouth Billy Bass' singing fish wall mount – ubiquitous at the time – which waggled its tail and 'sang' 'Take Me To The River'. Stevie gives a demonstration and dissolves into giggles, something we don't see too often in this documentary. For a moment we get a glimpse of the younger, girlish, fun-loving Stevie rather than the older, tougher Ms Nicks – but she was tougher because she had to be.

The fact was that making *Say You Will* was as difficult as everyone had feared, and Stevie openly admitted that "[Lindsey and I] have a lot of the same problems that we've always had, which is our egos. And we're filming a documentary at the studio, so there's a crew with us at all times. There were a couple of times where I've gotten just furious and walked out of the room yelling, and I've nearly run over the sound guy. It's like the TV show *Big Brother*. If we could vote each other out, we'd be fine! My vote would come up 'Lindsey'. Lindsey's would say 'Stevie' [laughs]." This observation was close to the mark, and the cutaway conversations between individual members of the band, confiding to camera – and therefore, the world – was reminiscent of the Diary Room. The main difference here was that the 'contestants' would be famous for actually doing something.

One of the many things Stevie and Lindsey were arguing about was the fact that Lindsey wanted to make *Say You Will* a double album. Stevie warned that this would be an unreasonable move during a recession, expecting people to spend their hard-earned cash on a double album made by a group of people who, in a few years, would be eligible to draw a pension. Put simply, Stevie just didn't think anybody would buy it, and where would that leave them? Well, hardly scanning the ads in the back of the newspaper for work, admittedly, but they all had lifestyles they were quite keen to maintain. Warners had taken a risk on them. It needed to pay off. After much wrangling, Lindsey addressed the camera himself, stating that it was 'his call' to make it a single album, adding, "I have a new house to pay for, a family..."

Stevie gritted her teeth, exhausted by the now constant aggravation but determined to see the project through. All that mattered right now was that the album would soon be finished and released to the world on April 15, 2003, another addition to Fleetwood Mac's golden legacy. In the meantime, "if we have that final fight that means we can't walk back into this house and Lindsey and I blow up into a mass of exploding timbers, the fact is the record will be done, and even if we're dead, people will at least have the record to enjoy and the music will live on..."

Not everyone *would* enjoy *Say You Will,* however, and one of those who found the album difficult to listen to was Stevie Nicks herself. "I'd be lying if I said that record is what I wanted because it isn't," she said frankly in an interview with *The Age.* "I argued with Lindsey all the way through it and he argued with me. It wasn't very much fun and I wasn't that pleased with the music. I felt my demos were better." However, Stevie assured readers – and herself – that as soon as the band hit the stage on the obligatory tour, "we get lost on the fun parts of the show. We're always going to rise above and concentrate on the good things."

'The good things' wouldn't just come to mind on their own – Stevie and Lindsey would have to work at this, and after having suffered the mother of all fall-outs during the making of *Say You Will*, it took Stevie to make the first move and ensure the 136-date five-leg *Say You Will* tour wasn't going to be a complete nightmare for all concerned.

Fleetwood Mac would set off on May 7, 2003 in Columbus, Ohio, touring the US until October before heading out for the European leg in the second week of November. The band would then take in Australia from February 2004 before the fourth and final leg of the tour in North America, the last show taking place on September 14, 2004 in Michigan. Knowing they would be on the road together for well over a year, Nicks steeled herself and invited Lindsey over for a heart-to-heart. It was better to thrash out whatever needed to be thrashed – metaphorically speaking, of course – in advance than endure a living hell. Judging by some of the scenes during the making of the album, this was a talk that needed to be had.

Stevie sat Lindsey down and told him: "I believe you and I need to remember who we were when we were 16 and 17 years old. We need to remember we were really good friends before we ever had a date. We need to remember how much we respected each other, how much fun we had – and how much fun we can have when we're both in good spirits. And we need to take that power couple on to the stage. Or we need to not go on tour."

"I walk on stage, I'm strong, I'm still pretty cute – and I rock."

Evidently the tete-a-tete was successful much to the relief of Mick Fleetwood, but one of Lindsey's gripes that would surface was Stevie's stage-wear. We all know that Lindsey, according to Stevie, had a problem with her being 'sexy' onstage in the past, grabbing the attention with her sparkling, low-cut costumes that flowed and moved as she whirled around the stage. This time, Stevie agreed to compromise. She knew she was going to look spectacular whatever she wore anyway.

"Mr Buckingham is never crazy about my flamboyant clothes," said Stevie. "His comment to me is, 'Can't you just be a little more casual?' So I said, 'OK,' and went into a little black sweater with little pearl buttons and I did exactly what he wanted. It was a little more sedate but still fabulous." Naturellement. A liberal spritz of her favourite fragrance (a floral number called 'Fracas' by Robert Piguet), a last minute zhuzh of her wavy locks and 'Mama', as those in the Mac entourage called her, was ready to rock.

Contrary to the experience in the studio, there was much merriment to be had on the *Say You Will* tour. Lindsey's niece Cory Buckingham was in the entourage, working for the band as something of an ambience director and an assistant to the tour manager, fixing the ribbons to Stevie's mic-stand, making sure those last minute tweaks that make all the difference have been made, and, much to the delight of fans, publishing an online tour diary which gave Mac fanatics an inside scoop into life on the road with their favourite band. She wrote humourously about Stevie's manager's Maltese dog, who had become friends with Nicks' two beloved Yorkies (oh yes, the dogs were on the tour too, don't you worry about that). Cory was in pieces when she spotted the Maltese performing his favourite trick. "Stevie's manager holds a treat in the air and says, 'Stand back!' and moves her hand in a circle, and he stands up on his hind legs and twirled just like Stevie. [She] got a huge kick out of that one." Cory also reported back on how Stevie just couldn't stop singing. She sang as she walked off stage, sang while she had her make-up refreshed... Nicks even serenaded Cory down the radio after a show, filling the loading dock with the sound of that inimitable voice.

Something else that amused Cory was how much Stevie loved taking pictures, although "The best part, I say this with love, is that she doesn't really know how to use [the camera]," writes Buckingham's niece. "Every time she takes a picture, she has to take it three times, while saying, 'This damn camera...'" Stevie was determined to capture every moment for posterity. In the meantime, Lindsey would read, John McVie would be "happy with a cup of coffee and a computer" and Mick, as always, took care of everybody and kept them laughing. Stevie in particular missed Christine McVie, but everyone was putting extra effort into keeping the vibe up. On one occasion, knowing that Stevie turned up every day at the venue with her long hair in rollers, one "very creative crew member" who enjoyed teasing Ms Nicks about her maiden aunt look ordered in a "truckload of velcro curlers and distributed them to the whole crew and staff", writes Cory. "When Stevie showed up and saw every single member of the crew with a curler in their hair, she died. To top it all off, John wanted to play too, so we put some double stick tape on a curler and put it next to him so

he could stick it to his hat before she turned and looked at him during 'Gold Dust Woman'. We like practical jokes around here..."

One of the highlights of the *Say You Will* tour for everyone involved would be the Australian leg – even if Stevie did have to leave her precious pooches at home ("It was terrible!"). The weather was stunning, the general mood was happy and the shopping opportunities were out of this world. One slightly unusual little store Stevie went into was 'Just White', a doll shop in Perth owned by a certain 74-year-old lady called Margaret Michaels. That lady would earn herself a nightly dedication from Stevie on stage, much to the fans' bemusement. "You just made my life so much better," she purred, before dedicating 'Beautiful Child' to the shop owner. Before the tour left for Australia, Stevie had visited a close friend of hers who was in hospital with cancer. On the day Fleetwood Mac hit Perth, on February 27, 2004, Stevie received the awful news that she had passed away.

Needing a little retail therapy, Stevie wandered the streets until she happened upon 'Just White'. As any self-respecting Stevie devotee knows, Ms Nicks is extremely fond of dolls. Once inside, one doll stood out to Stevie. "I looked at [it] and [my friend's] spirit was just there. I just felt it so strongly. I've had the doll with me since then and I sit her up near me and it has really helped me get through this very difficult period."

And Ms Michaels? Well, she's "not really into that sort of thing," she admitted, but "she was so warm and so sincere, lovely."

Stevie would celebrate her 55th birthday during the North American leg of the tour on a beautiful early summer's day, and she would be presented by band and crew with a rather unusual cake: made with dark chocolate, it was covered in little gravestones – each represented a song that she'd had to retire from the set due to vocal issues she'd suffered from during the tour. Fortunately she saw the humour in it, as macabre as it was.

The *Say You Will* tour was a triumph, grossing $27,711,129, and the band parted as friends. It was time for a break – a long one – although a break for Stevie isn't really a break at all. It's just a break from Fleetwood Mac.

Stevie's favourite horror movie: The Haunting (An adaptation of the Shirley Jackson book The Haunting Of Hill House).

Stevie's favourite dish to make at home: An omelette.

Stevie's favourite coffee: Folgers. It "brings your morning to life" apparently.

So now you know. Unless you knew already; if so… well, now you've been reminded.

Chapter 32

Eccentric, moi?

– "One of Stevie's almost comedic needs is what we call hotel-hopping," reveals Mick Fleetwood, "where we all check into a hotel and she goes, 'Oh, I need to try another one,' and just checks out. She should be a hotel critic."

– In addition to her own extensive wardrobe, Stevie has another wardrobe filled with tiny shawls, Ralph Lauren cashmere and Rhiannon outfits which have been made especially for her Chinese-crested Yorkie, Sulamith.

– Stevie doesn't like to throw any clothes away, especially if they were gifts. Even if they don't fit her. "It's like a piece of love. I could outfit everybody in Los Angeles in these things."

– As for her famous journals, despite the concept of a diary usually involving the addition of the date and year on the top of the page, Stevie just writes the name of the day on each page and hopes someone else will write the date on.

– What would Stevie take with her in a fire drill? Tapes, notebooks, guitar, "two or three dolls…"

Hawaii was, as always, the go-to place to relax after a tour, and Nicks whisked some of her closest girlfriends off with her to soak

up some rays. Stevie being Stevie, however, as soon as her mind had cleared, was ready to start brainstorming on her next creative project – in this case, a musical adaptation of Evangeline Walton's *Mabinogion Tetralogy*, the stories that inspired Nicks' song 'Rhiannon'. Stevie and her friends knuckled down to some serious study of Welsh mythology in the incongruous surroundings of glorious Maui.

"It could be a movie. It could be a record. It could be a couple of records. It could be a mini-series. It could be an animated cartoon..." Stevie said, listing off the possibilities to *The Telegraph*'s Craig McLean. It had been some years since Stevie had last considered the idea in earnest – of course, she had wanted to work on a *Mabinogion* reimagining for the big screen before she'd even made *Bella Donna*. Maybe this idea's time had finally come. Or... maybe not. A call came through from Stevie's management, summoning Ms Nicks to the very un-Rhiannon-like surroundings of Las Vegas. Celine Dion and Elton John were playing shows back-to-back at Caesar's Palace, and, presumably wanting to have a break, suggested Stevie Nicks perform there for one week for a handsome fee.

"I'm, like, 'Howard, I am on a spiritual quest here; I really cannot come to Vegas.' And he's, like, 'Stevie, you have to, please, just come tomorrow...' We went to Vegas." The *Mabinogion Tetralogy* would just have to wait. Stevie's residency began on May 10, 2005.

Nicks was excited by the idea of performing at kitsch Vegas, and she loved that she could sashay straight from the stage to her hotel every night rather than pack up and leave for the next city. Admittedly, when she and Waddy headed over there to check out Celine and Elton's show at Caesar's before starting their own stint there, they were dumbstruck by the sheer size of the stage. Waddy and Stevie nicknamed it the 'flea circus', concerned they'd look miniscule onstage, and Stevie was pretty small to begin with. The sound, on the other hand, would be huge and Stevie and her band would enjoy their time at Caesar's so much that, in Nicks' opinion, Vegas would certainly be an option for her golden years. She could see herself performing there as 'a little old lady'.

Even after this week was complete, however, Stevie would still not be able to return to her *Mabinogion* venture quite yet. Don Henley had

been in touch, suggesting the pair of them embark on a co-headline tour in June, and, "when Don Henley asks you to rock with him, you don't say no," Stevie said mock-solemnly. "Plus, I thought, 'I have this amazing show left over [from Vegas]... what the hell, let's do it.'" And so the work began, commencing with the swapping of set-lists and the inevitable "arguing", joked Henley. There were also certain logistics Stevie required for performing that weren't necessary for Henley: in order to look her best, Stevie needed "special lighting, proper performing temperature, time for costume changes..."

Henley was a little lower maintenance. "I'm just a guy... Guys don't mind sweating. I'm just going to go first and that will make my life a lot simpler." The tour would be titled simply 'Two Voices', and while the pair performed separate sets, Don would join Stevie on their duet 'Leather And Lace', amongst others, and even slow-dance with his co-headliner during 'Gold Dust Woman'. Fans were practically wetting themselves with excitement to see another little slice of long-gone rock'n'roll romance apparently springing back to life tantalisingly before their very eyes. Everyone had seen the incredible response Stevie and Lindsey's rekindled (if only on-stage) affair had garnered. Now this. What next? Dinner onstage with Joe Walsh? Spooning on the drum riser with Jimmy Iovine?

After ten dates together, Don unfortunately had to return to LA to reconvene with the Eagles who would be touring for three months, but Stevie continued to play shows for the rest of the summer, booking 23 more dates and adding the singer-songwriter Vanessa Carlton as a support artist. Carlton was "a special one" in Stevie's eyes, and an artist Nicks often found difficult to watch without crying in the wings, so much did Carlton remind her of herself as a younger artist.*

* Stevie and Vanessa would become so close that Stevie would even be invited to officiate Carlton's marriage in December 2013 to Deer Tick frontman John McCauley. A year earlier, Stevie had written out her 'rules of engagement' on a stack of hotel stationary for Vanessa, titled: "How to get what you want out of life and men..." one of them being: "He must have a good job. He must be happy and satisfied with his own life. You are there to enhance his life, not take away from it, and he is there to enhance your life, not fuck it up." "That's my favourite one," laughed Vanessa. "Thank you, Stevie!" The world awaits the Stevie Nicks Guide To Life.

The dates were titled 'The Gold Dust Tour', and the final show would be at the Coliseum at Caesar's, Las Vegas; Stevie's new favourite place to play. With a long, black 'cold-shoulder' gown and her hair tied up for the encore, Stevie looked more like an operatic diva than a rock singer, although her voice, naturally, proved that nothing had changed.

After this exhilarating closing show at Sin City, Stevie headed back to the tranquillity of Paradise Valley. Four days later, on August 10, 2005, her father Jess Nicks passed away. Jess was 80 when he died, and had suffered from heart disease since 1974. He had joined his daughter on her most recent tour, zooming around the venues on a mobility scooter, but he was elderly, his health was failing and, just before Stevie's tour concluded, he suffered a fall in his hotel room. He died the following week.

Stevie was philosophical. She knew he was no longer physically robust, especially having had three operations on his heart, but he'd had a happy, successful life and loved touring with Stevie and watching her star rise over the years. "I took [his passing] with the grace he would have wanted," she said. "I'm just glad he's not in pain anymore." Stevie noted that her 'force of nature' of a father had also timed his departure perfectly. "He waited until the Fleetwood Mac tour was over – I asked him for that. He waited until this summer tour was over – I asked him for that. He couldn't leave us during a tour. The last show was Saturday in Vegas. I got here to Phoenix Sunday night. It is Wednesday night. He waited for me."

★ ★ ★

Stevie Nicks would, as so many of us do when faced with such a loss, throw herself into work once the initial grief had become more manageable. From February 2006, Stevie resumed the *Gold Dust* Tour, taking it to Australia and New Zealand, countries she always enjoyed visiting. Supporting Nicks on this leg of the tour would be none other than old friend Dave Stewart, and they loved staying up late together, reminiscing and listening to music.

"We decided to stay one time in this resort, and it was pouring with rain, so there was no point in being there," remembers Dave. "So we

went for this strange meal and then went up to her room and she said, 'I always watch this channel', and she put on the TV and it was a music channel called Rage. This is about 2am now, and she put it on and shouts over the top of every song, 'This is my favourite one!' She loves music, rocking out..." Little did they know they would be working together in the studio in the relatively near future. Better late than never.

This year would also see Stevie touring with Tom Petty & the Heartbreakers – the "best summer I've ever had. And you can interpret that any way you want," she said, not a little slyly. After 27 shows on the road together, Tom presented Stevie with a diamond-studded platinum sheriff's badge, engraved with the words 'To Our Honorary Heartbreaker, Stevie Nicks', and on the back, much to Stevie's delight, she noted the inscription: 'To The Only Girl In Our Band.' "I keep it on my black velvet top hat," she says proudly. "It goes with me everywhere. It's probably the most beautiful piece of jewellery a man has ever given me, ever."

But during breaks from touring, Stevie would continue with a mission she had first embarked on a year earlier. Stevie's manager, who also handles Chris Isaak's career, had visited the Walter Reed Army Medical Center with Isaak in Washington. When the *Gold Dust* tour hit DC, the suggestion was made that maybe Stevie herself could visit the troops. "And there changed my life," declared Nicks, who was sincerely touched by what she saw and learned that day.

She would go on to spend a great deal of time with hospitalised soldiers in the coming years, as well sending baby supplies to war widows, writing to injured GIs, bringing them T-shirts and even loading up hundreds of iPods, programmed with music from her and her niece Jessica's collection to give to the soldiers to pass the time and use the power of music to lift their spirits. The time she spent with the patients was worth more than any amount of money she could donate, and the "rock'n'roll fairy princess", as she described herself, couldn't help "falling in love with every one of them". And in turn, her genuine concern and kindness would change their lives, too.

Nicks would spend increasing amounts of time on the road over the following few years, which can't have been easy during this time, struggling, as she was, with the menopause. "I fight it every day," she

admitted, explaining that it made her feel down and affected he
Still, she worked and wrote on, motivating herself with a sense o
Stevie always feels that, unless she has achieved something, or done
something special, she cannot relax at the end of the day. "Sometimes
I'll get out of bed in the middle of the night and go into my office
and put the paper in the typewriter and get out my books that are
inspirational to me – Oscar Wilde, Keats, Canadian poets, European
poets – and I'll just open a page and read something and say, 'OK, this
is my information for today, this is what is supposed to come through to
me today.'" Duly inspired, Stevie would start to write "for one or two
hours", and only then would she be able to go to sleep.

Yet another Best Of Stevie Nicks album was on the horizon, this
one being titled *Crystal Visions*, her ninth album over all. Again, it
presented all of the old favourites – 'Edge Of Seventeen', 'Rhiannon',
'Stand Back' – but also a dance remix of 'Dreams', courtesy of the
Iranian-American DJ duo Deep Dish, a pair fond of remixing songs
by prominent female artists including Gabrielle, Cher, Madonna and
Janet Jackson, amongst others. In addition, fans purchasing *Crystal
Visions* would also be treated to a live version of Stevie singing Led
Zeppelin's 'Rock And Roll', a version of 'Landslide' performed with
the Melbourne Symphony Orchestra and, if you went for the deluxe
DVD package, exclusive audio commentary from Nicks and some rare
footage from the *Bella Donna* sessions. The album, released on March 27,
2007, hit number 21 in the *Billboard* chart and would be certified gold in
Australia, perhaps unsurprisingly given the presence of the Melbourne
Symphony Orchestra.

Stevie would spend the summer of 2007 on a US tour to promote the
record, adding one-off dates during the rest of the year before continuing
to tour the States in 2008. Stevie was nothing if not a grafter, but the fact
was that *Crystal Visions* had not been a smash hit. Nicks needed a fresh
approach. On discussing her plight with Dave Grohl (as you do), the Foo
Fighter and former Nirvana drummer suggested she make a documentary
film, and he had an idea of who would be the perfect director too –
someone she knew rather well, indeed. Dave Grohl commanded Stevie
to "Go home and call Dave Stewart right now."

As well as being a sought-after producer, Dave Stewart was an avid film-maker. In this visual age, having a DVD to accompany her next album could be the perfect way to freshen up Stevie's career, but the idea of being filmed wasn't immediately appealing – it would require hours in hair and make-up, for one thing (and that's just for Dave) – but Stevie did at least have a little time to think about it. Fleetwood Mac had scheduled their extensive *Unleashed* tour – their first in five years – to take place from March 2009 after several weeks of rehearsals, so there was nothing Stevie could do until they had returned home at the end of the year. Stevie would also be releasing *The Soundstage Sessions* on March 31st, the first live album of her solo career, featuring Vanessa Carlton. *The Soundstage Sessions* had been recorded two years previously in front of a select audience at WTTW's Grainger Studio in Chicago, and would include a cover of Dave Matthews' 'Crash Into Me'. Intimate, slickly produced and atmospheric, Stevie was "as proud of this" as any of her previous work.

Stevie and Fleetwood Mac knew all too well that hitting the road was the best way to make money in the now somewhat broken music industry – a world of downloads and stolen music – as was reissuing work from their already well-wrung back catalogue. The *Unleashed* tour would not only bear the irresistible sub-title 'Fleetwood Mac's Greatest Hits' (i.e. no unknown quantities for the audience's ears to contend with) but it would mark another *Rumours* package, with previously unreleased tracks and 'never seen before' DVD footage. Music was no longer enough these days, especially if you were essentially repackaging work that fans would already have in their possession anyway. You had to add visuals and 'extras' if you wanted to survive the digital age. And, most importantly, you had to get back out there and play some shows.

The tour was titled *Unleashed* because, according to the band's press statement on the announcement of the dates, that was how they all felt once they hit the stage together. For Stevie, it was still strange without Christine, although Lindsey Buckingham admitted he preferred the band as a foursome. Either way, all of them would have been thrilled to have McVie back in the fold, not that anybody thought that could possibly be on the cards. And so, as each show was about to start, Lindsey and Stevie linked little fingers as they ascended in the backstage lift together,

Nicks as ever eager to squeeze her former paramour for that little bit more. She'd appeal to him, telling him she was nervous, her puppy-dog eyes wide open and a worried look on her face. "What do you want me to say?" was the unsatisfactory response. Worth a try.

Lindsey would insist to interviewer Rob Trucks that the one thing he has never done is "cheat on my wife", but Stevie revealed during press for *Unleashed* that they are still attracted to each other, and the audience sees that connection onstage – not least because they want to see it too. (Although to be fair, even Helen Keller would have clocked the theatrical sexual tension; sincere as their bond certainly was, Stevie and Lindsey were laying on the psychodrama pretty thick by now.) And so the fantasy is retained in a kind of parallel universe; after the show, they go back to normal, and leave the theatre in separate limousines that drive them to separate hotels, which is interesting in itself.

"When you had a love affair like we did, it never really goes away," Stevie would explain. "Obviously I didn't go out with him because he was a jerk, I went out with him because he was a beautiful guy with a gorgeous smile and a wonderful laugh and he was a lot of fun *in the beginning...*" Say no more.

It was on the *Unleashed* tour that Stevie would write 'Moonlight – A Vampire's Dream'. Nicks had watched *New Moon*, the latest movie adaptation of Stephanie Meyer's *Twilight Saga* books, and she was hooked, as one might expect. She wept as she watched the rejection of the female protagonist, thinking of all of the times she'd felt the same. A demo swiftly followed. "I finished it in Australia and my assistant recorded it on a camera," explained Stevie. "She went and hid it down the hall like she wasn't listening but she was, and I was by myself and I played the song. [Then I] said, 'OK, you can come out now, Karen. I'm ready to make a record.'"

★ ★ ★

Stevie already had plenty of material for her next solo album, but she was also excited by the idea that her new record would be accompanied by a unique DVD. It would be enjoyable to work on, especially if Dave

Stewart was involved – one mutual friend affectionately described him as "as batty as she is" – and, no doubt new visual content would boost sales too. The concept Stevie had in her head was that of a compilation of archive footage at this stage, although Stewart had other ideas. But in the meantime, the call was made, and Dave Stewart was more than happy to work with Nicks on her next opus, *In Your Dreams*.

There were a few dates in Stevie's diary to honour before work could commence in earnest, among them the 2010 Grammy Awards in January. Stevie had been invited to appear alongside the singer Taylor Swift. "I didn't want to do it," said Stevie flatly. "I didn't want to stand next to her, at five foot 11 and 100 pounds, and be broadcast to 50 million people. But she wouldn't hear it. She had a plan." Swift, who just an hour earlier had graciously accepted a Grammy for Best Country Album (for *Fearless*), hit the stage in a white blouse and jeans to sing 'Today Was A Fairytale' before being joined by the now perennially black-clad Nicks with whom Swift attempted to harmonise on 'Rhiannon'. The results were mixed, but Nicks, as always, was pitch-perfect.

Taylor Swift was fortunate to have Stevie onstage with her, particularly as Nicks had very strong feelings about younger female singing stars, and she was vocal about it too, because she wanted them to learn from her advice – and her mistakes.

The publicity stunt kiss between Britney Spears and Madonna at the MTV Video Music Awards in 2003, for example, was, "the most obnoxious moment in television history. Madonna will be fine, but will Britney get over it? [She] should be smarter than that," Stevie said, adding that both Spears and Christina Aguilera should "wear more clothes and try writing decent songs. I have never been to a strip club, but I turn on MTV and see in every single video what it must be like." Echoing her speech to Prince back in the early eighties, Stevie rightly pointed out that, if you had to work so very hard at appearing to be sexy, then perhaps you weren't that sexy after all, perhaps your music had no sensuality, perhaps your music is so dull, indeed, that you have no choice but to pelvic thrust your way through a pop video in a leather bikini in order to detract from its mediocrity. (If the latter is the case, it might be advisable to do something else. To paraphrase the British

broadcaster Lauren Laverne, none of us will live long enough to hear all of the good stuff as it is.)

Katy Perry, on the other hand, was tops with Nicks. Perry, alongside John Mayer, would have the honour of having 'Landslide' dedicated to her by Stevie onstage during the *Fleetwood Mac Live* tour in 2013. They'd spent time together and got on, but Perry was already a favourite of Nicks because her music was on her 'treadmill list', i.e., tunes to walk on the treadmill to. If you make it onto that, you're a friend of Stevie's for the mere fact that you're helping her to stay the weight she wants to be.

Miley Cyrus also gets Stevie's vote of approval. Despite the bizarre tongue-out 'twerking' performance with Robin Thicke in 2013 – again, at the MTV VMAs and, again, garnering priceless publicity thanks to the world's apparent outrage – Stevie insists that, "unlike some of the other singers / actresses that we are always worried about [no doubt referring to Lindsey Lohan here*], Miley has an ability to become a great actress and a great singer and probably a great songwriter and go on until she's my age."

And the... erm... 'twerking'? "I think she won't be very happy with what went down. When you're young, you don't think about even five years from now. I actually didn't either, but I was really focused on who I wanted to be and what I wanted to be and I knew I was going to be in this business for a long time." And she was right. The year 2010, more than 40 years after Stevie had first picked up a guitar and started to play, would see her approaching her 62nd birthday and preparing to make a new studio album that would coincide with the 30-year anniversary of *Bella Donna* – her first foray as a solo artist.

* When asked by the *New York Times* what she thought of the rumour that 'troubled' actress Lindsay Lohan was slated to play Ms Nicks on the big screen, Stevie blurted: "Over my dead body. She needs to stop doing drugs and get a grip. Then maybe we'll talk." A little harsh coming from a self-proclaimed former chemical enthusiast, one might feel, but, as Nicks insists, she got it together after rehab – Lindsay apparently didn't.

Pick 'n' Nicks – A Stevie Smorgasbord

Stevie home essentials: candles, cashmere, good speakers, good friends.

Learn from Stevie: Don't do Botox. Stevie tried it once. Never again. Also – drop the internet addiction. "[It's] ruining our society and making everybody rude. I think it's the reason why people just don't care and the reason why nothing lasts and people don't meet anybody..." Stevie also believes social media to be "evil".

Stevie drama: Nicks' grand piano has bullet-holes in it. No, not a particularly bad fight between Stevie and Lindsey; the instrument was caught in a drive-by shooting while being transported from LA to Phoenix.

Did you know? UK-based artist Johanna Pieterman can paint a Celtic-style portrait of Stevie Nicks with your spirit animal of choice (usually an owl, wolf, stallion, or unicorn). Fancy that!

Chapter 33

In Your Dreams rule 1 – You're busy, remember? So always have a Girl Friday: "I said to Dave, 'You know I wrote a song 'with' Edgar Allen Poe in the 1800s ['Annabel Lee']?'" He said, 'Darling, can you find it?' I said, 'Yes! It's in Phoenix in a vault!' So I sent Lori home to look for it…"

In Your Dreams rule 2 – Mornings are not to be rushed in the world of the rock goddess. Here is Stevie's morning routine: "I got up at nine… well, I didn't get up at nine, I woke up at nine, drank coffee, nine to ten, ten to 11, 11 to 12 – that was my 'me time', then I got up, took my bath and did my vocal exercises at the same time – multitasking – got dressed and then at 2pm I'd be heading down the stairs." On days off, however, Stevie's 'top priority' would be to get up by 11am "to watch my soaps: All My Children, One Life To Live and General Hospital."

In Your Dreams rule 3 – On show while you're working? Choose your most flattering but practical 'uniform' and stick to it so you don't have to worry about how you look. Stevie's uniform: a black chiffon blouse ("I have about 300 of them"), slinky black trousers and snow boots. Voila.

After initial discussions with Dave Stewart, who would be producing *In Your Dreams*, Stevie decided sessions should be held at 'Tara', her white 1930s mansion which is empty and free for her to use for special

occasions such as this, where they could save money (rather than spend $2,500 every day at a studio), work as long as she liked, dress everyone up in her costumes (and oh, she did, engineers and all) if she fancied it and allow people to stay if they wished. There was also a complete top-of-the-range studio built into the house – Pro-tools rig, microphone hanging over the coffee table to capture any spontaneous moments of musical genius, the lot. Work began right after the Grammy Awards ceremony, on February 1, 2010 and when Dave Stewart first suggested filming themselves as they made the record, Stevie's "life passed before my eyes". In fact, the words she uttered were actually "in your dreams", hence the title. Archive footage she was happy to work with. This, on the other hand... "I've known him since 1984, and I was thinking I can be pretty grubby for this experience, and he said, 'Well, darling, what if brilliant things happen and we don't film it, and then we are really sorry?'"

What really swung it for Stevie was watching the 2007 Tom Petty documentary *Runnin' Down A Dream*, particularly the section that touched on the Travelling Wilburys, Petty's supergroup with Bob Dylan, Roy Orbison, George Harrison, Jeff Lynne and Jim Keltner. "We got to see them really be who they were, just looking so handsome and playing this amazing music... and then within minutes it seemed two of them had died. If they hadn't have done that, what a shame that would have been. That was what came into my head: what a shame that would be if you, Miss Vanity, said no to this because you don't want to spend half an hour in make-up or pick a uniform."

Stevie herself would generally stay at her condominium overlooking the sea, developing some of her songs there in private and bringing them into 'work', having nurtured them protectively in the dark first. But when Dave Stewart suggested they write some songs together, Stevie smilingly agreed while thinking "Not a chance..." However, Nicks would give him a chance, and the results would be beyond what she had hoped for. For one thing, Dave and Stevie's friendship didn't have the "baggage", as Stevie puts it, that she'd had to consider with Lindsey. It was an obstacle that had stopped them from even trying to write together; it was all just too personal. So, tentatively, Stevie decided to give Stewart one of her treasured books of poetry to see what he made

of it, and what chords and melodies her words inspired in him. Dave already had the vague structure of a song in mind, a track reminiscent of 'Don't Come Around Here No More'.

"I did not expect him to read all of that poetry," Stevie said in an interview at Hamptons International Film Festival. "If I'd have given it to Lindsey, he'd have been like, 'Yeah sure, I'm gonna read all this...' And it's all the fairies and the lost love affairs... so I didn't expect Dave to read this book, but he did." Sitting with Stevie one afternoon by the fire, blazing away as always, Dave picked out a poem and, peering at Nicks through his ubiquitous dark glasses*, suggested they work it up into a song.

Impressed that Dave had even bothered to sit down and pore over her writings, Stevie decided to go with it. Dave picked up his guitar, Stevie leant in to the microphone, someone pressed 'record' and "within five minutes [we] had a song that was really good. That was the first song we wrote, the first time I have ever written a song with someone else. I have written with Mike Campbell but he sends me a CD in the mail or in a car – he doesn't come with it." Ordinarily Stevie would receive a disc of a dozen songs and play them through, listening to them with Lori and Sharon and thinking about what would be a good fit. But this time she simply "recited my words in a singsongy way" as Stewart played. "It was like an epiphany for me. I thought, 'Now I understand why Paul McCartney and John Lennon wrote songs together.' Together, they're more than the sum of their parts."

The rapport between Nicks and Stewart was partly because they'd had parallel pasts – both had been one half of a famous duo, both had been in love with their intense former musical partners, and both had had to cope with everything that this brought with it. In turn, they became a duo themselves. "I've become somebody who collaborates a lot," mused Stewart. "There's a great thing about collaboration: you learn how to become calm and patient and not really take yourself too seriously all the time, but on the other hand you've got your eye on the

* Sunglasses indoors, year-round roaring fires in sunny LA... welcome to Hollywood.

vision. I allow people to feel like they can do anything. Whoever is in the room, they realise, 'Fuck, I can do anything I want.'"

That first song they wrote together was the moody 'You May Be The One' ("wonder who that one's about..." crooned Stevie in jest, when describing the song. Clue: it's not about Dave.) And so began the "most fun year of my life", an 11-month, five-day-a-week "magical mystery tour", as Nicks described it, very much in her element. Her beautiful home was filled with people, music, creativity and laughter and quite frankly she didn't want it to end (and to be fair, the engineers alone must have been wondering whether it actually was ever going to end. Eleven months might be an average time-scale for Fleetwood Mac, but...). Dave had "created a magical sandbox in my house – which is a very Alice In Wonderland house – and allowed us to play.

"We had dinners every night and it was like the old wild crazy days," Stevie said. "I'd bring down clothes and make everybody dress up, and we filmed it. It turned into more than a documentary, it's really a film. We made serious movie videos as we went along in the back yard of my house. All these amazing fairytale animals..." That was one thing Stevie learned about Dave – if she suggested something, no matter how outlandish, her trusty producer would make it happen. "Like, don't say, 'Dave, I think there should be a white horse out in the backyard tomorrow.' And then you wake up and you look out your window and there's a beautiful white horse in the trees in your backyard." He'd also laid on a fog machine for extra atmosphere. That's Dave Stewart for you. (Said white horse would accompany Stevie on the cover image of the album.)

The documentary presents us with the album's trajectory, the often surreal and theatrical video concepts and something of an inside track of how Stevie likes to work, and indeed play. Naturally she is presenting herself in a certain way; she knows young girls revere her, and thus requests that the editors exclude any film of her, say, swearing like a sailor, ("Take that fucking track off," she barks at one point, later admitting: "I tried very hard not to swear in this film, because that's not the role model that I want to be." Quite fucking right too, Mama.) but we see how much she loves to kick back at the end of the day and have a 'disco' in

her own home, how her beloved dogs are always present when a cuddle with something small and hairy is required, so to speak, and how, with Dave Stewart's help, she is able to inject that sense of fantastical whimsy she loves so much directly into her sessions like never before. Acclaimed as it undoubtedly would be, this might not necessarily be her greatest solo work in many people's eyes, but Stevie would enjoy making *In Your Dreams* so much that it would be her favourite record, her "own little *Rumours*". It was being made in an utterly different way, and it was certainly the first time pictures of the recording sessions would be posted on Twitter in real time (again, thanks to Dave).

In addition to the songs written with Stewart, *In Your Dreams* would include songs from way back, one of which was written when Stevie was just 17. 'Annabel Lee' was inspired by the Edgar Allen Poe poem of the same name – although arguably this track dates back even further if Stevie's suggestion that she actually wrote this 'with' Poe in a former life is true. 'For What It's Worth', the song written for the man who "saved her life" after rehab, would also find a home here (and be later released as a single), as would 'Moonlight (A Vampire's Dream)', written on the last Fleetwood Mac tour (Stevie would have a picture of *Twilight Saga* romantic leads 'Bella', portrayed by Kristen Stewart and 'Edward', played by Robert Pattinson, on her piano as they recorded this song) and 'Italian Summer', a song inspired by a trip to Ravello, Italy. Stevie and the girls watched from their window in the Palazzo Sasso hotel up in the hills on the Amalfi Coast as an electric storm followed a wild fireworks display in the town one night – it was as if nature was joining in with the celebrations. Stevie was moved to write a poem, which would become the lyrics to 'Italian Summer', and she gave the original to the hotel's owner as a gift.

The twinkling 'Italian Summer' is a big production number, and a song Stevie is especially proud of. "I want to go to Italy and sing that song," she says. "No one seems to be able to put that together. You know, if I don't get to go to Italy to sing that song, I'm going to go over there myself with a boom box, and I am standing on the corner in a long red dress, and I'm singing that song for the Italians because I think they need to hear it."

Two other particularly special songs would be 'New Orleans', a heartfelt gesture of solidarity dedicated to the Louisiana city that was still picking up the pieces after Hurricane Katrina, and 'Soldier's Angel', naturally borne of Nicks' time spent with hospitalised troops*. This track would kickstart a healing process, not just for those who heard it, but because accompanying her on the song would be Lindsey Buckingham, and joining Stevie and Dave for sessions at Tara would be "like a big cashmere hug, and he's not used to that", said Stevie. "Everybody was lovely to him and everybody was thrilled with what he was doing, Dave was filming him from every angle, and Lindsey felt a part [of it]. He could not deny how beautiful our situation was or how much fun we were having, and this was a very serious song we were doing." Stevie had called on Lindsey because she knew he was the only person who would be able to do her original piano demo of the song justice: "It's very old school Stevie and Lindsey," she observed, and working on the song gave them "a moment of clarity" together in a new context. Lindsey was not in control of the sessions, he was out of his comfort zone and, strangely, that meant he could actually relax more.

Naturally there would be a duet with Dave on *In Your Dreams*, a sweet if rather weak moment for the pair. 'Cheaper Than Free', a repetitive ballad, would feature lyrics that bordered on the banal ('what's deeper than a deep well? The love into which I fell.... / More exciting than high fashion? High passion...' You get the idea.) The title, 'Cheaper Than Free', was inadvertently given to Dave and Stevie by the movie star Reese Witherspoon, who was hanging out with Stevie and co. during an early session at the Village Recorder nearby. When Stevie started talking about how much money would be saved if they used her house instead of a studio, Reese chuckled that it would be "cheaper than free"... and immediately the Stewart/Nicks songwriting cogs started whirring.

* Stevie has set up her own charitable foundation, Stevie Nicks' Band Of Soldiers. She says, "I refuse to be pulled into the politics of war. But once these soldiers sign up, go to war and come back to a hospital, I will do whatever it takes to make them better."

By December 2010, the album was complete one whole year after its inception, and Stevie had a moment to breathe, give Tara a bit of an airing and build up her strength for her next move. Stevie had agreed to tour with Rod Stewart in the spring of 2011, two months before the release of *In Your Dreams* in May. It would be another co-headline show, just 18 dates, and the pair were sure to have some laughs on the road, singing all the old favourites in a three-hour show. The initial idea to team them up had actually come from Rod's daughters Kimberly and Ruby – "They love Stevie," Rod said. "She's just ultra-cool – she has a cult." (Hopefully he means a 'cult following'.)

Stevie and Rod hadn't worked with each other in the past, although they'd partied together during the seventies. Nicks remembers attending a New Year's party at Stewart's home in Los Angeles where her eye had inevitably been caught by Rod's collection of Tiffany lamps. As she made her way towards them, glass of wine in hand, the host himself swooped in and took her drink away, fearing she was drunk and was about to cause some expensive damage. "I was horrified," said Stevie in an interview with *Rolling Stone*, although Stewart laughingly smoothed it over. "Bitch I am sometimes, I probably wanted more wine for myself."

Rehearsals would show the fundamental differences between Rod and Stevie: Nicks was "a professional, nervous, doesn't want any mistakes". Rod admitted he was "just the opposite. I like the element of risk." Stevie was also wearily amused by the fact that, whenever they stayed together on the tour, "At six o'clock every morning he would put on 'Do You Think I'm Sexy?' as loud as it would go to get us out of bed." Some alarm clock. All the same, despite what Rod calls a "shaky start" he had to admit she was "wonderful to work with. By the end of the tour, she'd bought all my children a piece of jewellery, the three girl singers in the band jewellery, she bought me a piece of jewellery and what did I buy her? A Jo Malone candle. I felt so cheap," he said in an interview with Hitfix's Melinda Newman. They would tour again together the following year*

* Rod would join Stevie onstage for a duet of 'Leather And Lace', although he wouldn't take it entirely seriously, gooning about with a pair of frilly knickers for Stevie's line 'Take from me my lace.' Ahem.

which at least presented Rod with the opportunity to buy her something even more glamorous. And candles are, to be fair, tres Stevie.

During rehearsals with Rod, it had transpired that the smash hit teen TV show *Glee* had released an album featuring a version of 'Landslide' sung by Gwyneth Paltrow, who had made a guest appearance on the show. And, as it turned out, the record was doing rather well. "The *Glee* album with Gwyneth's 'Landslide' just hit number one," Stevie grinned the night before her tour with Rod began. "Ka-ching, ka-ching... I don't care who sings it, as long as they keep singing it."*

In Your Dreams would enter the *Billboard* chart on May 3, 2011 at number six (and at 14 on the UK album chart), and so, warmed up by the short tour with Rod, Stevie, with her band in tow, "stomped around the world like a door-to-door salesman" to promote the record and entertain her fans.

"Stevie is married to that microphone," said Waddy. "She can't do without it. She loves it, she needs it, and it's her. It's an incredible reality. Stevie is married to that tour, she is married to her fans, and married to the responsibility of being that girl for all those people. People think that artists are selfish, but Stevie Nicks is selfless. Hey, her only vice is wanting a fine hotel room, since she spends so much time on the road." But she also knew she had to sell that record; "the state of the music business" left her no choice. Fortunately for her, and all of Fleetwood Mac, the interest in the group as a whole and as individuals was, in Lindsey's opinion, higher than ever, as generation after generation of younger listeners discovered the band for themselves.

But Mick Fleetwood was getting a little edgy. Stevie wanted to spend another year on the road for *In Your Dreams*, which clashed somewhat

* Stevie visited the set of *Glee*, thrilling the cast and crew, and she was devastated when she heard that Cory Monteith, one of the show's stars, had died at the age of 31 on July 13, 2013. The cause of death was a toxic combination of heroin and alcohol. Stevie wrote to the cast of *Glee* expressing her sadness, also calling Monteith's fiancée and co-star Lea Michele to offer her support. "She sent me the most beautiful letter, as well a necklace that was hers and a beautiful book of pictures," Lea told MTV.com.

with what Fleetwood had in mind for the Mac – a world tour that would take them into the New Year of 2014. "I was fed up with waiting," he admitted in an interview with *The Sunday Express*' Charlotte Heathcote. "I was being a brat. I said, 'I don't think Fleetwood Mac is going to work again. We may not ever do this.' It all worked out for the best, Stevie was made aware of this and it all happened." She wouldn't budge until she was ready, however.

Mick was not the only member of Fleetwood Mac keen to get Stevie's attention. Still basking in the afterglow of that 'cashmere hug', Lindsey Buckingham revealed to the writer and broadcaster Pete Paphides, during an interview for BBC Radio 4's *Follow Up Albums* series, that he wanted to record with Stevie again as Buckingham Nicks.

"I would love to record with Stevie again," he admitted, adding coyly, "if you talk to her, put in a good word for me." Paphides told him that he had indeed spoken to her, having interviewed her for this very programme (which focused on *Tusk* – although her section was not broadcast, having apparently been censored by a member of Nicks' staff, according to *The Quietus*). "Oh good," replied Buckingham. "Well, I have written a bunch of songs, and I do want her to hear them, and I hope that we do [work together again]." It also appeared that, perhaps, Lindsey was sending a message to Stevie by pulling his Buckingham Nicks-era instrumental 'Stephanie', a favourite of Stevie's, and adding it to his own set list on his solo tour. Even if the Buckingham Nicks reunion was a no-go subject for Stevie, Lindsey had evidently softened more than ever, indicating that touring with the Mac would be an ever more appealing prospect.

Even so, from Stevie's point of view, as well as feeling *In Your Dreams* 'deserved' another year on the road, she also believed Fleetwood Mac "should stay off the grid for three years," she said, "It's just smart to keep us out of the spotlight for three years." Three was also a 'magic' number, of course; and it would be, as Stevie put it, a "perfect harmonic convergence" when they did reconvene in January 2013 for rehearsals. "Everyone went along with it. And now they all know it was really a great idea – because we were gone long enough that it was us coming back. I told the press last year that 2013 was going to be the year of

Fleetwood Mac. And I was just hoping with all my heart that this big statement was gonna come true!" And it would. 2012, in the meantime, was all hers to do with what she wished. But Stevie would have another, more personal reason for wanting more time before Fleetwood Mac went back out on the road; four days before New Year 2012, the Nicks family was hit by personal tragedy. Barbara Nicks, Stevie's beloved mother, died after a battle with pneumonia. She was 84.

Stevie was about to resume editing her *In Your Dreams* documentary when Barbara passed, and in response Nicks retreated altogether, even going down with a two-month case of pneumonia herself, almost in sympathy. Stevie had long suffered from respiratory weakness, and the grief struck her immune system hard. Fleetwood Mac were recording an EP, simply titled *Extended Play*, to be released on iTunes, but "I didn't go [to the studio]. I didn't want to go. I didn't want to go anywhere. I didn't leave the house for almost five months," Nicks confessed in an interview with *Herald Scotland*. All she wanted to do was pack up her favourite things and retreat to Tara, where she stayed in bed and watched the HBO series *Game Of Thrones,* which at least distracted her, the archaic supernatural themes, mythical beasts and dark saga-like story-lines making for perfect Stevie-viewing material. (The show even inspired Stevie to write a series of poems into the bargain, one for each of the characters.) Nicks did manage to drop in on the very final sessions for *Extended Play,* which is when the previously impatient Lindsey, the man she used to dread seeing at the studio, presented her with the song 'Sad Angel'. "I wrote that song for Stevie," he told *Rolling Stone.* "She always had to fight for everything. She was coming off a solo album and was in the process of reintegrating herself mentally in the band, and we're all warriors with a sword in one sort or another. I just wrote, 'Sad Angel have you come to fight the war / We fall to earth together, the crowd calling out for more.'" No doubt Stevie found she had a little something in her eye when Lindsey played her this.

The death of Barbara Nicks, the woman who had encouraged Stevie's dreams and guided her when she was lost, left Stevie by her own

admission "a little crazy," to the extent that, after an "exhausting day of interviews", she spoke out about the behaviour of the 'outspoken' Nicki Minaj on the TV show *American Idol* a little too openly, and her words swiftly flew around the internet in a miasma of scandal and outrage. Singer Minaj, a judge on the show alongside Stevie's friend Mariah Carey, had lashed out at Carey, allegedly referring to her as "her fucking highness" before, again, allegedly, saying, "If I had a gun, I would shoot the bitch." TV talent shows are clearly very serious business.

Asked for her response to the story by *The Daily.com*, Stevie let fly. "How dare this little girl! If I had been Mariah I would have walked over to Nicki and strangled her to death right there... I would have killed her in front of all those people and had to go to jail for it." Mariah Carey had reportedly hired security to protect her from Nicki Minaj on the show. It sounds like all she really had to do was call Stevie Nicks.

In all seriousness, Stevie herself was stunned by what she'd allowed herself to blurt out, fatigued, unhappy and riled to hear of her friend being insulted. "That was the first time that something really awful happened that I couldn't call my mum and say, 'What do I do?'" she said. What Stevie could do, however, was imagine what her mother would have said to her in a situation such as this.

"I spent a whole night not sleeping, that first night when it was all over the internet, and I could just hear my mother saying to me, 'Rushing in to save your friend was not wrong. But the words that you used were unacceptable, so apologise to this girl and she'll move on. But you should never move on, you should always remember to step back and take a breath before you say anything in a super emotional experience like that, because words are treacherous.'"

It was almost a "visitation", as Stevie describes it, and the following day Nicks issued a statement, apologising to Minaj. Stevie explained how protective she felt towards Carey and how exhausted she was that day. "I spoke without thinking," she wrote. "I think all artists should be respectful toward one another and that includes me. I am truly sorry."

Stevie would appear on *American Idol** herself (fortunately Nicki Minaj was not present) alongside her sometime producer and lover Jimmy Iovine some months later, just before Fleetwood Mac began their tour, and while she had previously joked that she would be a sharp-shooting Simon Cowell-type on the show if she had the chance, Stevie was, of course, a warm and sympathetic mentor, and the contestants adored her. She was kind and encouraging, harmonising with the hopefuls as they sang and urging them sincerely to put their hearts into it. She bantered with Jimmy, whom she insisted she still found "gorgeous", cheekily complimenting his "little Greek body", and as he referred to one contestant's song choice – 'Sweet Dreams' – as "the way you think of me", Stevie added, quick as a flash, "or a beautiful nightmare". Possibly the best back-handed compliment one could receive. But Stevie's loss was still close to the surface, and she was close to tears throughout the show. "My mom died, so now I don't have any problems. That's my problem, my mom isn't here anymore." No matter how close she still felt to Barbara spiritually, her mother's rings "dancing on my fingers" to remind her of their closeness even after death, nothing would ever feel quite the same again.

★ ★ ★

Another lesson Stevie took from the memories she had of her mother was that it was "really easy to say you're sorry. Just walk up to someone and say 'I am really sorry'..." Stevie said, quoting Barbara. These words came back to her on the threshold of the *Fleetwood Mac Live* tour in the spring of 2013. She realised it was time for another pre-tour heart

* Stevie Nicks would appear on the small and indeed silver screen increasingly during this period. As well as *American Idol* and her own film *In Your Dreams*, Stevie also starred in Dave Grohl's *Sound City* documentary, focusing on the studio of the same name that had kickstarted her career, and was given a cameo role in an episode of *American Horror Story: Coven*, playing herself as a 'white witch' and singing 'Seven Wonders', 'Rhiannon' and 'Has Anyone Ever Written Anything For You?'. For someone who always shied away from acting (although does being a self-confessed drama queen count?), Stevie was a natural.

to heart with Lindsey, but this one would finally "change everything", according to Nicks.

'Sorry' was "something we didn't say very much [to each other]", at least until now. Having thought long and hard about what she wanted to say, and inviting Lindsey over (hopefully suggesting he had several hours to spare) Stevie poured her heart out, the past unfurling before them once again, and she set the record straight and delivered a few home truths now he at last seemed prepared to accept them.

"[His] response was good. It was more or less, 'I wish you'd told me all this a long time ago.' I didn't take the time to explain that I wasn't happy because I thought [he] knew." A weight lifted from both of them, although Stevie admitted feeling some frustration that they hadn't had this chat three decades ago. Imagine the angst they could have saved themselves, although it is hard to say whether or not Buckingham would have just stormed off. Everything has its proper time, and this, it would seem, was it. The result would make Fleetwood Mac a happier place to be than, perhaps, it had ever been. There was just one missing piece of the jigsaw now: Christine McVie. Stevie had thought about her every day since her 'big sister' had left the band in 1998, declaring in an interview with *The Observer* in 2009 that she would "beg, borrow and scrape together $5 million and give it to her in cash if she would come back. That's how much I miss her." Well, that wouldn't be necessary. Rumours were flying almost as soon as the world tour had been announced that Christine might be coming back to the Fleetwood Mac fold, but Stevie batted away the barrage of questions, telling the press that "as much as we'd all like to think that she'll just change her mind one day, I don't think it'll happen."

However, as the months rolled on, Christine McVie stated publicly that she might "pop back to do a little duet or something when they're in London", and lo and behold, on September 25, 2013, during Fleetwood Mac's three-night residency at London's O2 Arena, just before the band played 'Don't Stop', Stevie Nicks would introduce to the stage her "mentor, big sister, best friend..." and the writer of that very song. On came Christine McVie to thunderous applause, although Stevie would reveal in the cold light of day that Christine could have performed more

songs with the band if Lindsey had allowed it. "I think his words were, 'She can't just come and go...' That's important to him, but it's not so important to me."

Lindsey needn't have worried. Four months later, the worst kept secret in rock'n'roll would be officially revealed when Mick Fleetwood announced that Christine McVie would be rejoining Fleetwood Mac for their 2014 *On With The Show* tour of the US. So what had changed? Well, Christine initially started to shy away from touring when she developed a fear of flying. Then she convinced herself that she wanted to stay at home and be a 'country lady', renovate a house in Kent, walk dogs, drive a Range Rover and "bake cookies. I don't know what I was thinking," she admitted, calling it a "deluded idea". Clearly it was what she needed at the time, but the road was calling her – and the fact that she was now 70 years old, the age when most people would be quite happy to start baking cookies and communing with canines, didn't make a blind bit of difference, and after a course of therapy to help her with her phobia of flying, she was ready to join her friends once again. One reason, perhaps, for her change of heart might have been seeing how John had suffered with his health in recent months. In October, John McVie had been diagnosed with cancer of the liver.

The Australia and New Zealand legs of the tour were cancelled so he could undergo treatment, and Christine felt 'renewed love' for how her stoic former husband was handling – and beating – the illness. Shortly after the *On With The Show* announcement, Stevie reassured the press that John was going to be just fine. "I'm not the least bit worried about John," she told *Us Weekly*. "He's very, very strong and a man of very few words. He's not a person to mess with." At the time of writing, John admittedly looks suddenly older in publicity shots of the band, but the dates are going ahead and McVie is in remission. Well, when you're faced with a command like 'On with the show', what choice does a pro like McVie have but to rise to it? Anticipation is high for the tour, which begins in September 2014, and the love for Fleetwood Mac just keeps on growing.

★ ★ ★

And so to the future. Stevie Nicks has always talked about the long term, discussing how she would still be performing as 'a little old lady', taking better care of her health so she could do just that and never, never just putting her feet up. Stevie still wants to release the children's stories she'd written in the eighties – 'A Goldfish And A Ladybug' and 'The Golden Fox Of The Last Fox Hunt' – and would love to make a record for children. "You can teach children an incredible amount through music," Stevie says. "I'd also like to record an album of songs by my grandfather, AJ Nicks." In her heart, her career is at least partly dedicated to him, the man who set her on the path to show business at such a young age, with greater success than he could ever have imagined. "He wanted to be a famous country and western star. I have to believe that he is enjoying this with me," says Stevie. "He would be really happy for me, because for the first time in a long time, this is fun."

In addition to all of these plans, there is still the *Mabinogion* movie concept, and a "ten-song ballet opus of 'Rhiannon'." As for a book, Stevie has warned her fans there will not be a 'tell-all' book, unless everyone else in her life is so old by the time she writes it that they just won't care any more about what goes in. "If I ever write a book, it will be vignettes, you know, 'the day I met Lindsey', 'the day I joined Fleetwood Mac', 'the day I decided to do a record with Dave Stewart'," Stevie told the audience at the Hamptons International Film Festival after a screening of *In Your Dreams*. "It'll be the magical moments. I am never going to write a book to drag people through the dredges of my life. I've done enough interviews, everybody knows that there were some very bad times in my life, but I survived." Rather, it would be about the "beautiful, romantic things. That's the stuff I'd like to tell you about."

Stevie is admittedly at that age where, for most people, their memories are in bolder relief than their dreams. However, Stevie is still dreaming, still creating and still sharing the magic and escapism the world so sorely needs, fulfilling her mission on earth (and in rock'n'roll, there are weddings all the time, regardless of age). She has no teenage children to worry about, no 'failed marriage' to lament having lost, or having given her 'best years' to. And as for death? "I'm not afraid of it at all.

I try to get as much done as I can, because you don't know how long you're going to be here," she told *Playboy*, way back in 1982. An old soul. "That's why it's important that I type a page or two every night – even if that's at 11 am. See, I think you live on earth a certain number of times until you finish what it is that you were meant to do here. And then you go on. I don't think I'll be back. I think I'm done."

In the meantime, "they'll probably be wheeling me out onstage in a wheelchair with rhinestones and raven feathers hot-glued to it. You know me," she says with a twinkle in her eye. "It has to be fabulous." The future may take her back to her past, in that Stevie still hankers for San Francisco, just as she did in her song 'Gypsy'. Little has changed in her heart. San Francisco was the place where it all began for her and Lindsey back in 1967, after all, and where now, all of the rock'n'roll ghosts – those of Jimi, Janis, Jim Morrison – can still be sensed hanging around at the Fillmore. "So," says Stevie. "If you're in the Haight 10 years from now and a blur of feathers and rhinestones whizzes past you on a rocket-powered wheelchair and someone goes, 'What was that?' you can say, 'Oh... that's Stevie.'"

Acknowledgments

Thanks, love and white-winged doves must go to the following gold dust men and women:

The brilliant, wise and supportive Dylan Howe – to whom this and all of my work is dedicated whether he likes it or not. Thank you. Keith Olsen, Rupert Hine, Fay Armstrong, Kenny Loggins, Mandi Davis, Shannon Trotta, Ian Sanders, Rudy Noriega, Dave Stewart and Waddy Wachtel (for warm vibes on initial approach – I appreciated it), the NBT massive, David Fricke, Gavin Martin, Daryl Easlea, Paul Silveira, Gareth Thomas at UCA, and all of those who assisted me, or at least tried to, in my quest. Your support, contributions and generosity are very much appreciated. (Oddly enough, it appears I am long-lost cousins with longtime Nicks collaborator Benmont Tench from the Heartbreakers. Did that help me get an interview with him? No it did not.)

Huge thanks go to my editor Chris Charlesworth – I have so enjoyed working with you on this! – David Barraclough, Jacqui Black and all at Omnibus Press, Charlie Harris at Midas PR, Simon Benham, my lovely family and friends, Marzipan (my familiar), you for picking up this book and, of course, Stevie Nicks for being the most fascinating subject to write about. This book was, by happy accident, completed on the full moon before Stevie Nicks' 66th birthday.

Bibliography

Books

Bishop, Stephen. *Songs In The Rough* (St Martin's Press, 1996)

Boyd, Dr Jenny & George-Warren, Holly. *It's Not Only Rock 'n' Roll* (John Blake Publishing, 2013)

Caillat, Ken & Stiefel, Steve. *Making Rumours – The Inside Story Of The Classic Fleetwood Mac Album* (John Wiley & Sons, 2013)

Elliott, Marc. *To The Limit: The Untold Story Of The Eagles* (Da Capo, 2004)

Fleetwood, Mick & Davis, Stephen. *Fleetwood – My Life And Adventures In Fleetwood Mac* (William Morrow, 1990)

Goldberg, Danny. *Bumping Into Geniuses – My Life Inside The Rock and Roll Business* (Penguin, 2010)

Halliburton, Sandra. *Read Between My Lines – The Musical & Life Journey Of Stevie Nicks* (SK Halliburton Enterprises, 2006)

Harris, Carol Ann. *Storms – My Life With Lindsey Buckingham and Fleetwood Mac* (Chicago Press Review, 2009)

Trucks, Rob. *Fleetwood Mac's Tusk (33 1/3)* (Continuum, 2011)

Wilson, Ann & Nancy & Cross, Charles. *Kicking and Dreaming: A Story of Heart, Soul and Rock & Roll* (It Books, 2012)

Zollo, Paul. *Conversations With Tom Petty* (Omnibus Press 2004)

Magazine Articles

Appleford, Steve. Fleetwood Mac Takes Reunion Right To The Top (*Philadelphia Inquirer*, September 21, 1997)

BBC News report: Death of John Lennon (December 8, 1980)

BBC Radio 4, Follow Up Records, Pete Paphides and Lindsey Buckingham, reference from *The Quietus* (May 2012)

Benson, Joe. Off The Record interview (September 24, 2000)

Billboard review (March 3, 1974)

Bird, Rick. Stevie Nicks Keeps Rocking And Twirling (*Cincinnati Post*, December 12, 2001)

Bright, Spencer. Come Into My Parlour (*Vox*, February 1992)

Brown, Mark. Going Your Own Way Easier Said Than Done (*Rocky Mountain News*, July 9, 2004), The Wild Heart Press Kit (Modern Records, 1983)

Timespace Liner Notes, Modern Records / Atlantic Records / EMI Records (September 1991)

Tom Moncrieff / Javier Pacheco (Fritz) Q&A, Penguin Q&A Sessions

Tsavdari, Dora. Nicks' song sung for shop owner (*Daily Telegraph [Australia]*, March 9, 2004)

Vare, Ethlie Ann & Ochs, Ed. *Everything You Want to Know About Stevie Nicks.* (Ballantine, 1984)

Vena, Jocelyn. Lea Michele Credits Stevie Nicks With Helping Her Through 'Worst Year Of My Life' (*MTV.com*, November 12, 2013)

Waddy Wachtel interview with *Blackcat* (2001–2003)

WBNC Boston radio interview (July 5, 1983)

White, Timothy. Long Distance Winner – *Billboard* interview (April 18, 1998)

Williams, Chris. The Rebounding Talents Of Nicks (*Entertainment Weekly Online*, May 1, 1998)

Willsher, Kim. For Sale: Honky Chateau Where Elton And Bowie Recorded Classic Hits (*Observer*, August 4, 2013)

Yuan, Jada. Stevie Nicks: The Fairy Godmother Of Rock (*New York Magazine*, October 6, 2013)

Song Index

Index

List of Selected Tables for Analysis and Design

SIXTH EDITION

Modern Control Systems

Richard C. Dorf
University of California, Davis

ADDISON-WESLEY
PUBLISHING COMPANY

Reading, Massachusetts•Menlo Park, California•New York
Don Mills, Ontario•Wokingham, England•Amsterdam•Bonn
Sydney•Singapore•Tokyo•Madrid•San Juan•Milan•Paris

This book is in the Addison-Wesley Series in Electrical and Computer Engineering: Control Engineering
Consulting Editor: Karl J. Åström

Adaptive Control, 09720
 Karl J. Åström and Björn Wittenmark
Introduction to Robotics, Second Edition, 09528
 John J. Craig
Modern Control Systems, Sixth Edition, 51713
 Richard C. Dorf
Digital Control of Dynamic Systems, Second Edition, 11938
 Gene F. Franklin, J. David Powell, and Michael L. Workman

Computer Control of Machines and Processes, 10645
 John G. Bollinger and Neil A. Duffie
Feedback Control of Dynamic Systems, Second Edition, 50862
 Gene F. Franklin, J. David Powell, and Abbas Emami-Naeini
Adaptive Control of Mechanical Manipulators, 10490
 John J. Craig

Library of Congress Cataloging-in-Publication Data

Dorf, Richard C.
 Modern control systems / Richard C. Dorf. — 6th ed.
 p. cm.
 Includes bibliographical references and index.
 ISBN 0-201-51713-2
 1. Feedback control systems. I. Title.
 TJ216.D67 1992
 629.8'3—dc20 91-2731
 CIP

2 3 4 5 6 7 8 9 10-HA-95949392

Man cannot inherit the past, he has to recreate it.

TO

MY STUDENTS as they seek to create

PREFACE

The National Academy of Engineering identified in 1990 the ten outstanding engineering achievements of the preceding twenty-five years. These feats included five accomplishments made possible by utilizing modern control engineering: the Apollo lunar landing, satellites, computer-aided manufacturing, computerized axial tomography, and the jumbo jet.

Automation and robotics are critical ingredients in the world's efforts toward an improved standard of living for all. Automation, the automatic operation of processes, and robotics, which includes the manipulator, controller, and associated devices, are all critical to effective operation of our plants, factories, and institutions. The most important and productive approach to learning is for each of us to rediscover and recreate anew the answers and methods of the past. Thus the ideal is to present the student with a series of problems and questions and point to some of the answers that have been obtained over the past decades. The traditional method—to confront the student not with the problem but with the finished solution—is to deprive the student of all excitement, to shut off the creative impulse, to reduce the adventure of humankind to a dusty heap of theorems. The issue, then, is to present some of the unanswered and important problems which we continue to confront. For it may be asserted that what we have truly learned and understood we discovered ourselves.

The purpose of this book is to present the structure of feedback control theory and to provide a sequence of exciting discoveries as we proceed through the text and problems. If this book is able to assist the student in discovering feedback control system theory and practice, it will have succeeded.

The book is organized around the concepts of control system theory as they have been developed in the frequency- and time-domain. A real attempt has been

made to make the selection of topics, as well as the systems discussed in the examples and problems, modern in the best sense. Therefore this book includes a discussion of sensitivity, performance indices, state variables, robotics, and computer control systems, to name a few. However, a valiant attempt has been made to retain the classical topics of control theory that have proved to be so very useful in practice.

Written in an integrated form, the text should be read from the first to the last chapter. However, it is not necessary to include all the sections of a given chapter in any given course, and there appears to be quite a large number of combinations of sequences of the sections for study. The book is designed for an introductory undergraduate course in control systems for engineering students. There is very little demarcation between electrical, mechanical, chemical, and industrial engineering in control system practice; therefore this text is written without any conscious bias toward one discipline. Thus it is hoped that this book will be equally useful for all engineering disciplines and, perhaps, will assist in illustrating the unity of control engineering. The problems and examples are chosen from all fields, and the examples of the sociological, biological, ecological, and economic control systems are intended to provide the reader with an awareness of the general applicability of control theory to many facets of life.

The book is primarily concerned with linear, constant parameter control systems. This is a deliberate limitation because I believe that for an introduction to control systems, it is wisest initially to consider linear systems. Nevertheless, several nonlinear systems are introduced and discussed where appropriate.

Chapter 1 provides an introduction to and basic history of control theory. Chapter 2 is concerned with developing mathematical models of these systems. With the models available, the text describes the characteristics of feedback control systems in Chapter 3 and illustrates why feedback is introduced in a control system. Chapter 4 examines the performance of control systems, and Chapter 5 investigates the stability of feedback systems. Chapter 6 is concerned with the *s*-plane representation of the characteristic equation of a system and the root locus. Chapters 7 and 8 treat the frequency response of a system and the investigation of stability using the Nyquist criterion. Chapter 9 develops the time-domain concepts in terms of the state variables of a system. Chapter 10 describes and develops several approaches to designing and compensating a control system. Chapter 11 discusses computer control systems, robust systems, and robotics. Finally, Chapter 12 introduces and illustrates the all-important topic of engineering design.

This book is suitable for an introductory course in control systems. In its first five editions, the text has been used in senior-level courses for engineering students at more than 400 colleges and universities. Also, it has been used in courses for engineering graduate students with no previous background in control system theory.

The text presumes a reasonable familiarity with the Laplace transformation and transfer functions as developed in a first course in linear system analysis or network analysis. These concepts are discussed in Chapter 2 and are used to

develop mathematical models for control system components. Answers to selected exercises are provided along with the exercises. Answers to selected problems are provided at the end of the book.

The sixth edition has incorporated several important developments in the field of control systems, with particular reference to robots and robust systems. In addition, a valuable feature is the exercises immediately preceding the problems. The purpose of these exercises is to permit students to utilize readily the concepts and methods introduced in each chapter in the solution of relatively straightforward exercises before attempting the more complex problems. The sixth edition expands the emphasis on design and incorporates a design example and several design problems in each chapter.

The sixth edition uses the computer program the Control System Design Program (CSDP) to assist in the solution of selected examples throughout the book. The student should first understand and use the tools and concepts before proceeding to utilize computer solutions. Nevertheless, the computer-aided analysis of the CSDP can be an invaluable aid in solving complex problems.

This edition also provides a preview as well as a summary of the terms and concepts for each chapter. There is an expanded Chapter 11, which discusses the useful proportional-integral-derivative (PID) controller and robust control systems. An enhanced Chapter 12 encompassing the all-important topic of design of real-world, complex control systems completes this edition.

This material has been developed with the assistance of many individuals to whom I wish to express my sincere appreciation. Finally, I can only partially acknowledge the encouragement and patience of my wife, Joy, who helped to make this book possible.

Davis, California R.C.D.

CONTENTS

Feedback Control System Characteristics 115

The Performance of Feedback Control Systems 157

Stability in the Frequency Domain 353

Time-Domain Analysis of Control Systems 429

CHAPTER 1

Introduction to Control Systems

Preview

A system, consisting of interconnected components, is built to achieve a desired purpose. The performance of this system can be examined, and methods for controlling its performance can be proposed. It is the purpose of this chapter to describe the general approach to designing and building a control system.

In order to understand the purpose of a control system, it is useful to examine some examples of control systems through the course of history. Even these early systems incorporated the idea of feedback, which we will discuss throughout this book.

Modern control engineering practice includes the use of control strategies for aircraft, rapid transit, the artificial heart, and steel making, among others. We will examine these very interesting applications of control engineering.

1

1.1 Introduction

Engineering is concerned with understanding and controlling the materials and forces of nature for the benefit of humankind. Control system engineers are concerned with understanding and controlling segments of their environment, often called *systems,* in order to provide useful economic products for society. The twin goals of understanding and control are complementary because, in order to be controlled more effectively, the systems under control must be understood and modeled. Furthermore, control engineering must often consider the control of poorly understood systems such as chemical process systems. The present challenge to control engineers is the modeling and control of modern, complex, interrelated systems such as traffic-control systems, chemical processes, and robotic systems. However, simultaneously, the fortunate engineer has the opportunity to control many very useful and interesting industrial automation systems. Perhaps the most characteristic quality of control engineering is the opportunity to control machines, and industrial and economic processes for the benefit of society.

Control engineering is based on the foundations of feedback theory and linear system analysis, and it integrates the concepts of network theory and communication theory. Therefore control engineering is not limited to any engineering discipline but is equally applicable for aeronautical, chemical, mechanical, environmental, civil, and electrical engineering. For example, quite often a control system includes electrical, mechanical, and chemical components. Furthermore, as the understanding of the dynamics of business, social, and political systems increases, the ability to control these systems will increase also.

A *control system* is an interconnection of components forming a system configuration that will provide a desired system response. The basis for analysis of a system is the foundation provided by linear system theory, which assumes a cause-effect relationship for the components of a system. Therefore a component or *process* to be controlled can be represented by a block as shown in Fig. 1.1. The input-output relationship represents the cause and effect relationship of the process, which in turn represents a processing of the input signal to provide an output signal variable, often with a power amplification. An *open-loop* control system utilizes a controller or control actuator in order to obtain the desired response, as shown in Fig. 1.2.

In contrast to an open-loop control system, a closed-loop control system utilizes an additional measure of the actual output in order to compare the actual output with the desired output response. The measure of the output is called the *feedback signal.* A simple *closed-loop feedback control system* is shown in Fig. 1.3.

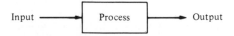

Figure 1.1. Process to be controlled.

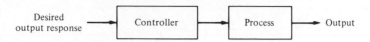

Figure 1.2. Open-loop control system.

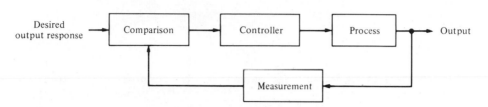

Figure 1.3. Closed-loop feedback control system.

A standard definition of a feedback control system is as follows: A feedback control system is a control system that tends to maintain a prescribed relationship of one system variable to another by comparing functions of these variables and using the difference as a means of control.

A feedback control system often uses a function of a prescribed relationship between the output and reference input to control the process. Often the difference between the output of the process under control and the reference input is amplified and used to control the process so that the difference is continually reduced. The feedback concept has been the foundation for control system analysis and design.

Due to the increasing complexity of the system under control and the interest in achieving optimum performance, the importance of control system engineering has grown in this decade. Furthermore, as the systems become more complex, the interrelationship of many controlled variables must be considered in the control scheme. A block diagram depicting a *multivariable control system* is shown in Fig. 1.4. A humorous example of a closed-loop feedback system is shown in Fig. 1.5.

A common example of an open-loop control system is an electric toaster in the kitchen. An example of a closed-loop control system is a person steering an automobile (assuming his or her eyes are open).

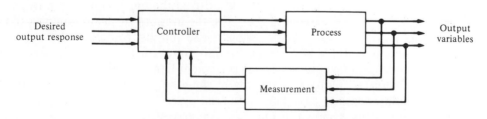

Figure 1.4. Multivariable control system.

Figure 1.5. Rube Goldberg's elaborate creations were almost all closed-loop feedback systems. Goldberg called this simply, "Be Your Own Dentist." (© Rube Goldberg, permission granted by King Features Syndicate, Inc., 1979.)

1.2 History of Automatic Control

The use of feedback in order to control a system has had a fascinating history. The first applications of feedback control rest in the development of float regulator mechanisms in Greece in the period 300 to 1 B.C. [1, 2]. The water clock of Ktesibios used a float regulator (refer to Problem 1.11). An oil lamp devised by Philon in approximately 250 B.C. used a float regulator in an oil lamp for maintaining a constant level of fuel oil. Heron of Alexandria, who lived in the first century A.D., published a book entitled *Pneumatica,* which outlined several forms of water-level mechanisms using float regulators [1].

The first feedback system to be invented in modern Europe was the temperature regulator of Cornelis Drebbel (1572–1633) of Holland [1]. Dennis Papin [1647–1712] invented the first pressure regulator for steam boilers in 1681. Papin's pressure regulator was a form of safety regulator similar to a pressure-cooker valve.

The first automatic feedback controller used in an industrial process is generally agreed to be James Watt's *flyball governor* developed in 1769 for controlling the speed of a steam engine [1, 2]. The all-mechanical device, shown in Fig. 1.6, measured the speed of the output shaft and utilized the movement of the flyball with speed to control the valve and therefore the amount of steam entering the engine. As the speed increases, the ball weights rise and move away from the shaft axis thus closing the valve. The flyweights require power from the engine in order to turn and therefore make the speed measurement less accurate.

The first historical feedback system claimed by the Soviet Union is the water-level float regulator said to have been invented by I. Polzunov in 1765 [4]. The level regulator system is shown in Fig. 1.7. The float detects the water level and controls the valve that covers the water inlet in the boiler.

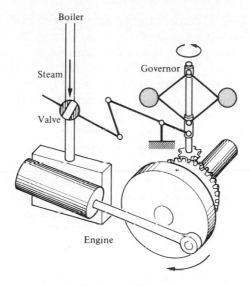

Figure 1.6. Watt flyball governor.

The period preceding 1868 was characterized by the development of automatic control systems by intuitive invention. Efforts to increase the accuracy of the control system led to slower attenuation of the transient oscillations and even to unstable systems. It then became imperative to develop a theory of automatic control. J. C. Maxwell formulated a mathematical theory related to control theory using a differential equation model of a governor [5]. Maxwell's study was concerned with the effect various system parameters had on the system performance. During the same period, I. A. Vyshnegradskii formulated a mathematical theory of regulators [6].

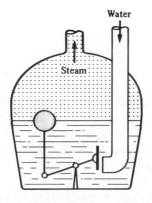

Figure 1.7. Water-level float regulator.

Prior to World War II, control theory and practice developed in the United States and Western Europe in a different manner than in the U.S.S.R. and Eastern Europe. A main impetus for the use of feedback in the United States was the development of the telephone system and electronic feedback amplifiers by Bode, Nyquist, and Black at Bell Telephone Laboratories [7, 8, 9, 10, 12]. The frequency domain was used primarily to describe the operation of the feedback amplifiers in terms of bandwidth and other frequency variables. In contrast, the eminent mathematicians and applied mechanicians in the Soviet Union inspired and dominated the field of control theory. Therefore, the Russian theory tended to utilize a time-domain formulation using differential equations.

A large impetus to the theory and practice of automatic control occurred during World War II when it became necessary to design and construct automatic airplane pilots, gun-positioning systems, radar antenna control systems, and other military systems based on the feedback control approach. The complexity and expected performance of these military systems necessitated an extension of the available control techniques and fostered interest in control systems and the development of new insights and methods. Prior to 1940, for most cases, the design of control systems was an art involving a trial-and-error approach. During the 1940s, mathematical and analytical methods increased in number and utility, and control engineering became an engineering discipline in its own right [10, 11, 12].

Frequency-domain techniques continued to dominate the field of control following World War II with the increased use of the Laplace transform and the complex frequency plane. During the 1950s, the emphasis in control engineering theory was on the development and use of the *s*-plane methods and, particularly, the root locus approach. Furthermore, during the 1980s, the utilization of digital computers for control components became routine. These new controlling elements possessed an ability to calculate rapidly and accurately that was formerly not available to the control engineer. There are now over two hundred thousand digital process control computers installed in the United States [13, 44]. These computers are employed especially for process control systems in which many variables are measured and controlled simultaneously by the computer.

With the advent of Sputnik and the space age, another new impetus was imparted to control engineering. It became necessary to design complex, highly accurate control systems for missiles and space probes. Furthermore, the necessity to minimize the weight of satellites and to control them very accurately has spawned the important field of optimal control. Due to these requirements, the time-domain methods developed by Liapunov, Minorsky, and others have met with great interest in the last decade. Furthermore, new theories of optimal control have been developed by L. S. Pontryagin in the Soviet Union and R. Bellman in the United States. It now is clear that control engineering must consider both the time-domain and the frequency-domain approaches simultaneously in the analysis and design of control systems.

A selected history of control system development is summarized in Table 1.1.

Table 1.1. Selected Historical Developments of Control Systems

1769	James Watt's steam engine and governor developed. The Watt steam engine is often used to mark the beginning of the Industrial Revolution in Great Britain. During the industrial revolution, great strides were made in the development of mechanization, a technology preceding automation.
1800	Eli Whitney's concept of interchangeable parts manufacturing demonstrated in the production of muskets. Whitney's development is often considered as the beginning of mass production.
1868	J. C. Maxwell formulates a mathematical model for a governor control of a steam engine.
1913	Henry Ford's mechanized assembly machine introduced for automobile production.
1927	H. W. Bode analyzes feedback amplifiers.
1932	H. Nyquist develops a method for analyzing the stability of systems.
1952	Numerical control (NC) developed at Massachusetts Institute of Technology for control of machine-tool axes.
1954	George Devol develops "programmed article transfer," considered to be the first industrial robot design.
1960	First Unimate robot introduced, based on Devol's designs. Unimate installed in 1961 for tending die-casting machines.
1980	Robust control system design widely studied.
1990	Export-oriented manufacturing companies emphasize automation.

1.3　Two Examples of Engineering Creativity

Harold S. Black graduated from Worcester Polytechnic Institute in 1921 and joined Bell Laboratories of American Telegraph and Telephone (AT&T). In 1921, the major task confronting Bell Labs was the improvement of the telephone system and the design of improved signal amplifiers. Black was assigned the task of linearizing, stabilizing, and improving the amplifiers that were used in tandem to carry conversations over distances of several thousand miles.

In a recent article, Black reports [8]:

> Then came the morning of Tuesday, August 2, 1927, when the concept of the negative feedback amplifier came to me in a flash while I was crossing the Hudson River on the Lackawanna Ferry, on my way to work. For more than 50 years I have pondered how and why the idea came, and I can't say any more today than I could that morning. All I know is that after several years of hard work on the problem, I suddenly realized that if I fed the amplifier output back to the input, in reverse phase, and kept the device from oscillating (singing, as we called it then), I would have exactly what I wanted: a means of canceling out the distortion in the output. I opened my morning newspaper and on a page of *The New York Times* I sketched a simple canonical diagram of a negative feedback amplifier plus

the equations for the amplification with feedback. I signed the sketch, and 20 minutes later, when I reached the laboratory at 463 West Street, it was witnessed, understood, and signed by the late Earl C. Blessing.

I envisioned this circuit as leading to extremely linear amplifiers (40 to 50 db of negative feedback), but an important question is: How did I know I could avoid self-oscillations over very wide frequency bands when many people doubted such circuits would be stable? My confidence stemmed from work that I had done two years earlier on certain novel oscillator circuits and three years earlier in designing the terminal circuits, including the filters, and developing the mathematics for a carrier telephone system for short toll circuits.

Another example of the discovery of an engineering solution to a control system problem was that of the creation of a gun director by David B. Parkinson of Bell Telephone Laboratories. In the spring of 1940, Parkinson was a 29-year-old engineer intent on improving the automatic level recorder, an instrument that used strip-chart paper to plot the record of a voltage. A critical component was a small potentiometer that was used to control the pen of the recorder through an actuator.

Parkinson had a dream about an antiaircraft gun that was successfully felling airplanes. Parkinson described the situation [58]:

> After three or four shots one of the men in the crew smiled at me and beckoned me to come closer to the gun. When I drew near he pointed to the exposed end of the left trunnion. Mounted there was the control potentiometer of my level recorder!

The next morning Parkinson realized the significance of his dream:

> If my potentiometer could control the pen on the recorder, something similar could, with suitable engineering, control an antiaircraft gun.

After considerable effort, an engineering model was delivered for testing to the U.S. Army on December 1, 1941. Production models were available by early 1943 and eventually 3000 gun controllers were delivered. Input to the controller was provided by radar and the gun was aimed by taking the data of the airplane's present position and calculating the target's future position.

1.4 Control Engineering Practice

Control engineering is concerned with the analysis and design of goal-oriented systems. Therefore the mechanization of goal-oriented policies has grown into a hierarchy of goal-oriented control systems. Modern control theory is concerned with systems with the self-organizing, adaptive, robust, learning, and optimum qualities. This interest has aroused even greater excitement among control engineers.

The control of an industrial process (manufacturing, production, and so on) by automatic rather than human means is often called *automation.* Automation is prevalent in the chemical, electric power, paper, automobile, and steel industries, among others. The concept of automation is central to our industrial society. Automatic machines are used to increase the production of a plant per worker in order to offset rising wages and inflationary costs. Thus industries are concerned with the productivity per worker of their plant. *Productivity* is defined as the ratio of physical output to physical input. In this case we are referring to labor productivity, which is real output per hour of work. In a study conducted by the U.S. Commerce Department it was determined that labor productivity grew at an average annual rate of 2.8% from 1948 to 1990 [13]. In order to continue these productivity gains, expenditures for factory automation in the United States are expected to increase from $5.0 billion in 1988 to $12.0 billion in 1994 [26]. Worldwide expenditures for process control and manufacturing plant control are expected to grow from $12.0 billion in 1988 to $28.0 billion in 1994 [26]. The U.S. manufacturers currently supply approximately one-half of worldwide control equipment.

The transformation of the U.S. labor force in the country's brief history follows the progressive mechanization of work that attended the evolution of the agrarian republic into an industrial world power. In 1820 more than 70% of the labor force worked on the farm. By 1900 fewer than 40% were engaged in agriculture. Today, fewer than 5% work in agriculture [15].

In 1925 some 588,000 people—about 1.3% of the nation's labor force—were needed to mine 520 million tons of bituminous coal and lignite, almost all of it from underground. By 1980 production was up to 774 million tons, but the work force had been reduced to 208,000. Furthermore, only 136,000 of that number were employed in underground mining operations. The highly mechanized and highly productive surface mines, with just 72,000 workers, produced 482 million tons, or 62% of the total [27].

The easing of human labor by technology, a process that began in prehistory, is entering a new stage. The acceleration in the pace of technological innovation inaugurated by the Industrial Revolution has until recently resulted mainly in the displacement of human muscle power from the tasks of production. The current revolution in computer technology is causing an equally momentous social change: the expansion of information gathering and information processing as computers extend the reach of the human brain [56].

The decline in the work week in the United States is illustrated by Fig. 1.8.

Control systems are used to achieve (1) increased productivity and (2) improved performance of a device or system. Automation is used to improve productivity and obtain high quality products. Automation is the automatic operation or control of a process, device, or system. We utilize automatic control of machines and processes in order to produce a product within specified tolerances [28].

The term *automation* first became popular in the automobile industry. Transfer lines were coupled with automatic machine tools to create long machinery

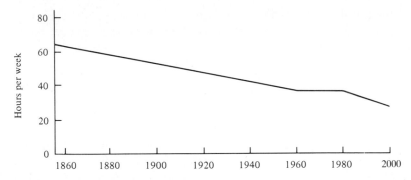

Figure 1.8. The work week in U.S. manufacturing industries was shortened from 67 hours in 1860 to about 38 hours in 1990.

lines that could produce engine parts, such as the cylinder block, virtually without operator intervention. In body-parts manufacturing, automatic-feed mechanisms were coupled with high-speed stamping presses to increase productivity in sheet-metal forming. In many other areas where designs were relatively stable, such as radiator production, entire automated lines replaced manual operations.

With the demand for flexible, custom production emerging in the 1990s, a need for flexible automation and robots is growing [31].

There are about 150,000 control engineers in the United States and also in Japan, and over 100,000 control engineers in the Soviet Union. In the United States alone, the control industry does a business of over $40 billion per year! The theory, practice, and application of automatic control is a large, exciting, and extremely useful engineering discipline. One can readily understand the motivation for a study of modern control systems.

1.5 Examples of Modern Control Systems

Feedback control is a fundamental fact of modern industry and society. Driving an automobile is a pleasant task when the auto responds rapidly to the driver's commands. Many cars have power steering and brakes, which utilize hydraulic amplifiers for amplification of the force to the brakes or the steering wheel. A simple block diagram of an automobile steering control system is shown in Fig. 1.9(a). The desired course is compared with a measurement of the actual course in order to generate a measure of the error as shown in Fig. 1.9(b). This measurement is obtained by visual and tactile (body movement) feedback. There is an additional feedback from the feel of the steering wheel by the hand (sensor). This feedback system is a familiar version of the steering control system in an ocean liner or the flight controls in a large airplane. All these systems operate in a closed-loop sequence as shown in Fig. 1.10. The actual and desired outputs are compared, and a measure of the difference is used to drive the power amplifier. The

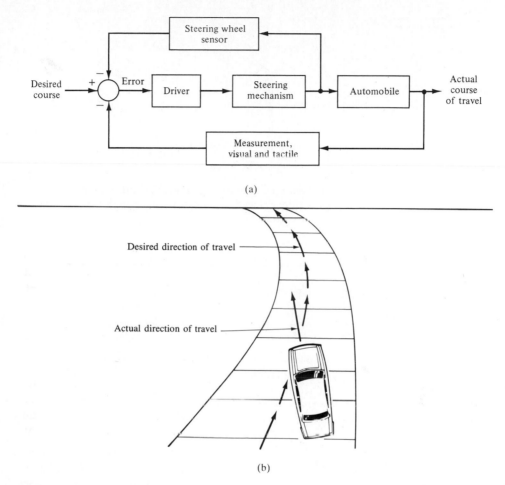

(a)

(b)

Figure 1.9. (a) Automobile steering control system. (b) The driver uses the difference between the actual and desired direction of travel to generate a controlled adjustment of the steering wheel.

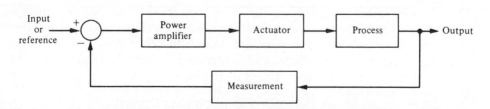

Figure 1.10. Basic closed-loop control system.

Figure 1.11. A manual control system for regulating the level of fluid in a tank by adjusting the output valve. The operator views the level of fluid through a port in the side of the tank.

power amplifier causes the actuator to modulate the process in order to reduce the error. The sequence is such that if the ship, for instance, is heading incorrectly to the right, the rudder is actuated in order to direct the ship to the left. The system shown in Fig. 1.10 is a *negative feedback* control system, because the output is subtracted from the input and the difference is used as the input signal to the power amplifier.

A basic manually controlled closed-loop system for regulating the level of fluid in a tank is shown in Fig. 1.11. The input is a reference level of fluid that the operator is instructed to maintain. (This reference is memorized by the operator.) The power amplifier is the operator and the sensor is visual. The operator compares the actual level with the desired level and opens or closes the valve (actuator) to maintain the desired level.

Other familiar control systems have the same basic elements as the system shown in Fig. 1.10. A refrigerator has a temperature setting or desired temperature, a thermostat to measure the actual temperature and the error, and a compressor motor for power amplification. Other examples in the home are the oven, furnace, and water heater. In industry, there are speed controls, process temperature and pressure controls, position, thickness, composition, and quality controls among many others [25, 29, 30].

In its modern usage, automation can be defined as a technology that uses programmed commands to operate a given process, combined with feedback of information to determine that the commands have been properly executed. Automation is often used for processes that were previously operated by humans. When automated, the process can operate without human assistance or interference. In fact, most automated systems are capable of performing their functions with greater accuracy and precision, and in less time, than humans are able to do.

An example of a semiautomated process that incorporates human workers and robots is shown in Fig. 1.12.

A robot is a computer controlled machine and is a technology closely associated with automation. Industrial robotics can be defined as a particular field of

Figure 1.12. An illustration of a typical hybrid (human-robot) workstation. This illustration is based on the on-line operation phase of a production line where operator and intelligent robot cooperation must occur.

automation in which the automated machine (i.e., the robot) is designed to substitute for human labor [18, 19]. To do this, robots possess certain human-like characteristics. Today, the most common human-like characteristic is a mechanical manipulator that is patterned somewhat after the human arm and wrist. We recognize that the automatic machine is well suited to some tasks, as noted in Table 1.2, while other tasks are best carried out by humans.

Another very important application of control technology is in the control of the modern automobile [20, 59]. Control systems for suspension, steering, and engine control are being introduced. Many new autos have a four-wheel-steering system, as well as an antiskid control system.

There has been considerable discussion recently concerning the gap between practice and theory in control engineering. However, it is natural that theory precedes the applications in many fields of control engineering. Nonetheless, it is

Table 1.2. Task Difficulty: Human Versus Automatic Machine

Tasks Difficult for a Machine	Tasks Difficult for a Human
Inspect seedlings in a nursery.	Inspect a system in a hot, toxic environment.
Drive a vehicle through rugged terrain.	Repetitively assemble a clock.
Identify the most expensive jewels on a tray of jewels.	Land an airliner at night, in bad weather.

interesting to note that in the electric power industry, the largest industry in the United States, the gap is relatively insignificant. The electric power industry is primarily interested in energy conversion, control, and distribution. It is critical that computer control be increasingly applied to the power industry in order to improve the efficient use of energy resources. Also, the control of power *plants* for minimum waste emission has become increasingly important. The modern, large-capacity plants, which exceed several hundred megawatts, require automatic control systems that account for the interrelationship of the process variables and the optimum power production. It is common to have as many as 90 or more manipulated variables under coordinated control. A simplified model showing several of the important control variables of a large boiler-generator system is shown in Fig. 1.13. This is an example of the importance of measuring many variables, such as pressure and oxygen, in order to provide information to the computer for control calculations. It is estimated that more than two hundred thousand computer control systems have been installed in the United States [44, 50]. The diagram of a computer control system is shown in Fig. 1.14. The electric power industry has utilized the modern aspects of control engineering for significant and interesting applications. It appears that in the process industry, the factor that maintains the applications gap is the lack of instrumentation to measure all the important process variables, including the quality and composition of the product. As these instruments become available, the applications of modern control theory to industrial systems should increase measurably.

Another important industry, the metallurgical industry, has had considerable success in automatically controlling its processes. In fact, in many cases, the control applications are beyond the theory. For example, a hot-strip steel mill, which involves a $100-million investment, is controlled for temperature, strip width, thickness, and quality.

Rapidly rising energy costs coupled with threats of energy curtailment are resulting in new efforts for efficient automatic energy management. Computer controls are used to control energy use in industry and to stabilize and connect loads evenly to gain fuel economy [30].

There has been considerable interest recently in applying the feedback control concepts to automatic warehousing and inventory control. Furthermore, automatic control of agricultural systems (farms) is meeting increased interest. Auto-

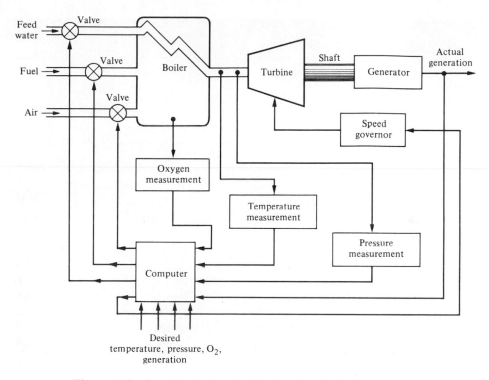

Figure 1.13. Coordinated control system for a boiler-generator.

matically controlled silos and tractors have been developed and tested. Automatic control of wind turbine generators, solar heating and cooling, and automobile engine performance are important modern examples [20, 32].

Also, there have been many applications of control system theory to biomedical experimentation, diagnosis, prosthetics, and biological control systems [24, 38]. The control systems under consideration range from the cellular level to the central nervous system, and include temperature regulation and neurological, respiratory, and cardiovascular control. Most physiological control systems are closed-loop systems. However, we find not one controller but rather control loop

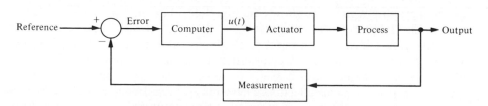

Figure 1.14. A computer control system.

Figure 1.15. The Utah/MIT Dextrous Robotic Hand: A dextrous robotic hand having 18 degrees of freedom, developed as a research tool by the Center for Engineering Design at the University of Utah and the Artificial Intelligence Laboratory at M.I.T. It is controlled by five Motorola 68000 microprocessors and actuated by 36 high-performance electropneumatic actuators via high-strength polymeric tendons. The hand has three fingers and a thumb. It uses touch sensors and tendons for control. (Photograph by Michael Milochik. Courtesy of University of Utah.)

within control loop, forming a hierarchy of systems. The modeling of the structure of biological processes confronts the analyst with a high-order model and a complex structure. Prosthetic devices that aid the 46 million handicapped individuals in the United States are designed to provide automatically controlled aids to the disabled [19, 22, 24, 36]. An artificial hand that uses force feedback signals and is controlled by the amputee's bioelectric control signals, which are called electromyographic signals, is shown in Fig. 1.15. The Jarvik artificial heart is shown in Fig. 1.16.

Finally, it has become of interest and value to attempt to model the feedback processes prevalent in the social, economic, and political spheres. This approach is undeveloped at present but appears to have a reasonable future. Society, of course, is comprised of many feedback systems and regulatory bodies such as the Interstate Commerce Commission and the Federal Reserve Board, which are controllers exerting the necessary forces on society in order to maintain a desired

Figure 1.16. The Jarvik-7 artificial heart. William Schroeder received such an artificial heart on November 25, 1984, in Louisville, Kentucky. This system is driven by an external air compressor that moves the heart diaphragms. This is an advanced control system for the human blood-flow system. (Courtesy of Symbion, Inc.) [47]

output. A simple lumped model of the national income feedback control system is shown in Fig. 1.17. This type of model helps the analyst to understand the effects of government control—granted its existence—and the dynamic effects of government spending. Of course, many other loops not shown also exist, since, theoretically, government spending cannot exceed the tax collected without a deficit, which is itself a control loop containing the Internal Revenue Service and the Congress. Of course, in a communist country the loop due to consumers is deemphasized and the government control is emphasized. In that case, the measurement block must be accurate and must respond rapidly; both are very difficult characteristics to realize from a bureaucratic system. This type of political or social feedback model, while usually nonrigorous, does impart information and understanding.

Feedback control systems are used extensively in industrial applications. An industrial robot is shown in Fig. 1.18. Thousands of industrial robots are currently in use. Manipulators can pick up objects weighing hundreds of pounds and position them with an accuracy of one-tenth of an inch or better [28]. A mobile automaton capable of avoiding objects and traveling through a room or industrial plant is shown in Fig. 1.19.

Figure 1.17. A feedback control system model of the economy.

Figure 1.18. The T^3 industrial robot. (Courtesy of Cincinnati Milacron.)

Figure 1.19. The automaton vehicle used by SRI in the application of artificial intelligence principles to the development of integrated robot systems. The vehicle is propelled by electric motors and carries a television camera and optical range finder in the movable "head." The vehicle responds to commands from a computer. The sensors are the bump detector, the TV camera, and the range finder [36]. (Courtesy of Stanford Research Institute.)

The potential future application of feedback control systems and models appears to be unlimited. Estimates of the U.S. markets for several control systems applications are given in Table 1.3. It appears that the theory and practice of modern control systems have a bright and important future and certainly justify the study of modern automatic control system theory and application. In the next chapter, we shall study the system models further to obtain quantitative mathematical models useful for engineering analysis and design.

Table 1.3. Applications of Control Systems

Application	(Millions of dollars)*				
	1972	1973	1976	1980	1990
Motor controls (speed, position)	90.3	100.5	112	150	250
Numerical controls	43.4	47.3	76	100	170
Thickness controls (steel, paper)	45.4	57.8	99	180	240
Process controls (oil, chemical)	318.5	357.2	449	700	2000
Pollution monitoring and control	14.0	17.0	26	75	300
Nuclear reactor control	9.3	11.1	19	25	60

*U.S. market estimates for several control system applications. The examples given in parentheses are not all-inclusive of the applications.

1.6 Control Engineering Design

Design is a purposeful activity in which a designer has in mind an idea about a desired outcome. It is the process of originating systems and predicting how these systems will fulfill objectives. Engineering design is the process of producing a set of descriptions of a system that satisfy a set of performance requirements and constraints.

The design process can be considered to incorporate three phases: analysis, synthesis, and evaluation. The first task is to diagnose, define, and prepare—that is, to understand the problem and produce an explicit statement of goals. The second task involves finding plausible solutions. The third task concerns judging the validity of solutions relative to the goals and selecting among alternatives. A cycle is implied in which the solution is revised and improved by reexamining the analysis. These three phases form the basis of a framework for planning, organizing, and evolving design projects.

Engineering design is the process of converting an idea or market need into the detailed information from which a product, process, or system can be made. A four-phase process of engineering design is summarized in Fig. 1.20. It is this process that we utilize in a design example for each chapter.

1.7 Design Example: Insulin Delivery Control System

Control systems have been utilized in the biomedical field to create implanted automatic drug-delivery systems to patients [54, 55]. Automatic systems can be used to regulate blood pressure, blood sugar level, and heart rate. A common application of control engineering is in the field of open-loop system drug delivery

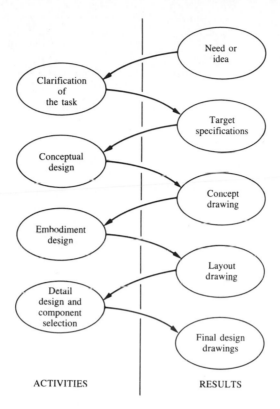

ACTIVITIES RESULTS

Figure 1.20. The design process.

in which mathematical models of the dose-effect relationship of the drugs are used. A drug-delivery system implanted in the body uses an open-loop system since miniaturized glucose sensors are not yet available. The best solutions rely on individually programmable pocket-sized insulin pumps that can deliver insulin according to a preset time history. More complicated systems will use closed-loop control for the measured blood glucose levels.

The goal of this design is (1) to design the block diagram of an open-loop control system and (2) to design a closed-loop control system to regulate the blood sugar concentration of a diabetic. The blood glucose and insulin concentrations are shown in Fig. 1.21 for a normal person. The designed system must provide the insulin from a reservoir implanted within the person.

An open-loop system would use a preprogrammed signal generator and miniature motor pump to regulate the insulin delivery rate as shown in Fig. 1.22(a). The feedback control system would use a sensor to measure the actual glucose level and compare that level with the desired level, thus turning the motor pump on when it is required as shown in Fig. 1.22(b).

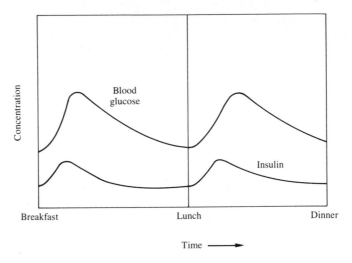

Figure 1.21. The blood glucose and insulin levels for a healthy person.

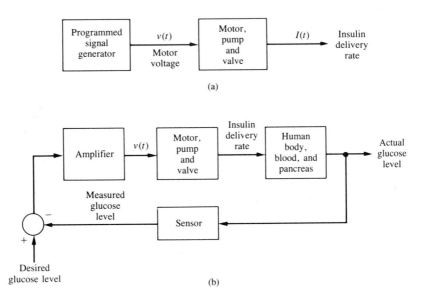

Figure 1.22. (a) Open-loop control and (b) closed-loop control of blood glucose.

Exercises

(Exercises are straightforward applications of the concepts of the chapter.)

E1.1. A precise optical signal source can control the output power level to within 1% [51]. A laser is controlled by an input current to yield the power output. A microprocessor

controls the input current to the laser. The microprocessor compares the desired power level with a measured signal proportional to the laser power output obtained from a sensor. Show the block diagram to represent this closed-loop control system.

E1.2. An automobile driver uses a control system to maintain the speed of the car at a prescribed level. Draw a block diagram to illustrate this feedback system.

E1.3. The number of robots sold annually for automation of U.S. industry could grow to 20,000 by 1992. Visit a local fast-food restaurant and discuss whether a robot could replace one or more of the workers.

E1.4. An autofocus camera will adjust the distance of the lens from the film by using a beam of infrared or ultrasound to determine the distance to the subject. Draw a block diagram of this open-loop control system and briefly explain its operation.

Problems

(Problems require extending the concepts of this chapter to new situations.)

P1.1. Draw a schematic block diagram of a home heating system. Identify the function of each element of the thermostatically controlled heating system.

P1.2. Control systems have, in the past, used a human operator as part of a closed-loop control system. Draw the block diagram of the valve control system shown in Fig. P1.2.

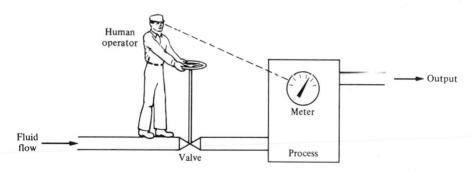

Figure P1.2. Fluid flow control.

P1.3. In a chemical process control system, it is valuable to control the chemical composition of the product. In order to control the composition, a measurement of the composition may be obtained by using an infrared stream analyzer as shown in Fig. P1.3. The valve on the additive stream may be controlled. Complete the control feedback loop and draw a block diagram describing the operation of the control loop.

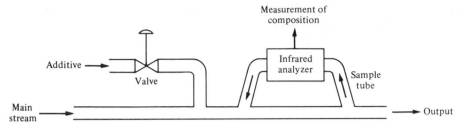

Figure P1.3.

P1.4. The accurate control of a nuclear reactor is important for power system generators. Assuming the number of neutrons present is proportional to the power level, an ionization chamber is used to measure the power level. The current, i, is proportional to the power level. The position of the graphite control rods moderates the power level. Complete the control system of the nuclear reactor shown in Fig. P1.4 and draw the block diagram describing the operation of the control loop.

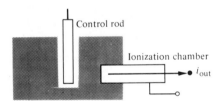

Figure P1.4. Nuclear reactor control.

P1.5. A light-seeking control system, used to track the sun, is shown in Fig. P1.5. The output shaft, driven by the motor through a worm reduction gear, has a bracket attached on which are mounted two photocells. Complete the closed-loop system in order that the system follows the light source.

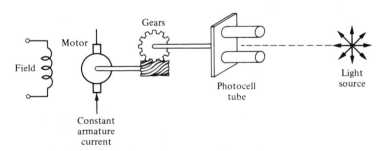

Figure P1.5. A photocell is mounted in each tube. The light reaching each cell is equal only when the light source is exactly in the middle as shown.

P1.6. Feedback systems are not always negative feedback systems in nature. Economic inflation, which is evidenced by continually rising prices, is a *positive feedback* system. A positive feedback control system, as shown in Fig. P1.6, *adds* the feedback signal to the input signal, and the resulting signal is used as the input to the process. A simple model of the price-wage inflationary spiral is shown in Fig. P1.6. Add additional feedback loops, such as legislative control or control of the tax rate, in order to stabilize the system. It is assumed that an increase in workers' salaries, after some time delay, results in an increase in prices. Under what conditions could prices be stabilized by falsifying or delaying the availability of cost-of-living data? How would a national wage and price economic guideline program affect the feedback system?

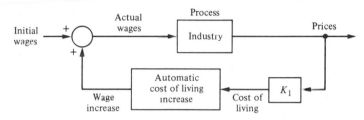

Figure P1.6. Positive feedback.

P1.7. The story is told about the sergeant who stopped at the jewelry store every morning at nine o'clock and compared and reset his watch with the chronometer in the window. Finally, one day the sergeant went into the store and complimented the owner on the accuracy of the chronometer.

"Is it set according to time signals from Arlington?" asked the sergeant.

"No," said the owner, "I set it by the five o'clock (P.M.) cannon fired from the fort. Tell me, Sergeant, why do you stop every day and check your watch?"

The sergeant replied, "I'm the gunner at the fort!"

Is the feedback prevalent in this case positive or negative? The jeweler's chronometer loses one minute each 24-hour period and the sergeant's watch loses one minute during each eight hours. What is the net time error of the cannon at the fort after 15 days?

P1.8. The student–teacher learning process is inherently a feedback process intended to reduce the system error to a minimum. The desired output is the knowledge being studied and the student may be considered the process. With the aid of Fig. 1.3, construct a feedback model of the learning process and identify each block of the system.

P1.9. Models of physiological control systems are valuable aids to the medical profession. A model of the heart-rate control system is shown in Fig. P1.9 [24, 38]. This model includes the processing of the nerve signals by the brain. The heart-rate control system is, in fact, a multivariable system, and the variables x, y, w, v, z, and u are vector variables. In other words, the variable x represents many heart variables x_1, x_2, \ldots, x_n. Examine the model of the heart-rate control system and add or delete the blocks, if necessary. Determine a control-system model of one of the following physiological control systems:

1. Respiratory control system
2. Adrenalin control system

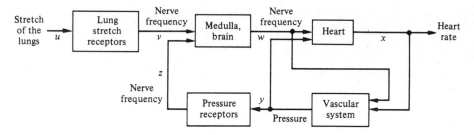

Figure P1.9. Heart rate control.

3. Human arm control system
4. Eye control system
5. Pancreas and the blood-sugar-level control system
6. Circulatory system

P1.10. The role of air traffic control systems is increasing as airplane traffic increases at busy airports. A tragic example of a traffic control mishap was the collision of the Pacific Southwest Airways 727 and a privately owned Cessna at San Diego airport in October 1978 [25]. Engineers are developing flight control systems, air traffic control systems, and collision avoidance systems [41]. Investigate these and other systems designed to improve air traffic safety; select one and draw a simple block diagram of its operation.

P1.11. Automatic control of water level using a float level was used in the Middle East for a water clock [1, 11]. The water clock, shown in Fig. P1.11, was used from sometime before Christ until the 17th century. Discuss the operation of the water clock and establish how the float provides a feedback control which maintains the accuracy of the clock.

Figure P1.11. (From Newton, Gould, and Kaiser, *Analytical Design of Linear Feedback Controls.* Wiley, New York, 1957, with permission.)

P1.12. An automatic turning gear for windmills was invented by Meikle in about 1750 [1, 11]. The fantail gear shown in Fig. P1.12 automatically turns the windmill into the wind. The fantail windmill at right angle to the mainsail is used to turn the turret. The gear ratio is of the order of 3000 to 1. Discuss the operation of the windmill and establish the feedback operation that maintains the main sails into the wind.

Figure P1.12. (From Newton, Gould, and Kaiser, *Analytical Design of Linear Feedback Controls*. Wiley, New York, 1957, with permission.)

P1.13. A common example of a two-input control system is a home shower with separate valves for hot and cold water. The objective is to obtain (1) a desired temperature of the shower water and (2) a desired flow of water. Draw a block diagram of the closed-loop control system. Would you be willing to take a shower under open-loop control by another person?

P1.14. Adam Smith (1723–1790) discussed the issue of free competition between the participants of an economy in his book *Wealth of Nations*. It may be said that Smith employed social feedback mechanisms to explain his theories [39]. Smith suggests that (1) the available workers as a whole compare the various possible employments and enter that one which offers the greatest rewards; and (2) in any employment the rewards diminish as the number of competing workers rises. Let r = total of rewards averaged over all trades; c = total of rewards in a particular trade; q = influx of workers into the specific trade. Draw a feedback loop to represent this system.

P1.15. Small computers are used in automobiles to control emissions and obtain improved gas mileage. A computer controlled transmission and engine that automatically adjusts itself to the road and driving conditions could improve automobile performance up to 30%. Sketch a block diagram of such a system for an automobile.

P1.16. All humans have experienced a fever associated with an illness. A fever is related to the changing of the control input in your body's thermostat. This thermostat, within the brain, normally regulates your temperature near 98°F in spite of external temperatures ranging from 0 to 100°F or more. For a fever, the input or desired temperature is increased. Even to many scientists it often comes as a surprise to learn that fever does not indicate something wrong with body temperature control but rather well contrived regulation at an

elevated level of desired input. Sketch a block diagram of the temperature control system and explain how aspirin will lower a fever.

P1.17. An outfielder for a baseball team uses feedback to judge a fly ball [34]. Determine the method used by the fielder to judge where the ball will land so he can be in the right spot to catch it.

P1.18. A cutaway view of a commonly used pressure regulator is shown in Fig. P1.18. The desired pressure is set by turning a calibrated screw. This compresses the spring and sets up a force that opposes the upward motion of the diaphragm. The bottom side of the diaphragm is exposed to the water pressure that is to be controlled. Thus the motion of the diaphragm is an indication of the pressure difference between the desired and the actual pressures. It acts like a comparator. The valve is connected to the diaphragm and moves according to the pressure difference until it reaches a position in which the difference is zero. Sketch a block diagram showing the control system with the output pressure as the regulated variable.

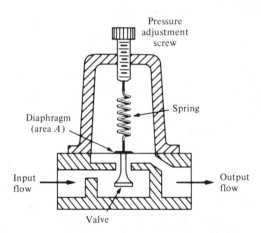

Figure P1.18. Pressure regulator.

P1.19. A horizontal airfoil creates vertical lift, and an upright wing can produce a horizontal force to push a boat. In England John Walker has used this idea to develop an automatically controlled wingsail to power a personal sailing ship or a large cargo boat, as shown in Fig. P1.19, on next page [60]. The controls are required to turn the sails at the appropriate angle to maximize the force. Furthermore, the ship will not heel over due to the force. Examine the dynamics of the system and draw a closed-loop feedback control system block diagram.

P1.20. Ichiro Masaki of General Motors has patented a system that automatically adjusts a car's speed to keep a safe distance from vehicles in front. Using a video camera, the system detects and stores a reference image of the car in front. It then compares this image with a stream of incoming live images as the two cars move down the highway and calculates the distance. Masaki suggests that the system could control steering as well as speed, allowing drivers to lock on to the car ahead and get a "computerized tow." Draw a block diagram for the control system.

Figure P1.19. Wingsail ship.

Design Problems ✦

(Design problems emphasize the design task.)

DP1.1. The road and vehicle noise that invades an automobile's cabin hastens occupant fatigue. Design the block diagram of an "antinoise" system that will eliminate the effect of unwanted noises. Indicate the device within each block.

DP1.2. Many cars are fitted with cruise control that, at the press of a button, automatically maintains a set speed. In this way the driver can cruise at a speed limit or economic speed without continually checking the speedometer. Design a feedback control in block diagram form for a cruise control system.

DP1.3. As part of the automation of a dairy farm, the automation of cow milking is under study [57]. Design a milking machine that can milk cows four or five times a day at the cow's demand. Show a block diagram and indicate the devices in each block.

DP1.4. A large braced robot arm for welding large structures is shown in Fig. DP1.4. Draw the block diagram of a closed-loop feedback control system for accurately controlling the location of the weld tip.

Weld tip

Workpiece

Figure DP1.4. Robot welder.

DP1.5. Vehicle traction control, which includes antiskid braking and antispin accelera-
tion, can enhance vehicle performance and handling. The objective of this control is to
maximize tire traction by preventing locked brakes as well as tire spinning during accel-
eration. Wheel slip, the difference between the vehicle speed and the wheel speed, is chosen
as the controlled variable because of its strong influence on the tractive force between the
tire and the road [59]. The adhesion coefficient, between the wheel and the road, reaches
a maximum at a low slip. Develop a block diagram model of one wheel of a traction control
system.

DP1.6. The front-page engineering story of 1990 was the plight of the Hubble space tele-
scope. Launched on April 24, 1990, into a 610-kilometer-high orbit, the $2.5 billion U.S.
spacecraft was to have been the most precise observatory ever built. But once the telescope
was in orbit, the nightmare began. First, a loop of cable on one of the two high-gain com-
munications antennas turned out to be improperly tied to the antenna's mast, limiting the
time during which the antenna could transmit data back to earth. Next, the solar panels
vibrated for three to six minutes each time the spacecraft passed into or out of sunlight,
throwing off the sensors fixing the telescope on a guide star and disrupting the observation
in progress. Worst of all, the telescope's 2.4-meter-diameter (94.5-inch) main mirror was
found to have been ground and polished to the wrong shape, thus rendering it unable to
focus an image.

 To compensate for the aberration in the main mirror over the long term, NASA is
modifying the curvature or "prescription" of the lenses of an already planned second wide-
field and planetary camera scheduled to replace the current one during a routine mainte-
nance mission in 1993. The most challenging problem now is damping the jitter that

vibrates the spacecraft each time it passes into or out of the earth's shadow. The worst vibration has a period of about 10 seconds, or a frequency of 0.1 hertz.

Design a feedback system that will reduce the vibrations of the Hubble space telescope.

Terms and Concepts

Automation The control of an industrial process by automatic means.

Closed-loop feedback control system A system that uses a measurement of the output and compares it with the desired output.

Control system An interconnection of components forming a system configuration that will provide a desired response.

Design The process of conceiving the form and parts of a system to achieve a purpose.

Feedback signal A measure of the output of the system used for feedback to control the system.

Flyball governor A mechanical device for controlling the speed of a steam engine.

Multivariable control system A system with more than one input variable and more than one output variable.

Negative feedback The output signal is fedback so that it subtracts from the input signal.

Open-loop control system A system that utilizes a device to control the process without using feedback. Thus the output has no effect upon the signal to the process.

Plant See Process.

Positive feedback The output signal is fedback so that it adds to the input signal.

Process The device, plant, or system under control.

Productivity The ratio of physical output to physical input of an industrial process.

System An interconnection of elements and devices for a desired purpose.

References

1. O. Mayr, *The Origins of Feedback Control,* M.I.T. Press, Cambridge, Mass., 1970.
2. O. Mayr, "The Origins of Feedback Control," *Scientific American,* **223,** 4, October 1970; pp. 110–18.
3. O. Mayr, *Feedback Mechanisms in the Historical Collections of the National Museum of History and Technology,* Smithsonian Institution Press, Washington, D.C., 1971.
4. E. P. Popov, *The Dynamics of Automatic Control Systems,* Gostekhizdat, Moscow, 1956; Addison-Wesley, Reading, Mass., 1962.

 5. J. C. Maxwell, "On Governors," *Proc. of the Royal Society of London,* **16,** 1868; in *Selected Papers on Mathematical Trends in Control Theory.* Dover, New York, 1964; pp. 270–83.
 6. I. A. Vyshnegradskii, "On Controllers of Direct Action," *Izv. SPB Tekhnolog. Inst.,* 1877.
 7. H. W. Bode, "Feedback—The History of an Idea," in *Selected Papers on Mathematical Trends in Control Theory.* Dover, New York, 1964; pp. 106–23.
 8. H. S. Black, "Inventing the Negative Feedback Amplifier," *IEEE Spectrum,* December 1977; pp. 55–60.
 9. J. E. Brittain, *Turning Points in American Electrical History,* IEEE Press, New York, 1977, Sect. II-E.
10. G. J. Thaler, *Automatic Control Systems,* West Publishing, St. Paul, Minn., 1989.
11. G. Newton, L. Gould, and J. Kaiser, *Analytical Design of Linear Feedback Controls,* John Wiley & Sons, New York, 1957.
12. M. D. Fagen, *A History of Engineering and Science on the Bell Systems,* Bell Telephone Laboratories, 1978; Ch. 3.
13. B. W. Niebel, *Modern Manufacturing Process Engineering,* McGraw-Hill, New York, 1989.
14. J. Gertber, *Low Cost Automation,* IFAC Conference, Pergamon Press, New York, 1990.
15. W. D. Rasmussen, "The Mechanization of Agriculture," *Scientific American,* September 1982; pp. 26–37.
16. R. Shonreshi, "Optically Driven Learning Control for Industrial Manipulators," *IEEE Control Systems,* October 1989; pp. 21–26.
17. W. B. Arthur, "Positive Feedbacks in the Economy," *Scientific American,* February 1990; pp. 92–99.
18. S. Derby, "Mechatronics for Robots," *Mechanical Engineering,* July 1990; pp. 40–42.
19. S. T. Venkataraman, *Dextrous Robot Hands,* Springer-Verlag, New York, 1990.
20. J. Krueger, "Developments in Automotive Electronics," *Automotive Engineering,* September 1990; pp. 37–44.
21. "High Speed Trains," *The Economist,* September 30, 1989; pp. 52–53.
22. L. A. Geddes, *Principles of Applied Biomedical Instrumentation,* John Wiley & Sons, New York, 1989.
23. B. W. Mar and O. A. Bakken, "Applying Classical Control Theory to Energy-Economics Modeling," *Management Science,* January 1984; pp. 81–91.
24. U. Zwiener et al., "Non-Invasive System Analysis of the Arterial Pressure Control by Digital Modelling," *Proceed. of the IFAC World Congress,* July 1987; pp. 50–56.
25. P. K. Shih, "Structures for Hypervelocity Flight," *Aerospace America,* May 1989; pp. 14–18.
26. M. L. Dertouzos, *Made in America,* M.I.T. Press, Cambridge, Mass., 1989.
27. R. C. Dorf, *The Encyclopedia of Robotics,* John Wiley & Sons, New York; 1988.
28. R. C. Dorf, *Robotics and Automated Manufacturing,* Reston Publishing, Reston, Virginia, 1983.
29. "Industrial U.S. Market Report," *Electronics,* January 6, 1990; pp. 90–94.
30. K. S. Betts, "Process Control Takes Command," *Mechanical Engineering,* July 1990; pp. 64–68.
31. S. Ashley, "A Mosaic for Machine Tools," *Mechanical Engineering,* September 1990; pp. 38–43.

32. P. M. Moretti and L. V. Divone, "Modern Windmills," *Scientific American,* June 1986; pp. 110–18.
33. M. Drela and J. S. Langford, "Human Powered Flight," *Scientific American,* November 1985; pp. 114–51.
34. P. J. Brancazio, "Science and the Game of Baseball," *Science Digest,* July 1984; pp. 66–70.
35. H. Chestnut, "Applying Adaptive Control Principles to Resolving International Conflicts," *Proceed. of the IFAC World Congress,* July 1987; pp. 149–59.
36. R. C. Dorf, *Introduction to Computers and Computer Science,* Boyd and Fraser, San Francisco, 3d ed., 1982; Chs. 13, 14.
37. J. D. Erickson, "Manned Spacecraft Automation and Robotics," *Proceed. of the IEEE,* March 1987; pp. 417–27.
38. R. C. Dorf and J. Unmack, "A Time-Domain Model of the Heart Rate Control System," *Proceed. of the San Diego Symposium for Biomedical Engineering,* 1965; pp. 43–47.
39. O. Mayr, "Adam Smith and the Concept of the Feedback System," *Technology and Culture,* **12,** 1, January 1971; pp. 1–22.
40. C. F. Lorenzo, "An Intelligent Control System for Rocket Engines," *Proceed. of the American Automatic Control Conference,* 1990; pp. 974–82.
41. S. Winchester, "Leviathans of the Sky," *Atlantic Monthly,* October 1990; pp. 107–17.
42. H. Tamura, *Large-Scale Systems Control,* Marcel Dekker, New York, 1990.
43. R. T. Howe et al., "Silicon Micromechanics: Sensors and Actuators on a Chip," *IEEE Spectrum,* July 1990; pp. 29–35.
44. P. Cleaveland, "Programmable Controllers: What's Ahead," *Instruments and Control Systems,* March 1990; pp. 37–58.
45. "Some Industry Views on Control Use," *IEEE Control Systems,* December 1987; pp. 20–24.
46. G. J. Blickley, "Where Control Dollars Are Spent," *Control Engineering,* August 1987; p. 13.
47. K. Fitzgerald, "The Artificial Heart," *IEEE Spectrum,* November 1989; p. 22.
48. J. D. Ryder and D. G. Fink, *Engineers and Electrons,* IEEE Press, Piscataway, N.J., 1984.
49. D. G. Johnson, *Programmable Controllers for Factory Automation,* Marcel Dekker, New York, 1987.
50. H. Van Dyke Parunak, "Focus on Intelligent Control," *Inter. J. of Integrated Manufacturing,* February 1990; pp. 1–5.
51. C. W. De Silva, *Control Sensors and Actuators,* Prentice Hall, Englewood Cliffs, N.J., 1989.
52. A. Goldsmith, "Autofocus Cameras," *Popular Science,* March 1988; pp. 70–72.
53. P. Dorato, "Robust Control: A Historical Review," *IEEE Control Systems,* April 1987; pp. 44–46.
54. G. W. Neat, "Expert Adaptive Control for Drug Delivery Systems," *IEEE Control Systems,* June 1989; pp. 20–23.
55. S. S. Hacisalihzade, "Control Engineering and Therapeutic Drug Delivery," *IEEE Control Systems,* June 1989; pp. 44–46.
56. R. Kurzweil, *The Age of Intelligent Machines,* M.I.T. Press, Cambridge, Mass., 1990.
57. C. Klomp et al., "Development of an Autonomous Cow-Milking Robot Control System," *IEEE Control Systems,* October 1990; pp. 11–19.

58. G. Zorpette, "Parkinson's Gun Director," *IEEE Spectrum,* April 1989; p. 43.
59. H. S. Tan and M. Tomizuka, "Controller Design for Robust Vehicle Traction," *IEEE Control Systems,* April 1990; pp. 107–13.
60. D. Scott, "Wingsail Trimaran," *Popular Science,* June 1990, pp. 116–17.
61. T. S. Perry, "Improving Air Traffic Control System," *IEEE Spectrum,* February 1991, pp. 22–36.

CHAPTER 2

Mathematical Models of Systems

Preview

In order to analyze and design control systems, we use quantitative mathematical models of these systems. We will consider a wide range of systems including mechanical, electrical, and fluid. We will first describe the dynamic behavior of these systems using differential equations. In order to use the Laplace transform we will develop the means of obtaining a linear model of components of a system. Then we will be able to unite the differential equations describing the system and obtain the Laplace transform of these equations.

We will then proceed to obtain the input-output relationship for components and subsystems in the form of a transfer function. Then the set of transfer functions representing the interconnected components will be represented by a block diagram model or a signal-flow graph. Using various analytical methods, we will be able to obtain the equations for selected outputs of a control system as they are regulated by selected inputs of the system.

2.1 Introduction

In order to understand and control complex systems, one must obtain quantitative *mathematical models* of these systems. Therefore it is necessary to analyze the relationships between the system variables and to obtain a mathematical model. Because the systems under consideration are dynamic in nature, the descriptive equations are usually *differential equations.* Furthermore, if these equations can be *linearized,* then the *Laplace transform* can be utilized in order to simplify the method of solution. In practice, the complexity of systems and the ignorance of all the relevant factors necessitate the introduction of *assumptions* concerning the system operation. Therefore we shall often find it useful to consider the physical system, delineate some necessary assumptions, and linearize the system. Then, by using the physical laws describing the linear equivalent system, we can obtain a set of linear differential equations. Finally, utilizing mathematical tools, such as the Laplace transform, we obtain a solution describing the operation of the system. In summary, the approach to dynamic system problems can be listed as follows:

1. Define the system and its components.
2. Formulate the mathematical model and list the necessary assumptions.
3. Write the differential equations describing the model.
4. Solve the equations for the desired output variables.
5. Examine the solutions and the assumptions.
6. Reanalyze or design.

2.2 Differential Equations of Physical Systems

The differential equations describing the dynamic performance of a physical system are obtained by utilizing the physical laws of the process [1, 2, 3]. This approach applies equally well to mechanical [1], electrical [3], fluid, and thermodynamic systems [4]. A summary of the variables of dynamic systems is given in Table 2.1 [5]. We prefer to use the International System of units (SI) in contrast to the British System of units. The International System of units is given in Table 2.2. The conversion of other systems of units to SI units is facilitated by Table

Table 2.1. Summary of Through- and Across-Variables for Physical Systems

System	Variable Through Element	Integrated Through Variable	Variable Across Element	Integrated Across Variable
Electrical	Current, i	Charge, q	Voltage difference, v_{21}	Flux linkage, λ_{21}
Mechanical translational	Force, F	Translational momentum, P	Velocity difference, v_{21}	Displacement difference, y_{21}
Mechanical rotational	Torque, T	Angular momentum, h	Angular velocity difference, ω_{21}	Angular displacement difference, θ_{21}
Fluid	Fluid volumetric rate of flow, Q	Volume, V	Pressure difference, P_{21}	Pressure momentum, γ_{21}
Thermal	Heat flow rate, q	Heat energy, H	Temperature difference, τ_{21}	

Table 2.2. The International System of Units (SI)

	Unit	Symbol
Basic Units		
Length	meter	m
Mass	kilogram	kg
Time	second	s
Temperature	kelvin	K
Electric current	ampere	A
Derived Units		
Velocity	meters per second	m/s
Area	square meter	m^2
Force	newton	$N = kgm/s^2$
Torque	kilogram-meter	kgm
Pressure	pascal	Pa
Energy	joule	$J = Nm$
Power	watt	$W = J/s$

Table 2.3. Conversion Factors for Converting to SI Units

From	Multiply by	To Obtain
Length		
inches	25.4	millimeters
feet	30.48	centimeters
Speed		
miles per hour	0.4470	meters per second
Mass		
pounds	0.4536	kilograms
Force		
pounds-force	4.448	newtons
Torque		
foot-pounds	0.1383	kilogram-meters
Power		
horsepower	746	watts
Energy		
British thermal unit	1055	joules
kilowatt-hour	3.6×10^6	joules

2.3. A summary of the describing equations for lumped, linear, dynamic elements is given in Table 2.4 [5]. The equations in Table 2.4 are idealized descriptions and only approximate the actual conditions (for example, when a linear, lumped approximation is used for a distributed element).

■ Nomenclature

- *Through-variable:* F = force, T = torque, i = current, Q = fluid volumetric flow rate, q = heat flow rate.
- *Across-variable:* v = translational velocity, ω = angular velocity, v = voltage, P = pressure, τ = temperature.
- *Inductive storage:* L = inductance, $1/k$ = reciprocal translational or rotational stiffness, I = fluid inertance.
- *Capacitive storage:* C = capacitance, M = mass, J = moment of inertia, C_f = fluid capacitance, C_t = thermal capacitance.
- *Energy dissipators:* R = resistance, f = viscous friction, R_f = fluid resistance, R_t = thermal resistance.

The symbol $v(t)$ is used for both voltage in electrical circuits and velocity in translational mechanical systems, and is distinguished within the context of each differential equation. For mechanical systems, one utilizes Newton's laws, and for

Table 2.4. Summary of Describing Differential Equations for Ideal Elements

Type of Element	Physical Element	Describing Equation	Energy E or Power \mathcal{P}	Symbol
	Electrical inductance	$v_{21} = L\dfrac{di}{dt}$	$E = \dfrac{1}{2}Li^2$	
Inductive storage	Translational spring	$v_{21} = \dfrac{1}{K}\dfrac{dF}{dt}$	$E = \dfrac{1}{2}\dfrac{F^2}{K}$	
	Rotational spring	$\omega_{21} = \dfrac{1}{K}\dfrac{dT}{dt}$	$E = \dfrac{1}{2}\dfrac{T^2}{K}$	
	Fluid inertia	$P_{21} = I\dfrac{dQ}{dt}$	$E = \dfrac{1}{2}IQ^2$	
	Electrical capacitance	$i = C\dfrac{dv_{21}}{dt}$	$E = \dfrac{1}{2}Cv_{21}^2$	
	Translational mass	$F = M\dfrac{dv_2}{dt}$	$E = \dfrac{1}{2}Mv_2^2$	
Capacitive storage	Rotational mass	$T = J\dfrac{d\omega_2}{dt}$	$E = \dfrac{1}{2}J\omega_2^2$	
	Fluid capacitance	$Q = C_f\dfrac{dP_{21}}{dt}$	$E = \dfrac{1}{2}C_f P_{21}^2$	
	Thermal capacitance	$q = C_t\dfrac{d\tau_2}{dt}$	$E = C_t\tau_2$	
	Electrical resistance	$i = \dfrac{1}{R}v_{21}$	$\mathcal{P} = \dfrac{1}{R}v_{21}^2$	
	Translational damper	$F = fv_{21}$	$\mathcal{P} = fv_{21}^2$	
Energy dissipators	Rotational damper	$T = f\omega_{21}$	$\mathcal{P} = f\omega_{21}^2$	
	Fluid resistance	$Q = \dfrac{1}{R_f}P_{21}$	$\mathcal{P} = \dfrac{1}{R_f}P_{21}^2$	
	Thermal resistance	$q = \dfrac{1}{R_t}\tau_{21}$	$\mathcal{P} = \dfrac{1}{R_t}\tau_{21}$	

electrical systems Kirchhoff's voltage laws. For example, the simple spring-mass-damper mechanical system shown in Fig. 2.1 is described by Newton's second law of motion. (This system could represent, for example, an automobile shock absorber.) Therefore, we obtain

$$M\frac{d^2y(t)}{dt^2} + f\frac{dy(t)}{dt} + Ky(t) = r(t), \qquad (2.1)$$

Figure 2.1. Spring-mass-damper system.

where K is the spring constant of the ideal spring and f is the friction constant. Equation 2.1 is a linear constant coefficient differential equation of second order.

Alternatively, one may describe the electrical RLC circuit of Fig. 2.2 by utilizing Kirchhoff's current law. Then we obtain the following integrodifferential equation:

$$\frac{v(t)}{R} + C\frac{dv(t)}{dt} + \frac{1}{L}\int_0^t v(t)\,dt = r(t). \tag{2.2}$$

The solution of the differential equation describing the process may be obtained by classical methods such as the use of integrating factors and the method of undetermined coefficients [1]. For example, when the mass is displaced initially a distance $y(t) = y(0)$ and released, the dynamic response of an _underdamped_ system is represented by an equation of the form

$$y(t) = K_1 e^{-\alpha_1 t} \sin(\beta_1 t + \theta_1). \tag{2.3}$$

A similar solution is obtained for the voltage of the RLC circuit when the circuit is subjected to a constant current $r(t) = I$. Then the voltage is

$$v(t) = K_2 e^{-\alpha_2 t} \cos(\beta_2 t + \theta_2). \tag{2.4}$$

A voltage curve typical of an underdamped RLC circuit is shown in Fig. 2.3.

In order to further reveal the close similarity between the differential equa-

Figure 2.2. RLC circuit.

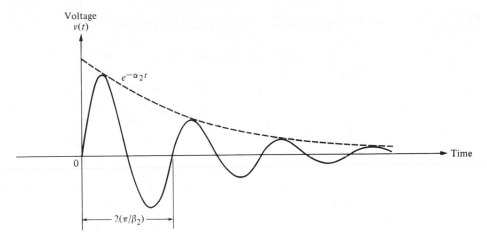

Figure 2.3. Typical voltage curve for underdamped *RLC* circuit.

tions for the mechanical and electrical systems, we shall rewrite Eq. (2.1) in terms of velocity,

$$v(t) = \frac{dy(t)}{dt}.$$

Then we have

$$M\frac{dv(t)}{dt} + fv(t) + K\int_0^t v(t)\, dt = r(t). \tag{2.5}$$

One immediately notes the equivalence of Eqs. (2.5) and (2.2) where velocity $v(t)$ and voltage $v(t)$ are equivalent variables, usually called *analogous* variables, and the systems are analogous systems. Therefore the solution for velocity is similar to Eq. (2.4) and the curve for an underdamped system is shown in Fig. 2.3. The concept of analogous systems is a very useful and powerful technique for system modeling. The voltage-velocity analogy, often called the force–current analogy, is a natural analogy because it relates the analogous through- and across-variables of the electrical and mechanical systems. However, another analogy that relates the velocity and current variables is often used and is called the force-voltage analogy.

Analogous systems with similar solutions exist for electrical, mechanical, thermal, and fluid systems. The existence of analogous systems and solutions provides the analyst with the ability to extend the solution of one system to all analogous systems with the same describing differential equations. Therefore what one learns about the analysis and design of electrical systems is immediately extended to an understanding of fluid, thermal, and mechanical systems.

2.3 Linear Approximations of Physical Systems

A great majority of physical systems are linear within some range of the variables. However, all systems ultimately become nonlinear as the variables are increased without limit. For example, the spring-mass-damper system of Fig. 2.1 is linear and described by Eq. (2.1) so long as the mass is subjected to small deflections $y(t)$. However, if $y(t)$ were continually increased, eventually the spring would be overextended and break. Therefore the question of linearity and the range of applicability must be considered for each system.

A system is defined as linear in terms of the system excitation and response. In the case of the electrical network, the excitation is the input current $r(t)$ and the response is the voltage $v(t)$. In general, a *necessary condition* for a linear system can be determined in terms of an excitation $x(t)$ and a response $y(t)$. When the system at rest is subjected to an excitation $x_1(t)$, it provides a response $y_1(t)$. Furthermore, when the system is subjected to an excitation $x_2(t)$, it provides a corresponding response $y_2(t)$. For a linear system, it is *necessary* that the excitation $x_1(t) + x_2(t)$ result in a response $y_1(t) + y_2(t)$. This is usually called the *principle of superposition.*

Furthermore, it is necessary that the magnitude scale factor is preserved in a linear system. Again, consider a system with an input x which results in an output y. Then it is necessary that the response of a linear system to a constant multiple β of an input x is equal to the response to the input multiplied by the same constant so that the output is equal to βy. This is called the property of *homogeneity.* A system is linear if and only if the properties of superposition and homogeneity are satisfied.

A system characterized by the relation $y = x^2$ is not linear because the superposition property is not satisfied. A system represented by the relation $y = mx + b$ is not linear because it does not satisfy the homogeneity property. However, this device may be considered linear about an operating point x_0, y_0 for small changes Δx and Δy. When $x = x_0 + \Delta x$ and $y = y_0 + \Delta y$, we have

$$y = mx + b$$

or

$$y_0 + \Delta y = mx_0 + m\,\Delta x + b$$

and therefore $\Delta y = m\,\Delta x$, which satisfies the necessary conditions.

The linearity of many mechanical and electrical elements can be assumed over a reasonably large range of the variables [7]. This is not usually the case for thermal and fluid elements, which are more frequently nonlinear in character. Fortunately, however, one can often linearize nonlinear elements assuming small-signal conditions. This is the normal approach used to obtain a linear equivalent circuit for electronic circuits and transistors. Consider a general element with an excitation (through-) variable $x(t)$ and a response (across-) variable $y(t)$. Several

examples of dynamic system variables are given in Table 2.1. The relationship of the two variables is written as

$$y(t) = g(x(t)), \tag{2.6}$$

where $g(x(t))$ indicates $y(t)$ is a function of $x(t)$. The relationship might be shown graphically, as in Fig. 2.4. The normal operating point is designated by x_0. Because the curve (function) is continuous over the range of interest, a *Taylor series* expansion about the operating point may be utilized. Then we have

$$y = g(x) = g(x_0) + \left.\frac{dg}{dx}\right|_{x=x_0} \frac{(x - x_0)}{1!} + \left.\frac{d^2g}{dx^2}\right|_{x=x_0} \frac{(x - x_0)^2}{2!} + \cdots \tag{2.7}$$

The slope at the operating point,

$$\left.\frac{dg}{dx}\right|_{x=x_0},$$

is a good approximation to the curve over a small range of $(x - x_0)$, the deviation from the operating point. Then, as a reasonable approximation, Eq. (2.7) becomes

$$y = g(x_0) + \left.\frac{dg}{dx}\right|_{x=x_0} (x - x_0) = y_0 + m(x - x_0), \tag{2.8}$$

where m is the slope at the operating point. Finally, Eq. (2.8) can be rewritten as the linear equation

$$(y - y_0) = m(x - x_0)$$

or

$$\Delta y = m \, \Delta x. \tag{2.9}$$

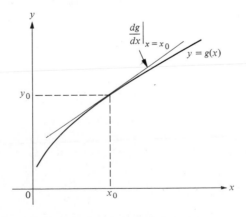

Figure 2.4. A graphical representation of a nonlinear element.

This *linear approximation* is as accurate as the assumption of small signals is applicable to the specific problem.

If the dependent variable y depends upon several excitation variables, x_1, x_2, \ldots, x_n, then the functional relationship is written as

$$y = g(x_1, x_2, \ldots, x_n). \tag{2.10}$$

The Taylor series expansion about the operating point $x_{1_0}, x_{2_0}, \ldots, x_{n_0}$ is useful for a linear approximation to the nonlinear function. When the higher-order terms are neglected, the linear approximation is written as

$$y = g(x_{1_0}, x_{2_0}, \ldots, x_{n_0}) + \frac{\partial g}{\partial x_1}\bigg|_{x=x_0} (x_1 - x_{1_0}) + \frac{\partial g}{\partial x_2}\bigg|_{x=x_0} (x_2 - x_{2_0})$$
$$+ \cdots + \frac{\partial g}{\partial x_n}\bigg|_{x=x_0} (x_n - x_{n_0}), \tag{2.11}$$

where x_0 is the operating point. An example will clearly illustrate the utility of this method.

■ Example 2.1 Pendulum oscillator model

Consider the pendulum oscillator shown in Fig. 2.5(a). The torque on the mass is

$$T = MgL \sin \theta, \tag{2.12}$$

where g is the gravity constant. The equilibrium condition for the mass is $\theta_0 = 0°$. The nonlinear relation between T and θ is shown graphically in Fig. 2.5(b). The first derivative evaluated at equilibrium provides the linear approximation, which is

$$T = MgL \frac{\partial \sin \theta}{\partial \theta}\bigg|_{\theta=\theta_0} (\theta - \theta_0)$$
$$= MgL(\cos 0°)(\theta - 0°) \tag{2.13}$$
$$= MgL\theta.$$

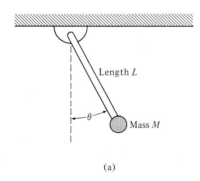

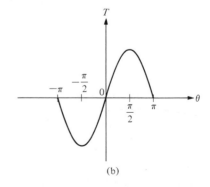

(a) (b)

Figure 2.5. Pendulum oscillator.

This approximation is reasonably accurate for $-\frac{\pi}{4} \leq \theta \leq \frac{\pi}{4}$. For example, the response of the linear model for the swing through $\pm 30°$ is within 2% of the actual nonlinear pendulum response.

2.4 The Laplace Transform

The ability to obtain linear approximations of physical systems allows the analyst to consider the use of the *Laplace transformation*. The Laplace transform method substitutes the relatively easily solved algebraic equations for the more difficult differential equations [1, 3]. The time response solution is obtained by the following operations:

1. Obtain the differential equations.
2. Obtain the Laplace transformation of the differential equations.
3. Solve the resulting algebraic transform of the variable of interest.

The Laplace transform exists for linear differential equations for which the transformation integral converges. Therefore, in order that $f(t)$ be transformable, it is sufficient that

$$\int_0^\infty |f(t)| e^{-\sigma_1 t} \, dt < \infty$$

for some real, positive σ_1 [1]. If the magnitude of $f(t)$ is $|f(t)| < Me^{\alpha t}$ for all positive t, the integral will converge for $\sigma_1 > \alpha$. The region of convergence is therefore given by $\infty > \sigma_1 > \alpha$, and σ_1 is known as the abscissa of absolute convergence. Signals that are physically possible always have a Laplace transform. The Laplace transformation for a function of time, $f(t)$, is

$$F(s) = \int_0^\infty f(t) e^{-st} \, dt = \mathcal{L} \{f(t)\}. \tag{2.14}$$

The *inverse Laplace transform* is written as

$$f(t) = \frac{1}{2\pi j} \int_{\sigma - j\infty}^{\sigma + j\infty} F(s) e^{+st} \, ds. \tag{2.15}$$

The transformation integrals have been used to derive tables of Laplace transforms that are ordinarily used for the great majority of problems. A table of Laplace transforms is provided in Appendix A. Some important Laplace transform pairs are given in Table 2.5.

Alternatively, the Laplace variable s can be considered to be the differential operator so that

$$s \equiv \frac{d}{dt}. \tag{2.16}$$

Then we also have the integral operator

$$\frac{1}{s} \equiv \int_{0+}^{t} dt. \tag{2.17}$$

The inverse Laplace transformation is usually obtained by using the Heaviside partial fraction expansion. This approach is particularly useful for systems analysis and design, because the effect of each characteristic root or eigenvalue may be clearly observed.

In order to illustrate the usefulness of the Laplace transformation and the steps involved in the system analysis, reconsider the spring-mass-damper system described by Eq. (2.1), which is

$$M \frac{d^2 y}{dt^2} + f \frac{dy}{dt} + Ky = r(t). \tag{2.18}$$

We wish to obtain the response, y, as a function of time. The Laplace transform of Eq. (2.18) is

$$M\left(s^2 Y(s) - sy(0^+) - \frac{dy(0^+)}{dt}\right) + f(sY(s) - y(0^+)) + KY(s) = R(s). \tag{2.19}$$

Table 2.5. Important Laplace Transform Pairs

$f(t)$	$F(s)$
Step function, $u(t)$	$\dfrac{1}{s}$
e^{-at}	$\dfrac{1}{s+a}$
$\sin \omega t$	$\dfrac{\omega}{s^2 + \omega^2}$
$\cos \omega t$	$\dfrac{s}{s^2 + \omega^2}$
$e^{-at}f(t)$	$F(s+a)$
t^n	$\dfrac{n!}{s^{n+1}}$
$f^{(k)}(t) = \dfrac{d^k f(t)}{dt^k}$	$s^k F(s) - s^{k-1}f(0^+) - s^{k-2}f'(0^+)$ $- \cdots - f^{(k-1)}(0^+)$
$\displaystyle\int_{-\infty}^{t} f(t)dt$	$\dfrac{F(s)}{s} + \dfrac{\int_{-\infty}^{0} f\, dt}{s}$
Impulse function $\delta(t)$	1

When

$$r(t) = 0, \qquad y(0^+) = y_0, \qquad \frac{dy}{dt}\bigg|_{t=0+} = 0,$$

we have

$$Ms^2 Y(s) - Msy_0 + fsY(s) - fy_0 + KY(s) = 0. \qquad (2.20)$$

Solving for $Y(s)$, we obtain

$$Y(s) - \frac{(Ms + f)y_0}{Ms^2 + fs + K} = \frac{p(s)}{q(s)}. \qquad (2.21)$$

The denominator polynomial $q(s)$, when set equal to zero, is called the *characteristic equation*, because the roots of this equation determine the character of the time response. The roots of this characteristic equation are also called the *poles* or *singularities* of the system. The roots of the numerator polynomial $p(s)$ are called the *zeros* of the system; for example, $s = -f/M$. Poles and zeros are critical frequencies. At the poles the function $Y(s)$ becomes infinite; while at the zeros, the function becomes zero. The complex frequency *s-plane* plot of the poles and zeros graphically portrays the character of the natural transient response of the system.

For a specific case, consider the system when $K/M = 2$ and $f/M = 3$. Then Eq. (2.21) becomes

$$Y(s) = \frac{(s + 3)y_0}{(s + 1)(s + 2)}. \qquad (2.22)$$

The poles and zeros of $Y(s)$ are shown on the *s*-plane in Fig. 2.6.

Expanding Eq. (2.22) in a partial fraction expansion, we obtain

$$Y(s) = \frac{k_1}{s + 1} + \frac{k_2}{s + 2}, \qquad (2.23)$$

where k_1 and k_2 are the coefficients of the expansion. The coefficients k_i, are called *residues* and are evaluated by multiplying through by the denominator factor of

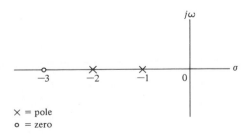

\times = pole
o = zero

Figure 2.6. An *s*-plane pole and zero plot.

Eq. (2.22) corresponding to k_i and setting s equal to the root. Evaluating k_1 when $y_0 = 1$, we have

$$k_1 = \left.\frac{(s - s_1)p(s)}{q(s)}\right|_{s=s_1}$$

$$= \left.\frac{(s + 1)(s + 3)}{(s + 1)(s + 2)}\right|_{s_1=-1} = 2 \qquad (2.24)$$

and $k_2 = -1$. Alternatively, the residues of $Y(s)$ at the respective poles may be evaluated graphically on the s-plane plot, since Eq. (2.24) may be written as

$$k_1 = \left.\frac{s + 3}{s + 2}\right|_{s=s_1=-1}$$

$$= \left.\frac{s_1 + 3}{s_1 + 2}\right|_{s_1=-1} = 2. \qquad (2.25)$$

The graphical representation of Eq. (2.25) is shown in Fig. 2.7. The graphical method of evaluating the residues is particularly valuable when the order of the characteristic equation is high and several poles are complex conjugate pairs.

The inverse Laplace transform of Eq. (2.22) is then

$$y(t) = \mathcal{L}^{-1}\left\{\frac{2}{s + 1}\right\} + \mathcal{L}^{-1}\left\{\frac{-1}{s + 2}\right\}. \qquad (2.26)$$

Using Table 2.5, we find that

$$y(t) = 2e^{-t} - 1e^{-2t}. \qquad (2.27)$$

Finally, it is usually desired to determine the *steady-state* or *final value* of the response of $y(t)$. For example, the final or steady-state rest position of the spring-mass-damper system should be calculated. The final value can be determined from the relation

$$\lim_{t \to \infty} y(t) = \lim_{s \to 0} sY(s), \qquad (2.28)$$

where a simple pole of $Y(s)$ at the origin is permitted, but poles on the imaginary axis and in the right half-plane and higher-order poles at the origin are excluded.

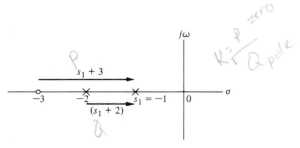

Figure 2.7. Graphical evaluation of the residues.

Therefore, for the specific case of the spring, mass, and damper, we find that

$$\lim_{t\to\infty} y(t) = \lim_{s\to 0} sY(s) = 0. \tag{2.29}$$

Hence the final position for the mass is the normal equilibrium position $y = 0$.

In order to illustrate clearly the salient points of the Laplace transform method, let us reconsider the mass-spring-damper system for the underdamped case. The equation for $Y(s)$ may be written as

$$Y(s) = \frac{(s + f/M)(y_0)}{(s^2 + (f/M)s + K/M)} \tag{2.30}$$

$$= \frac{(s + 2\zeta\omega_n)(y_0)}{s^2 + 2\zeta\omega_n s + \omega_n^2},$$

where ζ is the dimensionless *damping ratio* and ω_n is the *natural frequency* of the system. The roots of the characteristic equation are

$$s_1, s_2 = -\zeta\omega_n \pm \omega_n\sqrt{\zeta^2 - 1}, \tag{2.31}$$

where, in this case $\omega_n = \sqrt{K/M}$ and $\zeta = f/(2\sqrt{KM})$. When $\zeta > 1$, the roots are real; and when $\zeta < 1$, the roots are complex and conjugates. When $\zeta = 1$, the roots are repeated and real and the condition is called *critical damping*.

When $\zeta < 1$, the response is underdamped and

$$s_{1,2} = -\zeta\omega_n \pm j\omega_n\sqrt{1 - \zeta^2}. \tag{2.32}$$

The s-plane plot of the poles and zeros of $Y(s)$ is shown in Fig. 2.8, where $\theta = \cos^{-1}\zeta$. As ζ varies with ω_n constant, the complex conjugate roots follow a circular locus as shown in Fig. 2.9. The transient response is increasingly oscillatory as the roots approach the imaginary axis when ζ approaches zero.

The inverse Laplace transform can be evaluated using the graphical residue evaluation. The partial fraction expansion of Eq. (2.30) is

$$Y(s) = \frac{k_1}{(s - s_1)} + \frac{k_2}{(s - s_2)}. \tag{2.33}$$

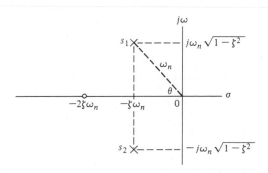

Figure 2.8. An s-plane plot of the poles and zeros of $Y(s)$.

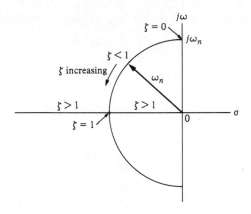

Figure 2.9. The locus of roots as ζ varies with ω_n constant.

Since s_2 is the complex conjugate of s_1, the residue k_2 is the complex conjugate of k_1 so that we obtain

$$Y(s) = \frac{k_1}{(s - s_1)} + \frac{k_1^*}{(s - s_1^*)},$$

where the asterisk indicates the conjugate relation. The residue k_1 is evaluated from Fig. 2.10 as

$$k_1 = \frac{(y_0)(s_1 + 2\zeta\omega_n)}{(s_1 - s_1^*)} \tag{2.34}$$

$$= \frac{(y_0)M_1 e^{j\theta}}{M_2 e^{j\pi/2}},$$

where M_1 is the magnitude of $(s_1 + 2\zeta\omega_n)$ and M_2 is the magnitude of $(s_1 - s_1^*)$.†
In this case, we obtain

$$k_1 = \frac{(y_0)(\omega_n e^{j\theta})}{(2\omega_n \sqrt{1 - \zeta^2}\ e^{j\pi/2})} \tag{2.35}$$

$$= \frac{(y_0)}{2\sqrt{1 - \zeta^2}\ e^{j(\pi/2-\theta)}},$$

where $\theta = \cos^{-1}\zeta$. Therefore,

$$k_2 = \frac{(y_0)}{2\sqrt{1 - \zeta^2}}\ e^{j(\pi/2-\theta)}. \tag{2.36}$$

†A review of complex numbers appears in Appendix E.

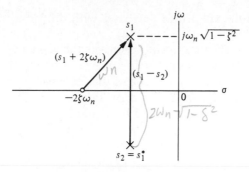

Figure 2.10. Evaluation of the residue k_1.

Finally, we find that

$$y(t) = k_1 e^{s_1 t} + k_2 e^{s_2 t}$$

$$= \frac{y_0}{2\sqrt{1 - \zeta^2}} (e^{j(\theta - \pi/2)} e^{-\zeta \omega_n t} e^{j\omega_n \sqrt{1 - \zeta^2} t} + e^{j(\pi/2 - \theta)} e^{-\zeta \omega_n t} e^{-j\omega_n \sqrt{1 - \zeta^2} t}) \quad (2.37)$$

$$= \frac{y_0}{\sqrt{1 - \zeta^2}} e^{-\zeta \omega_n t} \sin (\omega_n \sqrt{1 - \zeta^2}\, t + \theta).$$

The transient response of the overdamped ($\zeta > 1$) and underdamped ($\zeta < 1$) cases are shown in Fig. 2.11. The transient response occurs when $\zeta < 1$ exhibits an

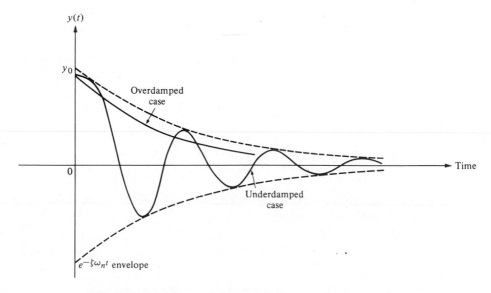

Figure 2.11. Response of the spring-mass-damper system.

oscillation in which the amplitude decreases with time, and it is called a *damped oscillation.*

The direct and clear relationship between the *s*-plane location of the poles and the form of the transient response is readily interpreted from the *s*-plane pole-zero plots. Furthermore, the magnitude of the response of each root, represented by the residue, is clearly visualized by examining the graphical residues on the *s*-plane. The Laplace transformation and the *s*-plane approach is a very useful technique for system analysis and design where emphasis is placed on the transient and steady-state performance. In fact, because the study of control systems is concerned primarily with the transient and steady-state performance of dynamic systems, we have real cause to appreciate the value of the Laplace transform techniques.

2.5 The Transfer Function of Linear Systems

The *transfer function* of a linear system is defined as the ratio of the Laplace transform of the output variable to the Laplace transform of the input variable, with all initial conditions assumed to be zero. The transfer function of a system (or element) represents the relationship describing the dynamics of the system under consideration.

A transfer function may only be defined for a linear, stationary (constant parameter) system. A nonstationary system, often called a time-varying system, has one or more time-varying parameters, and the Laplace transformation may not be utilized. Furthermore, a transfer function is an input–output description of the behavior of a system. Thus the transfer function description does not include any information concerning the internal structure of the system and its behavior.

The transfer function of the spring-mass-damper system is obtained from the original describing equation, Eq. (2.19), rewritten with zero initial conditions as follows:

$$Ms^2 Y(s) + f s Y(s) + K Y(s) = R(s). \tag{2.38}$$

Then the transfer function is

$$\frac{\text{Output}}{\text{Input}} = G(s) = \frac{Y(s)}{R(s)} = \frac{1}{Ms^2 + fs + K}. \tag{2.39}$$

The transfer function of the *RC* network shown in Fig. 2.12 is obtained by writing the Kirchhoff voltage equation, which yields

$$V_1(s) = \left(R + \frac{1}{Cs} \right) I(s). \tag{2.40}$$

The output voltage is

$$V_2(s) = I(s)\left(\frac{1}{Cs} \right). \tag{2.41}$$

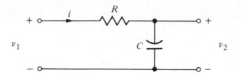

Figure 2.12. An *RC* network.

Therefore, solving Eq. (2.40) for $I(s)$ and substituting in Eq. (2.41), we have

$$V_2(s) = \frac{(1/Cs)V_1(s)}{R + 1/Cs}. \tag{2.42}$$

Then the transfer function is obtained as the ratio $V_2(s)/V_1(s)$, which is

$$G(s) = \frac{V_2(s)}{V_1(s)} = \frac{1}{RCs + 1}$$

$$= \frac{1}{\tau s + 1} \tag{2.43}$$

$$= \frac{(1/\tau)}{s + 1/\tau},$$

where $\tau = RC$, the *time constant* of the network. Equation (2.43) could be immediately obtained if one observes that the circuit is a voltage divider, where

$$\frac{V_2(s)}{V_1(s)} = \frac{Z_2(s)}{Z_1(s) + Z_2(s)} \tag{2.44}$$

and $Z_1(s) = R$, $Z_2 = 1/Cs$.

A multiloop electrical circuit or an analogous multiple mass mechanical system results in a set of simultaneous equations in the Laplace variable. It is usually more convenient to solve the simultaneous equations by using matrices and determinants [1, 3, 16]. An introduction to matrices and determinants is provided in Appendix C [45].

■ **E x a m p l e 2.2 Transfer function of system**

Consider the mechanical system shown in Fig. 2.13(a) and its electrical circuit analog shown in Fig. 2.13(b). The electrical circuit analog is a force-current analog as outlined in Table 2.1. The velocities, $v_1(t)$ and $v_2(t)$, of the mechanical system are directly analogous to the node voltage $v_1(t)$ and $v_2(t)$ of the electrical circuit. The simultaneous equations, assuming the initial conditions are zero, are

$$M_1sV_1(s) + (f_1 + f_2)V_1(s) - f_1V_2(s) = R(s), \tag{2.45}$$

$$M_2sV_2(s) + f_1(V_2(s) - V_1(s)) + K\frac{V_2(s)}{s} = 0. \tag{2.46}$$

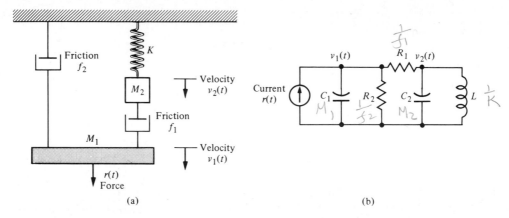

Figure 2.13. (a) Two-mass mechanical system. (b) Two-node electric circuit analog $C_1 = M_1$, $C_2 = M_2$, $L = 1/K$, $R_1 = 1/f_1$, $R_2 = 1/f_2$.

Rearranging Eqs. (2.45) and (2.46) we obtain

$$(M_1 s + (f_1 + f_2))V_1(s) + (-f_1)V_2(s) = R(s), \tag{2.47}$$

$$(-f_1)V_1(s) + \left(M_2 s + f_1 + \frac{K}{s} \right) V_2(s) = 0, \tag{2.48}$$

or, in matrix form, we have

$$\begin{bmatrix} (M_1 s + f_1 + f_2) & (-f_1) \\ (-f_1) & \left(M_2 s + f_1 + \dfrac{K}{s} \right) \end{bmatrix} \begin{bmatrix} V_1(s) \\ V_2(s) \end{bmatrix} = \begin{bmatrix} R(s) \\ 0 \end{bmatrix}. \tag{2.49}$$

Assuming the velocity of M_1 is the output variable, we solve for $V_1(s)$ by matrix inversion or Cramer's rule to obtain [1, 3]

$$V_1(s) = \frac{(M_2 s + f_1 + (K/s))R(s)}{(M_1 s + f_1 + f_2)(M_2 s + f_1 + (K/s)) - f_1^2}. \tag{2.50}$$

Then the transfer function of the mechanical (or electrical) system is

$$G(s) = \frac{V_1(s)}{R(s)} = \frac{(M_2 s + f_1 + (K/s))}{(M_1 s + f_1 + f_2)(M_2 s + f_1 + (K/s)) - f_1^2} \tag{2.51}$$

$$= \frac{(M_2 s^2 + f_1 s + K)}{(M_1 s + f_1 + f_2)(M_2 s^2 + f_1 s + K) - f_1^2 s}.$$

If the transfer function in terms of the position $x_1(t)$ is desired, then we have

$$\frac{X_1(s)}{R(s)} = \frac{V_1(s)}{sR(s)} = \frac{G(s)}{s}. \tag{2.52}$$

As an example, let us obtain the transfer function of an important electrical control component, the *dc motor* [7].

■ Example 2.3 Transfer function of dc motor

The *dc motor* is a power actuator device that delivers energy to a load as shown in Fig. 2.14(a) and a sketch of a dc motor is shown in Fig. 2.14(b). A cutaway view of a pancake dc motor is given in Fig. 2.15. The dc motor converts direct current (dc) electrical energy into rotational mechanical energy. A major fraction of the torque generated in the rotor (armature) of the motor is available to drive an external load. Because of features such as high torque, speed controllability over a wide range, portability, well-behaved speed-torque characteristics, and adaptability to various types of control methods, dc motors are still widely used in numerous control applications including robotic manipulators, tape transport mechanisms, disk drives, machine tools, and servovalve actuators.

The transfer function of the dc motor will be developed for a linear approximation to an actual motor, and second-order effects, such as hysteresis and the voltage drop across the brushes, will be neglected. The input voltage may be applied to the field or armature terminals. The air-gap flux of the motor is proportional to the field current, provided the field is unsaturated, so that

$$\phi = K_f i_f. \tag{2.53}$$

The torque developed by the motor is assumed to be related linearly to ϕ and the armature current as follows:

$$T_m = K_1 \phi i_a(t) = K_1 K_f i_f(t) i_a(t). \tag{2.54}$$

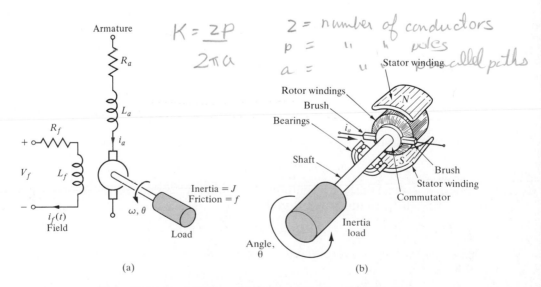

$$K = \frac{2p}{2\pi a}$$

2 = number of conductors
p = " " poles
a = " " called paths

(a)

(b)

Figure 2.14. A dc motor. (a) Wiring diagram. (b) Sketch.

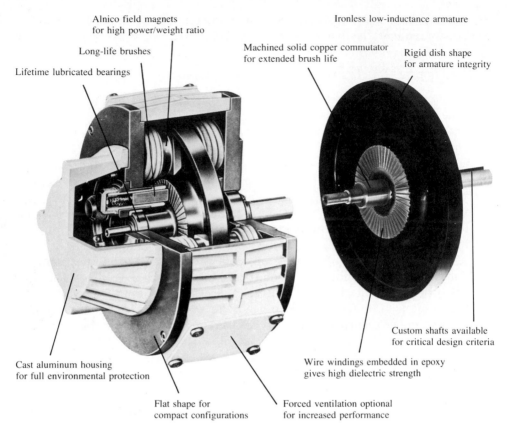

Alnico field magnets
for high power/weight ratio

Ironless low-inductance armature

Long-life brushes

Machined solid copper commutator
for extended brush life

Rigid dish shape
for armature integrity

Lifetime lubricated bearings

Custom shafts available
for critical design criteria

Cast aluminum housing
for full environmental protection

Wire windings embedded in epoxy
gives high dielectric strength

Flat shape for
compact configurations

Forced ventilation optional
for increased performance

Figure 2.15. A pancake dc motor with a flat wound armature and a permanent magnet rotor. These motors are capable of providing high torque with a low rotor inertia. A typical mechanical time constant is in the range of 15 ms. (Courtesy of Mavilor Motors.)

It is clear from Eq. (2.54) that in order to have a linear element one current must be maintained constant while the other current becomes the input current. First, we shall consider the field current controlled motor, which provides a substantial power amplification. Then we have in Laplace transform notation

$$T_m(s) = (K_1 K_f I_a) I_f(s) = K_m I_f(s), \qquad (2.55)$$

where $i_a = I_a$ is a constant armature current and K_m is defined as the motor constant. The field current is related to the field voltage as

$$V_f(s) = (R_f + L_f s) I_f(s). \qquad (2.56)$$

The motor torque $T_m(s)$ is equal to the torque delivered to the load. This relation may be expressed as

$$T_m(s) = T_L(s) + T_d(s), \qquad (2.57)$$

where $T_L(s)$ is the load torque and $T_d(s)$ is the disturbance torque, which is often negligible. However, the disturbance torque often must be considered in systems subjected to external forces such as antenna wind-gust forces. The load torque for rotating inertia as shown in Fig. 2.14 is written as

$$T_L(s) = Js^2\theta(s) + fs\theta(s). \tag{2.58}$$

Rearranging Eqs. (2.55), (2.56), and (2.57), we have

$$T_L(s) = T_m(s) - T_d(s), \tag{2.59}$$

$$T_m(s) = K_m I_f(s), \tag{2.60}$$

$$I_f(s) = \frac{V_f(s)}{R_f + L_f s}. \tag{2.61}$$

Therefore the transfer function of the motor-load combination is

$$\frac{\theta(s)}{V_f(s)} = \frac{K_m}{s(Js + f)(L_f s + R_f)} \tag{2.62}$$

$$= \frac{K_m/JL_f}{s(s + f/J)(s + R_f/L_f)}.$$

The block diagram model of the field controlled dc motor is shown in Fig. 2.16. Alternatively, the transfer function may be written in terms of the time constants of the motor as

$$\frac{\theta(s)}{V_f(s)} = G(s) = \frac{K_m/fR_f}{s(\tau_f s + 1)(\tau_L s + 1)}, \tag{2.63}$$

where $\tau_f = L_f/R_f$ and $\tau_L = J/f$. Typically, one finds that $\tau_L > \tau_f$ and often the field time constant may be neglected.

The *armature controlled dc motor* utilizes a constant field current, and therefore the motor torque is

$$T_m(s) = (K_1 K_f I_f)I_a(s) = K_m I_a(s). \tag{2.64}$$

The armature current is related to the input voltage applied to the armature as

$$V_a(s) = (R_a + L_a s)I_a(s) + V_b(s), \tag{2.65}$$

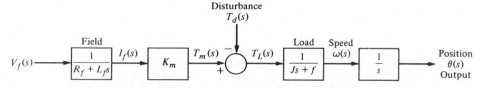

Figure 2.16. Block diagram model of field controlled dc motor.

where $V_b(s)$ is the back electromotive-force voltage proportional to the motor speed. Therefore we have

$$V_b(s) = K_b\omega(s), \tag{2.66}$$

and the armature current is

$$I_a(s) = \frac{V_a(s) - K_b\omega(s)}{(R_a + L_a s)}. \tag{2.67}$$

Equations (2.58) and (2.59) represent the load torque so that

$$T_L(s) = Js^2\theta(s) + fs\theta(s) = T_m(s) - T_d(s). \tag{2.68}$$

The relations for the armature controlled dc motor are shown schematically in Fig. 2.17. Using Eqs. (2.64), (2.67), and (2.68), or, alternatively, the block diagram, we obtain the transfer function

$$G(s) = \frac{\theta(s)}{V_a(s)} = \frac{K_m}{s[(R_a + L_a s)(Js + f) + K_b K_m]} \tag{2.69}$$

$$= \frac{K_m}{s(s^2 + 2\zeta\omega_n s + \omega_n^2)}.$$

However, for many dc motors, the time constant of the armature, $\tau_a = L_a/R_a$, is negligible, and therefore

$$G(s) = \frac{\theta(s)}{V_a(s)} = \frac{K_m}{s[R_a(Js + f) + K_b K_m]} = \frac{[K_m/(R_a f + K_b K_m)]}{s(\tau_1 s + 1)}, \tag{2.70}$$

where the equivalent time constant $\tau_1 = R_a J/(R_a f + K_b K_m)$.

It is of interest to note that K_m is equal to K_b. This equality may be shown by considering the steady-state motor operation and the power balance when the rotor resistance is neglected. The power input to the rotor is $(K_b\omega)i_a$ and the power delivered to the shaft is $T\omega$. In the steady-state condition, the power input is equal to the power delivered to the shaft so that $(K_b\omega)i_a = T\omega$; and since $T = K_m i_a$ (Eq. 2.64), we find that $K_b = K_m$.

Electric motors are used for moving loads when a rapid response is not

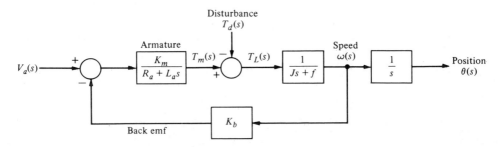

Figure 2.17. Armature controlled dc motor.

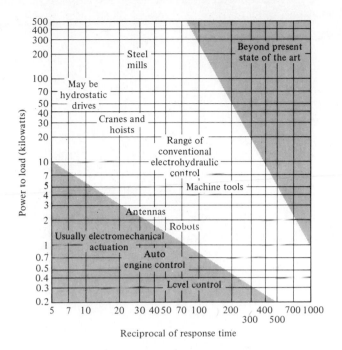

Figure 2.18. Range of control response time and power to load for electromechanical and electrohydraulic devices.

required and for relatively low power requirements. Actuators that operate as a result of hydraulic pressure are used for large loads. Figure 2.18 shows the usual ranges of use for electromechanical drives as contrasted to electrohydraulic drives. Typical applications are also shown on the figure.

■ Example 2.4 Transfer function of hydraulic actuator

A useful actuator for the linear positioning of a mass is the hydraulic actuator shown in Table 2.6, entry 9 [10]. The hydraulic actuator is capable of providing a large power amplification. It will be assumed that the hydraulic fluid is available from a constant pressure source and that the compressibility of the fluid is negligible. A downward input displacement, x, moves the control valve, and thus fluid passes into the upper part of the cylinder and the piston is forced downward. A small, low-power displacement of $x(t)$ causes a larger, high-power displacement, $y(t)$. The volumetric fluid flow rate Q is related to the input displacement $x(t)$ and the differential pressure across the piston as $Q = g(x, P)$. Using the Taylor series linearization as in Eq. (2.11), we have

$$
\begin{aligned}
Q &= \left(\frac{\partial g}{\partial x}\right)_{x_0 P_0} x + \left(\frac{\partial g}{\partial P}\right)_{P_0 x_0} P \\
&= k_x x - k_P P
\end{aligned}
\tag{2.71}
$$

Table 2.6. Transfer Functions of Dynamic Elements and Networks

Element or System	G(s)

1. Integrating circuit

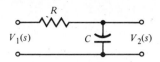

$$\frac{V_2(s)}{V_1(s)} = \frac{1}{RCs + 1}$$

2. Differentiating circuit

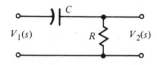

$$\frac{V_2(s)}{V_1(s)} = \frac{RCs}{RCs + 1}$$

3. Differentiating circuit

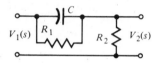

$$\frac{V_2(s)}{V_1(s)} = \frac{s + 1/R_1C}{s + (R_1 + R_2)/R_1R_2C}$$

4. Lead-lag filter circuit

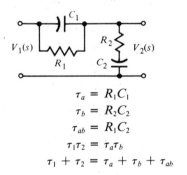

$$\tau_a = R_1C_1$$
$$\tau_b = R_2C_2$$
$$\tau_{ab} = R_1C_2$$
$$\tau_1\tau_2 = \tau_a\tau_b$$
$$\tau_1 + \tau_2 = \tau_a + \tau_b + \tau_{ab}$$

$$\frac{V_2(s)}{V_1(s)} = \frac{(1 + s\tau_a)(1 + s\tau_b)}{\tau_a\tau_b s^2 + (\tau_a + \tau_b + \tau_{ab})s + 1}$$
$$= \frac{(1 + s\tau_a)(1 + s\tau_b)}{(1 + s\tau_1)(1 + s\tau_2)}$$

5. dc-motor, field controlled

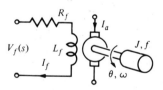

$$\frac{\theta(s)}{V_f(s)} = \frac{K_m}{s(Js + f)(L_f s + R_f)}$$

6. dc-motor, armature controlled

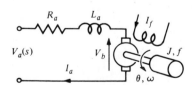

$$\frac{\theta(s)}{V_a(s)} = \frac{K_m}{s[(R_a + L_a s)(Js + f) + K_b K_m]}$$

Table 2.6.—*Continued*

Element or System	$G(s)$

7. ac-motor, two-phase control field

$$\frac{\theta(s)}{V_c(s)} = \frac{K_m}{s(\tau s + 1)}$$

$$\tau = J/(f - m)$$

m = slope of linearized torque-speed curve (normally negative)

8. Amplidyne

$$\frac{V_d(s)}{V_c(s)} = \frac{(K/R_cR_q)}{(s\tau_c + 1)(s\tau_q + 1)}$$

$$\tau_c = L_c/R_c, \quad \tau_q = L_q/R_q$$

For the unloaded case, $i_d \simeq 0$, $\tau_c \simeq \tau_q$, 0.05 sec $< \tau_c < 0.5$ sec

9. Hydraulic actuator

$$\frac{Y(s)}{X(s)} = \frac{K}{s(Ms + B)}$$

$$K = \frac{Ak_x}{k_p}, \quad B = \left(f + \frac{A^2}{k_p}\right)$$

$$k_x = \left.\frac{\partial g}{\partial x}\right|_{x0}, \quad k_p = \left.\frac{\partial g}{\partial P}\right|_{P0},$$

$$g = g(x, P) = \text{flow}$$

$$A = \text{area of piston}$$

10. Gear train

Gear ratio $= n = \dfrac{N_1}{N_2}$

$$N_2\theta_L = N_1\theta_m, \quad \theta_L = n\theta_m$$

$$\omega_L = n\omega_m$$

11. Potentiometer

$$\frac{V_2(s)}{V_1(s)} = \frac{R_2}{R} = \frac{R_2}{R_1 + R_2}$$

$$\frac{R_2}{R} = \frac{\theta}{\theta_{max}}$$

Continued

Table 2.6.—*Continued*

Element or System	$G(s)$

12. Potentiometer error detector bridge

$$V_2(s) = k_s(\theta_1(s) - \theta_2(s))$$

$$V_2(s) = k_s\theta_{\text{error}}(s)$$

$$k_s = \frac{V_{\text{battery}}}{\theta_{\text{max}}}$$

13. Tachometer

$$V_2(s) = K_t\omega(s) = K_t s\theta(s);$$

$$K_t = \text{constant}$$

14. dc-amplifier

$$\frac{V_2(s)}{V_1(s)} = \frac{k_a}{s\tau + 1}$$

R_o = output resistance

C_o = output capacitance

$$\tau = R_o C_o, \ \tau \ll 1$$

and is often negligible for

servomechanism amplifier

15. Accelerometer

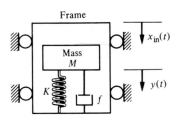

$$x_o(t) = y(t) - x_{\text{in}}(t),$$

$$\frac{X_o(s)}{X_{\text{in}}(s)} = \frac{-s^2}{s^2 + (f/M)s + K/M}$$

For low-frequency oscillations, where $\omega < \omega_n$,

$$\frac{X_o(j\omega)}{X_{\text{in}}(j\omega)} \simeq \frac{\omega^2}{K/M}$$

16. Thermal heating system

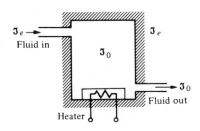

$$\frac{\tau(s)}{q(s)} = \frac{1}{C_t s + (QS + 1/R)}, \text{ where}$$

$\tau = \tau_o - \tau_e$ = temperature difference

due to thermal process

C_t = thermal capacitance

Q = fluid flow rate = constant

S = specific heat of water

R_t = thermal resistance of insulation

$q(s)$ = rate of heat flow of heating element

where $g = g(x, P)$ and (x_0, P_0) is the operating point. The force developed by the actuator piston is equal to the area of the piston, A, multiplied by the pressure, P. This force is applied to the mass, and therefore we have

$$AP = M\frac{d^2y}{dt^2} + f\frac{dy}{dt}.$$ (2.72)

Thus, substituting Eq. (2.71) into Eq. (2.72), we obtain

$$\frac{A}{k_P}(k_x x - Q) = M\frac{d^2y}{dt^2} + f\frac{dy}{dt}.$$ (2.73)

Furthermore, the volumetric fluid flow is related to the piston movement as

$$Q = A\frac{dy}{dt}.$$ (2.74)

Then, substituting Eq. (2.74) into Eq. (2.73) and rearranging, we have

$$\frac{Ak_x}{k_P}x = M\frac{d^2y}{dt^2} + \left(f + \frac{A^2}{k_P}\right)\frac{dy}{dt}.$$ (2.75)

Therefore, using the Laplace transformation, we have the transfer function

$$\frac{Y(s)}{X(s)} = \frac{K}{s(Ms + B)},$$ (2.76)

where

$$K = \frac{Ak_x}{k_P} \quad \text{and} \quad B = \left(f + \frac{A^2}{k_P}\right).$$

Note that the transfer function of the hydraulic actuator is similar to that of the electric motor. Also, for an actuator operating at high pressure levels and requiring a rapid response of the load, the effect of the compressibility of the fluid must be accounted for [4, 5].

The SI units of the variables are given in Table B.1 in Appendix B. Also a complete set of conversion factors for the British system of units are given in Table B.2.

The transfer function concept and approach is very important because it provides the analyst and designer with a useful mathematical model of the system elements. We shall find the transfer function to be a continually valuable aid in the attempt to model dynamic systems. The approach is particularly useful since the s-plane poles and zeros of the transfer function represent the transient response of the system. The transfer functions of several dynamic elements are given in Table 2.6.

2.6 Block Diagram Models

The dynamic systems that comprise automatic control systems are represented mathematically by a set of simultaneous differential equations. As we have noted in the previous sections, the introduction of the Laplace transformation reduces the problem to the solution of a set of linear algebraic equations. Since control systems are concerned with the control of specific variables, the interrelationship of the controlled variables to the controlling variables is required. This relationship is typically represented by the transfer function of the subsystem relating the input and output variables. Therefore one can correctly assume that the transfer function is an important relation for control engineering.

The importance of the cause and effect relationship of the transfer function is evidenced by the interest in representing the relationship of system variables by diagrammatic means. The *block diagram* representation of the systems relationships is prevalent in control system engineering. Block diagrams consist of *unidirectional*, operational blocks that represent the transfer function of the variables of interest. A block diagram of a field controlled dc motor and load is shown in Fig. 2.19. The relationship between the displacement $\theta(s)$ and the input voltage $V_f(s)$ is clearly portrayed by the block diagram.

In order to represent a system with several variables under control, an interconnection of blocks is utilized. For example, the system shown in Fig. 2.20 has two input variables and two output variables [6]. Using transfer function relations, we can write the simultaneous equations for the output variables as

$$C_1(s) = G_{11}(s)R_1(s) + G_{12}(s)R_2(s), \tag{2.77}$$

$$C_2(s) = G_{21}(s)R_1(s) + G_{22}(s)R_2(s), \tag{2.78}$$

where $G_{ij}(s)$ is the transfer function relating the ith output variable to the jth input variable. The block diagram representing this set of equations is shown in Fig. 2.21. In general, for J inputs and I outputs, we write the simultaneous equation in matrix form as

$$\begin{bmatrix} C_1(s) \\ C_2(s) \\ \vdots \\ C_I(s) \end{bmatrix} = \begin{bmatrix} G_{11}(s) \cdots G_{1J}(s) \\ G_{21}(s) \cdots G_{2J}(s) \\ \vdots \qquad \vdots \\ G_{I1}(s) \cdots G_{IJ}(s) \end{bmatrix} \begin{bmatrix} R_1(s) \\ R_2(s) \\ \vdots \\ R_J(s) \end{bmatrix} \tag{2.79}$$

or, simply,

$$\mathbf{C} = \mathbf{GR}. \tag{2.80}$$

$$V_f(s) \longrightarrow \boxed{G(s) = \dfrac{K_m}{s(Js + f)(L_f s + R_f)}} \overset{\text{Output}}{\longrightarrow} \theta(s)$$

Figure 2.19. Block diagram of dc motor.

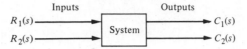

Figure 2.20. General block representation of two-input, two-output system.

Here the **C** and **R** matrices are column matrices containing the I output and the J input variables, respectively, and **G** is an I by J transfer function matrix. The matrix representation of the interrelationship of many variables is particularly valuable for complex multivariable control systems. An introduction to matrix algebra is provided in Appendix C for those unfamiliar with matrix algebra or who would find a review helpful [2].

The block diagram representation of a given system may often be reduced by block diagram reduction techniques to a simplified block diagram with fewer blocks than the original diagram. Since the transfer functions represent linear systems, the multiplication is commutative. Therefore, as in Table 2.7, entry 1, we have

$$X_3(s) = G_1(s)G_2(s)X_2(s) = G_2(s)G_1(s)X_1(s).$$

When two blocks are connected in cascade as in entry 1 of Table 2.7 we assume that

$$X_3(s) = G_2(s)G_1(s)X_1(s)$$

holds true. This assumes that when the first block is connected to the second block, loading of the first block is negligible. Loading and interaction between interconnected components or systems may occur. If loading of interconnected devices does occur, the engineer must account for this change in the transfer function and use the corrected transfer function in subsequent calculations.

Block diagram transformations and reduction techniques are derived by considering the algebra of the diagram variables. For example, consider the block

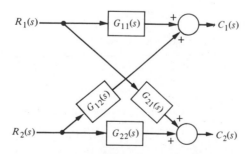

Figure 2.21. Block diagram of interconnected system.

Table 2.7. Block Diagram Transformations

Transformation	Original Diagram	Equivalent Diagram
1. Combining blocks in cascade	$X_1 \rightarrow G_1(s) \rightarrow X_2 \rightarrow G_2(s) \rightarrow X_3$	$X_1 \rightarrow G_1 G_2 \rightarrow X_3$ or $X_1 \rightarrow G_2 G_1 \rightarrow X_3$
2. Moving a summing point behind a block		
3. Moving a pickoff point ahead of a block		
4. Moving a pickoff point behind a block		
5. Moving a summing point ahead of a block		
6. Eliminating a feedback loop		$X_1 \rightarrow \dfrac{G}{1 \mp GH} \rightarrow X_2$

diagram shown in Fig. 2.22. This negative feedback control system is described by the equation for the actuating signal

$$E_a(s) = R(s) - B(s)$$
$$= R(s) - H(s)C(s). \tag{2.81}$$

Because the output is related to the actuating signal by $G(s)$, we have

$$C(s) = G(s)E_a(s), \tag{2.82}$$

and therefore

$$C(s) = G(s)(R(s) - H(s)C(s)). \tag{2.83}$$

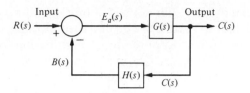

Figure 2.22. Negative feedback control system.

Solving for $C(s)$, we obtain

$$C(s)(1 + G(s)H(s)) = G(s)R(s). \qquad (2.84)$$

Therefore the transfer function relating the output $C(s)$ to the input $R(s)$ is

$$\frac{C(s)}{R(s)} = \frac{G(s)}{1 + G(s)H(s)}. \qquad (2.85)$$

This *closed-loop transfer function* is particularly important because it represents many of the existing practical control systems.

The reduction of the block diagram shown in Fig. 2.22 to a single block representation is one example of several useful block diagram reductions. These diagram transformations are given in Table 2.7. All the transformations in Table 2.7 can be derived by simple algebraic manipulation of the equations representing the blocks. System analysis by the method of block diagram reduction has the advantage of affording a better understanding of the contribution of each component element than is possible to obtain by the manipulation of equations. The utility of the block diagram transformations will be illustrated by an example of a block diagram reduction.

■ Example 2.5 Block diagram reduction

The block diagram of a multiple-loop feedback control system is shown in Fig. 2.23. It is interesting to note that the feedback signal $H_1(s)C(s)$ is a positive feedback signal and the loop $G_3(s)G_4(s)H_1(s)$ is called a *positive feedback loop*. The

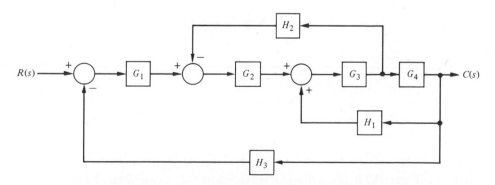

Figure 2.23. Multiple-loop feedback control system.

block diagram reduction procedure is based on the utilization of rule 6, which eliminates feedback loops. Therefore, the other tranformations are used in order to transform the diagram to a form ready for eliminating feedback loops. First, in order to eliminate the loop $G_3G_4H_1$, we move H_2 behind block G_4 by using rule 4, and therefore obtain Fig. 2.24(a). Eliminating the loop $G_3G_4H_1$ by using rule 6, we obtain Fig. 2.24(b). Then, eliminating the inner loop containing H_2/G_4, we obtain Fig. 2.24(c). Finally, by reducing the loop containing H_3 we obtain the closed-loop system transfer function as shown in Fig. 2.24(d). It is worthwhile to examine the form of the numerator and denominator of this closed-loop transfer function. We note that the numerator is composed of the cascade transfer function of the feedforward elements connecting the input $R(s)$ and the output $C(s)$. The denominator is comprised of 1 minus the sum of each loop transfer function. The sign of the loop $G_3G_4H_1$ is plus because it is a positive feedback loop, whereas

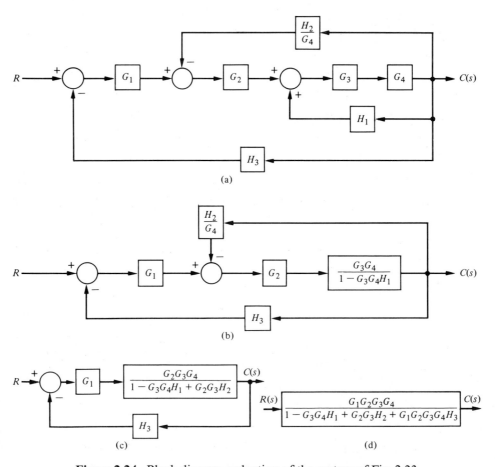

Figure 2.24. Block diagram reduction of the system of Fig. 2.23.

the loops $G_1G_2G_3G_4H_3$ and $G_2G_3H_2$ are negative feedback loops. The denominator can be rewritten as

$$q(s) = 1 - (+G_3G_4H_1 - G_2G_3H_2 - G_1G_2G_3G_4H_3) \tag{2.86}$$

in order to illustrate this point. This form of the numerator and denominator is quite close to the general form for multiple-loop feedback systems, as we shall find in the following section.

The block diagram representation of feedback control systems is a valuable and widely used approach. The block diagram provides the analyst with a graphical representation of the interrelationships of controlled and input variables. Furthermore, the designer can readily visualize the possibilities for adding blocks to the existing system block diagram in order to alter and improve the system performance. The transition from the block diagram method to a method utilizing a line path representation instead of a block representation is readily accomplished and is presented in the following section.

2.7 Signal-Flow Graph Models

Block diagrams are adequate for the representation of the interrelationships of controlled and input variables. However, for a system with reasonably complex interrelationships, the block diagram reduction procedure is cumbersome and often quite difficult to complete. An alternative method for determining the relationship between system variables has been developed by Mason and is based on a representation of the system by line segments [4]. The advantage of the line path method, called the signal-flow graph method, is the availability of a flow graph gain formula, which provides the relation between system variables without requiring any reduction procedure or manipulation of the flow graph.

The transition from a block diagram representation to a directed line segment representation is easy to accomplish by reconsidering the systems of the previous section. A *signal-flow graph* is a diagram consisting of nodes that are connected by several directed branches and is a graphical representation of a set of linear relations. Signal-flow graphs are particularly useful for feedback control systems because feedback theory is primarily concerned with the flow and processing of signals in systems. The basic element of a signal flow graph is a unidirectional path segment called a *branch,* which relates the dependency of an input and an output variable in a manner equivalent to a block of a block diagram. Therefore, the branch relating the output of a dc motor, $\theta(s)$, to the field voltage, $V_f(s)$, is similar to the block diagram of Fig. 2.19 and is shown in Fig. 2.25. The input and output points or junctions are called *nodes.* Similarly, the signal-flow graph rep-

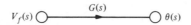

Figure 2.25. Signal-flow graph of the dc motor.

Figure 2.26. Signal-flow graph of interconnected system.

resenting Eqs. (2.77) and (2.78) and Fig. 2.21 is shown in Fig. 2.26. The relation between each variable is written next to the directional arrow. All branches leaving a node pass the nodal signal to the output node of each branch (unidirectionally). All branches entering a node summate as a total signal at the node. A *path* is a branch or a continuous sequence of branches that can be traversed from one signal (node) to another signal (node). A *loop* is a closed path that originates and terminates on the same node, and along the path no node is met twice. Therefore, reconsidering Fig. 2.26, we obtain

$$C_1(s) = G_{11}(s)R_1(s) + G_{12}(s)R_2(s), \tag{2.87}$$

$$C_2(s) = G_{21}(s)R_1(s) + G_{22}(s)R_2(s). \tag{2.88}$$

The flow graph is simply a pictorial method of writing a system of algebraic equations so as to indicate the interdependencies of the variables. As another example, consider the following set of simultaneous algebraic equations:

$$a_{11}x_1 + a_{12}x_2 + r_1 = x_1 \tag{2.89}$$

$$a_{21}x_1 + a_{22}x_2 + r_2 = x_2. \tag{2.90}$$

The two input variables are r_1 and r_2, and the output variables are x_1 and x_2. A signal-flow graph representing Eqs. (2.89) and (2.90) is shown in Fig. 2.27. Equations (2.89) and (2.90) may be rewritten as

$$x_1(1 - a_{11}) + x_2(-a_{12}) = r_1, \tag{2.91}$$

$$x_1(-a_{21}) + x_2(1 - a_{22}) = r_2. \tag{2.92}$$

Figure 2.27. Signal-flow graph of two algebraic equations.

The simultaneous solution of Eqs. (2.91) and (2.92) using Cramer's rule results in the solutions

$$x_1 = \frac{(1 - a_{22})r_1 + a_{12}r_2}{(1 - a_{11})(1 - a_{22}) - a_{12}a_{21}} = \frac{(1 - a_{22})}{\Delta} r_1 + \frac{a_{12}}{\Delta} r_2, \qquad (2.93)$$

$$x_2 = \frac{(1 - a_{11})r_2 + a_{21}r_1}{(1 - a_{11})(1 - a_{22}) - a_{12}a_{21}} = \frac{(1 - a_{11})}{\Delta} r_2 + \frac{a_{21}}{\Delta} r_1. \qquad (2.94)$$

The denominator of the solution is the determinant Δ of the set of equations and is rewritten as

$$\begin{aligned} \Delta &= (1 - a_{11})(1 - a_{22}) - a_{12}a_{21} \\ &= 1 - a_{11} - a_{22} + a_{11}a_{22} - a_{12}a_{21}. \end{aligned} \qquad (2.95)$$

In this case, the denominator is equal to 1 minus each self-loop a_{11}, a_{22}, and $a_{12}a_{21}$, plus the product of the two nontouching loops a_{11} and a_{22}.

The numerator for x_1 with the input r_1 is 1 times $(1 - a_{22})$, which is the value of Δ not touching the path 1 from r_1 to x_1. Therefore the numerator from r_2 to x_1 is simply a_{12} because the path through a_{12} touches all the loops. The numerator for x_2 is symmetrical to that of x_1.

In general, the linear dependence T_{ij} between the independent variable x_i (often called the input variable) and a dependent variable x_j is given by Mason's *loop rule* [8, 11]:

$$T_{ij} = \frac{\Sigma_k P_{ij_k}\Delta_{ij_k}}{\Delta}, \qquad (2.96)$$

where
$P_{ij_k} = k$th path from variable x_i to variable x_j,
Δ = determinant of the graph,
Δ_{ij_k} = cofactor of the path P_{ij_k},

and the summation is taken over all possible k paths from x_i to x_j. The cofactor Δ_{ij_k} is the determinant with the loops touching the kth path removed. The determinant Δ is

$$\Delta = 1 - \sum_{n=1}^{N} L_n + \sum_{m=1,q=1}^{M,Q} L_m L_q - \sum L_r L_s L_t + \cdots, \qquad (2.97)$$

where L_q equals the value of the qth loop transmittance. Therefore the rule for evaluating Δ in terms of loops $L_1, L_2, L_3, \ldots, L_N$ is

$\Delta = 1 -$ (sum of all different loop gains)
 $+$ (sum of the gain products of all combinations of 2 nontouching loops)
 $-$ (sum of the gain products of all combinations of 3 nontouching loops)
 $+ \ldots.$

Two loops are nontouching if they do not have any common nodes.

The gain formula is often used to relate the output variable $C(s)$ to the input variable $R(s)$ and is given in somewhat simplified form as

$$T = \frac{\Sigma_k P_k \Delta_k}{\Delta}, \tag{2.98}$$

where $T(s) = C(s)/R(s)$. The path gain or transmittance P_k (or P_{ijk}) is defined as the continuous succession of branches that are traversed in the direction of the arrows and with no node encountered more than once. A loop is defined as a closed path in which no node is encountered more than once per traversal.

Several examples will illustrate the utility and ease of this method. Although the gain equation (2.96) appears to be formidable, one must remember that it represents a summation process, not a complicated solution process.

■ E x a m p l e 2.6: Transform Function of Interacting System

A two-path signal-flow graph is shown in Fig. 2.28. An example of a control system with multiple signal paths is the multi-legged robot shown in Fig. 2.29. The paths connecting the input $R(s)$ and output $C(s)$ are

$$\text{path 1: } P_1 = G_1 G_2 G_3 G_4$$

and

$$\text{path 2: } P_2 = G_5 G_6 G_7 G_8.$$

There are four self-loops:

$$L_1 = G_2 H_2, \quad L_2 = H_3 G_3, \quad L_3 = G_6 H_6, \quad L_4 = G_7 H_7.$$

Loops L_1 and L_2 do not touch L_3 and L_4. Therefore, the determinant is

$$\Delta = 1 - (L_1 + L_2 + L_3 + L_4) + (L_1 L_3 + L_1 L_4 + L_2 L_3 + L_2 L_4). \tag{2.99}$$

The cofactor of the determinant along path 1 is evaluated by removing the loops that touch path 1 from Δ. Therefore we have

$$L_1 = L_2 = 0 \quad \text{and} \quad \Delta_1 = 1 - (L_3 + L_4).$$

Figure 2.28. Two-path interacting system.

Figure 2.29. This six-legged robot can climb into a truck or lift and maneuver at the same time. It walks over rough terrain and is a forerunner of robots for many uses. (Courtesy of Odetics, Inc., Anaheim, Calif.)

Similarly, the cofactor for path 2 is

$$\Delta_2 = 1 - (L_1 + L_2).$$

Therefore the transfer function of the system is

$$\frac{C(s)}{R(s)} = T(s) = \frac{P_1\Delta_1 + P_2\Delta_2}{\Delta} \tag{2.100}$$

$$= \frac{G_1G_2G_3G_4(1 - L_3 - L_4) + G_5G_6G_7G_8(1 - L_1 - L_2)}{1 - L_1 - L_2 - L_3 - L_4 + L_1L_3 + L_1L_4 + L_2L_3 + L_2L_4}.$$

The signal-flow graph gain formula provides a reasonably straightforward approach for the evaluation of complicated systems. In order to compare the method with block diagram reduction, which is really not much more difficult, let us reconsider the complex system of Example 2.4.

■ Example 2.7: Transfer Function of Multiple Loop System

A multiple-loop feedback system is shown in Fig. 2.23 in block diagram form. There is no reason to redraw the diagram in signal-flow graph form, and so we shall proceed as usual by using the signal-flow gain formula, Eq. (2.98). There is

one forward path $P_1 = G_1G_2G_3G_4$. The feedback loops are

$$L_1 = -G_2G_3H_2, \quad L_2 = G_3G_4H_1, \quad L_3 = -G_1G_2G_3G_4H_3. \qquad (2.101)$$

All the loops have common nodes and therefore are all touching. Furthermore, the path P_1 touches all the loops and hence $\Delta_1 = 1$. Thus the closed-loop transfer function is

$$T(s) = \frac{C(s)}{R(s)} = \frac{P_1\Delta_1}{1 - L_1 - L_2 - L_3}$$

$$= \frac{G_1G_2G_3G_4}{1 + G_2G_3H_2 - G_3G_4H_1 + G_1G_2G_3G_4H_3}. \qquad (2.102)$$

■ Example 2.8: Transfer Function of Complex System

Finally, we shall consider a reasonably complex system that would be difficult to reduce by block diagram techniques. A system with several feedback loops and feedforward paths is shown in Fig. 2.30. The forward paths are

$$P_1 = G_1G_2G_3G_4G_5G_6, \quad P_2 = G_1G_2G_7G_6, \quad P_3 = G_1G_2G_3G_4G_8.$$

The feedback loops are

$$L_1 = -G_2G_3G_4G_5H_2, \quad L_2 = -G_5G_6H_1, \quad L_3 = -G_8H_1, \quad L_4 = -G_7H_2G_2,$$

$$L_5 = -G_4H_4, \quad L_6 = -G_1G_2G_3G_4G_5G_6H_3, \quad L_7 = -G_1G_2G_7G_6H_3,$$

$$L_8 = -G_1G_2G_3G_4G_8H_3.$$

Loop L_5 does not touch loop L_4 and loop L_7; loop L_3 does not touch loop L_4; and all other loops touch. Therefore the determinant is

$$\Delta = 1 - (L_1 + L_2 + L_3 + L_4 + L_5 + L_6 + L_7 + L_8)$$

$$+ (L_5L_7 + L_5L_4 + L_3L_4). \qquad (2.103)$$

Figure 2.30. Multiple-loop system.

The cofactors are

$$\Delta_1 = \Delta_3 = 1 \quad \text{and} \quad \Delta_2 = 1 - L_5 = 1 + G_4 H_4.$$

Finally, the transfer function is then

$$T(s) = \frac{C(s)}{R(s)} = \frac{P_1 + P_2\Delta_2 + P_3}{\Delta} \tag{2.104}$$

Signal-flow graphs and the signal-flow gain formula may be used profitably for the analysis of feedback control systems, analog computer diagrams, electronic amplifier circuits, statistical systems, mechanical systems, among many other examples.

2.8 Computer Analysis of Control Systems

When a model is available for a component or system, a computer can be utilized to investigate the behavior of the system. A computer model of a system in a mathematical form suitable for demonstrating the system's behavior may be utilized to investigate various designs of a planned system without actually building the system itself. A *computer simulation* uses a model and the actual conditions of the system being modeled and actual input commands to which the system will be subjected.

A system may be simulated using analog or digital computers. An electronic analog computer is used to establish a model of a system, using the analogy between the voltage of the electronic amplifier and the variable of the system being modeled [1, 7, 9, 14, 16]. An electronic analog computer usually has available the mathematical functions of integration, multiplication by a constant, multiplication of two variables, and the summation of several variables, among others. These functions are often sufficient to develop a simulation model of a system. The analog simulation model of a second-order system is shown in Fig. 2.31 for the system with negative unity feedback and a plant transfer function

$$G(s) = \frac{C(s)}{E(s)} = \frac{K}{s(s+p)}. \tag{2.105}$$

The differential equation necessary to yield the simulation of the plant is obtained by cross-multiplying in Eq. (2.105) to yield

$$s(s + p)C(s) = KE(s). \tag{2.106}$$

Since $sC(s)$ is the derivative of $c(t)$ in the s-domain we have:

$$\frac{d^2c(t)}{dt^2} = -p\frac{dc(t)}{dt} + Ke(t). \tag{2.107}$$

This equation is represented on the analog diagram by the integration in the center of the diagram with the output dc/dt. This analog simulation arrangement

Figure 2.31. An analog computer simulation model for a second-order system with negative unity feedback.

may be realized physically on an electronic analog computer in order to yield an output recording of the simulated response of the system. The parameters K and p may be varied in order to ascertain the effect of the parameter change.

Simulation models may also be utilized with digital computers. A computer simulation may be developed in common computer language such as Pascal or BASIC or in a language specifically developed for simulation [15, 16]. Two widely used languages for the simulation of systems operating in continuous time are CSMP and ACSL. CSMP is an acronym for Continuous System Modeling Program and is an IBM product available for most IBM computers. A graphic feature is also available with CSMP. CSMP provides up to 42 functions such as integration and random number generation and including many nonlinear functions. A portion of a CSMP computer program for simulating the second-order control system of Eq. (2.105) is shown in Fig. 2.32. In this simulation, COUT = $c(t)$ and CDOT = dc/dt. The function REALPL simulates the function with one real pole, p. This simulation will yield an output printed at spacings of one-half second over a 20-second interval.

Digital simulation software like CSMP has been available for mainframe computers for over a decade. These programs run on either mainframe computers or minicomputers and often the only graphical output available is in the form of

```
          DYNAMIC
                  ERROR = RIN − COUT
                  CONTL = GAIN*ERROR
                  CDOT = REALPL (0.0, P, CONTL)
                  COUT = INTGRL (0,0, CDOT)
          PARAMETER P = 1.5, RIN = 1.0
          PARAMETER GAIN = (1.0, 5.0, 10.0)
                  TIMER FINTIM = 20.0, OUTDEL = 0.5
          PRINT COUT, CDOT
```

Figure 2.32. A portion of a digital computer program written in the simulation language CSMP is shown for a second-order unity feedback system.

a line printer plot. All of these programs have the disadvantage of being available on computer systems that are not typically perceived by student and faculty as being user friendly. Programs for use on more user-friendly systems have recently become available. Several simulation programs are now available for a personal computer similar to those available on mainframe computers [16]. These programs are written to be interactive and are considerably more user friendly than the batch-mode mainframe simulators in use today. They offer user help, error detection, and medium resolution graphics for presentation of system responses.

Assuming that a model and the simulation are reliably accurate, the advantages of computer simulation are [42]:

1. System performance can be observed under all conceivable conditions.
2. Results of field-system performance can be extrapolated with a simulation model for prediction purposes.
3. Decisions concerning future systems presently in a conceptual stage can be examined.
4. Trials of systems under test can be accomplished in a much reduced period of time.
5. Simulation results can be obtained at lower cost than real experimentation.

Figure 2.33. (a) An open-loop system. (b) The response of the open-loop system to a unit step input when $K = 1$. The response asymptotically approaches a final value of 1.0.

(a)

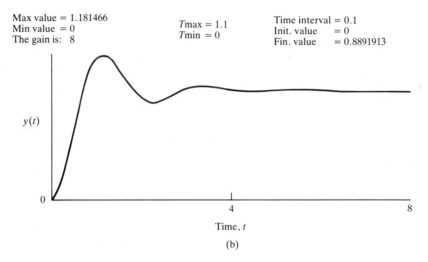

(b)

Figure 2.34. (a) A closed-loop system. (b) The response of the closed-loop system to a unit step input when $K = 8$.

6. Study of hypothetical situations can be achieved even when the hypothetical situation would be unrealizable in actual life at the present time.

7. Computer modeling and simulation is often the only feasible or safe technique to analyze and evaluate a system.

The Control System Design Program (CSDP) permits the analyst to determine the response of control systems for various input signals using the IBM PC or a compatible computer. For example, the response of the open-loop control system shown in Fig. 2.33(a) is shown in Fig. 2.33(b) for a unit step input when

$$G(s) = \frac{K}{(s + 1)^2} \tag{2.108}$$

and $K = 1$.

Utilizing CSDP one can proceed to readily obtain the response of the closed-loop system shown in Fig. 2.34(a) when $G(s)$ is that of Eq. (2.108) and $K = 8$. The response of this closed-loop system to a unit step input is shown in Fig. 2.34(b).

2.9 Design Examples

■ Example 2.9 Electric traction motor control

A majority of modern trains and local transit vehicles utilize electric traction motors. The electric motor drive for a railway vehicle is shown in block diagram form in Fig. 2.35(a) incorporating the necessary control of the velocity of the vehi-

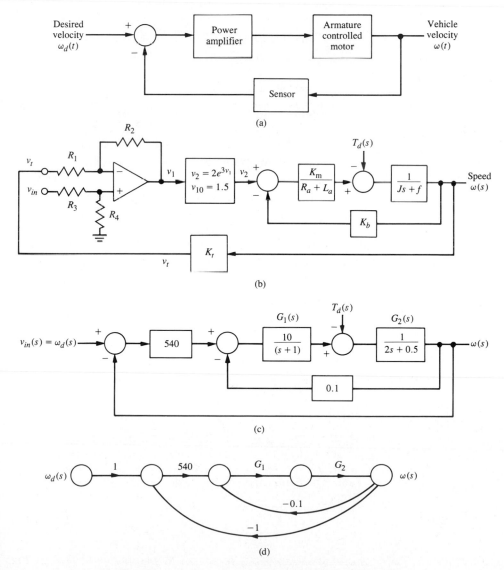

Figure 2.35. Speed control of an electric traction motor.

cle. The goal of the design is to obtain a system model and the closed-loop transfer function of the system, $\omega(s)/\omega_d(s)$.

The first step is to describe the transfer function of each block. We propose the use of a tachometer to generate a voltage proportional to velocity and to connect that voltage, v_t, to one input of a difference amplifier, as shown in Fig. 2.35(b). The power amplifier is nonlinear and can be approximately represented by $v_2 = 2e^{3v_1}$, an exponential function with a normal operating point, $v_{10} = 1.5V$. Using the technique in Section 2.3, we then obtain a linear model

$$v_2 = 2\left[\frac{dg(v_1)}{dv_1}\bigg|_{v_{10}}\right]\Delta v_1$$

$$= 2[3e^{3v}_{10}]\,\Delta v_1 \tag{2.109}$$

$$= 2[270]\,\Delta v_1$$

$$= 540\,\Delta v_1.$$

Then, discarding the delta notation and writing the transfer function, we have

$$V_2(s) = 540V_1(s).$$

The transfer function of the differential amplifier is

$$v_1 = \frac{1 + R_2/R_1}{1 + R_3/R_4}\,v_{in} - \frac{R_2}{R_1}\,v_t\,. \tag{2.110}$$

We wish to obtain an input control that sets $\omega_d(t) = v_{in}$ where the units of ω_d are rad/s and the units of v_{in} are volts. Then, when $v_{in} = 10\ V$, the steady-state speed is $\omega = 10$ rad/s. We note that $v_t = K_t\omega_d$, in steady state and we expect, in balance, the steady-state output, v_1, to be

$$v_1 = \frac{1 + R_2/R_1}{1 + R_3/R_4}\,v_{in} - \left(\frac{R_2}{R_1}\right)K_t(v_{in}). \tag{2.111}$$

When the system is in balance $v_1 = 0$ and when $K_t = 0.1$, we have

$$\frac{1 + R_2/R_1}{1 + R_3/R_4} = \left(\frac{R_2}{R_1}\right)K_t = 1.$$

This relation can be achieved when

$$R_2/R_1 = 10 \quad\text{and}\quad R_3/R_4 = 10.$$

Table 2.8. Parameters of a Large dc Motor

$K_m = 10$	$J = 2$
$R_a = 1$	$f = 0.5$
$L_a = 1$	$K_b = 0.1$

The parameters of the motor and load are given in Table 2.8. The overall system is shown in Figure 2.35(c). Using Mason's signal flow rule with the signal flow diagram of Figure 2.35(d), we have

$$
\begin{aligned}
\frac{\omega(s)}{\omega_d(s)} &= \frac{540G_1(s)G_2(s)}{1 + 0.1G_1G_2 + 540G_1G_2} \\
&= \frac{540G_1G_2}{1 + 540.1G_1G_2} \\
&= \frac{5400}{(s + 1)(2s + 0.5) + 5401} \\
&= \frac{5400}{2s^2 + 2.5s + 5401.5} \\
&= \frac{2700}{s^2 + 1.25s + 2700.75}.
\end{aligned}
\tag{2.112}
$$

Since the characteristic equation is second order, we note that $\omega_n = 52$ and $\zeta = 0.012$, and we expect the response of the system to be highly oscillatory.

■ Example 2.10 Mechanical accelerometer

A mechanical accelerometer is used to measure the acceleration of a levitated test sled, as shown in Fig. 2.36. The test sled is magnetically levitated above a guide rail a small distance δ. The accelerometer provides a measurement of the accel-

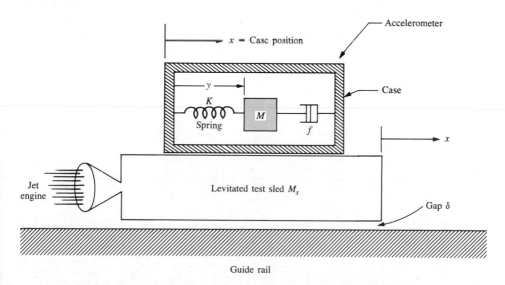

Figure 2.36. An accelerometer mounted on a jet engine test sled.

eration $a(t)$ of the sled since the position y of the mass M, with respect to the accelerometer case, is proportional to the acceleration of the case (and the sled). The goal is to design an accelerometer with an appropriate dynamic responsiveness. We wish to design an accelerometer with an acceptable time for the desired measurement characteristic, $y(t) = qa(t)$, to be attained (q is a constant).

The sum of the forces acting on the mass is

$$-f\frac{dy}{dt} - Ky = M\frac{d^2}{dt^2}(y - x)$$

or

$$M\frac{d^2y}{dt^2} + f\frac{dy}{dt} + Ky = M\frac{d^2x}{dt^2}. \tag{2.113}$$

Since

$$M_s\frac{d^2x}{dt^2} = F(t),$$

the engine force, we have

$$M\ddot{y} + f\dot{y} + Ky = \frac{M}{M_s}F(t)$$

or

$$\ddot{y} + \frac{f}{M}\dot{y} + \frac{K}{M}y = \frac{F(t)}{M_s}. \tag{2.114}$$

We select the coefficients where $f/M = 3$, $K/M = 2$, $F(t)/M_s = Q(t)$, and we consider the initial conditions $y(0) = -1$ and $\dot{y}(0) = 2$. We then obtain the Laplace transform equation, when the force and thus $Q(t)$ is a step function, as follows:

$$(s^2Y(s) - sy(0) - \dot{y}(0)) + 3(sY(s) - y(0)) + 2Y(s) = Q(s). \tag{2.115}$$

Since $Q(s) = P/s$, where P is the magnitude of the step function, we obtain

$$(s^2Y(s) + s - 2) + 3(sY(s) + 1) + 2Y(s) = \frac{P}{s}$$

or

$$(s^2 + 3s + 2)Y(s) = \frac{-(s^2 + s - P)}{s}. \tag{2.116}$$

Thus the output transform is

$$Y(s) = \frac{-(s^2 + s - P)}{s(s^2 + 3s + 2)} = \frac{-(s^2 + s - P)}{s(s + 1)(s + 2)}. \tag{2.117}$$

Expanding in partial fraction form,

$$Y(s) = \frac{k_1}{s} + \frac{k_2}{s+1} + \frac{k_3}{s+2}. \qquad (2.118)$$

We then have

$$k_1 = \frac{-(s^2 + s - P)}{(s+1)(s+2)} \bigg|_{s=0} = \frac{P}{2}. \qquad (2.119)$$

Similarly, $k_2 = -P$ and $k_3 = \dfrac{P-2}{2}$.

Thus

$$Y(s) = \frac{P}{2s} - \frac{P}{s+1} + \frac{(P-2)}{2(s+2)}. \qquad (2.220)$$

Therefore the output measurement is

$$y(t) = \tfrac{1}{2}[P - 2Pe^{-t} + (P-2)e^{-2t}] \,, \ t \geqslant 0$$

A plot of $y(t)$ is shown in Fig. 2.37 for $P = 3$. We can see that $y(t)$ is proportional to the magnitude of the force, and thus the acceleration, after four seconds. If this period is excessively long, we must increase the spring constant, K, and the fric-

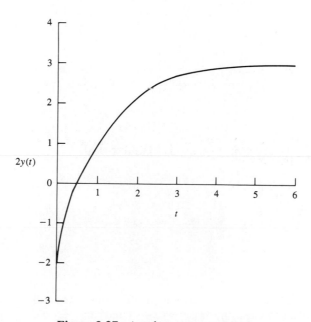

Figure 2.37. Accelerometer response.

tion, f, while reducing the mass, M. If we are able to select the components so that $f/M = 12$ and $K/M = 32$, the accelerometer will attain the proportional response in one second. (It is left to the reader to show this.)

2.10 Summary

In this chapter, we have been concerned with quantitative mathematical models of control components and systems. The differential equations describing the dynamic performance of physical systems were utilized to construct a mathematical model. The physical systems under consideration included mechanical, electrical, fluid, and thermodynamic systems. A linear approximation using a Taylor series expansion about the operating point was utilized to obtain a small-signal linear approximation for nonlinear control components. Then, with the approximation of a linear system, one may utilize the Laplace transformation and its related input–output relationship, the transfer function. The transfer function approach to linear systems allows the analyst to determine the response of the system to various input signals in terms of the location of the poles and zeros of the transfer function. Using transfer function notations, block diagram models of systems of interconnected components were developed. The block functions were

Figure 2.38. A keyboard instrument playing robot with the capability to see, hear, and speak. It can operate an electronic organ with its hands and feet. Equipped with arms and legs, it has a total of 50 joints. It has fingers capable of striking keys at a rate of 15 strokes per second. (Courtesy of Sumitomo Electric.)

obtained. Additionally, an alternative use of transfer function models in signal-flow graph form was investigated. The signal-flow graph gain formula was investigated. The signal-flow graph gain formula was found to be useful for obtaining the relationship between system variables in a complex feedback system. The advantage of the signal-flow graph method was the availability of Masons's flow graph gain formula, which provides the relation between system variables without requiring any reduction or manipulation of the flow graph. Thus in Chapter 2 we have obtained a useful mathematical model for feedback control systems by developing the concept of a transfer function of a linear system and the relationship among system variables using block diagram and signal-flow graph models. Finally, we considered the utility of the computer simulation of linear and nonlinear systems in order to determine the response of a system for several conditions of the system parameters and the environment. An example of a complex system which requires all the approaches discussed in Chapter 2 is shown in Fig. 2.38.

Exercises

(Exercises are straightforward applications of the concepts of the chapter.)

E2.1. A unity, negative feedback system has a nonlinear function $c = f(e) = e^2$ as shown in the Fig. E2.1. For an input r in the range of zero to four calculate and plot the open-loop and closed-loop output versus input and show that the feedback system results in a more linear relationship.

Close switch for closed loop

Figure E2.1. Open and closed loop.

E2.2. A thermistor has a response to temperature represented by

$$R = R_o e^{-0.1T},$$

where $R_o = 10,000\ \Omega$, $R =$ resistance, and $T =$ temperature in degrees Celsius. Find the linear model for the thermistor operating at $T = 20°C$ and for a small range of variation of temperature.

Answer: $\Delta R = -135\ \Delta T$

E2.3. The force versus displacement for a spring is shown in Fig. E2.3 for the spring-mass-damper system of Fig. 2.1. Graphically find the spring constant for the equilibrium point of $y = 0.5$ cm and a range of operation of ± 1.5 cm.

Figure E2.3. Spring behavior.

E2.4. A laser jet printer uses a laser beam to print copy rapidly for a computer [18, 19]. The laser is positioned by a control input, $r(t)$, so that we have

$$Y(s) = \frac{500(s + 100)}{s^2 + 60s + 500} R(s).$$

(a) If $r(t)$ is a unit step input, find the output $y(t)$. (b) What is the final value of $y(t)$?

E2.5. A switching circuit is used to convert one level of DC voltage to an output DC voltage. The switching circuit is shown in Fig. E2.5(a), on next page [27]. The filter circuit to filter out the high frequencies is shown in Fig. E2.5(b). Calculate the transfer function $V_2(s)/V_1(s)$.

E2.6. A nonlinear device is represented by the function

$$y = f(x)$$
$$= x^{1/2}$$

where the operating point for the input x is $x_o = 1/2$. Determine the linear approximation in the form of Eq. 2.9.

Answer: $\Delta y = \Delta x / \sqrt{2}$

E2.7. A lamp's intensity stays constant when monitored by an optotransistor-controlled feedback loop. When the voltage drops, the lamp's output also drops, and optotransistor Q_1 draws less current. As a result, a power transistor conducts more heavily and charges a capacitor more rapidly [8]. The capacitor voltage controls the lamp voltage directly. A flow diagram of the system is shown in the Fig. E2.7, on page 88. Find the closed-loop transfer

(b)

Figure E2.5. (a) Prototype circuit for switcher. (b) Filter circuit for 150 w switcher (idealized). (Photo courtesy of Ron Burian and TESLAco.)

function, $I(s)/R(s)$ where $I(s)$ is in the lamp intensity and $R(s)$ is the command or desired level of light.

E2.8. A four-wheel antilock automobile braking system uses electronic feedback to control automatically the brake force on each wheel [24]. A simplified flow graph of a brake control system is shown in Fig. E2.8, on next page where $F_f(s)$ and $F_R(s)$ are the braking force of the front and rear wheels, respectively, and $R(s)$ is the desired automobile response on an icy road. Find $F_f(s)/R(s)$.

(a)

Filter

Q_1

Iris

Opaque
tube

(b)

Figure E2.7. Lamp controller.

Figure E2.8. Brake control system.

E2.9. A control engineer, N. Minorsky, designed an innovative ship steering system in the 1930s for the U.S. Navy. The system is represented by the signal-flow graph shown in Fig. E2.9 where $C(s)$ is the ship's course, $R(s)$ is the desired course, and $A(s)$ is the rudder angle [41]. Find the transfer function $C(s)/R(s)$.

Figure E2.9. Ship steering system.

E2.10. Off-road vehicles experience many disturbance inputs as they traverse over rough roads. An active suspension system can be controlled by a sensor which looks "ahead" at the road conditions. An example of a simple suspension system that can accommodate the bumps is shown in Fig. E2.10. Find the appropriate gain K_1 so that the vehicle does not bounce when the desired deflection is $R(s) = 0$.

Answer: $K_1 K_2 = 1$

Figure E2.10. Active suspension system.

E2.11. A spring exhibits a force versus displacement characteristic as shown in Fig. E2.11. For small deviations from the operating point, find the spring constant when x_o is (a) -1.4, (b) 0, (c) 3.5.

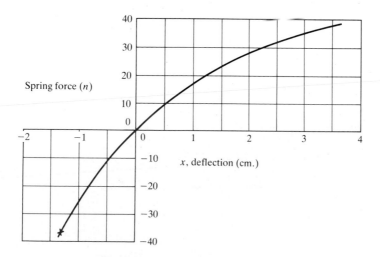

Figure E2.11. Spring characteristic.

E2.12. One of the most potentially beneficial applications of automotive control systems is the active control of the suspension system. One feedback control system uses a shock absorber consisting of a cylinder filled with a compressible fluid that provides both spring and damping forces [24]. The cylinder has a plunger activated by a gear motor, a displacement-measuring sensor, and a piston. Spring force is generated by piston displacement, which compresses the fluid. During piston displacement, the pressure imbalance across the piston is used to control damping. The plunger varies the internal volume of the cylinder. This feedback system is shown in Fig. E2.12. Develop a linear model for this device using a block diagram model.

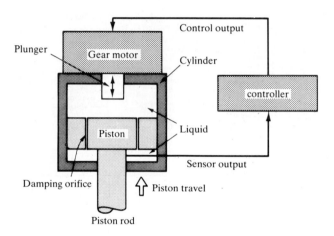

Figure E2.12. Shock absorber.

E2.13. Find the transfer function

$$\frac{C_1(s)}{R_2(s)}$$

for the multivariable system in Fig. E2.13.

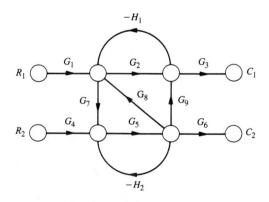

Figure E2.13. Multivariable system.

E2.14. Obtain the differential equations in terms of i_1 and i_2 for the circuit in Fig. E2.14.

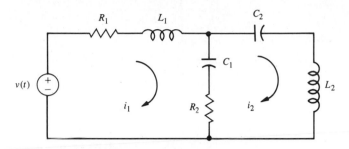

Figure E2.14. Electric circuit.

E2.15. The position control system for a spacecraft platform is governed by the following equations:

$$\frac{d^2p}{dt^2} + \frac{dp}{dt} + 4p = \theta$$

$$v_1 = r - p$$

$$\frac{d\theta}{dt} = 0.4v_2$$

$$v_2 = 7v_1.$$

The variables involved are as follows:

$$r(t) = \text{desired platform position}$$
$$p(t) = \text{actual platform position}$$
$$v_1(t) = \text{amplifier input voltage}$$
$$v_2(t) = \text{amplifier output voltage}$$
$$\theta(t) = \text{motor shaft position}$$

Draw a signal flow diagram of the system, identifying the component parts and their transmittances, then determine the system transfer function $P(s)/R(s)$.

E2.16. A spring used in an auto shock absorber develops a force, f, represented by the relation

$$f = kx^3,$$

where x is the displacement of the spring. Determine a linear model for the spring when $x_0 = 1$.

E2.17. The output, y, and input, x, of a device are related by

$$y = x + 0.5x^3.$$

(a) Find the values of the output for steady-state operation at the two operating points $x_0 = 1$ and $x_0 = 2$. (b) Obtain a linearized model for both operating points and compare them.

E2.18. The transfer function of a system is

$$\frac{C(s)}{R(s)} = \frac{10(s + 2)}{s^2 + 8s + 15}$$

Determine $c(t)$ when $r(t)$ is a unit step input.

Answer: $c(t) = 1.33 + 1.67e^{-3t} - 3e^{-5t}, t \geq 0$

Problems

(Problems require an extension of the concepts of the chapter to new situations.)

P2.1. An electric circuit is shown in Fig. P2.1. Obtain a set of simultaneous integrodifferential equations representing the network.

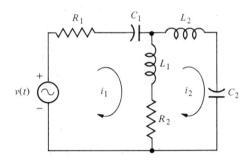

Figure P2.1. Electric circuit.

P2.2. A dynamic vibration absorber is shown in Fig. P2.2. This system is representative of many situations involving the vibration of machines containing unbalanced components. The parameters M_2 and k_{12} may be chosen so that the main mass M_1 does not vibrate when $F(t) = a \sin \omega_0 t$. (a) Obtain the differential equations describing the system. (b) Draw the analogous electrical circuit based on the force-current analogy.

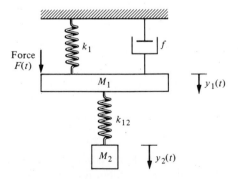

Figure P2.2. Vibration absorber.

P2.3. A coupled spring-mass system is shown in Fig. P2.3. The masses and springs are assumed to be equal. (a) Obtain the differential equations describing the system. (b) Draw an analogous electrical circuit based on the force–current analogy.

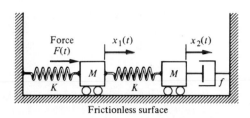

Figure P2.3. Two mass system.

P2.4. A nonlinear amplifier can be described by the following characteristic:

$$v_o(t) = \begin{cases} v_{in}^2 & v_{in} \geqslant 0 \\ -v_{in}^2 & v_{in} < 0 \end{cases}.$$

The amplifier will be operated over a range for v_{in} of ± 0.5 volts at the operating point. Describe the amplifier by a linear approximation (a) when the operating point is $v_{in} = 0$; and (b) when the operating point is $v_{in} = 1$ volt. Obtain a sketch of the nonlinear function and the approximation for each case.

P2.5. Fluid flowing through an orifice can be represented by the nonlinear equation

$$Q = K(P_1 - P_2)^{1/2},$$

where the variables are shown in Fig. P2.5 and K is a constant. (a) Determine a linear approximation for the fluid flow equation. (b) What happens to the approximation obtained in (a) if the operating point is $P_1 - P_2 = 0$?

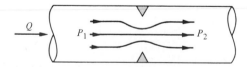

Figure P2.5. Flow through an orifice.

P2.6. Using the Laplace transformation, obtain the current $I_2(s)$ of Problem 2.1. Assume that all the initial currents are zero, the initial voltage across capacitor C_1 is zero, $v(t)$ is zero, and the initial voltage across C_2 is 10 volts.

P2.7. Obtain the transfer function of the differentiating circuit shown in Fig. P2.7.

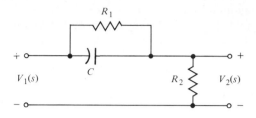

Figure P2.7.

P2.8. A bridged-T network is often used in ac control systems as a filter network. The circuit of one bridged-T network is shown in Fig. P2.8. Show that the transfer function of the network is

$$\frac{V_{out}(s)}{V_{in}(s)} = \frac{1 + 2R_1Cs + R_1R_2C^2s^2}{1 + (2R_1 + R_2)Cs + R_1R_2C^2s^2}.$$

Draw the pole-zero diagram when $R_1 = 0.5$, $R_2 = 1$, and $C = 0.5$.

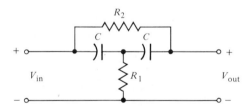

Figure P2.8. Bridged-T network.

P2.9. Determine the transfer function $X_1(s)/F(s)$ for the coupled spring-mass system of Problem 2.3. Draw the s-plane pole-zero diagram for low damping when $M = 1$, $f/K = 1$ and

$$\zeta = \frac{1}{2}\frac{f}{\sqrt{KM}} = 0.2.$$

P2.10. Determine the transfer function $Y_1(s)/F(s)$ for the vibration absorber system of Problem 2.2. Determine the necessary parameters M_2 and k_{12} so that the mass M_1 does not vibrate when $F(t) = a \sin \omega_0 t$.

P2.11. For electromechanical systems that require large power amplification, rotary amplifiers are often used. An amplidyne is a power amplifying rotary amplifier. An amplidyne and a servomotor are shown in Fig. P2.11. Obtain the transfer function $\theta(s)/V_c(s)$ and draw the block diagram of the system.

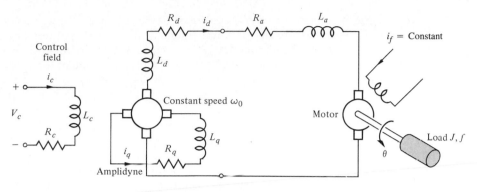

Figure P2.11. Amplidyne and motor.

P2.12. An electromechanical open-loop control system is shown in Fig. P2.12. The generator, driven at a constant speed, provides the field voltage for the motor. The motor has an inertia J_m and bearing friction f_m. Obtain the transfer function $\theta_L(s)/V_f(s)$ and draw a block diagram of the system. The generator voltage can be assumed to be proportional to the field current.

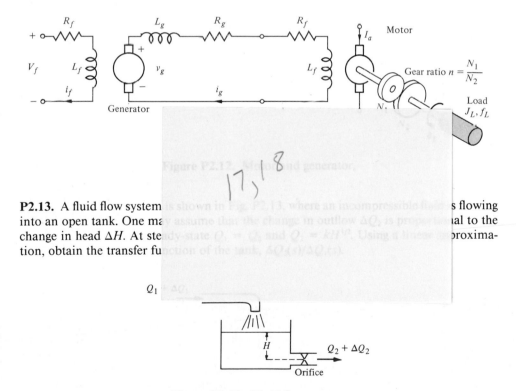

Figure P2.12. Motor and generator.

17,$\frac{8}{}$

P2.13. A fluid flow system is shown in Fig. P2.13, where an incompressible fluid is flowing into an open tank. One may assume that the change in outflow ΔQ_2 is proportional to the change in head ΔH. At steady-state $Q_1 = Q_2$ and $Q_2 = k H^{1/2}$. Using a linear approximation, obtain the transfer function of the tank, $\Delta Q_2(s)/\Delta Q_1(s)$.

Figure P2.13. Fluid flow system.

P2.14. A rotating load is connected to a field-controlled dc electric motor through a gear system. The motor is assumed to be linear. A test results in the output load reaching a speed of 1 rad/sec within ½ sec when a constant 100 v is applied to the motor terminals. The output steady-state speed is 2 rad/sec. Determine the transfer function of the motor, $\theta(s)/V_f(s)$ in rad/V. The inductance of the field may be assumed to be negligible (see Fig. 2.16). Also, note that the application of 100 V to the motor terminals is a step input of 100 V in magnitude.

P2.15. As the complexity of interconnected power systems grows, the potential for inter-active dynamic phenomena increases. Mechanical analogies can be used to explain com-plex interactive dynamics. Consider the weight–rubber band analogy shown in Fig. P2.15. In this weight-rubber band analogy, the weights represent the rotating mass of the turbine generators and the rubber bands are analogous to the inductance of transmission lines. Any disturbance—a "pull" on a weight—causes oscillations to be set up in all synchronous machines in the system. Determine a set of differential equations to describe this system.

Figure P2.15. Three mass analogy.

P2.16. Obtain a signal-flow graph to represent the following set of algebraic equations where x_1 and x_2 are to be considered the dependent variables and 8 and 13 are the inputs:

$$x_1 + 2x_2 = 8,$$

$$2x_1 + 3x_2 = 13.$$

Determine the value of each dependent variable by using the gain formula. After solving for x_1 by Mason's formula, verify the solution by using Cramer's rule.

P2.17. A mechanical system is shown in Fig. P2.17, which is subjected to a known dis-placement $x_3(t)$ with respect to the reference. (a) Determine the two independent equations of motion. (b) Obtain the equations of motion in terms of the Laplace transform assuming that the initial conditions are zero. (c) Draw a signal-flow graph representing the system of equations. (d) Obtain the relationship between $X_1(s)$ and $X_3(s)$, $T_{13}(s)$, by using Mason's gain formula. Compare the work necessary to obtain $T_{13}(s)$ by matrix methods to that using Mason's gain formula.

Figure P2.17. Mechanical system.

P2.18. An *LC* ladder network is shown in Fig. P2.18. One may write the equations describing the network as follows:

$$I_1 = (V_1 - V_a)Y_1, \qquad V_a = (I_1 - I_a)Z_2,$$

$$I_a = (V_a - V_2)Y_3, \qquad V_2 = I_a Z_4.$$

Construct a flow graph from the equations and determine the transfer function $V_2(s)/V_1(s)$.

Figure P2.18. LC Ladder network.

P2.19. The basic noninverting operational amplifier is shown in Fig. P2.19(a), on next page and the signal-flow representation of the equations of the circuit is shown in Fig. P2.19(b) [8]. (a) Write the voltage equations and verify the representations in the flow graph. (b) Using the signal-flow graph, calculate the gain of the amplifier and verify that $T(s) = (R_1 + R_f)/R_1$ when $A \gg 10^3$.

P2.20. The source follower amplifier provides lower output impedence and essentially unity gain. The circuit diagram is shown in Fig. P2.20(a), and the small signal model is shown in Fig. P2.20(b). This circuit uses an FET and provides a gain of approximately unity. Assume that $R_2 \gg R_1$ for biasing purposes and that $R_g \gg R_2$. (a) Solve for the amplifier gain. (b) Solve for the gain when $g_m = 2000 \ \mu$mhos and $R_s = 10$ Kohms where $R_s = R_1 + R_2$. (c) Sketch a signal-flow diagram that represents the circuit equations.

(a)

(b)

$$k = \frac{R_1}{R_1 + R_f}$$

Figure P2.19. Source follower.

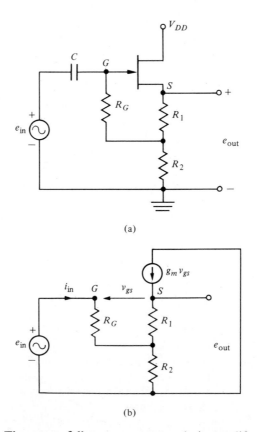

(a)

(b)

Figure P2.20. The source follower or common drain amplifier using an FET.

P2.21. A hydraulic servomechanism with mechanical feedback is shown in Fig. P2.21 [17]. The power piston has an area equal to A. When the valve is moved a small amount Δz, then the oil will flow through to the cylinder at a rate $p \cdot \Delta z$, where p is the port coefficient. The input oil pressure is assumed to be constant. (a) Determine the closed-loop signal-flow graph for this mechanical system. (b) Obtain the closed-loop transfer function $Y(s)/X(s)$.

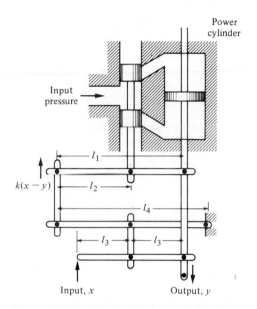

Figure P2.21. Hydraulic servomechanism.

P2.22. Figure P2.22 shows two pendulums suspended from frictionless pivots and connected at their midpoints by a spring [1]. Assume that each pendulum can be represented by a mass M at the end of a massless bar of length L. Also assume that the displacement is small and linear approximations can be used for $\sin \theta$ and $\cos \theta$. The spring located in the middle of the bars is unstretched when $\theta_1 = \theta_2$. The input force is represented by $f(t)$, which influences the left-hand bar only. (a) Obtain the equations of motion and draw a signal-flow diagram for them. (b) Determine the transfer function $T(s) = \theta_1(s)/F(s)$. (c) Draw the location of the poles and zeros of $T(s)$ on the s-plane.

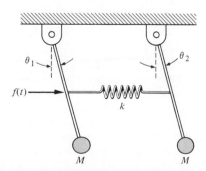

Figure P2.22. The bars are each of length L and the spring is located at $L/2$.

P2.23. The small-signal equivalent circuit of a common-emitter transistor amplifier is shown in Fig. P2.23. The transistor amplifier includes a feedback resistor R_f. Obtain a signal-flow graph model of the feedback amplifier and determine the input-output ratio v_{ce}/v_{in}.

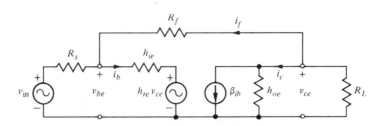

Figure P2.23. CE amplifier.

P2.24. A two-transistor series voltage feedback amplifier is shown in Fig. P2.24(a). This ac equivalent circuit neglects the bias resistors and the shunt capacitors. A signal-flow graph representing the circuit is shown in Fig. P2.24(b). This flow graph neglects the effect of h_{re}, which is usually an accurate approximation, and assumes that $(R_2 + R_L) \gg R_1$. (a) Determine the voltage gain, e_{out}/e_{in}. (b) Determine the current gain, i_{c_2}/i_{b_1}. (c) Determine the input impedance, e_{in}/i_{b_1}.

Figure P2.24. Feedback amplifier.

P2.25. Often overlooked is the fact that H. S. Black, who is noted for developing a negative feedback amplifier in 1927, three years earlier had invented a circuit design technique known as feedforward correction [22, 23]. Recent experiments have shown that this technique offers the potential for yielding excellent amplifier stabilization. Black's amplifier is shown in Fig. P2.25(a) in the form recorded in 1924. The signal-flow graph is shown in Fig. P2.25(b). Determine the transfer function between the output $C(s)$ and the input $R(s)$ and between the output and the disturbance $D(s)$. $G(s)$ is used for the amplifier represented by μ in Fig. P2.25(a).

(a) (b)

Figure P2.25. H. S. Black's amplifier.

(a)

(b)

Figure P2.26. (a) The Armatrol robot has four axes of revolution and a two-fingered gripper with feedback from all axes. (Courtesy of Feedback, Inc.) (b) The spring-mass-damper model.

P2.26. A robot such as the one shown in Fig. P2.26(a) on the previous page includes significant flexibility in the arm members with a heavy load in the gripper [32]. A two-mass model of the robot is shown in Fig. P2.26(b). Find the transfer function $Y(s)/F(s)$.

P2.27. Magnetic levitation trains provide a high speed, very low friction alternative to steel wheels on steel rails. The train floats on an air gap as shown in Fig. P2.27 [29]. The levitation force F_L is controlled by the coil current i in the levitation coils and may be approximated by

$$F_L = k \frac{i^2}{z^2},$$

where z is the air gap. This force is opposed by the downward force $F = mg$. Determine the linearized relationship between the air gap z and the controlling current near the equilibrium condition.

Figure P2.27. Cutaway view of train.

P2.28. A multiple-loop model of an urban ecological system might include the following variables: number of people in the city (P), modernization (M), migration into the city (C), sanitation facilities (S), number of diseases (D), bacteria/area (B), and amount of garbage/ area (G), where the symbol for the variable is given in the parentheses. The following causal loops are hypothesized:

1. $P \rightarrow G \rightarrow B \rightarrow D \rightarrow P$
2. $P \rightarrow M \rightarrow C \rightarrow P$
3. $P \rightarrow M \rightarrow S \rightarrow D \rightarrow P$
4. $P \rightarrow M \rightarrow S \rightarrow B \rightarrow D \rightarrow P$

Draw a signal-flow graph for these causal relationships, using appropriate gain symbols. Indicate whether you believe each gain transmission is positive or negative. For example,

the causal link S to B is negative because improved sanitation facilities lead to reduced bacteria/area. Which of the four loops are positive feedback loops and which are negative feedback loops?

P2.29. We desire to balance a rolling ball on a tilting beam as shown in Fig. P2.29. We will assume the motor input current i controls the torque with negligible friction. Assume the beam may be balanced near the horizontal ($\phi = 0$); therefore we have a small deviation of ϕ. Find the transfer function $X(s)/I(s)$ and draw a block diagram illustrating the transfer function showing $\phi(s)$, $X(s)$ and $I(s)$.

Figure P2.29. Tilting beam and ball.

P2.30. The measurement or sensor element in a feedback system is important to the accuracy of the system [37]. The dynamic response of the sensor is often important. Most sensor elements possess a transfer function

$$H(s) = \frac{k}{\tau s + 1}.$$

Investigate several sensor elements available today and determine the accuracy available and the time constant of the sensor. Consider two of the following sensors: (1) linear position, (2) temperature with a thermistor, (3) strain measurement, (4) pressure.

P2.31. A cable reel control system uses a tachometer to measure the speed of the cable as it leaves the reel. The output of the tachometer is used to control the motor speed of the reel as the cable is unwound off the reel. The system is shown in Fig. P2.31. The radius of the reel, R, is 4 meters when full and 2 meters when empty. The moment of inertia of the reel is $I = 18.5R^4 - 221$. The rate of change of the radius is

$$\frac{dR}{dt} = \frac{-D^2\omega}{2\pi W},$$

where $W =$ width of the reel and $D =$ diameter of the cable. The actual speed of the cable is $v(t) = R\omega$. The desired cable speed is 50 m/sec. Develop a digital computer simulation of this system and obtain the response of the speed over 20 seconds for the three values of gain $K = 0.5$, 1.0, and 1.5. The reel angular velocity $\omega = d\theta/dt$ is equal to $1/I$ times the integral of the torque. Note that the inertia changes with time as the reel is unwound. However, an equation for I within the simulation will account for this change.

Figure P2.31. Cable reel control system.

P2.32. An interacting control system with two inputs and two outputs is shown in Fig. P2.32. Solve for $C_1(s)/R_1(s)$ and $C_2(s)/R_1(s)$, when $R_2 = 0$.

Figure P2.32.

P2.33. The system shown in Fig. P2.33(a), on the next page consists of two electric motors which are coupled by a continuous flexible belt. The belt also passes over a swinging arm which is instrumented to allow measurement of the belt speed and tension. The basic control problem is to regulate the belt speed and tension by varying the motor torques.

An example of a practical system similar to that shown occurs in textile fiber manufacturing processes when yarn is wound from one spool to another at high speed. Between the two spools the yarn is processed in some way which may require the yarn speed and tension to be controlled to within defined limits. A model of the system is shown in Fig. P2.33(b). Find $C_2(s)/R_1(s)$. Determine a relationship for the system that will make C_2 independent of R_1.

P2.34. Find the transfer function for $C(s)/R(s)$ for the idle speed control system for a fuel injected engine as shown in Fig. P2.34, on page 106.

(a)

(b)

Figure P2.33. (a) A model of the coupled motor drives. (b) The coupled motor drives. Courtesy of TecQuipment Inc.

P2.35. The suspension system for one wheel of an old-fashioned pick-up truck is illustrated in Fig. P2.35. The mass of the vehicle is m_1 and the mass of the wheel is m_2. The suspension spring has a spring constant k_1 and the tire has a spring constant k_2. The damping constant of the shock absorber is f. Obtain the transfer function $Y_1(s)/X(s)$, which represents the vehicle response to bumps in the road.

Figure P2.34.

Figure P2.35. Pick-up truck suspension.

P2.36. A feedback control system has the structure shown in Fig. P2.36. Determine the closed-loop transfer function $C(s)/R(s)$ (a) by block diagram manipulation and (b) by using a signal flow graph and Mason's formula. (c) Select the gains K_1 and K_2 so that the closed-loop response to a step input is critically damped with two equal roots at $s = -10$. (d) Plot the critically damped response for a unit step input. What is the time required for the step response to reach 90% of its final value?

Figure P2.36.

P2.37. A system is represented by Fig. P2.37. (a) Determine the partial fraction expansion and $c(t)$ for a ramp input, $r(t) = t, t \geq 0$. (b) Obtain a plot of $c(t)$ for part (a) and find $c(t)$ for $t = 1.5s$. (c) Determine the impulse response of the system $c(t)$ for $t \geq 0$. (d) Obtain a plot of $c(t)$ for part (c) and find $c(t)$ for $t = 1.5s$.

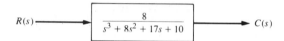

Figure P2.37.

P2.38. A two-mass system is shown in Fig. P2.38 with an input force $u(t)$. When $m_1 = m_2 = 1$ and $K_1 = K_2 = 1$, find the set of differential equations describing the system.

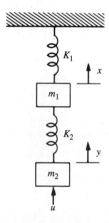

Figure P2.38. Two mass sytem.

P2.39. A winding oscillator consists of two steel spheres on each end of a long slender rod, as shown in Fig. P2.39. The rod is hung on a thin wire that can be twisted many revolutions without breaking. The device will be wound up 4000 degrees. How long will it take until the motion decays to a swing of only 10 degrees? Assume that the damping constant for the sphere in air is $2 \times 10^{-4} \, N \cdot m/rad$ and each sphere has a mass of 1 kg.

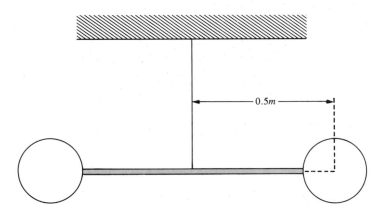

Figure P2.39. Winding oscillator.

P2.40. A damping device is used to reduce the undesired vibrations of machines. A viscous fluid, such as a heavy oil, is placed between the wheels, as shown in Fig. P2.40. When vibration becomes excessive, the relative motion of the two wheels creates damping. When the device is rotating without vibration, there is no relative motion and no damping occurs. Find $\theta_1(s)$ and $\theta_2(s)$. Assume that the shaft has a spring constant K and that f is the damping constant of the fluid. The load torque is T.

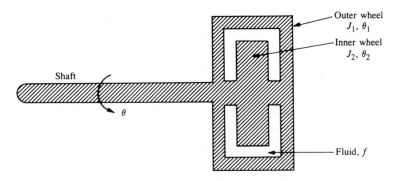

Figure P2.40. Cutaway view of damping device.

P2.41. For the circuit of Fig. P2.41, determine the transform of the output voltage $V_0(s)$. Assume that the circuit is in steady state when $t < 0$. Assume that the switch moves instantaneously from contact 1 to contact 2 at $t = 0$.

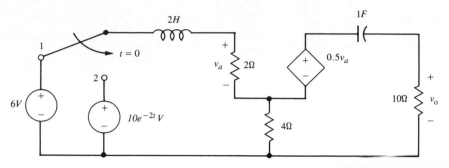

Figure P2.41.

P2.42. The lateral control of a rocket with a gimbalcd engine is shown in Fig. P2.42. The lateral deviation from the desired trajectory is h, and the forward rocket speed is V. The control torque of the engine is T_c, and the disturbance torque is T_d. Derive the describing equations of a linear model of the system and draw the block diagram with the appropriate transfer functions.

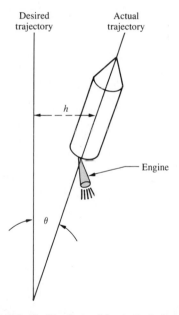

Figure P2.42. Rocket with gimbaled engine.

P2.43. In many applications, such as reading product codes in supermarkets and in printing and manufacturing, an optical scanner is utilized to read codes, as shown in Fig. P2.43. As the mirror rotates, a friction force is developed that is proportional to its angular speed. The friction constant is equal to $0.05 \ N \cdot s/rad$, and the moment of inertia is equal to 0.1 kg-m^2. The output variable is the velocity, $\omega(t)$. (a) Obtain the differential equation for the motor. (b) Find the response of the system when the input motor torque is a unit step and the initial velocity at $t = 0$ is equal to 1.

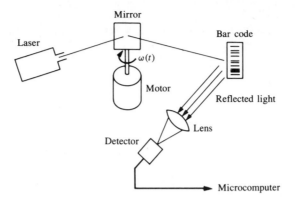

Figure P2.43. Optical scanner.

P2.44. An ideal set of gears is shown as item 10 of Table 2.6. Neglect the inertia and friction of the gears and assume that the work done by one gear is equal to that of the other. Derive the relationships given in item 10 of Table 2.6. Also determine the relationship between the torques T_m and T_L.

P2.45. An ideal set of gears is connected to a load inertia with friction coefficient f as shown in Fig. P2.45. Obtain the torque equation, in terms of θ_1, at the input side of the gears where the input is a torque T. The gear ratio is $n = N_1/N_2$.

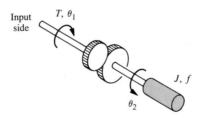

Figure P2.45.

Design Problems ◆

(Design problems emphasize the design task.)

DP2.1. A control system is shown in Fig. DP2.1. The transfer functions $G_2(s)$ and $H_2(s)$ are fixed. Determine the transfer functions $G_1(s)$ and $H_1(s)$ so that the closed-loop transfer function $C(s)/R(s)$ is exactly equal to 1.

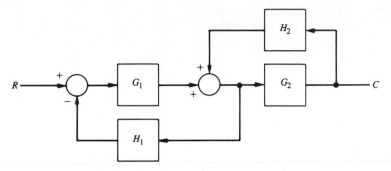

Figure DP2.1. Selection of transfer functions.

DP2.2. The television beam circuit of a television set is represented by the model in Fig. DP2.2. Select the unknown conductance, G, so that the voltage, v, is 24 V. Each conductance is given in siemens (S).

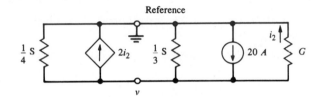

Figure DP2.2. Television beam circuit.

DP2.3. An input $r(t) = e^{-t}u(t)$ is applied to a black box with a transfer function $G(s)$. The resulting output response, when the initial conditions are zero, is

$$c(t) = 2 - 3e^{-t} + e^{-2t} \cos 2t, \; t \geq 0.$$

Determine $G(s)$ for this system.

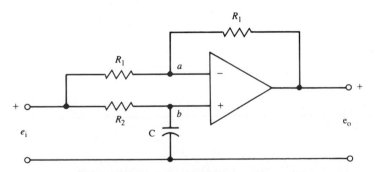

Figure DP2.4. Operational amplifier circuit.

DP2.4. An operational amplifier circuit that can serve as a filter circuit is shown in Fig. DP2.4. (a) Determine the transfer function of the circuit, assuming an ideal op

amp. Find $e_o(t)$ when the input is $e_i(t) = At, t \geq 0$.

Terms and Concepts

Actuator The device that causes the process to provide the output. The device that provides the motive power to the process.

Block diagrams Unidirectional, operational blocks that represent the transfer functions of the elements of the system.

Characteristic equation The relation formed by equating to zero the denominator of a transfer function.

Critical damping The case where damping is on the boundary between under-damped and overdamped.

Damped oscillation An oscillation in which the amplitude decreases with time.

Damping ratio A measure of damping. A dimensionless number for the second-order characteristic equation.

dc motor An electric actuator that uses an input voltage as a control variable.

Laplace transform A transformation of a function $f(t)$ from the time domain into the complex frequency domain yielding $F(s)$.

Linear approximation An approximate model that results in a linear relationship between the output and the input of the device.

Mason loop rule A rule that enables the user to obtain a transfer function by tracing paths and loops within a system.

Mathematical models Descriptions of the behavior of a system using mathematics.

Signal-flow graph A diagram that consists of nodes connected by several directed branches and that is a graphical representation of a set of linear relations.

Simulation A model of a system that is used to investigate the behavior of a system by utilizing actual input signals.

Transfer function The ratio of the Laplace transform of the output variable to the Laplace transform of the input variable.

References

1. R. C. Rosenberg and D. C. Karnopp, *Introduction to Physical System Design,* McGraw-Hill, New York, 1986.
2. R. C. Dorf, *Introduction to Electric Circuits,* John Wiley & Sons, New York, 1989.
3. J. W. Nilsson, *Electric Circuits,* 3rd ed., Addison-Wesley, Reading, Mass., 1990.
4. E. Kamen, *Introduction to Signals and Systems,* 2nd ed., Macmillan, New York, 1990.

5. F. Raven, *Automatic Control Engineering*, 2nd ed., McGraw-Hill, New York, 1990.
6. R. C. Dorf, *The Encyclopedia of Robotics*, John Wiley & Sons, New York, 1988.
7. S. Ashley, "A Mosaic for Machine Tools," *Mechanical Engineering*, September 1990; pp. 38–43.
8. D. L. Schilling, *Electronic Circuits*, 3rd ed., McGraw-Hill, New York, 1989.
9. B. C. Kuo, *Automatic Control Systems*, 3rd ed., Prentice Hall, Englewood Cliffs, N.J., 1990.
10. J. L. Shearer, *Dynamic Modeling and Control of Engineering Systems*, Macmillan, New York, 1990.
11. S. Franco, *Design with Operational Amplifiers*, McGraw-Hill, New York, 1988.
12. R. J. Smith and R. C. Dorf, *Circuits, Devices and Systems*, 5th ed., John Wiley & Sons, New York, 1991.
13. S. Derby, "Mechatronics for Robots," *Mechanical Engineering*, July 1990; pp. 40–44.
14. H. M. Paynter, "The Differential Analyzer," *IEEE Control Systems*, December 1989; pp. 3–8.
15. J. J. Ovaska, "Modular Control System Simulator," *Simulation*, October 1989; pp. 181–85.
16. R. C. Dorf, *Introduction to Computers and Computer Science*, 3rd ed., Boyd and Fraser, San Francisco, 1982.
17. A. Wolfe, "Micromachine," *Mechanical Engineering*, September 1990; pp. 49–53.
18. P. C. Krause, *Electromechanical Motion Devices*, McGraw-Hill, New York, 1989.
19. A. Dane, "Hubble: Heartbreak and Hope," *Popular Mechanics*, October 1990; pp. 130–31.
20. T. Yoshikawa, *Foundation of Robotics*, M.I.T. Press, Cambridge, Mass., 1990.
21. J. G. Bollinger, *Computer Control of Machines and Processes*, Addison-Wesley, Reading, Mass., 1989.
22. R. K. Jurgen, "Feedforward Correction: A Late-Blooming Design," *IEEE Spectrum*, April 1972; pp. 41–43.
23. H. S. Black, "Stabilized Feed-Back Amplifiers," *Electrical Engineering*, **53**, January 1934; pp. 114–20. Also in *Turning Points in American History*, J. E. Brittain, ed., IEEE Press, New York, 1977; pp. 359–61.
24. D. H. McMahon, "Vehicle Modeling for Automated Highway Systems," *Proceed. of the American Control Conference*, 1990; pp. 297–303.
25. D. E. Johnson, J. L. Hilburn, and J. R. Johnson, *Basic Electric Circuits*, 2nd ed., Prentice Hall, Englewood Cliffs, N.J., 1990.
26. R. C. Dorf, *Energy, Resources, and Policy*, Addison-Wesley, Reading, Mass., 1978.
27. S. Cuk and J. F. Brewer, "Low-Noise, Low Cost 150w Off-Line Switcher," *Power Conversion International*, April 1983; pp. 40–58.
28. G. J. Thaler, *Automatic Control Systems*, West Publishing, St. Paul, Minn., 1990.
29. "The Flying Train Takes Off," *U.S. News and World Report*, July 23, 1990; p. 52.
30. H. Oman, "Accelerating Hypersonic Airplanes with Ground-Power," *IEEE AES Magazine*, April 1990; pp. 9–14.
31. J. Murphy, *Power Control of AC Motors*, Pergamon Press, New York, 1990.
32. S. C. Jacobsen, "Control Strategies for Tendon-Driven Manipulators," *IEEE Control Systems*, February 1990; pp. 23–28.
33. Z. Wang, "Design and Characterization of a Linear Motion Piezoelectric Micropositioner," *IEEE Control Systems*, February 1990; pp. 10–15.
34. A. Marchant, *Optical Recording*, Addison-Wesley, Reading, Mass., 1990.
35. J. B. Shung et al., "Feedback Control and Simulation of a Wheelchair," *Trans. of the*

American Society of Mechanical Engineers, J. of Dynamic Systems, June 1983; pp. 96–100.

36. L. V. Merritt, "The Space Station Rotary Joint Motor Controller," *Motion,* February 1990; pp. 14–21.

37. C. W. DeSilva, *Control Sensors and Actuators,* Prentice Hall, Englewood Cliffs, N.J., 1990.

38. D. M. Auslander, *Real-Time Software for Control,* Prentice Hall, Englewood Cliffs, N.J., 1990.

39. R. E. Klein, "Using Bicycles to Teach System Dynamics," *IEEE Control Systems,* April 1989; pp. 4–8.

40. R. Kurzweil, *The Age of Intelligent Machines,* M.I.T. Press, Cambridge, Mass., 1990.

41. S. Bennett, "Nicholas Minorsky and the Automatic Steering of Ships," *IEEE Control Systems,* November 1984; pp. 10–15.

42. G. Jackson, "Software for Control Systems Design," *Mechanical Engineering,* July 1990; pp. 44–45.

43. K. Andersen, "Artificial Neural Networks Applied to Arc Welding Control," *IEEE Trans. Industry Applications,* October 1990; pp. 824–28.

44. "Hubble's Legacy," *Scientific American,* June 1990; pp. 18–19.

45. R. C. Houts, *Signal Analysis in Linear Systems,* W. B. Saunders, Philadelphia, 1991.

◆

Feedback Control System Characteristics

Preview

With the mathematical models obtained in Chapter 2 we are able to develop analytical tools for describing the characteristics of a feedback control system. In this chapter, we will develop the concepts of the system error signal. This signal is used to control the process, and our ultimate goal is to reduce the error to the smallest feasible amount.

We also develop the concept of the sensitivity of a system to a parameter change, since it is desirable to minimize the effects of unwanted parameter variation. We also will describe the transient performance of a feedback system and show how this performance can be readily improved.

We wish to reduce the effect of unwanted input signals, called disturbances, on the output signal. We will show how we may design a control system to reduce the impact of disturbance signals. Of course, the benefits of a control system come with an attendant cost. We will demonstrate how the cost of using feedback in a control system is associated with the selection of the feedback sensor device.

3.1 Open- and Closed-Loop Control Systems

Now that we are able to obtain mathematical models of the components of control systems, we shall examine the characteristics of control systems. A control system was defined in Section 1.1 as an interconnection of components forming a system configuration that will provide a desired system response. Because a desired system response is known, a signal proportional to the error between the desired and the actual response is generated. The utilization of this signal to control the process results in a closed-loop sequence of operations that is called a feedback system. This closed-loop sequence of operations is shown in Fig. 3.1. The introduction of feedback in order to improve the control system is often necessary. It is interesting that this is also the case for systems in nature, such as biological and physiological systems, and feedback is inherent in these systems. For example, the human heart-rate control system is a feedback control system.

In order to illustrate the characteristics and advantages of introducing feedback, we shall consider a simple, single-loop feedback system. Although many control systems are not single-loop in character, a single-loop system is illustrative. A thorough comprehension of the benefits of feedback can best be obtained from the single-loop system and then extended to multiloop systems.

An open-loop control system is shown in Fig. 3.2. For contrast, a closed-loop,

Figure 3.1. A closed-loop system.

Figure 3.2. An open-loop system.

Figure 3.3. A closed-loop control system.

negative feedback control system is shown in Fig. 3.3. The two control systems are shown in both block diagram and signal-flow graph form, although signal-flow graphs will be used predominantly for subsequent diagrams. The prime difference between the open- and closed-loop systems is the generation and utilization of the *error signal*. The closed-loop system, when operating correctly, operates so that the error will be reduced to a minimum value. The signal $E_a(s)$ is a measure of the error of the system and is equal to the error $E(s) = R(s) - C(s)$ when $H(s) = 1$. The output of the open-loop system is

$$C(s) = G(s)R(s). \tag{3.1}$$

The output of the closed-loop system is

$$C(s) = G(s)E_a(s) = G(s)(R(s) - H(s)C(s)),$$

and therefore

$$C(s) = \frac{G(s)}{1 + GH(s)} R(s). \tag{3.2}$$

The actuating error signal is

$$E_a(s) = \frac{1}{1 + GH(s)} R(s). \tag{3.3}$$

It is clear that in order to reduce the error, the magnitude of $1 + GH(s)$ must be greater than one over the range of s under consideration.

3.2 Sensitivity of Control Systems to Parameter Variations

A process, represented by the transfer function $G(s)$, whatever its nature, is subject to a changing environment, aging, ignorance of the exact values of the process parameters, and other natural factors that affect a control process. In the open-

loop system, all these errors and changes result in a changing and inaccurate output. However, a closed-loop system senses the change in the output due to the process changes and attempts to correct the output. The *sensitivity* of a control system to parameter variations is of prime importance. A primary advantage of a closed-loop feedback control system is its ability to reduce the system's sensitivity [1, 2, 25].

For the closed-loop case, if $GH(s) \gg 1$ for all complex frequencies of interest, then from Eq. (3.2) we obtain

$$C(s) \cong \frac{1}{H(s)} R(s). \tag{3.4}$$

Then, the output is affected only by $H(s)$, which may be a constant. If $H(s) = 1$, we have the desired result; that is, the output is equal to the input. However, before we use this approach for all control systems, we must note that the requirement that $G(s)H(s) \gg 1$ may cause the system response to be highly oscillatory and even unstable. But the fact that as we increase the magnitude of the loop transfer function $G(s)H(s)$, we reduce the effect of $G(s)$ on the output, is an exceedingly useful concept. Therefore, the *first advantage* of a feedback system is that the effect of the *variation of the parameters* of the process, $G(s)$, is reduced.

In order to illustrate the effect of parameter variations, let us consider a change in the process so that the new process is $G(s) + \Delta G(s)$. Then, in the open-loop case, the change in the transform of the output is

$$\Delta C(s) = \Delta G(s)R(s). \tag{3.5}$$

In the closed-loop system, we have

$$C(s) + \Delta C(s) = \frac{G(s) + \Delta G(s)}{1 + (G(s) + \Delta G(s))H(s)} R(s). \tag{3.6}$$

Then the change in the output is

$$\Delta C(s) = \frac{\Delta G(s)}{(1 + GH(s) + \Delta GH(s))(1 + GH(s))} R(s). \tag{3.7}$$

When $GH(s) \gg \Delta GH(s)$, as is often the case, we have

$$\Delta C(s) = \frac{\Delta G(s)}{(1 + GH(s))^2} R(s). \tag{3.8}$$

Examining Eq. (3.8), we note that the change in the output of the closed-loop system is reduced by the factor $1 + GH(s)$, which is usually much greater than one over the range of complex frequencies of interest. The factor $1 + GH(s)$ plays a very important role in the characteristics of feedback control systems.

The *system sensitivity* is defined as the ratio of the percentage change in the system transfer function to the percentage change of the process transfer function. The system transfer function is

$$T(s) = \frac{C(s)}{R(s)}, \tag{3.9}$$

and therefore the sensitivity is defined as

$$S = \frac{\Delta T(s)/T(s)}{\Delta G(s)/G(s)} .$$
(3.10)

In the limit, for small incremental changes, Eq. (3.10) becomes

$$S = \frac{\partial T/T}{\partial G/G} = \frac{\partial \ln T}{\partial \ln G} .$$
(3.11)

Clearly, from Eq. (3.5), the sensitivity of the open-loop system is equal to one. The sensitivity of the closed-loop is readily obtained by using Eq. (3.11). The system transfer function of the closed-loop system is

$$T(s) = \frac{G}{1 + GH} .$$
(3.12)

Therefore the sensitivity of the feedback system is

$$S = \frac{\partial T}{\partial G} \cdot \frac{G}{T} = \frac{1}{(1 + GH)^2} \cdot \frac{G}{G/(1 + GH)} = \frac{1}{1 + GH(s)} .$$
(3.13)

Again we find that the sensitivity of the system may be reduced below that of the open-loop system by increasing $GH(s)$ over the frequency range of interest.

The sensitivity of the feedback system to changes in the feedback element $H(s)$ is

$$S_H^T = \frac{\partial T}{\partial H} \cdot \frac{H}{T} = \left(\frac{G}{1 + GH}\right)^2 \cdot \frac{-H}{G/(1 + GH)} = \frac{-GH}{1 + GH} .$$
(3.14)

When GH is large, the sensitivity approaches unity and the changes in $H(s)$ directly affect the output response. Therefore it is important to use feedback components that will not vary with environmental changes or that can be maintained constant.

Very often the transfer function of the system $T(s)$ is a fraction of the form [1]:

$$T(s, \alpha) = \frac{N(s, \alpha)}{D(s, \alpha)}$$
(3.15)

where α is a parameter that may be subject to variation due to the environment. Then we may obtain the sensitivity to α by rewriting Eq. (3.11) as:

$$S_\alpha^T = \frac{\partial \ln T}{\partial \ln \alpha} = \frac{\partial \ln N}{\partial \ln \alpha}\bigg|_{\alpha_0} - \frac{\partial \ln D}{\partial \ln \alpha}\bigg|_{\alpha_0}$$
(3.16)

$$= S_\alpha^N - S_\alpha^D,$$

where α_0 is the normal value of the parameter.

The ability to reduce the effect of the variation of parameters of a control system by adding a feedback loop is an important advantage of feedback control systems. To obtain highly accurate open-loop systems, the components of the

open-loop $G(s)$ must be selected carefully in order to meet the exact specifications. However, a closed-loop system allows $G(s)$ to be less accurately specified because the sensitivity to changes or errors in $G(s)$ is reduced by the loop gain 1 + $GH(s)$. This benefit of closed-loop systems is a profound advantage for the electronic amplifiers of the communication industry. A simple example will illustrate the value of feedback for reducing sensitivity.

■ Example 3.1 Inverting Amplifier

The integrated circuit operational amplifier can be fabricated on a single chip of silicon and sold for less than a dollar. As a result, IC operational amplifiers (op amps) are widely used. The model symbol of an op amp is shown in Fig. 3.4(a). We can assume that the gain A is at least 10^4. The basic inverting amplifier circuit is shown in Fig. 3.4(b). Because of the high input impedance of the op amp, the amplifier input current is negligibly small. At node n we may write the current equation as

$$\frac{e_{in} - v_n}{R_1} + \frac{v_o - v_n}{R_f} = 0. \tag{3.17}$$

Because the gain of the amplifier is A, $v_o = Av_n$ and therefore

$$v_n = \frac{v_o}{A}, \tag{3.18}$$

and we may substitute Eq. (3.18) into Eq. (3.17), obtaining

$$\frac{e_{in}}{R_1} - \frac{v_o}{AR_1} + \frac{v_o}{R_f} - \frac{v_o}{AR_f} = 0. \tag{3.19}$$

Solving for the output voltage, we have

$$v_o = \frac{A(R_f/R_1)e_{in}}{(R_f/R_1) - A}. \tag{3.20}$$

Alternatively, we may rewrite Eq. (3.20) as follows:

$$\frac{v_o}{e_{in}} = \frac{A}{1 - A(R_1/R_f)} = \frac{A}{1 - Ak}, \tag{3.21}$$

(a) (b)

Figure 3.4. (a) An operational amplifier model symbol. (b) Inverting amplifier circuit.

Figure 3.5. Signal-flow graph of inverting amplifier.

where $k = R_1/R_f$. The signal-flow graph representation of the inverting amplifier is shown in Fig. 3.5. Note that when $A \gg 1$ we have

$$\frac{v_o}{e_{in}} = -\frac{R_f}{R_1}. \tag{3.22}$$

The feedback factor in the diagram is $H(s) = k$ and the open-loop transfer function is $G(s) = A$.

The op amp is subject to variations in the amplification A. The sensitivity of the open loop is unity. The sensitivity of the closed-loop amplifier is

$$S_A^T = \frac{\partial T/T}{\partial A/A} = \frac{1}{1 - GH} = \frac{1}{1 - AK}. \tag{3.23}$$

If $A = 10^4$ and $k = 0.1$, we have

$$S_A^T = \frac{1}{1 - 10^3}, \tag{3.24}$$

or the magnitude of the sensitivity is approximately equal to 0.001, which is one-thousandth of the magnitude of the open loop sensitivity. The sensitivity due to changes in the feedback resistance R_f (or the factor k) is

$$S_k^T = \frac{GH}{1 - GH} = \frac{Ak}{1 - Ak}, \tag{3.25}$$

and the sensitivity to k is approximately equal to 1.

We shall return to the concept of sensitivity in subsequent chapters to emphasize the importance of sensitivity in the design and analysis of control systems.

3.3 Control of the Transient Response of Control Systems

One of the most important characteristics of control systems is their transient response. The *transient response* is the response of a system as a function of time. Because the purpose of control systems is to provide a desired response, the transient response of control systems often must be adjusted until it is satisfactory. If an open-loop control system does not provide a satisfactory response, then the process, $G(s)$, must be replaced with a suitable process. By contrast, a closed-loop system can often be adjusted to yield the desired response by adjusting the feedback loop parameters. It should be noted that it is often possible to alter the response of an open-loop system by inserting a suitable cascade filter, $G_1(s)$,

Figure 3.6. Cascade filter open-loop system.

preceding the process, $G(s)$, as shown in Fig. 3.6. Then it is necessary to design the cascade transfer function $G_1(s)G(s)$ so that the resulting transfer function provides the desired transient response.

In order to make this concept more readily comprehensible, let us consider a specific control system, which may be operated in an open- or closed-loop manner. A speed control system, which is shown in Fig. 3.7, is often used in industrial processes to move materials and products. Several important speed control systems are used in steel mills for rolling the steel sheets and moving the steel through the mill. The transfer function of the open-loop system was obtained in Eq. (2.70) and for $\omega(s)/V_a(s)$ we have

$$\frac{\omega(s)}{V_a(s)} = G(s) = \frac{K_1}{(\tau_1 s + 1)}, \tag{3.26}$$

where

$$K_1 = \frac{K_m}{(R_a f + K_b K_m)} \quad \text{and} \quad \tau_1 = \frac{R_a J}{(R_a f + K_b K_m)}.$$

In the case of a steel mill, the inertia of the rolls is quite large and a large armature controlled motor is required. If the steel rolls are subjected to a step command for a speed change of

$$V_a(s) = \frac{k_2 E}{s}, \tag{3.27}$$

the output response is

$$\omega(s) = G(s)V_a(s). \tag{3.28}$$

The transient speed change is then

$$\omega(t) = K_1(k_2 E)(1 - e^{-t/\tau_1}). \tag{3.29}$$

Figure 3.7. Open-loop speed control system.

Figure 3.8. Closed-loop speed control system.

If this overdamped transient response is too slow, there is little choice but to choose another motor with a different time constant τ_1, if possible. However, because τ_1 is dominated by the load inertia, little hope for much alteration of the transient response remains.

A closed-loop speed control system is easily obtained by utilizing a tachometer to generate a voltage proportional to the speed, as shown in Fig. 3.8. This voltage is subtracted from the potentiometer voltage and amplified as shown in Fig. 3.8. A practical transistor amplifier circuit for accomplishing this feedback in low power applications is shown in Fig. 3.9 [3]. The closed-loop transfer function is

$$\frac{\omega(s)}{R(s)} = \frac{K_a G(s)}{1 + K_a K_t G(s)}$$

$$= \frac{K_a K_1}{\tau_1 s + 1 + K_a K_t K_1} \tag{3.30}$$

$$= \frac{K_a K_1/\tau_1}{s + [(1 + K_a K_t K_1)/\tau_1]} .$$

The amplifier gain K_a may be adjusted to meet the required transient response specifications. Also, the tachometer gain constant K_t may be varied, if necessary. The transient response to a step change in the input command is then

$$\omega(t) = \frac{K_a K_1}{(1 + K_a K_t K_1)} (k_2 E)(1 - e^{-pt}), \tag{3.31}$$

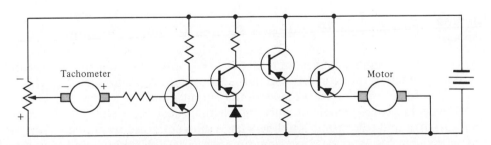

Figure 3.9. Transistorized speed control system.

where $p = (1 + K_a K_t K_1)/\tau_1$. Because the load inertia is assumed to be very large, we alter the response by increasing K_a, and we have the approximate response

$$\omega(t) \simeq \frac{1}{K_t} (k_2 E) \left[- exp\left(\frac{-(K_a K_t K_1)t}{\tau_1} \right) \right]. \tag{3.32}$$

For a typical application, the open-loop pole might be $1/\tau_1 = 0.10$, whereas the closed-loop pole could be at least $(K_a K_t K_1)/\tau_1 = 10$, a factor of 100 in the improvement of the speed of response. It should be noted that in order to attain the gain $K_a K_t K_1$, the amplifier gain K_a must be reasonably large, and the armature voltage signal to the motor and its associated torque signal will be larger for the closed-loop than for the open-loop operation. Therefore a larger motor will be required in order to avoid saturation of the motor.

Also, while we are considering this speed control system, it will be worthwhile to determine the sensitivity of the open- and closed-loop systems. As before, the sensitivity of the open-loop system to a variation in the motor constant or the potentiometer constant k_2 is unity. The sensitivity of the closed-loop system to a variation in K_m is

$$S^T_{K_m} = \frac{1}{1 + GH(s)}$$

$$= \frac{1}{1 + K_a K_t G(s)} \tag{3.33}$$

$$= \frac{[s + (1/\tau_1)]}{[s + (K_a K_t K_1 + 1)/\tau_1]} .$$

Using the typical values given in the previous paragraph, we have

$$S^T_{K_m} = \frac{(s + 0.10)}{(s + 10)} . \tag{3.34}$$

We find that the sensitivity is a function of s and must be evaluated for various values of frequency. This type of frequency analysis is straightforward but will be deferred until a later chapter. However, it is clearly seen that at a specific frequency, for example, $s = j\omega = j1$, the magnitude of the sensitivity is approximately $|S^T_{K_m}| \cong 0.1$.

3.4 Disturbance Signals in a Feedback Control System

The third most important effect of feedback in a control system is the control and partial elimination of the effect of disturbance signals. A *disturbance signal* is an unwanted signal which affects the system's output signal. Many control systems are subject to extraneous disturbance signals that cause the system to provide an inaccurate output. Electronic amplifiers have inherent noise generated within the integrated circuits or transistors; radar antennas are subjected to wind gusts; and

Figure 3.10. Steel rolling mill.

many systems generate unwanted distortion signals due to nonlinear elements. Feedback systems have the beneficial aspect that the effect of distortion, noise, and unwanted disturbances can be effectively reduced.

As a specific example of a system with an unwanted disturbance, let us reconsider the speed control system for a steel rolling mill. Rolls passing steel through are subject to large load changes or disturbances. As a steel bar approaches the rolls (see Fig. 3.10), the rolls turn unloaded. However, when the bar engages in the rolls, the load on the rolls increases immediately to a large value. This loading effect can be approximated by a step change of disturbance torque as shown in Fig. 3.11. Alternatively, we might examine the speed–torque curves of a typical motor as shown in Fig. 3.12.

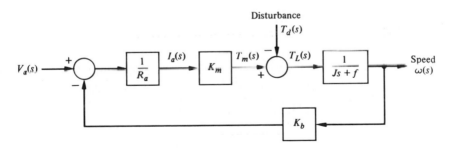

Figure 3.11. Open-loop speed control system.

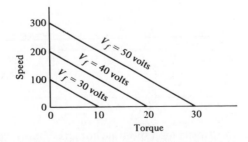

Figure 3.12. Motor speed–torque curves.

The transfer function model of an armature controlled dc-motor with a load torque disturbance was determined in Example 2.3 and is shown in Fig. 3.11, where it is assumed that L_a is negligible. Change in speed due to load disturbance is

$$\omega(s) = \left(\frac{-1}{Js + f + (K_m K_b / R_a)} \right) T_d(s). \tag{3.35}$$

The steady-state error in speed due to the load torque $T_d(s) = D/s$ is found by using the final-value theorem. Therefore, for the open-loop system, we have

$$\lim_{t \to \infty} \omega(t) = \lim_{s \to 0} s\omega(s) = \lim_{s \to 0} s \left(\frac{-1}{Js + f + (K_m K_b / R_a)} \right) \left(\frac{D}{s} \right)$$
$$= \frac{-D}{f + (K_m K_b / R_a)}. \tag{3.36}$$

The closed-loop speed control system is shown in block diagram form in Fig. 3.13. The closed-loop system is shown in the more general signal-flow graph form in Fig. 3.14. The output, $\omega(s)$, of the closed-loop system of Fig. 3.14 can be obtained by utilizing the signal-flow gain formula and is

$$\omega(s) = \frac{-G_2(s)}{1 + G_1(s)G_2(s)H(s)} T_d(s). \tag{3.37}$$

Then, if $G_1 G_2 H(s)$ is much greater than one over the range of s, we obtain the approximate result

$$\omega(s) \simeq \frac{-1}{G_1(s)H(s)} T_d(s). \tag{3.38}$$

Therefore if $G_1(s)$ is made sufficiently large, the effect of the disturbance can be decreased by closed-loop feedback.

Figure 3.13. Closed-loop speed tachometer control system.

Figure 3.14. Signal-flow graph of closed-loop system.

The output for the speed control system of Fig. 3.13 due to the load disturbance, when the input $R(s) = 0$, may be obtained by using Mason's formula as

$$\omega(s) = \frac{-[1/(Js + f)]}{1 + (K_tK_aK_m/R_a)[1/(Js + f)] + (K_mK_b/R_a)[1/(Js + f)]} T_d(s)$$

$$= \frac{-1}{Js + f + (K_m/R_a)(K_tK_a + K_b)} T_d(s).$$

(3.39)

Again, the steady-state output is obtained by utilizing the final-value theorem, and we have

$$\lim_{t \to \infty} \omega(t) = \lim_{s \to 0} (s\omega(s))$$

$$= \frac{-1}{f + (K_m/R_a)(K_tK_a + K_b)} D;$$

(3.40)

when the amplifier gain is sufficiently high, we have

$$\omega(\infty) \simeq \frac{-R_a}{K_aK_mK_t} D.$$

(3.41)

The ratio of closed-loop to open-loop steady-state speed output due to an undesirable disturbance is

$$\frac{\omega_c(\infty)}{\omega_0(\infty)} = \frac{R_af + K_mK_b}{K_aK_mK_t},$$

(3.42)

and is usually less than 0.02.

This advantage of a feedback speed control system can also be illustrated by considering the speed–torque curves for the closed-loop system. The closed-loop system speed–torque curves are shown in Fig. 3.15. Clearly, the improvement of the feedback system is evidenced by the almost horizontal curves, which indicate that the speed is almost independent of the load torque.

In general, a primary reason for introducing feedback is the ability to alleviate the effects of disturbances and noise signals occurring within the feedback loop. A noise signal that is prevalent in many systems is the noise generated by the measurement sensor. This disturbance or noise, $N(s) = T_d(s)$, can be represented

Figure 3.15. The closed-loop system speed–torque curves.

as shown in Fig. 3.16. The effect of the noise on the output is

$$C(s) = \frac{-G_1 G_2 H_2(s)}{1 + G_1 G_2 H_1 H_2(s)} N(s), \tag{3.43}$$

which is approximately

$$C(s) \cong -\frac{1}{H_1(s)} N(s). \tag{3.44}$$

Clearly, the designer must obtain a maximum value of $H_1(s)$, which is equivalent to maximizing the signal-to-noise ratio of the measurement sensor. This necessity is equivalent to requiring that the feedback elements $H(s)$ be well designed and operated with minimum noise, drift, and parameter variation. This is equivalent to the requirement determined from the sensitivity function, Eq. (3.14), which showed that $S_H^T \cong 1$. Therefore one must be aware of the necessity of assuring the quality and constancy of the feedback sensors and elements. This is usually possible because the feedback elements operate at low power levels and can be well designed at reasonable cost.

The equivalency of sensitivity S_G^T and the response of the closed-loop system to a disturbance input can be illustrated by considering Fig. 3.14. The sensitivity of the system to G_2 is

$$S_{G_2}^T = \frac{1}{1 + G_1 G_2 H(s)} \cong \frac{1}{G_1 G_2 H(s)}. \tag{3.45}$$

Figure 3.16. Closed-loop control system with measurement noise.

Figure 3.17. Closed-loop control system with output noise.

The effect of the disturbance on the output is

$$\frac{C(s)}{T_d(s)} = \frac{-G_2(s)}{1 + G_1 G_2 H(s)} \cong \frac{-1}{G_1 H(s)}. \tag{3.46}$$

In both cases, we found that the undesired effects could be alleviated by increasing $G_1(s) = K_a$, the amplifier gain. The utilization of feedback in control systems is primarily to reduce the sensitivity of the system to parameter variations and the effect of disturbance inputs. It is noteworthy that the effort to reduce the effects of parameter variations or disturbances is equivalent and we have the fortunate circumstance that they reduce simultaneously. As a final illustration of this fact, we note that for the system shown in Fig. 3.17, the effect of the noise or disturbance on the output is

$$\frac{C(s)}{T_d(s)} = \frac{1}{1 + GH(s)}, \tag{3.47}$$

which is identically equal to the sensitivity S_G^T.

Quite often, noise is present at the input to the control system. For example, the signal at the input to the system might be $r(t) + n(t)$, where $r(t)$ is the desired system response and $n(t)$ is the noise signal. The feedback control system, in this case, will simply process the noise as well as the input signal $r(t)$ and will not be able to improve the signal-noise ratio, which is present at the input to the system. However, if the frequency spectrums of the noise and input signals are of a different character, the output signal-noise ratio can be maximized, often by simply designing a closed-loop system transfer function which has a low-pass frequency response.

3.5 Steady-State Error

A feedback control system is valuable because it provides the engineer with the ability to adjust the transient response. In addition, as we have seen, the sensitivity of the system and the effect of disturbances can be reduced significantly. However, as a further requirement, one must examine and compare the final steady-state error for an open-loop and a closed-loop system. The *steady-state error* is the error after the transient response has decayed leaving only the continuous response.

$$R(s) \;\bigcirc\!\!\!\xrightarrow{ G(s) }\!\!\!\bigcirc\; C(s)$$

Figure 3.18. Open-loop control system.

The error of the open-loop system shown in Fig. 3.18 is

$$E_0(s) = R(s) - C(s)$$
$$= (1 - G(s))R(s). \tag{3.48}$$

The error of the closed-loop system, $E_c(s)$, shown in Fig. 3.19, when $H(s) = 1$, is

$$1 - \frac{G}{1+G} = \frac{1+G-G}{1+G} \qquad E_c(s) = \frac{1}{1 + G(s)} R(s). \tag{3.49}$$

In order to calculate the steady-state error, we utilize the final-value theorem, which is

$$\lim_{t \to \infty} e(t) = \lim_{s \to 0} sE(s). \tag{3.50}$$

Therefore, using a unit step input as a comparable input, we obtain for the open-loop system

$$e_0(\infty) = \lim_{s \to 0} s(1 - G(s))\left(\frac{1}{s}\right)$$
$$= \lim_{s \to 0} (1 - G(s)) \tag{3.51}$$
$$= 1 - G(0).$$

For the closed-loop system, when $H(s) = 1$, we have

$$e_c(\infty) = \lim_{s \to 0} s\left(\frac{1}{1 + G(s)}\right)\left(\frac{1}{s}\right)$$
$$= \frac{1}{1 + G(0)}. \tag{3.52}$$

The value of $G(s)$ when $s = 0$ is often called the dc-gain and is normally greater than one. Therefore, the open-loop system will usually have a steady-state error of significant magnitude. By contrast, the closed-loop system with a reasonably large dc-loop gain $GH(0)$ will have a small steady-state error.

Figure 3.19. Closed-loop control system.

Upon examination of Eq. (3.51), one notes that the open-loop control system can possess a zero steady-state error by simply adjusting and calibrating the dc-gain, $G(0)$, of the system, so that $G(0) = 1$. Therefore, one may logically ask, what is the advantage of the closed-loop system in this case? Again, we return to the concept of the sensitivity of the system to parameter changes as our answer to this question. In the open-loop system, one may calibrate the system so that $G(0) = 1$, but during the operation of the system it is inevitable that the parameters of $G(s)$ will change due to environmental changes and the dc-gain of the system will no longer be equal to one. However, because it is an open-loop system the steady-state error will remain other than zero until the system is maintained and recalibrated. By contrast, the closed-loop feedback system continually monitors the steady-state error and provides an actuating signal in order to reduce the steady-state error. Thus we find that it is the sensitivity of the system to parameter drift, environmental effects, and calibration errors that encourages the introduction of negative feedback. An example of a ingenious feedback control system is shown in Fig. 3.20.

Figure 3.20. The Grip II is a prosthesis artificial hand that is cable operated. It can be used to operate an automobile manual shift, drive a nail, slice a tomato, and other normal tasks requiring two hands. It is based on a "pull to close" cable action and has a gripping force ranging from 0 to 110 pounds. The hand provides the movement of a thumb and forefinger and closes when effort is exerted on the cable by the person's back muscles. A person's vision system provides feedback, but the person does lack the normal sense of touch most of us use to grasp an object lightly. (Courtesy of Therapeutic Recreation Systems, Inc.)

The advantage of the closed-loop system in reducing the steady-state error of the system resulting from parameter changes and calibration errors may be illustrated by an example. Let us consider a system with a process transfer function

$$G(s) = \frac{K}{\tau s + 1}, \tag{3.53}$$

which would represent a thermal control process, a voltage regulator, or a water-level control process. For a specific setting of the desired input variable, which may be represented by the normalized unit step input function, we have $R(s) = 1/s$. Then, the steady-state error of the open-loop system is, as in Eq. (3.51),

$$e_0(\infty) = 1 - G(0) = 1 - K \tag{3.54}$$

when a consistent set of dimensional units are utilized for $R(s)$ and K. The steady-state error for the closed-loop system, with unity-feedback, is

$$e_c(\infty) = \frac{1}{1 + G(0)} = \frac{1}{1 + K}. \tag{3.55}$$

For the open-loop system, one would calibrate the system so that $K = 1$ and the steady-state error is zero. For the closed-loop system, one would set a large gain K, for example, $K = 100$. Then the closed-loop system steady-state error is $e_c(\infty) = \frac{1}{101}$.

If the calibration of the gain setting drifts or changes in some way by $\Delta K/K = 0.1$, a 10% change, the open-loop steady-state error is $\Delta e_0(\infty) = 0.1$ and the percent change from the calibrated setting is

$$\frac{\Delta e_0(\infty)}{|r(t)|} = \frac{0.10}{1}, \tag{3.56}$$

or 10%. By contrast, the steady-state error of the closed-loop system, with $\Delta K/K = 0.1$, is $e_c(\infty) = \frac{1}{91}$ if the gain decreases. Thus the change in the

$$\Delta e_c(\infty) = \frac{1}{101} - \frac{1}{91}, \tag{3.57}$$

and the relative change is

$$\frac{\Delta e_c(\infty)}{|r(t)|} = 0.0011, \tag{3.58}$$

or 0.11%. This is indeed a significant improvement.

3.6 The Cost of Feedback

The addition of feedback to a control system results in the advantages outlined in the previous sections. However, it is natural that these advantages have an attendant cost. The cost of feedback is first manifested in the increased number of *components* and the *complexity* of the system. In order to add the feedback, it

is necessary to consider several feedback components, of which the measurement component (sensor) is the key component. The sensor is often the most expensive component in a control system. Furthermore, the sensor introduces noise and inaccuracies into the system.

The second cost of feedback is the *loss of gain*. For example, in a single-loop system, the open-loop gain is $G(s)$ and is reduced to $G(s)/(1 + G(s))$ in a unity negative feedback system. The reduction in closed-loop gain is $1/(1 + G(s))$, which is exactly the factor that reduces the sensitivity of the system to parameter variations and disturbances. Usually, we have open-loop gain to spare, and we are more than willing to trade it for increased control of the system response.

However, we should note that it is the gain of the input-output transmittance that is reduced. The control system does possess a substantial power gain, which is fully utilized in the closed-loop system.

Finally, a cost of feedback is the introduction of the possibility of *instability*. While the open-loop system is stable, the closed-loop system may not be always stable. The question of the stability of a closed-loop system is deferred until Chapter 5, where it can be treated more completely.

The addition of feedback to dynamic systems results in several additional problems for the designer. However, for most cases, the advantages far outweigh the disadvantages, and a feedback system is utilized. Therefore it is necessary to consider the additional complexity and the problem of stability when designing a control system. One complex control system is shown in Fig. 3.21.

Figure 3.21. The Belgrade-USC hand [9]. This dextrous hand using sensory integration has five fingers but only two motors. There are no tendons; rather a mechanical linkage allows all the fingers to close as far as possible, thus making the hand automatically adapt to the shape of the grasped object.

It has become clear that it is desired that the output of the system $C(s)$ equal the input $R(s)$. However, upon reflection, one might ask, "Why not simply set the transfer function $G(s) = C(s)/R(s)$ equal to 1?" (See Fig. 3.2.) The answer to this question becomes apparent once we recall that the process (or plant) $G(s)$ was necessary in order to provide the desired output; that is, the transfer function $G(s)$ represents a real process and possesses dynamics that cannot be neglected. If we set $G(s)$ equal to 1, we imply that the output is directly connected to the input. However, one must recall that a specific output, such as temperature, shaft rotation, or engine speed, is desired, whereas the input might be a potentiometer setting or a voltage. The process $G(s)$ is necessary in order to provide the physical process between $R(s)$ and $C(s)$. Therefore, a transfer function $G(s) = 1$ is unrealizable, and we must settle for a practical transfer function.

3.7 Design Example: English Channel Boring Machines

The construction of the tunnel under the English Channel from France to Great Britain began in December 1987. The first connection of the boring tunnels from each country was achieved in November 1990. The tunnel is 23.5 miles long and is bored 200 feet below sea level. The tunnel, when completed in 1992, will accommodate 500 train trips daily and may have a total cost of over $14 billion. This construction will be a critical link between Europe and Great Britain, making it possible for a train to reach Paris from London in three hours.

The machines operating from both ends of the Channel are boring toward the middle. In order to link up in the middle of the Channel with the necessary accuracy, a laser guidance system keeps the machines precisely aligned. A model of the boring machine control is shown in Fig. 3.22, where $C(s)$ is the actual angle of direction of travel of the boring machine and $R(s)$ is the desired angle. The effect of load on the machine is represented by the disturbance $D(s)$.

The design objective is to select the gain K so that the response to input angle changes is desirable while maintaining minimal error due to the disturbance. Using Mason's rule, the output due to the two inputs is

$$C(s) = T(s)R(s) + T_d(s)D(s)$$

$$= \frac{KG(s)}{1 + KG(s)} R(s) + \frac{G(s)}{1 + KG(s)} D(s) \tag{3.59}$$

$$= \frac{K}{s^2 + 12s + K} R(s) + \frac{1}{s^2 + 12s + K} D(s).$$

Thus, to reduce the effect of the disturbance, we wish to set the gain greater than 10. When we select $K = 100$ and let $d(t) = 0$, we have the step response for a unit step input $r(t)$, as shown in Fig. 3.23(a). Letting the input $r(t) = 0$ and determining the response to the unit step disturbance, we obtain $c(t)$, as shown in Fig. 3.23(b). Clearly, the effect of the disturbance is quite small. If we set the gain K

Figure 3.22. A block diagram model of a boring machine control system.

Figure 3.23. The response $c(t)$ to (a) an input step $r(t)$ and (b) a disturbance step input $d(t)$ for $K = 100$.

Figure 3.24. The response $c(t)$ for a step input (solid line) and for a step disturbance (dashed line) for $K = 50$.

equal to 50, the responses of $c(t)$ due to a unit step input $r(t)$ and $d(t)$ are displayed together in Fig. 3.24. Since the overshoot of the response is small (less than 2%) and the steady state is attained in one second, we would prefer $K = 50$. The results are summarized in Table 3.1.

The steady-state error of the system to a unit step input $R(s) = 1/s$ is

$$\lim_{t \to \infty} e(t) = \lim_{s \to 0} s \frac{1}{1 + KG(s)} \left(\frac{1}{s} \right) \tag{3.60}$$

$$= 0.$$

The steady-state value of $c(t)$ when the disturbance is a unit step, $D(s) = 1/s$, and the desired value is $r(t) = 0$ is

$$\lim_{t \to \infty} c(t) = \lim_{s \to 0} s \left[\frac{G(s)}{1 + KG(s)} \right] D(s)$$

$$= \lim_{s \to 0} \left[\frac{1}{s(s + 12) + K} \right] \tag{3.61}$$

$$= \frac{1}{K}.$$

Thus the steady-state value is 0.01 and 0.02 for $K = 100$ and 50, respectively.

Table 3.1. Response of the Boring System for Two Gains

Gain K	Overshoot of response to $r(t)$ = step	Time for response to $r(t)$ = step to reach steady state	Steady-state response $c(t)$ for $d(t)$ = step with $r(t)$ = 0	Steady-state error of response to $r(t)$ = step with $d(t)$ = 0
100	10%	1.5s	0.01	0
50	1%	1.0s	0.02	0

Finally, we examine the sensitivity of the system to a change in the process $G(s)$ using Eq. (3.13). Then,

$$S = \frac{1}{1 + KG(s)}$$
$$= \frac{s(s + 12)}{s(s + 12) + K}.$$

(3.62)

For low frequencies ($|s| < 4$), the sensitivity can be approximated by

$$S \simeq \frac{12s}{K},$$

(3.63)

where $K \geq 50$. Thus the sensitivity of the system is reduced by increasing the gain K. In this case we choose K, which reasonably satisfies all our design requirements, thus selecting $K = 50$ for a reasonable design compromise.

3.8 Summary

The fundamental reasons for using feedback, despite its cost and additional complexity, are as follows:

1. Decrease in the sensitivity of the system to variations in the parameters of the process $G(s)$
2. Ease of control and adjustment of the transient response of the system
3. Improvement in the rejection of the disturbance and noise signals within the system
4. Improvement in the reduction of the steady-state error of the system

The benefits of feedback can be illustrated by considering the system shown in Fig. 3.25(a). This system can be considered for several values of gain, K. Table 3.2 summarizes the results of the system operated as an open loop system (disconnect the feedback path) and for several values of gain, K with the feedback

(a)

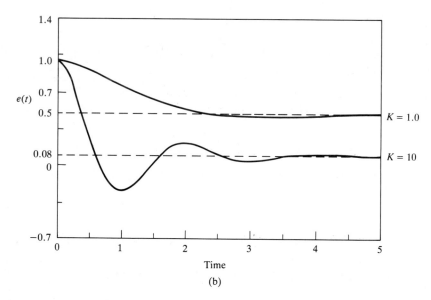

Time

(b)

Figure 3.25. (a) A single-loop feedback control system. (b) The error response for a unit step disturbance.

Table 3.2.

	Open Loop	Closed Loop		
	$K = 1$	$K = 1$	$K = 8$	$K = 10$
Rise time (seconds) (10% to 90% of final value)	3.35	1.52	0.45	0.38
Percent overshoot (%)	0	4.31	33	40
Final value of $c(t)$ due to a disturbance, $D(s) = \dfrac{1}{s}$	1.0	0.50	0.11	0.09
Percent steady-state error for unit step input	0	50%	11%	9%
Percent change in steady-state error due to 10% decrease in K	10%	5.3%	1.2%	0.9%

connected. It is clear that the rise time of the system and sensitivity of the system is reduced as the gain is increased. Also, the feedback system demonstrates excellent reduction of the steady state error as the gain is increased. Finally, Fig. 3.25(b) shows the response for a unit step disturbance (when $R(s) = 0$) and shows how a larger gain will reduce the effect of the disturbance.

Feedback control systems possess many beneficial characteristics, and it is not surprising that one finds a multitude of feedback control systems in industry, government, and nature.

Exercises

E3.1. A closed-loop system is used to track the sun in order to obtain maximum power from a photovoltaic array. The tracking system may be represented by Fig. 3.3 with $H(s)$ = 1 and

$$G(s) = \frac{100}{3s + 1}.$$

(a) Calculate the sensitivity of this system. (b) Calculate the time constant of the closed-loop system response.

Answers: $s = (3s + 1)/(3s + 100)$; $\tau_c = 3/101$

E3.2. A digital audio system is designed to minimize the effect of disturbances and noise as shown in Fig. E3.2. As an approximation, we may represent $G(s) = K_2$. (a) Calculate the sensitivity of the system due to K_2. (b) Calculate the effect of the disturbance on V_{out}. (c) What value would you select for K_1 to minimize the effect of the disturbance?

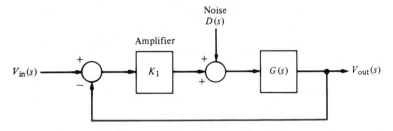

Figure E3.2. Digital audio system.

E3.3. A robot arm and camera could be used to pick fruit as shown in Fig. E3.3(a). The camera is used to close the feedback loop to a microcomputer, which controls the arm [14]. The process is

$$G(s) = \frac{K}{(s + 2)^2}.$$

(a) Calculate the expected steady-state error of the gripper for a step command A as a function of K. (b) Name a possible disturbance signal for this system.

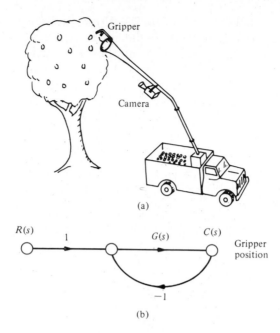

(a)

(b)

Figure E3.3. Robot fruit picker.

E3.4. A magnetic disk drive requires a motor to position a read/write head over tracks of data on a spinning disk as shown in Fig. E3.4, on the next page. The motor and head may be represented by

$$G(s) = \frac{10}{s(\tau s + 1)},$$

where $\tau = 0.001$ sec. The controller takes the difference of the actual and desired positions and generates an error. This error is multiplied by an amplifier K. (a) What is the steady-state position error for a step change in the desired input? (b) Calculate the required K in order to yield a steady-state error of 1 mm for a ramp input of 10 cm/sec.

Answers: $e_{ss} = 0$; $K = 10$

E3.5. Most people have experienced an out of focus slide projector. A projector with an automatic focus adjusts for variations in slide position and temperature disturbances [19]. Draw the block diagram of an autofocus system and describe how the system works. An unfocused slide projection is a visual example of steady-state error.

E3.6. Four-wheel drive autos are popular in regions where winter road conditions are often slippery due to snow and ice. A four-wheel drive with antilock brakes uses a sensor to keep each wheel rotating to maintain traction. One system is shown in Fig. E3.6. Find the closed-loop response of this system as it attempts to maintain a constant speed of the wheel. Use a computer program to determine the response when $R(s) = A/s$.

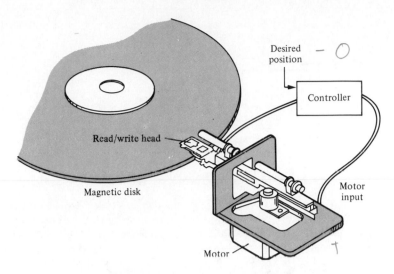

Figure E3.4. Disk drive control.

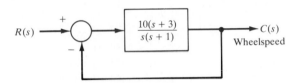

Figure E3.6. Four-wheel drive auto.

Problems

P3.1. The open-loop transfer function of a fluid-flow system obtained in Problem 2.13 can be written as

$$G(s) = \frac{\Delta Q_2(s)}{\Delta Q_1(s)} = \frac{1}{\tau s + 1},$$

where $\tau = RC$, R is a constant equivalent to the resistance offered by the orifice so that $1/R = \frac{1}{2} k H_0^{-1/2}$, and C = the cross-sectional area of the tank. Since $\Delta H = R \Delta Q_2$, we have for the transfer function relating the head to the input change:

$$G_1(s) = \frac{\Delta H(s)}{\Delta Q_1(s)} = \frac{R}{RCs + 1}.$$

For a closed-loop feedback system, a float level sensor and valve may be used as shown in Fig. P3.1 [11]. Assuming the float is a negligible mass, the valve is controlled so that a reduction in the flow rate, ΔQ_1, is proportional to an increase in head, ΔH, or $\Delta Q_1 = -K \Delta H$. Draw a closed-loop flow graph or block diagram. Determine and compare the open-loop and closed-loop system for (a) sensitivity to changes in the equivalent coefficient R and the feedback coefficient K; (b) ability to reduce the effects of a disturbance in the level $\delta H(s)$; and (c) steady-state error of the level (head) for a step change of the input $\Delta Q_1(s)$.

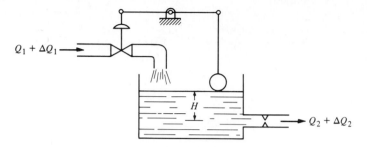

Figure P3.1. Tank level control.

P3.2. It is important to ensure passenger comfort on ships by stabilizing the ship's oscillations due to waves [5, 6]. Most ship stabilization systems use fins or hydrofoils projecting into the water in order to generate a stabilization torque on the ship. A simple diagram of a ship stabilization system is shown in Fig. P3.2. The rolling motion of a ship can be regarded as an oscillating pendulum with a deviation from the vertical of θ degrees and a typical period of 3 sec. The transfer function of a typical ship is

$$G(s) = \frac{\omega_n^2}{s^2 + 2\zeta\omega_n s + \omega_n^2},$$

where $\omega_n = 2\pi/T = 2$, $T = 3.14$ sec, and $\zeta = 0.10$. With this low damping factor ζ, the oscillations continue for several cycles and the rolling amplitude can reach 18° for the expected amplitude of waves in a normal sea. Determine and compare the open-loop and closed-loop system for (a) sensitivity to changes in the actuator constant K_a and the roll sensor K_1; and (b) the ability to reduce the effects of the disturbance of the waves. Note that the desired roll $\theta_d(s)$ is zero degrees.

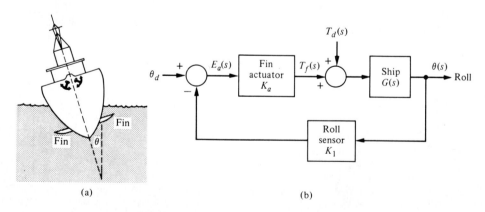

(a) (b)

Figure P3.2. Ship stabilization system.

P3.3. One of the most important variables that must be controlled in industrial and chemical systems is temperature. A simple representation of a thermal control system is shown

in Fig. P3.3 [20]. The temperature T of the process is controlled by the heater with a resistance R. An approximate representation of the dynamics linearly relates the heat loss from the process to the temperature difference $(T - T_e)$. This relation holds if the temperature difference is relatively small and the energy storage of the heater and the vessel walls is negligible. Also, it is assumed that the voltage connected to the heater e_h is proportional to e_{desired} or $e_h = kE_b = k_a E_b e(t)$, where k_a is the constant of the actuator. Then the linearized open-loop response of the system is

$$T(s) = \frac{(k_1 k_a E_b)}{\tau s + 1} E(s) + \frac{T_e(s)}{\tau s + 1},$$

where

$\tau = MC/\rho A,$
$M = $ mass in tank,
$A = $ surface area of tank,
$\rho = $ heat transfer constant,
$C = $ specific heat constant,
$k_1 = $ a dimensionality constant,
$e_{th} = $ output voltage of thermocouple.

Determine and compare the open-loop and closed-loop systems for (a) sensitivity to changes in the constant $K = k_1 k_a E_b$; (b) ability to reduce the effects of a step disturbance in the environmental temperature $\Delta T_e(s)$; and (c) the steady-state error of the temperature controller for a step change in the input, e_{desired}.

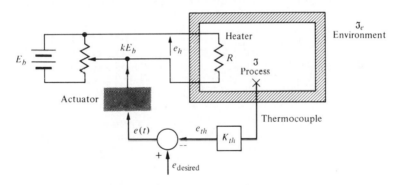

Figure P3.3. Temperature control.

P3.4. A control system has two forward signal paths as shown in Fig. P3.4. (a) Determine the overall transfer function $T(s) = C(s)/R(s)$. (b) Calculate the sensitivity S_G^T using Eq. (3.16). (c) Does the sensitivity depend on $U(s)$ or $M(s)$?

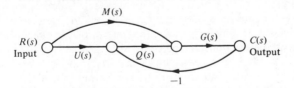

Figure P3.4. Two path system.

P3.5. Large microwave antennas have become increasingly important for missile tracking, radio astronomy, and satellite tracking. A large antenna, for example, with a diameter of 60 ft, is subject to large wind gust torques. A proposed antenna is required to have an error of less than 0.20° in a 35 mph wind. Experiments show that this wind force exerts a maximum disturbance at the antenna of 200,000 lb-ft at 35 mph, or equivalent to 20 volts at the input, $T_d(s)$, to the amplidyne. Also, one problem of driving large antennas is the form of the system transfer function that possesses a structural resonance. The antenna servo-system is shown in Fig. P3.5. The transfer function of the antenna, drive motor, and amplidyne is approximated by

$$G(s) = \frac{\omega_n^2}{s^2 + 2\zeta\omega_n s + \omega_n^2},$$

where $\zeta = 0.6$ and $\omega_n = 10$. The transfer function of the magnetic amplifier is approximately

$$G_1(s) = \frac{k_a}{\tau s + 1},$$

where $\tau = 0.20$ sec. (a) Determine the sensitivity of the system to a change of the parameter k_a. (b) The system is subjected to a disturbance $T_d(s) = 15/s$. Determine the required magnitude of k_a in order to maintain the steady-state error of the system less than 0.20° when the input $R(s)$ is zero. (c) Determine the error of the system when subjected to a disturbance $T_d(s) = 15/s$ when it is operating as an open-loop system ($k_s = 0$) with $R(s) = 0$.

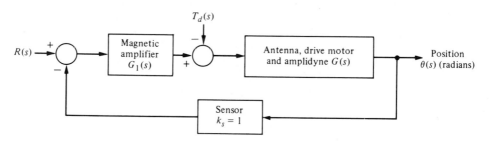

Figure P3.5. Antenna control system.

P3.6. An automatic speed control system will be necessary for passenger cars traveling on the automatic highways of the future. A model of a feedback speed control system for a standard vehicle is shown in Fig. P3.6. The load disturbance due to a percent grade, $\Delta D(s)$, is shown also. The engine gain K_e varies within the range of 10 to 1,000 for various models of automobiles. The engine time constant, τ_e, is 20 sec. (a) Determine the sensitivity of the system to changes in the engine gain K_e. (b) Determine the effect of the load torque on the speed. (c) Determine the constant percent grade $\Delta D(s) = \Delta d/s$ for which the engine stalls in terms of the gain factors. Note that since the grade is constant, the steady-state solution is sufficient. Assume that $R(s) = 30/s$ km/hr and that $K_e K_1 \gg 1$. When $(K_g/K_1) = 2$, what percent grade Δd would cause the automobile to stall?

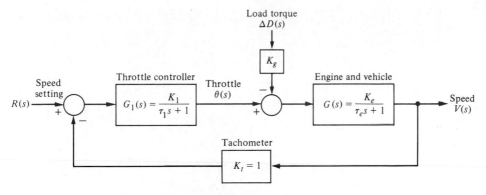

Figure P3.6. Automobile speed control.

P3.7. A robot using an electro-hydraulic actuator is shown in Fig. P3.7(a), on the next page. The EHA 1050 is a microprocessor-controlled hydraulic robot incorporating five axes and a two-fingered gripper that can be programmed by either a remote teaching pendant or an optional external computer. The robot can store eight program sequences in its non-volatile memory, each consisting of up to 64 preprogrammed arm positions. The closed-loop system provides continuous position feedback from all axes including gripper, thus allowing object recognition and maximum grip control.

The robot's two-speed system automatically switches from normal to low speed as the arm approaches programmed preset coordinates, thus enabling more precise positioning. The ARMDRAULIC 1052 robot has a maximum payload of five pounds fully retracted, and three pounds at full extension.

The system will be deflected by the load carried in the gripper. Thus the system may be represented by Fig. P3.7(b) where the load torque is D/s. Assume $R(s) = 0$ at the index position. (a) What is the effect of $T_L(s)$ on $C(s)$? (b) Determine the sensitivity of the closed loop to K_2. (c) What is the steady-state error when $R(s) = 1/s$ and $T_L(s) = 0$?

P3.8. Extreme temperature changes result in many failures of electronic circuits [18]. Temperature control feedback systems reduce the change of temperature by using a heater to overcome outdoor low temperatures. A block diagram of one system is shown in Fig. P3.8, on the next page. The effect of a drop in environmental temperature is a step decrease in $D(s)$. The actual temperature of the electronic circuit is $C(s)$. The dynamics of the electronic circuit temperature change are represented by

$$G(s) = \frac{324}{s^2 + 20s + 324}.$$

(a) Determine the sensitivity of the system to K. (b) Obtain the effect of the disturbance $D(s)$ on the output $C(s)$.

P3.9. A useful unidirectional sensing device is the photoemitter sensor [6]. A light source is sensitive to the emitter current flowing and alters the resistance of the photosensor. Both the light source and the photoconductor are packaged in a single four-terminal device. This device provides a large gain and total isolation. A feedback circuit utilizing this device is

(a)

(b)

Figure P3.7. Robot control. (Courtesy of Feedback, Inc.)

Figure P3.8. Temperature control.

shown in Fig. P3.9(a), and the nonlinear resistance-current characteristic is shown in Fig. 3.9(b) for the Raytheon CK1116. The resistance curve can be represented by the equation

$$\log_{10} R = \frac{0.175}{(i - 0.005)^{1/2}}$$

where i is the lamp current. The normal operating point is obtained when $e_{out} = 35$ V, and $e_{in} = 2.0$ V. (a) Determine the closed-loop transfer function of the system. (b) Determine the sensitivity of the system to changes in the gain K.

(a) (b)

Figure P3.9. Photosensor system.

P3.10. For a paper processing plant, it is important to maintain a constant tension on the continuous sheet of paper between the windoff and windup rolls. The tension varies as the widths of the rolls change, and an adjustment in the take-up motor speed is necessary, as shown in Fig. P3.10. If the windup motor speed is uncontrolled, as the paper transfers from the windoff roll to the windup roll, the velocity v_0 decreases and the tension of the paper drops [10, 15]. The three-roller and spring combination provides a measure of the tension of the paper. The spring force is equal to $k_1 y$ and linear differential transformer, rectifier, and amplifier may be represented by $e_0 = -k_2 y$. Therefore the measure of the tension is described by the relation $2T(s) = k_1 y$, where y is the deviation from the equilibrium condition and $T(s)$ is the vertical component of the deviation in tension from the equilibrium condition. The time constant of the motor is $\tau = L_a/R_a$ and the linear velocity of the windup roll is twice the angular velocity of the motor; that is, $v_0(t) = 2\omega_0(t)$. The equation of the motor is then

$$E_0(s) = \frac{1}{K_m}[\tau s \omega_0(s) + \omega_0(s)] + k_3 \, \Delta T(s),$$

where ΔT = a tension disturbance. (a) Draw the closed-loop block diagram for the system, including the disturbance $\Delta T(s)$. (b) Add the effect of a disturbance in the windoff roll velocity $\Delta V_1(s)$ to the block diagram. (c) Determine the sensitivity of the system to the motor constant K_m. (d) Determine the steady-state error in the tension when a step disturbance in the input velocity $\Delta V_1(s) = A/s$ occurs.

Figure P3.10. Paper tension control.

P3.11. One important objective of the paper-making process is to maintain uniform consistency of the stock output as it progresses to drying and rolling. A diagram of the thick stock consistency dilution control system is shown in Fig. P3.11(a). The amount of water added determines the consistency. The signal-flow diagram of the system is shown in Fig. P3.11(b). Let $H(s) = 1$ and

$$G_c(s) = \frac{K}{(10s + 1)},$$

$$G(s) = \frac{1}{(2s + 1)}.$$

Determine (a) the closed-loop transfer function $T(s) = C(s)/R(s)$, (b) the sensitivity S_K^T, and (c) the steady-state error for a step change in the desired consistency $R(s) = A/s$. (d) Calculate the value of K required for an allowable steady-state error of 1%.

Figure P3.11. Paper making control.

P3.12. Two feedback systems are shown in signal-flow diagram form in Fig. P3.12(a) and (b). (a) Evaluate the closed-loop transfer functions T_1 and T_2 for each system. (b) Show that $T_1 = T_2 = 100$ when $K_1 = K_2 = 100$. (c) Compare the sensitivities of the two systems with respect to the parameter K_1 for the nominal values of $K_1 = K_2 = 100$.

(a) (b)

Figure P3.12.

P3.13. One form of closed-loop transfer function is

$$T(s) = \frac{G_1(s) + kG_2(s)}{G_3(s) + kG_4(s)}.$$

(a) Use Eq. (3.16) to show that [1]

$$S_k^T = \frac{k(G_2G_3 - G_1G_4)}{(G_3 + kG_4)(G_1 + kG_2)}.$$

(b) Determine the sensitivity of the system shown in Fig. P3.13, using the equation verified in part (a).

Figure P3.13.

P3.14. A proposed hypersonic plane, as shown in Fig. P3.14(a) on the next page would climb to 100,000 feet and fly 3800 miles per hour, and cross the Pacific in two hours. Control of speed of the aircraft could be represented by the model of Fig. P3.14(b). Find the sensitivity of the closed-loop transfer function, $T(s)$, to a small change in the parameter, a.

P3.15. The steering control of a modern ship may be represented by the system shown in Fig. P3.15 [5, 6]. Find the steady state effect of a constant wind force represented by $D(s) = 1/s$ for $K = 5$ and $K = 30$. (a) Assume that the rudder input $R(s)$ is zero, without any disturbance, and has not been adjusted. (b) Show that the rudder can then be used to bring the ship deviation back to zero.

(a)

(b)

Figure P3.14. Hypersonic airplane speed control.

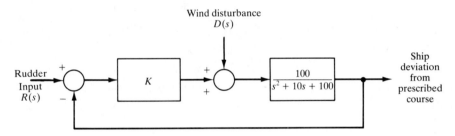

Figure P3.15. Ship steering control.

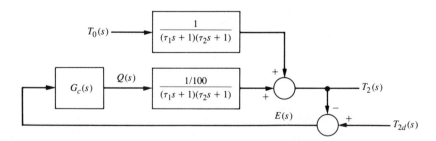

Figure P3.16. Two tank temperature control.

P3.16. A two-tank system containing a heated liquid has the model shown in Fig. P3.16, where T_0 is the temperature of the fluid flowing into the first tank and T_2 is the temperature of the liquid flowing out of the second tank. The system of two tanks has a heater in tank 1 with a controllable heat input Q [23]. The time constants are $\tau_1 = 10s$ and $\tau_2 = 50s$. (a)

Determine $T_2(s)$ in terms of $T_0(s)$ and $T_{2d}(s)$. (b) if $T_{2d}(s)$, the desired output temperature, is changed instantaneously from $T_{2d}(s) = A/s$ to $T_{2d}(s) = 2A/s$ where $T_0(s) = A/s$, determine the transient response of $T_2(t)$ when $G_c(s) = K = 500$. (c) Find the steady-state error, e_{ss}, for the system of part (b), where $E(s) = T_{2d}(s) - T_2(s)$.

P3.17. A robot gripper, shown in part (a) of Fig. P3.17, is to be controlled so that it closes to an angle θ by using a dc motor control system, as shown in part (b). The model of the

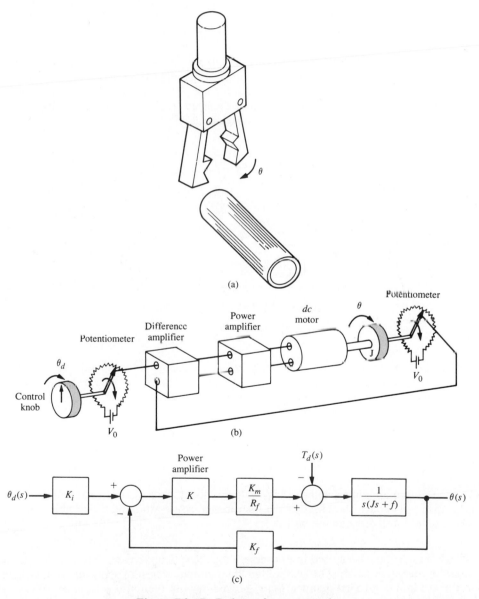

Figure P3.17. Robot gripper control.

control system is shown in part (c), where $K_m = 30$, $R_f = 1\Omega$, $K_f = K_i = 1$, $J = 0.1$, and $f = 1$. (a) Determine the response, $\theta(t)$, of the system to a step change in $\theta_d(t)$ when $K = 20$. (b) Assuming $\theta_d(t) = 0$, find the effect of a load disturbance $T_d(s) = A/s$. (c) Determine the steady-state error, e_{ss}, when the input is $r(t) = t$, $t > 0$. (Assume that $T_d = 0$.)

Design Problems ◆

DP3.1. A closed-loop speed-control system is subjected to a disturbance due to a load, as shown in Fig. DP3.1. The desired speed is $\omega_d(t) = 100$ rad/second and the load disturbance is a unit step input $D(s) = 1/s$. Assume that the speed has attained the no-load speed of 100 rad/s and is in steady state. (a) Determine the steady-state effect of the load disturbance and (b) plot $c(t)$ for the step disturbance for selected values of gain so that $10 \leq K \leq 25$. Determine a suitable value for the gain K.

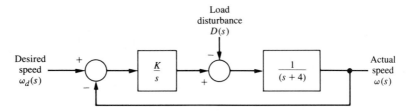

Figure DP3.1. Speed control system.

DP3.2. The control of the roll angle of an airplane is achieved by using the torque developed by the ailerons, as shown in Fig. DP3.2(a) and (b), on the next page. A linear model of the roll control system for a small experimental aircraft is shown in Fig. DP3.2(c), where $q(t)$ is the flow of fluid into a hydraulic cylinder and

$$G(s) = \frac{1}{s^2 + 3s + 9}.$$

The goal is to maintain a small roll angle θ due to disturbances. Select an appropriate gain, KK_1, that will reduce the effect of the disturbance while attaining a desirable transient response to a step disturbance, with $\theta_d(t) = 0$.

DP3.3. Lasers have been used in eye surgery for more than 25 years. They can cut tissue or aid in coagulation [24]. The laser allows the ophthalmologist to apply heat to a location in the eye in a controlled manner. Many procedures use the retina as a laser target. The

Figure DP3.2. Control of the roll angle of an airplane.

retina is the thin sensory tissue that rests on the inner surface of the back of the eye and is the actual transducer of the eye, converting light energy into electrical pulses. On occasion, this layer will detach from the wall, resulting in the death of the detached area from lack of blood and leading to partial if not total blindness in that eye. A laser can be used to "weld" the retina into its proper place on the inner wall.

Automated control of position enables the ophthalmologist to indicate to the controller where lesions should be inserted. The controller then monitors the retina and controls

Figure DP3.3. Laser eye surgery system.

the laser's position such that each lesion is placed at the proper location. A wide-angle video-camera system is required to monitor the movement of the retina, as shown in Fig. DP3.3(a). If the eye moves during the irradiation, the laser must be either redirected or turned off. The position-control system is shown in Fig. DP3.3(b). Select an appropriate gain for the controller so that the transient response to a step change in $r(t)$ is satisfactory and the effect of the disturbance due to noise in the system is minimized. Also ensure that the steady-state error for a step input command is zero.

Terms and Concepts

Disturbance signal An unwanted input signal that affects the system's output signal.

Error signal The difference between the desired output, $R(s)$, and the actual output $C(s)$. Therefore $E(s) = R(s) - C(s)$.

Steady-state error The error when the time period is large and the transient response has decayed, leaving the continuous response.

System sensitivity The proportional change of the transfer function of a system to a proportional change in the system parameter.

Transient response The response of a system as a function of time.

References

1. R. C. Dorf, *Introduction to Electric Circuits,* John Wiley & Sons, New York, 1989.
2. J. W. Nilsson, *Electric Circuits,* 3rd ed., Addison-Wesley, Reading, Mass., 1990.
3. *Motomatic Speed Control,* Electro-Craft Corp., Hopkins, Minn., 1990.
4. D. L. Schilling, *Electronic Circuits,* 3rd ed., McGraw-Hill, New York, 1989.
5. J. Van Amerongen and H. R. Lemke, "Adaptive Control Aspects of a Rudder Roll Stabilization System," *Proceedings of the 1987 IFAC Congress on Automatic Control;* pp. 215–30.
6. C. L. Nachtigal, *Instrumentation and Control,* John Wiley & Sons, New York, 1990.
7. T. Yoshikawa, *Foundations of Robotics,* M.I.T. Press, Cambridge, Mass., 1990.
8. M. Swartz, "Robert Radocy Picks Up the Pieces," *Esquire,* December 1984; pp. 94–97.
9. S. N. Kolpashnikov and I. B. Chelpanov, "Industrial Robot Grasping Devices," *Advanced Manufacturing Engineering,* October 1989; pp. 277–86.
10. B, W Niebel, *Modern Manufacturing Process Engineering,* McGraw-Hill, New York, 1989.
11. K. Betts, "Process Control Takes Command," *Mechanical Engineering,* July 1990; pp. 64–68.
12. J. Williams, "Take Advantage of Thermal Effects to Solve Circuit Design Problems," *Electronic Design News,* June 28, 1984; pp. 239–48.
13. A. Isidori, *Nonlinear Control Systems,* Springer-Verlag, New York, 1990.
14. R. C. Dorf, *Encyclopedia of Robotics,* John Wiley & Sons, New York, 1988.
15. D. J. Bak, "Dancer Arm Feedback Regulates Tension Control," *Design News,* April 6, 1987; pp. 132–33.
16. B. Frohring, "Waveform Recorder Design for Dynamic Performance," *HP Journal,* February 1988; pp. 39–47.
17. S. C. Jacobsen, "Control Strategies for Tendon-Driven Manipulators," *IEEE Control Systems,* February 1990; pp. 23–28.
18. S. Franco, *Design with Operational Amplifiers and Analog Integrated Circuits,* McGraw-Hill, New York, 1988.
19. "The Smart Projector Demystified," *Science Digest,* May 1985; p. 76.
20. R. Kurzweil, *The Age of Intelligent Machines,* M.I.T. Press, Cambridge, Mass., 1990.
21. C. W. DeSilva, *Control Sensors and Actuators,* Prentice Hall, Englewood Cliffs, N.J. 1990.

22. Y. Dote, *Servo Motor and Motion Control,* Prentice Hall, Englewood Cliffs, N.J., 1990.
23. W. Luyben, *Process Modeling and Control for Chemical Engineers,* 2nd ed., McGraw-Hill, New York, 1990.
24. M. S. Markow, "An Automated Laser System for Eye Surgery," *IEEE Engineering in Medicine and Biology,* December 1989; pp. 24–29.
25. W. R. Perkins, "Sensitivity Function Methods in Control System Education," Proceed. of IFAC Advances in Control Education, June 1991; pp. 14–22.

CHAPTER 4

The Performance of Feedback Control Systems

Preview

The ability to adjust the transient and steady-state response of a control system is a beneficial outcome of structuring a feedback system. We wish to adjust one or more parameters in order to provide a desirable response. Thus we must define the desired response in terms of specifications for the system.

We will use selected input signals to test the response of a control system. This response will be characterized by a selected set of response measures such as the overshoot of a response to a step input. We will then analyze the performance of a system in terms of the s-plane location of the poles and zeros of the transfer function of the system.

We will see that one of the most important measures of performance is the steady-state error. The concept of a performance index which adequately represents the system's performance by a single number (or index) will be considered. As is clear, in this chapter, we will strive to delineate a set of quantitative performance measures that adequately represent the performance of the control system. This approach will enable us to adjust the system and thus achieve a performance that we can describe as the best we can achieve.

4.1 Introduction

The ability to adjust the transient and steady-state performance is a distinct advantage of feedback control systems. In order to analyze and design control systems, we must define and measure the performance of a system. Then, based on the desired performance of a control system, the parameters of the system may be adjusted in order to provide the desired response. Because control systems are inherently dynamic systems, the performance is usually specified in terms of both the time response for a specific input signal and the resulting steady-state error.

The design *specifications* for control systems normally include several time-response indices for a specified input command as well as a desired steady-state accuracy. However, often in the course of any design, the specifications are revised in order to effect a compromise. Therefore, specifications are seldom a rigid set of requirements, but rather a first attempt at listing a desired performance. The effective compromise and adjustment of specifications can be graphically illustrated by examining Fig. 4.1. Clearly, the parameter p may minimize the performance measure M_2 by selecting p as a very small value. However, this results in large measure M_1, an undesirable situation. Obviously, if the performance measures are equally important, the crossover point at p_{\min} provides the best compromise. This type of compromise is normally encountered in control-

Figure 4.1. Two performance measures vs. parameter p.

system design. It is clear that if the original specifications called for both M_1 and M_2 to be zero, the specifications could not be simultaneously met and would have to be altered to allow for the compromise resulting with p_{min}.

The specifications stated in terms of the measures of performance indicate to the designer the quality of the system. In other words, the performance measures are an answer to the question: How well does the system perform the task it was designed for?

4.2 Time-Domain Performance Specifications

The time-domain performance specifications are important indices because control systems are inherently time-domain systems. That is, the system transient or time performance is the response of prime interest for control systems. It is necessary to determine initially if the system is stable by utilizing the techniques of ensuing chapters. If the system is stable, then the response to a specific input signal will provide several measures of the performance. However, because the actual input signal of the system is usually unknown, a standard *test input signal* is normally chosen. This approach is quite useful because there is a reasonable correlation between the response of a system to a standard test input and the system's ability to perform under normal operating conditions. Furthermore, using a standard input allows the designer to compare several competing designs. Also, many control systems experience input signals very similar to the standard test signals.

The standard test input signals commonly used are (1) the step input, (2) the ramp input, and (3) the parabolic input. These inputs are shown in Fig. 4.2. The equations representing these test signals are given in Table 4.1, where the Laplace transform can be obtained by using Table 2.5. The ramp signal is the integral of the step input, and the parabola is simply the integral of the ramp input. A *unit impulse* function is also useful for test signal purposes. The unit impulse is based on a rectangular function $f_\epsilon(t)$ such that

$$f_\epsilon(t) = \begin{cases} 1/\epsilon, & 0 \le t \le \epsilon, \\ 0, & t > \epsilon, \end{cases}$$

(a)

(b)

(c)

Figure 4.2. Test input signals.

Table 4.1. Test Signal Inputs

Test Signal	$r(t)$	$R(s)$
Step	$r(t) = A,\ t > 0$ $= 0,\ t < 0$	$R(s) = A/s$
Ramp	$r(t) = At,\ t > 0$ $= 0,\ t < 0$	$R(s) = A/s^2$
Parabolic	$r(t) = At^2,\ t > 0$ $= 0,\ t < 0$	$R(s) = 2A/s^3$

where $\epsilon > 0$. As ϵ approaches zero, the function $f_\epsilon(t)$ approaches the impulse function $\delta(t)$, which has the following properties:

$$\int_0^\infty \delta(t)dt = 1,$$

$$\int_0^\infty \delta(t - a)g(t) = g(a). \tag{4.1}$$

The impulse input is useful when one considers the convolution integral for an output $c(t)$ in terms of an input $r(t)$, which is written as

$$c(t) = \int_0^t g(t - \tau)r(\tau)d\tau$$

$$= \mathcal{L}^{-1}\{G(s)R(s)\}. \tag{4.2}$$

This relationship is shown in block diagram form in Fig. 4.3. Clearly, if the input is an impulse function of unit amplitude, we have

$$c(t) = \int_0^t g(t - \tau)\delta(\tau)d\tau. \tag{4.3}$$

The integral has a value only at $\tau = 0$, and therefore

$$c(t) = g(t),$$

the impulse response of the system $G(s)$. The impulse response test signal can often be used for a dynamic system by subjecting the system to a large amplitude, narrow width pulse of area A.

Figure 4.3. Open-loop control system.

The standard test signals are of the general form

$$r(t) = t^n, \tag{4.4}$$

and the Laplace transform is

$$R(s) = \frac{n!}{s^{n+1}}. \tag{4.5}$$

Clearly, one may relate the response to one test signal to the response of another test signal of the form of Eq. (4.4). The step input signal is the easiest to generate and evaluate and is usually chosen for performance tests.

Initially, let us consider a single-loop second-order system and determine its response to a unit step input. A closed-loop feedback control system is shown in Fig. 4.4. The closed-loop output is

$$
\begin{aligned}
C(s) &= \frac{G(s)}{1 + G(s)} R(s) \\
&= \frac{K}{s^2 + ps + K} R(s).
\end{aligned}
\tag{4.6}
$$

Utilizing the generalized notation of Section 2.4, we may rewrite Eq. (4.6) as

$$C(s) = \frac{\omega_n^2}{s^2 + 2\zeta\omega_n s + \omega_n^2} R(s). \tag{4.7}$$

With a unit step input, we obtain

$$C(s) = \frac{\omega_n^2}{s(s^2 + 2\zeta\omega_n s + \omega_n^2)}, \tag{4.8}$$

for which the transient output, as obtained from the Laplace transform table in Appendix A, is

$$c(t) = 1 - \frac{1}{\beta} e^{-\zeta\omega_n t} \sin(\omega_n \beta t + \theta), \tag{4.9}$$

where $\beta = \sqrt{1 - \zeta^2}$ and $\theta = \tan^{-1}\beta/\zeta$. The transient response of this second-order system for various values of the damping ratio ζ is shown in Fig. 4.5. As ζ decreases, the closed-loop roots approach the imaginary axis and the response becomes increasingly oscillatory. The response as a function of ζ and time is also shown in Fig. 4.5(b) for a step input.

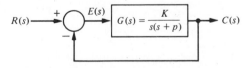

Figure 4.4. Closed-loop control system.

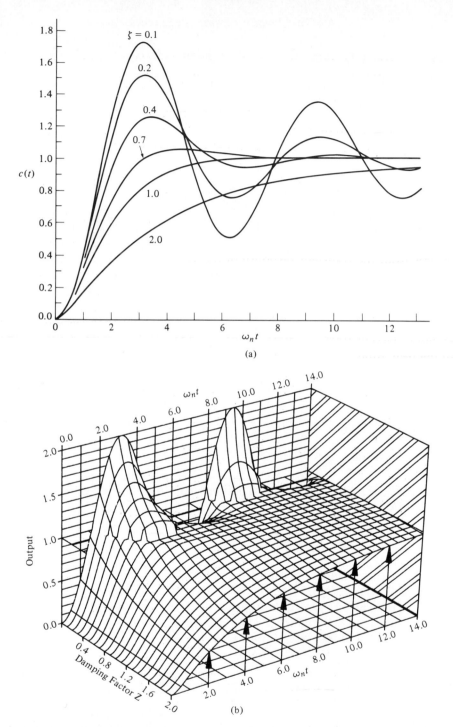

Figure 4.5. (a) Transient response of a second-order system (Eq. 4.9) for a step input. (b) The transient response of a second–order-system (Eq. 4.9) for a step input as a function of $\zeta = Z$ and $\omega_n t$. (Courtesy of Professor R. Jacquot, University of Wyoming.)

The Laplace transform of the unit impulse is $R(s) = 1$, and therefore the output for an impulse is

$$C(s) = \frac{\omega_n^2}{s^2 + 2\zeta\omega_n s + \omega_n^2}, \tag{4.10}$$

which is $T(s) = C(s)/R(s)$, the transfer function of the closed-loop system. The transient response for an impulse function input is then

$$c(t) = \frac{\omega_n}{\beta} e^{-\zeta\omega_n t} \sin \omega_n \beta t, \tag{4.11}$$

which is simply the derivative of the response to a step input. The impulse response of the second-order system is shown in Fig. 4.6 for several values of the damping ratio, ζ. Clearly, one is able to select several alternative performance measures from the transient response of the system for either a step or impulse input.

Standard performance measures are usually defined in terms of the step response of a system as shown in Fig. 4.7. The swiftness of the response is measured by the *rise time* T_r and the *peak time*. For underdamped systems with an overshoot, the 0 to 100% rise time is a useful index. If the system is overdamped, then the peak time is not defined and the 10–90% rise time, T_{r_1}, is normally used. The similarity with which the actual response matches the step input is measured by the percent overshoot and settling time T_s. The *percent overshoot*, P.O., is defined as

$$\text{P.O.} = \frac{M_{p_t} - fv}{fv} \times 100\% \tag{4.12}$$

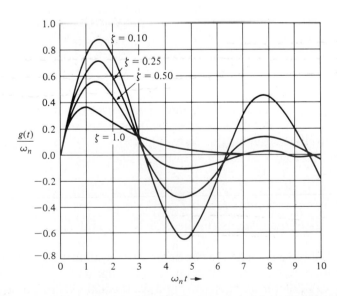

Figure 4.6. Response of a second-order system for an impulse function input.

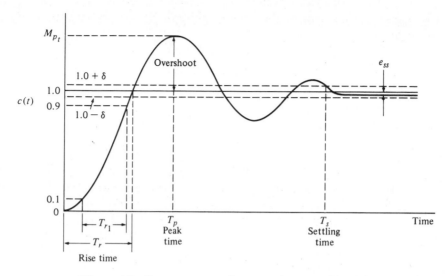

Figure 4.7. Step response of a control system (Eq. 4.9).

for a unit step input, where M_{p_t} is the peak value of the time response and fv is the final value of the response. Normally fv is the magnitude of the input, but many systems have a final value significantly different than the desired input magnitude. For the system with a unit step represented by Eq. (4.8), we have $fv = 1$.

The *settling time, T_s,* is defined as the time required for the system to settle within a certain percentage δ of the input amplitude. This band of $\pm \delta$ is shown in Fig. 4.7. For the second-order system with closed-loop damping constant $\zeta \omega_n$, the response remains within 2% after four time constants, or

$$T_s = 4\tau = \frac{4}{\zeta \omega_n}. \tag{4.13}$$

Therefore we will define the settling time as four time constants of the dominant response. Finally, the steady-state error of the system may be measured on the step response of the system as shown in Fig. 4.7.

Therefore the transient response of the system may be described in terms of two factors:

1. The swiftness of response, T_r and T_p
2. The closeness of the response to the desired M_{p_t} and T_s

As nature would have it, these are contradictory requirements and a compromise must be obtained. In order to obtain an explicit relation for M_{p_t} and T_p as a function of ζ, one can differentiate Eq. (4.9) and set it equal to zero. Alternatively, one

$c(t) = Eq\ 49$

may utilize the differentiation property of the Laplace transform, which may be written as

$$\mathcal{L}\left\{\frac{dc(t)}{dt}\right\} = sC(s)$$

[handwritten: $\mathcal{L}[s(cs)$ $= \dfrac{\omega_n}{\beta} e^{-\delta\omega_n t}\sin \omega_n \beta t$]

when the initial value of $c(t)$ is zero. Therefore we may acquire the derivative of $c(t)$ by multiplying Eq. (4.8) by s and thus obtaining the right side of Eq. (4.10). Taking the inverse transform of the right side of Eq. (4.10) we obtain Eq. (4.11), which is equal to zero when $\omega_n\beta t = \pi$. Therefore we find that the peak time relationship for this second-order system is *[handwritten: $n=1$]*

$$T_p = \frac{\pi}{\omega_n\sqrt{1-\zeta^2}}, \tag{4.14}$$

and the peak response is *[handwritten: Substitute T_p into 4.8 for t to obtain]*

$$M_{p_t} = 1 + e^{-\zeta\pi/\sqrt{1-\zeta^2}}. \tag{4.15}$$

Therefore the percent overshoot is *[handwritten: use Eq 4.12]*

$$\text{P.O.} = 100e^{-\zeta\pi/\sqrt{1-\zeta^2}}. \tag{4.16}$$

The percent overshoot versus the damping ratio ζ is shown in Fig. 4.8. Also, the normalized peak time, $\omega_n T_p$, is shown versus the damping ratio ζ in Fig. 4.8. The percent overshoot versus the damping ratio is listed in Table 4.2 for selected values of the damping ratio. Again, we are confronted with a necessary compromise between the swiftness of response and the allowable overshoot.

[handwritten: $\delta\downarrow$, $T_p\downarrow$ $\omega p\uparrow$]
[handwritten: $\delta\uparrow$ $T_p\uparrow$ $Op\downarrow$]

Figure 4.8. Percent overshoot and peak time versus damping ratio ζ for a second-order system (Eq. 4.8).

Table 4.2. Percent Peak Overshoot Versus Damping Ratio for a Second-Order System

Damping ratio	0.9	0.8	0.7	0.6	0.5	0.4	0.3
Percent overshoot	0.2	1.5	4.6	9.5	16.3	25.4	37.2

The curves presented in Fig. 4.8 are exact only for the second-order system of Eq. (4.8). However, they provide a remarkably good source of data, because many systems possess a dominant pair of roots and the step response can be estimated by utilizing Fig. 4.8. This approach, while an approximation, avoids the evaluation of the inverse Laplace transformation in order to determine the percent overshoot and other performance measures. For example, for a third-order system with a closed-loop transfer function

$$T(s) = \frac{1}{(s^2 + 2\zeta s + 1)(\gamma s + 1)}, \qquad (4.17)$$

the s-plane diagram is shown in Fig. 4.9. This third-order system is normalized with $\omega_n = 1$. It was ascertained experimentally that the performance as indicated by the percent overshoot, M_{p_t}, and the settling time, T_s, was represented by the second-order system curves when [4]

$$|1/\gamma| \geq 10|\zeta\omega_n|.$$

In other words, the response of a third-order system can be approximated by the *dominant roots* of the second-order system as long as the real part of the dominant roots is less than ⅒ of the real part of the third root.

Using a computer simulation, when $\zeta = 0.45$ one can determine the response of a system to a unit step input. When $\gamma = 2.25$ we find that the response is overdamped because the real part of the complex poles is -0.45, whereas the real

Figure 4.9. An s-plane diagram of a third-order system.

(a)

(b)

Figure 4.10. (a) Percent overshoot as a function of ζ and ω_n when a second-order transfer function contains a zero. (From R. N. Clark, *Introduction to Automatic Control Systems,* New York, Wiley, 1962, redrawn with permission.) (b) The response for the second-order transfer function with a zero for four values of the ratio $(a/\zeta\, w_n)$: $A = 5$, $B = 2$, $C = 1$ and $D = 0.5$.

Table 4.3. The Response of a Second-Order System with a Zero $(0 < \zeta < 1)$

$a/\zeta\,\omega_n$	Percent Overshoot	Settling Time	Peak Time
5	4.6	5.7	4.1
2	40.1	10.4	2.6
1	68.1	10.3	2.1
0.5	145.0	13.3	2.5

pole is equal to -0.444. The settling time is found via the simulation to be 12.8 seconds. If $\gamma = 0.90$ or $1/\gamma = 1.11$ is compared to $\zeta\omega_n = 0.45$ of the complex poles we find that the overshoot is 12% and the settling time is 6.4 seconds. If the complex roots were entirely dominant, we would expect the overshoot to be 20% and the settling time to be $4/\zeta\omega_n = 8.9$ seconds.

Also, we must note that the performance measures of Fig. 4.8 are correct only for a transfer function without finite zeros. If the transfer function of a system possesses finite zeros and they are located relatively near the dominant poles, then the zeros will materially affect the transient response of the system [5].

The transient response of a system with one zero and two poles may be affected by the location of the zero [5]. The percent overshoot for a step input as a function of $a/\zeta\omega_n$ is given in Fig. 4.10(a) for the system transfer function

$$T(s) = \frac{(\omega_n^2/a)(s + a)}{s^2 + 2\zeta\omega_n s + \omega_n^2}.$$

The actual transient response for a step input is shown in Fig. 4.10(b) for selected values of $a/\zeta\omega_n$. The actual response for these selected values is summarized in Table 4.3 when $0 < \zeta < 1$.

The correlation of the time-domain response of a system with the s-plane location of the poles of the closed-loop transfer function is very useful for selecting the specifications of a system. In order to illustrate clearly the utility of the s-plane, let us consider a simple example.

■ Example 4.1 Parameter Selection

A single-loop feedback control system is shown in Fig. 4.11. We desire to select the gain K and the parameter p so that the time-domain specifications will be satisfied. The transient response to a step should be as fast in responding as is reasonable and have an overshoot of less than 5%. Furthermore, the settling time should be less than four seconds. The minimum damping ratio ζ for an overshoot of 4.3% is 0.707. This damping ratio is shown graphically in Fig. 4.12. Because the settling time is

$\zeta\,(5\%) = 0.690$
using
Eq 4.16

$$T_s = \frac{4}{\zeta\omega_n} \leq 4 \text{ sec}, \tag{4.18}$$

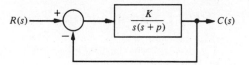

Figure 4.11. Single-loop feedback control system.

we require that the real part of the complex poles of $T(s)$ is

$$\zeta\omega_n \geq 1.$$

This region is also shown in Fig. 4.12. The region that will satisfy both time-domain requirements is shown cross-hatched on the s-plane of Fig. 4.12. If the closed-loop roots are chosen as the limiting point, in order to provide the fastest response, as r_1 and \hat{r}_1, then $r_1 = -1 + j1$ and $\hat{r}_1 = -1 - j1$. Therefore $\zeta = 1/\sqrt{2}$ and $\omega_n = 1/\zeta = \sqrt{2}$. The closed-loop transfer function is

$$T(s) = \frac{G(s)}{1 + G(s)} = \frac{K}{s^2 + ps + K}$$

$$= \frac{\omega_n^2}{s^2 + 2\zeta\omega_n s + \omega_n^2}.$$

(4.19)

Therefore we require that $K = \omega_n^2 = 2$ and $p = 2\zeta\omega_n = 2$. A full comprehension of the correlation between the closed-loop root location and the system transient response is important to the system analyst and designer. Therefore we shall consider the matter more fully in the following section.

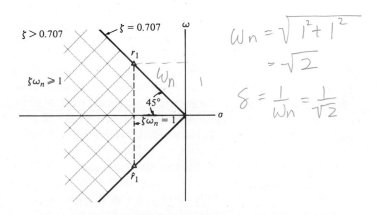

Figure 4.12. Specifications and root locations on the s-plane.

4.3 The s-Plane Root Location and the Transient Response

The transient response of a closed-loop feedback control system can be described in terms of the location of the poles of the transfer function. The closed-loop transfer function is written in general as

$$T(s) = \frac{C(s)}{R(s)} = \frac{\Sigma P_i(s)\Delta_i(s)}{\Delta(s)}, \tag{4.20}$$

where $\Delta(s) = 0$ is the characteristic equation of the system. For the single-loop system of Fig. 4.11, the characteristic equation reduces to $1 + G(s) = 0$. It is the poles and zeros of $T(s)$ that determine the transient response. However, for a closed-loop system, the poles of $T(s)$ are the roots of the characteristic $\Delta(s) = 0$ and the poles of $\Sigma P_i(s)\Delta_i(s)$. The output of a system without repeated roots and a unit step input can be formulated as a partial fraction expansion as

$$C(s) = \frac{1}{s} + \sum_{i=1}^{M} \frac{A_i}{s + \sigma_i} + \sum_{k=1}^{N} \frac{B_k}{s^2 + 2\alpha_k s + (\alpha_k^2 + \omega_k^2)}, \tag{4.21}$$

where the A_i and B_k are the residues. The roots of the system must be either $s = -\sigma_i$ or complex conjugate pairs as $s = -\alpha_k \pm j\omega_k$. Then the inverse transform results in the transient response as a sum of terms as follows:

$$c(t) = 1 + \sum_{i=1}^{M} A_i e^{-\sigma_i t} + \sum_{k=1}^{N} B_k \left(\frac{1}{\omega_k}\right) e^{-\alpha_k t} \sin \omega_k t. \tag{4.22}$$

The transient response is composed of the steady-state output, exponential terms, and damped sinusoidal terms. Obviously, in order for the response to be stable— that is, bounded for a step input—one must require that the real part of the roots, σ_i or α_k, be in the left-hand portion of the s-plane. The impulse response for various root locations is shown in Fig. 4.13. The information imparted by the location of the roots is graphic, indeed, and usually well worth the effort of determining the location of the roots in the s-plane.

It is important for the control system analyst to understand the relationship between the complex-frequency representation of a linear system, through the poles and zeros of its transfer function, and its time-domain response to step and other inputs. Many of the analysis and design calculations in such areas as signal processing and control are done in the complex-frequency plane, where a system model is represented in terms of the poles and zeros of its transfer function $T(s)$. On the other hand, system performance is often analyzed by examining time-domain responses, particularly when dealing with control systems.

The capable system designer will be able to envision the effects on the step and impulse responses of adding, deleting, or moving poles and zeros of $T(s)$ in the s-plane. Likewise, the designer should be able to visualize what changes should be made in the poles and zeros of $H(s)$ in order to effect desired changes in the model's step and impulse responses.

An experienced designer is aware of the effects of zero locations on system

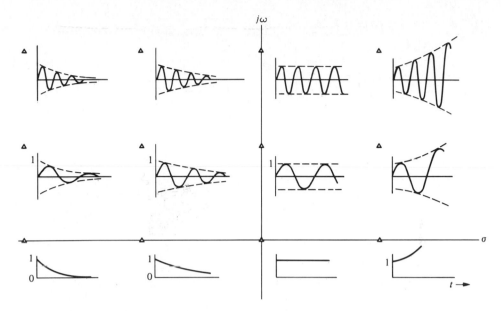

Figure 4.13. Impulse response for various root locations in the s-plane. (The conjugate root is not shown.)

response. The poles of $T(s)$ determine the particular response modes that will be present and the zeros of $T(s)$ establish the relative weightings of the individual mode functions. For example, moving a zero closer to a specific pole will reduce the relative contribution of the mode corresponding to the pole.

A computer program can be developed that allows a person to specify arbitrary sets of poles and zeros for the transfer function of a system. Then the computer will evaluate and plot the system's impulse and step responses individually. It will also display them along with the appropriate pole-zero plot.

Once the program has been run for a set of poles and zeros, the user can modify the locations of one or more of them. Plots are then presented showing the old and new poles and zeros in the complex plane, and the old and new impulse and step responses.

4.4 The Steady-State Error of Feedback Control Systems

One of the fundamental reasons for using feedback, despite its cost and increased complexity, is the attendant improvement in the reduction of the steady-state error of the system. As was illustrated in Section 3.5, the steady-state error of a stable closed-loop system is usually several orders of magnitude smaller than the error of the open-loop system. The system actuating signal, which is a measure of the system error, is denoted as $E_a(s)$. However, the actual system error is $E(s) =$

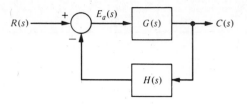

Figure 4.14. Closed-loop control system.

$R(s) - C(s)$. Considering the closed-loop feedback system of Fig. 4.14, we have

$$E(s) = R(s) - \frac{G(s)}{1 + GH(s)} R(s) = \frac{[1 + GH(s) - G(s)]}{1 + GH(s)} R(s). \quad (4.23)$$

The system error is equal to the actuating signal when $H(s) = 1$, which is a common situation. Then

$$E(s) = \frac{1}{1 + G(s)} R(s).$$

The steady-state error, when $H(s) = 1$, is then

$$\lim_{t \to \infty} e(t) = e_{ss} = \lim_{s \to 0} \frac{sR(s)}{1 + G(s)}. \quad (4.24)$$

It is useful to determine the steady-state error of the system for the three standard test inputs for a unity feedback system ($H(s) = 1$).

Step Input. The steady-state error for a step input is therefore

$$e_{ss} = \lim_{s \to 0} \frac{s(A/s)}{1 + G(s)} = \frac{A}{1 + G(0)}. \quad (4.25)$$

Clearly, it is the form of the loop transfer function $GH(s)$ that determines the steady-state error. The loop transfer function is written in general form as

$$G(s) = \frac{K\prod_{i=1}^{M}(s + z_i)}{s^{N}\prod_{k=1}^{Q}(s + p_k)}, \quad (4.26)$$

where \prod denotes the product of the factors. Therefore the loop transfer function as s approaches zero depends upon the number of integrations N. If N is greater than zero, then $G(0)$ approaches infinity and the steady-state error approaches zero. The number of integrations is often indicated by labeling a system with a *type number* which is simply equal to N.

type o if $n = 0$, $G(s) = \frac{K}{1} = K_p$ $e_{ss} = \frac{A}{1 + K_p}$ constant

≥ 1 if $n \geq 1$, $G(s) = \frac{K}{0} = \infty$ $e_{ss} = \frac{A}{\infty} = 0$

Therefore, for a type-zero system, $N = 0$, the steady-state error is

$$e_{ss} = \frac{A}{1 + G(0)}$$ (4.27)

$$= \frac{A}{1 + (K\prod_{i=1}^{M} z_i / \prod_{k=1}^{Q} p_k)} \cdot$$

The constant $G(0)$ is denoted by K_p, the position error constant, so that

$$e_{ss} = \frac{A}{1 + K_p} \cdot$$ (4.28)

Clearly, the steady-state error for a unit step input with one integration or more, $N \geq 1$, is zero because

$$e_{ss} = \lim_{s \to 0} \frac{A}{1 + (K\prod z_i / s^N \prod p_k)}$$ (4.29)

$$= \lim_{s \to 0} \frac{As^N}{s^N + (K\prod z_i / \prod p_k)} = 0.$$

Ramp Input. The steady-state error for a ramp (velocity) input is

$$e_{ss} = \lim_{s \to 0} \frac{s(A/s^2)}{1 + G(s)} = \lim_{s \to 0} \frac{A}{s + sG(s)} = \lim_{s \to 0} \frac{A}{sG(s)} \cdot$$ (4.30)

Again, the steady-state error depends upon the number of integrations N. For a type-zero system, $N = 0$, the steady-state error is infinite. For a type-one system, $N = 1$, the error is

$$e_{ss} = \lim_{s \to 0} \frac{A}{s\{[K\prod(s + z_i)]/[s\prod(s + p_k)]\}}$$

$$= \frac{A}{(K\prod z_i / \prod p_k)} = \frac{A}{K_v},$$ (4.31)

type	e_{ss}
0	∞
1	$\frac{A}{K_v}$
≥ 2	0

where K_v is designated the *velocity error constant*. When the transfer function possesses two or more integrations, $N \geq 2$, we obtain a steady-state error of zero.

Acceleration Input. When the system input is $r(t) = At^2/2$, the steady-state error is then

$$e_{ss} = \lim_{s \to 0} \frac{s(A/s^3)}{1 + G(s)}$$ (4.32)

$$= \lim_{s \to 0} \frac{A}{s^2 G(s)} \cdot$$

The steady-state error is infinite for <u>one integration</u>; and for <u>two integrations</u>, $N = 2$, we obtain

$$e_{ss} = \frac{A}{K\prod z_i / \prod p_k} = \frac{A}{K_a},$$ (4.33)

where K_a is designated the acceleration constant. When the number of integrations equals or exceeds three, then the steady-state error of the system is zero.

Control systems are often described in terms of their type number and the error constants, K_p, K_v, and K_a. Definitions for the error constants and the steady-state error for the three inputs are summarized in Table 4.4. The usefulness of the error constants can be illustrated by considering a simple example.

■ Example 4.2 Mobile robot steering control

A severely disabled person could use a mobile robot to serve as an assisting device or servant as shown in Fig. 4.15(a) [31]. The steering control system can be represented by the block diagram shown in Fig. 4.15(b). The steering controller, $G_1(s)$, is

$$G_1(s) = K_1 + K_2/s.$$ (4.34)

The steady-state error of the system for a step input when $K_2 = 0$ and $G_1(s) = K_1$ is therefore

$$e_{ss} = \frac{A}{1 + K_p},$$ (4.35)

where $K_p = KK_1$. When K_2 is greater than zero, we have <u>a type-one system</u>,

$$G_1(s) = \frac{K_1 s + K_2}{s},$$

and the steady-state error is zero for a step input.

Table 4.4. Summary of Steady-State Errors

Number of Integrations in $G(s)$, type number	Step, $r(t) = A$, $R(s) = A/s$	Ramp, At, A/s^2	Parabola, $At^2/2$, A/s^3
0	$e_{ss} = \dfrac{A}{1 + K_p}$	Infinite	Infinite
1	$e_{ss} = 0$	$\dfrac{A}{K_v}$	Infinite
2	$e_{ss} = 0$	0	$\dfrac{A}{K_a}$

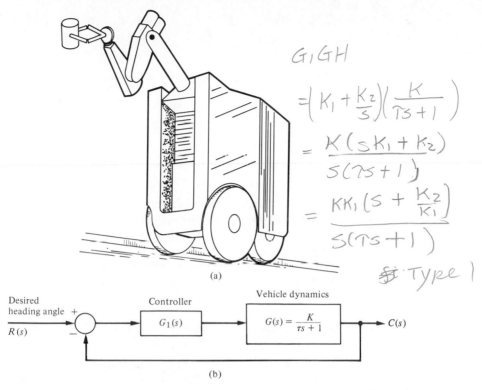

$$G_1 GH$$

$$= \left(K_1 + \frac{K_2}{s}\right)\left(\frac{K}{\tau s + 1}\right)$$

$$= \frac{K(sK_1 + K_2)}{s(\tau s + 1)}$$

$$= \frac{KK_1\left(s + \frac{K_2}{K_1}\right)}{s(\tau s + 1)}$$

∴ Type 1

(a)

Desired
heading angle +
$R(s)$

Controller
$G_1(s)$

Vehicle dynamics
$G(s) = \dfrac{K}{\tau s + 1}$

$C(s)$

(b)

Figure 4.15. (a) A mobile robotic aid for the severely handicapped would allow the disabled person to control the motion of the cart and robot. (b) Block diagram of steering control system.

If the steering command is a ramp input, the steady-state error is then

$$e_{ss} = \frac{A}{K_v}, \qquad \text{for type 1} \qquad (4.36)$$

where

$$K_v = \lim_{s \to 0} sG_1(s)G(s) = K_2 K.$$

The transient response of the vehicle to a triangular wave input when $G_1(s) = (K_1 s + K_2)/s$ is shown in Fig. 4.16. The transient response clearly shows the effect of the steady-state error, which may not be objectionable if K_v is sufficiently large.

The error constants, K_p, K_v, and K_a, of a control system describe the ability of a system to reduce or eliminate the steady-state error. They are therefore utilized as numerical measures of the steady-state performance. The designer determines the error constants for a given system and attempts to determine methods of increasing the error constants while maintaining an acceptable transient

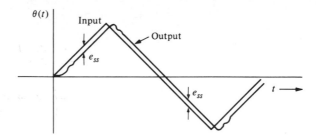

Figure 4.16. Triangular wave response.

response. In the case of the steering control system, it is desirable to increase the gain factor KK_2 in order to increase K_v and reduce the steady-state error. However, an increase in KK_2 results in an attendant decrease in the damping ratio, ζ, of the system and therefore a more oscillatory response to a step input. Again, a compromise would be determined that would provide the largest K_v based on the smallest ζ allowable.

4.5 Performance Indices

An increased amount of emphasis on the mathematical formulation and measurement of control system performance can be found in the recent literature on automatic control. A *performance index* is a quantitative measure of the performance of a system and is chosen so that emphasis is given to the important system specifications. Modern control theory assumes that the systems engineer can specify quantitatively the required system performance. Then a performance index can be calculated or measured and used to evaluate the system's performance. A quantitative measure of the performance of a system is necessary for the operation of modern adaptive control systems, for automatic parameter optimization of a control system, and for the design of optimum systems.

Whether the aim is to improve the design of a system or to design an adaptive control system, a performance index must be chosen and measured. Then the system is considered an *optimum control system* when the system parameters are adjusted so that the index reaches an extremum value, commonly a minimum value. A performance index, in order to be useful, must be a number that is always positive or zero. Then the best system is defined as the system that minimizes this index.

A suitable performance index is the integral of the square of the error, ISE, which is defined as

$$I_1 = \int_0^T e^2(t) \, dt. \tag{4.37}$$

The upper limit T is a finite time chosen somewhat arbitrarily so that the integral approaches a steady-state value. It is usually convenient to choose T as the set-

tling time, T_s. The step response for a specific feedback control system is shown in Fig. 4.17(b); and the error, in Fig. 4.17(c). The error squared is shown in Fig. 4.17(d); and the integral of the error squared, in Fig. 4.17(e). This criterion will discriminate between excessively overdamped systems and excessively underdamped systems. The minimum value of the integral occurs for a compromise value of the damping. The performance index of Eq. (4.37) is easily adapted for practical measurements, because a squaring circuit is readily obtained. Furthermore, the squared error is mathematically convenient for analytical and computational purposes.

Another readily instrumented performance criterion is the integral of the absolute magnitude of the error, IAE, which is written as

$$I_2 = \int_0^T |e(t)|\ dt. \tag{4.38}$$

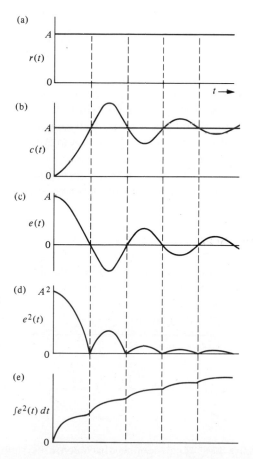

Figure 4.17. The calculation of the integral squared error.

This index is particularly useful for computer simulation studies. In order to reduce the contribution of the large initial error to the value of the performance integral, as well as to place an emphasis on errors occurring later in the response, the following index has been proposed [6]:

$$I_3 = \int_0^T t|e(t)|\ dt. \tag{4.39}$$

This performance index is designated the integral of time multiplied by absolute error, ITAE. Another similar index is the integral of time multiplied by the squared error, ITSE, which is

$$I_4 = \int_0^T te^2(t)\ dt. \tag{4.40}$$

The performance index I_3, ITAE, provides the best selectivity of the performance indices; that is, the minimum value of the integral is readily discernible as the system parameters are varied. The general form of the performance integral is

$$I = \int_0^T f(e(t),\ r(t),\ c(t),\ t)\ dt, \tag{4.41}$$

where f is a function of the error, input, output, and time. Clearly, one can obtain numerous indices based on various combinations of the system variables and time. It is worth noting that the minimization of IAE or ISE is often of practical significance. For example, the minimization of a performance index can be directly related to the minimization of fuel consumption for aircraft and space vehicles.

Performance indices are useful for the analysis and design of control systems. Two examples will illustrate the utility of this approach.

■ E x a m p l e 4.3 Performance criteria

A single-loop feedback control system is shown in Fig. 4.18, where the natural frequency is the normalized value, $\omega_n = 1$. The closed-loop transfer function is then

$$T(s) = \frac{1}{s^2 + 2\zeta s + 1}. \tag{4.42}$$

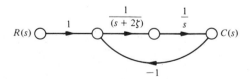

Figure 4.18. Single-loop feedback control system.

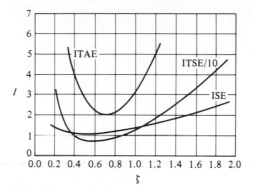

Figure 4.19. Three performance criteria for a second-order system. (Courtesy of Professor R. C. H. Wheeler, U.S. Naval Postgraduate School.)

Three performance indices—ISE, ITSE, and ITAE—calculated for various values of the damping ratio ζ and for a step input are shown in Fig. 4.19. These curves show the selectivity of the ITAE index in comparison with the ISE index. The value of the damping ratio ζ selected on the basis of ITAE is 0.7, which, for a second-order system, results in a swift response to a step with a 5% overshoot.

■ Example 4.4 Space telescope control system

The signal-flow graph of a space telescope pointing control system is shown in Fig. 4.20 [12]. We desire to select the magnitude of the gain K_3 in order to minimize the effect of the disturbance $U(s)$. The disturbance in this case is equivalent to an initial attitude error. The closed-loop transfer function for the disturbance is obtained by using the signal-flow gain formula as

$$\frac{C(s)}{U(s)} = \frac{P_1(s)\,\Delta_1(s)}{\Delta(s)}$$

$$= \frac{1 \cdot (1 + K_1 K_3 s^{-1})}{1 + K_1 K_3 s^{-1} + K_1 K_2 K_p\, s^{-2}} \tag{4.43}$$

$$= \frac{s(s + K_1 K_3)}{s^2 + K_1 K_3 s + K_1 K_2 K_p}.$$

Typical values for the constants are $K_1 = 0.5$ and $K_1 K_2 K_p = 2.5$. Then the natural frequency of the vehicle is $f_n = \sqrt{2.5}/2\pi = 0.25$ cycles/sec. For a unit step disturbance, the minimum ISE can be analytically calculated. The attitude $c(t)$ is

$$c(t) = \frac{\sqrt{10}}{\beta}\left[e^{-0.25 K_3 t} \sin\left(\frac{\beta}{2} t + \psi\right)\right], \tag{4.44}$$

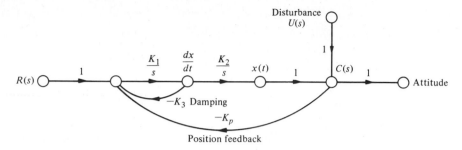

Figure 4.20. A space telescope pointing control system.

where $\beta = K_3\sqrt{(K_3^2/8)} - 5$. Squaring $c(t)$ and integrating the result, we have

$$
I = \int_0^\infty \frac{10}{\beta^2} e^{-0.5K_3 t} \sin^2\left(\frac{\beta}{2}t + \psi\right) dt
$$

$$
= \int_0^\infty \frac{10}{\beta^2} e^{-0.5K_3 t}\left(\frac{1}{2} - \frac{1}{2}\cos(\beta t + 2\psi)\right) dt \qquad (4.45)
$$

$$
= \left(\frac{1}{K_3} + 0.1K_3\right)
$$

Differentiating I and equating the result to zero, we obtain

$$
\frac{dI}{dK_3} = -K_3^{-2} + 0.1 = 0. \qquad (4.46)
$$

Therefore the minimum ISE is obtained when $K_3 = \sqrt{10} = 3.2$. This value of K_3 corresponds to a damping ratio ζ of 0.50. The values of ISE and IAE for this system are plotted in Fig. 4.21. The minimum for the IAE performance index is obtained when $K_3 = 4.2$ and $\zeta = 0.665$. While the ISE criterion is not as selective as the IAE criterion, it is clear that it is possible to solve analytically for the min-

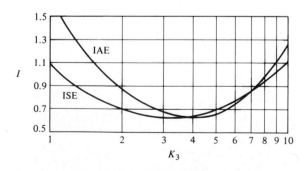

Figure 4.21. The performance indices of the telescope control system versus K_3.

imum value of ISE. The minimum of IAE is obtained by measuring the actual value of IAE for several values of the parameter of interest.

A control system is optimum when the selected performance index is minimized. However, the optimum value of the parameters depends directly upon the definition of optimum, that is, the performance index. Therefore, in the two examples, we found that the optimum setting varied for different performance indices.

The coefficients that will minimize the ITAE performance criterion for a step input have been determined for the general closed-loop transfer function [6]:

$$T(s) = \frac{C(s)}{R(s)} = \frac{b_0}{s^n + b_{n-1}s^{n-1} + \cdots + b_1s + b_0}. \tag{4.47}$$

This transfer function has a steady-state error equal to zero for a step input. The optimum coefficients for the ITAE criterion are given in Table 4.5. The responses using optimum coefficients for a step input are given in Fig. 4.22 for ISE, IAE, and ITAE. Other standard forms based on different performance indices are available and can be useful in aiding the designer to determine the range of coefficients for a specific problem. A final example will illustrate the utility of the standard forms for ITAE.

■ Example 4.5 Two-camera control

A very accurate and rapidly responding control system is required for a system which allows live actors seemingly to perform inside of complex miniature sets. The two-camera system is shown in Fig. 4.23(a), where one camera is trained on the actor and the other on the miniature set. The challenge is to obtain rapid and accurate coordination of the two cameras by using sensor information from the foreground camera to control the movement of the background camera. The block diagram of the background camera system is shown in Fig. 4.23(b) for one axis of movement of the background camera. The closed-loop transfer function is

$$T(s) = \frac{K_a K_m \omega_0^2}{s^3 + 2\zeta\omega_0 s^2 + \omega_0^2 s + K_a K_m \omega_0^2}. \tag{4.48}$$

Table 4.5. The Optimum Coefficients of $T(s)$ Based on the ITAE Criterion for a Step Input

$$s + \omega_n$$
$$s^2 + 1.4\omega_n s + \omega_n^2$$
$$s^3 + 1.75\omega_n s^2 + 2.15\omega_n^2 s + \omega_n^3$$
$$s^4 + 2.1\omega_n s^3 + 3.4\omega_n^2 s^2 + 2.7\omega_n^3 s + \omega_n^4$$
$$s^5 + 2.8\omega_n s^4 + 5.0\omega_n^2 s^3 + 5.5\omega_n^3 s^2 + 3.4\omega_n^4 s + \omega_n^5$$
$$s^6 + 3.25\omega_n s^5 + 6.60\omega_n^2 s^4 + 8.60\omega_n^3 s^3 + 7.45\omega_n^4 s^2 + 3.95\omega_n^5 s + \omega_n^6$$

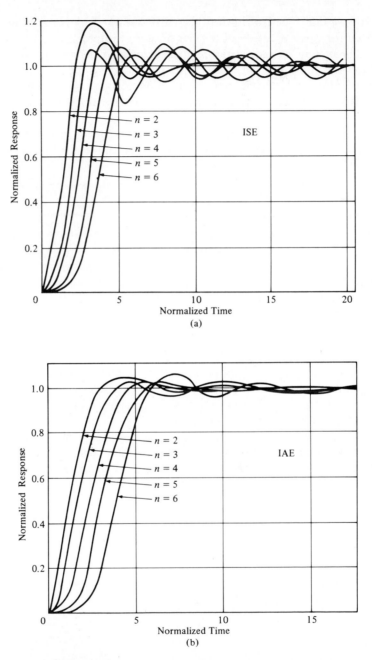

Figure 4.22. Step responses of a normalized transfer function using optimum coefficients for (a) ISE, (b) IAE, and (c) ITAE.

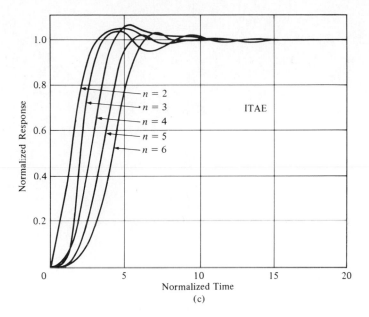

Figure 4.22.—*Continued*

The standard form for a third-order system given in Table 4.5 requires that

$$2\zeta\omega_0 = 1.75\omega_n, \qquad \omega_0^2 = 2.15\omega_n^2, \qquad K_a K_m \omega_0^2 = \omega_n^3.$$

Because a rapid response is required, a large ω_n will be selected so that the settling time will be less than one second. Thus, ω_n will be set equal to 50 rad/sec. Then, for an ITAE system, it is necessary that the parameters of the camera dynamics be

$$\omega_0 = 73 \text{ rad/sec}$$

and

$$\zeta = 0.60.$$

The amplifier and motor gain are required to be

$$K_a K_m = \frac{\omega_n^3}{\omega_0^2} = \frac{\omega_n^3}{2.15\omega_n^2} = \frac{\omega_n}{2.15} = 23.2.$$

Then, the closed-loop transfer function is

$$T(s) = \frac{125,000}{s^3 + 87.5s + 5375s + 125,000}$$

$$= \frac{125,000}{(s + 35.5)(s + 26 + j53.4)(s + 26 - j53.4)}. \tag{4.49}$$

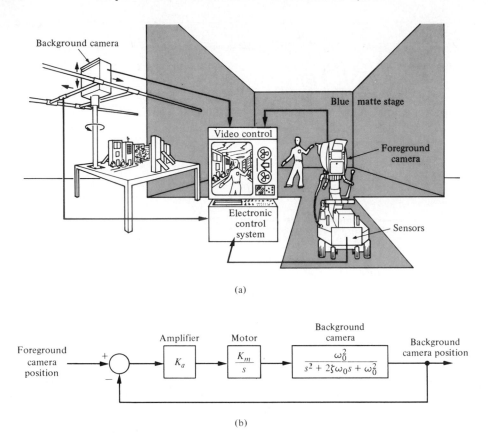

(a)

(b)

Figure 4.23. The foreground camera, which may be either a film or video camera, is trained on the blue cyclorama stage. The electronic servo control installation permits the slaving, by means of electronic servo devices, of the two cameras. The background camera reaches into the miniature set with a periscope lens and instantaneously reproduces all movements of the foreground camera in the scale of the miniature. The video control installation allows the composite image to be monitored and recorded live. (Part (a) reprinted with permission from Electronic Design 24, 11, May 24, 1976. Copyright © Hayden Publishing Co., Inc., 1976.)

The locations of the closed-loop roots dictated by the ITAE system are shown in Fig. 4.24. The damping ratio of the complex roots is $\zeta = 0.49$, and using Fig. 4.8 one may estimate the overshoot to be approximately 20%. The settling time is approximately $4(\frac{1}{26}) = 0.15$ seconds. This is only an approximation because the complex conjugate roots are not dominant; however, it does indicate the magnitude of the performance measures. The actual response to a step input using a computer simulation with CSDP showed the overshoot to be only 2% and the settling time equal to 0.08 seconds [32]. This illustrates the damping effect of the real root.

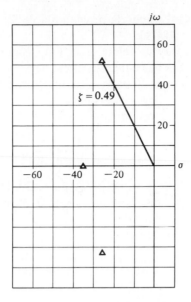

Figure 4.24. The closed-loop roots of a minimum ITAE system.

For a ramp input, the coefficients have been determined that minimize the ITAE criterion for the general closed-loop transfer function [6]:

$$T(s) = \frac{b_1 s + b_0}{s^n + b_{n-1} s^{n-1} + \cdots + b_1 s + b_0}. \tag{4.50}$$

This transfer function has a steady-state error equal to zero for a ramp input. The optimum coefficients for this transfer function are given in Table 4.6. The transfer function, Eq. (4.50), implies that the plant $G(s)$ has two or more pure integrations, as required to provide zero steady-state error.

4.6 The Simplification of Linear Systems

It is quite useful to study complex systems with high-order transfer functions by using lower-order approximate models. Thus, for example, a fourth-order system could be approximated by a second-order system leading to a use of the indices

Table 4.6. The Optimum Coefficients of $T(s)$ Based on the ITAE Criterion for a Ramp Input

$$s^2 + 3.2\omega_n s + \omega_n^2$$
$$s^3 + 1.75\omega_n s^2 + 3.25\omega_n^2 s + \omega_n^3$$
$$s^4 + 2.41\omega_n s^3 + 4.93\omega_n^2 s^2 + 5.14\omega_n^3 s + \omega_n^4$$
$$s^5 + 2.19\omega_n s^4 + 6.50\omega_n^2 s^3 + 6.30\omega_n^3 s^2 + 5.24\omega_n^4 s + \omega_n^5$$

in Fig. 4.8. There are several methods now available for reducing the order of a systems transfer function [10, 11].

One relatively simple way to delete a certain insignificant pole of a transfer function is to note a pole that has a negative real part that is much larger than the other poles. Thus that pole is expected to insignificantly affect the transient response.

For example, if we have a system plant where

$$G(s) = \frac{K}{s(s + 2)(s + 30)},$$

we can safely neglect the impact of the pole at $s = 30$. However, we must retain the steady state response of the system and thus we reduce the system to

$$G(s) = \frac{(K/30)}{s(s + 2)}.$$

We will let the high-order system be described by the transfer function

$$H(s) = K \frac{a_m s^m + a_{m-1} s^{m-1} + \cdots + a_1 s + 1}{b_n s^n + b_{n-1} s^{n-1} + \cdots + b_1 s + 1}, \tag{4.51}$$

in which the poles are in the left-hand s plane and $m \le n$. The lower-order approximate transfer function is

$$L(s) = K \frac{c_p s^p + \cdots + c_1 s + 1}{d_g s^g + \cdots + d_1 s + 1}, \tag{4.52}$$

where $p \le g < n$. Notice that the gain constant K is the same for the original and approximate system in order to ensure the same steady-state response. The method outlined in the following paragraph is based on selecting c_i and d_i in such a way that $L(s)$ has a frequency response (see Chapter 7) very close to that of $H(s)$ [10, 11]. This is equivalent to stating that $H(j\omega)/L(j\omega)$ is required to deviate the least amount from unity for various frequencies. The c and d coefficients are obtained by utilizing the following equation:

$$M^{(k)}(s) = \frac{d^k}{ds^k} M(s) \tag{4.53}$$

and

$$\Delta^{(k)}(s) = \frac{d^k}{ds^k} \Delta(s), \tag{4.54}$$

where $M(s)$ and $\Delta(s)$ are the numerator and denominator polynomials of $H(s)/L(s)$, respectively. We also define

$$M_{2q} = \sum_{k=0}^{2q} \frac{(-1)^{k+q} M^{(k)}(0) M^{(2q-k)}(0)}{k!(2q - k)!}, \qquad q = 0, 1, 2 \ldots \tag{4.55}$$

and a completely identical equation for Δ_{2q}. The solutions for the c and d coefficients are obtained by equating

$$M_{2q} = \Delta_{2q} \tag{4.56}$$

for $q = 1, 2, \ldots$ up to the number required to solve for the unknown coefficients [10].

Let us consider an example in order to clarify the use of these equations.

■ Example 4.6 A simplified model

Consider the third-order system

$$H(s) = \frac{6}{s^3 + 6s^2 + 11s + 6} = \frac{1}{1 + (^{11}\!\!/_6)s + s^2 + (^{1}\!\!/_6)s^3}. \tag{4.57}$$

Using the second-order model

$$L(s) = \frac{1}{1 + d_1 s + d_2 s^2}, \tag{4.58}$$

$M(s) = 1 + d_1 s + d_2 s^2$ and $\Delta(s) = 1 + (^{11}\!\!/_6)s + s^2 + (^{1}\!\!/_6)s^3$. Then

$$M^0(s) = 1 + d_1 s + d_2 s^2 \tag{4.59}$$

and $M^0(0) = 1$. Similarly,

$$M^1 = \frac{d}{ds}(1 + d_1 s + d_2 s^2) = d_1 + 2\,d_2 s. \tag{4.60}$$

Therefore $M^1(0) = d_1$. Continuing this process, we find that

$$
\begin{array}{ll}
M^0(0) = 1 & \Delta^0(0) = 1 \\
M^1(0) = d_1 & \Delta^1(0) = {}^{11}\!\!/_6 \\
M^2(0) = 2d_2 & \Delta^2(0) = 2 \\
M^3(0) = 0 & \Delta^3(0) = 1
\end{array}
\tag{4.61}
$$

We now equate $M_{2q} = \Delta_{2q}$ for $q = 1$ and 2. We find that for $q = 1$,

$$M_2 = (-1)\frac{M^0(0)M^2(0)}{2} + \frac{M^1(0)M^1(0)}{1} + (-1)\frac{M^2(0)M^0(0)}{2} \tag{4.62}$$

$$= -d_2 + d_1^2 - d_2 = -2d_2 + d_1^2.$$

Then, because the equation for Δ_2 is identical, we have

$$\Delta_2 = -\frac{\Delta^0(0)\,\Delta^2(0)}{2} + \frac{\Delta^1(0)\,\Delta^1(0)}{1} + (-1)\frac{\Delta^2(0)\,\Delta^0(0)}{2} \tag{4.63}$$

$$= -1 + \frac{121}{36} - 1 = \frac{49}{36}.$$

Therefore, because $M_2 = \Delta_2$, we have

$$-2d_2 + d_1^2 = {}^{49}\!/\!{}_{36}. \tag{4.64}$$

Completing the process for $M_4 = \Delta_4$, when $q = 2$, we obtain

$$d_2^2 = {}^{7}\!/\!{}_{18}. \tag{4.65}$$

Then the solution for $L(s)$ is $d_1 = 1.615$ and $d_2 = 0.625$. (The other sets of solutions are rejected because they lead to unstable poles.) It is interesting to see that the poles of $H(s)$ are $s = -1, -2, -3$, whereas the poles of $L(s)$ are at $s = -1.029$ and -1.555. The lower-order system transfer function is

$$
\begin{aligned}
L(s) &= \frac{1}{1 + 1.615s + 0.625s^2} \\
&= \frac{1.60}{s^2 + 2.584s + 1.60}.
\end{aligned} \tag{4.66}
$$

Because the lower-order model has two poles, we can estimate that we would obtain a slightly overdamped response with a settling time of approximately four seconds.

It is sometimes desirable to retain the dominant poles of the original system, $H(s)$, in the low-order model. This can be accomplished by specifying the denominator of $L(s)$ to be the dominant poles of $H(s)$ and allow the numerator of $L(s)$ to be subject to approximation. A complex system such as the robot system shown in Fig. 4.25 is an example of a high-order system that can be favorably represented by a low-order model.

4.7 Design Example: Hubble Telescope Pointing Control

The Hubble space telescope, the most complex and expensive scientific instrument that has ever been built, is orbiting the earth. Launched to 380 miles above the earth on April 24, 1990, the telescope has pushed technology to new limits. The telescope's 2.4 meter (94.5-inch) mirror has the smoothest surface of any mirror made and its pointing system can center it on a dime 400 miles away [23, 24]. The mirror, as it turns out, has a spherical aberration. However, the Hubble telescope can point accurately. Consider the model of the telescope-pointing system shown in Fig. 4.26.

The goal of the design is to choose K_1 and K so that (1) the percent overshoot of the output to a step command, $r(t)$, is less than or equal to 10%, (2) the steady-state error to a ramp command is minimized, and (3) the effect of a step disturbance is reduced. Since the system has an inner loop, block diagram reduction can be used to obtain the simplified system of Fig. 4.26(b).

Mason's formula can be used to obtain the output due to the two inputs

$$C(s) = T(s)R(s) + [T(s)/K]\,D(s), \tag{4.67}$$

where

$$T(s) = \frac{KG(s)}{1 + KG(s)} = \frac{KG(s)}{1 + L(s)}.$$

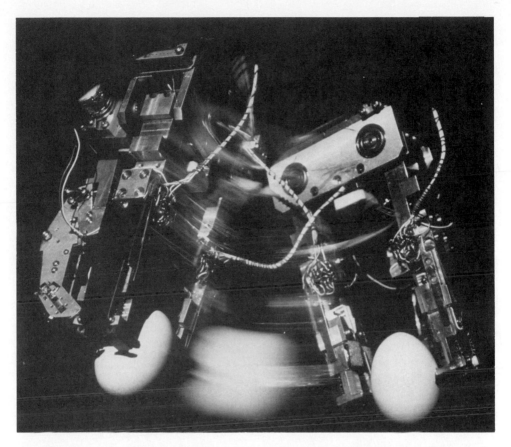

Figure 4.25. A high-performance robot with a delicate touch illustrates the challenge of modern high-performance control systems. (Photo courtesy of Hitachi America Ltd.)

The error $E(s)$ is

$$E(s) = \frac{1}{1 + L(s)} R(s) - \frac{G(s)}{1 + L(s)} D(s). \tag{4.68}$$

First, let us select K and K_1 to meet the percent overshoot requirement for a step input, $R(s) = A/s$. Setting $D(s) = 0$, we have

$$
\begin{aligned}
C(s) &= \frac{KG(s)}{1 + KG(s)} R(s) \\
&= \frac{K}{s(s + K_1) + K} \left(\frac{A}{s}\right) \\
&= \frac{K}{s^2 + K_1 s + K} \left(\frac{A}{s}\right).
\end{aligned}
\tag{4.69}
$$

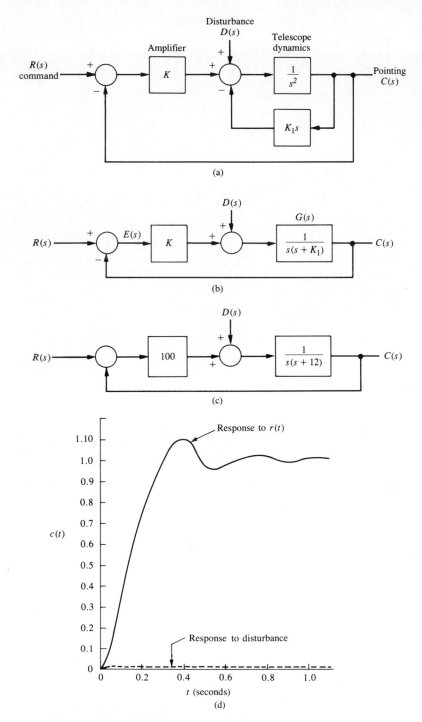

Figure 4.26. (a) The Hubble telescope pointing system, (b) reduced block diagram, (c) system design, and (d) system response to a unit step input command and a unit step disturbance input.

In order to set the overshoot at 10%, we select $\zeta = 0.6$ by examining Fig. 4.8 or using Eq. (4.14) to determine that the overshoot will be 9.5% for $\zeta = 0.6$. We next examine the steady-state error for a ramp, $r(t) = Bt$, $t \geq 0$, using (Eq. 4.30):

$$e_{ss} = \lim_{s \to 0} \left\{ \frac{B}{sKG(s)} \right\}$$

$$= \frac{B}{(K/K_1)} \, . \tag{4.70}$$

The steady-state error due to a step disturbance is equal to zero. (Can you show this?) The transient response of the error due to the step disturbance input can be reduced by increasing K (see Eq. 4.68). Thus, in summary, we seek a large K, a ζ of the characteristic equation equal to 0.6, and a large value of (K/K_1) in order to obtain a low steady-state error for the ramp input (see Eq. 4.70).

For our design, we need to select K. The characteristic equation of the system is

$$(s^2 + 2\zeta\omega_n s + \omega_n^2) = (s^2 + 2(0.6)\omega_n s + K). \tag{4.71}$$

Therefore $\omega_n = \sqrt{K}$ and the second term of the denominator of Eq. (4.69) requires $K_1 = 2(0.6)\omega_n$. Then, $K_1 = 1.2\sqrt{K}$ or the ratio K/K_1 becomes

$$\frac{K}{K_1} = \frac{K}{1.2\sqrt{K}}$$

$$= \frac{\sqrt{K}}{1.2} \, .$$

Selecting $K = 25$, we have $K_1 = 6$ and $K/K_1 = 4.17$. If we select $K = 100$, we have $K_1 = 12$ and $K/K_1 = 8.33$. Realistically, we must limit K so that the system's operation remains linear. Using $K = 100$, we obtain the system shown in Fig. 4.26(c). The responses of the system to a unit step input command and a unit step disturbance input are shown in Fig. 4.26(d). Note how the effect of the disturbance is relatively insignificant.

4.8 Summary

In this chapter we have considered the definition and measurement of the performance of a feedback control system. The concept of a performance measure or index was discussed and the usefulness of standard test signals was outlined. Then several performance measures for a standard step input test signal were delineated. For example, the overshoot, peak time, and settling time of the response of the system under test for a step input signal were considered. The fact that often the specifications on the desired response are contradictory was noted and the concept of a design compromise was proposed. The relationship between the location of the s-plane root of the system transfer function and the system

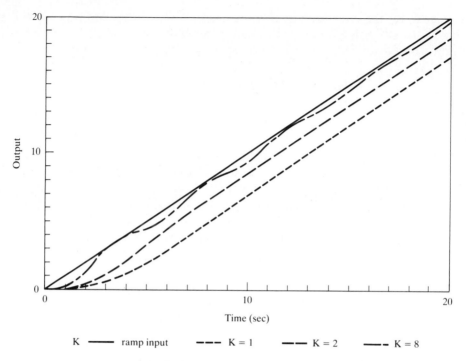

Figure 4.27. The response of a feedback system to a ramp input with $K = 1, 2,$ and 8 when $G(s) = K/[s(s + 1)(s + 3)]$. Note the steady-state error is reduced as K is increased, but the response becomes oscillatory at $K = 8$.

response was discussed. A most important measure of system performance is the steady-state error for specific test input signals. Thus the relationship of the steady-state error of a system in terms of the system parameters was developed by utilizing the final-value theorem. The capability of a feedback control system is demonstrated in Fig. 4.27. Finally, the utility of an integral performance index was outlined and several examples of design which minimized a system's performance index were completed. Thus we have been concerned with the definition and usefulness of quantitative measures of the performance of feedback control systems.

Exercises

E4.1. A motor control system for a computer disk drive must reduce the effect of disturbances and parameter variations, as well as reduce the steady-state error. We desire to have no steady-state error for the head-positioning control system, which is of the form shown in Figure 4.14 where $H(s) = 1$. (a) What type number is required? (How many integrations?) (b) If the input is a ramp signal, then in order to achieve a zero steady-state error, what type number is required?

E4.2. The engine, body, and tires of a racing vehicle affect the acceleration and speed attainable [25]. The speed control of the car is represented by the model shown in Fig. E4.2. (a) Calculate the steady-state error of the car to a step command in speed. (b) Calculate overshoot of the speed to a step command.

Figure E4.2. Racing car speed control.

E4.3. For years, Amtrak has struggled to attract passengers on its routes in the Midwest, using technology developed decades ago. During the same time, foreign railroads were developing new passenger rail systems that could profitably compete with air travel. Two of these systems, the French TGV and the Japanese Shinkansen, reach speeds of 160 mph [23, 24]. The Transrapid-06, a U.S. experimental magnetic levitation train is shown in Fig. E4.3(a).

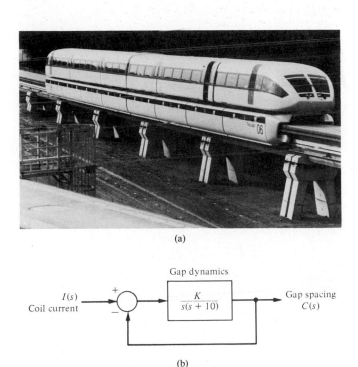

(a)

(b)

Figure E4.3. Levitated train control.

The use of magnetic levitation and electromagnetic propulsion to provide contactless vehicle movement makes the Transrapid-06 technology radically different from the existing Metroliner. The underside of the TR-06 carriage (where the wheel trucks would be on a conventional car) wraps around a guideway. Magnets on the bottom of the guideway attract electro magnets on the "wraparound," pulling it up toward the guideway. This suspends the vehicles about one centimeter above the guideway. (See problem 2.27.)

The levitation control is represented by Fig. E4.3(b). (a) Using Table 4.5 for a step input, select K so that the system provides an optimum ITAE response. (b) Using Fig. 4.8, determine the expected overshoot to a step input of $I(s)$.

Answers: K = 50 ; 4.5%

E4.4. A feedback system with negative unity feedback has a plant

$$G(s) = \frac{s + 6}{s(s + 4)}$$

(see Fig. 4.14). (a) Determine the closed-loop transfer function $T(s) = C(s)/R(s)$. (b) Find the time response $c(t)$ for a step input $r(t) = A$ for $t > 0$. (c) Using Fig. 4.10, determine the overshoot of the response. (d) Using the final value theorem, determine the steady-state value of $c(t)$.

E4.5. A low inertia plotter is shown in Fig. E4.5(a), on the next page. This system may be represented by the block diagram shown in Fig. E4.5(b) [19]. (a) Calculate the steady-state error for a ramp input. (b) Select a value of K that will result in zero overshoot to a step input but as rapid response as is attainable.

Plot the poles and zeros of this system and discuss the dominance of the complex poles. What overshoot for a step input do you expect?

E4.6. Effective control of insulin injections can result in better lives for diabetic persons. Automatically controlled insulin injection by means of a pump and a sensor that measures blood sugar can be very effective. A pump and injection system has a feedback control as shown in Fig. E4.6, on the next page. Calculate the suitable gain K so that the overshoot of the step response due to the drug injection is approximately 15%. $R(s)$ is the desired blood-sugar level and $C(s)$ is the actual blood-sugar level. (Hint: use Fig. 4.10.)

Answer: K = 1.67

E4.7. A control system for positioning the head of a floppy disk drive has a closed-loop transfer function

$$T(s) = \frac{0.313(s + 0.8)}{(s + 0.25)(s^2 + 0.3s + 1)} \cdot$$

Plot the poles and zeros of this system and discuss the dominance of the complex poles. What overshoot for a step input do you expect?

E4.8. A prototype for a microwave-powered aircraft was recently tested. The energy to drive the small airplane's electric engine is powered by microwave power beamed up from an earth station. A commercial version will have a 36m wingspan and a 24m long fuselage and it will be used for unmanned reconnaissance and radio relay [21]. If the aircraft flies at 50,000 ft, determine the accuracy of the beam transmission required if it is cruising at 16 mph. Assume the movement is a ramp input and determine the maximum steady-state error allowable.

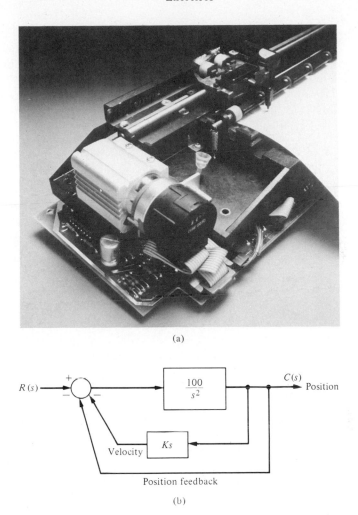

(a)

(b)

Figure E4.5. (a) The Hewlett-Packard *x-y* plotter. (Courtesy of Hewlett-Packard Co.) (b) Block diagram of plotter.

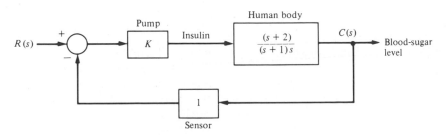

Figure E4.6. Blood-sugar level control.

Problems

P4.1. An important problem for television camera systems is the jumping or wobbling of the picture due to the movement of the camera. This effect occurs when the camera is mounted in a moving truck or airplane. A system called the Dynalens system has been designed which reduces the effect of rapid scanning motion and is shown in Fig. P4.1 [27]. A maximum scanning motion of 25°/sec is expected. Let $K_g = K_t = 1$ and assume that τ_g is negligible. (a) Determine the error of the system $E(s)$. (b) Determine the necessary loop gain, $K_a K_m K_t$, when a 1°/sec steady-state error is allowable. (c) The motor time constant is 0.40 sec. Determine the necessary loop gain so that the settling time of v_b is less than or equal to 0.04 sec.

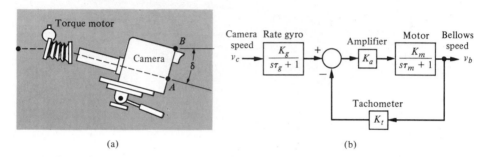

(a) (b)

Figure P4.1. Camera wobble control.

P4.2. A laser beam can be used to weld, drill, etch, cut, and mark metals, as shown in Fig. P4.2(a), on the next page [19]. Assume we have a work requirement for an accurate laser to mark a parabolic path with a closed-loop control system as shown in Fig. P4.2(b). Calculate the necessary gain to result in a steady-state error of 1 mm for $r(t) = t^2$, cm/s^2.

P4.3. A specific closed-loop control system is to be designed for an underdamped response to a step input. The specifications for the system are as follows:

$$20\% > \text{percent overshoot} > 10\%$$

$$\text{Settling time} < 0.8 \text{ sec}$$

(a) Identify the desired area for the dominant roots of the system. (b) Determine the smallest value of a third root, r_3, if the complex conjugate roots are to represent the dominant response. (c) The closed-loop system transfer function $T(s)$ is third order and the feedback has a unity gain. Determine the forward transfer function $G(s) = C(s)/E(s)$ when the settling time is 0.8 sec and the percent overshoot is 20%.

P4.4. The open-loop transfer function of a unity negative feedback system is

$$G(s) = \frac{K}{s(s + 2)}.$$

A system response to a step input is specified as follows:

$$\text{peak time } T_p = 1.1 \text{ sec}$$

$$\text{percent overshoot} = 5\%.$$

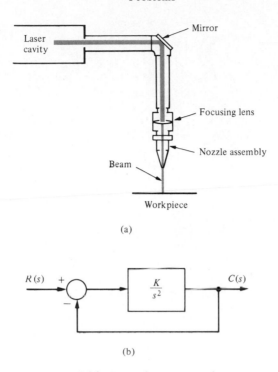

(a)

(b)

Figure P4.2. Laser beam control.

(a) Determine whether both specifications can be met simultaneously. (b) If the specifications cannot be met simultaneously, determine a compromise value for K so that the peak time and percent overshoot specifications are relaxed the same percentage.

P4.5. A space telescope is to be launched to carry out astronomical experiments [12]. The pointing control system is desired to achieve 0.01 minutes of arc and track solar objects with apparent motion up to 0.21 minutes per second. The system is illustrated in Fig. P4.5 (a), on the next page. The control system is shown in Fig. P4.5(b). Assume that $\tau_1 = 1$ sec and $\tau_2 = 0$ (an approximation). (a) Determine the gain $K = K_1 K_2$ required so that the response to a step command is as rapid as reasonable with an overshoot of less than 5%. (b) Determine the steady-state error of the system for a step and a ramp input. (c) Determine the value of $K_1 K_2$ for an ITAE optimal system for (1) a step input and (2) a ramp input.

P4.6. A robot is programmed to have a tool or welding torch follow a prescribed path [15]. Consider a robot tool that is to follow a sawtooth path as shown in Fig. P4.6(a), on the following page. The transfer function of the plant is

$$G(s) = \frac{1000(s + 2)}{s(s + 10)(s + 12)}$$

for the closed-loop system shown in Fig. 4.6(b). Calculate the steady-state error.

(a)

Controller $G_1(s)$

Input
$R(s)$ $+$ $\dfrac{K_2(\tau_1 s + 1)}{(\tau_2 s + 1)}$ $\dfrac{K_1}{s^2}$ Pointing
angle
$C(s)$

(b)

Figure P4.5. (a) The space telescope. (b) The space telescope pointing control system.

$r(t)$

10

0

0 10 20 30 40

Time (sec)

(a)

$R(s)$ $+$ $G(s)$ $C(s)$
Path
trajectory

(b)

Figure P4.6. Robot path control.

(a)

(b)

Figure P4.7. (a) Astronaut Bruce McCandless II is shown a few meters away from the earth-orbiting space shuttle *Challenger*. He used a nitrogen-propelled hand-controlled device called the manned maneuvering unit. (Courtesy of National Aeronautics and Space Administration.) (b) Block diagram of controller.

P4.7. Astronaut Bruce McCandless II took the first untethered walk in space on February 7, 1984, using the gas-jet propulsion device illustrated in Fig. P4.7(a) on the previous page. The controller can be represented by a gain K_2 as shown in Fig. P4.7(b). The inertia of the man and equipment with his arms at his sides is 25 Kg-m². (a) Determine the necessary gain K_3 to maintain a steady-state error equal to 1 cm when the input is a ramp $r(t) = t$ (meters). (b) With this gain K_3, determine the necessary gain $K_1 K_2$ in order to restrict the percent overshoot to 10%. (c) Determine analytically the gain $K_1 K_2$ in order to minimize the ISE performance index for a step input.

P4.8. Photovoltaic arrays (solar cells) generate a dc voltage that can be used to drive dc motors or that can be converted to ac power and added to the distribution network. It is desirable to maintain the power out of the array at its maximum available as the solar incidence changes during the day. One such closed-loop system is shown in Fig. P4.8. The transfer function for the process is

$$G(s) = \frac{K}{s + 4},$$

where $K = 10$. Find (a) the time constant of the closed-loop system and (b) the settling time of the system when disturbances such as clouds occur.

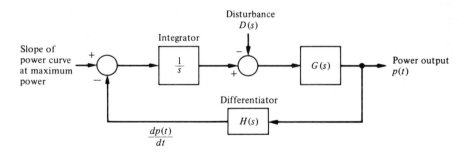

Figure P4.8. Solar cell control.

P4.9. The antenna that receives and transmits signals to the *Telstar* communication satellite is the largest horn antenna ever built. The microwave antenna is 177 ft long, weighs 340 tons, and rolls on a circular track. A photo of the antenna is shown in Fig. P4.9, on the next page. The *Telstar* satellite is 34 inches in diameter and moves about 16,000 mph at an altitude of 2500 miles. The antenna must be positioned accurately to ½₀ of a degree, because the microwave beam is 0.2° wide and highly attenuated by the large distance. If the antenna is following the moving satellite, determine the K_v necessary for the system.

P4.10. A speed-control system of an armature controlled dc-motor uses the back emf voltage of the motor as a feedback signal. (a) Draw the block diagram of this system (see Eq. 2.66). (b) Calculate the steady-state error of this system to a step input command setting the speed to a new level. Assume that $R_a = L_a = J = f = 1$, the motor constant is $k_m = 1$, and $K_b = 1$. (c) Select a feedback gain for the back emf signal to yield a step response with an overshoot of 15%.

Figure P4.9. A model of the antenna for the Telstar System at Andover, Maine. (Photo courtesy of Bell Telephone Laboratories, Inc.)

P4.11. A simple unity feedback control system has a process transfer function

$$\frac{C(s)}{E(s)} = G(s) = \frac{K}{s}.$$

The system input is a step function with an amplitude A. The initial condition of the system at time t_0 is $c(t_0) = Q$, where $c(t)$ is the output of the system. The performance index is defined as

$$I = \int_0^\infty e^2(t)\, dt.$$

(a) Show that $I = (A - Q)^2/2K$. (b) Determine the gain K that will minimize the performance index I. Is this gain a practical value? (c) Select a practical value of gain and determine the resulting value of the performance index.

P4.12. Train travel between cities will increase as trains are developed that travel at high speeds, making the train-travel time from city center to city center equivalent to airline-travel time. The Japanese National Railway has a train called the Bullet Express (Fig. P4.12) that travels between Tokyo and Osaka on the Tokaido line. This train travels the 320 miles in 3 hours and 10 minutes, an average speed of 101 mph [24]. This speed will be increased as new systems are used, such as magnetically levitated systems to float vehicles above an aluminum guideway. In order to maintain a desired speed, a speed control

Figure P4.12. Fifty minutes out of Tokyo, the Bullet Express whizzes past Mt. Fuji. (Photo courtesy of the Japan National Tourist Organization.)

system is proposed which yields a zero steady-state error to a ramp input. A third-order system is sufficient. Determine the optimum system for an ITAE performance criterion and estimate the settling time and overshoot for a step input when $\omega_n = 6$.

P4.13. It is desired to approximate a fourth-order system by a lower-order model. The transfer function of the original system is

$$H(s) = \frac{s^3 + 7s^2 + 24s + 24}{s^4 + 10s^3 + 35s^2 + 50s + 24} = \frac{s^3 + 7s^2 + 24s + 24}{(s + 1)(s + 2)(s + 3)(s + 4)}.$$

Show that if we obtain a second-order model by the method of Section 4.6, and we do not specify the poles and the zero of $L(s)$, we have

$$L_1(s) = \frac{0.2917s + 1}{0.399s^2 + 1.375s + 1} = \frac{0.731(s + 3.428)}{(s + 1.043)(s + 2.4)}.$$

P4.14. For the original system of problem 4.13, it is desired to find the lower-order model when the poles of the second-order model are specified as -1 and -2 and the model has one unspecified zero. Show that this low-order model is

$$L(s) = \frac{0.986s + 2}{s^2 + 3s + 2} = \frac{0.986(s + 2.028)}{(s + 1)(s + 2)}.$$

P4.15. A magnetic amplifier with a low output impedance is shown in Fig. P4.15 in cascade with a low pass filter and a preamplifier. The amplifier has a high input impedance and a gain of one and is used for adding the signals as shown. Select a value for the capacitance C so that the transfer function $V_o(s)/V_{in}(s)$ has a damping ratio of $1/\sqrt{2}$. The time constant of the magnetic amplifier is equal to one second and the gain is $K = 10$. Calculate the settling time of the resulting system.

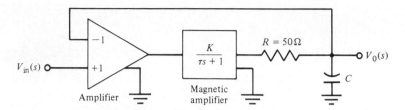

Figure P4.15. Feedback amplifier.

P4.16. Electronic pacemakers for human hearts regulate the speed of the heart pump. A proposed closed-loop system that includes a pacemaker and the measurement of the heart rate is shown in Fig. P4.16. The transfer function of the heart pump and the pacemaker is found to be

$$G(s) = \frac{K}{s(s/12 + 1)}.$$

Design the amplifier gain to yield a tightly controlled system with a settling time to a step disturbance of less than one second. The overshoot to a step in desired heart rate should be less than 10%. (a) Find a suitable range of K. (b) If the nominal value of K is $K = 10$, find the sensitivity of the system to small changes in K. (c) Evaluate the sensitivity at DC (set $s = 0$). (d) Evaluate the magnitude of the sensitivity at the normal heart rate of 60 beats/minute.

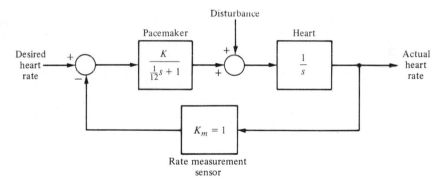

Figure P4.16. Heart pacemaker.

P4.17. Consider the original third-order system given in Example 4.6. Determine a first-order model with one pole unspecified and no zeros that will represent the third-order system.

P4.18. A closed-loop control system with negative unity feedback has a plant with a transfer function

$$G(s) = \frac{8}{s(s^2 + 6s + 12)}.$$

(a) Determine the closed-loop transfer function $T(s)$. (b) Determine a second-order approximation for $T(s)$ using the method of Section 4.6. (c) Using CSDP or a suitable computer program, plot the response of $T(s)$ and the second-order approximation to a unit step input and compare the results.

Design Problems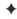

DP4.1. The roll control autopilot of a jet fighter is shown in Fig. DP4.1. The goal is to select a suitable K so that the response to a unit step command $\phi_d(t) = A$, $t \geq 0$, will provide a response $\phi(t)$ with a fast response and an overshoot of less than 20%. (a) Determine the closed-loop transfer function $\phi(s)/\phi_d(s)$. (b) Determine the roots of the characteristic equation for $K = 0.7$, 3, and 6. (c) Using the concept of dominant roots, find the expected overshoot and peak time for the approximate second-order system. (d) Plot the actual response and compare with the approximate results of part (c). (e) Select the gain K so that the percentage overshoot is equal to 16%. What is the resulting peak time?

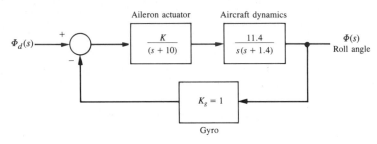

Figure DP4.1. Roll angle control.

DP4.2. The design of the control for a welding arm with a long reach requires the careful selection of the parameters. The system is shown in Fig. DP4.2, where $\zeta = 0.2$ and the gain K and the natural frequency ω_n can be selected. (a) Determine K and ω_n so that the response a unit step input achieves a peak time for the first overshoot (above the desired level of one) is less than or equal to 1 second and the overshoot is less than 5%. (Hint: Try $0.1 < K/\omega_n < 0.3$.) (b) Plot the response of the system designed in part (a) to a step input.

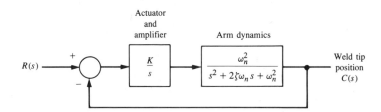

Figure DP4.2. Welding tip position control.

DP4.3. Active suspension systems for modern automobiles provide a quality, firm ride. The design of an active suspension system adjusts the valves of the shock absorber so that the ride fits the conditions. A small electric motor, as shown in Fig. DP4.3, changes the valve settings [33]. Select a design value for K and the parameter q in order to satisfy the ITAE performance for a step command, $R(s)$, and a settling time for the step response of less than or equal to 0.5 second. Upon completion of your design, predict the resulting overshoot for a step input.

Figure DP4.3. Active suspension system.

Terms and Concepts

Dominant roots The roots of the characteristic equation that cause the dominant transient response of the system.

Optimum control system A system whose parameters are adjusted so that the performance index reaches an extremum value.

Overshoot The amount the system output response proceeds beyond the desired response.

Peak time The time for a system to respond to a step input and rise to a peak response.

Performance index A quantitative measure of the performance of a system.

Rise time The time for a system to respond to a step input and attain a response equal to the magnitude of the input.

Settling time The time required for the system output to settle within a certain percentage of the input amplitude.

Specifications A set of prescribed performance criteria.

Test input signal An input signal used as a standard test of a system's ability to respond adequately.

Type number The number, N, of poles of the transfer function, $G(s)$, at the origin. $G(s)$ is the forward path transfer function.

Velocity error constant, K_v The constant evaluated as $\lim_{s \to 0} [s\, G(s)]$ for a type one system. The steady state error for a ramp input for a type one system is equal to A/K_v.

References

1. J. L. Shearer, *Dynamic Modeling of Engineering Systems,* Macmillan, New York, 1990.
2. R. C. Dorf, *Introduction to Electric Circuits,* John Wiley & Sons, New York, 1989.
3. D. L. Schilling, *Electronic Circuits,* 3rd ed., McGraw-Hill, New York, 1989.
4. P. R. Clement, "A Note on Third-Order Linear Systems," *IRE Transactions on Automatic Control,* June 1960; p. 151.

5. R. N. Clark, *Introduction to Automatic Control Systems,* John Wiley & Sons, New York, 1962; pp. 115–24.

6. D. Graham and R. C. Lathrop, "The Synthesis of Optimum Response: Criteria and Standard Forms, Part 2," *Trans. of the AIEE,* **72,** November 1953; pp. 273–88.

7. S. Franco, *Design with Operational Amplifiers and Analog Integrated Circuits,* McGraw-Hill, New York, 1988.

8. K. J. Astrom and B. Wittenmark, *Adaptive Control,* Addison-Wesley, Reading, Mass., 1989.

9. L. E. Ryan, "Control of an Impact Printer Hammer," *ASME J. of Dynamic Systems,* March 1990; pp. 69–75.

10. T. C. Hsia, "On the Simplification of Linear Systems," *IEEE Transactions on Automatic Control,* June 1972; pp. 372–74.

11. E. J. Davison, "A Method for Simplifying Linear Dynamic Systems," *IEEE Transactions on Automatic Control,* January 1966; pp. 93–101.

12. B. Sridhar, "Design of a Precision Pointing Control System for the Space Infrared Telescope Facility," *IEEE Control Systems,* February 1986; pp. 28–34.

13. T. Beardsley, "Hubble's Legacy," *Scientific American,* June 1990; pp. 18–19.

14. C. Phillips and R. Harbor, *Feedback Control Systems,* Prentice Hall, Englewood Cliffs, N.J., 1991.

15. J. Cloutier, "Assessment of Air-to-Air Missile Guidance and Control Technology," *IEEE Control Systems,* October 1989; pp. 27–34.

16. H. Inooka, "Experimental Studies of Manual Optimization in Control Tasks," *IEEE Control Systems,* August 1990; pp. 20–23.

17. E. J. Stefanides, "Electric Signals Set Air Regulator's Pressures," *Design News,* June 22, 1987; pp. 86–88.

18. D. F. Enns, "Multivariable Flight Control for an Attack Helicopter," *IEEE Control Systems,* April 1987; pp. 86–88.

19. R. Kurzweil, *The Age of Intelligent Machines,* M.I.T. Press, Cambridge, Mass., 1990.

20. E. Kamen, *Signals and Systems,* 2nd ed., Macmillan, New York, 1990.

21. D. McLean, *Automatic Flight Control Systems,* Prentice Hall, Englewood Cliffs, N.J., 1990.

22. E. K. Parsons, "Pointing Control on a Flexible Structure," *IEEE Control Systems,* April 1989; pp. 79–86.

23. H. Kirrmann, "Train Control Systems," *IEEE Micro,* August 1990; pp. 79–80.

24. D. MacKenzie, "French Line Up Europe's High Speed Trains," *New Scientist,* April 28, 1990; p. 41.

25. D. Fuller, "Little Engines That Can," *High Technology,* June 1986; pp. 12–23.

26. D. L. Trumper, "An Electronically Controlled Pressure Regulator," *ASME J. of Dynamic Systems,* March 1989; pp. 75–82.

27. J. De La Cierva, "Rate Servo Keeps TV Picture Clear," *Control Engineering,* May 1965; p. 112.

28. K. K. Chew, "Control of Errors in Disk Drive Systems," *IEEE Control Systems,* January 1990; pp. 16–19.

29. J. J. Moskwa, "Algorithms for Automotive Engine Control," *IEEE Control Systems,* April 1990; pp. 88–92.

30. J. Nilsson, *Electric Circuits,* 3rd ed., Addison-Wesley, Reading, Mass., 1990.

31. R. C. Dorf, *The Encyclopedia of Robotics,* John Wiley & Sons, New York, 1988.

32. R. C. Dorf and R. Jacquot, *The Control System Design Program,* Addison-Wesley, Reading, Mass., 1988.

33. D. Sherman, "Riding on Electrons," *Popular Science,* September 1990; pp. 74–77.

CHAPTER 5

The Stability of Linear Feedback Systems

Preview

The idea of a stable system is familiar to us. We know that an unstable device will exhibit an erratic and destructive response. Thus we seek to ensure that a system is stable and exhibits a bounded transient response.

The stability of a feedback system is related to the location of the roots of the characteristic equation of the system transfer function. Thus we wish to develop a few methods for determining whether a system is stable, and if so, how stable it is.

In this chapter we consider the characteristic equation and examine the determination of the location of its roots. We also will consider a method of the determination of a system's stability that does not require the determination of the roots, but uses only the polynomial coefficients of the characteristic equation.

5.1 The Concept of Stability

The transient response of a feedback control system is of primary interest and must be investigated. A very important characteristic of the transient performance of a system is the *stability* of the system. A *stable system* is defined as a system with a bounded system response. That is, if the system is subjected to a bounded input or disturbance and the response is bounded in magnitude, the system is said to be stable.

The concept of stability can be illustrated by considering a right circular cone placed on a plane horizontal surface. If the cone is resting on its base and is tipped slightly, it returns to its original equilibrium position. This position and response is said to be stable. If the cone rests on its side and is displaced slightly, it rolls with no tendency to leave the position on its side. This position is designated as the neutral stability. On the other hand, if the cone is placed on its tip and released, it falls onto its side. This position is said to be unstable. These three positions are illustrated in Fig. 5.1.

The stability of a dynamic system is defined in a similar manner. The response to a displacement, or initial condition, will result in either a decreasing, neutral, or increasing response. Specifically, it follows from the definition of stability that a linear system is stable if and only if the absolute value of its impulse response, $g(t)$, integrated over an infinite range, is finite. That is, in terms of the convolution integral Eq. (4.1) for a bounded input, one requires that $\int_0^\infty |g(t)|\, dt$ be finite. The location in the s-plane of the poles of a system indicate the resulting transient response. The poles in the left-hand portion of the s-plane result in a decreasing response for disturbance inputs. Similarly, poles on the $j\omega$-axis and in the right-hand plane result in a neutral and an increasing response, respectively, for a disturbance input. This division of the s-plane is shown in Fig. 5.2. Clearly the poles of desirable dynamic systems must lie in the left-hand portion of the s-plane [20].

A common example of the potential destabilizing effect of feedback is that of feedback in audio amplifier and speaker systems used for public address in auditoriums. In this case a loudspeaker produces an audio signal that is an amplified version of the sounds picked up by a microphone. In addition to other audio inputs, the sound coming from the speaker itself may be sensed by the micro-

| (a) Stable | (b) Neutral | (c) Unstable |

Figure 5.1. The stability of a cone.

Figure 5.2. Stability in the *s*-plane.

phone. How strong this particular signal is depends upon the distance between the loud speaker and the microphone. Because of the attenuating properties of air, the larger this distance is, the weaker the signal is that reaches the microphone. In addition, due to the finite propagation speed of sound waves, there is time delay between the signal produced by the loudspeaker and that sensed by the microphone. In this case, the output from the feedback path is added to the external input. This is an example of positive feedback.

As the distance between the loud speaker and the microphone decreases, we find that if the microphone is placed too close to the speaker then the system will be unstable. The result of this instability is an excessive amplification and distortion of audio signals and an oscillatory squeal.

Another example of an unstable system is shown in Fig. 5.3. The first bridge across the Tacoma Narrows at Puget Sound, Washington, was opened to traffic on July 1, 1940. The bridge was found to oscillate whenever the wind blew. After four months, on November 7, 1940, a wind produced an oscillation that grew in amplitude until the bridge broke apart. Figure 5.3(a) shows the condition of beginning oscillation; Fig. 5.3(b) shows the catastrophic failure [11].

In terms of linear systems, we recognize that the stability requirement may be defined in terms of the location of the poles of the closed-loop transfer function. The closed-loop system transfer function is written as

$$T(s) = \frac{p(s)}{q(s)} = \frac{K\prod_{i=1}^{M}(s + z_i)}{s^N \prod_{k=1}^{Q}(s + \sigma_k) \prod_{m=1}^{R}[s^2 + 2\alpha_m s + (\alpha_m^2 + \omega_m^2)]}, \quad (5.1)$$

where $q(s) = \Delta(s)$ is the characteristic equation whose roots are the poles of the closed-loop system. The output response for an impulse function input is then

$$c(t) = \sum_{k=1}^{Q} A_k e^{-\sigma_k t} + \sum_{m=1}^{R} B_m \left(\frac{1}{\omega_m}\right) e^{-\alpha_m t} \sin \omega_m t \quad (5.2)$$

when $N = 0$. Clearly, in order to obtain a bounded response, the poles of the closed-loop system must be in the left-hand portion of the *s*-plane. Thus, *a necessary and sufficient condition that a feedback system be stable is that all the poles of the system transfer function have negative real parts.*

Figure 5.3(a).

Figure 5.3(b). (Photos courtesy of F. B. Farquharson.)

In order to ascertain the stability of a feedback control system, one could determine the roots of the characteristic equation $q(s)$. However, we are first interested in determining the answer to the question: "Is the system stable?" If we calculate the roots of the characteristic equation in order to answer this question, we have determined much more information than is necessary. Therefore, several methods have been developed which provide the required "yes" or "no" answer to the stability question. The three approaches to the question of stability are: (1) The s-plane approach, (2) the frequency plane $(j\omega)$ approach, and (3) the time-domain approach. The real frequency $(j\omega)$ approach is outlined in Chapter 8, and the discussion of the time-domain approach is deferred until Chapter 9.

5.2 The Routh-Hurwitz Stability Criterion

The discussion and determination of stability has occupied the interest of many engineers. Maxwell and Vishnegradsky first considered the question of stability of dynamic systems. In the late 1800s, A. Hurwitz and E. J. Routh published independently a method of investigating the stability of a linear system [2, 3]. The Routh-Hurwitz stability method provides an answer to the question of stability by considering the characteristic equation of the system. The characteristic equation in the Laplace variable is written as

$$\Delta(s) = q(s) = a_n s^n + a_{n-1} s^{n-1} + \cdots + a_1 s + a_0 = 0. \tag{5.3}$$

In order to ascertain the stability of the system, it is necessary to determine if any of the roots of $q(s)$ lie in the right half of the s-plane. If Eq. (5.3) is written in factored form, we have

$$a_n(s - r_1)(s - r_2) \cdots (s - r_n) = 0, \tag{5.4}$$

where $r_i = i$th root of the characteristic equation. Multiplying the factors together, we find that

$$\begin{aligned}
q(s) = {} & a_n s^n - a_n(r_1 + r_2 + \cdots + r_n)s^{n-1} \\
& + a_n(r_1 r_2 + r_2 r_3 + r_1 r_3 + \cdots)s^{n-2} \\
& - a_n(r_1 r_2 r_3 + r_1 r_2 r_4 \cdots)s^{n-3} + \cdots \\
& + a_n(-1)^n r_1 r_2 r_3 \cdots r_n = 0.
\end{aligned} \tag{5.5}$$

In other words, for an nth-degree equation, we obtain

$$\begin{aligned}
q(s) = {} & a_n s^n - a_n(\text{sum of all the roots})s^{n-1} \\
& + a_n(\text{sum of the products of the roots taken 2 at a time})s^{n-2} \\
& - a_n(\text{sum of the products of the roots taken 3 at a time})s^{n-3} \\
& + \cdots + a_n(-1)^n(\text{product of all } n \text{ roots}) = 0.
\end{aligned} \tag{5.6}$$

Examining Eq. (5.5), we note that all the coefficients of the polynomial must have the same sign if all the roots are in the left-hand plane. Also, it is necessary

$s = r\,\text{mm}$

for a stable system that all the coefficients be nonzero. However, although these requirements are necessary, they are not sufficient; that is, if they are not satisfied, we immediately know the system is unstable. However, if they are satisfied, we must proceed to ascertain the stability of the system. For example, when the characteristic equation is

$$q(s) = (s + 2)(s^2 - s + 4) = (s^3 + s^2 + 2s + 8), \qquad (5.7)$$

the system is unstable and yet the polynomial possesses all positive coefficients.

The *Routh-Hurwitz criterion* is a necessary and sufficient criterion for the stability of linear systems. The method was originally developed in terms of determinants, but we shall utilize the more convenient array formulation.

The Routh-Hurwitz criterion is based on ordering the coefficients of the characteristic equation

$$a_n s^n + a_{n-1} s^{n-1} + a_{n-2} s^{n-2} + \cdots + a_1 s + a_0 = 0 \qquad (5.8)$$

into an array or schedule as follows [4]:

$$
\begin{array}{c|ccc}
s^n & a_n & a_{n-2} & a_{n-4} \quad \cdots \\
s^{n-1} & a_{n-1} & a_{n-3} & a_{n-5} \quad \cdots
\end{array}
$$

Then, further rows of the schedule are completed as follows:

$$
\begin{array}{c|ccc}
s^n & a_n & a_{n-2} & a_{n-4} \\
s^{n-1} & a_{n-1} & a_{n-3} & a_{n-5} \\
s^{n-2} & b_{n-1} & b_{n-3} & b_{n-5} \\
s^{n-3} & c_{n-1} & c_{n-3} & c_{n-5} \\
\cdot & \cdot & \cdot & \cdot \\
\cdot & \cdot & \cdot & \cdot \\
\cdot & \cdot & \cdot & \cdot \\
s^0 & h_{n-1} &
\end{array}
$$

where

$$b_{n-1} = \frac{(a_{n-1})(a_{n-2}) - a_n(a_{n-3})}{a_{n-1}} = \frac{-1}{a_{n-1}} \begin{vmatrix} a_n & a_{n-2} \\ a_{n-1} & a_{n-3} \end{vmatrix},$$

$$b_{n-3} = -\frac{1}{a_{n-1}} \begin{vmatrix} a_n & a_{n-4} \\ a_{n-1} & a_{n-5} \end{vmatrix},$$

and

$$c_{n-1} = \frac{-1}{b_{n-1}} \begin{vmatrix} a_{n-1} & a_{n-3} \\ b_{n-1} & b_{n-3} \end{vmatrix},$$

and so on. The algorithm for calculating the entries in the array can be followed on a determinant basis or by using the form of the equation for b_{n-1}.

The Routh-Hurwitz criterion states that the number of roots of q(s) with positive real parts is equal to the number of changes in sign of the first column of the array. This criterion requires that there be no changes in sign in the first column for a stable system. This requirement is both necessary and sufficient.

There are three distinct cases that must be treated separately, requiring suitable modifications of the array calculation procedure. The three cases are: (1) No element in the first column is zero; (2) there is a zero in the first column, but some other elements of the row containing the zero in the first column are nonzero; and (3) there is a zero in the first column, and the other elements of the row containing the zero are also zero.

In order to clearly illustrate this method, several examples will be presented for each case.

Case 1. No element in the first column is zero.

■ **E x a m p l e 5.1 Second-order system**

The characteristic equation of a second-order system is

$$q(s) = a_2 s^2 + a_1 s + a_0.$$

The array is written as

$$
\begin{array}{c|cc}
s^2 & a_2 & a_0 \\
s & a_1 & 0 \\
s^0 & b_1 & 0
\end{array}
$$

where

$$b_1 = \frac{a_1 a_0 - (0)a_2}{a_1} = \frac{-1}{a_1} \begin{vmatrix} a_2 & a_0 \\ a_1 & 0 \end{vmatrix} = a_0.$$

Therefore the requirement for a stable second-order system is simply that all the coefficients be positive.

■ **E x a m p l e 5.2 Third-order system**

The characteristic equation of a third-order system is

$$q(s) = a_3 s^3 + a_2 s^2 + a_1 s + a_0.$$

The array is

$$
\begin{array}{c|cc}
s^3 & a_3 & a_1 \\
s^2 & a_2 & a_0 \\
s^1 & b_1 & 0 \\
s^0 & c_1 & 0
\end{array}
$$

where

$$b_1 = \frac{a_2 a_1 - a_0 a_3}{a_2} \quad \text{and} \quad c_1 = \frac{b_1 a_0}{b_1} = a_0.$$

For the third-order system to be stable, it is necessary and sufficient that the coefficients be positive and $a_2 a_1 \geq a_0 a_3$. The condition when $a_2 a_1 = a_0 a_3$ results in

a borderline stability case, and one pair of roots lies on the imaginary axis in the s-plane. This borderline case is recognized as Case 3 because there is a zero in the first column when $a_2 a_1 = a_0 a_3$, and it will be discussed under Case 3.

As a final example of characteristic equations that result in no zero elements in the first row, let us consider a polynomial

$$q(s) = (s - 1 + j\sqrt{7})(s - 1 - j\sqrt{7})(s + 3) = s^3 + s^2 + 2s + 24. \quad (5.9)$$

The polynomial satisfies all the necessary conditions because all the coefficients exist and are positive. Therefore, utilizing the Routh-Hurwitz array, we have

$$
\begin{array}{c|cc}
s^3 & 1 & 2 \\
s^2 & 1 & 24 \\
s^1 & -22 & 0 \\
s^0 & 24 & 0
\end{array}
$$

Because two changes in sign appear in the first column, we find that two roots of $q(s)$ lie in the right-hand plane, and our prior knowledge is confirmed.

Case 2. *Zeros in the first column while some other elements of the row containing a zero in the first column are nonzero.*

If only one element in the array is zero, it may be replaced with a small positive number ϵ which is allowed to approach zero after completing the array. For example, consider the following characteristic equation:

$$q(s) = s^5 + 2s^4 + 2s^3 + 4s^2 + 11s + 10. \quad (5.10)$$

The Routh-Hurwitz array is then

$$
\begin{array}{c|ccc}
s^5 & 1 & 2 & 11 \\
s^4 & 2 & 4 & 10 \\
s^3 & \epsilon & 6 & 0 \\
s^2 & c_1 & 10 & 0 \\
s^1 & d_1 & 0 & 0 \\
s^0 & 10 & 0 & 0
\end{array}
$$

where

$$c_1 = \frac{4\epsilon - 12}{\epsilon} = \frac{-12}{\epsilon} \quad \text{and} \quad d_1 = \frac{6c_1 - 10\epsilon}{c_1} \to 6.$$

There are two sign changes due to the large negative number in the first column, $c_1 = -12/\epsilon$. Therefore the system is unstable and two roots lie in the right half of the plane.

■ Example 5.3 Unstable system

As a final example of the type of Case 2, consider the characteristic equation

$$q(s) = s^4 + s^3 + s^2 + s + K, \quad (5.11)$$

where it is desired to determine the gain K that results in borderline stability. The Routh-Hurwitz array is then

$$
\begin{array}{c|ccc}
s^4 & 1 & 1 & K \\
s^3 & 1 & 1 & 0 \\
s^2 & \epsilon & K & 0 \\
s^1 & c_1 & 0 & 0 \\
s^0 & K & 0 & 0
\end{array}
$$

where

$$
c_1 = \frac{\epsilon - K}{\epsilon} \rightarrow \frac{-K}{\epsilon}.
$$

Therefore, for any value of K greater than zero, the system is unstable. Also, because the last term in the first column is equal to K, a negative value of K will result in an unstable system. Therefore the system is unstable for all values of gain K.

Case 3. Zeros in the first column, and the other elements of the row containing the zero are also zero.

Case 3 occurs when all the elements in one row are zero or when the row consists of a single element which is zero. This condition occurs when the polynomial contains singularities that are symmetrically located about the origin of the s-plane. Therefore Case 3 occurs when factors such as $(s + \sigma)(s - \sigma)$ or $(s + j\omega)(s - j\omega)$ occur. This problem is circumvented by utilizing the *auxiliary equation,* which immediately precedes the zero entry in the Routh array. The order of the auxiliary equation is always even and indicates the number of symmetrical root pairs.

In order to illustrate this approach, let us consider a third-order system with a characteristic equation:

$$
q(s) = s^3 + 2s^2 + 4s + K, \tag{5.12}
$$

where K is an adjustable loop gain. The Routh array is then

$$
\begin{array}{c|cc}
s^3 & 1 & 4 \\
s^2 & 2 & K \\
s^1 & \dfrac{8 - K}{2} & 0 \\
s^0 & K & 0.
\end{array}
$$

Therefore, for a stable system, we require that

$$
0 \leq K \leq 8.
$$

When $K = 8$, we have two roots on the $j\omega$-axis and a borderline stability case. Note that we obtain a row of zeros (Case 3) when $K = 8$. The auxiliary equation, $U(s)$, is the equation of the row preceding the row of zeros. The equation of the

row preceding the row of zeros is, in this case, obtained from the s^2-row. We recall that this row contains the coefficients of the even powers of s and therefore in this case, we have

$$U(s) = 2s^2 + Ks^0 = 2s^2 + 8 = 2(s^2 + 4) = 2(s + j2)(s - j2). \quad (5.13)$$

In order to show that the auxiliary equation, $U(s)$, is indeed a factor of the characteristic equation, we divide $q(s)$ by $U(s)$ to obtain

$$
\begin{array}{r}
\tfrac{1}{2}s + 1 \\
2s^2 + 8 \overline{\smash{)}\, s^3 + 2s^2 + 4s + 8} \\
\underline{s^3 \qquad\quad + 4s} \\
2s^2 \qquad + 8 \\
2s^2 \qquad + 8
\end{array}
$$

Therefore, when $K = 8$, the factors of the characteristic equation are

$$q(s) = (s + 2)(s + j2)(s - j2). \quad (5.14)$$

Strictly, the borderline case response is an unacceptable oscillation.

■ **Example 5.4 Robot control**

Let us consider the control of a robot arm as shown in Fig. 5.4. It is predicted that there will be about 100,000 robots in service throughout the world by 1996 [6]. The robot shown in Fig. 5.4 is a six-legged micro robot system using highly flexible legs with high gain controllers that may become unstable and oscillate. Under this condition, we have the characteristic polynomial

$$q(s) = s^5 + s^4 + 4s^3 + 24s^2 + 3s + 63. \quad (5.15)$$

The Routh-Hurwitz array is

$$
\begin{array}{c|ccc}
s^5 & 1 & 4 & 3 \\
s^4 & 1 & 24 & 63 \\
s^3 & -20 & -60 & 0 \\
s^2 & 21 & 63 & 0 \\
s^1 & 0 & 0 & 0.
\end{array}
$$

Therefore the auxiliary equation is

$$U(s) = 21s^2 + 63 = 21(s^2 + 3) = 21(s + j\sqrt{3})(s - j\sqrt{3}), \quad (5.16)$$

which indicates that two roots are on the imaginary axis. In order to examine the remaining roots, we divide by the auxiliary equation to obtain

$$\frac{q(s)}{s^2 + 3} = s^3 + s^2 + s + 21.$$

Figure 5.4. A completely integrated, six-legged, micro robot system. The legged design provides maximum dexterity. Legs also provide a unique sensory system for environmental interaction. It is equipped with a sensor network that includes 150 sensors of 12 different types. The legs are instrumented so that it can determine the lay of the terrain, the surface texture, hardness, and even color. The gyro-stabilized camera and rangefinder can be used for gathering data beyond the robot's immediate reach. This high performance system is able to walk quickly, climb over obstacles, and perform dynamic motions. Courtesy of IS Robotics Corporation.

Establishing a Routh-Hurwitz array for this equation, we have

$$
\begin{array}{c|cc}
s^3 & 1 & 1 \\
s^2 & 1 & 21 \\
s^1 & -20 & 0 \\
s^0 & 21 & 0
\end{array}.
$$

The two changes in sign in the first column indicate the presence of two roots in the right-hand plane, and the system is unstable. The roots in the right-hand plane are $s = +1 \pm j\sqrt{6}$.

■ Example 5.5 Disk-drive control

Large disk-storage devices are used with today's computers [17]. The data head is moved to different positions on the spinning disk and rapid, accurate response is required. A block diagram of a disk-storage data-head positioning system is

Figure 5.5. Head position control.

shown in Fig. 5.5. It is desired to determine the range of K and a for which the system is stable. The characteristic equation is

$$1 + G(s) = 1 + \frac{K(s + a)}{s(s + 1)(s + 2)(s + 3)} = 0.$$

Therefore $q(s) = s^4 + 6s^3 + 11s^2 + (K + 6)s + Ka = 0$. Establishing the Routh array, we have

$$
\begin{array}{c|ccc}
s^4 & 1 & 11 & Ka \\
s^3 & 6 & (K + 6) & \\
s^2 & b_3 & Ka & \\
s^1 & c_3 & & \\
s^0 & Ka & &
\end{array}
$$

where

$$b_3 = \frac{60 - K}{6}$$

and

$$c_3 = \frac{b_3(K + 6) - 6Ka}{b_3}.$$

The coefficient c_3 sets the acceptable range of K and a, while b_3 requires that K be less than 60. Setting $c_3 = 0$ we obtain

$$(K - 60)(K + 6) + 36Ka = 0.$$

The required relationship between K and a is then

$$a \le \frac{(60 - K)(K + 6)}{36K}$$

when a is positive. Therefore, if $K = 40$, we require $a \le 0.639$.

5.3 The Relative Stability of Feedback Control Systems

The verification of stability of the Routh-Hurwitz criterion provides only a partial answer to the question of stability. The Routh-Hurwitz criterion ascertains the absolute stability of a system by determining if any of the roots of the character-

Figure 5.6. Root locations in the s-plane.

istic equation lie in the right half of the s-plane. However, if the system satisfies the Routh-Hurwitz criterion and is absolutely stable, it is desirable to determine the *relative stability;* that is, it is necessary to investigate the relative damping of each root of the characteristic equation. The relative stability of a system may be defined as the property that is measured by the relative settling times of each root or pair of roots. Therefore relative stability is represented by the real part of each root. Thus root r_2 is relatively more stable than the roots r_1, \hat{r}_1 as shown in Fig. 5.6. The relative stability of a system can also be defined in terms of the relative damping coefficients ζ of each complex root pair and therefore in terms of the speed of response and overshoot instead of settling time.

Hence the investigation of the relative stability of each root is clearly necessary because, as we found in Chapter 4, the location of the closed-loop poles in the s-plane determines the performance of the system. Thus it is imperative that we reexamine the characteristic equation $q(s)$ and consider several methods for the determination of relative stability.

Because the relative stability of a system is dictated by the location of the roots of the characteristic equation, a first approach using an s-plane formulation is to extend the Routh-Hurwitz criterion to ascertain relative stability. This can be simply accomplished by utilizing a change of variable, which shifts the s-plane axis in order to utilize the Routh-Hurwitz criterion. Examining Fig. 5.6, we notice that a shift of the vertical axis in the s-plane to $-\sigma_1$ will result in the roots r_1, \hat{r}_1 appearing on the shifted axis. The correct magnitude to shift the vertical axis must be obtained on a trial-and-error basis. Then, without solving the fifth-order polynomial $q(s)$, one may determine the real part of the dominant roots r_1, \hat{r}_1.

■ Example 5.6 Axis shift

Consider the simple third-order characteristic equation

$$q(s) = s^3 + 4s^2 + 6s + 4. \qquad (5.17)$$

Initially, one might shift the axis other than one unit and obtain a Routh-Hurwitz array without a zero occurring in the first column. However, upon setting the shifted variable s_n equal to $s + 1$, we obtain

$$(s_n - 1)^3 + 4(s_n - 1)^2 + 6(s_n - 1) + 4 = s_n^3 + s_n^2 + s_n + 1. \qquad (5.18)$$

Then the Routh array is established as

$$
\begin{array}{c|cc}
s_n^3 & 1 & 1 \\
s_n^2 & 1 & 1 \\
s_n^1 & 0 & 0 \\
s_n^0 & 1 & 0.
\end{array}
$$

Clearly, there are roots on the shifted imaginary axis and the roots can be obtained from the auxiliary equation, which is

$$
\begin{aligned}
U(s_n) = s_n^2 + 1 &= (s_n + j)(s_n - j) \\
&= (s + 1 + j)(s + 1 - j).
\end{aligned} \tag{5.19}
$$

The shifting of the s-plane axis in order to ascertain the relative stability of a system is a very useful approach, particularly for higher-order systems with several pairs of closed-loop complex conjugate roots.

5.4 The Determination of Root Locations in the s-Plane

The relative stability of a feedback control system is directly related to the location of the closed-loop roots of the characteristic equation in the s-plane. Therefore it is often necessary and easiest to simply determine the values of the roots of the characteristic equation. This approach has become particularly attractive today due to the availability of digital computer programs for determining the roots of polynomials. However, this approach may even be the most logical when using manual calculations if the order of the system is relatively low. For a third-order system or lower, it is usually simpler to utilize manual calculation methods.

The determination of the roots of a polynomial can be obtained by utilizing *synthetic division* which is based on the remainder theorem; that is, upon dividing the polynomial by a factor, the remainder is zero when the factor is a root of the polynomial. Synthetic division is commonly used to carry out the division process. The relations for the roots of a polynomial as obtained in Eq. (5.6) are utilized to aid in the choice of a first estimate of a root.

■ E x a m p l e 5.7 Synthetic division

Let us determine the roots of the polynomial

$$
q(s) = s^3 + 4s^2 + 6s + 4. \tag{5.20}
$$

Establishing a table of synthetic division, we have

$$
\begin{array}{cccc|l}
1 & 4 & 6 & 4 & \underline{-1} = \text{trial root} \\
 & -1 & -3 & -3 & \\
\hline
1 & 3 & 3 & 1 & = \text{remainder}
\end{array}
$$

for a trial root of $s = -1$. In this table, we multiply by the trial root and successively add in each column. With a remainder of one, we might try $s = -2$, which results in the form

$$
\begin{array}{rrrr|r}
1 & 4 & 6 & 4 & \underline{-2} \\
 & -2 & -4 & -4 & \\
\hline
1 & 2 & 2 & 0 &
\end{array}
$$

Because the remainder is zero, one root is equal to -2 and the remaining roots may be obtained from the remaining polynomial $(s^2 + 2s + 2)$ by using the quadratic root formula.

The search for a root of the polynomial can be aided considerably by utilizing the rate of change of the polynomial at the estimated root in order to obtain a new estimate. The *Newton-Raphson method* is a rapid method utilizing synthetic division to obtain the value of

$$
\left. \frac{dq(s)}{ds} \right|_{s=s_1},
$$

where s_1 is a first estimate of the root. The Newton-Raphson method is an iteration approach utilized in many digital computer root-solving programs. A new estimate s_{n+1} of the root is based on the last estimate as [18, 19]

$$
s_{n+1} = s_n - \frac{q(s_n)}{q'(s_n)}, \tag{5.21}
$$

where

$$
q'(s_n) = \left. \frac{dq(s)}{ds} \right|_{s=s_n}.
$$

The synthetic division process may be utilized to obtain $q(s_n)$ and $q'(s_n)$. The synthetic division process for a trial root may be written for the polynomial

$$
q(s) = a_m s^m + a_{m-1} s^{m-1} + \cdots + a_1 s + a_0
$$

as

$$
\begin{array}{ccccc|c}
a_m & a_{m-1} & \cdots & a_1 & a_0 & \underline{s_n} \\
 & b_m s_n & \cdots & & b_1 s_n & \\
\hline
b_m & b_{m-1} & \cdots & b_1 & b_0 &
\end{array}
$$

where $b_0 = q(s_n)$, the remainder of the division process. When s_n is a root of $q(s)$, the remainder is equal to zero and the remaining polynomial

$$
b_m s^{m-1} + b_{m-1} s^{m-2} + \cdots + b_1
$$

may itself be factored. The derivative evaluated at the *n*th estimate of the root, $q'(s_n)$, may also be obtained by repeating the synthetic division process on the b_m,

b_{m-1}, \ldots, b_1 coefficients. The value of $q'(s_n)$ is the remainder of this repeated synthetic division process. This process converges as the square of the absolute error. The Newton-Raphson method, using synthetic division, is readily illustrated, as can be seen by repeating Example 5.7.

■ **Example 5.8 Newton-Raphson method**

For the polynomial $q(s) = s^3 + 4s^2 + 6s + 4$, we establish a table of synthetic division for a first estimate as follows:

$$
\begin{array}{rrrr|r}
1 & 4 & 6 & 4 & \underline{-1} \\
 & -1 & -3 & -3 & \\
\hline
1 & 3 & 3 & 1 = q(s_1) \\
 & -1 & -2 & \\
\hline
1 & 2 & 1 = q'(s_1)
\end{array}
$$

The derivative of $q(s)$ evaluated at s_1 is determined by continuing the synthetic division as shown. Then the second estimate becomes

$$s_2 = s_1 - \frac{q(s_1)}{q'(s_1)} = -1 - \left(\frac{1}{1}\right) = -2.$$

As we found in Example 5.7, s_2 is, in fact, a root of the polynomial and results in a zero remainder.

■ **Example 5.9 Third-order system**

Let us consider the polynomial

$$q(s) = s^3 + 3.5s^2 + 6.5s + 10. \tag{5.22}$$

From Eq. (5.6), we note that the sum of all the roots is equal to -3.5 and that the product of all the roots is -10. Therefore, as a first estimate, we try $s_1 = -1$ and obtain the following table:

$$
\begin{array}{rrrr|r}
1 & 3.5 & 6.5 & 10 & \underline{-1} \\
 & -1 & -2.5 & -4 & \\
\hline
1 & 2.5 & 4 & 6 = q(s_1) \\
 & -1 & -1.5 & \\
\hline
1 & 1.5 & 2.5 = q'(s_1)
\end{array}
$$

Therefore a second estimate is

$$s_2 = -1 - \left(\frac{6}{2.5}\right) = -3.40.$$

Now let us use a second estimate that is convenient for these manual calculations. Therefore, on the basis of the calculation of $s_2 = -3.40$, we will choose a second estimate $s_2 = -3.00$. Establishing a table for $s_2 = -3.00$ and completing the synthetic division, we find that

$$s_3 = -s_2 - \frac{q(s_2)}{q'(s_2)} = -3.00 - \frac{(-5)}{12.5} = -2.60.$$

Finally, completing a table for $s_3 = -2.50$, we find that the remainder is zero and the polynomial factors are $q(s) = (s + 2.5)(s^2 + s + 4)$.

The availability of a digital computer or a programmable calculator enables one to readily determine the roots of a polynomial by using root determination programs, which usually use the Newton-Raphson algorithm, Eq. (5.21). This, as is the case for time-shared computers with remote consoles, is a particularly useful approach when a computer is readily available for immediate access. The availability of a console connected in a time-shared manner to a large digital computer or a personal computer is particularly advantageous for a control engineer, because the ability to perform on-line calculations aids in the iterative analysis and design process.

5.5 Design Example: Tracked Vehicle Turning Control

The design of a turning control for a tracked vehicle involves the selection of two parameters [22]. In Fig. 5.7 the system shown in part (a) has the model shown in part (b). The two tracks are operated at different speeds in order to turn the vehi-

Figure 5.7. Turning control for a two-track vehicle.

cle. Select K and a so that the system is stable and the steady-state error for a ramp command is less than or equal to 24% of the magnitude of the command.
 The characteristic equation of the feedback system is

$$1 + G_cG(s) = 0$$

or

$$1 + \frac{K(s + a)}{s(s + 1)(s + 2)(s + 5)} = 0. \tag{5.23}$$

Therefore we have

$$s(s + 1)(s + 2)(s + 5) + K(s + a) = 0$$

or

$$s^4 + 8s^3 + 17s^2 + (K + 10)s + Ka = 0. \tag{5.24}$$

In order to determine the stable region for K and a, we establish the Routh array as

s^4	1	17	Ka
s^3	8	$K + 10$	0
s^2	b_3	Ka	
s^1	c_3		
s^0	Ka		

where

$$b_3 = \frac{126 - K}{8} \quad \text{and} \quad c_3 = \frac{b_3(K + 10) - 8Ka}{b_3}.$$

In order for the elements of the first column to be positive, we require that Ka, b_3, and c_3 be positive. Therefore we require

$$K < 126$$

$$Ka > 0 \tag{5.25}$$

$$(K + 10)(126 - K) - 64\,Ka > 0.$$

The region of stability for $K > 0$ is shown in Fig. 5.8. The steady-state error to a ramp input $r(t) = At, t > 0$ is

$$e_{ss} = A/K_v,$$

where

$$K_v = \lim_{s \to 0} sG_cG = Ka/10.$$

Therefore we have

$$e_{ss} = \frac{10A}{Ka}. \tag{5.26}$$

Figure 5.8. The stable region.

When e_{ss} is equal to 23.8% of A, we require that $Ka = 42$. This can be satisfied by the selected point in the stable region when $K = 70$ and $a = 0.6$, as shown in Fig. 5.8. Of course, another acceptable design would be attained when $K = 50$ and $a = 0.84$. We can calculate a series of possible combinations of K and a that can satisfy $Ka = 42$ that lie within the stable region, and all will be acceptable design solutions. However, not all selected values of K and a will lie within the stable region. Note that K cannot exceed 126.

5.6 Summary

In this chapter we have considered the concept of the stability of a feedback control system. A definition of a stable system in terms of a bounded system response was outlined and related to the location of the poles of the system transfer function in the s-plane.

The Routh-Hurwitz stability criterion was introduced and several examples were considered. The relative stability of a feedback control system was also considered in terms of the location of the poles and zeros of the system transfer function in the s-plane. Finally, the determination of the roots of the characteristic equation was considered and the Newton-Raphson method was illustrated.

Exercises

E5.1. A system has a characteristic equation $s^3 + 3Ks^2 + (2 + K)s + 4 = 0$. Determine the range of K for a stable system.
Answer: $K > 0.53$

E5.2. A system has a characteristic equation $s^3 + 9s^2 + 26s + 24 = 0$. (a) Using the Routh criterion, show that the system is stable. (b) Using the Newton-Raphson method, find the three roots.

E5.3. Find the roots of the characteristic equation $s^4 + 9.5s^3 + 30.5s^2 + 37s + 12 = 0$.

E5.4. A control system has the structure shown in Fig. E5.4. Determine the gain at which the system will become unstable.

Figure E5.4. Feedforward system.

E5.5. A feedback system has a loop transfer function

$$GH(s) = \frac{K}{(s + 1)(s + 3)(s + 6)},$$

where $K = 10$. Find the roots of this system's characteristic equation.

E5.6. For the feedback system of Exercise E5.5, find the value of K when two roots lie on the imaginary axis. Determine the value of the three roots.

Answer: $s = -10, \pm j5.2$

E5.7. A negative feedback system has a loop transfer function

$$GH(s) = \frac{K(s + 2)}{s(s - 2)}.$$

(a) Find the value of the gain when the ζ of the closed-loop roots is equal to 0.707. (b) Find the value of the gain when the closed-loop system has two roots on the imaginary axis.

E5.8. Designers have developed small, fast, vertical-takeoff fighter aircraft that are invisible to radar (Stealth aircraft). The aircraft concept shown in Fig. E5.8(a), on the next page uses quickly turning jet nozzles to steer the airplane [19]. The control system for the heading or direction control is shown in Fig. E5.8(b). Determine the maximum gain of the system for stable operation.

E5.9. A system has a characteristic equation

$$s^3 + 3s^2 + (K + 1)s + 4 = 0$$

Find the range of K for a stable system.

Answer: $K > \frac{1}{3}$

E5.10. We all use our eyes and ears to achieve balance. Our orientation system allows us to sit or stand in a desired position even while in motion. This orientation system is primarily run by the information received in the inner ear, where the semicircular canals

(a)

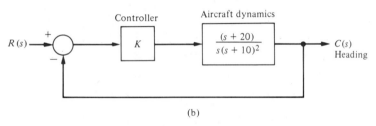

(b)

Figure E5.8. Aircraft heading control.

sense angular acceleration and the otoliths measure linear acceleration. But these acceleration measurements need to be supplemented by visual signals. Try the following experiment: (a) Stand with one foot in front of another and with your hands resting on your hips and your elbows bowed outward. (b) Close your eyes. Did you find that you experienced a low-frequency oscillation that grew until you lost balance? Is this orientation position stable with and without the use of your eyes?

Problems

P5.1. Utilizing the Routh-Hurwitz criterion, determine the stability of the following polynomials:

(a) $s^2 + 4s + 1$

(b) $s^3 + 4s^2 + 5s + 6$

(c) $s^3 + 3s^3 - 6s + 10$

(d) $s^4 + s^3 + 2s^2 + 4s + 8$

(e) $s^4 + s^3 + 3s^2 + 2s + K$

(f) $s^5 + s^4 + 2s^3 + s + 3$

(g) $s^5 + s^4 + 2s^3 + s^2 + s + K$

For all cases, determine the number of roots, if any, in the right-hand plane. Also, when it is adjustable, determine the range of K that results in a stable system.

P5.2. An antenna control system was analyzed in Problem 3.5 and it was determined that in order to reduce the effect of wind disturbances, the gain of the magnetic amplifier k_a should be as large as possible. (a) Determine the limiting value of gain for maintaining a stable system. (b) It is desired to have a system settling time equal to two seconds. Using a shifted axis and the Routh-Hurwitz criterion, determine the value of gain that satisfies this requirement. Assume that the complex roots of the closed-loop system dominate the transient response. (Is this a valid approximation in this case?)

P5.3. Arc welding is one of the most important areas of application for industrial robots [6]. In most manufacturing welding situations, uncertainties in dimensions of the part, geometry of the joint, and the welding process itself require the use of sensors for maintaining weld quality. Several systems use a vision system to measure the geometry of the puddle of melted metal as shown in Fig. P5.3. This system uses a constant rate of feeding the wire to be melted. (a) Calculate the maximum value for K for the system that will result in an oscillatory response. (b) For ½ of the maximum value of K found in part (a), determine the roots of the characteristic equation. (c) Estimate the overshoot of the system of part (b) when it is subjected to a step input.

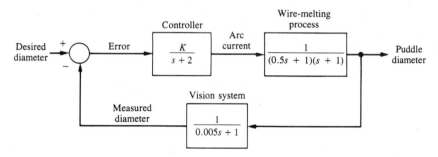

Figure P5.3. Welder control.

P5.4. A feedback control system is shown in Fig. P5.4. The process transfer function is

$$G(s) = \frac{K(s + 40)}{s(s + 10)},$$

and the feedback transfer function is $H(s) = 1/(s + 20)$. (a) Determine the limiting value of gain K for a stable system. (b) For the gain that results in borderline stability, determine the magnitude of the imaginary roots. (c) Reduce the gain to ½ the magnitude of the borderline value and determine the relative stability of the system (1) by shifting the axis and using the Routh-Hurwitz criterion and (2) by determining the root locations. Show the roots are between -1 and -2.

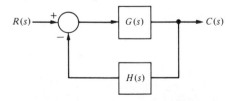

Figure P5.4. Feedback system.

P5.5. Determine the relative stability of the systems with the following characteristic equations (a) by shifting the axis in the s-plane and using the Routh-Hurwitz criterion and (b) by determining the location of the roots in the s-plane:

1. $s^3 + 3s^2 + 4s + 2 = 0$
2. $s^4 + 9s^3 + 30s^2 + 42s + 20 = 0$
3. $s^3 + 19s^2 + 110s + 200 = 0$

P5.6. A unity-feedback control system is shown in Fig. P5.6. Determine the relative stability of the system with the following transfer functions by locating the roots in the s-plane:

(a) $G(s) = \dfrac{65 + 33s}{s^2(s + 9)}$

(b) $G(s) = \dfrac{24}{s(s^3 + 10s^2 + 35s + 50)}$

(c) $G(s) = \dfrac{3(s + 4)(s + 8)}{s(s + 5)^2}$

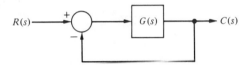

Figure P5.6. Unity feedback system.

P5.7. The linear model of a phase detector (phase-lock loop) can be represented by Fig. P5.7 [7]. The phase-lock systems are designed to maintain zero difference in phase between the input carrier signal and a local voltage-controlled oscillator. Phase-lock loops find application in color television, missile tracking, and space telemetry. The filter for a particular application is chosen as

$$F(s) = \frac{10 (s + 10)}{(s + 1)(s + 100)}.$$

It is desired to minimize the steady-state error of the system for a ramp change in the phase information signal. (a) Determine the limiting value of the gain $K_a K = K_v$ in order to maintain a stable system. (b) It is decided that a steady-state error equal to $1°$ is acceptable for a ramp signal of 100 rad/sec. For that value of gain K_v, determine the location of the roots of the system.

Figure P5.7. Phase-lock loop system.

P5.8. A very interesting and useful velocity control system has been designed for a wheelchair control system [13]. It is desirable to enable people paralyzed from the neck down to drive themselves about in motorized wheelchairs. A proposed system utilizing velocity sensors mounted in a headgear is shown in Fig. P5.8. The headgear sensor provides an output proportional to the magnitude of the head movement. There is a sensor mounted at 90° intervals so that forward, left, right, or reverse can be commanded. Typical values for the time constants are $\tau_1 = 0.5$ sec, $\tau_3 = 1$ sec, and $\tau_4 = \frac{1}{4}$ sec. (a) Determine the limiting gain $K = K_1 K_2 K_3$ for a stable system. (b) When the gain K is set equal to $\frac{1}{6}$ of the limiting value, determine if the settling time of the system is less than 4 sec. (c) Determine the value of gain that results in a system with a settling time of 4 sec. Also, obtain the value of the roots of the characteristic equation when the settling time is equal to 4 sec.

Figure P5.8. Wheelchair control system.

P5.9. A cassette tape storage device has been designed for mass-storage [13]. It is necessary to control accurately the velocity of the tape. The speed control of the tape drive is represented by the system shown in Fig. P5.9. (a) Determine the limiting gain for a stable system. (b) Determine a suitable gain so that the overshoot to a step command is approximately 5%.

Figure P5.9. Tape drive control.

P5.10. Robots can be used in manufacturing and assembly operations where accurate, fast, and versatile manipulation is required [9]. The open-loop transfer function of a direct-drive arm may be approximated by

$$GH(s) = \frac{K(s + 2)}{s(s + 5)(s^2 + 2s + 5)}.$$

(a) Determine the value of gain K when the system oscillates. (b) Calculate the roots of the closed-loop system for the K determined in part (a).

P5.11. A feedback control system has a characteristic equation:

$$s^3 + (4 + K)s^2 + 6s + 16 + 8K = 0.$$

The parameter K must be positive. What is the maximum value K can assume before the system becomes unstable? When K is equal to the maximum value, the system oscillates. Determine the frequency of oscillation.

P5.12. A feedback control system has a characteristic equation:

$$s^6 + 2s^5 + 5s^4 + 8s^3 + 8s^2 + 8s + 4 + 0.$$

Determine if the system is stable and determine the values of the roots.

P5.13. The stability of a motorcycle and rider is an important area for study because many motorcycle designs result in vehicles that are difficult to control [10]. The handling characteristics of a motorcycle must include a model of the rider as well as one of the vehicle. The dynamics of one motorcycle and rider can be represented by an open-loop transfer function (Fig. P5.4)

$$GH(s) = \frac{K(s^2 + 30s + 1125)}{s(s + 20)(s^2 + 10s + 125)(s^2 + 60s + 3400)}.$$

(a) As an approximation, calculate the acceptable range of K for a stable system when the numerator polynomial (zeros) and the denominator polynomial ($s^2 + 60s + 3400$) are neglected. (b) Calculate the actual range of acceptable K accounting for all zeros and poles.

P5.14. A system has a transfer function

$$T(s) = \frac{1}{s^3 + 1.3s^2 + 2.0s + 1}.$$

(a) Determine if the system is stable. (b) Determine the roots of the characteristic equation (c) Plot the response of the system to a unit step input.

Design Problems

DP5.1. The control of the spark ignition of an automotive engine requires constant performance over a wide range of parameters [21]. The control system is shown in Fig. DP5.1, on the next page with a controller gain K to be selected. The parameter p is, equal to 2 for many autos but can equal zero for high performance autos. Select a gain K that will result in a stable system for both values of p.

DP5.2. An automatically guided vehicle on Mars is represented by the system in Fig. DP5.2. The system has a steerable wheel in both the front and back of the vehicle and the design requires the selection of $H(s)$ where $H(s) = Ks + 1$. Determine (a) the value of K required for stability, (b) the value of K when one root of the characteristic equation is equal to $s = -\frac{1}{2}$, and (c) the value of the two remaining roots for the gain selected in part (b). (d) Find the response of the system to a step command for the gain selected in part (b).

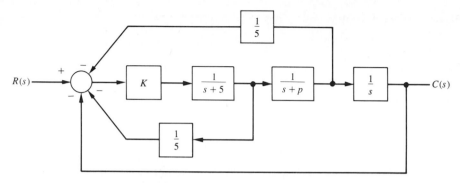

Figure DP5.1. Automobile engine control.

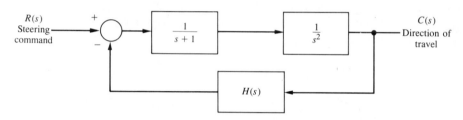

Figure DP5.2. Mars guided vehicle control.

DP5.3. A unity negative feedback system with

$$G(s) = \frac{K(s + 2)}{s(1 + \tau s)(1 + 2s)}$$

has two parameters to be selected. (a) Determine and plot the regions of stability for this system. (b) Select τ and K so that the ready state error to a ramp input is less than or equal to 25% of the input magnitude. (c) Determine the percent overshoot for a step input for the design selected in part (b).

DP5.4. The attitude control system of a space shuttle rocket is shown in Fig. DP5.4 [4]. (a) Determine the range of gain K and parameter m so that the system is stable and plot the region of stability. (b) Select the gain and parameter values so that the steady-state error to a ramp input is less than or equal to 10% of the input magnitude. (c) Determine the percent overshoot for a step input for the design selected in part (b).

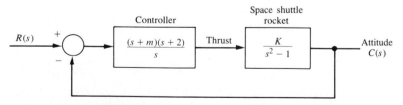

Figure DP5.4. Shuttle attitude control.

Terms and Concepts

Auxiliary equation The equation that immediately precedes the zero entry in the Routh array.

Newton-Raphson method An iterative approach to solving for roots of a polynomial equation.

Relative stability The property that is measured by the relative settling times of each root or pair of roots of the characteristic equation.

Routh-Hurwitz criterion A criterion for determining the stability of a system by examining the characteristic equation of the transfer function. The criterion states that the number of roots of the characteristic equation with positive real parts is equal to the number of changes of sign of the coefficients in the first column of the Routh array.

Stability A performance measure of a system. A system is stable if all the poles of the transfer function have negative real parts.

Stable system A dynamic system with a bounded system response to a bounded input.

Synthetic division A method of determining the roots of the characteristic equation based on the remainder theorem of mathematics.

References

1. R. C. Dorf, *Introduction to Electric Circuits,* John Wiley & Sons, New York, 1989.
2. A. Hurwitz, "On the Conditions Under Which an Equation Has Only Roots with Negative Real Parts," *Mathematische Annalen,* **46,** 1895; pp. 273–84. Also in *Selected Papers on Mathematical Trends in Control Theory,* Dover, New York, 1964; pp. 70–82.
3. E. J. Routh, *Dynamics of a System of Rigid Bodies,* Macmillan, New York, 1892.
4. R. DeMeis, "Shuttling to the Space Station," *Aerospace America,* March 1990; pp. 44–47.
5. J. V. Ringwood, "Shape Control in Sendzimir Mills Using Roll Actuators," *IEEE Transactions on Automatic Control,* April 1990; pp. 453–59.
6. R. C. Dorf, *Encyclopedia of Robotics,* John Wiley & Sons, New York, 1988.
7. J. R. Pierce, *Signals: The Science of Telecommunications,* W. H. Freeman, San Francisco, 1990.
8. H. Tamura, *Large-Scale Systems Control,* Marcel Dekker, New York, 1990.
9. S. Derby, "Mechatronics for Robots," *Mechanical Engineering,* July 1990; pp. 40–42.
10. F. Raven, *Automatic Control Engineering,* 2nd ed., McGraw-Hill, New York, 1990.
11. F. B. Farquharson, "Aerodynamic Stability of Suspension Bridges, with Special Reference to the Tacoma Narrows Bridge," *Bulletin 116, Part I,* The Engineering Experiment Station, University of Washington, 1950.
12. R. C. Dorf, *Introduction to Computers and Computer Science,* 3rd ed., Boyd and Fraser, San Francisco, 1982.
13. P. C. Krause, *Electromechanical Motion Devices,* McGraw-Hill, New York, 1989.

14. R. C. Rosenberg and D. C. Karnopp, *Introduction to Physical System Design,* McGraw-Hill, New York, 1987.
15. T. Yoshikawa, *Foundations of Robotics,* M.I.T. Press, Cambridge, Mass., 1990.
16. B. E. Jeppsen, "A New Family of Dot Matrix Line Printers," *HP Journal,* June 1985; pp. 4–9.
17. R. E. Ziemer, *Signals and Systems,* 2nd ed., Macmillan, New York, 1989.
18. R. C. Dorf and R. Jacquot, *Control System Design Program,* Addison-Wesley, Reading, Mass., 1988.
19. R. A. Hammond, "Fly by Wire Control Systems," *Simulation,* October 1989; pp. 159–67.
20. P. P. Vardyanathan and S. K. Mitra, "A Unified Structural Interpretation of Some Well Known Stability Test Procedures for Linear Systems," *Proceedings of the IEEE,* November 1989; pp. 478–79.
21. P. G. Scotson, "Self-Tuning Optimization of Spark Ignition Automotive Engines," *IEEE Control Systems,* April 1990; pp. 94–99.
22. G. G. Wang, "Design of Turning Control for a Tracked Vehicle," *IEEE Control Systems,* April 1990; pp. 122–25.
23. A. Dane, "Hubble: Heartbreaks and Hope," *Popular Mechanics,* October 1990; pp. 130–31.
24. T. Beardsley, "Hubble's Legacy," *Scientific American,* June 1990; pp. 18–19.
25. C. Phillips and R. Harbor, *Feedback Control Systems,* Prentice Hall, Englewood Cliffs, N.J., 1991.

CHAPTER 6

The Root Locus Method

Preview

Since the performance of a feedback system can be adjusted by changing one or more parameters, we described that performance in terms of the s-plane location of the roots of the characteristic equation in the preceeding chapters. Thus it is very useful to determine how the roots of the characteristic equations move around the s-plane as we change a parameter.

The locus of roots in the s-plane can be determined by a graphical method. Once you understand this graphical method, then we will proceed to demon-

235

strate the utility of computer generation of the locus of roots as a parameter is varied.

Since we can determine how the roots migrate as one parameter varies, it is possible to show they will vary as two parameters vary. This provides us with the opportunity to design a system with two adjustable parameters so as to achieve a very desirable performance.

Using the concept of the root locus as a parameter varies, we also will be able to define a measure of the sensitivity of a specified root to a small incremental change in the parameter.

6.1 Introduction

The relative stability and the transient performance of a closed-loop control system are directly related to the location of the closed-loop roots of the characteristic equation in the s-plane. Also, it is frequently necessary to adjust one or more system parameters in order to obtain suitable root locations. Therefore, it is worthwhile to determine how the roots of the characteristic equation of a given system migrate about the s-plane as the parameters are varied; that is, it is useful to determine the *locus* of roots in the s-plane as a parameter is varied. The *root locus method* was introduced by Evans in 1948 and has been developed and utilized extensively in control engineering practice [1, 2, 3]. The root locus technique is a graphical method for drawing the locus of roots in the s-plane as a parameter is varied. In fact, the root locus method provides the engineer with a measure of the sensitivity of the roots of the system to a variation in the parameter being considered. The root locus technique may be used to great advantage in conjunction with the Routh-Hurwitz criterion and the Newton-Raphson method.

The root locus method provides graphical information, and therefore an approximate sketch can be used to obtain qualitative information concerning the stability and performance of the system. Furthermore, the locus of roots of the characteristic equation of a multiloop system may be investigated as readily as for a single-loop system. If the root locations are not satisfactory, the necessary parameter adjustments can often be readily ascertained from the root locus.

6.2 The Root Locus Concept

The dynamic performance of a closed-loop control system is described by the closed-loop transfer function

$$T(s) = \frac{C(s)}{R(s)} = \frac{p(s)}{q(s)}, \tag{6.1}$$

where $p(s)$ and $q(s)$ are polynomials in s. The roots of the characteristic equation $q(s)$ determine the modes of response of the system. For a closed-loop system, we found in Section 2.7 that by using Mason's signal-flow gain formula, we had

$$\Delta(s) = 1 - \sum_{n=1}^{N} L_n + \sum_{m,q}^{M,N} L_m L_q - \sum L_r L_s L_t + \dots, \tag{6.2}$$

where L_q equals the value of the qth self-loop transmittance. Clearly, we have a characteristic equation, which may be written as

$$q(s) = \Delta(s) = 1 + F(s). \tag{6.3}$$

In order to find the roots of the characteristic equation we set Eq. (6.3) equal to zero and obtain

$$1 + F(s) = 0. \tag{6.4}$$

Of course, Eq. (6.4) may be rewritten as

$$F(s) = -1, \tag{6.5}$$

and the roots of the characteristic equation must also satisfy this relation. In the case of the simple single-loop system, as shown in Fig. 6.1, we have the characteristic equation

$$1 + GH(s) = 0, \tag{6.6}$$

where $F(s) = G(s)H(s)$. The characteristic roots of the system must satisfy Eq. (6.5), where the roots lie in the s-plane. Because s is a complex variable, Eq. (6.5) may be rewritten in polar form as

$$|F(s)|\underline{/F(s)} = -1, \tag{6.7}$$

and therefore it is necessary that

$$|F(s)| = 1$$

and

$$\underline{/F(s)} = 180° \pm k360°, \tag{6.8}$$

where $k = 0, \pm 1, \pm 2, \pm 3, \dots$. The graphical computation required for Eq. (6.8) is readily accomplished by using a protractor for estimating angles.

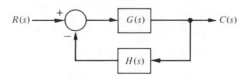

Figure 6.1. Closed-loop control system.

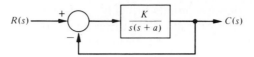

Figure 6.2. Unity feedback control system.

The simple second-order system considered in the previous chapters is shown in Fig. 6.2. The characteristic equation representing this system is

$$\Delta(s) = 1 + G(s) = 1 + \frac{K}{s(s + a)} = 0$$

or, alternatively,

$$q(s) = s^2 + as + K = s^2 + 2\zeta\omega_n s + \omega_n^2 = 0. \tag{6.9}$$

The locus of the roots as the gain K is varied is found by requiring that

$$|G(s)| = \left|\frac{K}{s(s + a)}\right| = 1 \tag{6.10}$$

and

$$\underline{/G(s)} = \pm 180°, \pm 540°, \ldots \tag{6.11}$$

The gain K may be varied from zero to an infinitely large positive value. For a second-order system, the roots are

$$s_1, s_2 = -\zeta\omega_n \pm \omega_n\sqrt{\zeta^2 - 1}, \quad = \frac{a}{2} \pm \sqrt{K}\sqrt{\frac{a^2}{4K} - 1} \tag{6.12}$$

and for $\zeta < 1$, we know that $\theta = \cos^{-1}\zeta$. Graphically, for two open-loop poles as shown in Fig. 6.3, the locus of roots is a vertical line for $\zeta \leq 1$ in order to satisfy

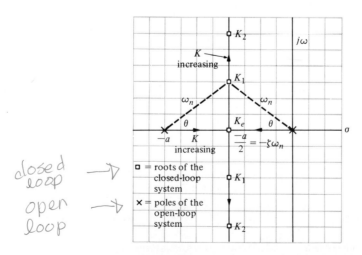

Figure 6.3. Root locus for a second-order system when $K_c < K_1 < K_2$.

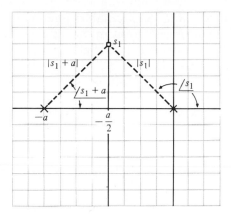

Figure 6.4. Evaluation of the angle and gain at s_1.

the angle requirement, Eq. (6.11). For example, as shown in Fig. 6.4, at a root s_1, the angles are

$$\left/\frac{K}{s(s + a)}\right|_{s=s_1} = -\underline{/s_1} - \underline{/(s_1 + a)}$$

$$= -[(180° - \theta) + \theta] = -180°. \tag{6.13}$$

This angle requirement is satisfied at any point on the vertical line which is a perpendicular bisector of the line 0 to $-a$. Furthermore, the gain K at the particular point s_1 is found by using Eq. (6.10) as

$$\left|\frac{K}{s(s + a)}\right|_{s=s_1} = \frac{K}{|s_1|\ |s_1 + a|} = 1 \tag{6.14}$$

and thus

$$K = |s_1|\ |s_1 + a|, \tag{6.15}$$

where $|s_1|$ is the magnitude of the vector from the origin to s_1, and $|s_1 + a|$ is the magnitude of the vector from $-a$ to s_1.

In general, the function $F(s)$ may be written as

$$F(s) = \frac{K(s + z_1)(s + z_2)(s + z_3) \cdots (s + z_m)}{(s + p_1)(s + p_2)(s + p_3) \cdots (s + p_n)}. \tag{6.16}$$

Then the magnitude and angle requirement for the root locus are

used to determine K

$$|F(s)| = \frac{K|s + z_1|\ |s + z_2| \cdots}{|s + p_1|\ |s + p_2| \cdots} = 1 \tag{6.17}$$

and

$$\underline{/F(s)} = \underline{/s + z_1} + \underline{/s + z_2} + \cdots - (\underline{/s + p_1} + \underline{/s + p_2} + \cdots). \tag{6.18}$$

used to determine the location of the roots

The magnitude requirement, Eq. (6.17), enables one to determine the value of K for a given root location s_1. A test point in the s-plane, s_1, is verified as a root location when Eq. (6.18) is satisfied. The angles are all measured in a counter-clockwise direction from a horizontal line.

In order to further illustrate the root locus procedure, let us reconsider the second-order system of Fig. 6.2. The effect of varying the parameter, a, can be effectively portrayed by rewriting the characteristic equation for the root locus form with a as the muliplying factor in the numerator. Then the characteristic equation is

$$1 + F(s) = 1 + \frac{K}{s(s + a)} = 0$$

or, alternatively,

$$s^2 + as + K = 0.$$

Dividing by the factor $(s^2 + K)$, we obtain

$$1 + \frac{as}{s^2 + K} = 0. \tag{6.19}$$

Then the magnitude criterion is satisfied when

$$\frac{a|s_1|}{|s_1^2 + K|} = 1 \tag{6.20}$$

at the root s_1. The angle criterion is

$$\underline{/s_1} - (\underline{/s_1 + j\sqrt{K}} + \underline{/s_1 - j\sqrt{K}}) = \pm 180°, \pm 540°, \ldots.$$

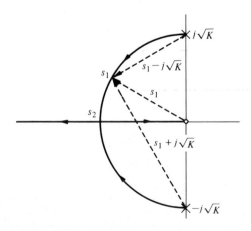

Figure 6.5. Root locus as a function of the parameter a.

In order to construct the root locus, we find the points in the s-plane that satisfy the angle criterion. The points in the s-plane that satisfy the angle criterion are located on a trial-and-error basis by searching in an orderly manner for a point with a total angle of $\pm 180°$, $\pm 540°$, or in general,

$$\frac{\pm(2q + 1)180°}{n_p - n_z}.$$

The algebraic sum of the angles from the poles and zeros is measured with a protractor. Using a protractor we find the locus of roots as shown in Fig. 6.5. Specifically, at the root s_1, the magnitude of the parameter, a, is found from Eq. (6.20) as

$$a = \frac{|s_1 - j\sqrt{K}| \, |s_1 + j\sqrt{K}|}{|s_1|}. \tag{6.21}$$

The roots of the system merge on the real axis at the point s_2 and provide a critically damped response to a step input. The parameter, a, has a magnitude at the critically damped roots $s_2 = \sigma_2$ equal to

$$a = \frac{|\sigma_2 - j\sqrt{K}| \, |\sigma_2 + j\sqrt{K}|}{\sigma_2} \tag{6.22}$$

$$= \frac{1}{\sigma_2} (\sigma_2^2 + K),$$

where σ_2 is evaluated from the s-plane vector lengths as $\sigma_2 = \sqrt{K}$. As a increases beyond the critical value, the roots are both real and distinct; one root is larger than σ_2 and one is smaller.

In general, an orderly process for locating the locus of roots as a parameter varies is desirable. In the following section, we shall develop such an orderly approach to obtaining a root locus diagram.

6.3 The Root Locus Procedure

The characteristic equation of a system provides a valuable insight concerning the response of the system when the roots of the equation are determined. In order to locate the roots of the characteristic equation in a graphical manner on the s-plane, we shall develop an orderly procedure that facilitates the rapid sketching of the locus. First, we write the characteristic equation as

$$1 + F(s) = 0 \tag{6.23}$$

and rearrange the equation, if necessary, so that the parameter of interest, k, appears as the multiplying factor in the form,

$$1 + kP(s) = 0. \tag{6.24}$$

Second, we factor $P(s)$, if necessary, and write the polynomial in the form of poles and zeros as follows:

$$1 + k \frac{\prod_{i=1}^{M} (s + z_i)}{\prod_{j=1}^{n} (s + p_j)} = 0. \tag{6.25}$$

Then we locate the poles and zeros on the s-plane with appropriate markings. Now, we are usually interested in determining the locus of roots as k varies as

$$0 \le k \le \infty.$$

Rewriting Eq. (6.25), we have

$$\prod_{j=1}^{n} (s + p_j) + k \prod_{i=1}^{M} (s + z_i) = 0. \tag{6.26}$$

Therefore, when $k = 0$, the roots of the characteristic equation are simply the poles of $P(s)$. Furthermore, when k approaches infinity, the roots of the characteristic equation are simply the zeros of $P(s)$. Therefore we note that *the locus of the roots of the characteristic equation $1 + kP(s) = 0$ begins at the poles of $P(s)$ and ends at the zeros of $P(s)$ as k increases from 0 to infinity.* For most functions, $P(s)$, that we will encounter, several of the zeros of $P(s)$ lie at infinity in the s-plane.

 The root locus on the real axis always lies in a section of the real axis to the left of an odd number of poles and zeros. This fact is clearly ascertained by examining the angle criterion of Eq. (6.18). These useful steps in plotting a root locus will be illustrated by a suitable example.

■ E x a m p l e 6.1 Second-order system

A single-loop feedback control system possesses the following characteristic equation:

$$1 + GH(s) = 1 + \frac{K(\tfrac{1}{2}s + 1)}{s(\tfrac{1}{4}s + 1)} = 0. \tag{6.27}$$

First, the transfer function $GH(s)$ is rewritten in terms of poles and zeros as follows:

$$1 + \frac{2K(s + 2)}{s(s + 4)} = 0, \tag{6.28}$$

and the multiplicative gain parameter is $k = 2K$. In order to determine the locus of roots for the gain $0 \le K \le \infty$, we locate the poles and zeros on the real axis as shown in Fig. 6.6(a). Clearly, the angle criterion is satisfied on the real axis between the points 0 and -2, because the angle from pole p_1 is 180° and the angle from the zero and pole p_2 is zero degrees. The locus begins at the pole and ends at the zeros, and therefore the locus of roots appears as shown in Fig. 6.6(b),

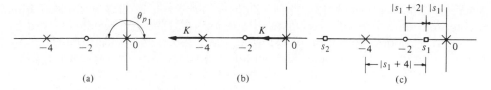

Figure 6.6. Root locus of a second-order system with a zero.

where the direction of the locus at K is increasing ($K \uparrow$) is shown by an arrow. We note that because the system has two real poles and one real zero, the second locus segment ends at a zero at negative infinity. In order to evaluate the gain K at a specific root location on the locus, we utilize the magnitude criterion, Eq. (6.17). For example, the gain K at the root $s = s_1 = -1$ is found from (6.17) as

$$\frac{(2K)|s_1 + 2|}{|s_1| \, |s_1 + 4|} = 1$$

or

$$K = \frac{|-1| \, |-1 + 4|}{2|-1 + 2|} = \frac{3}{2}. \tag{6.29}$$

This magnitude can also be evaluated graphically as is shown in Fig. 6.6(c). Finally, for the gain of $K = \frac{3}{2}$, one other root exists, located on the locus to the left of the pole at -4. The location of the second root is found graphically to be located at $s = -6$, as shown in Fig. 6.6(c).

Because the loci begin at the poles and end at the zeros, the *number of separate loci* is equal to the number of poles if the number of poles is greater than the number of zeros. In the unusual case when the number of zeros is greater than the number of poles, the number of separate loci would be the number of zeros. Therefore, as we found in Fig. 6.6, the number of separate loci is equal to two because there are two poles and one zero.

The root loci must be symmetrical with respect to the horizontal real axis because the complex roots must appear as pairs of complex conjugate roots.

When the number of finite zeros of $P(s)$, n_z, is less than the number of poles, n_p, by the number $N = n_p - n_z$, then N sections of loci must end at zeros at infinity. These sections of loci proceed to the zeros at infinity along *asymptotes* as k approaches infinity. These linear *asymptotes are centered* at a point on the real axis given by

$$\sigma_A = \frac{\sum \text{poles of } P(s) - \sum \text{zeros of } P(s)}{n_p - n_z} = \frac{\sum_{j=1}^{n} p_j - \sum_{i=1}^{M} z_i}{n_p - n_z}. \tag{6.30}$$

The angle of the asymptotes with respect to the real axis is

$$\phi_A = \frac{(2q + 1)}{n_p - n_z} 180°, \quad q = 0, 1, 2, \ldots, (n_p - n_z - 1), \tag{6.31}$$

where q is an integer index [3]. The usefulness of this rule is obvious for sketching the approximate form of a root locus. Equation (6.31) can be readily derived by considering a point on a root locus segment at a remote distance from the finite poles and zeros in the s-plane. The net phase angle at this remote point is 180°, because it is a point on a root locus segment. The finite poles and zeros of $P(s)$ are a great distance from the remote point, and so the angle from each pole and zero, ϕ, is essentially equal and therefore the net angle is simply $\phi(n_p - n_z)$, where n_p and n_z are the number of finite poles and zeros, respectively. Thus we have

$$\phi(n_p - n_z) = 180°,$$

or, alternatively,

$$\phi = \frac{180°}{n_p - n_z}.$$

Accounting for all possible root locus segments at remote locations in the s-plane, we obtain Eq. (6.31).

The center of the linear asymptotes, often called the *asymptote centroid*, is determined by considering the characteristic equation $1 + GH(s) = 0$ (Eq. 6.25). For large values of s, only the higher-order terms need be considered so that the characteristic equation reduces to

$$1 + \frac{ks^M}{s^n} = 0.$$

However, this relation, which is an approximation, indicates that the centroid of $(n - M)$ asymptotes is at the origin, $s = 0$. A better approximation is obtained if we consider a characteristic equation of the form

$$1 + \frac{k}{(s - \sigma_A)^{n-M}} = 0$$

with a centroid at σ_A.

The centroid is determined by considering the first two terms of Eq. (6.25), which may be found from the relation

$$1 + \frac{k \prod_{i=1}^{M} (s + z_i)}{\prod_{j=1}^{n} (s + p_j)} = 1 + k \frac{(s_M + b_{M-1}s^{M-1} + \cdots + b_0)}{(s^n + a_{n-1}s^{n-1} + \cdots + a_0)}.$$

From Chapter 5, especially Eq. (5.5), we note that

$$b_{M-1} = \sum_{i=1}^{M} z_i \quad \text{and} \quad a_{n-1} = \sum_{j=1}^{n} p_j.$$

Considering only the first two terms of this expansion we have

$$1 + \frac{k}{s^{n-M} + (a_{n-1} - b_{M-1})s^{n-M-1}} = 0.$$

The first two terms of

$$1 + \frac{k}{(s - \sigma_A)^{n-M}} = 0$$

are

$$1 + \frac{k}{s^{n-M} + (n - M)\sigma_A s^{n-M-1}} = 0.$$

Equating the term for s^{n-M-1}, we obtain

$$(a_{n-1} - b_{M-1}) = (n - M)\sigma_A,$$

which is equivalent to Eq. (6.30).

For example, reexamine the system shown in Fig. 6.2 and discussed in Section 6.2. The characteristic equation is written as

$$1 + \frac{K}{s(s + a)} = 0.$$

Because $n_p - n_z = 2$, we expect two loci to end at zeros at infinity. The asymptotes of the loci are located at a center

$$\sigma_A = \frac{-a}{2},$$

and at angles of

$$\phi_A = 90°, \qquad q = 0,$$

and

$$\psi_A = 270°, \qquad q = 1.$$

Therefore the root locus is readily sketched and the locus as shown in Fig. 6.3 is obtained. An example will further illustrate the process of utilizing the asymptotes.

■ Example 6.2 Fourth-order system

A feedback control system has a characteristic equation as follows:

$$1 + F(s) = 1 + \frac{K(s + 1)}{s(s + 2)(s + 4)^2}. \tag{6.32}$$

We wish to sketch the root locus in order to determine the effect of the gain K. The poles and zeros are located in the s-plane as shown in Fig. 6.7(a). The root loci on the real axis must be located to the left of an odd number of poles and

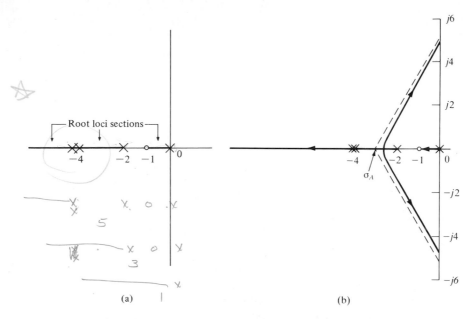

Figure 6.7. Root locus of a fourth-order system with a zero.

zeros and are therefore located as shown in Fig. 6.7(a) as heavy lines. The inter-section of the asymptotes is

$$\sigma_A = \frac{(-2) + 2(-4) - (-1)}{4 - 1} = \frac{-9}{3} = -3. \tag{6.33}$$

The angles of the asymptotes are

$$\phi_A = +60°, \qquad q = 0,$$

$$\phi_A = 180°, \qquad q = 1,$$

$$\phi_A = 300°, \qquad q = 2,$$

where there are three asymptotes since $n_p - n_z = 3$. Also, we note that the root loci must begin at the poles, and therefore two loci must leave the double pole at $s = -4$. Then, with the asymptotes drawn in Fig. 6.7(b), we may sketch the form of the root locus as shown in Fig. 6.7(b). The actual shape of the locus in the area near σ_A would be graphically evaluated, if necessary. The actual point at which *the root locus crosses the imaginary axis* is readily evaluated by utilizing the *Routh-Hurwitz criterion.*

The root locus in the previous example left the real axis at a *breakaway point.* The locus breakaway from the real axis occurs where the net change in angle caused by a small vertical displacement is zero. The locus leaves the real axis where there are a multiplicity of roots, typically two roots. The breakaway point

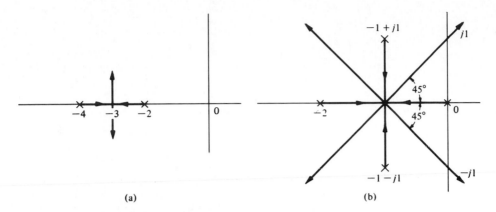

Figure 6.8. Illustration of the breakaway point.

for a simple second-order system is shown in Fig. 6.8(a) and, for a special case of a fourth-order system, in Fig. 6.8(b). In general, due to the phase criterion, *the tangents to the loci at the breakaway point are equally spaced over 360°*. Therefore, in Fig. 6.8(a), we find that the two loci at the breakaway point are spaced 180° apart, whereas in Fig. 6.8(b), the four loci are spaced 90° apart.

The breakaway point on the real axis can be evaluated graphically or analytically. The most straightforward method of evaluating the breakaway point involves the rearranging of the characteristic equation in order to isolate the multiplying factor K. Then the characteristic equation is written as

$$p(s) = K. \tag{6.34}$$

For example, consider a unity feedback closed-loop system with an open-loop transfer function

$$G(s) = \frac{K}{(s + 2)(s + 4)},$$

which has a characteristic equation as follows:

$$1 + G(s) = 1 + \frac{K}{(s + 2)(s + 4)} = 0. \tag{6.35}$$

Alternatively, the equation may be written as

$$K = p(s) = -(s + 2)(s + 4). \tag{6.36}$$

The root loci for this system are shown in Fig. 6.8(a). We expect the breakaway point to be near $s = \sigma = -3$ and plot $p(s)|_{s=\sigma}$ near that point as shown in Fig. 6.9. In this case, $p(s)$ equals zero at the poles $s = -2$ and $s = -4$. The plot of $p(s)$ versus σ is symmetrical and the maximum point occurs at $s = \sigma = -3$, the breakaway point. Analytically, the very same result may be obtained by determining the maximum of $K = p(s)$. In order to find the maximum analytically,

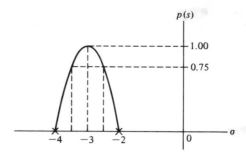

Figure 6.9. A graphical evaluation of the breakaway point.

we differentiate, set the differentiated polynomial equal to zero, and determine the roots of the polynomial. Therefore we may evaluate

$$\frac{dK}{ds} = \frac{dp(s)}{ds} = 0 \tag{6.37}$$

in order to find the breakaway point. Clearly, Eq. (6.37) is an analytical expression of the graphical procedure outlined in Fig. 6.9 and will result in an equation of only one order less than the total number of poles and zeros ($n_p + n_z - 1$). In almost all cases, we will prefer to use the graphical method of locating the break-away point when it is necessary to do so.

The proof of Eq. (6.37) is obtained from a consideration of the characteristic equation

$$1 + F(s) = 1 + \frac{KY(s)}{X(s)} = 0,$$

which may be written as

$$1 + F(s) = X(s) + KY(s) = 0. \tag{6.38}$$

For a small increment in K, we have

$$X(s) + (K + \Delta K)Y(s) = 1 + \frac{\Delta KY(s)}{X(s) + KY(s)} = 0. \tag{6.39}$$

Because the denominator is the original characteristic equation, at a breakaway point a multiplicity of roots exists and

$$\frac{Y(s)}{X(s) + KY(s)} = \frac{C_i}{(s - s_i)^n} = \frac{C_i}{(\Delta s_i)^n}. \tag{6.40}$$

Then we may write Eq. (6.39) as

$$1 + \frac{\Delta K C_i}{(\Delta s_i)^n} = 0 \tag{6.41}$$

or, alternatively,

$$\frac{\Delta K}{\Delta s} = \frac{-(\Delta s)^{n-1}}{C_i}.$$ (6.42)

Therefore, as we let Δs approach zero, we obtain

$$\frac{dK}{ds} = 0$$ (6.43)

at the breakaway points.

Now, reconsidering the specific case where

$$G(s) = \frac{K}{(s + 2)(s + 4)},$$

we obtain $p(s)$ as

$$K = p(s) = -(s + 2)(s + 4) = -(s^2 + 6s + 8).$$ (6.44)

Then, differentiating, we have

$$\frac{dK}{ds} = -(2s + 6) = 0$$ (6.45)

or the breakaway point occurs at $s = -3$. A more complicated example will illustrate the approach and exemplify the advantage of the graphical technique.

■ **Example 6.3 Third-order system**

A feedback control system is shown in Fig. 6.10. The characteristic equation is

$$1 + G(s)H(s) = 1 + \frac{K(s + 1)}{s(s + 2)(s + 3)} = 0.$$ (6.46)

The number of poles, n_p, minus the number of zeros, n_z, is equal to two, and so we have two asymptotes at $\pm 90°$ with a center at $\sigma_A = -2$. The asymptotes and the sections of loci on the real axis are shown in Fig. 6.11(a). A breakaway point

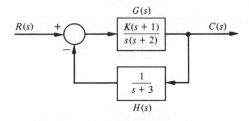

Figure 6.10. Closed-loop system.

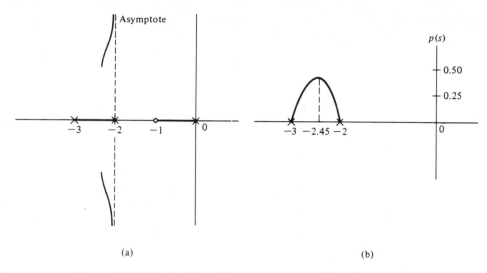

Figure 6.11. Evaluation of the asymptotes and breakaway point.

occurs between $s = -2$ and $s = -3$. In order to evaluate the breakaway point, we rewrite the characteristic equation so that K is separated as follows:

$$s(s + 2)(s + 3) + K(s + 1) = 0$$

or

$$p(s) = \frac{-s(s + 2)(s + 3)}{(s + 1)} = K. \tag{6.47}$$

Then, evaluating $p(s)$ at various values of s between $s = -2$ and $s = -3$, we obtain the results of Table 6.1 as shown in Fig. 6.11(b). Alternatively, we differentiate Eq. (6.47) and set equal to zero to obtain

$$\frac{d}{ds}\left(\frac{-s(s + 2)(s + 3)}{(s + 1)}\right) = \frac{(s^3 + 5s^2 + 6s) - (s + 1)(3s^2 + 10s + 6)}{(s + 1)^2} = 0$$

$$= 2s^3 + 8s^2 + 10s + 6 = 0. \tag{6.48}$$

Now, in order to locate the maximum of $p(s)$, we locate the roots of Eq. (6.48) by synthetic division or by the Newton-Raphson method to obtain $s = -2.45$. It is evident from this one example that the evaluation of $p(s)$ near the expected breakaway point will result in the simplest method of evaluating the breakaway

Table 6.1.

$p(s)$	0	+0.412	+0.420	+0.417	+0.390	0
s	−2.00	−2.40	−2.45	−2.50	−2.60	−3.0

point. As the order of the characteristic equation increases, the usefulness of the graphical (or tabular) evaluation of the breakaway point will increase in contrast to the analytical approach.

The *angle of departure of the locus from a pole* and the *angle of arrival at the locus at a zero* can be determined from the phase angle criterion. The angle of locus departure from a pole is the difference between the net angle due to all other poles and zeros and the criterion angle of $\pm180°\,(2q+1)$, and similarly for the locus angle of arrival at zero. The angle of departure (or arrival) is particularly of interest for complex poles (and zeros) because the information is helpful in completing the root locus. For example, consider the third-order open-loop transfer function

$$F(s) = G(s)H(s) = \frac{K}{(s+p_3)(s^2+2\zeta\omega_n s+\omega_n^2)}. \tag{6.49}$$

The pole locations and the vector angles at one complex pole p_1 are shown in Fig. 6.12(a). The angles at a test point s_1, an infinitesimal distance from p_1, must meet the angle criterion. Therefore, since $\theta_2 = 90°$, we have

$$\theta_1 + \theta_2 + \theta_3 = \theta_1 + 90° + \theta_3 = +180°,$$

or the angle of departure at pole p_1 is

$$\theta_1 = 90° - \theta_3$$

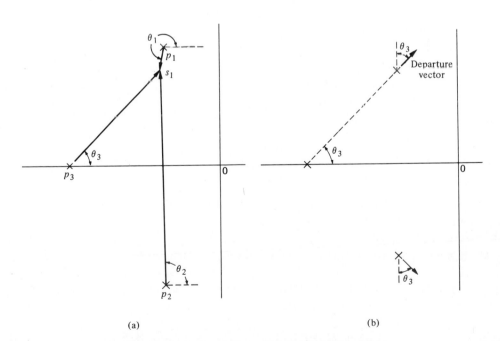

(a) (b)

Figure 6.12. Illustration of the angle of departure.

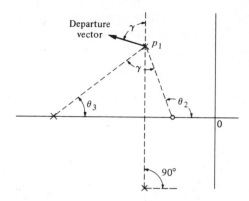

Figure 6.13. Evaluation of the angle of departure.

as shown in Fig. 6.12(b). The departure at pole p_2 is the negative of that at p_1 because p_1 and p_2 are complex conjugates. Another example of a departure angle is shown in Fig. 6.13. In this case, the departure angle is found from

$$\theta_2 - (\theta_1 + \theta_3 + 90°) = 180°.$$

Since $(\theta_2 - \theta_3) = \gamma$, we find that the departure angle is $\theta_1 = 90° + \gamma$.

It is worthwhile at this point to summarize the steps utilized in the root locus method and then illustrate their use in a complete example. The steps utilized in evaluating the locus of roots of a characteristic equation are as follows:

1. Write the characteristic equation in pole-zero form so that the parameter of interest k appears as $1 + kF(s) = 0$.
2. Locate the open-loop poles and zeros of $F(s)$ in the s-plane.
3. Locate the segments of the real axis that are root loci.
4. Determine the number of separate loci.
5. Locate the angles of the asymptotes and the center of the asymptotes.
6. Determine the breakaway point on the real axis (if any).
7. By utilizing the Routh-Hurwitz criterion, determine the point at which the locus crosses the imaginary axis (if it does so).
8. Estimate the angle of locus departure from complex poles and the angle of locus arrival at complex zeros.

■ **Example 6.4 Fourth-order system**

1. We desire to plot the root locus for the characteristic equation of a system when

$$1 + \frac{K}{s(s + 4)(s + 4 + j4)(s + 4 - j4)} = 0 \qquad (6.50)$$

as K varies from zero to infinity.

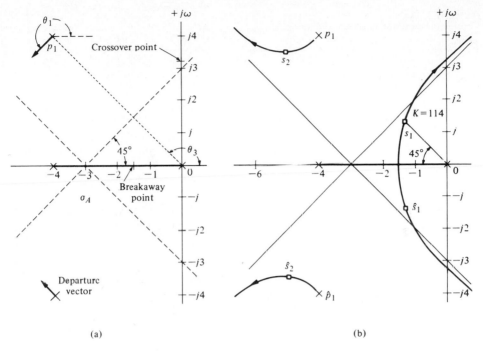

Figure 6.14. The root locus for Example 6.4.

2. The poles are located on the s-plane as shown in Fig. 6.14(a).
3. A segment of the root locus exists on the real axis between $s = 0$ and $s = -4$.
4. Because the number of poles n_p is equal to four, we have four separate loci.
5. The angles of the asymptotes are

$$\phi_A = \frac{(2q + 1)}{4} 180°, \quad q = 0, 1, 2, 3,$$

$$\phi_A = +45°, 135°, 225°, 315°.$$

The center of the asymptotes is

$$\sigma_A = \frac{-4 - 4 - 4}{4} = -3.$$

Then the asymptotes are drawn as shown in Fig. 6.14(a).
6. The breakaway point is estimated by evaluating

$$K = p(s) = -s(s + 4)(s + 4 + j4)(s + 4 - j4)$$

between $s = -4$ and $s = 0$. We expect the breakaway point to lie between $s = -3$ and $s = -1$ and, therefore, we search for a maximum value of $p(s)$ in that region. The resulting values of $p(s)$ for several values of s are given in

Table 6.2.

$p(s)$	0	51	68.5	80	85	75	0
s	-4.0	-3.0	-2.5	-2.0	-1.5	-1.0	0

Table 6.2. The maximum of $p(s)$ is found to lie at approximately $s = -1.5$ as indicated in the table. A more accurate estimate of the breakaway point is normally not necessary or worthwhile. The breakaway point is then indicated on Fig. 6.14(a).

7. The characteristic equation is rewritten as

$$s(s + 4)(s^2 + 8s + 32) + K = s^4 + 12s^3 + 64s^2 + 128s + K = 0. \quad (6.51)$$

Therefore, the Routh-Hurwitz array is

$$
\begin{array}{c|cc}
s^4 & 1 & 64 \quad K \\
s^3 & 12 & 128 \\
s^2 & b_1 & K \\
s & c_1 \\
s^0 & K
\end{array}
$$

where

$$b_1 = \frac{12(64) - 128}{12} = 53.33 \quad \text{and} \quad c_1 = \frac{53.33(128) - 12K}{53.33}.$$

Hence the limiting value of gain for stability is $K = 570$ and the roots of the auxiliary equation are

$$53.33s^2 + 570 = 53.33(s^2 + 10.6) = 53.33(s + j3.25)(s - j3.25). \quad (6.52)$$

The points where the locus crosses the imaginary axis are shown in Fig. 6.14(a).

8. The angle of departure at the complex pole p_1 can be estimated by utilizing the angle criterion as follows:

$$\theta_1 + 90° + 90° + \theta_3 = 180°,$$

where θ_3 is the angle subtended by the vector form pole p_3. The angles from the pole at $s = -4$ and $s = -4 - j4$ are each equal to 90°. Since $\theta_3 = 135°$, we find that

$$\theta_1 = -135° = +225°$$

as shown in Fig. 6.14(a).

Utilizing all the information obtained from the eight steps of the root locus method, the complete root locus is plotted by using a protractor to locate points that satisfy the angle criterion. The root locus for this system is shown in Fig.

6.14(b). When complex roots near the origin have a damping ratio of $\zeta = 0.707$, the gain K can be determined graphically as shown in Fig. 6.14(b). The vector lengths to the root location s_1 from the open-loop poles are evaluated and result in a gain at s_1 of

$$K = |s_1| \, |s_1 + 4| \, |s_1 - p_1| \, |s_1 - \hat{p}_1| \tag{6.53}$$
$$= (1.9)(3.0)(3.8)(6.0) = 130.$$

The remaining pair of complex roots occurs at s_2 and \hat{s}_2 when $K = 130$. The effect of the complex roots at s_2 and \hat{s}_2 on the transient response will be negligible compared to the roots s_1 and \hat{s}_1. This fact can be ascertained by considering the damping of the response due to each pair of roots. The damping due to s_1 and \hat{s}_1 is

$$e^{-\zeta_1 w_n t} = e^{-\sigma_1 t},$$

and the damping factor due to s_2 and \hat{s}_2 is

$$e^{-\zeta_2 w_{n2} t} = e^{-\sigma_2 t},$$

where σ_2 is approximately five times as large as σ_1. Therefore, the transient response term due to s_2 will decay much more rapidly than the transient response term due to s_1. Thus the response to a unit step input may be written as

$$c(t) = 1 + c_1 e^{-\sigma_1 t} \sin(\omega_1 t + \theta_1) + c_2 e^{-\sigma_2 t} \sin(\omega_2 t + \theta_2) \tag{6.54}$$
$$\cong 1 + c_1 e^{-\sigma_1 t} \sin(\omega_1 t + \theta_1).$$

The complex conjugate roots near the origin of the s-plane relative to the other roots of the closed-loop system are labeled the *dominant roots* of the system because they represent or dominate the transient response. The relative dominance of the roots is determined by the ratio of the real parts of the complex roots and will result in reasonable dominance for ratios exceeding five.

Of course, the dominance of the second term of Eq. (6.54) also depends upon the relative magnitudes of the coefficients c_1 and c_2. These coefficients, which are the residues evaluated at the complex roots, in turn depend upon the location of the zeros in the s-plane. Therefore, the concept of dominant roots is useful for estimating the response of a system but must be used with caution and with a comprehension of the underlying assumptions.

A computer program written in BASIC for the calculation of the root locus is available [4]. The Control System Design Program (CSDP) provides the user with a table of roots for selected values of the parameter K [4] (See Appendix F).

For example, refer back to Example 6.2. After several tries, you should be able to determine that when $K = 1.925$, the breakaway occurs from the real axis with two real roots at $s = -2.6$. In the same way you will find that when $K = 200$, the two roots on the imaginary axis are at $s = \pm j4.82$.

Similarly, for Example 6.4, using CSDP, one can determine that breakaway from the real axis occurs at $K = 84$ when $s = -1.57$. In the same way when $K = 600$ we find that two roots are on the imaginary axis at $s = \pm j3.33$.

6.4 An Example of a Control System Analysis and Design Utilizing the Root Locus Method

The analysis and design of a control system can be accomplished by utilizing the Laplace transform, a signal-flow diagram, the s-plane, and the root locus method. It will be worthwhile at this point in the development to examine a control system and select suitable parameter values based on the root locus method.

An automatic self-balancing scale in which the weighing operation is controlled by the physical balance function through an electrical feedback loop is shown in Fig. 6.15 [5]. The balance is shown in the equilibrium condition, and x is the travel of the counterweight W_c from an unloaded equilibrium condition. The weight to be measured, W, is applied 5 cm from the pivot, and the length of the beam to the viscous damper, l_i is 20 cm. It is desired to accomplish the following items:

1. Select the parameters and the specifications of the feedback system.
2. Obtain a model and signal-flow diagram representing the system.
3. Select the gain K based on a root locus diagram.
4. Determine the dominant mode of response.

The inertia of the beam will be chosen to be equal to 0.05 kg-m^2. We must select a battery voltage that is large enough to provide a reasonable position sensor gain, so let us choose $E_{bb} = 24$ volts. We will utilize a lead screw of 20 turns/cm and a potentiometer for x equal to 6 cm in length. Accurate balances are required, and

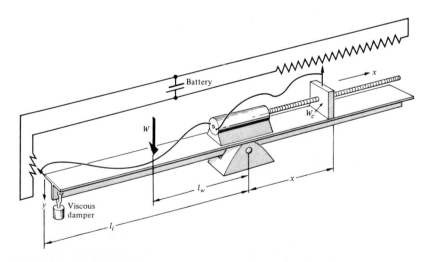

Figure 6.15. An automatic self-balancing scale. (From J. H. Goldberg, *Automatic Controls,* Allyn and Bacon, Boston, 1964, with permission.)

Table 6.3.

$W_e = 2\,Ng$	Lead screw gain $K_s = \dfrac{1}{4000\pi}$ m/rad
$I = 0.05$ kg-m^2	
$l_w = 5$ cm	Input potentiometer gain $K_i = 4800$ v/m
$l_i = 20$ cm	
$f = 10\sqrt{3}$ kg/m/sec	Feedback potentiometer gain $K_f = 400$ v/m

therefore an input potentiometer for y will be chosen to be 0.5 cm in length. A reasonable viscous damper will be chosen with a damping constant $f = 10\sqrt{3}$ kg/m/sec. Finally, a counterweight W_c is chosen so that the expected range of weights W can be balanced. Therefore, in summary, the *parameters* of the system are selected as listed in Table 6.3.

Specifications. A rapid and accurate response resulting in a small steady-state weight measurement error is desired. Therefore we will require the system be at least a type-one system so that a zero measurement error is obtained. An underdamped response to a step change in the measured weight, W, is satisfactory, and therefore a dominant response with $\zeta = 0.5$ will be specified. The settling time of the balance following the introduction of a weight to be measured should be less than 2 sec in order to provide a rapid weight-measuring device. The specifications are summarized in Table 6.4.

The derivation of a model of the electromechanical system may be accomplished by obtaining the equations of motion of the balance. For small deviations from balance, the deviation angle θ is

$$\theta \cong \frac{y}{l_i}. \tag{6.55}$$

The motion of the beam about the pivot is represented by the torque equation:

$$I\frac{d^2\theta}{dt^2} = \Sigma \text{ torques.}$$

Therefore, in terms of the deviation angle, the motion is represented by

$$I\frac{d^2\theta}{dt^2} = l_w W - xW_c - l_i^2 f\frac{d\theta}{dt}. \tag{6.56}$$

Table 6.4. Specifications

Steady-state error	$K_p = \infty$
Underdamped response	$\zeta = 0.5$
Settling time	Less than 2 sec

The input voltage to the motor is

$$v_m(t) = K_i y - K_f x. \tag{6.57}$$

The transfer function of the motor is

$$\frac{\theta_m(s)}{V_m(s)} = \frac{K_m}{s(\tau s + 1)}, \tag{6.58}$$

where τ will be considered to be negligible with respect to the time constants of the overall system, and θ_m is the output shaft rotation. A signal-flow graph representing Eqs. (6.56) through (6.58) is shown in Fig. 6.16. Examining the forward path from W to $X(s)$ we find that the system is a type-one system due to the integration preceding $Y(s)$. Therefore the steady-state error of the system is zero.

The closed-loop transfer function of the system is obtained by utilizing Mason's flow-graph formula and is found to be

$$\frac{X(s)}{W(s)} = \frac{(l_w l_i K_i K_m K_s / I s^3)}{1 + (l_i^2 f / I s) + (K_m K_s K_f / s) + (l_i K_i K_m K_s W_c / I s^3) + (l_i^2 f K_m K_s K_f / I s^2)}, \tag{6.59}$$

where the numerator is the path factor from W to X, the second term in the denominator is the loop L_1, the third term is the loop factor L_2, the fourth term is the loop L_3, and the fifth term is the two nontouching loops $L_1 L_2$. Therefore the closed-loop transfer function is

$$\frac{X(s)}{W(s)} = \frac{l_w l_i K_i K_m K_s}{s(Is + l_i^2 f)(s + K_m K_s K_f) + W_c K_m K_s K_i l_i}. \tag{6.60}$$

The steady-state gain of the system is then

$$\lim_{t \to \infty} \left(\frac{x(t)}{|W|} \right) = \lim_{s \to 0} s \left(\frac{X(s)}{W(s)} \right) = \frac{l_w}{W_c} = 2.5 \text{ cm/kg} \tag{6.61}$$

when $W(s) = |W|/s$. In order to obtain the root locus as a function of the motor constant K_m, we substitute the selected parameters into the characteristic equa-

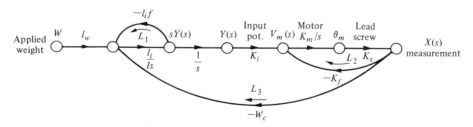

Figure 6.16. Signal-flow graph model of the automatic self-balancing scale.

tion, which is the denominator of Eq. (6.60). Therefore we obtain the following characteristic equation:

$$s(s + 8\sqrt{3})\left(s + \frac{K_m}{10\pi}\right) + \frac{96K_m}{10\pi} = 0. \tag{6.62}$$

Rewriting the characteristic equation in root locus form, we first isolate K_m as follows:

$$s^2(s + 8\sqrt{3}) + s(s + 8\sqrt{3})\frac{K_m}{10\pi} + \frac{96K_m}{10\pi} = 0. \tag{6.63}$$

Then, rewriting Eq. (6.63) in root locus form, we have

$$1 + KP(s) = 1 + \frac{(K_m/10\pi)[s(s + 8\sqrt{3}) + 96]}{s^2(s + 8\sqrt{3})} = 0$$
$$= 1 + \frac{(K_m/10\pi)(s + 6.93 + j6.93)(s + 6.93 - j6.93)}{s^2(s + 8\sqrt{3})}. \tag{6.64}$$

The root locus as K_m varies is shown in Fig. 6.17. The dominant roots can be placed at $\zeta = 0.5$ when $K = 25.3 = K_m/10\pi$. In order to achieve this gain,

$$K_m = 795 \frac{\text{rad/sec}}{\text{volt}} = 7600 \frac{\text{rpm}}{\text{volt}}, \tag{6.65}$$

an amplifier would be required to provide a portion of the required gain. The real part of the dominant roots is greater than four and therefore the settling time, $4/\sigma$, is less than 1 sec, and the settling time requirement is satisfied. The third root of the characteristic equation is a real root at $s = -30.2$, and the underdamped

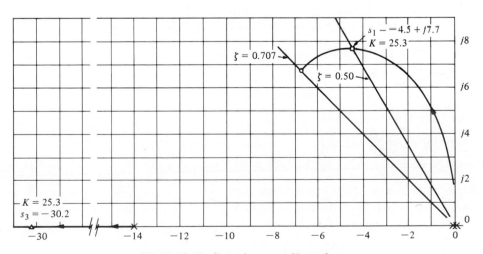

Figure 6.17. Root locus as K_m varies.

roots clearly dominate the response. Therefore the system has been analyzed by the root locus method and a suitable design for the parameter K_m has been achieved. The efficiency of the s-plane and root locus methods is clearly demonstrated by this example.

6.5 Parameter Design by the Root Locus Method

The original development of the root locus method was concerned with the determination of the locus of roots of the characteristic equation as the system gain, K, is varied from zero to infinity. However, as we have seen, the effect of other system parameters may be readily investigated by using the root locus method. Fundamentally, the root locus method is concerned with a characteristic equation (Eq. 6.23), which may be written as

$$1 + F(s) = 0. \tag{6.66}$$

Then the standard root locus method we have studied may be applied. The question arises: How do we investigate the effect of two parameters, α and β? It appears that the root locus method is a single-parameter method; however, fortunately it can be readily extended to the investigation of two or more parameters. This method of *parameter design* uses the root locus approach to select the values of the parameters.

The characteristic equation of a dynamic system may be written as

$$a_n s^n + a_{n-1} s^{n-1} + \cdots + a_1 s + a_0 = 0. \tag{6.67}$$

Clearly, the effect of the coefficient a_1 may be ascertained from the root locus equation

$$1 + \frac{a_1 s}{a_n s^n + a_{n-1} s^{n-1} + \cdots + a_2 s^2 + a_0} = 0. \tag{6.68}$$

If the parameter of interest, α, does not appear solely as a coefficient, the parameter is isolated as

$$a_n s^n + a_{n-1} s^{n-1} + \cdots + (a_{n-q} - \alpha)s^{n-q}$$
$$+ \alpha s^{n-q} + \cdots + a_1 s + a_0 = 0. \tag{6.69}$$

Then, for example, a third-order equation of interest might be

$$s^3 + (3 + \alpha)s^2 + 3s + 6 = 0. \tag{6.70}$$

In order to ascertain the effect of the parameter α, we isolate the parameter and rewrite the equation in root locus form as shown in the following steps:

$$s^3 + 3s^2 + \alpha s^2 + 3s + 6 = 0, \tag{6.71}$$

$$1 + \frac{\alpha s^2}{s^3 + 3s^2 + 3s + 6} = 0. \tag{6.72}$$

Then, in order to determine the effect of two parameters, we must repeat the root locus approach twice. Thus, for a characteristic equation with two variable parameters, α and β, we have

$$a_n s^n + a_{n-1} s^{n-1} + \cdots + (a_{n-q} - \alpha) s^{n-q} + \alpha s^{n-q} + \cdots$$
$$+ (a_{n-r} - \beta) s^{n-r} + \beta s^{n-r} + \cdots + a_1 s + a_0 = 0. \quad (6.73)$$

The two variable parameters have been isolated and the effect of α will be determined, followed by the determination of the effect of β. For example, for a certain third-order characteristic equation with α and β as parameters, we obtain

$$s^3 + s^2 + \beta s + \alpha = 0. \quad (6.74)$$

In this particular case, the parameters appear as the coefficients of the characteristic equation. The effect of varying β from zero to infinity is determined from the root locus equation

$$1 + \frac{\beta s}{s^3 + s^2 + \alpha} = 0. \quad (6.75)$$

One notes that the denominator of Eq. (6.75) is the characteristic equation of the system with $\beta = 0$. Therefore one first evaluates the effect of varying α from zero to infinity by utilizing the equation

$$s^3 + s^2 + \alpha = 0,$$

rewritten as

$$1 + \frac{\alpha}{s^2(s + 1)} = 0, \quad (6.76)$$

where β has been set equal to zero in Eq. (6.74). Then, upon evaluating the effect of α, a value of α is selected and used with Eq. (6.75) to evaluate the effect of β. This two-step method of evaluating the effect of α and then β may be carried out as a two-root locus procedure. First we obtain a locus of roots as α varies, and we select a suitable value of α; the results are satisfactory root locations. Then we obtain the root locus for β by noting that the poles of Eq. (6.75) are the roots evaluated by the root locus of Eq. (6.76). A limitation of this approach is that one will not always be able to obtain a characteristic equation that is linear in the parameter under consideration, for example, α.

In order to illustrate this approach effectively, let us obtain the root locus for α and then β for Eq. (6.74). A sketch of the root locus as α varies for Eq. (6.76) is shown in Fig. 6.18(a), where the roots for two values of gain α are shown. If the gain α is selected as α_1, then the resultant roots of Eq. (6.76) become the poles of Eq. (6.75). The root locus of Eq. (6.75) as β varies is shown in Fig. 6.18(b), and a suitable β can be selected on the basis of the desired root locations.

Using the root locus method, we will further illustrate this parameter design approach by a specific design example.

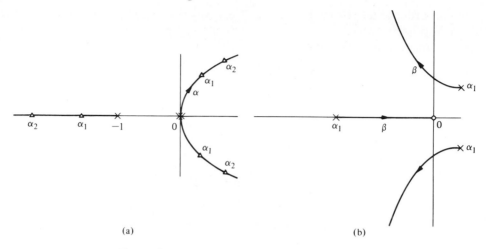

Figure 6.18. Root loci as a function of α and β.

■ Example 6.5 Disk drive control

A feedback control system is to be designed to satisfy the following specifications:

1. Steady-state error for a ramp input \leq 35% of input slope
2. Damping ratio of dominant roots \geq 0.707
3. Settling time of the system \leq 3 sec

The structure of the feedback control system is shown in Fig. 6.19, where the amplifier gain K_1 and the derivative feedback gain K_2 are to be selected. The steady-state error specification can be written as follows:

$$e_{ss} = \lim_{t \to \infty} e(t) = \lim_{s \to 0} sE(s) = \lim_{s \to 0} \frac{s(|R|/s^2)}{1 + G_2(s)}, \tag{6.77}$$

where $G_2(s) = G(s)/(1 + G(s)H_1(s))$. Therefore the steady-state error requirement is

$$\frac{e_{ss}}{|R|} = \frac{2 + K_1 K_2}{K_1} \leq 0.35. \tag{6.78}$$

Thus we will select a small value of K_2 to achieve a low value of steady-state error. The damping ratio specification requires that the roots of the closed-loop system be below the line at 45° in the left-hand s-plane. The settling time specification can be rewritten in terms of the real part of the dominant roots as

$$T_s = \frac{4}{\sigma} \leq 3 \text{ sec.} \tag{6.79}$$

(a)

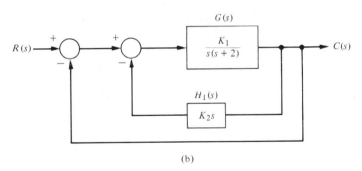

(b)

Figure 6.19. (a) The HP 9795 disk drive and data pack designed to locate stored data in minimum access time [13]. (Courtesy of Hewlett-Packard Co.) (b) Block diagram. © Copyright 1984, Hewlett-Packard Company. Reproduced with permission.

Therefore it is necessary that $\sigma \geq \frac{4}{3}$ and this area in the left-hand s-plane is indicated along with the ζ-requirement in Fig. 6.20. In order to satisfy the specifications, all the roots must lie within the shaded area of the left-hand plane.

The parameters to be selected are $\alpha = K_1$ and $\beta = K_2 K_1$. The characteristic equation is

$$1 + GH(s) = s^2 + 2s + \beta s + \alpha = 0. \tag{6.80}$$

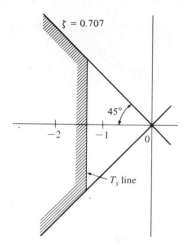

Figure 6.20. A region in the s-plane for desired root location.

The locus of roots as $\alpha = K_1$ varies is determined from the following equation:

$$1 + \frac{\alpha}{s(s + 2)} = 0. \tag{6.81}$$

(See Fig. 6.21a.) For a gain of $K_1 = \alpha = 20$, the roots are indicated on the locus. Then the effect of varying $\beta = 20K_2$ is determined from the locus equation

$$1 + \frac{\beta s}{s^2 + 2s + \alpha} = 0, \tag{6.82}$$

where the poles of this root locus are the roots of the locus of Fig. 6.21(a). The root locus for Eq. (6.82) is shown in Fig. 6.21(b) and roots with $\zeta = 0.707$ are obtained when $\beta = 4.3 = 20K_2$ or when $K_2 = 0.215$. The real part of these roots is $\sigma = 3.15$, and therefore the settling time is equal to 1.27 sec, which is considerably less than the specification of 3 sec.

The root locus method may be extended to more than two parameters by extending the number of steps in the method outlined in this section. Furthermore, a family of root loci can be generated for two parameters in order to determine the total effect of varying two parameters. For example, let us determine the effect of varying α and β of the following characteristic equation:

$$s^3 + 3s^2 + 2s + \beta s + \alpha = 0. \tag{6.83}$$

The root locus equation as a function of α is

$$1 + \frac{\alpha}{s(s + 1)(s + 2)} = 0. \tag{6.84}$$

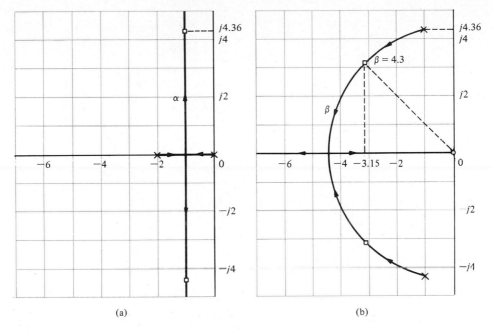

Figure 6.21. Root loci as a function of α and β.

The root locus as a function of β is

$$1 + \frac{\beta s}{s^3 + 3s^2 + 2s + \alpha} = 0. \tag{6.85}$$

The root locus for Eq. (6.84) as a function of α is shown in Fig. 6.22 (unbroken lines). The roots of this locus, indicated by a cross, become the poles for the locus of Eq. (6.85). Then the locus of Eq. (6.85) is continued on Fig. 6.22 (dotted lines), where the locus for β is shown for several selected values of α. This family of loci, often called root contours, illustrates the effect of α and β on the roots of the characteristic equation of a system [3].

6.6 Sensitivity and the Root Locus

One of the prime reasons for the utilization of negative feedback in control systems is to reduce the effect of parameter variations. The effect of parameter variations, as we found in Section 3.2, can be described by a measure of the *sensitivity* of the system performance to specific parameter changes. In Section 3.2, we defined the *logarithmic sensitivity* originally suggested by Bode as

$$S_k^T = \frac{d \ln T}{d \ln k} = \frac{\partial T/T}{\partial k/k}, \tag{6.86}$$

where the system transfer function is $T(s)$ and the parameter of interest is k.

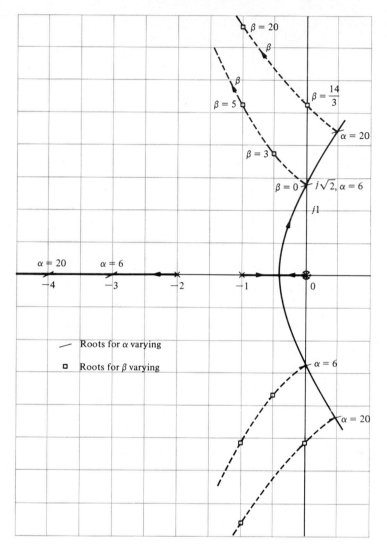

Figure 6.22. Two-parameter root locus.

In recent years, with the increased utilization of the pole–zero (s-plane) approach, it has become useful to define a measure of sensitivity in terms of the positions of the roots of the characteristic equation [6,7]. Because the roots of the characteristic equation represent the dominant modes of transient response, the effect of parameter variations on the position of the roots is an important and useful measure of the sensitivity. The *root sensitivity* of a system $T(s)$ can be defined as

$$S_k^{r_i} = \frac{\partial r_i}{\partial \ln k} = \frac{\partial r_i}{\partial k/k}, \tag{6.87}$$

where r_i equals the ith root of the system so that

$$T(s) = \frac{K_1 \prod_{j=1}^{m} (s + Z_j)}{\prod_{i=1}^{n} (s + r_i)},$$ (6.88)

and k is the parameter. The root sensitivity relates the changes in the location of the root in the s-plane to the change in the parameter. The root sensitivity is related to the Bode logarithmic sensitivity by the relation

$$S_k^T = \frac{\partial \ln K_1}{\partial \ln k} - \sum_{i=1}^{n} \frac{\partial r_i}{\partial \ln k} \cdot \frac{1}{(s + r_i)}$$ (6.89)

when the zeros of $T(s)$ are independent of the parameter k so that

$$\frac{\partial Z_j}{\partial \ln k} = 0.$$

This logarithmic sensitivity can be readily obtained by determining the derivative of $T(s)$, Eq. (6.88), with respect to k. For the particular case when the gain of the system is independent of the parameter k, we have

$$S_k^T = - \sum_{i=1}^{n} S_k^{r_i} \cdot \frac{1}{(s + r_i)},$$ (6.90)

and the two sensitivity measures are directly related.

The evaluation of the root sensitivity for a control system can be readily accomplished by utilizing the root locus methods of the preceding section. The root sensitivity $S_k^{r_i}$ may be evaluated at root r_i by examining the root contours for the parameter k. We can change k by a small, finite amount Δk and evaluate the new, modified root $(r_i + \Delta r_i)$ at $k + \Delta k$. Then, using Eq. (6.87) we have

$$S_k^{r_i} = \frac{\Delta r_i}{\Delta k / k}$$ (6.91)

An example will illustrate the process of evaluating the root sensitivity.

■ **E x a m p l e 6.6 Root sensitivity of a control system**

The characteristic equation of the feedback control system shown in Fig. 6.23 is

$$1 + \frac{K}{s(s + \beta)} = 0$$

Figure 6.23. A feedback control system.

or, alternatively,

$$s^2 + \beta s + K = 0. \tag{6.92}$$

The gain K will be considered to be the parameter α. Then the effect of a change in each parameter can be determined by utilizing the relations

$$\alpha = \alpha_0 \pm \Delta\alpha$$

$$\beta = \beta_0 \pm \Delta\beta,$$

where α_0 and β_0 are the nominal or desired values for the parameters α and β, respectively. We shall consider the case when the nominal pole value is $\beta_0 = 1$ and the desired gain is $\alpha_0 = K = 0.5$. Then the root locus as a function of $\alpha = K$ can be obtained by utilizing the root locus equation

$$1 + \frac{K}{s(s + \beta_0)} = 1 + \frac{K}{s(s + 1)} = 0 \tag{6.93}$$

as shown in Fig. 6.24. The nominal value of gain $K = \alpha_0 = 0.5$ results in two complex roots, $r_1 = -0.5 + j0.5$ and $r_2 = \hat{r}_1$, as shown in Fig. 6.24. In order to evaluate the effect of unavoidable changes in the gain, the characteristic equation with $\alpha = \alpha_0 \pm \Delta\alpha$ becomes

$$s^2 + s + \alpha_0 \pm \Delta\alpha = s^2 + s + 0.5 \pm \Delta\alpha$$

or

$$1 + \frac{\pm\Delta\alpha}{s^2 + s + 0.5} = 1 + \frac{\pm\Delta\alpha}{(s + r_1)(s + \hat{r}_1)} = 0. \tag{6.94}$$

Therefore the effect of changes in the gain can be evaluated from the root locus of Fig. 6.24. For a 20% change in α, we have $\pm\Delta\alpha = \pm0.1$. The root locations

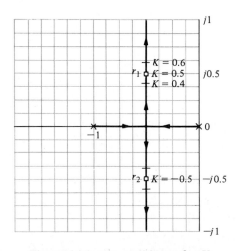

Figure 6.24. The root locus for K.

for a gain $\alpha = 0.4$ and $\alpha = 0.6$ are readily determined by root locus methods, and the root locations for $\pm \Delta \alpha = \pm 0.1$ are shown on Fig. 6.24. When $\alpha = K = 0.6$, the root in the second quadrant of the s-plane is

$$r_1 + \Delta r_1 = -0.5 + j0.59,$$

and the change in the root is $\Delta r_1 = +j0.09$. When $\alpha = K = 0.4$, the root in the second quadrant is

$$r_1 + \Delta r_1 = -0.5 + j0.387,$$

and the change in the root is $\Delta r = -j0.11$. Thus the root sensitivity for r_1 is

$$S_{+\Delta K}^{r_1} = S_{K+}^{r_i} = \frac{\Delta r_1}{\Delta K/K} = \frac{+j0.09}{+0.2} = j0.45 = 0.45\underline{/+90^\circ} \tag{6.95}$$

for positive changes of gain. For negative increments of gain, the sensitivity is

$$S_{-\Delta K}^{r_1} = S_{K}^{r_i} = \frac{\Delta r_1}{\Delta K/K} = \frac{-j0.11}{+0.2} = -j0.55 = 0.55\underline{/-90^\circ}.$$

Of course, for infinitesimally small changes in the parameter ∂K, the sensitivity will be equal for negative or positive increments in K. The angle of the root sensitivity indicates the direction the root would move as the parameter varies. The angle of movement for $+\Delta \alpha$ is always 180° minus the angle of movement for $-\Delta \alpha$ at the point $\alpha = \alpha_0$.

The pole β varies due to environmental changes, and it may be represented by $\beta = \beta_0 + \Delta \beta$, where $\beta_0 = 1$. Then the effect of variation of the poles is represented by the characteristic equation

$$s^2 + s + \Delta \beta s + K = 0,$$

or, in root locus form, we have

$$1 + \frac{\Delta \beta s}{s^2 + s + K} = 0. \tag{6.96}$$

Again, the denominator of the second term is the unchanged characteristic equation when $\Delta \beta = 0$. The root locus for the unchanged system ($\Delta \beta = 0$) is shown in Fig. 6.24 as a function of K. For a design specification requiring $\zeta = 0.707$, the complex roots lie at

$$r_1 = -0.5 + j0.5 \quad \text{and} \quad r_2 = \hat{r}_1 = -0.5 - j0.5.$$

Then, because the roots are complex conjugates, the root sensitivity for r_1 is the conjugate of the root sensitivity for $\hat{r}_1 = r_2$. Using the parameter root locus techniques discussed in the preceding section, we obtain the root locus for $\Delta \beta$ as shown in Fig. 6.25. We are normally interested in the effect of a variation for the parameter so that $\beta = \beta_0 \pm \Delta \beta$, for which the locus as $\Delta \beta$ decreases is obtained from the root locus equation

$$1 + \frac{-(\Delta \beta)s}{s^2 + s + K} = 0. \tag{6.97}$$

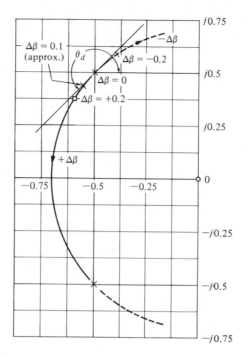

Figure 6.25. The root locus for the parameter β.

Examining Eq. (6.97), we note that the equation is of the form

$$1 - kP(s) = 0.$$

Comparing this equation with Eq. (6.24) (Section 6.3), we find that the sign preceding the gain k is negative in this case. In a manner similar to the development of the root locus method in Section 6.3, we require that the root locus satisfy the equations

$$|kP(s)| = 1, \quad \underline{/P(s)} = 0° \pm q360°, \tag{6.98}$$

where $q = 0, 1, 2, \ldots$. The locus of roots follows a zero-degree locus (Eq. 6.98) in contrast with the 180° locus considered previously. However, the root locus rules of Section 6.3 may be altered to account for the zero-degree phase angle requirement, and then the root locus may be obtained as in the preceding sections. Therefore, in order to obtain the effect of reducing β, one determines the zero-degree locus in contrast to the 180° locus as shown by a dotted locus in Fig. 6.25. Therefore, to find the effect of a 20% change of the parameter β, we evaluate the new roots for $\pm\Delta\beta = \pm0.20$ as shown in Fig. 6.25. The root sensitivity is readily evaluated graphically and, for a positive change in β, is

$$S_{\beta+}^{r_1} = \frac{\Delta r_1}{(\Delta\beta/\beta)} = \frac{0.16\underline{/-131°}}{0.20} = 0.80\underline{/-131°}. \tag{6.99}$$

The root sensitivity for a negative change in β is

$$S_{\beta-}^{r_1} = \frac{\Delta r_1}{(\Delta\beta/\beta)} = \frac{0.125\underline{/38°}}{0.20} = 0.625\underline{/+38°}. \tag{6.100}$$

As the percentage change $(\Delta\beta/\beta)$ decreases, the sensitivity measures, $S_{\beta+}^{r_1}$ and $S_{\beta-}^{r_1}$, will approach equality in magnitude and a difference in angle of 180°. Thus for small changes when $\Delta\beta/\beta \leq 0.10$, the sensitivity measures are related as

$$|S_{\beta+}^{r_1}| = |S_{\beta-}^{r_1}| \tag{6.101}$$

and

$$\underline{/S_{\beta+}^{r}} = 180° + \underline{/S_{\beta-}^{r}}. \tag{6.102}$$

Often the desired root sensitivity measure is for small changes in the parameter. When the relative change in the parameter is such that $\Delta\beta/\beta = 0.10$, a root locus approximation is satisfactory. The root locus for Eq. (6.98) when $\Delta\beta$ is varying leaves the pole at $\Delta\beta = 0$ at an angle of departure θ_d. Since θ_d is readily evaluated, one can estimate the increment in the root change by approximating the root locus with the line at θ_d. This approximation is shown in Fig. 6.25 and is accurate for only relatively small changes in $\Delta\beta$. However, the use of this approximation allows the analyst to avoid drawing the complete root locus diagram. Therefore, for Fig. 6.25, the root sensitivity may be evaluated for $\Delta\beta/\beta = 0.10$ along the departure line, and one obtains

$$S_{\beta+}^{r_1} = \frac{0.74\underline{/-135°}}{0.10} = 0.74\underline{/-135°}. \tag{6.103}$$

The root sensitivity measure for a parameter variation is useful for comparing the sensitivity for various design parameters and at different root locations. Comparing Eq. (6.103) for β with Eq. (6.94) for α, we find that the sensitivity for β is greater in magnitude by approximately 50% and the angle for $S_{\beta-}^{r}$ indicates that the approach of the root toward the $j\omega$-axis is more sensitive for changes in β. Therefore, the tolerance requirements for β would be more stringent than for α. This information provides the designer with a comparative measure of the required tolerances for each parameter.

■ **E x a m p l e 6.7 Root sensitivity to a parameter**

A unity feedback control system has a forward transfer function

$$G(s) = \frac{20.7(s + 3)}{s(s + 2)(s + \beta)}, \tag{6.104}$$

where $\beta = \beta_0 + \Delta\beta$ and $\beta_0 = 8$. The characteristic equation as a function of $\Delta\beta$ is

$$s(s + 2)(s + 8 + \Delta\beta) + 20.7(s + 3) = 0$$

or

$$s(s + 2)(s + 8) + \Delta\beta s(s + 2) + 20.7(s + 3) = 0. \qquad (6.105)$$

When $\Delta\beta = 0$, the roots may be determined by the root locus method or the Newton-Raphson method, and thus we evaluate the roots as

$$r_1 = -2.36 + j2.48, \qquad r_2 = \hat{r}_1, \qquad r_3 = -5.27.$$

The root locus for $\Delta\beta$ is determined by using the root locus equation

$$1 + \frac{\Delta\beta s(s + 2)}{(s + r_1)(s + \hat{r}_1)(s + r_3)} = 0. \qquad (6.106)$$

The poles and zeros of Eq. (6.106) are shown in Fig. 6.26. The angle of departure at r_1 is evaluated from the angles as follows:

$$180° = -(\theta_d + 90° + \theta_{p_3}) + (\theta_{z_1} + \theta_{z_2})$$
$$= -(\theta_d + 90° + 40°) + (133° + 98°). \qquad (6.107)$$

Therefore $\theta_d = -80°$ and the locus is approximated near r_1 by the line at an angle of θ_d. For a change of $\Delta r_1 = 0.2/{-80°}$ along the departure line, the $+\Delta\beta$ is evaluated by determining the vector lengths from the poles and zeros. Then we have

$$+\Delta\beta = \frac{4.8(3.75)(0.2)}{(3.25)(2.3)} = 0.48. \qquad (6.108)$$

Therefore the sensitivity at r_1 is

$$S_\beta^{r_1} = \frac{\Delta r_1}{\Delta\beta/\beta} = \frac{0.2/{-80°}}{0.48/8} = 3.34/{-80°}, \qquad (6.109)$$

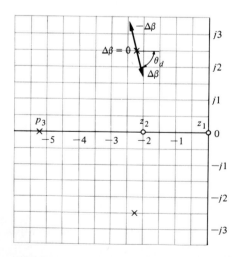

Figure 6.26. Pole and zero diagram for the parameter β.

which indicates that the root is quite sensitive to this 6% change in the parameter β. For comparison, it is worthwhile to determine the sensitivity of the root, r_1, to a change in the zero, $s = -3$. Then the characteristic equation is

$$s(s + 2)(s + 8) + 20.7(s + 3 + \Delta\gamma) = 0$$

or

$$1 + \frac{20.7 \, \Delta\gamma}{(s + r_1)(s + \hat{r}_1)(s + r_3)} = 0. \tag{6.110}$$

The pole–zero diagram for Eq. (6.110) is shown in Fig. 6.27. The angle of departure at root r_1 is $180° = -(\theta_d + 90° + 40°)$ or

$$\theta_d = +50°. \tag{6.111}$$

For a change of $r_1 = 0.2 \underline{/+50°}$, the $\Delta\gamma$ is positive, and obtaining the vector lengths, we find

$$|\Delta\gamma| = \frac{5.22(4.18)(0.2)}{20.7} = 0.21. \tag{6.112}$$

Therefore, the sensitivity at r_1 for $+\Delta\gamma$ is

$$S_\gamma^{r_1} = \frac{\Delta r_1}{\Delta\gamma/\gamma} = \frac{0.2\underline{/+50°}}{0.21/3} = 2.84\underline{/\,| \, 50°}. \tag{6.113}$$

Thus we find that the magnitude of the root sensitivity for the pole β and the zero γ is approximately equal. However, the sensitivity of the system to the pole can be considered to be less than the sensitivity to the zero because the angle of the sensitivity $S_\gamma^{r_1}$ is equal to $+50°$ and the direction of the root change is toward the $j\omega$-axis.

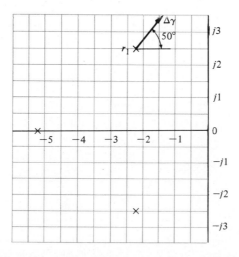

Figure 6.27. Pole–zero diagram for the parameter γ.

Evaluating the root sensitivity in the manner of the preceding paragraphs, we find that for the pole $s = -\delta_0 = -2$ the sensitivity is

$$S_{\delta-}^{r_1} = 2.1\underline{/+27°}. \tag{6.114}$$

Thus, for the parameter δ, the magnitude of the sensitivity is less than for the other parameters, but the direction of the change of the root is more important than for β and γ.

In order to utilize the root sensitivity measure for the analysis and design of control systems, a series of calculations must be performed for various selections of possible root configurations and the zeros and poles of the open-loop transfer function. Therefore the use of the root sensitivity measure as a design technique is somewhat limited by the relatively large number of calculations required and by the lack of an obvious direction for adjusting the parameters in order to provide a minimized or reduced sensitivity. However, the root sensitivity measure can be utilized as an analysis measure, which permits the designer to compare the sensitivity for several system designs based on a suitable method of design. The root sensitivity measure is a useful index of sensitivity of a system to parameter variations expressed in the s-plane. The weakness of the sensitivity measure is that it relies on the ability of the root locations to represent the performance of the system. As we have seen in the preceding chapters, the root locations represent the performance quite adequately for many systems, but due consideration must be given to the location of the zeros of the closed-loop transfer function and the dominancy of the pertinent roots. The root sensitivity measure is a suitable measure of system performance sensitivity and can be used reliably for system analysis and design.

6.7 Design Example: Laser Manipulator Control System

Lasers can be used to drill the hip socket for appropriate insertion of an artificial hip joint. The use of lasers for surgery requires high accuracy for position and velocity response. Let us consider the system shown in Fig. 6.28, which uses a dc motor manipulator for the laser. The amplifier gain K must be adjusted so that the steady-state error for a ramp input, $r(t) = At$ (where $A = 1$ mm/s), is less than or equal to 0.1 mm while a stable response is maintained.

In order to obtain the steady-state error required and a good response, we

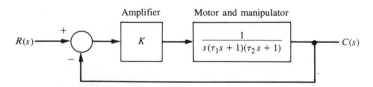

Figure 6.28. Laser manipulator control system.

select a motor with a field time constant $\tau_1 = 0.1s$ and a motor plus load time constant of $\tau_2 = 0.2s$. We then have

$$T(s) = \frac{KG(s)}{1 + KG(s)}$$

$$= \frac{K}{s(\tau_1 s + 1)(\tau_2 s + 1) + K}$$

$$= \frac{K}{0.02s^3 + 0.3s^2 + s + K} \qquad (6.115)$$

$$= \frac{50K}{s^3 + 15s^2 + 50s + 50K}.$$

The steady state for a ramp, $R(s) = A/s^2$, from Eq. (4.31), is

$$e_{ss} = \frac{A}{K_v} = \frac{A}{K}.$$

Since we desire $e_{ss} = 0.1$ mm (or less) and $A = 1$ mm, we require $K = 10$ (or greater).

In order to ensure a stable system, we obtain the characteristic equation from Eq. (6.115) as

$$s^3 + 15s^2 + 50s + 50K = 0.$$

Establishing the Routh-Hurwitz array, we have

$$
\begin{array}{c|cc}
s^3 & 1 & 50 \\
s^2 & 15 & 50K \\
s^1 & b_1 & 0 \\
s^0 & 50\ K &
\end{array}
$$

where

$$b_1 = \frac{750 - 50K}{15}.$$

Therefore the system is stable for

$$0 \le K \le 15.$$

Then using $K = 10$, where the system is stable, we examine the root locus for $K > 0$. Since there are three loci and the centroid $\sigma = -5$, we obtain the root locus shown in Fig. 6.29. The breakaway point is $s = -2.11$ and the roots at $K = 10$ are $r_2 = -13.98$, $r_1 = -0.51 + j5.96$, and \hat{r}_1. The ζ of the complex roots is 0.085 and $\zeta\omega_n = 0.51$. Thus, assuming that the complex roots are dominant, we expect (using Eq. 4.16) an overshoot of 76% and a settling time of

$$T_s = \frac{4}{\zeta\omega_n}$$

$$= \frac{4}{0.51} = 7.8s.$$

Figure 6.29. Root locus for a laser control system.

Figure 6.30. The response to a ramp input for a laser control system.

Plotting the actual system response, we find that the overshoot is 72% and the settling time is 7.9 s. Thus the complex roots are essentially dominant. The system response to a step input is highly oscillatory and cannot be tolerated for laser surgery. The command signal must be limited to a low velocity ramp signal. The response to a ramp signal is shown in Fig. 6.30.

6.8 Summary

The relative stability and the transient response performance of a closed-loop control system is directly related to the location of the closed-loop roots of the characteristic equation. Therefore we have investigated the movement of the characteristic roots on the s-plane as the system parameters are varied by utilizing the root locus method. The root locus method, a graphical technique, can be used to obtain an approximate sketch in order to analyze the initial design of a system and determine suitable alterations of the system structure and the parameter values. A computer is commonly used to calculate several accurate roots at important points on the locus. A summary of 15 typical root locus diagrams is shown in Table 8.7.

Furthermore, we extended the root locus method for the design of several parameters for a closed-loop control system. Then the sensitivity of the characteristic roots was investigated for undesired parameter variations by defining a root sensitivity measure. It is clear that the root locus method is a powerful and useful approach for the analysis and design of modern control systems and will continue to be one of the most important procedures of control engineering.

Exercises

E6.1. Let us consider a device that consists of a ball rolling on the inside rim of a hoop [20]. This model is similar to the problem of liquid fuel sloshing in a rocket. The hoop is free to rotate about its horizontal principal axis as shown in Fig. E6.1. The angular position of the hoop may be controlled via the torque T applied to the hoop from a torque motor

Figure E6.1. Hoop rotated by motor.

attached to the hoop drive shaft. If negative feedback is used, the system characteristic equation is

$$1 + \frac{Ks(s + 4)}{s^2 + 2s + 2} = 0.$$

(a) Sketch the root locus. (b) Find the gain when the roots are both equal. (c) Find these two equal roots. (d) Find the settling time of the system when the roots are equal.

E6.2. A tape recorder has a speed control system so that $H(s) = 1$ with negative feedback and

$$G(s) = \frac{K}{s(s + 2)(s^2 + 4s + 5)}.$$

(a) Draw a root locus for K and show that the dominant roots are $s = -0.35 \pm j0.80$ when $K = 6.5$. (b) For the dominant roots of part (a), calculate the settling time and overshoot for a step input.

E6.3. A control system for an ac induction motor has negative unity feedback and a process [14]

$$G(s) = \frac{K(s^2 + 4s + 8)}{s^2(s + 4)}.$$

It is desired that the dominant roots have a ζ equal to 0.5. Using the root locus, show that $K = 7.35$ is required and the dominant roots are $s = -1.3 \pm j2.2$.

E6.4. Consider a unity feedback system with

$$G(s) = \frac{K(s + 1)}{s^2 + 4s + 5}.$$

(a) Find the angle of departure of the root locus from the complex poles. (b) Find the entry point for the root locus as it enters the real axis.

Answers: $\pm 225°$; -2.4

E6.5. Consider a feedback system with a loop transfer function

$$GH(s) = \frac{K}{(s + 1)(s + 3)(s + 6)}.$$

(a) Find the breakaway point or the real axis. (b) Find the asymptote centroid. (c) Find the value of K at the breakaway point.

E6.6. The United States is planning to have an operating space station in orbit by the mid-1990s. One version of the space station is shown in Fig. E6.6, on the next page. It is critical to keep this station in the proper orientation toward the sun and the earth for generating power and communications. The orientation controller may be represented by a unity feedback system with an actuator and controller,

$$G(s) = \frac{K(s + 30)}{s(s^2 + 20s + 100)}.$$

Sketch the root locus of the system as K increases. Find the value of K that results in an oscillatory response.

Figure E6.6. Space station.

E6.7. The elevator in a modern office building travels at a top speed of 25 feet per second and is still able to stop within one eighth of an inch of the floor outside. The transfer function of the unity feedback elevator drive is

$$G(s) = \frac{K(s + 10)}{s(s + 1)(s + 20)(s + 50)}.$$

Determine the gain K when the complex roots have a ζ equal to 0.8.

E6.8. Draw the root locus for a unity feedback system (Fig. 6.1) with

$$G(s) = \frac{K(s + 1)}{s^2(s + 9)}.$$

(a) Find the gain when all three roots are real and equal. (b) Find the roots when all the roots are equal as in part (a).

Answers: $K = 27$; $s = -3$

E6.9. The world's largest telescope, completed in 1990, is located in Hawaii [9]. The primary mirror has a diameter of 10 m and consists of a mosaic of 36 hexagonal segments with the orientation of each segment actively controlled. This unity feedback system for the mirror segments (Fig. 6.1) has

$$G(s) = \frac{K}{s(s^2 + s + 1)}.$$

(a) Find the asymptotes and draw them in the s-plane. (b) Find the angle of departure from the complex poles. (c) Determine the gain when two roots lie on the imaginary axis. (d) Sketch the root locus.

E6.10. A unity feedback system (Fig. 6.1) has

$$G(s) = \frac{K(s + 2)}{s(s + 1)}.$$

(a) Find the breakaway and entry points on the real axis. (b) Find the gain and the roots when the real part of the complex roots is located at -2. (c) Sketch the locus.

Answers: (a) $-0.59, -3.41$; (b) $K = 3, s = -2 \pm j\sqrt{2}$

E6.11. A robot force control system with unity feedback (Fig. 6.1) has a plant [8]

$$G(s) = \frac{K(s + 2.5)}{(s^2 + 2s + 2)(s^2 + 4s + 5)}.$$

(a) Using the Control System Design Program or equivalent [4], find the gain K that results in dominant roots with a damping ratio of 0.707. Sketch the locus. (b) Find the actual percent overshoot and peak time for the gain K of part (a).

E6.12. A unity feedback system (Fig. 6.1) has a plant

$$G(s) = \frac{K(s + 1)}{s(s^2 + 4s + 8)}.$$

Using the Control System Design Program [4] or equivalent, find (a) The root locus for $K > 0$. (b) The roots when $K = 10$ and 20. (c) The 0–100% rise time, percent overshoot, and settling time of the system for a unit step input when $K = 10$ and 20.

E6.13. A unity feedback system has a process

$$G(s) = \frac{4(s + z)}{s(s + 1)(s + 3)}.$$

(a) Draw the root locus as z varies from 0 to 100. (b) Using the locus, estimate the percent overshoot and settling time of the system at $z = 0.6, 2$, and 4 for a step input. (c) Use the Control System Design Program to determine the actual overshoot and settling time at $z = 0.6, 2$, and 4.

E6.14. A unity feedback system has the process

$$G(s) = \frac{K(s + 10)}{s(s + 5)}.$$

(a) Determine the breakaway and entry points of the root locus and sketch the root locus for $K > 0$. (b) Determine the gain K when the two characteristic roots have a ζ of $1/\sqrt{2}$. (c) Calculate the roots.

E6.15. (a) Plot the root locus for

$$GH(s) = \frac{K(s + 1)(s + 2)}{s^3}.$$

(b) Calculate the range of K for which the system is stable. (c) Predict the steady-state error of the system for a ramp input.

Answers: (b) $K > \frac{2}{3}$, (c) $e_{ss} = 0$

E6.16. A negative unity feedback system has a plant transfer function

$$G(s) = \frac{Ke^{-sT}}{s + 1},$$

where $T = 0.1$ second. Show that an approximation for the time delay is

$$e^{-sT} \cong \frac{\left(\dfrac{2}{T} - s\right)}{\left(\dfrac{2}{T} + s\right)}.$$

Using

$$e^{-0.1s} = \frac{20 - s}{20 + s},$$

obtain the root locus for the system for $K > 0$. Determine the range of K for which the system is stable.

E6.17. A control system as shown in Fig. E6.17 has a plant

$$G(s) = \frac{1}{s(s - 1)}.$$

(a) When $G_c(s) = K$, show that the system is always unstable by sketching the root locus.
(b) When

$$G_c(s) = \frac{K(s + 2)}{(s + 10)},$$

sketch the root locus and determine the range of K for which the system is stable. Determine the value of K and the complex roots when two roots lie on the $j\omega$ axis.

Figure E6.17. Feedback system.

E6.18. A closed-loop negative feedback system is used to control the yaw of the A-6 Intruder attack jet, which was widely used in the Persian Gulf war (Fig. E6.18). When $H(s) = 1$ and

$$G(s) = \frac{K}{s(s + 3)(s^2 + 2s + 2)},$$

determine (a) the root locus breakaway point and (b) the value of the roots on the $j\omega$-axis and the gain required for those roots. Sketch the root locus.

Answer: breakaway: $s = -2.29$
$j\omega$-axis: $s = \pm j1.09$, $K = 8$

Figure E6.18. The A-6 Intruder, a U.S. Navy attack jet.

Problems

P6.1. Draw the root locus for the following open-loop transfer functions of the system shown in Fig. P6.1 when $0 < K < \infty$:

(a) $GH(s) = \dfrac{K}{s(s + 1)^2}$

(b) $GH(s) = \dfrac{K}{(s^2 + s + 2)(s + 1)}$

(c) $GH(s) = \dfrac{K(s + 1)}{s(s + 2)(s + 3)}$

(d) $GH(s) = \dfrac{K(s^2 + 4s + 8)}{s^2(s + 4)}$

Figure P6.1.

P6.2. The linear model of a phase detector was presented in Problem 5.7. Draw the root locus as a function of the gain $K_v = K_a K$. Determine the value of K_v attained if the complex roots have a damping ratio equal to 0.60 [10].

P6.3. A unity feedback system (Fig. 6.1) has

$$G(s) = \dfrac{K}{s(s + 1)(s + 4)}.$$

Find (a) the breakaway point in the real axis and the gain K for this point, (b) the gain and the roots when two roots lie on the imaginary axis, and (c) the roots when $K = 2.5$. (d) Sketch the root locus.

P6.4. The analysis of a large antenna was presented in Problem 3.5. Plot the root locus of the system as $0 < k_a < \infty$. Determine the maximum allowable gain of the amplifier for a stable system.

P6.5. Automatic control of helicopters is necessary because, unlike fixed-wing aircraft, which possess a fair degree of inherent stability, the helicopter is quite unstable. A helicopter

control system that utilizes an automatic control loop plus a pilot stick control is shown in Fig. P6.5 [15]. When the pilot is not using the control stick, the switch may be considered to be open. The dynamics of the helicopter are represented by the transfer function

$$G_2(s) = \frac{25(s + 0.03)}{(s + 0.4)(s^2 - 0.36s + 0.16)}.$$

(a) With the pilot control loop open (hands-off control), plot the root locus for the automatic stabilization loop. Determine the gain K_2 that results in a damping for the complex roots equal to $\zeta = 0.707$. (b) For the gain K_2 obtained in part (a), determine the steady-state error due to a wind gust $T_d(s) = 1/s$. (c) With the pilot loop added, draw the root locus as K_1 varies from zero to ∞ when K_2 is set at the value calculated in (a). (d) Recalculate the steady-state error of part (b) when K_1 is equal to a suitable value based on the root locus.

Figure P6.5. Helicopter control.

P6.6. An attitude control system for a satellite vehicle within the earth's atmosphere is shown in Fig. P6.6. The transfer functions of the system are

$$G(s) = \frac{K(s + 0.20)}{(s + 0.90)(s - 0.60)(s - 0.10)},$$

$$G_c(s) = \frac{(s + 1.20 + j1.4)(s + 1.20 - j1.4)}{(s + 4.0)}.$$

(a) Draw the root locus of the system as K varies from 0 to ∞. (b) Determine the gain K which results in a system with a 2.5% settling time less than 12 sec and a damping ratio for the complex roots greater than 0.40.

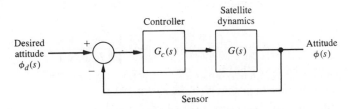

Figure P6.6. Satellite attitude control.

P6.7. The speed control system for an isolated power system is shown in Fig. P6.7. The valve controls the steam flow input to the turbine in order to account for load changes, $\Delta L(s)$,

within the power distribution network. The equilibrium speed desired results in a generator frequency equal to 60 cps. The effective rotary inertia, J, is equal to 4000 and the friction constant, f, is equal to 0.75. The steady-state speed regulation factor, R, is represented by the equation $R \cong (\omega_0 - \omega_r)/\Delta L$, where ω_r equals the speed at rated load and ω_0 equals the speed at no load. Clearly, it is desired to obtain a very small R, usually less than 0.10. (a) Using root locus techniques, determine the regulation, R, attainable when the damping ratio of the roots of the system must be greater than 0.60. (b) Verify that the steady-state speed deviation for a load torque change, $\Delta L(s) = \Delta L/s$, is, in fact, approximately equal to $R\Delta L$ when $R \leq 0.1$.

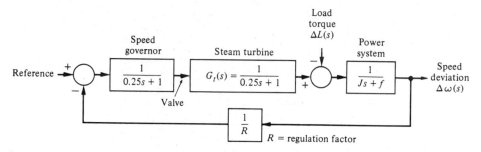

Figure P6.7. Power system control.

P6.8. Reconsider the power control system of the preceding problem when the steam turbine is replaced by a hydroturbine. For hydroturbines, the large inertia of the water used as a source of energy causes a considerably larger time constant. The transfer function of a hydroturbine may be approximated by

$$G_t(s) = \frac{-\tau s + 1}{(\tau/2)s + 1},$$

where $\tau = 1$ sec. With the rest of the system remaining as given in Problem 6.7, repeat parts (a) and (b) of Problem 6.7.

P6.9. The achievement of safe, efficient control of the spacing of automatically controlled guided vehicles is an important part of future use of the vehicles in a manufacturing plant [6]. It is important that the system eliminate the effects of disturbances such as oil on the floor as well as maintain accurate spacing between vehicles on a guideway. The system can be represented by the block diagram of Fig. P6.9, on the next page. The vehicle dynamics can be represented by

$$G(s) = \frac{(s + 0.1)(s^2 + 2s + 289)}{s(s - 0.4)(s + 0.8)(s^2 + 1.45s + 361)}.$$

(a) Neglect the pole of the feedback sensor and draw the root locus of the system. (b) Determine all the roots when the loop gain $K = K_1 K_2 K_4/250$ is equal to 4000.

P6.10. Unlike the present day *Concorde*, a turn-of-the-century supersonic passenger jet would have the range to cross the Pacific in a single hop and the efficiency to make it economic. This new aircraft shown in Fig. P6.10(a) will require the use of temperature resistant, lightweight materials and advanced computer control systems.

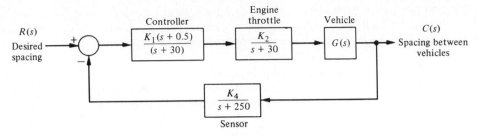

Figure P6.9 Guided vehicle control.

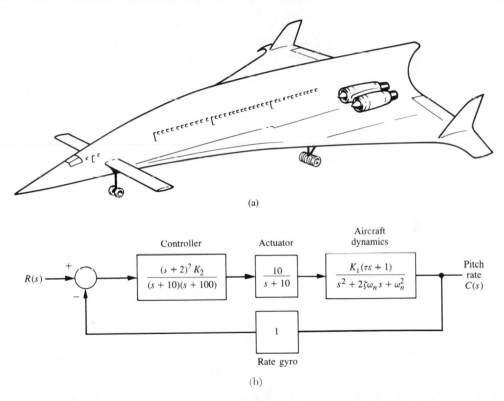

Figure P6.10. (a) A supersonic jet aircraft of the future. (b) Control system.

The plane would carry 300 passengers at three times the speed of sound for up to 7500 miles. The flight control system requires good quality handling and comfortable flying conditions. An automatic flight control system can be designed for SST vehicles. The desired characteristics of the dominant roots of the control system shown in Fig. P6.10(b) have a ζ = 0.707. The characteristics of the aircraft are ω_n = 2.5, ζ = 0.30, and τ = 0.1. The gain factor K_1, however, will vary over the range 0.02 at medium-weight cruise conditions to 0.20 at light-weight descent conditions. (a) Draw the root locus as a function of the loop gain

K_1 K_2. (b) Determine the necessary gain K_2 in order to yield roots with $\zeta = 0.707$ when the aircraft is in the medium-cruise condition. (c) With the gain K_2 as found in (b), determine the ζ of the roots when the gain K_1 results from the condition of light-descent.

P6.11. A computer system for a military application requires a high performance magnetic tape transport system [13]. However, the environmental conditions imposed on a military system result in a severe test of control engineering design. A direct-drive dc-motor system for the magnetic tape reel system is shown in Fig. P6.11, on the next page where r equals the reel radius and J equals the reel and rotor inertia. A complete reversal of the tape reel direction is required in 6 msec, and the tape reel must follow a step command in 3 msec or less. The tape is normally operating at a speed of 100 in/sec. The motor and components selected for this system possess the following characteristics:

$$K_b = 0.40 \qquad\qquad K_T/LJ = 2.0$$
$$K_p = 1 \qquad\qquad\qquad r = 0.2$$
$$\tau_1 = \tau_a = 1 \text{ msec} \qquad K_1 = 2.0$$
$$K_2 \text{ is adjustable.}$$

The inertia of the reel and motor rotor is 2.5×10^{-3} when the reel is empty, and 5.0×10^{-3} when the reel is full. A series of photocells is used for an error sensing device. The time constant of the motor is $L/R = 0.5$ msec. (a) Draw the root locus for the system when $K_2 = 10$ and $J = 5.0 \times 10^{-3}$, and $0 < K_a < \infty$. (b) Determine the gain K_a that results in a well-damped system so that the ζ of all the roots is greater than or equal to 0.60. (c) With the K_a determined from part (b), draw a root locus for $0 < K_2 < \infty$.

P6.12. A precision speed control system (Fig. P6.12) on the next page is required for a platform used in gyroscope and inertial system testing where a variety of closely controlled speeds is necessary. A direct-drive dc torque motor system was utilized in order to provide (1) a speed range of 0.01°/sec to 600°/sec, and (2) 0.1% steady-state error maximum for a step input. The direct-drive dc torque motor avoids the use of a gear train with its attendant backlash and friction. Also the direct-drive motor has a high torque capability, high efficiency, and low motor time constants. The motor gain constant is nominally $K_m = 1.8$ but is subject to variations up to 50%. The amplifier gain K_a is normally greater than 10 and subject to a variation of 10%. (a) Determine the minimum loop gain necessary to satisfy the steady-state error requirement. (b) Determine the limiting value of gain for stability. (c) Draw the root locus as K_a varies from 0 to ∞. (d) Determine the roots when $K_a = 50$ and estimate the response to a step input.

P6.13. A unity feedback system (Fig. 6.1) has

$$G(s) = \frac{K}{s(s + 4)(s^2 + 4s + 5)}.$$

(a) Find the breakaway points on the real axis and the gain for this point. (b) Find the gain to provide two complex roots nearest the $j\omega$ axis with a damping ratio of 0.707. (c) Are the two roots of part (b) dominant? (d) Determine the settling time of the system when the gain of part (b) is used.

(a)

(b)

Figure P6.11. Tape control system.

Figure P6.12. Speed control.

P6.14. The open-loop transfer function of a single-loop negative feedback system is

$$GH(s) = \frac{K(s + 2)(s + 3)}{s^2(s + 1)(s + 24)(s + 30)}.$$

This system is called a *conditionally stable* system because the system is stable for only a range of the gain K as follows: $k_1 < K < k_2$. Using the Routh-Hurwitz criteria and the root locus method, determine the range of the gain for which the system is stable. Sketch the root locus for $0 < K < \infty$.

P6.15. Let us again consider the stability and ride of a rider and high performance motorcycle as outlined in Problem 5.13. The dynamics of the motorcycle and rider can be represented by the open-loop transfer function

$$GH(s) = \frac{K(s^2 + 30s + 625)}{s(s + 20)(s^2 + 20s + 200)(s^2 + 60s + 3400)}.$$

Draw the root locus for the system; determine the ζ of the dominant roots when $K = 3 \times 10^4$.

P6.16. Control systems for maintaining constant tension on strip steel in a hot strip finishing mill are called "loopers." A typical system is shown in Fig. P6.16. The looper is an arm 2 to 3 ft long with a roller on the end and is raised and pressed against the strip by a motor. The typical speed of the strip passing the looper is 2000 ft/min. A voltage proportional to the looper position is compared with a reference voltage and integrated where it is assumed that a change in looper position is proportional to a change in the steel strip tension. The time constant of the filter, τ, is negligible relative to the other time constants in the system. (a) Draw the root locus of the control system for $0 < K_a < \infty$. (b) Determine the gain K_a that results in a system whose roots have a damping ratio of $\zeta = 0.707$ or greater. (c) Determine the effect of τ as τ increases from a negligible quantity.

(a)

(b)

Figure P6.16. Steel mill control system.

P6.17. Reconsider the vibration absorber discussed in Problems 2.2 and 2.10 as a design problem. Using the root locus method, determine the effect of the parameters M_2 and k_{12}. Determine the specific values of the parameters M_2 and k_{12} so that the mass M_1 does not vibrate when $F(t) = a \sin \omega_0 t$. Assume that $M_1 = 1$, $k_1 = 1$, and $f_1 = 1$. Also assume that $k_{12} < 1$ and the term k_{12}^2 may be neglected.

P6.18. A feedback control system is shown in Fig. P6.18. The filter $G_c(s)$ is often called a compensator, and the design problem is that of selecting the parameters α and β. Using the root locus method, determine the effect of varying the parameters. Select a suitable filter so that the settling time is less than 4 sec and the damping ratio of the dominant roots is greater than 0.60.

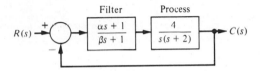

Figure P6.18. Filter design.

P6.19. In recent years, many automatic control systems for guided vehicles in factories have been utilized. One such system uses a guidance cable embedded in the floor to guide the vehicle along the desired lane [6]. An error detector is composed of two coils mounted on the front of the cart which senses a magnetic field produced by the current in the guidance cable. An example of a guided vehicle in a factory is shown in Fig. P6.19(a), on the next page. We have

$$G(s) = \frac{K_a(s^2 + 3.6s + 81)}{s(s + 1)(s + 5)}$$

when K_a equals the amplifier gain. (a) Draw a root locus and determine a suitable gain K_a so that the damping ratio of the complex roots is 0.707. (b) Determine the root sensitivity of the system for the complex root r_1 as a function of (1) K_a and (2) the pole of $G(s)$, $s = -1$.

P6.20. Determine the root sensitivity for the dominant roots of the design for Problem 6.18 for the gain $K = 4\alpha/\beta$ and the pole $s = -2$.

P6.21. Determine the root sensitivity of the dominant roots of the power system of Problem 6.7. Evaluate the sensitivity for variations of (a) the poles at $s = -4$, and (b) the feedback gain, $1/R$.

P6.22. Determine the root sensitivity of the dominant roots of Problem 6.1(a) when K is set so that the damping ratio of the unperturbed roots is 0.707. Evaluate and compare the sensitivity as a function of the poles and zeros of $GH(s)$.

P6.23. Repeat Problem 6.22 for the open-loop transfer function $GH(s)$ of Problem 6.1(c).

P6.24. For systems of relatively high degree, the form of the root locus can often assume an unexpected pattern. The root loci of four different feedback systems of third order or higher are shown in Fig. P6.24, on page 291. The open-loop poles and zeros of $KF(s)$ are shown and the form of the root loci as K varies from zero to infinity is presented. Verify the diagrams of Fig. P6.24 by constructing the root loci.

(a)

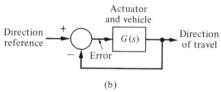

(b)

Figure P6.19. (a) An automatically guided vehicle. (Photo courtesy of Control Engineering Corp.) (b) Block diagram.

P6.25. Solid-state integrated electronic circuits are comprised of distributed R and C elements. Therefore feedback electronic circuits in integrated circuit form must be investigated by obtaining the transfer function of the distributed RC networks. It has been shown that the slope of the attenuation curve of a distributed RC network is n 3db/octave, where n is the order of the RC filter [17]. This attenuation is in contrast with the normal n 6db/octave for the lumped parameter circuits. (The concept of the slope of an attenuation curve is considered in Chapter 7. If the reader is unfamiliar with this concept, this problem may be reexamined following the study of Chapter 7.) An interesting case arises when the distributed RC network occurs in a series-to-shunt feedback path of a transistor amplifier. Then the loop transfer function may be written as

$$GH(s) = \frac{K(s - 1)(s + 3)^{1/2}}{(s + 1)(s + 2)^{1/2}}.$$

(a) Using the root locus method, determine the locus of roots as K varies from zero to infinity. (b) Calculate the gain at borderline stability and the frequency of oscillation for this gain.

P6.26. A single-loop negative feedback system has a loop transfer function

$$GH(s) = \frac{K(s + 1)^2}{s(s^2 + 1)(s + 4)}.$$

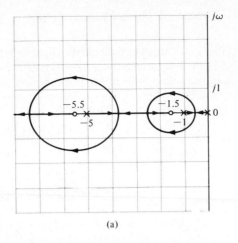

(a)

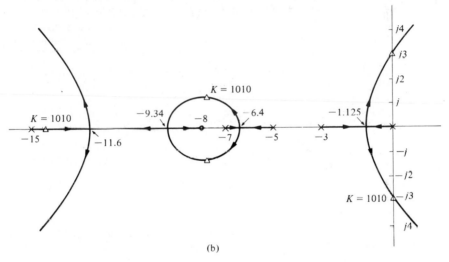

(b)

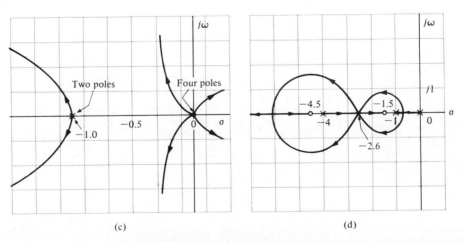

(c) (d)

Figure P6.24. Root loci of four systems.

(a) Sketch the root locus for $0 \le K \le \infty$ to indicate the significant features of the locus. (b) Determine the range of the gain K for which the system is stable. (c) For what value of K in the range $K \ge 0$ do purely imaginary roots exist? What are the values of these roots? (d) Would the use of the dominant roots approximation for an estimate of settling time be justified in this case for a large magnitude of gain ($K > 10$)?

P6.27. A unity negative feedback system has a transfer function

$$G(s) = \frac{K(s^2 + 0.105625)}{s(s^2 + 1)} = \frac{K(s + j0.325)(s - j0.325)}{s(s^2 + 1)}.$$

Calculate the root locus as a function of K. Carefully calculate where the segments of the locus enter and leave the real axis.

P6.28. To meet current U.S. emissions standards for automobiles, hydrocarbon (HC) and carbon monoxide (CO) emissions are usually controlled by a catalytic converter in the automobile exhaust. Federal standards for nitrogen oxides (NO_x) emissions are met mainly by exhaust-gas recirculation (EGR) techniques. However, as NO_x emissions standards were tightened from the current limit of 2.0 grams per mile to 1.0 grams per mile, these techniques alone were no longer sufficient.

Although many schemes are under investigation for meeting the emissions standards for all three emissions, one of the most promising employs a three-way catalyst—for HC, CO, and NO_x emissions—in conjunction with a closed-loop engine-control system. The approach is to use a closed-loop engine control as shown in Fig. P6.28 [21]. The exhaust gas sensor gives an indication of a rich or lean exhaust and this is compared to a reference. The difference signal is processed by the controller and the output of the controller modulates the vacuum level in the carburetor to achieve the best air-fuel ratio for proper operation of the catalytic converter. The open-loop transfer function is represented by

$$GH(s) = \frac{K(s + 1)(s + 6)}{s(s + 4)(s + 3)}.$$

Calculate the root locus as a function of K. Carefully calculate where the segments of the locus enter and leave the real axis. Determine the roots when $K = 2$.

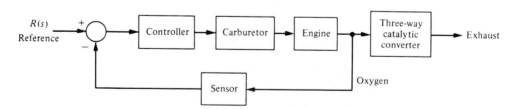

Figure P6.28. Auto engine control.

P6.29. A unity feedback control system has a transfer function

$$G(s) = \frac{K(s^2 + 4s + 8)}{s^2(s + 4)}.$$

It is desired that the dominant roots have a damping ratio equal to 0.5. Find the gain K when this condition is satisfied. Show that at this gain the imaginary roots are $s = -1.3 \pm j2.2$.

P6.30. An RLC network is shown in Fig. P6.30. The nominal values (normalized) of the network elements are $L = C = 1$ and $R = 2.5$. Show that the root sensitivity of the two roots of the input impedance $Z(s)$ to a change in R is different by a factor of 4.

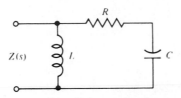

Figure P6.30. RLC network.

P6.31. The development of high speed aircraft and missiles requires information about aerodynamic parameters prevailing at very high speeds. Wind tunnels are used to test these parameters. These wind tunnels are constructed by compressing air to very high pressures and releasing it through a valve to create a wind. Since the air pressure drops as the air escapes it is necessary to open the valve wider to maintain a constant wind speed. Thus a control system is needed to adjust the valve to maintain a constant wind speed. The open-loop transfer function for a unity feedback system is

$$GH(s) = \frac{K(s + 4)}{s(s + 0.16)(s + 7.3 + 9.7831j)(s + 7.3 - 9.7831j)}$$

Draw the root locus and show the location of the roots for $K = 326$ and $K = 1350$.

P6.32. A mobile robot suitable for nighttime guard duty is shown in Fig. P6.32, on the next page. This guard never sleeps and can tirelessly patrol large warehouses and outdoor yards. The steering control system for the mobile robot has a unity feedback with

$$G(s) = \frac{K(s + 1)(s + 5)}{s(s + 1.5)(s + 2)}.$$

(a) Find K for all breakaway and entry points on the real axis. (b) Find K when the damping ratio of the complex roots is 0.707. (c) Find the minimum value of the damping ratio for the complex roots and the associated gain K. (d) Find the overshoot and settling time for a unit step input for the gain, K, determined in (c) and (d).

P6.33. The Bell-Boeing V-22 Osprey Tiltrotor is both an airplane and a helicopter. Its advantage is the ability to rotate its engines to 90° from a vertical position, as shown in Fig. P6.33(a), for takeoffs and landings and then to switch the engines to a horizontal position for cruising as an airplane [19]. The altitude control system in the helicopter mode is shown in Fig. P6.33(b). (a) Determine the root locus as K varies and determine the range of K for a stable system. (b) For $K = 280$ find the actual $c(t)$ for a unit step input $r(t)$ and the percentage overshoot and settling time. (c) When $K = 280$ and $r(t) = 0$, find $c(t)$ for a unit step disturbance, $D(s) = 1/s$. (d) Add a prefilter between $R(s)$ and the summing node so that

$$G_p(s) = \frac{1}{s^2 + 1.5s + 0.5}$$

and repeat (b).

Figure P6.32. Two mobile sentry robots. (Courtesy of Denning Mobile Robots Inc.)

(a)

(b)

Figure P6.33. Osprey tiltrotor aircraft control.

P6.34. The fuel control for an automobile uses a diesel pump that is subject to parameter variations [23]. A unity negative feedback of the form shown in Fig. 6.1 has a plant

$$G(s) = \frac{K(s + 1.5)}{(s + 1)(s + 2)(s + 4)(s + 10)}.$$

(a) Sketch the root locus as K varies from 0 to 2000. (b) Find the roots for K equal to 400, 500, and 600. (c) Predict how the percent overshoot to a step will vary for the gain K, assuming dominant roots. (d) Find the actual time response for a step input for all three gains and compare the actual overshoot with the predicted overshoot.

P6.35. A powerful electrohydraulic forklift can be used to lift pallets weighing several tons on top of 35 ft scaffolds at a construction site. The negative unity feedback system has a plant transfer function

$$G(s) = \frac{K(s + 1)^2}{s(s^2 + 1)}.$$

(a) Sketch the root locus for $K > 0$. (b) Find the gain K when two complex roots have a ζ of 0.707 and calculate all three roots. (c) Find the entry point of the root locus at the real axis. (d) Estimate the expected overshoot to a step input and compare it with the actual overshoot determined from CSDP or another computer program.

P6.36. A microrobot with a high-performance manipulator has been designed for testing very small particles such as simple living cells [25]. The single loop unity negative feedback system has a plant transfer function

$$G(s) = \frac{K(s + 1)(s + 2)(s + 3)}{s^3(s - 1)}.$$

(a) Sketch the root locus for $K > 0$. (b) Find the gain and roots when the characteristic equation has two imaginary roots. (c) Determine the characteristic roots when $K = 20$ and $K = 100$. (d) For $K = 20$, estimate the percent overshoot to a step input and compare the estimate to the actual overshoot determined from CSDP or another computer program.

P6.37. Identify the parameters K, a, and b of the system shown in Fig. P6.37. The system is subject to a unit step input and the output response has an overshoot but ultimately attains the final value of 1. When the closed-loop system is subjected to a ramp input, the output response follows the ramp input with a finite steady-state error. When the gain is doubled to $2K$, the output response to an impulse input is a pure sinusoid with a period 0.314 sec. Determine K, a, and b.

Figure P6.37. Feedback system.

P6.38. A unity feedback system, as shown in Fig. 6.1, has

$$G(s) = \frac{K(s + 1)}{s(s - 3)}.$$

This system is open-loop unstable. (a) Determine the range of K so that the system is stable. (b) Plot the root locus. (c) Determine the roots for $K = 10$. (d) For $K = 10$, predict the percent overshoot for a step input using Fig. 4.10. (e) Determine the actual overshoot by plotting the response.

Design Problems ✦

DP6.1. A high performance aircraft, shown in Fig. DP6.1(a) uses the ailerons, rudder, and elevator to steer through a three-dimensional flight path [22]. The pitch rate control system for a fighter aircraft at 10,000 m and Mach 0.9 can be represented by the system in Fig. DP6-1(b), where

$$G(s) = \frac{-18(s + 0.015)(s + 0.45)}{(s^2 + 1.2s + 12)(s^2 + 0.01s + 0.0025)}.$$

(a) Plot the root locus when the controller is a gain, so that $G_c(s) = K$, and determine K when zeta for the roots with $\omega_n > 2$ is larger than 0.15 (seek a maximum ζ). (b) Plot the response, $q(t)$, for a step input $r(t)$. (c) A designer suggests an anticipatory controller so that $G_c(s) = K_1 + K_2s = K(s + 2)$. Plot the root locus for this system as K varies and determine K so that the ζ of all the closed-loop roots is $0.8 < \zeta < 0.6$. (d) Plot the response, $q(t)$, for a step input $r(t)$.

Ailerons

Rudder

Elevator

(a)

Controller Aircraft

Pitch rate command $R(s)$ $+$ $E(s)$ $G_c(s)$ $G(s)$ Pitch rate $Q(s)$

(b)

Figure DP6.1. Pitch rate control.

DP6.2. A large helicopter uses two tandem rotors rotating in opposite directions, as shown in Fig. DP6.2(a). The controller adjusts the tilt angle of the main rotor and thus the forward motion as shown in Fig. DP6.2(b). The helicopter dynamics are represented by

$$G(s) = \frac{10}{s^2 + 4.5s + 9},$$

and the controller is selected as

$$G_c(s) = K_1 + \frac{K_2}{s} = \frac{K(s + 1)}{s}.$$

(a) Plot the root locus of the system and determine K when ζ of the complex roots is equal to 0.6. (b) Plot the response of the system to a step input $r(t)$ and find the settling time and overshoot for the system of part (a). What is the steady-state error for a step input? (c) Repeat parts (a) and (b) when the ζ of the complex roots is 0.41. Compare the results with those obtained in parts (a) and (b).

(a)

Controller Tilt Helicopter
 angle dynamics

$R(s)$ —→ + —→ $G_c(s)$ —→ $G(s)$ —→ $C(s)$
 −

(b)

Figure DP6.2. Two-rotor helicopter velocity control.

DP6.3. Rover, the vehicle illustrated in Fig. DP6.3(a), has been designed for maneuvering at 0.25 mph over Martian terrain. Because Mars is 189 million miles from Earth and it would

take up to 40 minutes each way to communicate with Earth [24], Rover must act indepen-
dently and reliably. Resembling a cross between a small flatbed truck and a jacked-up jeep,
Rover will be constructed of three articulated sections, each with its own two independent
axle-bearing one-meter conical wheels. A pair of sampling arms—one for chipping and drill-
ing, the other for manipulating fine objects—jut from its front end like pincers. The control
of the arms can be represented by the system shown in Fig. DP6.3(b). (a) Plot the root locus
for K and identify the roots for $K = 4.1$ and 41. (b) Determine the gain K that results in an
overshoot to a step of approximately 1%. (c) Determine the gain that minimizes the settling
time while maintaining an overshoot of less than 1%.

(a)

(b)

Figure DP6.3. Mars vehicle robot control.

DP6.4. A welding torch is remotely controlled to achieve high accuracy while operating in
changing and hazardous environments [22]. A model of the welding arm position control is
shown in Fig. DP6.4, with the disturbance representing the environmental changes. (a) With
$D(s) = 0$, select K_1 and K to provide high quality performance of the position control system.
Select a set of performance criteria and examine the results of your design. (b) For the system
in part (a), let $R(s) = 0$ and determine the effect of a unit step $D(s) = 1/s$ by obtaining $c(t)$.

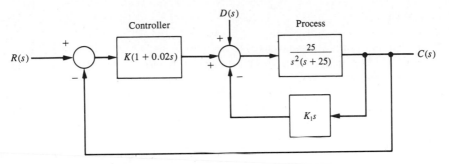

Figure DP6.4. Remotely controlled welder.

Terms and Concepts

Angle of departure The angle at which a locus leaves a complex pole in the s-plane.

Asymptote The path the root locus follows as the parameter becomes very large and approaches infinity. The number of asymptotes is equal to the number of poles minus the number of zeros.

Asymptote centroid The center of the linear asymptotes, σ_A.

Breakaway point The point on the real axis where the locus departs from the real axis of the s-plane.

Locus A path or trajectory that is traced out as a parameter is changed.

Number of separate loci Equal to the number of poles of the transfer function, assuming that the number of poles is greater than the number of zeros of the transfer function.

Parameter design A method of selecting one or two parameters using the root locus method.

Root locus The locus or path of the roots traced out on the s-plane as a parameter is changed.

Root locus method The method for determining the locus of roots of the characteristic equation $1 + KP(s) = 0$ as K varies from 0 to infinity.

Root locus segments on the real axis The root locus lying in a section of the real axis to the left of an odd number of poles and zeros.

Root sensitivity The sensitivity of the roots as a parameter changes from its normal value. The root sensitivity is the incremental change in the root divided by the proportional change of the parameter.

References

1. W. R. Evans, "Graphical Analysis of Control Systems," *Trans. of the AIEE,* **67,** 1948; pp. 547–51. Also in G. J. Thaler, ed., *Automatic Control,* Dowden, Hutchinson, and Ross, Stroudsburg, Pa., 1974; pp. 417–21.
2. W. R. Evans, "Control System Synthesis by Root Locus Method," *Trans. of the AIEE,* **69,** 1950; pp. 1–4. Also in G. J. Thaler, ed., *Automatic Control,* Dowden, Hutchinson, and Ross, Stroudsburg, Pa., 1974; pp. 423–25.
3. W. R. Evans, *Control System Dynamics,* McGraw-Hill, New York, 1954.
4. R. C. Dorf and R. Jacquot, *Control Systems Design Program,* Addison-Wesley, Reading, Mass., 1988.
5. J. G. Goldberg, *Automatic Controls,* Allyn and Bacon, Boston, 1964.
6. R. C. Dorf, *The Encyclopedia of Robotics,* John Wiley & Sons, New York, 1988.
7. H. Ur, "Root Locus Properties and Sensitivity Relations in Control Systems," *I.R.E. Trans. on Automatic Control,* January 1960; pp. 57–65.
8. S. P. Patarinski, "Mechanics and Coordinated Control of Twin Articulated Robot Arms," *Mechatronics,* **1,** 1991; pp. 59–71.
9. J. N. Aubrun et al., "Dynamic Analysis of the Actively Controlled Segmented Mirror of the Keck Ten-Meter Telescope," *IEEE Control Systems,* December 1987; pp. 3–9.
10. C. L. Phillips and R. Harbor, *Feedback Control Systems,* 2nd ed., Prentice Hall, Englewood Cliffs, N.J., 1991.
11. W. L. Brogan, *Modern Control Theory,* Prentice Hall, Englewood Cliffs, N.J., 1991.
12. J. Grossman, "Goalpost Brown's Amazing Flying Camera," *Inc.,* January 1985; pp. 80–88.
13. K. K. Chew, "Control of Errors in Disk Drive Systems," *IEEE Control Systems,* January 1990; pp. 16–19.
14. J. Slotline, *Applied Nonlinear Control,* Prentice Hall, Englewood Cliffs, N.J., 1991.
15. R. C. Nelson, *Flight Stability and Control,* McGraw-Hill, New York, 1989.
16. R. C. Dorf, *Introduction to Electric Circuits,* John Wiley & Sons, New York, 1989.
17. S. Franco, *Design with Operational Amplifiers,* McGraw-Hill, New York, 1988.
18. B. W. Dickenson, *Systems Analysis and Design,* Prentice Hall, Englewood Cliffs, New Jersey, 1991.
19. D. McLean, *Automatic Flight Control Systems,* Prentice Hall, Englewood Cliffs, N.J., 1990.
20. P. E. Wellstead, "The Ball and Hoop System," *Automatica,* **19,** 4, 1983; pp. 401–406.
21. K. J. Astrom and B. Wittenmark, *Adaptive Control,* Addison-Wesley, Reading, Mass., 1988.
22. K. Andersen, "Artificial Neural Networks Applied to Arc Welding Process Control," *IEEE Trans. on Industry Applications,* October 1990; pp. 824–830.
23. H. Kuraoka, "Application of Design to Automotive Fuel Control," *IEEE Control Systems,* April 1990; pp. 102–105.
24. H. E. McCurdy, *The Space Station Decision,* Johns Hopkins University Press, Baltimore, 1990.
25. I. W. Hunter, Manipulation and Dynamic Mechanical Testing of Microscopic Objects Using a Tele-Micro-Robot System," *IEEE Control Systems,* February 1990; pp. 3–8.

CHAPTER 7

Frequency
Response Methods

Preview

We have examined the use of test input signals such as a step and a ramp signal. In this chapter, we will use a steady-state sinusoidal input signal and consider the response of the system as the frequency of the sinusoid is varied. Thus we will look at the response of the system to a changing frequency, ω.

We will examine the response of $G(s)$ when $s = j\omega$ and develop several forms of plotting the complex number for $G(j\omega)$ when ω is varied. These plots provide insight regarding the performance of a system. We are able to develop several performance measures for the frequency response of a system. The measures can be used as system specifications and we can adjust parameters in order to meet the specifications.

We will consider the graphical development of one or more forms for the frequency response plot. We can then proceed to use computer-generated data to readily obtain these plots.

7.1 Introduction

In the preceding chapters the response and performance of a system have been described in terms of the complex frequency variable s and the location of the poles and zeros on the s-plane. A very practical and important alternative approach to the analysis and design of a system is the *frequency response* method. *The frequency response of a system is defined as the steady-state response of the system to a sinusoidal input signal.* The sinusoid is a unique input signal, and the resulting output signal for a linear system, as well as signals throughout the system, is sinusoidal in the steady state; it differs from the input waveform only in amplitude and phase angle.

One advantage of the frequency response method is the ready availability of sinusoid test signals for various ranges of frequencies and amplitudes. Thus the experimental determination of the frequency response of a system is easily accomplished and is the most reliable and uncomplicated method for the experimental analysis of a system. Often, as we shall find in Section 7.4, the unknown transfer function of a system can be deduced from the experimentally determined frequency response of a system [1,2]. Furthermore, the design of a system in the frequency domain provides the designer with control of the bandwidth of a system and some measure of the response of the system to undesired noise and disturbances.

A second advantage of the frequency response method is that the transfer function describing the sinusoidal steady-state behavior of a system can be obtained by replacing s with $j\omega$ in the system transfer function $T(s)$. The transfer function representing the sinusoidal steady-state behavior of a system is then a function of the complex variable $j\omega$ and is itself a complex function $T(j\omega)$ which possesses a magnitude and phase angle. The magnitude and phase angle of $T(j\omega)$ are readily represented by graphical plots that provide a significant insight for the analysis and design of control systems.

The basic disadvantage of the frequency response method for analysis and design is the indirect link between the frequency and the time domain. Direct correlations between the frequency response and the corresponding transient response characteristics are somewhat tenuous, and in practice the frequency response characteristic is adjusted by using various design criteria which will normally result in a satisfactory transient response.

The Laplace transform pair was given in Section 2.4 and is written as:

$$F(s) = \mathcal{L}\{f(t)\} = \int_0^\infty f(t)e^{-st}\, dt \qquad (7.1)$$

and

$$f(t) = \mathcal{L}^{-1}\{F(s)\} = \frac{1}{2\pi j} \int_{\sigma-j\infty}^{\sigma+j\infty} F(s)e^{st} \, ds, \qquad (7.2)$$

where the complex variable $s = \sigma + j\omega$. Similarly, the *Fourier transform* pair is written as

$$F(j\omega) = \mathcal{F}\{f(t)\} = \int_{\infty}^{\infty} f(t)e^{-j\omega t} \, dt \qquad (7.3)$$

and

$$f(t) = \mathcal{F}^{-1}\{\mathcal{F}(j\omega)\} = \frac{1}{2\pi} \int_{-\infty}^{\infty} F(j\omega)e^{j\omega t} \, d\omega. \qquad (7.4)$$

The Fourier transform exists for $f(t)$ when

$$\int_{-\infty}^{\infty} |f(t)| \, dt < \infty.$$

The Fourier and Laplace transforms are closely related, as we can see by examining Eqs. (7.1) and (7.3). When the function $f(t)$ is defined only for $t \geq 0$, as is often the case, the lower limits on the integrals are the same. Then, we note that the two equations differ only in the complex variable. Thus, if the Laplace transform of a function $f_1(t)$ is known to be $F_1(s)$, we can obtain the Fourier transform of this same time function $F_1(j\omega)$ by setting $s = j\omega$ in $F_1(s)$.

Again, we might ask, because the Fourier and Laplace transforms are so closely related, why not always use the Laplace transform? Why use the Fourier transform at all? The Laplace transform permits us to investigate the s-plane location of the poles and zeros of a transfer $T(s)$ as in Chapter 6. However, the frequency response method allows us to consider the transfer function $T(j\omega)$ and concern ourselves with the amplitude and phase characteristics of the system. This ability to investigate and represent the character of a system by amplitude and phase equations and curves is an advantage for the analysis and design of control systems.

If we consider the frequency response of the closed-loop system, we might have an input $r(t)$ that has a Fourier transform, in the frequency domain, as follows:

$$R(j\omega) = \int_{-\infty}^{\infty} r(t)e^{-j\omega t} \, dt. \qquad (7.5)$$

Then the output frequency response of a single-loop control system can be obtained by substituting $s = j\omega$ in the closed-loop system relationship, $C(s) = T(s)R(s)$, so that we have

$$C(j\omega) = T(j\omega)R(j\omega) = \frac{G(j\omega)}{1 + G(j\omega)H(j\omega)} R(j\omega). \qquad (7.6)$$

Utilizing the inverse Fourier transform, the output transient response would be

$$c(t) = \mathcal{F}^{-1}\{C(j\omega)\} = \frac{1}{2\pi} \int_{-\infty}^{\infty} C(j\omega)e^{j\omega t} \, d\omega. \tag{7.7}$$

However, it is usually quite difficult to evaluate this inverse transform integral for any but the simplest systems, and a graphical integration may be used. Alternatively, as we will note in succeeding sections, several measures of the transient response can be related to the frequency characteristics and utilized for design purposes.

7.2 Frequency Response Plots

The transfer function of a system $G(s)$ can be described in the frequency domain by the relation†

$$G(j\omega) = G(s)|_{s=j\omega} = R(\omega) + jX(\omega), \tag{7.8}$$

where

$$R(\omega) = Re[G(j\omega)]$$

and

$$X(\omega) = Im[G(j\omega)].$$

Alternatively, the transfer function can be represented by a magnitude $|G(j\omega)|$ and a phase $\phi(j\omega)$ as

$$G(j\omega) = |G(j\omega)|e^{j\phi(j\omega)} = |G(\omega)|\underline{/\phi(\omega)}, \tag{7.9}$$

where

$$\phi(\omega) = \tan^{-1} X(\omega)/R(\omega)$$

and

$$|G(\omega)|^2 = [R(\omega)]^2 + [X(\omega)]^2.$$

The graphical representation of the frequency response of the system $G(j\omega)$ can utilize either Eq. (7.8) or Eq. (7.9). The *polar plot* representation of the frequency response is obtained by using Eq. (7.8). The coordinates of the polar plot are the real and imaginary parts of $G(j\omega)$ as shown in Fig. 7.1. An example of a polar plot will illustrate this approach.

†See Appendix E for a review of complex numbers.

Figure 7.1. The polar plane.

■ Example 7.1 Frequency response of an *RC* filter

A simple *RC* filter is shown in Fig. 7.2. The transfer function of this filter is

$$G(s) = \frac{V_2(s)}{V_1(s)} = \frac{1}{RCs + 1}, \tag{7.10}$$

and the sinusoidal steady-state transfer function is

$$G(j\omega) = \frac{1}{j\omega(RC) + 1} = \frac{1}{j(\omega/\omega_1) + 1}, \tag{7.11}$$

where

$$\omega_1 = 1/RC.$$

Then the polar plot is obtained from the relation

$$G(j\omega) = R(\omega) + jX(\omega)$$

$$= \frac{1 - j(\omega/\omega_1)}{(\omega/\omega_1)^2 + 1} \tag{7.12}$$

$$= \frac{1}{1 + (\omega/\omega_1)^2} - \frac{j(\omega/\omega_1)}{1 + (\omega/\omega_1)^2}.$$

The locus of the real and imaginary parts is shown in Fig. 7.3 and is easily shown to be a circle with the center at (½, 0). When $\omega = \omega_1$, the real and imaginary parts are equal, and the angle $\phi(\omega) = 45°$. The polar plot can also be readily obtained from Eq. (7.9) as

$$G(j\omega) = |G(\omega)|\underline{/\phi(\omega)}, \tag{7.13}$$

Figure 7.2. An *RC* filter.

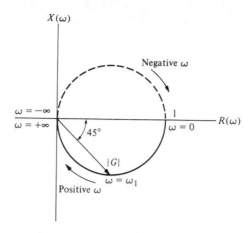

Figure 7.3. Polar plot for RC filter.

where

$$|G(\omega)| = \frac{1}{[1 + (\omega/\omega_1)^2]^{1/2}} \quad \text{and} \quad \phi(\omega) = -\tan^{-1}(\omega/\omega_1).$$

Clearly, when $\omega = \omega_1$, magnitude is $|G(\omega_1)| = 1/\sqrt{2}$ and phase $\phi(\omega_1) = -45°$. Also, when ω approaches $+\infty$, we have $|G(\omega)| \to 0$ and $\phi(\omega) = -90°$. Similarly, when $\omega = 0$, we have $|G(\omega)| = 1$ and $\phi(\omega) = 0$.

■ Example 7.2 Polar plot of a transfer function

The polar plot of a transfer function will be useful for investigating system stability and will be utilized in Chapter 8. Therefore it is worthwhile to complete another example at this point. Consider a transfer function

$$|G(s)|_{s=j\omega} = G(j\omega) = \frac{K}{j\omega(j\omega\tau + 1)} = \frac{K}{j\omega - \omega^2\tau}. \tag{7.14}$$

Then the magnitude and phase angle are written as

$$|G(\omega)| = \frac{K}{(\omega^2 + \omega^4\tau^2)^{1/2}} \tag{7.15}$$

and

$$\phi(\omega) = -\tan^{-1}\left(\frac{1}{-\omega\tau}\right).$$

The phase angle and the magnitude are readily calculated at the frequencies $\omega = 0$, $\omega = 1/\tau$, and $\omega = +\infty$. The values of $|G(\omega)|$ and $\phi(\omega)$ are given in Table 7.1, and the polar plot of $G(j\omega)$ is shown in Fig. 7.4.

Table 7.1.

ω	0	$\frac{1}{2}\tau$	$1/\tau$	∞
$\lvert G(\omega)\rvert$	∞	$4K\tau/\sqrt{5}$	$K\tau/\sqrt{2}$	0
$\phi(\omega)$	$-90°$	$-117°$	$-135°$	$-180°$

There are several possibilities for coordinates of a graph portraying the frequency response of a system. As we have seen, we may choose to utilize a polar plot to represent the frequency response (Eq. 7.8) of a system. However, the limitations of polar plots are readily apparent. The addition of poles or zeros to an existing system requires the recalculation of the frequency response as outlined in Examples 7.1 and 7.2. (See Table 7.1.) Furthermore, the calculation of the frequency response in this manner is tedious and does not indicate the effect of the individual poles or zeros.

Therefore the introduction of *logarithmic plots*, often called *Bode plots*, simplifies the determination of the graphical portrayal of the frequency response. The logarithmic plots are called Bode plots in honor of H. W. Bode, who used them extensively in his studies of feedback amplifiers [4,5]. The transfer function in the frequency domain is

$$G(j\omega) = \lvert G(\omega)\rvert e^{j\phi(\omega)}. \tag{7.16}$$

The natural logarithm of Eq. (7.16) is

$$\ln G(j\omega) = \ln \lvert G(\omega)\rvert + j\phi(\omega), \tag{7.17}$$

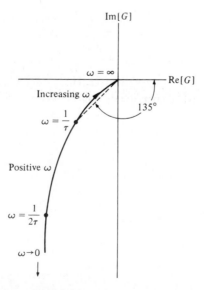

Figure 7.4. Polar plot for $G(j\omega) = K/j\omega(j\omega\tau + 1)$.

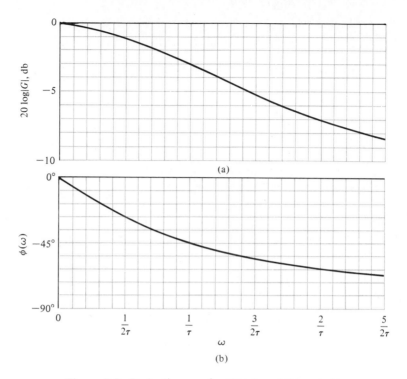

Figure 7.5. Bode diagram for $G(j\omega) = 1/(j\omega\tau + 1)$.

where $\ln |G|$ is the magnitude in nepers. The logarithm of the magnitude is normally expressed in terms of the logarithm to the base 10, so that we use

$$\text{Logarithmic gain} = 20 \log_{10}|G(\omega)|,$$

where the units are decibels (db). A decibel conversion table is given in Appendix D. The logarithmic gain in db and the angle $\phi(\omega)$ can be plotted versus the frequency ω by utilizing several different arrangements. For a Bode diagram, the plot of logarithmic gain in db versus ω is normally plotted on one set of axes, and the phase $\phi(\omega)$ versus ω on another set of axes, as shown in Fig. 7.5. For example, the Bode diagram of the transfer function of Example 7.1 can be readily obtained, as we will find in the following example.

■ E x a m p l e 7.3 Bode diagram of an RC filter

The transfer function of Example 7.1 is

$$G(j\omega) = \frac{1}{j\omega(RC) + 1} = \frac{1}{j\omega\tau + 1}, \tag{7.18}$$

where

$$\tau = RC,$$

the time constant of the network. The logarithmic gain is

$$20 \log |G| = 20 \log \left(\frac{1}{1 + (\omega\tau)^2}\right)^{1/2} = -10 \log (1 + (\omega\tau)^2). \qquad (7.19)$$

For small frequencies, that is $\omega \ll 1/\tau$, the logarithmic gain is

$$20 \log |G| = -10 \log (1) = 0 \text{ db}, \qquad \omega \ll 1/\tau. \qquad (7.20)$$

For large frequencies, that is $\omega \gg 1/\tau$, the logarithmic gain is

$$20 \log |G| = -20 \log \omega\tau \qquad \omega \gg 1/\tau, \qquad (7.21)$$

and at $\omega = 1/\tau$, we have

$$20 \log |G| = -10 \log 2 = -3.01 \text{ db}.$$

The magnitude plot for this network is shown in Fig. 7.5(a). The phase angle of this network is

$$\phi(j\omega) = -\tan^{-1} \omega\tau. \qquad (7.22)$$

The phase plot is shown in Fig. 7.5(b). The frequency $\omega = 1/\tau$ is often called the *break frequency* or *corner frequency*.

Examining the Bode diagram of Fig. 7.5, we find that a linear scale of frequency is not the most convenient or judicious choice and we should consider the use of a logarithmic scale of frequency. The convenience of a logarithmic scale of frequency can be seen by considering Eq. (7.21) for large frequencies $\omega \gg 1/\tau$, as follows:

$$20 \log |G| = -20 \log \omega\tau = -20 \log \tau - 20 \log \omega. \qquad (7.23)$$

Then, on a set of axes where the horizontal axis is $\log \omega$, the asymptotic curve for $\omega \gg 1/\tau$ is a straight line, as shown in Fig. 7.6. The slope of the straight line can be ascertained from Eq. (7.21). An interval of two frequencies with a ratio equal

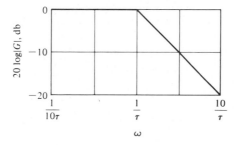

Figure 7.6. Asymptotic curve for $(j\omega\tau + 1)^{-1}$.

to 10 is called a decade, so that the range of frequencies from ω_1 to ω_2, where $\omega_2 = 10\omega_1$, is called a decade. Then, the difference between the logarithmic gains, for $\omega \gg 1/\tau$, over a decade of frequency is

$$20 \log |G(\omega_1)| - 20 \log |G(\omega_2)| = -20 \log \omega_1\tau - (-20 \log \omega_2\tau)$$

$$= -20 \log \frac{\omega_1\tau}{\omega_2\tau} \tag{7.24}$$

$$= -20 \log (\tfrac{1}{10}) = +20 \text{ db.}$$

That is, the slope of the asymptotic line for this first-order transfer function is -20 db/decade, and the slope is shown for this transfer function in Fig. 7.6. Instead of using a horizontal axis of log ω and linear rectangular coordinates, it is simpler to use semilog paper with a linear rectangular coordinate for db and a logarithmic coordinate for ω. Alternatively, we could use a logarithmic coordinate for the magnitude as well as for frequency and avoid the necessity of calculating the logarithm of the magnitude.

The frequency interval $\omega_2 = 2\omega_1$ is often used and is called an octave of frequencies. The difference between the logarithmic gains for $\omega \gg 1/\tau$, for an octave, is

$$20 \log |G(\omega_1)| - 20 \log |G(\omega_2)| = -20 \log \frac{\omega_1\tau}{\omega_2\tau} \tag{7.25}$$

$$= -20 \log (\tfrac{1}{2}) = 6.02 \text{ db.}$$

Therefore the slope of the asymptotic line is -6 db/octave or -20 db/decade.

The primary advantage of the logarithmic plot is the conversion of multiplicative factors such as $(j\omega\tau + 1)$ into additive factors $20 \log (j\omega\tau + 1)$ by virtue of the definition of logarithmic gain. This can be readily ascertained by considering a generalized transfer function as

$$G(j\omega) = \frac{K_b \prod_{i=1}^{Q} (1 + j\omega\tau_i)}{(j\omega)^N \prod_{m=1}^{M} (1 + j\omega\tau_m) \prod_{k=1}^{R} [(1 + (2\zeta_k/\omega_{n_k})j\omega + (j\omega/\omega_{n_k})^2)]}. \tag{7.26}$$

This transfer function includes Q zeros, N poles at the origin, M poles on the real axis, and R pairs of complex conjugate poles. Clearly, obtaining the polar plot of such a function would be a formidable task indeed. However, the logarithmic magnitude of $G(j\omega)$ is

$$20 \log |G(\omega)| = 20 \log K_b + 20 \sum_{i=1}^{Q} \log |1 + j\omega\tau_i|$$

$$-20 \log |(j\omega)^N| - 20 \sum_{m=1}^{M} \log |1 + j\omega\tau_m| \tag{7.27}$$

$$-20 \sum_{k=1}^{R} \log \left|1 + \left(\frac{2\zeta_k}{\omega_{n_k}}\right) j\omega + \left(\frac{j\omega}{\omega_{n_k}}\right)^2\right|,$$

and the Bode diagram can be obtained by adding the plot due to each individual factor. Furthermore, the separate phase angle plot is obtained as

$$\phi(\omega) = + \sum_{i=1}^{Q} \tan^{-1} \omega\tau_i - N(90°) - \sum_{m=1}^{M} \tan^{-1} \omega\tau_m$$

$$- \sum_{k=1}^{R} \tan^{-1} \left(\frac{2\zeta_k \omega_{n_k} \omega}{\omega_{n_k}^2 - \omega^2} \right),$$

(7.28)

which is simply the summation of the phase angles due to each individual factor of the transfer function.

Therefore the four different kinds of factors that may occur in a transfer function are as follows:

1. Constant gain K_b
2. Poles (or zeros) at the origin $(j\omega)$
3. Poles or zeros on the real axis $(j\omega\tau + 1)$
4. Complex conjugate poles (or zeros) $[1 + (2\zeta/\omega_n)j\omega + (j\omega/\omega_n)^2]$

We can determine the logarithmic magnitude plot and phase angle for these four factors and then utilize them to obtain a Bode diagram for any general form of a transfer function. Typically, the curves for each factor are obtained and then added together graphically to obtain the curves for the complete transfer function. Furthermore, this procedure can be simplified by using the asymptotic approximations to these curves and obtaining the actual curves only at specific important frequencies.

Constant Gain K_b. The logarithmic gain is

$$20 \log K_b = \text{constant in db,}$$

and the phase angle is zero. The gain curve is simply a horizontal line on the Bode diagram.

Poles (or Zeros) at the Origin $(j\omega)$. A pole at the origin has a logarithmic magnitude

$$20 \log \left| \frac{1}{j\omega} \right| = -20 \log \omega \text{ db}$$

(7.29)

and a phase angle $\phi(\omega) = -90°$. The slope of the magnitude curve is -20 db/decade for a pole. Similarly for a multiple pole at the origin, we have

$$20 \log \left| \frac{1}{(j\omega)^N} \right| = -20 N \log \omega,$$

(7.30)

and the phase is $\phi(\omega) = -90°N$. In this case the slope due to the multiple pole is $-20N$ db/decade. For a zero at the origin, we have a logarithmic magnitude

$$\omega = t \Rightarrow \phi \, dB \qquad 20 \log |j\omega| = +20 \log \omega, \qquad (7.31)$$

where the slope is $+20$ db/decade and the phase angle is $+90°$. The Bode diagram of the magnitude and phase angle of $(j\omega)^{\pm N}$ is shown in Fig. 7.7 for $N = 1$ and $N = 2$.

 Poles or Zeros on the Real Axis. The pole factor $(1 + j\omega\tau)^{-1}$ has been considered previously and we found that

$$20 \log \left| \frac{1}{1 + j\omega\tau} \right| = -10 \log (1 + \omega^2\tau^2). \qquad (7.32)$$

The asymptotic curve for $\omega \ll 1/\tau$ is $20 \log 1 = 0$ db, and the asymptotic curve for $\omega \gg 1/\tau$ is $-20 \log \omega\tau$ which has a slope of -20 db/decade. The intersection of the two asymptotes occurs when

$$20 \log 1 = 0 \text{ db} = -20 \log \omega\tau$$

or when $\omega = 1/\tau$, the *break frequency*. The actual logarithmic gain when $\omega = 1/\tau$ is -3 db for this factor. The phase angle is $\phi(\omega) = -\tan^{-1} \omega\tau$ for the denominator factor. The Bode diagram of a pole factor $(1 + j\omega\tau)^{-1}$ is shown in Fig. 7.8.
 The Bode diagram of a zero factor $(1 + j\omega\tau)$ is obtained in the same manner as that of the pole. However, the slope is positive at $+20$ db/decade, and the phase angle is $\phi(\omega) = +\tan^{-1} \omega\tau$.
 A linear approximation to the phase angle curve can be obtained as shown in Fig. 7.8. This linear approximation, which passes through the correct phase at the break frequency, is within 6° of the actual phase curve for all frequencies. This approximation will provide a useful means for readily determining the form of the phase angle curves of a transfer function $G(s)$. However, often the accurate phase angle curves are required and the actual phase curve for the first-order factor must be drawn. Therefore it is often worthwhile to prepare a cardboard (or plastic) template which can be utilized repeatedly to draw the phase curves for

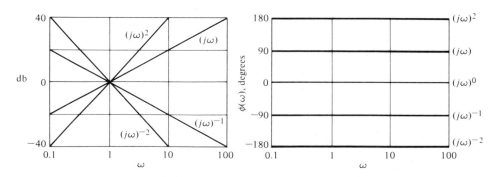

Figure 7.7. Bode diagram for $(j\omega)^{\pm N}$.

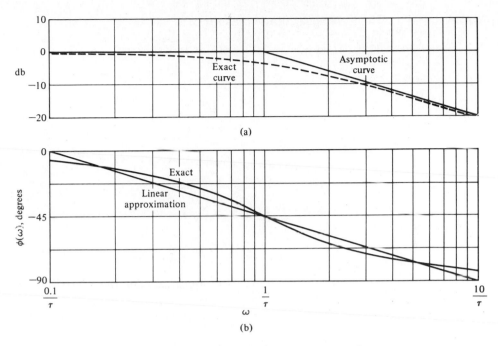

Figure 7.8. Bode diagram for $(1 + j\omega\tau)^{-1}$.

the individual factors. The exact values of the frequency response for the pole $(1 + j\omega\tau)^{-1}$ as well as the values obtained by using the approximation for comparison are given in Table 7.2.

Complex Conjugate Poles or Zeros $[1 + (2\zeta/\omega_n)j\omega + (j\omega/\omega_n)^2]$. The quadratic factor for a pair of complex conjugate poles can be written in normalized form as

$$[1 + j2\zeta u - u^2]^{-1}, \tag{7.33}$$

Table 7.2.

$\omega\tau$	0.10	0.50	0.76	1	1.31	2	5	10
20 log $\|(1 + j\omega\tau)^{-1}\|$, db	−0.04	−1.0	−2.0	−3.0	−4.3	−7.0	−14.2	−20.04
Asymptotic approximation, db	0	0	0	0	−2.3	−6.0	−14.0	−20.0
$\phi(\omega)$, degrees	−5.7	−26.6	−37.4	−45.0	−52.7	−63.4	−78.7	−84.3
Linear approximation, degrees	0	−31.5	−39.5	−45.0	−50.3	−58.5	−76.5	−90.0

where $u = \omega/\omega_n$. Then, the logarithmic magnitude is

$$20 \log |G(\omega)| = -10 \log ((1 - u^2)^2 + 4\zeta^2 u^2), \tag{7.34}$$

and the phase angle is

$$\phi(\omega) = -\tan^{-1}\left(\frac{2\zeta u}{1 - u^2}\right). \tag{7.35}$$

When $u \ll 1$, the magnitude is

$$db = -10 \log 1 = 0 \text{ db},$$

and the phase angle approaches $0°$. When $u \gg 1$, the logarithmic magnitude approaches

$$db = -10 \log u^4 = -40 \log u,$$

which results in a curve with a slope of -40 db/decade. The phase angle, when $u \gg 1$, approaches $-180°$. The magnitude asymptotes meet at the 0-db line when $u = \omega/\omega_n = 1$. However, the difference between the actual magnitude curve and the asymptotic approximation is a function of the damping ratio and must be accounted for when $\zeta < 0.707$. The Bode diagram of a quadratic factor due to a pair of complex conjugate poles is shown in Fig. 7.9. The maximum value of the frequency response, M_{p_ω}, occurs at the *resonant frequency* ω_r. When the damping ratio approaches zero, then ω_r approaches ω_n, the natural frequency. The resonant frequency is determined by taking the derivative of the magnitude of Eq. (7.33) with respect to the normalized frequency, u, and setting it equal to zero. The resonant frequency is represented by the relation

$$\omega_r = \omega_n\sqrt{1 - 2\zeta^2}, \qquad \zeta < 0.707, \tag{7.36}$$

and the maximum value of the magnitude $|G(\omega)|$ is

$$M_{p_\omega} = |G(\omega_r)| = (2\zeta\sqrt{1 - \zeta^2})^{-1}, \qquad \zeta < 0.707, \tag{7.37}$$

for a pair of complex poles. The maximum value of the frequency response M_{p_ω}, and the resonant frequency ω_r are shown as a function of the damping ratio ζ for a pair of complex poles in Fig. 7.10. Assuming the dominance of a pair of complex conjugate closed-loop poles, we find that these curves are useful for estimating the damping ratio of a system from an experimentally determined frequency response.

The frequency response curves can be evaluated graphically on the s-plane by determining the vector lengths and angles at various frequencies ω along the $(s = +j\omega)$-axis. For example, considering the second-order factor with complex conjugate poles, we have

$$G(s) = \frac{1}{(s/\omega_n)^2 + 2\zeta s/\omega_n + 1} = \frac{\omega_n^2}{s^2 + 2\zeta\omega_n s + \omega_n^2}. \tag{7.38}$$

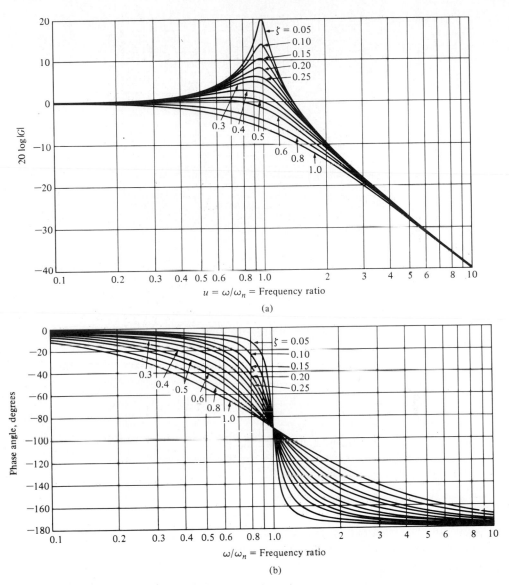

Figure 7.9. Bode diagram for $G(j\omega) = [1 + (2\zeta/\omega_n)j\omega + (j\omega/\omega_n)^2]^{-1}$.

The poles lie on a circle of radius ω_n and are shown for a particular ζ in Fig. 7.11(a). The transfer function evaluated for real frequency $s = j\omega$ is written as

$$G(j\omega) = \left.\frac{\omega_n^2}{(s - s_1)(s - s_1^*)}\right|_{s = j\omega} = \frac{\omega_n^2}{(j\omega - s_1)(j\omega - s_1^*)}, \qquad (7.39)$$

where s_1 and s_1^* are the complex conjugate poles. The vectors $(j\omega - s_1)$ and $(j\omega - s_1^*)$ are the vectors from the poles to the frequency $j\omega$, as shown in Fig.

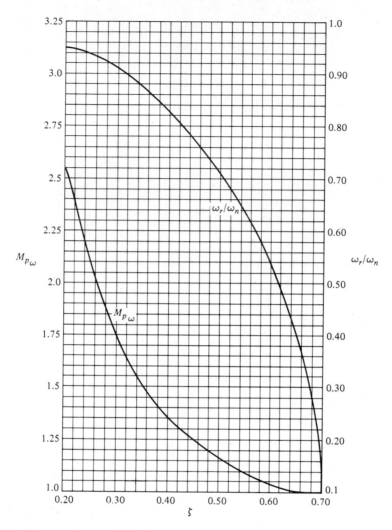

Figure 7.10. The maximum of the frequency response, M_{p_ω}, and the resonant frequency, ω_r, versus ζ for a pair of complex conjugate poles.

7.11(a). Then the magnitude and phase may be evaluated for various specific frequencies. The magnitude is

$$|G(\omega)| = \frac{\omega_n^2}{|j\omega - s_1|\,|j\omega - s_1^*|},$$

(7.40)

and the phase is

$$\phi(\omega) = -\underline{/(j\omega - s_1)} - \underline{/(j\omega - s_1^*)}.$$

Figure 7.11. Vector evaluation of the frequency response.

The magnitude and phase may be evaluated for three specific frequencies:

$$\omega = 0, \qquad \omega = \omega_r, \qquad \omega = \omega_d,$$

as shown in Fig. 7.11 in parts (b), (c), and (d), respectively. The magnitude and phase corresponding to these frequencies are shown in Fig. 7.12.

■ **E x a m p l e 7.4 Bode diagram of twin-T network**

As an example of the determination of the frequency response using the pole-zero diagram and the vectors to $j\omega$, consider the twin-T network shown in Fig. 7.13 [13]. The transfer function of this network is

$$G(s) = \frac{E_{out}(s)}{E_{in}(s)} = \frac{(s\tau)^2 + 1}{(s\tau)^2 + 4s\tau + 1}, \tag{7.41}$$

Figure 7.12. Bode diagram for complex conjugate poles.

where $\tau = RC$. The zeros are at $\pm j1$ and the poles are at $-2 \pm \sqrt{3}$ in the $s\tau$-plane as shown in Fig. 7.14(a). Clearly, at $\omega = 0$, we have $|G| = 1$ and $\phi(\omega) = 0°$. At $\omega = 1/\tau$, $|G| = 0$ and the phase angle of the vector from the zero at $s\tau = j1$ passes through a transition of 180°. When ω approaches ∞, $|G| = 1$ and $\phi(\omega) = 0$ again. Evaluating several intermediate frequencies, we can readily obtain the frequency response, as shown in Fig. 7.14(b).

In the previous examples the poles and zeros of $G(s)$ have been restricted to the left-hand plane. However, a system may have zeros located in the right-hand s-plane and may still be stable. Transfer functions with zeros in the right-hand s-plane are classified as *nonminimum phase-shift* transfer functions. If the zeros of a transfer function are all reflected about the $j\omega$-axis, there is no change in the magnitude of the transfer function, and the only difference is in the phase-shift characteristics. If the phase characteristics of the two system functions are compared, it can be readily shown that the net phase shift over the frequency range from zero to infinity is less for the system with all its zeros in the left-hand s-

Figure 7.13. Twin-T network.

Figure 7.14. Twin-T network. (a) Pole–zero pattern. (b) Frequency response.

plane. Thus the transfer function $G_1(s)$, with all its zeros in the left-hand s-plane, is called a *minimum phase* transfer function. The transfer function $G_2(s)$, with $|G_2(j\omega)| = |G_1(j\omega)|$ and all the zeros of $G_1(s)$ reflected about the $j\omega$-axis into the right-hand s-plane, is called a *nonminimum phase* transfer function. Reflection of any zero or pair of zeros into the right-half plane results in a nonminimum phase transfer function.

The two pole-zero patterns shown in Fig. 7.15(a) and (b) have the same amplitude characteristics as can be deduced from the vector lengths. However, the phase characteristics are different for Fig. 7.15(a) and (b). The minimum phase characteristic of Fig. 7.15(a) and the nonminimum phase characteristic of Fig. 7.15(b) are shown in Fig. 7.16. Clearly, the phase shift of

$$G_1(s) = \frac{s + z}{s + p}$$

Figure 7.15. Pole-zero patterns giving the same amplitude response and different phase characteristics.

Figure 7.16. The phase characteristics for the minimum phase and nonminimum phase transfer function.

ranges over less than 80°, whereas the phase shift of

$$G_2(s) = \frac{s - z}{s + p}$$

ranges over 180°. The meaning of the term minimum phase is illustrated by Fig. 7.16. The range of phase shift of a minimum phase transfer function is the least

Figure 7.17. The all-pass network pole-zero pattern and frequency response.

possible or minimum corresponding to a given amplitude curve, whereas the range of the nonminimum phase curve is greater than the minimum possible for the given amplitude curve.

A particularly interesting nonminimum phase network is the *all-pass* network, which can be realized with a symmetrical lattice network [8]. A symmetrical pattern of poles and zeros is obtained as shown in Fig. 7.17(a). Again, the magnitude $|G|$ remains constant; in this case, it is equal to unity. However, the angle varies from $0°$ to $-360°$. Because $\theta_2 = 180° - \theta_1$ and $\theta_2^* = 180° - \theta_1^*$, the phase is given by $\phi(\omega) = -2(\theta_1 + \theta_1^*)$. The magnitude and phase characteristic of the all-pass network is shown in Fig. 7.17(b). A nonminimum phase lattice network is shown in Fig. 7.17(c).

7.3 An Example of Drawing the Bode Diagram

The Bode diagram of a transfer function $G(s)$, which contains several zeros and poles, is obtained by adding the plot due to each individual pole and zero. The simplicity of this method will be illustrated by considering a transfer function that possesses all the factors considered in the preceding section. The transfer function of interest is

$$G(j\omega) = \frac{5(1 + j0.1\omega)}{j\omega(1 + j0.5\omega)(1 + j0.6(\omega/50) + (j\omega/50)^2)}. \tag{7.42}$$

The factors, in order of their occurrence as frequency increases, are as follows:

1. A constant gain $K = 5$
2. A pole at the origin
3. A pole at $\omega = 2$
4. A zero at $\omega = 10$
5. A pair of complex poles at $\omega = \omega_n = 50$

First, we plot the magnitude characteristic for each individual pole and zero factor and the constant gain.

1. The constant gain is $20 \log 5 = 14$ db, as shown in Fig. 7.18.
2. The magnitude of the pole at the origin extends from zero frequency to infinite frequencies and has a slope of -20 db/decade intersecting the 0-db line at $\omega = 1$, as shown in Fig. 7.18.
3. The asymptotic approximation of the magnitude of the pole at $\omega = 2$ has a slope of -20 db/decade beyond the break frequency at $\omega = 2$. The asymptotic magnitude below the break frequency is 0 db, as shown in Fig. 7.18.
4. The asymptotic magnitude for the zero at $\omega = +10$ has a slope of $+20$ db/decade beyond the break frequency at $\omega = 10$, as shown in Fig. 7.18.

Figure 7.18. Magnitude asymptotes of poles and zeros used in the example.

5. The asymptotic approximation for the pair of complex poles at $\omega = \omega_n = 50$ has a slope of -40 db/decade due to the quadratic forms. The break frequency is $\omega = \omega_n = 50$, as shown in Fig. 7.18. This approximation must be corrected to the actual magnitude because the damping ratio is $\zeta = 0.3$ and the magnitude differs appreciably from the approximation, as shown in Fig. 7.19.

Therefore the total asymptotic magnitude can be plotted by adding the asymptotes due to each factor, as shown by the solid line in Fig. 7.19. Examining the asymptotic curve of Fig. 7.19, one notes that the curve can be obtained

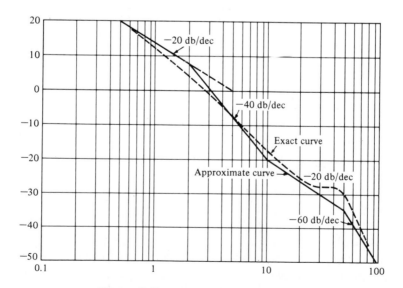

Figure 7.19. Magnitude characteristic.

directly by plotting each asymptote in order as frequency increases. Thus the slope is -20 db/decade due to $(j\omega)^{-1}$ intersecting 14 db at $\omega = 1$. Then at $\omega = 2$, the slope becomes -40 db/decade due to the pole at $\omega = 2$. The slope changes to -20 db/decade due to the zero at $\omega = 10$. Finally, the slope becomes -60 db/decade at $\omega = 50$ due to the pair of complex poles at $\omega_n = 50$.

The exact magnitude curve is then obtained by utilizing Table 7.2, which provides the difference between the actual and asymptotic curves for a single pole or zero. The exact magnitude curve for the pair of complex poles is obtained by utilizing Fig. 7.9(a) for the quadratic factor. The exact magnitude curve for $G(j\omega)$ is shown by a dashed line in Fig. 7.19.

The phase characteristic can be obtained by adding the phase due to each individual factor. Usually, the linear approximation of the phase characteristic for a single pole or zero is suitable for the initial analysis or design attempt. Thus the individual phase characteristics for the poles and zeros are shown in Fig. 7.20.

1. The phase of the constant gain is, of course, $0°$.
2. The phase of the pole at the origin is a constant $-90°$.
3. The linear approximation of the phase characteristic for the pole at $\omega = 2$ is shown in Fig. 7.20, where the phase shift is $-45°$ at $\omega = 2$.
4. The linear approximation of the phase characteristic for the zero at $\omega = 10$ is also shown in Fig. 7.20, where the phase shift is $+45°$ at $\omega = 10$.
5. The actual phase characteristic for the pair of complex poles is obtained from Fig. 7.9 and is shown in Fig. 7.20.

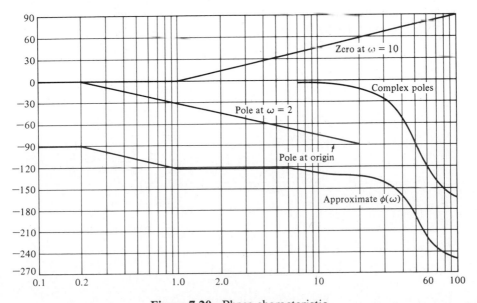

Figure 7.20. Phase characteristic.

Therefore the total phase characteristic, $\phi(\omega)$, is obtained by adding the phase due to each factor as shown in Fig. 7.20. While this curve is an approximation, its usefulness merits consideration as a first attempt to determine the phase characteristic. Thus, for example, a frequency of interest, as we shall note in the following section, is that frequency for which $\phi(\omega) = -180°$. The approximate curve indicates that a phase shift of $-180°$ occurs at $\omega = 46$. The actual phase shift at $\omega = 46$ can be readily calculated as

$$\phi(\omega) = -90° - \tan^{-1} \omega\tau_1 + \tan^{-1} \omega\tau_2 - \tan^{-1} \frac{2\zeta u}{1 - u^2}, \qquad (7.43)$$

where

$$\tau_1 = 0.5, \qquad \tau_2 = 0.1, \qquad u = \omega/\omega_n = \omega/50.$$

Then we find that

$$\phi(46) = -90° - \tan^{-1} 23 + \tan^{-1} 4.6 - \tan^{-1} 3.55$$
$$= -175°, \qquad (7.44)$$

and the approximate curve has an error of $5°$ at $\omega = 46$. However, once the approximate frequency of interest is ascertained from the approximate phase curve, the accurate phase shift for the neighboring frequencies is readily determined by using the exact phase shift relation (Eq. 7.43). This approach is usually preferable to the calculation of the exact phase shift for all frequencies over several decades. In summary, one may obtain approximate curves for the magnitude and phase shift of a transfer function $G(j\omega)$ in order to determine the important frequency ranges. Then, within the relatively small important frequency ranges, the exact magnitude and phase shift can be readily evaluated by using the exact equations, such as Eq. (7.43).

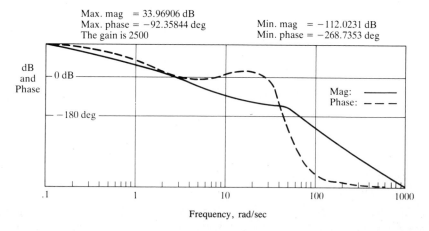

Figure 7.21. The Bode plot of the $G(j\omega)$ of Eq. 7.42 obtained from the Control System Design Program.

The frequency response of $G(j\omega)$ can be calculated and plotted using a computer program. The Control System Design Program (CSDP) will readily generate the frequency response, providing 30 points of actual data over a two-decade range as well as providing the Bode plot [see Appendix F].

The Bode plot for the example in Section 7.3 (Eq. 7.42) can be readily obtained using CSDP, as shown in Fig. 7.21. The plot is generated for four decades and the 0 db line is indicated as well as the -180 degree line. The data above the plot indicates that the magnitude is 34 db and the phase is -92.36 degrees at $\omega = 0.1$. Similarly, the data indicates that the magnitude is -43 db and the phase is -243 degrees at $\omega = 100$. Using the tabular data provided by CSDP, one finds that the magnitude is 0 db at $\omega = 3.0$ and the phase is -180 degrees at $\omega = 50$.

7.4 Frequency Response Measurements

A sine wave can be used to measure the open-loop frequency response of a control system. In practice a plot of amplitude versus frequency and phase versus frequency will be obtained [8,16]. From these two plots the open-loop transfer function $GH(j\omega)$ can be deduced. Similarly, the closed-loop frequency response of a control system, $T(j\omega)$, may be obtained and the actual transfer function deduced.

A device called a wave analyzer can be used to measure the amplitude and phase variations as the frequency of the input sine wave is altered. Also, a device called a transfer function analyzer can be used to measure the open-loop and closed-loop transfer functions [8].

The HP Dynamic Signal Analyzer shown in Fig. 7.22 is an example of a fre-

Figure 7.22. The HP 3562A Dynamic Signal Analyzer performs frequency response measurements from dc to 100 kHz. Built-in analysis and modeling capabilities can derive poles and zeros from measured frequency responses or construct phase and magnitude responses from user-supplied models. (Courtesy of Hewlett-Packard Co.)

quency response measurement tool. This device can also synthesize the frequency response of a model of a system allowing a comparison with an actual response.

As an example of determining the transfer function from the Bode plot, let us consider the plot shown in Fig. 7.23. The system is a stable circuit consisting of resistors and capacitors. Because the phase and magnitude decline as ω increases between 10 and 1000, and because the phase is $-45°$ and the gain -3 db at 370 rad/sec, we can deduce that one factor is a pole near $\omega = 370$. Beyond 370 rad/sec, the magnitude drops sharply at -40 db/decade, indicating that another pole exists. However, the phase drops to $-66°$ at $\omega = 1250$ and then starts to rise again, eventually approaching 0° at large values of ω. Also, because the magnitude returns to 0 db as ω exceeds 50,000, we determine that there are

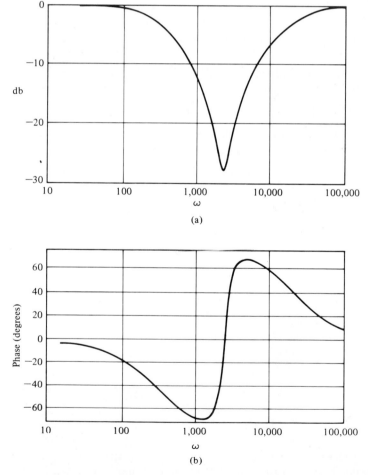

Figure 7.23. A Bode diagram for a system with an unidentified transfer function.

two zeros as well as two poles. We deduce that the numerator is a quadratic factor with a small ζ yielding the sharp phase change. Therefore the transfer function is

$$T(s) = \frac{(s/\omega_n)^2 + (2\zeta/\omega_n)s + 1}{(\tau_1 s + 1)(\tau_2 s + 1)},$$

where we know $\tau_1 = \frac{1}{370}$. Reviewing Fig. 7.9, we note that the phase passes through $+90°$ for a quadratic numerator at $\omega = \omega_n$. Because τ_1 yields $-90°$ by $\omega = 1000$, we deduce that $\omega_n = 2500$. Drawing the asymptotic curve for the pole $1/\tau_1$ and the numerator, we estimate $\zeta = 0.15$. Finally, the pole $p = 1/\tau_2$ yields a $45°$ phase shift from the asymptotic approximation so that $p = 20,000$. Therefore

$$T(s) = \frac{(s/2500)^2 + (0.3/2500)s + 1}{(s/370 + 1)(s/20,000 + 1)}.$$

This frequency response is actually obtained from a bridged-T network.

7.5 Performance Specifications in the Frequency Domain

We must continually ask the question: How does the frequency response of a system relate to the expected transient response of the system? In other words, given a set of time-domain (transient performance) specifications, how do we specify the frequency response? For a simple second-order system we have already answered this question by considering the performance in terms of over-shoot, settling time, and other performance criteria such as Integral Squared Error. For the second-order system shown in Fig. 7.24, the closed-loop transfer function is

$$T(s) = \frac{\omega_n^2}{s^2 + 2\zeta\omega_n s + \omega_n^2}. \tag{7.45}$$

The frequency response of this feedback system will appear as shown in Fig. 7.25. Because this is a second-order system, the damping ratio of the system is related to the maximum magnitude M_{p_ω}. Furthermore, the resonant frequency ω_r and the -3-db *bandwidth* can be related to the speed of the transient response. Thus, as the bandwidth ω_B increases, the rise time of the step response of the system will decrease. Furthermore, the overshoot to a step input can be related to M_{p_ω} through the damping ratio ζ. The curves of Fig. 7.10 relate the resonance magnitude and

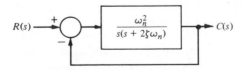

Figure 7.24. A second-order closed-loop system.

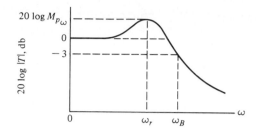

Figure 7.25. Magnitude characteristic of the second-order system.

frequency to the damping ratio of the second-order system. Then the step response overshoot may be estimated from Fig. 4.8 or may be calculated by utilizing Eq. (4.15). Thus we find as the resonant peak M_{p_ω} increases in magnitude, the overshoot to a step input increases. In general, the magnitude M_{p_ω} indicates the relative stability of a system.

The bandwidth of a system ω_B as indicated on the frequency response can be approximately related to the natural frequency of the system. The response of the second-order system to a unit step input is

$$c(t) = 1 + e^{-\zeta\omega_n t} \cos(\omega_1 t + \theta). \tag{7.46}$$

The greater the magnitude of ω_n when ζ is constant, the more rapid the response approaches the desired steady-state value. Thus desirable frequency-domain specifications are as follows:

1. Relatively small resonant magnitudes; $M_{p_\omega} < 1.5$, for example.
2. Relatively large bandwidths so that the system time constant $\tau = 1/\zeta\omega_n$ is sufficiently small.

The usefulness of these frequency-response specifications and their relation to the actual transient performance depend upon the approximation of the system by a second-order pair of complex poles. This approximation was discussed in Section 6.3, and the second-order poles of $T(s)$ are called the *dominant roots*. Clearly, if the frequency response is dominated by a pair of complex poles the relationships between the frequency response and the time response discussed in this section will be valid. Fortunately, a large proportion of control systems satisfy this dominant second-order approximation in practice.

The steady-state error specification can also be related to the frequency response of a closed-loop system. As we found in Section 4.4, the steady-state error for a specific test input signal can be related to the gain and number of integrations (poles at the origin) of the open-loop transfer function. Therefore, for the system shown in Fig. 7.24, the steady-state error for a ramp input is specified in terms of K_v, the velocity constant. The steady-state error for the system is

$$\lim_{t\to\infty} e(t) = R/K_v, \tag{7.47}$$

where R = magnitude of the ramp input. The velocity constant for the closed-loop system of Fig. 7.24 is

$$K_v = \lim_{s \to 0} sG(s) = \lim_{s \to 0} s \left(\frac{\omega_n^2}{s(s + 2\zeta\omega_n)} \right) = \frac{\omega_n}{2\zeta}. \tag{7.48}$$

In Bode diagram form (in terms of time constants), the transfer function $G(s)$ is written as

$$G(s) = \frac{(\omega_n/2\zeta)}{s((\frac{1}{2}\zeta\omega_n)s + 1)} = \frac{K_v}{s(\tau s + 1)}, \tag{7.49}$$

and the gain constant is K_v for this type-one system. For example, reexamining the example of Section 7.3, we had a type-one system with an open-loop transfer function

$$G(j\omega) = \frac{5(1 + j\omega\tau_2)}{j\omega(1 + j\omega\tau_1)(1 + j0.6u - u^2)}, \tag{7.50}$$

where $u = \omega/\omega_n$. Therefore in this case we have $K_v = 5$. In general, if the open-loop transfer function of a feedback system is written as

$$G(j\omega) = \frac{K \prod_{i=1}^{M} (1 + j\omega\tau_i)}{(j\omega)^N \prod_{k=1}^{Q} (1 + j\omega\tau_k)}, \tag{7.51}$$

then the system is type N and the gain K is the gain constant for the steady-state error. Thus for a type-zero system that has an open-loop transfer function

$$G(j\omega) = \frac{K}{(1 + j\omega\tau_1)(1 + j\omega\tau_2)}. \tag{7.52}$$

$K = K_p$ (the position error constant) and appears as the low frequency gain on the Bode diagram.

Furthermore, the gain constant $K = K_v$ for the type-one system appears as the gain of the low frequency section of the magnitude characteristic. Considering only the pole and gain of the type-one system of Eq. (7.50), we have

$$G(j\omega) = \left(\frac{5}{j\omega} \right) = \left(\frac{K_v}{j\omega} \right), \qquad \omega < 1/\tau_1, \tag{7.53}$$

and the K_v is equal to the frequency when this portion of the magnitude characteristic intersects the 0-db line. For example, the low frequency intersection of $(K_v/j\omega)$ in Fig. 7.19 is equal to $\omega = 5$, as we expect.

Therefore the frequency response characteristics represent the performance of a system quite adequately, and with some experience they are quite useful for the analysis and design of feedback control systems.

7.6 Log Magnitude and Phase Diagrams

There are several alternative methods of presenting the frequency response of a function $GH(j\omega)$. We have seen that suitable graphical presentations of the frequency response are (1) the polar plot and (2) the Bode diagram. An alternative approach to graphically portraying the frequency response is to plot the logarithmic magnitude in db versus the phase angle for a range of frequencies. Because this information is equivalent to that portrayed by the Bode diagram, it is normally easier to obtain the Bode diagram and transfer the information to the coordinates of the log magnitude versus phase diagram. Alternatively, one can construct templates for first- and second-order factors and work directly on the log-magnitude–phase diagram. The gain and phase of cascaded transfer functions can then be added vectorially directly on the diagram.

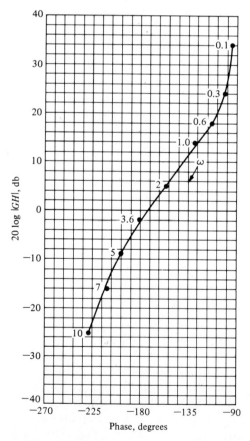

Figure 7.26. Log-magnitude–phase curve for $GH_1(j\omega)$.

An illustration will best portray the use of the log-magnitude–phase diagram. The log-magnitude–phase diagram for a transfer function

$$GH_1(j\omega) = \frac{5}{j\omega(0.5j\omega + 1)((j\omega/6) + 1)} \tag{7.54}$$

is shown in Fig. 7.26. The numbers indicated along the curve are for values of frequency, ω.

The log-magnitude–phase curve for the transfer function

$$GH_2(j\omega) = \frac{5(0.1j\omega + 1)}{j\omega(0.5j\omega + 1)(1 + j0.6(\omega/50) + (j\omega/50)^2)} \tag{7.55}$$

considered in Section 7.3 is shown in Fig. 7.27. This curve is obtained most readily by utilizing the Bode diagrams of Figs. 7.19 and 7.20 to transfer the frequency response information to the log magnitude and phase coordinates. The

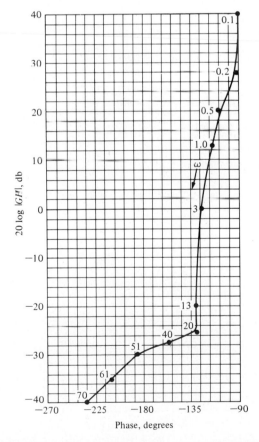

Figure 7.27. Log-magnitude–phase curve for $GH_2(j\omega)$.

shape of the locus of the frequency response on a log-magnitude–phase diagram is particularly important as the phase approaches 180° and the magnitude approaches 0 db. Clearly, the locus of Eq. (7.54) and Fig. 7.26 differs substantially from the locus of Eq. (7.55) and Fig. 7.27. Therefore, as the correlation between the shape of the locus and the transient response of a system is established, we will obtain another useful portrayal of the frequency response of a system. In the following chapter, we will establish a stability criterion in the frequency domain for which it will be useful to utilize the logarithmic-magnitude–phase diagram to investigate the relative stability of closed-loop feedback control systems.

7.7 Design Example: Engraving Machine Control System

The engraving machine shown in Fig. 7.28(a) uses two drive motors and associated lead screws to position the engraving scribe in the x direction. A separate motor is used for both the y and z axis as shown. The block diagram model for

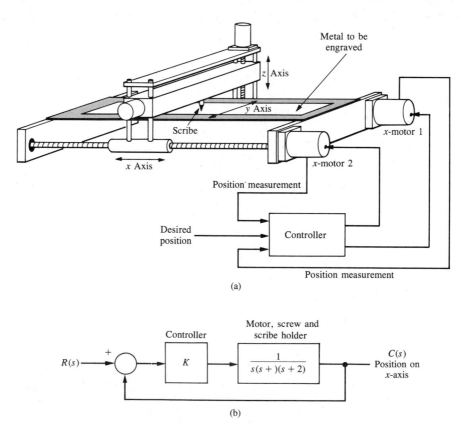

Figure 7.28. (a) Engraving machine control system. (b) Block diagram model.

Table 7.3. Frequency Response for $G(j\omega)$

ω	0.2	0.4	0.8	1.0	1.4	1.8		
20 log $	G	$	14	7	-1	-4	-9	-13
ϕ	$-107°$	$-123°$	$-150.5°$	$-162°$	$-179.5°$	$-193°$		

the x-axis position control system is shown in Fig. 7.28(b). The goal is to select an appropriate gain K so that the time response to step commands is acceptable by utilizing frequency response methods.

In order to represent the frequency response of the system, we will first obtain the open-loop Bode diagram and the closed-loop Bode diagram. Then we will use the closed-loop Bode diagram to predict the time response of the system and check the predicted results with the actual results.

In order to plot the frequency response, we arbitrarily select $K = 2$ and proceed with obtaining the Bode diagram. If the resulting system is not acceptable, we will later adjust the gain.

The frequency response of $G(j\omega)$ is partially listed in Table 7.3 and it is plotted in Fig. 7.29. We need the frequency response of the closed-loop transfer function

$$T(s) = \frac{2}{s^3 + 3s^2 + 2s + 2} .$$ (7.56)

Therefore we let $s = j\omega$, obtaining

$$T(j\omega) = \frac{2}{(2 - 3\omega^2) + j\omega(2 - \omega^2)} .$$ (7.57)

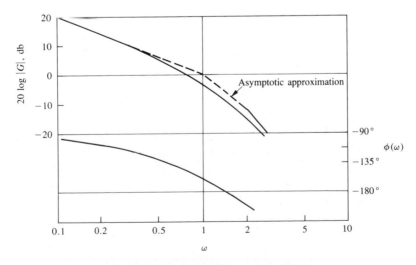

Figure 7.29. Bode diagram for $G(j\omega)$.

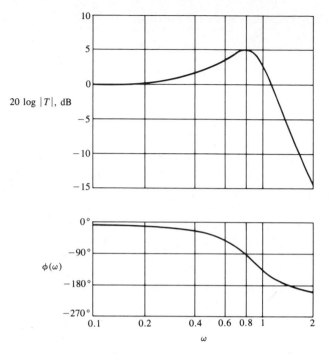

Figure 7.30. Bode diagram for closed-loop system.

The Bode diagram of the closed-loop system is shown in Fig. 7.30, where $20 \log |T| = 5$ db at $\omega_r = 0.8$. Therefore

$$20 \log M_{P_\omega} = 5$$

or

$$M_{P_\omega} = 1.78.$$

If we assume that the system has dominant second-order roots, we can approximate the system with a second-order frequency response of the form shown in Fig. 7.9. Since $M_{P_\omega} = 1.78$, we use Fig. 7.10 to estimate ζ to be 0.29. Using this ζ and $\omega_r = 0.8$, we can use Fig. 7.10 to estimate $\omega_n/\omega_r = 0.91$. Therefore

$$\omega_n = \frac{0.8}{0.91} = 0.88.$$

Since we are now approximating $T(s)$ as a second-order system, we have

$$T(s) \cong \frac{\omega_n^2}{s^2 + 2\zeta\omega_n s + \omega_n^2}$$

$$= \frac{0.774}{s^2 + 0.51s + 0.774}.$$

(7.58)

We use Fig. 4.8 to predict the overshoot to a step input as 37% for $\zeta = 0.29$. The settling time is estimated as

$$T_s = \frac{4}{\zeta\omega_n} = \frac{4}{(0.29)0.88} = 15.7 \text{ seconds.}$$

The actual overshoot for a step input is 34% and the actual settling time is 17 seconds. Clearly, the second-order approximation is reasonable in this case and can be used to determine suitable parameters on a system. If we require a system with lower overshoot, we would reduce K to 1 and repeat the procedure.

7.8 Summary

In this chapter we have considered the representation of a feedback control system by its frequency response characteristics. The frequency response of a system was defined as the steady-state response of the system to a sinusoidal input signal. Several alternative forms of frequency response plots were considered. The polar plot of the frequency response of a system $G(j\omega)$ was considered. Also, logarithmic plots, often called Bode plots, were considered and the value of the logarithmic measure was illustrated. The ease of obtaining a Bode plot for the various factors of $G(j\omega)$ was noted, and an example was considered in detail. The asymptotic approximation for drawing the Bode diagram simplifies the computation considerably. Several performance specifications in the frequency domain were discussed; among them were the maximum magnitude M_{p_ω} and the resonant frequency ω_r. The relationship between the Bode diagram plot and the system error constants (K_p and K_v) was noted. Finally, the log magnitude versus phase diagram was considered for graphically representing the frequency response of a system.

Exercises

E7.1. With increased track densities for computer disk drives, it is necessary carefully to design the head positioning control [8]. The transfer function is

$$G(s) = \frac{K}{(s + 1)^2}.$$

Plot the polar plot for this system when $K = 4$. Calculate the phase and magnitude at $\omega = 0.5, 1, 2,$ and so on.

E7.2. The tendon-operated robotic hand shown in Fig. 1.15 uses a pneumatic actuator [1]. The actuator can be represented by

$$G(s) = \frac{2572}{s^2 + 386s + 15,434} = \frac{2572}{(s + 45.3)(s + 341)}.$$

Plot the frequency response of $G(j\omega)$. Show that the magnitude of $G(j\omega)$ is -15.6 db at $\omega = 10$ and -30 db at $\omega = 200$. Also show that the phase is $-150°$ at $\omega = 700$.

E7.3. A robot arm has a joint control open-loop transfer function

$$G(s) = \frac{300(s + 100)}{s(s + 10)(s + 40)}.$$

Prove that the frequency equals 28.3 rad/sec when the phase angle of $(j\omega)$ is $-180°$. Find the magnitude of $G(j\omega)$ at that frequency.

E7.4. The frequency response for a process of the form

$$G(s) = \frac{Ks}{(s + a)(s^2 + 20s + 100)}$$

is shown in Fig. E7.4. Determine K and a by examining the frequency response curves.

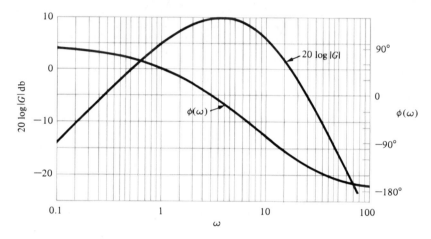

Figure E7.4. Bode diagram.

E7.5. The magnitude plot of a transfer function

$$G(s) = \frac{K(1 + 0.5s)(1 + as)}{s(1 + s/8)(1 + bs)(1 + s/36)}$$

is shown in Fig. E7.5, on the next page. Determine K, a, and b from the plot.

Answers: $K = 8$, $a = \frac{1}{4}$, $b = \frac{1}{24}$

E7.6. Several studies have proposed an extravehicular robot that could move about a NASA space station and perform physical tasks at various worksites. One such robot is shown in Fig. E7.6. The arm is controlled by a unity feedback control with

$$G(s) = \frac{K}{s(s/10 + 1)(s/100 + 1)}.$$

Draw the Bode diagram for $K = 100$ and determine the frequency when 20 log $|G|$ is zero db.

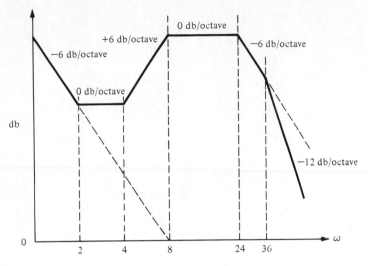

Figure E7.5. Bode diagram.

Figure E7.6. Space station robot.

(a)

X=1.37kHz ΔYa=4.076 dB
Ya=−4.9411 ΔX=1.275kHz

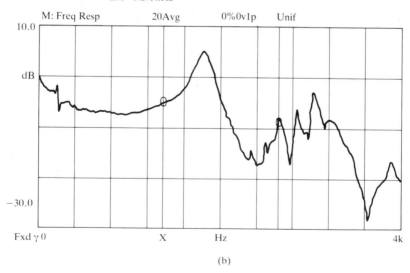

M: Freq Resp 20Avg 0%0v1p Unif

(b)

Figure E7.8. (a) Head positioner (b) frequency response.

E7.7. Consider a system with a closed-loop transfer function

$$T(s) = \frac{C(s)}{R(s)} = \frac{4}{(s^2 + s + 1)(s^2 + 0.4s + 4)}.$$

This system will have no steady-state error for a step input. (a) Using the Control System Design Program (CSDP) or equivalent, plot the frequency response, noting the two peaks in the magnitude response. (b) Predict the time response to a step input, noting that the system has four poles and it cannot be represented as a dominant second-order system. (c) Using CSDP, plot the step response.

E7.8. The dynamic analyzer shown in Fig. 7.22 can be used to display the frequency response of a selected $G(j\omega)$ model. Figure E7.8(a) shows a head positioning mechanism for a disk drive. This device uses a linear motor to position the head. Figure E7.8(b) shows the actual frequency response of the head positioning mechanism. Estimate the poles and zeros of the device. Note $X = 1.37$ kHz at the first cursor and $\Delta X = 1.257$ kHz to the second cursor.

Problems

P7.1. Sketch the polar plot of the frequency response for the following transfer functions:

(a) $GH(s) = \dfrac{1}{(1 + 0.5s)(1 + 2s)}$

(b) $GH(s) = \dfrac{(1 + 0.5s)}{s^2}$

(c) $GH(s) = \dfrac{(s + 3)}{(s^2 + 4s + 16)}$

(d) $GH(s) = \dfrac{30(s + 8)}{s(s + 2)(s + 4)}$

P7.2. Draw the Bode diagram representation of the frequency response for the transfer functions given in problem P7.1.

P7.3. A rejection network that can be utilized instead of the twin-T network of Example 7.4 is the bridged-T network shown in Fig. P7.3. The transfer function of this network is

$$G(s) = \frac{s^2 + \omega_n^2}{s^2 + 2(\omega_n s/Q) + \omega_n^2}$$

(can you show this?), where $\omega_n^2 = 2/LC$ and $Q = \omega_n L/R_1$ and R_2 is adjusted so that $R_2 = (\omega_n L)^2/4R_1$ [13]. (a) Determine the pole-zero pattern and, utilizing the vector approach, evaluate the approximate frequency response. (b) Compare the frequency response of the twin-T and bridged-T networks when $Q = 10$.

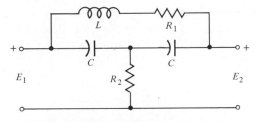

Figure P7.3. Bridged-T network.

P7.4. A control system for controlling the pressure in a closed chamber is shown in Fig. P7.4. The transfer function for the measuring element is

$$H(s) = \frac{450}{s^2 + 90s + 900},$$

and the transfer function for the valve is

$$G_1(s) = \frac{1}{(0.1s + 1)(1/15s + 1)}.$$

The controller transfer function is

$$G_c(s) = (10 + 2s).$$

Obtain the frequency response characteristics for the loop transfer function

$$G_c(s)G_1(s)H(s) \cdot [1/s].$$

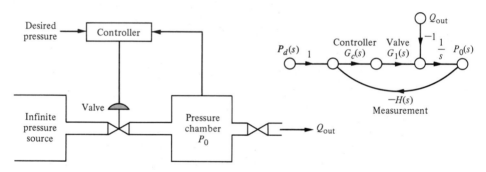

Figure P7.4. (a) Pressure controller (b) flowgraph.

P7.5. The robot industry in the United States is growing at a rate of 30% a year [1]. A typical industrial robot has six axes or degrees of freedom. A position control system for a force-sensing joint has a transfer function

$$G(s) = \frac{K}{(1 + s/2)(1 + s)(1 + s/10)(1 + s/30)},$$

where $H(s) = 1$ and $K = 10$. Plot the Bode diagram of this system.

P7.6. The asymptotic logarithmic magnitude curves for two transfer functions are given in Fig. P7.6, on the next page. Sketch the corresponding asymptotic phase shift curves for each system. Determine the transfer function for each system. Assume that the systems have minimum phase transfer functions.

P7.7. A feedback control system is shown in Fig. P7.7. The specification for the closed-loop system requires that the overshoot to a step input is less than 16%. (a) Determine the corresponding specification in the frequency domain M_{p_ω} for the closed-loop transfer function

$$\frac{C(j\omega)}{R(j\omega)} = T(j\omega).$$

(b) Determine the resonant frequency, ω_r. (c) Determine the bandwidth of the closed-loop system.

Figure P7.6.

Figure P7.7.

P7.8. Driverless vehicles can be used in warehouses, airports, and many other applications. These vehicles follow a wire imbedded in the floor and adjust the steerable front wheels in order to maintain proper direction, as shown in Fig. P7.8(a), on the next page [1]. The sensing coils, mounted on the front wheel assembly, detect an error in the direction of travel and adjust the steering. The overall control system is shown in Fig. P7.8(b). The open-loop transfer function is

$$GII(s) = \frac{K}{s(s + \pi)^2} - \frac{K_v}{s(s/\pi + 1)^2}.$$

It is desired to have the bandwidth of the closed-loop system exceed 2π rad/sec. (a) Set $K_v = 2\pi$ and plot the Bode diagram. (b) Using the Bode diagram obtain the logarithmic magnitude versus phase angle curve.

P7.9. Draw the logarithmic magnitude versus phase angle curves for the transfer functions a and b of Problem P7.1.

P7.10. A linear actuator is utilized in the system shown in Fig. P7.10 to position a mass M. The actual position of the mass is measured by a slide wire resistor and thus $H(s) = 1.0$. The amplifier gain is to be selected so that the steady-state error of the system is less than 1% of the magnitude of the position reference $R(s)$. The actuator has a field coil with a resistance $R_f = 0.1$ ohm and $L_f = 0.2$ henries. The mass of the load is 0.1 kg and the friction is 0.2 n-sec/m. The spring constant is equal to 0.4 n/m. (a) Determine the gain K necessary to maintain a steady-state error for a step input less than 1%. That is, K_p must be greater than 99. (b) Draw the Bode diagram of the loop transfer function $GH(s)$. (c) Draw the logarithmic magnitude versus phase angle curve for $GH(j\omega)$. (d) Draw the Bode diagram for the closed-loop transfer function $Y(j\omega)/R(j\omega)$. Determine M_{p_ω}, ω_r, and the bandwidth.

(b)

Figure P7.8. Steerable wheel control.

Figure P7.10. Linear actuator control.

P7.11. The block diagram of a feedback control system is shown in Fig. P7.11(a). The transfer functions of the blocks are represented by the frequency response curves shown in Fig. P7.11(b). (a) When G_3 is disconnected from the system, determine the damping ratio ζ of the system. (b) Connect G_3 and determine the damping ratio ζ. Assume that the systems have minimum phase transfer functions.

(a)

(b)

Figure P7.11. Feedback system.

P7.12. A position control system may be constructed by using an ac motor and ac components as shown in Fig. P7.12. The syncro and control transformer may be considered to be a transformer with a rotating winding. The syncro position detector rotor turns with the load through an angle θ_0. The syncro motor is energized with an ac reference voltage, for example, 115 volts, 60 cps. The input signal or command is $R(s) = \theta_{in}(s)$ and is applied by turning the rotor of the control transformer. The ac two-phase motor operates as a result of the amplified error signal. The advantages of an ac control system are (1) freedom from dc drift effects and (2) the simplicity and accuracy of ac components. In order to measure the open-loop frequency response, one simply disconnects X from Y and X' from Y'. Then one applies a sinusoidal modulation signal generator to the Y–Y' terminals and measures the response at X–X'. [The error $(\theta_0 - \theta_i)$ will be adjusted to zero before applying the ac generator.] The resulting frequency response of the loop, $GH(j\omega)$, is shown in Fig. P7.12(b). Determine the transfer function $GH(j\omega)$. Assume that the system has a minimum phase transfer function.

(a)

(b)

Figure P7.12. (a) AC motor control (b) frequency response.

P7.13. Automatic steering of a ship would be a particularly useful application of feedback control theory. In the case of heavily traveled seas, it is important to maintain the motion of the ship along an accurate track. An automatic system is able to maintain a much smaller error from the desired heading than is a helmsman who recorrects at infrequent intervals. A mathematical model of the steering system has been developed for a ship moving at a constant velocity and for small deviations from the desired track. For a large tanker, the transfer function of the ship is

$$G(s) = \frac{E(s)}{\delta(s)} = \frac{0.164(s + 0.2)(-s + 0.32)}{s^2(s + 0.25)(s - 0.009)},$$

where $E(s)$ is the Laplace transform of the deviation of the ship from the desired heading and $\delta(s)$ is the Laplace transform of the angle of deflection of the steering rudder.

Verify that the frequency response of the ship, $E(j\omega)/\delta(j\omega)$, is that shown in Fig. P7.13.

Figure P7.13. Frequency response of ship control system.

P7.14. In order to determine the transfer function of a plant $G(s)$, the frequency response may be measured using a sinusoidal input. One system yields the following data. Determine the transfer function $G(s)$.

ω, rad/sec	0.1	1	2	4	5	6.3	8	10	12.5	20	31
$\lvert G(j\omega)\rvert$	50	5.02	2.57	1.36	1.17	1.03	0.97	0.97	0.74	0.13	0.026
Phase, degrees	-90	-92.4	-96.2	-100	-104	110	-120	-143	-169	-245	-258

P7.15. A bandpass amplifier may be represented by the circuit model shown in Fig. P7.15 [13]. When $R_1 = R_2 = 1 \text{ k}\Omega$, $C_1 = 100$ pf, $C_2 = 1$ μf, and $K = 100$, show that

$$ G(s) = \frac{10^9 s}{(s + 1000)(s + 10^7)} . $$

(a) Sketch the Bode diagram of $G(j\omega)$. (b) Find the midband gain (in db). (c) Find the high and low frequency -3 db points.

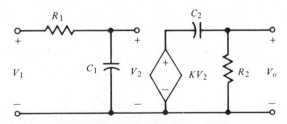

Figure P7.15. Bandpass amplifier.

P7.16. On April 13, 1985, a communications satellite was launched, but the ignited rocket failed to drive the satellite to its desired orbit. In August 1985, the space shuttle Discovery salvaged the satellite using a complicated scheme. Fig. P7.16 illustrates how a crew member, with his feet strapped to the platform on the end of the shuttle's robot arm, used his arms to stop the satellite's spin and ignite the engine switch. The control system has the form shown in Fig. 3.14, where $G_1 = K = 8$ and $H(s) = 1$. The control system of the robot arm has a closed-loop transfer function

$$\frac{C(s)}{R(s)} = \frac{8}{s^2 + 4s + 8}.$$

(a) Determine the response $c(t)$ to a unit step disturbance. (b) Determine the bandwidth of the system.

Figure P7.16. Satellite repair.

P7.17. The experimental Oblique Wing Aircraft (OWA) has a wing that pivots as shown in Fig. P7.17, on the next page. The wing is in the normal unskewed position for low speeds and can move to a skewed position for improved supersonic flight [14]. The aircraft control system has $H(s) = 1$ and

$$G(s) = \frac{4\,(0.5s + 1)}{s(2s + 1)\left[\left(\dfrac{s}{8}\right)^2 + \left(\dfrac{s}{20}\right) + 1\right]}.$$

(a) Using the Control System Design Program or equivalent, find the Bode diagram. (b) Find the frequency, ω_1, when the magnitude is 0 db and the frequency, ω_2, when the phase is -180 degrees.

P7.18. Remote operation plays an important role in hostile environments, such as those in nuclear or high-temperature environments and in deep space. In spite of the efforts of many researchers, a teleoperation system that is comparable to the human's direct operation has not been developed. Research engineers have been trying to improve teleopera-

Maximum skewed wing position

Figure P7.17. The Oblique Wing Aircraft top and side view.

tions by feeding back rich sensory information acquired by the robot to the operator with a sensation of presence. This concept is called tele-existence or telepresence [19].

The tele-existence master-slave system consists of a master system with a visual and auditory sensation of presence, a computer control system, and an anthropomorphic slave robot mechanism with an arm having seven degrees of freedom and a locomotion mechanism. The operator's head movement, right arm movement, right hand movement, and other auxiliary motion are measured by the master system. A specially designed stereo visual and auditory input system mounted on the neck mechanism of the slave robot gathers visual and auditory information of the remote environment. These pieces of information are sent back to the master system and are applied to the specially designed stereo display system to evoke the sensation of presence of the operator. A diagram of the loco-mation system and robot is shown in Fig. P7.18, on the next page. The locomotion control system has the loop transfer

$$GH(s) = \frac{12(s + 0.5)}{s^2 + 13s + 30}.$$

Obtain the Bode diagram for $GH(j\omega)$ and determine the frequency when $20 \log |GH|$ is very close to 0 db.

P.7.19. Low altitude wind shear is a major cause of air carrier accidents in the United States. Most of these accidents have been caused by either microbursts (small scale, low altitude, intense thunderstorm downdrafts that impact the surface and cause strong divergent outflows of wind) or by the gust front at the leading edge of expanding thunderstorm outflows. A microburst encounter is a serious problem for either *landing* or *departing* aircraft since the aircraft is at low altitudes and is traveling at just over 25% above its stall speed [20].

The design of the control of an aircraft encountering wind shear after takeoff may be treated as a problem of stabilizing the climb rate about a desired value of the climb rate. The resulting controller is a feedback one utilizing only climb rate information.

Figure P7.18. A tele-existence robot.

The standard negative unity feedback system of Fig. 7.24 has a loop transfer function

$$G(s) = \frac{-200s^2}{s^3 + 14s^2 + 44s + 40}.$$

Note the negative gain in $G(s)$. This system represents the control system for climb rate. Draw the Bode diagram and determine gain (in db) when the phase is $-180°$.

P7.20. Space robotics is an emerging field. For the successful development of space projects, robotics and automation will be a key technology. Autonomous and dexterous space robots can reduce the workload of astronauts and increase operational efficiency in many missions. Figure P7.20 shows a concept called a free-flying robot [1,19]. A major characteristic of space robots, which clearly distinguishes them from robots operated on earth, is the lack of a fixed base. Any motion of the manipulator arm will induce reaction forces and moments in the base, which disturb its position and attitude.

The control of one of the joints of the robot can be represented by the loop transfer function

$$GH(s) = \frac{600(s + 6)}{s^2 + 10s + 400}.$$

Figure P7.20. A space robot with three arms, shown capturing a satellite.

(a) Plot the Bode diagram of $GH(j\omega)$. (b) Determine the maximum value of 20 log $|GH|$, the frequency at which it occurs, and the phase at that frequency.

P7.21. A dc motor controller used extensively in automobiles is shown in Fig. P7.21(a). The measured plot of $\Theta(s)/I(s)$ is shown in Fig. P7.21(b). Determine the transfer function of $\Theta(s)/I(s)$.

Figure P7.21. Motor controller.

Design Problems ◆

DP7.1. The behavior of a human steering an automobile remains interesting [6,17]. The design and development of systems for four-wheel steering, active suspensions, active, independent braking, and "drive-by-wire" steering provide the engineer with considerably more freedom in altering vehicle handling qualities than existed in the past.

The vehicle and the driver are represented by the model in Fig. DP7.1, where the driver develops anticipation of the vehicle deviation from the center line. For $K = 1$, plot the Bode diagram of (a) the open-loop transfer function $G_c(s)G(s)$ and (b) the closed-loop transfer function $T(s)$. (c) Repeat parts (a) and (b) when $K = 10$. (d) A driver can select the gain K. Determine the appropriate gain so that $M_{P\omega} \leq 2$ and the bandwidth is the maximum attainable for the closed-loop system. (e) Determine the steady-state error of the system for a ramp input, $r(t) = t$.

Figure DP7.1.

DP7.2. The unmanned exploration of planets such as Mars requires a high level of auton-
omy because of the communication delays between robots in space and their Earth-based
stations. This impacts all the components of the system: planning, sensing, and mecha-
nism. In particular, such a level of autonomy can be achieved only if each robot has a
perception system that can reliably build and maintain models of the environment. The
Robotics Institute of Carnegie-Mellon University has proposed a perception system that
is designed for application to autonomous planetary exploration. The perception system is
a major part of the development of a complete system that includes planning and mecha-
nism design. The target vehicle is the Ambler, a six-legged walking machine being devel-
oped at CMU, shown in Fig. DP7.2(a) [18]. The control system of one leg is shown in Fig.
DP7.2(b).

(a)

(b)

Figure DP7.2. (a) The six-legged Ambler. (b) Block diagram of the control system for
one leg.

(a) Draw the Bode diagram for $G_c(s)G(s)$ for $0.1 \leq \omega \leq 100$ when $K = 20$. Determine (1) the frequency when the phase is $-180°$ and (2) the frequency when $20 \log |GG_c| = 0$ db. (b) Plot the Bode diagram for the closed-loop transfer function $T(s)$ when $K = 20$. (c) Determine M_{P_ω}, ω_r, and ω_B for the closed-loop system when $K = 20$ and $K = 40$. (d) Select the best gain of the two specified in part (c) when it is desired that the overshoot of the system to a step input, $r(t)$, is less than 35% and the settling time is as short as feasible.

Terms and Concepts

Bandwidth The frequency at which the frequency response has declined 3 db from its low-frequency value.

Bode plot The logarithm of the magnitude of the transfer function is plotted versus the logarithm of ω, the frequency. The phase, ϕ, of the transfer function is separately plotted versus the logarithm of the frequency.

Break frequency The frequency at which the asymptotic approximation of the frequency response for a pole (or zero) changes slope.

Corner frequency See Break frequency.

Decibel (db) The units of the logarithmic gain.

Fourier transform The transformation of a function of time, $f(t)$, into the frequency domain.

Frequency response The steady-state response of a system to a sinusoidal input signal.

Logarithmic magnitude The logarithm of the magnitude of the transfer function, $20 \log_{10} |G|$.

Logarithmic plot See Bode plot.

Maximum value of the frequency response A pair of complex poles will result in a maximum value for the frequency response occuring at the resonant frequency.

Minimum phase All the zeros of a transfer function lie in the left-hand side of the s-plane.

Natural frequency The frequency of natural oscillation that would occur for two complex poles if the damping was equal to zero.

Nonminimum phase Transfer functions with zeros in the right-hand s-plane.

Polar plot A plot of the real part of $G(j\omega)$ versus the imaginary part of $G(j\omega)$.

Resonant frequency The frequency, ω_r, at which the maximum value of the frequency response of a complex pair of poles is attained.

Transfer function in the frequency domain The ratio of the output to the input signal where the input is a sinusoid. It is expressed as $G(j\omega)$.

References

1. R. C. Dorf, *Encyclopedia of Robotics,* John Wiley & Sons, New York, 1988.
2. V. Feliu, "Adaptive Control of a Single-Link Flexible Manipulator," *IEEE Control Systems,* February 1990; pp. 29–32.
3. E. K. Parsons, "An Experiment Demonstrating Pointing Control," *IEEE Control Systems,* April 1989; pp. 79–86.
4. H. W. Bode, "Relations Between Attenuation and Phase in Feedback Amplifier Design," *Bell System Tech. J.,* July 1940; pp. 421–54. Also in *Automatic Control: Classical Linear Theory,* G. J. Thaler, ed., Dowden, Hutchinson, and Ross, Stroudsburg, Pa., 1974; pp. 145–78.
5. M. D. Fagen, *A History of Engineering and Science in the Bell System,* Bell Telephone Laboratories, Murray Hill, N.J., 1978; Ch. 3.
6. R. A. Hess, "A Control Theoretic Model of Driver Steering Behavior," *IEEE Control Systems,* August 1990; pp. 3–8.
7. S. Winchester, "Leviathans of the Sky," *Atlantic Monthly,* October 1990; pp. 107–18.
8. L. B. Jackson, *Signals, Systems, and Transforms,* Addison-Wesley, Reading, Mass., 1991.
9. M. Rimer and D. K. Frederick, "Solutions of the Grumman F-14 Benchmark Control Problem," *IEEE Control Systems,* August 1987; pp. 36–40.
10. K. Egilmez, "A Logical Approach to Knowledge-Based Control," *J. of Intelligent Manufacturing,* no. 1, 1990; pp. 59–76.
11. C. Philips and R. Harbor, *Feedback Control Systems,* Prentice Hall, Englewood Cliffs, N.J., 1991.
12. J. F. Manji, "Smart Cars of the Twenty-first Century," *Automation,* October 1990; pp. 18–25.
13. S. Franco, *Design with Operational Amplifiers and Analog Integrated Circuits,* McGraw-Hill, New York, 1988.
14. R. C. Nelson, *Flight Stability and Automatic Control,* McGraw-Hill, New York, 1989.
15. R. C. Dorf and R. G. Jacquot, *Control System Design Program,* Addison-Wesley, Reading, Mass., 1988.
16. R. J. Smith and R. C. Dorf, *Circuits, Devices, and Systems,* 5th ed., John Wiley & Sons, New York, 1991.
17. J. Krueger, "Developments in Automotive Electronics," *Automotive Engineering,* September 1990; pp. 37–44.
18. M. Hebert, "A Perception System for a Planetary Explorer," *Proceed. of the IEEE Conference on Decision and Control,* 1989; pp. 80–89.
19. S. Tachi, "Tele-Existence Master-Slave System for Remote Manipulation," *Proceed. of IEEE Conference on Decision and Control,* December 1990; pp. 85–90.
20. G. Leitman, "Aircraft Control Under Conditions of Windshear," *Proceed. of IEEE Conference on Decision and Control,* December 1990; pp. 747–49.
21. K. Yoshida, "Control of Space Free-Flying Robot," *Proceed. of IEEE Conference on Decision and Control,* December 1990; pp. 97–101.
22. T. Kawabe, "Controller for Servo Positioning System of an Automobile," *Proceed. of IEEE Conference on Decision and Control,* December 1990; pp. 2170–74.

CHAPTER 8

Stability in the Frequency Domain

Preview

As we noted in earlier chapters, it is important to determine whether a system is stable. If it is stable, then the degree of stability is important to determine. We may use the frequency response of a transfer function around a feedback loop $GH(j\omega)$ to provide answers to our inquiry about the system's relative stability.

We will use some concepts developed in the theory of complex variables to obtain a stability criterion in the frequency domain. Then this criterion can be extended to indicate relative stability by indicating how close we come to operating at the edge of instability.

We will then demonstrate how we can examine the frequency response of the closed-loop transfer function, $T(j\omega)$, as well as the loop transfer function $GH(j\omega)$.

Finally, we will use these methods to analyze the response and performance of a system with a pure time delay, without attenuation, located within the feedback loop of a closed-loop control system.

8.1 Introduction

For a control system, it is necessary to determine whether the system is stable. Furthermore, if the system is stable, it is often necessary to investigate the relative stability. In Chapter 5, we discussed the concept of stability and several methods of determining the absolute and relative stability of a system. The Routh-Hurwitz method discussed in Chapter 5 is a useful method for investigating the characteristic equation expressed in terms of the complex variable $s = \sigma + j\omega$. Then in Chapter 6, we investigated the relative stability of a system utilizing the root locus method, which is also in terms of the complex variable s. In this chapter, we are concerned with investigating the stability of a system in the real frequency domain, that is, in terms of the frequency response discussed in Chapter 7.

The frequency response of a system represents the sinusoidal steady-state response of a system and provides sufficient information for the determination of the relative stability of the system. The frequency response of a system can readily be obtained experimentally by exciting the system with sinusoidal input signals; therefore it can be utilized to investigate the relative stability of a system when the system parameter values have not been determined. Furthermore, a frequency-domain stability criterion would be useful for determining suitable approaches to altering a system in order to increase its relative stability.

A frequency domain stability criterion was developed by H. Nyquist in 1932 and remains a fundamental approach to the investigation of the stability of linear control systems [1, 2]. The *Nyquist stability criterion* is based upon a theorem in the theory of the function of a complex variable due to Cauchy. Cauchy's theorem is concerned with *mapping contours* in the complex s-plane, and fortunately the theorem can be understood without a formal proof, which uses complex variable theory.

In order to determine the relative stability of a closed-loop system, we must investigate the characteristic equation of the system:

$$F(s) = 1 + P(s) = 0. \tag{8.1}$$

For a multiloop system, we found in Section 2.7 that, in terms of signal-flow graphs, the characteristic equation is

$$F(s) = \Delta(s) = 1 - \Sigma L_n + \Sigma L_m L_q \cdots,$$

where $\Delta(s)$ is the graph determinant. Therefore we can represent the characteristic equation of single-loop or multiple-loop systems by Eq. (8.1), where $P(s)$ is a

rational function of s. In order to ensure stability, we must ascertain that all the zeros of $F(s)$ lie in the left-hand s-plane. In order to investigate this, Nyquist proposed a mapping of the right-hand s-plane into the $F(s)$-plane. Therefore, to utilize and understand Nyquist's criterion, we shall first consider briefly the mapping of contours in the complex plane.

8.2 Mapping Contours in the s-Plane

We are concerned with the mapping of contours in the s-plane by a function $F(s)$. A *contour map* is a contour or trajectory in one plane mapped or translated into another plane by a relation $F(s)$. Since s is a complex variable, $s = \sigma + j\omega$, the function $F(s)$ is itself complex and can be defined as $F(s) = u + jv$ and can be represented on a complex $F(s)$-plane with coordinates u and v. As an example, let us consider a function $F(s) = 2s + 1$ and a contour in the s-plane as shown in Fig. 8.1(a). The mapping of the s-plane unit square contour to the $F(s)$ plane is accomplished through the relation $F(s)$, and so

$$u + jv = F(s) = 2s + 1 = 2(\sigma + j\omega) + 1. \tag{8.2}$$

Therefore, in this case, we have

$$u = 2\sigma + 1 \tag{8.3}$$

and

$$v = 2\omega. \tag{8.4}$$

Thus the contour has been mapped by $F(s)$ into a contour of an identical form, a square, with the center shifted by one unit and the magnitude of a side multiplied by 2. This type of mapping, which retains the angles of the s-plane contour

$$N = Z - P = 1 - 0 = 1$$

(a) (b)

Figure 8.1. Mapping a square contour by $F(s) = 2s + 1 = 2(s + \frac{1}{2})$.

on the $F(s)$-plane, is called a *conformal mapping*. We also note that a closed contour in the s-plane results in a closed contour in the $F(s)$-plane.

The points A, B, C, and D, as shown in the s-plane contour, map into the points A, B, C, and D shown in the $F(s)$-plane. Furthermore, a direction of traversal of the s-plane contour can be indicated by the direction $ABCD$ and the arrows shown on the contour. Then a similar traversal occurs on the $F(s)$-plane contour as we pass $ABCD$ in order, as shown by the arrows. By convention, the area within a contour to the right of the traversal of the contour is considered to be the *area enclosed* by the contour. Therefore we will assume *clockwise traversal* of a contour to be positive and the area enclosed within the contour to be on the right. This convention is opposite to that usually employed in complex variable theory but is equally applicable and is generally used in control system theory. Readers might consider the area on the right as they walk along the contour in a clockwise direction and call this rule "clockwise and eyes right."

Typically, we are concerned with an $F(s)$ that is a rational function of s. Therefore it will be worthwhile to consider another example of a mapping of a contour. Let us again consider the unit square contour for the function

$$F(s) = \frac{s}{s + 2}.$$ (8.5)

Several values of $F(s)$ as s traverses the square contour are given in Table 8.1, and the resulting contour in the $F(s)$-plane is shown in Fig. 8.2(b). The contour in the $F(s)$-plane encloses the origin of the $F(s)$-plane because the origin lies within the enclosed area of the contour in the $F(s)$-plane.

Cauchy's theorem is concerned with mapping a function $F(s)$, which has a finite number of poles and zeros within the contour so that we may express $F(s)$ as

$$F(s) = \frac{K \prod_{i=1}^{n} (s + s_i)}{\prod_{k=1}^{M} (s + s_k)},$$ (8.6)

where s_i are the zeros of the function $F(s)$ and s_k are the poles of $F(s)$. The function $F(s)$ is the characteristic equation, and so

$$F(s) = 1 + P(s),$$ (8.7)

where

$$P(s) = \frac{N(s)}{D(s)}.$$

Table 8.1.

$s = \sigma + j\omega$	Point A $1 + j1$		Point B $1 - j1$		Point C $-1 - j1$		Point D $-1 + j1$	
	$1 + j1$	1	$1 - j1$	$-j1$	$-1 - j1$	-1	$-1 + j1$	$j1$
$F(s) = u + jv$	$\dfrac{4 + 2j}{10}$	$\dfrac{1}{3}$	$\dfrac{4 - 2j}{10}$	$\dfrac{1 - 2j}{5}$	$-j$	-1	$+j$	$\dfrac{1 + 2j}{5}$

(a)　　　　　　　　　　　(b)

$$N = Z - P$$
$$= 1 - 0$$
$$= 1$$

Figure 8.2. Mapping for $F(s) = s/(s + 2)$.

Therefore we have

$$F(s) = 1 + \frac{N(s)}{D(s)} = \frac{D(s) + N(s)}{D(s)} = \frac{K \prod_{i=1}^{n} (s + s_i)}{\prod_{k=1}^{M} (s + s_k)}, \qquad (8.8)$$

and the poles of $P(s)$ are the poles of $F(s)$. However, it is the zeros of $F(s)$ that are the characteristic roots of the system and that indicate the response of the system. This is clear if we recall that the output of the system is

$$C(s) = T(s)R(s) = \frac{\Sigma P_k \Delta_k}{\Delta(s)} R(s) = \frac{\Sigma P_k \Delta_k}{F(s)} R(s), \qquad (8.9)$$

where P_k and Δ_k are the path factors and cofactors as defined in Section 2.7.

Now, reexamining the example when $F(s) = 2(s + \frac{1}{2})$, we have one zero of $F(s)$ at $s = -\frac{1}{2}$, as shown in Fig. 8.1. The contour that we chose (that is, the unit square) enclosed and encircled once the zero within the area of the contour. Similarly, for the function $F(s) = s/(s + 2)$, the unit square encircled the zero at the origin but did not encircle the pole at $s = -2$. The encirclement of the poles and zeros of $F(s)$ can be related to the encirclement of the origin in the $F(s)$-plane by a *theorem* of *Cauchy*, commonly known as the *principle of the argument*, which states [3, 7]:

> If a contour Γ_s in the s-plane encircles Z zeros and P poles of $F(s)$ and does not pass through any poles or zeros of $F(s)$ as the traversal is in the clockwise direction along the contour, the corresponding contour Γ_F in the $F(s)$-plane encircles the origin of the $F(s)$-plane $N = Z - P$ times in the clockwise direction.

Thus for the examples shown in Figs. 8.1 and 8.2, the contour in the $F(s)$-plane encircles the origin once, because $N = Z - P = 1$, as we expect. As another

example, consider the function $F(s) = s/(s + \frac{1}{2})$. For the unit square contour shown in Fig. 8.3(a), the resulting contour in the $F(s)$ plane is shown in Fig. 8.3(b). In this case, $N = Z - P = 0$ as is the case in Fig. 8.3(b), since the contour Γ_F does not encircle the origin.

Cauchy's theorem can be best comprehended by considering $F(s)$ in terms of the angle due to each pole and zero as the contour Γ_s is traversed in a clockwise direction. Thus let us consider the function

$$F(s) = \frac{(s + z_1)(s + z_2)}{(s + p_1)(s + p_2)},\tag{8.10}$$

where z_i is a zero of $F(s)$ and p_k is a pole of $F(s)$. Equation (8.10) can be written as

$$F(s) = |F(s)|\underline{/F(s)}$$

$$= \frac{|s + z_1|\ |s + z_2|}{|s + p_1|\ |s + p_2|}\ (\underline{/s + z_1} + \underline{/s + z_2} - \underline{/s + p_1} - \underline{/s + p_2})\tag{8.11}$$

$$= |F(s)|(\phi_{z_1} + \phi_{z_2} - \phi_{p_1} - \phi_{p_2}).$$

Now, considering the vectors as shown for a specific contour Γ_s (Fig. 8.4a), we can determine the angles as s traverses the contour. Clearly, the net angle change as s traverses along Γ_s a full rotation of 360° for ϕ_{p_1}, ϕ_{p_2} and ϕ_{z_2} is zero degrees. However, for ϕ_{z_1} as s traverses 360° around Γ_s, the angle ϕ_{z_1} traverses a full 360° clockwise. Thus, as Γ_s is completely traversed, the net angle of $F(s)$ is equal to 360° since only one zero is enclosed. If Z zeros were enclosed within Γ_s, then the net angle would be equal to $\phi_z = 2\pi(Z)$ rad. Following this reasoning, if Z zeros and P poles are encircled as Γ_s is traversed, then $2\pi(Z) - 2\pi(P)$ is the net resul-

$N = 0$
$= Z - P$
$= 1 - 1$
$= 0$

(a) (b)

Figure 8.3. Mapping for $F(s) = s/(s + \frac{1}{2})$.

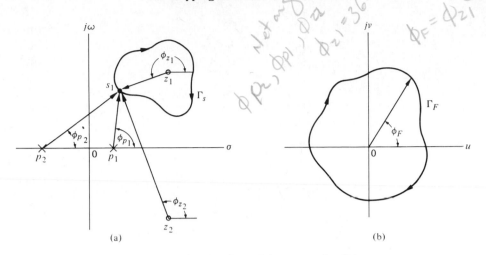

Figure 8.4. Evaluation of the net angle of Γ_F.

tant angle of $F(s)$. Thus the net angle of Γ_F of the contour in the $F(s)$-plane, ϕ_F, is simply

$$\phi_F = \phi_Z - \phi_P$$

or

$$2\pi N = 2\pi Z - 2\pi p, \qquad (8.12)$$

and the net number of encirclements of the origin of the $F(s)$-plane is $N = Z - P$. Thus for the contour shown in Fig. 8.4(a), which encircles one zero, the contour Γ_F shown in Fig. 8.4(b) encircles the origin once in the clockwise direction.

As an example of the use of Cauchy's theorem, consider the pole-zero pattern shown in Fig. 8.5(a) with the contour Γ_s to be considered. The contour encloses and encircles three zeros and one pole. Therefore we obtain

$$N = 3 - 1 = +2,$$

and Γ_F completes two clockwise encirclements of the origin in the $F(s)$-plane as shown in Fig. 8.5(b).

For the pole and zero pattern shown and the contour Γ_s as shown in Fig. 8.6(a), one pole is encircled and no zeros are encircled. Therefore we have

$$N = Z - P = -1,$$

and we expect one encirclement of the origin by the contour Γ_F in the $F(s)$-plane. However, since the sign of N is negative, we find that the encirclement moves in the counterclockwise direction as shown in Fig. 8.6(b).

Now that we have developed and illustrated the concept of mapping of contours through a function $F(s)$, we are ready to consider the stability criterion proposed by Nyquist.

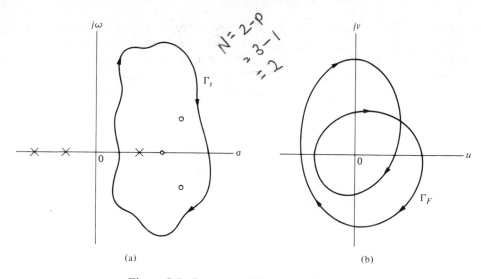

Figure 8.5. Example of Cauchy's theorem.

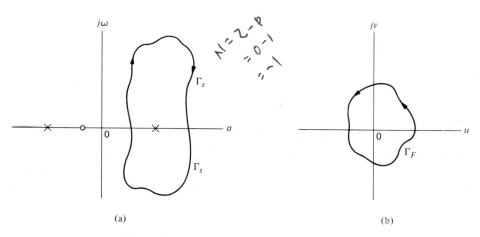

Figure 8.6. Example of Cauchy's theorem.

8.3 The Nyquist Criterion

In order to investigate the stability of a control system, we consider the characteristic equation, which is $F(s) = 0$, so that

$$F(s) = 1 + P(s) = \frac{K\prod_{i=1}^{n}(s + s_i)}{\prod_{k=1}^{M}(s + s_k)} = 0. \tag{8.13}$$

For a system to be stable, all the zeros of $F(s)$ must lie in the left-hand s-plane. Thus we find that the roots of a stable system [the zeros of $F(s)$] must lie to the

left of the $j\omega$-axis in the s-plane. Therefore we chose a contour Γ_s in the s-plane which encloses the entire right-hand s-plane, and we determine whether any zeros of $F(s)$ lie within Γ_s by utilizing Cauchy's theorem. That is, we plot Γ_F in the $F(s)$-plane and determine the number of encirclements of the origin N. Then the number of zeros of $F(s)$ within the Γ_s contour [and therefore unstable zeros of $F(s)$] is

$$Z = N + P. \tag{8.14}$$

Thus if $P = 0$, as is usually the case, we find that the number of unstable roots of the system is equal to N, the number of encirclements of the origin of the $F(s)$ plane.

The Nyquist contour that encloses the entire right-hand s-plane is shown in Fig. 8.7. The contour Γ_s passes along the $j\omega$-axis from $-j\infty$ to $+j\infty$, and this part of the contour provides the familiar $F(j\omega)$. The contour is completed by a semi-circular path of radius r where r approaches infinity.

Now, the Nyquist criterion is concerned with the mapping of the characteristic equation

$$F(s) = 1 + P(s) \tag{8.15}$$

and the number of encirclements of the origin of the $F(s)$-plane. Alternatively, we may define the function $F'(s)$ so that

$$F'(s) = F(s) - 1 = P(s). \tag{8.16}$$

The change of functions represented by Eq. (8.16) is very convenient because $P(s)$ is typically available in factored form, while $1 + P(s)$ is not. Then the mapping of Γ_s in the s-plane will be through the function $F'(s) = P(s)$ into the $P(s)$-plane. In this case the number of clockwise encirclements of the origin of the $F(s)$-plane becomes the number of clockwise encirclements of the -1 point in the

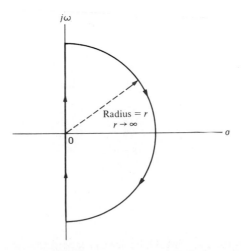

Figure 8.7. Nyquist contour.

$F'(s) = P(s)$ plane because $F'(s) = F(s) - 1$. Therefore the *Nyquist stability criterion* can be stated as follows:

> A feedback system is stable if and only if the contour Γ_p in the $P(s)$-plane does not encircle the $(-1, 0)$ point when the number of poles of $P(s)$ in the right-hand s-plane is zero ($P = 0$).

When the number of poles of $P(s)$ in the right-hand s-plane is other than zero, the Nyquist criterion is:

> A feedback control system is stable if and only if, for the contour Γ_p, the number of counterclockwise encirclements of the $(-1, 0)$ point is equal to the number of poles of $P(s)$ with positive real parts.

The basis for the two statements is the fact that for the $F'(s) = P(s)$ mapping, the number of roots (or zeros) of $1 + P(s)$ in the right-hand s-plane is represented by the expression

$$Z = N + P.$$

Clearly, if the number of poles of $P(s)$ in the right-hand s-plane is zero ($P = 0$), we require for a stable system that $N = 0$ and the contour Γ_p must not encircle the -1 point. Also, if P is other than zero and we require for a stable system that $Z = 0$, then we must have $N = -P$, or P counterclockwise encirclements.

It is best to illustrate the use of the Nyquist criterion by completing several examples.

■ Example 8.1 System with two real poles

A single-loop control system is shown in Fig. 8.8, where

$$GH(s) = \frac{K}{(\tau_1 s + 1)(\tau_2 s + 1)}. \tag{8.17}$$

In this case, $P(s) = GH(s)$, and we utilize a contour $\Gamma_p = \Gamma_{GH}$ in the $GH(s)$ plane. The contour Γ_s in the s-plane is shown in Fig. 8.9(a), and the contour Γ_{GH} is shown in Fig. 8.9(b) for $\tau_1 = 1$, $\tau_2 = \frac{1}{10}$, and $K = 100$. The magnitude and phase of

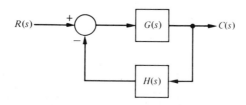

Figure 8.8. Single-loop feedback control system.

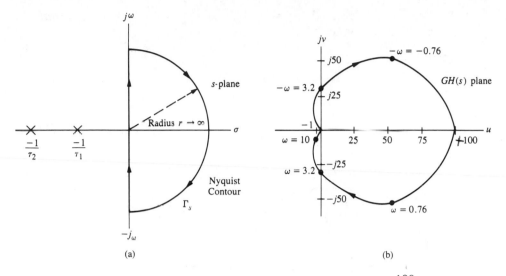

Figure 8.9. Nyquist contour and mapping for $GH(s) = \dfrac{100}{(s + 1)(s/10 + 1)}$

$GH(j\omega)$ for selected values of ω are given in Table 8.2. We use these values to obtain the polar plot of Fig. 8.9(b).

We note that the number of poles of $GH(s)$ in the right-hand s-plane is zero and thus $P = 0$. Therefore, for this system to be stable we require $N = Z = 0$, and the contour must not encircle the -1 point in the $GH(s)$ plane. Examining Fig. 8.9(b) and Eq. (8.17), we find that, irrespective of the value of K, the contour does not encircle the -1 point and the system is always stable for all K greater than zero.

■ Example 8.2 System with a pole at the origin

A single-loop control system is shown in Fig. 8.8, where

$$GH(s) = \frac{K}{s(\tau s + 1)}.$$

In this single-loop case, $P(s) = GH(s)$ and we determine the contour $\Gamma_p = \Gamma_{GH}$ in the $GH(s)$-plane. The contour Γ_s in the s-plane is shown in Fig. 8.10(a), where an

Table 8.2.

ω	0	0.1	0.76	1	2	10	20	100	∞		
$	GH(j\omega)	$	100	96	79.6	70.7	50.2	6.8	2.24	0.10	0
$\underline{/GH(j\omega)}$ (degrees)	0	-5.7	-41.5	-50.7	-74.7	-129.3	-150.5	-173.7	-180		

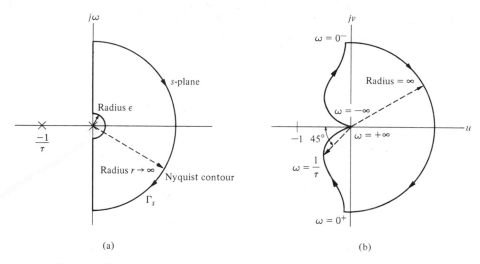

Figure 8.10. Nyquist contour and mapping for $GH(s) = K/s(\tau s + 1)$.

infinitesimal detour around the pole at the origin is effected by a small semicircle of radius ϵ, where $\epsilon \to 0$. This detour is a consequence of the condition of Cauchy's theorem which requires that the contour cannot pass through the pole of the origin. A sketch of the contour Γ_{GH} is shown in Fig. 8.10(b). Clearly, the portion of the contour Γ_{GH} from $\omega = 0^+$ to $\omega = +\infty$ is simply $GH(j\omega)$, the real frequency polar plot. Let us consider each portion of the Nyquist contour Γ_s in detail and determine the corresponding portions of the $GH(s)$-plane contour Γ_{GH}.

(a) The Origin of the s-Plane. The small semicircular detour around the pole at the origin can be represented by setting $s = \epsilon e^{j\phi}$ and allowing ϕ to vary from $-90°$ at $\omega = 0^-$ to $+90°$ at $\omega = 0^+$. Because ϵ approaches zero, the mapping $GH(s)$ is

$$\lim_{\epsilon \to 0} GH(s) = \lim_{\epsilon \to 0} \left(\frac{K}{\epsilon e^{j\phi}}\right) = \lim_{\epsilon \to 0} \left(\frac{K}{\epsilon}\right) e^{-j\phi}. \qquad (8.18)$$

Therefore the angle of the contour in the $GH(s)$-plane changes from $90°$ at $\omega = 0^-$ to $-90°$ at $\omega = 0^+$, passing through $0°$ at $\omega = 0$. The radius of the contour in the $GH(s)$-plane for this portion of the contour is infinite, and this portion of the contour is shown in Fig. 8.10(b).

(b) The Portion from $\omega = 0^+$ to $\omega = +\infty$. The portion of the contour Γ_s from $\omega = 0^+$ to $\omega = +\infty$ is mapped by the function $GH(s)$ as the real frequency polar plot because $s = j\omega$ and

$$GH(s)|_{s=j\omega} = GH(j\omega) \qquad (8.19)$$

for this part of the contour. This results in the real frequency polar plot shown in Fig. 8.10(b). When ω approaches $+\infty$, we have

$$\lim_{\omega \to +\infty} GH(j\omega) = \lim_{\omega \to +\infty} \frac{K}{+j\omega(j\omega\tau + 1)} \qquad (8.20)$$

$$= \lim_{\omega \to \infty} \left| \frac{K}{\tau\omega^2} \right| \underline{/-(\pi/2) - \tan^{-1} \omega\tau}.$$

Therefore the magnitude approaches zero at an angle of $-180°$.

(c) The Portion from $\omega = +\infty$ *to* $\omega = -\infty$. The portion of Γ_s from $\omega = +\infty$ to $\omega = -\infty$ is mapped into the point zero at the origin of the $GH(s)$-plane by the function $GH(s)$. The mapping is represented by

$$\lim_{r \to \infty} GH(s)|_{s=re^{j\phi}} = \lim_{r \to \infty} \left| \frac{K}{r^2} \right| e^{-2j\phi} \qquad (8.21)$$

as ϕ changes from $\phi = +90°$ at $\omega = +\infty$ to $\phi = -90°$ at $\omega = -\infty$. Thus the contour moves from an angle of $-180°$ at $\omega = +\infty$ to an angle of $+180°$ at $\omega = -\infty$. The magnitude of the $GH(s)$ contour when r is infinite is always zero or a constant.

(d) The Portion from $\omega = -\infty$ *to* $\omega = 0^-$. The portion of the contour Γ_s from $\omega = -\infty$ to $\omega = 0^-$ is mapped by the function $GH(s)$ as

$$GH(s)|_{s=-j\omega} = GH(-j\omega). \qquad (8.22)$$

Thus we obtain the complex conjugate of $GH(j\omega)$, and the plot for the portion of the polar plot from $\omega = -\infty$ to $\omega = 0^-$ is symmetrical to the polar plot from $\omega = +\infty$ to $\omega = 0^+$. This symmetrical polar plot is shown on the $GH(s)$-plane in Fig. 8.10(b).

Now, in order to investigate the stability of this second-order system, we first note that the number of poles P within the right-hand s-plane is zero. Therefore, for this system to be stable, we require $N = Z = 0$, and the contour Γ_{GH} must not encircle the -1 point in the GH-plane. Examining Fig. 8.10(b), we find that irrespective of the value of the gain K and the time constant τ, the contour does not encircle the -1 point, and the system is always stable. As in Chapter 6, we are considering positive values of gain K. If negative values of gain are to be considered, one should use $-K$, where $K \geq 0$.

We may draw two general conclusions from this example as follows:

1. The plot of the contour Γ_{GH} for the range $-\infty < \omega < 0^-$ will be the complex conjugate of the plot for the range $0^+ < \omega < +\infty$ and the polar plot of $GH(s)$ will be symmetrical in the $GH(s)$-plane about the u-axis. Therefore *it is sufficient to construct the contour* Γ_{GH} *for the frequency range* $0^+ < \omega < +\infty$ *in order to investigate the stability.*

2. The magnitude of $GH(s)$ as $s = re^{j\phi}$ and $r \to \infty$ will normally approach zero or a constant.

■ **E x a m p l e 8.3 System with three poles**

Let us again consider the single-loop system shown in Fig. 8.8 when

$$GH(s) = \frac{K}{s(\tau_1 s + 1)(\tau_2 s + 1)}. \tag{8.23}$$

The Nyquist contour Γ_s is shown in Fig. 8.10(a). Again this mapping is symmetrical for $GH(j\omega)$ and $GH(-j\omega)$ so that it is sufficient to investigate the $GH(j\omega)$-locus. The origin of the s-plane maps into a semicircle of infinite radius as in the last example. Also, the semicircle $re^{j\phi}$ in the s-plane maps into the point $GH(s) = 0$ as we expect. Therefore, in order to investigate the stability of the system, it is sufficient to plot the portion of the contour Γ_{GH} which is the real frequency polar plot $GH(j\omega)$ for $0^+ < \omega < 0^+ +\infty$. Therefore, when $s = +j\omega$, we have

$$
\begin{aligned}
GH(j\omega) &= \frac{K}{j\omega(j\omega\tau_1 + 1)(j\omega\tau_2 + 1)} \\
&= \frac{-K(\tau_1 + \tau_2) - jK(1/\omega)(1 - \omega^2\tau_1\tau_2)}{1 + \omega^2(\tau_1^2 + \tau_2^2) + \omega^4\tau_1^2\tau_2^2} \\
&= \frac{K}{[\omega^4(\tau_1 + \tau_2)^2 + \omega^2(1 - \omega^2\tau_1\tau_2)^2]^{1/2}} \\
&\quad \times \underline{/-\tan^{-1}\omega\tau_1 - \tan^{-1}\omega\tau_2 - (\pi/2)}.
\end{aligned}
\tag{8.24}
$$

When $\omega = 0^+$, the magnitude of the locus is infinite at an angle of $-90°$ in the $GH(s)$-plane. When ω approaches $+\infty$, we have

$$
\begin{aligned}
\lim_{\omega \to \infty} GH(j\omega) &= \lim_{\omega \to \infty} \left| \frac{1}{\omega^3} \right| \underline{/-(\pi/2) - \tan^{-1}\omega\tau_1 - \tan^{-1}\omega\tau_2} \\
&= \left(\lim_{\omega \to \infty} \left| \frac{1}{\omega^3} \right| \right) \underline{/-(3\pi/2)}.
\end{aligned}
\tag{8.25}
$$

Therefore $GH(j\omega)$ approaches a magnitude of zero at an angle of $-270°$. In order for the locus to approach at an angle of $-270°$, the locus must cross the u-axis in the $GH(s)$-plane as shown in Fig. 8.11. Thus it is possible to encircle the -1 point as is shown in Fig. 8.11. The number of encirclements, when the -1 point lies within the locus as shown in Fig. 8.11, is equal to two and the system is unstable with two roots in the right-hand s-plane. The point where the $GH(s)$-locus intersects the real axis can be found by setting the imaginary part of $GH(j\omega) = u + jv$ equal to zero. We then have from Eq. (8.24)

$$v = \frac{-K(1/\omega)(1 - \omega^2\tau_1\tau_2)}{1 + \omega^2(\tau_1^2 + \tau_2^2) + \omega^4\tau_1^2\tau_2^2} = 0. \tag{8.26}$$

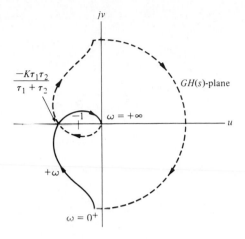

Figure 8.11. Nyquist diagram for $GH(s) = K/s(\tau_1 s + 1)(\tau_2 s + 1)$.

Thus $v = 0$ when $1 - \omega^2 \tau_1 \tau_2 = 0$ or $\omega = 1/\sqrt{\tau_1 \tau_2}$. The magnitude of the real part, u, of $GH(j\omega)$ at this frequency is

$$u = \frac{-K(\tau_1 + \tau_2)}{1 + \omega^2(\tau_1^2 + \tau_2^2) + \omega^4 \tau_1^2 \tau_2^2}\bigg|_{\omega^2 = 1/\tau_1 \tau_2} \tag{8.27}$$

$$= \frac{-K(\tau_1 + \tau_2)\tau_1 \tau_2}{\tau_1 \tau_2 + (\tau_1^2 + \tau_2^2) + \tau_1 \tau_2} = \frac{-K\tau_1 \tau_2}{\tau_1 + \tau_2}.$$

Therefore the system is stable when

$$\frac{-K\tau_1 \tau_2}{\tau_1 + \tau_2} \geq 1$$

or

$$K \leq \frac{\tau_1 + \tau_2}{\tau_1 \tau_2}. \tag{8.28}$$

■ Example 8.4 System with two poles at the origin

Again let us determine the stability of the single-loop system shown in Fig. 8.8 when

$$GH(s) = \frac{K}{s^2(\tau s + 1)}. \tag{8.29}$$

The real frequency polar plot is obtained when $s = j\omega$, and we have

$$GH(j\omega) = \frac{K}{-\omega^2(j\omega\tau + 1)} \tag{8.30}$$

$$= \frac{K}{[\omega^4 + \tau^2 \omega^6]^{1/2}} \underline{/-\pi - \tan^{-1} \omega\tau}.$$

Figure 8.12. Nyquist contour plot for $GH(s) = K/s^2(\tau s + 1)$.

We note that the angle of $GH(j\omega)$ is always $-180°$ or greater, and the locus of $GH(j\omega)$ is above the u-axis for all values of ω. As ω approaches 0^+, we have

$$\lim_{\omega \to 0+} GH(j\omega) = \left(\lim_{\omega \to 0+} \left| \frac{K}{\omega^2} \right| \right) \underline{/-\pi}. \tag{8.31}$$

As ω approaches $+\infty$, we have

$$\lim_{\omega \to +\infty} GH(j\omega) = \left(\lim_{\omega \to +\infty} \frac{K}{\omega^3} \right) \underline{/-3\pi/2}. \tag{8.32}$$

At the small semicircular detour at the origin of the s-plane where $s = \epsilon e^{j\phi}$, we have

$$\lim_{\epsilon \to 0} GH(s) = \lim_{\epsilon \to 0} \frac{K}{\epsilon^2} e^{-2j\phi}, \tag{8.33}$$

where $-\pi/2 \le \phi \le \pi/2$. Thus the contour Γ_{GH} ranges from an angle of $+\pi$ at $\omega = 0^+$ to $-\pi$ at $\omega = 0^+$ and passes through a full circle of 2π rad as ω changes from $\omega = 0^-$ to $\omega = 0^+$. The complete contour plot of Γ_{GH} is shown in Fig. 8.12. Because the contour encircles the -1 point twice, there are two roots of the closed-loop system in the right-hand plane and the system, irrespective of the gain K, is unstable.

■ Example 8.5 System with a pole in the right-hand s-plane

Let us consider the control system shown in Fig. 8.13 and determine the stability of the system. First, let us consider the system without derivative feedback so that $K_2 = 0$. We then have the open-loop transfer function

$$GH(s) = \frac{K_1}{s(s - 1)}. \tag{8.34}$$

Figure 8.13. Second-order feedback control system.

Thus the open-loop transfer function has one pole in the right-hand s-plane, and therefore $P = 1$. In order for this system to be stable, we require $N = -P = -1$, one counterclockwise encirclement of the -1 point. At the semicircular detour at the origin of the s-plane, we let $s = \epsilon e^{j\phi}$ when $-\pi/2 \leq \phi \leq \pi/2$. Then we have, when $s = \epsilon e^{j\phi}$,

$$\lim_{\epsilon \to 0} GH(s) = \lim_{\epsilon \to 0} \frac{K_1}{-\epsilon e^{j\phi}} = \left(\lim_{\epsilon \to 0} \left| \frac{K_1}{\epsilon} \right| \right) \underline{/-180° - \phi}. \tag{8.35}$$

Therefore this portion of the contour Γ_{GH} is a semicircle of infinite magnitude in the left-hand GH-plane, as shown in Fig. 8.14. When $s = j\omega$, we have

$$GH(j\omega) = \frac{K_1}{j\omega(j\omega - 1)} = \frac{K_1}{(\omega^2 + \omega^4)^{1/2}} \underline{/(-\pi/2) - \tan^{-1}(-\omega)} \tag{8.36}$$

$$= \frac{K_1}{(\omega^2 + \omega^4)^{1/2}} \underline{/(+\pi/2) + \tan^{-1}\omega}.$$

Finally, for the semicircle of radius r as r approaches infinity, we have

$$\lim_{r \to \infty} GH(s)|_{s = re^{j\phi}} = \left(\lim_{r \to \infty} \left| \frac{K_1}{r^2} \right| \right) e^{-2j\phi}, \tag{8.37}$$

Figure 8.14. Nyquist diagram for $GH(s) = K_1/s(s - 1)$.

Table 8.3.

s	$j0^-$	$j0^+$	$j1$	$+j\infty$	$-j\infty$
$\|GH\|/K_1$	∞	∞	$1/\sqrt{2}$	0	0
$\underline{/GH}$	$-90°$	$+90°$	$+135°$	$+180°$	$-180°$

where ϕ varies from $\pi/2$ to $-\pi/2$ in a clockwise direction. Therefore the contour Γ_{GH}, at the origin of the GH-plane, varies 2π rad in a counterclockwise direction, as shown in Fig. 8.14. Several important values of the $GH(s)$-locus are given in Table 8.3. The contour Γ_{GH} in the $GH(s)$-plane encircles the -1 point once in the clockwise direction and $N = +1$. Therefore

$$Z = N + P = 2. \tag{8.38}$$

and the system is unstable because two zeros of the characteristic equation, irrespective of the value of the gain K, lie in the right half of the s-plane.

Let us now reconsider the system when the derivative feedback is included in the system shown in Fig. 8.13. Then the open-loop transfer function is

$$GH(s) = \frac{K_1(1 + K_2 s)}{s(s - 1)}. \tag{8.39}$$

The portion of the contour Γ_{GH} when $s = \epsilon e^{j\phi}$ is the same as the system without derivative feedback, as is shown in Fig. 8.15. However, when $s = re^{j\phi}$ as r approaches infinity, we have

$$\lim_{r \to \infty} GH(s)|_{s=re^{j\phi}} = \lim_{r \to \infty} \left| \frac{K_1 K_2}{r} \right| e^{-j\phi}, \tag{8.40}$$

Figure 8.15. Nyquist diagram for $GH(s) = K_1(1 + K_2 s)/s(s - 1)$.

and the Γ_{GH}-contour at the origin of the GH-plane varies π rad in a counterclockwise direction, as shown in Fig. 8.15. The frequency locus $GH(j\omega)$ crosses the u-axis and is determined by considering the real frequency transfer function

$$
\begin{aligned}
GH(j\omega) &= \frac{K_1(1 + K_2 j\omega)}{-\omega^2 - j\omega} \\
&= \frac{-K_1(\omega^2 + \omega^2 K_2) + j(\omega - K_2\omega^3)K_1}{\omega^2 + \omega^4}.
\end{aligned}
\tag{8.41}
$$

The $GH(j\omega)$-locus intersects the u-axis at a point where the imaginary part of $GH(j\omega)$ is zero. Therefore

$$
\omega - K_2\omega^3 = 0
$$

at this point, or $\omega^2 = 1/K_2$. The value of the real part of $GH(j\omega)$ at the intersection is then

$$
u\big|_{\omega^2=1/K_2} = \frac{-\omega^2 K_1(1 + K_2)}{\omega^2 + \omega^4}\bigg|_{\omega^2=1/K_2} = -K_1 K_2.
\tag{8.42}
$$

Therefore, when $-K_1 K_2 < -1$ or $K_1 K_2 > 1$, the contour Γ_{GH} encircles the -1 point once in a counterclockwise direction, and therefore $N = -1$. Then Z, the number of zeros of the system in the right-hand plane, is

$$
Z = N + P = -1 + 1 = 0.
\tag{8.43}
$$

Thus the system is stable when $K_1 K_2 > 1$. Often, it may be useful to utilize a computer or calculator program to calculate the Nyquist diagram [5].

8.4 Relative Stability and the Nyquist Criterion

We discussed the relative stability of a system in terms of the s-plane in Section 5.3. For the s-plane, we defined the relative stability of a system as the property measured by the relative settling time of each root or pair of roots. We would like to determine a similar measure of relative stability useful for the frequency-response method. The Nyquist criterion provides us with suitable information concerning the absolute stability and, furthermore, can be utilized to define and ascertain the relative stability of a system.

The Nyquist stability criterion is defined in terms of the $(-1, 0)$ point on the polar plot or the 0 db, 180° point on the Bode diagram or log-magnitude–phase diagram. Clearly, the proximity of the $GH(j\omega)$-locus to this stability point is a measure of the relative stability of a system. The polar plot for $GH(j\omega)$ for several values of K and

$$
GH(j\omega) = \frac{K}{j\omega(j\omega\tau_1 + 1)(j\omega\tau_2 + 1)}
\tag{8.44}
$$

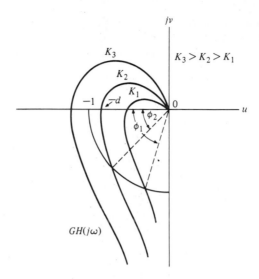

Figure 8.16. Polar plot for $GH(j\omega)$ for three values of gain.

is shown in Fig. 8.16. As K increases, the polar plot approaches the -1 point and eventually encircles the -1 point for a gain $K = K_3$. We determined in Section 8.3 that the locus intersects the u-axis at a point

$$u = \frac{-K\tau_1\tau_2}{\tau_1 + \tau_2}. \tag{8.45}$$

Therefore the system has roots on the $j\omega$-axis when

$$u = -1 \quad \text{or} \quad K = \left(\frac{\tau_1 + \tau_2}{\tau_1\tau_2}\right).$$

As K is decreased below this marginal value, the stability is increased and the margin between the gain $K = (\tau_1 + \tau_2)/\tau_1\tau_2$ and a gain $K = K_2$ is a measure of the relative stability. This measure of relative stability is called the *gain margin* and is defined as *the reciprocal of the gain* $|GH(j\omega)|$ *at the frequency at which the phase angle reaches 180°* (that is, $v = 0$). The gain margin is a measure of the factor by which the system gain would have to be increased for the $GH(j\omega)$ locus to pass through the $u = -1$ point. Thus, for a gain $K = K_2$ in Fig. 8.16, the gain margin is equal to the reciprocal of $GH(j\omega)$ when $v = 0$. Because $\omega = 1/\sqrt{\tau_1\tau_2}$ when the phase shift is 180°, we have a gain margin equal to

$$\frac{1}{|GH(j\omega)|} = \left[\frac{K_2\tau_1\tau_2}{\tau_1 + \tau_2}\right]^{-1} = \frac{1}{d}. \tag{8.46}$$

The gain margin can be defined in terms of a logarithmic (decibel) measure as

$$20 \log\left(\frac{1}{d}\right) = -20 \log d \text{ db}. \tag{8.47}$$

For example, when $\tau_1 = \tau_2 = 1$, the system is stable when $K \leq 2$. Thus when $K = K_2 = 0.5$, the gain margin is equal to

$$\frac{1}{d} = \left[\frac{K_2 \tau_1 \tau_2}{\tau_1 + \tau_2} \right]^{-1} = 4, \tag{8.48}$$

or, in logarithmic measure,

$$20 \log 4 = 12 \text{ db.} \tag{8.49}$$

Therefore the gain margin indicates that the system gain can be increased by a factor of four (12 db) before the stability boundary is reached.

An alternative measure of relative stability can be defined in terms of the phase angle margin between a specific system and a system that is marginally stable. Several roots of the characteristic equation lie on the $j\omega$-axis when the $GH(j\omega)$-locus intersects the $u = -1$, $v = 0$ point in the GH-plane. Therefore a measure of relative stability, the *phase margin,* is defined as *the phase angle through which the GH($j\omega$) locus must be rotated in order that the unity magnitude $|GH(j\omega)| = 1$ point passes through the $(-1, 0)$ point in the GH($j\omega$) plane.* This measure of relative stability is called the phase margin and is equal to the additional phase lag required before the system becomes unstable. This information can be determined from the Nyquist diagram shown in Fig. 8.16. For a gain $K = K_2$, an additional phase angle, ϕ_2, may be added to the system before the system becomes unstable. Furthermore, for the gain K_1, the phase margin is equal to ϕ_1, as shown in Fig. 8.16.

The gain and phase margins are easily evaluated from the Bode diagram, and because it is preferable to draw the Bode diagram in contrast to the polar plot, it is worthwhile to illustrate the relative stability measures for the Bode diagram. The critical point for stability is $u = -1$, $v = 0$ in the $GH(j\omega)$ plane which is equivalent to a logarithmic magnitude of 0 db and a phase angle of 180° (or $-180°$) on the Bode diagram.

The gain margin and phase margin can be readily calculated by utilizing a computer program [6]. A computer program for accomplishing this calculation is given in Table 8.4 in the computer language BASIC [7]. This program can readily be converted to other languages. The symbols used are W $= \omega$; G2 $= |G(s)|^2$; P $=$ phase of $G(s)$; and PM $=$ phase margin. The program is shown for the case where $GH(j\omega)$ is as given in Eq. (8.50). The calculations commence at $\omega = 0.1$ and increase by 2% at each iteration at line 50.

The Bode diagram of

$$GH(j\omega) = \frac{1}{j\omega(j\omega + 1)(0.2j\omega + 1)} \tag{8.50}$$

is shown in Fig. 8.17. The phase angle when the logarithmic magnitude is 0 db is equal to 137°. Thus the phase margin is $180° - 137° = 43°$, as shown in Fig. 8.17. The logarithmic magnitude when the phase angle is $-180°$ is -15 db, and therefore the gain margin is equal to 15 db, as shown in Fig. 8.17.

The frequency response of a system can be graphically portrayed on the

Table 8.4. A Computer Program in BASIC Computer Language for Calculating the Gain Margin and Phase Margin for the Third-Order System $GH(j\omega) = 1/j\omega(j\omega + 1)(0.2j\omega + 1)$

```
10 LET W = 0.1
20 GOSUB 100
30 IF G2 < = 1 THEN 60
35 IF G2 < = 100 THEN 50
40 LET W = 2*W
45 GO TO 20
50 LET W = 1.02*W
55 GO TO 20
60 IF P> = 180 THEN 140
65 PRINT "UNITY GAIN", "W =" W, "P=" P
70 LET W = 1.02*W
75 GOSUB 100
80 IF P> = 180 THEN 90
85 GO TO 70
90 PRINT "W =" W, "GAIN MARGIN =" 4.343*LOG(1/G2)
95 GO TO 200
100 LET P = 57.3*(ATN(W) + ATN(0.2*W) + 1.571)
110 LET X = W*W
120 LET G2 = 1/((1 + X)*(1 + 0.04*X)*X)
130 RETURN
140 PRINT "W =" W, "SYSTEM UNSTABLE"
200 END
```

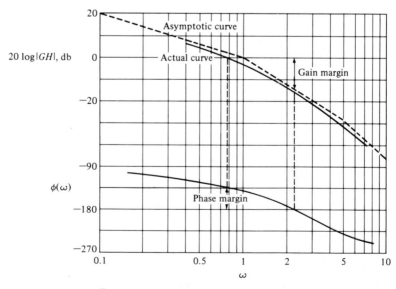

Figure 8.17. Bode diagram for $GH_1(j\omega) = 1/j\omega(j\omega + 1)(0.2j\omega + 1)$.

logarithmic–magnitude–phase-angle diagram. For the log-magnitude–phase diagram, the critical stability point is the 0 db, $-180°$ point, and the gain margin and phase margin can be easily determined and indicated on the diagram. The log-magnitude–phase locus of

$$GH_1(j\omega) = \frac{1}{j\omega(j\omega + 1)(0.2j\omega + 1)} \tag{8.51}$$

is shown in Fig. 8.18. The indicated phase margin is 43° and the gain margin is 15 db. For comparison, the locus for

$$GH_2(j\omega) = \frac{1}{j\omega(j\omega + 1)^2} \tag{8.52}$$

is also shown in Fig. 8.18. The gain margin for GH_2 is equal to 5.7 db, and the phase margin for GH_2 is equal to 20°. Clearly, the feedback system $GH_2(j\omega)$ is relatively less stable than the system $GH_1(j\omega)$. However, the question still remains: How much less stable is the system $GH_2(j\omega)$ in comparison to the system $GH_1(j\omega)$? In the following paragraph we shall answer this question for a

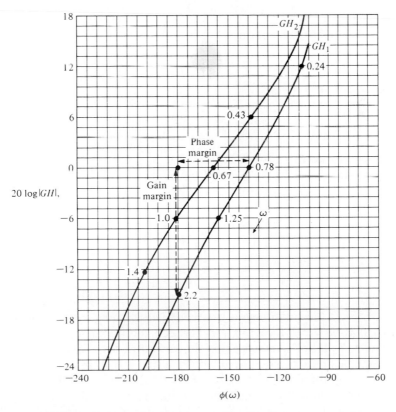

Figure 8.18. Log-magnitude–phase curve for GH_1 and GH_2.

second-order system, and the usefulness of the relation that we develop will depend upon the presence of dominant roots.

Let us now determine the phase margin of a second-order system and relate the phase margin to the damping ratio ζ of an underdamped system. Consider the loop-transfer function

$$GH(j\omega) = \frac{\omega_n^2}{j\omega(j\omega + 2\zeta\omega_n)}. \tag{8.53}$$

The characteristic equation for this second-order system is

$$s^2 + 2\zeta\omega_n s + \omega_n^2 = 0.$$

Therefore the closed-loop roots are

$$s = -\zeta\omega_n \pm j\omega_n\sqrt{1 - \zeta^2}.$$

The magnitude of the frequency response is equal to 1 at a frequency ω_c, and thus

$$\frac{\omega_n^2}{\omega_c(\omega_c^2 + 4\zeta^2\omega_n^2)^{1/2}} = 1. \tag{8.54}$$

Rearranging Eq. (8.54), we obtain

$$(\omega_c^2)^2 + 4\zeta^2\omega_n^2(\omega_c^2) - \omega_n^4 = 0. \tag{8.55}$$

Solving for ω_c, we find that

$$\frac{\omega_c^2}{\omega_n^2} = (4\zeta^4 + 1)^{1/2} - 2\zeta^2. \tag{8.56}$$

The phase margin for this system is

$$\phi_{pm} = 180° - 90° - \tan^{-1}\left(\frac{\omega_c}{2\zeta\omega_n}\right)$$

$$= 90° - \tan^{-1}\left(\frac{1}{2\zeta}[(4\zeta^4 + 1)^{1/2} - 2\zeta^2]^{1/2}\right) \tag{8.57}$$

$$= \tan^{-1}\left(2\zeta\left[\frac{1}{(4\zeta^4 + 1)^{1/2} - 2\zeta^2}\right]^{1/2}\right).$$

Equation (8.57) is the relationship between the damping ratio ζ and the phase margin ϕ_{pm} that provides a correlation between the frequency response and the time response. A plot of ζ versus ϕ_{pm} is shown in Fig. 8.19. The actual curve of ζ versus ϕ_{pm} can be approximated by the dashed line shown in Fig. 8.19. The slope of the linear approximation is equal to 0.01, and therefore an approximate linear relationship between the damping ratio and the phase margin is

$$\zeta = 0.01\phi_{pm}, \tag{8.58}$$

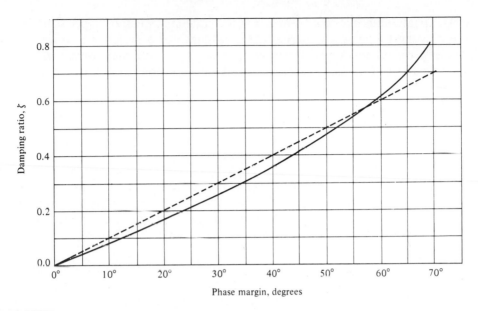

Figure 8.19. Damping ratio versus phase margin for a second-order system.

where the phase margin is measured in degrees. This approximation is reasonably accurate for $\zeta \leq 0.7$, and is a useful index for correlating the frequency response with the transient performance of a system. Equation (8.58) is a suitable approximation for a second-order system and may be used for higher-order systems if one can assume that the transient response of the system is primarily due to a pair of dominant underdamped roots. The approximation of a higher-order system by a dominant second-order system is a useful approximation indeed! Although it must be used with care, control engineers find this approach to be a simple, yet fairly accurate, technique of setting the specifications of a control system.

Therefore, for the system with a loop-transfer function

$$GH(j\omega) = \frac{1}{j\omega(j\omega + 1)(0.2j\omega + 1)}, \qquad (8.59)$$

we found that the phase margin was 43°, as shown in Fig. 8.17. Thus the damping ratio is approximately

$$\zeta \simeq 0.01\phi_{pm} = 0.43. \qquad (8.60)$$

Then the peak response to a step input for this system is approximately

$$M_{pt} = 1.22 \qquad (8.61)$$

as obtained from Fig. 4.8 for $\zeta = 0.43$.

The phase margin of a system is a quite suitable frequency response measure for indicating the expected transient performance of a system. Another useful index of performance in the frequency domain is M_{p_ω}, the maximum magnitude of the closed-loop frequency response, and we shall now consider this practical index.

8.5 The Closed-Loop Frequency Response

The transient performance of a feedback system can be estimated from the closed-loop frequency response. The *closed-loop frequency response* is the frequency response of the closed-loop transfer function $T(j\omega)$. The open- and closed-loop frequency responses for a single-loop system are related as follows:

$$\frac{C(j\omega)}{R(j\omega)} = T(j\omega) = \frac{G(j\omega)}{1 + GH(j\omega)}. \tag{8.62}$$

The Nyquist criterion and the phase margin index are defined for the open-loop transfer function $GH(j\omega)$. However, as we found in Section 7.2, the maximum magnitude of the closed-loop frequency response can be related to the damping ratio of a second-order system of

$$M_{p_\omega} = |T(\omega_r)| = (2\zeta\sqrt{1 - \zeta^2})^{-1}, \qquad \zeta < 0.707. \tag{8.63}$$

This relation is graphically portrayed in Fig. 7.10. Because this relationship between the closed-loop frequency response and the transient response is a useful relationship, we would like to be able to determine M_{p_ω} from the plots completed for the investigation of the Nyquist criterion. That is, it is desirable to be able to obtain the closed-loop frequency response (Eq. 8.62) from the open-loop frequency response. Of course, we could determine the closed-loop roots of $1 + GH(s)$ and plot the closed-loop frequency response. However, once we have invested all the effort necessary to find the closed-loop roots of a characteristic equation, then a closed-loop frequency response is not necessary.

The relation between the closed-loop and open-loop frequency response is easily obtained by considering Eq. (8.62) when $H(j\omega) = 1$. If the system is not in fact a unity feedback system where $H(j\omega) = 1$, we will simply redefine the system output to be equal to the output of $H(j\omega)$. Then Eq. (8.62) becomes

$$T(j\omega) = M(\omega)e^{j\phi(\omega)} = \frac{G(j\omega)}{1 + G(j\omega)}. \tag{8.64}$$

The relationship between $T(j\omega)$ and $G(j\omega)$ is readily obtained in terms of complex variables utilizing the $G(j\omega)$-plane. The coordinates of the $G(j\omega)$-plane are u and v, and we have

$$G(j\omega) = u + jv. \tag{8.65}$$

Therefore the magnitude of the closed-loop response $M(\omega)$ is

$$M = \left| \frac{G(j\omega)}{1 + G(j\omega)} \right| = \left| \frac{u + jv}{1 + u + jv} \right| = \frac{(u^2 + v^2)^{1/2}}{((1 + u)^2 + v^2)^{1/2}}. \qquad (8.66)$$

Squaring Eq. (8.66) and rearranging, we obtain

$$(1 - M^2)u^2 + (1 - M^2)v^2 - 2M^2u = M^2. \qquad (8.67)$$

Dividing Eq. (8.67) by $(1 - M^2)$ and adding the term $[M^2/(1 - M^2)]^2$ to both sides of Eq. (8.67), we have

$$u^2 + v^2 - \frac{2M^2u}{1 - M^2} + \left(\frac{M^2}{1 - M^2} \right)^2 = \left(\frac{M^2}{1 - M^2} \right) + \left(\frac{M^2}{1 - M^2} \right)^2. \qquad (8.68)$$

Rearranging, we obtain

$$\left(u - \frac{M^2}{1 - M^2} \right)^2 + v^2 = \left(\frac{M}{1 - M^2} \right)^2, \qquad (8.69)$$

which is the equation of a circle on the u, v-plane with the center at

$$u = \frac{M^2}{1 - M^2}, \qquad v = 0.$$

The radius of the circle is equal to $|M/(1 - M^2)|$. Therefore we can plot several circles of constant magnitude M in the $G(j\omega) = u + jv$ plane. Several constant M circles are shown in Fig. 8.20. The circles to the left of $u = -\frac{1}{2}$ are for $M > 1$, and the circles to the right of $u = -\frac{1}{2}$ are for $M < 1$. When $M = 1$, the circle becomes the straight line $u = -\frac{1}{2}$, which is evident from inspection of Eq. (8.67).

The open-loop frequency response for a system is shown in Fig. 8.21 for two gain values where $K_2 > K_1$. The frequency response curve for the system with gain K_1 is tangent to magnitude circle M_1 at a frequency ω_{r_1}. Similarly, the fre-

Figure 8.20. Constant M circles.

Figure 8.21. Polar plot of $G(j\omega)$ for two values of a gain.

quency response curve for gain K_2 is tangent to magnitude circle M_2 at the frequency ω_{r_2}. Therefore the closed-loop frequency response magnitude curves are estimated as shown in Fig. 8.22. Clearly, we can obtain the closed-loop frequency response of a system from the $(u + jv)$ plane. If the maximum magnitude, M_{p_ω}, is the only information desired, then it is sufficient to read this value directly from the polar plot. The maximum magnitude of the closed-loop frequency response, M_{p_ω}, is the value of the M circle that is tangent to the $G(j\omega)$-locus. The point of tangency occurs at the frequency ω_r, the resonant frequency. The complete closed-loop frequency response of a system can be obtained by reading the magnitude M of the circles that the $G(j\omega)$-locus intersects at several frequencies. Therefore the system with a gain $K = K_2$ has a closed-loop magnitude M_1 at the frequencies ω_1 and ω_2. This magnitude is read from Fig. 8.21 and is shown on the closed-loop frequency response in Fig. 8.22. The *bandwidth* for K_1, is shown as ω_{B_1}.

Figure 8.22. Closed-loop frequency response of $T(j\omega) = G(j\omega)/1 + G(j\omega)$.

It may be empirically shown that the crossover frequency on the open-loop Bode diagram, ω_c, is related to the closed-loop system bandwidth, ω_B, by the approximation $\omega_B = 1.6\omega_c$ for ζ in the range 0.2 to 0.8.

In a similar manner, we can obtain circles of constant closed-loop phase angles. Thus, for Eq. (8.64), the angle relation is

$$\phi = \underline{/T(j\omega)} = \underline{/(u + jv)/(1 + u + jv)}$$

$$= \tan^{-1}\left(\frac{v}{u}\right) - \tan^{-1}\left(\frac{v}{1 + u}\right). \tag{8.70}$$

Taking the tangent of both sides and rearranging, we have

$$u^2 + v^2 + u - \frac{v}{N} = 0, \tag{8.71}$$

where $N = \tan \phi = $ constant. Adding the term $\frac{1}{4}[1 + (1/N^2)]$ to both sides of the equation and simplifying, we obtain

$$(u + 0.5)^2 + \left(v - \frac{1}{2N}\right)^2 = \frac{1}{4}\left(1 + \frac{1}{N^2}\right), \tag{8.72}$$

which is the equation of a circle with its center at $u = -0.5$ and $v = +(1/2N)$. The radius of the circle is equal to $\frac{1}{2}[1 + (1/N^2)]^{1/2}$. Therefore the constant phase angle curves can be obtained for various values of N in a manner similar to the M circles.

The constant M and N circles can be used for analysis and design in the polar plane. However, it is much easier to obtain the Bode diagram for a system, and it would be preferable if the constant M and N circles were translated to a logarithmic gain phase. N. B. Nichols transformed the constant M and N circles to the log-magnitude–phase diagram, and the resulting chart is called the *Nichols chart* [7]. The M and N circles appear as contours on the Nichols chart shown in Fig. 8.23. The coordinates of the log-magnitude–phase diagram are the same as those used in Section 7.5. However, superimposed on the log-magnitude–phase plane we find constant M and N lines. The constant M lines are given in decibels and the N lines in degrees. An example will illustrate the use of the Nichols chart to determine the closed-loop frequency response.

■ **Example 8.6 Stability using the Nichols chart**

Consider a feedback system with a loop transfer function

$$G(j\omega) = \frac{1}{j\omega(j\omega + 1)(0.2j\omega + 1)}. \tag{8.73}$$

The $G(j\omega)$-locus is plotted on the Nichols chart and is shown in Fig. 8.24. The maximum magnitude, $M_{p\omega}$, is equal to $+2.5$ db and occurs at a frequency $\omega_r = 0.8$. The closed-loop phase angle at ω_r is equal to $-72°$. The 3-db closed-loop bandwidth where the closed-loop magnitude is -3 db is equal to $\omega_B = 1.33$, as

Figure 8.23. Nichols chart.

Figure 8.24. Nichols diagram for $G(j\omega) = 1/j\omega(j\omega + 1)(0.2j\omega + 1)$.

shown in Fig. 8.24. The closed-loop phase angle at ω_B is equal to $-142°$. One can also use the Control Systems Design Program to obtain the closed-loop frequency response. Using CSDP it was verified that the bandwidth was 1.33 and the closed-loop phase angle was $-142°$.

■ Example 8.7 Third order system

Let us consider a system with an open-loop transfer function

$$G(j\omega) = \frac{0.64}{j\omega[(j\omega)^2 + j\omega + 1]}, \tag{8.74}$$

where $\zeta = 0.5$ for the complex poles and $H(j\omega) = 1$. The Nichols diagram for this system is shown in Fig. 8.25. The phase margin for this system as it is determined from the Nichols chart is 30°. On the basis of the phase, we estimate the system damping ratio as $\zeta = 0.30$. The maximum magnitude is equal to $+9$ db occurring at a frequency $\omega_r = 0.88$. Therefore

$$20 \log M_{p_\omega} = 9 \text{ db}$$

or

$$M_{p_\omega} = 2.8.$$

Utilizing Fig. 7.10 to estimate the damping ratio, we find that $\zeta \simeq 0.175$.

We are confronted with two conflicting damping ratios, where one is obtained from a phase margin measure and another from a peak frequency-response measure. In this case, we have discovered an example in which the correlation between the frequency domain and the time domain is unclear and uncertain. This apparent conflict is caused by the nature of the $G(j\omega)$-locus, which slopes rapidly toward the 180° line from the 0-db axis. If we determine the roots of the characteristic equation for $1 + GH(s)$, we obtain

$$q(s) = (s + 0.77)(s^2 + 0.225s + 0.826) = 0. \tag{8.75}$$

The damping ratio of the complex conjugate roots is equal to 0.124, where the complex roots do not dominate the response of the system. Therefore the real root will add some damping to the system and one might estimate the damping ratio as being approximately the value determined from the M_{p_ω} index; that is, $\zeta = 0.175$. A designer must use the frequency-domain to time-domain correlations with caution. However, one is usually safe if the lower value of the damping ratio resulting from the phase margin and the M_{p_ω} relation is utilized for analysis and design purposes.

The Nichols chart can be used for design purposes by altering the $G(j\omega)$-locus in a suitable manner in order to obtain a desirable phase margin and M_{p_ω}. The system gain K is readily adjusted in order to provide a suitable phase margin and M_{p_ω} by inspecting the Nichols chart. For example, let us reconsider the previous example, where

$$G(j\omega) = \frac{K}{j\omega[(j\omega)^2 + j\omega + 1]}. \tag{8.76}$$

Figure 8.25. Nichols diagram for $G(j\omega) = 0.64/j\omega[(j\omega)^2 + j\omega + 1]$.

The $G(j\omega)$-locus on the Nichols chart for $K = 0.64$ is shown in Fig. 8.25. Let us determine a suitable value for K so that the system damping ratio is greater than 0.30. Examining Fig. 7.10, we find that it is required that M_{p_ω} be less than 1.75 (4.9 db). From Fig. 8.25, we find that the $G(j\omega)$-locus will be tangent to the 4.9 db curve if the $G(j\omega)$-locus is lowered by a factor of 2.2 db. Therefore, K should be reduced by 2.2 db or the factor antilog (2.2/20) = 1.28. Thus the gain K must be less than 0.64/1.28 = 0.50 if the system damping ratio is to be greater than 0.30.

8.6 The Stability of Control Systems with Time Delays

The Nyquist stability criterion has been discussed and illustrated in the previous sections for control systems whose transfer functions are rational polynomials of $j\omega$. There are many control systems that have a time delay within the closed loop of the system which affects the stability of the system. A *time delay* is the time interval between the start of an event at one point in a system and its resulting action at another point in the system. Fortunately, the Nyquist criterion can be utilized to determine the effect of the time delay on the relative stability of the feedback system. A pure time delay, without attenuation, is represented by the transfer function

$$G_d(s) = e^{-sT}, \tag{8.77}$$

where T is the delay time. The Nyquist criterion remains valid for a system with a time delay because the factor e^{-sT} does not introduce any additional poles or zeros within the contour. The factor adds a phase shift to the frequency response without altering the magnitude curve.

This type of time delay occurs in systems that have a movement of a material that requires a finite time to pass from an input or control point to an output or measured point [8, 12].

For example, a steel rolling mill control system is shown in Fig. 8.26. The motor adjusts the separation of the rolls so that the thickness error is minimized.

Figure 8.26. Steel rolling mill control system.

If the steel is traveling at a velocity v, then the time delay between the roll adjustment and the measurement is

$$T = \frac{d}{v}. \qquad (8.78)$$

Therefore, in order to have a negligible time delay, we must decrease the distance to the measurement and increase the velocity of the flow of steel. Usually, we cannot eliminate the effect of time delay and thus the loop transfer function is

$$G(s)G_c(s)e^{-sT}. \qquad (8.79)$$

However, one notes that the frequency response of this system is obtained from the loop-transfer function

$$GH(j\omega) = GG_c(j\omega)e^{-j\omega T}. \qquad (8.80)$$

The usual loop-transfer function is plotted on the $GH(j\omega)$-plane and the stability ascertained relative to the -1 point. Alternatively, we can plot the Bode diagram, including the delay factor, and investigate the stability relative to the 0 db, $-180°$ point. The delay factor $e^{-j\omega T}$ results in a phase shift

$$\phi(\omega) = -\omega T \qquad (8.81)$$

and is readily added to the phase shift resulting from $GG_c(j\omega)$. Note that the angle is in radians in Eq. (8.81). An example will show the simplicity of this approach on the Bode diagram.

■ Example 8.8 Liquid level control system

A level control system is shown in Fig. 8.27(a) and the block diagram in Fig. 8.27(b). The time delay between the valve adjustment and the fluid output is $T = d/v$. Therefore, if the flow rate is 5 m³/sec, the cross-sectional area of the pipe is 1 m², and the distance is equal to 5 m, then we have a time delay $T = 1$ sec. The loop-transfer function is then

$$GH(s) = G_A(s)G(s)G_f(s)e^{-sT}$$

$$= \frac{31.5}{(s + 1)(30s + 1)[(s^2/9) + (s/3) + 1]} e^{-sT}. \qquad (8.82)$$

The Bode diagram for this system is shown in Fig. 8.28. The phase angle is shown both for the denominator factors alone and with the additional phase lag due to the time delay. The logarithmic gain curve crosses the 0-db line at $\omega = 0.8$. Therefore the phase margin of the system without the pure time delay would be 40°. However, with the time delay added, we find that the phase margin is equal to $-3°$, and the system is unstable. Therefore the system gain must be reduced in order to provide a reasonable phase margin. In order to provide a phase margin of 30°, the gain would have to be decreased by a factor of 5 db to $K = 31.5/1.78 = 17.7$.

(a)

(b)

Figure 8.27. Liquid level control system.

A time delay, e^{-sT}, in a feedback system introduces an additional phase lag and results in a less stable system. Therefore as pure time delays are unavoidable in many systems, it is often necessary to reduce the loop gain in order to obtain a stable response. However, the cost of stability is the resulting increase in the steady-state error of the system as the loop gain is reduced.

8.7 System Bandwidth

The bandwidth of the closed-loop control system is an excellent measurement of the range of fidelity of response of the system. In systems where the low frequency magnitude is 0 db on the Bode diagram, the bandwidth is measured at the -3 db frequency. The speed of response to a step input will be roughly proportional to w_B and the settling time is inversely proportional to w_B. Thus we seek a large bandwidth consistent with reasonable system components.

Consider the following two closed-loop system transfer functions:

$$T_1(s) = \frac{1}{s+1}$$

Figure 8.28. Bode diagram for level control system.

and

$$T_2(s) = \frac{1}{5s + 1}.$$ (8.83)

The frequency response of the two systems is contrasted in part (a) of Fig. 8.29 and the step response of the systems is shown in part (b). Also, the response to a

Figure 8.29. Response of two first-order systems.

ramp is shown in part (c) of that figure. Clearly, the system with the larger bandwidth provides the faster step response and higher fidelity ramp response.

Consider two second-order systems with closed-loop transfer functions:

$$T_3(s) = \frac{100}{s^2 + 10s + 100}$$

and

$$T_4(s) = \frac{900}{s^2 + 30s + 900} . \qquad (8.84)$$

Both systems have a ζ of 0.5. The frequency response of both closed-loop systems is shown in Fig. 8.30(a). The natural frequency is 10 and 30 for systems three and four, respectively. The bandwidth is 15 and 40 for systems three and four, respec-

Figure 8.30. Response of two second-order systems.

tively. Both systems have a 15% overshoot, but T_4 has a peak time of 0.1 second compared to 0.3 for T_3, as shown in Fig. 8.30(b). Also, note that the settling time for T_4 is 0.37 second, while it is 0.8 second for T_3. Clearly, the system with a larger bandwidth provides a faster response. In general, we will pursue the design of systems with good stability and large bandwidth.

8.8 Design Example: Remotely Controlled Battlefield Vehicle

The use of remotely controlled vehicles for reconnaissance on the battlefield may be an idea whose time has come. One concept of a roving vehicle is shown in Fig. 8.31(a) and a proposed speed-control system is shown in Fig. 8.31(b). The desired speed $R(s)$ is transmitted by radio to the vehicle and the disturbance $D(s)$ represents hills and rocks. The goal is to achieve good overall control with low steady-state error and low-overshoot response to step commands, $R(s)$.

(a)

(b)

Figure 8.31. (a) Remotely controlled reconnaissance vehicle. (b) Speed-control system.

First, in order to achieve low steady-state error for a unit step command, we calculate e_{ss} as

$$e_{ss} = \lim_{s \to 0} sE(s)$$

$$= \lim_{s \to 0} s \left[\frac{R(s)}{1 + G_cG(s)} \right] \tag{8.85}$$

$$= \frac{1}{1 + G_cG(s)} = \frac{1}{1 + K/2} .$$

If we select $K = 20$, we will obtain a steady-state error of 9% of the magnitude of the input command. Using $K = 20$, we reformulate $G(s)$ for Bode diagram calculations, obtaining

$$G(s) = \frac{10(1 + s/2)}{(1 + s)(1 + s/2 + s^2/4)} . \tag{8.86}$$

The calculations for $0 \le \omega \le 6$ provide the data summarized in Table 8.5. The Nichols diagram for $K = 20$ is shown in Fig. 8.32. Examining the Nichols chart, we find that M_{P_ω} is 12 db and the phase margin is 25 degrees. The step response of this system is underdamped and we predict an excessive overshoot of approximately 50%.

In order to reduce the overshoot to a step input, we can reduce the gain to achieve a predicted overshoot. In order to limit the overshoot to 25%, we select a desired ζ of the dominant roots as 0.4 (from Fig. 4.8) and thus require $M_{P_\omega} = 1.35$ (from Fig. 7.10) or $20 \log M_{P_\omega} = 2.6$ db. In order to lower the gain, we will move the frequency response vertically down on the Nichols chart, as shown in Fig. 3.32. At $\omega_1 = 2.8$, we just intersect the 2.6-db closed-loop curve. The reduction (vertical drop) in gain is equal to 13 db or a factor of 4.5. Thus $K = 20/4.5 = 4.44$. For this reduced gain, the steady-state error is

$$e_{ss} = \frac{1}{(1 + 4.4/2)} = 0.31,$$

or we have a 31% steady-state error.

The actual step response when $K = 4.44$, as shown in Fig. 8.33, has an overshoot of 5%. If we use a gain of 10, we have an overshoot of 30% with a steady-state error of 17%. The performance of the system is summarized in Table 8.6. As a suitable compromise, we select $K = 10$ and draw the frequency response on

Table 8.5. Frequency Response Data for Design Example

ω	0	1.2	1.6	2.0	2.8	4	6
db	20	18.4	17.8	16.0	10.5	2.7	−5.2
degrees	0	−65	−86	−108	−142	−161	−170°

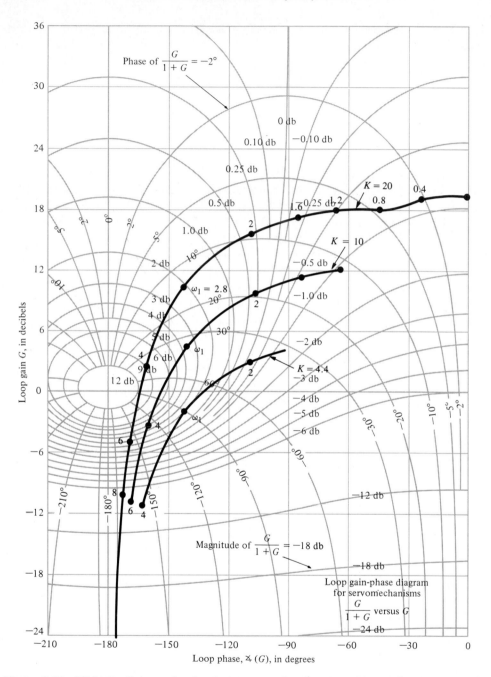

Figure 8.32. Nichol's diagram for the design example when $K = 20$ and for two reduced gains.

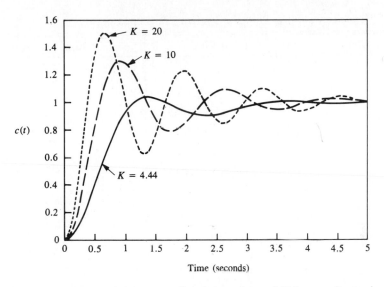

Figure 8.33. The response of the system for three values of K for a unit step input, $r(t)$.

the Nichols chart by moving the response for $K = 20$ down by $20 \log 2 = 6$ db, as shown on Fig. 8.32.

Examining the Nichols chart for $K = 10$, we have $M_{P_\omega} = 7$ db, and the phase margin is 34 degrees. Thus we estimate a ζ for the dominant roots of 0.34, which should result in an overshoot to a step input of 30%. The actual response, as recorded in Table 8.6, is 30%, as expected. The bandwidth of the system is $\omega_B \cong$ 5. Thus we predict a settling time

$$T_s = \frac{4}{\zeta \omega_n}$$

$$= \frac{4}{(0.34)(\omega_B/1.4)} = 3.3 \text{ seconds},$$

since $\omega_B \cong 1.4 \, \omega_n$ for $\zeta = 0.34$. The actual settling time is approximately five seconds, as shown in Fig. 8.33.

Table 8.6. Actual Response for Selected Gains

K	4.44	10	20
Percent overshoot	5%	30%	50%
Settling time (seconds)	3.5	5	6
Peak time (seconds)	1.4	1.0	0.7
e_{ss}	31%	17%	9%

Table 8.7. Transfer-Function Plots for Typical Transfer Function

	$G(s)$	Polar Plot	Bode Diagram
1.	$\dfrac{K}{s\tau_1 + 1}$		
2.	$\dfrac{K}{(s\tau_1 + 1)(s\tau_2 + 1)}$		
3.	$\dfrac{K}{(s\tau_1 + 1)(s\tau_2 + 1)(s\tau_3 + 1)}$		
4.	$\dfrac{K}{s}$		

Nichols Diagram	Root Locus	Comments
		Stable; gain margin $= \infty$
		Elementary regulator; stable; gain margin $= \infty$
		Regulator with additional energy-storage component; unstable, but can be made stable by reducing gain
		Ideal integrator; stable

Continued

Table 8.7.—_Continued_

G(s)	Polar Plot	Bode Diagram
5. $\dfrac{K}{s(s\tau_1 + 1)}$		
6. $\dfrac{K}{s(s\tau_1 + 1)(s\tau_2 + 1)}$		
7. $\dfrac{K(s\tau_a + 1)}{s(s\tau_1 + 1)(s\tau_2 + 1)}$		
8. $\dfrac{K}{s^2}$		

Nichols Diagram	Root Locus	Comments
		Elementary instrument servo; inherently stable; gain margin $= \infty$
		Instrument servo with field-control motor or power servo with elementary Ward–Leonard drive; stable as shown, but may become unstable with increased gain
		Elementary instrument servo with phase-lead (derivative) compensator; stable
		Inherently unstable; must be compensated

Continued

Table 8.7.—*Continued*

G(s)	Polar Plot	Bode Diagram
9. $$\dfrac{K}{s^2(s\tau_1 + 1)}$$		
10. $$\dfrac{K(s\tau_a + 1)}{s^2(s\tau_1 + 1)}$$ $$\tau_a > \tau_1$$		
11. $$\dfrac{K}{s^3}$$		
12. $$\dfrac{K(s\tau_a + 1)}{s^3}$$		

Nichols Diagram	Root Locus	Comments
		Inherently unstable; must be compensated
		Stable for all gains
		Inherently unstable
		Inherently unstable

Continued

Table 8.7.—_Continued_

$G(s)$	Polar Plot	Bode Diagram
13. $$\dfrac{K(s\tau_a + 1)(s\tau_b + 1)}{s^3}$$		
14. $$\dfrac{K(s\tau_a + 1)(s\tau_b + 1)}{s(s\tau_1 + 1)(s\tau_2 + 1)(s\tau_3 + 1)(s\tau_4 + 1)}$$		
15. $$\dfrac{K(s\tau_a + 1)}{s^2(s\tau_1 + 1)(s\tau_2 + 1)}$$		

The steady-state effect of a unit step disturbance can be determined by using the final value theorem with $R(s) = 0$, as follows:

$$c(\infty) = \lim_{s \to 0} s \left[\frac{G(s)}{1 + GG_c(s)} \right] \left(\frac{1}{s} \right)$$

$$\tag{8.87}$$

$$= \frac{1}{4 + 2K}.$$

Nichols Diagram	Root Locus	Comments
Conditionally stable; becomes unstable if gain is too low		Conditionally stable; becomes unstable if gain is too low
Conditionally stable; stable at low gain, becomes unstable as gain is raised, again becomes stable as gain is further increased, and becomes unstable for very high gains		Conditionally stable; stable at low gain, becomes unstable as gain is raised, again becomes stable as gain is further increased, and becomes unstable for very high gains
Conditionally stable; becomes unstable at high gain		Conditionally stable; becomes unstable at high gain

Thus the unit disturbance is reduced by the factor $(4 + 2K)$. For $K = 10$, we have $c(\infty) = \frac{1}{24}$ or the steady-state disturbance is reduced to 4% of the disturbance magnitude. Thus we have achieved a reasonable design with $K = 10$.

8.9 Summary

The stability of a feedback control system can be determined in the frequency domain by utilizing Nyquist's criterion. Furthermore, Nyquist's criterion provides us with two relative stability measures: (1) gain margin and (2) phase mar-

gin. These relative stability measures can be utilized as indices of the transient performance on the basis of correlations established between the frequency domain and the transient response. The magnitude and phase of the closed-loop system can be determined from the frequency response of the open-loop transfer function by utilizing constant magnitude and phase circles on the polar plot. Alternatively, we can utilize a log-magnitude–phase diagram with closed-loop magnitude and phase curves superimposed (called the Nichols chart) to obtain the closed-loop frequency response. A measure of relative stability, the maximum magnitude of the closed-loop frequency response, M_{p_ω}, is available from the Nichols chart. The frequency measure, M_{p_ω}, can be correlated with the damping ratio of the time response and is a useful index of performance. Finally, a control system with a pure time delay can be investigated in a similar manner to systems without time delay. A summary of the Nyquist criterion, the relative stability measures, and the Nichols diagram are given in Table 8.7 for several transfer functions.

Exercises

E8.1. A system has a transfer function

$$G(s) = \frac{4(1 + s/2)}{s(1 + 2s)(1 + s/20 + s^2/64)}.$$

Plot the Bode diagram for the frequency range of 0.1 to 10. Show that the phase margin is approximately 60° and the gain margin is approximately 10 db.

E8.2. A system has a transfer function

$$G(s) = \frac{K(1 + s/5)}{s(1 + s/2)(1 + s/10)},$$

where $K = 6.14$. Using a computer or calculator program show that the system crossover (0 db) frequency is 3.5 rad/sec and the phase margin is 45°.

E8.3. An integrated circuit is available to serve as a feedback system to regulate the output voltage of a power supply. The Bode diagram of the required loop transfer function $GH(j\omega)$ is shown in Fig. E8.3, on the next page.
 Estimate the gain and phase margin of the regulator.

Answer: $GM = 25$ db, $PM = 75°$

E8.4. An integrated CMOS digital circuit can be represented by the Bode diagram shown in Fig. E8.4, on the next page. (a) Find the gain and phase margin of the circuit. (b) Estimate how much you would need to reduce the system gain (db) to obtain a phase margin of 60°.

E8.5. Consider a system with a loop transfer function

$$G(s) = \frac{100}{s(s + 10)},$$

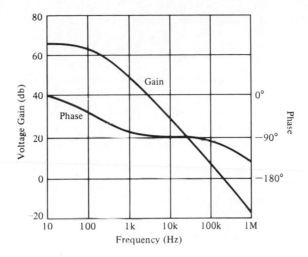

Figure E8.3. Power supply regulator.

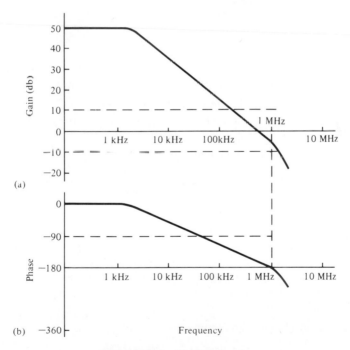

Figure E8.4. CMOS circuit.

where $H(s) = 1$. We wish to obtain a resonant peak $M_{p_\omega} = 3.0$ db for the closed-loop system. The peak occurs between 8 and 9 rad/sec and is only 1.25 db at 8.66 rad/sec. Plot the Nichols chart for the range of frequency from 8 to 15 rad/sec. Show that the system gain needs to be raised by 4.6 db to 171. Determine the resonant frequency for the adjusted system.

E8.6. A system has an open-loop transfer function

$$G(s) = \frac{K(s + 100)}{s(s + 10)(s + 40)}.$$

When $K = 500$, the system is unstable. If we reduce the gain to 50, show that the resonant peak is 3.5 db. Find the phase margin of the system with $K = 50$.

E8.7. A Nichols chart is given in Fig. E8.7, on the next page for a system where $G(j\omega)$ is plotted. Using the table below, find (a) the peak resonance M_{p_ω} in db; (b) the resonant frequency ω_r; (c) the 3 db bandwidth; (d) the phase margin of the system.

	ω_1	ω_2	ω_3	ω_4
rad/sec	1	3	6	10

E8.8. Consider a unity feedback system with

$$G(s) = \frac{K}{s(s + 1)(s + 2)}.$$

(a) For $K = 4$ show that the gain margin is 3.5 db. (b) If we wish to achieve a gain margin equal to 16 db, determine the value of the gain K.

Answer: (b) $K = 0.98$

E8.9. For the system of E8.8 find the phase margin of the system for $K = 3$.

E8.10. Consider the wind tunnel control system of Problem P6.31. Draw the Bode diagram and show that the phase margin is 25° and the gain margin is 10 db. Also, show that the bandwidth of the closed-loop system is 6 rad/sec.

E8.11. Consider a unity feedback system with

$$G(s) = \frac{40(1 + 0.4s)}{s(1 + 2s)(1 + 0.24s + 0.04s^2)}.$$

(a) Using the Control System Design Program or equivalent plot the Bode diagram. (b) Find the gain margin and the phase margin.

E8.12. An actuator for a disk drive uses a shock mount to absorb vibrational energy at approximately 60 Hz [15]. The Bode diagram of $G(s)$ of the control system is shown in Fig. E8.12, on page 408. (a) Find the expected percent overshoot for a step input for the closed-loop system, (b) estimate the bandwidth of the closed loop system, and (c) estimate the settling time of the system.

E8.13. A unity feedback system has a process

$$G(s) = \frac{150}{s(s + 5)}.$$

(a) Find the maximum magnitude of the closed-loop frequency response using the Nichol's chart or the Control System Design Program. (b) Find the bandwidth and the resonant frequency of this system. (c) Use these frequency measures to estimate the overshoot of the system to a step response.

Answers: (a) 7.5 db, (b) $\omega_B = 19$, $\omega_r = 12.6$

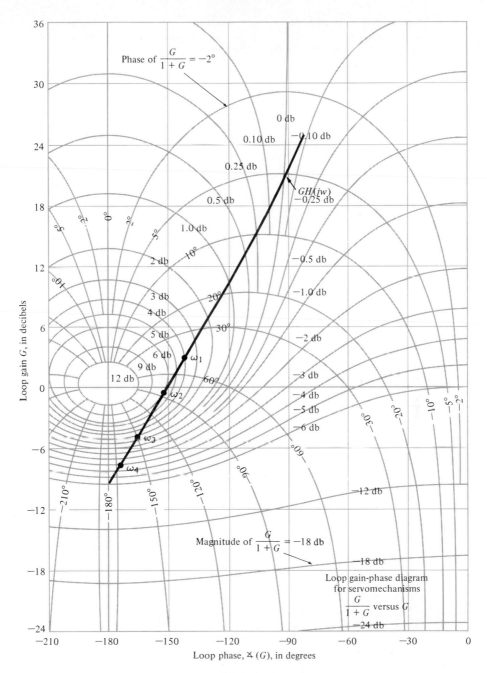

Figure E8.7. Nichols chart for $G(j\omega)$.

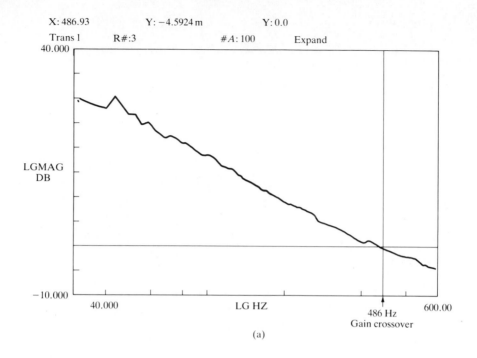

(a)

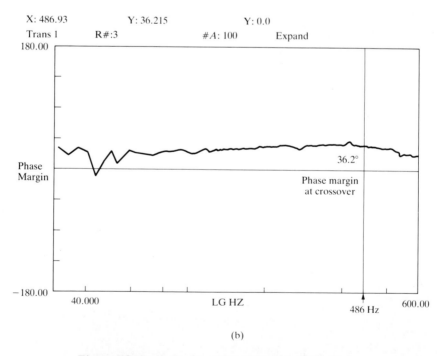

(b)

Figure E8.12. Bode diagram of the disk drive $G(s)$.

E8.14. A unity feedback system has a process

$$G(s) = \frac{K}{(s-1)}.$$

Determine the range of K for which the system is stable by drawing the polar plot.

E8.15. Consider a unity feedback system with

$$G(s) = \frac{1000}{(s+100)}$$

Find the bandwidth of the open-loop system and the closed-loop system and compare the results.

Answers: open-loop $\omega_B = 100$, closed-loop $\omega_B = 1100$

E8.16. The pure time delay e^{-sT} may be approximated by a transfer function as

$$e^{-sT} \cong \frac{(1 - Ts/2)}{(1 + Ts/2)}$$

for $0 < \omega < 2/T$. Obtain the Bode diagram for the actual transfer function and the approximation for $T = 2$ for $0 < \omega < 1$.

E8.17. A unity feedback system has a plant

$$G(s) = \frac{K(s+3)}{s(s+1)(s+5)}.$$

(a) Plot the Bode diagram and (b) determine the gain K required in order to obtain a phase margin of 40°. What is the steady-state error for a ramp input for the gain of part (b)?

E8.18. A closed-loop system, as shown in Fig. 8.8, has $H(s) = 1$ and

$$G(s) = \frac{K}{s(\tau_1 s + 1)(\tau_2 s + 1)},$$

where $\tau_1 = 0.02$ and $\tau_2 = 0.2$ seconds. (a) Select a gain K so that the steady-state error for a ramp input is 10% of the magnitude of the ramp function A, where $r(t) = At, t \geq 0$. (b) Plot the Bode plot of $G(s)$ and determine the phase and gain margin. (c) Using the Nichols chart, determine the bandwidth ω_B, the resonant peak M_{p_ω}, and the resonant frequency ω_r of the closed-loop system.

Answers: (a) $K = 10$
(b) $P.M. = 32°$, $G.M. = 15$ db
(c) $\omega_B = 10.3$, $M_{p_\omega} = 1.84$, $\omega_r = 6.5$

Problems

P8.1. For the polar plots of Problem P7.1 use the Nyquist criterion to ascertain the stability of the various systems. In each case specify the values of N, P, and Z.

P8.2. Sketch the polar plots of the following loop transfer functions $GH(s)$ and determine whether the system is stable by utilizing the Nyquist criterion.

$$\text{(a) } GH(s) = \frac{K}{s(s^2 + s + 4)},$$

$$\text{(b) } GH(s) = \frac{K(s + 2)}{s^2(s + 4)}.$$

If the system is stable, find the maximum value for K by determining the point where the polar plot crosses the u-axis.

P8.3. The polar plot of a conditionally stable system is shown in Fig. P8.3 for a specific gain K. Determine whether the system is stable and find the number of roots (if any) in the right-hand s-plane. The system has no poles of $GH(s)$ in the right-half plane.

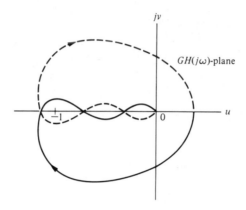

Figure P8.3 Polar plot of conditionally stable system.

P8.4. (a) Find a suitable contour Γ_s in the s-plane that can be used to determine whether all roots of the characteristic equation have damping ratios greater than ζ_1. (b) Find a suitable contour Γ_s in the s-plane that can be used to determine whether all the roots of the characteristic equation have real parts less than $s = -\sigma_1$. (c) Using the contour of part (b) and Cauchy's theorem, determine whether the following characteristic equation has roots with real parts less than $s = -1$:

$$q(s) = s^3 + 8s^2 + 30s + 36.$$

P8.5. A speed control for a gasoline engine is shown in Fig. P8.5. Because of the restriction at the carburetor intake and the capacitance of the reduction manifold, the lag τ_t occurs

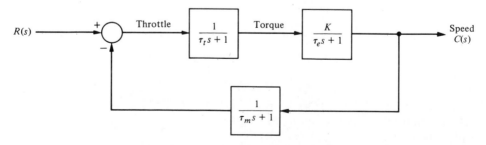

Figure P8.5 Engine speed control.

(a)

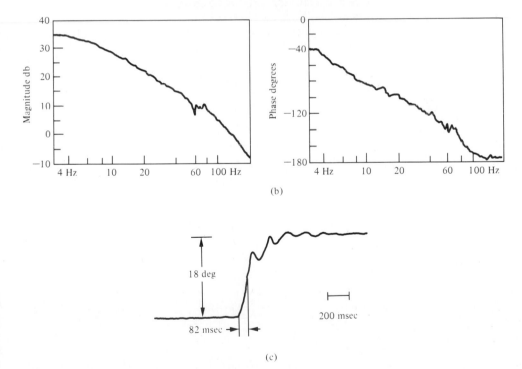

(b)

(c)

Figure P8.6. (a) The MIT arm. (b) Frequency response; (c) position response. (Photo courtesy of Massachusetts Institute of Technology.)

and is equal to 1 sec. The engine time constant τ_e is equal to $J/f = 2$ sec. The speed measurement time constant is $\tau_m = 0.5$ sec. (a) Determine the necessary gain K if the steady-state speed error is required to be less than 10% of the speed reference setting. (b) With the gain determined from (a), utilize the Nyquist criterion to investigate the stability of the system. (c) Determine the phase and gain margins of the system.

P8.6. A direct-drive arm is an innovative mechanical arm in which no reducers are used between motors and their loads. Because the motor rotors are directly coupled to the loads, the drive systems have no backlash, small friction, and high mechanical stiffness, which are all important features for fast and accurate positioning and dexterous handling using sophisticated torque control.

The goal of the MIT direct-drive arm project is to achieve arm speeds of 10 m/sec [13]. The arm has torques of up to 660 n-m (475 ft-lb). Feedback and a set of position and velocity sensors are used with each motor. The arm is shown in Fig. P8.6(a), with a motor visible on the side facing the reader. The frequency response of one joint of the arm is shown in Fig. P8.6(b). The two poles appear at 3.7 Hz. and 68 Hz. Figure P8.6(c) shows the step response with position and velocity feedback used. The time constant of the closed-loop system is 82 msec. Develop the block diagram of the drive system and prove that 82 msec is a reasonable result.

P8.7. A vertical takeoff (VTOL) aircraft is an inherently unstable vehicle and requires an automatic stabilization system. An attitude stabilization system for the K-16B U.S. Army VTOL aircraft has been designed and is shown in block diagram form in Fig. P8.7 [11]. At 40 knots, the dynamics of the vehicle are approximately represented by the transfer function

$$G(s) = \frac{10}{(s^2 + 0.36)}.$$

The actuator and filter is represented by the transfer function

$$G_1(s) = \frac{K_1(s + 8)}{(s + 2)}.$$

(a) Draw the Bode diagram of the loop transfer function $G_1(s)G(s)H(s)$ when the gain is $K_1 = 2$. (b) Determine the gain and phase margins of this system. (c) Determine the steady-state error for a wind disturbance of $T(s) = 1/s$. (d) Determine the maximum amplitude of the resonant peak of the closed-loop frequency response and the frequency of the resonance. (e) Estimate the damping ratio of the system from M_{p_ω} and the phase margin.

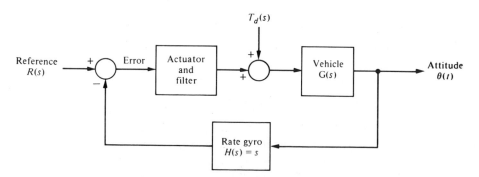

Figure P8.7 VTOL aircraft stabilization system.

P8.8. Electrohydraulic servomechanisms are utilized in control systems requiring a rapid response for a large mass. An electrohydraulic servomechanism can provide an output of 100 kW or greater. A photo of a servo valve and actuator is shown in Fig. P8.8(a). The output sensor yields a measurement of actuator position, which is compared with V_{in}. The

(a)

(b)

Figure P8.8. (a) A servo valve and actuator. (Courtesy of Moog, Inc., Industrial Division); (b) block diagram.

error is amplified and controls the hydraulic valve position, thus controlling the hydraulic fluid flow to the actuator. The block diagram of a closed-loop electrohydraulic servomechanism using pressure feedback to obtain damping is shown in Fig. P8.8(b) [9, 13]. Typical values for this system are $\tau = 0.02$ sec, and for the hydraulic system are $\omega_2 = 7(2\pi)$ and $\zeta_2 = 0.05$. The structural resonance ω_1 is equal to $10(2\pi)$ and the damping is $\zeta_1 = 0.05$. The loop gain is $K_A K_1 K_2 = 1.0$. (a) Sketch the Bode diagram and determine the phase margin of the system. (b) The damping of the system can be increased by drilling a small hole in the piston so that $\zeta_2 = 0.25$. Sketch the Bode diagram and determine the phase margin of this system.

P8.9. The key to future exploration and use of space is the reusable earth-to-orbit transport system, popularly known as the space shuttle. The shuttle, shown in Fig. P8.9(a), carries large payloads into space and returns them to earth for reuse. The shuttle, roughly the size

(a)

(b)

Figure P8.9. (a) The Earth orbiting space shuttle *Columbia* against the blackness of space on June 22, 1983. The remote manipulator robot is shown with the cargo bay doors open in this top view, taken by a satellite. (b) Pitch rate control system. (Courtesy of NASA.)

of a DC-9 with an empty weight of 75,000 kg, uses elevons at the trailing edge of the wing and a brake on the tail to control the flight. The block diagram of a pitch rate control system is shown in Fig. P8.9(b). The sensor is represented by a gain, $H(s) = 0.5$, and the vehicle by the transfer function

$$G(s) = \frac{0.30(s + 0.05)(s^2 + 1600)}{(s^2 + 0.05s + 16)(s + 70)}.$$

The controller $G_c(s)$ can be a gain or any suitable transfer function. (a) Draw the Bode diagram of the system when $G_c(s) = 2$ and determine the stability margin. (b) Draw the Bode diagram of the system when

$$G_c(s) = K_1 + K_2/s \quad \text{and} \quad K_2/K_1 = 0.5.$$

The gain K_1 should be selected so that the gain margin is 10 db.

P8.10. Machine tools are often automatically controlled by a punched tape reader as shown in Fig. P8.10. These automatic systems are often called numerical machine controls. Considering one axis, the desired position of the machine tool is compared with the actual position and is used to actuate a solenoid coil and the shaft of a hydraulic actuator. The transfer function of the actuator (see Table 2.4) is

$$G_a(s) = \frac{X(s)}{Y(s)} = \frac{K_a}{s(\tau_a s + 1)},$$

where $K_a = 1$ and $\tau_a = 0.4$ sec. The output voltage of the difference amplifier is

$$E_0(s) = K_1(X(s) - X_d(s)),$$

where $x_d(t)$ is the desired position input from the tape reader. The force on the shaft is proportional to the current i so that $F = K_2 i(t)$, where $K_2 = 3.0$. The spring constant K_s is equal to 1.5 and $R = 0.1$ and $L = 0.2$. (a) Determine the gain K_1 that results in a system with a phase margin of 30°. (b) For the gain K_1 of part (a), determine $M_{p\omega}$, ω_r and the closed-loop system bandwidth. (c) Estimate the percent overshoot of the transient response for a step input, $X_d(s) = 1/s$, and the settling time.

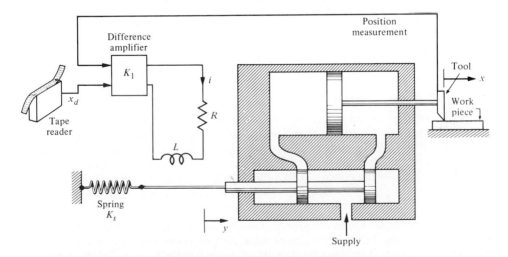

Figure P8.10. Machine tool control.

P8.11. A control system for a chemical concentration control system is shown in Fig. P8.11. The system receives a granular feed of varying composition, and it is desired to maintain a constant composition of the output mixture by adjusting the feed-flow valve. The transfer function of the tank and output valve is

$$G(s) = \frac{5}{5s + 1}$$

and the controller is

$$G_c(s) = K_1 + \frac{K_2}{s}.$$

The transport of the feed along the conveyor requires a transport (or delay) time, $T = 2$ sec. (a) Sketch the Bode diagram when $K_1 = K_2 = 1$, and investigate the stability of the system. (b) Sketch the Bode diagram when $K_1 = 0.1$ and $K_2 = 0.05$, and investigate the stability of the system. (c) When $K_1 = 0$, use the Nyquist criterion to calculate the maximum allowable gain K_2 for the system to remain stable.

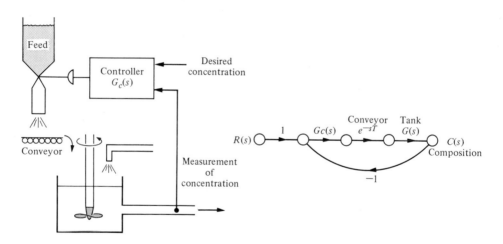

Figure P8.11. Chemical concentration control.

P8.12. A simplified model of the control system for regulating the pupillary aperture in the human eye is shown in Fig. P8.12, on the next page [14]. The gain K represents the pupillary gain and τ is the pupil time constant which is 0.5 sec. The time delay T is equal to 0.1 sec. The pupillary gain is equal to 4.0. (a) Assuming the time delay is negligible, draw the Bode diagram for the system. Determine the phase margin of the system. (b) Include the effect of the time delay by adding the phase shift due to the delay. Determine the phase margin of the system with the time delay included.

P8.13. A controller is used to regulate the temperature of a mold for plastic part fabrication, as shown in Fig. P8.13. The value of the delay time is estimated as 2 sec. (a) Utilizing the Nyquist criterion, determine the stability of the system for $K_a = K = 1$. (b) Determine a suitable value for K_a for a stable system when $K = 1$.

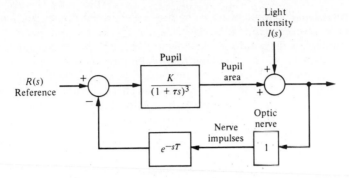

Figure P8.12. Human pupil aperature control.

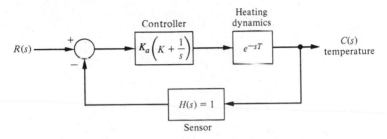

Figure P8.13. Temperature regulator.

P8.14. The closed-loop performance of a high-frequency operational amplifier can be predicted using the Nichols chart. One inverting operational amplifier has an open-loop response as given below.

f(MHz)	GH (dB)	/GH (degrees)
1	33	−132
2	26	−120
4	21	−114
6	17	−114
10	12	−120
15	6	−128
17	5	−132
20	3	−137
25	0	−142
30	−2	−148
38	−5	−155
42	−7	−160

Obtain the Nichols chart and show that the $M_{p\omega}$ is +4.0 db when $\omega = 25$ MHz.

P8.15. Electronics and computers are being used to control automobiles. An example of an automobile control system, the steering control for the General Motors Firebird III research automobile, is the control stick shown in Fig. P8.15(a). The control stick, called a Unicontrol, is used for steering and controlling the throttle. A typical driver has a reaction time of $T = 0.2$ sec. (a) Using the Nichols chart, determine the magnitude of the gain K that will result in a system with a peak magnitude of the closed-loop frequency response M_{p_ω} less than or equal to 2 db. (b) Estimate the damping ratio of the system based on (1) M_{p_ω} and (2) the phase margin. Compare the results and explain the difference, if any. (c) Determine the closed-loop 3-db bandwidth of the system.

(a)

(b)

Figure P8.15. Automobile steering control.

P8.16. Consider the automatic ship steering system discussed in Problem P7.13. The frequency response of the open-loop portion of the ship steering control system is shown in Fig. P7.13. The deviation of the tanker from the straight track is measured by radar and is used to generate the error signal as shown in Fig. P8.16. This error signal is used to control

the rudder angle $\delta(s)$. (a) Is this system stable? Discuss what an unstable ship steering system indicates in terms of the transient response of the system. Recall that the system under consideration is a ship attempting to follow a straight track. (b) Is it possible to stabilize this system by lowering the gain of the transfer function $G(s)$? (c) Is it possible to stabilize this system? Can you suggest a suitable feedback compensator? (d) Repeat parts (a), (b), and (c) when switch S is closed.

Figure P8.16. Automatic ship steering.

P8.17. An electric carrier that automatically follows a tape track laid out on a factory floor is shown in Fig. P8.17(a), on the next page [13]. Closed-loop feedback systems are used to control the guidance and speed of the vehicle. The cart senses the tape path by means of an array of 16 phototransistors. The block diagram of the steering system is shown in Fig. P8.17(b). Select a gain K so that the phase margin is approximately 30°.

P8.18. The primary objective of many control systems is to maintain the output variable at the desired or reference condition when the system is subjected to a disturbance [10]. A typical chemical reactor control scheme is shown in Fig. P8.18. The disturbance is represented by $U(s)$ and the chemical process by G_3 and G_4. The controller is represented by G_1 and the valve by G_2. The feedback sensor is $H(s)$ and will be assumed to be equal to one. We will assume that G_2, G_3, and G_4 are all of the form

$$G_i(s) = \frac{K_i}{1 + \tau_i s},$$

where $\tau_3 = \tau_4 = 4$ sec and $K_3 = K_4 = 0.1$. The valve constants are $K_2 = 20$ and $\tau_2 = 0.5$ sec. It is desired to maintain a steady-state error less than 5% of the desired reference position. (a) When $G_1(s) = K_1$, find the necessary gain to satisfy the error constant requirement. For this condition, determine the expected overshoot to a step change in the reference signal $r(t)$. (b) If the controller has a proportional term plus an integral term so that $G_1(s) = K_1(1 + 1/s)$, determine a suitable gain to yield a system with an overshoot less than 30% but greater than 5%. For parts (a) and (b) use the approximation of damping ratio as a function of phase margin that yields $\zeta = 0.01 \, \phi_{pm}$. For these calculations, assume that $U(s) = 0$. (c) Estimate the settling time of the step response of the system for the controller of parts (a) and (b). (d) The system is expected to be subjected to a step disturbance $U(s) = A/s$. For ease, assume that the desired reference is $r(t) = 0$ when the system has settled. Determine the response of the system of part (b) to the disturbance.

(a)

Phototransistor
array

$R(s)$ —→ (+ / −) → Error → K → Motor and cart dynamics $\dfrac{1}{(s/20 + 1)(s^2 + s + 4)}$ → Cart heading $C(s)$

(b)

Figure P8.17. (a) An electric carrier vehicle (photo courtesy of Control Engineering Corporation). (b) Block diagram.

$U(s)$

$R(s)$ —→ (+ / −) → $G_1(s)$ → $G_2(s)$ → (+ / +) → $G_3(s)$ → $G_4(s)$ → $C(s)$

$H(s)$

Figure P8.18. Chemical reactor control.

P8.19. A model of a driver of an automobile attempting to steer a course is shown in Fig. P8.19, where $K = 5.3$. (a) Find the frequency response and the gain and phase margin when the reaction time T is zero. (b) Find the phase margin when the reaction time is 0.1 second. (c) Find the reaction time that will cause the system to be borderline stable (phase margin $= 0°$).

Figure P8.19. Automobile and driver control.

P8.20. In the United States over $4.3 billion are spent annually for solid waste collection and disposal. One system, which uses a remote control pick-up arm for collecting waste bags, is shown in Fig. P8.20 [20]. The open-loop transfer of the remote pick-up arm is

$$GH(s) = \frac{0.3}{s(1 + 3s)(1 + s)}.$$

(a) Plot the Nichols chart and show that the gain margin is approximately 11.5 db. (b) Determine the phase margin and the M_{p_ω} for the closed loop. Also determine the closed-loop bandwidth.

Figure P8.20. Waste collection system.

P8.21. The Bell-Boeing V-22 Osprey Tiltrotor is both an airplane and a helicopter. Its advantage is the ability to rotate its engines to 90° from a vertical position, as shown in Fig. P8.21(a), for takeoffs and landings and then switch the engines to horizontal for cruising as an airplane. The altitude control system in the helicopter mode is shown in Fig. P8.21(b). (a) Obtain the frequency response of the system for $K = 100$. (b) Find the gain margin and the phase margin for this system. (c) Select a suitable gain K so that the phase margin is 40°. (Increase the gain above $K = 100$.) (d) Find the response $c(t)$ of the system for the gain selected in part (c).

(a)

Figure P8.21. Tiltrotor aircraft control.

P8.22. Consider a unity feedback system with

$$G(s) = \frac{K}{s(s+1)(s+2)}.$$

(a) Draw the Bode diagram accurately for $K = 4$. Determine (b) the gain margin, (c) the value of K required to provide a gain margin equal to 16 db, and (d) the value of K to yield a steady-state error of 10% of the magnitude A for the ramp input $r(t) = At,\ t > 0$. Can this gain be utilized and achieve acceptable performance?

P8.23. The Nichols diagram for a $GH(j\omega)$ of a closed-loop system is shown in Fig. P8.23, on the next page. The frequency for each point on the graph is given in the table below.

Point	1	2	3	4	5	6	7	8	9
ω	1	2.0	2.6	3.4	4.2	5.2	6.0	7.0	8.0

Determine (a) the resonant frequency, (b) the bandwidth, (c) the phase margin, and (d) the gain margin. (e) Estimate the overshoot and settling time of the response to a step input.

P8.24. A specialty machine shop is improving the efficiency of its surface grinding process. The existing machine is sound mechanically but manually operated. Automating the machine will free the operator for other tasks, which will increase overall throughput of the machine shop. The grinding machine is shown in Fig. P8.24(a), on page 424 with all three axes automated with motors and feedback systems. The control system for the y-axis is shown in Fig. P8.24(b). In order to achieve a low steady-state error to a ramp command, we choose $K = 10$. Draw the Bode diagram of the open-loop system and obtain the Nichols chart plot. Determine the gain and phase margin of the system and the bandwidth of the closed-loop system. Estimate the ζ of the system and the predicted overshoot and settling time.

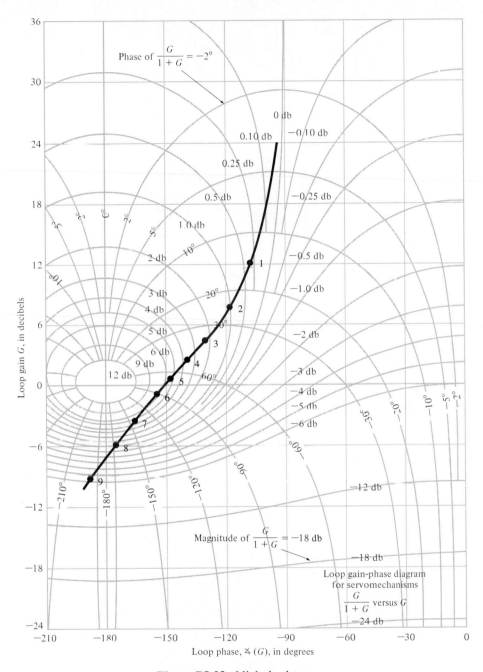

Figure P8.23. Nichols chart.

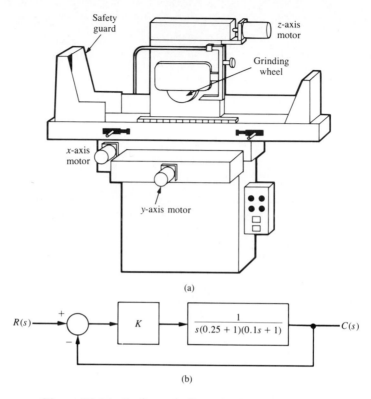

(a)

$$R(s) \xrightarrow{+} \bigcirc \xrightarrow{} \boxed{K} \xrightarrow{} \boxed{\dfrac{1}{s(0.25 + 1)(0.1s + 1)}} \xrightarrow{} C(s)$$

(b)

Figure P8.24. Surface grinding wheel control system.

Design Problems ◆

DP8.1. A mobile robot for toxic waste cleanup is shown in Fig. DP8.1a [24]. The closed-loop speed control is represented by Fig. 8.8 with $H(s) = 1$. The Nichol's chart in Fig. DP8.1(b) shows the plot of $G(j\omega)/k$ versus ω. The value of the frequency at points indicated

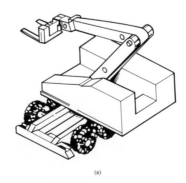

(a)

Figure DP8.1(a). Mobile robot for toxic waste cleanup.

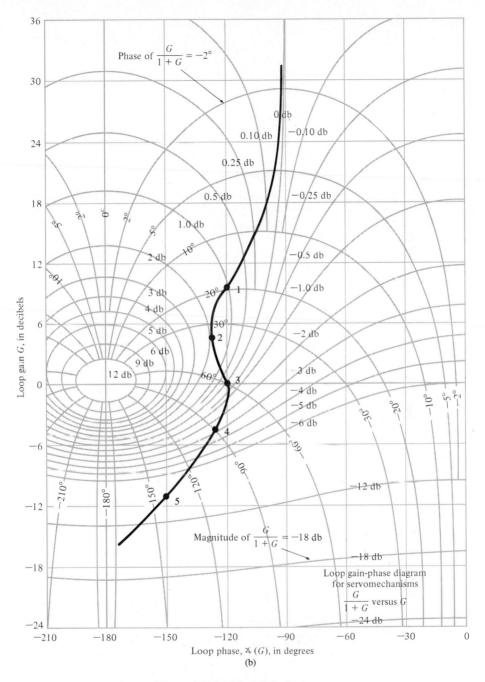

Figure DP8.1(b). Nichols chart.

is recorded in the table below.

Point	1	2	3	4	5
ω	2	5	10	20	50

(a) Determine the gain and phase margin of the closed-loop system when $k = 1$. (b) Determine the resonant peak in db and the resonant frequency for $k = 1$. (c) Determine the system bandwidth and estimate the settling time and percent overshoot of this system for a step input. (d) Determine the appropriate gain k so that the overshoot to a step input is 30%, and estimate the settling time of the system.

DP8.2. Flexible-joint robot arms are constructed of lightweight materials and exhibit lightly damped open-loop dynamics [23]. A feedback control system for a flexible arm is shown in Fig. DP8.2. Select K so that the system has maximum phase margin. Predict the overshoot for a step input based on the phase margin attained and compare it to the actual overshoot for a step input. Determine the bandwidth of the closed-loop system and predict the settling time of the system to a step input and compare it to the actual settling time. Discuss the suitability of this control system.

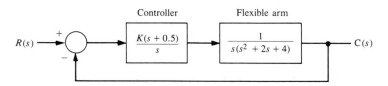

Figure DP8.2. Control of a flexible robot arm.

DP8.3. An automatic drug delivery system is used in the regulation of critical care patients suffering from cardiac failure [18]. The goal is to maintain stable patient status within narrow bounds. Consider the use of a drug delivery system for the regulation of blood pressure by the infusion of a drug. The feedback control system is shown in Fig. DP8.3. Select an appropriate gain K that maintains narrow deviation for blood pressure while achieving a good dynamic response.

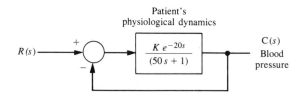

Figure DP8.3. Automatic drug delivery.

DP8.4. A robot tennis player is shown in Fig. DP8.4(a), and a simplified control system for $\Theta_2(t)$ is shown in Fig. DP8.4(b). The goal of the control system is to attain the best step response while attaining a high K_v for the system. Select $K_{v_1} = 0.325$ and $K_{v_2} = 0.45$ and determine the phase margin, gain margin, and closed-loop bandwidth for each case. Estimate the step response for each case and select the best value for K.

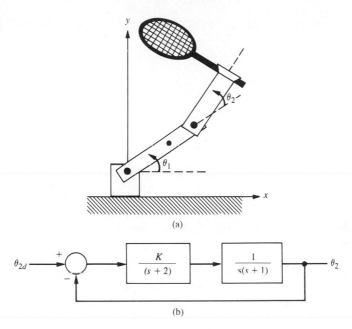

(a)

(b)

Figure DP8.4. An articulated two-link tennis player robot.

Terms and Concepts

Cauchy's Theorem If a contour encircles Z zero and P poles of $F(s)$ traversing clockwise, the corresponding contour in the $F(s)$-plane encircles the origin of the $F(s)$-plane $N = Z - P$ times clockwise.

Closed-loop frequency response The frequency response of the closed-loop transfer function $T(j\omega)$.

Conformal mapping A contour mapping that retains the angles on the s-plane on the $F(s)$-plane.

Contour map A contour or trajectory in one plane is mapped into another plane by a relation $F(s)$.

Gain margin The reciprocal of the gain $|GH|$ at the frequency at which the phase angle reaches $180°$.

Nichols chart A chart displaying the curves for the relationship between the open-loop and closed-loop frequency response.

Nyquist stability criterion A feedback system is stable if, and only if, the contour in the $G(s)$ plane does not encircle the $(-1, 0)$ point when the number of poles of $G(s)$ in the right-hand s-plane is zero. If $G(s)$ has P poles in the right-hand plane, then the number of counterclockwise encirclements of the $(-1, 0)$ point must be equal to P for a stable system.

Phase margin The phase angle through which the $GH(j\omega)$ locus must be rotated

in order that the unity magnitude point passes through the $(-1, 0)$ point in the $GH(j\omega)$ plane.

Principle of the argument See Cauchy's Theorem.

Time delay A pure time delay, T, so that events occurring at time t at one point in the system occur at another point in the system at a later time, $t + T$.

References

1. H. Nyquist, "Regeneration Theory," *Bell Systems Tech. J.,* January 1932; pp. 126–47. Also in *Automatic Control: Classical Linear Theory,* G. J. Thaler, ed., Dowden, Hutchinson, and Ross, Stroudsburg, Pa.; 1932; pp. 105–26.
2. M. D. Fagen, *A History of Engineering and Science in the Bell System,* Bell Telephone Laboratories, Inc., Murray Hill, N.J., 1978; Chapter 5.
3. E. Kamen, *Introduction to Signals and Systems,* Macmillan, New York, 1988.
4. W. Shepard and L. N. Hulley, *Power Electronics and Motor Control,* Cambridge University Press, New York, 1987.
5. R. C. Dorf and R. Jacquot, *Control System Design Program,* Addison-Wesley, Reading, Mass., 1988.
6. L. B. Jackson, *Signals, Systems and Transforms,* Addison-Wesley, Reading, Mass., 1991.
7. H. M. James, N. B. Nichols, and R. S. Phillips, *Theory of Servomechanisms,* McGraw-Hill, New York, 1947.
8. J. V. Ringwood, "Shape Control in Sendzimir Mills Using Roll Actuators," *IEEE Trans. on Automatic Control,* April 1990; pp. 453–59.
9. V. D. Hunt, *Mechatronics,* Chapman and Hall, New York, 1989.
10. W. L. Brogan, *Modern Control Theory,* Prentice Hall, Englewood Cliffs, N.J., 1991.
11. R. C. Nelson, *Flight Stability and Control,* McGraw-Hill, New York, 1989.
12. R. C. Dorf, *Robotics and Automated Manufacturing,* Reston Publishing, Reston, Virginia, 1983.
13. R. C. Dorf, *The Encyclopedia of Robotics,* John Wiley & Sons, New York, 1988.
14. A. T. Bahill and L. Stark, "The Trajectories of Saccadic Eye Movements," *Scientific American,* January 1979; pp. 108–17.
15. K. K. Chew, "Control of Errors in Disk Drive Systems," *IEEE Control Systems,* January 1990; pp. 16–19.
16. J. Slottine, *Applied Nonlinear Control,* Prentice Hall, Englewood Cliffs, N.J., 1991.
17. J. F. Engleberger, *Robotics in Service,* M.I.T. Press, Cambridge, Mass., 1989.
18. G. W. Neat, "Expert Adaptive Control for Drug Delivery Systems," *IEEE Control Systems,* June 1989; pp. 20–23.
19. J. C. Maciejowski, *Multivariable Feedback Design,* Addison-Wesley, Reading, Mass., 1990.
20. R. Kurzweil, *The Age of Intelligent Machines,* M.I.T. Press, Cambridge, Mass., 1990.
21. R. P. Brennan, *Levitating Trains,* John Wiley & Sons, New York, 1990.
22. D. M. Schneider, "Control of Processes with Time Delays," *IEEE Trans. on Industry Applications,* April 1988; pp. 186–91.
23. F. Ghorbel, "Adaptive Control of Flexible-Joint Manipulators," *IEEE Control Systems,* December 1989; pp. 9–12.
24. N. A. Hootsmans, "Large Motion Control of Mobile Manipulators," *Proceed. of the 1991 IEEE Conference on Robotics,* April 1991; pp. 2336–41.

Time-Domain Analysis of Control Systems

Preview

In the preceding chapters we used the Laplace transform or sinusoidal steady-state frequency response to describe the performance of a feedback system. These methods are attractive since they provide a practical approach to analysis of a system. However, we recall that it is the response of the system over a time period that is actually our focus of interest. Thus, in this chapter, we turn to a method of analysis in the time domain.

In this chapter, we will reconsider the differential equations describing a

control system and select a certain form of differential equations. We will use a set of variables that can be used to establish a set of first-order differential equations.

Using matrix methods we will be able to determine the transient response of a control system and examine the stability of these systems. These time-domain matrix methods lend themselves readily to computer solution. Furthermore, it is feasible to propose new feedback structures based on the utilization of this new set of time-domain variables, called state variables.

9.1 Introduction

In the preceding chapters, we have developed and studied several useful approaches to the analysis and design of feedback systems. The Laplace transform was utilized to transform the differential equations representing the system into an algebraic equation expressed in terms of the complex variable s. Utilizing this algebraic equation, we were able to obtain a transfer function representation of the input–output relationship. Then the root locus and s-plane methods were developed on the basis of the Laplace transform representation. Furthermore, the steady-state representation of the system in terms of the real frequency variable ω was developed, and several useful techniques for analysis were studied. The frequency-domain approach, in terms of the complex variable s or the real frequency variable ω, is extremely useful; it is and will remain one of the primary tools of the control engineer. However, the limitations of the frequency-domain techniques and the recently acquired attractiveness of the time-domain approach require a reconsideration of the time-domain formulation of the equations representing control systems.

The frequency-domain techniques are limited in applicability to linear, time-invariant systems. Furthermore, they are particularly limited in their usefulness for multivariable control systems due to the emphasis on the input-output relationship of transfer functions. By contrast, the time-domain techniques can be readily utilized for nonlinear, time-varying, and multivariable systems. *A time-varying control system is a system for which one or more of the parameters of the system may vary as a function of time.* For example, the mass of a missile varies as a function of time as the fuel is expended during flight. A multivariable system, as discussed in Section 2.6, is a system with several input and output signals. The solution of a time-domain formulation of a control system problem is facilitated by the availability and ease of use of digital and analog computers. Therefore we are interested in reconsidering the time-domain description of dynamic systems as they are represented by the system differential equation. The *time-domain* is the mathematical domain that incorporates the response and description of a system in terms of time, t.

The time-domain representation of control systems is an essential basis for modern control theory and system optimization. In Chapter 10, we shall have an opportunity to design an optimum control system by utilizing time-domain

Input signals Output signals

Figure 9.1. System block diagram.

methods. In this chapter, we shall develop the time-domain representation of control systems, investigate the stability of these systems, and illustrate several methods for the solution of the system time response.

9.2 The State Variables of a Dynamic System

The time-domain analysis and design of control systems utilize the concept of the state of a system [1, 2, 3, 5]. *The state of a system is a set of numbers such that the knowledge of these numbers and the input functions will, with the equations describing the dynamics, provide the future state and output of the system.* For a dynamic system, the state of a system is described in terms of a set of *state variables* $[x_1(t), x_2(t), \ldots, x_n(t)]$. The state variables are those variables that determine the future behavior of a system when the present state of the system and the excitation signals are known. Consider the system shown in Fig. 9.1, where $c_1(t)$ and $c_2(t)$ are the output signals and $u_1(t)$ and $u_2(t)$ are the input signals. A set of state variables (x_1, x_2, \ldots, x_n) for the system shown in Fig. 9.1 is a set such that knowledge of the initial values of the state variables $[x_1(t_0), x_2(t_0), \ldots, x_n(t_0)]$ at the initial time t_0, and of the input signals $u_1(t)$ and $u_2(t)$ for $t \geq t_0$, suffices to determine the future values of the outputs and state variables [2].

A simple example of a state variable is the state of an On-Off light switch. The switch can be in either the On or the Off position and thus the state of the switch can assume one of two possible values. Thus if we know the present state (position) of the switch at t_0 and if an input is applied, we are able to determine the future value of the state of the element.

The concept of a set of state variables that represent a dynamic system can be illustrated in terms of the spring-mass-damper system shown in Fig. 9.2. The

Figure 9.2. A spring-mass-damper system.

number of state variables chosen to represent this system should be as few as possible in order to avoid redundant state variables. A set of state variables sufficient to describe this system is the position and the velocity of the mass. Therefore we will define a set of state variables as (x_1, x_2), where

$$x_1(t) = y(t) \quad \text{and} \quad x_2(t) = \frac{dy(t)}{dt} .$$

The differential equation describes the behavior of the system and is usually written as

$$M \frac{d^2 y}{dt^2} + f \frac{dy}{dt} + Ky = u(t). \tag{9.1}$$

In order to write Eq. (9.1) in terms of the state variables, we substitute the definition of the state variables and obtain

$$M \frac{dx_2}{dt} + fx_2 + Kx_1 = u(t). \tag{9.2}$$

Therefore we can write the differential equations that describe the behavior of the spring-mass-damper system as a set of two first-order differential equations as follows:

$$\frac{dx_1}{dt} = x_2. \tag{9.3}$$

$$\frac{dx_2}{dt} = \frac{-f}{M} x_2 - \frac{K}{M} x_1 + \frac{1}{M} u. \tag{9.4}$$

This set of differential equations describes the behavior of the state of the system in terms of the rate of change of each state variable.

As another example of the state variable characterization of a system, let us consider the RLC circuit shown in Fig. 9.3. The state of this system can be described in terms of a set of state variables (x_1, x_2), where x_1 is the capacitor voltage $v_c(t)$ and x_2 is equal to the inductor current $i_L(t)$. This choice of state variables is intuitively satisfactory because the stored energy of the network can be described in terms of these variables as

$$\mathcal{E} = (1/2)Li_L^2 + (1/2)Cv_c^2. \tag{9.5}$$

Figure 9.3. An RLC circuit.

Therefore, $x_1(t_0)$ and $x_2(t_0)$ represent the total initial energy of the network and thus the state of the system at $t = t_0$. For a passive RLC network, the number of state variables required is equal to the number of independent energy-storage elements. Utilizing Kirchhoff's current law at the junction, we obtain a first-order differential equation by describing the rate of change of capacitor voltage as

$$i_r = C\frac{dv_c}{dt} = +u(t) - i_L. \tag{9.6}$$

Kirchhoff's voltage law for the right-hand loop provides the equation describing the rate of change of inductor current as

$$L\frac{di_L}{dt} = -Ri_L + v_c. \tag{9.7}$$

The output of this system is represented by the linear algebraic equation

$$v_{\text{out}} = Ri_L(t).$$

We can rewrite Eqs. (9.6) and (9.7) as a set of two first-order differential equations in terms of the state variables x_1 and x_2 as follows:

$$\frac{dx_1}{dt} = -\frac{1}{C}x_2 + \frac{1}{C}u(t), \tag{9.8}$$

$$\frac{dx_2}{dt} = +\frac{1}{L}x_1 - \frac{R}{L}x_2. \tag{9.9}$$

The output signal is then

$$c_1(t) = v_{\text{out}}(t) = Rx_2. \tag{9.10}$$

Utilizing Eqs. (9.8) and (9.9) and the initial conditions of the network represented by $[x_1(t_0), x_2(t_0)]$, we can determine the system's future behavior and its output.

The state variables that describe a system are not a unique set, and several alternative sets of state variables can be chosen. For example, for a second-order system, such as the mass-spring-damper or RLC circuit, the state variables may be any two independent linear combinations of $x_1(t)$ and $x_2(t)$. Therefore, for the RLC circuit, we might choose the set of state variables as the two voltages, $v_c(t)$ and $v_L(t)$, where v_L is the voltage drop across the inductor. Then the new state variables, x_1^* and x_2^*, are related to the old state variables, x_1 and x_2, as

$$x_1^* = v_c = x_1, \tag{9.11}$$

$$x_2^* = v_L = v_c - Ri_L = x_1 - Rx_2. \tag{9.12}$$

Equation (9.12) represents the relation between the inductor voltage and the former state variables v_c and i_L. Thus, in an actual system, there are several choices of a set of state variables that specify the energy stored in a system and therefore adequately describe the dynamics of the system. A widely used choice is a set of state variables that can be readily measured.

An alternative approach to developing a model of a device is the use of the bond graph. Bond graphs can be used for electrical, mechanical, hydraulic, and thermal devices or systems as well as for combinations of various types of elements. Bond graphs produce a set of equations in the state-variable form [2].

The state variables of a system characterize the dynamic behavior of a system. The engineer's interest is primarily in physical systems, where the variables are voltages, currents, velocities, positions, pressures, temperatures, and similar physical variables. However, the concept of system state is not limited to the analysis of physical systems and is particularly useful for analyzing biological, social, and economic systems as well as physical systems. For these systems, the concept of state is extended beyond the concept of energy of a physical system to the broader viewpoint of variables that describe the future behavior of the system.

9.3 The State Vector Differential Equation

The state of a system is described by the set of first-order differential equations written in terms of the state variables (x_1, x_2, \ldots, x_n). These first-order differential equations can be written in general form as

$$
\begin{aligned}
\dot{x}_1 &= a_{11}x_1 + a_{12}x_2 + \cdots + a_{1n}x_n + b_{11}u_1 + \cdots + b_{1m}u_m, \\
\dot{x}_2 &= a_{21}x_1 + a_{22}x_2 + \cdots + a_{2n}x_n + b_{21}u_1 + \cdots + b_{2m}u_m, \\
&\vdots \\
\dot{x}_n &= a_{n1}x_1 + a_{n2}x_2 + \cdots + a_{nn}x_n + b_{n1}u_1 + \cdots + b_{nm}u_m,
\end{aligned}
\tag{9.13}
$$

where $\dot{x} = dx/dt$. Thus this set of simultaneous differential equations can be written in matrix form as follows [5, 7]:

$$
\frac{d}{dt}
\begin{bmatrix} x_1 \\ x_2 \\ \vdots \\ x_n \end{bmatrix}
=
\begin{bmatrix}
a_{11} & a_{11} \cdots a_{1n} \\
a_{21} & a_{22} \cdots a_{2n} \\
\vdots & \ddots \vdots \\
a_{n1} & a_{n2} \cdots a_{nn}
\end{bmatrix}
\begin{bmatrix} x_1 \\ x_2 \\ \vdots \\ x_n \end{bmatrix}
$$

$$
+
\begin{bmatrix} b_{11} \\ \vdots \\ b_{n1} \end{bmatrix}
\begin{bmatrix} \cdots \\ \\ \cdots \end{bmatrix}
\begin{bmatrix} b_{1m} \\ \vdots \\ b_{nm} \end{bmatrix}
\begin{bmatrix} u_1 \\ \vdots \\ u_m \end{bmatrix}.
\tag{9.14}
$$

The column matrix consisting of the state variables is called the *state vector* and is written as

$$
\mathbf{x} =
\begin{bmatrix} x_1 \\ x_2 \\ \vdots \\ x_n \end{bmatrix},
\tag{9.15}
$$

where the boldface indicates a matrix. The matrix of input signals is defined as **u**. Then the system can be represented by the compact notation of the *state vector differential equation* as

$$\dot{x} = Ax + Bu. \tag{9.16}$$

The matrix **A** is an $n \times m$ square matrix and **B** is an $n \times m$ matrix.* The vector matrix differential equation relates the rate of change of the state of the system to the state of the system and the input signals. In general, the outputs of a linear system can be related to the state variables and the input signals by the vector matrix equation

$$c = Dx + Hu, \tag{9.17}$$

where **c** is the set of output signals expressed in column vector form.

The solution of the state vector differential equation (Eq. 9.16) can be obtained in a manner similar to the approach we utilize for solving a first-order differential equation. Consider the first-order differential equation

$$\dot{x} = ax + bu, \tag{9.18}$$

where $x(t)$ and $u(t)$ are scalar functions of time. We expect an exponential solution of the form e^{at}. Taking the Laplace transform of Eq. (9.18), we have

$$sX(s) - x(0) = aX(s) + bU(s),$$

and therefore

$$X(s) = \frac{x(0)}{s - a} + \frac{b}{s - a} U(s). \tag{9.19}$$

The inverse Laplace transform of Eq. (9.19) results in the solution

$$x(t) = e^{at}x(0) + \int_0^t e^{+a(t-\tau)}bu(\tau)\, d\tau. \tag{9.20}$$

We expect the solution of the vector differential equation to be similar to Eq. (9.20) and to be of exponential form. The matrix exponential function is defined as

$$e^{At} = \exp(At) = I + At + \frac{A^2t^2}{2!} + \cdots + \frac{A^kt^k}{k!} + \cdots, \tag{9.21}$$

which converges for all finite t and any **A** [7]. Then the solution of the vector differential equation is found to be [1]

$$x(t) = \exp(At)x(0) + \int_0^t \exp[A(t - \tau)]Bu(\tau)\, d\tau. \tag{9.22}$$

*Boldfaced lowercase letters denote vector quantities and boldfaced uppercase letters denote matrices. For an introduction to matrices and elementary matrix operations, refer to Appendix C and references [3] and [7].

Equation (9.22) may be obtained by taking the Laplace transform of Eq. (9.16) and rearranging to obtain

$$\mathbf{X}(s) = [s\mathbf{I} - \mathbf{A}]^{-1}\mathbf{x}(0) + [s\mathbf{I} - \mathbf{A}]^{-1}\mathbf{B}\mathbf{U}(s), \qquad (9.23)$$

where we note that $[s\mathbf{I} - \mathbf{A}]^{-1} = \phi(s)$, which is the Laplace transform of $\phi(t) = \exp(\mathbf{A}t)$. Taking the inverse Laplace transform of Eq. (9.23) and noting that the second term on the right-hand side involves the product $\phi(s)\mathbf{B}\mathbf{U}(s)$, we obtain Eq. (9.22). The matrix exponential function describes the unforced response of the system and is called the *fundamental* or *transition matrix* $\phi(t)$. Therefore Eq. (9.22) can be written as

$$\mathbf{x}(t) = \phi(t)\mathbf{x}(0) + \int_0^t \phi(t - \tau)\mathbf{B}\mathbf{u}(\tau)\, d\tau. \qquad (9.24)$$

The solution to the unforced system (that is, when $\mathbf{u} = 0$) is simply

$$
\begin{bmatrix} x_1(t) \\ x_2(t) \\ \vdots \\ x_n(t) \end{bmatrix}
=
\begin{bmatrix} \phi_{11}(t) \cdots \phi_{1n}(t) \\ \phi_{21}(t) \cdots \phi_{2n}(t) \\ \vdots \qquad \vdots \\ \phi_{n1}(t) \cdots \phi_{nn}(t) \end{bmatrix}
\begin{bmatrix} x_1(0) \\ x_2(0) \\ \vdots \\ x_n(0) \end{bmatrix}. \qquad (9.25)
$$

We note, therefore, that in order to determine the transition matrix, all initial conditions are set to 0 except for one state variable, and the output of each state variable is evaluated. That is, the term $\phi_{ij}(t)$ is the response of the ith state variable due to an initial condition on the jth state variable when there are zero initial conditions on all the other states. We shall utilize this relationship between the initial conditions and the state variables to evaluate the coefficients of the transition matrix in a later section. However, first we shall develop several suitable signal-flow state models of systems and investigate the stability of the systems by utilizing these flow graphs.

9.4 Signal-Flow Graph State Models

The state of a system describes that system's dynamic behavior where the dynamics of the system are represented by a series of first-order differential equations. Alternatively, the dynamics of the system can be represented by a vector differential equation as in Eq. (9.16). In either case, it is useful to develop a state flow graph model of the system and use this model to relate the state variable concept to the familiar transfer function representation.

As we have learned in previous chapters, a system can be meaningfully described by an input-output relationship, the transfer function $G(s)$. For example, if we are interested in the relation between the output voltage and the input voltage of the network of Fig. 9.3, we can obtain the transfer function

$$G(s) = \frac{V_0(s)}{U(s)}.$$

The transfer function for the RLC network is of the form

$$G(s) = \frac{V_0(s)}{U(s)} = \frac{\alpha}{s^2 + \beta s + \gamma}, \qquad (9.26)$$

where α, β, and γ are functions of the circuit parameters R, L, and C. The values of α, β, and γ can be determined from the flow graph representing the differential equations that describe the circuit. For the RLC circuit (see Eqs. 9.8 and 9.9), we have

$$\dot{x}_1 = -\frac{1}{C}x_2 + \frac{1}{C}u(t), \qquad (9.27)$$

$$\dot{x}_2 = \frac{1}{L}x_1 - \frac{R}{L}x_2, \qquad (9.28)$$

$$v_{out} = Rx_2. \qquad (9.29)$$

The flow graph representing these simultaneous equations is shown in Fig. 9.4, where $1/s$ indicates an integration. Using Mason's signal-flow gain formula, we obtain the transfer function

$$\frac{V_{out}(s)}{U(s)} = \frac{+R/LCs^2}{1 + (R/Ls) + (1/LCs^2)} = \frac{+R/LC}{s^2 + (R/L)s + (1/LC)}. \qquad (9.30)$$

Unfortunately, many electric circuits, electromechanical systems, and other control systems are not so simple as the RLC circuit of Fig. 9.3, and it is often a difficult task to determine a series of first-order differential equations describing the system. Therefore it is often simpler to derive the transfer function of the system by the techniques of Chapter 2 and then derive the state model from the transfer function.

The signal-flow graph state model can be readily derived from the transfer function of a system. However, as we noted in Section 9.3, there is more than one alternative set of state variables, and therefore there is more than one possible form for the signal-flow graph state model. In general, we can represent a transfer function as

$$G(s) = \frac{C(s)}{U(s)} = \frac{s^m + b_{m-1}s^{m-1} + \cdots + b_1 s + b_0}{s^n + a_{n-1}s^{n-1} + \cdots + a_1 s + a_0}, \qquad (9.31)$$

Figure 9.4. Flow graph for the RLC network.

where $n \geq m$ and all the a coefficients are real positive numbers. If we multiply the numerator and denominator by s^{-n}, we obtain

$$G(s) = \frac{s^{-(n-m)} + b_{m-1}s^{-(n-m+1)} + \cdots + b_1 s^{-(n-1)} + b_0 s^{-n}}{1 + a_{n-1}s^{-1} + \cdots + a_1 s^{-(n-1)} + a_0 s^{-n}}. \tag{9.32}$$

Our familiarity with Mason's flow graph gain formula causes us to recognize the familiar feedback factors in the denominator and the forward-path factors in the numerator. Mason's flow graph formula was discussed in Section 2.7 and is written as

$$G(s) = \frac{C(s)}{U(s)} = \frac{\Sigma_k P_k \Delta_k}{\Delta}. \tag{9.33}$$

When all the feedback loops are touching and all the forward paths touch the feedback loops, Eq. (9.33) reduces to

$$G(s) = \frac{\Sigma_k P_k}{1 - \Sigma_{q=1}^{N} L_q} = \frac{\text{Sum of the forward-path factors}}{1 - \text{sum of the feedback loop factors}}. \tag{9.34}$$

There are several flow graphs that could represent the transfer function. Two flow-graph configurations are of particular interest, and we will consider these in greater detail.

In order to illustrate the derivation of the signal-flow graph state model, let us initially consider the fourth-order transfer function

$$G(s) = \frac{C(s)}{U(s)} = \frac{b_0}{s^4 + a_3 s^3 + a_2 s^2 + a_1 s + a_0}$$

$$= \frac{b_0 s^{-4}}{1 + a_3 s^{-1} + a_2 s^{-2} + a_1 s^{-3} + a_0 s^{-4}}. \tag{9.35}$$

First we note that the system is fourth order, and hence we identify four state variables (x_1, x_2, x_3, x_4). Recalling Mason's gain formula, we note that the denominator can be considered to be one minus the sum of the loop gains. Furthermore, the numerator of the transfer function is equal to the forward-path factor of the flow graph. The flow graph must utilize a minimum number of integrators equal to the order of the system. Therefore we use four integrators to represent this system. The necessary flow-graph nodes and the four integrators are shown in Fig. 9.5. Considering the simplest series interconnection of integrators, we can represent the transfer function by the flow graph of Fig. 9.6. Examining Fig. 9.6, we note that all the loops are touching and that the transfer function of this flow

Figure 9.5. Flow-graph nodes and integrators for fourth-order system.

Figure 9.6. Flow-graph state model for $G(s)$ of Eq. (9.35).

graph is indeed Eq. (9.35). This can be readily verified by the reader by noting that the forward-path factor of the flow graph is b_0/s^4 and the denominator is equal to 1 minus the sum of the loop gains.

Now, consider the fourth-order transfer function when the numerator polynomial is a polynomial in s so that we have

$$G(s) = \frac{b_3 s^3 + b_2 s^2 + b_1 s + b_0}{s^4 + a_3 s^3 + a_2 s^2 + a_1 s + a_0}$$

$$= \frac{b_3 s^{-1} + b_2 s^{-2} + b_1 s^{-3} + b_0 s^{-4}}{1 + a_3 s^{-1} + a_2 s^{-2} + a_1 s^{-3} + a_0 s^{-4}}. \tag{9.36}$$

The numerator terms represent forward-path factors in Mason's gain formula. The forward paths will touch all the loops, and a suitable signal-flow graph realization of Eq. (9.36) is shown in Fig. 9.7. The forward-path factors are b_3/s, b_2/s^2, b_1/s^3, and b_0/s^4 as required to provide the numerator of the transfer function. Recall that Mason's flow-graph gain formula indicates that the numerator of the transfer function is simply the sum of the forward-path factors. This general form of a signal-flow graph can represent the general transfer function of Eq. (9.36) by utilizing n feedback loops involving the a_n coefficients and m forward-path factors involving the b_m coefficients.

The state variables are identified in Fig. 9.7 as the output of each energy storage element; that is, the output of each integrator. In order to obtain the set of

Figure 9.7. Flow-graph state model for $G(s)$ of Eq. (9.36).

first-order differential equations representing the state model of Fig. 9.7, we will introduce a new set of flow graph nodes immediately preceding each integrator of Fig. 9.7 [1]. The nodes are placed before each integrator, and therefore they represent the derivative of the output of each integrator. The signal-flow graph, including the added nodes, is shown in Fig. 9.8. Using the flow graph of Fig. 9.8, we are able to obtain the following set of first-order differential equations describing the state of the model:

$$\dot{x}_1 = x_2,$$

$$\dot{x}_2 = x_3,$$

$$\dot{x}_3 = x_4,$$

$$\dot{x}_4 = -a_0 x_1 - a_1 x_2 - a_2 x_3 - a_3 x_4 + u.$$

(9.37)

Furthermore, the output is simply

$$c(t) = b_0 x_1 + b_1 x_2 + b_2 x_3 + b_3 x_4.$$

(9.38)

Then, in matrix form, we have

$$\dot{\mathbf{x}} = \mathbf{A}\mathbf{x} + \mathbf{b}u$$

(9.39)

or

$$\frac{d}{dt}\begin{bmatrix} x_1 \\ x_2 \\ x_3 \\ x_4 \end{bmatrix} = \begin{bmatrix} 0 & 1 & 0 & 0 \\ 0 & 0 & 1 & 0 \\ 0 & 0 & 0 & 1 \\ -a_0 & -a_1 & -a_2 & -a_3 \end{bmatrix}\begin{bmatrix} x_1 \\ x_2 \\ x_3 \\ x_4 \end{bmatrix} + \begin{bmatrix} 0 \\ 0 \\ 0 \\ 1 \end{bmatrix} u(t),$$

(9.40)

and the output is

$$c(t) = \mathbf{D}\mathbf{x} = [b_0, b_1, b_2, b_3]\begin{bmatrix} x_1 \\ x_2 \\ x_3 \\ x_4 \end{bmatrix}.$$

(9.41)

Figure 9.8. Flow graph of Fig. 9.7 with nodes inserted.

Figure 9.9. Alternative flow-graph state model for Eq. (9.36).

The flow-graph structure of Fig. 9.7 is not a unique representation of Eq. (9.36); another equally useful structure can be obtained. A flow graph that represents Eq. (9.36) equally well is shown in Fig. 9.9. In this case, the forward-path factors are obtained by feeding forward the signal $U(s)$.

Then the output signal $c(t)$ is equal to the first state variable $x_1(t)$. This flow graph structure has the forward-path factors b_0/s^4, b_1/s^3, b_2/s^2, b_3/s, and all the forward paths touch the feedback loops. Therefore the resulting transfer function is indeed equal to Eq. (9.36).

Using the flow graph of Fig. 9.9 to obtain the set of first-order differential equations, we obtain

$$
\begin{aligned}
\dot{x}_1 &= -a_3 x_1 + x_2 + b_3 u, \\
\dot{x}_2 &= -a_2 x_1 + x_3 + b_2 u, \\
\dot{x}_3 &= -a_1 x_1 + x_4 + b_1 u, \\
\dot{x}_4 &= \quad a_0 x_1 + b_0 u.
\end{aligned}
\tag{9.42}
$$

Thus in matrix form we have

$$
\frac{d\mathbf{x}}{dt} =
\begin{bmatrix}
-a_3 & 1 & 0 & 0 \\
-a_2 & 0 & 1 & 0 \\
-a_1 & 0 & 0 & 1 \\
-a_0 & 0 & 0 & 0
\end{bmatrix}
\mathbf{x} +
\begin{bmatrix}
b_3 \\
b_2 \\
b_1 \\
b_0
\end{bmatrix}
u(t).
\tag{9.43}
$$

Although the flow graph of Fig. 9.9 represents the same transfer function as the flow graph of Fig. 9.7, the state variables of each graph are not equal because the structure of each flow graph is different. The signal-flow graphs can be recognized as being equivalent to an analog computer diagram. Furthermore, we recognize that the initial conditions of the system can be represented by the initial conditions of the integrators, $x_1(0)$, $x_2(0)$, ..., $x_n(0)$. Let us consider a control system and determine the state vector differential equation by utilizing the two forms of flow-graph state models.

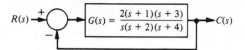

Figure 9.10. Single-loop control system.

■ Example 9.1 Third-order system

A single-loop control system is shown in Fig. 9.10. The closed-loop transfer function of the system is

$$T(s) = \frac{C(s)}{R(s)} = \frac{2s^2 + 8s + 6}{s^3 + 8s^2 + 16s + 6}. \tag{9.44}$$

Multiplying the numerator and denominator by s^{-3}, we have

$$T(s) = \frac{C(s)}{R(s)} = \frac{2s^{-1} + 8s^{-2} + 6s^{-3}}{1 + 8s^{-1} + 16s^{-2} + 6s^{-3}}. \tag{9.45}$$

The signal-flow graph state model using the feedforward of the state variables to provide the output signal is shown in Fig. 9.11. The vector differential equation for this flow graph is

$$\dot{\mathbf{x}} = \begin{bmatrix} 0 & 1 & 0 \\ 0 & 0 & 1 \\ -6 & -16 & -8 \end{bmatrix} \mathbf{x} + \begin{bmatrix} 0 \\ 0 \\ 1 \end{bmatrix} u(t), \tag{9.46}$$

and the output is

$$c(t) = [6, 8, 2] \begin{bmatrix} x_1 \\ x_2 \\ x_3 \end{bmatrix}. \tag{9.47}$$

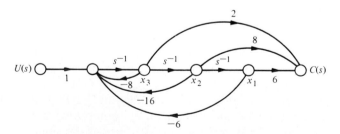

Figure 9.11. Flow-graph state model for $T(s)$.

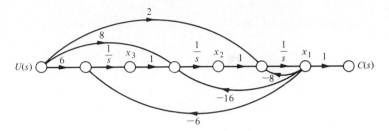

Figure 9.12. Alternative flow-graph state model for $T(s)$.

The flow-graph state model using the feedforward of the input variable is shown in Fig. 9.12. The vector differential equation for this flow graph is

$$\dot{\mathbf{x}} = \begin{bmatrix} -8 & 1 & 0 \\ -16 & 0 & 1 \\ -6 & 0 & 0 \end{bmatrix} \mathbf{x} + \begin{bmatrix} 2 \\ 8 \\ 6 \end{bmatrix} u(t), \tag{9.48}$$

and the output is $c(t) = x_1(t)$.

We note that both signal-flow graph representations of the transfer function $T(s)$ are readily obtained. Furthermore, it was not necessary to factor the numerator or denominator polynomial in order to obtain the state differential equations. Avoiding the factoring of polynomials permits us to avoid the tedious effort involved. Each of the two signal-flow graph state models represents an analog computer simulation of the transfer function. Both models require three integrators because the system is third order. However, it is important to emphasize that the state variables of the state model of Fig. 9.11 are not identical to the state variables of the state model of Fig. 9.12. Of course, one set of state variables is related to the other set of state variables by a suitable linear transformation of variables. A linear matrix transformation is represented by $\mathbf{y} = \mathbf{Bx}$, which transforms the \mathbf{x}-vector into the \mathbf{y}-vector by means of the \mathbf{B}-matrix (see Appendix C, especially Section C-3, for an introduction to matrix algebra). Finally, we note that the transfer function of Eq. (9.31) represents a single output linear constant coefficient system, and thus the transfer function can represent an nth-order differential equation

$$\frac{d^n c}{dt^n} + a_{n-1} \frac{d^{n-1} c}{dt^{n-1}} + \cdots + a_0 c(t)$$

$$= \frac{d^m u}{dt^m} + b_{m-1} \frac{d^{m-1} u}{dt^{m-1}} + \cdots + b_0 u(t). \tag{9.49}$$

Thus we can obtain the n first-order equations for the nth-order differential equation by utilizing the signal-flow graph state models of this section.

9.5 The Stability of Systems in the Time Domain

The stability of a system modeled by a state variable flow-graph model can be readily ascertained. The stability of a system with an input–output transfer function $T(s)$ can be determined by examining the denominator polynomial of $T(s)$. Therefore if the transfer function is written as

$$T(s) = \frac{p(s)}{q(s)},$$

where $p(s)$ and $q(s)$ are polynomials in s, then the stability of the system is represented by the roots of $q(s)$. The polynomial $q(s)$, when set equal to zero, is called the characteristic equation and is discussed in Section 2.4. The roots of the characteristic equation must lie in the left-hand s-plane for the system to exhibit a stable time response. Therefore in order to ascertain the stability of a system represented by a transfer function, we investigate the characteristic equation and utilize the Routh-Hurwitz criterion. If the system we are investigating is represented by a signal-flow graph state model, we obtain the characteristic equation by evaluating the flow graph determinant. As an illustration of this method, let us investigate the stability of the system of Example 9.1.

■ **E x a m p l e 9.2 Stability of a system**

The transfer function $T(s)$ examined in Example 9.1 is

$$T(s) = \frac{2s^2 + 8s + 6}{s^3 + 8s^2 + 16s + 6}. \tag{9.50}$$

Clearly, the characteristic equation for this system is

$$q(s) = s^3 + 8s^2 + 16s + 6. \tag{9.51}$$

Of course, this characteristic equation is also readily obtained from either the flow-graph model shown in Fig. 9.7 or the one shown in Fig. 9.9. Using the Routh-Hurwitz criterion, we find that the system is stable and all the roots of $q(s)$ lie in the left-hand s-plane.

We often determine the flow-graph state model directly from a set of state differential equations. In this case, we can use the flow graph directly to determine the stability of the system by obtaining the characteristic equation from the flow-graph determinant $\Delta(s)$. An illustration of this approach will aid in comprehending this method.

■ **E x a m p l e 9.3 Spread of an epidemic disease**

The spread of an epidemic disease can be described by a set of differential equations. The population under study is made up of three groups, x_1, x_2, and x_3, such that the group x_1 is susceptible to the epidemic disease, group x_2 is infected with

the disease, and group x_3 has been removed from x_1 and x_2. The removal of x_3 will be due to immunization, death, or isolation from x_1. The feedback system can be represented by the following equations:

$$\frac{dx_1}{dt} = -\alpha x_1 - \beta x_2 + u_1(t), \tag{9.52}$$

$$\frac{dx_2}{dt} = \beta x_1 - \gamma x_2 + u_2(t), \tag{9.53}$$

$$\frac{dx_3}{dt} = \alpha x_1 + \gamma x_2. \tag{9.54}$$

The rate at which new susceptibles are added to the population is equal to $u_1(t)$ and the rate at which new infectives are added to the population is equal to $u_2(t)$. For a closed population, we have $u_1(t) = u_2(t) = 0$. It is interesting to note that these equations could equally well represent the spread of information of a new idea through a populace.

The state variables for this system are x_1, x_2, and x_3. The signal-flow diagram that represents this set of differential equations is shown in Fig. 9.13. The vector differential equation is equal to

$$\frac{d}{dt}\begin{bmatrix} x_1 \\ x_2 \\ x_3 \end{bmatrix} = \begin{bmatrix} -\alpha & -\beta & 0 \\ \beta & -\gamma & 0 \\ \alpha & \gamma & 0 \end{bmatrix}\begin{bmatrix} x_1 \\ x_2 \\ x_3 \end{bmatrix} + \begin{bmatrix} 1 & 0 \\ 0 & 1 \\ 0 & 0 \end{bmatrix}\begin{bmatrix} u_1(t) \\ u_2(t) \end{bmatrix}. \tag{9.55}$$

By examining Eq. (9.55) and the signal-flow graph, we find that the state variable x_3 is dependent on x_1 and x_2 and does not affect the variables x_1 and x_2.

Let us consider a closed population so that $u_1(t) = u_2(t) = 0$. The equilibrium point in the state space for this system is obtained by setting $dx/dt = \mathbf{0}$. The equilibrium point in the state space is the point to which the system settles in the equilibrium, or rest, condition. Examining Eq. (9.55), we find that the equilibrium

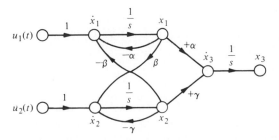

Figure 9.13. State model flow graph for the spread of an epidemic disease.

point for this system is $x_1 = x_2 = 0$. Thus, in order to determine if the system is stable and the epidemic disease is eliminated from the population, we must obtain the characteristic equation of the system. From the signal-flow graph shown in Fig. 9.13, we obtain the flow graph determinant

$$\Delta(s) = 1 - (-\alpha s^{-1} - \gamma s^{-1} - \beta^2 s^{-2}) + (\alpha\gamma s^{-2}), \qquad (9.56)$$

where there are three loops, two of which are nontouching. Thus the characteristic equation is

$$q(s) = s^2 \Delta(s) = s^2 + (\alpha + \gamma)s + (\alpha\gamma + \beta^2) = 0. \qquad (9.57)$$

Examining Eq. (9.57), we find that this system is stable when $(\alpha + \gamma) > 0$ and $(\alpha\gamma + \beta^2) > 0$.

A method of obtaining the characteristic equation directly from the vector differential equation is based on the fact that the solution to the unforced system is an exponential function. The vector differential equation without input signals is

$$\dot{\mathbf{x}} = \mathbf{A}\mathbf{x}, \qquad (9.58)$$

where \mathbf{x} is the state vector. The solution is of exponential form, and we can define a constant λ such that the solution of the system for one state might be $x_i(t) = k_i e^{\lambda_i t}$. The λ_i are called the characteristic roots of the system, which are simply the roots of the characteristic equation. If we let $\mathbf{x} = \mathbf{c}e^{\lambda t}$ and substitute into Eq. (9.58), we have

$$\lambda \mathbf{c}e^{\lambda t} = \mathbf{A}\mathbf{c}e^{\lambda t} \qquad (9.59)$$

or

$$\lambda \mathbf{x} = \mathbf{A}\mathbf{x}. \qquad (9.60)$$

Equation (9.60) can be rewritten as

$$(\lambda \mathbf{I} - \mathbf{A})\mathbf{x} = \mathbf{0}, \qquad (9.61)$$

where \mathbf{I} equals the identity matrix and $\mathbf{0}$ equals the null matrix. The solution of this set of simultaneous equations has a nontrivial solution if and only if the determinant vanishes; that is, only if

$$\det(\lambda \mathbf{I} - \mathbf{A}) = 0. \qquad (9.62)$$

The nth-order equation in λ resulting from the evaluation of this determinant is the characteristic equation, and the stability of the system can be readily ascertained. Let us reconsider Example 9.3 in order to illustrate this approach.

■ **Example 9.4 Closed epidemic system**

The vector differential equation of the epidemic system is given in Eq. (9.55). The characteristic equation is then

$$\det(\lambda \mathbf{I} - \mathbf{A}) = \det \left\{ \begin{bmatrix} \lambda & 0 & 0 \\ 0 & \lambda & 0 \\ 0 & 0 & \lambda \end{bmatrix} - \begin{bmatrix} -\alpha & -\beta & 0 \\ \beta & -\gamma & 0 \\ \alpha & \gamma & 0 \end{bmatrix} \right\}$$

$$= \det \begin{bmatrix} (\lambda + \alpha) & \beta & 0 \\ -\beta & (\lambda + \gamma) & 0 \\ -\alpha & -\gamma & \lambda \end{bmatrix} \tag{9.63}$$

$$= \lambda[(\lambda + \alpha)(\lambda + \gamma) + \beta^2]$$

$$= \lambda[\lambda^2 + (\alpha + \gamma)\lambda + (\alpha\gamma + \beta^2)] = 0.$$

Thus we obtain the characteristic equation of the system, and it is similar to that obtained in Eq. (9.57) by flow-graph methods. The additional root $\lambda = 0$ results from the definition of x_3 as the integral of $(\alpha x_1 + \gamma x_2)$, and x_3 does not affect the other state variables. Thus the root $\lambda = 0$ indicates the integration connected with x_3. The characteristic equation indicates that the system is stable when $(\alpha + \gamma) > 0$ and $(\alpha\gamma + \beta^2) > 0$.

■ **Example 9.5 Inverted pendulum stabilty**

The problem of balancing a broomstick on the end of one's finger is not unlike the problem of controlling the attitude of a missile during the initial stages of launch. This problem is the classic and intriguing problem of the inverted pendulum mounted on a cart, as shown in Fig. 9.14. The cart must be moved so that mass m is always in an upright position. The state variables must be expressed

Figure 9.14. A cart and an inverted pendulum.

in terms of the angular rotation $\theta(t)$ and the position of the cart $y(t)$. The differential equations describing the motion of the system can be obtained by writing the sum of the forces in the horizontal direction and the sum of the moments about the pivot point [2, 3, 15]. We will assume that $M \gg m$ and the angle of rotation θ is small so that the equations are linear. The sum of the forces in the horizontal direction is

$$M\ddot{y} + ml\ddot{\theta} - u(t) = 0, \tag{9.64}$$

where $u(t)$ equals the force on the cart and l is the distance from the mass m to the pivot point. The sum of the torques about the pivot point is

$$ml\ddot{y} + ml^2\ddot{\theta} - mlg\theta = 0. \tag{9.65}$$

The state variables for the two second-order equations are chosen as $(x_1, x_2, x_3, x_4) = (y, \dot{y}, \theta, \dot{\theta})$. Then Eqs. (9.64) and (9.65) are written in terms of the state variables as

$$M\dot{x}_2 + ml\dot{x}_4 - u(t) = 0 \tag{9.66}$$

and

$$\dot{x}_2 + l\dot{x}_4 - gx_3 = 0. \tag{9.67}$$

In order to obtain the necessary first-order differential equations, we solve for $l\dot{x}_4$ in Eq. (9.67) and substitute into Eq. (9.66) to obtain

$$M\dot{x}_2 + mgx_3 = u(t), \tag{9.68}$$

since $M \gg m$. Substituting \dot{x}_2 from Eq. (9.66) into Eq. (9.67), we have

$$Ml\dot{x}_4 - Mgx_3 + u(t) = 0. \tag{9.69}$$

Therefore the four first-order differential equations can be written as

$$\dot{x}_1 = x_2,$$

$$\dot{x}_2 = \frac{-mg}{M} x_3 + \frac{1}{M} u(t),$$

$$\dot{x}_3 = x_4, \tag{9.70}$$

$$\dot{x}_4 = \frac{g}{l} x_3 - \frac{1}{Ml} u(t).$$

Thus the system matrix is

$$\mathbf{A} = \begin{bmatrix} 0 & 1 & 0 & 0 \\ 0 & 0 & -(mg/M) & 0 \\ 0 & 0 & 0 & 1 \\ 0 & 0 & g/l & 0 \end{bmatrix}. \tag{9.71}$$

The characteristic equation can be obtained from the determinant of $(\lambda \mathbf{I} - \mathbf{A})$ as follows:

$$\det \begin{bmatrix} \lambda & -1 & 0 & 0 \\ 0 & \lambda & m/Mg & 0 \\ 0 & 0 & \lambda & -1 \\ 0 & 0 & -(g/l) & \lambda \end{bmatrix} = \lambda \left[\lambda \left(\lambda^2 - \frac{g}{l} \right) \right] = \lambda^2 \left(\lambda^2 - \frac{g}{l} \right) = 0. \quad (9.72)$$

The characteristic equation indicates that there are two roots at $\lambda = 0$, a root at $\lambda = +\sqrt{g/l}$, and a root at $\lambda = -\sqrt{g/l}$. Clearly, the system is unstable, because there is a root in the right-hand plane at $\lambda = +\sqrt{g/l}$.

A control system can be designed so that if $u(t)$ is a function of the state variables, a stable system will result. The design of a stable feedback control system is based on a suitable selection of a feedback system structure. Therefore, considering the control of the cart and the unstable inverted pendulum shown in Fig. 9.14, we must measure and utilize the state variables of the system in order to control the cart. Thus if we desire to measure the state variable $x_3 = \theta$, we could use a potentiometer connected to the shaft of the pendulum hinge. Similarly, we could measure the rate of change of the angle, $x_4 = \dot{\theta}$, by using a tachometer generator. The state variables, x_1 and x_2, which are the position and velocity of the cart, can also be measured by suitable sensors. If the state variables are all measured, then they can be utilized in a feedback controller so that $u = \mathbf{hx}$, where \mathbf{h} is the feedback matrix. The state vector \mathbf{x} represents the state of the system; therefore, knowledge of $\mathbf{x}(t)$ and the equations describing the system dynamics provide sufficient information for control and stabilization of a system. This design approach is called *state-variable feedback* [4, 7]. In order to illustrate the utilization of state-variable feedback, let us reconsider the unstable portion of the inverted pendulum system and design a suitable state-variable feedback control system.

■ **E x a m p l e 9.6 Inverted pendulum control**

In order to investigate the unstable portion of the inverted pendulum system, let us consider a reduced system. If we assume that the control signal is an acceleration signal and that the mass of the cart is negligible, we can focus on the unstable dynamics of the pendulum. When $u(t)$ is an acceleration signal, Eq. (9.67) becomes

$$gx_3 - l\dot{x}_4 = \dot{x}_2 = \ddot{y} = u(t). \quad (9.73)$$

For the reduced system, where the control signal is an acceleration signal, the position and velocity of the cart are integral functions of $u(t)$. The portion of the state vector under consideration is $[x_3, x_4] = [\theta, \dot{\theta}]$. Thus the state vector differential equation reduces to

$$\frac{d}{dt} \begin{bmatrix} x_3 \\ x_4 \end{bmatrix} = \begin{bmatrix} 0 & 1 \\ g/l & 0 \end{bmatrix} \begin{bmatrix} x_3 \\ x_4 \end{bmatrix} + \begin{bmatrix} 0 \\ -(1/l) \end{bmatrix} u(t). \quad (9.74)$$

Clearly, the A matrix of Eq. (9.74) is simply the lower right-hand portion of the A matrix of Eq. (9.71) and the system has the characteristic equation $[\lambda^2 - (g/l)]$ with one root in the right-hand s-plane. In order to stabilize the system, we generate a control signal that is a function of the two state variables x_3 and x_4. Then we have

$$u(t) = \mathbf{hx}$$

$$= [h_1, h_2] \begin{bmatrix} x_3 \\ x_4 \end{bmatrix} \tag{9.75}$$

$$= h_1 x_3 + h_2 x_4.$$

Substituting this control signal relationship into Eq. (9.74), we have

$$\begin{bmatrix} \dot{x}_3 \\ \dot{x}_4 \end{bmatrix} = \begin{bmatrix} 0 & 1 \\ g/l & 0 \end{bmatrix} \begin{bmatrix} x_3 \\ x_4 \end{bmatrix} + \begin{bmatrix} 0 \\ -(1/l)(h_1 x_3 + h_2 x_4) \end{bmatrix}. \tag{9.76}$$

Combining the two additive terms on the right side of the equation, we find

$$\begin{bmatrix} \dot{x}_3 \\ \dot{x}_4 \end{bmatrix} = \begin{bmatrix} 0 & 1 \\ 1/l(g - h_1) & -(h_2/l) \end{bmatrix} \begin{bmatrix} x_3 \\ x_4 \end{bmatrix}. \tag{9.77}$$

Therefore, obtaining the characteristic equation, we have

$$\det \begin{bmatrix} +\lambda & -1 \\ -(1/l)(g - h_1) & \left(\lambda + h_2/l\right) \end{bmatrix} = \lambda\left(\lambda + \frac{h_2}{l}\right) - \frac{1}{l}(g - h_1)$$

$$= \lambda^2 + \left(\frac{h_2}{l}\right)\lambda + \frac{1}{l}(h_1 - g). \tag{9.78}$$

Thus for the system to be stable, we require that $(h_2/l) > 0$ and $h_1 > g$. Hence we have stabilized an unstable system by measuring the state variables x_3 and x_4 and using the control function $u = h_1 x_3 + h_2 x_4$ to obtain a stable system.

In this section we have developed a useful method of investigating the stability of a system represented by a state vector differential equation. Furthermore, we have established an approach for the design of a feedback control system by using the state variables as the feedback variables in order to increase the stability of the system. In the next two sections, we will be concerned with developing two methods for obtaining the time response of the state variables.

9.6 The Time Response and the Transition Matrix

It is often desirable to obtain the time response of the state variables of a control system and thus examine the performance of the system. The transient response of a system can be readily obtained by evaluating the solution to the state vector differential equation. We found in Section 9.3 that the solution for the state vector differential equation (Eq. 9.34) was

$$\mathbf{x}(t) = \boldsymbol{\phi}(t)\mathbf{x}(0) + \int_0^t \boldsymbol{\phi}(t - \tau)\mathbf{B}\mathbf{u}(\tau)\, d\tau. \tag{9.79}$$

Clearly, if the initial conditions $\mathbf{x}(0)$, the input $\mathbf{u}(\tau)$, and the transition matrix $\phi(t)$ are known, the time response of $\mathbf{x}(t)$ can be numerically evaluated. Thus the problem focuses on the evaluation of $\phi(t)$, the transition matrix that represents the response of the system. Fortunately, the transition matrix can be readily evaluated by using the signal-flow graph techniques with which we are already familiar.

However, before proceeding to the evaluation of the transition matrix using signal-flow graphs, we should note that several other methods exist for evaluating the transition matrix, such as the evaluation of the exponential series

$$\phi(t) = e^{At} = \sum_{k=0}^{\infty} \frac{A^k t^k}{k!}$$

in a truncated form [7, 14]. Several efficient methods exist for the evaluation of $\phi(t)$ by means of a computer algorithm.

A series of computer programs to assist in the calculation of the state variable response of systems is often available in local computer centers. Personal computers can be used to obtain the state variable response of a dynamic system [14]. The personal computer affords the user the advantage of interactive use of the computer for design purposes. Control System Design Program uses a truncated series to solve Eq. (9.16) and yields the state variable response, and it is available for a personal computer [14].

In addition, we found in Eq. (9.23) that $\phi(s) = [s\mathbf{I} - \mathbf{A}]^{-1}$. Therefore, if $\phi(s)$ is obtained by completing the matrix inversion, we can obtain $\phi(t)$ by noting that $\phi(t) = \mathcal{L}^{-1}\{\phi(s)\}$. However, the matrix inversion process is unwieldy for higher-order systems.

The usefulness of the signal-flow graph state model for obtaining the transition matrix becomes clear upon consideration of the Laplace transformation version of Eq. (9.79) when the input is zero. Taking the Laplace transformation of Eq. (9.79), when $\mathbf{u}(\tau) = 0$, we have

$$\mathbf{X}(s) = \phi(s)\mathbf{x}(0). \tag{9.80}$$

Therefore we can evaluate the Laplace transform of the transition matrix from the signal-flow graph by determining the relation between a state variable $X_i(s)$ and the state initial conditions $[x_1(0), x_2(0), \ldots, x_n(0)]$. Then the state transition matrix is simply the inverse transform of $\phi(s)$; that is,

$$\phi(t) = \mathcal{L}^{-1}\{\phi(s)\}. \tag{9.81}$$

The relationship between a state variable $X_i(s)$ and the initial conditions $\mathbf{x}(0)$ is obtained by using Mason's gain formula. Thus for a second-order system, we would have

$$X_1(s) = \phi_{11}(s)x_1(0) + \phi_{12}(s)x_2(0),$$
$$X_2(s) = \phi_{21}(s)x_1(0) + \phi_{22}(s)x_2(0), \tag{9.82}$$

and the relation between $X_2(s)$ as an output and $x_1(0)$ as an input can be evaluated by Mason's formula. All the elements of the transition matrix, $\phi_{ij}(s)$, can be

obtained by evaluating the individual relationships between $X_i(s)$ and $x_j(0)$ from the state model flow graph. An example will illustrate this approach to the determination of the transition matrix.

■ Example 9.7 Evaluation of the transition matrix

The signal-flow graph state model of the RLC network of Fig. 9.3 is shown in Fig. 9.4. This RLC network, which was discussed in Sections 9.3 and 9.4, can be represented by the state variables $x_1 = v_c$ and $x_2 = i_L$. The initial conditions, $x_1(0)$ and $x_2(0)$, represent the initial capacitor voltage and inductor current, respectively. The flow graph, including the initial conditions of each state variable, is shown in Fig. 9.15. The initial conditions appear as the initial value of the state variable at the output of each integrator.

In order to obtain $\phi(s)$, we set $U(s) = 0$. When $R = 3$, $L = 1$, and $C = \frac{1}{2}$, we obtain the signal-flow graph shown in Fig. 9.16, where the output and input nodes are deleted because they are not involved in the evaluation of $\phi(s)$. Then, using Mason's gain formula, we obtain $X_1(s)$ in terms of $x_1(0)$ as

$$X_1(s) = \frac{1 \cdot \Delta_1(s) \cdot [x_1(0)/s]}{\Delta(s)}, \tag{9.83}$$

where $\Delta(s)$ is the graph determinant and $\Delta_1(s)$ is the path cofactor. The graph determinant is

$$\Delta(s) = 1 + 3s^{-1} + 2s^{-2}.$$

The path cofactor is $\Delta_1 = 1 + 3s^{-1}$ because the path between $x_1(0)$ and $X_1(s)$ does not touch the loop with the factor $-3s^{-1}$. Therefore the first element of the transition matrix is

$$\phi_{11}(s) = \frac{(1 + 3s^{-1})(1/s)}{1 + 3s^{-1} + 2s^{-2}}$$

$$= \frac{(s + 3)}{(s^2 + 3s + 2)}. \tag{9.84}$$

Figure 9.15. Flow graph of the RLC network.

Figure 9.16. Flow graph of the RLC network with $U(s) = 0$.

The element $\phi_{12}(s)$ is obtained by evaluating the relationship between $X_1(s)$ and $x_2(0)$ as

$$X_1(s) = \frac{(-2s^{-1})(x_2(0)/s)}{1 + 3s^{-1} + 2s^{-2}} . \tag{9.85}$$

Therefore we obtain

$$\phi_{12}(s) = \frac{-2}{s^2 + 3s + 2} . \tag{9.86}$$

Similarly, for $\phi_{21}(s)$ we have

$$\phi_{21}(s) = \frac{(s^{-1})(1/s)}{1 + 3s^{-1} + 2s^{-2}}$$

$$= \frac{1}{s^2 + 3s + 2} . \tag{9.87}$$

Finally, for $\phi_{22}(s)$ we obtain

$$\phi_{22}(s) = \frac{1(1/s)}{1 + 3s^{-1} + 2s^{-2}}$$

$$= \frac{s}{s^2 + 3s + 2} . \tag{9.88}$$

Therefore, the transition matrix in Laplace transformation forms is

$$\phi(s) = \begin{bmatrix} (s + 3)/(s^2 + 3s + 2) & -2/(s^2 + 3s + 2) \\ 1/(s^2 + 3s + 2) & s/(s^2 + 3s + 2) \end{bmatrix} . \tag{9.89}$$

The factors of the characteristic equation are $(s + 1)$ and $(s + 2)$ so that

$$(s + 1)(s + 2) = s^2 + 3s + 2.$$

Then the transition matrix is

$$\phi(t) = \mathcal{L}^{-1}\{\phi(s)\} = \begin{bmatrix} (2e^{-t} - e^{-2t}) & (-2e^{-t} + 2e^{-2t}) \\ (e^{-t} - e^{-2t}) & (-e^{-t} + 2e^{-2t}) \end{bmatrix} . \tag{9.90}$$

Figure 9.17. Time response of the state variables of the RLC network for $x_1(0) = x_2(0) = 1$.

Figure 9.18. Trajectory of the state vector in the (x_1 vs. x_2)-plane.

The evaluation of the time response of the RLC network to various initial conditions and input signals can now be evaluated by utilizing Eq. (9.79). For example, when $x_1(0) = x_2(0) = 1$ and $u(t) = 0$, we have

$$\begin{bmatrix} x_1(t) \\ x_2(t) \end{bmatrix} = \phi(t) \begin{bmatrix} 1 \\ 1 \end{bmatrix} = \begin{bmatrix} e^{-2t} \\ e^{-2t} \end{bmatrix}. \tag{9.91}$$

The response of the system for these initial conditions is shown in Fig. 9.17. The trajectory of the state vector $[x_1(t), x_2(t)]$ on the (x_1 vs. x_2)-plane is shown in Fig. 9.18.

The evaluation of the time response is facilitated by the determination of the transition matrix. Although this approach is limited to linear systems, it is a powerful method and utilizes the familiar signal-flow graph to evaluate the transition matrix.

9.7 A Discrete-Time Evaluation of the Time Response

The response of a system represented by a state vector differential equation can be obtained by utilizing a *discrete-time approximation*. The discrete-time approximation is based on the division of the time axis into sufficiently small time incre-

ments. Then the values of the state variables are evaluated at the successive time intervals; that is, $t = 0, T, 2T, 3T, \ldots$, where T is the increment of time $\Delta t = T$. This approach is a familiar method utilized in numerical analysis and digital computer numerical methods. If the time increment, T, is sufficiently small compared with the time constants of the system, the response evaluated by discrete-time methods will be reasonably accurate.

The linear state vector differential equation is written as

$$\dot{\mathbf{x}} = \mathbf{A}\mathbf{x} + \mathbf{B}\mathbf{u}. \tag{9.92}$$

The basic definition of a derivative is

$$\dot{\mathbf{x}}(t) = \lim_{\Delta t \to 0} \frac{\mathbf{x}(t + \Delta t) - \mathbf{x}(t)}{\Delta t}. \tag{9.93}$$

Therefore we can utilize this definition of the derivative and determine the value of $\mathbf{x}(t)$ when t is divided in small intervals $\Delta t = T$. Thus, approximating the derivative as

$$\dot{\mathbf{x}} = \frac{\mathbf{x}(t + T) - \mathbf{x}(t)}{T}, \tag{9.94}$$

we substitute into Eq. (9.92) to obtain

$$\frac{\mathbf{x}(t + T) - \mathbf{x}(t)}{T} = \mathbf{A}\mathbf{x}(t) + \mathbf{B}\mathbf{u}(t). \tag{9.95}$$

Solving for $\mathbf{x}(t + T)$, we have

$$\begin{align} \mathbf{x}(t + T) &= T\mathbf{A}\mathbf{x}(t) + \mathbf{x}(t) + T\mathbf{B}\mathbf{u}(t) \tag{9.96} \\ &= (T\mathbf{A} + \mathbf{I})\mathbf{x}(t) + T\mathbf{B}\mathbf{u}(t), \end{align}$$

where t is divided into intervals of width T. Therefore the time t is written as $t = kT$, where k is an integer index so that $k = 0, 1, 2, 3, \ldots$. Then Eq. (9.96) is written as

$$\mathbf{x}[(k + 1)T] = (T\mathbf{A} + \mathbf{I})\mathbf{x}(kT) + T\mathbf{B}\mathbf{u}(kT). \tag{9.97}$$

Therefore the value of the state vector at the $(k + 1)$st time instant is evaluated in terms of the values of \mathbf{x} and \mathbf{u} at the kth time instant. Equation (9.97) can be rewritten as

$$\mathbf{x}(k + 1) = \psi(t)\mathbf{x}(k) + T\mathbf{B}\mathbf{u}(k), \tag{9.98}$$

where $\psi(T) = (T\mathbf{A} + \mathbf{I})$ and the symbol T is omitted from the arguments of the variables. Equation (9.98) clearly relates the resulting operation for obtaining $\mathbf{x}(t)$ by evaluating the discrete-time approximation $\mathbf{x}(k + 1)$ in terms of the previous value $\mathbf{x}(k)$. This recurrence operation is a sequential series of calculations and is very suitable for digital computer calculation. In order to illustrate this approximate approach, let us reconsider the evaluation of the response of the *RLC* network of Fig. 9.3.

■ Example 9.8 Response of RLC network

We shall evaluate the time response of the RLC network without determining the transition matrix by using the discrete-time approximation. Therefore, as in Example 9.7, we will let $R = 3$, $L = 1$, and $C = \frac{1}{2}$. Then, as we found in Eqs. (9.27) and (9.28), the state vector differential equation is

$$\dot{\mathbf{x}} = \begin{bmatrix} 0 & -(1/C) \\ 1/L & -(R/L) \end{bmatrix} \mathbf{x} + \begin{bmatrix} +(1/C) \\ 0 \end{bmatrix} u(t) \tag{9.99}$$

$$= \begin{bmatrix} 0 & -2 \\ 1 & -3 \end{bmatrix} \mathbf{x} + \begin{bmatrix} +2 \\ 0 \end{bmatrix} u(t).$$

Now we must choose a sufficiently small time interval T so that the approximation of the derivative (Eq. 9.94) is reasonably accurate. A suitable interval T must be chosen so that the solution to Eq. (9.97) is stable. Usually we choose T to be less than one-half of the smallest time constant of the system. Therefore, since the shortest time constant of this system is 0.5 sec [recalling that the characteristic equation is $[(s + 1)(s + 2)]$, we might choose $T = 0.2$. Alternatively, if a digital computer is used for the calculations and the number of calculations is not important, we would choose $T = 0.05$ in order to obtain greater accuracy. However, we note that as we decrease the increment size, the number of calculations increases proportionally if we wish to evaluate the output from 0 to 10 sec, for example. Using $T = 0.2$ sec, Eq. (9.97) is

$$\mathbf{x}(k + 1) = (0.2\mathbf{A} + \mathbf{I})\mathbf{x}(k) + 0.2\mathbf{B}u(k). \tag{9.100}$$

Therefore

$$\psi(T) = \begin{bmatrix} 1 & -0.4 \\ 0.2 & 0.4 \end{bmatrix} \tag{9.101}$$

and

$$T\mathbf{B} = \begin{bmatrix} +0.4 \\ 0 \end{bmatrix}. \tag{9.102}$$

Now let us evaluate the response of the system when $x_1(0) = x_2(0) = 1$ and $u(t) = 0$ as in Example 9.7. The response at the first instant, when $t = T$, or $k = 0$, is

$$\mathbf{x}(1) = \begin{bmatrix} 1 & -0.4 \\ 0.2 & 0.4 \end{bmatrix} \mathbf{x}(0) = \begin{bmatrix} 0.6 \\ 0.6 \end{bmatrix}. \tag{9.103}$$

Then the response at the time $t = 2T = 0.4$ sec, or $k = 1$, is

$$\mathbf{x}(2) = \begin{bmatrix} 1 & -0.4 \\ 0.2 & 0.4 \end{bmatrix} \mathbf{x}(1) = \begin{bmatrix} 0.36 \\ 0.36 \end{bmatrix}. \tag{9.104}$$

The value of the response as $k = 2, 3, 4, \ldots$ is then evaluated in a similar manner.

Table 9.1.

Time t	0	0.2	0.4	0.6	0.8
Exact $x_1(t)$	1	0.67	0.448	0.30	0.20
Approximate $x_1(t)$, $T = 0.1$	1	0.64	0.41	0.262	0.168
Approximate $x_1(t)$, $T = 0.2$	1	0.60	0.36	0.216	0.130

Now let us compare the actual response of the system evaluated in the previous section using the transition matrix with the approximate response determined by the discrete-time approximation. We found in Example 9.7 that the exact value of the state variables, when $x_1(0) = x_2(0) = 1$, is $x_1(t) = x_2(t) = e^{-2t}$. Therefore the exact values can be readily calculated and compared with the approximate values of the time response in Table 9.1. The approximate time response values for $T = 0.1$ sec are also given in Table 9.1. The error, when $T = 0.2$, is approximately a constant equal to 0.07, and thus the percentage error compared to the initial value is 7%. When T is equal to 0.1 sec, the percentage error compared to the initial value is approximately 3.5%. If we use $T = 0.05$, the value of the approximation, when time $t = 0.2$ sec, is $x_1(t) = 0.655$, and the error has been reduced to 1.5% of the initial value.

Therefore, if one is using a digital computer to evaluate the transient response by evaluating the discrete-time response equations, a value of T equal to one-tenth of the smallest time constant of the system would be selected. The value of this method merits another illustration of the evaluation of the time response of a system.

■ Example 9.9 Time response of an epidemic

Let us reconsider the state variable representation of the spread of an epidemic disease presented in Example 9.3. The state vector differential equation was given in Eq. (9.55). When the constants are $\alpha = \beta = \gamma = 1$, we have

$$\dot{x} = \begin{bmatrix} -1 & -1 & 0 \\ 1 & -1 & 0 \\ 1 & 1 & 0 \end{bmatrix} x + \begin{bmatrix} 1 & 0 \\ 0 & 1 \\ 0 & 0 \end{bmatrix} u. \tag{9.105}$$

The characteristic equation of this system, as determined in Eq. (9.57), is $s(s^2 + s + 2) = 0$, and thus the system has complex roots. Let us determine the transient response of the spread of disease when the rate of new susceptibles is zero; that is, when $u_1 = 0$. The rate of adding new infectives is represented by $u_2(0) = 1$ and $u_2(k) = 0$ for $k \geq 1$; that is, one new infective is added at the initial time only (this is equivalent to a pulse input). The time constant of the complex roots is $1/\zeta\omega_n = 2$ sec, and therefore we will use $T = 0.2$ sec. (Note that the actual time units might be months and the units of the input in thousands.)

Then the discrete-time equation is

$$\mathbf{x}(k+1) = \begin{bmatrix} 0.8 & -0.2 & 0 \\ 0.2 & 0.8 & 0 \\ 0.2 & 0.2 & 1 \end{bmatrix} \mathbf{x}(k) + \begin{bmatrix} 0 \\ 0.2 \\ 0 \end{bmatrix} u_2(k). \qquad (9.106)$$

Therefore the response at the first instant, $t = T$, is obtained when $k = 0$ as

$$\mathbf{x}(1) = \begin{bmatrix} 0 \\ 0.2 \\ 0 \end{bmatrix}, \qquad (9.107)$$

when $x_1(0) = x_2(0) = x_3(0) = 0$. Then the input $u_2(k)$ is zero for $k \geq 1$ and the response at $t = 2T$ is

$$\mathbf{x}(2) = \begin{bmatrix} 0.8 & -0.2 & 0 \\ 0.2 & 0.8 & 0 \\ 0.2 & 0.2 & 1 \end{bmatrix} \begin{bmatrix} 0 \\ 0.2 \\ 0 \end{bmatrix} = \begin{bmatrix} -0.04 \\ 0.16 \\ 0.04 \end{bmatrix}. \qquad (9.108)$$

The response at $t = 3T$ is then

$$\mathbf{x}(3) = \begin{bmatrix} 0.8 & -0.2 & 0 \\ 0.2 & 0.8 & 0 \\ 0.2 & 0.2 & 1 \end{bmatrix} \begin{bmatrix} -0.04 \\ 0.16 \\ 0.04 \end{bmatrix} = \begin{bmatrix} -0.064 \\ 0.120 \\ 0.064 \end{bmatrix}, \qquad (9.109)$$

and the ensuing values can then be readily evaluated. Of course, the actual physical value of x_1 cannot become negative. The negative value of x_1 is obtained as a result of an inadequate model.

The discrete-time approximate method is particularly useful for evaluating the time response of nonlinear systems. The transition matrix approach is limited to linear systems, but the discrete-time approximation is not limited to linear systems and can be readily applied to nonlinear and time-varying systems. The basic state vector differential equation can be written as

$$\dot{\mathbf{x}} = \mathbf{f}(\mathbf{x}, \mathbf{u}, t), \qquad (9.110)$$

where \mathbf{f} is a function, not necessarily linear, of the state vector \mathbf{x} and the input vector \mathbf{u}. The column vector \mathbf{f} is the column matrix of functions of \mathbf{x} and \mathbf{u}. If the system is a linear function of the control signals, Eq. (9.110) becomes

$$\dot{\mathbf{x}} = \mathbf{f}(\mathbf{x}, t) + \mathbf{B}\mathbf{u}. \qquad (9.111)$$

If the system is not time-varying—that is, if the coefficients of the differential equation are constants—Eq. (9.111) is then

$$\dot{\mathbf{x}} = \mathbf{f}(\mathbf{x}) + \mathbf{B}\mathbf{u}. \qquad (9.112)$$

Let us consider Eq. (9.112) for a nonlinear system and determine the discrete-time approximation. Using Eq. (9.94) as the approximation to the derivative we have

$$\frac{\mathbf{x}(t + T) - \mathbf{x}(t)}{T} = \mathbf{f}(\mathbf{x}(t)) + \mathbf{B}\mathbf{u}(t). \tag{9.113}$$

Therefore, solving for $\mathbf{x}(k + 1)$ when $t = kT$, we obtain

$$\mathbf{x}(k + 1) = \mathbf{x}(k) + T[\mathbf{f}(\mathbf{x}(k)) + \mathbf{B}\mathbf{u}(k)]. \tag{9.114}$$

Similarly, the general discrete-time approximation to Eq. (9.110) is

$$\mathbf{x}(k + 1) = \mathbf{x}(k) + T\mathbf{f}(\mathbf{x}(k), \mathbf{u}(k), k). \tag{9.115}$$

Now let us reconsider the previous example when the system is nonlinear.

■ **Example 9.10 Improved model of an epidemic**

The spread of an epidemic disease is actually best represented by a set of nonlinear equations as

$$\begin{aligned}
\dot{x}_1 &= -\alpha x_1 - \beta x_1 x_2 + u_1(t), \\
\dot{x}_2 &= \beta x_1 x_2 - \gamma x_2 + u_2(t), \\
\dot{x}_3 &= \alpha x_1 + \gamma x_2,
\end{aligned} \tag{9.116}$$

where the interaction between the groups is represented by the nonlinear term $x_1 x_2$. Now, the transition matrix approach and the characteristic equation are not applicable because the system is nonlinear. As in the previous example, we will let $\alpha = \beta = \gamma = 1$ and $u_1(t) = 0$. Also, $u_2(0) = 1$ and $u_2(k) = 0$ for $k \geq 1$. We will again select the time increment as $T = 0.2$ sec and the initial conditions as $\mathbf{x}^T(0) = [1, 0, 0]$. Then, substituting the $t = kT$ and

$$\dot{x}_i(k) = \frac{x_i(k + 1) - x_i(k)}{T} \tag{9.117}$$

into Eq. (9.116), we obtain

$$\frac{x_1(k + 1) - x_1(k)}{T} = -x_1(k) - x_1(k)x_2(k),$$

$$\frac{x_2(k + 1) - x_2(k)}{T} = +x_1(k)x_2(k) - x_2(k) + u_2(k), \tag{9.118}$$

$$\frac{x_3(k + 1) - x_3(k)}{T} = x_1(k) + x_2(k).$$

Solving these equations for $x_i(k + 1)$ and recalling that $T = 0.2$, we have

$$x_1(k + 1) = 0.8x_1(k) - 0.2x_1(k)x_2(k),$$

$$x_2(k + 1) = 0.8x_2(k) + 0.2x_1(k)x_2(k) + 0.2u_2(k), \qquad (9.119)$$

$$x_3(k + 1) = x_3(k) + 0.2x_1(k) + 0.2x_2(k).$$

Then the response of the first instant, $t = T$, is

$$x_1(1) = 0.8x_1(0) = 0.8,$$

$$x_2(1) = 0.2u_2(k) = 0.2, \qquad (9.120)$$

$$x_3(1) = 0.2x_1(0) = 0.2.$$

Again, using Eq. (9.119) and noting that $u_2(1) = 0$, we have

$$x_1(2) = 0.8x_1(1) - 0.2x_1(1)x_2(1) = 0.608,$$

$$x_2(2) = 0.8x_2(1) + 0.2x_1(1)x_2(1) = 0.192, \qquad (9.121)$$

$$x_3(2) = x_3(1) + 0.2x_1(1) + 0.2x_2(1) = 0.40.$$

At the third instant, when $t = 3T$, we obtain

$$x_1(3) = 0.463,$$

$$x_2(3) = 0.177, \qquad (9.122)$$

$$x_3(3) = 0.56.$$

The evaluation of the ensuing values follows in a similar manner. We note that the response of the nonlinear system differs considerably from the response of the linear model considered in the previous example.

Finally, in order to illustrate the utility of the time-domain approach, let us consider a system that is both nonlinear and time-varying.

■ Example 9.11 Seasonal model of an epidemic

Let us again consider the spread of an epidemic disease which is represented by the nonlinear differential equations of Eq. (9.116) when the coefficient β is time-varying. The time variation, $\beta(t)$, might represent the cyclic seasonal variation of interaction between the susceptible group and the infected group; that is, the interaction between $x_1(t)$ and $x_2(t)$ is greatest in the winter when people are together indoors and is least during the summer. Therefore we represent the time variation of β as

$$\beta(t) = \beta_0 + \sin \omega_0 t$$

$$= 1 + \sin \left(\frac{\pi}{2} \right) t. \qquad (9.123)$$

Then, the nonlinear time-varying differential equations are

$$\dot{x}_1(t) = -\alpha_1 x_1(t) - \beta(t)x_1(t)x_2(t) + u_1(t),$$

$$\dot{x}_2(t) = \beta(t)x_1(t)x_2(t) - \gamma x_2(t) + u_2(t), \qquad (9.124)$$

$$\dot{x}_3(t) = \alpha x_1(t) + \gamma x_2(t).$$

As in Example 9.10, we will let $\alpha = \gamma = 1$, $u_1(t) = 0$, $u_2(0) = 1$ and $u_2(k) = 0$ for $k \geq 1$. Also, we will again select the time increment as $T = 0.2$ sec and the initial conditions as $\mathbf{x}^T(0) = [1, 0, 0]$. Then substituting $t = kT$ and

$$\dot{x}_i(k) = \frac{x_i(k + 1) - x_i(k)}{T} \qquad (9.125)$$

into Eq. (9.124), we obtain

$$\frac{x_1(k + 1) - x_1(k)}{T} = -x_1(k) - \beta(k)x_1(k)x_2(k),$$

$$\frac{x_2(k + 1) - x_2(k)}{T} = \beta(k)x_1(k)x_2(k) - x_2(k) + u_2(k), \qquad (9.126)$$

$$\frac{x_3(k + 1) - x_3(k)}{T} = x_1(k) + x_2(k).$$

Solving these equations for $x_i(k + 1)$ and again recalling that $T = 0.2$, we obtain

$$x_1(k + 1) = 0.8x_1(k) - 0.2\beta(k)x_1(k)x_2(k),$$

$$x_2(k + 1) = 0.8x_2(k) + 0.2\beta(k)x_1(k)x_2(k) + 0.2u_2(k), \qquad (9.127)$$

$$x_3(k + 1) = x_3(k) + 0.2x_1(k) + 0.2x_2(k).$$

Then the response at the first instant, $t = T$, is

$$x_1(1) = 0.8x_1(0) = 0.8,$$

$$x_2(1) = 0.2u_2(0) = 0.2, \qquad (9.128)$$

$$x_3(1) = 0.2x_1(0) = 0.2.$$

Noting that

$$\beta(k) = 1 + \sin(\pi/2)kT = 1 + \sin(0.314k), \qquad (9.129)$$

we evaluate the response at the second instant as

$$x_1(2) = 0.8x_1(1) - 0.2\beta(1)x_1(1)x_2(1) = 0.598,$$

$$x_2(2) = 0.8x_2(1) + 0.2\beta(1)x_1(1)x_2(1) = 0.202, \qquad (9.130)$$

$$x_3(2) = x_3(1) + 0.2x_1(1) + 0.2x_2(1) = 0.40.$$

Max. value = 1 Tmax = 0 Time interval = 0.05
Min. value = 3.354669E−04 Tmin = 4 Init. value = 1
 Fin. value = 3.354669E−04

Figure 9.19. The response of x_1 for Example 9.8 using the Control System Design Program.

The evaluation of the ensuing values of the time response follows in a similar manner by using Eq. (6.129) to account for the time-varying parameter.

The evaluation of the time response of the state variables of linear systems is readily accomplished by using either (1) the transition matrix approach or (2) the discrete-time approximation. The transition matrix of linear systems is readily obtained from the signal-flow graph state model. For a nonlinear system, the discrete-time approximation provides a suitable approach, and the discrete-time approximation method is particularly useful if a digital computer is used for numerical calculations.

The Control System Design Program (CSDP) will readily calculate the state response, obtaining

$$x[(n + 1)T] = \phi(T)x(nT) + \mathbf{T}u(nT).$$

For example, the response of x_1 for Example 9.8 is shown in Fig. 9.19 [14].

9.8 Design Example: Automatic Test System

An automatic test and inspection system uses a dc motor to move a set of test probes, as shown in Fig. 9.20. Low throughput and a high degree of error are

Figure 9.20. Automatic test system.

Figure 9.21. A dc motor with mounted encoder wheel.

possible from manually testing various panels of switches, relay, and indicator lights. Automating the test from a controller requires placing a plug across the leads of a part, and testing for continuity, resistance, or functionality. The system uses a dc motor with an encoded disk to measure position and velocity, as shown in Fig. 9.21. The parameters of the system are shown in Fig. 9.22 with K representing the required power amplifier.

We select the state variables as $x_1 = \Theta$, $x_2 = d\Theta/dt$, and $x_3 = i_f$, as shown in Fig. 9.23. State variable feedback is available, and we let

$$u = [-K_1, -K_2, -K_3]\mathbf{x}$$

or

$$u = -K_1x_1 - K_2x_2 \quad K_3x_3, \tag{9.131}$$

as shown in Fig. 9.24. The goal is to select the gains so that the response to a step command has a settling time of less than two seconds and an overshoot of less than 4.0%.

In order to achieve accurate output position, we let $K_1 = 1$ and determine K, K_2, and K_3. The characteristic equation of the system may be obtained several ways.

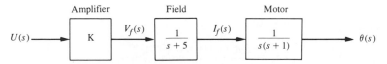

Figure 9.22. Block diagram.

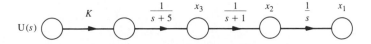

Figure 9.23. Signal flow graph.

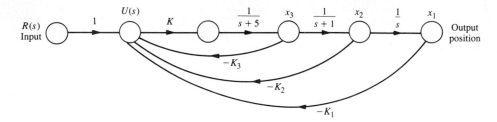

Figure 9.24. Feedback system.

Since $u = \mathbf{hx}$ is already given in Eq. (9.131), we use Fig. 9.23 to obtain

$$\dot{\mathbf{x}} = \mathbf{Ax} + \mathbf{bu}$$

$$= \begin{bmatrix} 0 & 1 & 0 \\ 0 & -1 & 1 \\ 0 & 0 & -5 \end{bmatrix} \mathbf{x} + \begin{bmatrix} 0 \\ 0 \\ K \end{bmatrix} u \tag{9.132}$$

Adding u as defined by Eq. (9.131), we have

$$\dot{\mathbf{x}} = \begin{bmatrix} 0 & 1 & 0 \\ 0 & -K & 1 \\ -K & -KK_2 & -(5 + K_3 K) \end{bmatrix} \mathbf{x} \tag{9.133}$$

when $K_1 = 1$. The characteristic equation can also be readily obtained from Fig. 9.24 by letting $G(s)$ be the forward path transfer function and letting $H(s)$ be the equivalent feedback transfer function of Fig. 9.25. Then

$$G(s) = \frac{K}{s(s + 1)(s + 5)}$$

and

$$H(s) = K_1 + sK_2 + K_3(s + 1)s$$

$$= K_3 \left[s^2 + \frac{K_2 + K_3}{K_3} s + \frac{K_1}{K_2} \right] \tag{9.134}$$

Thus we can plot a root locus for $K_3 K$ as

$$1 + \frac{KK_3(s^2 + as + b)}{s(s + 1)(s + 5)} = 0, \tag{9.135}$$

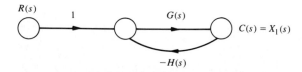

Figure 9.25. Equivalent model of feedback system.

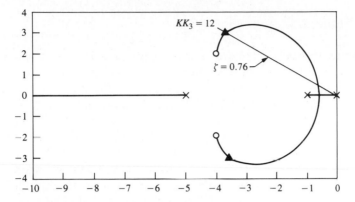

Figure 9.26. Root locus for automatic test system.

where a and b are chosen by selecting K_2 and K_3. Letting $K_1 = 1$ and setting $a = 8$ and $b = 30$, we place the zeros at $s = -4 \pm j2$ in order to pull the locus to the left in the s-plane. Then,

$$\frac{K_2 + K_3}{K_3} = 8 \quad \text{and} \quad \frac{1}{K_3} = 20.$$

Therefore $K_1 = 1$, $K_2 = 0.35$, and $K_3 = 0.05$. A plot of the root locus is shown in Fig. 9.26. When $KK_3 = 12$, the roots lie on the $\zeta = 0.76$ line, as shown in Fig. 9.26. Then, since $K_3 = 0.05$, we have $K = 240$. The roots at $K = 240$ are

$$s = -10.62, \quad s = -3.69 \pm j3.00.$$

The step response of this system is shown in Fig. 9.27. The overshoot is 3% and the settling time is 1.8 seconds. Thus the design is quite acceptable.

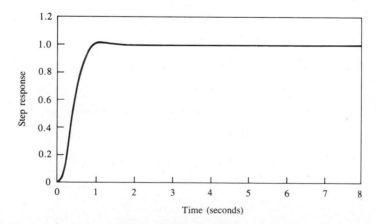

Figure 9.27. Step response.

9.9 Summary

In this chapter we have considered the description and analysis of systems in the time domain. The concept of the state of a system and the definition of the state variables of a system were discussed. The selection of a set of state variables in terms of the variables that describe the stored energy of a system was examined, and the nonuniqueness of a set of state variables was noted. The state vector differential equation and the solution for $x(t)$ were discussed. Two alternative signal-flow graph model structures were considered for representing the transfer function (or differential equation) of a system. Using Mason's gain formula, we noted the ease of obtaining the flow-graph model. The vector differential equation representing these flow-graph models was also examined. Then the stability of a system represented by a state variable formulation was considered in terms of the vector differential equation. The time response of a linear system and its associated transition matrix was discussed and the utility of Mason's gain formula for obtaining the transition matrix was illustrated. Finally, a discrete-time evaluation of the time response of a nonlinear system and a time-varying system were considered. It was noted that the flow-graph state model is equivalent to an analog computer diagram where the output of each integrator is a state variable. Also, we found that the discrete-time approximation for a time response, as well as the transition matrix formulation for linear systems, is readily applicable for programming and solution by using a digital computer. The time-domain approach is applicable to biological, chemical, sociological, business, and physiological systems as well as to physical systems and thus appears to be an approach of general interest.

Exercises

E9.1. For the circuit shown in Fig. E9.1 identify a set of state variables.

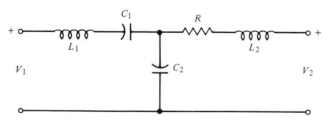

Figure E9.1. RLC motor.

E9.2. A robot-arm drive system for one joint can be represented by the differential equation [1]

$$\frac{dv(t)}{dt} = -k_1 v(t) - k_2 y(t) + k_3 i(t),$$

where $v(t)$ = velocity, $y(t)$ = position, and $i(t)$ is the control-motor current. Put the equations in state-variable form and set up the matrix form for $k_1 = k_2 = 1$.

E9.3. A system can be represented by the state vector differential equation of Eq. (9.16) where

$$A = \begin{bmatrix} 0 & 1 \\ -1 & -1 \end{bmatrix}.$$

Find the characteristic roots of the system.

Answer: $s = -\frac{1}{2} \pm j\sqrt{3}/2$

E9.4. A system is represented by Eq. (9.16) where

$$A = \begin{bmatrix} 0 & 1 & 0 \\ 0 & 0 & 1 \\ -1 & -k & -2 \end{bmatrix}.$$

Find the range of k where the system is stable.

E9.5. A system is represented by a flow graph as shown in Fig. E9.5. Write the state equations for this flow graph in the form of Eqs. (9.16) and (9.17).

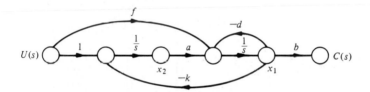

Figure E9.5. System flow graph.

E9.6. A system is represented by Eq. (9.16) where

$$A = \begin{bmatrix} 0 & 1 \\ 0 & 0 \end{bmatrix}.$$

(a) Find the matrix $\phi(t)$. (b) For the initial conditions $x_1(0) = x_2(0) = 1$, find $\mathbf{x}(t)$.

Answer: (b) $x_1 = (1 + t)$, $x_2 = 1$, $t \geq 0$

E9.7. Consider the spring and mass shown in Fig. 9.2 where $M = 1$, $K = 100$, and $f = 20$. (a) Find the state vector differential equation. (b) Find the roots of the characteristic equation for this system.

E9.8. The manual low-altitude hovering task above a moving landing deck of a small ship is very demanding, in particular, in adverse weather and sea conditions. The hovering condition is shown in Fig. E9.8. The A matrix is

$$A = \begin{bmatrix} 0 & 1 & 0 \\ 0 & 0 & 1 \\ 0 & -4 & -1 \end{bmatrix}.$$

Find the roots of the characteristic equation.

Figure E9.8. Helicopter hovering task.

Figure E9.9. Single leg control.

E9.9. The ability to balance actively is a key ingredient in the mobility of a device that hops and runs on one springy leg as shown in Fig. E9.9 [21], on the previous page. The control of the attitude of the device uses a gyroscope as shown and a feedback such that $\mathbf{u} = \mathbf{Hx}$ where

$$\mathbf{H} = \begin{bmatrix} -1 & 0 \\ 0 & -k \end{bmatrix}$$

and

$$\mathbf{A} = \begin{bmatrix} 0 & 1 \\ 1 & 0 \end{bmatrix}.$$

Determine a value for k so that the response of each hop is critically damped.

E9.10. A hovering vehicle (flying saucer) control system is represented by two state variables and [17]

$$A = \begin{bmatrix} 0 & 6 \\ -1 & -5 \end{bmatrix}.$$

(a) Find the roots of the characteristic equation. (b) Find the transition matrix $\phi(t)$.

E9.11. A fruit-picker robot is shown in Fig. E.9.11. This system may be represented by the state equations of Fig. 9.11. Using the Control System Design Program obtain x_1 and $c(t)$.

Figure E9.11. Fruit-picker robot.

E9.12. Use a state variable model to describe the circuit of Fig. E9.12. Obtain the response to an input unit step when the initial current is zero and the initial capacitor voltage is zero. Use the Control System Design Program to obtain the plot.

Figure E9.12. RLC series circuit.

E9.13. A system is described by two differential equations as

$$\frac{dy}{dt} + y - 2u + aw = 0$$

$$\frac{dw}{dt} - by + 4u = 0,$$

where w and y are functions of time, and u is an input $u(t)$. (a) Select a set of state variables. (b) Write the matix differential equation and specify the elements of the matrices. (c) Determine the range of values of the parameters a and b for a stable system. (d) Find the characteristic roots of the system in terms of the parameters a and b.

Answers: (c) $ab \geq 0$, (d) $s = -\frac{1}{2} \pm \frac{\sqrt{1 - 4ab}}{2}$

E9.14. Develop the state space representation of a radioactive material of mass M to which additional radioactive material is added at the rate $r(t) = Ku(t)$, where K is a constant. Identify the state variables.

Problems

P9.1. An *RLC* circuit is shown in Fig. P9.1. (a) Identify a suitable set of state variables. (b) Obtain the set of first-order differential equations in terms of the state variables. (c) Write the state equations in matrix form. (d) Draw the state variable flow graph.

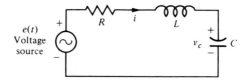

Figure P9.1. RLC circuit.

P9.2. A *balanced* bridge network is shown in Fig. P9.2. (a) Show that the **A** and **B** matrices for this circuit are

$$\mathbf{A} = \begin{bmatrix} -(2/(R_1 + R_2)C & 0 \\ 0 & 2R_1R_2/(R_1 + R_2)L \end{bmatrix},$$

$$\mathbf{B} = 1/(R_1 + R_2)\begin{bmatrix} 1/C & 1/C \\ R_2/L & -R_2/L \end{bmatrix}.$$

(b) Draw the state model flow graph. The state variables are $(x_1, x_2) = (v_c, i_l)$.

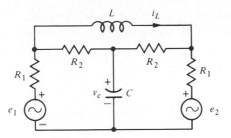

Figure P9.2. Balanced bridge network.

P9.3. An RLC network is shown in Fig. P9.3. Define the state variables as $x_1 = i_L$ and $x_2 = v_c$. (a) Obtain the vector differential cquation. (b) Draw the state model flow graph.

Partial answer:

$$\mathbf{A} = \begin{bmatrix} 0 & 1/L \\ -(1/C) & (1/RC) \end{bmatrix}.$$

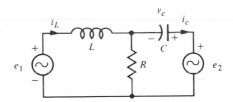

Figure P9.3. RLC circuit.

P9.4. The transfer function of a system is

$$T(s) = \frac{C(s)}{R(s)} = \frac{s^2 + 2s + 3}{s^3 + 2s^2 + 3s + 4}.$$

(a) Draw the flow-graph state model where all the state variables are fed back to the input node and the state variables are fed forward to the ouput signal, as in Fig. 9.7. (b) Determine the vector differential equation for the flow graph of (a). (c) Draw the flow-graph state model where the input signal is fed forward to the state variables, as in Fig. 9.9. (d) Determine the vector differential equation for the flow graph of (c).

P9.5. A closed-loop control system is shown in Fig. P9.5. (a) Determine the closed-loop transfer function $T(s) = C(s)/R(s)$. (b) Draw the state model flow graph for the system using the form of Fig. 9.7, where the state variables are fed back to the input node. (c) Determine the state vector differential equation.

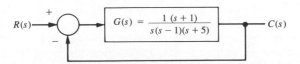

Figure P9.5. Closed-loop control system.

P9.6. Consider the case of the rabbits and foxes in Australia. The number of rabbits is x_1 and if left alone would grow indefinitely (until the food supply was exhausted) so that [7]

$$\dot{x}_1 = kx_1.$$

However, with foxes present on the continent, we have

$$\dot{x}_1 = kx_1 - ax_2,$$

where x_2 is the number of foxes. Now, if the foxes must have rabbits to exist, we have

$$\dot{x}_2 = -hx_2 + bx_1.$$

Determine if this system is stable and thus decays to the condition $x_1(t) = x_2(t) = 0$ at $t = \infty$. What are the requirements on a, b, h, and k for a stable system? What is the result when k is greater than h?

P9.7. An automatic depth-control system for a robot submarine is shown in Fig. P9.7. The depth is measured by a pressure transducer. The gain of the stern plane actuator is $K = 1$ when the velocity is 25 m/sec. The submarine has the approximate transfer function

$$G(s) = \frac{(s + 1)^2}{(s^2 + 1)},$$

and the feedback transducer is $H(s) = 1$. (a) Obtain a flow-graph state model. (b) Determine the vector differential equation for the system. (c) Determine whether the system is stable.

Figure P9.7. Submarine depth control.

P9.8. The soft landing of a lunar module descending on the moon can be modeled as shown in Fig. P9.8, on the next page. Define the state variables as $x_1 = y$, $x_2 = dy/dt$, $x_3 = m$ and the control as $u = dm/dt$. Assume that g is the gravity constant on the moon. Find the state-space equations for this system. Is this a linear model?

P9.9. A speed-control system utilizing fluid flow components can be designed. The system is a pure fluid-control system because the system does not have any moving mechanical parts. The fluid may be a gas or a liquid. A system is desired which maintains the speed within 0.5% of the desired speed by using a tuning fork reference and a valve actuator. Fluid-control systems are insensitive and reliable over a wide range of temperature, electromagnetic and nuclear radiation, acceleration, and vibration. The amplification within the system is achieved by using a fluid jet deflection amplifier. The system can be designed for a 500-kw steam turbine with a speed of 12,000 rpm. The block diagram of the system is shown in Fig. P9.9. The friction of the large inertia turbine is negligible and thus $f = 0$.

Figure P9.8. Lunar module landing control.

Figure P9.9. Steam turbine control.

The closed-loop gain is $K_1/J = 1$, where $K_1 = J = 10^4$. (a) Determine the closed-loop transfer function

$$T(s) = \frac{\omega(s)}{R(s)},$$

and draw the state model flow graph for the form of Fig. 9.7, where all the state variables are fed back to the input node. (b) Determine the state vector differential equation. (c) Determine whether the system is stable by investigating the characteristic equation obtained from the **A** matrix.

P9.10. Many control systems must operate in two dimensions, for example, the x- and and y-axes. A two-axis control system is shown in Fig. P9.10, on the next page, where a set of state variables is identified. The gain of each axis is K_1 and K_2 respectively. (a) Obtain the state vector differential equation. (b) Find the characteristic equation from the **A** matrix, and determine whether the system is stable for suitable values of K_1 and K_2.

P9.11. Consider the problem of rabbits and foxes in Australia as discussed in Problem P9.6. The values of the constants are $k = 1$, $h = 3$, and $a = b = 2$. Is this system stable? (a) Determine the transition matrix for this system. (b) Using the transition matrix, determine the response of the system when $x_1(0) = x_2(0) = 10$.

P9.12. The potential for an electrically propelled car for general use has been demonstrated [19]. One electric vehicle that has been built using a microprocessor for control of

Figure P9.10. Two-axis control system.

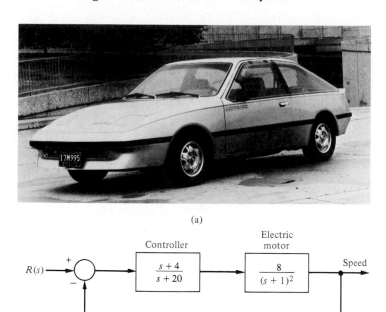

(a)

(b)

Figure P9.12. (a) An electric vehicle that has been built using a microprocessor for control of the motor and diagnostics. (b) A block diagram of the motor control system. (Photo courtesy of General Electric.)

the motor and diagnostics is shown in Fig. P9.12(a). This vehicle has a 75-mile range and is able to travel at up to 50 mph on a 5% grade. The block diagram of the motor control system is shown in Fig. P9.12(b). (a) Determine a flow-graph representation of this system. (b) Obtain the transition matrix $\phi(t)$. (c) Is the system stable?

P9.13. Reconsider the *RLC* circuit of Problem P9.1 when $R = 2.5$, $L = \frac{1}{4}$, and $C = \frac{1}{6}$. (a) Determine whether the system is stable by finding the characteristic equation with the aid of the **A** matrix. (b) Determine the transition matrix of the network. (c) When the initial inductor current is 0.1 amp, $v_c(0) = 0$, and $e(t) = 0$, determine the response of the system. (d) Repeat part (b) when the initial conditions are zero and $e(t) = E$, for $t > 0$, where E is a constant.

P9.14. Consider the system discussed in Problem P9.5. (a) Determine whether the system is stable by obtaining the characteristic equation from the **A** matrix. (b) An additional feedback signal is to be added in order to stabilize the system. If $R(s) = -KsC(s)$, the state variable x_2 is fed back so that $r(t) = Kx_2(t)$. Determine the minimum value of K so that the system is stable.

P9.15. Reconsider the rabbits-and-foxes ecology discussed in Problems P9.6 and P9.11 when we take the depletion of food into account. Then we have

$$\dot{x}_1 = kx_1 - ax_2 + ax_3,$$

$$\dot{x}_2 = -hx_2 + bx_1,$$

$$\dot{x}_3 = \beta x_3 - \gamma x_1,$$

where $x_3 =$ the amount of rabbit food per unit area. Again, assume that $k = 1$, $h = 3$, and $a = b = 2$. In this case $\beta = 1$ and $\alpha = 0.1$. Determine a suitable value for γ in order to eliminate the rabbits.

P9.16. A system for dispensing radioactive fluid into capsules is shown in Fig. P9.16(a). The horizontal axis moving the tray of capsules is actuated by a linear motor. The x-axis control is shown in Fig. P9.16(b). Obtain (a) a state-variable representation and (b) the time-response of the system. (c) Determine the characteristic roots of the system.

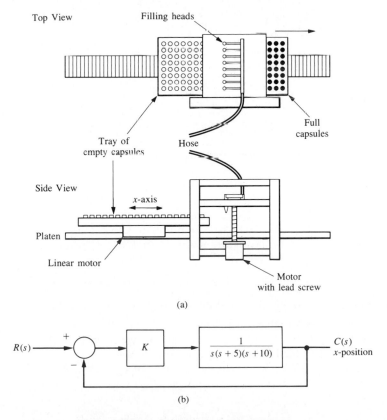

Figure P9.16. Automatic fluid dispenser.

P9.17. The dynamics of a controlled submarine are significantly different from those of an aircraft, missile, or surface ship. This difference results primarily from the moment in the vertical plane due to the buoyancy effect. Therefore it is interesting to consider the control of the depth of a submarine. The equations describing the dynamics of a submarine can be obtained by using Newton's laws and the angles defined in Fig. P9.17. In order to simplify the equations, we will assume that θ is a small angle and the velocity v is constant and equal to 25 ft/sec. The state variables of the submarine, considering only vertical control, are $x_1 = \theta$, $x_2 = d\theta/dt$ and $x_3 = \alpha$, where α is the angle of attack. Thus the state vector differential equation for this system, when the submarine has an Albacore type hull, is

$$
\dot{\mathbf{x}} = \begin{bmatrix} 0 & 1 & 0 \\ -0.0071 & -0.111 & 0.12 \\ 0 & 0.07 & -0.3 \end{bmatrix} \mathbf{x} + \begin{bmatrix} 0 \\ -0.095 \\ +0.072 \end{bmatrix} u(t),
$$

where $u(t) = \delta_s(t)$, the deflection of the stern plane. (a) Determine whether the system is stable. (b) Using the discrete-time approximation, determine the response of the system to a stern plane step command of $0.285°$ with the initial conditions equal to zero. Use a time increment of T equal to 2 sec. (c) (optional) Using a time increment of $T = 1$ sec and a digital computer, obtain the transient response for each state for 80 sec. Compare the response calculated for (b) and (c).

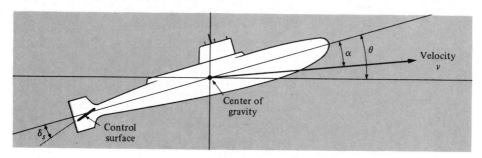

Figure P9.17. Submarine depth control.

P9.18. An interesting mechanical system with a challenging control problem is the ball and beam shown in Fig. P9.18(a), on the next page. It consists of a rigid beam which is free to rotate in the plane of the paper around a center pivot, with a solid ball rolling along a groove in the top of the beam. The control problem is to position the ball at a desired point on the beam using a torque applied to the beam as a control input at the pivot.

A linear model of the system with a measured value of the angle ϕ and its angular velocity $\dfrac{d\phi}{dt} = \omega$ is available. Select a feedback scheme so that the response of the closed-loop system has an overshoot of 4% and the settling time is 1 sec for a step input.

P9.19. Consider the control of the robot shown in Fig. P9.19(a), on page 478. The motor turning at the elbow moves the wrist through the forearm, which has some flexibility as represented by Fig. 9.19(b). The spring has a spring constant k and friction damping constant f. Let the state variables be $x_1 = \phi_1 - \phi_2$ and $x_2 = \omega_2/\omega_0$, where

$$
\omega_0^2 = \frac{k(J_1 + J_2)}{J_1 J_2}.
$$

Write the state variable equation in matrix form.

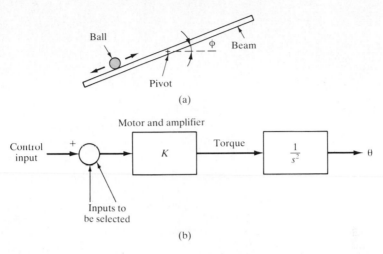

Figure P9.18. (a) Ball and beam. (b) Model of the ball and beam.

P9.20. The derivative of a state variable can be approximated by the equation

$$\dot{x}(t) \simeq \frac{1}{2T}[3x(k + 1) - 4x(k) + x(k - 1)].$$

This approximation of the derivative utilizes two past values to estimate the derivative, whereas Eq. (9.94) uses one past value of the state variable. Using this approximation for the derivative, repeat the calculations for Example 9.8. Compare the resulting approximation for $x_1(t)$, $T = 0.2$, with the results given in Table 9.1. Is this approximation more accurate?

P9.21. There are several forms that are equivalent signal-flow graph state models. Two equivalent state flow-graph models for a fourth-order equation (Eq. 9.36) are shown in Fig. 9.7 and Fig. 9.9. Another alternative structure for a state flow-graph model is shown in Fig. P9.21, on the next page. In this case the system is second order and the input-output transfer function is

$$G(s) = \frac{C(s)}{U(s)} = \frac{b_1 s + b_0}{s^2 + a_1 s + a_0}.$$

(a) Verify that the flow graph of Fig. P9.21 is in fact a model of $G(s)$. (b) Show that the vector differential equation representing the flow-graph model of Fig. P9.21 is

$$\dot{\mathbf{x}} = \begin{bmatrix} 0 & 1 \\ -a_0 & -a_1 \end{bmatrix} \mathbf{x} + \begin{bmatrix} h_1 \\ h_0 \end{bmatrix} u(t),$$

where $h_1 = b_1$ and $h_0 = b_0 - b_1 a_1$.

P9.22. A nuclear reactor that has been operating in equilibrium at a high thermal-neutron flux level is suddenly shut down. At shutdown, the density of xenon 135(X) and iodine 135(I) are 3×10^{15} and 7×10^{16} atoms per unit volume, respectively. The half lives of I 135 and Xe 135 nucleides are 6.7 and 9.2 hours, respectively. The decay equations are

$$\dot{I} = -\frac{0.693}{6.7} I,$$

$$\dot{X} = -\frac{0.693}{9.2} X - I.$$

(a)

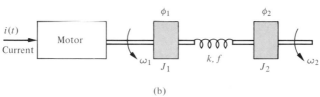

(b)

Figure P9.19. (a) An industrial robot. (Courtesy of GCA Corporation.)

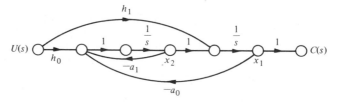

Figure P9.21. Model of second-order system.

Determine the concentrations of I 135 and Xe 135 as functions of time following shutdown by determining (a) the transition matrix and the system response, and (b) a discrete-time evaluation of the time response. Verify that the response of the system is that shown in Fig. P9.22.

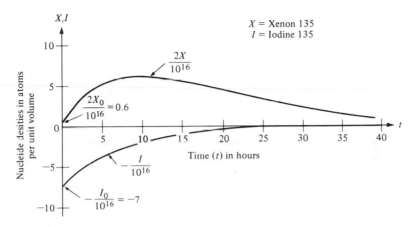

Figure P9.22. Nuclear reactor response.

P9.23. Consider the following mathematical model of the social interaction of humans that is often called group dynamics. The four system variables of interest are (1) the intensity of interaction (or communication) among the members of the group, $x_1(t)$; (2) the amount of friendliness or group identification among group members, $x_2(t)$; (3) the total amount of activity carried on by a member of the group, $x_3(t)$; (4) the amount of activity imposed on the group by its external environment, $u(t)$. A simple model might be represented by the set of equations [7]

$$\dot{x}_1 = a_1 x_2 + a_2 x_3,$$

$$\dot{x}_2 = b(x_1 - \beta x_2),$$

$$\dot{x}_3 = c_1(x_2 - \gamma x_3) + c_2(u - x_3).$$

The first equation indicates that interaction results from friendliness or activity. The second equation indicates that friendliness will increase as the amount of interaction grows larger than friendliness. The third equation relates the effect of all variables on a change of activity. (a) Determine the requirements on the coefficients for a stable system. When the system is stable, the changes in the variables evidently decay to zero, and equilibrium is attained when $u(t) = 0$. Determine the values of the variables at equilibrium when $u(t) = 0$. Is this representative of the social disintegration of the group? Is an external force $u(t)$ required to maintain the group activity? (b) The problem of group morale has also been studied with the aid of this model. A group is said to have positive morale when the activity $x_3(t)$ exceeds that required by an external social force $u(t) = U$, where U is a constant. Determine the necessary relationship for the coefficients a_1, a_2, β, and γ for positive morale. (c) Determine the transient response of a group, such as a college social fraternity, which is highly active and is subjected to a high level of external social forces, $u(t) = U$. Assume that initially $x_1(0) = x_2(0) = x_3(0) = 0$, that $a_1 = a_2 = b = \beta = c_1 = c_2 = 1$, and $\gamma = -2$.

P9.24. Consider the automatic ship steering system discussed in Problems P7.13 and P8.16. The state variable form of the system differential equation is

$$\dot{\mathbf{x}}(t) = \begin{bmatrix} -0.05 & -6 & 0 & 0 \\ -10^{-3} & -0.15 & 0 & 0 \\ 1 & 0 & 0 & 13 \\ 0 & 1 & 0 & 0 \end{bmatrix} \mathbf{x}(t) + \begin{bmatrix} -0.2 \\ 0.03 \\ 0 \\ 0 \end{bmatrix} \delta(t),$$

where $\mathbf{x}^T(t) = [\dot{v}, \omega_s, y, \theta]$. The state variables are $x_1 = \dot{v} =$ the transverse velocity; $x_2 = \omega_s =$ angular rate of ship's coordinate frame relative to response frame; $x_3 = y =$ deviation distance on an axis perpendicular to the track; $x_4 = \theta =$ deviation angle. (a) Determine whether the system is stable. (b) Feedback can be added so that

$$\delta(t) = -k_1 x_1 - k_3 x_3.$$

Determine whether this system is stable for suitable values of k_1 and k_3.

P9.25. It is desirable to use well-designed controllers to maintain building temperature with solar collector space heating systems. One solar heating system can be described by [10]

$$\frac{dx_1}{dt} = 3x_1 + u_1 + u_2,$$

$$\frac{dx_2}{dt} = 2x_2 + u_2 + d,$$

where $x_1 =$ temperature deviation from desired equilibrium and $x_2 =$ temperature of the storage material (such as a water tank). Also, u_1 and u_2 are the respective flow rates of conventional and solar heat, where the transport medium is forced air. A solar disturbance on the storage temperature (such as overcast skies) is represented by d. Write the matrix equations and solve for the system response from equilibrium when $u_1 = 0$, $u_2 = 1$, and $d = 1$.

P9.26. For the fourth-order system of Problem P4.12, determine the state vector equations. Then for the approximate second-order model determine the state vector equations and compare with the fourth-order equations.

P9.27. Consider a model of the interaction of the OPEC nations and the United States. The OPEC nations want to increase the price of their oil and maintain control over their destiny. The United States wishes to decrease the price of the imported oil and decrease the OPEC nations' control. The two state variables are price, p, and control, c. One model is then

$$p(k + 1) = p(k) - u_1(k) + u_2(k),$$

$$c(k + 1) = c(k) - u_1(k) + u_2(k),$$

where $u_1(k) =$ action by the United States, and $u_2(k) =$ action by OPEC. The United States selects a control action so that $u_1(k) = 0.5p(k)$, and OPEC selects $u_2(k) = 0.4c(k - 1)$. Examine the response of this system for several time periods. What will be the ultimate outcome if this model is a true representation? Assume that $p(0) = c(0) = 10$ and $c(-1) = 10$. Reexamine the situation if $u_2(k) = 0.6c(k)$.

P9.28. A gyroscope with a single degree of freedom is shown in Fig. P9.28. Gyroscopes sense the angular motion of a system and are used in automatic flight control systems. The gimbal moves about the output axis OB. The input is measured around the input axis OA.

Figure P9.28. Gyroscope.

The equation of motion about the output axis is obtained by equating the rate of change of angular momentum to the sum of torques. Obtain a state-space representation of the gyro system.

P9.29. An *RL* circuit is shown in Fig. P9.29. (a) Select the two stable variables and obtain the vector differential equation where the output is $v_0(t)$. (b) Determine if the state variables are observable when $R_1/L_1 = R_2/L_2$. (c) Find the conditions when the system has two equal roots.

Figure P9.29. RLC circuit.

P9.30. There has been considerable engineering effort directed at finding ways to perform manipulative operations in space—for example, assembling a space station and acquiring target satellites. To perform such tasks, space shuttles carry a remote manipulator system (RMS) in the cargo bay [11]. The RMS has proven its effectiveness on recent shuttle missions, but now a new design approach is being considered—a manipulator with inflatable arm segments. Such a design might reduce manipulator weight by a factor of four while producing a manipulator that, prior to inflation, occupies only one-eighth as much space in the shuttle's cargo bay as the present RMS.

The use of an RMS for constructing a space structure in the shuttle bay is shown in Fig. P9.30(a), and a model of the flexible RMS arm is shown in Fig. P9.30(b), where J is the inertia of the drive motor and L is the distance to the center of gravity of the load component. Derive the state equations for this system.

(a)

(b)

Figure P9.30. Remote manipulator system.

P9.31. A manipulator control system has a plant transfer function of

$$G(s) = \frac{1}{s(s + 0.4)}$$

and negative unity feedback [22]. Represent this system by a state-variable signal-flow graph and a vector differential equation. (a) Plot the response of the closed-loop system to a step input. (b) Use state variable feedback so that the overshoot is 5% and the settling time is 1.35 sec. (c) Plot the response of the state variable feedback system to a step input.

P9.32. Obtain the state equations for the two-input and one-output circuit shown in Fig. P9.32, where the output is i_2.

Figure P9.32. Two-input RLC circuit.

Figure P9.33. Extender for increasing the strength of the human arm in load maneuvering tasks.

P9.33. Extenders are robot manipulators which extend (i.e., increase) the strength of the human arm in load maneuvering tasks (Fig. P9.33) [23]. The system is represented by the transfer function

$$\frac{C(s)}{U(s)} = G(s) = \frac{1}{s^2 + 4s + 3}.$$

Using the form in Fig. 9.6, determine the state variable equations and the state transition matrix.

P9.34. A drug taken orally is ingested at a rate r. The mass of the drug in the gastrointestinal tract is denoted by m_1 and in the bloodstream by m_2. The rate of change of the mass of the drug in the gastrointestinal tract is equal to the rate at which the drug is ingested minus the rate at which the drug enters the blood stream, a rate that is taken to be proportional to the mass present. The rate of change of the mass in the blood stream is proportional to the amount coming from the gastrointestinal tract minus the rate at which mass is lost by metabolism, which is proportional to the mass present in the blood. Develop the state space representation of this system.

For the special case where the coefficients of A are equal to 1 (with the appropriate sign), determine the response when $m_1(0) = 1$ and $m_2(0) = 0$. Plot the state variables versus time and on the $x_1 - x_2$ state plane.

P9.35. The dynamics of a rocket are represented by

$$\frac{C(s)}{U(s)} = G(s) = \frac{1}{s^2},$$

and state variable feedback is used where $x_1 = c(t)$ and $u = -x_2 - 0.5x_1$. Determine the roots of the characteristic equation of this system and the response of the system when the initial conditions are $x_1(0) = 0$ and $x_2(0) = 1$.

Design Problems

DP9.1. A spring-mass-damper system, as shown in Fig. 9.2, is used as a shock absorber for a large high-performance motorcycle. The original parameters selected are $m = 1$ kg, $f = 9$ N·s/m, and $k = 20$ N/m. (a) Determine the system matrix, the characteristic roots,

and the transition matrix, $\phi(t)$. The harsh initial conditions are assumed to be $y(0) = 1$ and $dy/dt\vert_{t=0} = 2$. (b) Plot the response of $y(t)$ and dy/dt for the first two seconds. (c) Redesign the shock absorber by changing the spring constant and the damping constant in order to reduce the effect of a high rate of acceleration force, d^2y/dt^2, on the rider. The mass must remain constant at 1 kg.

DP9.2. The motion control of a lightweight hospital transport vehicle can be represented by a system of two masses is shown in Fig. DP9.2, where $m_1 = m_2 = 1$ and $k_1 = k_2 = 1$ [24]. (a) Determine the state vector differential equation. (b) Find the roots of the characteristic equation. (c) We wish to stabilize the system by letting $u = -kx_i$, where u is the force on the lower mass and x_i is one of the state variables. Select an appropriate state variable x_i. (d) Choose a value for the gain k and sketch the root locus as k varies.

Figure DP9.2. Model of hospital vehicle.

DP9.3. Consider the inverted pendulum mounted to a motor, as shown in Fig. DP9.3. The motor and load are assumed to have no friction damping. The pendulum to be balanced is attached to the horizontal shaft of a servomotor. The servomotor carries a tach-

Figure DP9.3. Motor and inverted pendulum.

ogenerator, so that a velocity signal is available, but there is no position signal. When the motor is unpowered, the pendulum will hang vertically downward and if slightly disturbed will perform oscillations. If the pendulum is lifted to the top of its arc, it is unstable in that position. Devise a feedback compensator, $G_c(s)$, using only the velocity signal from the tachometer.

Terms and Concepts

Discrete-time approximation An approximation used to obtain the time response of a system based on the division of the time into small increments Δt.

Fundamental matrix See Transition matrix.

State of a system A set of numbers such that the knowledge of these numbers and the input function will, with the equations describing the dynamics, provide the future state of the system.

State-variable feedback The control signal for the process is a direct function of all the state variables.

State variables The set of variables that describe the system.

State vector The vector matrix containing all n state variables, x_1, x_2, \ldots, x_n.

State vector differential equation The differential equation for the state vector: $\dot{\mathbf{x}} = \mathbf{Ax} + \mathbf{Bu}$.

Time domain The mathematical domain that incorporates the time response and the description of a system in terms of time, t.

Time varying system A system for which one or more parameters may vary with time.

Transition matrix, $\phi(t)$ The matrix exponential function that describes the unforced response of the system.

References

1. R. C. Dorf, *Encyclopedia of Robotics,* John Wiley & Sons, New York, 1988.
2. L. B. Jackson, *Signals, Systems, and Transforms,* Addison-Wesley, Reading, Mass., 1991.
3. E. Kamen, *Introduction to Signals and Systems,* 2nd ed., Macmillan, New York, 1990.
4. R. C. Dorf, *Robotics and Automated Manufacturing,* Reston Publishing, Reston, Va., 1983.
5. R. E. Ziemer, *Signals and Systems,* 2nd ed., Macmillan, New York, 1989.
6. J. F. Engelberger, *Robotics in Service,* M.I.T. Press, Cambridge, Mass., 1989.
7. D. F. Delchamps, *State Space and Input-Output Linear Systems,* Springer-Verlag, New York, 1988.
8. K. J. Astrom, *Adaptive Control,* Addison-Wesley, Reading, Mass., 1989.
9. D. I. Lewin, "Orbital Mass Transit," *Mechanical Engineering,* July 1990; pp. 78–80.

10. T. Soderstrom, *System Identification,* Prentice Hall, Englewood Cliffs, N.J., 1989.
11. R. DeMeis, "Shuttling to the Space Station," *Aerospace America,* March 1990; pp. 44–47.
12. K. C. Cheok and N. K. Loh, "A Ball-Balancing Demonstration of Optimal Control," *IEEE Control Systems,* February 1987; pp. 54–57.
13. L. E. Ryan, "Closed-Loop Control of Impact Printer Hammer," *J. of Dynamic Systems,* March 1990; pp. 69–75.
14. R. C. Dorf and R. Jacquot, *Control System Design Program,* Addison-Wesley, Reading, Mass., 1988.
15. C. W. Anderson, "Learning to Control an Inverted Pendulum," *IEEE Control Systems,* April 1989; pp. 31–35.
16. F. Demeester, "Real-Time Optical Measurement of Robot Structural Deflections," *Mechatronics,* vol. 1, 1990; pp. 73–86.
17. J. C. Maciejowski, *Multivariable Feedback Design,* Addison-Wesley, Reading, Mass., 1990.
18. P. M. Leucht, "Active Four-Wheel Steering Design for an Advanced Vehicle," *Proceed. of American Automatic Control Conference,* 1990; pp. 2379–85.
19. I. Ha, "Feedback Linearizing Control of Vehicle Acceleration," *IEEE Trans. on Automatic Control,* July 1989; pp. 689–98.
20. E. K. Parsons, "An Experiment Demonstrating Pointing Control on a Flexible Structure," *IEEE Control Systems,* April 1989; pp. 79–83.
21. S. Boyd, "Linear Controller Design," *IEEE Proceed.,* March 1990; pp. 529–74.
22. H. C. Fowler, "Performance of a Direct Drive Manipulator," *Proceed. of 1991 IEEE Conference on Robotics,* April 1991; pp. 230–39.
23. H. Kazerooni, "Control of Robotic Systems Worn by Humans," *Proceed. of 1991 IEEE Conference on Robotics,* April 1991; pp. 2399–2403.
24. T. Skewis, "A Hospital Transport Robot," *Proceed. of 1991 IEEE Conference on Robotics,* April 1991; pp. 58–63.

CHAPTER 10

The Design and Compensation of Feedback Control Systems

Preview

Thus far we have striven to achieve the desired performance of a system by adjusting one or two parameters. However, parameter adjustment may not result in the desired performance. Thus it may be necessary to introduce a new block within the feedback loop that will compensate for the original system's limitation. This block with a transfer function $G_c(s)$, is called a compensator. It is the purpose of this chapter to develop several design techniques in the frequency and time domain that enable us to achieve the desired system performance.

We will discuss various candidates for service as compensators and show how they help to achieve improved performance. We will also use the method of state variable feedback discussed in Chapter 9 to obtain a so-called optimum performance from a closed-loop control system.

10.1 Introduction

The performance of a feedback control system is of primary importance. This subject was discussed at length in Chapter 4 and quantitative measures of performance were developed. We have found that a suitable control system is stable and that it results in an acceptable response to input commands, is less sensitive to system parameter changes, results in a minimum steady-state error for input commands, and, finally, is able to eliminate the effect of undesirable disturbances. A feedback control system that provides an optimum performance without any necessary adjustments is rare indeed. Usually we find it necessary to compromise among the many conflicting and demanding specifications and to adjust the system parameters to provide a suitable and acceptable performance when it is not possible to obtain all the desired optimum specifications.

We have considered at several points in the preceding chapters the question of design and adjustment of the system parameters in order to provide a desirable response and performance. In Chapter 4, we defined and established several suitable measures of performance. Then, in Chapter 5, we determined a method of investigating the stability of a control system, since we recognized that a system is unacceptable unless it is stable. In Chapter 6, we utilized the root locus method to effect a design of a self-balancing scale (Section 6.4) and then illustrated a method of parameter design by using the root locus method (Section 6.5). Furthermore, in Chapters 7 and 8, we developed suitable measures of performance in terms of the frequency variable ω and utilized them to design several suitable control systems. Finally, using time-domain methods in Chapter 9, we investigated the selection of feedback parameters in order to stabilize a system. Thus we have been considering the problems of the design of feedback control systems as an integral part of the subjects of the preceding chapters. It is now our purpose to study the question somewhat further and to point out several significant design and compensation methods.

We have found in the preceding chapters that it is often possible to adjust the system parameters in order to provide the desired system response. However, we often find that we are not able simply to adjust a system parameter and thus obtain the desired performance. Rather we are forced to reconsider the structure of the system and redesign the system in order to obtain a suitable one. That is, we must examine the scheme or plan of the system and obtain a new design or plan that results in a suitable system. Thus *the design of a control system is concerned with the arrangement, or the plan, of the system structure and the selection of suitable components and parameters.* For example, if we desire a set of performance measures to be less than some specified values, we often encounter a conflicting set of requirements. Thus if we wish a system to have a percent overshoot less than 20% and $\omega_n T_p = 3.3$, we obtain a conflicting requirement on the system damping ratio, ζ, as can be seen by examining Fig. 4.8 again. Now, if we are unable to relax these two performance requirements, we must alter the system in some way. The alteration or adjustment of a control system in order to provide a suitable performance is called *compensation;* that is, compensation is the adjustment of a system in order to make up for deficiencies or inadequacies. It is the purpose of this chapter to consider briefly the issue of the design and compensation of control systems.

In redesigning a control system in order to alter the system response, an additional component is inserted within the structure of the feedback system. It is this additional component or device that equalizes or compensates for the performance deficiency. The compensating device may be an electric, mechanical, hydraulic, pneumatic, or other type of device or network, and is often called a *compensator.* Commonly, an electric circuit serves as a compensator in many control systems. The transfer function of the compensator is designated as $G_c(s) = E_{out}(s)/E_{in}(s)$ and the compensator can be placed in a suitable location within the structure of the system. Several types of compensation are shown in Fig. 10.1 for a simple single-loop feedback control system. The compensator placed in the feedforward path is called a *cascade* or series compensator. Similarly, the other

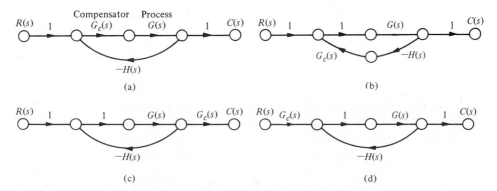

Figure 10.1. Types of compensation. (a) Cascade compensation. (b) Feedback compensation. (c) Output or load compensation. (d) Input compensation.

compensation schemes are called feedback, output or load, and input compensation, as shown in Fig. 10.1(b), (c), and (d), respectively. The selection of the compensation scheme depends upon a consideration of the specifications, the power levels at various signal nodes in the system, and the networks available for use. Usually the output $C(s)$ is a direct output of the process $G(s)$ and the output compensation of Fig. 10.1(c) is not physically realizable. It will not be possible for us to consider all the possibilities in this chapter, and the reader is referred to Chapters 11 and 12 following the introductory material of this chapter.

10.2 Approaches to Compensation

The performance of a control system can be described in terms of the time-domain performance measures or the frequency-domain performance measures. The performance of a system can be specified by requiring a certain peak time, T_p, maximum overshoot, and settling-time for a step input. Furthermore, it is usually necessary to specify the maximum allowable steady-state error for several test signal inputs and disturbance inputs. These performance specifications can be defined in terms of the desirable location of the poles and zeros of the closed-loop system transfer function, $T(s)$. Thus the location of the s-plane poles and zeros of $T(s)$ can be specified. As we found in Chapter 6, the locus of the roots of the closed-loop system can be readily obtained for the variation of one system parameter. However, when the locus of roots does not result in a suitable root configuration, we must add a compensating network (Fig. 10.1) in order to alter the locus of the roots as the parameter is varied. Therefore we can use the root locus method and determine a suitable compensator network transfer function so that the resultant root locus results in the desired closed-loop root configuration.

Alternatively, we can describe the performance of a feedback control system in terms of frequency performance measures. Then a system can be described in terms of the peak of the closed-loop frequency response, M_{p_ω}, the resonant frequency ω_r, the bandwidth, and the phase margin of the system. We can add a suitable compensation network, if necessary, in order to satisfy the system specifications. The design of the network $G_c(s)$, is developed in terms of the frequency response as portrayed on the polar plane, the Bode diagram, or the Nichols chart. Because a cascade transfer function is readily accounted for on a Bode plot by adding the frequency response of the network, we usually prefer to approach the frequency response methods by utilizing the Bode diagram.

Thus the compensation of a system is concerned with the alteration of the frequency response or the root locus of the system in order to obtain a suitable system performance. For frequency response methods we are concerned with altering the system so that the frequency response of the compensated system will satisfy the system specifications. Thus, in the case of the frequency response approach, we use compensation networks to alter and reshape the frequency characteristics represented on the Bode diagram and Nichols chart.

Alternatively, the compensation of a control system can be accomplished in the s-plane by root locus methods. For the case of the s-plane, the designer wishes to alter and reshape the root locus so that the roots of the system will lie in the desired position in the s-plane.

The time-domain method, expressed in terms of state variables, can also be utilized to design a suitable compensation scheme for a control system. Typically, we are interested in controlling the system with a control signal, $\mathbf{u}(t)$, which is a function of several measurable state variables. Then we develop a state-variable controller that operates on the information available in measured form. This type of system compensation is quite useful for system optimization and will be considered briefly in this chapter.

We have illustrated several of the aforementioned approaches in the preceding chapters. In Example 6.5, we utilized the root locus method in considering the design of a feedback network in order to obtain a satisfactory performance. In Chapter 8, we considered the selection of the gain in order to obtain a suitable phase margin and, therefore, a satisfactory relative stability. Also, in Example 9.6, we compensated for the unstable response of the pendulum by controlling the pendulum with a function of several of the state variables of the system.

Quite often, in practice, the best and simplest way to improve the performance of a control system is to alter, if possible, the process itself. That is, if the system designer is able to specify and alter the design of the process that is represented by the transfer function $G(s)$, then the performance of the system can be readily improved. For example, in order to improve the transient behavior of a servomechanism position controller, we can often choose a better motor for the system. In the case of an airplane control system we might be able to alter the aerodynamic design of the airplane and thus improve the flight transient characteristics. Thus a control-system designer should recognize that an alteration of the process may result in an improved system. However, often the process is fixed and unalterable or has been altered as much as possible and is still found to result in an unsatisfactory performance. Then the addition of compensation networks becomes useful for improving the performance of the system. In the following sections we will assume that the process has been improved as much as possible and the $G(s)$ representing the process is unalterable.

It is the purpose of this chapter to further describe the addition of several compensation networks to a feedback control system. First, we shall consider the addition of a so-called phase-lead compensation network and describe the design of the network by root locus and frequency response techniques. Then, using both the root locus and frequency response techniques, we shall describe the design of the integration compensation networks in order to obtain a suitable system performance. Finally, we shall determine an optimum controller for a system described in terms of state variables. While these three approaches to compensation are not intended to be discussed in a complete manner, the discussion that follows should serve as a worthwhile introduction to the design and compensation of feedback control systems.

10.3 Cascade Compensation Networks

In this section we shall consider the design of a cascade or feedback network as shown in Fig. 10.1(a) and Fig. 10.1(b), respectively. The compensation network, $G_c(s)$, is cascaded with the unalterable process $G(s)$ in order to provide a suitable loop transfer function $G_c(s)G(s)H(s)$. Clearly, the compensator $G_c(s)$ can be chosen to alter either the shape of the root locus or the frequency response. In either case the network may be chosen to have a transfer function

$$G_c(s) = \frac{K \prod_{i=1}^{M} (s + z_i)}{\prod_{j=1}^{N} (s + p_j)}. \tag{10.1}$$

Then the problem reduces to the judicious selection of the poles and zeros of the compensator. In order to illustrate the properties of the compensation network we shall consider a first-order compensator. The compensation approach developed on the basis of a first-order compensator can then be extended to higher-order compensators.

Consider the first-order compensator with the transfer function

$$G_c(s) = \frac{K(s + z)}{(s + p)}. \tag{10.2}$$

The design problem becomes, then, the selection of z, p, and K in order to provide a suitable performance. When $|z| < |p|$, the network is called a *phase-lead network* and has a pole–zero s-plane configuration as shown in Fig. 10.2. If the pole was negligible, that is, $|p| \gg |z|$, and the zero occurred at the origin of the s-plane, we would have a differentiator so that

$$G_c(s) \simeq \left(\frac{K}{p}\right) s. \tag{10.3}$$

Figure 10.2. Pole–zero diagram of the phase-lead network.

Thus a compensation network of the form of Eq. (10.2) is a differentiator type network. The differentiator network of Eq. (10.3) has a frequency characteristic as

$$G_c(j\omega) = j\left(\frac{K}{p}\right)\omega = \left(\frac{K}{p}\omega\right)e^{+j90°} \qquad (10.4)$$

and phase angle of $+90°$, often called a phase-lead angle. Similarly, the frequency response of the differentiating network of Eq. (10.2) is

$$\begin{aligned}
G_c(j\omega) &= \frac{K(j\omega + z)}{(j\omega + p)} \\
&= \frac{(Kz/p)(j(\omega/z) + 1)}{(j(\omega/p) + 1)} \\
&= \frac{K_1(1 + j\omega\alpha\tau)}{(1 + j\omega\tau)},
\end{aligned} \qquad (10.5)$$

where $\tau = 1/p$, $p = \alpha z$, and $K_1 = K/\alpha$. The frequency response of this phase-lead network is shown in Fig. 10.3. The angle of the frequency characteristic is

$$\phi(\omega) = \tan^{-1}\alpha\omega\tau - \tan^{-1}\omega\tau. \qquad (10.6)$$

Since the zero occurs first on the frequency axis, we obtain a phase-lead characteristic as shown in Fig. 10.3. The slope of the asymptotic magnitude curve is $+6$ db/octave.

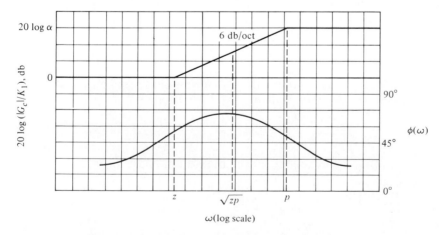

Figure 10.3. Bode diagram of the phase-lead network.

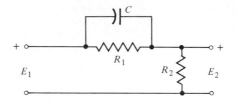

Figure 10.4. Phase-lead network.

The phase-lead compensation transfer function can be obtained with the network shown in Fig. 10.4. The transfer function of this network is

$$G_c(s) = \frac{E_2(s)}{E_1(s)} = \frac{R_2}{R_2 + \{R_1(1/Cs)/[R_1 + (1/Cs)]\}}$$

$$= \left(\frac{R_2}{R_1 + R_2}\right)\frac{(R_1Cs + 1)}{\{[R_1R_2/(R_1 + R_2)]Cs + 1\}}.$$

(10.7)

Therefore we let

$$\tau = \frac{R_1R_2}{R_1 + R_2}C \quad \text{and} \quad \alpha = \frac{R_1 + R_2}{R_2}$$

and obtain the transfer function

$$G_c(s) = \frac{(1 + \alpha\tau s)}{\alpha(1 + \tau s)},$$

(10.8)

which is equal to Eq. (10.5) when an additional cascade gain K is inserted.

The maximum value of the phase lead occurs at a frequency ω_m, where ω_m is the geometric mean of $p = 1/\tau$ and $z = 1/\alpha\tau$; that is, the maximum phase lead occurs halfway between the pole and zero frequencies on the logarithmic frequency scale. Therefore

$$\omega_m = \sqrt{zp} = \frac{1}{\tau\sqrt{\alpha}}.$$

In order to obtain an equation for the maximum phase-lead angle, we rewrite the phase angle of Eq. (10.5) as

$$\phi = \tan^{-1}\frac{\alpha\omega\tau - \omega\tau}{1 + (\omega\tau)^2\alpha}.$$

(10.9)

Then, substituting the frequency for the maximum phase angle, $\omega_m = 1/\tau\sqrt{\alpha}$, we have

$$\tan \phi_m = \frac{(\alpha/\sqrt{\alpha}) - (1/\sqrt{\alpha})}{1 + 1}$$

(10.10)

$$= \frac{\alpha - 1}{2\sqrt{\alpha}}.$$

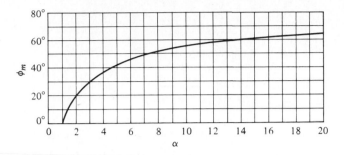

Figure 10.5. Maximum phase angle ϕ_m versus α for a lead network.

Because the tan ϕ_m equals $(\alpha - 1)/2\sqrt{\alpha}$, we utilize the triangular relationship and note that

$$\sin \phi_m = \frac{\alpha - 1}{\alpha + 1}. \tag{10.11}$$

Equation (10.11) is very useful for calculating a necessary α ratio between the pole and zero of a compensator in order to provide a required maximum phase lead. A plot of ϕ_m versus α is shown in Fig. 10.5. Clearly, the phase angle readily obtainable from this network is not much greater than 70°. Also, since $\alpha = (R_1 + R_2)/R_2$, there are practical limitations on the maximum value of α that one should attempt to obtain. Therefore, if one required a maximum angle of greater than 70°, two cascade compensation networks would be utilized. Then the equivalent compensation transfer function is $G_{c_1}(s)G_{c_2}(s)$ when the loading effect of $G_{c_2}(s)$ on $G_{c_1}(s)$ is negligible.

It is often useful to add a cascade compensation network that provides a phase-lag characteristic. The *phase-lag network* is shown in Fig. 10.6. The transfer function of the phase-lag network is

$$G_c(s) = \frac{E_2(s)}{E_1(s)} = \frac{R_2 + (1/Cs)}{R_1 + R_2 + (1/Cs)}$$

$$= \frac{R_2Cs + 1}{(R_1 + R_2)Cs + 1}. \tag{10.12}$$

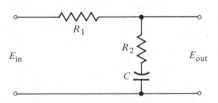

E_{in} R_1 R_2 E_{out} C

Figure 10.6. Phase-lag network.

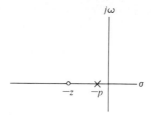

Figure 10.7. Pole-zero diagram of the phase-lag network.

When $\tau = R_2C$ and $\alpha = (R_1 + R_2)/R_2$, we have

$$G_c(s) = \frac{1 + \tau s}{1 + \alpha \tau s}$$

$$= \frac{1}{\alpha} \frac{(s + z)}{(s + p)},$$

(10.13)

where $z = 1/\tau$ and $p = 1/\alpha\tau$. In this case, because $\alpha > 1$, the pole lies closest to the origin of the s-plane as shown in Fig. 10.7. This type of compensation network

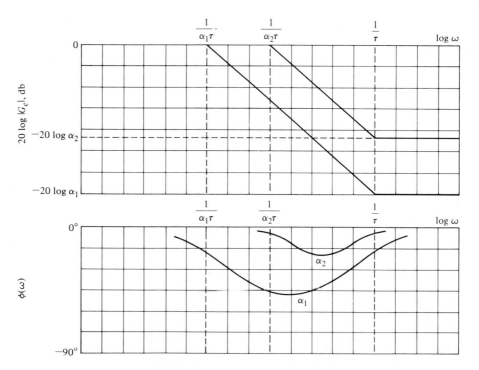

Figure 10.8. Bode diagram of the phase-lag network.

is often called an integrating network. The Bode diagram of the phase-lag network is obtained from the transfer function

$$G_c(j\omega) = \frac{1 + j\omega\tau}{1 + j\omega\alpha\tau} \tag{10.14}$$

and is shown in Fig. 10.8. The form of the Bode diagram of the lag network is similar to that of the phase-lead network; the difference is the resulting attenuation and phase-lag angle instead of amplification and phase-lead angle. However, note that the shape of the diagrams of Figs. 10.3 and 10.8 are similar. Therefore it can be shown that the maximum phase lag occurs at $\omega_m = \sqrt{zp}$.

In the succeeding sections, we wish to utilize these compensation networks in order to obtain a desired system frequency locus or s-plane root location. The lead network is utilized to provide a phase-lead angle and thus a satisfactory phase margin for a system. Alternatively, the use of the phase-lead network can be visualized on the s-plane as enabling us to reshape the root locus and thus provide the desired root locations. The phase-lag network is utilized not to provide a phase-lag angle, which is normally a destabilizing influence, but rather to provide an attenuation and increase the steady-state error constant [3]. These approaches to compensation utilizing the phase-lead and phase-lag networks will be the subject of the following four sections.

10.4 System Compensation on the Bode Diagram Using the Phase-Lead Network

The Bode diagram is used in order to design a suitable phase-lead network in preference to other frequency response plots. The frequency response of the cascade compensation network is added to the frequency response of the uncompensated system. That is, because the total loop transfer function of Fig. 10.1(a) is $G_c(j\omega)G(j\omega)H(j\omega)$, we will first plot the Bode diagram for $G(j\omega)H(j\omega)$. Then we can examine the plot for $G(j\omega)H(j\omega)$ and determine a suitable location for p and z of $G_c(j\omega)$ in order to satisfactorily reshape the frequency response. The uncompensated $G(j\omega)$ is plotted with the desired gain to allow an acceptable steady-state error. Then the phase margin and the expected M_p are examined to find whether they satisfy the specifications. If the phase margin is not sufficient, phase lead can be added to the phase angle curve of the system by placing the $G_c(j\omega)$ in a suitable location. Clearly, in order to obtain maximum additional phase lead, we desire to place the network such that the frequency ω_m is located at the frequency where the magnitude of the compensated magnitude curves crosses the 0-db axis. (Recall the definition of phase margin.) The value of the added phase lead required allows us to determine the necessary value for α from Eq. (10.11) or Fig. 10.5. The zero $\omega = 1/\alpha\tau$ is located by noting that the maximum phase lead should occur at $\omega_m = \sqrt{zp}$, halfway between the pole and the zero. Because the total

magnitude gain for the network is 20 log α, we expect a gain of 10 log α at ω_m. Thus we determine the compensation network by completing the following steps:

1. Evaluate the uncompensated system phase margin when the error constants are satisfied.
2. Allowing for a small amount of safety, determine the necessary additional phase lead, ϕ_m.
3. Evaluate α from Eq. (10.11).
4. Evaluate 10 log α and determine the frequency where the uncompensated magnitude curve is equal to -10 log α db. This frequency is the new 0-db crossover frequency and ω_m simultaneously, because the compensation network provides a gain of 10 log α at ω_m.
5. Draw the compensated frequency response, check the resulting phase margin, and repeat the steps if necessary. Finally, for an acceptable design, raise the gain of the amplifier in order to account for the attenuation $(1/\alpha)$.

■ Example 10.1 A lead compensator for a type 2 system

Let us consider a single-loop feedback control system as shown in Fig. 10.1(a), where

$$G(s) = \frac{K_1}{s^2} \tag{10.15}$$

and $H(s) = 1$. The uncompensated system is a type 2 system and at first appears to possess a satisfactory steady-state error for both step and ramp input signals. However, uncompensated, the response of the system is an undamped oscillation because

$$T(s) = \frac{C(s)}{R(s)} = \frac{K_1}{s^2 + K_1}. \tag{10.16}$$

Therefore the compensation network is added so that the loop transfer function is $G_c(s)G(s)H(s)$. The specifications for the system are

Settling time, $T_s \leq 4$ sec,

Percent overshoot for a step input $\leq 20\%$.

Using Fig. 4.8, we estimate that the damping ratio should be $\zeta \geq 0.45$. The settling time requirement is

$$T_s = \frac{4}{\zeta\omega_n} = 4, \tag{10.17}$$

and therefore

$$\omega_n = \frac{1}{\zeta} = \frac{1}{0.45} = 2.22.$$

Perhaps the simplest way to check the value of ω_n for the frequency response is to relate ω_n to the bandwidth, ω_B, and evaluate the $-3db$ bandwidth of the closed-loop system. For a closed-loop system with $\zeta = 0.45$, we estimate from Fig. 7.9 that $\omega_B = 1.36\omega_n$. Therefore we require a closed-loop bandwidth $\omega_B = 1.36(2.22) = 3.02$. The bandwidth can be checked following compensation by utilizing the Nichols chart. For the uncompensated system, the bandwidth of the system is $\omega_B = 1.36\omega_n$ and $\omega_n = \sqrt{K}$. Therefore a loop gain equal to $K = \omega_n^2 \approx 5$ would be sufficient. To provide a suitable margin for the settling time we will select $K = 10$ in order to draw the Bode diagram of

$$GH(j\omega) = \frac{K}{(j\omega)^2}.$$

The Bode diagram of the uncompensated system is shown as solid lines in Fig. 10.9.

By using Eq. (8.58), the phase margin of the system is required to be approximately

$$\phi_{pm} = \frac{\zeta}{0.01} = \frac{0.45}{0.01} = 45°. \tag{10.18}$$

The phase margin of the uncompensated system is 0° because the double integration results in a constant 180° phase lag. Therefore we must add a 45° phase-lead angle at the crossover (0-db) frequency of the compensated magnitude curve. Evaluating the value of α, we have

$$\frac{\alpha - 1}{\alpha + 1} = \sin \phi_m$$
$$= \sin 45°, \tag{10.19}$$

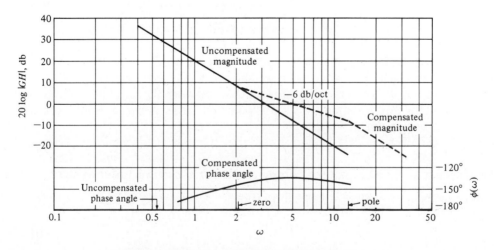

Figure 10.9. Bode diagram for Example 10.1.

and therefore $\alpha = 5.8$. In order to provide a margin of safety, we will use $\alpha = 6$. The value of $10 \log \alpha$ is then equal to 7.78 db. Then the lead network will add an additional gain of 7.78 db at the frequency ω_m, and it is desired to have ω_m equal to compensated slope near the 0-db axis (the dashed line) so that the new crossover is ω_m and the dashed magnitude curve is 7.78 db above the uncompensated curve at the crossover frequency. Thus the compensated crossover frequency is located by evaluating the frequency where the uncompensated magnitude curve is equal to -7.78 db, which in this case is $\omega = 4.9$. Then the maximum phase-lead angle is added to $\omega = \omega_m = 4.9$ as shown in Fig. 10.9. The bandwidth of the compensated system can be obtained from the Nichols chart. For estimating the bandwidth, we can simply examine Fig. 8.23 and note that the -3-db line for the closed-loop system occurs when the magnitude of $GH(j\omega)$ is -6-db and the phase shift of $GH(j\omega)$ is approximately $-140°$. Therefore, in order to estimate the bandwidth from the open-loop diagram, we will approximate the bandwidth as the frequency for which $20 \log |GH|$ is equal to -6 db. Thus the bandwidth of the uncompensated system is approximately equal to $\omega_B = 4.4$, while the bandwidth of the compensated system is equal to $\omega_B = 8.4$. The lead compensation doubles the bandwidth in this case and the specification that $\omega_B > 3.02$ is satisfied. Therefore the compensation of the system is completed and the system specifications are satisfied. The total compensated loop transfer function is

$$G_c(j\omega)G(j\omega)H(j\omega) = \frac{10[(j\omega/2.1) + 1]}{(j\omega)^2[(j\omega/12.6) + 1]}. \tag{10.20}$$

The transfer function of the compensator is

$$\begin{aligned} G_c(s) &= \frac{(1 + \alpha\tau s)}{\alpha(1 + \tau s)} \\ &= \frac{1}{6} \frac{[1 + (s/2.1)]}{[1 + (s/12.6)]} \end{aligned} \tag{10.21}$$

in the form of Eq. (10.8). Because an attenuation of ⅙ results from the passive RC network, the gain of the amplifier in the loop must be raised by a factor of six so that the total dc loop gain is still equal to 10 as required in Eq. (10.20). When we add the compensation network Bode diagram to the uncompensated Bode diagram as in Fig. 10.9, we are assuming that we can raise the amplifier gain in order to account for this $1/\alpha$ attenuation. The pole and zero values are simply read from Fig. 10.9, noting that $p = \alpha z$.

■ **Example 10.2 A lead compensator for a second-order system**

A feedback control system has a loop transfer function

$$GH(s) = \frac{K}{s(s + 2)}. \tag{10.22}$$

It is desired to have a steady-state error for a ramp input less than 5% of the magnitude of the ramp. Therefore we require that

$$K_v = \frac{A}{e_{ss}} = \frac{A}{0.05A} = 20.$$
(10.23)

Furthermore, we desire that the phase margin of the system be at least 45°. The first step is to plot the Bode diagram of the uncompensated transfer function

$$GH(j\omega) = \frac{K_v}{j\omega(0.5j\omega + 1)}$$
(10.24)

$$= \frac{20}{j\omega(0.5j\omega + 1)}$$

as shown in Fig. 10.10(a). The frequency at which the magnitude curve crosses the 0-db line is 6.2 rad/sec, and the phase margin at this frequency is determined readily from the equation of the phase of $GH(j\omega)$, which is

$$\underline{/GH(j\omega)} = \phi(\omega) = -90° - \tan^{-1}(0.5\omega).$$
(10.25)

At the crossover frequency, $\omega = \omega_c = 6.2$ rad/sec, we have

$$\phi(\omega) = -162°,$$
(10.26)

and therefore the phase margin is 18°. Using Eq. (10.25) to evaluate the phase margin is often easier than drawing the complete phase angle curve, which is shown in Fig. 10.10(a). Thus we need to add a phase-lead network so that the phase margin is raised to 45° at the new crossover (0-db) frequency. Because the

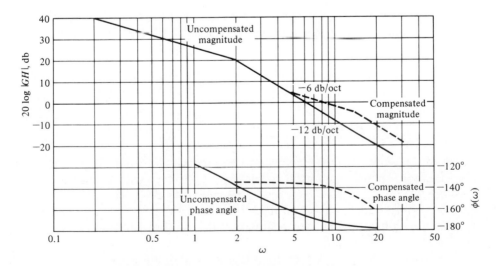

Figure 10.10(a). Bode diagram for Example 10.2.

compensation crossover frequency is greater than the uncompensated crossover frequency, the phase lag of the uncompensated system is greater also. We shall account for this additional phase lag by attempting to obtain a maximum phase lead of $45° - 18° = 27°$ plus a small increment (10%) of phase lead to account for the added lag. Thus we will design a compensation network with a maximum phase lead equal to $27° + 3° = 30°$. Then, calculating α, we obtain

$$\frac{\alpha - 1}{\alpha + 1} = \sin 30°$$
$$= 0.5,$$

(10.27)

and therefore $\alpha = 3$.

The maximum phase lead occurs at ω_m, and this frequency will be selected so that the new crossover frequency and ω_m coincide. The magnitude of the lead network at ω_m is $10 \log \alpha = 10 \log 3 = 4.8$ db. The compensated crossover frequency is then evaluated where the magnitude of $GH(j\omega)$ is -4.8 db and thus $\omega_m = \omega_c = 8.4$. Drawing the compensated magnitude line so that it intersects the 0-db axis at $\omega = \omega_c = 8.4$, we find that $z = 4.8$ and $p = \alpha z = 14.4$. Therefore the compensation network is

$$G_c(s) = \frac{1}{3} \frac{(1 + s/4.8)}{(1 + s/14.4)}.$$

(10.28)

The total dc loop gain must be raised by a factor of 3 in order to account for the factor $1/\alpha = \tfrac{1}{3}$. Then the compensated loop transfer function is

$$G_c(s)GH(s) = \frac{20[(s/4.8) + 1]}{s(0.5s + 1)[(s/14.4) + 1]}.$$

(10.29)

In order to verify the final phase margin, we can evaluate the phase of $G_c(j\omega)GH(j\omega)$ at $\omega = \omega_c = 8.4$ and therefore obtain the phase margin. The phase angle is then

$$\phi(\omega_c) = -90° - \tan^{-1} 0.5\omega_c - \tan^{-1} \frac{\omega_c}{14.4} + \tan^{-1} \frac{\omega_c}{4.8}$$
$$= -90° - 76.5° - 30.0° + 60.2°$$
$$= -136.3°.$$

(10.30)

Therefore the phase margin for the compensated system is $43.7°$. If we desire to have exactly $45°$ phase margin, we would repeat the steps with an increased value of α—for example, with $\alpha = 3.5$. In this case, the phase lag increased by $7°$ between $\omega = 6.2$ and $\omega = 8.4$, and therefore the allowance of $3°$ in the calculation of α was not sufficient. The step response of this system yields a 28% overshoot with a settling time of 0.75 sec.

The Nichols diagram for the compensated and uncompensated system is shown on Fig. 10.10(b). The reshaping of the frequency response locus is clear on this diagram. One notes the increased phase margin for the compensated system

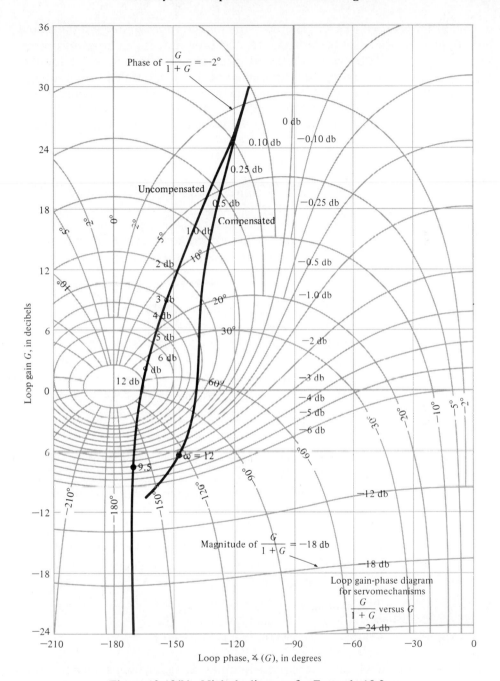

Figure 10.10(b). Nichols diagram for Example 10.2.

as well as the reduced magnitude of M_{p_ω}, the maximum magnitude of the closed-loop frequency response. In this case, M_{p_ω} has been reduced from an uncompensated value of $+12$ db to a compensated value of approximately $+3.2$ db. Also, we note that the closed-loop 3-db bandwidth of the compensated system is equal to 12 rad/sec compared with 9.5 rad/sec for the uncompensated system.

Looking again at Examples 10.1 and 10.2, we note that the system design is satisfactory when the asymptotic curve for the magnitude $20 \log |GG_c|$ crosses the 0 db line with a slope of -6 db/octave.

10.5 Compensation on the *s*-Plane Using the Phase-Lead Network

The design of the phase-lead compensation network can also be readily accomplished on the *s*-plane. The phase-lead network has a transfer function

$$G_c(s) = \frac{[s + (1/\alpha\tau)]}{[s + (1/\tau)]}$$

$$= \frac{(s + z)}{(s + p)},$$

$\qquad(10.31)$

where α and τ are defined for the *RC* network in Eq. (10.7). The locations of the zero and pole are selected in order to result in a satisfactory root locus for the compensated system. The specifications of the system are used to specify the desired location of the dominant roots of the system. The *s*-plane root locus method is as follows:

1. List the system specifications and translate these specifications into a desired root location for the dominant roots.
2. Sketch the uncompensated root locus and determine whether the desired root locations can be realized with an uncompensated system.
3. If the compensator is necessary, place the zero of the phase-lead network directly below the desired root location (or to the left of the second pole).
4. Determine the pole location so that the total angle at the desired root location is 180° and therefore is on the compensated root locus.
5. Evaluate the total system gain at the desired root location and then calculate the error constant.
6. Repeat the steps if the error constant is not satisfactory.

Therefore we first locate our desired dominant root locations so that the dominant roots satisfy the specifications in terms of ζ and ω_n as shown in Fig. 10.11(a). The root locus of the uncompensated system is sketched as illustrated in Fig. 10.11(b). Then the zero is added to provide a phase lead of $+90°$ by placing it directly below the desired root location. Actually, some caution must be main-

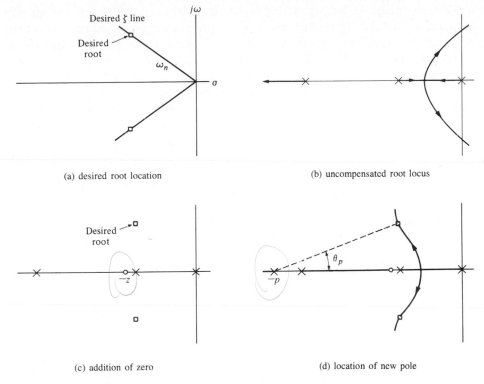

(a) desired root location

(b) uncompensated root locus

(c) addition of zero

(d) location of new pole

Figure 10.11. Compensation on the *s*-plane using a phase-lead network.

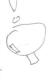

tained because the zero must not alter the dominance of the desired roots; that is, the zero should not be placed nearer the origin than the second pole on the real axis or a real root near the origin will result and will dominate the system response. Thus, in Fig. 10.11(c), we note that the desired root is directly above the second pole, and we place the zero *z* somewhat to the left of the pole.

Consequently the real root will be near the real zero and the coefficient of this term of the partial fraction expansion will be relatively small. Thus the response due to this real root will have very little effect on the overall system response. Nevertheless, the designer must be continually aware that the compensated system response will be influenced by the roots and zeros of the system and the dominant roots will not by themselves dictate the response. It is usually wise to allow for some margin of error in the design and to test the compensated system using a digital simulation.

Because the desired root is a point on the root locus when the final compensation is accomplished, we expect the algebraic sum of the vector angles to be 180° at that point. Thus we calculate the angle from the pole of compensator, θ_p, in order to result in a total angle of 180°. Then, locating a line at an angle θ_p intersecting the desired root, we are able to evaluate the compensator pole, *p*, as shown in Fig. 10.11(d).

The advantage of the s-plane method is the ability of the designer to specify the location of the dominant roots and, therefore, the dominant transient response. The disadvantage of the method is that one cannot directly specify an error constant (for example, K_v) as in the Bode diagram approach. After the design is completed, one evaluates the gain of the system at the root location, which depends upon p and z, and then calculates the error constant for the compensated system. If the error constant is not satisfactory, one must repeat the design steps and alter the location of the desired root as well as the location of the compensator pole and zero. We shall reconsider the two examples we completed in the preceding section and design a compensation network using the root locus (s-plane) approach.

■ **E x a m p l e 10.3 Lead compensator on the s-plane**

Let us reconsider the system of Example 10.1 where the open-loop uncompensated transfer function is

$$GH(s) = \frac{K_1}{s^2}.$$

(10.32)

The characteristic equation of the uncompensated system is

$$1 + GH(s) = 1 + \frac{K_1}{s^2} = 0,$$

(10.33)

and the root locus is the $j\omega$-axis. Therefore we desire to compensate this system with a network, $G_c(s)$, where

$$G_c(s) = \frac{s + z}{s + p}$$

(10.34)

and $|z| < |p|$. The specifications for the system are

Settling time, $T_s \leq 4$ sec,

Percent overshoot for a step input $\leq 30\%$.

Therefore the damping ratio should be $\zeta \geq 0.35$. The settling time requirement is

$$T_s = \frac{4}{\zeta \omega_n} = 4,$$

and therefore $\zeta \omega_n = 1$. Thus we will choose a desired dominant root location as

$$r_1, \hat{r}_1 = -1 \pm j2 \quad = tan\left(cos^{-1} 0.45\right)$$

(10.35)

as shown in Fig. 10.12 (thus $\zeta = 0.45$).
 Now we place the zero of the compensator directly below the desired location

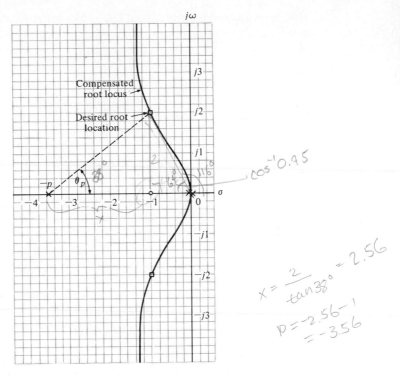

Figure 10.12. Phase-lead compensation for Example 10.3.

at $s = -z = -1$, as shown in Fig. 10.12. Then, measuring the angle at the desired root, we have

$$\phi = -2(116°) + 90° = -142°.$$

Therefore, in order to have a total of $180°$ at the desired root, we evaluate the angle from the undetermined pole, θ_p, as

$$-180° = -142° - \theta_p \qquad (10.36)$$

or $\theta_p = 38°$. Then a line is drawn at an angle $\theta_p = 38°$ intersecting the desired root location and the real axis, as shown in Fig. 10.12. The point of intersection with the real axis is then $s = -p = -3.6$. Therefore the compensator is

$$G_c(s) = \frac{s + 1}{s + 3.6}, \qquad (10.37)$$

and the compensated transfer function for the system is

$$GH(s)G_c(s) = \frac{K_1(s + 1)}{s^2(s + 3.6)}. \qquad (10.38)$$

The gain K_1 is evaluated by measuring the vector lengths from the poles and zeros to the root location. Hence

$$K_1 = \frac{(2.23)^2(3.25)}{2} = 8.1. \tag{10.39}$$

Finally, the error constants of this system are evaluated. We find that this system with two open-loop integrations will result in a zero steady-state error for a step and ramp input signal. The acceleration constant is

$$K_a = \frac{8.1}{3.6} = 2.25. \tag{10.40}$$

The steady-state performance of this system is quite satisfactory, and therefore the compensation is complete. When we compare the compensation network evaluated by the s-plane method with the network obtained by using the Bode diagram approach, we find that the magnitudes of the poles and zeros are different. However, the resulting system will have the same performance and we need not be concerned with the difference. In fact, the difference arises from the arbitrary design step (Number 3), which places the zero directly below the desired root location. If we placed the zero at $s = -2.1$, we would find that the pole evaluated by the s-plane method is approximately equal to the pole evaluated by the Bode diagram approach.

The specifications for the transient response of this system were originally expressed in terms of the overshoot and the settling time of the system. These specifications were translated, on the basis of an approximation of the system by a second-order system, to an equivalent ζ and ω_n and therefore a desired root location. However, the original specifications will be satisfied only if the roots selected are dominant. The zero of the compensator and the root resulting from the addition of the compensator pole result in a third-order system with a zero. The validity of approximating this system with a second-order system without a zero is dependent upon the validity of the dominance assumption. Often the designer will simulate the final design by using an analog computer or a digital computer and obtain the actual transient response of the system. In this case, an analog computer simulation of the system resulted in an overshoot of 40% and a settling time of 3.8 sec for a step input. These values compare moderately well with the specified values of 30% and 4 sec and justify the utilization of the dominant root specifications. The difference in the overshoot from the specified value is due to the third root, which is not negligible. Thus again we find that the specification of dominant roots is a useful approach but must be utilized with caution and understanding. A second attempt to obtain a compensated system with an overshoot of 30% would utilize a compensator with a zero at -2 and then calculate the necessary pole location to yield the desired root locations for the dominant roots. This approach would move the third root farther to the left in the s-plane, reduce the effect of the third root on the transient response, and reduce the overshoot.

■ **E x a m p l e 10.4 Lead compensator for a type 1 system**

Now let us reconsider the system of Example 10.2 and design a compensator based on the *s*-plane approach. The open-loop system transfer function is

$$GH(s) = \frac{K}{s(s + 2)}.$$ (10.41)

It is desired that the damping ratio of the dominant roots of the system be $\zeta = 0.45$ and that the velocity error constant be equal to 20. In order to satisfy the error constant requirement, the gain of the uncompensated system must be $K = 40$. When $K = 40$, the roots of the uncompensated system are

$$s^2 + 2s + 40 = (s + 1 + j6.25)(s + 1 - j6.25).$$ (10.42)

The damping ratio of the uncompensated roots is approximately 0.16, and therefore a compensation network must be added. In order to achieve a rapid settling time, we will select the real part of the desired roots as $\zeta\omega_n = 4$ and therefore $T_s = 1$ sec. Also, the natural frequency of these roots is fairly large, $\omega_n = 9$; hence the velocity constant should be reasonably large. The location of the desired roots is shown on Fig. 10.13(a) for $\zeta\omega_n = 4$, $\zeta = 0.45$, and $\omega_n = 9$.

The zero of the compensator is placed at $s = -z = -4$, directly below the desired root location. Then the angle at the desired root location is

$$\phi = -116° - 104° + 90° = -130°.$$ (10.43)

Therefore the angle from the undetermined pole is determined from

$$-180° = -130° - \theta_p,$$

and thus $\theta_p = 50°$. This angle is drawn to intersect the desired root location, and p is evaluated as $s = -p = -10.6$, as shown in Fig. 10.13(a). The gain of the compensated system is then

$$K = \frac{9(8.25)(10.4)}{8} = 96.5.$$ (10.44)

The compensated system is then

$$G_c(s)GH(s) = \frac{96.5(s + 4)}{s(s + 2)(s + 10.6)}.$$ (10.45)

Therefore the velocity constant of the compensated system is

$$K_v = \lim_{s \to 0} s\{G(s)H(s)G_c(s)\} = \frac{96.5(4)}{2(10.6)} = 18.2.$$ (10.46)

The velocity constant of the compensated system is less than the desired value of 20. Therefore we must repeat the design procedure for a second choice of a desired root. If we choose $\omega_n = 10$, the process can be repeated and the resulting gain K will be increased. The compensator pole and zero location will also be

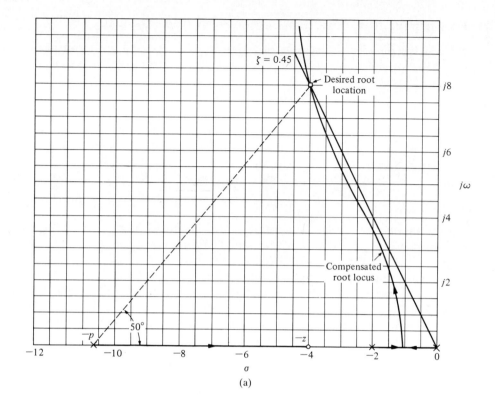

(a)

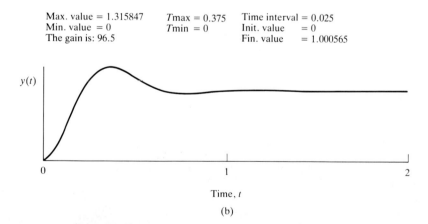

Max. value = 1.315847	*T*max = 0.375	Time interval = 0.025
Min. value = 0	*T*min = 0	Init. value = 0
The gain is: 96.5		Fin. value = 1.000565

(b)

Figure 10.13. (a) Design of a phase-lead network on the *s*-plane for Example 10.4. (b) Step response of the compensated system of Example 10.4.

altered. Then the velocity constant can be again evaluated. We will leave it as an exercise for the reader to show that for $\omega_n = 10$, the velocity constant is $K_v = 22.7$ when $z = 4.5$ and $p = 11.6$.

Finally, for the compensation network of Eq. (10.45) we have

$$G_c(s) = \frac{s + 4}{s + 10.6} = \frac{(s + 1/\alpha\tau)}{(s + 1/\tau)}. \tag{10.47}$$

The design of an *RC*-lead network as shown in Fig. 10.4 follows directly from Eqs. (10.47) and (10.7), and is

$$G_c(s) = \left(\frac{R_2}{R_1 + R_2}\right) \frac{(R_1 Cs + 1)}{(R_1 R_2/(R_1 + R_2)Cs + 1)}. \tag{10.48}$$

Thus in this case we have

$$\frac{1}{R_1 C} = 4$$

and

$$\alpha = \frac{R_1 + R_2}{R_2} = \frac{10.6}{4}.$$

Then, choosing $C = 1$ μf, we obtain $R_1 = 250{,}000$ ohms and $R_2 = 152{,}000$ ohms. The step response of the compensated system yields a 32% overshoot with a settling time of 0.8 sec as shown in Fig. 10.13(b). As shown here, we may use the Control System Design Program to verify the actual transient response.

The phase-lead compensation network is a useful compensator for altering the performance of a control system. The phase-lead network adds a phase-lead angle in order to provide adequate phase margin for feedback systems. Using an s-plane design approach, we can choose the phase-lead network in order to alter the system root locus and place the roots of the system in a desired position in the s-plane. When the design specifications include an error constant requirement, the Bode diagram method is more suitable, because the error constant of a system designed on the s-plane must be ascertained following the choice of a compensator pole and zero. Therefore the root locus method often results in an iterative design procedure when the error constant is specified. On the other hand, the root locus is a very satisfactory approach when the specifications are given in terms of overshoot and settling time, thus specifying the ζ and ω_n of the desired dominant roots in the s-plane. The use of a lead network compensator always extends the bandwidth of a feedback system, which may be objectionable for systems subjected to large amounts of noise. Also, lead networks are not suitable for providing high steady-state accuracy systems requiring very high error constants. In order to provide large error constants, typically K_p and K_v, we must consider the use of integration-type compensation networks, and therefore this will be the subject of concern in the following section.

10.6 System Compensation Using Integration Networks

For a large percentage of control systems, the primary objective is to obtain a high steady-state accuracy. Another goal is to maintain the transient performance of these systems within reasonable limits. As we found in Chapters 3 and 4, the steady-state accuracy of many feedback systems can be increased by increasing the amplifier gain in the forward channel. However, the resulting transient response may be totally unacceptable, if not even unstable. Therefore it is often necessary to introduce a compensation network in the forward path of a feedback control system in order to provide a sufficient steady-state accuracy.

Consider the single-loop control system shown in Fig. 10.14. The compensation network is to be chosen in order to provide a large error constant. The steady-state error of this system is

$$\lim_{t \to \infty} e(t) = \lim_{s \to 0} s \left[\frac{R(s)}{1 + G_c(s)G(s)H(s)} \right]. \tag{10.49}$$

We found in Section 3.5 that the steady-state error of a system depends upon the number of poles at the origin for $G_c(s)G(s)H(s)$. A pole at the origin can be considered an integration, and therefore the steady-state accuracy of a system ultimately depends upon the number of integrations in the transfer function $G_c(s)G(s)H(s)$. If the steady-state accuracy is not sufficient, we will introduce an *integration-type network* $G_c(s)$ in order to compensate for the lack of integration in the original transfer function $G(s)H(s)$.

One form of controller widely used is the proportional plus integral (PI) controller, which has a transfer function

$$G_c(s) = K_P + \frac{K_I}{s}. \tag{10.50}$$

For an example, let us consider a temperature control system where the transfer function $H(s) = 1$, and the transfer function of the heat process is

$$G(s) = \frac{K_1}{(\tau_1 s + 1)(\tau_2 s + 1)}.$$

The steady-state error of the uncompensated system is then

$$\lim_{t \to \infty} e(t) = \lim_{s \to 0} s \left\{ \frac{A/s}{1 + G(s)H(s)} \right\}$$

$$= \frac{A}{1 + K_1}, \tag{10.51}$$

where $R(s) = A/s$, a step input signal. Clearly, in order to obtain a small steady-state error (less than 0.05 A, for example), the magnitude of the gain K_1 must be quite large. However, when K_1 is quite large, the transient performance of the

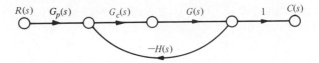

Figure 10.14. Single-loop feedback control system.

system will very likely be unacceptable. Therefore we must consider the addition of a compensation transfer function $G_c(s)$, as shown in Fig. 10.14. In order to eliminate the steady-state error of this system, we might choose the compensation as

$$G_c(s) = K_2 + \frac{K_3}{s} = \frac{K_2 s + K_3}{s}. \qquad (10.52)$$

This PI compensation can be readily constructed by using an integrator and an amplifier and adding their output signals. Now, the steady-state error for a step input of the system is always zero, because

$$\lim_{t \to \infty} e(t) = \lim_{s \to 0} s \frac{A/s}{1 + G_c(s)GH(s)}$$

$$= \lim_{s \to 0} \frac{A}{1 + [(K_2 s + K_3)/s]\{K_1/[(\tau_1 s + 1)(\tau_2 s + 1)]\}} \qquad (10.53)$$

$$= 0.$$

The transient performance can be adjusted to satisfy the system specifications by adjusting the constants K_1, K_2, and K_3. The adjustment of the transient response is perhaps best accomplished by using the root locus methods of Chapter 6 and drawing a root locus for the gain $K_2 K_1$ after locating the zero $s = -K_3/K_2$ on the s-plane by the method outlined for the s-plane in the preceding section.

The addition of an integration as $G_c(s) = K_2 + (K_3/s)$ can also be used to reduce the steady-state error for a ramp input, $r(t) = t, t \ge 0$. For example, if the uncompensated system $GH(s)$ possessed one integration, the additional integration due to $G_c(s)$ would result in a zero steady-state error for a ramp input. In order to illustrate the design of this type of integration compensation, we will consider a temperature control system in some detail.

■ **Example 10.5 Temperature control system**

The uncompensated loop transfer function of a temperature control system is

$$GH(s) = \frac{K_1}{(2s + 1)(0.5s + 1)}, \qquad (10.54)$$

where K_1 can be adjusted. In order to maintain zero steady-state error for a step input, we will add the compensation network

$$G_c(s) = K_2 + \frac{K_3}{s}$$

(10.55)

$$= K_2 \left(\frac{s + K_3/K_2}{s} \right).$$

Furthermore, the transient response of the system is required to have an overshoot less than or equal to 10%. Therefore the dominant complex roots must be on (or below) the $\zeta = 0.6$ line, as shown in Fig. 10.15. We will adjust the compensator zero so that the real part of the complex roots is $\zeta \omega_n = 0.75$ and thus the settling time is $T_s = 4/\zeta \omega_n = {}^{16}\!/_3$ sec. Now, as in the preceding section, we will determine the location of the zero, $z = -K_3/K_2$, by ensuring that the angle at the desired root is $-180°$. Therefore the sum of the angles at the desired root is

$$-180° = -127° - 104° - 38° + \theta_z,$$

where θ_z is the angle from the undetermined zero. Therefore we find that $\theta_z = +89°$ and the location of the zero is $z = -0.75$. Finally, in order to determine the gain at the desired root, we evaluate the vector lengths from the poles and zeros and obtain

$$K = K_1 K_2 = \frac{1.25(1.03)1.6}{1.0} = 2.08.$$

The compensated root locus and the location of the zero are shown in Fig. 10.15. It should be noted that the zero, $z = -K_3/K_2$, should be placed to the left of the

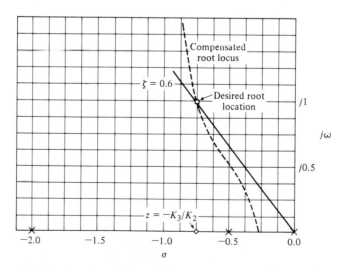

Figure 10.15. The s-plane design of an integration compensator.

pole at $s = -0.5$ in order to ensure that the complex roots dominate the transient response. In fact, the third root of the compensated system of Fig. 10.15 can be determined as $s = -1.0$, and therefore this real root is only ⅔ times the real part of the complex roots. Thus, although complex roots dominate the response of the system, the equivalent damping of the system is somewhat less than $\zeta = 0.60$ due to the real root and zero.

The closed-loop transfer function of the system of Fig. 10.14 is

$$T(s) = \frac{G_p G_c G(s)}{1 + G_c G(s)} \tag{10.56}$$

$$= \frac{2.08(s + 0.75)G_p(s)}{(s + 1)(s + r_1)(s + \hat{r}_1)}$$

where $r_1 = -0.75 + j1$. The effect of the zero is to increase the overshoot to a step input (see Fig. 4.10). Thus, if we wish to attain an overshoot of 5%, we may use a prefilter $G_p(s)$ so that the zero is eliminated in $T(s)$ by setting

$$G_p(s) = \frac{0.75}{(s + 0.75)}. \tag{10.57}$$

Note that the overall dc gain (set $s = 0$) is $T(0) = 1.0$ when $G_p(s) = 1$ or if we use the prefilter of Eq. (10.57). The overshoot without the prefilter is 20% and with the prefilter it is 5%.

10.7 Compensation on the s-Plane Using a Phase-Lag Network

The phase-lag RC network of Fig. 10.6 is an integration-type network and can be used to increase the error constant of a feedback control system. We found in Section 10.3 that the transfer function of the RC phase-lag network is of the form

$$G_c(s) = \frac{1}{\alpha} \frac{(s + z)}{(s + p)}, \tag{10.58}$$

as given in Eq. (10.13), where

$$z = \frac{1}{\tau} = \frac{1}{R_2 C},$$

$$\alpha = \frac{R_1 + R_2}{R_2},$$

$$p = \frac{1}{\alpha \tau}.$$

The steady-state error of an uncompensated system is

$$\lim_{t \to 0} e(t) = \lim_{s \to 0} s \left\{ \frac{R(s)}{1 + GH(s)} \right\}. \tag{10.59}$$

Then, for example, the velocity constant of a type-one system is

$$K_v = \lim_{s \to 0} s\{GH(s)\}, \tag{10.60}$$

as shown in Section 4.4. Therefore, if $GH(s)$ is written as

$$GH(s) = \frac{K \prod_{i=1}^{M} (s + z_i)}{s \prod_{j=1}^{Q} (s + p_j)}. \tag{10.61}$$

we obtain the velocity constant

$$K_v = \frac{K \prod_{i=1}^{M} z_i}{\prod_{j=1}^{Q} p_j}. \tag{10.62}$$

We will now add the integration type phase-lag network as a compensator and determine the compensated velocity constant. If the velocity constant of the uncompensated system (Eq. 10.62) is designated as $K_{v_{\text{uncomp}}}$, we have

$$K_{v_{\text{comp}}} = \lim_{s \to 0} s\{G_c(s)GH(s)\}$$

$$= \lim_{s \to 0} (G_c(s))K_{v_{\text{uncomp}}} \tag{10.63}$$

$$= \left(\frac{z}{p}\right)\left(\frac{1}{\alpha}\right) K_{v_{\text{uncomp}}}$$

$$= \left(\frac{z}{p}\right)\left(\frac{K}{\alpha}\right)\left(\frac{\prod z_i}{\prod p_j}\right).$$

The gain on the compensated root locus at the desired root location will be (K/α). Now, if the pole and zero of the compensator are chosen so that $|z| = \alpha|p| < 1$, the resultant K_v will be increased at the desired root location by the ratio $z/p = \alpha$. Then, for example, if $z = 0.1$ and $p = 0.01$, the velocity constant of the desired root location will be increased by a factor of 10. However, if the compensator pole and zero appear relatively close together on the s-plane, their effect on the location of the desired root will be negligible. Therefore the compen-

sator pole-zero combination near the origin can be used to increase the error constant of a feedback system by the factor α while altering the root location very slightly. The factor α does have an upper limit, typically about 100, because the required resistors and capacitors of the network become excessively large for a higher α. For example, when $z = 0.1$ and $\alpha = 100$, we find from Eq. (10.58) that

$$z = 0.1 = \frac{1}{R_2 C}$$

and

$$\alpha = 100 = \frac{R_1 + R_2}{R_2}.$$

If we let $C = 10 \mu f$, then $R_2 = 1$ megohm and $R_1 = 99$ megohms. As we increase α, we increase the required magnitude of R_1. However, we should note that an attenuation, α, of 1000 or more may be obtained by utilizing pneumatic process controllers, which approximate a phase-lag characteristic (Fig. 10.8).

The steps necessary for the design of a phase-lag network on the s-plane are as follows:

1. Obtain the root locus of the uncompensated system.

2. Determine the transient performance specifications for the system and locate suitable dominant root locations on the uncompensated root locus that will satisfy the specifications.

3. Calculate the loop gain at the desired root location and, thus, the system error constant.

4. Compare the uncompensated error constant with the desired error constant and calculate the necessary increase that must result from the pole–zero ratio of the compensator, α.

5. With the known ratio of the pole–zero combination of the compensator, determine a suitable location of the pole and zero of the compensator so that the compensated root locus will still pass through the desired root location.

The fifth requirement can be satisfied if the magnitude of the pole and zero is less than one and they appear to merge as measured from the desired root location. The pole and zero will appear to merge at the root location if the angles from the compensator pole and zero are essentially equal as measured to the root location. One method of locating the zero and pole of the compensator is based on the requirement that the difference between the angle of the pole and the angle of the zero as measured at the desired root is less than 2°. An example will illustrate this approach to the design of a phase-lag compensator.

■ **E x a m p l e 10.6 Design of a phase lag compensator**

Consider the uncompensated system of Example 10.2, where the uncompensated open-loop transfer function is

$$GH(s) = \frac{K}{s(s+2)}. \tag{10.64}$$

It is required that the damping ratio of the dominant complex roots is 0.45, while a system velocity constant equal to 20 is attained. The uncompensated root locus is a vertical line at $s = -1$ and results in a root on the $\zeta = 0.45$ line at $s = -1 \pm j2$, as shown in Fig. 10.16. Measuring the gain at this root, we have $K = (2.24)^2 = 5$. Therefore the velocity constant of the uncompensated system is

$$K_v = \frac{K}{2} = \frac{5}{2} = 2.5.$$

Thus the ratio of the zero to the pole of the compensator is

$$\left|\frac{z}{p}\right| = \alpha = \frac{K_{v_{comp}}}{K_{v_{uncomp}}} = \frac{20}{2.5} = 8. \tag{10.65}$$

Examining Fig. 10.17, we find that we might set $z = -0.1$ and then $p = -0.1/8$. The difference of the angles from p and z at the desired root is approximately 1°, and therefore $s = -1 \pm j2$ is still the location of the dominant roots. A sketch of the compensated root locus is shown as a heavy line in Fig. 10.17. Therefore the compensated system transfer function is

$$G_c(s)GH(s) = \frac{5(s+0.1)}{s(s+2)(s+0.0125)}, \tag{10.66}$$

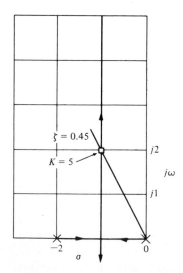

Figure 10.16. Root locus of the uncompensated system of Example 10.6.

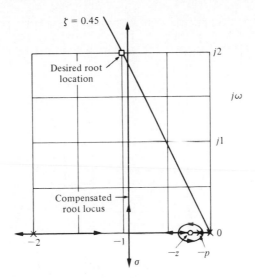

Figure 10.17. Root locus of the compensated system of Example 10.6. Note that the actual root will differ from the desired root by a slight amount. The vertical portion of the locus leaves the σ axis at $\sigma = -0.95$.

where $(K/\alpha) = 5$ or $K = 40$ in order to account for the attenuation of the lag network.

■ **Example 10.7 Lag compensation of a third-order system**

Let us now consider a system that is difficult to compensate by a phase-lead network. The open-loop transfer function of the uncompensated system is

$$GH(s) = \frac{K}{s(s + 10)^2}. \tag{10.67}$$

It is specified that the velocity constant of this system be equal to 20, while the damping ratio of the dominant roots be equal to 0.707. The gain necessary for a K_v of 20 is

$$K_v = 20 = \frac{K}{(10)^2}$$

or $K = 2000$. However, using Routh's criterion, we find that the roots of the characteristic equation lie on the $j\omega$-axis at $\pm j10$ when $K = 2000$. Clearly, the roots of the system when the K_v-requirement is satisfied are a long way from satisfying the damping ratio specification, and it would be difficult to bring the dominant roots from the $j\omega$-axis to the $\zeta = 0.707$ line by using a phase-lead compensator. Therefore we will attempt to satisfy the K_v and ζ-requirements by using a phase-lag network. The uncompensated root locus of this system is shown in Fig.

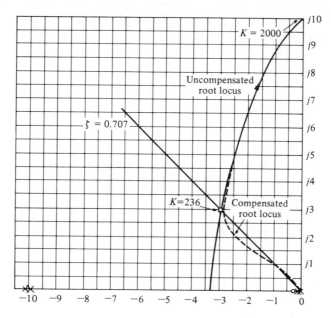

Figure 10.18. Design of a phase-lag compensator on the s-plane.

10.18 and the roots are shown when $\zeta = 0.707$ and $s = -2.9 \pm j2.9$. Measuring the gain at these roots, we find that $K = 236$. Therefore the necessary ratio of zero to pole of the compensator is

$$\alpha = \left| \frac{z}{p} \right| = \frac{2000}{236} = 8.5.$$

Thus we will choose $z = 0.1$ and $p = 0.1/9$ in order to allow a small margin of safety. Examining Fig. 10.18, we find that the difference between the angle from the pole and zero of $G_c(s)$ is negligible. Therefore the compensated system is

$$G_c(s)GH(s) = \frac{236(s + 0.1)}{s(s + 10)^2(s + 0.0111)}, \tag{10.68}$$

where $(K/\alpha) = 236$ and $\alpha = 9$.

The design of an integration compensator in order to increase the error constant of an uncompensated control system is particularly illustrative using s-plane and root locus methods. We shall now turn to similarly useful methods of designing integration compensation using Bode diagrams.

10.8 Compensation on the Bode Diagram Using a Phase-Lag Network

The design of a phase-lag RC network suitable for compensating a feedback control system can be readily accomplished on the Bode diagram. The advantage of the Bode diagram is again apparent for we will simply add the frequency response

of the compensator to the Bode diagram of the uncompensated system in order to obtain a satisfactory system frequency response. The transfer function of the phase-lag network written in Bode diagram form is

$$G_c(j\omega) = \frac{1 + j\omega\tau}{1 + j\omega\alpha\tau},$$ (10.69)

as we found in Eq. (10.14). The Bode diagram of the phase-lag network is shown in Fig. 10.8 for two values of α. On the Bode diagram, the pole and zero of the compensator have a magnitude much smaller than the smallest pole of the uncompensated system. Thus the phase lag is not the useful effect of the compensator, but rather it is the attenuation $-20 \log \alpha$ that is the useful effect for compensation. The phase-lag network is used to provide an attenuation and therefore to lower the 0-db (crossover) frequency of the system. However, at lower crossover frequencies we usually find that the phase margin of the system is increased and our specifications can be satisfied. The design procedure for a phase-lag network on the Bode diagram is as follows:

1. Draw the Bode diagram of the uncompensated system with the gain adjusted for the desired error constant.

2. Determine the phase margin of the uncompensated system and, if it is insufficient, proceed with the following steps.

3. Determine the frequency where the phase margin requirement would be satisfied if the magnitude curve crossed the 0-db line at this frequency, ω_c'. (Allow for 5° phase lag from the phase-lag network when determining the new crossover frequency.)

4. Place the zero of the compensator one decade below the new crossover frequency ω_c' and thus ensure only 5° of lag at ω_c' (see Fig. 10.8).

5. Measure the necessary attenuation at ω_c' in order to ensure that the magnitude curve crosses at this frequency.

6. Calculate α by noting that the attenuation is $-20 \log \alpha$.

7. Calculate the pole as $\omega_p = 1/\alpha\tau = \omega_z/\alpha$ and the design is completed.

An example of this design procedure will illustrate that the method is simple to carry out in practice.

■ **Example 10.8** **Design of a phase-lag network**

Let us reconsider the system of Example 10.6 and design a phase-lag network so that the desired phase margin is obtained. The uncompensated transfer function is

$$GH(j\omega) = \frac{K}{j\omega(j\omega + 2)}$$ (10.70)

$$= \frac{K_v}{j\omega(0.5j\omega + 1)},$$

where $K_v = K/2$. It is desired that $K_v = 20$ while a phase margin of 45° is attained. The uncompensated Bode diagram is shown as a solid line in Fig. 10.19. The uncompensated system has a phase margin of 20°, and the phase margin must be increased. Allowing 5° for the phase-lag compensator, we locate the frequency ω where $\phi(\omega) = -130°$, which is to be our new crossover frequency ω'_c. In this case we find that $\omega'_c = 1.5$, which allows for a small margin of safety. The attenuation

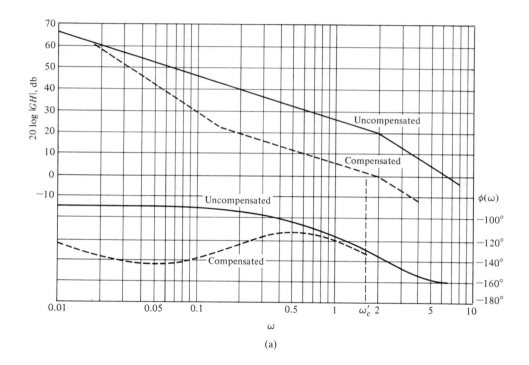

(a)

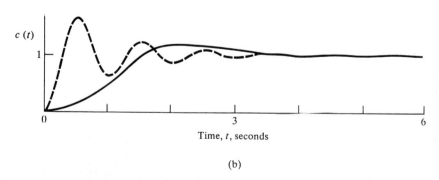

(b)

Figure 10.19. (a) Design of a phase-lag network on the Bode diagram for Example 10.8. (b) Time response to a step input for the uncompensated system (dashed line) and the compensated system (solid line) of Example 10.8.

necessary to cause ω'_c to be the new crossover frequency is equal to 20 db, accounting for a 2-db difference between the actual and asymptotic curves. Then we find that 20 db $=$ 20 log α, or $\alpha =$ 10. Therefore the zero is one decade below the crossover, or $\omega_z = \omega'_c/10 =$ 0.15, and the pole is at $\omega_p = \omega_z/10 =$ 0.015. The compensated system is then

$$G_c(j\omega)GH(j\omega) = \frac{20(6.66j\omega + 1)}{j\omega(0.5j\omega + 1)(66.6j\omega + 1)}. \tag{10.71}$$

The frequency response of the compensated system is shown in Fig. 10.19(a) with dashed lines. It is evident that the phase lag introduces an attenuation that lowers the crossover frequency and therefore increases the phase margin. Note that the phase angle of the lag network has almost totally disappeared at the crossover frequency ω'_c. As a final check, we numerically evaluate the phase margin at $\omega'_c =$ 1.5 and find that $\phi_{pm} =$ 45°, which is the desired result. Using the Nichols chart, we find that the closed-loop bandwidth of the system has been reduced from $\omega =$ 10 rad/sec for the uncompensated system to $\omega =$ 2.5 rad/sec for the compensated system.

The time response of the system is shown in Fig. 10.19(b). Note that the overshoot is 25% and the peak time is two seconds. Thus the response is within the specifications. The response is easy to check using the Control System Design Program.

■ Example 10.9 Lag compensation of a third-order system

Let us reconsider the system of Example 10.7, which is

$$GH(j\omega) = \frac{K}{j\omega(j\omega + 10)^2} \tag{10.72}$$

$$= \frac{K_v}{j\omega(0.1j\omega + 1)^2}$$

where $K_v = K/100$. A velocity constant of K_v equal to 20 is specified. Furthermore, a damping ratio of 0.707 for the dominant roots is required. From Fig. 8.19 we estimate that a phase margin of 65° is required. The frequency response of the uncompensated system is shown in Fig. 10.20. The phase margin of the uncompensated system is zero degrees. Allowing 5° for the lag network, we locate the frequency where the phase is −110°. This frequency is equal to 1.74, and therefore we shall attempt to locate the new crossover frequency at $\omega'_c =$ 1.5. Measuring the necessary attenuation at $\omega = \omega'_{c_1}$, we find that 23 db is required; 23 $=$ 20 log α, or $\alpha =$ 14.2. The zero of the compensator is located one decade below the crossover frequency, and thus

$$\omega_z = \frac{\omega'_c}{10} = 0.15.$$

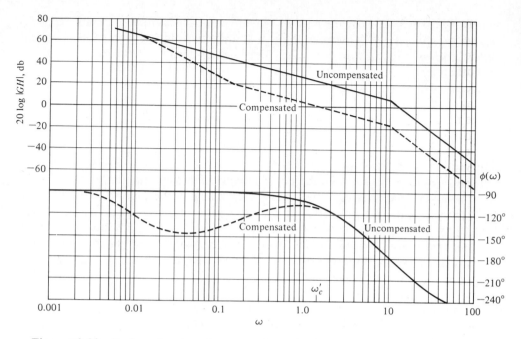

Figure 10.20. Design of a phase-lag network on the Bode diagram for Example 10.9.

The pole is then

$$\omega_p = \frac{\omega_z}{\alpha} = \frac{0.15}{14.2}.$$

Therefore the compensated system is

$$G_c(j\omega)GH(j\omega) = \frac{20(6.66j\omega + 1)}{j\omega(0.1j\omega + 1)^2(94.6j\omega + 1)}. \qquad (10.73)$$

The compensated frequency response is shown in Fig. 10.20. As a final check, we numerically evaluate the phase margin at $\omega_c' = 1.5$ and find that $\phi_{pm} = 67°$, which is within the specifications.

Therefore a phase-lag compensation network can be used to alter the frequency response of a feedback control system in order to attain satisfactory system performance. Examining both Examples 10.8 and 10.9, we note again that the system design is satisfactory when the asymptotic curve for the magnitude of the compensated system crosses the 0-db line with a slope of -6 db/octave. The attenuation of the phase-lag network reduces the magnitude of the crossover (0-db) frequency to a point where the phase margin of the system is satisfactory. Thus, in contrast to the phase-lead network, the phase-lag network reduces the closed-loop bandwidth of the system as it maintains a suitable error constant.

One might ask, why do we not place the compensator zero more than one decade below the new crossover ω_c' (see item 4 of the design procedure) and thus

ensure less than 5° of lag at ω_c' due to the compensator? This question can be answered by considering the requirements placed on the resistors and capacitors of the lag network by the values of the poles and zeros (see Eq. 10.12). As the magnitudes of the pole and zero of the lag network are decreased, the magnitudes of the resistors and the capacitor required increase proportionately. The zero of the lag compensator in terms of the circuit components is $z = 1/R_2C$, and the α of the network is $\alpha = (R_1 + R_2)/R_2$. Thus, considering Example 10.9, we require a zero at $z = 0.15$, which can be obtained with $C = 1\ \mu f$ and $R_2 = 6.66$ megohms. However, for $\alpha = 14$ we require a resistance R_1 of $R_1 = R_2(\alpha - 1) = 88$ megohms. Clearly, a designer does not wish to place the zero z further than one decade below ω_c' and thus require larger values of R_1, R_2, and C.

The phase-lead compensation network alters the frequency response of a network by adding a positive (leading) phase angle and, therefore increases the phase margin at the crossover (0-db) frequency. It becomes evident that a designer might wish to consider using a compensation network that provided the attenuation of a phase-lag network and the lead-phase angle of a phase-lead network. Such a network does exist. It is called a *lead-lag network* and is shown in Fig. 10.21. The transfer function of this network is

$$\frac{E_2(s)}{E_1(s)} = \frac{(R_1C_1s + 1)(R_2C_2s + 1)}{R_1R_2C_1C_2s^2 + (R_1C_1 + R_1C_2 + R_2C_2)s + 1}. \qquad (10.74)$$

When $\alpha\tau_1 = R_1C_1$, $\beta\tau_2 = R_2C_2$, $\tau_1\tau_2 = R_1R_2C_1C_2$, we note that $\alpha\beta = 1$ and then Eq. (10.74) is

$$\frac{E_2(s)}{E_1(s)} = \frac{(1 + \alpha\tau_1s)(1 + \beta\tau_2s)}{(1 + \tau_1s)(1 + \tau_2s)}, \qquad (10.75)$$

where $\alpha > 1$ and $\beta < 1$. The first terms in the numerator and denominator, which are a function of τ_1, provide the phase-lead portion of the network. The second terms, which are a function of τ_2, provide the phase-lag portion of the compensation network. The parameter β is adjusted to provide suitable attenuation of the low frequency portion of the frequency response, and the parameter α is adjusted to provide an additional phase lead at the new crossover (0-db) frequency. Alternatively, the compensation can be designed on the s-plane by placing the lead pole and zero compensation in order to locate the dominant roots in

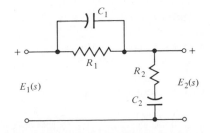

Figure 10.21. An *RC* lead-lag network.

a desired location. Then the phase-lag compensation is used to raise the error constant at the dominant root location by a suitable ratio, $1/\beta$. The design of a phase lead-lag compensator follows the procedures already discussed, and the reader is referred to further literature illustrating the utility of lead-lag compensation [2, 3].

10.9 Compensation on the Bode Diagram Using Analytical and Computer Methods

It is desirable to use computers, when appropriate, to assist the designer in the selection of the parameters of a compensator. The development of algorithms for computer-aided design is an important alternative approach to the trial-and-error methods considered in earlier sections. By the use of compensators, computer programs have been developed for the selection of suitable parameter values based on satisfaction of frequency response criteria such as phase margin [5, 6].

An analytical technique of selecting the parameters of a lead or lag network has been developed for Bode diagrams [6, 7]. For a single-stage compensator

$$G_c(s) = \frac{1 + \alpha\tau s}{1 + \tau s}, \tag{10.76}$$

where $\alpha < 1$ yields a lag compensator and $\alpha > 1$ yields a lead compensator. The phase contribution of the compensator at the desired crossover frequency ω_c (see Eq. 10.9) is

$$p = \tan \phi = \frac{\alpha\omega_c\tau - \omega_c\tau}{1 + (\omega_c\tau)^2\alpha}. \tag{10.77}$$

The magnitude M (in db) of the compensator at ω_c is

$$c = 10^{M/10} = \frac{1 + (\omega_c\alpha\tau)^2}{1 + (\omega_c\tau)^2}. \tag{10.78}$$

Eliminating $\omega_c\tau$ from Eqs. (10.77) and (10.78), we obtain the nontrivial solution equation for α as

$$(p^2 - c + 1)\alpha^2 + 2p^2 c\alpha + p^2 c^2 + c^2 - c = 0. \tag{10.79}$$

For a single-stage compensator it is necessary that $c > p^2 + 1$. If we solve for α from Eq. (10.79), we can obtain τ from

$$\tau = \frac{1}{\omega_c} \sqrt{\frac{1 - c}{c - \alpha^2}}. \tag{10.80}$$

The design steps for a lead compensator are:

1. Select the desired ω_c.
2. Determine the phase margin desired and therefore the required phase ϕ for Eq. (10.77).

3. Verify that the phase lead is applicable, $\phi > 0$ and $M > 0$.

4. Determine whether a single stage will be sufficient when $c > p^2 + 1$.

5. Determine α from Eq. (10.79).

6. Determine τ from Eq. (10.80).

If we need to design a single lag compensator, then $\phi < 0$ and $M < 0$ (step 3). Also, step 4 will require $c < [1/(1 + p^2)]$. Otherwise the method is the same.

■ Example 10.10 Design using an analytical technique

Let us reconsider the system of Example 10.1 and design a lead network by the analytical technique. Examine the uncompensated curves in Fig. 10.9. We select $\omega_c = 5$. Then, as before, we desire a phase margin of 45°. The compensator must yield this phase, so

$$p = \tan 45° = 1. \tag{10.81}$$

The required magnitude contribution is 8 db or $M = 8$, so that

$$c = 10^{8/10} = 6.31. \tag{10.82}$$

Using c and p, we obtain

$$-4.31\alpha^2 + 12.62\alpha + 73.32 = 0. \tag{10.83}$$

Solving for α we obtain $\alpha = 5.84$. Solving Eq. (10.80), we obtain $\tau = 0.087$. Therefore the compensator is

$$G_c(s) = \frac{1 + 0.515s}{1 + 0.087s}. \tag{10.84}$$

The pole is equal to 11.5 and the zero is 1.94. This design is similar to that obtained by the iteration technique of Section 10.4.

10.10 The Design of Control Systems in the Time Domain

The design of automatic control systems is an important function of control engineering. The purpose of design is to realize a system with practical components which will provide the desired operating performance. The desired performance can be readily stated in terms of time-domain performance indices. For example, the maximum overshoot and rise time for a step input are valuable time-domain indices. In the case of steady-state and transient performance, the performance indices are normally specified in the time domain and, therefore, it is natural that we wish to develop design procedures in the time domain.

The performance of a control system can be represented by integral performance measures, as we found in Section 4.5. Therefore the design of a system must be based on minimizing a performance index such as the integral of the squared error (ISE), as in Section 4.5. Systems that are adjusted to provide a min-

imum performance index are often called *optimum control systems*. In this section, we shall consider the design of an optimum control system where the system is described by a state variable formulation.

However, before proceeding to the specifics, we should note that we earlier designed a system in the time domain in Example 9.6. In this example, we considered the unstable portion of an inverted pendulum system and developed a suitable feedback control so that the system was stable. This design was based on measuring the state variables of the system and using them to form a suitable control signal $u(t)$ so that the system was stable. In this section, we shall again consider the measurement of the state variables and their use in developing a control signal $u(t)$ so that the performance of the system is optimized.

The performance of a control system, written in terms of the state variables of a system, can be expressed in general as

$$J = \int_0^{t_f} g(\mathbf{x}, \mathbf{u}, t)\, dt, \tag{10.85}$$

where \mathbf{x} equals the state vector and \mathbf{u} equals the control vector.*

We are interested in minimizing the error of the system and, therefore, when the desired state vector is represented as $\mathbf{x}_d = \mathbf{0}$, we are able to consider the error as identically equal to the value of the state vector. That is, we desire the system to be at equilibrium, $\mathbf{x} = \mathbf{x}_d = \mathbf{0}$, and in any deviation from equilibrium is considered an error. Therefore we will consider, in this section, the design of optimum control systems using *state-variable feedback* and error-squared performance indices [1, 2, 3].

The control system we will consider is shown in Fig. 10.22 and can be represented by the vector differential equation

$$\dot{\mathbf{x}} = \mathbf{A}\mathbf{x} + \mathbf{B}\mathbf{u}. \tag{10.86}$$

We will select a feedback controller so that \mathbf{u} is some function of the measured state variables \mathbf{x} and therefore

$$\mathbf{u} = \mathbf{h}(\mathbf{x}). \tag{10.87}$$

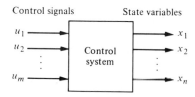

Figure 10.22. A control system in terms of x and u.

*Note that J is used to denote the performance index, instead of I, which was used in Chapter 4. This will enable the reader to distinguish readily the performance index from the identity matrix, which is represented by the boldfaced capital \mathbf{I}.

For example, we might use

$$u_1 = k_1 x_1,$$

$$u_2 = k_2 x_2,$$

$$\vdots$$

$$u_m = k_m x_m.$$

(10.88)

Alternatively, we might choose the control vector as

$$u_1 = k_1(x_1 + x_2),$$

$$u_2 = k_2(x_2 + x_3),$$

$$\vdots$$

(10.89)

The choice of the control signals is somewhat arbitrary and depends partially upon the actual desired performance and the complexity of the feedback structure allowable. Often we are limited in the number of state variables available for feedback, since we are only able to utilize measurable state variables.

Now, in our case we limit the feedback function to a linear function so that $\mathbf{u} = \mathbf{Hx}$, where \mathbf{H} is an $m \times n$ matrix. Therefore, in expanded form, we have

$$\begin{bmatrix} u_1 \\ u_2 \\ \vdots \\ u_m \end{bmatrix} = \begin{bmatrix} h_{11} \cdots h_{1n} \\ \vdots \qquad \vdots \\ h_{m1} \cdots h_{mn} \end{bmatrix} \begin{bmatrix} x_1 \\ x_2 \\ \vdots \\ x_n \end{bmatrix}.$$

(10.90)

Then, substituting Eq. (10.90) into Eq. (10.86), we obtain

$$\dot{\mathbf{x}} = \mathbf{Ax} + \mathbf{BHx} = \mathbf{Dx},$$

(10.91)

where \mathbf{D} is the $n \times n$ matrix resulting from the addition of the elements of \mathbf{A} and \mathbf{BH}.

Now, returning to the error-squared performance index, we recall from Section 4.5 that the index for a single state variable, x_1, is written as

$$J = \int_0^{t_f} (x_1(t))^2 \, dt.$$

(10.92)

A performance index written in terms of two state variables would then be

$$J = \int_0^{t_f} (x_1^2 + x_2^2) \, dt.$$

(10.93)

Therefore, because we wish to define the performance index in terms of an integral of the sum of the state variables squared, we will utilize the matrix operation

$$\mathbf{x}^T \mathbf{x} = [x_1, x_2, x_3, \ldots, x_n] \begin{bmatrix} x_1 \\ x_2 \\ \vdots \\ x_n \end{bmatrix} = (x_1^2 + x_2^2 + x_3^2 + \ldots + x_n^2), \quad (10.94)$$

where \mathbf{x}^T indicates the transpose of the \mathbf{x} matrix.* Then the general form of the performance index, in terms of the state vector, is

$$J = \int_0^{t_f} (\mathbf{x}^T\mathbf{x}) \, dt. \tag{10.95}$$

Again considering Eq. (10.95), we will let the final time of interest be $t_f = \infty$. In order to obtain the minimum value of J, we postulate the existence of an exact differential so that

$$\frac{d}{dt}(\mathbf{x}^T\mathbf{P}\mathbf{x}) = -\mathbf{x}^T\mathbf{x}, \tag{10.96}$$

where \mathbf{P} is to be determined. A symmetric \mathbf{P} matrix will be used in order to simplify the algebra without any loss of generality. Then, for a symmetric \mathbf{P} matrix, $p_{ij} = p_{ji}$. Completing the differentiation indicated on the left-hand side of Eq. (10.96), we have

$$\frac{d}{dt}(\mathbf{x}^T\mathbf{P}\mathbf{x}) = \dot{\mathbf{x}}^T\mathbf{P}\mathbf{x} + \mathbf{x}^T\mathbf{P}\dot{\mathbf{x}}.$$

Then, substituting Eq. (10.91), we obtain

$$\begin{aligned}\frac{d}{dt}(\mathbf{x}^T\mathbf{P}\mathbf{x}) &= (\mathbf{D}\mathbf{x})^T\mathbf{P}\mathbf{x} + \mathbf{x}^T\mathbf{P}(\mathbf{D}\mathbf{x}) \\ &= \mathbf{x}^T\mathbf{D}^T\mathbf{P}\mathbf{x} + \mathbf{x}^T\mathbf{P}\mathbf{D}\mathbf{x} \\ &= \mathbf{x}^T(\mathbf{D}^T\mathbf{P} + \mathbf{P}\mathbf{D})\mathbf{x}, \end{aligned} \tag{10.97}$$

where $(\mathbf{D}\mathbf{x})^T = \mathbf{x}^T\mathbf{D}^T$ by the definition of the transpose of a product. If we let $(\mathbf{D}^T\mathbf{P} + \mathbf{P}\mathbf{D}) = -\mathbf{I}$, then Eq. (10.97) becomes

$$\frac{d}{dt}(\mathbf{x}^T\mathbf{P}\mathbf{x}) = -\mathbf{x}^T\mathbf{x}, \tag{10.98}$$

which is the exact differential we are seeking. Substituting Eq. (10.98) into Eq. (10.95), we obtain

$$\begin{aligned}J &= \int_0^{\infty} -\frac{d}{dt}(\mathbf{x}^T\mathbf{P}\mathbf{x}) \, dt \\ &= -\mathbf{x}^T\mathbf{P}\mathbf{x}\,|_0^{\infty} \\ &= \mathbf{x}^T(0)\mathbf{P}\mathbf{x}(0). \end{aligned} \tag{10.99}$$

In the evaluation of the limit at $t = \infty$, we have assumed that the system is stable and hence $\mathbf{x}(\infty) = 0$ as desired. Therefore, in order to minimize the performance index J, we consider the two equations

$$J = \int_0^{\infty} \mathbf{x}^T\mathbf{x}\,dt = \mathbf{x}^T(0)\mathbf{P}\mathbf{x}(0) \tag{10.100}$$

*The matrix operation $\mathbf{x}^T\mathbf{x}$ is discussed in Appendix C, Section C.4.

and

$$\mathbf{D}^T\mathbf{P} + \mathbf{P}\mathbf{D} = -\mathbf{I}. \tag{10.101}$$

The design steps are then as follows:

1. Determine the matrix \mathbf{P} which satisfies Eq. (10.101), where \mathbf{D} is known.
2. Minimize J by determining the minimum of Eq. (10.100).

■ Example 10.11 State variable feedback

Consider the control system shown in Fig. 10.23 in signal-flow graph form. The state variables are identifed as x_1 and x_2. The performance of this system is quite unsatisfactory because an undamped response results for a step input or disturbance signal. The vector differential equation of this system is

$$\frac{d}{dt}\begin{bmatrix} x_1 \\ x_2 \end{bmatrix} = \begin{bmatrix} 0 & 1 \\ 0 & 0 \end{bmatrix}\begin{bmatrix} x_1 \\ x_2 \end{bmatrix} + \begin{bmatrix} 0 \\ 1 \end{bmatrix} u(t), \tag{10.102}$$

where

$$\mathbf{A} = \begin{bmatrix} 0 & 1 \\ 0 & 0 \end{bmatrix}.$$

We will choose a feedback control system so that

$$u(t) = -k_1 x_1 - k_2 x_2, \tag{10.103}$$

and therefore the control signal is a linear function of the two state variables. The sign of the feedback is negative in order to provide negative feedback. Then Eq. (10.102) becomes

$$\dot{x}_1 = x_2, \qquad\qquad\qquad\qquad (10.104)$$
$$\dot{x}_2 = -k_1 x_1 - k_2 x_2,$$

or, in matrix form, we have

$$\dot{\mathbf{x}} = \mathbf{D}\mathbf{x}$$
$$= \begin{bmatrix} 0 & 1 \\ -k_1 & -k_2 \end{bmatrix}\mathbf{x}. \tag{10.105}$$

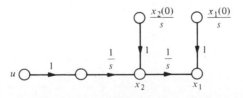

Figure 10.23. Signal-flow graph of the control system of Example 10.11.

We note that x_1 would represent the position of a position-control system and the transfer function of the system would be $G(s) = 1/Ms^2$, where $M = 1$ and the friction is negligible. In any case, in order to avoid needless algebraic manipulation, we will let $k_1 = 1$ and determine a suitable value for k_2 so that the performance index is minimized. Then, writing Eq. (10.101), we have

$$\mathbf{D}^T\mathbf{P} + \mathbf{PD} = -\mathbf{I},$$

$$\begin{bmatrix} 0 & -1 \\ 1 & -k_2 \end{bmatrix}\begin{bmatrix} p_{11} & p_{12} \\ p_{12} & p_{22} \end{bmatrix} + \begin{bmatrix} p_{11} & p_{12} \\ p_{12} & p_{22} \end{bmatrix}\begin{bmatrix} 0 & 1 \\ -1 & -k_2 \end{bmatrix} = \begin{bmatrix} -1 & 0 \\ 0 & -1 \end{bmatrix}. \quad (10.106)$$

Completing the matrix multiplication and addition, we have

$$-p_{12} - p_{12} = -1,$$

$$p_{11} - k_2 p_{12} - p_{22} = 0, \quad (10.107)$$

$$p_{12} - k_2 p_{22} + p_{12} - k_2 p_{22} = -1.$$

Then, solving these simultaneous equations, we obtain

$$p_{12} = \frac{1}{2}, \qquad p_{22} = \frac{1}{k_2}, \qquad p_{11} = \frac{k_2^2 + 2}{2k_2}.$$

The integral performance index is then

$$J = \mathbf{x}^T(0)\mathbf{P}\mathbf{x}(0), \quad (10.108)$$

and we shall consider the case where each state is initially displaced one unit from equilibrium so that $\mathbf{x}^T(0) = [1, 1]$. Therefore Eq. (10.108) becomes

$$J = [1, 1]\begin{bmatrix} p_{11} & p_{12} \\ p_{12} & p_{22} \end{bmatrix}\begin{bmatrix} 1 \\ 1 \end{bmatrix}$$

$$= [1, 1]\begin{bmatrix} (p_{11} + p_{12}) \\ (p_{12} + p_{22}) \end{bmatrix} \quad (10.109)$$

$$= (p_{11} + p_{12}) + (p_{12} + p_{22}) = p_{11} + 2p_{12} + p_{22}.$$

Substituting the values of the elements of \mathbf{P}, we have

$$J = \frac{k_2^2 + 2}{2k_2} + 1 + \frac{1}{k_2}$$

$$= \frac{k_2^2 + 2k_2 + 4}{2k_2}. \quad (10.110)$$

In order to minimize as a function of k_2, we take the derivative with respect to k_2 and set it equal to zero as follows:

$$\frac{\partial J}{\partial k_2} = \frac{2k_2(2k_2 + 2) - 2(k_2^2 + 2k_2 + 4)}{(2k_2)^2} = 0. \quad (10.111)$$

Therefore $k_2^2 = 4$ and $k_2 = 2$ when J is a minimum. The minimum value of J is obtained by substituting $k_2 = 2$ into Eq. (10.110). Thus we obtain

$$J_{min} = 3.$$

The system matrix \mathbf{D}, obtained for the compensated system, is then

$$\mathbf{D} = \begin{bmatrix} 0 & 1 \\ -1 & -2 \end{bmatrix} \qquad (10.112)$$

The characteristic equation of the compensated system is therefore

$$\det[\lambda\mathbf{I} - \mathbf{D}] = \det\begin{bmatrix} \lambda & -1 \\ 1 & \lambda + 2 \end{bmatrix} , \qquad (10.113)$$
$$= \lambda^2 + 2\lambda + 1.$$

Because this is a second-order system, we note that the characteristic equation is of the form $(s^2 + 2\zeta\omega_n s + \omega_n^2)$, and therefore the damping ratio of the compensated system is $\zeta = 1.0$. This compensated system is considered to be an optimum system in that the compensated system results in a minimum value for the performance index. Of course, we recognize that this system is optimum only for the specific set of initial conditions that were assumed. The compensated system is shown in Fig. 10.24. A curve of the performance index as a function of k_2 is shown in Fig. 10.25. It is clear that this system is not very sensitive to changes in k_2 and will maintain a near minimum performance index if the k_2 is altered some percentage. We define the sensitivity of an optimum system as

$$S_k^{opt} = \frac{\Delta J/J}{\Delta k/k}, \qquad (10.114)$$

where k is the design parameter. Then for this example we have $k = k_2$, and therefore

$$S_{k_2}^{opt} \simeq \frac{0.08/3}{0.5/2} = 0.107. \qquad (10.115)$$

Figure 10.24. Compensated control system of Example 10.11.

Figure 10.25. Performance index versus the parameter k_2.

■ Example 10.12 Determination of an optimum system

Now let us reconsider the system of Example 10.11, where both the feedback gains, k_1 and k_2, are unspecified. In order to simplify the algebra without any loss in insight into the problem, let us set $k_1 = k_2 = k$. The reader can prove that if k_1 and k_2 are unspecified then $k_1 = k_2$ when the minimum of the performance index (Eq. 10.100) is obtained. Then for the system of the previous example, Eq. (10.105) becomes

$$\dot{x} = Dx \qquad (10.116)$$

$$= \begin{bmatrix} 0 & 1 \\ -k & -k \end{bmatrix} x.$$

In order to determine the **P** matrix we utilize Eq. (10.101), which is

$$D^T P + PD = -I. \qquad (10.117)$$

Solving the set of simultaneous equations resulting from Eq. (10.117), we find that

$$p_{12} = \frac{1}{2k}, \qquad p_{22} = \frac{(k+1)}{2k^2}, \qquad p_{11} = \frac{(1+2k)}{2k}.$$

Let us consider the case where the system is initially displaced one unit from equilibrium so that $x^T(0) = [1, 0]$. Then the performance index (Eq. 10.100) becomes

$$J = \int_0^\infty x^T x \, dt = x^T(0)Px(0) = p_{11}. \qquad (10.118)$$

Figure 10.26. Performance index versus the feedback gain k for Example 10.12.

Thus the performance index to be minimized is

$$J = p_{11} = \frac{(1 + 2k)}{2k} = 1 + \frac{1}{2k}. \tag{10.119}$$

Clearly, the minimum value of J is obtained when k approaches infinity; the result is $J_{\min} = 1$. A plot of J versus k is shown in Fig. 10.26. This plot illustrates that the performance index approaches a minimum asymptotically as k approaches an infinite value. Now we recognize that in providing a very large gain k, we can cause the feedback signal

$$u(t) = -k(x_1(t) + x_2(t))$$

to be very large. However, we are restricted to realizable magnitudes of the control signal $u(t)$. Therefore we must introduce a *constraint* on $u(t)$ so that the gain k is not made too large. Then, for example, if we establish a constraint on $u(t)$ so that

$$|u(t)| \leq 50, \tag{10.120}$$

we require that the maximum accceptable value of k in this case is

$$k_{\max} = \frac{|u|_{\max}}{x_1(0)} = 50. \tag{10.121}$$

Then the minimum value of J is

$$
J_{min} = 1 + \frac{1}{2k_{max}}
$$

$$
= 1.01,
$$

(10.122)

which is sufficiently close to the absolute minimum of J in order to satisfy our requirements.

Upon the examination of the performance index (Eq. 10.95), we recognize that the reason the magnitude of the control signal is not accounted for in the original calculations is that $u(t)$ is not included within the expression for the performance index. However, there are many cases where we are concerned with the expenditure of the control signal energy. For example, in a space vehicle attitude control system, $[u(t)]^2$ represents the expenditure of jet fuel energy and must be restricted in order to conserve the fuel energy for long periods of flight. In order to account for the expenditure of the energy of the control signal, we will utilize the performance index

$$
J = \int_0^\infty (\mathbf{x}^T \mathbf{I} \mathbf{x} + \lambda \mathbf{u}^T \mathbf{u})\, dt,
$$

(10.123)

where λ is a scalar weighting factor and \mathbf{I} = identity matrix. The weighting factor λ will be chosen so that the relative importance of the state variable performance is contrasted with the importance of the expenditure of the system energy resource which is represented by $\mathbf{u}^T \mathbf{u}$. As in the previous paragraphs we will represent the state variable feedback by the matrix equation.

$$
\mathbf{u} = \mathbf{Hx}
$$

(10.124)

and the system with this state variable feedback as

$$
\dot{\mathbf{x}} = \mathbf{Ax} + \mathbf{Bu}
$$

$$
= \mathbf{Dx}.
$$

(10.125)

Now, substituting Eq. (10.124) into Eq. (10.123), we have

$$
J = \int_0^\infty (\mathbf{x}^T \mathbf{I} \mathbf{x} + \lambda (\mathbf{Hx})^T (\mathbf{Hx}))\, dt
$$

$$
= \int_0^\infty [\mathbf{x}^T (\mathbf{I} + \lambda \mathbf{H}^T \mathbf{H}) \mathbf{x}]\, dt
$$

(10.126)

$$
= \int_0^\infty \mathbf{x}^T \mathbf{Q} \mathbf{x}\, dt,
$$

where $\mathbf{Q} = (\mathbf{I} + \lambda \mathbf{H}^T \mathbf{H})$ is an $n \times n$ matrix. Following the development of Eqs. (10.95) through (10.99), we postulate the existence of an exact differential so that

$$
\frac{d}{dt} (\mathbf{x}^T \mathbf{P} \mathbf{x}) = -\mathbf{x}^T \mathbf{Q} \mathbf{x}.
$$

(10.127)

Then in this case we require that

$$\mathbf{D}^T\mathbf{P} + \mathbf{P}\mathbf{D} = -\mathbf{Q}. \tag{10.128}$$

and thus we have as before (Eq. 10.99)

$$J = \mathbf{x}^T(0)\mathbf{P}\mathbf{x}(0). \tag{10.129}$$

Now the design steps are exactly as for Eqs. (10.100) and (10.101) with the exception that the left side of Eq. (10.128) equals $-\mathbf{Q}$ instead of $-\mathbf{I}$. Of course, if $\lambda = 0$, Eq. (10.128) reduces to Eq. (10.101). Now let us reconsider the previous example when λ is other than zero and account for the expenditure of control signal energy.

■ E x a m p l e 10.13 Optimum system with energy constraint

Let us reconsider the system of Example 10.11, which is shown in Fig. 10.23. For this system we use a state variable feedback so that

$$\mathbf{u} = \mathbf{H}\mathbf{x}$$

$$= \begin{bmatrix} k & 0 \\ 0 & k \end{bmatrix}\begin{bmatrix} x_1 \\ x_2 \end{bmatrix} = k\mathbf{I}\mathbf{x}. \tag{10.130}$$

Therefore the matrix \mathbf{Q} is then

$$\mathbf{Q} = (\mathbf{I} + \lambda\mathbf{H}^T\mathbf{H})$$

$$= (\mathbf{I} + \lambda k^2\mathbf{I}) \tag{10.131}$$

$$= (1 + \lambda k^2)\mathbf{I}.$$

As in Example 10.12 we will let $\mathbf{x}^T(0) = [1, 0]$ so that $J = p_{11}$. We evaluate p_{11} from Eq. (10.128) as

$$\mathbf{D}'\mathbf{P} + \mathbf{P}\mathbf{D} = -\mathbf{Q} \tag{10.132}$$

$$= -(1 + \lambda k^2)\mathbf{I}.$$

Thus we find that

$$J = p_{11} = (1 + \lambda k^2)\left(1 + \frac{1}{2k}\right), \tag{10.133}$$

and we note that the right-hand side of Eq. (10.133) reduces to Eq. (10.119) when $\lambda = 0$. Now the minimum of J is found by taking the derivative of J, which is

$$\frac{dJ}{dk} = 2\lambda k + \frac{\lambda}{2} - \frac{1}{2k^2} \tag{10.134}$$

$$= \frac{4\lambda k^3 + \lambda k^2 - 1}{2k^2} = 0.$$

Therefore the minimum of the performance index occurs when $k = k_{min}$, where k_{min} is the solution of Eq. (10.134).

Figure 10.27. Performance index versus the feedback gain k for Example 10.13.

A simple method of solution for Eq. (10.134) is the Newton-Raphson method, illustrated in Section 5.4. Let us complete this example for the case where the control energy and the state variables squared are equally important so that $\lambda = 1$. Then Eq. (10.134) becomes $4k^3 + k^2 - 1 = 0$, and using the Newton-Raphson method, we find that $k_{min} = 0.555$. The value of the performance index J obtained with k_{min} is considerably greater than that of the previous example, because the expenditure of energy is equally weighted as a cost. The plot of J versus k for this case is shown in Fig. 10.27. The plot of J versus k for Example 10.12 is also shown for comparison on Fig. 10.27. It has become clear from this and the previous examples that the actual minimum obtained depends upon the initial conditions, the definition of the performance index, and the value of the scalar factor λ.

The design of several parameters can be accomplished in a similar manner to that illustrated in the examples. Also, the design procedure can be carried out for higher-order systems. However, we must then consider the use of a digital computer to determine the solution of Eq. (10.101) in order to obtain the **P** matrix. Also, the computer would provide a suitable approach for evaluating the minimum value of J for the several parameters. The newly emerging field of adaptive and optimal control systems is based on the formulation of the time-domain equations and the determination of an optimum feedback control signal $\mathbf{u}(t)$ [1, 2, 9]. The design of control systems using time-domain methods will continue to develop in the future and will provide the control engineer with many interesting challenges and opportunities.

10.11 State-Variable Feedback

In Section 10.10 we considered the use of state-variable feedback in achieving optimization of a performance index. In this section we will use *state-variable feedback* in order to achieve the desired pole location of the closed-loop transfer function $T(s)$. The approach is based on the feedback of all the state variables, and therefore

$$\mathbf{u} = \mathbf{Hx}. \tag{10.135}$$

When using this state-variable feedback, the roots of the characteristic equation are placed where the transient performance meets the desired response. As an example of state-variable feedback, consider the feedback system shown in Fig. 10.28. This position control uses a field controlled motor, and the transfer function was obtained in Section 2.5 as

$$G(s) = \frac{K}{s(s + f/J)(s + R_f/L_f)}, \tag{10.136}$$

where $K = K_a K_m/JL_f$. For our purposes we will assume that $f/J = 1$ and $R_f/L_f = 5$. As shown in Fig. 10.28, the system has feedback of the three state variables: position, velocity, and field current. We will assume that the feedback constant for the position is equal to 1, as shown in Fig. 10.29, which provides a signal-flow

Figure 10.28. Position control system with state-variable feedback.

Figure 10.29. Signal-flow graph of the state-variable feedback system.

graph representation of the system. Without state-variable feedback of x_2 and x_3, we set $K_3 = K_2 = 0$ and we have

$$G(s) = \frac{K}{s(s + 1)(s + 5)}. \tag{10.137}$$

This system will become unstable when $K \geq 30$. However, with variable feedback of all the state variables, we can ensure that the system is stable and set the transient performance of the system to a desired performance.

In general, the state-variable feedback signal-flow graph can be converted to the block diagram form shown in Fig. 10.30. The transfer function $G(s)$ remains unaffected (as in Eq. 10.137) and the $H(s)$ accounts for the state-variable feedback. Therefore

$$H(s) = K_3 \left[s^2 + \left(\frac{K_3 + K_2}{K_3} \right) s + \frac{1}{K_3} \right] \tag{10.138}$$

and

$$G(s)H(s) = \frac{M[s^2 + Qs + (1/K_3)]}{s(s + 1)(s + 5)}, \tag{10.139}$$

where $M = KK_3$ and $Q = (K_3 + K_2)/K_3$. Since K_3 and K_2 can be set independently, the designer can select the location of the zeros of $G(s)H(s)$.

(a) (b)

Figure 10.30. Equivalent block diagram representation of the state-variable feedback system.

As an illustration, let us choose the zeros of $GH(s)$ so that they cancel the real poles of $G(s)$. We set the numerator polynomial

$$H(s) = K_3\left(s^2 + Qs + \frac{1}{K_3}\right)$$

$$= K_3(s + 1)(s + 5).$$

(10.140)

This requires $K_3 = \frac{1}{5}$ and $Q = 6$, which sets $K_2 = 1$. Then

$$GH(s) = \frac{M(s + 1)(s + 5)}{s(s + 1)(s + 5)},$$

(10.141)

where $M = KK_3$. The closed-loop transfer function is then

$$\frac{C(s)}{R(s)} = T(s) = \frac{G(s)}{1 + G(s)H(s)} = \frac{K}{(s + 1)(s + 5)(s + M)}.$$

(10.142)

Therefore, although we could choose $M = 10$, which would ensure the stability of the system, the closed-loop response of the system will be dictated by the poles at $s = -1$ and $s = -5$. Therefore we will usually choose the zeros of $GH(s)$ in order to achieve closed-loop roots in a desirable location in the left-hand plane and to ensure system stability.

■ Example 10.14 State variable feedback design

Let us again consider the system of Fig. 10.30(b) and set the zeros of $GH(s)$ at $s = -4 + j2$ and $s = -4 - j2$. Then the numerator of $GH(s)$ will be

$$H(s) = K_3\left(s^2 + Qs + \frac{1}{K_3}\right)$$

$$= K_3(s + 4 + j2)(s + 4 - j2)$$

(10.143)

$$= K_3(s^2 + 8s + 20).$$

Therefore $K_3 = \frac{1}{20}$ and $Q = 8$ resulting in $K_2 = \frac{8}{20}$. The resulting root locus for

$$G(s)H(s) = \frac{M(s^2 + 8s + 20)}{s(s + 1)(s + 5)}$$

(10.144)

is shown in Fig. 10.31. The system is stable for all values of gain $M = KK_3$. For $M = 10$ the complex roots have $\zeta = 0.73$, so that we might expect an overshoot for a step input of approximately 5%. The settling time will be approximately 1 second. The closed-loop transfer function is

$$\frac{C(s)}{R(s)} = T(s) = \frac{G(s)}{1 + G(s)(H(s)}$$

(10.145)

$$= \frac{200}{(s + 3.45 + j3.2)(s + 3.45 - j3.2)(s + 9.1)}.$$

Figure 10.31. Compensated system root locus.

An alternative approach is to set the closed-loop roots of $1 + G(s)H(s) = 0$ at desired locations and then solve for the gain values of K, K_3, and K_2 that are required. For example, if we desire closed-loop roots at $s = -10$, $s = -5 + j$ and $s = -5-j$, we have the characteristic equation

$$q(s) = (s + 10)(s^2 + 10s + 26)$$
$$= s^3 + 20s^2 + 126s + 260 = 0. \tag{10.146}$$

Because

$$1 + G(s)H(s) = s(s + 1)(s + 5) + M\left(s^2 + Qs + \frac{1}{K_3}\right) = 0, \tag{10.147}$$

we equate Eq. (10.146) and Eq. (10.147), obtaining $M = 14$, $Q = 121/14$, $K_3 = 14/260$ and $K_2 = 0.41$.

In many cases the state variables are available and we can use state-variable feedback to obtain a stable, well-compensated system.

10.12 Design Example: Rotor Winder Control System

Our goal is to replace a manual operation with a machine to wind copper wire onto the rotors of small motors. Each motor has three separate windings of several hundred turns of wire. It is important that the windings are consistent, and that the throughput of the process is high. The operator simply inserts an unwound rotor, pushes a start button, and then removes the completely wound rotor. The dc motor is used to achieve accurate, rapid windings. Thus the goal is to achieve high steady-state accuracy for both position and velocity. The control

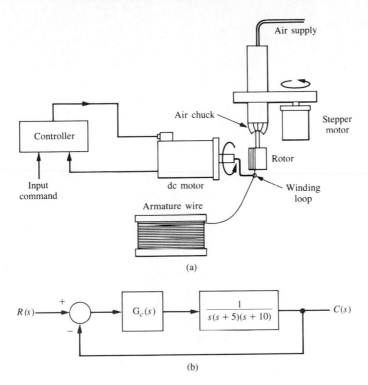

Figure 10.32. Rotor winder control system.

system is shown in Fig. 10.32(a) and the block diagram in Fig. 10.32(b). This system has zero steady-state error for a step input and the steady-state error for a ramp input is

$$e_{ss} = A/K_v,$$

where

$$K_v = \underset{s \to 0}{\text{limit}} \; \frac{G_c(0)}{50}.$$

When $G_c(s) = K$, we have $K_v = K/50$. If we select $K = 500$, we will have $K_v = 10$, but the overshoot to a step is 70% and the settling time is 8 seconds.

First, let us try a lead compensator so that

$$G_c(s) = \frac{K(s + z_1)}{(s + p_1)}. \tag{10.148}$$

Selecting $z = 4$ and the pole p so that the complex roots have a ζ of 0.6, we have

$$G_c(s) = \frac{191.2(s + 4)}{(s + 7.3)}. \tag{10.149}$$

Table 10.1. Design Example Results

Controller	Gain, K	Lead Network	Lag Network	Lead-lag Network
Step overshoot	70%	3%	12%	5%
Settling time (seconds)	8	1.5	2.5	2.0
Steady-state error for ramp	10%	48%	2.6%	4.8%
K_v	10	2.1	38	21

Therefore the response to a step input has a 3% overshoot and a settling time of 1.5 seconds. However, the

$$K_v = \frac{191.2(4)}{7.3(50)} = 2.1,$$

which is inadequate.

If we use a phase-lag design, we select

$$G_c(s) = \frac{K(s + z_2)}{(s + p_2)}$$

in order to achieve $K_v = 38$. Thus the velocity constant of the lag-compensated system is

$$K_v = \frac{Kz}{50p}.$$

Using a root locus, we select $K = 105$ in order to achieve a reasonable uncompensated step response with an overshoot of less than or equal to 10%. We select $\alpha = z/p$ to achieve the desired K_v. We then have

$$\alpha = \frac{50K_v}{K}$$

$$= \frac{50(38)}{105}$$

$$= 18.1.$$

Selecting $z_1 = 0.1$ in order to not impact the uncompensated root locus, we have $p_z = 0.0055$. We then obtain a step response with a 12% overshoot and a settling time of 2.5 seconds.

The results for the simple gain, the lead network, and the lag network are summarized in Table 10.1. Let us return to the lead-network system and add a lag network so that the compensator is

$$G_c(s) = \frac{K(s + z_1)(s + z_2)}{(s + p_1)(s + p_2)}. \qquad (10.150)$$

The lead compensator of Eq. (10.149) requires $K = 191.2$, $z_1 = 4$, and $p_1 = 7.3$. The root locus for the system is shown in Fig. 10.33. We recall that this lead

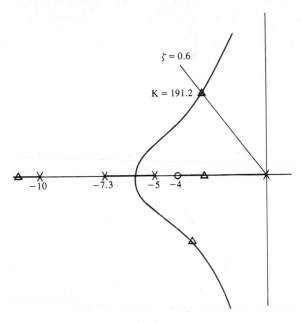

Figure 10.33. Root locus for lead compensator.

network resulted in $K_v = 2.1$ (see Table 10.1). In order to obtain $K_v = 21$, we use $\alpha = 10$ and select $z_2 = 0.1$ and $p_z = 0.01$. Then the total system is

$$G(s)G_c(s) = \frac{191.2(s + 4)(s + 0.1)}{s(s + 5)(s + 10)(s + 7.28)(s + 0.01)}. \tag{10.151}$$

The step response and ramp response of this system are shown in Fig. 10.34 in parts (a) and (b), respectively, and are summarized in Table 10.1. Clearly, the lead-lag design is suitable for satisfaction of the design goals.

10.13 Summary

In this chapter we have considered several alternative approaches to the design and compensation of feedback control systems. In the first two sections, we discussed the concepts of design and compensation and noted the several design cases which we completed in the preceding chapters. Then, the possibility of introducing cascade compensation networks within the feedback loops of control systems was examined. The cascade compensation networks are useful for altering the shape of the root locus or frequency response of a system. The phase-lead network and the phase-lag network were considered in detail as candidates for system compensators. Then system compensation was studied by using a phase-lead s-plane network on the Bode diagram and the root locus s-plane. We noted that the phase-lead compensator increases the phase margin of the system and

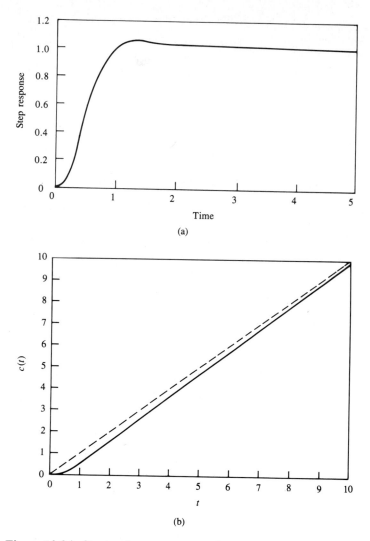

Figure 10.34. Step and ramp response for rotor winder system.

thus provides additional stability. When the design specifications include an error constant, the design of a phase-lead network is more readily accomplished on the Bode diagram. Alternatively, when an error constant is not specified, but the settling time and overshoot for a step input are specified, the design of a phase-lead network is more readily carried out on the s-plane. When large error constants are specified for a feedback system, it is usually easier to compensate the system by using integration (phase-lag) networks. We also noted that the phase-lead compensation increases the system bandwidth, whereas the phase-lag compensation

decreases the system bandwidth. The bandwidth often may be an important factor when noise is present at the input and generated within the system. Also we noted that a satisfactory system is obtained when the asymptotic course for magnitude of the compensated system crosses the 0-db line with a slope of −6 db/octave. The characteristics of the phase-lead and phase-lag compensation networks are summarized in Table 10.2. Operational amplifier circuits for phase-lead and lag, and PI and PD compensators are summarized in Table 10.3.

The design of control systems in the time domain was briefly examined. Specifically, the optimum design of a system using state-variable feedback and an integral performance index was considered. Finally, the s-plane design of systems utilizing state-variable feedback was examined.

Table 10.2. A Summary of the Characteristics of Phase-Lead and Phase-Lag Compensation Networks

	Compensation	
	Phase-lead	**Phase-lag**
Approach	Addition of phase-lead angle near crossover frequency or to yield desired dominant roots in s-plane	Addition of phase-lag to yield an increased error constant while maintaining desired dominant roots in s-plane or phase margin on Bode diagram
Results	1. Increases system bandwidth 2. Increases gain at higher frequencies	1. Decreases system bandwidth
Advantages	1. Yields desired response 2. Speeds dynamic response	1. Suppresses high frequency noise 2. Reduces steady-state error
Disadvantages	1. Requires additional amplifier gain 2. Increases bandwidth and thus susceptibility to noise 3. May require large values of components for RC network	1. Slows down transient response 2. May require large values of components for RC network
Applications	1. When fast transient response is desired	1. When error constants are specified
Not applicable	1. When phase decreases rapidly near crossover frequency	1. When no low frequency range exists where phase is equal to desired phase margin

Table 10.3. Operational Amplifier Circuits for Compensators

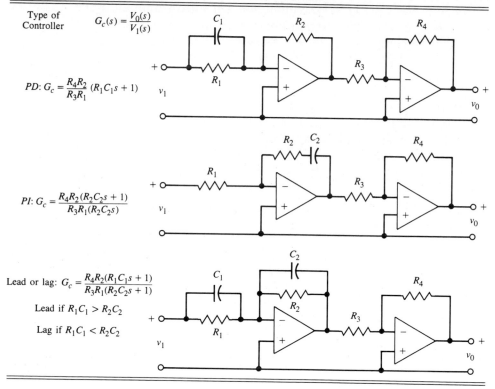

Type of Controller	$G_c(s) = \dfrac{V_0(s)}{V_1(s)}$
PD: $G_c = \dfrac{R_4R_2}{R_3R_1}(R_1C_1s + 1)$	
PI: $G_c = \dfrac{R_4R_2(R_2C_2s + 1)}{R_3R_1(R_2C_2s)}$	
Lead or lag: $G_c = \dfrac{R_4R_2(R_1C_1s + 1)}{R_3R_1(R_2C_2s + 1)}$ Lead if $R_1C_1 > R_2C_2$ Lag if $R_1C_1 < R_2C_2$	

Exercises

E10.1. A negative feedback control system has a transfer function

$$G(s) = \frac{K}{(s + 3)}.$$

We select a compensator,

$$G_c(s) = \frac{s + a}{s},$$

in order to achieve zero steady-state error for a step input. Select a and K so that the overshoot to a step is approximately 5% and the settling time is approximately 1 sec.

Answer: K = 5, a = 6.4

E10.2. A control system with negative unity feedback has a process

$$G(s) = \frac{400}{s(s + 40)},$$

and we wish to use a proportional plus integral compensation where

$$G_c(s) = K_1 + \frac{K_2}{s}.$$

Note that the steady-state error of this system for a ramp input is zero. (a) Set $K_2 = 1$ and find a suitable value of K_1 so the step response will have an overshoot of approximately 20%. (b) What is the expected settling time of the compensated system?

E10.3. A unity negative feedback control system in a manufacturing system has a process transfer function

$$G(s) = \frac{e^{-s}}{s + 1},$$

and it is proposed to use a compensator to achieve a 5% overshoot to a step input. The compensator is [4]

$$G_c(s) = K\left(1 + \frac{1}{\tau s}\right),$$

which provides proportional plus integral control. Show that one solution is $K = 0.5$ and $\tau = 1$.

E10.4. Consider a unity negative feedback system with

$$G(s) = \frac{K}{s(s + 2)(s + 3)},$$

where K is set equal to 20 in order to achieve a specified $K_v = 3.33$. We wish to add a lead-lag compensator

$$G_c(s) = \frac{(s + 0.15)(s + 0.7)}{(s + 0.015)(s + 7)}.$$

Show that the gain margin of the compensated system is 24 db and the phase margin is 75°.

E10.5. Consider a unity feedback system with the transfer function

$$G(s) = \frac{K}{s(s + 2)(s + 4)}.$$

It is desired to obtain the dominant roots with $\omega_n = 3$ and $\zeta = 0.5$. We wish to obtain a $K_v = 2.7$. Show that we require a compensator

$$G_c(s) = \frac{7.53(s + 2.2)}{(s + 16.4)}.$$

Determine the value of K that should be selected.

E10.6. Reconsider the wind tunnel control system of Problem 6.31. When $K = 326$, find $T(s)$ and estimate the expected overshoot and settling time. Compare your estimates with the actual overshoot of 60% and a settling time of 4 sec. Explain the discrepancy in your estimates.

E10.7. NASA astronauts retrieved a satellite and brought it into the cargo bay of the space shuttle, as shown in Fig. E10.7(a). An astronaut within the shuttle controlled the robot arm

(a)

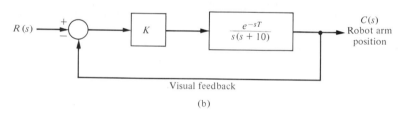

Visual feedback

(b)

Figure E10.7. Retrieval of a satellite.

upon which Joseph Allen is seen standing. A model of the feedback control system is shown in Fig. E10.7(b). Determine the value of K that will result in a phase margin of 50° when $T = 0.1$ sec.

Answer: $K = 37$

E10.8. A negative-unity feedback system has a plant

$$G(s) = \frac{2257}{s(\tau s + 1)},$$

where $\tau = 2.8$ ms. Select a compensator

$$G_c(s) = K_1 + K_2/s$$

so that the dominant roots of the characteristic equation have ζ equal to $1\sqrt{2}$. Plot $c(t)$ for a step input.

E10.9. A control system with a controller is shown in Fig. E10.9. Select K_1 and K_2 so that the overshoot to a step input is less than 1% and the velocity constant, K_v, is equal to 10. Use the Control System Design Program to verify the results of your design.

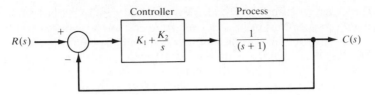

Figure E10.9. Design of a controller.

E10.10. A control system with a controller is shown in Fig. E10.10. We will select $K_2 = 4$ in order to provide a reasonable steady state error to a step [13]. Using the Control System Design Program, find K_1 to obtain a phase margin of 60°. Find the peak time and percent overshoot of this system.

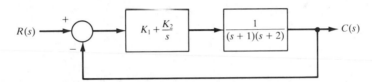

Figure E10.10. Design of a PI controller.

E10.11. A unity feedback system has

$$G(s) = \frac{1350}{s(s + 2)(s + 30)}.$$

A lead network is selected so that

$$G_c(s) = \frac{(1 + 0.25s)}{(1 + 0.025s)}.$$

Determine the peak magnitude and the bandwidth of the closed-loop frequency response using the (a) Nichols chart, and (b) Control System Design Program plot of the closed-loop frequency response.

Answer: $M_{p_\omega} = 2.3$ db, $\omega_B = 22$

E10.12. The control of an automobile ignition system has unity negative feedback and a loop transfer function $G_c(s)G(s)$, where

$$G(s) = \frac{K}{s(s + 10)}$$

and

$$G_c(s) = K_1 + K_2/s.$$

A designer selects $K_2/K_1 = 0.5$ and asks you to determine KK_1 so that the dominant roots have a ζ of $1/\sqrt{2}$ and the settling time is less than 2 sec.

E10.13. The design of Example 10.3 determined a lead network in order to obtain desirable dominant root locations using a cascade compensator $G_c(s)$ in the system configuration shown in Fig. 10.1(a). The same lead network would be obtained if we used the feedback compensation configuration of Fig. 10.1(b). Determine the closed-loop transfer function, $T(s) = C(s)/R(s)$, of both the cascade and feedback configuration and show how the transfer function of each configuration differs. Explain how the response to a step, $R(s)$, will be different for each system.

E10.14. A robot will be operated by NASA to build a permanent lunar station. The position control system for the gripper tool is shown in Fig. 10.1(a), where $H(s) = 1$ and

$$G(s) = \frac{3}{s(s + 1)(0.5s + 1)}.$$

Determine a compensator lag network, $G_c(s)$, that will provide a phase margin of 45 degrees.

Answer: $G_c(s) = \dfrac{1 + 20s}{1 + 106s}$

Problems

P10.1. The design of the lunar excursion module (LEM) is an interesting control problem. The *Apollo 11* lunar landing vehicle is shown in Fig. P10.1(a), on next page. The attitude control system for the lunar vehicle is shown in Fig. P10.1(b). The vehicle damping is negligible and the attitude is controlled by gas jets. The torque, as a first approximation, will be considered to be proportional to the signal $V(s)$ so that $T(s) = K_2 V(s)$. The loop gain may be selected by the designer in order to provide a suitable damping. A damping ratio of $\zeta = 0.5$ with a settling time of less than 2 sec is required. Using a lead-network compensation, select the necessary compensator $G_c(s)$ by using (a) frequency response techniques and (b) root locus methods.

P10.2. A magnetic tape-recorder transport for modern computers requires a high-accuracy, rapid-response control system. The requirements for a specific transport are as follows: (1) the tape must stop or start in 10 msec; (2) it must be possible to read 45,000 characters per second. This system was discussed in Problem P6.11. It is desired to set $J = 5 \times 10^{-3}$, and K_1 is set on the basis of the maximum error allowable for a velocity input. In this case, it is desired to maintain a steady-state speed error of less than 5%. We will use a tachometer in this case and set $K_a = 50,000$ and $K_2 = 1$. In order to provide a suitable performance, a compensator $G_c(s)$ is inserted immediately following the photocell transducer. Select a compensator $G_c(s)$ so that the overshoot of the system for a step input is less than 30%. We will assume that $\tau_1 = \tau_a = 0$.

P10.3. A simplified version of the attitude rate control for the F-94 or X-15 type aircraft is shown in Fig. P10.3. When the vehicle is flying at four times the speed of sound (Mach 4) at an altitude of 100,000 ft, the parameters are

$$\frac{1}{\tau_a} = 1.0, \qquad K_1 = 0.5, \qquad \zeta\omega_a = 1.0, \qquad \omega_a = 2.$$

Design a compensator, $G_c(s)$, so that the response to a step input has an overshoot of less than 10% and a settling time of less than 5 sec.

(a)

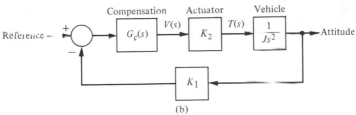

(b)

Figure P10.1. (a) *Apollo 11* lunar excursion module viewed from the command ship. Inside the LEM were astronauts Neil Armstrong and Edwin Aldrin, Jr. The LEM landed on the moon on July 20, 1969. (Photo courtesy of NASA Manned Spacecraft Center.)

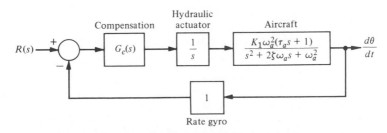

Figure P10.3. Aircraft attitude control.

P10.4. Magnetic particle clutches are useful actuator devices for high power requirements because they can typically provide a 200-w mechanical power output. The particle clutches provide a high torque-to-inertia ratio and fast time constant response. A particle-clutch positioning system for nuclear reactor rods is shown in Fig. P10.4. The motor drives two counter-rotating clutch housings. The clutch housings are geared through parallel gear trains, and the direction of the servo output is dependent on the clutch that is energized. The time constant of a 200-w clutch is $\tau = \frac{1}{40}$ sec. The constants are such that $K_T n/J = 1$. It is desired that the maximum overshoot for a step input is in the range of 10% to 20%. Design a compensating network so that the system is adequately stabilized. The settling time of the system should be less than or equal to 1 sec. This system requires two compensation networks in cascade.

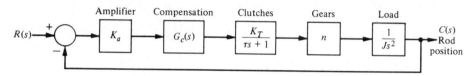

Figure P10.4. Nuclear reactor rod control.

P10.5. A stabilized precision rate table uses a precision tachometer and a dc direct-drive torque motor, as shown in Fig. P10.5. It is desired to maintain a high steady-state accuracy for the speed control. In order to obtain a zero steady-state error for a step command design, select a proportional plus integral compensator as discussed in Section 10.6. Select the appropriate gain constants so that the system has an overshoot of approximately 10% and a settling time in the range of 0.4 to 0.6 sec.

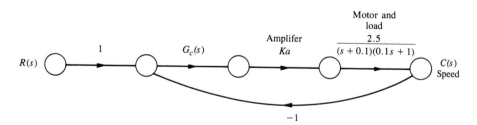

Figure P10.5. Stabilized rate table.

P10.6. Repeat Problem P10.5 by using a lead network compensator and compare the results.

P10.7. The primary control loop of a nuclear power plant includes a time delay due to the time necessary to transport the fluid from the reactor to the measurement point (see Fig. P10.7). The transfer function of the controller is

$$G_1(s) = \left(K_1 + \frac{K_2}{s} \right).$$

The transfer function of the reactor and time delay is

$$G(s) = \frac{e^{-sT}}{\tau s + 1},$$

where $T = 0.4$ sec and $\tau = 0.2$ sec. Using frequency response methods, design the controller so that the overshoot of the system is less than 20%. Estimate the settling time of the system designed. Use the Control System Design Program to determine the actual overshoot and settling time.

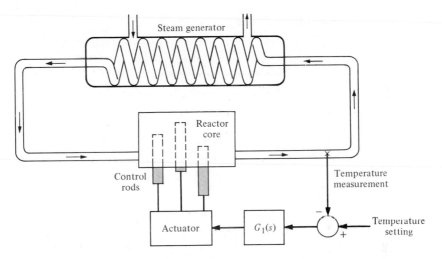

Figure P10.7. Nuclear reactor control.

P10.8. A chemical reactor process whose production rate is a function of catalyst addition is shown in block diagram form in Fig. P10.8 [4]. The time delay is $T = 10$ min and the time constant, τ, is approximately 10 min. The gain of the process is $K = 1$. Design a compensation by using Bode diagram methods in order to provide a suitable system response. It is desired to have a steady-state error for a step input, $R(s) = A/s$, less than 0.05 A. For the system with the compensation added, estimate the settling time of the system.

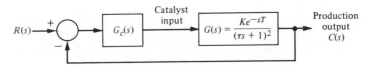

Figure P10.8. Chemical reactor control.

P10.9. A numerical path-controlled machine turret lathe is an interesting problem in attaining sufficient accuracy [2]. A block diagram of a turret lathe control system is shown

in Fig. P10.9. The gear ratio is $n = 0.1$, $J = 10^{-3}$, and $f = 10^{-2}$. It is necessary to attain an accuracy of 5×10^{-4} in., and therefore a steady-state position accuracy of 3% is specified for a ramp input. Design a cascade compensator to be inserted before the silicon-controlled rectifiers in order to provide a response to a step command with an overshoot of less than 5%. A suitable damping ratio for this system is 0.7. The gain of the silicon-controlled rectifiers is $K_R = 5$. Design a suitable lag compensator by using the (a) Bode diagram method and (b) s-plane method.

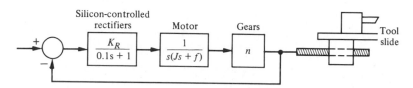

Figure P10.9. Path-controlled turret lathe.

P10.10. The HS *Denison*, shown in Fig. P10.10(a), on the next page, is a large hydrofoil seacraft built by Grumman Corp. for the U.S. Maritime Administration. The *Denison* is an 80-ton hydrofoil capable of operating in seas ranging to 9 ft in amplitude at a speed of 60 knots as a result of the utilization of an automatic stabilization control system. Stabilization is achieved by means of flaps on the main foils and the incidence of the aft foil. The stabilization control system maintains a level flight through rough seas. Thus a system that minimizes deviations from a constant lift force or, equivalently, that minimizes the pitch angle θ has been designed. A block diagram of the lift control system is shown in Fig. P10.10(b). The desired response of the system to wave disturbance is a constant-level travel of the craft. Establish a set of reasonable specifications and design a compensator $G_c(s)$ so that the performance of the system is suitable. Assume that the disturbance is due to waves with a frequency $\omega = 1$ rad/sec.

P10.11. A first-order system is represented by the time-domain differential equation

$$\dot{x} = 3x + 2u.$$

A feedback controller is to be designed where

$$u(t) = -kx$$

and the desired equilibrium condition is $x(t) = 0$ as $t \rightarrow \infty$. The performance integral is defined as

$$J = \int_0^\infty x^2 \, dt,$$

and the initial value of the state variable is $x(0) = 1$. Obtain the value of k in order to make J a minimum. Is this k physically realizable? Select a practical value for the gain k and evaluate the performance index with that gain. Is the system stable without the feedback due to $u(t)$?

P10.12. In order to account for the expenditure of energy and resources, the control signal is often included in the performance integral. Then, the system may not utilize an unlim-

(a)

(b)

Figure P10.10. (a) The HS *Denison* hydrofoil. (Photo courtesy of Grumman Aircraft Engineering Corp.) (b) A block diagram of the lift control system.

ited control signal $u(t)$. One suitable performance index, which includes the effect of the magnitude of the control signal, is

$$J = \int_0^\infty (x^2(t) + \lambda u^2(t))\, dt.$$

(a) Repeat Problem P10.11 for the performance index. (b) If $\lambda = 1$, obtain the value of k that minimizes the performance index. Calculate the resulting minimum value of J.

P10.13. An unstable robot system is described by the vector differential equation [10]

$$\frac{d}{dt}\begin{bmatrix} x_1 \\ x_2 \end{bmatrix} = \begin{bmatrix} 1 & 0 \\ -1 & 2 \end{bmatrix}\begin{bmatrix} x_1 \\ x_2 \end{bmatrix} + \begin{bmatrix} 1 \\ 1 \end{bmatrix} u(t).$$

Both state variables are measurable, and so the control signal is set as $u(t) = -k(x_1 + x_2)$. Following the method of Section 10.10, design gain k so that the performance

index is minimized. Evaluate the minimum value of the performance index. Determine the sensitivity of the performance to a change in k. Assume that the initial conditions are

$$\mathbf{x}(0) = \begin{bmatrix} 1 \\ 1 \end{bmatrix}.$$

Is the system stable without the feedback signals due to $u(t)$?

P10.14. Determine the feedback gain k of Example 10.12 that minimizes the performance index

$$J = \int_0^\infty \mathbf{x}^T\mathbf{x} \, dt$$

when $\mathbf{x}^T(0) = [1, 1]$. Plot the performance index J versus the gain k.

P10.15. Determine the feedback gain k of Example 10.13 that minimizes the performance index

$$J = \int_0^\infty (\mathbf{x}^T\mathbf{x} + \mathbf{u}^T\mathbf{u}) \, dt$$

when $\mathbf{x}^T(0) = [1, 1]$. Plot the performance index J versus the gain k.

P10.16. For the solutions of Problems P10.13., P10.14, and P10.15 determine the roots of the closed-loop optimal control system. Note how the resulting closed-loop roots depend upon the performance index selected.

P10.17. A system has the vector differential equation as given in Eq. (10.101). It is desired that both state variables are used in the feedback so that $u(t) = -k_1x_1 - k_2x_2$. Also, it is desired to have a natural frequency, ω_n, for this system equal to 2. Find a set of gains k_1 and k_2 in order to achieve an optimal system when J is given by Eq. (10.95). Assume $\mathbf{x}^T(0) = [1, 0]$.

P10.18. A unity feedback control system for a robot submarine has a plant with a third-order transfer function:

$$G(s) = \frac{K}{s(s + 10)(s + 50)}.$$

It is desired that the overshoot be approximately 7.5% for a step input and the settling time of the system be 400 msec. Find a suitable phase-lead compensator by using root locus methods. Let the zero of the compensator be located at $s = -15$ and determine the compensator pole. Determine the resulting system K_v.

P10.19. Now that expenditures for manned space exploration have leveled off, NASA is developing remote manipulators. These manipulators can be used to extend the hand and the power of humankind through space by means of radio. A concept of a remote manipulator is shown in Fig. P10.19(a), on the next page. The closed loop control is shown schematically in Fig. P10.19(b). Assuming an average distance of 238,855 miles from earth to moon, the time delay in transmission of a communication signal T is 1.28 sec. The operator uses a control stick to control remotely the manipulator placed on the moon to assist in geological experiments, and the TV display to access the response of the manipulator. The time constant of the manipulator is ⅓ sec. (a) Set the gain K_1 so that the system has a phase margin of approximately 20°. Evaluate the percentage steady-state error for this system for a step input. (b) In order to reduce the steady-state error for a position command input to 5%, add a lag compensation network in cascade with K_1.

TV camera

TV display

Receiving
antenna

Remote
manipulator

Control
to
signal
transmitting
antenna

Control
stick

Moon's
surface

Man's
desired
action

K_1

Transmitted
signal

e^{-sT}

Remote
manipulator

$\dfrac{1}{\tau s + 1}$

Position of
manipulator

e^{-sT}

Video
return
signal

(b)

Figure P10.19. (a) Conceptual diagram of a remote manipulator on the moon controlled by a person on the earth. (b) Feedback diagram of the remote manipulator control system with τ = transmission time delay of the video signal.

P10.20. There have been significant developments in the application of robotics technology to nuclear power plant maintenance problems. Thus far, robotics technology in the nuclear industry has been used primarily on spent-fuel reprocessing and waste management. Today, the industry is beginning to apply the technology to such areas as primary containment inspection, reactor maintenance, facility decontamination, and accident recovery activities. These developments suggest that the application of remotely operated devices can significantly reduce radiation exposure to personnel and improve maintenance-program performance.

Currently, an operational robotic system is under development to address particular operational problems within a nuclear power plant. This device, IRIS (Industrial Remote Inspection System), is a general-purpose surveillance system that conducts particular

inspection and handling tasks with the goal of significantly reducing personnel exposure to high radiation fields [16]. The device is shown in Fig. P10.20. The closed loop transfer function is

$$G(s) = \frac{Ke^{-sT}}{(s + 1)(s + 3)}.$$

(a) Determine a suitable gain K for the system when $T = 0.5$ sec so that the overshoot to a step input is less than 30%. Determine the steady-state error. (b) Design a lead compensator

$$G_c(s) = \frac{s + 2}{s + b}$$

to improve the step response for the system in part (a) so that the steady-state error is less than 12%.

Manipulator/Arm

Surveillance camera

Communication

3-D Driving camera

Figure P10.20. Remote controlled robot for nuclear plants.

P10.21. An uncompensated control system with unity feedback has a plant transfer function

$$G(s) = \frac{K}{s(s/2 + 1)(s/6 + 1)}.$$

It is desired to have a velocity error constant of $K_v = 20$. It is also desired to have a phase margin approximately to 45° and a closed-loop bandwidth greater than $\omega = 4$ rad/sec. Use two identical cascaded phase-lead networks to compensate the system.

P10.22. For the system of Problem P10.21, design a phase-lag network to yield the desired specifications, with the exception that a bandwidth equal to or greater than 2 rad/sec will be acceptable.

P10.23. For the system of Problem P10.21 we wish to achieve the same phase margin and K_v, but in addition we wish to limit the bandwidth to less than 10 rad/sec but greater than 2 rad/sec. Utilize a lead-lag compensation network to compensate the system. The lead-lag network could be of the form

$$G_c(s) = \frac{(1 + s/10a)(1 + s/b)}{(1 + s/a)(1 + s/10b)},$$

where a is to be selected for the lag portion of the compensator and b is to be selected for the lead portion of the compensator. The ratio α is chosen to be 10 for both the lead and lag portions.

P10.24. For the system of Example 10.10, determine the optimum value for k_2 when k_1 = 1 and $x^T(0) = [1, 0]$.

P10.25. The stability and performance of the rotation of a robot (similar to waist rotation) is a challenging control problem. The system requires high gains in order to achieve high resolution; yet a large overshoot of the transient response cannot be tolerated. The block diagram of an electro-hydraulic system for rotation control is shown in Fig. P10.25 [16]. The arm-rotating dynamics are represented by

$$G(s) = \frac{360}{s(s^2/6400 + s/50 + 1)}.$$

It is desired to have $K_v = 10$ for the compensated system. Design a compensator that results in an overshoot to a step input of less than 15%.

Figure P10.25. Robot position control.

P10.26. The possibility of overcoming wheel friction, wear, and vibration by contactless suspension for passenger-carrying mass-transit vehicles is being investigated throughout the world. One design uses a magnetic suspension with an attraction force between the vehicle and the guideway with an accurately controlled airgap. A system is shown in Fig. P10.26, which incorporates feedback compensation. Using root-locus methods, select a suitable value for K_1 and b so the system has a damping ratio for the underdamped roots of $\zeta = 0.50$. Assume, if appropriate, that the pole of the airgap feedback loop ($s = -200$) can be neglected.

Figure P10.26. Airgap control of train.

P10.27. A computer uses a printer as a fast output device. It is desirable to maintain accurate position control while moving the paper rapidly through the printer. Consider a system with unity feedback and a transfer function for the motor and amplifier as

$$G(s) = \frac{0.15}{s(s+1)(5s+1)}.$$

Design a lead network compensator so that the system bandwidth is 0.75 rad/sec and the phase margin is 30°. Use a lead network with $\alpha = 10$.

P10.28. An engineering design team is attempting to control a process shown in Fig. P10.28. The system has a controller $D(s)$, but the design team is unable to appropriately select $D(s)$. It is agreed that a system with a phase margin of 50° is acceptable, but $D(s)$ is unknown. You are asked to determine $D(s)$.

First, let $D(s) = K$ and using the Control System Design Program (CSDP) or an equivalent program find (a) a value of K which yields a phase margin of 50° and the system's step response for this value of K. (b) Determine the settling time, percent overshoot, and the peak time. (c) Obtain the system's closed-loop frequency response and determine $M_{p\omega}$ and the bandwidth.

The team has decided to let

$$D(s) = \frac{K(s+12)}{(s+20)}$$

and to repeat parts (a), (b), and (c) as above. Determine the gain K that results in a phase margin of 50° and then proceed to evaluate the time response and the closed-loop frequency response. Prepare a table contrasting the results of the two selected controllers for $D(s)$ by comparing settling time, percent overshoot, peak time, $M_{p\omega}$, and bandwidth.

Figure P10.28. Controller design.

P10.29. An adaptive suspension vehicle uses a legged locomotion principle. The control of the leg can be represented by a unity feedback system with [10]

$$G(s) = \frac{K}{s(s+10)(s+5)}.$$

It is desired to achieve a steady-state error for a ramp input of 1% and a damping ratio of the dominant roots of 0.707. Determine a suitable lag compensator. Using the Control System Design Program, determine the actual overshoot and settling time of this system.

P10.30. A liquid level control system (see Fig. 8.26) has a loop transfer function

$$G_c(s)G(s)H(s)$$

where $H(s) = 1$, $G_c(s)$ is a compensator, and the plant is

$$G(s) = \frac{10e^{-sT}}{s^2(s + 10)}$$

where $T = 50$ ms. Design a compensator so that M_{P_ω} does not exceed 3.5 db and ω_r is approximately 1.4 rad/s. Predict the overshoot and settling time of the compensated system when the input is a step.

P10.31. An automated guided vehicle (AGV) can be considered as an automated mobile conveyor designed to transport materials. Most AGVs require some type of guide path. The steering stability of the guidance control system has not been fully solved. The slight "snaking" of the AGV about the track generally has been acceptable, although it indicates instability of the steering guidance control system [9].

Most AGVs have a specification of maximum speed of about 1 m/sec, although in practice they are usually operated at half that speed. In a fully automated manufacturing environment, there should be few personnel in the production area; therefore the AGV should be able to be run at full speed. As the speed of the AGV increases, so does the difficulty in designing stable and smooth tracking controls.

A steering system for an AGV is shown in Fig. P10.31, where $\tau_1 = 40$ ms and $\tau_2 = 1$ ms. It is required that the velocity constant, K_v, is 100 so that the steady-state error for a ramp input is 1% of the slope of the ramp. Neglect τ_2 and design a lead compensator so that the phase margin is

$$45° \leq \text{PM} < 65°.$$

Attempt to obtain the two limiting cases for phase margin and compare your results for the two designs by determining the actual percent overshoot and settling time for a step input.

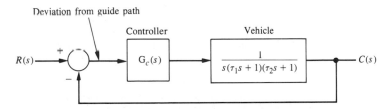

Figure P10.31. Steering control for vehicle.

P10.32. For the systems of Problem P10.31, use a phase-lag compensator and attempt to achieve a phase margin of approximately 50°. Determine the actual overshoot and peak time for the compensated system.

P10.33. When a motor drives a flexible structure, the structure's natural frequencies, as compared to the bandwidth of the servodrive, determine the contribution of the structural flexibility to the errors of the resulting motion. In current industrial robots, the drives are often relatively slow and the structures are relatively rigid, so that overshoots and other errors are caused mainly by the servodrive. However, depending on the accuracy required, the structural deflections of the driven members may become significant. Structural flexi-

bility must be considered the major source of motion errors in space structures and manipulators. Because of weight restrictions in space, large arm lengths result in flexible structures. Furthermore, future industrial robots should require lighter and more flexible manipulators.

To investigate the effects of structural flexibility and how different control schemes can reduce unwanted oscillations, an experimental apparatus consisting of a dc motor driving a slender aluminum beam was constructed. The purpose of the experiments was to identify simple and effective control strategies to deal with the motion errors that occur when a servomotor is driving a very flexible structure [14].

The experimental apparatus is shown in Fig. P10.33(a) and the control system is shown in Fig. P10.33(b). The goal is that the system will have a K_v of 100. (a) When $G_c(s)$ = K, determine K and plot the Bode diagram. Find the phase margin and gain margin. (b) Using the Nichols chart, find ω_r, M_{P_ω}, and ω_B. (c) Select a compensator so that the phase margin is greater than 35° and find ω_r, M_{P_ω}, and ω_B for the compensated system.

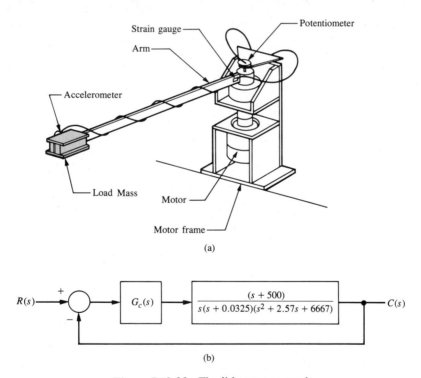

Figure P10.33. Flexible arm control.

P10.34. A human's ability to perform physical tasks is limited not by intellect but by physical strength. If in an appropriate environment a machine's mechanical power is closely integrated with a human arm's mechanical strength under the control of the human intellect, the resulting system will be superior to a loosely integrated combination of a human and a fully automated robot.

Extenders are defined as a class of robot manipulators that extend the strength of the human arm while maintaining human control of the task [15]. The defining characteristic of an extender is the transmission of both power and information signals. The extender is worn by the human; the physical contact between the extender and the human allows direct transfer of mechanical power and information signals. Because of this unique interface, control of the extender trajectory can be accomplished without any type of joystick, keyboard, or master-slave system. The human provides a control system for the extender, while the extender actuators provide most of the strength necessary for the task. The human becomes a part of the extender and "feels" a scaled-down version of the load that the extender is carrying. The extender is distinguished from a conventional master-slave system; in that type of system, the human operator is either at a remote location or close to the slave manipulator but is not in direct physical contact with the slave in the sense of transfer of power. An extender is shown in Fig. P10.34(a) [15]. The block diagram of the system is shown in Fig. P10.34(b). The goal is that the compensated system will have a velocity constant, K_v, equal to 80, that the settling time will be 1.6 sec, and that the overshoot will be 16% so that the dominant roots have a ζ of 0.5. Determine a lead-lag compensator using root locus methods.

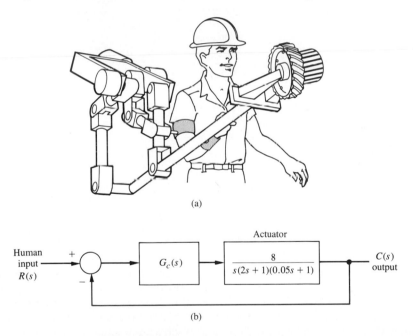

(a)

(b)

Figure P10.34. Extender robot control.

P10.35. A magnetically levitated train is operating in Berlin, Germany, as shown in Fig. P10.35(a). The M-Bahn 1600-m line represents the current state of worldwide systems. Fully automated trains can run at short intervals and operate with excellent energy efficiency. The control system for the levitation of the car is shown in Fig. P10.35(b). Select a compensator so that the phase margin of the system is $55° \leq PM \leq 65°$. Predict the response of the system to a step command and determine the actual step response for comparison.

(a)

(b)

Figure P10.35. Magnetically levitated train. (Photo courtesy of AEG Westinghouse Transportation Systems.)

P10.36. Engineers are developing new sensors for machining and other manufacturing processes. A new sensing technique gleans information about the cutting process from acoustic emission (AE) signals. AE is a low-amplitude, high-frequency stress wave from a rapid release of strain energy in a continuous medium. AE is sensitive to material, tool geometry, tool wear, and cutting parameters such as feed and speed. AE sensors are commonly piezoelectric crystals sensitive in the 100 kHz to 1 MHz range. They are cost effective and can be mounted on most machine tools.

Current research has been extracting depth-of-cut information from AE signals. One study links sensitivity of the AE power signal to small depth-of-cut changes in diamond turning [18]. The power of the AE signals is sensitive to small, instantaneous changes in depth of cut during diamond turning and conventional milling. A milling machine using an AE sensor is shown in Fig. P10.36(a). The system for controlling the depth of cut of a milling machine is shown in Fig. P10.36(b). Design a compensator so that the percent overshoot to a step input is less than or equal to 20% while the velocity constant is greater than 8.

(b)

Figure P10.36. Milling machine control.

P10.37. A system's open-loop transfer function is a pure time delay of 1 sec so that $G(s) = e^{-s}$. Select a compensator $G_c(s)$ so that the steady-state error for a step input is less than 2% of the magnitude of the step and the phase margin is greater than 30°.

P10.38. A unity-negative feedback system has

$$G(s) = \frac{1}{s(s + 5)(s + 10)}.$$

The objective is that the dominant roots have a ζ equal to 0.707 while achieving zero steady-state error for a ramp input. Select a proportional plus integral (PI) controller so that the requirements are met. Determine the resulting peak time and settling time of the system.

Design Problems ✦

DP10.1. Two robots are shown in Fig. DP10.1 cooperating with each other to manipulate a long shaft prior to inserting it into the hole in the block resting on the table. Long part insertion is a good example of a task that can benefit from cooperative control. The feedback control system of one robot joint of the form shown in Fig. 10.1, has $H(s) = 1$ and

$$G(s) = \frac{4}{s(s + 0.5)}.$$

The specifications require a steady-state error for a unit ramp input of 0.0125, and the step response has an overshoot of less than 20% with a settling time of less than 2 sec. Determine a lead-lag compensator that will meet the specifications, and plot the compensated and uncompensated response for the ramp and step inputs.

Figure DP10.1. Two robots cooperate to insert a shaft.

DP10.2. The heading control of the traditional bi-wing aircraft shown in Fig. DP10.2(a), on the next page is represented by the block diagram of Fig. DP10.2(b). (a) Determine the minimum value of the gain K when $G_c(s) = K$ so that the steady-state effect of a unit step disturbance, $D(s) = 1/s$, is less than or equal to 10% of the unit step [$c(\infty) = 0.01$]. (b) Determine if the system using the gain of part (a) is stable. (c) Design a compensator using one stage of lead compensation so that the phase margin is 30°. (d) Design a two-stage lead compensator so that the phase margin is 55°. (e) Compare the bandwidth of the systems of part (c) and (d). (f) Plot the step response $c(t)$ for the systems of part (c) and (d) and compare percent overshoot, settling time, and peak time.

DP10.3. NASA has identified the need for large deployable space structures, which will be constructed of lightweight materials and will contain large numbers of joints or structural connections. This need is evident for programs such as the space station. These deployable space structures may have precision shape requirements and a need for vibrations suppression during on-orbit operations [8].

 One such structure is the mast flight system, which is shown in Fig. DP10.3(a). The intent of the system is to provide an experimental test bed for controls and dynamics. The basic element in the mast flight system is a 60.7-m-long truss beam structure, which is attached to the shuttle orbiter. Included at the tip of the truss structure are the primary

(a)

(b)

Figure DP10.2. (a) Bi-wing aircraft (Source: *The Illustrated London News,* Oct. 9, 1920.) (b) Control system.

(a)

(b)

Figure DP10.3. Mast flight system.

actuators and collocated sensors. A deployment/retraction subsystem, which also secures the stowed beam package during launch and landing, is provided.

The system uses a large motor to move the structure and has the block diagram shown in Fig. DP10.3(b). The goal is an overshoot to a step response of less than or equal to 16%; thus we estimate the system ζ as 0.5 and the required phase margin as 50°. Design for $0.1 < K < 1$ and record overshoot, rise time, and phase margin for selected gains.

DP10.4. A robot using a vision system as the measurement device is shown in Fig. DP10.4. The control system is of the form shown in Fig. 10.14, where

$$G(s) = \frac{1}{(s + 1)(0.5s + 1)}$$

and $G_c(s)$ is selected as a PI controller so that the steady-state error for a step input is equal to zero. We then have

$$G_c(s) = K_1 + \frac{K_2}{s} = \frac{K_1 s + K_2}{s}.$$

Determine a suitable G_c so that (a) the percent overshoot for a step input is 5% or less; (b) the settling time is less than 6 sec; (c) the system K_v is greater than 0.9; and (d) the peak time for a step input is minimized.

Figure DP10.4. A robot and vision system.

Terms and Concepts

Cascade compensation network A compensator network placed in cascade or series with the system process.

Compensation The alteration or adjustment of a control system in order to provide a suitable performance.

Compensator An additional component or circuit that is inserted into the system to equalize or compensate for the performance deficiency.

Design of a control system The arrangement or the plan of the system structure and the selection of suitable components and parameters.

Integration network A network that acts, in part, like an integrator.

Lag network See Phase lag network.

Lead-lag network A network with the characteristics of both a lead network and a lag network.

Lead network See Phase lead network.

Phase-lag network A network that provides a negative phase angle and a significant attenuation over the frequency range of interest.

Phase-lead network A network that provides a positive phase angle over the frequency range of interest. Thus phase lead can be used to cause a system to have an adequate phase margin.

PID controller See Three-mode controller.

Process controller See Three-mode controller.

Three-mode controller A controller with three terms so that the output of the controller is the sum of a proportional term, an integrating term, and a differentiating term, with an adjustable gain for each term.

References

1. R. C. Dorf and R. Jacquot, *Control System Design Program,* Addison-Wesley, Reading, Mass., 1988.
2. C. L. Phillips and R. D. Harbor, *Feedback Control Systems,* Prentice Hall, Englewood Cliffs, N.J., 1988.
3. D. F. Delchamps, *State-Space and Input-Output Linear Systems,* Springer-Verlag, New York, 1988.
4. F. H. Raven, *Automatic Control Engineering,* McGraw-Hill, New York, 1987.
5. J. R. Mitchell and W. L. McDaniel, Jr., "A Computerized Compensator Design Algorithm with Launch Vehicle Applications," *IEEE Trans. on Automatic Control,* June 1976; pp. 366–71.
6. W. R. Wakeland, "Bode Compensator Design," *IEEE Trans. on Automatic Control,* October 1976; pp. 771–73.
7. J. R. Mitchell, "Comments on Bode Compensator Design," *IEEE Trans. on Automatic Control,* October 1977; pp. 869–70.
8. F. Ham, "Active Vibration Suppression for the Mast Flight System," *IEEE Control Systems,* January 1989; pp. 85–89.
9. E. Sung, "Parallel Linkage Steering for an Automated Guided Vehicle," *IEEE Control Systems,* October 1989; pp. 3–8.
10. K. J. Waldron and R. B. McGhee, "The Adaptive Suspension Vehicle," *IEEE Control Systems,* December 1986; pp. 7–12.
11. B. Anderson, "Controller Reduction: Concepts and Approaches," *IEEE Trans. on Automatic Control,* August 1989; pp. 802–12.

12. H. Butler, "Model Reference Adaptive Control of a Direct-Drive dc Motor," *IEEE Control Systems,* January 1989; pp. 80–84.
13. C. L. Phillips, "Analytical Bode Design of Controllers," *IEEE Trans. on Education,* February 1985; pp. 43–44.
14. R. L. Wells, "Control of a Flexible Robot Arm," *IEEE Control Systems,* January 1990; pp. 9–15.
15. H. Kazerooni, "Force Augmentation in Human-Robot Interaction," *IEEE Proceed. of the American Control Conference,* May 1990; pp. 2821–26.
16. R. C. Dorf, *The Encyclopedia of Robotics,* John Wiley & Sons, New York, 1988.
17. S. Boyd, "Linear Controller Design," *Proceed. of the IEEE,* March 1990; pp. 529–74.
18. J. Koelsch, "Sensors—the Missing Link," *Manufacturing Engineering,* October 1990; pp. 53–56.

♦

CHAPTER 11

Robust Control Systems

Preview

We have described the benefits of using a compensator, $G_c(s)$, in order to achieve the desired performance of a feedback system. In this chapter we extend the concept of compensation and introduce a powerful controller, the proportional-integral-derivative (PID) device.

The design of highly accurate control systems in the presence of significant uncertainty requires the designer to seek a robust system. Thus, in this chapter we will utilize three methods for robust design.

573

Figure 11.1. Block diagram of a computer control system.

11.1 Introduction

The use of a digital computer as a compensator device has grown during the past decade as the price and reliability of digital computers have improved dramatically [1,2]. A block diagram of a single-loop digital control system is shown in Fig. 11.1. The digital computer in this system configuration receives the error, $e(t)$, and performs calculations in order to provide an output $u*(t)$. The computer may be programmed to provide an ouput, $u*(t)$, so that the performance of the process is near or equal to the desired performance. Many computers are able to receive and manipulate several inputs, so a digital computer control system can often be a multivariable system.

11.2 Digital Computer Control System Applications

A more complete block diagram of a computer control system is shown in Fig. 11.2. This diagram recognizes that a digital computer receives and operates on signals in digital (numerical) form, as contrasted to continuous signals [3]. A *digital control system* uses digital signals and a digital computer to control a process. The measurement data are converted from analog form to digital form by means of the converter shown in Fig. 11.2. After the digital computer has processed the inputs, it provides an output in digital form. This output is then converted to analog form by the digital-to-analog converter shown in Fig. 11.2.

Figure 11.2. Block diagram of a computer control system, including the signal converters.

While digital computers or microprocessors require a sequence of discrete signals as inputs, they provide a series of output signals that are converted to a continuous signal by the digital-to-analog converter. Thus, if the time interval between each digital signal is small compared to the time constants of the actuator and process, the system essentially acts as a continuous system. The digital computer and the analog-to-digital and digital-to-analog converter can all be then represented by the summation node and $G_c(s)$, as shown in Fig. 11.3.

The period between digital data is called the sampling period, T. If the time constant τ of the system is much greater than T, then the system may be considered continuous. For example, many microprocessors accommodate data at a rate equal to 1 megahertz so that $T = 1$ μs. Thus if $\tau > 100$ μs, we may consider the system continuous. Most electromechanical and chemical control systems have time constants that exceed 1 ms.

Digital control systems are used in many applications: for machine tools, metal working processes, chemical processes, aircraft control, and automobile traffic control, among others [1,2,3]. An example of a computer control system used in the aircraft industry is shown in Fig. 11.4. Automatic computer controlled systems are used for purposes as diverse as measuring the objective refraction of the human eye and controlling the engine spark timing or air-fuel ratio of automobile engines. The latter innovations are necessary to reduce automobile emissions and increase fuel economy.

The advantage of using digital control includes (1) improved sensitivity, (2) digitally coded signals, (3) digital sensors and transducers, and (4) the use of microprocessors. Improved sensitivity results from the low energy signals required by digital sensors and devices. The use of digitally coded signals permits the wide application of digital devices and communications. Digital sensors and transducers can effectively measure, transmit, and couple signals and devices. In addition, many systems are inherently digital because they send out pulse signals. Examples of such a digital system are a radar tracking system and a space satellite. However, we must reemphasize that data rates are usually so high that most digital control systems may be treated as continuous systems.

Figure 11.3. Continuous system model of the computer control system of Fig. 11.2.

Figure 11.4. The flight deck of the Boeing 757 and 767 features digital control electronics, including an engine indicating system and a crew alerting system. All systems controls are within reach of either pilot. The system includes an inertial reference system making use of laser gyroscopes and an electronic attitude director indicator. A flight-management computer system integrates navigation, guidance, and performance data functions. When coupled with the automatic flight-control system (automatic pilot), the flight-management system provides accurate engine thrust settings and flight-path guidance during all phases of flight from immediately after takeoff to final approach and landing. The system can predict the speeds and altitudes that will result in the best fuel economy and command the airplane to follow the most fuel-efficient, or the "least time," flight paths. (Courtesy of Boeing Airplane Co.)

11.3 Automatic Assembly and Robots

Automatic handling equipment for home, school, and industry is particularly useful for hazardous, repetitious, dull, or simple tasks. Machines that automatically load and unload, cut, weld, or cast are used by industry in order to obtain accuracy, safety, economy, and productivity [1,2,14,15]. The use of computers integrated with machines that perform tasks as a human worker does has been foreseen by several authors. In his famous 1923 play, entitled *R.U.R.* [23], Karel Capek called artificial workers *robots,* deriving the word from the Czech noun *robota,* meaning "work." Two modern "robots" that appeared in the films *Star Wars* and *The Empire Strikes Back* are shown in Fig. 11.5.

Figure 11.5. Two modern "robots" appeared in the films *Star Wars* and *The Empire Strikes Back*. R2-D2 (left) and C-3PO were the able assistants and supporters of Luke and Leia, the hero and heroine of the film. (Courtesy of Twentieth Century Fox-Film Corporation.)

Robots are programmable computers integrated with machines. They often substitute for human labor in specific repeated tasks. Some devices even have anthropomorphic mechanisms, including what we might recognize as mechanical arms, wrists, and hands. Robots can be used extensively in space exploration and assembly [1]. They can be flexible, accurate aids on assembly lines, as shown in Fig. 11.6.

A *robot* can be defined as a reprogrammable, multifunctional manipulator designed to move material, parts, tools, or specialized devices through variable

Figure 11.6. At its Mirafiori auto assembly plant, Fiat of Italy uses 190 Unimate robots for welding and loading and unloading tasks. The robots are shown here on both sides of the welding line. (Courtesy of Unimation, Inc.)

programmed motions for the performance of a variety of tasks. It is the ability of the robot to be reprogrammed that enables the user to use rapidly the robot in new tasks. Approximately 25,000 robots have been installed for industrial uses over the past decade, and about 3,000 new robots are now being installed annually.

11.4 Robust Control Systems

Designing highly accurate systems in the presence of significant plant uncertainty is a classical feedback design problem. The theoretical bases for the solution of this problem date back to the works of H. S. Black and H. W. Bode in the early 1930s, when this problem was referred to as the sensitivities design problem. However, a significant amount of literature has been published since then regarding the design of systems subject to large plant uncertainty. The designer seeks to obtain a system that performs adequately over a large range of uncertain parameters. A system is said to be *robust* when it is durable, hardy, and resilient.

A control system is robust when (1) it has low sensitivities, (2) it is stable over the range of parameter variations, and (3) the performance continues to meet the specifications in the presence of a set of changes in the system parameters [4,7]. Robustness is the sensitivity to effects that are not considered in the analysis and design phase—for example, disturbances, measurement noise, and unmodeled dynamics. The system should be able to withstand these neglected effects when performing the tasks of interest.

For small parameter perturbations, we may use, as a measure of robustness, the differential sensitivities discussed in Sections 3.2 (system sensitivity) and 6.6 (root sensitivity).

System sensitivity is defined as

$$S_\alpha^T = \frac{\partial T/T}{\partial \alpha/\alpha}, \tag{11.1}$$

where α is the parameter and T the transfer function of the system.

Root sensitivity is defined as

$$S_\alpha^{r_i} = \frac{\partial r_i}{\partial \alpha/\alpha}. \tag{11.2}$$

When the zeros of $T(s)$ are independent of the parameter α, we showed that

$$S_\alpha^T = -\sum_{i=1}^{n} S_\alpha^{r_i} \cdot \frac{1}{(s + r_i)} \tag{11.3}$$

for an nth order system. For example, if we have a closed-loop system, as shown in Fig. 11.7, where the variable parameter is α, then $T(s) = 1/[s + (\alpha + 1)]$ and

$$S_\alpha^T = \frac{1}{s + \alpha + 1}. \tag{11.4}$$

Furthermore, the root is $s = r_1 = -(\alpha + 1)$ and

$$S_\alpha^{r_1} = -1. \tag{11.5}$$

Therefore

$$S_\alpha^T = -S_\alpha^{r_1} \frac{1}{(s + \alpha + 1)}. \tag{11.6}$$

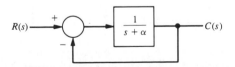

Figure 11.7. A first-order system.

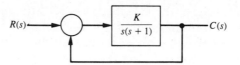

Figure 11.8. A second-order system.

Let us examine the sensitivity of the second-order system shown in Fig. 11.8. The transfer function of the closed-loop system is

$$T(s) = \frac{K}{s^2 + s + K}.$$

(11.7)

As we saw in Eq. (3.13), the system sensitivity for K is

$$S_K^T = \frac{1}{1 + GH(s)} = \frac{s(s + 1)}{s^2 + s + K}.$$

(11.8)

A Bode plot of the asymptotes of $20 \log |T(j\omega)|$ and $20 \log |S(j\omega)|$ are shown in Fig. 11.9 for $K = \frac{1}{4}$ (critical damping). Note that the sensitivity is small for lower frequencies, while the transfer function primarily passes low frequencies. Also, note for this case, $T(s) = 1 - S(s)$.

Of course, the sensitivity S only represents robustness for small changes in gain. If K changes from $\frac{1}{4}$ within the range $K = \frac{1}{16}$ to $K = 1$, the resulting range of step response is shown in Fig. 11.10. This system, with an expected wide range

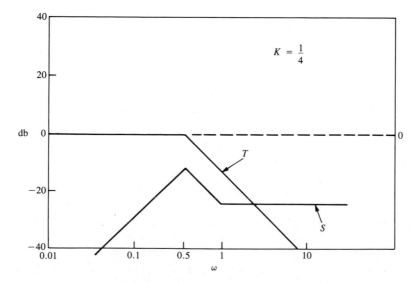

Figure 11.9. Sensitivity and $20 \log T(j\omega)$ for the second-order system in Fig. 11.8.

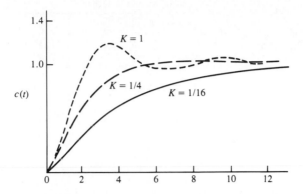

Figure 11.10. Step response for selected gain K.

of K, may not be considered adequately robust. A robust system would be expected to yield essentially the same (within an agreed-upon variation) response to a selected input.

■ Example 11.1 Sensitivity of a controlled system

Consider the system shown in Fig. 11.11, where $G(s) = 1/s^2$ and a PD controller $G_c(s) = b_1 + b_2 s$. Then, the sensitivity with respect to changes in $G(s)$ is

$$S_G^T = \frac{1}{1 + GG_c} = \frac{s^2}{s^2 + b_2 s + b_1} \tag{11.9}$$

and

$$T(s) = \frac{b_2 s + b_1}{s^2 + b_2 s + b_1}. \tag{11.10}$$

Consider the condition $\zeta = 1$ and $\omega_n = \sqrt{b_1}$. Then $b_2 = 2\omega_n$ to achieve $\zeta = 1$. Therefore we may plot $20 \log|S|$ and $20 \log|T|$ on a Bode diagram, as shown in Fig. 11.12. Note that the frequency ω_n is an indicator on the boundary between the frequency region in which the sensitivity is the important design criterion and the region in which the stability margin is important. Thus, if we specify ω_n properly to take into consideration the extent of modeling error and the frequency of

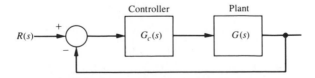

Figure 11.11. A system with a PD controller.

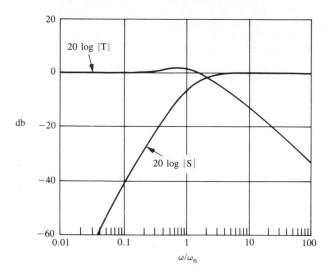

Figure 11.12. Sensitivity and $T(s)$ for the second-order system in Fig. 11.11.

external disturbance, we can expect that the system has an acceptable amount of robustness. Note $G_c(s)$ is a proportional-derivative (PD) controller.

■ E x a m p l e 11.2 System with a right-hand plane zero

Consider the system shown in Fig. 11.13, where the plant has a zero in the right-hand plane. The closed-loop transfer function is

$$T(s) = \frac{K(s-1)}{s^2 + (2+K)s + (1-K)}.$$ (11.11)

The system is stable for a gain $-2 < K < 1$. The steady-state error is

$$e_{ss} = \frac{1-2K}{1-K}$$ (11.12)

and $e_{ss} = 0$ when $K = \frac{1}{2}$. The response to a negative unit step input $R(s) = -1/s$ is shown in Fig. 11.14. Note the initial undershoot at $t = 1$ second. This system

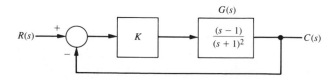

Figure 11.13. A second-order system.

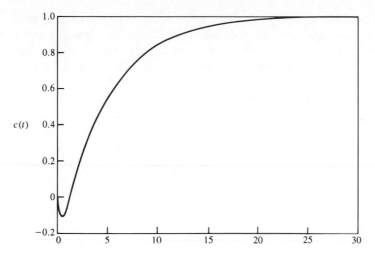

Figure 11.14. Step response of the system in Fig. 11.13 with $K = \frac{1}{2}$.

is sensitive to changes in K as recorded in Table 11.1. The performance of this system might be considered acceptable for a change of gain of only \pm 10%. Thus this system would not be considered robust.

11.5 The Design of Robust Control Systems

The design of robust control systems is based on two tasks: determining the structure of the controller and adjusting the controller's parameters to give an "optimal" system performance. This design process is normally done with "assumed complete knowledge" of the plant. Furthermore, the plant is normally described by a linear time-invariant continuous model. The structure of the controller is chosen such that the system's response can meet certain performance criteria.

One possible objective in the design of a control system is that the controlled system's output should exactly and instantaneously reproduce its input. That is, the system's transfer function should be unity,

$$T(s) = C(s)/R(s) = 1. \tag{11.13}$$

In other words, the system should be presentable on a Bode gain versus frequency diagram with a 0-db gain of infinite bandwidth and zero phase shift. In practice,

Table 11.1. Results for Example 11.2.

K	0.25	0.45	0.50	0.55	0.75		
$	e_{ss}	$	0.67	0.18	0	0.22	1.0
Undershoot	5%	9%	10%	11%	15%		
settling time (seconds)	15	24	27	30	45		

this is not possible since every system will contain inductive- and capacitive-type components that store energy in some form. It is these elements and their interconnections with energy dissipative components that produce the system's dynamic response characteristics. Such systems reproduce some inputs almost exactly, while other inputs are not reproduced at all, signifying that the system's bandwidth is less than infinite.

Once it is recognized that the system's dynamics cannot be ignored, a new design objective is needed. One possible design objective is to maintain the magnitude response curve as flat and as close to unity for a large bandwidth as possible for a given plant and controller combination [25].

Another important goal of a control system design is that the effect on the output of the system due to disturbances is minimized. Thus we wish to minimize $C(s)/D(s)$ over a range of frequency.

Consider the control system shown in Fig. 11.15, where $G(s) = G_1(s)G_2(s)$ is the plant and $D(s)$ is the disturbance. We then have

$$T(s) = \frac{C(s)}{R(s)} = \frac{G_c G_1 G_2}{1 + G_c G_1 G_2} \tag{11.14}$$

and

$$\frac{C(s)}{D(s)} = \frac{G_2(s)}{1 + G_c G_1 G_2}. \tag{11.15}$$

Note that both the reference and disturbance transfer functions have the same denominator, or, in other words, they have the same characteristic equation—that is,

$$1 + G_c(s)G_1(s)G_2(s) = 1 + L(s) = 0. \tag{11.16}$$

Furthermore, we recall that the sensitivity of $T(s)$ with respect to $G(s)$ is

$$S_G^T = \frac{1}{1 + G_c G_1 G_2(s)} \tag{11.17}$$

and the characteristic equation is the influencing factor on the sensitivity. Equation 11.17 shows that for low sensitivity S we require a high value of loop gain

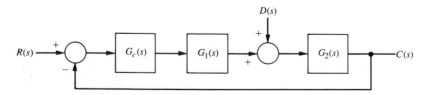

Figure 11.15. A system with a disturbance.

$L(j\omega)$, but it is known that high gain could cause instability or poor responsiveness of $T(s)$. Thus the designer seeks the following:

1. $T(s)$ with wide bandwidth and faithful reproduction of $R(s)$.
2. Large loop gain $L(s)$ in order to minimize sensitivity S.
3. Large loop gain $L(s)$ attained primarily by $G_c(s)G_1(s)$ since $C(s)/D(s) \approx 1/G_cG_1(s)$.

Setting the design of robust systems in frequency domain terms, we are required to find a proper compensator, $G_c(s)$, such that the closed-loop sensitivity is less than some tolerance value and sensitivity minimization involves finding a proper compensator such that the closed-loop sensitivity equals or is arbitrarily close to the minimal attainable sensitivity. Similarly, the gain margin problem is to find a proper compensator to achieve some prescribed gain margin, and gain margin maximization involves finding a proper compensator to achieve the maximal attainable gain margin. For the frequency domain specifications, we require the following for the Bode diagram of $G_cG(j\omega)$, shown in Fig. 11.16:

1. For relative stability, $G_cG(j\omega)$ must have, for an adequate range of ω, not more than -20 db/decade slope at or near the crossover frequency ω_c.
2. Steady-state accuracy achieved by the low frequency gain.
3. Accuracy over a bandwidth ω_B by not allowing $|G_cG(\omega)|$ to fall below a prescribed level,
4. Disturbance rejection by high gain for $G_c(j\omega)$ over the system bandwidth.

Using the root sensitivity concept, we can state that we require that S_α^r be minimized while attaining $T(s)$ with dominant roots that will provide the appro-

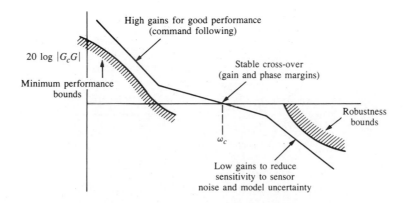

Figure 11.16. Bode diagram for 20 log $|G_cG(j\omega)|$.

priate response and minimize the effect of $D(s)$. Again we see that the goal is to have the gain of the loop primarily attained by $G_c(s)$. As an example, let $G_c(s) = K$, $G_1(s) = 1$, and $G_2(s) = 1/s(s + 1)$ for the system in Fig. 11.15. This system has two roots and we select a gain K so that $C(s/D(s))$ is minimized, S_K^r is minimized, and $T(s)$ has desirable dominant roots. The sensitivity is

$$S_K^r = \frac{dr}{dK} \cdot \frac{K}{r} = \frac{ds}{dK}\bigg|_{s=r} \cdot \frac{K}{r} \tag{11.18}$$

and the characteristic equation is

$$s(s + 1) + K = 0. \tag{11.19}$$

Therefore $dK/ds = -(2s + 1)$ since $K = -s(s + 1)$. We then obtain

$$S_K^r = \frac{-1}{(2s + 1)} \cdot \frac{(-s(s + 1))}{s}\bigg|_{s=r}. \tag{11.20}$$

When $\zeta < 1$, the roots are complex and $r = -0.5 + j\omega$. Then,

$$|S_K^r| = \left(\frac{0.25 + \omega^2}{4\omega^2}\right)^{1/2}. \tag{11.21}$$

The magnitude of the sensitivity is plotted in Fig. 11.17 for $K = 0.2$ to $K = 5$. Also, the percent overshoot to a step is shown. Clearly, it is best to reduce the sensitivity but to limit K to 1.5 or less. We then attain the majority of the attain-

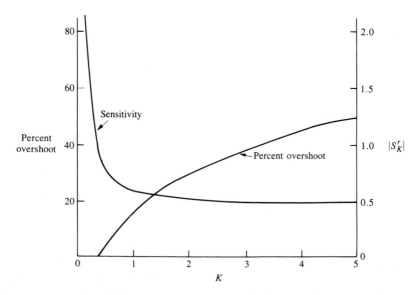

Figure 11.17. Sensitivity and percent overshoot for a second-order system.

able reduction in sensitivity while maintaining good performance for the step response. In general, we can use the design procedure as follows:

1. Draw the root locus of the compensated system with $G_c(s)$ chosen to attain the desired location for the dominant roots.
2. Maximize the gain of $G_c(s)$ so that the effect of the disturbance is reduced.
3. Determine S_α^r and attain the minimum value of the sensitivity consistent with the transient response required as described in step 1.

■ Example 11.3 Sensitivity and compensation

Let us reconsider the system in Example 10.1 when $G(s) = 1/s^2$, $G_1(s) = 1$, and $G_c(s)$ is to be selected by frequency response methods. Therefore the compensator is to be selected to achieve an appropriate gain and phase margin while minimizing sensitivity and the effect of the disturbance. Thus we choose

$$G_c(s) = \frac{K(s/z + 1)}{(s/p + 1)}. \tag{11.22}$$

As in Example 10.1, we choose $K = 10$ to reduce the effect of the disturbance. In order to attain a phase margin of 45° we select $z = 2.1$ and $p = 12.6$. We then attain the compensated diagram shown in Fig. 11.18. Recall that the closed-loop bandwidth is $\omega_B = 1.6\,\omega_c$. Thus we will increase the bandwidth by using the compensator and improve the fidelity of reproduction of the input signals.

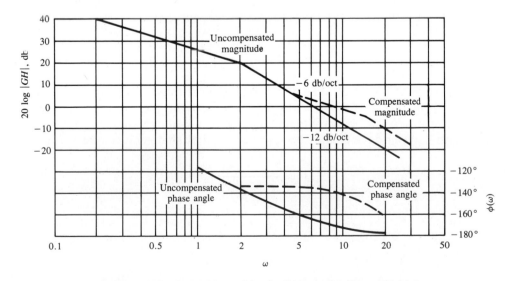

Figure 11.18. Compensated Bode diagram for Example 11.3.

The sensitivity may be ascertained at ω_c as

$$|S_G^T(\omega_c)| = \left| \frac{1}{1 + G_cG(j\omega)} \right|_{\omega_c}. \tag{11.23}$$

In order to estimate $|S_G^T|$, we recall that the Nichols chart enables us to obtain

$$|T(\omega)| = \left| \frac{G_cG(\omega)}{1 + G_cG(\omega)} \right|. \tag{11.24}$$

Thus we can plot a few points of $G_cG(j\omega)$ on the Nichols chart and read $T(\omega)$ from the Nichols chart. Then,

$$|S_G^T(\omega_1)| = \frac{|T(\omega_1)|}{|G_cG(\omega_1)|}, \tag{11.25}$$

where ω_1 is chosen arbitrarily as $\omega_c/2.5$. In general, we choose a frequency below ω_c to determine the value of $|S|$. Of course, we desire a low value of sensitivity. The Nichols chart for the compensated system is shown in Fig. 11.19. For $\omega_1 = \omega_c/2.5 = 2$, we have $20 \log T = 2.5$ db and $20 \log G = 9$ db. Therefore

$$|S(\omega_1)| = \frac{|T|}{|G_cG|} = \frac{1.33}{2.8} = 0.47.$$

■ **E x a m p l e 11.4 Sensitivity with a lead compensator**

Let us again consider the system in Example 11.3, using the root locus design obtained in Example 10.3. The compensator was chosen as

$$G_c(s) = \frac{8.1(s + 1)}{(s + 3.6)}, \tag{11.26}$$

for the system of Fig. 11.20. The dominant roots are thus $s = -1 \pm j2$. Since the gain is 8.1, the effect of the disturbance is reduced and the time response meets the specifications. The sensitivity at r may be obtained by assuming that the system, with dominant roots, may be approximated by the second-order system

$$T(s) = \frac{K}{s^2 + 2\zeta\omega_n s + K}$$

$$= \frac{K}{s^2 + 2s + K},$$

since $\zeta\omega_n = 1$. The characteristic equation is thus

$$s^2 + 2s + K = 0.$$

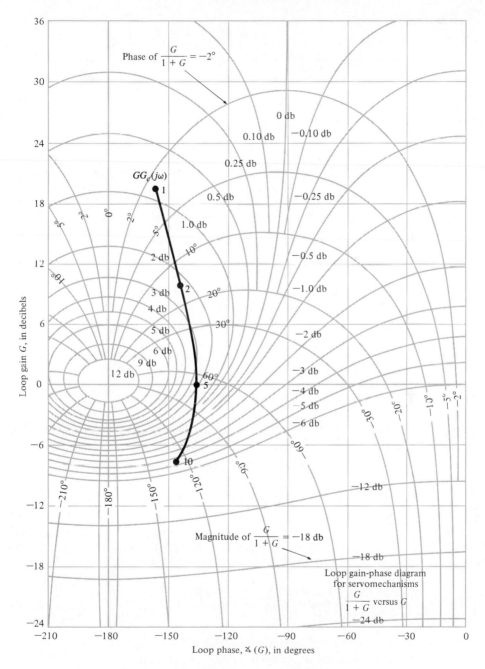

Figure 11.19. Nichols chart for Example 11.3

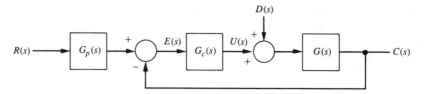

Figure 11.20. Feedback control system with a desired input $R(s)$ and an undesired input $D(s)$.

Then $dK/ds = -(2s + 2)$ and $K = -(s^2 + 2s)$. Therefore

$$S_K^r = \frac{-1}{(2s + 2)} \cdot \frac{-(s^2 + 2s)}{s}\bigg|_{s=r}$$

$$= \frac{(s + 2)}{2s + 2)}\bigg|_{s=r} \tag{11.27}$$

where $r = -1 + j2$. Then, substituting $s = r$, we obtain

$$|S_K^r| = 0.56.$$

If we raise the gain K to $K = 10$, we expect $r \cong -1.1 \pm j2.2$. Then the sensitivity is

$$|S_K^r| = 0.53.$$

Thus as K increases the sensitivity decreases but the transient performance deteriorates.

11.6 Three-Term (PID) Controllers

One form of controller available and widely used in industrial process control is called a *three-term controller* or *process controller*. This controller has a transfer function

$$\frac{U(s)}{E(s)} = G_c(s) = K_p + \frac{K_I}{s} + K_D s. \tag{11.28}$$

The controller provides a proportional term, an integration term, and a derivative term [26]. The equation for the output in the time domain is

$$u(t) = K_p e(t) + K_I \int e(t)\, dt + K_D \frac{de(t)}{dt}. \tag{11.29}$$

The three-mode controller is also called a PID controller because it contains a proportional, an integration, and a derivative term. The transfer function of the derivative term is actually

$$G_d(s) = \frac{K_D s}{\tau_d s + 1},\tag{11.30}$$

but usually τ_d is much smaller than the time constants of the process itself and it may be neglected.

If we set $K_D = 0$, then we have the familiar PI controller discussed in Section 10.6. When $K_I = 0$, we have

$$G_c(s) = K_p + K_D(s),\tag{11.31}$$

which is called a proportional plus derivative (PD) controller (Example 11.1).

Many industrial processes are controlled using proportional-integral-derivative (PID) controllers. The popularity of PID controllers can be attributed partly to their robust performance in a wide range of operating conditions and partly to their functional simplicity, which allows engineers to operate them in a simple and straightforward manner. To implement such a controller, three parameters must be determined for the given process: proportional gain, integral gain, and derivative gain.

Consider the PID controller

$$
\begin{aligned}
G_c(s) &= K_1 + \frac{K_2}{s} + K_3 s \\[6pt]
&= \frac{K_3 s^2 + K_1 s + K_2}{s} \\[6pt]
&= \frac{K_3(s^2 + as + b)}{s},
\end{aligned}
\tag{11.32}
$$

where $a = K_1/K_3$ and $b = K_2/K_3$. Therefore a PID controller introduces a transfer function with one pole at the origin and two zeros that can be located anywhere in the left-hand s-plane.

Recall that a root locus begins at the poles and ends at the zeros. If we have a system as shown in Fig. 11.20 with

$$G(s) = \frac{1}{(s + 2)(s + 3)}$$

and we use a PID controller with complex zeros, we can plot the root locus as shown in Fig. 11.21. As the gain, K_3, of the controller is increased, the complex

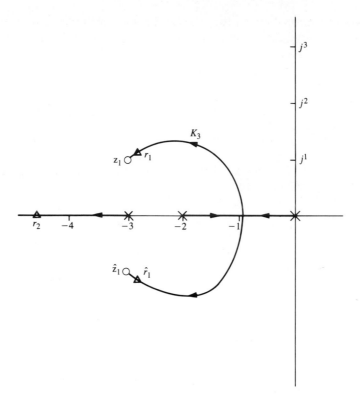

Figure 11.21. Root locus for plant with a PID controller.

roots approach the zeros. The closed-loop transfer function is

$$T(s) = \frac{G(s)G_c(s)G_p(s)}{1 + G(s)G_c(s)}$$

$$= \frac{K_3(s + z_1)(s + \hat{z}_1)}{(s + r_2)(s + r_1)(s + \hat{r}_1)} G_p(s) \qquad (11.33)$$

$$\cong \frac{K_3 G_p(s)}{(s + r_2)}.$$

because the zeros and the complex roots are approximately equal ($r_1 \approx z_1$). Setting $G_p(s) = 1$, we have

$$T(s) = \frac{K_3}{s + r_2}$$

$$\approx \frac{K_3}{s + K_3} \qquad (11.34)$$

when $K_3 \gg 1$. The only limiting factor is the allowable magnitude of $U(s)$ (Fig. 11.20) when K_3 is large. If K_3 is 100, the system has a fast response and zero

steady-state error. Furthermore, the effect of the disturbance is reduced significantly.

In general, we note that PID controllers are particularly useful for reducing steady-state error and improving the transient response when $G(s)$ has one or two poles (or may be approximated by a second-order plant).

We may use frequency response methods to represent the addition of a PID controller. The PID controller, Eq. (11.32), may be rewritten as

$$G_c(s) = \frac{K_2\left(\dfrac{K_3}{K_2}s^2 + \dfrac{K_1}{K_2}s + 1\right)}{s}$$

$$= \frac{K_2(\tau s + 1)\left(\dfrac{\tau}{\alpha}s + 1\right)}{s}.$$

(11.35)

The Bode diagram of Eq. (11.35) is shown in Fig. 11.22 for $\omega\tau$, $K_2 = 2$, and $\alpha = 10$. The PID controller is a form of a lag-lead compensator with a variable gain, K_2. Of course, it is possible that the controller will have complex zeros and a Bode diagram that will be dependent on the ζ of the complex zeros. The contribution by the zeros to the Bode chart may be visualized by reviewing Fig. 7.9 for complex poles and noting that the phase and magnitude change as ζ changes. The PID controller with complex zeros is

$$G_c(\omega) = \frac{K_2[1 + (2\zeta/\omega_n)j\omega - (\omega/\omega_n)^2]}{j\omega}.$$

(11.36)

Normally, we choose $0.9 < \zeta < 0.7$.

Figure 11.22. Bode diagram for a PID controller.

11.7 The Design of Robust PID Controlled Systems

The selection of the three coefficients of PID controllers is basically a search prob-
lem in a three-dimensional space. Points in the search space correspond to differ-
ent selections of a PID controller's three parameters. By choosing different points
of the space, we can produce, for example, different step responses for a step
input. A PID controller can be determined by moving in this search space on a
trial and error basis.

The main problem in the selection of the three coefficients is that these coef-
ficients do not readily translate into the desired performance and robustness char-
acteristics that the control system designer has in mind. Several rules and meth-
ods have been proposed to solve this problem. In this section we consider several
design methods using root locus and performance indices.

The first design method uses the ITAE performance index of Section 4.5 and
the optimum coefficients of Table 4.5 for a step input or Table 4.6 for a ramp
input. Thus we select the three PID coefficients to minimize the ITAE perfor-
mance index, which produces an excellent transient response to a step (Fig. 4.22c)
or a ramp. The design procedure consists of three steps:

1. Select the ω_n of the closed-loop system by specifying the settling time.
2. Determine the three coefficients using the appropriate optimum equation
 (Table 4.5) and the ω_n of step 1 to obtain $G_c(s)$.
3. Determine a prefilter $G_p(s)$ so that the closed-loop system transfer function,
 $T(s)$, does not have any zeros as required by Eq. (4.47).

■ Example 11.5 Robust control of temperature

Consider a temperature controller with a control system as shown in Fig. 11.20
and a plant

$$G(s) = \frac{1}{(s + 1)^2}.\tag{11.37}$$

If $G_c(s) = 1$, the steady-state error is 50% and the settling time is 3.2 seconds for
a step input. We desire to obtain an optimum ITAE performance for a step input
and a settling time of less than 0.5 seconds. Using a PID controller, we have

$$G_c(s) = \frac{K_3s^2 + K_1s + K_2}{s}.\tag{11.38}$$

Therefore the closed loop transfer function without prefiltering $[G_p(s) = 1]$ is

$$T_1(s) = \frac{C(s)}{R(s)} = \frac{G_cG(s)}{1 + G_cG(s)}$$

$$= \frac{K_3s^2 + K_1s + K_2}{s^3 + (2 + K_3)s^2 + (1 + K_1)s + K_2}.\tag{11.39}$$

The optimum coefficients of the characteristic equation for ITAE are obtained from Table 4.5 as

$$(s^3 + 1.75\, \omega_n s^2 + 2.15\, \omega_n^2 s + \omega_n^3).\tag{11.40}$$

We need to select ω_n in order to meet the settling time requirement. Since $T_s = 4/\zeta\omega_n$ and ζ is unknown, but near 0.8, we set $\omega_n = 10$. Then, equating the denominator of Eq. (11.39) to Eq. (11.40), we obtain the three coefficients as $K_1 = 214$, $K_3 = 15.5$, and $K_2 = 1000$.
Then Eq. (11.39) becomes

$$\begin{aligned}
T_1(s) &= \frac{15.5 s^2 + 214 s + 1000}{s^3 + 17.5 s^2 + 215 s + 1000} \\
&= \frac{15.5(s + 6.9 + j4.1)(s + 6.9 - j4.1)}{s^3 + 17.5 s^2 + 215 s + 1000}.
\end{aligned}\tag{11.41}$$

The response of this system to a step input has an overshoot of 32% as recorded in Table 11.2.
We select a prefilter $G_p(s)$ so that we achieve the desired ITAE response as

$$\begin{aligned}
T(s) &= \frac{G_c G G_p(s)}{1 + G_c G(s)} \\
&= \frac{1000}{s^3 + 17.5 s^2 + 215 s + 1000}.
\end{aligned}\tag{11.42}$$

Therefore we require

$$G_p(s) = \frac{64.5}{(s^2 + 13.8 s + 64.5)}\tag{11.43}$$

in order to eliminate the zeros in Eq. (11.41) and bring the overall numerator to 1000. The response of the system, $T(s)$, to a step input is indicated in Table 11.2. The system has a small overshoot, a settling time of less than ½ second, and zero steady-state error. Furthermore, for a disturbance $D(s) = 1/s$, the maximum value of $c(t)$ due to the disturbance is 0.4% of the magnitude of the disturbance. This is a very favorable design.

Table 11.2. Results for Example 11.5

Controller	$G_c = 1$	PID and $G_p = 1$	PID with $G_p(s)$ prefilter
Percent overshoot	0	31.7%	1.9%
Settling time (seconds)	3.2	0.20	0.45
Steady-state error	50.1%	0.0%	0.00%
$\lvert c(t)/d(t)\rvert_{\text{maximum}}$	52%	0.4%	0.4%

■ Example 11.6 Robust system design

Let us reconsider the system in Example 11.5 when the plant varies significantly so that

$$G(s) = \frac{K}{(\tau s + 1)^2},$$

(11.44)

where $0.5 \leq \tau \leq 1$, and $1 \leq K \leq 2$. It is desired to achieve robust behavior using an ITAE optimum system with a prefilter while attaining an overshoot of less than 4% and a settling time of less than 2 seconds while $G(s)$ can attain any value in the range indicated above. We select $\omega_n = 8$ in order to attain the settling time and determine the ITAE coefficients for $K = 1$ and $\tau = 1$. Then, completing the calculation, we obtain the system without a prefilter $[G_p(s) = 1]$ as

$$T_1(s) = \frac{12(s^2 + 11.38s + 42.67)}{s^3 + 14s^2 + 137.6s + 512}$$

(11.45)

and

$$G_c(s) = \frac{12(s^2 + 11.38s + 42.67)}{s}.$$

(11.46)

We select a prefilter

$$G_p(s) = \frac{42.67}{(s^2 + 11.38s + 42.67)}$$

(11.47)

to obtain the optimum ITAE transfer function

$$T(s) = \frac{512}{s^3 + 14s^2 + 137.6s + 512}.$$

(11.48)

We then obtain the step response for the four conditions: $\tau = 1$, $K = 1$; $\tau = 0.5$, $K = 1$; $\tau = 1$, $K = 2$; and $\tau = 0.5$, $K = 2$. The results are summarized in Table 11.3. Clearly, this is a very robust system.

The value of ω_n that can be chosen will be limited by considering the maximum allowable $u(t)$ where $u(t)$ is the output of the controller, as shown in Fig. 11.20. If the maximum value of $e(t)$ is 1, then $u(t)$ would normally be limited to 100 or less. As an example, consider the system in Fig. 11.20 with a PID controller, $G(s) = 1/s(s + 1)$, and the necessary prefilter $G_p(s)$ to achieve ITAE performance. If we select $\omega_n = 10$, 20, and 40, the maximum value of $u(t)$ is recorded

Table 11.3. Results for Example 11.6

Plant Conditions	$\tau = 1$ $K = 1$	$\tau = 0.5$ $K = 1$	$\tau = 1$ $K = 2$	$\tau = 0.5$ $K = 2$
Percent overshoot	2%	0%	0%	1%
Settling time (seconds)	1.25	0.8	0.8	0.9

Table 11.4. Maximum Value of Plant Input

ω_n	10	20	40
$u(t)$ maximum for $R(s) = 1/s$	35	135	550
Settling time (seconds)	0.9	0.5	0.3

in Table 11.4. If we wish to limit $u(t)$ to a maximum equal to 100, we need to limit ω_n to 16. Thus we are limited in the settling time we can achieve.

Let us consider the design of a PID compensator using frequency response techniques for a system with a time delay so that

$$G(s) = \frac{Ke^{-Ts}}{(\tau s + 1)}. \qquad (11.49)$$

This type of plant represents many industrial processes which incorporate a time delay. We use a PID compensator to introduce two equal zeros so that

$$G_c(s) = \frac{K_2(\tau_1 s + 1)^2}{s}. \qquad (11.50)$$

The design method is as follows:

1. Plot the uncompensated Bode diagram for $K_2 G(s)/s$ with a gain K_2 that satisfies the steady-state error requirement.
2. Place the two equal zeros at or near the crossover frequency, ω_c.
3. Test the results and adjust K or the zero locations, if necessary.

■ **Example 11.7 PID control of a system with a delay**

Consider the system of Fig. 11.19 when

$$G(s) = \frac{20e^{-0.1s}}{(0.1s + 1)}, \qquad (11.51)$$

where $K = 20$ is selected to achieve a small steady-state error for a step input. We want an overshoot to a step input of less than 5%.

Plotting the Bode diagram for $G(j\omega)$, we find that the uncompensated system has a negative phase margin and the system is unstable.

We will use a PID controller of the form of Eq. (11.50) to attain a desirable phase margin of 70°. Then the loop transfer function is

$$GG_c(s) = \frac{20e^{-0.1s}(\tau_1 s + 1)^2}{s(0.15s + 1)}, \qquad (11.52)$$

where $K_2K = 20$. We plot the Bode diagram without the two zeros, as shown in Fig. 11.23. The phase margin is $-32°$ and the system is unstable prior to the introduction of the zeros.

Figure 11.23. Bode diagram for $G(s)/s$ for Example 11.7.

Since we have introduced a pole at the origin because of the integral term in the PID compensator, we may reduce the gain K_2K because e_{ss} is now zero. We place the two zeros at or near the crossover, $\omega_c = 11$. We choose to set $\tau_1 = 0.06$ so that the two zeros are set at $\omega = 16.7$. Also, we reduce the gain to 4.5. Then we obtain the frequency response shown in Fig. 11.24, where

$$G_c G(s) = \frac{4.5 \, (0.06s + 1)^2 e^{-0.1s}}{s(0.1s + 1)}. \qquad (11.53)$$

The new crossover frequency is $\omega_c' = 4.5$ and the phase margin is 70°. The step response of this system has no overshoot and has a settling time of 0.80 seconds. This response satisfies the requirements. However, if the designer wanted to adjust the system further, we could raise K_2K to 10 and achieve a somewhat faster response with an overshoot of less than 5%.

As a final consideration of the design of robust control systems using a PID controller, we turn to an s-plane root locus method. This design approach may be simply stated as follows:

1. Place the poles and zeros of $G(s)/s$ on the s-plane.
2. Select a location for the zeros of $G_c(s)$ that will result in an acceptable root locus and suitable dominant roots.

Figure 11.24. Bode diagram for $G_cG(s)$ for Example 11.7.

3. Test the transient response of the compensated system and iterate step 2, if necessary.

11.8 Design Example: Aircraft Autopilot

A typical aircraft autopilot control system consists of electrical, mechanical, and hydraulic devices that move the flaps, elevators, fuel-flow controllers, and other components that cause the aircraft to vary its flight. Sensors provide information on velocity, heading, rate of rotation, and other flight data. This information is combined with the desired flight characteristics (commands) electronically available to the autopilot. The autopilot should be able to fly the aircraft on a heading and under conditions set by the pilot. The command often consists of a predetermined heading. Design often focuses on a forward-moving aircraft that moves somewhat up or down without moving right or left and without rolling (rotating the wingtips). Such a study is called pitch plane design. The aircraft is represented by a plant

$$G(s) = \frac{K}{(s + 1/\tau)(s^2 + 2\zeta_1\omega_1 s + \omega_1^2)},\tag{11.54}$$

where τ is the time constant of the actuator. Let $\tau = \frac{1}{4}$, $\omega_1 = 2$, and ζ equal to $\frac{1}{2}$. Then, the s-plane plot has two complex poles—a pole at the origin and a pole at

Figure 11.25. Root locus for Example 11.8. The complex poles can vary within the dashed-line box.

$s = -4$, as shown in Fig. 11.25. The complex poles, representing the aircraft dynamics, can vary within the dashed-line box shown in Fig. 11.25. We then choose the zeros of the controller as $s = -1.3 \pm j2$, as shown. We select the gain K so that the roots r_2 and \hat{r}_2 are complex with a ζ of $1/\sqrt{2}$. The other roots r_1 and \hat{r}_1 lie very near the zeros. Therefore the closed-loop transfer function is approximately

$$T(s) \cong \frac{\omega_n^2}{s^2 + 2\zeta\omega_n s + \omega_n^2}$$

$$= \frac{5}{s^2 + 3.16s + 5},$$

(11.55)

since $\omega_n = \sqrt{5}$ and $\zeta = 1/\sqrt{2}$. The resulting response to a step input has an overshoot of 4.5% and a settling time of 2.5 seconds.

<h2>11.9 The Future Evolution of Robotics and Control Systems</h2>

The continuing goal of robot and control systems is to provide extensive flexibility and a high level of autonomy. The two system concepts are approaching this goal by different evolutionary pathways, as illustrated in Fig. 11.26. Today's

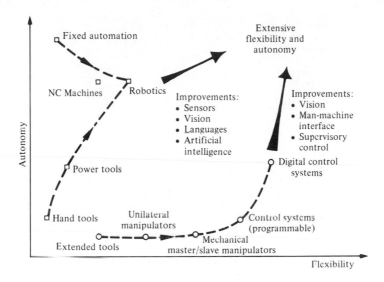

Figure 11.26. Future evolution of control systems and robotics.

industrial robot is perceived as quite autonomous—once it is programmed, further intervention is not normally required. Because of sensory limitations, these robot systems have limited flexibility in adapting to work environment changes, which is the motivation of computer vision research. The control system is very adaptable, but it relies on human supervision. Advanced robotic systems are striving for task adaptability through enhanced sensory feedback. Research areas concentrating on artificial intelligence, sensor integration, computer vision, and off-line CAD/CAM robot programming will make robots more universal and economical. Control systems are moving toward autonomous operation as an enhancement to human control. Research in supervisory control, human-machine interface methods to reduce operator burden, and computer data base management is intended to improve operator efficiency. Many research activities are common to both systems and are aimed toward reducing implementation cost and expanding the realm of application. These include improved communications methods and advanced programming languages.

11.10 Summary

The use of a digital computer as the compensation device for a closed-loop control system has grown during the past decade as the price and reliability of computers have improved dramatically. A computer can be used to complete many calculations during the sampling interval and to provide an output signal that is used to drive an actuator of a process. Computer control is used today for chemical processes, aircraft control, machine tools, and many common processes. Computers can also be used in devices commonly called robots (Fig. 11.27).

The design of highly accurate control systems in the presence of significant

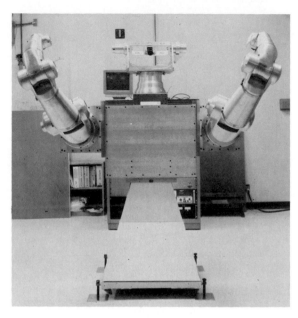

Figure 11.27. Anthropomorphic robot with two arms. (Courtesy of Lockheed Missiles and Space Co.)

plant uncertainty requires the designer to seek a robust control system. A robust control system exhibits low sensitivities to parameter change and is stable over a wide range of parameter variations.

The three-mode or PID controller was considered as a compensator that aids in the design of robust control systems. The design issue for a PID controller is the selection of the gain and two zeros of the controller transfer function. We utilized three design methods for the selection of the controller: (1) the root locus method, (2) the frequency response method, and (3) the ITAE performance index method. An operational amplifier circuit used for a PID controller is shown in Fig. 11.28.

In general, the use of a PID controller will enable the designer to attain a robust control system.

$$G_c(s) = \frac{V_0(s)}{V_1(s)} = \frac{R_4 R_2 (R_1 C_1 s + 1)(R_2 C_2 s + 1)}{R_3 R_1 (R_2 C_2 s)}$$

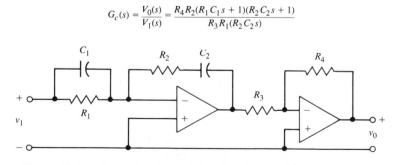

Figure 11.28. Operational amplifier circuit used for PID controller.

Exercises

E11.1. Consider a system of the form shown in Fig. 11.20 where

$$G(s) = \frac{1}{(s + 1)}.$$

Using the ITAE performance method for a step input, determine the required $G_c(s)$. Assume $\omega_n = 20$ for Table 4.6. Determine the step response with and without a prefilter $G_p(s)$.

E11.2. For the ITAE design obtained in E11.1, determine the response due to a disturbance $D(s) = 1/s$.

E11.3. A closed-loop unity feedback system has

$$G(s) = \frac{9}{s(s + p)},$$

where p is normally equal to 3. Determine S_p^T and plot $|T(j\omega)|$ and $|S(j\omega)|$ on a Bode plot.

E11.4. A PID controller is used in the system in Fig. 11.20 where

$$G(s) = \frac{1}{(s + 2)(s + 8)}.$$

The gain K_3 of the controller (Eq. 11.32) is limited to 180. Select a set of compositor zeros so that the pair of closed-loop roots is approximately equal to the zeros. Find the step response for the approximation in Eq. (11.34) and the actual response and compare them.

E11.5. A system has a plant

$$G(s) = \frac{15,900}{s\left(\dfrac{s}{100} + 1\right)\left(\dfrac{s}{200} + 1\right)}$$

and negative unity feedback with a PD compensator

$$G_c(s) = K_1 + K_2 s.$$

The objective is to design $G_c(s)$ so that the overshoot to a step is less than 25% and the settling time is less than 60 ms.

E11.6 Consider the control system shown in Fig. E11.6 when $G(s) = \dfrac{1}{(s + 4)}$, select a PI controller so that the settling time is less than 1 second for an ITAE step response. Plot $c(t)$ for a step input $r(t)$ with and without a prefilter. Determine and plot $c(t)$ for a step disturbance. Discuss the effectiveness of the system.

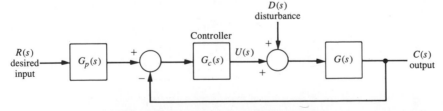

Figure E11.6. System with PI controller.

E11.7 For the control system of Figure E11.6 with $G(s) = \dfrac{1}{(s+4)^2}$, select a PID controller to achieve a settling time of less than 0.8 seconds for an ITAE step response. Plot $c(t)$ for a step input $r(t)$ with and without a prefilter. Determine and plot $c(t)$ for a step disturbance. Discuss the effectiveness of the system.

E11.8 Repeat Exercise 11.6 while striving to achieve a minimum settling time while adding the constraint that $|u(t)| \le 100$ for $t > 0$ for a unit step input, $r(t) = 1, t \ge 0$.

Problems

P11.1. Interest in unmanned underwater vehicles (UUVs) has been increasing recently, with a large number of possible applications being considered. These include intelligence-gathering, mine detection, and surveillance. Regardless of the intended mission, a strong need exists for reliable and robust control of the vehicle. The proposed vehicle is shown in Fig. P11.1(a) [13].

It is desired to control the vehicle through a range of operating conditions. The vehicle is 30 feet long with a vertical sail near the front. The control inputs are sternplane, rudder, and shaft speed commands. In this case we wish to control the vehicle roll by using the stern planes. The control system is shown in Fig. P11.1(b), where $R(s) = 0$, the desired roll angle, and $D(s) = 1/s$. We select $G_c(s) = K(s+1)$, where $K = 2$. (a) Plot $20\log|T|$ and $20\log|S_K^T|$ on a Bode diagram. (b) Evaluate $|S_K^T|$ at ω_B, $\omega_{B/2}$, and $\omega_{B/4}$.

P11.2. A new suspended, mobile, remote-controlled video-camera system to bring three-dimensional mobility to professional NFL football is shown in Fig. P11.2(a) [24]. The cam-

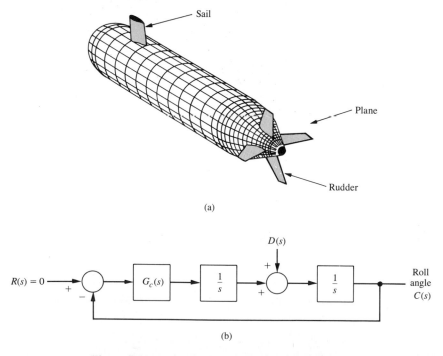

(a)

(b)

Figure P11.1. Control of an underwater vehicle.

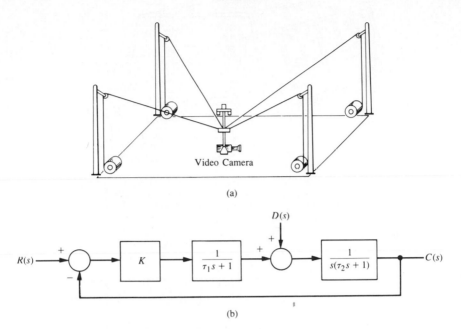

Figure P11.2. Remote controlled tv camera.

era can be moved over the field as well as up and down. The motor control on each pulley is represented by the system in Fig. P11.2(b), where $\tau_1 = 20$ ms and $\tau_2 = 2$ ms. (a) Select K so that $M_{p_\omega} = 1.84$. (b) Plot $20 \log|T|$ and $20 \log|S_K^T|$ on one Bode diagram. (c) Evaluate $|S_K^T|$ at ω_B, $\omega_{B/2}$, and $\omega_{B/4}$. (d) Let $R(s) = 0$ and determine the effect of $D(s) = 1/s$ for the gain K of part (a) by plotting $c(t)$.

P11.3. Magnetic levitation (maglev) trains may replace airplanes on routes shorter than 200 miles. The maglev train developed by a German firm uses electromagnetic attraction to propel and levitate heavy vehicles, carrying up to 400 passengers at 300-mph speeds. But the ¼-inch gap between car and track is hard to maintain [12].

The air-gap control system is shown in Fig. P11.3(a), on the next page. The block diagram of the air-gap control system is shown in Fig. P11.3(b). The compensator is

$$G_c(s) = \frac{K(s + 1)}{(s + 10)}.$$

(a) Find the range of K for a stable system. (b) Select a gain so that the steady-state error of the system is zero for a step input command. (c) Find $c(t)$ for the gain of part (b). (d) Find $c(t)$ when K varies $\pm 10\%$ from the gain of part (b).

P11.4. Computer control of a robot to spray-paint an automobile is shown by the system shown in Fig. P11.4(a), on the next page [1]. We wish to investigate the system when $K = 2, 4,$ and 6. (a) For the three values of K, determine ζ, ω_n, percent overshoot, settling time, and steady-state error for a step input. Record your results in a table. (d) Determine the sensitivity $|S_K^r|$ for the three values of K. (c) Select the best of the three values of K. (d) For the value selected in part (c), determine $c(t)$ for a disturbance $D(s) = 1/s$ when $R(s) = 0$.

P11.5. An automatically guided vehicle is shown in Fig. P11.5(a) and its control system is shown in Fig. P11.5(b). The goal is to accurately track the guide wire, to be insensitive to

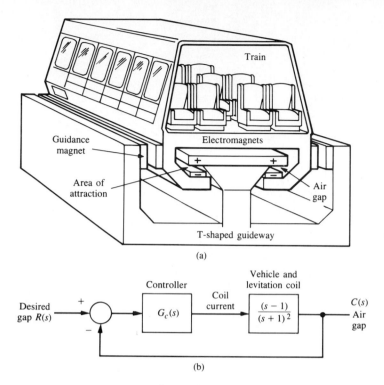

(a)

(b)

Figure P11.3. Maglev train control.

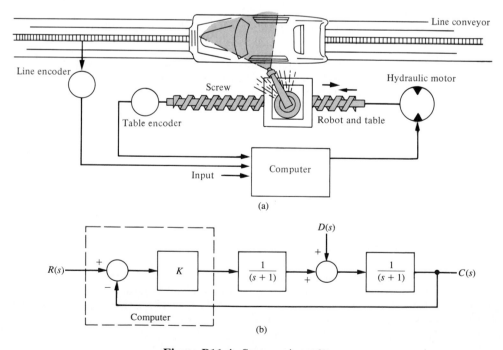

(a)

(b)

Figure P11.4. Spray paint robot.

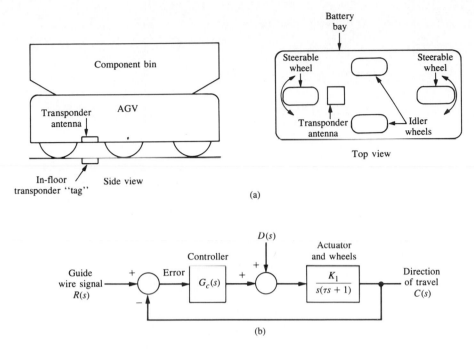

Figure 11.5. Automatically-guided vehicle.

changes in the gain K_1, and to reduce the effect of the disturbance. The gain K_1 is normally equal to 1 and $\tau_1 = \frac{1}{25}$ sec. (a) Select a compensator, $G_c(s)$, so that the percent overshoot to a step input is less than or equal to 10%, the settling time is less than 100 ms, and the velocity constant, K_v, for a ramp input is 100. (b) For the compensator selected in part (a), determine the sensitivity of the system to small changes in K_1 by determining $S_{K_1}^r$ or $S_{K_1}^T$. (c) If K_1 changes to 2 while $G_c(s)$ of part (a) remains unchanged, find the step response of the system and compare selected performance figures with those obtained in part (a). (d) Determine the effect of $D(s) = 1/s$ by plotting $c(t)$ when $R(s) = 0$.

P11.6. A roll-wrapping machine (RWM) receives, wraps, and labels large paper rolls produced in a paper mill [15]. The RWM consists of several major stations: positioning station, waiting station, wrapping station, and so forth. We will focus on the positioning station shown in Fig. P11.6(a). The positioning station is the first station that sees a paper roll. This station is responsible for receiving and weighing the roll, measuring its diameter and width, determining the desired wrap for the roll, positioning it for down-stream processing, and finally ejecting it from the station.

Functionally, the RWM can be categorized as a complex operation because each functional step (e.g., measuring the width) involves a large number of field device actions and relies upon a number of accompanying sensors.

The control system for accurately positioning the width-measuring arm is shown in Fig. P11.6(b). The pole of the positioning arm, p, is normally equal to 2, but it is subject to change because of loading and misalignment of the machine. (a) For p = 2, design a compensator so that the complex roots are $s = -2 \pm j2\sqrt{3}$. (b) Plot $c(t)$ for a step input $R(s) = 1/s$. (c) Plot $c(t)$ for a disturbance $D(s) = 1/s$, with $R(s) = 0$. (d) Repeat parts (b)

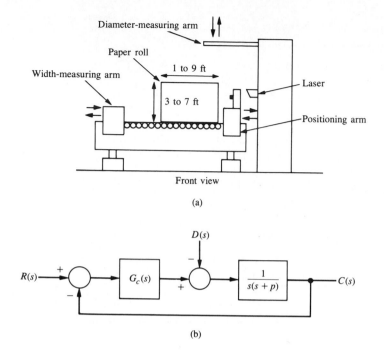

(b)

Figure P11.6. Roll-wrapping machine control.

and (c) when p changes to 1 and $G_c(s)$ remains as designed in part (a). Compare the results for the two values of the pole p.

P11.7. The function of a steel plate mill is to roll reheated slabs into plates of scheduled thickness and dimension [27]. The final products are of rectangular plane view shapes having a width of up to 3300 mm and a thickness of 180 mm.

A schematic layout of the mill is shown in Fig. P11.7(a). The mill has two major roll-

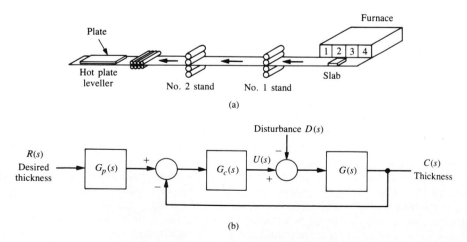

(b)

Figure P11.7. Steel rolling mill control.

ing stands, denoted No. 1 and No. 2. These are equipped with large rolls (up to 508 mm in diameter), which are driven by high-power electric motors (up to 4470 kW). Roll gaps and forces are maintained by large hydraulic cylinders.

Typical operation of the mill can be described as follows. Slabs coming from the reheating furnace initially go through the No. 1 stand, whose function is to reduce the slabs to the required width. The slabs proceed through the No. 2 stand, where finishing passes are carried out to produce required slab thickness, and finally through the hot plate leveller, which gives each plate a smooth finishing surface.

One of the key systems controls the thickness of the plates by adjusting the rolls. The block diagram of this control system is shown in Fig. P11.7(b). The plant is represented by

$$G(s) = \frac{1}{s(s^2 + 4s + 5)}.$$

The controller is a PID with two equal real zeros. (a) Select the PID zeros and the gains so that the real part of the four closed-loop roots are equal. (b) For the design of part (a), obtain the step response without a prefilter $[G_p(s) = 1]$. (c) Repeat part (b) for an appropriate prefilter. (d) For the system, determine the effect of a unit step disturbance by evaluating $c(t)$ with $r(t) = 0$.

P11.8. A motor and load with negligible friction and a voltage-to-current amplifier, K_a, is used in a feedback control system, as shown in Fig. P11.8. A designer selects a PID controller

$$G_c(s) = K_1 + \frac{K_2}{s} + K_3 s,$$

where $K_1 = 5$, $K_2 = 500$, and $K_3 = 0.0475$. (a) Determine the appropriate value of K_a so that the phase margin of the system is 42 degrees. (b) For the gain K_a, plot the root locus of the system and determine the roots of the system for the K_a of part (a). (c) Determine the maximum value of $c(t)$ when $D(s) = 1/s$ and $R(s) = 0$ for the K_a of part (a).

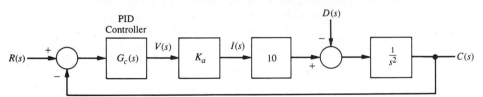

Figure P11.8.

Design Problems ◆

DP11.1. A position control system for a large turntable is shown in Fig. DP11.1(a) and the block diagram of the system is shown in Fig. DP11.1(b). This system uses a large torque motor with $K_m = 15$. The objective is to reduce the steady-state effect of a step change in the load disturbance to 5% of the magnitude of the step disturbance while maintaining a fast response to a step input command, $R(s)$, with less than 5% overshoot. Select K_1 and the compensator when (a) $G_c(s) = K$ and (b) $G_c(s) = K_2 + K_3 s$ (a PD compensator). Plot the step response for the disturbance and the input for both compensators.

(a)

(b)

Figure DP11.1. Turntable control.

DP11.2. Digital audio tape (DAT) stores 1.3 gigabytes of data in a package the size of a credit card—roughly nine more times than half-inch-wide reel-to-reel tape or quarter-inch-wide cartridge tape. A DAT sells for a few dollars—about the same as a floppy disk even though it can store 1000 times more data. A DAT can record for two hours (longer than either reel-to-reel or cartridge tape), which means that it can run longer unattended and requires fewer tape changes and hence fewer interruptions of data transfer. DAT gives access to a given data file within 20 sec, on the average, compared with a few to several minutes for either cartridge or reel-to-reel tape [17].

The tape drive electronically controls the relative speeds of the drum and tape so that the heads follow the tracks on the tape, as shown in Fig. DP11.2(a). The control system is much more complex than that for a CD ROM because more motors have to be accurately controlled: capstan, take-up and supply reels, drum, and tension control.

Let us consider the speed control system shown in Fig. DP11.2(b). The motor and load transfer function varies because the tape moves from one reel to the other. The transfer function is

$$G(s) = \frac{K_m}{(s + p_1)(s + p_2)},$$

where the nominal values are $K_m = 4$, $p_1 = 1$, and $p_2 = 4$. However, the range of variation is: $3 \le K_m \le 5$; $0.5 \le p_1 \le 1.5$; $3.5 \le p_2 \le 4.5$. The system must respond rapidly with an overshoot to a step of less than 13% and a settling time of less than 0.5 sec. The system

requires a fast peak time so the overdamped condition is not allowed. Determine a PID controller that results in an acceptable response over the range of parameter variation. The gain K_mK_3 cannot exceed 20 when the nominal $K_m = 4$ and K_3 is defined in Eq. (11.32).

(a)

(b)

Figure DP11.2. Control of a DAT player.

DP11.3. The Gamma-Ray Imaging Device (GRID) is a NASA experiment to be flown on a long-duration, high-altitude balloon during the coming solar maximum. The GRID on a balloon is an instrument that will qualitatively improve hard X-ray imaging and carry out the first gamma-ray imaging for the study of solar high-energy phenomena in the next phase of peak solar activity. From its long-duration balloon platform, GRID will observe numerous hard X-ray bursts, coronal hard X-ray sources, "superhot" thermal events, and microflares [19]. Parts (a) and (b) of Fig. DP11.3 depict the system elements. The major components of the GRID experiment consist of a 5.2-meter canister and mounting gondola, a high-altitude balloon, and a cable connecting the gondola and balloon. The instrument-sun pointing requirements of the experiment are 0.1 degrees pointing accuracy and 0.2 arc second per 4 ms pointing stability.

An optical sun sensor provides a measure of the sun-instrument angle and is modeled as a first-order system with a dc gain and a pole at $s = -500$. A torque motor actuates the

canister/gondola assembly. The azimuth angle control system is shown in Fig. DP11.3(c).
(a) The PID controller is selected by the design team so that

$$G_c(s) = \frac{K_3(s^2 + as + b)}{s},$$

where $a = 6$, and b is to be selected. A prefilter is used as shown in Fig. DP11.3(c). Deter-
mine the value of K_3 and b so that the dominant roots have a ζ of 0.8 and the overshoot
to a step input is less than 3%. Determine the actual step response percent overshoot, t_p,
and T_s. (b) Design a PID filter using the ITAE performance criteria when $\omega_n = 8$. Compare
the actual results with those obtained in part (a).

Figure DP11.3. The GRID device.

DP11.4. Many university and government laboratories have constructed robot hands
capable of grasping and manipulating objects. But teaching the artificial devices to perform
even simple tasks required formidable computer programming. Now, however, the Dex-
terous Hand Master (DAM) can be worn over a human hand to record the side-to-side and
bending motions of finger joints. Each joint is fitted with a sensor that changes its signal
depending on position. The signals from all the sensors are translated into computer data
and used to operate robot hands.

The DAM is shown in parts (a) and (b) of Fig. DP11.4. The joint angle control system is shown in part (c). The normal value of K_m is 1.0. The goal is to design a PID controller so that the steady-state error for a ramp input is zero. Also, the settling time must be less than 3 sec for the ramp input. It is desired that the controller is

$$G_c(s) = \frac{K_3(s^2 + 6s + 18)}{s}.$$

(a) Select K_3 and obtain the ramp response. Plot the root locus as K_3 varies. (b) If K_m changes to one-half of its normal value, and $G_c(s)$ remains as designed in part (a), obtain the ramp response of the system. Compare the results of parts (a) and (b) and discuss the robustness of the system.

Figure DP11.4. Dexterous Hand Master.

DP11.5. Objects smaller than the wavelengths of visible light are a staple of contemporary science and technology. Biologists study single molecules of protein or DNA; materials scientists examine atomic-scale flaws in cyrstals; microelectronics engineers lay out circuit patterns only a few tens of atoms thick. Until recently, this minute world could be seen only by cumbersome, often destructive methods such as electron microscopy and X-ray diffraction. It lay beyond the reach of any instrument as simple and direct as the familiar light microscope. New microscopes, typified by the scanning tunneling microscope (STM), are now available [10].

The precision of position control required is in the order of nanometers. The STM relies on piezoelectric sensors that change size when an electric voltage across the material is changed. The "aperture" in the STM is a tiny tungsten probe, its tip ground so fine that it may consist of only a single atom and measure just 0.2 nanometer in width. Piezoelectric controls maneuver the tip to within a nanometer or two of the surface of a conducting specimen—so close that the electron clouds of the atom at the probe tip and of the nearest atom of the specimen overlap. A feedback mechanism senses the variations in tunneling current and varies the voltage applied to a third, z, control. The z-axis piezoelectric moves the probe vertically to stabilize the current and to maintain a constant gap between the microscope's tip and the surface. The control system is shown in Fig. DP11.5(a), and the block diagram is shown in Fig. DP11.5(b). The process is

$$G(s) = \frac{17,640}{s(s^2 + 59.4s + 1764)}$$

and the controller is chosen to have two real, unequal zeros so that (Eq. 11.35) we have:

$$G_c(s) = \frac{K_2(\tau_1 s + 1)(\tau_2 s + 1)}{s}.$$

(a)

(b)

Figure DP11.5. Microscope control.

(a) Use the ITAE design method to determine $G_c(s)$. (b) Determine the step response of the system with and without a prefilter $G_p(s)$. (c) Determine the response of the system to a disturbance when $D(s) = 1/s$. (d) Using the prefilter and $G_c(s)$ of parts (a) and (b), determine the actual response when the process changes to

$$G(s) = \frac{16,000}{s(s^2 + 40s + 1600)}.$$

DP11.6. The system described in DP11.5 is to be designed using the frequency response techniques described in Section 11.6 with

$$G_c(s) = \frac{K_2(\tau_1 s + 1)(\tau_2 s + 1)}{s}.$$

Select the coefficients of $G_c(s)$ so that the phase margin is approximately 70°. Obtain the step response of the system with and without a prefilter, $G_p(s)$.

Terms and Concepts

Digital computer compensator A system that uses a digital computer as the compensator element.

Digital control system A control system that uses digital signals and a digital computer to control a process.

PID controller A controller with three terms in which the output of the controller is the sum of a proportional term, an integrating term, and a differentiating term, with an adjustable gain for each term.

Prefilter A transfer function, $G_p(s)$, that filters the input signal $R(s)$ prior to the calculation of the error signal.

Robot A programmable computer integrated with a manipulator; a reprogrammable, multifunctional manipulator used for a variety of tasks.

Robust control A system that exhibits the desired performance in the presence of significant plant uncertainty.

Sampling period The period when all the numbers leave or enter the computer; the period during which the sampled variable is held constant.

Three-term controller See PID controller.

References

1. R. C. Dorf, *Encyclopedia of Robotics,* John Wiley & Sons, New York, 1988.
2. G. Franklin, *Digital Control Systems,* 2nd ed., Addison-Wesley, Reading, Mass., 1991.
3. J. G. Bollinger and N. A. Duffie, *Computer Control of Machines and Processes,* Addison-Wesley, Reading, Mass., 1988.
4. P. Dorato, *Robust Control,* IEEE Press, New York, 1987.
5. B. Barmish, "The Robust Root Locus," *Automatica,* vol. 26, no. 2, 1990; pp. 283–92.
6. M. Morari, *Robust Process Control,* Prentice Hall, Englewood Cliffs, N.J., 1991.

7. P. Dorato, "Case Studies in Robust Control Design," *IEEE Proceed. of the Decision and Control Conference,* December 1990; pp. 2030–31.

8. P. Dorato, *Recent Advances in Robust Control,* IEEE Press, New York, 1990.

9. K. Lorell, "Control Technology Test Bed for Large Segmented Reflectors," *IEEE Control Systems,* October 1989; pp. 13–20.

10. H. K. Wickramasinghe, "Scanned-Probe Microscopes," *Scientific American,* October 1989; pp. 98–106.

11. K. Chew, "Digital Control of Errors in Disk Drive Systems," *IEEE Control Systems,* January 1990; pp. 16–19.

12. "The Flying Train Takes Off," *U.S. News and World Report,* July 23, 1990; pp. 52–53.

13. M. Ruth, "Robust Control of an Undersea Vehicle," *Proceed. of the American Automatic Control Conference,* June 1990; pp. 2374–79.

14. T. Yoshikawa, *Foundations of Robotics,* M.I.T. Press, Cambridge, Mass., 1990.

15. M. Mavrovouniotis, *Artificial Intelligence in Process Engineering,* Academic Press, New York, 1990.

16. K. Wright, "The Shape of Things to Go," *Scientific American,* May 1990; pp. 92–101.

17. E. Tan, "Digital Audio Tape for Data Storage," *IEEE Spectrum,* October 1989; pp. 34–38.

18. C. T. Chen, "The Inward Approach in the Design of Control Systems," *IEEE Trans. on Automatic Control,* August 1990; pp. 270–78.

19. J. Walls, "Active Control of the Gamma Ray Imaging Device Experiment," *Proceed. of the American Automatic Control Conference,* 1990; pp. 1082–83.

20. J. Slotine, *Applied Nonlinear Control,* Prentice Hall, Englewood Cliffs, N.J., 1991.

21. S. Boyd, "Linear Controller Design," *Proceed. of the IEEE,* March 1990; pp. 529–72.

22. M. Rimer, "Solutions of the Second Benchmark Control Problem," *IEEE Control Systems,* August 1990; pp. 33–39.

23. K. Capek, *Rossum's Universal Robots;* English edition by P. Selver and N. Playfair, Doubleday, Page, New York, 1923.

24. L. L. Cone, "Skycam: An Aerial Robotic Camera System," *Byte,* October 1985; pp. 122–28.

25. J. Umland, "Magnitude and Symmetric Optimum Criterion for the Design of Linear Control Systems," *IEEE Trans. on Industry Applications,* June 1990; pp. 489–97.

26. P. J. Gawthrop and P. Nomikos, "Automatic Tuning of Commercial PID Controllers," *IEEE Control Systems,* January 1990; pp. 34–41.

27. T. S. Ng, "An Expert System for Shape Diagnosis in a Plate Mill," *IEEE Transactions on Industry Applications,* December 1990; pp. 1057–64.

Design Case Studies

Preview

Engineering design is the central task of the engineer. The design of control systems for practical applications requires the creative configuration and specification of the system and its performance. The control engineer attempts to achieve the best performance available and may be required to reconfigure the system in order to attain the best performance.

 In this chapter we use the methods of the preceding chapters to achieve the design of control systems for actual systems. These case studies will illustrate the complexity and challenge of control-system design.

12.1 Engineering Design

Engineering design is the central task of the engineer. *Design is the process of conceiving or inventing the forms, parts, and details of a system to achieve a reasoned purpose.* It is a complex process in which both creativity and analysis play a central role.

Design activity can be thought of as planning for the emergence of a particular product or system. Design is a structured, innovative act whereby the engineer creatively uses knowledge and materials to specify the shape, function, and material content of a system. The design steps are (1) to determine a need arising from the values of various groups, covering the spectrum from public policy makers to the consumer; (2) to specify in detail what the solution to that need must be and to embody these values; (3) to develop and evaluate various alternative solutions to meet these specifications; and (4) to decide which one is to be designed in detail and fabricated.

Of course, the design process is not a linear, step-by-step activity, but rather an iterative, reactive process. It includes several test points and continuous examination of intermediate results. Another factor in realistic design is the limitation of time. Design takes place under imposed schedules, and we eventually settle for a design which may be less than ideal but considered "good enough."

A major challenge for the designer is to write the specifications for the technical product. *Specifications* are statements that explicitly state what the device or product is to be and do. The design of technical systems aims to achieve appropriate design specifications and rests on four characteristics: (1) complexity, (2) tradeoffs, (3) gaps, and (4) risk.

Complexity of design results from the wide range of tools, issues, and knowledge to be used in the process. The large number of factors to be considered illustrates the complexity of the design specification activity, not only in assigning these factors their relative importance in a particular design, but also in giving them substance either in numerical or written form, or both.

The concept of *tradeoff* involves the need to make a judgment about how much of a compromise is made between two conflicting criteria, both of which are desirable. The design process requires an efficient compromise between desirable but conflicting criteria.

In making a technical device there is frequently a design *gap* or void to the extent that the final product does not appear the same as it had been visualized. For example, our image of the problem we're solving is not what appears in written description and ultimately in the specifications. Such gaps are intrinsic in the progression from an abstract idea to its realization.

This inability to make absolutely sure predictions of the performance of a technological object leads to major uncertainties about the actual effects of the designed devices and products. These uncertainties are embodied in the idea of unintended consequences or *risk*. The result is that designing a system is a risk-taking activity.

Complexity, tradeoff, gaps, and risk are inherent in designing new systems

and devices. While they can be minimized by considering all the effects of a given design, they are always present in the design process.

Within engineering design, there is a fundamental difference between the two major types of thinking that must take place: engineering analysis and synthesis. Attention is focused on models of the physical systems that are analyzed to provide insight and that point in directions for improvement. On the other hand, *synthesis* is the process by which these new physical configurations are created.

Design is an iterative process that may proceed in many directions before the desired one is found. It is a deliberate process by which a designer creates something new in response to a recognized need while recognizing realistic constraints.

The main approach to the most effective engineering design is parameter analysis and optimization. Parameter analysis is based on (1) identification of the key parameters; (2) generation of the system configuration; and (3) evaluation of how well the configuration meets the needs. These three steps form an iterative loop. Once the key parameters are identified and the configuration synthesized, the designer can optimize the parameters. Typically, the designer strives to identify a limited set of parameters—hopefully less than five—to be adjusted.

12.2 Control-System Design

The design of control systems is a specific example of engineering design. Again, the goal of control engineering design is to obtain the configuration, specifications, and identification of the key parameters of a proposed system to meet an actual need.

The first step in the design process consists of identifying the variables that we desire to control. For example, we may state that the goal is to accurately control the velocity of a motor. The second step is to write the specifications in terms of the accuracy we must attain. This required accuracy of control will then lead to the identification of a sensor to measure the controlled variable.

The designer then proceeds to the first attempt to configure a system that will result in the desired control performance. This system configuration will normally consist of a sensor, the process under control, an actuator, and a controller, as shown in Fig. 12.1. The next step consists of identifying a candidate for the

Figure 12.1. The control system configuration.

actuator. This will, of course, depend on the process, but the actuation chosen must be capable of effectively adjusting the performance of the process. For example, if we wish to control the speed of a rotating flywheel, we will select a motor as the actuator. The sensor, in this case, will need to be capable of accurately measuring the speed.

The next step is the selection of a controller, which will often consist of a summing amplifier that will compare the desired response and the actual response and then forward this error-measurement signal to a compensator.

The final step in the design process is the adjustment of the parameters of the system in order to achieve the desired performance. If we can achieve the desired performance by adjusting the parameters, we will finalize the design and proceed to document the results. If not, we will need to establish an improved system configuration and perhaps select an enhanced actuator and sensor. Then we will repeat the design steps until we are able to meet the specifications, or until we decide the specifications are too demanding and should be relaxed. The control system design process is summarized in Fig. 12.2.

Figure 12.2. The control system design process.

The performance specifications will describe how the closed-loop system should perform and will include (1) good regulation against disturbances; (2) desirable responses to commands; (3) realistic actuator signals; (4) low sensitivities; and (5) robustness.

The controller design problem is as follows: Given a model of the system to be controlled (including its sensors and actuators) and a set of design goals, find a suitable controller, or determine that none exists.

12.3 The Design of an *X-Y* Plotter

Many physical phenomena are characterized by parameters that are transient or slowly varying. If these changes can be recorded, they can be examined at leisure and stored for future reference or comparison. To accomplish this recording, a number of electro-mechanical instruments have been developed, among them the *X-Y* recorder. In this instrument, the displacement along the *X*-axis represents a variable of interest or time, and the displacement along the *Y*-axis varies as a function of yet another variable [10].

Such recorders can be found in many laboratories recording experimental data such as changes in temperature, variations in transducer output levels, and stress versus applied strain, to name just a few. The HP 7090 plotting system is shown in Fig. 12.3.

The purpose of a plotter is to accurately follow the input signal as it varies. We will consider the design of the movement of one axis, since the movement

Figure 12.3. The HP 7090A Measurement Plotting System©. Copyright 1986, Hewlett-Packard Co. Reproduced with permission.

dynamics of both axes are identical. Thus we will strive to control very accurately the position and the movement of the pen as it follows the input signal.

In order to achieve accurate results, our goal is to achieve (1) a step response with an overshoot of less than 5% and a settling time less than 0.5 second, and (2) a percentage steady-state error for a step equal to zero. If we achieve these specifications, we will have a fast and accurate response.

Since we wish to move the pen, we select a dc motor as the actuator. The feedback sensor will be a 500-line optical encoder. By detecting all state changes of the two-channel quadrature output of the encoder, 2000 encoder counts per revolution of the motor shaft can be detected. This yields an encoder resolution of 0.001 inch at the pen tip. The encoder is mounted on the shaft of the motor. Since the encoder provides digital data, it is compared with the input signal by using a microprocessor. Next, we propose to use the difference signal calculated by the microprocessor as the error signal, and then use the microprocessor to calculate the necessary algorithm to obtain the designed compensator. The output of the compensator is then converted to an analog signal that will drive the motor.

The model of the feedback position-control system is shown in Fig. 12.4. Since the microprocessor calculation speed is very fast compared to the rate of change of the encoder and input signals, we assume that the continuous signal model is very accurate.

The model for the motor and pen carriage is

$$G(s) = \frac{1}{s(s + 10)(s + 1000)},$$
(12.1)

and our initial attempt at a specification of a compensator is to use a simple gain so that

$$G_c(s) = K.$$

In this case we have only one parameter to adjust—that is, K. In order to achieve a fast response, we have to adjust K so that it will provide two dominant s-plane roots with a damping ratio of 0.707, which will result in a step response

Figure 12.4. Model of the pen-plotter control system.

Figure 12.5. Root locus for the pen plotter, showing the roots with a damping ratio of $1\sqrt{2}$. The dominant roots are $s = -4.9 \pm j4.9$.

overshoot of about 4.5 percent. A sketch of the root locus (note the break in the real axis) is shown in Fig. 12.5.

Adjusting the gain to $K = 47,200$, we obtain a system with an overshoot of 3.6% to a step input and a settling time of 0.8 second. Since the transfer function has a pole at the origin, we have a steady-state error of zero for a step input.

This system does not meet our specifications, so we select a compensator that will reduce the settling time. Let us select a lead compensator so that

$$G_c(s) = \frac{K\alpha(s + z)}{(s + p)}, \tag{12.2}$$

where $p = \alpha z$. Let us use the method of Section 10.5, which selects the phase-lead compensator on the s-plane. Therefore we place the zero at $s = -20$ and determine the location of the pole, p, that will place the dominant roots on the line that has the damping ratio of $1\sqrt{2}$. Thus we find that $p = 60$ and that $\alpha = 3$, so that

$$G(s)G_c(s) = \frac{142,600(s + 20)}{s(s + 10)(s + 60)(s + 1000)}. \tag{12.3}$$

Obtaining the actual step response, we determined that the percent overshoot was 2% and that the settling time was 0.35 seconds, which meet the specifications.

The third design approach is to recognize that the encoder can be used to

Table 12.1. Results for Three Designs

	Step Response	
System	Percent Overshoot	Settling Time (milliseconds)
Gain adjustment	3.6	800
Gain and lead compensator adjustment	2.0	350
Gain adjustment plus velocity signal multiplied by gain K_2	4.3	8

generate a velocity signal by counting the rate at which encoder lines pass by a point. Thus we can use the microprocessor. Since the position signal and the velocity signal are available, we may describe the compensator as

$$G_c(s) = K_1 + K_2 s, \qquad (12.4)$$

where K_1 is the gain for the error signal and K_2 is the gain for the velocity signal. Then we may write

$$G(s)G_c(s) = \frac{K_2(s + K_1/K_2)}{s(s + 10)(s + 1000)}.$$

If we set $K_1/K_2 = 10$, we cancel the pole at $s = -10$ and obtain

$$G(s)G_c(s) = \frac{K_2}{s(s + 1000)}.$$

The characteristic equation for this system is

$$s^2 + 1000s + K_2 = 0, \qquad (12.5)$$

and we desire that ζ is $1/\sqrt{2}$. Noting that $2\zeta\omega_n = 1000$, we have $\omega_n = 707$ and $K_2 = \omega_n^2$. Therefore we obtain $K_2 = 5 \times 10^5$ and the compensated system is

$$G_c G(s) = \frac{5 \times 10^5}{s(s + 1000)}. \qquad (12.6)$$

The response of this system will provide an overshoot of 4.3% and a settling time of 8 milliseconds.

The results for the three approaches to system design are compared in Table 12.1. Clearly, the best design uses the velocity feedback, and this is the actual design adopted for the HP 7090A.

12.4 The Design of a Space Telescope Control System

Scientists have proposed the operation of a space vehicle as a space-based research laboratory and test bed for equipment to be used on a manned space station. The industrial space facility (ISF) would remain in space and the astro-

(a)

$$U(s)$$

Command signal
from earth station

$$\frac{1}{(s + 1)^2}$$

$$C(s)$$

Telescope
angle

(b)

Figure 12.6. (a) The industrial space facility and the space shuttle shown in docking position. Courtesy of Space Industries, Inc. (b) The model of a low-power actuator and telescope.

nauts would be able to use it only when the shuttle is attached, as shown in Fig. 12.6(a) [14]. The ISF will be the first permanent, human-operated commercial space facility designed for R & D, testing, and, eventually, processing in the space environment.

We will consider an experiment operated in space but controlled from earth. The goal is to manipulate and position a small telescope to accurately point at a planet. The goal is to have a steady-state error equal to zero, while maintaining a fast response to a step with an overshoot of less than 5%. The actuator chosen is a low-power actuator, and the model of the combined actuator and telescope is shown in Fig. 12.6(b). The command signal is received from an earth station with a delay of $\pi/16$ seconds. A sensor will measure the pointing direction of the telescope accurately. However, this measurement is relayed back to earth with a delay

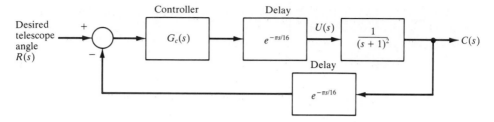

Figure 12.7. Feedback control system for the telescope experiment.

of $\pi/16$ seconds. Thus the total transfer function of the telescope, actuator, sensor, and round-trip delay (Fig. 12.7) is

$$G(s) = \frac{e^{-s\pi/8}}{(s + 1)^2}.$$ (12.7)

We propose a controller that is the three-term controller described in Section 10.6 and Section 11.5, where

$$
\begin{aligned}
G_c(s) &= K_1 + \frac{K_2}{s} + K_3 s \\
&= \frac{K_1 s + K_2 + K_3 s^2}{s}.
\end{aligned}
$$ (12.8)

Clearly, the use of only the proportional term will not be acceptable since we require a steady-state error of zero for a step input. Thus we must use a finite value of K_2 and thus we may elect to use either proportional plus integral control (PI) or proportional plus integral plus derivative control (PID).

We will first try PI control, so that

$$G_c(s) = K_1 + \frac{K_2}{s} = \frac{K_1 s + K_2}{s}.$$ (12.9)

Since we have a pure delay, e^{-sT}, we use the frequency response methods for the design process. Thus we will translate the overshoot specification to the frequency domain. If we have two dominant characteristic roots, the overshoot to a step is 5% when $\zeta = 0.7$ or the phase margin is about 70°.

If we choose $K_1 = 0.022$ and $K_2 = 0.22$, we have

$$G_c(s)G(s) = \frac{0.22(0.1s + 1)e^{-s\pi/8}}{s(s + 1)^2}$$ (12.10)

and the Bode diagram is shown in Fig. 12.8. The location of the zero at $s = 10$ was chosen to add a phase lead angle so that the desired phase margin is attained. An iterative procedure of using the Control System Design Program (CSDP) or equivalent yields a series of trials for K_1 and K_2 until the desired phase margin is achieved. Note that we have achieved a phase margin of about 63 degrees. The

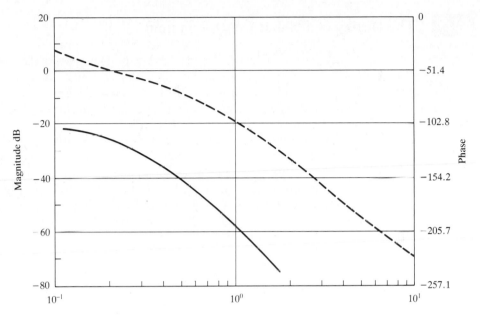

Figure 12.8. Bode diagram for the system with the PI controller.

actual step response was plotted using CSDP, and it is determined that the over-shoot was 4.7% with a setting time of 16 seconds.

The proportional plus integral plus derivative controller is

$$G_c(s) = \frac{K_1s + K_2 + K_3s^2}{s}. \tag{12.11}$$

Now, we have three parameters to vary in order to achieve the desired phase margin. If we select, after some iteration, $K_1 = 0.8$, $K_2 = 0.5$, and $K_3 = 10^{-3}$, we obtain a phase margin of 64 degrees. The percentage overshoot is 3.7% and the setting time is 5.8 seconds. Perhaps the easiest way to select the gain constants is to initially let K_3 be a small, but nonzero, number and $K_1 = K_2 = 0$. Then plot the frequency response using CSDP. In this case, we choose $K_3 = 10^{-3}$ and obtain a Bode plot. We then use $K_1 \approx K_2$ and iterate to obtain the appropriate values of these unspecified gains.

The performance of the PI and the PID compensated systems is recorded in Table 12.2. Clearly, the PID controller is the most desirable.

Table 12.2. Step Response of the Space Telescope for Two Controllers

	Steady-State Error	Percent Overshoot	Settling Time (seconds)
PI controller	0	4.7	16.0
PID controller	0	3.7	5.8

12.5 The Design of a Robot Control System

The concept of robot replication is relatively easy to grasp. The central idea is that robots replicate themselves and develop a factory that automatically produces robots. An example of a robot replication facility is shown in Fig. 12.9. In order to achieve the rapid and accurate control of a robot, it is important to keep the robot arm stiff and yet lightweight.

The specifications for controlling the motion of a lightweight, flexible arm are (1) a settling time of less than two seconds; (2) a percent overshoot of less than 10% for a step input; and (3) a steady-state error of zero for a step input.

The block diagram of the proposed system with a controller is shown in Fig. 12.10. The configuration proposes the use of velocity feedback as well as the use of a controller $G_c(s)$. Since the robot is quite light and flexible, the transfer function of the arm is

$$\frac{C(s)}{U(s)} = \left(\frac{1}{s^2}\right) G(s)$$

and

$$G(s) = \frac{(s^2 + 4s + 10{,}004)(s^2 + 12s + 90{,}036)}{(s + 10)(s^2 + 2s + 2501)(s^2 + 6s + 22{,}509)}. \tag{12.12}$$

Therefore the complex zeros are located at

$$s = -2 \pm j100$$

and

$$s = -6 \pm j300.$$

Figure 12.9. A robot replication facility.

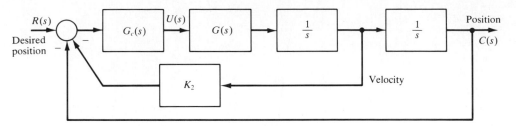

Figure 12.10. Proposed configuration for control of the lightweight robot arm.

The complex poles are located at

$$s = -1 \pm j50$$

and

$$s = -3 \pm j150.$$

A sketch of the root locus when $K_2 = 0$ and the controller is an adjustable gain, K_1, is shown in Fig. 12.11. Clearly, the system is unstable since two roots of the characteristic equation appear in the right-hand s-plane for $K_1 > 0$.

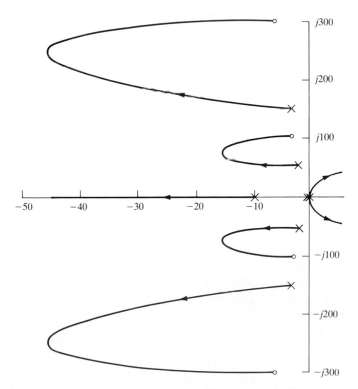

Figure 12.11. Root locus of the system if $K_2 = 0$ and K_1 is varied from $K_1 = 0$ to $K_1 = \infty$.

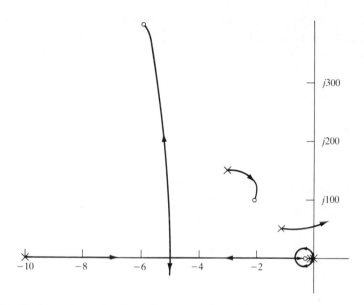

Figure 12.12. Root locus for the robot controller with a zero inserted at $s = -0.2$.

It is clear that we need to introduce the use of velocity feedback by setting K_2 to a positive magnitude. Then we have $H(s) = (1 + K_2 s)$ and therefore the loop transfer function is

$$\left(\frac{1}{s^2}\right) G(s)H(s) = \frac{K_1 K_2 \left(s + \dfrac{1}{K_2}\right)(s^2 + 4s + 10{,}004)(s^2 + 12s + 90{,}036)}{s^2(s + 10)(s^2 + 2s + 2501)(s^2 + 6s + 22{,}509)}$$

where K_1 is the gain of $G_c(s)$. We now have available two parameters, K_1 and K_2, that we may adjust. We select $5 < K_2 < 10$ in order to place the adjustable zero near the origin.

When $K_2 = 5$ and K_1 is varied, we obtain the root locus sketched in Fig. 12.12. When $K_1 = 0.8$ and $K_2 = 5$, we obtain a step response with a percent overshoot of 12% and a settling time of 1.8 seconds. This is the optimum achievable response. If one tries $K_2 = 7$ or $K_2 = 4$, the overshoot will be larger than desired. Therefore we have achieved the best performance with this system. If we desired to continue the design process, we would use a lead network for $G_c(s)$ in addition to retaining the velocity feedback with $K_2 = 5$.

One possible selection of a lead network is

$$G_c(s) = \frac{K_1(s + z)}{(s + p)}. \tag{12.13}$$

If one selects $z = 1$ and $p = 5$, then when $K_1 = 5$ we obtain a step response with an overshoot of 8% and a settling time of 1.6 seconds.

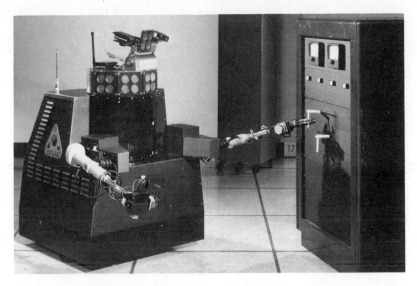

Figure 12.13. Hermies II, an upgraded version of an 18-degree-of-freedom robot developed at the Center for Engineering Systems Advanced Research (Oak Ridge National Laboratory). Both robotic manipulators are now operational and the unit has a phased array of 20 Polaroid transceivers for position and object sensing. (Courtesy of Oak Ridge National Laboratory, Oak Ridge, Tennessee.)

12.6 The Design of a Mobile Robot Control System

An 18-degree-of-freedom mobile robot is shown in Fig. 12.13. The objective is to accurately control the position of one of the wheels of the robot. Each wheel control will be identical. The goal is to obtain a fast response with a rapid rise time and settling time to a step command while not exceeding an overshoot of 5%.

The specifications are then (1) a percent overshoot equal to 5%; (2) minimum settling time and rise time. Rise time is defined as the time to reach the magnitude of the command and is illustrated in Fig. 4.7 by T_R.

In order to configure the system, we choose a power amplifier and motor so that the system is described by Fig. 12.14. Then, obtaining the transfer function of the motor and power amplifier, we have

$$G(s) = \frac{1}{s(s + 10)(s + 20)}.$$ (12.14)

First we select the controller as a simple gain, K, in order to determine the response that can be achieved without a compensator. Plotting the root locus, we find that when $K = 700$ the dominant complex roots have a damping ratio of 0.707 and we expect a 5% overshoot. Then using the Control System Design Program, we find that the overshoot is 5%, the rise time is 0.48 seconds, and the settling time is 1.12 seconds. These values are recorded as item 1 in Table 12.3.

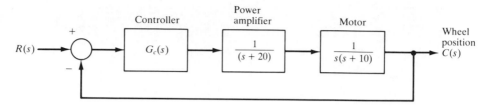

Figure 12.14. Model of the wheel control for a mobile robot.

The next step is to introduce a lead compensator, so that

$$G_c(s) = \frac{K(s + z)}{(s + p)}. \qquad (12.15)$$

We will select the zero at $s = -11$ so that the complex roots near the origin dominate. Then using the method of Section 10.5, we find that we require the pole at $s = -62$. Evaluating the gain at the roots shown in Fig. 12.15, we find that $K = 8000$. Then the step response has a rise time of 0.25 seconds and a settling time of 0.60 seconds. This is an improved response and we could finalize this system as acceptable.

However, if we wish to try to speed up the response, we could select a compensator with two lead elements as follows:

$$G_c(s) = \frac{K(s + z)^2}{(s + p)^2}.$$

Again placing the zero at $s = -11$, we find that two poles will be required at $s = -24$, so that

$$G_c(s) = \frac{K(s + 11)^2}{(s + 24)^2} \qquad (12.16)$$

and $K = 8200$ in order to obtain dominant roots with a ζ of 0.707. The sketch of the root locus is shown in Fig. 12.16. The dominant complex roots have a ζ of 0.707 when $K = 8200$. The overshoot is 5.1%, rise time is 0.20 seconds, and the settling time is 0.38 seconds as recorded as item 3 in Table 12.3. The double lead compensator gives the fastest response, and we will choose this compensator for the final system.

Table 12.3. Performance for Three Controllers

Compensator $G_c(s)$	K	Percent Overshoot	Settling Time (seconds)	Rise Time (seconds)
1. K	700	5.0	1.12	0.40
2. $K(s + 11)/(s + 62)$	8000	5.0	0.60	0.25
3. $K(s + 11)^2/(s + 24)^2$	8200	5.1	0.38	0.20

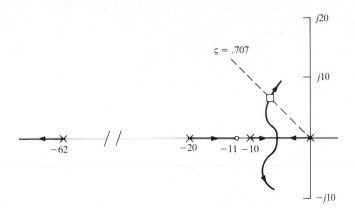

Figure 12.15. Root locus for a lead compensator $G_c(s)$.

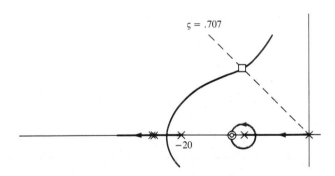

Figure 12.16. Root locus for two lead compensators.

12.7 The Design of an ROV Control System

The design of a remotely operated vehicle (ROV) for undersea exploration as shown in Fig. 12.17 requires the control of the heading (direction) of the vehicle. The system will use an electric motor and propeller to drive the ROV, and an electrically controlled rudder will provide the steering.

The configuration for the control system is shown in Fig. 12.18. Our goal is to obtain a rapid response to a step command with 25% overshoot or less and a steady-state error of less than 3.33% for a ramp command.

Therefore we desire a velocity constant, K_v, for the ramp command of

$$K_v = \frac{1}{0.0333} = 30.$$

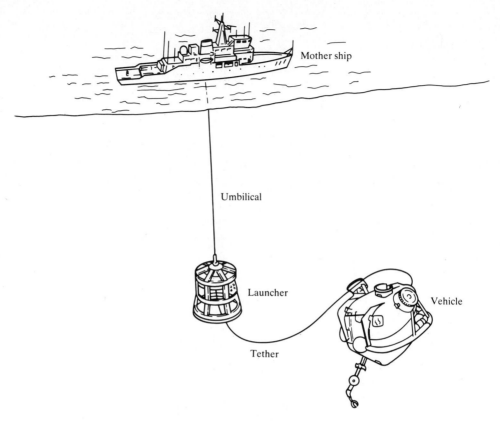

Figure 12.17. A remotely operated vehicle (ROV) for undersea exploration.

If we select a compensator as a simple gain K, we have

$$K_v = \lim_{s \to 0} s\{G_c(s)G(s)\}$$

$$= \lim_{s \to 0} s \left\{ \frac{K}{s(s + 5)^2} \right\}$$

$$= \frac{K}{25}.$$

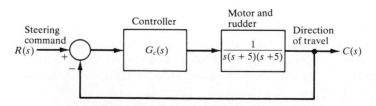

Figure 12.18. Steering control system for the ROV.

This would require $K = 750$ in order to achieve the desired K_v of 30. However, using the Routh criteria with the characteristic equation, it may be shown that the system has two roots on the imaginary axis when $K = 250$. Therefore we cannot attain the desired K_v with a simple gain K.

Let us try to design a lag network compensator so that we may achieve the desired K_v and the desired step response. Therefore we propose that

$$G_c(s) = \frac{K(s + z)}{(s + p)},$$
(12.17)

where $z > p$. The specification for the overshoot of 25% or less will lead us to select a damping ratio for the complex roots of 0.45 (see Fig. 4.8). We expect the real root introduced by the compensator to provide some damping to the system, and we allow for that by selecting $\zeta = 0.45$ for the complex roots. We will use the root locus method of Section 10.7 to obtain the desired lag compensator. Later in this section we also use the frequency response method of Section 10.8 to obtain the desired compensator.

First we draw the root locus of the uncompensated system and determine that $K = 53.5$ when the complex roots have $\zeta = 0.45$. Since K_v is desired as 30, we have the actual K_v as

$$K_{v\text{uncomp.}} = \frac{53.5}{25} = 2.14.$$

Therefore

$$\alpha = \left| \frac{z}{p} \right| = \frac{K_{v\text{comp.}}}{K_{v\text{uncomp.}}} = \frac{30}{2.14} = 14.0.$$

We will use $\alpha = 14.5$ to allow for some margin of error. Then we choose $z = 0.10$ and therefore

$$p = \frac{z}{\alpha} = \frac{0.1}{14.5} = 0.0069.$$

Thus the compensated system is

$$G_c(s)G(s) = \frac{53.5(s + 0.1)}{s(s + 5)^2(s + 0.0069)}.$$
(12.18)

Using the Control System Design Program, we obtain the step response and determine that the percent overshoot is 25%, the rise time is 1.2 seconds, and the settling time is 7 seconds. The results are summarized as item 2 in Table 12.4.

Now let us use the frequency response method of design for the lag compensator discussed in Section 10.8. We will use the Bode diagram and attempt to obtain a phase margin of about 60 degrees, which should result in a step response with an overshoot of 25%. First we plot the Bode diagram with

$$G_c G(s) = \frac{K_v}{s(0.2s + 1)^2},$$
(12.19)

Table 12.4. Performance Results

Compensator, $G_c(s)$	Percent Overshoot	Rise Time (seconds)	Settling Time (seconds)	K_v
1. $G_c = 53.5$	0	—	90	2.14
2. $G_c(s) = \dfrac{53.5(s + 0.1)}{(s + 0.0069)}$	25	1.2	7.0	30
3. $G_c(s) = \dfrac{30(3s + 1)}{(170s + 1)}$	25	2.0	12.0	30

where $K_v = 30$. Then we find that the system has a phase margin of $-15°$, as shown in Fig. 12.19. We examine the diagram and determine that the frequency where the phase is $-130°$ is $\omega_c' = 3.3$. This is the new desired crossover frequency. Then set the zero at $\omega_z = \omega_c'/10 = 0.33$. Measuring the attenuation required at ω_z, we find that 35 db attenuation is necessary. Then

$$20 \log \alpha = 35$$

and therefore $\alpha = 56.2$. Using this α, we have

$$\omega_p = \frac{\omega_z}{\alpha} = \frac{0.33}{56.2} = 0.0059.$$

Figure 12.19. Bode diagram to determine lag compensator.

The compensated system is then

$$G_c(s)G(s) = \frac{30(3s + 1)}{s(0.2s + 1)^2(170s + 1)}. \tag{12.20}$$

Using CSDP to obtain the step response, we have an overshoot of 25% and a settling time of 12 seconds. The results are summarized as item 3 in Table 12.4.

It is clear that a lag network compensator will provide the desired K_v for the system as well as a reasonable step response. The design using the root locus procedure resulting in item 2 of Table 12.4 will be selected since it provides a shorter rise time.

12.8 The Design of a Solar-Powered Racing Car Motor Control System

A group of 14 cars completed the race of solar-powered cars in Australia in 1987. The *Sunraycer,* shown in Fig. 12.20, won the 1867-mile Pentax World Solar Challenge race [18]. Powered by 9500 solar cells, the electric auto completed the race with an average speed of 41.6 miles per hour.

Let us consider the design of the ac motor drive for a solar-powered vehicle. A block diagram of the drive system is shown in Fig. 12.21, where the disturbance incorporates the effects of wind, component change, and road variations. The goal is to maintain low steady-state error and low overshoot for step changes in the input command, $R(s)$, while minimizing the effects of a step disturbance $D(s) = 1/s$.

We will attempt to maintain an overshoot of less than 10% when

$$G(s) = \frac{1}{(s + 1)^2}. \tag{12.21}$$

Figure 12.20. The *Sunraycer,* a solar-powered electric car.

Figure 12.21. Speed control system for a solar-powered electric car.

We will try to design a system by considering $G_c(s)$ as a gain, a lead network, a lag network, and a PID controller.

First, we let $G_c(s) = K$ and determine $K = 6.11$ when the maximum allowable overshoot is obtained. The results of the response to $R(s)$ and $D(s)$ are summarized in Table 12.5. This simple system has a significant steady-state error for a step command and the effect of the disturbance is significant.

The next approach is to design a lead network with

$$G_c(s) = \frac{s + z}{s + p}, \tag{12.22}$$

where α cannot exceed 20. We select

$$G_c(s) = \frac{391(s + 1.1)}{(s + 20)}$$

where the zero of $G_c(s)$ is placed to the left of the poles of $G(s)$. We achieve significant improvement in terms of the steady-state error and the effect of the disturbance, as summarized in Table 12.5.

If we design a lag network, we obtain

$$G_c(s) = \frac{5.4(s + 0.1)}{(s + 0.005)}. \tag{12.23}$$

Table 12.5. Design Results for Solar-Powered Auto

		Step Input, $R(s) = 1/s$			Step Disturbance $D(s) = 1/s$	
$G_c(s)$		Percent Over shoot (%)	Steady-State Error (%)	Settling Time (seconds)	$c(\infty)$ Steady-State $c(t)$ (%)	$c(t)$ maximum (%)
K	$K = 6.11$	10	14.1	4.1	14	18
Lead	$K = 391$	10	4.1	0.4	4.4	4.4
Lag	$K = 5.4$	10	1.3	19.5	0.9	19
PID	$K = 86$	10	0	0.2	0	0.06
PID with filter	$K = 15.5$	2	0	0.75	0	0.4

The lag network reduces the steady-state error and the steady-state effect of the disturbance, as summarized in Table 12.5. Unfortunately, the settling time and the maximum value of $c(t)$ due to the disturbance are both increased significantly above those achieved with the lead network design.

Now, let us try to achieve the design of a PID controller. We will use the ITAE optimum coefficients provided in Table 4.5 for a step input. Then, the controller is

$$G_c(s) = \frac{K_2(s^2 + as + b)}{s}, \tag{12.24}$$

where $a = K_1/K_2$ and $b = K_3/K_2$. We select $\omega_n = 10$ for the third-order optimum equation

$$s^3 + 1.75\omega_n s^2 + 2.15\omega_n^2 s + \omega_n^3.$$

The optimum coefficients are $K_1 = 214$, $K_2 = 15.5$, and $K_3 = 1000$. Therefore we have

$$G_c(s) = \frac{15.5(s^2 + 13.8s + 64.5)}{s}. \tag{12.25}$$

Without a prefilter $[G_p(s) = 1]$, this system gives an overshoot to a step of 30%. In order to reduce the overshoot to 10%, we increase the gain of $G_c(s)$ to 86 so that

$$G_c(s) = \frac{86(s^2 + 13.8s + 64.5)}{s}. \tag{12.26}$$

The effect of increasing the gain to 86 can be illustrated by Fig. 12.22. The steady-state error is then zero and the settling time is reduced 0.2 seconds. The effect of the disturbance is reduced to 0.06% of the magnitude of the disturbance, as recorded in Table 12.5.

An alternative is to utilize a prefilter $G_p(s)$, as shown in Fig. 12.21, with $G_c(s)$ as given in Eq. (12.25). Using the prefilter

$$G_p(s) = \frac{64.5}{(s^2 + 13.8s + 64.5)}, \tag{12.27}$$

we have the optimum closed-loop transfer function for the ITAE index as

$$T(s) = \frac{1000}{s^3 + 17.5s^2 + 215s + 1000}. \tag{12.28}$$

The overshoot is then 2%, and the maximum value of $c(t)$ for a unit step disturbance is 0.4%. The PID controller with a prefilter provides an excellent system response.

Figure 12.22. Root locus design for solar-powered racing car.

12.9 Summary

Engineering design is the central task of the engineer. The design of control systems incorporates obtaining the configuration, specifications, and identification of the key parameters of the proposed system to meet an actual need. Then the designer attempts to optimize the parameters to achieve the best system performance.

The designer of a control system needs to choose an actuator and a sensor

and to determine a linear model of these devices as well as the process under control. The next step is to select a controller and to optimize the parameters of the system. If a suitable performance cannot be achieved, the designer will need to reconfigure the system and perhaps select an improved actuator and sensor.

In this chapter we have illustrated the design process by examining a number of case studies. The creativity of the designer will be challenged by the complexity of the required design. The utility of a number of control schemes was illustrated by a series of case studies.

Design Problems ✦

DP12.1. Consider the device for the magnetic levitation of a steel ball, as shown in Fig. DP12.1(a) and (b). Obtain a design that will provide a stable response where the ball will remain within 10% of its desired position.

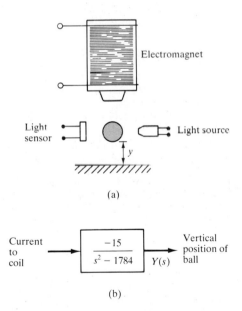

(a)

(b)

Figure DP12.1. (a) The levitation of a ball using an electromagnet. (b) The model of the electromagnet and the ball.

P12.2. A photovoltaic system is mounted on a space station in order to develop the power for the station. The photovoltaic panels should follow the sun with good accuracy in order to maximize the energy from the panels. The system uses a dc motor so that the transfer function of the panel mount and the motor is

$$G(s) = \frac{1}{s(s + 25)}.$$

We will select a controller $G_c(s)$ assuming that an optical sensor is available to accurately track the sun's position, and thus $H(s) = 1$.

The goal is to design $G_c(s)$ so that (1) the percent overshoot to a step is less than 7% and (2) the steady-state error to a ramp input should be less than or equal to 1%. Determine the best phase-lead controller.

DP12.3. The control of the fuel-to-air ratio in an automobile carburetor became of prime importance in the 1980s as automakers worked to reduce exhaust-pollution emissions. Thus auto engine designers turned to the feedback control of the fuel-to-air ratio. A sensor was placed in the exhaust stream and used as an input to a controller. The controller actually adjusts the orifice that controls the flow of fuel into the engine.

Select the devices and develop a linear model for the entire system. Assume that the sensor measures the actual fuel-to-air ratio with a delay. With this model, determine the optimum controller when a system is desired with a zero steady-state error to a step input and the overshoot for a step command is less than 10%.

DP12.4. High-performance tape transport systems are designed with a small capstan to pull the tape past the read/write heads and with take-up reels turned by dc motors. The tape is to be controlled at speeds up to 200 inches per second, with start-up as fast as possible, while preventing permanent distortion of the tape. Since we wish to control the speed and the tension of the tape, we will use a dc tachometer for the speed sensor and a potentiometer for the position sensor. We will use a dc motor for the actuator. Then the linear model for the system is a feedback system with $H(s) = 1$ and

$$\frac{C(s)}{E(s)} = G(s) = \frac{K(s + 4000)}{s(s + 1000)(s + 3000)(s + p_1)(s + p_1^*)},$$

where $p_1 = +2000 + j2000$ and $C(s)$ is position.

The specifications for the system are (1) settling time of less than 12 ms, (2) an overshoot to a step position command of less than 10%, and (3) a steady-state velocity error of less than .5%. Determine a compensator scheme to achieve these stringent specifications.

DP12.5. Electromagnetic suspension systems for aircushioned trains are known as magnetic levitation (maglev) trains. One maglev train uses a superconducting magnet system, as shown in Fig. DP12.5, on the next page [19]. It uses superconducting coils and the levitation distance $x(t)$ is inherently unstable. The model of the levitation is

$$\frac{X(s)}{V(s)} = \frac{K}{(s\tau_1 + 1)(s^2 - \omega_1^2)},$$

where $V(s)$ is the coil voltage; τ_1 is the magnet time constant; and ω_1 is the natural frequency. The system uses a position sensor with a negligible time constant. A train traveling at 300 km/h would have $\tau_1 = 1$ second and $\omega_1 = 100$ rad/s. Determine a controller that can maintain steady, accurate levitation when disturbances occur along the railway.

DP12.6. The four-wheel-steering automobile has several benefits. The system gives the driver a greater degree of control over the automobile. The driver gets a more forgiving vehicle over a wide variety of conditions. The system enables the driver to make sharp, smooth lane transitions. It also prevents yaw, which is the swaying of the rear end during sudden movements. Furthermore, the four-wheel-steering system gives a car increased maneuverability. This enables the driver to park the car in extremely tight quarters. Finally, with additional closed-loop computer operating systems, a car could be prevented from sliding out of control in abnormal icy or wet road conditions.

Figure DP12.5. Maglev train.

The system works by moving the rear wheels relative to the front-wheel-steering angle. The control system takes information about the front wheels' steering angle and passes it to the actuator in the back. This actuator then moves the rear wheels appropriately.

When the rear wheels are given a steering angle relative to the front ones, the vehicle can vary its lateral acceleration response according to the transfer function

$$G(s) = K \frac{1 + (1 + \lambda)T_1 s + (1 + \lambda)T_2 s^2}{1 + (2\zeta/\omega_n)s + (1/\omega_n^2)s^2},$$

where $\lambda = 2q/(1 - q)$ and q is the ratio of rear wheel angle to front wheel steering angle [17]. We will assume that $T_1 = T_2 = 1$ second and $\omega_n = 4$. Design a unity feedback system for $G(s)$, selecting an appropriate set of parameters (λ, K, ζ) so that the steering control response is rapid and yet will yield modest overshoot characteristics. In addition, q must be between 0 and 1.

DP12.7. A bridge played a leading role in the Broadway musical *Starlight Express* [12]. The biggest star of the show is an eight-ton automatically controlled bridge that hangs 90 feet above the stage and extends up to 60 feet across it. The bridge is under the control of a computer and is shown in Fig. DP12.7.

Starlight Express dramatizes a young boy's dream of racing railroad trains. Twenty-seven actors portray the trains by zooming around on roller skates. The skaters crisscross the stage by means of the bridge, which connects the sides of the three-tiered set. The bridge is in motion almost constantly throughout the show, operating like a gantry robot with six axes of motion. Its ascents and descents are controlled by hydraulics; 360-degree rotation, tilting, and extension are the work of dc drives. The entire bridge moves upstage and downstage on the tracks located just below the ceiling.

The movements of the bridge coincide precisely with musical cues in the score and the skaters' movements. When the bridge is lowered and its sides extended to connect with either side of the stage, gates open just in time for the skaters to get across.

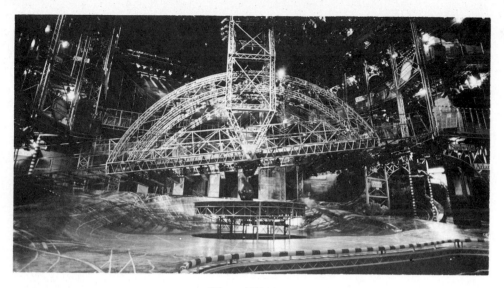

Figure DP12.7.

Commands for moving the bridge require position as well as velocity accuracy. A computer is available for controlling all six axes of motion independently. Assume that the rotational motion of the bridge is controlled while the other axes are fixed. Then obtain a model of the bridge motion and its control. Design a three-term (PID) controller that will provide 1-mm position accuracy with a rapid response to both step and velocity commands. Establish a set of specifications and proceed to the determination of a suitable controller.

DP12.8. The automatic control of an airplane is one example where multiple-variable feedback methods are required. In this system, the attitude of an aircraft is controlled by three sets of surfaces: elevators, rudder, and ailerons, as shown in Fig. DP12.8(a). By manipulating these surfaces, a pilot can set the aircraft on a desired flight path.

An autopilot, which will be considered here, is an automatic control system that controls the roll angle ϕ by adjusting aileron surfaces. The deflection of the aileron surfaces by an angle Θ generates a torque due to air pressure on these surfaces. This causes a rolling motion of the aircraft. The aileron surfaces are controlled by a hydraulic actuator with a transfer function b/s.

The actual roll angle ϕ is measured and compared with the input. The difference between the desired roll angle ϕ_d and the actual angle ϕ will drive the hydraulic actuator, which in turn adjusts the deflection of the aileron surface.

A simplified model where the rolling motion can be considered independent of other motions is assumed, and its block diagram is shown in Fig. DP12.8(b). Assume that $K_1 = 1$ and that the roll rate $\dot{\phi}$ is fed back using a rate gyro. Establish a set of specifications and select the two parameters K_a and K_2 for the best performance.

DP12.9. The goal is to design an elevator control system so that the elevator moves from floor to floor rapidly and stops accurately at the selected floor (Fig. DP12.9). The elevator can contain from one to three occupants. However the weight of the elevator is greater than the weight of the occupants and you may assume that the elevator weighs 1000

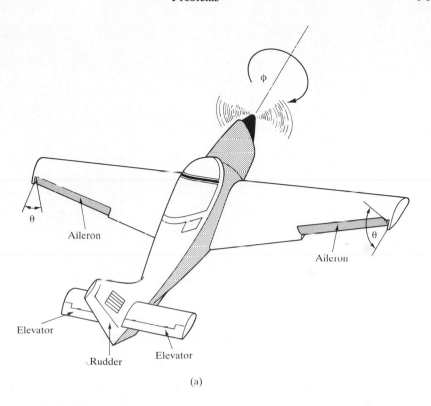

(a)

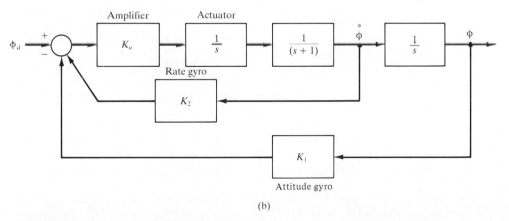

(b)

Figure DP12.8. (a) An airplane with a set of ailerons. (b) The block diagram for controlling the roll rate of the airplane.

pounds and each occupant weighs 150 pounds. Design a system to accurately control the elevator to within one centimeter. Assume that the large dc motor is field controlled. Assume that the time constant of the motor and load is one second and the time constant of the power amplifier driving the motor is one-half second.

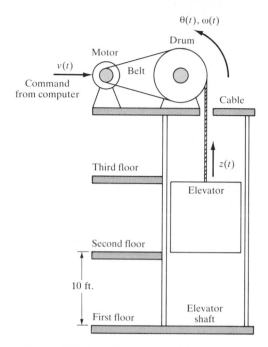

Figure DP12.9. Elevator position control.

DP12.10. The efficiency of a diesel engine is very sensitive to the speed of rotation. Thus we wish to control the speed of the diesel engine that drives the electric motors of a diesel-electric locomotive for large railroad trains. The locomotive is powered by dc motors located on each of the axles. Consider the model of the electric drive shown in Fig. DP12.10 where the throttle position is set by moving the input potentiometer.

The controlled speed ω_0 is sensed by a tachometer, which supplies a feedback voltage v_0. The tachometer may be belt driven from the motor shaft. An electronic amplifier amplifies the error $(v_r - v_0)$ between the reference and feedback voltage signals and provides a voltage v_f that is supplied to the field winding of a dc generator.

The generator is run at a constant speed ω_d by the diesel engine and generates a voltage v_g that is supplied to the armature of a dc motor. The motor is armature controlled with a fixed current i supplied to its field. As a result, the motor produces a torque T and drives the load connected to its shaft so that the controlled speed ω_0 tends to equal the command speed ω_r.

It is known that the generator constant k_g is 100 and the motor constant is $K_m = 10$. The back emf constant is $K_b = 31/50$. The constants for the motor are $J = 1$, $f = 1$, $L_a = 0.2$ and $R_a = 1$. The generator has a field resistance, $R_f = 1$ and a field inductance $L_f = 0.1$. Also the tachometer has a gain of $K_t = 1$ and the generator has $L_g = 0.1$ and $R_g = 1$. All three constants are in the appropriate SI units.

(a) Develop a linear model for the system and analyze the performance of the system as K is adjusted. What is the steady-state error for a fixed throttle position so that $v_r = A$? (b) Include the effect of a load torque disturbance, T_d, in the model of the system and determine the effect of a load disturbance torque on the speed, $\omega(s)$. For the design of part (a), what is the steady-state error introduced by the disturbance? (c) Select the three state

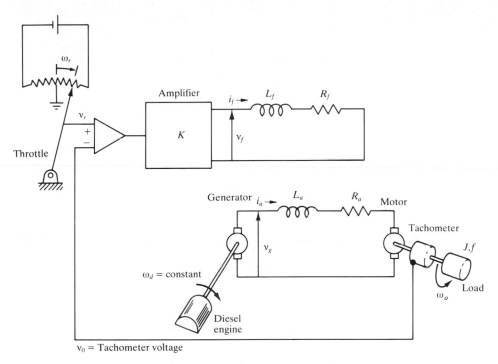

v_0 = Tachometer voltage

Figure DP12.10. Diesel-electric locomotive.

variables that are readily measured and obtain the state vector differential equation. Then design a state-variable feedback system to achieve favorable performance.

DP12.11. A high performance helicopter has a model shown in Fig. DP.12.11. The goal is to control the pitch angle, θ, of the helicopter by adjusting the rotor angle, δ.

The equations of motion of the helicopter are

$$\frac{d^2\theta}{dt^2} = -\sigma^1 \frac{d\theta}{dt} - \alpha^1 \frac{dx}{dt} + n\delta$$

$$\frac{d^2x}{dt^2} = g\theta - \alpha^2 \frac{d\theta}{dt} - \sigma^2 \frac{dx}{dt} + g\delta$$

where x is the translation in the horizontal direction. For a military, high-performance helicopter we find that

$$\sigma^1 = 0.415 \qquad \alpha^2 = 1.43$$
$$\sigma^2 = 0.0198 \qquad n = 6.27$$
$$\alpha^1 = 0.0111 \qquad g = 9.8$$

all in appropriate SI units.

Find (a) the state variable representation of this system and (b) the transfer function representation for $\theta(s)/\delta(s)$. (c) Use state variable feedback to achieve adequate performances for the controlled system. (d) Use a lead-lag compensator and an appropriate amplifier gain to achieve an adequate response for the system in the transfer function form.

Figure DP12.11. Helicopter pitch angle, θ, control.

Desired specifications include (1) a steady-state for an input step command for $\theta_d(s)$, the desired pitch angle, less than 20% of the input step magnitude; (2) an overshoot for a step input command less than 20% and (3) a settling time for a step command of less than 1.5 sec.

DP12.12. A pilot crane control is shown in Fig. DP12.12(a). The trolley is moved by an input $F(t)$ in order to control $x(t)$ and $\phi(t)$ [13]. The model of the pilot crane control is shown in Fig. DP12.12(b). Design a controller that will achieve control of the desired variables. First use $G_c(s) = K$ and then use more advanced controllers.

Figure DP12.12. Pilot crane control system.

DP12.13. Electronic systems currently make up about 6% of a car's value. That figure will climb to 20% by the year 2000 as antilock brakes, active suspensions, and other computer-dependent technologies move into full production. Much of the added computing power will be used for new technology for smart cars and smart roads, or IVHS (intelligent vehicle/highway systems) [11, 18]. The term refers to a varied assortment of electronics that provide real-time information on accidents, congestion, routing, and roadside services to drivers and traffic controllers. IVHS also encompasses devices that would make vehicles more autonomous: collision-avoidance systems and lane-tracking technology that alert drivers to impending disaster or allow a car to drive itself.

An example of an automated highway system is shown in Fig. DP12.13(a). A position control system for maintaining the distance between vehicles is shown in Fig. DP12.13(b). Design a controller so that the steady-state error for a ramp input is less than 25% of the input magnitude, A, of the ramp $R(s) = A/s^2$. The response to a step command should have an overshoot of less than 3% and a settling time of less than 1.5 sec.

(a)

(b)

Figure DP12.13. Vehicle distance control system.

DP12.14. The past several years have witnessed a significant engine model building activity in the automotive industry in a category referred to as "control-oriented" or "control design" models. These models contain representations of the throttle body, engine pumping phenomena, induction process dynamics, fuel system, engine torque generation, and rotating inertia.

The control of the fuel-to-air ratio in an automobile carburetor became of prime importance in the 1980s as automakers worked to reduce exhaust-pollution emissions. Thus auto engine designers turned to the feedback control of the fuel-to-air ratio. Operation of an engine at or near a particular air-to-fuel ratio requires management of both air and fuel flow into the manifold system. The fuel command is considered the input and the engine speed as the output [9, 11].

The block diagram of the system is shown in Fig. DP12.14, where $T = 0.066$ seconds. A compensator is required to yield zero steady-state error for a step input, and an overshoot of less than 10%. It is also desired that the settling time not exceed 10 sec.

Figure DP12.14. Engine control system.

DP12.15. Plastic extrusion is a well-established method widely used in the polymer processing industry [7]. Such extruders typically consist of a large barrel divided into several temperature zones, with a hopper at one end and a die at the other. Polymer is fed into the barrel in raw and solid form from the hopper and is pushed forward by a powerful screw. Simultaneously, it is gradually heated while passing through the various temperature zones set in gradually increasing temperatures. The heat produced by the heaters in the barrel, together with the heat released from the friction between the raw polymer and the surfaces of the barrel and the screw, eventually causes the melting of the polymer, which is then pushed by the screw out from the die, to be processed further for various purposes.

The output variables are the outflow from the die and the polymer temperature. The main controlling variable is the screw speed, since the response of the process to it is rapid.

The control system for the output polymer temperature is shown in Fig. DP12.15, on the next page. Select a controller to provide zero steady-state error for a step input and an overshoot of less than 10%. Also, try to minimize the settling time of the system.

DP12.16. A computer controller for a robot that picks up hot ingots and places them in a quenching tank is shown in Fig. DP12.16(a). The robot places itself over the ingot and then moves down in the y axis. The control system is shown in Fig. DP12.16(b), where

$$G(s) = \frac{e^{-sT}}{(s + 1)^2}$$

and $T = \pi/4$ sec. Design a controller that reduces the steady-state error for a step input to 10% of the input magnitude while maintaining an overshoot of less than 10%.

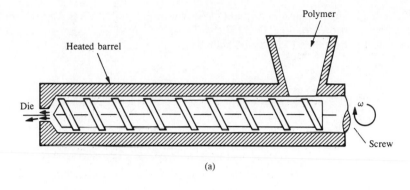

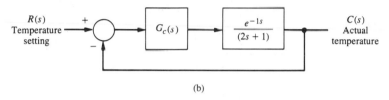

Figure DP12.15. Control system for an extruder.

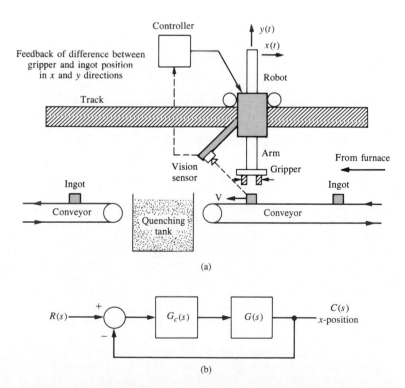

Figure DP12.16. Hot ingot robot control.

DP12.17. A high-performance jet airplane is shown in Fig. DP12.17(a), and the roll-angle control system is shown in Fig. DP12.17(b). Design a controller $G_c(s)$ so that the step response is well-behaved and the steady-state error is small.

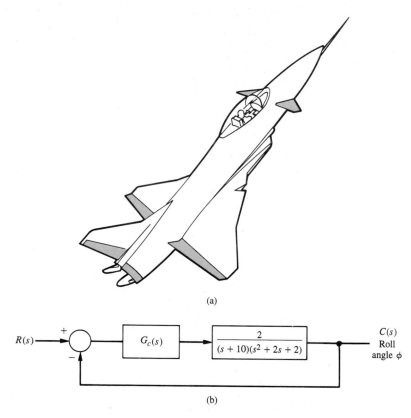

Figure DP12.17. Roll angle control of a jet airplane.

DP12.18. A two-tank system containing a heated liquid has the model shown in Fig. DP12.18(a), where T_0 is the temperature of the fluid flowing into the first tank and T_2 is the temperature of the liquid flowing out of the second tank. The block diagram model is shown in Fig. DP12.18(b). The system of the two tanks has a heater in tank 1 with a controllable heat input, Q. The time constants are $\tau_1 = 10$ sec and $\tau_2 = 50$ sec. (a) Determine $T_2(s)$ in terms of $T_0(s)$ and $T_{2d}(s)$. (b) If $T_{2d}(s)$, the desired output temperature, is changed instantaneously from $T_{2d}(s) = A/s$ to $T_{2d}(s) = 2A/s$, determine the transient response of $T_2(t)$ when $G_c(s) = K = 500$. Assume that prior to the abrupt temperature change the system is at steady state. (c) Find the steady-state error, e_{ss}, for the system of part (b), where $E(s) = T_{2d}(s) - T_2(s)$. (d) Let $G_c(s) = K/s$ and repeat parts (b) and (c). Use a gain, K, such that the percent overshoot is less than 10%. (e) Design a PI compensator that will result in a system with a settling time of $T_s < 150$ sec, and a percent overshoot of less than 10%, while maintaining a zero steady-state error. (f) Design a PID controller to achieve a settling time of less than 150 sec and an overshoot of less than 10%. (g) Prepare a table comparing the percent overshoot, settling time, and steady-state error for the designs of parts (b), through (f).

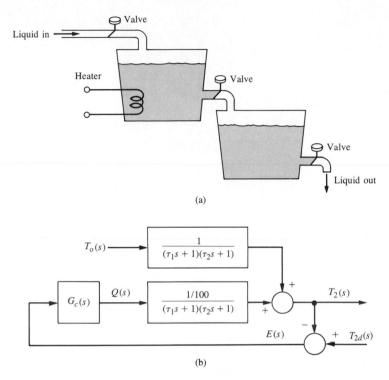

Figure DP12.18. Two-tank temperature control.

DP12.19. A rover vehicle designed for use on other planets and moons is shown in Fig. DP12.19(a), on the next page [14]. The block diagram of the steering control is shown in Fig. DP12.19(b), where

$$G(s) = \frac{(s + 1.5)}{(s + 1)(s + 2)(s + 4)(s + 10)}.$$

(a) When $G_c(s) = K$, draw the root locus as K varies from 0 to 1000. Find the roots for K equal to 100, 300, and 600. (b) Predict the overshoot, settling time, and steady-state error for a step input, assuming dominant roots. (c) Determine the actual time response for a step input for the three values of the gain K and compare the actual results with the predicted results. (d) Design a lead compensator so that the overshoot is less than 5%. The maximum gain K is 1500. Determine the actual percent overshoot, settling time, and steady-state error. (d) Design a PID controller so that the overshoot is less than 5%. Determine the actual performance of the system. (f) Prepare a table comparing the percent overshoot, settling time, and steady-state error for the designs of parts (a), (d), and (e).

DP12.20. One arm of a space robot is shown in Fig. DP12.20(a). The block diagram for the control of the arm is shown in Fig. DP12.1(b). The transfer function of the motor and arm is

$$G(s) = \frac{1}{s(s + 10)}.$$

(a)

$R(s)$ \longrightarrow $+$ \bigcirc $-$ \longrightarrow $G_c(s)$ \longrightarrow $G(s)$ \longrightarrow $\begin{array}{c} C(s) \\ \text{Steering} \\ \text{angle} \end{array}$

(b)

Figure DP12.19. Planetary rover vehicle steering control.

(a)

$$D(s)$$

$R(s) \longrightarrow G_p(s) \longrightarrow \overset{+}{\underset{-}{\bigcirc}} \longrightarrow \underset{\text{Controller}}{G_c(s)} \longrightarrow \overset{+}{\underset{+}{\bigcirc}} \longrightarrow \underset{\text{Arm}}{G(s)} \longrightarrow C(s)$$

(b)

Figure DP12.20. Space robot control.

(a) If $G(s) = K$, determine the gain necessary for an overshoot of 4.5%, and plot the step response. (b) Design a proportional plus derivative (PD) controller using the ITAE method and $\omega_n = 10$. Determine the required prefilter $G_p(s)$. (c) Design a PI controller and a prefilter using the ITAE method. (d) Design a PID controller and a prefilter using the ITAE method with $\omega_n = 10$. (e) Determine the effect of a unit step disturbance for each design. Record the maximum value of $c(t)$ and the final value of $c(t)$ for the disturbance input. (f) Determine the overshoot, peak time, and settling time for an input step $R(s)$ for each design above. (g) The plant is subject to variation due to load changes. Find the magnitude of the sensitivity at $\omega = 5$, $|S_G^T(j5)|$ where

$$T = \frac{GG_c}{1 + GG_c}.$$

(h) Based on the results of parts (e), (f), and (g), select the best controller.

Terms and Concepts

Complexity of design The intricate pattern of interwoven parts and knowledge required.

Design The process of conceiving or inventing the forms, parts, and details of a system to achieve a reasoned purpose.

Engineering design The process of designing a technical system.

Gap The void between what is intended (or visualized) as the product or device and the actual, practical form of the final design.

Optimization The adjustment of the parameters to achieve the most favorable or advantageous design.

Risk Uncertainties embodied in the unintended consequences of the design.

Specifications Statements that explicitly state what the device or product is to be and to do. A set of prescribed performance criteria.

Synthesis The process by which new physical configurations are created. The combining of separate elements or devices to form a coherent whole.

Tradeoff The need to make a judgment about how much compromise is made between conflicting criteria.

References

1. R. C. Dorf and R. Jacquot, *Control Systems Design Program,* Addison-Wesley, Reading, Mass., 1988.
2. B. Wada, "Adaptive Structures," *Mechanical Engineering,* November 1990; pp. 41–46.
3. J. G. Bollinger and N. A. Duffie, *Computer Control of Machines and Processes,* Addison-Wesley, Reading, Mass., 1988.

4. J. P. Peatmen, *Design with Microcontrollers,* McGraw-Hill, New York, 1988.
5. M. J. Shah, *Engineering Simulation,* Prentice Hall, Englewood Cliffs, N.J., 1988.
6. D. R. Pugh, "Technical Description of the Adaptive Suspension Vehicle," *International Journal of Robotics Research,* vol. 9, no. 2, 1990; pp. 24–42.
7. P. J. Gawthrop, "Automatic Tuning of Commercial PID Controllers," *IEEE Control Systems,* January 1990; pp. 34–41.
8. R. C. Dorf, *Encyclopedia of Robotics,* John Wiley & Sons, New York, 1988.
9. J. Cook, "Modeling of an Internal Combustion Engine for Control Analysis," *IEEE Control Systems,* August 1988; pp. 20–25.
10. S. T. Van Voorhis, "Digital Control of Measurement Graphics," *Hewlett-Packard Journal,* January 1986; pp. 24–26.
11. R. K. Jurgen, "Putting Electronics to Work in the 1991 Car Models," *IEEE Spectrum,* December 1990; pp. 75–75.
12. "Choreographing a Bridge," *Mechanical Engineering,* November 1987; pp. 42–43.
13. A. Marttinen, "Control Study with Pilot Crane," *IEEE Trans. on Education,* August 1990; pp. 298–305.
14. W. Whittaker, "Japan Robotics Aim for Unmanned Space Exploration," *IEEE Spectrum,* December 1990; pp. 64–68.
15. K. Wright, "The Shape of Things to Go," *Scientific American,* May 1990; pp. 92–101.
16. S. Boyd, *Linear Controller Design,* Prentice Hall, Englewood Cliffs, N.J., 1990.
17. H. Nakaya and Y. Oguchi, "Characteristics of the Four-Wheel Steering Vehicle," *Int. J. of Vehicle Design,* vol. 8, no. 3, 1987; pp. 314–25.
18. H. G. Wilson and P. B. MacCready, "Lessons of Sunraycer," *Scientific American,* March 1989; pp. 90–97.
19. "The Flying Train Takes Off," *U.S. News and World Report,* July 23, 1990; pp. 52–53.

APPENDIXES

Laplace Transform Pairs

Table A.1.

$F(s)$	$f(t),\ t \geq 0$
1. 1	$\delta(t_0)$, unit impulse at $t = t_0$
2. $1/s$	1, unit step
3. $\dfrac{n!}{s^{n+1}}$	t^n
4. $\dfrac{1}{(s + a)}$	e^{-at}
5. $\dfrac{1}{(s + a)^n}$	$\dfrac{1}{(n - 1)!}\, t^{n-1} e^{-at}$
6. $\dfrac{a}{s(s + a)}$	$1 - e^{-at}$
7. $\dfrac{1}{(s + a)(s + b)}$	$\dfrac{1}{(b - a)}(e^{-at} - e^{-bt})$
8. $\dfrac{s + \alpha}{(s + a)(s + b)}$	$\dfrac{1}{(b - a)}[(\alpha - a)e^{-at} - (\alpha - b)e^{-bt}]$
9. $\dfrac{ab}{s(s + a)(s + b)}$	$1 - \dfrac{b}{(b - a)}e^{-at} + \dfrac{a}{(b - a)}e^{-bt}$

Table A.1.—_Continued_

$F(s)$	$f(t), t \geq 0$
10. $\dfrac{1}{(s + a)(s + b)(s + c)}$	$\dfrac{e^{-at}}{(b - a)(c - a)} + \dfrac{e^{-bt}}{(c - a)(a - b)} + \dfrac{e^{-ct}}{(a - c)(b - c)}$
11. $\dfrac{s + \alpha}{(s + a)(s + b)(s + c)}$	$\dfrac{(\alpha - a)e^{-at}}{(b - a)(c - a)} + \dfrac{(\alpha - b)e^{-bt}}{(c - b)(a - b)} + \dfrac{(\alpha - c)e^{-ct}}{(a - c)(b - c)}$
12. $\dfrac{ab(s + \alpha)}{s(s + a)(s + b)}$	$\alpha - \dfrac{b(\alpha - a)}{(b - a)}e^{-at} + \dfrac{a(\alpha - b)}{(b - a)}e^{-bt}$
13. $\dfrac{\omega}{s^2 + \omega^2}$	$\sin \omega t$
14. $\dfrac{s}{s^2 + \omega^2}$	$\cos \omega t$
15. $\dfrac{s + \alpha}{s^2 + \omega^2}$	$\dfrac{\sqrt{\alpha^2 + \omega^2}}{\omega} \sin (\omega t + \phi), \phi = \tan^{-1} \omega/\alpha$
16. $\dfrac{\omega}{(s + a)^2 + \omega^2}$	$e^{-at} \sin \omega t$
17. $\dfrac{(s + a)}{(s + a)^2 + \omega^2}$	$e^{-at} \cos \omega t$
18. $\dfrac{s + \alpha}{(s + a)^2 + \omega^2}$	$\dfrac{1}{\omega}[(\alpha - a)^2 + \omega^2]^{1/2}e^{-at} \sin (\omega t + \phi), \phi = \tan^{-1}\dfrac{\omega}{\alpha - a}$
19. $\dfrac{\omega_n^2}{s^2 + 2\zeta\omega_n s + \omega_n^2}$	$\dfrac{\omega_n}{\sqrt{1 - \zeta^2}}e^{-\zeta\omega_n t} \sin \omega_n\sqrt{1 - \zeta^2}\, t, \quad \zeta < 1$
20. $\dfrac{1}{s[(s + a)^2 + \omega^2]}$	$\dfrac{1}{a^2 + \omega^2} + \dfrac{1}{\omega\sqrt{a^2 + \omega^2}}e^{-at} \sin (\omega t - \phi),$ $\phi = \tan^{-1}\omega/-a$
21. $\dfrac{\omega_n^2}{s(s^2 + 2\zeta\omega_n s + \omega_n^2)}$	$1 - \dfrac{1}{\sqrt{1 - \zeta^2}}e^{-\zeta\omega_n t} \sin (\omega_n\sqrt{1 - \zeta^2}\, t + \phi),$ $\phi = \cos^{-1}\zeta, \zeta < 1$

Table A.1.—*Continued*

$F(s)$	$f(t), t \geq 0$
22. $\dfrac{(s + \alpha)}{s[(s + a)^2 + \omega^2]}$	$\dfrac{\alpha}{a^2 + \omega^2} + \dfrac{1}{\omega}\left[\dfrac{(\alpha - a)^2 + \omega^2}{a^2 + \omega^2}\right]^{1/2} e^{-at} \sin(\omega t + \phi),$ $\phi = \tan^{-1}\dfrac{\omega}{\alpha - a} - \tan^{-1}\dfrac{\omega}{-a}$
23. $\dfrac{1}{(s + c)[(s + a)^2 + \omega^2]}$	$\dfrac{e^{-ct}}{(c - a)^2 + \omega^2} + \dfrac{e^{-at}\sin(\omega t + \phi)}{\omega[(c - a)^2 + \omega^2]^{1/2}}, \phi = \tan^{-1}\dfrac{\omega}{c - a}$

Symbols, Units and Conversion Factors

Table B.1. Symbols and Units

Parameter or Variable Name	Symbol	SI	English
Acceleration, angular	$\alpha(t)$	rad/sec^2	rad/sec^2
Acceleration, translational	$a(t)$	m/sec^2	ft/sec^2
Friction, rotational	f	$\dfrac{\text{n-m}}{\text{rad/sec}}$	$\dfrac{\text{ft-lb}}{\text{rad/sec}}$
Friction, translational	f	$\dfrac{\text{n}}{\text{m/sec}}$	$\dfrac{\text{lb}}{\text{ft/sec}}$
Inertia, rotational	J	$\dfrac{\text{n-m}}{\text{rad/sec}^2}$	$\dfrac{\text{ft-lb}}{\text{rad/sec}^2}$
Mass	M	kg	slugs
Position, rotational	$\Theta(t)$	rad	rad
Position, translational	$x(t)$	m	ft
Speed, rotational	$\omega(t)$	rad/sec	rad/sec
Speed, translational	$v(t)$	m/sec	ft/sec
Torque	$T(t)$	n-m	ft-lb

Table B.2. Conversion Factors

To Convert	Into	Multiply by	To Convert	Into	Multiply by
Btu	ft-lb	778.3	kw	Btu/min	56.92
Btu	joules	1054.8	kw	ft-lb/min	4.462×10^4
Btu/hr	ft-lb/sec	0.2162	kw	hp	1.341
Btu/hr	watts	0.2931			
Btu/min	hp	0.02356	miles (statute)	ft	5280
Btu/min	kw	0.01757	mph	ft/min	88
Btu/min	watts	17.57	mph	ft/sec	1.467
			mph	m/sec	0.44704
cal	joules	4.182	mils	cms	2.540×10^{-3}
cm	ft	3.281×10^{-2}	mils	in	0.001
cm	in	0.3937	min (angles)	deg	0.01667
cm^3	ft^3	3.531×10^{-5}	min (angles)	rad	2.909×10^{-4}
deg (angle)	rad	0.01745	n-m	ft-lb	0.73756
deg/sec	rpm	0.1667	n-m	dyne-cm	10^7
dynes	gm	1.020×10^{-3}	n-m-sec	watt	1.0
dynes	lb	2.248×10^{-6}			
dynes	newtons	10^{-5}	oz	gm	28.349527
			oz-in	dyne-cm	70,615.7
ft/sec	miles/hr	0.6818	$oz-in^2$	$gm-cm^2$	1.829×10^2
ft/sec	miles/min	0.01136	oz-in	ft-lb	5.208×10^{-3}
ft-lb	gm-cm	1.383×10^4	oz-in	gm-cm	72.01
ft-lb	oz-in	192			
ft-lb/min	Btu/min	1.286×10^{-3}	lb(force)	newtons	4.4482
ft-lb/sec	hp	1.818×10^{-3}	lb/ft^3	gm/cm^3	0.01602
ft-lb/sec	kw	1.356×10^{-3}	$lb-ft-sec^2$	$oz-in^2$	7.419×10^4
$\dfrac{\text{ft-lb}}{\text{rad/sec}}$	$\dfrac{\text{oz-in}}{\text{rpm}}$	20.11	rad	deg	57.30
			rad	min	3438
gm	dynes	980.7	rad	sec	2.063×10^5
gm	lb	2.205×10^{-3}	rad/sec	deg/sec	57.30
$gm-cm^2$	$oz-in^2$	5.468×10^{-3}	rad/sec	rpm	9.549
gm-cm	oz-in	1.389×10^{-2}	rad/sec	rps	0.1592
gm-cm	ft-lb	1.235×10^{-5}	rpm	deg/sec	6.0
			rpm	rad/sec	0.1047
hp	Btu/min	42.44			
hp	ft-lb/min	33,000	sec (angle)	deg	2.778×10^{-4}
hp	ft-lb/sec	550.0	sec (angle)	rad	4.848×10^{-6}
hp	watts	745.7	slugs (mass)	kg	14.594
			$slug-ft^2$	km^2	1.3558
in	meters	2.540×10^{-2}			
in	cm	2.540	watts	Btu/hr	3.413
			watts	Btu/min	0.05688
joules	Btu	9.480×10^{-4}	watts	ft-lb/min	44.27
joules	ergs	10^7	watts	hp	1.341×10^{-3}
joules	ft-lb	0.7376	watts	n-m/sec	1.0
joules	watt-hr	2.778×10^{-4}	watts-hr	Btu	3.413
kg	lb	2.205			
kg	slugs	6.852×10^{-2}			

An Introduction to Matrix Algebra

C.1 Definitions

There are many situations in which we have to deal with rectangular arrays of numbers or functions. The rectangular array of numbers (or functions)

$$
\mathbf{A} = \begin{bmatrix} a_{11} & a_{12} & \cdots & a_{1n} \\ a_{21} & a_{22} & \cdots & a_{2n} \\ \vdots & \vdots & & \vdots \\ a_{m1} & a_{m2} & \cdots & a_{2mn} \end{bmatrix} \tag{C.1}
$$

is known as a *matrix*. The numbers a_{ij} are called *elements* of the matrix, with the subscript i denoting the row and the subscript j denoting the column.

A matrix with m rows and n columns is said to be a matrix of *order* (m, n) or alternatively called an $m \times n$ (m by n) matrix. When the number of the columns equals the number of rows ($m = n$) the matrix is called a *square matrix* of order n. It is common to use boldfaced capital letters to denote an $m \times n$ matrix.

A matrix comprised of only one column, that is, an $m \times 1$ matrix, is known as a column matrix or, more commonly, a *column vector*. We shall represent a column vector with boldfaced lower-case letters as

$$
\mathbf{y} = \begin{bmatrix} y_1 \\ y_2 \\ \vdots \\ y_m \end{bmatrix}. \tag{C.2}
$$

Analogously, a *row vector* is an ordered collection of numbers written in a row—that is, a $1 \times n$ matrix. We will use boldfaced lowercase letters to represent vectors. Therefore a row vector will be written as

$$\mathbf{z} = [z_1, z_2, \ldots, z_n] \tag{C.3}$$

with n elements.

A few matrices with distinctive characteristics are given special names. A square matrix in which all the elements are zero except those on the principal diagonal, $a_{11}, a_{22}, \ldots, a_{nn}$, is called a *diagonal matrix*. Then, for example, a 3×3 diagonal matrix would be

$$\mathbf{B} = \begin{bmatrix} b_{11} & 0 & 0 \\ 0 & b_{22} & 0 \\ 0 & 0 & b_{33} \end{bmatrix}. \tag{C.4}$$

If all the elements of a diagonal matrix have the value 1, then the matrix is known as the *identity matrix* \mathbf{I}, which is written as

$$\mathbf{I} = \begin{bmatrix} 1 & 0 & \ldots & 0 \\ 0 & 1 & \ldots & 0 \\ \vdots & \vdots & \ldots & \vdots \\ 0 & 0 & \ldots & 1 \end{bmatrix}. \tag{C.5}$$

When all the elements of a matrix are equal to zero, the matrix is called the *zero* or *null matrix*. When the elements of a matrix have a special relationship so that $a_{ij} = a_{ji}$, it is called a *symmetrical* matrix. Thus, for example, the matrix

$$\mathbf{H} = \begin{bmatrix} 3 & -2 & 1 \\ -2 & 6 & 4 \\ 1 & 4 & 8 \end{bmatrix} \tag{C.6}$$

is a symmetrical matrix of order (3, 3).

C.2 Addition and Subtraction of Matrices

The addition of two matrices is possible only for matrices of the same order. The sum of two matrices is obtained by adding the corresponding elements. Thus if the elements of \mathbf{A} are a_{ij} and the elements of \mathbf{B} are b_{ij}, and if

$$\mathbf{C} = \mathbf{A} + \mathbf{B}, \tag{C.7}$$

then the elements of \mathbf{C} that are c_{ij} are obtained as

$$c_{ij} = a_{ij} + b_{ij}. \tag{C.8}$$

Then, for example, the matrix addition for two 3×3 matrices is as follows:

$$C = \begin{bmatrix} 2 & 1 & 0 \\ 1 & -1 & 3 \\ 0 & 6 & 2 \end{bmatrix} + \begin{bmatrix} 8 & 2 & 1 \\ 1 & 3 & 0 \\ 4 & 2 & 1 \end{bmatrix} = \begin{bmatrix} 10 & 3 & 1 \\ 2 & 2 & 3 \\ 4 & 8 & 3 \end{bmatrix}. \tag{C.9}$$

From the operation used for performing the operation of addition, we note that the process is commutative; that is

$$\mathbf{A} + \mathbf{B} = \mathbf{B} + \mathbf{A}. \tag{C.10}$$

Also, we note that the addition operation is associative, so that

$$(\mathbf{A} + \mathbf{B}) + \mathbf{C} = \mathbf{A} + (\mathbf{B} + \mathbf{C}). \tag{C.11}$$

In order to perform the operation of subtraction we note that if a matrix \mathbf{A} is multiplied by a constant α, then every element of the matrix is multiplied by this constant. Therefore we can write

$$\alpha\mathbf{A} = \begin{bmatrix} \alpha a_{11} & \alpha a_{12} & \cdots & \alpha a_{1n} \\ \alpha a_{12} & \alpha a_{22} & \cdots & \alpha a_{2n} \\ \vdots & \vdots & & \vdots \\ \alpha a_{m1} & \alpha a_{m2} & \cdots & \alpha a_{mn} \end{bmatrix} \tag{C.12}$$

Then, in order to carry out a subtraction operation, we use $\alpha = -1$, and $-\mathbf{A}$ is obtained by multiplying each element of \mathbf{A} by -1. Then, for example,

$$C = \mathbf{B} - \mathbf{A} = \begin{bmatrix} 2 & 1 \\ 4 & 2 \end{bmatrix} - \begin{bmatrix} 6 & 1 \\ 3 & 1 \end{bmatrix} - \begin{bmatrix} -4 & 0 \\ 1 & 1 \end{bmatrix}. \tag{C.13}$$

C.3 Multiplication of Matrices

Matrix multiplication is defined in such a way as to assist in the solution of simultaneous linear equations. The multiplication of two matrices \mathbf{AB} requires that the number of columns of \mathbf{A} is equal to the number of rows of \mathbf{B}. Thus if \mathbf{A} is of order $m \times n$ and \mathbf{B} is of order $n \times q$, then the product is of order $m \times q$. The elements of a product

$$C = \mathbf{AB} \tag{C.14}$$

are found by multiplying the ith row of \mathbf{A} and the jth column of \mathbf{B} and summing these products to give the element c_{ij}. That is,

$$c_{ij} = a_{i1}b_{1j} + a_{i2}b_{2j} + \cdots + a_{iq}b_{qj} = \sum_{k=1}^{q} a_{ik}b_{kj}. \tag{C.15}$$

Thus we obtain c_{11}, the first element of C, by multiplying the first row of A by the first column of B and summing the products of the elements. We should note that, in general, matrix multiplication is not commutative, that is

$$AB \neq BA. \tag{C.16}$$

Also, we will note that the multiplication of a matrix of $m \times n$ by a column vector (order $n \times 1$) results in a column vector of order $m \times 1$.

A specific example of multiplication of a column vector by a matrix is

$$\mathbf{x} = \mathbf{Ay} = \begin{bmatrix} a_{11} & a_{12} & a_{13} \\ a_{21} & a_{22} & a_{23} \end{bmatrix} \begin{bmatrix} y_1 \\ y_2 \\ y_3 \end{bmatrix}$$

$$= \begin{bmatrix} (a_{11}y_1 + a_{12}y_2 + a_{13}y_3) \\ (a_{21}y_1 + a_{22}y_2 + a_{23}y_3) \end{bmatrix}. \tag{C.17}$$

Note that A is of order 2×3 and y is of order 3×1. Therefore the resulting matrix x is of order 2×1, which is a column vector with two rows. There are two elements of x, and

$$x_1 = (a_{11}y_1 + a_{12}y_2 + a_{13}y_3) \tag{C.18}$$

is the first element obtained by multiplying the first row of A by the first (and only) column of y.

Another example, which the reader should verify, is

$$C = AB = \begin{bmatrix} 2 & -1 \\ -1 & 2 \end{bmatrix} \begin{bmatrix} 3 & 2 \\ -1 & -2 \end{bmatrix} = \begin{bmatrix} 7 & 6 \\ -5 & -6 \end{bmatrix}. \tag{C.19}$$

For example, the element c_{22} is obtained as $c_{22} = -1(2) + 2(-2) = -6$.

Now we are able to use this definition of multiplication in representing a set of simultaneous linear algebraic equations by a matrix equation. Consider the following set of algebraic equations:

$$3x_1 + 2x_2 + x_3 = u_1,$$

$$2x_1 + x_2 + 6x_3 = u_2, \tag{C.20}$$

$$4x_1 - x_2 + 2x_3 = u_3.$$

We can identify two column vectors as

$$\mathbf{x} = \begin{bmatrix} x_1 \\ x_2 \\ x_3 \end{bmatrix} \quad \text{and} \quad \mathbf{u} = \begin{bmatrix} u_1 \\ u_2 \\ u_3 \end{bmatrix}. \tag{C.21}$$

Then we can write the matrix equation

$$\mathbf{Ax} = \mathbf{u}, \tag{C.22}$$

where

$$A = \begin{bmatrix} 3 & 2 & 1 \\ 2 & 1 & 6 \\ 4 & -1 & 2 \end{bmatrix}.$$

We immediately note the utility of the matrix equation as a compact form of a set of simultaneous equations.

The multiplication of a row vector and a column vector can be written as

$$\mathbf{xy} = [x_1, x_2, \ldots, x_n] \begin{bmatrix} y_1 \\ y_2 \\ \vdots \\ y_n \end{bmatrix} = x_1 y_1 + x_2 y_2 + \cdots + x_n y_n. \tag{C.23}$$

Thus we note that the multiplication of a row vector and a column vector results in a number that is a sum of a product of specific elements of each vector.

As a final item in this section, we note that the multiplication of any matrix by the identity matrix results in the original matrix, that is $\mathbf{AI} = \mathbf{A}$.

C.4 Other Useful Matrix Operations and Definitions

The *transpose* of a matrix \mathbf{A} is denoted in this text as \mathbf{A}^T. One will often find the notation \mathbf{A}' for \mathbf{A}^T in the literature. The transpose of a matrix \mathbf{A} is obtained by interchanging the rows and columns of \mathbf{A}. Then, for example, if

$$\mathbf{A} = \begin{bmatrix} 6 & 0 & 2 \\ 1 & 4 & 1 \\ -2 & 3 & -1 \end{bmatrix},$$

then

$$\mathbf{A}^T = \begin{bmatrix} 6 & 1 & -2 \\ 0 & 4 & 3 \\ 2 & 1 & -1 \end{bmatrix}. \tag{C.24}$$

Therefore, we are able to denote a row vector as the transpose of a column vector and write

$$\mathbf{x}^T = [x_1, x_2, \ldots, x_n]. \tag{C.25}$$

Because \mathbf{x}^T is a row vector, we obtain a matrix multiplication of \mathbf{x}^T by \mathbf{x} as follows:

$$\mathbf{x}^T\mathbf{x} = [x_1, x_2, \ldots, x_n] \begin{bmatrix} x_1 \\ x_2 \\ \vdots \\ x_n \end{bmatrix} = x_1^2 + x_2^2 + \cdots + x_n^2. \tag{C.26}$$

Thus the multiplication $\mathbf{x}^T\mathbf{x}$ results in the sum of the squares of each element of \mathbf{x}.

The transpose of the product of two matrices is the product in reverse order of their transposes, so that

$$(\mathbf{AB})^T = \mathbf{B}^T\mathbf{A}^T. \tag{C.27}$$

The sum of the main diagonal elements of a square matrix \mathbf{A} is called the *trace* of \mathbf{A}, written as

$$\text{tr } \mathbf{A} = a_{11} + a_{22} + \cdots + a_{nn}. \tag{C.28}$$

The *determinant* of a square matrix is obtained by enclosing the elements of the matrix \mathbf{A} within vertical bars as, for example,

$$\det \mathbf{A} = \begin{vmatrix} a_{11} & a_{12} \\ a_{21} & a_{22} \end{vmatrix}. \tag{C.29}$$

If the determinant of \mathbf{A} is equal to zero, then the determinant is said to be singular. The value of a determinant is determined by obtaining the minors and cofactors of the determinants. The *minor* of an element a_{ij} of a determinant of order n is a determinant of order $(n-1)$ obtained by removing the row i and the column j of the original determinant. The cofactor of a given element of a determinant is the minor of the element with either a plus or minus sign attached; hence

$$\text{cofactor of } a_{ij} = \alpha_{ij} = (-1)^{i+j}M_{ij},$$

where M_{ij} is the minor of a_{ij}. For example, the cofactor of the element a_{23} of

$$\det \mathbf{A} = \begin{vmatrix} a_{11} & a_{12} & a_{13} \\ a_{21} & a_{22} & a_{23} \\ a_{31} & a_{32} & a_{33} \end{vmatrix} \tag{C.30}$$

is

$$\alpha_{23} = (-1)^5 M_{23} = -\begin{vmatrix} a_{11} & a_{12} \\ a_{31} & a_{32} \end{vmatrix}. \tag{C.31}$$

The value of a determinant of second order (2×2) is

$$\begin{vmatrix} a_{11} & a_{12} \\ a_{21} & a_{22} \end{vmatrix} = (a_{11}a_{22} - a_{21}a_{12}). \tag{C.32}$$

The general nth-order determinant has a value given by

$$\det \mathbf{A} = \sum_{j=1}^{n} a_{ij}\alpha_{ij} \quad \text{with } i \text{ chosen for one row, or}$$

$$\det \mathbf{A} = \sum_{i=1}^{n} a_{ij}\alpha_{ij} \quad \text{with } j \text{ chosen for one column.} \tag{C.33}$$

That is, the elements a_{ij} are chosen for a specific row (or column) and that entire row (or column) is expanded according to Eq. (C.33). For example, the value of a specific 3×3 determinant is

$$\det \mathbf{A} = \det \begin{bmatrix} 2 & 3 & 5 \\ 1 & 0 & 1 \\ 2 & 1 & 0 \end{bmatrix}$$

$$= 2 \begin{vmatrix} 0 & 1 \\ 1 & 0 \end{vmatrix} - 1 \begin{vmatrix} 3 & 5 \\ 1 & 0 \end{vmatrix} + 2 \begin{vmatrix} 3 & 5 \\ 0 & 1 \end{vmatrix} \qquad \text{(C.34)}$$

$$= 2(-1) - (-5) + 2(3) = 9,$$

where we have expanded in the first column.

The *adjoint matrix* of a square matrix \mathbf{A} is formed by replacing each element a_{ij} by the cofactor α_{ij} and transposing. Therefore

$$\text{adjoint } \mathbf{A} = \begin{bmatrix} \alpha_{11} & \alpha_{12} & \cdots & \alpha_{1n} \\ \alpha_{21} & \alpha_{22} & & \alpha_{2n} \\ \vdots & \vdots & & \vdots \\ \alpha_{n1} & \alpha_{n2} & \cdots & \alpha_{nn} \end{bmatrix}^{T} = \begin{bmatrix} \alpha_{11} & \alpha_{21} & \cdots & \alpha_{n1} \\ \alpha_{12} & \alpha_{22} & \cdots & \alpha_{n2} \\ \vdots & \vdots & & \vdots \\ \alpha_{1n} & \alpha_{2n} & \cdots & \alpha_{nn} \end{bmatrix}. \qquad \text{(C.35)}$$

C.5 Matrix Inversion

The inverse of a square matrix \mathbf{A} is written as \mathbf{A}^{-1} and is defined as satisfying the relationship

$$\mathbf{A}^{-1}\mathbf{A} = \mathbf{A}\mathbf{A}^{-1} = \mathbf{I}. \qquad \text{(C.36)}$$

The inverse of a matrix \mathbf{A} is

$$\mathbf{A}^{-1} = \frac{\text{adjoint of } \mathbf{A}}{\det \mathbf{A}} \qquad \text{(C.37)}$$

when the $\det \mathbf{A}$ is not equal to zero. For a 2×2 matrix we have the adjoint matrix

$$\text{adjoint } \mathbf{A} = \begin{bmatrix} a_{22} & -a_{12} \\ -a_{21} & a_{11} \end{bmatrix} \qquad \text{(C.38)}$$

and the $\det \mathbf{A} = a_{11}a_{22} - a_{12}a_{21}$. Consider the matrix

$$\mathbf{A} = \begin{bmatrix} 1 & 2 & 3 \\ 2 & -1 & 4 \\ 0 & -1 & 1 \end{bmatrix}. \qquad \text{(C.39)}$$

The determinant has a value $\det \mathbf{A} = -7$. The cofactor α_{11} is

$$\alpha_{11} = (-1)^{2} \begin{vmatrix} -1 & 4 \\ -1 & 1 \end{vmatrix} = 3. \qquad \text{(C.40)}$$

In a similar manner we obtain

$$\mathbf{A}^{-1} = \frac{\text{adjoint } \mathbf{A}}{\det \mathbf{A}} = \left(-\frac{1}{7}\right)\begin{bmatrix} 3 & -5 & 11 \\ -2 & 1 & 2 \\ -2 & 1 & -5 \end{bmatrix}. \tag{C.41}$$

C.6　Matrices and Characteristic Roots

A set of simultaneous linear algebraic equations can be represented by the matrix equation

$$\mathbf{y} = \mathbf{Ax}, \tag{C.42}$$

where the \mathbf{y} vector can be considered as a transformation of the vector \mathbf{x}. The question may be asked whether or not it may happen that a vector \mathbf{y} may be a scalar multiple of \mathbf{x}. Trying $\mathbf{y} = \lambda\mathbf{x}$, where λ is a scalar, we have

$$\lambda\mathbf{x} = \mathbf{Ax}. \tag{C.43}$$

Alternatively, Eq. (C.43) can be written as

$$\lambda\mathbf{x} - \mathbf{Ax} = (\lambda\mathbf{I} - \mathbf{A})\mathbf{x} = \mathbf{0}, \tag{C.44}$$

where $\mathbf{I} =$ identity matrix. Thus the solution for \mathbf{x} exists if and only if

$$\det(\lambda\mathbf{I} - \mathbf{A}) = 0. \tag{C.45}$$

This determinant is called the characteristic determinant of \mathbf{A}. Expansion of the determinant of Eq. (C.45) results in the *characteristic equation.* The characteristic equation is an nth-order polynomial in λ. The n roots of this characteristic equation are called the *characteristic roots.* For every possible value λ_i ($i = 1, 2, \ldots, n$) of the nth-order characteristic equation, we can write

$$(\lambda_i\mathbf{I} - \mathbf{A})\mathbf{x}_i = 0. \tag{C.46}$$

The vector \mathbf{x}_i is the *characteristic vector* for the ith root. Let us consider the matrix

$$\mathbf{A} = \begin{bmatrix} 2 & 1 & 1 \\ 2 & 3 & 4 \\ -1 & -1 & -2 \end{bmatrix}. \tag{C.47}$$

The characteristic equation is found as follows:

$$\det\begin{bmatrix} (\lambda - 2) & -1 & -1 \\ -2 & (\lambda - 3) & -4 \\ 1 & 1 & (\lambda + 2) \end{bmatrix} = (-\lambda^3 + 3\lambda^2 + \lambda - 3) = 0. \tag{C.48}$$

The roots of the characteristic equation are $\lambda_1 = 1$, $\lambda_2 = -1$, $\lambda_3 = 3$. When $\lambda = \lambda_1 = 1$, we find the first characteristic vector from the equation

$$\mathbf{Ax}_1 = \lambda_1\mathbf{x}_1, \tag{C.49}$$

and we have $\mathbf{x}_1^T = k[1, -1, 0]$, where k is an arbitrary constant usually chosen equal to 1. Similarly, we find

$$\mathbf{x}_2^T = [0, 1, -1]$$

and

$$\mathbf{x}_3^T = [2, 3, -1].\tag{C.50}$$

C.7 The Calculus of Matrices

The derivative of a matrix $\mathbf{A} = \mathbf{A}(t)$ is defined as

$$\frac{d}{dt}[\mathbf{A}(t)] = \begin{bmatrix} da_{11}(t)/dt & da_{12}(t)/dt & \cdots & da_{1n}(t)/dt \\ \vdots & \vdots & & \vdots \\ da_{n1}(t)/dt & da_{n2}(t)/dt & \cdots & da_{nn}(t)/dt \end{bmatrix}.\tag{C.51}$$

That is, the derivative of a matrix is simply the derivative of each element $a_{ij}(t)$ of the matrix.

The *matrix exponential function* is defined as the power series

$$\exp[\mathbf{A}] = e^{\mathbf{A}} = \mathbf{I} + \frac{\mathbf{A}}{1!} + \frac{\mathbf{A}^2}{2!} + \cdots + \frac{\mathbf{A}^k}{k!} + \cdots = \sum_{k=0}^{\infty} \frac{\mathbf{A}^k}{k!},\tag{C.52}$$

where $\mathbf{A}^2 = \mathbf{AA}$ and, similarly, \mathbf{A}^k implies \mathbf{A} multiplied k times. This series can be shown to be convergent for all square matrices. Also, a matrix exponential that is a function of time is defined as

$$e^{\mathbf{A}t} = \sum_{k=0}^{\infty} \frac{\mathbf{A}^k t^k}{k!}.\tag{C.53}$$

If we differentiate with respect to time, then we have

$$\frac{d}{dt}(e^{\mathbf{A}t}) = \mathbf{A}e^{\mathbf{A}t}.\tag{C.54}$$

Therefore, for a differential equation

$$\frac{dx}{dt} = \mathbf{A}x,\tag{C.55}$$

we might postulate a solution $\mathbf{x} = e^{\mathbf{A}t}\mathbf{c} = \boldsymbol{\phi}\mathbf{c}$, where the matrix $\boldsymbol{\phi}$ is $\boldsymbol{\phi} = e^{\mathbf{A}t}$ and \mathbf{c} is an unknown column vector. Then we have

$$\frac{dx}{dt} = \mathbf{A}x\tag{C.56}$$

or

$$\mathbf{A}e^{\mathbf{A}t} = \mathbf{A}e^{\mathbf{A}t},\tag{C.57}$$

and we have in fact satisfied the relationship, Eq. (C.55). Then, the value of c is simply $x(0)$, the initial value of x because, when $t = 0$, we have $x(0) = c$. Therefore the solution to Eq. (C.55) is

$$x(t) = e^{At}x(0). \qquad\qquad (C.58)$$

References

1. R. C. Dorf, *Matrix Algebra—A Programmed Introduction,* John Wiley & Sons, New York, 1969.
2. C. R. Wylie, Jr., *Advanced Engineering Mathematics,* 4th ed., McGraw-Hill, New York, 1975.

Decibel Conversion

M	0	1	2	3	4	5	6	7	8	9
0.0	$m =$	−40.00	−33.98	−30.46	−27.96	−26.02	−24.44	−23.10	−21.94	−20.92
0.1	−20.00	−19.17	−18.42	−17.72	−17.08	−16.48	−15.92	−15.39	−14.89	−14.42
0.2	−13.98	−13.56	−13.15	−12.77	−12.40	−12.04	−11.70	−11.37	−11.06	−10.75
0.3	−10.46	−10.17	−9.90	−9.63	−9.37	−9.12	−8.87	−8.64	−8.40	−8.18
0.4	−7.96	−7.74	−7.54	−7.33	−7.13	−6.94	−6.74	−6.56	−6.38	−6.20
0.5	−6.02	−5.85	−5.68	−5.51	−5.35	−5.19	−5.04	−4.88	−4.73	−4.58
0.6	−4.44	−4.29	−4.15	−4.01	−3.88	−3.74	−3.61	−3.48	−3.35	−3.22
0.7	−3.10	−2.97	−2.85	−2.73	−2.62	−2.50	−2.38	−2.27	−2.16	−2.05
0.8	−1.94	−1.83	−1.72	−1.62	−1.51	−1.41	−1.31	−1.21	−1.11	−1.01
0.9	−0.92	−0.82	−0.72	−0.63	−0.54	−0.45	−0.35	−0.26	0.18	−0.09
1.0	0.00	0.09	0.17	0.26	0.34	0.42	0.51	0.59	0.67	0.75
1.1	0.83	0.91	0.98	1.06	1.14	1.21	1.29	1.36	1.44	1.51
1.2	1.58	1.66	1.73	1.80	1.87	1.94	2.01	2.08	2.14	2.21
1.3	2.28	2.35	2.41	2.48	2.54	2.61	2.67	2.73	2.80	2.86
1.4	2.92	2.98	3.05	3.11	3.17	3.23	3.29	3.35	3.41	3.46
1.5	3.52	3.58	3.64	3.69	3.75	3.81	3.86	3.92	3.97	4.03
1.6	4.08	4.14	4.19	4.24	4.30	4.35	4.40	4.45	4.51	4.56
1.7	4.61	4.66	4.71	4.76	4.81	4.86	4.91	4.96	5.01	5.06
1.8	5.11	5.15	5.20	5.25	5.30	5.34	5.39	5.44	5.48	5.53
1.9	5.58	5.62	5.67	5.71	5.76	5.80	5.85	5.89	5.93	5.98
2.	6.02	6.44	6.85	7.23	7.60	7.96	8.30	8.63	8.94	9.25
3.	9.54	9.83	10.10	10.37	10.63	10.88	11.13	11.36	11.60	11.82
4.	12.04	12.26	12.46	12.67	12.87	13.06	13.26	13.44	13.62	13.80
5.	13.98	14.15	14.32	14.49	14.65	14.81	14.96	15.12	15.27	15.42
6.	15.56	15.71	15.85	15.99	16.12	16.26	16.39	16.52	16.65	16.78
7.	16.90	17.03	17.15	17.27	17.38	17.50	17.62	17.73	17.84	17.95
8.	18.06	18.17	18.28	18.38	18.49	18.59	18.69	18.79	18.89	18.99
9.	19.08	19.18	19.28	19.37	19.46	19.55	19.65	19.74	19.82	19.91
	0.	1.	2.	3.	4.	5.	6.	7.	8.	9.

Decibels = $20 \log_{10} M$

APPENDIX E

Complex Numbers

E.1 A Complex Number

We all are familiar with the solution of the algebraic equation

$$x^2 - 1 = 0, \tag{E.1}$$

which is $x = 1$. However, we often encounter the equation

$$x^2 + 1 = 0. \tag{E.2}$$

A number that satisfies Eq. (E.2) is not a real number. We note that Eq. (E.2) may be written as

$$x^2 = -1, \tag{E.3}$$

and we denote the solution of Eq. (E.3) by the use of an imaginary number $j1$, so that

$$j^2 = -1 \tag{E.4}$$

and

$$j = \sqrt{-1}. \tag{E.5}$$

An *imaginary number* is defined as the product of the imaginary unit j with a real number. Thus we may, for example, write an imaginary number as jb. A complex number is the sum of a real number and an imaginary number, so that

$$c = a + jb, \tag{E.6}$$

677

where a and b are real numbers. We designate a as the real part of the complex number and b as the imaginary part and use the notation

$$Re\{c\} = a \tag{E.7}$$

and

$$Im\{c\} = b. \tag{E.8}$$

E.2 Rectangular, Exponential, and Polar Forms

The complex number $a + jb$ may be represented on a rectangular coordinate place called a *complex plane*. The complex plane has a real axis and an imaginary axis, as shown in Fig. E.1. The complex number c is the directed line identified as c with coordinates a, b. The *rectangular form* is expressed in Eq. (E.6) and pictured in Fig. E.1.

Figure E.1. Rectangular form of a complex number.

An alternative way to express the complex number c is to use the distance from the origin and the angle θ, as shown in Fig. E.2. The *exponential form* is written as

Figure E.2. Exponential form of a complex number.

$$c = re^{j\theta}, \tag{E.9}$$

where

$$r = (a^2 + b^2)^{1/2} \tag{E.10}$$

and

$$\theta = \tan^{-1}(b/a). \tag{E.11}$$

Note that $a = r \cos \theta$ and $b = r \sin \theta$.

The number r is also called the *magnitude* of c, denoted as $|c|$. The angle θ can also be denoted by the form $\underline{/\theta}$. Thus we may represent the complex number in *polar form* as

$$c = |c|\underline{/\theta} \tag{E.12}$$
$$= r\underline{/\theta}.$$

■ Example E.1

Express $c = 4 + j3$ in exponential and polar form.

Solution First, draw the complex plane diagram as shown in Fig. E.3.

Figure E.3. Complex plane for Example E.1.

Then find r as

$$r = (4^2 + 3^2)^{1/2} = 5$$

and θ as

$$\theta = \tan^{-1}(\tfrac{3}{4}) = 36.9°.$$

The exponential form is then

$$c = 5e^{j36.9°}.$$

The polar form is

$$c = 5\underline{/36.9°}.$$

E.3 Mathematical Operations

The *conjugate* of the complex number $c = a + jb$ is called c^* and is defined as

$$c^* = a - jb \tag{E.13}$$

In polar form, we have

$$c^* = r\underline{/-\theta}. \tag{E.14}$$

To add or subtract two complex numbers, we add (or subtract) their real parts and their imaginary parts. Therefore, if $c = a + jb$ and $d = f + jg$, then

$$\begin{aligned} c + d &= (a + jb) + (f + jg) \\ &= (a + f) + j(b + g). \end{aligned} \tag{E.15}$$

The multiplication of two complex numbers is obtained as follows (note $j^2 = -1$):

$$\begin{aligned} cd &= (a + jb)(f + jg) \\ &= af + jag + jbf + j^2bg \\ &= (af - bg) + j(ag + bf). \end{aligned} \tag{E.16}$$

Alternatively, we use the polar form to obtain

$$\begin{aligned} cd &= (r_1\underline{/\theta_1})(r_2\underline{/\theta_2}) \\ &= r_1r_2\ \underline{/\theta_1 + \theta_2}, \end{aligned} \tag{E.17}$$

where

$$c = r_1\underline{/\theta_1} \quad \text{and} \quad d = r_2\underline{/\theta_2}.$$

Division of one complex number by another complex number is easily obtained using the polar form as follows:

$$\begin{aligned} \frac{c}{d} &= \frac{r_1\underline{/\theta_1}}{r_2\underline{/\theta_2}} \\ &= \frac{r_1}{r_2}\ \underline{/\theta_1 - \theta_2}. \end{aligned} \tag{E.18}$$

It is easiest to add and subtract complex numbers in rectangular form and to multiply and divide them in polar form.

A few useful relations for complex numbers are summarized in Table E.1.

Table E.1. Useful Relationships for Complex Numbers

(1) $\dfrac{1}{j} = -j$

(2) $(-j)(j) = 1$

(3) $j^2 = -1$

(4) $1\underline{/\pi/2} = j$

(5) $c^k = r^k\underline{/k\theta}$

■ Example E.2

Find $c + d$, $c - d$, cd, and c/d when $c = 4 + j3$ and $d = 1 - j$.

Solution First, we will express c and d in polar form as

$$c = 5\underline{/36.9°}$$

and

$$d = \sqrt{2}\,\underline{/-45°}.$$

Then, for addition, we have

$$c + d = (4 + j3) + (1 - j)$$
$$= 5 + j2.$$

For subtraction, we have

$$c - d = (4 + j3) - (1 - j)$$
$$= 3 + j4.$$

For multiplication, we use the polar form to obtain

$$cd = (5\underline{/36.9°})(\sqrt{2}\,\underline{/-45°})$$
$$= 5\sqrt{2}\,\underline{/-8.1°}.$$

For division, we have

$$\frac{c}{d} = \frac{5\underline{/36.9°}}{\sqrt{2}\,\underline{/-45°}}$$

$$= \frac{5}{\sqrt{2}}\,\underline{/81.9°}.$$

The Control System Design Program

F.1 Introduction

The Control System Design Program is a package of software tools organized to aid the engineer in designing feedback control systems. Given a single-input/single-output plant $G(s)$ and a controller $D(s)$ (Fig. F.1), the program provides the user with the following tools:

1. Open-loop time domain response to a step, ramp, or arbitrary input: data and graphical plot
2. Closed-loop time domain response to a step, ramp, impulse, or arbitrary input: data and graphical plot
3. Root locus data for a given gain
4. Open-loop frequency response (Bode plot): data and graphical plot
5. Closed-loop frequency response: data and graphical plot
6. State variable analysis: data and graphical plot

Figure F.1. Block diagram of a closed-loop system.

Using any or all of these techniques, it is possible for the designer to vary quickly and easily the gain and compensation to achieve the most desirable results.

F.2 Getting Started

F.2.1 Equipment Needed

To run the CSDP program, you need the following equipment, as a minimum:

1. IBM PC, XT, AT, or closely compatible system
2. One disk drive
3. 256K memory
4. CGA compatible graphics card
5. Color monitor or CGA compatible monochrome monitor
6. DOS 2.0 or later version

F.2.2 Customer Support

If you encounter technical problems in using this software, or find the diskette to be defective, you may obtain help by calling Addison-Wesley at one of the following numbers: Outside Massachusetts: (800)527-5210; Within Massachusetts: (617)944-3700 (Ask for the software hotline.)

F.2.3 Starting Up

The DOS operating system must be present prior to running CSDP and after quitting operation. To make a simple-to-use working copy, obtain a blank floppy diskette and follow these directions:

1. Insert the operating system (DOS) disk into drive A and turn the machine on. If the machine has a hard drive containing the operating system, then simply turn the computer on.
2. Format the blank disk using the "FORMAT A: /S" command followed by a carriage return ("/S" copies the DOS system files onto the blank disk). Following the instructions on the screen, remove the DOS disk, insert the blank disk, and press the Enter key.
3. When formatting is complete, remove the disk and insert the CSDP program disk. If you have a two-drive system, insert the newly formatted disk into drive B; otherwise, just continue. Copy the files CSDP.EXE and AUTOEXEC.BAT from the CSDP disk to the newly formatted disk by typing *COPY A:*. *B:*, followed by a carriage return. This will work with a one-drive system, but the disks will have to be swapped frequently.

 Note: For systems with a hard drive, the file CSDP.EXE can be copied to a directory on drive C by typing *COPY A:CSDP.EXE C:\ ⟨directory name⟩*.

4. Transfer the graphics printer driver program to your working disk, using the "COPY" command. On IBM machines the graphics program is called "graphics.com". If your system uses a different file name, then you must rename this file on your working disk.

The working disk is now ready. The file AUTOEXEC.BAT is provided to load the graphics printer driver and run CSDP as soon as you insert the disk and turn the machine on. Store the original CSDP disk someplace safe as a copy.

To run CSDP from the working disk, insert that disk into drive A. Turn on the computer. The program will automatically start after a few moments.

Note: Consult your DOS manual regarding utilities such as GRAPHICS.COM to allow output to be printed.

F.3 Main Task Menu Structure

The first choice you have to make occurs at the MAIN MENU. Here you are given three task sets to choose from: A, B, or C, depending upon which tool or tools you wish to use. The MAIN MENU screen looks like this:

```
         A                      B                      C
-  OPEN-LOOP TIME  -  CLOSED-LOOP TIME   -  STATE VARIABLE
   RESPONSE            RESPONSE             ANALYSIS

                  -  ROOT LOCUS
                     CALCULATION

                  -  OPEN-LOOP
                     FREQUENCY RESPONSE

                  -  CLOSED-LOOP
                     FREQUENCY RESPONSE
```

SELECT A TASK SET: A, B, OR C (OR TYPE 'Q' TO QUIT):

The tasks are broken up into these sets because each set has a different way of describing the system. The descriptions will be explained in the appropriate sections, and the differences should become clear.

The user must enter a system description the first time a particular task set is chosen. Once entered, the program will remember it (as long as you don't quit) and will give you the chance to modify the description every time you return to that task set. For task set B, you will enter the plant description and, if you choose, the compensator. You can then run any of the tools under task set B using this description.

In the following sections, each tool will be discussed. You will be told briefly what it does and what the system description looks like. A walk-through showing

the inputs is then given, and the expected outputs are discussed. The tasks are arranged in the order encountered in this text.

F.4 Task A: Open-Loop Time Response

F.4.1 Introduction

The open-loop time response is a method of determining the output of a system in time given the input signal and the plant description. In this case, the "open-loop" means that there is no feedback involved in the total system (see Fig. F.2).

Figure F.2. Block diagram of open-loop system.

The plant description for Task A, the open-loop time response, is represented by the s-domain transfer function:

$$P(s) = \frac{K * [\, b_n s^n + b_{n-1} s^{n-1} + \cdots + b_1 s + b_0\,]}{s^n + a_{n-1} s^{n-1} + \cdots + a_1 s + a_0} \tag{F.1}$$

The program shows it to you this way:

$$P(S) = \frac{K * [B(N)*S^N + B(N-1)*S^(N-1) + \cdots + B(1)*S + B(0)]}{S^N + A(N-1)*S^(N-1) + \cdots + A(1)*S + A(0)}. \tag{F.2}$$

Note that you are given the opportunity to specify equal order numerator and denominator polynomials. The numerator can be made a lower order by simply setting the higher order coefficients to zero. Also, because compensation does not usually occur in open-loop systems, it is assumed to be a simple gain, K.

F.4.2 Entering the Plant Description

To enter the coefficients, your plant description must be in the form shown above. This means that if a series of multiplicands are given, you must multiply them out to obtain the polynomial, making sure that the coefficient for s^n in the denominator is 1.

1. You are first asked for the order N of the system. Look at the denominator to figure this out; the largest order of s will tell you. Input this value. N has a minimum value of 1 and a maximum value of 10.

2. Next, enter the DENOMINATOR coefficients, starting with A(0). Make sure that each coefficient value is grouped with its proper order of s. For any orders of s not specified, enter a value of zero for that coefficient.

3. Then, enter the NUMERATOR coefficients, starting with B(0).

4. When you finish these steps, the values the computer received will be displayed for your review, and you will be asked if they are correct. Answer Y or N.

F.4.3 Adjustable Parameters

You are next asked to enter a couple of adjustable parameters. If you go to another task set and return to Task A, you will not need to reenter the plant description, but you will need to respecify these two parameters.

The first parameter is the gain, K. This can be any value except 0, which is not allowed. The second parameter is the simulation time increment, T, in seconds. The program calculates the output response incrementally, or in other words, at times 0, T, 2T, 3T, 4T, and so on, up to 80T. When all these points have been calculated, a "snapshot" of the response in time can be drawn on the screen. The duration of the response shown is given by the 80T. For example, if $T = 0.1$, the plot will range from $t = 0$ to $t = 8.0$ seconds.

T is a value (usually small and always greater than zero) that tells the program how often to calculate a new point. For responses with high frequency content, T should be small to resolve short duration events. For slowly changing responses, T can be longer to see a longer period of time. However, too large a value may make a stable system appear unstable. Trial and error may be required to find the best value of T, and this program is ideal for that. Start with a low value for T and increase it to obtain the total period 80T that you want while reviewing each response to verify it does not change due to changing T.

F.4.4 Input Function

The input specification is a general one for all three time-based response tools (open- and closed-loop response and state variable analysis). Thus this description will apply to all three tools.

The four choices of input function you can give to your system are IMPULSE, STEP, RAMP, and ARBITRARY. The IMPULSE function is described by the formula

$$\lim_{e \to 0} r(t) = \begin{cases} 1/e, & \text{if } 0 \le t \le e \\ 0, & t > e \end{cases} \tag{F.3}$$

and looks like a spike occurring at time zero. The program approximates this by letting $e = T$, the time increment you select.

The STEP function looks like an abrupt jump from zero to some constant value and is described by the formula

$$r(t) = \begin{cases} A, & t \ge 0 \\ 0, & t < 0. \end{cases} \tag{F.4}$$

You simply specify the amplitude A (height) of the step. It can be positive or negative, but not zero.

The RAMP function is a straight line sloping up or down away from t = 0 and is described by the formula

$$r(t) = \begin{cases} At, t \geq 0 \\ 0, t < 0. \end{cases}$$

You simply specify the slope A of the ramp. It can be positive or negative, but not zero.

The ARBITRARY function allows you to specify an arbitrary input of up to 80 points. You are prompted for the quantity of nonzero consecutive points, and then you enter them.

After choosing which input you want, you will have to wait a short time for the computer to do its work. Refer to Section F.12, "Error Messages," if an "overflow" occurs. The program is still operating.

F.4.5 Outputs: Data and Graphics

Two types of data output are available for all three time-based tools (open- and closed-loop response and state variable analysis). Thus this description will apply to all three tools.

After waiting, you are prompted for the first output type: Do you want to see the list of tabular data? If you answer Y, the calculated output value for each time increment is given. This is useful in determining various amplitudes on the graphic plot. If you choose, you may enter N and go on to view the graphical plot. You will have another opportunity later to view the data table.

You are next prompted to see if you want a screen plot, even if you answered N to the tabular data. If you answer N here, the program will go on to its final set of queries. If you want to see the plot, enter Y to view it. In addition to the plot, you get a set of basic data:

MAX VALUE:	Maximum value on the graph
MIN VALUE:	Minimum value on the graph
Tmax:	Time at which MAX VALUE occurs
Tmin:	Time at which MIN VALUE occurs
TIME INTERVAL:	Your entered value for T
INIT. VALUE:	Value at time t = 0
FIN. VALUE:	Value for the last time point
GAIN:	Your entered value for gain

You are again asked if you want to see the list of tabular data. If you enter Y, you may view it. You can go back and forth between the data and the plot as often as you want. If you answer N, the program goes on to the final questions.

F.4.6 Final Questions

You have the chance to change the time increment T and recalculate. This is desirable if you are trying to find the best value for T for your system and input. You also have the chance to change the gain, K, and redo the calculations.

If you want to try a different input type (with or without the same T or K values), type *Y* to either final question. Enter the values for T (and K, if necessary), and you will then be prompted to enter the input type. When you are through with the open-loop time response, just say *N* to these questions. You will then be returned to the MAIN MENU.

F.4.7 Example

The system we want to examine for the open-loop response is

$$P(s) = \frac{(s + 2)(s + 3)}{(s + 10)(s^2 + 4s + 5)}. \tag{F.6}$$

The program will not accept it in this form, so we multiply the terms out to obtain polynomials in the numerator and denominator:

$$P(s) = \frac{s^2 + 5s + 6}{s^3 + 14s^2 + 45s + 50}. \tag{F.7}$$

Now, we choose *A* at the MAIN MENU and proceed. You are shown the form that the equation must be in, and as you are faced with the following prompts, respond with the italic numbers shown below (enter "Return" after each entry):

INPUT THE PLANT ORDER N: *3*
INPUT THE DENOMINATOR COEFFICIENTS
A(0) = *50*
A(1) = *45*
A(2) = *14*
INPUT THE NUMERATOR COEFFICIENTS
B(0) = *6*
B(1) = *5*
B(2) = *1*
B(3) = *0*

Note that there was no s^3 term in the numerator, so B(3) was set equal to zero.

The next questions ask you to enter the gain, K, and the time interval, T. Enter 10 for K and .05 for T. Wait until the input type prompt comes up. When it does, we want to do a step input of height 1. Enter the italic values at the prompts.

F.5 Task Set B: Four Tools

F.5.1 The Menu

When you choose task set B, you will have four tools at your disposal, all having access to the same plant and compensator descriptions of Fig. F.1. The first time you type B at the MAIN MENU, you will have to enter the plant description and, optionally, the compensator description. You will then be presented with the following menu:

MENU FOR TASK SET B

1 CHANGE PLANT DATA FOR THIS TASK SET
2 INPUT OR CHANGE CONTROLLER DATA
3 CLOSED-LOOP TIME DOMAIN RESPONSE
4 ROOT LOCUS CALCULATIONS
5 OPEN-LOOP FREQUENCY RESPONSE
6 CLOSED-LOOP FREQUENCY RESPONSE
7 RETURN TO MAIN MENU

INPUT A NUMBER AND RETURN:

This section will cover each element in the above menu in the order shown. You are returned to this menu after completing any task within it. You will also go straight to this menu if you temporarily go to Tasks A or C and then return to B.

F.5.2 Plant Description

The plant description for Task B is represented by the s-domain transfer function:

$$G(s) = \frac{c_{n-1}s^{n-1} + \cdots + c_1 s + c_0}{s^n + d_{n-1}s^{n-1} + \cdots + d_1 s + d_0}. \tag{F.8}$$

The program shows it to you this way:

$$G(S) = \frac{C(N-1)*S^{\wedge}(N-1) + \cdots + C(1)*S + C(0)}{S^{\wedge}N + D(N-1)*S^{\wedge}(N-1) + \cdots + D(1)*S + D(0)}. \tag{F.9}$$

This transfer function differs from the open-loop time response (Task A) only in that the order of the numerator is always less than the order of the denominator.

To enter the coefficients, your plant description must be in the form shown above. This means that if a series of multiplicands are given for the polynomials, you must multiply them out, making sure that the coefficient for s^n in the denominator is 1.

Follow the menu to enter the coefficients as shown in Section F4.7. Once you are satisfied with the coefficients, the program will ask you if the controller is a simple gain. If so, this means that the compensation is described by K, a value chosen when a tool is selected. Answer Y, and you will be returned to the menu

for task set B. On the other hand, if your controller is also a transfer function, answer N and proceed to the next section. Note that a value for K is still expected for each tool.

F.5.3 Controller/Compensator Description

Before you enter the coefficients for the controller's transfer function, the program must first know if it has a higher order numerator than denominator. If not, answer N. The controller description will then be of the form:

$$D(s) = \frac{K * [\, s^m + p_{m-1}s^{m-1} + \cdots + p_1 s + p_0 \,]}{s^m + q_{m-1}s^{m-1} + \cdots + q_1 s + q_0}. \tag{F.10}$$

The program shows it as

$$D(S) = \frac{K * [S^M + P(M-1)*S^{(M-1)} + \cdots + P(1)*S + P(0)]}{S^M + Q(M-1)*S^{(M-1)} + \cdots + Q(1)*S + Q(0)}. \tag{F.11}$$

Note that here, the order of the numerator can equal that of the denominator. If the numerator order is less than the order of the denominator, set the higher coefficients of the numerator to zero. Note that K is included in the description but is specified while using the tools.

If the order of the numerator is greater than the order of the denominator, answer Y to the question. The controller transfer function will then be of the form

$$D(s) = \frac{K * [\, s^m + p_{n-1}s^{m-1} + \cdots + p_1 s + p_0 \,]}{s^{m-1} + q_{n-2}s^{m-2} + \cdots + q_1 s + q_0}. \tag{F.12}$$

The program shows:

$$D(S) = \frac{K * [S^M + P(M-1)*S^{(M-1)} + \cdots + P(1)*S + P(0)]}{S^{(M-1)} + Q(M-2)*S^{(M-2)} + \cdots + Q(1)*S + Q(0)}. \tag{F.13}$$

The data for either type are entered in the same fashion as for the plant description. The lower bound on the order M is 1. The upper bound depends on the order N of the plant. The sum of the two orders $(N + M)$ cannot exceed 10.

F.6 Closed-Loop Time Response

F.6.1 Introduction

The closed-loop time response is a method of determining the time response given the reference input signal and the plant and controller description. In this case, the "closed-loop" means that there is a unity gain feedback element added to the system (Fig. F.1). It may be instructive to compare the open-loop responses to the closed-loop to become acquainted with the advantages of adding feedback control.

F.6.2 Inputs

The plant description has already been entered, along with the controller, if desired. Thus when you choose menu item #3, you are only requested to enter the gain, K, and the time increment used for analysis.

 The gain, K, must be greater than zero for this case. The time increment, T, must also be greater than zero.

 Next, you will be required to enter the desired input function, r(t). You may choose an IMPULSE, a STEP, a RAMP, or an ARBITRARY function.

F.6.3 Outputs: Data and Graphics

The program will present you with tabular data and a graphical plot, if desired. The nature of these outputs is identical to the outputs for the open-loop time response, and the reader is directed to that section for more information. You have the chance to change the time increment T and recalculate. This is desirable if you are trying to find the best value for T for your system and input.

 You also have the chance to change the gain, K, and redo the calculations. If you want to try a different input type (with or without the same T or K values), type *Y* to either final question. Enter the values for T (and K, if necessary), and you will then be prompted to enter the input type. When you are through with the closed-loop time response, just say *N* to these questions. You will then be returned to the Menu for Task Set B.

F.7 Root Locus Calculations

F.7.1 Introduction

The root locus calculations will provide all the roots of the closed-loop system located in the s-plane for a particular gain. It also gives you the value of ZETA, the dimensionless damping ratio. By examining the locations of the roots of the system within the s-plane, it is possible to determine which gains will produce undesirable or unstable responses.

 One general approach to using this tool is to input a variety of gain values, starting at K = 0, and build a table of root values. Determine which gain values cause breakaway (the condition where two or more roots meet on the real axis and split away off the real axis, causing nonzero imaginary components). Once you have obtained enough root locations, you can plot them by hand on graph paper to see the general trends of the system as the gain varies. This plot is known as the *root locus*. An initial qualitative sketch will aid in the selection of gains and interpretation of the results.

F.7.2 Input

Only one input is required here: the gain value, K. It can be any value, positive, negative, or zero.

F.7.3 Output

A short wait is required for the calculations, but the program soon returns with the real and imaginary parts for each root, along with its value of ZETA. A pole that is canceled by a zero will still show up in the list of roots unless you recalculate the system description to explicitly remove the pole before entering the coefficients.

The program will then ask you if you want to perform the calculations again for a different gain value. If you answer *Y*, you will return to the input. You can do this as often as you need. If you answer *N*, you will return to the Menu for Task Set B.

F.8 Open-Loop Frequency Response

F.8.1 Introduction

The open-loop frequency response is a tool for determining the amplitude and phase angle with respect to frequency for a particular system description. It is commonly referred to as a "Bode plot." The "open-loop" refers to the fact that there is no feedback component assumed in the calculations. The frequency response is dependent upon the gain value, K, and allows you to determine gain and phase margins in a system. These margins will give you an idea of the relative stability of the system in the closed-loop condition. You also have a general idea of which frequencies will be passed and which will be rejected, and you will be able to determine phase distortion values.

F.8.2 Inputs

The frequency response is calculated over a range of frequencies defined by the user by specifying the number of decades you want to view and the low-end frequency value in units of radians/sec. For example, if you want to calculate the frequency response from 0.1 rad/sec to 100 rad/sec, you would request *3* decades with a low-end frequency value of *0.1* rad/sec. The low-end frequency value is not limited to powers of 10 but can be any frequency you desire. The range of decades allowed is 1 to 6, and the frequency value must be greater than zero.

The desired gain value, K, is entered next. It must be greater than zero. You are then asked to wait a short time while the program calculates the numbers. When it is finished, it asks you if you would like to view the tabular data. If you answer *Y*, the data will be presented. If you answer *N*, the program then asks if you want to see the screen plot. This gives you an opportunity to view the Bode plot first; you are given a chance to see the tabular data after that if you desire.

F.8.3 Outputs

The program calculates 30 points of output data over the two-decade range. The tabular data will appear as:

THE GAIN IS 5

RAD/SEC	MAG	DB	PHASE
.1	1.007	.06	−5.769
.12	1.01	.087	−6.943
.14	1.013	.119	−8.128
.	.	.	.
.	.	.	.
.	.	.	.

Two screens of data are presented, one decade at a time. The frequency increases in a logarithmic fashion, as is characteristic of Bode plots.

The table headings have the following interpretations:

RAD/SEC: Radian frequency used for a particular calculation
MAG: Magnitude, or the (output/input) ratio
DB: Logarithmically scaled magnitude: 20 log(out/in)
PHASE: Phase angle, in degrees

After viewing the tabular data, you have a chance to see a graphical plot of the data. Should you want to review the tabular data again, you will have the chance.

The Bode plot you will see shows the magnitude (in decibels, db) and phase plots for the number of frequency decades you chose. If the zero db line is crossed in this interval, a horizontal line indicating "0 db" will be added to the graph. Similarly, if the −180 degree line is crossed by the phase plot, a "−180 DEG" line will be indicated. Other data are provided with the plot:

MAX.MAG: Maximum magnitude, in db
MIN.MAG: Minimum magnitude, in db
MAX.PHASE: Maximum phase, in degrees
MIN.PHASE: Minimum phase, in degrees
GAIN value: Gain value entered

A horizontal logarithmic scale of frequency values is also shown at the bottom of the plot. Vertical values of magnitude and phase are not provided but can be obtained from the tabular data.

After viewing the plot, you are given another chance to view the tabular data. Thus you can go back and forth between the tabular data and graphical plot as desired.

When you are through viewing the tabular and plotted data, you are presented with a couple of final questions allowing you to retry the system using different input parameters. The first question asks if you want to use a different number of decades. Answer *Y* if you want to change the number of decades and/ or the low-end frequency value.

If you want the same range of frequencies but a different gain value, answer *N* to the prior question. The following question will give you the chance to change the gain, K, and redo the calculations.

When you are through with the open-loop frequency response, just say *N* to these questions. You will then be returned to the Menu for Task Set B.

F.9 Closed-Loop Frequency Response

F.9.1 Introduction

The closed-loop frequency response is a tool for determining the amplitude and phase angle with respect to frequency of a particular system description. It is commonly referred to as a "Bode plot." The "closed-loop" refers to the fact that there is a unity gain feedback component assumed in the calculations (Fig. F.1). The frequency response indicates which frequencies will be passed and which will be rejected, allowing you to determine the closed-loop bandwidth as a measure of system fidelity. Altering the gain, K, will modify the system's response to certain frequencies and the system's relative stability.

F.9.2 Inputs

The frequency response is calculated over a range of frequencies defined by the user by specifying the number of decades you want to view and the low-end frequency value in units of radians/sec. For example, if you want to calculate the frequency response from 1 rad/sec to 100 rad/sec, you would request 2 decades with a low-end frequency value of 1 rad/sec to be evaluated. The low-end frequency value is not limited to powers of 10 but can be any frequency you desire. The range of decades allowed is 1 to 6, and the frequency value must be greater than zero.

The desired gain value, K, is entered next. It must be greater than zero. You are then asked to wait a short time while the program calculates the numbers. When the program is finished, it asks you if you would like to view the tabular data. If you answer *Y*, the data will be presented. If you answer *N*, the program then asks if you want to see the screen plot. This gives you an opportunity to view the Bode plot first; you are then given a chance to see the tabular data.

F.9.3 Outputs

The program will present you with tabular data and a graphical plot, if desired. The nature of these outputs is identical to the outputs for the open-loop frequency response, and the reader is directed to Section F.8 for more information. To review, the data at the top of the graph are interpreted as follows:

MAX.MAG: Maximum magnitude, in db
MIN.MAG: Minimum magnitude, in db

MAX.PHASE: Maximum phase, in degrees
MIN.PHASE: Minimum phase, in degrees
GAIN value: Gain value entered

A horizontal logarithmic scale of frequency values is also shown at the bottom of the plot. Vertical values of magnitude and phase can be obtained from the tabular data.

When you are through viewing the tabular and plotted data, you are presented with a couple of final questions allowing you to retry the system using different input parameters. The first question asks if you want to use a different set of decades. Answer *Y* if you want to change the number of decades or the low-end frequency value.

If you want the same range of frequencies but a different gain value, answer *N* to the prior question. The following question will give you the chance to change the gain, K, and redo the calculations.

When you are through with the closed-loop frequency response, just say *N* to these questions. You will then be returned to the Menu for Task Set B.

F.10 State Variable Analysis

F.10.1 Introduction

State variable analysis provides a time-domain approach to solving a system. It is able to handle time-varying systems, and the calculations are facilitated by the use of the computer. This gives some distinct advantages over the more traditional frequency-domain approaches when systems have more than one variable or parameters that vary in time.

The state variable representation of a system consists of a series of independent, first-order differential equations—one equation for each distinct state variable. When the equations are rewritten in matrix form, it is then possible to enter the elements of the matrices and vectors into the program. Once this is done, an input type (as specified in the open-loop TIME response) is chosen, and the time-domain output response is calculated and presented.

F.10.2 Entering the Matrix Elements

The system is described by the state equations (given in matrix form)

$$\dot{x} = Ax + bu \qquad\qquad (F.14)$$

and

$$y(t) = [\, c_1\ c_2 \cdots c_n\,] \begin{bmatrix} x_1 \\ x_2 \\ \cdot \\ \cdot \\ x_n \end{bmatrix}. \qquad\qquad (F.15)$$

Because the state variables $[x_1\ x_2\ \ldots\ x_n]$ are solutions to first-order differential equations, it is also necessary to specify an initial state vector, meaning a series of initial values. This vector, $[x_1(0)\ x_2(0) \ldots x_n(0)]$, is entered later, when the type of input function is chosen. Note that the input, u(t), and the output, y(t), are single variables. This is because the program works with single-input, single-output systems.

The program expects you to enter the elements of matrix **A** and vectors **b** and **c**. It prompts you this way:

This task solves the STATE EQUATION: DX/DT = A*X + B*U X(0)
KNOWN

with OUTPUT EQUATION: Y = C*X

MATRIX A IS NxN—INPUT THE SYSTEM ORDER N:

The system order N must not be less than 1 or exceed 10.

You are then asked to input the elements of the **A** matrix, starting with A(1,1), A(1,2), and so on, up to A(N,N). If you made a mistake typing in the value, don't worry. You'll have a chance to correct it later.

Next, enter the elements for **b** and **c** vectors as prompted. Once again, there will be an opportunity to correct typing mistakes.

Once you complete an analysis using this tool (Task C), you are returned to the main menu. If you choose Task C again later, you are prompted first with a question: Do you want to review or change the state equation previously entered? If you want to enter an entirely new system, answer yes and you will be presented with the menu for matrix **A** just described. Then typing *S* at the arrow prompt will allow you to enter a new system description.

F.10.3 Methods of Calculation: The Phi and Gamma Matrices

The program solves the *continuous-time* state equations by finding and solving the discrete-time equivalent system

$$x[(n + 1)T] = \text{PHI}(T)*x[nT] + \text{GAMMA}(T)*u[nT]. \qquad (F.16)$$

For each point in discrete time, n, x_n is known and u_n is given. PHI and GAMMA are functions of matrix **A** and vector **b**, so it is possible to calculate the next point in time. T is a small interval of time that the user enters. Thus continuous time, t, is divided into equally spaced increments of nT along the time axis. The next state output $(x[(n + 1)T])$ is calculated on the basis of the previous one.

Hence, before the PHI and GAMMA matrices can be calculated, the value for T must be entered at the appropriate prompt. You will then be asked to enter the number of terms in the EXP(At) series. For the calculations, the computer approximates the exponential exp(At) using a series approximation. Usually four to seven terms are adequate for this approximation.

F.10.4 Entering the Input Type

Next, you will be required to enter the desired input function, u(t). You may choose an IMPULSE, a STEP, a RAMP, or an ARBITRARY function. Refer to Section F.4, "Open-Loop Time Response," for further details about these inputs.

Once you have chosen the input type, the program requires the initial state vector, $[x_1(0)\ x_2(0)\ \ldots\ x_n(0)]$, or $\mathbf{x}(0)$. These values are entered one at a time, as prompted.

F.10.5 Outputs: Data and Graphics

The program will present you with tabular data and a graphical plot, if desired. The nature of these outputs is identical to the outputs for the open-loop time response, and the reader is directed to Section F.4 for more information.

The data information at the top of the graph is the same as for other time response tools except for the lack of a GAIN value, which is not necessary for this task. The data are interpreted as follows:

MAX VALUE: Maximum value on graph
MIN VALUE: Minimum value on graph
Tmax: Time at which MAX VALUE occurs
Tmin: Time at which MIN VALUE occurs
TIME INTERVAL: Value entered for T
INIT. VALUE: Value at time $t = 0$
FIN. VALUE: Value for the last time point

Recall that you can go back and forth between the tabular data and the graphical plot as often as you need, just by answering Y to the appropriate questions. When you are satisfied, answer N, and you will be returned to the MAIN MENU.

F.11 Compensation of Feedback Systems

Compensation can be implemented explicitly by the designer in CSDP only for the tools in Task Set B. Compensation is rare for open-loop time responses, and for state analysis it is best added prior to using CSDP. For Task Set B tools, however, it is quite easy to add and remove compensation networks by choosing Task 2 while at the "Menu for Task Set B." The controller/compensator description was described fully in the previous section introducing Task Set B. (See Eq. F.12.)

The advantage of CSDP is that you have the freedom to access a variety of tools for the same system. Each tool gives you a different perspective on a particular system. As this last example showed, it is wise not to limit yourself to just one tool when solving a problem, but rather to submit the system to other tools. It may provide insight, uncover problems, or reassure you that your methods were correct.

F.12 Error Messages

There are a few types of error messages you may encounter while using CSDP. To help you deal with these conditions, a review of the error types you may encounter is presented here.

Note: None of these errors will stop the program from running. They are considered to be warnings.

F.12.1 Input Errors

If you get any messages, the most likely occurrence is during an input. This is a list of some of the warnings you may encounter:

?Redo from start: This warning usually means that you entered a non-numeric value for an input expecting a number, such as a coefficient of the plant description. All you must do is just retry that input.

***> Not a valid input** (or a variation): This means that your input was inappropriate. Maybe you entered a letter where a number should have gone. This message also occurs when you try to choose a menu selection that doesn't exist.

***> Value out of range:** Some inputs, such as the system order, N, have a certain range of values they will accept. Only use these values.

Most other input-type errors should be self-explanatory.

F.12.2 Run-Time Errors

There is only one error message which may occur during calculations:

Overflow: This warning signals that the program has an intermediate result that exceeded its largest number. There is very little chance you will ever see this error because the program will usually anticipate this problem. In rare cases, however, it might arise and stop the program. Reevaluate your entries to make sure they are valid.

ANSWERS

Chapter 1

1.1

1.7 The feedback is positive.
Time lost per day = ⅝ minutes.
Total error after 15 days = 25 minutes.

Chapter 2

2.1 $R_1 i_1 + \dfrac{1}{C_1} \int i_1 dt + L_1 \dfrac{d(i_1 - i_2)}{dt} + R_2(i_1 - i_2) = v(t)$ loop 1.

$L_2 \dfrac{di_2}{dt} + \dfrac{1}{C_2} \int i_2 dt + R_2(i_2 - i_1) + L_1 \dfrac{d(i_2 - i_1)}{dt} = 0$ loop 2.

2.4 a) $v_o = \dfrac{v_{in}}{2}$ for $-0.5 \le v_{in} \le 0.5$.

b) $v_o = 2v_{in} - 1$ for $0.5 \le v_{in} \le 1.5$ or $\Delta v_o = 2\Delta v_{in}$

2.7 $T(s) = \dfrac{s + 1/R_1 C}{s + (R_1 + R_2)/R_1 R_2 C}$.

2.8 $T(s) = \dfrac{s^2 + 4s + 8}{s^2 + 8s + 8}$.

2.14 $\dfrac{\theta(s)}{V_f(s)} = \dfrac{0.0278}{s(s + 1.39)}$.

2.16 $x_1 = 2; x_2 = 3$.

2.18 $T(s) = \dfrac{V_2(s)}{V_1(s)} = \dfrac{Y_1 Z_2 Y_3 Z_4}{1 + Y_1 Z_2 + Y_3 Z_2 + Y_3 Z_4 + Y_1 Z_2 Z_4 Y_3}$.

2.20 a) $\dfrac{e_0}{e_{in}} = \dfrac{g_m R_s}{1 + g_m R_s}$.

 b) $\dfrac{e_0}{e_{in}} = \dfrac{20}{21}$.

2.25 $C(s) = G(s)R(s)$.

 With the effect of the disturbance eliminated.

Chapter 3

3.1 a) Open loop $S_R^T = \dfrac{1}{RCs + 1}$.

 Closed loop $S_R^T = \dfrac{-KR}{RCs + 1 + KR}$,

 where

$$T(s) = \dfrac{G_1(s)}{1 + KG_1(s)}.$$

3.3 a) Closed loop $T(s) = \dfrac{KG_1(s)}{1 + KK_t G_1(s)}$; $G_1(s) = \dfrac{1}{\tau s + 1}$; $S_K^T = \dfrac{1}{1 + KK_t G_1(s)}$.

 b) $T(s) = \dfrac{G_1(s)}{1 + KK_t G_1(s)}$ $T_e(s) \approx \dfrac{T_e(s)}{KK_t}$.

 c) $e_{ss} = A/1 + KK_t$ closed-loop error.

3.7 a) $C(s) = \dfrac{G(s)T_L(s)}{1 + G_c(s)G(s)H(s)}$

 b) $S_{K_2}^T = \dfrac{1}{1 + G_c GH(s)}$

 c) $e_{ss} = 1 - \dfrac{1}{k_3}$

3.11. a) $T(s) = \dfrac{G_c G}{1 + G_c G} = \dfrac{K}{20s^2 + 12s + 1 + K}$

 b) $S_K^T = \dfrac{(10s + 1)(2s + 1)}{20s^2 + 12s + 1 + K}$

3.12 c) $S_{K_1}^{T_1} = 0.01; S_{K_1}^{T_2} = 0.1$.

Chapter 4

4.1 a) $E(s) = \dfrac{R(s)}{1 + K_a K_m K_t/(s\tau_m + 1)}$

 b) $K_a K_m \geq 24$

 c) $K_a K_m \geq 39$.

4.5 a) $T(s) = \dfrac{2}{s^2 + 2s + 2}$; $\zeta = 1/\sqrt{2}$.

c) ITAE for step input

$$T(s) = \dfrac{\omega_n^2}{s^2 + 1.4\omega_n s + \omega_n^2} ; \zeta = \dfrac{1}{\sqrt{2}}$$

$$= \dfrac{2}{s^2 + 2s + 2} .$$

4.7 a) A type one system, $K_p = \infty$, $K_v = 1/K_3$.

b) Set $\zeta = 0.6$, $\omega_n = 120$ and $K_1 K_2 = 36 \times 10^4$.

4.9 $K_v = 2.05$.

4.12 $T(s) = \dfrac{3.25\omega_n^2 s + \omega_n^3}{s^3 + 1.75\omega_n s^2 + 3.25\omega_n^2 s + \omega_n^3}$; $\omega_n = 6$

Chapter 5

5.1 a) Stable

b) Stable

c) Unstable

d) Unstable

5.10 $0 \le K \le 28.1$.

5.13 a) $0 < K < 32.3$.

Chapter 6

6.1 a) $\phi_A = +60°, -60°, -180°$.

$\sigma_A = -\frac{2}{3}$.

Locus crosses imaginary axis at $K = 2$ and $s = \pm j1$.

Breakaway from real axis at $s = -\frac{1}{3}$.

6.5 a) $K_2 = 1.6$; complex roots: $s = -3.83 \pm j3.88$.

real roots: $s = -1.33, -0.045$.

6.8 Require a zero degree locus, $\underline{/GH} = 0°, \pm 360°, \ldots$.

6.14 Stable for $320 \le K \le 27,000$.

6.26 b) Stable for $K \ge 2$.

c) $K = 2$, $s = \pm j1.4$.

d) Complex roots do not dominate.

6.29 $K = 7.35$.

6.30 $S_R^{r1} = \frac{5}{6}$; $S_R^{r2} = -\frac{10}{3}$.

Chapter 7

7.1 a)

ω	0	1	5	∞		
$	GH	$	1	0.4	0.037	0
ϕ	0°	−90°	−153°	−180°		

7.2 a)

ω	0.5	1	2	8
db	−3.27	−8	−15.3	−36.4
ϕ	−59°	−90°	−121°	−162°

7.3 b) Evaluate at $\omega = 1.1\omega_n$.

Twin T: $|G| = 0.05$.

Bridged T: $|G| = 0.707$; A narrower band filter.

7.6 a) $GH(s) = \dfrac{0.8(5s + 1)}{s(0.25s + 1)^2}$.

7.14 $G(s) = \dfrac{809.7}{s(s^2 + 6.35s + 161.3)}$.

Chapter 8

8.2 a) $K < 4$ for stability.

8.6 a) Phase margin $= +20°$.

Gain margin $= +6$ db.

b) $Mp_\omega = 10.5$ db at $\omega_\gamma = 0.0075$.

8.8 a) Phase margin $= -9°$, unstable.

$\omega_c = 49$.

8.9 a) $\omega_c = 8$ and phase margin $= 83°$.

8.12 a) Phase margin $= 27°$, stable.

b) Phase margin $= 13°$, stable.

8.17 $K = 3$ yields phase margin $= 30°$.

8.18 a) $K_1 = 95$.

Chapter 9

9.1 c) $\dot{x} = \begin{bmatrix} -R/L & -1/L \\ 1/C & 0 \end{bmatrix} x + \begin{bmatrix} 1/L \\ 0 \end{bmatrix} u(t)$, where $x_1 = i$, $x_2 = v_c$.

9.6 a) For stability; $h > k$, $ab > kh$.

b) When $h > k$, then rabbits grow in number.

9.10 b) Unstable system.

9.11 a) $\phi(t) = \begin{bmatrix} (2t + 1)e^{-t} & -2te^{-t} \\ 2te^{-t} & (-2t + 1)e^{-t} \end{bmatrix}$.

b) $x_1(t) = x_2(t) = 10e^{-t}$.

9.14 a) System is unstable.

b) Add $r(t) = -Kx_2(t)$; then stable for $K > 1$.

Chapter 10

10.1 a) Lead network compensation:

$$G(s) = \frac{20}{s^2}.$$

$$G_c(s) = \frac{(s/2.8) + 1}{(s/22.4) + 1}.$$

Phase margin $\simeq 50°$.

b) Root locus, choose $\zeta = 0.5$, $\omega_n = 4.5$.

$$G_c(s)G(s) = \frac{40(s + 2.28)}{s^2(s + 9.0)}.$$

10.5 $G_c(s) = K_2 + \dfrac{K_3}{s} = \dfrac{K_2 s + K_3}{s}.$

$e_{ss} = 0.$

One solution: Let $K_3/K_2 = 0.1$ and cancel one pole of $G(s)$,

set $\zeta = 0.6$, $\zeta\omega_n = 5$, $\omega_n = 8.333$,

roots $s = -5 \pm j6.67$.

10.6 Set phase margin $= 60°$.

$$G_c(s)G(s) = \frac{1000(s/10 + 1)}{(s/70 + 1)(0.1s + 1)(10s + 1)}.$$

10.9 Desire $K_v = 33.3$, use root locus.

Desire complex roots at $s = -3.2 \pm j3.2$ ($\zeta = 0.7$).

10.11 $J = p_{11} = \dfrac{1}{2(2k - 3)}$, so desire k large.

10.12 a) $J = \dfrac{(1 + \lambda k^2)}{2(2k - 3)}.$

b) $\lambda = 1$; $k = 3.3$.

10.13 $J = 1/(2k - 1).$

10.15 $k = 0.9$ for minimum J.

10.16 c) For Problem 10.15: $k = 0.9$.

Roots $s = -0.45 \pm j0.835$; $\zeta = 0.47$.

10.17 $k_2 = \sqrt{20}$ for minimum J; $J = \dfrac{k_2^2 - 20}{8k_2}.$

10.18 Set zero at $s = -15$; then find pole at $s = -63$. Then $K_v = 15$.

Chapter 11

P11.2 (b) $|S| = 0.3$ at $\omega_B/4$

P11.3 (a) Stable for $K < 10$

P11.8 (a) $K_a = 383$

Chapter 12

P12.1 $G_c(s) = -\dfrac{200(s^2 + 160s + 8900)}{s}$

PID controller